Escritos de cine

Daniel C. Narváez

Título original: Escritos de cine.

Primera edición: 2017.

© 2017, Daniel C. Narváez.

© Diseño de portada: Jana Navrátilová.

Quedan prohibidos, dentro de los límites establecidos en la ley y bajo los apercibimientos legalmente previstos, la reproducción total o parcial de esta obra por cualquier medio o procedimiento, ya sea electrónico o mecánico, el tratamiento informático, el alquiler o cualquier otra forma de cesión de la obra sin la autorización previa y por escrito de los titulares del copyright. Diríjase a CEDRO (Centro Español de Derechos Reprográficos, http://www.cedro.org) si necesita reproducir algún fragmento de esta obra.

ISBN: (Tapa blanda) 978-1545563434.

ISBN: (Libro electrónico) 1545563438.

"Dentro, al final de una habitación de techo bajo, negra como la boca de un lobo, el cuadrado de la pantalla, seis pies de alto, no mayor que un hombre, resplandece a través de la gran cantidad de público, una masa mesmerizada y sujeta a sus asientos por este ojo blanco de mirada fija."

Alfred Döblin

INDICE

Prólogo	7
La vision cinematográfica de D. W. Griffith	9
El cine del expresionismo alemán	27
Arte e ideología en Eisenstein	69
Representaciones de la angustia en el cine de Bergman y Dreyer	104
Leni Riefenstahl: el cine del odio	123
Bibliografía	143

PRÓLOGO

El presente libro reúne una serie de artículos publicados en diversas revistas especializadas en análisis del hecho cinematográfico. Aunque se ha conservado el contenido inicial, los textos se han revisado para corregir algunas imperfecciones de estilo y algún error ortográfico, por otro lado, siempre presentes en la edición de textos. En casos muy puntuales se han actualizado algunos datos.

Los artículos seleccionados analizan la obra de directores como David Wark Griffith, Serguei M. Eisenstein, Ingmar Bergman, Carl Th. Dreyer y Leni Riefenstahl; autores que aportaron un alto componente estético y teórico a la realización cinematográfica, desde posturas ideológicas tan dispares como el liberalismo anglosajón en Griffith, no exento de tintes racistas, el comunismo de Eisenstein, la simpatía con el nazismo en el caso de Riefenstahl y la angustia existencialista en el caso de los escandinavos Dreyer y Bergman.

Se incluye también un capítulo sobre el expresionismo cinematográfico alemán que es fruto de fundir en un único textos dos artículos publicados en su momento y que se acercaban a este movimiento desde dos perspectivas diferentes. Por un lado, la que atendía a la estética propia del lenguaje cinematográfico, y por otro, una que relacionaba las propuestas cinematográficas con las teorías de la arquitectura coetáneas a dicho movimiento artístico.

En cualquier caso, se trata de textos que se analizan temas, autores y argumentos desde una perspectiva muy personal, lo que no quita el rigor a la hora de cruzar estos temas con otros autores y puntos de vista, por ello, cada capítulo concluye con la bibliografía empleada en el momento de la redacción de cada uno de ellos.

Tan solo queda recomendar al lector que, durante el proceso de lectura de los capítulos, establezca su propio diálogo con las películas que se mencionan a lo largo de estas páginas.

ESCRITOS DE CINE

LA VISIÓN CINEMATOGRÁFICA DE D. W. GRIFFITH.

Nacido en Kentucky en 1875, hijo de un oficial sudista arruinado por la Guerra de Secesión, ejerció numerosos oficios: ascensorista, vendedor de libros, redactor de una revista baptista, crítico y actor de teatro, medio para el cual escribió la obra *El tonto y la chica* representada sin mucho éxito en Washington y Baltimore. En 1907 trabaja como actor en el film *Nido de águilas* del pionero cinematográfico Edwin S. Porter.

Su primera película la realiza en 1908: *The adventures of Dolly* (Las aventuras de Dorotea) iniciando un fructífero periodo de producción para la productora Biograph.

Desde 1908 hasta 1914 realizó más de cuatrocientas películas adaptando para ellas a Shakespeare, Poe, Jack London, Stevenson y Dickens; además de narrar historias del western, la reconstrucción histórica, la parábola social y muchos otros géneros. En 1916 inicia una serie de grandes producciones *The birth of a nation* e *Intolerance* –en las que se formaron como ayudantes de dirección nombres como Allan Dawn, Tod

Browning y Erich von Stroheim–, las cuales marcan su época de esplendor y al mismo tiempo su declive.

Junto a Douglas Fairbanks, Mary Pickford y Charles Chaplin, fue uno de los fundadores de la compañía independiente United Artists.

Tras realizar *Abraham Lincoln* (1930), su primer film sonoro interpretado por Walter Huston, la carrera de Griffith pierde consistencia y apenas un año después rueda su último film: *The struggle* (La lucha, 1931) auténtico fracaso en su carrera, tras lo cual no volvió a dirigir.

D. W. Griffith falleció en 1948 a la edad de 73 años olvidado por el Hollywood que el mismo ayudó a construir y consolidar.

Cuestiones de técnica cinematográfica.

Griffith no sólo es uno de los cineastas más prolíficos de la historia del séptimo arte, sino que a él se le deben la gran mayoría de los recursos artísticos de los que se vale el cine. Si a Méliès se le atribuye la paternidad de los primeros efectos especiales, al realizador norteamericano se le debe la sistematización del lenguaje narrativo cinematográfico como señala Gimferrer (1985: 11): "A partir de Griffith, el cine se convierte en un lenguaje narrativo estructurado según los módulos de la narrativa decimonónica, en el que el montaje alterna las diversas posibilidades del plano, desde el primer plano hasta el plano general". Sus innovaciones técnicas, tales como el primer plano, el flash back, el plano corto y plano largo, el montaje paralelo, continuidad dramática, persiguen crear un lenguaje narrativo plenamente desarrollado.

Para Griffith el plano es el poseedor de la carga dramática por excelencia y en consecuencia privilegia el

uso del primer plano, que hasta el momento era un simple recurso de presentación de los personajes, como parte fundamental de la narración fílmica y alternándolo dentro de los planos que constituyen el hilo narrativo. De la misma manera introdujo el efecto de mostrar el pensamiento de los protagonistas por medio del corte directo tras un primer plano y pasar a la imagen que se supone pensada.

Todos estos recursos los logra poner en escena gracias a la técnica del montaje, con el que conseguirá acrecentar las sensaciones que pretende transmitir, recurriendo a las acciones paralelas –heroína en peligro/salvador que tarda en llegar– como elemento de máximo dramatismo (Brunetta, 1987).

La estructura narrativa de sus historias, siguiendo la influencia ejercida en él por el pionero de la cinematografía Erwin Porter, se desarrolla, invariablemente, según el esquema:
1. Presentación dentro del marco moral/social preestablecido.
2. Alejamiento del protagonista de las "buenas" normas de comportamiento.
3. Peligro.
4. Salvación, con intervención del inevitable *agente externo*, y reunión de nuevo en el marco inicial.

El *last minute rescue* –presente desde su primer film *The adventures of Dolly*– el elemento griffithiano por excelencia. Este típico recurso se basa en el montaje alterno, por el cual Griffith, en palabras de Dell'Asta (1998:301) "crea el suspense por medio de un montaje cada vez más rápido entre la imagen de un personaje en peligro y la del salvador que acude en su ayuda". Este recurso alcanza su mayoría de edad en la secuencia final de *The birth of a nation*: la cabalgata de los jinetes del Ku Klux Klan. Se hace evidente el simbolismo y el

doble papel que juega el rescate; puesto que los defensores de la cabaña representan los buenos valores de la nación perfecta –el Sur– el rescate *in extremis* supone un soplo de esperanza para quienes creen en dichos pilares morales. El Klan –según el punto de vista de Griffith– adopta el papel de guardián y garantizador del puritanismo y la moralidad americana.

Así es paradójico comprobar las opiniones existentes con respecto al film; por un lado, *The birth of a nation* destaca por su maestría técnica, por otro el mensaje de tintes racistas la cubre con un velo de descrédito, el cual en ocasiones hace ver en Griffith a una víctima de la intolerancia que el mismo intentara combatir con su film *Intolerance*. En esta línea, Caparrós (2009:14) ofrece la siguiente valoración: "El nacimiento de una nación (1915), obra clave de la cinematografía mundial, sobre todo a nivel de lenguaje, que sería tachada de panfletaria en más de un país [...] La particular visión que ofrecía David Wark Griffith de la Guerra de Secesión y el problema de los negros del sur, levantó airadas protestas, incluso en USA, por su exarcebado racismo y por el fondo político de sus palpitantes imágenes".

La construcción de la secuencia final por medio del montaje predispone al espectador a aceptar –si fuera por unos instantes– el discurso propuesto como señala Arnheim (1976: 70): "el final de El nacimiento de una nación (1915), con su last minute rescue que ocupa una gran parte del relato, juega de manera deliberada con la angustia provocada en el espectador por la forma del montaje alternado, con la intención clara de forzar la simpatía por los salvadores".

En los finales de sus películas se asiste a un despliegue de fuerzas del bien para acabar con el peligro que se cierne sobre el esforzado héroe/heroína, recurriendo, si es preciso, a la truculencia para dar

entrada en escena a los agentes externos, que en ocasiones tienen un origen sobrenatural[6]. En este sentido, Pudovkin (1976:70) reflexionaba sobre este recurso con las siguientes palabras:

> El tempestuoso final de los films de Griffith se halla construido de modo que la agitación tumultuosa de los protagonistas repercute con eficacia progresiva en el espectador hasta alcanzar niveles insospechados. El efecto se logra frecuentemente gracias a la introducción de elementos como viento, tempestad, hielos que se rompen, ríos que se desbordan, precipitarse de cascadas.

Aunque no siempre esa truculencia ha de tener una manifestación espectacular. En el caso de *Enoch Arden* (1911), basado en un poema de Alfred Tennyson, se limita al empleo de la iluminación –contraluces, iluminación artificial graduada...– para culminar con la apertura de una ventana por la que la luz que entra tiene un simbolismo regenerador.

El mundo y su orden.

Una de las principales características de la obra de Griffith es la presencia de la moralidad a lo largo de su carrera. Partiendo de la simplicidad maniquea de sus primeras realizaciones, en las cuales sólo distingue bueno–malo según el esquema ya expuesto, deriva a una tenue carga filosófica que le hace filmar una serie de episodios sobre la intolerancia.

La moral de lo bueno y de lo malo que define su mundo sirve de pretexto para consumar una serie de estratificaciones sociales atendiendo a un esquema dualista –contraposición de parejas– que corresponde al

tipo: rico–pobre, negro–blanco, hombre–mujer y tras el cual se esconde la única división existente para él: héroe–villano. De este esquema se desprende una rudimentaria sociedad de clases que atendiendo a cada historia – film– quedaría reflejada de la siguiente manera:

Filme	Héroe /Heroína	Villano
The birth of a nation	Hombre blanco	Hombre negro
Broken blossoms	Mujer resignada	Hombre alcohólico

El mundo en el que se desarrollan sus dramas está asentado sobre una serie de valores morales de carácter maniqueo que, por otra parte, sientan escuela en la cinematografía estadounidense.

La ordenación de su *mundo* es la del viejo Sur, en el que impera una utópica armonía. Este punto queda claramente de manifiesto en *The birth of a nation*, film en el cual el Sur es el hogar de una exquisita aristocracia de terratenientes. En esta sociedad cada individuo tiene asumida una tarea que de ser alterada trastocaría el buen funcionamiento; es decir, el blanco es el patrón, y el negro es el obrero; división que, en Griffith, lejos de ser de base racista, responde a la defensa de la tradición; y, parafraseando palabras de Kant, se podría decir que la moralidad del individuo *griffithiano* consiste, además, en cumplir los deberes de su clase.

En cuanto a los habitantes de su *mundo* siempre son los mismos: "madres prematuramente envejecidas por el infortunio, cuyo destino invariable es contemplar entre lágrimas la fotografía del hijo ausente, y unas hijas virginales, siempre inmaculadamente compuestas y siempre metidas en conflictos" (García Escudero, 1970: 19).

Influenciado por Dickens, Griffith prefiere como

protagonistas a los desfavorecidos, de modo que las hermanas Gish –presentes en sus films hasta la saciedad– son las desvalidas protagonistas de *The orphans of the storm* (*Las dos huérfanas*, 1922), desventuradas que asumen los duros embites de la vida personificados por el alcohol (*The day after*), la vida licenciosa (*To save her soul*), o la intolerancia en todas sus formas (*Intolerance*), para salir finalmente victoriosas, respondiendo a un discurso moral "coherente con la esperanza evangélica de Griffith de ver triunfar a los corderos sobre los lobos, la mansedumbre sobre la violencia" (Brunetta, 1987: 120).

Los temas.
Como emanación directa de estas características del mundo ideado por Griffith surgen una serie de temas en sus películas.

La alienación producida por la avaricia la muestra en *Money mad* (*Locos por el dinero*, 1908). La codicia por el dinero alcanza el grado máximo de expresión en el robo: el ladrón que ha sustraído el dinero a una mujer es muerto por otros dos ladrones, a estos pretende robarles una anciana, quien provoca un incendio en el que perecen los tres. En este crudo relato, el castigo del delito es consumado por medio de un agente externo: el fuego, con el simbolismo que éste lleva implícito: purificación.

Ataca la vida licenciosa en *The fascinating Mrs Francis* (*La fascinadora señorita Francis*, 1909), donde el castigo a una vida lejos de los cánones morales queridos por el realizador es el abandono de la protagonista por sus pretendientes, y como símbolo: una flor marchita en sus manos, como anuncio de lo que será el resto de sus días.

The seventh day (*El séptimo día*, 1909) marca la

entrada del típico final *happy end*. La historia de este film expone el descuido de las obligaciones por parte de una mujer para con su familia, en beneficio de una vida nada recomendable, lo que la lleva a la crítica situación del divorcio, la intervención del juez arroja *luz* sobre la mujer y esta abandona su disoluta existencia.

Mayor empeño puso Griffith en mostrar el daño del alcohol en la sociedad; aunque para ello, como opina Brunetta (1987:11), "no se basa en ningún presupuesto social, ni mucho menos racional: se trata de un sermón puritano que implica la movilización de afectos y sentimientos religiosos".

Drunkard's reformation (*Reforma de un bebedor*, 1909) participa de las contraposiciones típicas del estilo griffithiano, a saber: casa (virtud) taberna (vicio). El esquema narrativo final quedaría como sigue:

1. El hombre desatiende a su familia por el alcohol.
2. La visión de un espectáculo le hace recapacitar.
3. Decide dejar la bebida. Reencuentro con su familia.

What drink did (*Lo que hizo la bebida*, 1909) tiene un esquema más complejo, si bien queda de manifiesto el atentado del vicio contra uno de los valores principales de la sociedad –para Griffith el principal– como es la familia. En este film, la muerte accidental de la hija del protagonista que acudía a la taberna en busca de su padre ebrio es el dramático agente externo que marca el sentimiento de arrepentimiento y la vuelta al buen camino.

Un tercer film –de los muchos que realizara sobre el tema– *The day after* (*El día después*) muestra los efectos después de una noche de copas. Estos tres films atacan el vicio desde un punto de vista puritano y

burgués, lejos de cualquier planteamiento lógico o en su defecto realista, ello queda de manifiesto por el tipo de personajes a los que recurre: los representantes del vicio se nutren, invariablemente, del proletariado; mientras que las esforzadas víctimas tienen una vida más acorde con presupuestos burgueses.

Fiel a la tradición cultural decimonónica, Griffith no hace más que dar continuidad a uno de los temas *edificantes* del momento: la lucha contra el alcoholismo, tema que contaba con numerosos exponentes literarios – caso de *L'assomoir* de Zola– de espectáculos precinematográficos –linterna mágica– y de las primeras realizaciones cinematográficas, tales como la producción Pathé *Les victimes de l'alcoolisme* (Zecca, 1902) o las italianas de Ambrosio Films *I drammi dell'alcolismo* y *L'incubo de un bevitore*. Manifestaciones todas en las que se muestran "historias perfectamente edificantes, que solían terminar más mal que bien y que casi siempre (pero no siempre) ilustraban de forma directa los peligros del alcohol." (Burch, 1995: 73 y 81).

Resulta paradójico que el realizador de la obra maestra *The birth of a nation*, en la cual se hacía apología del racismo, condenara el uso de la violencia en su film –con prólogo y epílogo ambientados en el presente– *Man's genesis* (*El origen del hombre*, 1912), en el cual un pastor protestante relata a dos niños los orígenes de la humanidad, los cuales han estado marcados por el uso de la violencia.

Dentro de su discurso moral, sobresale una serie de valores que reivindica como base de ese mundo ideal que anhela y recrea en sus films.

En films como *The Christmas burglars* (*Los ladrones de Navidad*, 1908), en la que unos ladrones hacen de Santa Claus; o *His ward's love* (*El amor de su tutor*, 1909), historia de amor entre un tutor protestante y una

muchacha en busca de marido; Griffith apunta por los valores positivos derivados de un sentimiento tan humano como es el amor. Otros sentimientos los relaciona de una manera más clara con la dimensión espiritual del hombre. Es el caso de la vindicación de la pobreza evangélica de *Simple charity* (*Caridad sencilla*, 1910), historia en la cual una sirvienta se desprende de su mejor vestido, con el cual pretendía seducir al hombre de la que estaba enamorada, para socorrer a un par de necesitados.

Igualmente son de destacar sus historias sobre la redención, en las cuales el individuo se libera del servilismo de una causa más o menos pecaminosa, baste citar como ejemplo: *A strange meeting* (*Un extraño encuentro*, 1909), en la que una mujer y un sacerdote rescatan a una joven caída en las trampas del vicio, llegando a un final feliz en la iglesia. *To save her soul* (*Para salvar su alma*, 1909) sigue un esquema similar: la joven que acude a la ciudad y comienza una carrera de vicio en la taberna, finalmente es rescatada por el sacerdote del pueblo con el inevitable final feliz en la iglesia. En *The way of the world* (*El camino del mundo*, 1910) junto a una crítica sobre las habladurías, vuelve al esquema anterior: un joven sacerdote rescata a una prostituta de su disoluta vida, logrando que ingrese en un convento. En este tipo de films se resalta la presencia de un vicio que intenta minar la sociedad; de la misma forma se presenta la labor de unos héroes –paladines del ordenado mundo puritano– que, al igual que ocurre en sus melodramas, acuden como salvadores para arrancar del Mal a aquel desdichado que ha caído en sus garras.

De nuevo Griffith ofrece su aportación a uno de los temas standard del cine *edificante* de corte decimonónico, el de la mujer que, tras abandonar el hogar o la casa paterna, se sumerge en la gran ciudad

donde "cede a sus mefistofélicas tentaciones y entra en una espiral de degradación que no pocas veces la conduce al borde de la muerte." (Dall'Asta, 1998:275).

La lucha directa del Bien contra el Mal la ilustra en *Dream street* (*Sueño callejero*, 1921), en la cual Satanás es representado por un violinista zíngaro – siempre la vertiente racial para identificar el Mal– y Jesucristo por un predicador callejero.

Tímidamente acomete estos temas desde una vertiente filosófica con *The sorrows of Satan* (1926), film a medio camino entre el Fausto de Goethe, por el protagonista vendido o a merced del Príncipe de las Tinieblas, y el *Nosferatu* de Murnau, por el papel redentor de la mujer; de cualquier manera, no deja de ser una historia de corte romántico.

Otro bloque temático es el que Griffith dedica a la fe, cuyo resultado más inmediato es la conversión y la vuelta al buen camino. *The salvation army lass* (*La muchacha del Ejército de Salvación*, 1909) es la historia de una joven miembro del Ejército de Salvación que consigue convertir a un preso evadido. *The converts* (*Los conversos*, 1910) versa sobre la recuperación de la fe perdida: un hombre, que por una apuesta se hace pasar por sacerdote, predica por las calles; al ver el éxito de su predicación, recupera la fe y decide hacerse sacerdote. *The greatests question* (*La gran pregunta*, 1919) es planteada como respuesta a las preguntas sobre el "más allá". La cinta finaliza con la seguridad que da la fe en Dios y, estableciendo una simplona relación: fe en Dios igual a prosperidad económica, el protagonista encuentra petróleo.

Entre todas las historias sobre el vicio, el poder de la fe o los sentimientos, Griffith realizó su film bíblico *Judith of Bethulia* (*Judit de Betulia*, 1913) basado en textos tradicionales y legendarios. La única

finalidad de la película era mostrar una fastuosa historia de imperios antiguos, basándose en el conocido episodio de Judith acabando con la vida del general babilónico Holofernes.

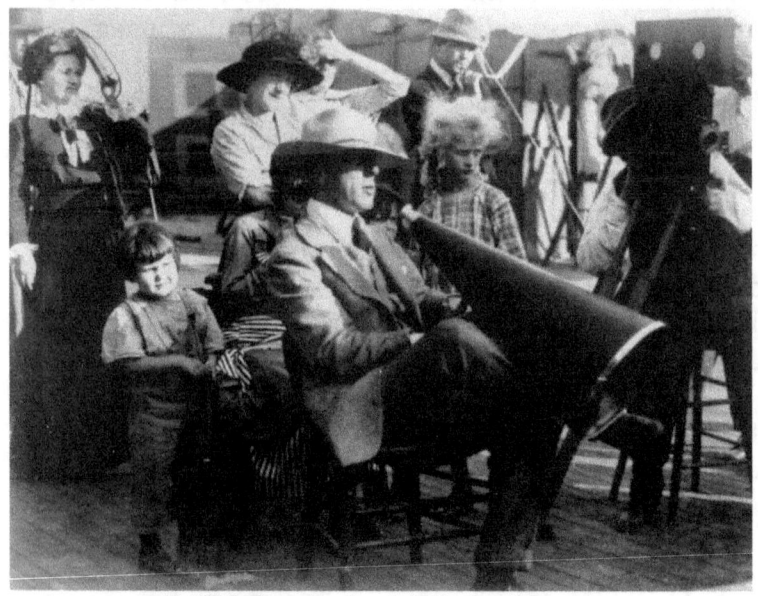

Griffith durante el rodaje de *Intolerance*

Griffith acomete la filmación de un largometraje, cuenta además con el apoyo inicial de la Biograph, empleando unos 50.000 dólares en su realización. Influido por el grandilocuente cine italiano del tipo *Quo vadis* o *Gli ultimi giorni di Pompeii*, Griffith estructura su film de manera similar, sentando las bases para el episodio babilónico de *Intolerance*[15], sentando las bases de un cine sólido, como menciona Ramírez (1998: 38): "a pesar de su extravagante interpretación de la Biblia, *Judith of Bethulia* es, con sus inmensos decorados, su llamativo vestuario, y la participación de cientos de extras un perfecto ejemplo de la construcción fílmica de

la época".

Intolerance (*Intolerancia*, 1916) supone un grandioso y espectacular discurso fílmico en contra del despotismo y la injusticia bajo cualquier concepto.

Fotograma del episodio *The life of Jesus of Nazareth*

Griffith moviliza en esta ocasión todos sus recursos para denunciar una lacra universal. Respondiendo al carácter metahistórico de la idea que articula el film, ilustra los efectos de la intolerancia en cuatro épocas distintas unidas por un *leitmotiv* consistente en una mujer meciendo una cuna. Estas cuatro historias son: la historia contemporánea, la matanza de San Bartolomé, la historia de Cristo y la caída de Babilonia; a las cuales se les une el citado leitmotiv y un epílogo que ilustra el futuro. El propio Griffith sintetizaba su film al sintetizarlo con esta definición (1981:41):

> Cuatro corrientes de agua que podríamos contemplar desde la cima de una colina. Al

principio estas cuatro corrientes fluirían separadas, suaves y mansamente. Pero a medida que van discurriendo se van aproximando cada vez más, con mayor celeridad, hasta llegar al final del trayecto, durante el último acto, cuando se juntan para formar un gran río de emoción manifiesta.

Como ilustración de la intolerancia social presenta el episodio contemporáneo: un obrero que cae en el círculo de un gangster. Cuando éste es asesinado se acusa al obrero, el cual es salvado –in extremis– por la confesión del verdadero culpable. Mientras se desarrolla esta historia, la asistencia social le arrebata a su hijo. La segunda historia tiene como título *The life of Jesus of Nazareth* (La vida de Jesus de Nazareth). Narra las diferencias doctrinales que mantuvo Jesús con los fariseos –los intolerantes– finalizando con la muerte del Mesías en la cruz. Hay que señalar que este episodio levantó graves críticas en la comunidad judía ya que presentaba al pueblo judío como deicida.

El tercer episodio es *"The war between the catholics and the hoguenots in 16th century France"* (La guerra entre católicos y hugonotes en la Francia del siglo XVI). Los protagonistas, una joven pareja hugonote, son víctimas del complot urdido por Catalina de Médicis y su hijo, Carlos IX. Consumada la matanza, Griffith muestra multitudes mutiladas o degolladas, mientras Carlos IX sufre un ataque de cólera.

Sin duda, decir *Intolerance*, es referirse al cuarto episodio: *"In the reign of Nebuchadnezzar: an epic of the Ancient World"* (En el reino de Nabucodonosor: historia épica del mundo antiguo). Esta parte narra las conspiraciones políticas de los sacerdotes de Baal cuya finalidad es destronar al rey Beltsasar, representante –por extraño que parezca– de la tolerancia.

Las tropas de Ciro asaltan la ciudad y acaban con los jerarcas babilónicos. Más que buscar el rigor del historiador Josefo o el episodio bíblico narrado en Daniel, Griffith realiza un cuadro épico sobre Babilonia, no escatimando presupuesto para llevar a cabo el proyecto. Se construyeron grandes escenarios: murallas de 70 metros de altura, decoración según la estética neobabilónica, (si bien hay numerosas alusiones a la pintura historicista del siglo XIX en la escena del banquete ya que adapta el grabado "El banquete de Baltasar" de John Martin –siguiendo una de las modas del momento como era el *tableau vivant* recurso puesto en práctica por los maestros del Kolossal italiano con una simple finalidad: acercar el cine a las clases medias, ya que, como señalan Ortiz y Piqueras (1995:54) "la tradición artística legitimaba el nuevo medio". Al mismo tiempo existe referencia a una arquitectura eclecticista, multitudes guerreando bajo los efectos luminosos de bengalas, etc. En definitiva, un despliegue más que suficiente para ilustrar cualquier tipo de intolerancia.

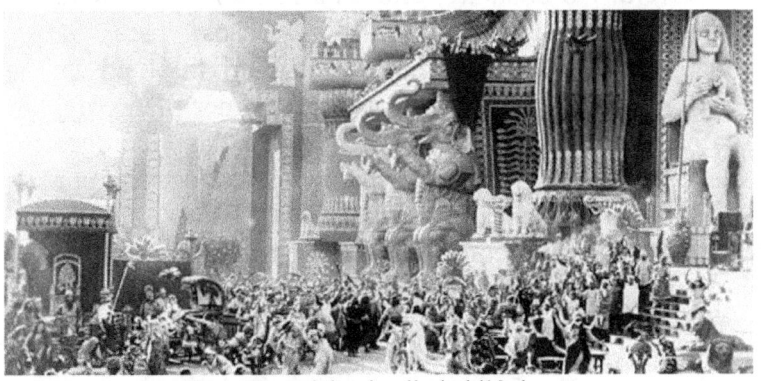
Fotograma del episodio babilónico.

No se limita el autor a denunciar los efectos de la intolerancia, sino que se atreve a ofrecer una esperanza

en el episodio titulado *"The future"*. Partiendo de la destrucción, tras una guerra mundial a gran escala –que incluye el bombardeo de Nueva York– sólo la intervención de origen divino puede poner fin a esta situación. Los ángeles vienen a la Tierra con un mensaje de Paz, momento en el que –por medio de acciones paralelas– las rejas de los presidios se abren, los soldados dejan de combatir y los campos de batalla se convierten en prados idílicos. La humanidad habita feliz en esta Tierra Nueva.

El mensaje *evangélico* de este film quedó un tanto desvirtuado por la gran puesta en escena y la propia perfección estética del mismo; no obstante, la esencia del film, su capacidad para transmitir un mensaje queda reflejado en la siguiente anécdota de Lenin, quien tras ver esta obra pidió que fuera distribuida por todo el territorio soviético, además de opinar: "De todas las artes, el cine es la que más nos interesa. El cine debe ser y será el principal instrumento cultural del proletariado".

Después de esta colosal película, inició el declive de su carrera. No obstante, gracias a la enorme cantidad de films realizados, sentó las bases para la cinematografía. Con él empieza el cine tal cual es concebido en la actualidad. El uso del primer plano, del flash back, del fundido en negro, de las acciones paralelas y toda una serie de elementos esbozados por los pioneros Edwin S. Porter y G.W. Bitzer, fueron inscritos por Griffith como los mecanismos inherentes a una nueva manifestación artística llamada cinematografía, no sólo por la utilización formal de estos, sino por la carga emotiva de la que los dotó.

Al margen de interpretaciones socio –políticas que se desprenden de su obra, lo cierto es que gracias a sus dramas de héroes y villanos, a esas lacrimosas historias de huérfanas y multitudes pseudo–babilónicas

correteando por fastuosos decorados de cartón piedra, Griffith es el primer gran cineasta, aún más, el gran maestro comprometido con su obra, puesto que la moral reflejada en sus films –ligada a la psicomaquia de todas las artes– es la que albergaba en el fondo de su mente, y esta vertiente, al igual que las innovaciones técnicas, ejercerán una gran influencia en posteriores maestros.

Filmografía.

1908: Las aventuras de Dorotea (The Adventures of Dolly) A Calamitous Elopement; The Red Girl; Ingomar, el bárbaro (The Barbarian Ingomar); The Call of The Wild; A Woman's Way; The Reckoning.
1909: The Sacrifice; El cuervo (Edgar Allan Poe); Tragic Love; El anillo de boda (At the Altar); The Voice of The Violin; El remedio (A Drunkard's Reformation); Twin Brothers, El club de los suicidas (The Suicide Club) Resurección (Resurrection) Two Memories; El violinista de Cremona (The Violin Maker of Cremona) El teléfono (The Lonely Villa) The Faded Lilies, El camino de un hombre (The Way of a Man) The Message; A Strange Meeting; The Mended Lute; The Sealed Room; The Broken Locket; En el viejo Kentucky (In Old Kentucky); El despertar (The Awakening); Pasa, Pippa (Pippa Passes); The Restoration; The Light That Came; Throught the Breakers; Un rincón en los trigales (A Corner in Wheat).
1910: The Rocky Road; Her Terrible Ordeal, El hilo del destino (The Thread of Destiny); En la vieja California (On Old California) As It Is In Life; El romance de las colinas del Oeste (A Romance of the Western Hills); El camino del mundo (The Way of the World); Ramona (Ramona); Lo que dijo la margarita (What the Daisy Said); A Flash of Light; La casa con las persianas echadas (The House With Closed Shutters); Las penas del infiel (The Sarrows of the Unfaithful); Wilful Peggy; Rose O'Salem Town; Examination Day at School; The Message of the Violin; The Fugitive;

Súnshine Sue; A Plain Song.

1911: The Two Paths; His Trust His Trust Fulfilled; Fate's Turning; Tres hermanas (Three Sisters) His Daughter; El Lirio de las calles (The Lile of the Tenements); Salvada por telégrafo (The Lonedale Operator); Enoch Arden (Enoch Arden); The Primal Call; Her Sacrifice; La última gota de agua (The Last Drop of Water); El despertar (Her Awakening); The Adventures of Billy; La Batalla (The Battle); The Miser's Heart; La esposa abandonada (A Woman Scorned) A Terrible Discovery.

1912: Under Burning Skies– La promesa de la India (Lola's Promise) The Goddess of Sagebrush Gulch: El trust de la muchacha (The Girl and her Trust); Fate's Interception; The Female of the Species; A Beast at Bay; Home Folks; La formación de un hombre (Man's Genesis); Arenas de Dee (The Sands of Dee); El enemigo invisible (An Unseen Enemy); Two Daughters of Eve; Amigos (Friends); The Musketeers of Pig Alley; The Informer; El sombrero de Nueva York (The New York Hat).

1913: The Massacre; Broken Ways The Little Tease, The Wanderer– The House of Darkness, Amor de madre (Her Mother's Oath).

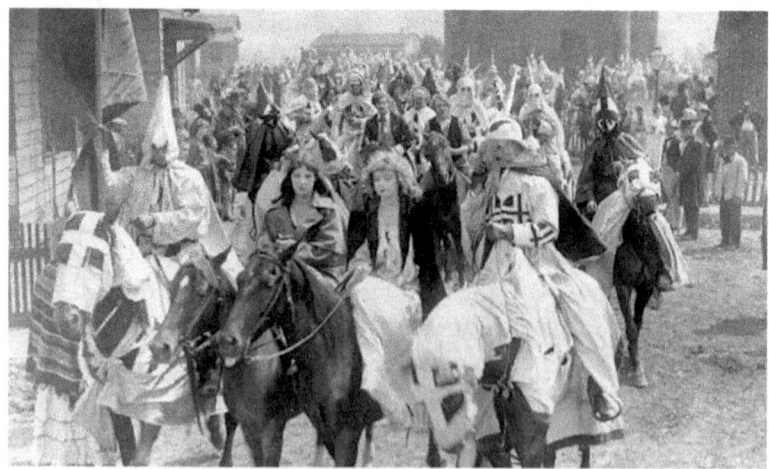

Fotograma de *The birth of a nation*.

1914: The Battle at Elderbush Gulch (La batalla de Elderbush Gulch); Judith de Bethulia (Judith of Bethulia).
1914: La batalla de los sexos (The Battle of the Sexes), La evasión (The Escape), Dulce hogar (Home Sweet Home), La conciencia vengadora (The Avenging Conscience).
1915: El nacimiento de una nación (The Birth of a Nation), El cordero (The lamb).
1916: Intolerancia (Intolerance).
1918: Corazones del mundo (Hearts of the World), El gran amor (The Great Love), Lo más grande en la vida (The Greatest Thing in Life).
1919: Un mundo aparte (A Romance of Happy Valley), Sobre las ruinas del mundo (The Girl Who Stayed at Home), La culpa ajena (Broken Blossoms), Pobre amor (True Heart Susie), Días rojos (Scarlet Days), El mayor problema (The Greatest Question).
1920: The Idol Dancer, Flor de amor (The Love Flower), Las dos tormentas (Way Down East)
1921: La calle de los sueños (Dream Street).
1922: Las dos huérfanas (Orphans of the Storm), Una noche misteriosa (One Exciting Night).
1923: Flor que renace (The White Rose).
1924: América (America), La aurora de la dicha (Ins't Life Wonderful).
1925: Sally, la hija del circo (Sally of the Sawdust).
1926: Crimen y castigo (That Royle Girl), Las tristezas de Satán (The Sorrows of Satan).
1928: Su mayor victoria (Drums of Love), La batalla de los sexos (The Batlle of the Sexes).
1929: La melodía del amor (Lady of the Pavements).
1930: Abraham Lincoln (Abraham Lincoln).
1931: La lucha (The Struggle).

EL CINE DEL EXPRESIONISMO ALEMÁN.

En el siglo XX surge uno de los movimientos artísticos más espectaculares en cuanto a su estética y que abarcará todas las formas de la realización artística: es el expresionismo.
Nacido en Alemania, y desarrollando su mayor esplendor durante la primera posguerra, extiende su influencia por todo el ámbito cultural germánico. Su vida, aunque breve (1905 – 1933), fue muy fecunda.

Al referirse a este movimiento habría que hablar más bien de forma de vivir, como indica Casals (1982:8): "El expresionismo no es una escuela estructurada con un programa definido y un estilo homogéneo. Es una sensibilidad difusa, un estado de espíritu por debajo del cual la nota dominante es la diversidad individual".

Las realizaciones expresionistas no se circunscriben únicamente a las artes plásticas –donde surgieron pintores de la talla de Kokoschka, Klee, Kandinsky, Nolde...– sino que se adentra en la arquitectura y el diseño –la Bauhaus– la literatura, en

todos sus géneros. Dentro de esta estructura cultural el cinematógrafo no podía pasar desapercibido para los estetas del expresionismo; es más, en las películas se unifican todos los elementos plásticos, literarios y emocionales del movimiento, llegando a convertirse estas obras en propios manuales del nuevo arte.

El estilo expresionista está marcado por la desolación, sentimiento que hace romper con toda la estética anterior y hace que el arte se sumerja en "lo que es oscuro e indeterminado, hacia la reflexión especulativa y obstinadamente repetida llamada Grübelei, que desemboca en la doctrina apocalíptica del expresionismo alemán" (Eisner, 1955:9).

Estéticamente, al expresionismo no le importa tanto la realidad como lo que subyace en ella, no le importa la forma sino el contenido, la idea, la esencia traspolada a condición de hecho metahistórico. El expresionismo adquiere una tarea fundamental: descubrir la realidad que rodea al artista, en tanto que individuo de una sociedad en crisis. Ello hace exclamar a Paul Klee: "El Arte no expresa lo que es visible, sino que hace visible".

Ante una sociedad en crisis, como es la de la Alemania de la Gran Guerra, los artistas vuelcan su creatividad en unos temas – que como diría August Macke– son manifestación de su vida interior. Así, los artistas buscan plasmar sus sentimientos recurriendo a una amplia temática encontrándose referencias a la alienación, el antiautoritarismo, la redención a través del amor, y como metáfora del sufrimiento del individuo y la nación surgen reflexiones y meditaciones pictóricas sobre los temas del Calvario, del Vía Crucis, de la muerte de Cristo que buscan de esta manera dar rienda suelta a los angustiosos sentimientos que los atenazan ante el derrumbamiento del viejo orden, como en el caso

del pintor Wilhelm Morgner cuya obra, en opinión de Elger (1991:200), "se identifica con el calvario de Jesucristo. También él adoptó las historias del Nuevo Testamento como el único símil posible para describir su situación y su estado psíquico en vísperas de la Primera Guerra Mundial".

Fruto de este último punto es la ruptura con los valores tradicionales e incluso con la crítica a estos ya apuntada por Nietzsche. Así el expresionismo hará tambalear tanto las ideas de Estado, Razón, Progreso como la de la muerte de Dios argumentada por Nietzsche a modo de alternativa a la cultura y al pensamiento tradicional. El artista expresionista intentará crear un *nuevo hombre* que en ocasiones está más cerca del delirio que de la atormentada realidad que lo envuelve.

En esta moderna sociedad, el cinematógrafo se convierte en un medio más que encuentra el expresionismo para reflejar sus temas, sus ideas, sus críticas, todo bajo una peculiar técnica que a grandes rasgos se puede resumir en la "voluntad de anular los efectos realistas de la fotografía a cambio de resaltar la expresividad y subjetividad propia de la pintura, enfatizando el principio estilístico de la deformación" (Ortíz y Piqueras, 1995:120).

El expresionismo cinematográfico.

Para considerar los temas habituales de los films expresionistas hay que tener presente la difícil situación que atravesaba Alemania en esa época, y la manera en que este sentimiento de desesperanza, angustia y miedo fue reflejado en el arte, como se ha visto al principio.

Los temas de este cine –que como factor común reflexionan sobre el fin del mundo (baste citar los casos

de la peste en *Nosferatu*, o la inundación de *Metrópolis*)– girarán alrededor de los siguientes.

Lo sobrenatural y fantástico, con una predilección por el tema de la muerte. Es en las películas mudas de Lang donde se muestra una y otra vez el tema de la muerte, es más, el leitmotiv de *Der müde Tod* (1923) es la muerte misma. El tema del film – la lucha entre la Muerte y el amor– había sido tratado en otras películas, pero Lang introduce aquí una novedad: la Muerte no aparece como un ser terrible, sino como algo inevitable y al mismo tiempo liberador (idea que años más tarde retoma Bergmann en *El séptimo sello*).

El guion de *Der müde Tod* lo realizó el propio Lang en colaboración con Thea von Harbou. Los operadores de cámara y fotógrafos fueron tres grandes nombres del cine alemán: Fritz Arno Wagner, Erich Nilzschmann y Hermann Saalfrank. Los decorados corrieron a cargo de Warm, Hertlh y Röhrig.

Lo sobrenatural y fantástico lo recrea el director de diversas maneras. Por un lado, creando una fusión entre los personajes y los elementos arquitectónicos entre los que se desenvuelven, algo que no era casual, sino ciertamente estudiado por este aprendiz de arquitecto que derivó su carrera detrás de la cámara. El misterioso reino de la muerte destaca por la enorme muralla que rodea sus dominios, y que por medio de trucos fotográficos –en el momento en el cual la protagonista tiene la alucinación– se abre una estilizada puerta ojival que da paso a las almas de los difuntos. Curiosamente, el interior de este palacio de la Muerte no es más que una catedral gótica en la que arden millones de velas: símbolo de las vidas que se consumen.

El horror, siendo el gran maestro Murnau, en concreto en *Nosferatu*, especialista en crear una atmósfera de terror mediante movimientos más directos

hacia la cámara (el vampiro avanzando desde la profundidad de un plano; movimiento que rompe en una serie de planos alternos). Construcción de la idea de peligro, que en caso mencionado lo crea de diferentes maneras:

- Con movimientos oblicuos en la pantalla: el buque que navega por un mar embravecido.
- Acelerado: trayecto de la carroza embrujada que transporta al viajero.
- Truculencia fotográfica: los ataúdes que se apilan solos en el carro.
- Objetos animados: la hamaca del marinero muerto que recuerda el paso del vampiro.

Otro de los principales temas del cine objeto de estudio es el de la tiranía. En las películas expresionistas se puede rastrear la necesidad del pueblo alemán de la dominación tiránica. Esta era el único camino viable frente a la alternativa del caos anárquico de la libertad gobernada por el instinto. El tirano que por y para la concreción de su poder comete actos de violencia y crímenes y que, teniendo precedentes en *Homunculus*, podemos encontrar en la figura de Caligari, ordenando según su voluntad a Cesare asesinar a sangre fría, en el rabino Löw manipulando al Golem, en Nosferatu, en Mabuse. Puede ponerse en relación con esto el tema la lucha entre padre e hijo, y del conflicto generacional. También el de la figura del monstruo (el ser antinatural o artificial), ya sea tirano o dominado: la encontramos en el Golem, en Cesare, en Nosferatu.

El film paradigmático reflejo de esta idea –y que hará escuela– es sin duda: *Das Kabinett des Dr Caligari*, película que supuso una revolución en el mundo de la cinematografía debido al tema –la pesadilla fruto de una mente enfermiza– la interpretación de los actores, los

decorados que su usan para ambientar la historia –una ciudad distorsionada que parece querer engullir a los protagonistas– y por la técnica empleada (flash–back, fundidos, empleo de iris para remarcar objetos y situaciones, utilización del raccord).

El guion del film es obra del austriaco Carl Mayer y el checo Hans Janowitz. La idea que querían transmitir – originalmente– en esta historia de un feriante y el sonámbulo que utiliza como atracción de feria, no es más que una crítica al poder del Estado que maneja a su antojo a los ciudadanos, figura que representa el sonámbulo Cesare. La dureza del guión original es dulcificada de manera que se introduce un prólogo y un epilogo desarrollado en un sanatorio mental.

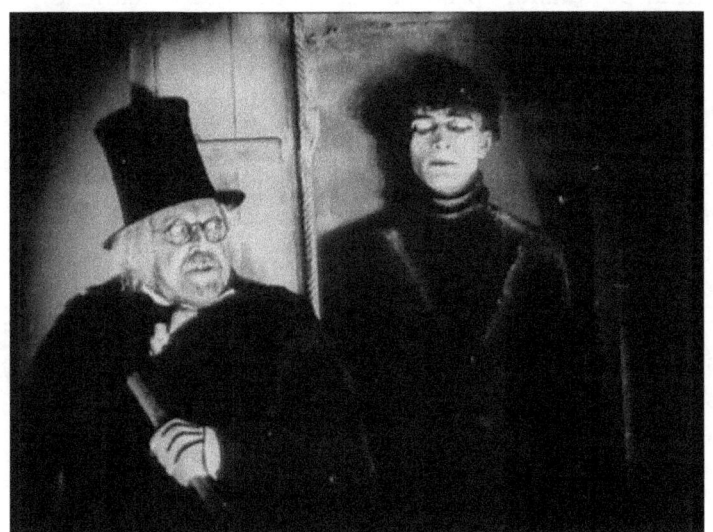

El Dr. Caligari (el tirano) y Cesare (la víctima).

La dirección corre a cargo de Robert Wiene, hijo de un famoso actor, y que cuenta con Willy Hameister como operador de fotografía. Para dar forma al guión

Wiene emplea la técnica del flash–back, convirtiendo la historia en el relato de un enfermo mental. Una vez rodado el material utiliza fundidos y sobreimpresiones para montar la película.

La personificación del tema de la tiranía y su poder descansan en los personajes de esta historia, en los que ya se encuentran las bases de la interpretación estándar del cine expresionista. Los actores muestran una peculiar concepción de la vida, que emana de los argumentos de las películas. Según estos, "la vida no es más que una especie de espejo cóncavo que proyecta personajes inconsistentes que flotan como imágenes de una linterna mágica" (Eisner, 1995:47).

Caligari y Cesare resultan los prototipos de personajes expresionistas: el sonámbulo, arrancado de su ambiente cotidiano, privado de toda individualidad, criatura abstracta mata sin motivo ni lógica, aunque en un momento dado puede liberarse del yugo de su opresor gracias al *deseo* (¿una forma de simbolizar el *amor*?) que en él despierta Jane, a quien rapta y que supone dar paso a su propia voluntad en lugar de ejercer la del amo. El Dr. Caligari, sin la menor sombra de escrúpulos actúa con una sensibilidad extrahumana, desafiando la moral tradicional.

Pero no es el único caso de reflexión sobre la tiranía, otro de los grandes films de esta generación ofrece también una aportación: *Der Golem* (Paul Wegener, 1920).

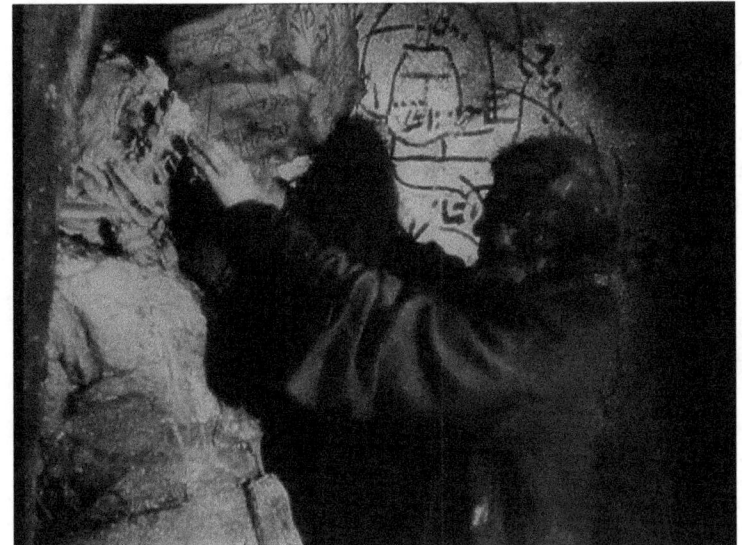

El rabino Löw

La historia narrada es la del rabino Löw y su labor por conseguir dar vida a un ser que libere a su oprimido pueblo. Utilizando viejas fórmulas cabalísticas crea al Golem: un hombre de barro animado por una palabra mágica de origen diabólico. Con el tiempo, la creación se revuelve contra su creador y causa el caos entre la comunidad. La rebelión del Golem, que vendría a simbolizar la entrada del pecado en la Creación, no es eterna, puesto que existe la esperanza, en la que se mezclan tintes evangélicos y filosóficos– de dar fin al Mal por medio de una criatura de naturaleza pura, en el film personificada en la figura de un niño.

Parte la historia del film de una leyenda judía de origen medieval, según la cual sólo los rabinos pueden modelar y animar estas estatuas de barro siguiendo las reglas del *Sefer Jetzirah* o Libro de la Creación. La figura obtenida será un vengador de la raza judía que los libre de la opresión sea cual sea su manifestación, en

este caso la del príncipe de Praga. Para que tome vida deberá serle inscrita en la frente o en la boca la palabra *aemaeth* –verdad– que según la tradición hebrea fue la palabra pronunciada por Dios cuando dotó de vida a Adán, que también fue modelado como si fuera una estatua de arcilla. Continúa advirtiendo la leyenda que cada viernes, antes de la puesta de sol que, da paso al día de reposo, debe borrarse la primera sílaba de dicha palabra quedando escrito *meth* cuyo significado es el de la muerte; asegurando así la inmovilidad del Golem durante la jornada del sabbath.

La historia del Golem ilustra, en definitiva, una historia recurrente en la narrativa fantástica: el afán del hombre por crear vida de la nada igualándose a Dios, no en vano el Golem estará modelado en arcilla para igualar la Creación suprema de Dios que modeló a su vez al hombre. Y al igual que el hombre se rebeló contra su creador, el Golem se rebela contra el suyo, ya que es una constante en la mitología como recuerda De Miguel (1989:226):

> La idea de la creación de un hombre artificial no es exclusiva de la ciencia ficción, desde siempre ha estado unida a las mitologías y a la leyenda. Leyendas bíblicas nos hablan de que Dios creó al hombre a su imagen y semejanza. Y la raza humana llevada por su narcisismo, su miedo a la muerte y su ambición, ha deseado duplicarse con sus propias creaciones. Todas las obras que ilustran el intento del hombre de emular a Dios creando vida, por regla general, van a ver castigada su audacia con el descontrol de la máquina que termina destruyendo a su creador, normalmente un sabio loco.

Aún más, este film ofrece "un agresivo carácter visionario vaticinador de males sociales y políticos"

(Cuellar, 1997:19).

El doble será otro de los temas recurrentes. Ya en *El estudiante de Praga* de 1913 como consecuencia de un pacto con el diablo, la imagen en el espejo del protagonista toma independencia de él, convirtiéndose en su enemiga. Caligari es por otra parte un respetable médico y Nosferatu es el Conde Orlock, un burgués que mediante un intermediario desea adquirir un terreno.

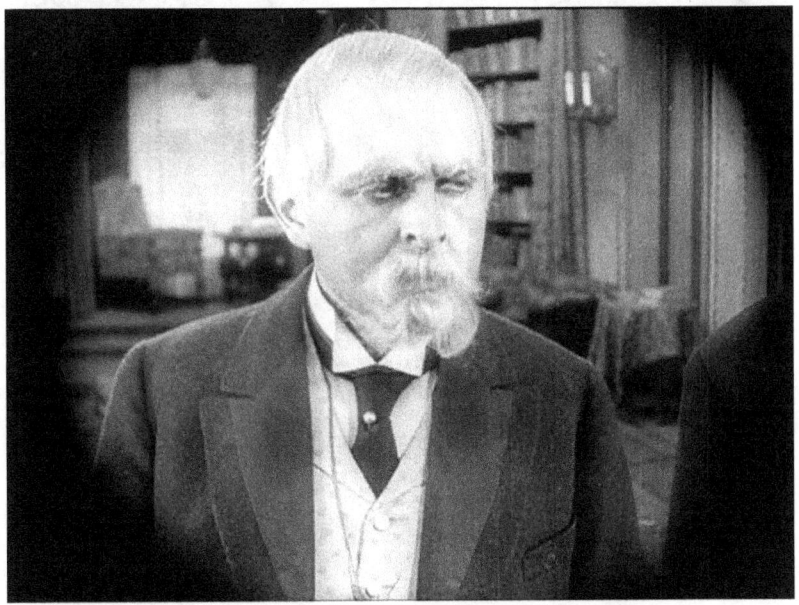

El Dr. Mabuse en una de sus múltiples caracterizaciones

El caso más claro de este tema es la película de Fritz Lang *Dr. Mabuse* (1924). La trama de *Dr. Mabuse*, dividida en dos episodios: *Der Spieler* e *Inferno*, está basada en la novela de Norbert Jacques adaptada por Thea von Harbou. Mabuse es un hombre que gracias a fuerzas "extraordinarias" hipnotiza a otros para conseguir ganar en el juego. El dinero que consigue lo invierte en fines criminales de considerable envergadura:

falsificación de moneda, especulación en bolsa, etc. Para poder acceder a los más diversos ambientes, Mabuse –interpretado por Rudolf Klein–Rogge– es un genio de la caracterización –un hito más dentro del desdoblamiento del personaje expresionista– por lo que se presenta como mendigo, marinero borracho, etc. Finalmente es apresado por el fiscal Wenck.

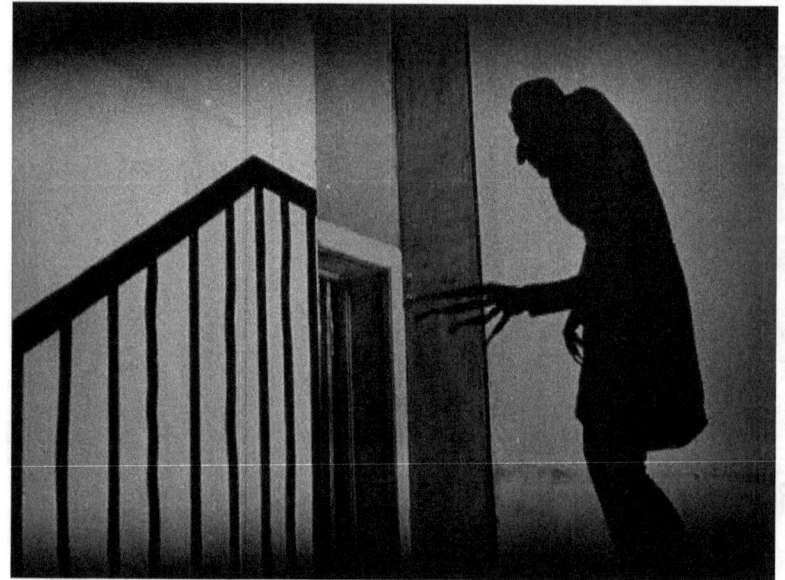

La importancia de la sombra en *Nosferatu*

Puesta en escena del filme expresionista.

Tan importante como las temáticas para la identidad del cine expresionista, son sus recursos estéticos. Todos ellos en función de lo que Eisner califica de intraducible: la "Stimmung" alemana, algo así como una "atmósfera sugiriendo las vibraciones del alma (y que) flota tanto en torno a los objetos como a las personas" (Eisner, 1955:23).

Uno de los recursos más importantes es el uso de la luz, herencia de las puestas en escenas teatrales de Max Reinhardt quien sistematizó la creación de contrastes de luces y sombras, la iluminación repentina de un objeto o un rostro dejando el resto en penumbras como medio de enfocar la atención del espectador sobre aquel.

En los films expresionistas, la luz es en algunos casos un elemento decorativo, formando etéreas figuras en el humo o al dibujarse en el polvo los rayos de sol ingresando por una ventana. Sin embargo, más que la luz, las sombras producidas por ella son las esenciales para el cine. Sombras que además del fin decorativo mencionado, muchas veces son ellas las encargadas de narrar, en lugar del cuerpo que las provoca

En el expresionismo cinematográfico se asiste a un empleo simbólico de la luz exponente de una lucha esotérica entre el Bien y el Mal que retoma una idea de la metafísica neoplatónica –de influencia medieval– según la cual la luz es el más noble de los fenómenos naturales, el menos material y el que más se acerca a la Forma pura.

Esta idea se encuentra basada en numerosos textos bíblicos y en comentarios teológicos de la Edad Media. Entre los textos bíblicos que identifican la luz con Dios, su obra creadora o su carácter se pueden citar: Job 37:3 (*Debajo de todos los cielos los dirige, y su luz hasta los fines de la tierra*), Salmo 27:1 (*Jehová es mi luz y mi salvación; ¿de quién temeré?*), Salmo 36:9 (*Porque contigo está el manantial de la vida, en tu luz veremos la luz*), Isaías 2:5 (*Venid, oh casa de Jacob, y caminaremos a la luz de Jehová*), Isaías 60:19 (*El sol nunca más te servirá de luz para el día, ni el resplandor de la luna te alumbrará, sino que Jehová te será por luz perpetua*), Juan 1, en donde continuamente se identifica

a Cristo con la luz que ilumina el mundo y 1ª de Juan 1:5 (*Dios es luz, y no hay ninguna tinieblas en él*).

Esta teología sobre la luz y su naturaleza influyó en los artistas desde la Edad Media. Estos siempre han tratado de representar esta idea de muy diversas maneras. Dante en *Divina Comedia* (Paraíso 37–22) expone: "la luz divina penetra por el universo según sea digno de ello, sin que nada pueda serle obstáculo". Para los constructores de las catedrales góticas la luz era el elemento primordial que debían reflejar sus construcciones, para de esta manera ilustrar no sólo el carácter iluminador de Dios, sino para hacer realidad la descripción de la Jerusalén Celeste descrita en el Apocalipsis; esta es la explicación a la apertura de grandes ventanales decorados con vidrieras de muy diversos colores. Esta idea la recoge Von Simson (1988:71) con estas palabras: "la luz y los objetos luminosos llevaban en sí no menos que la consonancia musical, una penetración en la perfección del cosmos y una adivinación del Creador".

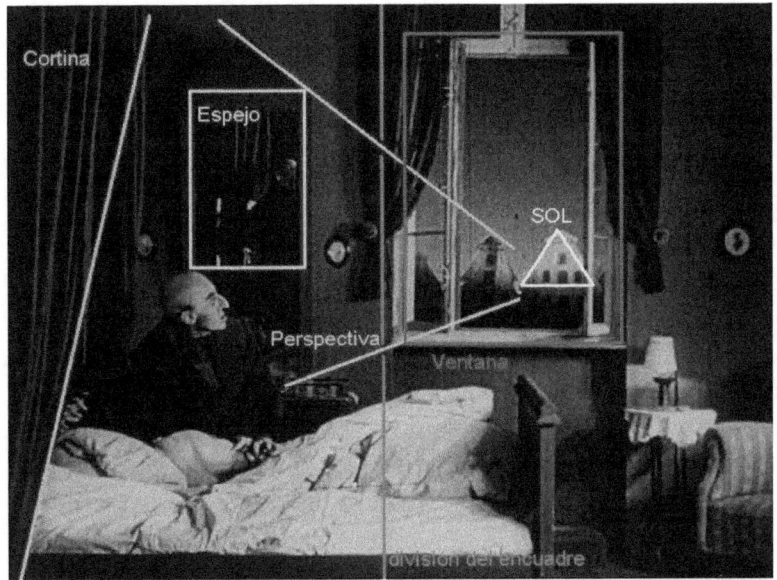
Construcción de ejes para remarcar el triunfo de la luz en *Nosferatu*.

Esta *lucha* es bien patente en numerosos films, pudiéndose partir de *Der Golem*. En la que Wegener se sirve de todos los efectos de iluminación vistos en Reinhardt: estrellas titilantes sobre el cielo, resplandor que brota del fuego del alquimista, una lámpara de aceite que ilumina la aparición de un personaje, una fila de antorchas oscilando en la noche... En los interiores –a semejanza de Rembrandt– una luz cálida lo inunda todo y modela la cara del rabino, el contorno de su discípulo. En cualquier caso, están cargadas de significado (en ocasiones netamente maniqueo) ya que las escenas de penumbra muestran las facetas negativas de personajes y situaciones y al contrario, las dominadas por la luz hablan del bien y de la resolución de conflictos.

La praxis fílmica del triunfo de la luz se encuentra sistematizada en las obras de F. W. Murnau, donde encontramos un esquema invariable: obsesión por

la idea de la Muerte, el Mal que daña la felicidad de la pareja–símbolo de la humanidad entera– y la derrota del Mal mediante la expiación de la mujer y el triunfo del sol sobre la oscuridad.

La obra capital de Murnau es *Nosferatu, eine Symphonie des Grauens*. (1922), peculiar adaptación del "Drácula" de Bram Stoker. Para destruir al agente maligno –Nosferatu, el no muerto– Murnau recurre al papel de la mujer como único ser capaz de acabar con el Mal. La mujer se ofrece en un purificador sacrificio para salvar el microcosmos en el que habita y que no es más que un símbolo de la humanidad entera, amenazada por la sombra del vampiro. No hay que olvidar que en este cine las sombras simbolizan el ineluctable destino, la muerte: Nosferatu, y su sombra sin cuerpo inclinado sobre el lecho de Hutter, subiendo las escaleras de la casa de Nina.

El momento culminante de esta expiación coincide con la salida del sol, cuyos rayos del amanecer acaban con la existencia del vampiro; la luz que reviste la escena tiene una áurea mística similar a los lienzos del tenebrismo barroco, de ahí la sobrenaturalidad del recurso.

Otro film paradigmático es *Sunrise* (1927), realizada por Murnau en Estados Unidos. De nuevo vuelve a buscar el protagonismo de la luz con su carga simbólica: su papel de redención–salvación. En este drama, el protagonista cae en las garras de un agente maligno: la infidelidad conyugal. Instigado por su amante, el protagonista planea asesinar a su mujer, pero la resignada actitud de ésta ofreciéndose a tan singular suplicio motiva la más honda reflexión en el protagonista, quien se arrepiente de su falta. En este momento, y tras una tempestad paralela al intento de homicidio y reflexión, el sol inicia su salida. Similar

esquema es el animador de su obra *Tabu* drama naturalista en el que las formas de una religión totémica representan el Mal que ejerce su influencia sobre la pareja protagonista. De nuevo se encuentra el esquema expuesto: tras asumir la mujer su papel expiatorio para salvar al ser amado, el sol comienza a surgir por el horizonte del Océano Pacífico.

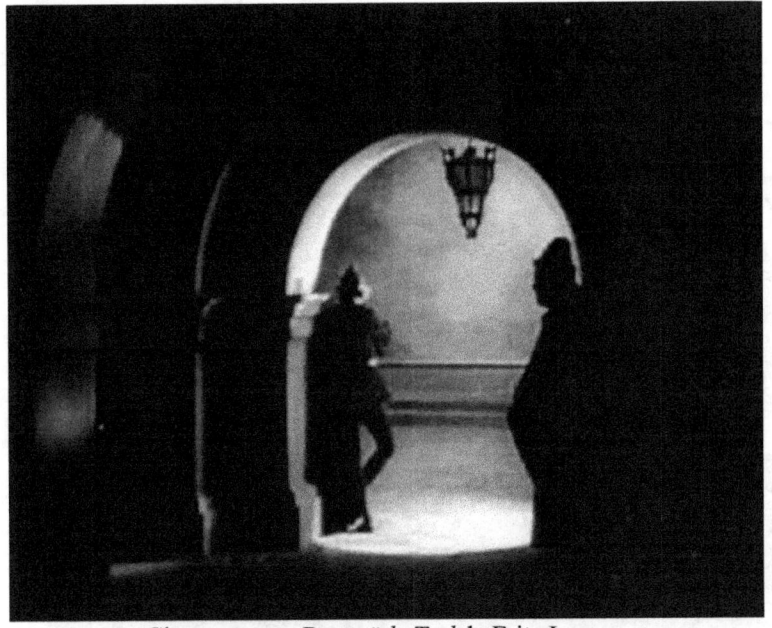

Claroscuro en *Der müde Tod* de Fritz Lang

Para Fritz Lang, en *Der müde Tod* (1921), la iluminación se presenta también como un importante elemento dramático: no en vano la luz cenital o lateral configurará al actor Bernhard Goetzke una apariencia siniestra: fosas oculares, mentón afilado, pómulos salientes; en definitiva: el rostro de la muerte; pero una muerte amistosa, cansada de matar.

En *Metropolis,* Lang maneja admirablemente las luces: aparece la ciudad futura, soberbia pirámide, acumulación de rascacielos que lanzan haces luminosos. La luz llega a crear la impresión sonora: el silbido de la sirena de la fábrica está representado por cuatro faros cuyos chorros se lanzan como gritos, la luz ocupa el primer plano para la creación del robot. Gracias a la iluminación, a las sobreimpresiones, el torbellino de las máquinas mezclado con los rascacielos arrastra a una pesadilla febril a Freder, quien pierde el conocimiento.

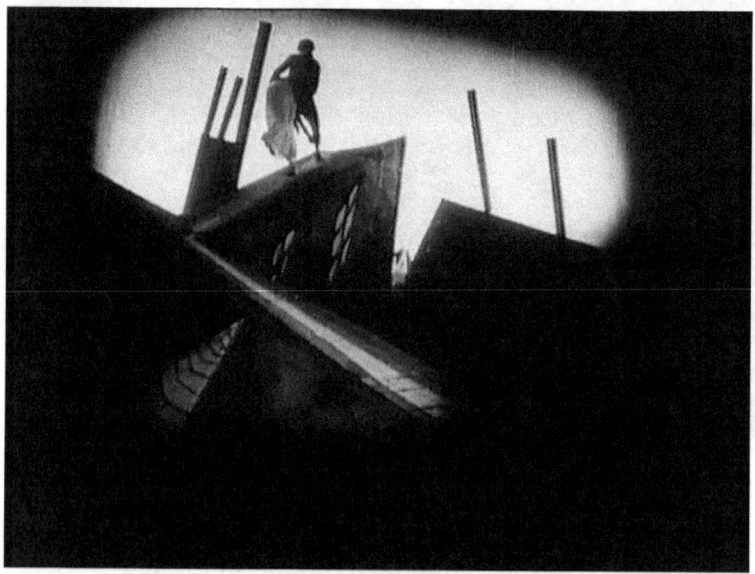

Exterior en *Das Kabinet des Dr. Caligari*

Los decorados del film expresionista intentan introducir al espectador en la psique del trastornado protagonista, su enfermizo mundo interior.

Uno de los elementos característicos de *Das Kabinett des Dr Caligari* son los decorados –a la sazón

algo imprescindible en el cine expresionista– y que crean un ambiente de personalidad propia que complementen el significado del film. Los decorados de la película son obra de tres pintores del grupo Der Sturm, a saber: Hermann Warm, Walter Röhrig y Walter Reinmann. La tarea que debían realizar era una ciudad entera, para lo cual montan armazones de madera que recubren con tela a la que pintan con líneas oblicuas, curvas y toda una serie de formas pictóricas. Creando toda una serie de espacios que participan del ambiente opresivo de la historia. En consecuencia, se pueden diferencias dos espacios:

a) Exteriores:
 La visión de conjunto que ofrece la ciudad es la de una aglomeración de puntiagudos tejados entre los que sobresale la torre de una iglesia, y que en ocasiones se asemeja a un maléfico reptil agazapado.
 Las calles de la ciudad muestran un ambiente laberíntico, con pronunciadas pendientes y recónditas esquinas. Se presentan como masas indefinidas y oscuras de aspecto orgánico y amenazador: como la calle–gruta que da acceso a la comisaría. Por otra parte, la calle principal que conduce al Ayuntamiento tiene un aspecto abstracto señalado por las líneas longitudinales que recorren las paredes, cortadas por formas angulares.
 Las casas se presentan con cubiertas inverosímiles, coronadas por largas y torcidas chimeneas que configuran un tétrico bosque; los muros – infinitamente doblados– niegan todo principio de sustentación y estableciendo todas unas líneas de fugas en todas direcciones que recuerdan la obra de Lyonel Feininger.
 El paisaje *natural* tampoco se escapa de esta peculiar concepción, ya que los caminos por los que

huyen Cesare y Caligari presentan igualmente una cierta abstracción: líneas irregulares, surcos bamboleantes, paisajes sin vida plagados de árboles esqueléticos y que hacen pensar en los campos de batalla de la reciente guerra mundial.

b) Interiores:

En su interior las viviendas muestran el estado anímico de cada uno de sus inquilinos; así Alan vive en una buhardilla de connotaciones románticas y con paredes inclinadas donde las sombras se dibujan constantemente en las paredes, por todo mobiliario destaca una cama y la solitaria presencia de una silla de respaldo descomunal. No menos inquietante resulta la ventana –vinculo de conexión con el mundo exterior– con unas rejas torcidas y con un vano trapezoidal. líneas quebradas que en el fondo no hacen más que anunciar la tragedia que se avecina.

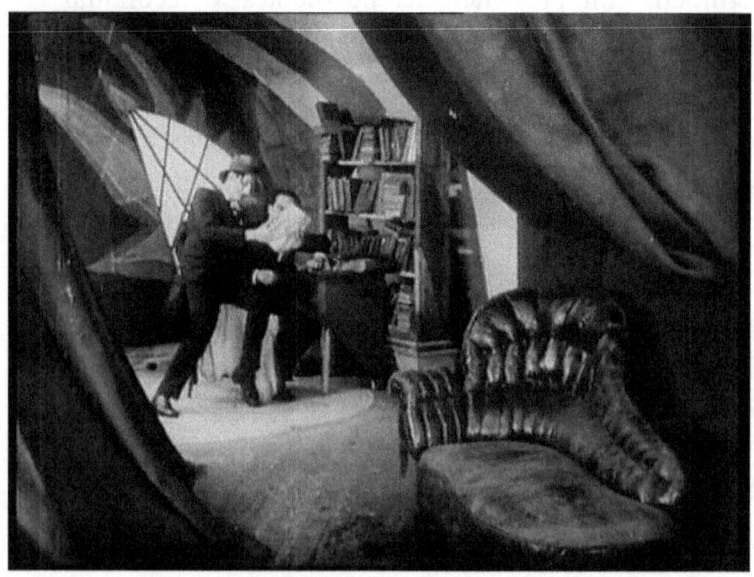

Interior en *Das Kabinet des Dr. Caligari*.

En la casa de Franz dominan las formas cavernosas que enlazan con una idea muy expresionista del seno materno como lugar de refugio de todo peligro exterior. La vivienda de Jane está dominada por los decorados sedosos creando un continuo efecto de *flou* y con dominio de formas circulares: flores de pétalos redondos, lámparas de globo, etc.

Pero incluso los decorados de otras estancias denotan un gran simbolismo, como el caso del despacho del Secretario de Estado: dominado por un frenético verticalismo en el que destaca un enorme taburete desde donde el político trabaja y controla a los subordinados. Tampoco se escapa de esta vorágine expresionista –una nueva visión crítica de los estamentos– la comisaría bunquerizada y de paranoicas proporciones.

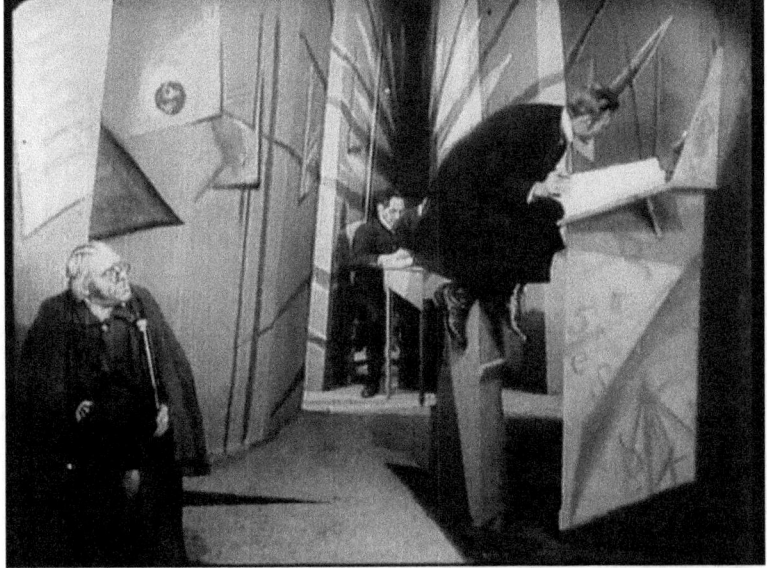

Despacho del Secretario de Estado en Das Kabinet des Dr. Caligari

Otros decorados habituales en los films

expresionistas tienen que ver con un retorno al pasado, fundamentalmente mágico, siguiendo algunas premisas de la literatura romántica. Uno de los ambientes predilectos por los cineastas expresionistas será la Edad Media.

Para los decorados de *Der Golem* Wegener elige al arquitecto expresionista Hans Poelzig (creador del Grosses Schaupielhaus) quien diseñó para ella una reconstrucción del ghetto medieval de Praga, bajo unos cánones neogóticos en el que abundan formas fálicas, cavernas y oquedades, de claras connotaciones eróticas y como reflejo de una sociedad en continua agitación. Los expresionistas recurrían a estas formas de connotación sexual con gran frecuencia para ilustrar, mediante las formas fálicas y las grutas – símbolo del seno materno–, la esperanza en el nacimiento de una nueva generación alejada del viejo sistema que había abocado a las gentes a un conflicto de gran escala.

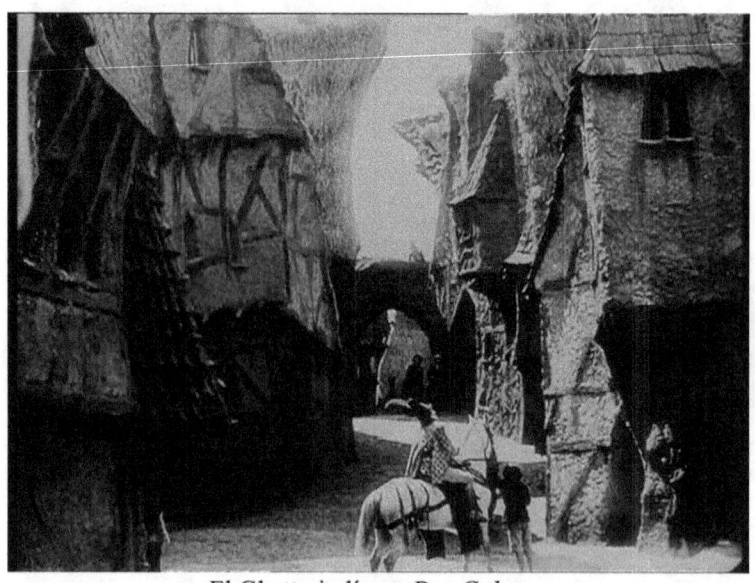

El Ghetto judío en *Der Golem*.

El empleo de esta simbología deriva de un desconcierto vital ante la crisis de valores de aquellos turbulentos años. García Martínez (1974: 111) comenta lo siguiente: "el expresionismo se confía al instinto y exalta el salvajismo sexual de los primitivos. En Nolde, Kirchner, en Dix, en Gross se refleja una erotomanía nutrida de rebelión; el sexo se hace angustia, pues es una imagen cabal de la sociedad en crisis y bancarrota".

Fausto de Murnau, uno de los últimos films expresionistas, también retoma la tradicional leyenda en un contexto medieval con aires apocalípticos. Aún en Los Nibelungos de Lang, basada en la saga–epopeya nacional germana, si bien sus decorados no son totalmente expresionistas, posee algunos elementos que sí lo son.

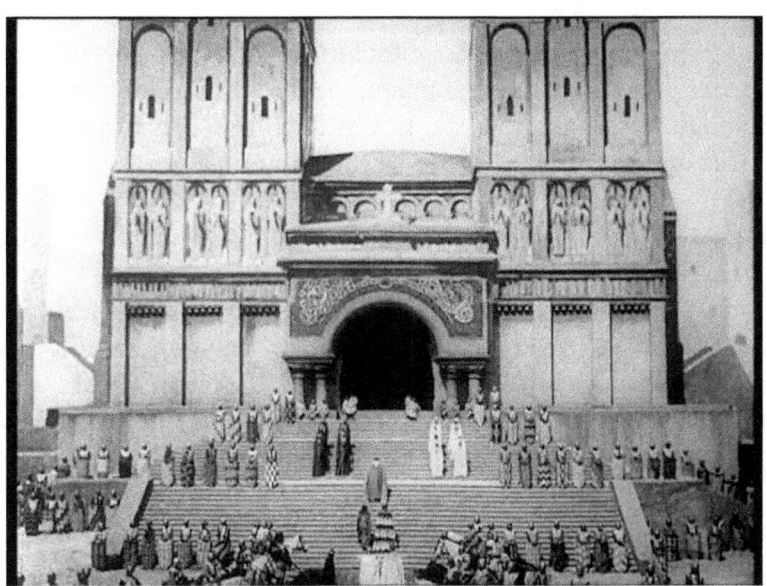

El ordenado mundo de Worms en *Die Nibelungen*.

La intención de Lang, por medio de un hábil uso de los decorados, en *Die Nibelungen* (1923), era mostrar cuatro mundos diferenciados:
- El mundo de Worms: cuna de una civilización refinada.
- El mundo de Sigfrido: caracterizado por bosques descomunales, prados misteriosos y un subsuelo repleto de tesoros.
- El mundo de Brunilda: una tierra pálida, helada un paisaje caótico de bloques de lava.
- El mundo de los Hunos de Atila: plagado de cavidades y laberintos.
Para esos paisajes artificiales, Lang trata de recrear cuadros famosos (en especial algunas obras de Arnold Boecklin). Lang aplica en forma magnífica el claroscuro y extrae de él cautivantes imágenes (secuencia del puente levadizo).

Por otro lado, la arquitectura equilibrada de *Die Nibelungen* no es expresionista, pero el realizador ha dotado de fuerza expresiva a la arquitectura reconstruida, vivificada mediante los recursos de la iluminación.

Interpretación.

La interpretación es uno de los aspectos quizás más llamativos del cine expresionista. Ya en Caligari (sus actores Krauss y Veidt fueron actores de la compañía de Reinhardt) la actuación realista es dejada a un lado. Cuando se quieren mostrar sentimientos (miedo, ira, deseo, etc.) se hace intentando exteriorizar estas emociones de la forma más extrema posible, a veces en forma violenta y abrupta, a veces con movimientos entrecortados y mecánicos, sumándole a esto, en algunos

casos, un excesivo maquillaje.

Para señalar la amenaza del Poder, encarnado en el personaje principal, Caligari (Werner Krauss) camina encorvado y con un aire misterioso, el empleo de trucajes fotográficos –rodaje a alta velocidad– acrecentará aún más su misterioso protagonismo en esta historia. Cesare (Conrad Veit) aprovechará al máximo su delgada silueta para personificar el mal, controlado por su amo, y se deslizará siniestramente.

El maquillaje remarcando sus facciones, sus ojeras romboidales, peinado desordenado –con una extraña semejanza con una figura del cuadro de Emil Nolde *Tomás dudando*– se revelan, en definitiva, como un paso más para hablar al espectador de un mundo de pesadilla que solo es fruto de los designios de un semejante.

En las películas de Fritz Lang se encuentra de manera constante el tratamiento de las masas humanas con las formas geométricas de connotaciones trascendentes como son las estructuras triangulares y cuadrangulares. No es de extrañar el dominio del lenguaje arquitectónico por parte de Fritz Lang ya que antes de iniciarse como realizador cinematográfico estudió arquitectura. Por su parte, Murnau se licenció en Historia del Arte, de modo que estaba familiarizado con la representación mística de la luz.

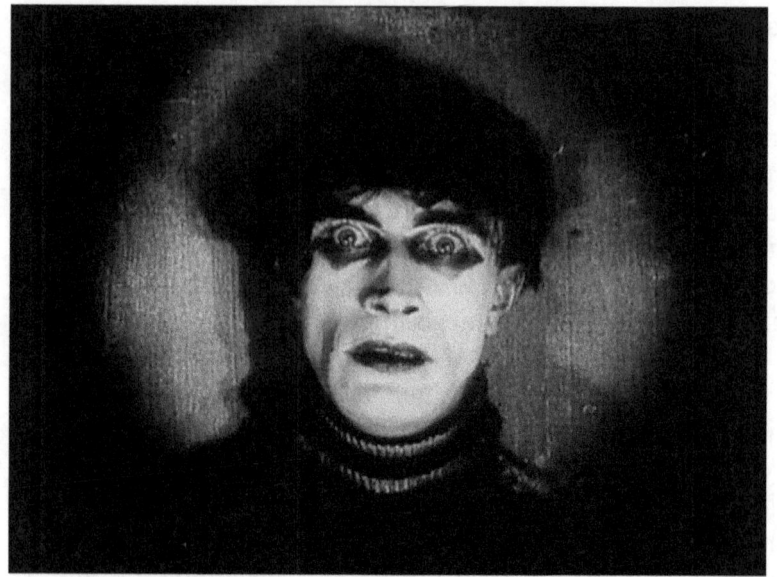

El sonámbulo Cesare en *Das Kabinet des Dr. Caligari*.

El cuerpo humano aislado es tratado en *Los Nibelungos* como elemento decorativo, absolutamente estático, privado de vida individual y fijado con simetría. Los extras son deshumanizados, rígidos, ocupando un lugar dentro de un cortejo delante de los héroes.

En *Metropolis* tras la destrucción del agente maligno en una hoguera de fuego purificador, nos muestra a toda la masa obrera, símbolo de la humanidad entera avanzando, en perfecta formación triangular, hacia la escalinata de la catedral gótica –la Jerusalén Celeste– donde se encuentra el Patrón. La visión de este acercamiento –por medio de un juego óptico– queda reflejado en la pantalla como si fuera ascendente, dando sensación de verticalidad; y dado el empleo de la simbología que reúne cada elemento escénico, ilustra perfectamente el acercamiento del Hombre a Dios. Ahora bien, Lang apunta la indecisión del Capataz y del

Patrón para iniciar un entendimiento, de tal modo que se hace necesaria la participación de un mediador, de un vínculo de unión entre el símbolo de la Humanidad y el símbolo del Patrón, esta figura es la que personifica el Hijo del Patrón. El apretón de manos del final, entre el Capataz, el Patrón y el Hijo, ante la puerta de la catedral y con una iluminación cenital – de aspecto sobrenatural– que no es más que la ilustración expresionista de una esperanza de tintes religiosos.

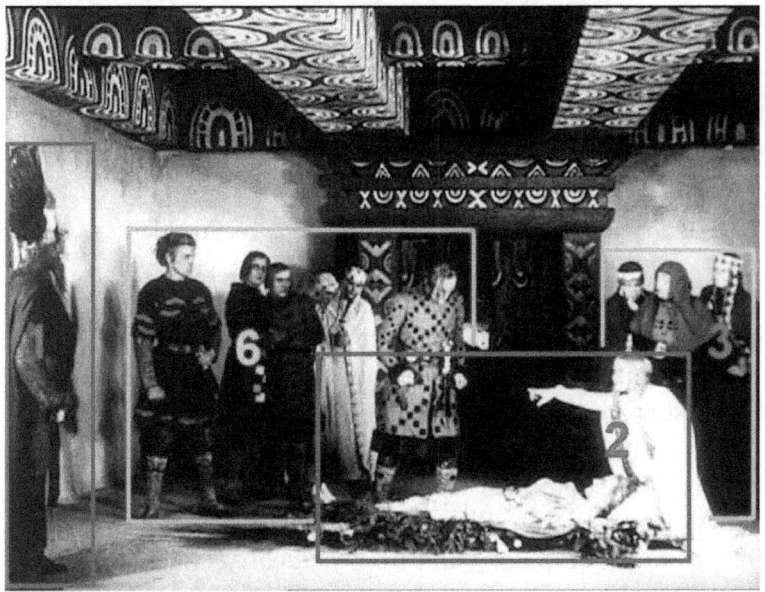

Ejes visuales y agrupaciones en *Die Nibelungen*.

Encuadre.

El encuadre es característico de las películas. La acción es casi teatral, no hay uso del fuera de campo, es decir que lo importante es lo que se ve, aunque sea tan intangible como una sombra.

Exterior en *Nosferatu* semejante a las obras de Friedrich.

Frecuentemente los encuadres se asemejan a composiciones pictóricas, sobre todo en el caso de Murnau y Lang, directores con un notorio conocimiento sobre historia del arte. Es común el uso de las diagonales no solo a nivel de la deformación de los decorados: también son comunes las figuras dispuestas en la pantalla en posición diagonal como, por ejemplo, la toma de la muerte del vampiro *Nosferatu*, causada por los rayos del sol. De igual modo en ocasiones se puede observar, en un encuadre fijo, surgir gradual y lentamente, una figura amenazante desde el fondo (como Cesare o Nosferatu).

En consonancia con el aspecto pictórico del encuadre, hay que decir que si bien el expresionismo cinematográfico rehuía la filmación en exteriores, los paisajes y tomas al aire libre de *Nosferatu*, uno de los films más emblemáticos, fueron realizados en la

naturaleza, logrando transportar a un pasado quizás aún más tenebroso y cargado de significado que los interiores y decorados del resto de films, ya que presenta –en perfecta armonía con el espíritu romántico que ambienta la narración– edificaciones semi–derruidas, arcos góticos y nublados paisajes amenazantes, el mar y las montañas, con una similitud a la obra del gran pintor del romanticismo alemán Caspar Friedrich.

El papel regenerador de la arquitectura y su puesta en escena.

Uno de los temas fundamentales de las obras expresionistas será la gran ciudad, lugar donde se manifiestan los sentimientos más oscuros de la civilización. Este carácter centralizador de los aspectos negativos del ser humano ya lo manifiesta Nietzsche (2004:252-254):

> Oh, Zaratustra, aquí está la gran ciudad: aquí tú no tienes nada que buscar y todo que perder. ¿Por qué querrías vadear este fango? ¡Ten compasión de tu piel! Es preferible que escupas a la puerta de la ciudad –¡y te des la vuelta! [...] Escupe a la ciudad de las almas aplastadas y de los pechos estrechos, de los ojos afilados, de los dedos viscosos, a la ciudad de los importunos, de los desvergonzados, de los escritorzuelos y vocingleros, de los ambiciosos sobrerrecalentados: –en donde todo lo podrido, desacreditado, lascivo, sombrío, superputrefacto, ulcerado, conjurado supura todo junto: ¡escupe a la gran ciudad y date la vuelta!

Las referencias, en diversas manifestaciones artísticas, son invariables: un lugar marcado por los efectos de la industrialización, un mundo carente de vida

y generadora de las calamidades que azotan a la sociedad. Todo un mundo apocalíptico despersonalizado y dominado por las referencias a la máquina como manifiestan los poemas de Gustav Heym (1981:55-61):

> Al igual que la danza de los coribantes, entre el ruido resuena por las calles la música de la multitud.
> El humo de las chimeneas, las nubes de la fábrica hacia él suben, azules como un humo de incienso […] Clava en la oscuridad su puño carnicero.
> Lo sacude, y un mar de fuego corre por la calle. Una humareda hierve.
> Y devora la calle, hasta que tarde empieza a amanecer.

Imágenes similares se encuentran en los cuadros de Ludwig Meidner donde la figura humana queda relegada a un segundo plano, siendo ocupado el discurso dramático por la explosión de la ciudad, volviéndose ésta en un espacio hostil al ser humano.

La arquitectura fue uno de los terrenos artísticos donde resultó más difícil llevar a la práctica los conceptos expresionistas, ya que la libertad creativa se veía mediatizada por condicionamientos materiales. Al mismo tiempo se puede señalar que si bien no existe un lenguaje formal propio del estilo expresionista, aparecen rasgos globales como la coexistencia de la ingravidez y la masa; la vuelta a las formas de la naturaleza; la búsqueda en las culturas primitivas; el uso de nuevos materiales.

Si aparecen en las obras una identidad estilística, consistente por un lado en la concepción de la obra como una unidad orgánica, cuyas partes se inter penetran y en el que se tiende a borrar los límites y compartimentaciones. Por otro lado, existe el empleo de un variado repertorio de elementos dramatizantes tales

como grandes cornisas y saledizos creadores de sombras, muros ondulados o inclinados, perfiles cortantes y puntiagudos, cubiertas exageradas; y el empleo del color con un valor psicológico. En definitiva, una relectura de espacios y relaciones entre ellos como propondrá Taut en uno de sus escritos (Casals, 1982:105):

> ¡Oh, nuestros conceptos: espacio, casa, estilo! ¡Cómo apestan estos conceptos! ¡Destruyámoslos, acabemos con ellos! ¡No conservemos nada! ¡Ahuyentemos sus escuelas, hagamos volar las pelucas profesionales, zarandeémosles de firme! ¡Aire, aire! ¡Que su polvoriento, enredado y gomoso mundo de conceptos, ideologías y sistemas sienta nuestro frío viento del norte! ¡muerte a sus conceptos piojosos! ¡Muerte a todo lo que obstruye! ¡Muerte a cuanto significa títulos, honores, autoridad! [...] En la distancia brilla nuestro mañana. ¡Hurra, tres veces hurra por nuestro reino sin violencia! ¡Hurra por lo limpio, por lo transparente! ¡Hurra por la pureza! ¡Hurra por el cristal! ¡Hurra y hurra otra vez por lo fluido, lo lleno de gracia, lo anguloso, lo chispeante, lo centelleante, la luz; hurra por la eterna arquitectura!

Terminada la Primera Guerra Mundial un grupo de arquitectos, entre ellos Walter Gropius y Bruno Taut, fundan el Arbeitsrat für Kunst (Consejo del Trabajo para el Arte), quienes establecen una serie de planteamientos utópicos encaminados a lograr la transformación espiritual del hombre, la cual sólo se lograría por la transformación de sus condiciones ambientales. Así, Taut redacta el *Architekturprogramm* en 1918 estableciendo una serie de medidas (construir viviendas populares de campo abierto, destruir los monumentos oficiales y las avenidas triunfales y formar talleres

experimentales con grupos de trabajadores y de artistas). En esta línea Gropius, como recoge Casals (1982:105) escribe, en un marcado estilo visionario, lo siguiente:

> Artistas, derribemos al fin los muros levantados entre las artes por nuestra deformadora educación académica y volvamos a ser todos, nuevamente constructores... Hoy todavía no hay arquitectos. Todos nosotros no hacemos sino preparar el camino para aquel que un día merecerá tal nombre, porque arquitecto significa señor del arte, que hará brotar jardines en el desierto y elevará maravillas hacía el cielo.

Los arquitectos expresionistas, harán uso de los nuevos materiales (vidrio, hormigón, acero...), buscando en ellos un efecto regenerador que ha de cambiar los valores sociales. De esta manera los materiales se revestirán de simbolismo y el vidrio sobresaldrá por encima de todos como: símbolo de la pureza, de la claridad, de la perfección. Según Taut, con el uso del cristal los espacios permanecen abiertos, el interior y el exterior se intercomunican, todos los efectos luminosos y todas las fantasías formales se hacen posibles y la arquitectura se hace flotante e ingrávida. Se referirá el vidrio como un material regenerador por medio del cual "todas las emociones íntimas y todos los grandes sentimientos han de despertar" (Taut, 1997:57). Estas ideas las llevará a la práctica en el Pabellón de Cristal, edificio visionario en el que Taut trata de materializar numerosas de las ideas de Scheerbart, quien en su obra *La arquitectura de cristal* (1998:85) menciona las posibilidades regeneradoras –con un marcado carácter espiritual– de este elemento, a saber:

> Si queremos elevar nuestra cultura a un nivel

superior, para bien o para mal, estaremos obligados a transformar nuestra arquitectura, y esto sólo nos será posible si a los espacios que habitamos les sustraemos su carácter cerrado. Esto podemos lograrlo con la introducción de la arquitectura de cristal, que deja que la luz del sol, la luz de la luna y de las estrellas no se filtre sólo a través de un par de ventanas, sino que entre directamente a través del mayor número posible de paredes que sean por entero de cristal, de cristal policromado. El nuevo entorno que habremos creado de esta forma nos tiene que traer una nueva cultura.

A la hora de buscar formas regeneradoras los expresionistas se volcarán de lleno en todas aquellas que tengan una conexión con la sexualidad, en donde encuentran las fuerzas originarias de la vida. Y con todas aquellas que tengan que ver con la vuelta a la naturaleza. De manera que en esa búsqueda de equilibrio entre arquitectura y naturaleza se inspiran en elementos naturales tratando de lograr una similitud entre los espacios arquitectónicos y las formas más básicas de la vida, como propugnará Finsterlin y llevará a la práctica Rudolf Steiner en su Goetheanum, edificio que se convertirá en el templo de la relación espiritual del hombre con el universo.

Espacio arquitectónico y cine.

La importancia del espacio arquitectónico será vital en la cinematografía expresionista donde se asiste a la construcción de una serie de escenarios urbanos y arquitectónicos de marcado carácter simbólico y psicológico que trata de crear un nuevo marco de civilización.

La primera realización que da cabida a nuevas

formas arquitectónicas para ambientar la historia es *Das Kabinet des Dr. Caligari* (Wiene, 1919). En donde se asiste a un despliegue dramático de la construcción, conseguido por medio de la ruptura de los planos suavizando o acentuando las aristas, incorporando enormes saledizos, muros ondulados, inclinados, cubiertas exageradas, etc. Tal y como Mendelsohn hiciera en la Fábrica Steinberg, Hermann & Co (1921–1923) o Fritz Häger en la Casa de Chile de Hamburgo (1922–1924), cuya fachada este se presenta excesivamente puntiaguda dotando a esta fachada de un dramático movimiento ascensional. De igual manera algunas perspectivas de la ciudad donde se desarrolla la historia de *Das Kabinet des Dr. Caligari* ya anticipan este dramatismo, por los tejados puntiagudos, por las perspectivas quebradas de las calles, las plantas de los edificios que se adivinan sinuosas y en esquizoide movimiento. El entramado urbano es laberíntico, con pronunciadas pendientes y recónditas esquinas. Las casas se presentan con cubiertas inverosímiles, coronadas por largas y torcidas chimeneas que configuran un tétrico bosque; los muros –infinitamente doblados– niegan todo principio de sustentación.

En definitiva, destaca que todo el decorado está dominado por líneas oblicuas, que visualmente transmiten un efecto y una carga emocional en el espectador acorde con el ambiente del film.

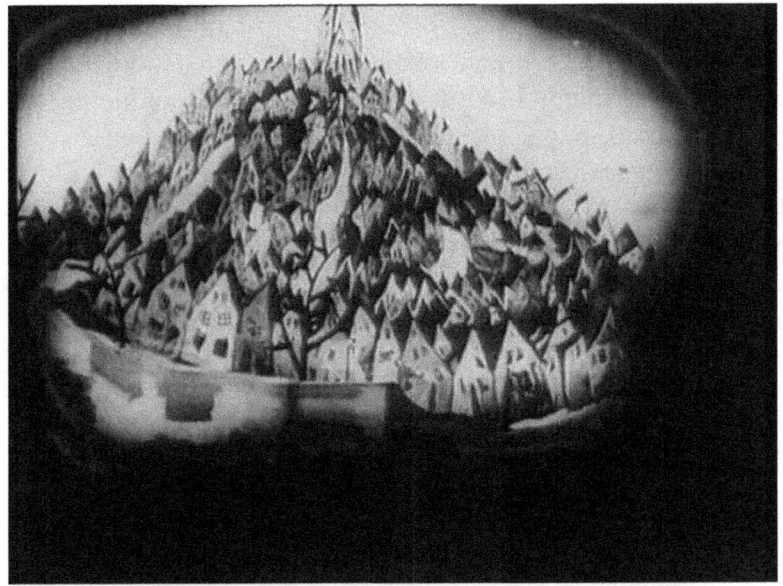

Influencia de *La arquitectura alpina* en Das Kabinet des Dr. Caligari.

Precisamente en esta realización cinematográfica se asiste a la puesta en escena, en muy pocos planos, de una de las teorías arquitectónicas defendida por Bruno Taut en sus escritos: La arquitectura alpina. Para presentar el escenario donde se va a desarrollar el film, una historia surgida de una mente desequilibrada, Robert Wiene ofrece un plano general donde se aprecia la ciudad construida siguiendo la orografía de una colina, adaptándose de nuevo al espacio natural y con la disposición de sus edificaciones como si fueran el brillo de una hoguera o el reflejo de un prisma. Este plano, que en realidad contiene un lienzo pintado por Hermann Warm, Walter Röhrig y Walter Reinmann –tres pintores del grupo Sturm– parece buscar su inspiración en Taut, quien en 1919 (fecha de realización del film) ya había escrito: "de la colina brota LA CASA, bañada por una

cálida luz dorada" (Taut, 1997:215). Pero también, y por la peculiaridad de la historia, la arquitectura tendrá un papel fundamental en recargar el ambiente claustrofóbico, pugnando por encontrar la libertad en las continuas formas ascendentes y las referencias al sempiterno uso de oquedades. El mismo plano comentado bien puede reivindicar otras palabras de Taut, a saber (1997:123):

> LAS ROCAS ESTAN VIVAS, HABLAN: Nosotras somos órganos de la divinidad tierra. Pero vosotros, gusanos, también lo sois. Vosotros, artistas constructores de cabañas, ¡convertíos antes en artistas! ¡Construid, construidnos! No queremos ser sólo grotescas, queremos ser bellas gracias al espíritu humano. ¡Construid la arquitectura del mundo!

Las edificaciones realizadas en numerosas películas presentan por otro lado una concepción orgánica, es decir, el edificio como un continuo de partes que se interpenetran como parte de un todo, pero que lejos de presentar formas nítidas, tiene un aspecto laberíntico y en movimiento como si en efecto el edificio estuviera vivo y el ser humano que lo habita no fuera más que una parte de ese todo.

En conjunto el aspecto del ghetto judío de Praga del film *Der Golem* (Wegener, 1920) representa esta idea: un espacio en continuo movimiento, con fachadas sinuosas, tejados puntiagudos, vanos igualmente desencajados, muros con una inclinación tal que pierden el sentido de la sostener la obra construida. Todo un programa de arquitectura de fachadas elemento privilegiado por Poelzig y en donde manifiesta todos "los elementos dinámicos, estáticos, fantásticos y patéticos de un edificio" (Eisner, 1955:23).

La construcción de esta ciudad efímera –que termina consumida por las llamas al final del film– fue obra del arquitecto Hans Poelzig, y en ella se puede encontrar una cierta conexión con numerosos proyectos ideados –y nunca construidos– por Hermann Finsterlin, arquitecto que había realizado maquetas y dibujos de formas arquitectónicas extrañas semejantes a organismos en continua metamorfosis, en un estado cambiante continuo y que según él mismo requería la complicidad del ser humano (Gössel y Leuthäuser, 2001:119-120):

> En el interior de la nueva casa uno no se sentirá como el morador de una glándula de vidrio, sino como habitante interno de un organismo, peregrino de un órgano a otro, simbiosis receptora y donante de un vientre materno fósil. Una porción del complicado sintagma de las formas del mundo reside en la sucesión de ciudad, casa, mueble, vasija: uno creciendo a partir del otro, como las gónadas en un organismo [...] De esa forma, la casa podría convertirse en una vivencia, en una bolsa marsupial viviente, que nos protege amorosamente y forma como el aguijón de un cínife, un cáliz que se colma nuevamente a diario con las fuerzas de una tierra palpitante, y no como féretro para cuatro momias de tela incorporadas a la fuerza y cortadas a medida.

En efecto, el aspecto de algunos espacios de interior se asemeja a los descritos por Finsterlin.

La vivienda del rabino Löw presenta una escalera cuya apariencia es similar a la guarida fetal, similar ocurre con algunas de las habitaciones donde los arcos apuntados se inclinan más allá de toda realidad de sustentación y recuerdan de nuevo la forma del útero, forma simbólica de la que se valen para "reencontrar las

fuentes originales de la vida universal" (Casals, 1982:107). Estas formas simbólicas que remiten una y otra vez a la simbología sexual se puede encontrar en otros ejemplos, estos si construidos, como la Torre Einstein de Erich Mendelsohn, o el Grosses Schauspielhaus del mismo Poelzig que retoma la idea de "guarida fetal" y la aplica al esquema clásico de la planta del teatro romano eliminando la separación de los espacios del público y la representación, exigencia obligada por las representaciones teatrales que Max Reinhardt llevaba a cabo en este marco.

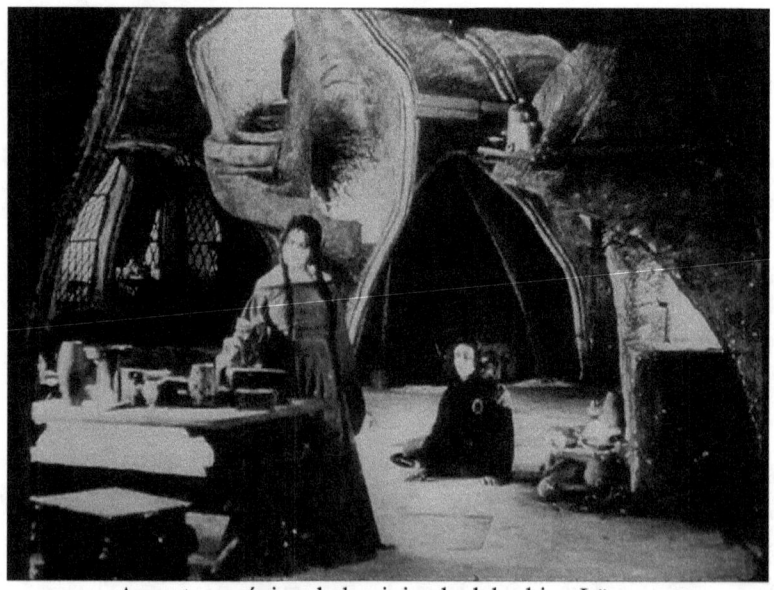

Aspecto orgánico de la vivienda del rabino Löw

No es disparatado pensar que en las películas expresionistas se privilegiarán estos tipos de espacios, ya que la historia que se presentaba en la pantalla debía contar hasta cierto punto con la complicidad de los espectadores, puesto que – retomando palabras de Taut–

los dos tipos de obras se dirigen "exclusivamente a las emociones" (Casals, 1982:103).

De igual manera, las formas arquitectónicas que se aprecian en la realización de Wegener se asemejan a la solución propuesta por Steiner –teórico de la antroposofía– en la construcción del Goetheanum: una mole de concreto coronada por dos cúpulas y que se asemeja desde la distancia a un animal agazapado esperando ponerse en movimiento. Más espectacular es el interior de este espacio: una sucesión de espacios tallados en caprichosas formas, cavernas sombrías que dan acceso a lugares destinados a la búsqueda del conocimiento, la búsqueda de respuestas a medida del ser humano. Este edificio, inaugurado en 1914, encontrara una original replica en los espacios interiores del film mencionado, encontrando casi una copia de algunas de las propuestas de Steiner en los decorados de Poelzig: el laboratorio del rabino Löw, la sala de lectura con sus arcos de influencia gótica totalmente desplazados, e incluso la propia apariencia del material empleado que en ningún momento remite al sillar que sería de esperar en una estructura medieval, sino a una adaptación del concreto.

Fruto del interés de la época por la tecnología y el maquinismo surge *Metrópolis*[44] (Lang, 1926), film cuya acción se sitúa en el año 2026. Como menciona Whitford (1991:143) "la tecnología pasó a ser un tema popular. Algunos libros técnicos de divulgación se vendieron como ningún otro título en los últimos años de la década de los veinte. Quizá la evidencia más espectacular de la fascinación por la máquina y de su reflejo social fue la película de Fritz Lang: Metropolis".

En el argumento, mientras que en la superficie de la ciudad los dueños disfrutan de todo tipo de lujos y comodidades, en el subsuelo habitan los obreros

sometidos a un trato inhumano: son utilizados como meros engranajes de la maquinaria que sostiene la vida de la ciudad. María, la hija de un obrero, predica –con resignación mesiánica– la llegada de un mediador entre el dueño y el trabajador. Freder, el hijo del amo de Metropolis, se enamora de María y llega a abandonar la fácil existencia de la superficie para asumir el papel de mediador. En medio de la acción aparece Rotwang, científico creador de la mujer robot quien a la larga desencadenará la ruina y la destrucción.

El espacio arquitectónico recreado por Lang[46] en su film tiene la intencionalidad de establecer un marco para la regeneración de una sociedad controlada y dirigida por el gran capital y determinada por el maquinismo. Sociedad delimitada en dos espacios altamente contrastados y que se conecta con las teorías del momento. Así, en 1923 Taut elabora un plan urbanístico para la ciudad de Magdeburgo en el que se prevén parques y equipamientos públicos, y se proyectan complejos residenciales para los trabajadores junto a edificios destinados a actividades colectivas. En consecuencia, Lang no hace sino recoger y adaptar una realidad existente en la Alemania de la República de Weimar.

Esta diferencia de espacios encuentra un interesante referente en un texto escrito, en esta ocasión por Georg Simmel en 1900 (Simmel, 1997:360):

> El hombre de la gran ciudad moderna precisa de un número infinito de proveedores, trabajadores y colaboradores, sin los cuales estaría desamparado, pero que solo tiene una vinculación absolutamente objetiva con ellos, por medio del dinero, de modo tal que no depende de una persona concreta, sino de la presentación objetiva, valorada en dinero, que

pueden realizar cualesquiera personalidades fácilmente intercambiables.

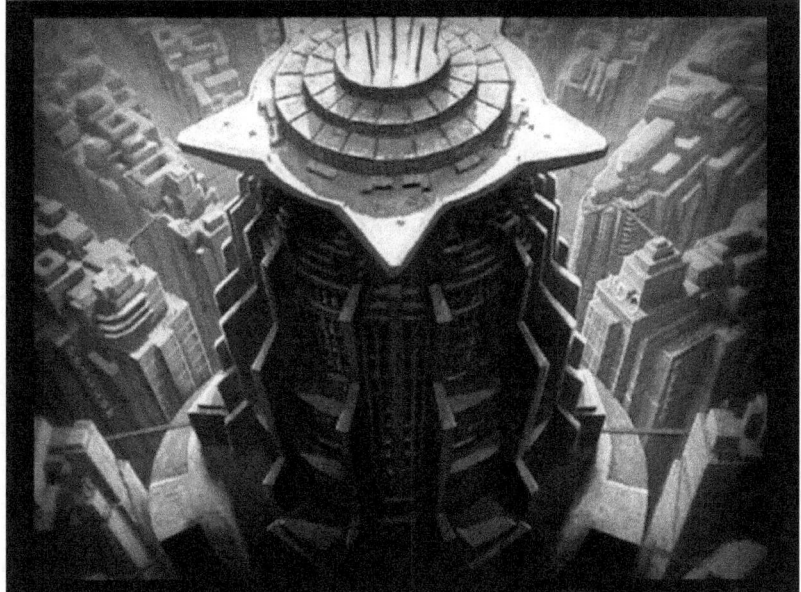

Vistas de la ciudad superior de *Metropolis*.

La construcción en la pantalla de esta idea, llevará a Lang a presentar dos espacios urbanos totalmente diferenciados, a saber:

El primero de ellos es la ciudad superior dominada por la presencia de un estadio olímpico de majestuosa construcción, jardines frondosos y locales de diversión como el Yoshiwara.

La ciudad es un conglomerado de rascacielos que recuerdan el proyecto La Corona de la Ciudad de Bruno Taut, que consistía en una ciudad de cristal que proyecta sus formas, mezcla de gótico y expresionismo, hacia lo alto, y donde destaca la construcción central de una torre acristalada (en el film el amo de la ciudad Joh Fredersen domina desde una torre similar toda la extensión de la urbe) que hace pensar en las palabras de Paul Scheerbart (1998:130):

> Las torres siempre deberían destacar un lugar o una ciudad. Por eso, es lógico que también se intente hacerlas resaltar por medio de la oscuridad de la noche. En este sentido, todas las torres deberán transformarse siguiendo los principios de la arquitectura de cristal, para convertirlas en auténticas torres luminosas.

Las comunicaciones que se extienden en la ciudad superior tienen un marcado aire visionario: carriles a distinto nivel, pasos acristalados, túneles entre los edificios, y un tránsito de vehículos entre los que no faltan aviones y dirigibles y que de nuevo parecen materializar un proyecto visionario de Scheerbart (1998:18):

> Treinta torres gigantes en tres círculos rodean una torre colosal en el centro de ciento cincuenta pisos, mientras las otras torres tienen solo ciento veinte,

ochenta y cuarenta pisos [...] Ahora imagine todos esos pisos conectados entre sí por puentes. Entonces deberá imaginar salas de estar dentro de estos pisos, que se mueven hacia arriba y abajo como ascensores, y también se mueven a través de los puentes. Además, cada torre rota. Y en esta arquitectura giratoria usted puede entonces, en una habitación simple, conducir por donde quiera.

De igual manera la propuesta teórica de Taut de la Corona de la Ciudad parece hacerse realidad en los fotogramas que ofrecen una panorámica de la ciudad, vista general ofrecida por el realizador desde el emblemático edificio que ocupa el centro de la gran urbe, una enorme torre de vidrio y concreto armado representativa del poder ejercido por el todopoderoso dueño de la ciudad, y que encuentra a su alrededor una serie de edificaciones de menor tamaño –en escala decreciente– "que se hallan al servicio de los más nobles deseos del pueblo, edificios que a su vez están separados por atrios de las actividades más profanas" (Taut, 1997:60).

El siguiente espacio es la ciudad subterránea, lugar dominado por la agobiante miseria de los obreros y su hábitat semejante a un hormiguero. La primera visión que ofrece el director es la de un cambio de turno: una masa de obreros derrotados, molidos, que avanzan pesadamente bajo un túnel neutro. La ciudad es una alineación de casas que se estructuran en torno a una plaza central. Son viviendas masificadas dominadas por las líneas rectas y angulosas, que le confieren al conjunto un aspecto de colmena. Las cubiertas son planas, sin salientes ni alerones. Un sistema de construcción alineado semejante al proyecto arquitectónico que Ernst May realizó en Frankfurt.

Bruno Taut y la propuesta de la Corona de la Ciudad (1919)

Si bien Taut se refería a la arquitectura como "una imagen cristalizada de la estratificación humana" (1997:57) Lang señala en sus imágenes que la arquitectura se reserva el derecho de cobijar a las clases sociales. De tal manera que Lang acota los espacios señalados por Taut para uso común –estadios, jardines, vías de comunicación, edificios representativos, etc.– a las clases adineradas; mientras que, para el espacio de los obreros, más que seguir las ideas de Taut en cuanto a zonas residenciales, parece inclinarse más por las propuestas de viviendas estandarizadas de Tony Garnier en su proyecto de 1917 *Une cité industrielle: Étude pour la construction des villes* como recuerdan Lupfer y Paul (2003:680-682):

> Las zonas destinadas a viviendas están ordenadas por una red de calles ortogonales, que delimitan bloques de tamaño regular. [...] La arquitectura se caracteriza por un diseño uniforme: volúmenes cúbicos, la superficie formada por muros lisos, una racionalidad de provocadora escasez. [...] Todo debía estar construido en hormigón armado.

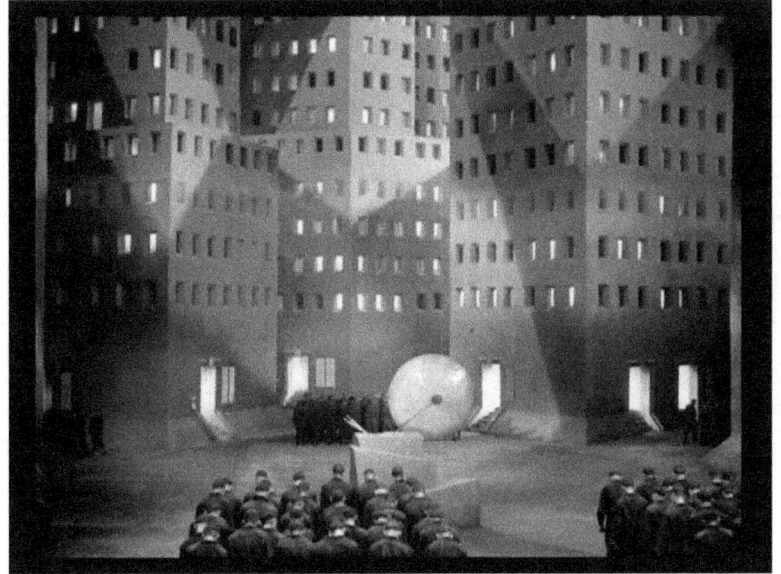

Las viviendas de los obreros de *Metropolis*.

Esta ciudad inferior, la de los oprimidos, es la que por otro lado ofrece un carácter mucho más racional que la superior, ya que tal y como propugnó Adolf Loos – *Ornament und Verbrechen* (Ornamento y delito, 1908), el ornamento no tendrá presencia alguna, aspecto que en manos del cineasta se convierte en un argumento que remarca aún más el espacio del dominio del gran capital sobre el trabajador.

El planteamiento vertical del urbanismo ficticio de Metropolis ejercerá un gran impacto, pues en 1927 tras el estreno y difusión del film Metropolis, aparece en escena la obra *Groszstadtarchitektur* del arquitecto alemán Ludwig Hilberseimer, quien a lo largo de su teoría sobre el urbanismo de la gran ciudad moderna reconoce la dependencia del urbanismo y el capital.

Bloque de viviendas de IG Farben (Hans Poelzig, 1927)

Propuesta de la gran ciudad de Hilberseimer (1927)

De igual manera que ocurriera en el film, el arquitecto plantea un entramado urbano dominado por la geometría y la proporción, por los desniveles creados por los edificios y como se salvan por medio de calles elevadas, distintos niveles de circulación, paseos y avenidas cuya perspectiva se pierden en el subterráneo de la ciudad, de la existencia de un edificio de cristal –de

nuevo la idea de Taut entra en escena– en el centro de la ciudad con una función representativa, y sobre todo destaca la sobrecogedora teoría de urbanización de los espacios de comercio y vivienda (Hilberseimer, 1979:17-18):

> Si la ciudad comercial y de habitación se construyen una sobre otra, los trayectos entre ambas no se harán horizontalmente sino, sobre todo, en vertical, y dentro de un mismo edificio, sin tener que salir a la calle. Con ello desaparecen los caminos largos y derrochados de tiempo actualmente necesarios, y debido a ello, tanto la vida como el tráfico se simplifican, quedando la circulación reducida al mínimo posible.

La carga simbólica del expresionismo alemán se diluye con la incorporación del *Kammerspielfilm*, nuevo estilo dentro de la cinematografía germana. En estos films se efectúa un descenso a la realidad cotidiana y se ofrecen historias, de gusto clasista, sin recurrir al exagerado dramatismo de las atormentadas luchas espirituales propuestas por los cineastas puramente expresionistas[54]. Como recuerda Casals (1982:125) "pese a una mayor sobriedad en la interpretación y a unas ciertas preocupaciones psicológicas y sociológicas, los "dramas cotidianos" de la Kammerspielfilm no deben ser vistos como una vuelta definitiva a la realidad, sino como una transposición al ámbito vital de la pequeña burguesía del mismo estado de espíritu, inquieto y desquiciado que se apreciaba en las películas fantásticas o de terror".

Finalmente, esta edad dorada del cine alemán se trunca de raíz en 1933 por el tránsito a una nueva estructura de poder que introdujo una "nueva" manera de concebir no solo el cine sino incluso el arte. A pesar de

esta brusca interrupción la impronta del expresionismo en la cinematografía fue tal que se encuentran pinceladas de esta peculiar manera de construir cine en autores tan lejanos en el tiempo como Eisenstein, Orson Welles y Lars von Trier, e incluso en películas espectaculares como *Batman*, o *Blade Runner;* e incluso en géneros como el de la animación con producciones tan sugerentes como la japonesa *Jin–Roh*.

ARTE E IDEOLOGÍA EN EISENSTEIN.

La Revolución de Octubre y las primeras obras.

La Revolución de Octubre trajo una influencia liberadora en el arte y la cultura rusa. En este momento surgieron una serie de artistas, poetas, músicos y cineastas inspirados por la Revolución que encontraron una gran libertad cultural promovida por los bolcheviques liderados por Lunatcharsky, intelectual con una visión panorámica de la cultura y del arte. Su influencia se hace extensiva al Comité Central del Partido Bolchevique y en el decreto, emanado de este, el 16 de junio de 1925: *Sobre la política del partido en materia de literatura artística.*

Los principales artistas de la vanguardia rusa apoyaron la Revolución, y algunos de ellos como Malevich, Tatin, Kandinsky, Rodchenko, y otros tendrán una intensa actividad política, influenciados de una parte por las proclamas de Maiakovski, como la Orden n° 2 al ejército de las artes (1921):

> Perdidos en disputas monótonas
> buscamos el sentido secreto,
> cuando un clamor sacude los objetos.

¡Dennos nuevas formas!
No hay más tontos boquiabiertos,
esperando la palabra del "maestro".
Dennos camaradas, un arte nuevo
que arranque a la República de la escoria.

Por otro lado destacan las propias palabras de Lenin (1975:227): "Vosotros los artistas sois unos individualistas obstinados; id a las masas; id a las fábricas y a los talleres. Allí recibiréis impulsos nuevos para vuestro trabajo creador, allí descubriréis lo que necesita en cada caso el proletariado".

Parte de esta renovación cultural es la formación del Proletkult, organización destinada a culturizar a las masas cuya función queda expresada en el manifiesto sobre el arte aprobado y difundido por el Comité Central de esta organización en 1923 (De Micheli, 2001:332):

> El arte debe constituir una parte intrínseca de la vida cotidiana, ya sea en las formas activamente figurativas (manifiestos, anuncios, teatro de agitación y propaganda, cine), ya sea en las formas materialmente organizativas (cultura psicofísica, organización de espectáculos de masas, fiestas, desfiles y manifestaciones, es decir, el ambiente material en el que se desarrolla la vida cotidiana y la construcción de objetos.

Precisamente, en 1920 Eisenstein entra a formar parte del Proletkult, y durante los cuatro años siguientes se forma teatralmente a las órdenes de Vsevolod Meyerhold. El interés de Eisenstein por el teatro fue una constante a lo largo de su carrera y, al igual que en cine, intentó introducir conceptos vanguardistas. Uno de estos conceptos innovadores data de 1934 cuando junto a Lev Kuleshov idea un espacio para adiestrar actores, se trata

de "un escenario principal con otros dos que lo flanquean. El escenario principal gira. El espectador se sienta en un disco central que también rota, girándolo hacia el área de acción en el momento adecuado. Las paredes pueden abrirse para mostrar la vista exterior" (Bordwell, 1985:36).

Pasado este tiempo debuta como realizador en el mundo del cine, esa "nueva manera de sentir" que diría Bresson, con su opera prima: *Kinodnevik Glumova* (*El noticiero de Glumov*, 1924), en donde el genio creador de Eisenstein comienza a aflorar iniciando una búsqueda teórica y práctica que lo acompañará hasta su muerte.

En estos primeros momentos, Eisenstein propone un nuevo cine afín a la Revolución al que da el nombre de Cine Dialéctico y que difiere de las teorías de los otros maestros del cine ruso del momento.

Otros dos grandes teóricos de la escena cinematográfica revolucionaria de los que Eisenstein extraerá ideas son Dziga Vertov, quien es partidario del Kino Glaz (Cine Ojo) un cine que trata de mostrar la verdad por medio de sus imágenes y que en consecuencia traslada la cámara a la calle donde filma a los "mortales en sus ocupaciones habituales"; el segundo cineasta a tener en cuenta –más teórico si cabe- es Lev Kuleshov, quien incide en la importancia del montaje e cuanto forma de expresar la "realidad", la cual puede ser creada y construida con distinta originalidad.

El Cine Dialéctico no tiene tanto la intención de reflejar la realidad como de establecer un juicio ideológico sobre ella. En definitiva, el único sentido de la realidad es el que se le da, la lectura que se hace de ella. Para conseguir este efecto, Eisenstein recurre a un elaborado sistema de montaje cuyo resultado final es un discurso articulado a base de –según su peculiar visión: fragmentos cinematográficos. El concepto de fragmento

en Eisenstein va más allá de la unidad mínima que comúnmente se asocia al plano. Para el maestro soviético –dado que usa planos muy cortos en sus películas- esta unidad fílmica está más en función de elementos técnicos (luminosidad, contraste, color, duración, etc) y narrativos (necesaria articulación entre los fragmentos que lo rodean)

Estos fragmentos, partes de un todo, se articulan según el modelo del conflicto y que se produce no solo entre fragmentos sino incluso dentro de ellos, dado que son entidades propias cargadas de significado. Como él mismo declaraba, el montaje de un film revolucionario debía (Da Silva, 1998:25):

> Estar basado en la yuxtaposición de escenas, pequeños sketches, agitación-propaganda, actos circenses, comedias, en una combinación de comentarios, gestos, música, film, escenificación y otros elementos visuales en principio heterogéneos, aunque montados, en cuanto atracciones del mismo estatuto, en un conjunto que hace converger la tradición de los espectáculos populares y el nuevo espacio del music-hall urbano. La luz, los efectos de sorpresa y conmoción definen una relación tensa con el espectador, una especie de movilización por la agresión, por el choque, una multiplicación de estímulos.

Todo ello se revela como una novedad a la hora de concebir la estructura narrativa de un film, que hasta el momento había estado influenciada por el modelo griffithiano heredero de la narrativa burguesa de Dickens[61]. Este tipo de argumento fílmico y su construcción –lo que Noel Burch denomina Modo de Representación Institucional- había demostrado su validez a la hora de consolidar los procesos del lenguaje

cinematográfico clásico. El mismo Eisenstein reconocía esta herencia: "lo mejor del cine soviético ha salido de *Intolerance*, en lo que a mí se refiere se lo debo todo" (Brunetta, 1987:138).

La teoría de Eisenstein del choque de imágenes, autentica agresión a los sentidos, tiene como misión ejercer una influencia directa en el espectador, hacerle participar de la lucha ideológica propuesta por las imágenes, participar –si fuera psicológicamente, de la lucha revolucionaria.

Estas ideas las sistematiza en la redacción de su ensayo: *Montaje de Atracciones*[62], publicada en la revista del LEF, en la que señala la gran importancia de producir ese choque emocional en el espectador. Así, de nuevo la influencia teatral emerge en la obra teórico y práctica de Eisenstein, ya que el montaje de atracciones no era más que una relectura de los conceptos propuestos en 1922 por el manifiesto FEKS (Fábrica de Actores Excéntricos).

Eisenstein pone en práctica esta teoría del choque emocional en sus primeros films. Así en *Stachka* (*La huelga*, 1924) se asiste a una continua referencia de atracciones. Una de las primeras secuencias yuxtapone una serie de planos en los que los informantes de la policía son asociados a los nombres e imágenes de animales traicioneros.

Montaje de atracciones: construcción del espía en *Stachka*.

Otra secuencia –de gran carácter psicológico– muestra la represión de la masa obrera asociándolo al degüelle de un buey. Aunque es en *Alexander Nevsky* donde alcanza su máxima expresión.

En este film perviven las ideas de choque de imágenes para construir en el espectador una determinada toma de conciencia. Así se detectan toda una serie de motivos visuales opuestos. El agua para el bando ruso significará vida (Alexander y la comunidad que dirige es una sociedad que extrae sus riquezas del lago) para los germanos el agua será la sepultura final tras la batalla.

Choque de imágenes: el agua vida y muerte

El vestuario de los rusos se asemeja al color de los elementos terrenales, mientras que el de los Teutones con el del frío y la ausencia de vida. Invierte de esta manera el significado tradicional de los colores que asocian el blanco al bien y el negro al mal.

Los soldados rusos muestran en todo momento su rostro en la batalla, por su parte los alemanes usan yelmos que les confiere el aspecto de cubos y seres desprovistos de personalidad.

En este film muestra otro elemento que será característico de su obra: las masas. Frente al tratamiento estético de Pudovkin, quien pretendía realzar la figura del individuo, Eisenstein hace de la masa un único individuo dramático.

Por otro lado, en su cine se aprecia un gran valor dramático en cada plano que configura la secuencia siendo paradigmático *Bronienosiets Potiomkin* (*El acorazado Potemkin*, 1925), film conmemorativo de la Revolución de 1905. La sublevación de los marineros del buque insignia de la flota zarista y la tragedia de los que simpatizaron con ellos se torna un auténtico *shock* visual por medio de primeros planos intercalados vigorosamente: el dolorido cuerpo del marinero azotado, el amargo rictus de Vakulenchuk antes de morir, la

crueldad de las botas de los cosacos, las bayonetas pasando por encima de los cuerpos muertos, etc. Planos que desde el punto de vista ideológico "hablan también respecto de la fuerza incontrolable de la revolución, de la lucha contra la opresión, de la solidaridad entre los trabajadores" (Da Silva, 1998:34).

Con todo, la secuencia de la escalinata de Odessa es la que resume la intención del film. Una y otra vez insiste Eisenstein en las atracciones: la inminencia del ataque a los marineros se resalta por planos de máquinas paradas; la muerte del médico –representante de la opresión zarista- se acentúa con un plano de las lentes colgando por la borda. Entre todo el caos que se genera en la represión y la huida por la escalinata "la multitud es individualizada por medio de grandes rostros o por detalles de actitudes y vestimentas, escogidos con un sentido inigualable de caracterización [...] el episodio, por otro lado, está puntuado por atracciones violentas y desgarrantes: la madre con el cadáver del hijo en los brazos, el carro de la criatura, abandonado, rodando por la escalera, el ojo vaciado sangrando por detrás de los lentes quebrados" (Sadoul, 1967:137).

Junto al significado político, Eisenstein utiliza en este film una serie de motivos que entroncan con la tradición artística, iconos a los que reviste de una lectura diferente, netamente ideológica; a saber:

1.- El pensador: una de las secuencias más cargadas de significado ideológico muestra a un marinero mientras lava la vajilla de los oficiales. Eisenstein construye esta secuencia por medio de primeros planos del marinero y planos detalle de la cubertería de plata, los lujosos platos, etc. El choque se produce cuando el marinero lava un plato que tiene escrito en su borde las palabras del Padrenuestro: "Danos el pan nuestro" cuya lectura produce un efecto

de concentración y reflexión que deriva en la toma de decisión de amotinarse. Recuérdese que la sublevación se origina en la negativa de los marineros a comer la carne podrida que les suministran los oficiales. El discurso para el público sería: la revolución -la liberación de la tiranía zarista y sus sostenedores pasa por una toma de conciencia previa.

2.- Las escaleras: como señala Balló (2000:111) la escalera "supone una estructura de poder y contrapoder, de opresión y rebelión [...] señala la distancia entre la masa y los elegidos, como se manifiesta en la mayoría de las películas basadas en la visualización del poder imperial". En la secuencia de la escalinata las subidas y bajadas remarcan el enfrentamiento -la lucha de conceptos antagonistas- entre opresores anónimos de los que tan solo se ve el rítmico descenso de las botas —de nuevo icono asociado al poder- y víctimas individualizadas. Todo ello presentado por una cámara bien con angulación enfatizada bien usando un vertiginoso travelling de retroceso. Una composición similar, pero paradigmática de una ideología situada en la antípoda del comunismo, se encuentra en *Triumph des Willens* (*Triunfo de la voluntad*, 1936) de Leni Riefenstahl, donde el desfile de las tropas de las SS descendiendo por una escalinata monumental guarda muchas similitudes con el caso presente.

Tampoco es casual la disposición de los grupos de individuos en la secuencia: en la parte superior la fuerza represora gubernamental; en la inferior: la masa reivindicativa que a la postre es masacrada.

3.- La Piedad: este referente icónico tiene unas marcadas connotaciones religiosas, que en manos de Eisenstein sufre una desacralización que no la hace perder el dramatismo, aún más, acaba por reforzarlo. El

motivo en si es la secuencia de la madre con el niño muerto en brazos —¿una anticipación del Guernica de Picasso?- que asciende la escalinata para enfrentarse a los verdugos. El realizador rompe así con la tradicional *pietá* estática y resignada para dotarla de actividad y dinamismo: es parte del proceso de toma de conciencia frente a la opresión, una lucha contra el conformismo establecido por la concepción ortodoxa del cristianismo.

El pensador o la toma de conciencia en *Bronienosiets Potiomkin*.

Las escaleras manifestación del poder opresor.

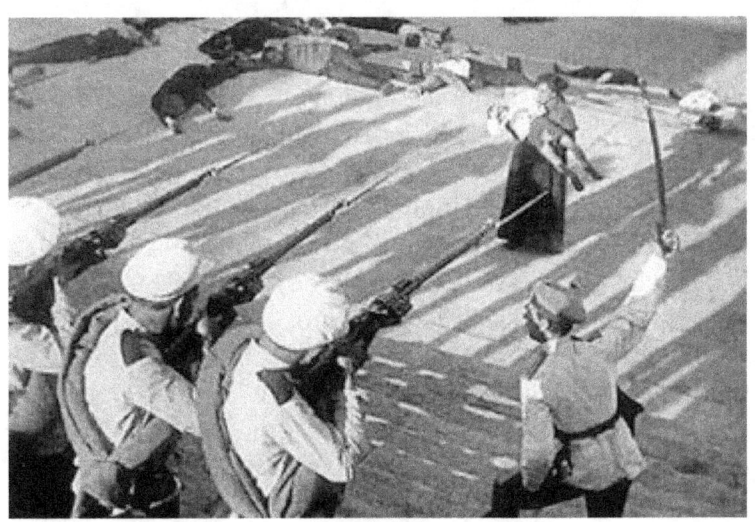
La piedad.

Una nueva producción cinematográfica de Eisenstein tiene lugar en 1927, año en el que se conmemora el 10° aniversario de la Revolución. En esa fecha filma *Oktiabr* (*Octubre,* 1927*)* película en la que adapta la obra de John Reed *Diez días que conmovieron*

al mundo. La idea teórica de la que parte es la del Cine de Masas, una concepción cinematográfica de nuevo cuño que trata de crear un cine pedagógico, que fuera un material didáctico que ayudara a consolidar la conciencia revolucionaria del espectador. La manera más sencilla de conseguir este propósito es mediante la realización de películas de genero histórico.

La praxis de esta nueva teoría, es decir: *Oktiabr*, integra dos géneros diametralmente opuestos: documental y ficción. La vertiente documental se encuentra en la localización exacta en donde ocurrieron los acontecimientos, los objetos reales asociados a los personajes e incluso en el uso de imágenes documentales –strictu senso- de algunos de los protagonistas, dándose la particulariad de que uno de los *personajes* que se incluían en la película original era Trotski, cuyo papel en la gestación y desarrollo de la Revolución había sido indiscutible, y que fue "eliminado" del metraje original por la censura stalinista.

El discurso didáctico del film muestra la necesidad de acabar con el dominio de los Romanov, la ineficacia del gobierno provisional de carácter burgués de los mencheviques liderados por Kerenski y la necesaria toma del poder por parte de los bolcheviques – el revolucionario del pueblo, el pueblo mismo única fuerza capaz de imponer orden en el proceso revolucionario.

Para argumentar todo ello recurre a imágenes de choque, como las secuencias que asocia las imágenes de los Romanov con los iconos rusos; o la secuencia en la que muestra a Kerenski ascendiendo lentamente la escalera –de nuevo asociada al poder del Palacio de Invierno, a la que contrapone la figura de un pavo real mecánico: símbolo de la vanidad y de la "intervención" extranjera en esa primera fase de la Revolución. Todo

ello por medio de un montaje transmisor de sentidos connotados, es decir, usando planos en los que relaciona "dos elementos diferentes para producir un efecto de causalidad, de paralelismos, de comparación" (Aumont, 1985:68).

El Realismo Socialista y el cine de Eisenstein.

La libertad creativa que se vive en la Rusia revolucionaria sufre un brusco viraje en 1928 con la entrada de la Nueva Política Económica implantada por Stalin. En este momento, los sectores artísticos y culturales ligados a la burocracia estalinista inician un proceso de homogeneización y depuración de la vida artística. En abril de 1932 el Comité Central hace público el decreto *Sobre la reorganización de los grupos literarios y artísticos* que en esencia supone la disolución de las corrientes artísticas ligadas a la vanguardia, y el giro a una creación artística oficial ligada a las necesidades ideológicas del Estado y del sector estalinista, es el llamado realismo socialista.

Este nuevo arte obligará a los artistas a presentar una serie de temas estereotipados como son la realidad en su vertiente revolucionaria, los personajes y situaciones típicas, los medios sociales, los héroes constructores de la sociedad socialista y en especial a Stalin y los acólitos de su corte de poder desde una perspectiva denominada realismo heroico.

Zdhanov, organizador de la cultura oficial tras la caída en desgracia de Lunatcharsky, describe el realismo socialista como sigue (Golomostock, 1991):

> Antes que nada, significa que deben conocer la vida para poder representarla fielmente (...) no escolarmente como un objeto muerto, ni incluso

como una realidad objetiva, sino representar la realidad en su dinámica revolucionaria. Después, en conformidad con el espíritu del socialismo, deben combinar fidelidad y representación artística históricamente concreta con el trabajo de modelación ideológica y de educación de los trabajadores.

La entrada en escena de esta nueva cultura politizada y dirigida por el Estado suponía la prohibición de obras de pintores vanguardistas como Malevich, Filonov y Lebedev, de escenógrafos como Meyerhold cuyas obras son tildadas –desde las páginas de Pravda– como burguesas y reaccionarias. Y encontrando en otros artistas, como Prokofiev, defensores acérrimos del compromiso del artista con el momento social e histórico que atraviesa Rusia: "El creador –poeta, escultor o pintor- debe servir al hombre y a su pueblo. Está llamado a embellecer la vida del ser humano y defenderla. Está obligado, ante todo, a mantener el espíritu cívico en su arte, a glorificar la vida y conducir al hombre hacia un futuro luminoso" (Theodorakis, 1984:28).

En definitiva, el realismo socialista impuso una visión monolítica de la cultura, rasgo que caracteriza a todas las manifestaciones del arte totalitario, como señala Haftmann (1975:142):

> El arte totalitario es el fenómeno de uniformidad estilística de toda dictadura. Así como esta procede a la movilización de las masas y a destruir el libre espíritu individual, del mismo modo el arte totalitario como norma vinculante adopta el tipo medio de la mentalidad de la gran masa y elimina lo particular. El contenido y su importancia propagandística son los elementos prioritarios. Lo

ilustra por medio de un realismo estereotipado, adecuado a los hábitos visuales de la masa [...] Toda forma liberal es combatida. Se exige la utilidad inmediata. En su más íntima esencia, el principio totalitario tiende a la aniquilación de la fe en el valor personal y en la función del espíritu aislado.

El cine, como manifestación artística, no escapa a la nueva coyuntura cultura que se impone en la Rusia Soviética, pues no en vano, el mismo Stalin manifestó que "el cine ayuda a la clase obrera y a su partido a educar a sus trabajadores en el espíritu del socialismo, a organizar a las masas para la lucha por el socialismo, a elevar su nivel de cultura y su capacidad de lucha política" (Vázquez Liñán, 2000:25).

El cine del realismo socialista estará marcado y vigilado por los intereses del propio Estado, quien privilegia dos temas básicos en toda la producción: la exaltación del héroe individualizado y positivo y el canto hacia la máquina como símbolo del desarrollo industrial.

La exaltación del héroe adquiere un carácter didáctico, puesto que se convierte en un ejemplo a seguir, un modelo de conducta. Eligiendo estos modelos en épocas remotas de Rusia, con especial predilección por la Edad Media, surgiendo así en la producción cinematográfica una peculiar panoplia de líderes "llenos de energía, con una visión progresista que anticipaba la victoria del socialismo" (Bordwell, 1999:239). Curiosamente, las figuras que serán presentadas como exponente de estas ideas son caudillos y reyes presentados como "progresistas", en la línea propuesta tanto por Stalin como por la historiografía surgida bajo su mandato que en definitiva no hacía más que apuntar hacia la personalidad de Stalin como el líder indiscutible.

El propio Eisenstein se había mostrado incondicional del nuevo concepto de arte desde 1934, fecha en la que comienza a publicar una serie de artículos en los que defiende la nueva estética ligada al poder, pero –influenciado por Lenin- sin perder de vista la tradición cultural anterior a la revolución que puede ser utilizada en la consecución de un arte total e innovador, en sus propias palabras: "Nuestro realismo, el realismo del futuro, tiene que incorporar todas las viejas artes. Pero éstas no bastan por sí solas. Esto no sólo es socialismo sino el método completo de la creación artística. En la obra de creación que hagamos, podemos utilizar toda la experiencia de la humanidad a lo largo de la historia" (Bordwell, 1999:196).

Eisenstein, en sus escritos, prestó una gran atención a la relación del cine con otras manifestaciones artísticas, especialmente la pintura de la que tomará constantes referencias. En concreto, en Iván se puede observar una clara referencia a los personajes pintados por El Greco, pintor por el que el cineasta ruso manifestó una especial predilección pues bien se puede observar el tratamiento formal que otorga Eisenstein a los personajes, y en especial al zar Iván: rostros de pómulos marcados por la incidencia de la luz, miradas penetrantes, fondos neutros, etc.

La ilustración de los arquetipos de la sociedad postrevolucionaria los ilustra con dos figuras tomadas del pasado ruso: Alexander Nevski e Iván IV.

Aleksandr Nevski (1938) encierra de nuevo una intencionalidad didáctica, en esta ocasión de carácter anticipatorio: el constante peligro del expansionismo alemán reflejado en el film por medio de la Orden Teutónica. No obstante, la censura estalinista se cebó en esta obra ya que en 1939, para sorpresa de las naciones europeas, Alemania y la URSS firmaron un acuerdo de

no agresión, que demostró su solidez en la invasión y reparto de Polonia por parte de las dos naciones, luego no era de buen gusto un film anti germano. Junto a esta advertencia del peligro alemán, Eisenstein propugna la necesidad de encontrar un líder –un jefe militar- que sea capaz de frenar ese avance imperialista. La figura – bolchevizada- de Alexander Nevski aúna en torno a si a todas las capas sociales del pueblo ruso: nobles, comerciantes, artesanos, campesinos, etc, trascendiendo así la figura personal para revestirse de un carácter más sublime: el de la patria misma.

Desde finales de los años 30, Eisenstein teoriza acerca del contrapunto audiovisual, expresión bajo la que engloba la suma de todos los elementos que constituyen la imagen fílmica y el sonido. Según esta teoría "los diversos elementos sonoros, palabras, ruidos, música, participan en igualdad con la imagen, y de modo bastante autónomo respecto a ella y a la constitución del sentido: pueden reforzarlo, contradecirlo o, simplemente, tener un discurso paralelo" (Aumont, 1985:85); teoría realmente globalizadora e integradora del audiovisual de un director que había expresado sus reticencias a la incorporación del sonido con estas palabras: "El cine sonoro es un arma de dos filos, que se utilizará según la ley del mínimo esfuerzo, es decir, simplemente para satisfacer la curiosidad del público" (Jeanne y Ford, 1974:22-23).

Para Eisenstein la película tiene momentos fuertes y débiles, cada plano posee un acento que se corresponde con su equivalente musical y es el realizador quien "coordina el ritmo de la banda sonora [...] con el ritmo del contenido interno y duración de los planos" (Bordwell, 1999:218). Estas correspondencias adquieren el carácter de verticalidad en el momento en que "relacionan la música con las tomas merced a un

movimiento idéntico que es la base de los movimientos musical y pictórico" (Eisenstein, 1999:127).

Eisenstein dota la narración de esta película de una rapidez, precisión y agudeza hasta el momento nunca vista, consiguió una estructura audiovisual que roza la perfección. En efecto, la novedad del film lo supone la incorporación de la banda sonora, esto es: la conjunción de música, ruidos y diálogos.

Los diálogos de Palenko y Eisenstein y la música de Prokofiev se funden en lo que el maestro ruso había desarrollado en la teoría del contrapunto audiovisual como el mismo explicaba (1999:115-116):

> Deseo destacar que en Alexander Nevski se emplearon literalmente todos los métodos posibles. Hay secuencias en las que las tomas se recortaron para ajustarlas a un curso musical previamente grabado. En otras la música entera fue escrita para el encuadre definitivo de la película. Algunas contienen ambos métodos [...] De la misma manera, pero a la inversa, algunos pasajes de la partitura sugirieron soluciones visuales plásticas que ni Prokofiev ni yo habíamos previsto. A menudo se adaptaban tan perfectamente al sonido interior unificado de la secuencia, que ahora parecen concebidas así de antemano.

Pero el enfrentamiento no solo se produce a nivel visual, en esta película Eisenstein experimenta con el choque sonoro. En efecto, la música "se encarga, aunque de una manera más local y episódica, tanto de describir como de expresar" (Aumont y Marie, 1990:209).

Esta capacidad narrativa de la música se encuentra a lo largo todo el film. El primer caso a los planos iniciales del film y que recuerda la victoria de Alexander sobre los suecos. En la secuencia en la cual

Alexander es elegido caudillo y dirige el levantamiento de Novgorod, la música que se oye es "En pie, pueblo de Rusia", similar es el caso del coro femenino que se deja oír entonando "¡Levántate, Rusia, nuestra madre!" mientras que Olga se viste la armadura. También Eisenstein y Prokofiev construyen una contraposición entre los motivos sonoros que identifican a los Teutones y a los rusos. Así, los primeros están dominados por la presencia de himnos católicos interpretados por un – siniestro- monje; mientras que en el bando ruso predominan melodías de carácter popular, composiciones por las que Prokofiev había demostrado un especial interés desde mediados de los años 30.

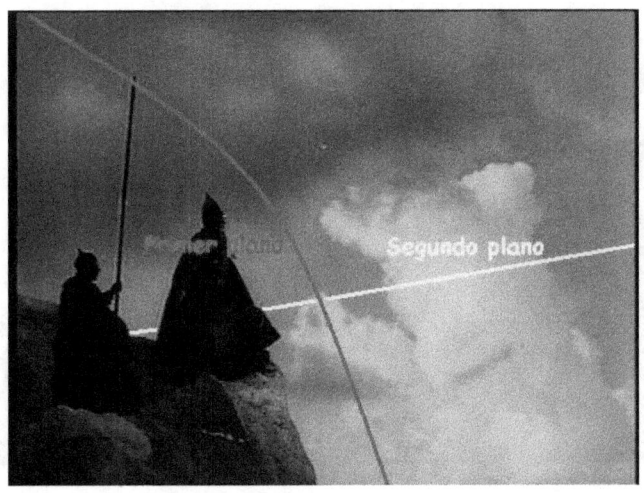

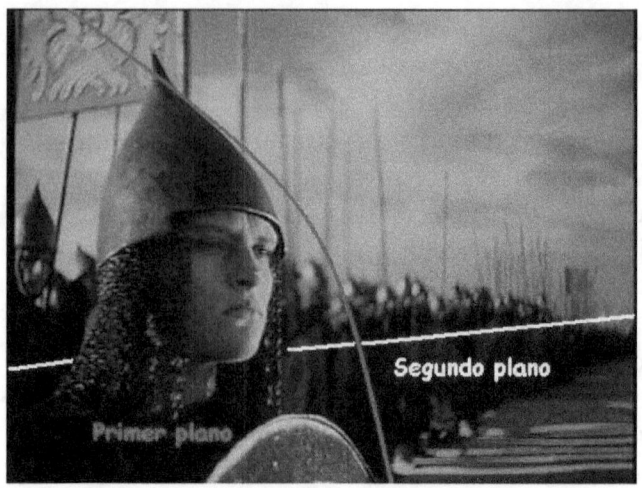

Estructura ritmo visual en *Alexander Nevsky*

El ritmo visual ascendente y descendente de los encuadres se corresponde con la composición musical.

Desde la apreciación visual la estructura compositiva de esta secuencia lo construye por medio de un montaje analítico en el que fragmenta la realidad en una relación de planos próximos y de escasa duración, de manera que el paso de un encuadre a otro produce de por sí una tensión emocional. Esta sensación de contenido dramatismo se acrecienta aún más con la confrontación de líneas horizontales (el avance teutón) y verticales (el muro de lanzas rusas) siendo siempre estos últimos elementos los que van a dominar y al final salir vencedores del conflicto.

Esa tensión, la espera ante el avance de los invasores, es acentuado con un movimiento visual ascendente y descendente en arcos que súbitamente caen sobre una horizontal que viene a simbolizar la incertidumbre.

En la secuencia de la batalla –una de las secuencias bélicas de mayor duración de la historia del cine- se asiste, por otro lado, a una perfecta armonía entre los diferentes planos fotográficos y los compases

musicales que remarcan el protagonismo de los personajes rusos: los únicos que hablan, los que manifiestan – exaltados o con indiferencia- la dimensión humana de la contienda; el contraste son los caballeros teutones a los que Eisenstein priva de personalidad al mostrarlos de manera recurrente ocultos tras sus yelmos.

Eisenstein agrupará los planos de manera que se correspondan con las frases musicales, alternando los planos generales con los primeros planos. Establece al mismo tiempo un ritmo visual en continuos ascensos y descensos –una especie de arco de tensión-, en los que la carga visual estará repartida hacia los extremos, y que son interrumpidos por planos generales de marcada horizontalidad. El efecto que consigue crear con esta disposición de las imágenes y de la música es el de anticipación de la tensión, es decir: en los planos que construyen el arco y que coinciden con una melodía ascendente marcan la tensión, se trata tanto de los planos generales en los que aparecen las figuras en la cumbre como los primeros planos de los guerreros rusos.

Por otro lado, crea un efecto de calma al introducir una serie de planos generales construidos por la horizontal del ejército ruso y el nevado paisaje tras el cual se encuentra la amenaza, la correspondencia musical es una melodía que remarca esta sensación de espera.

Pero el uso del sonido no queda relegado únicamente a la música, al mismo tiempo que ésta se convierte en constructora del dramatismo, los sonidos naturales emanados de la acción se revelan de gran importancia. En este sentido y dentro de la secuencia de la batalla, Eisenstein introduce la importancia del sonido en momentos decisivos. Así tras la repetitiva música que acompaña al avance de la caballería alemana y que va acelerándose conforme se encuentran más cerca de los

rusos, se interrumpe súbitamente en el momento en el que las dos fuerzas militares chocan privilegiando así el ruido natural de las armas. Algo similar ocurre en el ataque en tenaza de los rusos que cercan a los teutones cuando de nuevo la música se interrumpe y se oye el sonido del combate y con la muerte de uno de los caballeros alemanes vuelve la música a la pantalla con la interpretación de un tema victorioso.

Alexander Nevsky supuso la primera realización de Eisenstein con la que pudo comenzar a experimentar con el sonido. Tras esta producción, la serie de *Ivan Grozny* (*Iván el Terrible*, 1944 – 1948) continuó el camino iniciado en el uso del sonido, y aún más en la incorporación del color, un recurso para el que tenía en mente toda una nueva teoría. Acorde con los principios del realismo socialista no es de extrañar que Eisenstein manifestara su interés por centrarse en Iván IV, el "zar que enriqueció y fortaleció la posición económica de Rusia" (Eisenstein, 1982:26-27), al que va a bordar desde una perspectiva épica que le sirve para ilustrar la idea del líder absoluto que se convierte en personificación del pueblo.

Concebida como trilogía, finalmente la realización de *Iván el Terrible* quedó reducida a las dos primeras partes filmadas en el largo periodo de 1944 a 1946 en Kazajstán, lugar al que se habían trasladado los estudios cinematográficos tras el estallido de la guerra contra Alemania.

El proyecto de Eisenstein es mostrar al zar Iván como un exponente del progresismo que además se ayuda de una guardia de corps –la Oprichnina- para hacer realidad sus proyectos. Para construir esa imagen presenta a Iván como un ser atormentado, en ocasiones rayando la esquizofrenia, y en constante lucha contra los enemigos interiores y exteriores para salvaguardar el

poder. En definitiva, aparece como "el único líder fiable, enclaustrado por las exigencias de la vida pública, por la privación personal y sobresaliendo por la soledad del liderazgo, recurriendo a sus recursos y a los de los demás para cumplir con la tarea que, según él, la historia le ha puesto ante sí" (Bordwell, 1999:260).

Puesto que el componente psicológico está presente a lo largo de todo el film, Eisenstein recurre a una puesta en escena que remarca estos elementos. Así los decorados se revelan expresionistas con líneas quebradas, dominados por las sombras y por las arquitecturas que engullen a los actores; la actuación hierática muestra el interior de los personajes: sus pensamientos y emociones.

Al mismo tiempo se sirve de recursos técnicos para construir ese ambiente opresivo siendo el más espectacular el uso de la profundidad de campo por medio del empleo de un objetivo de gran angular que permite colocar la figura en gran primer plano, muy cerca de la cámara, y tener una perspectiva muy nítida de lo que acontece al fondo del encuadre, como en la toma del pueblo de Moscú que acude en procesión para rogar a Iván que vuelva a la capital. Más impactante es este tipo de encuadre en las escenas de interior en las que personajes y objetos, junto a este uso focal, hacen del escenario un lugar claustrofóbico no solo para los personajes sino incluso para los espectadores que son introducidos por el realizador en el peculiar mundo de Iván: un mundo de intrigas, conspiraciones y falsas lealtades.

Lo cierto es que las imágenes establecen cierto paralelismo entre los personajes históricos y los actuales: Iván y Stalin, Malyuta y Beria, la Oprichnina y la cohorte de acólitos de Stalin. Similitudes que no pasaron desapercibidas y motivaron la prohibición de la segunda

parte de la película por orden del Comité Central.

Por otro lado, la puesta en escena de la película revela una influencia directa del teatro Kabuki, del cual Eisenstein se había mostrado un incondicional desde que en 1929 asistiera a una representación de este género teatral japonés. El realizador quedará impactado con la estética kabuki y señalará que esta será la manera que habrá de seguir el cine sonoro puesto que en estas representaciones teatrales "sonido, movimiento, espacio, voz no se acompañan (ni siquiera en paralelo), sino que funcionan como elementos de igual importancia".

A grandes rasgos, la influencia "japonesa" en Eisenstein se hace evidente en rasgos como la apariencia de los actores gracias al uso de un determinado atrezzo y, por otro, el protagonismo de la música.

En el kabuki es fundamental el uso de máscaras para caracterizar a los actores, Eisenstein retoma esta idea y lo lleva a la pantalla por la propia caracterización, interpretación y filmación de los actores. En otras ocasiones la referencia es más directa aún, como en la secuencia del baile de la oprichnina donde Fiodor aparece en escena ataviado con ropas que recuerdan a la zarina Anastasia y ocultándose tras una máscara blanca.
Las posibilidades de conjugar música, danza e interpretación lo que más atrae a Eisenstein ya que la base del kabuki reside en la conjunción de diálogos con partes entonadas e intermedios de ballet, consiguiendo el efecto que él mismo señala: "oímos el movimiento y vemos el sonido" y que no ya había puesto en práctica en *Alexander Nevsky*.

Como ya se ha visto, Eisenstein había tomado influencias de pintores y artistas de épocas clásicas. Pero las referencias pictóricas irán más lejos, pues Eisenstein– desde finales de los años 30– empieza a mostrar interés por los artistas que teorizan sobre las relaciones entre

pintura y música. Este tema es de interés ya que en la secuencia del banquete de la Oprichnina Eisenstein pone en escena todo un despliegue de imágenes dominadas por tres colores: rojo, dorado (variante del amarillo) y negro.

Obviamente, el recurrir a estos colores se explica por la carga simbólica que el realizador encuentra en cada uno de ellos, para lo que recure a las teorías de artistas y pintores de la tradición cultural de finales del XIX.

Eisenstein reconoce el lenguaje de los colores refiriéndose a ellos como poseedores de una *tonalidad interior* que deben "contribuir al significado de un sentimiento interior (…) que haya expresión exterior en colores, líneas y formas" al mismo tiempo quelos "colores ejercen influencias específicas en el espectador." (Eisenstein, 1999:83).

Una vez establecida esta premisa, el cineasta comienza a delimitar los colores que considera básicos y a los que dotará de un significado concreto, a saber:

- Dorado (amarillo): Recurriendo a la tradición pictórica, Eisenstein retoma el simbolismo asociado a la traición, la discordia (Kandinsky, 2001:54). Coincidiendo con Kandinsky en la faceta negativa que posee el color: "El amarillo contemplado directamente (…) inquieta al espectador, le molesta y le excita y descubre el matiz de violencia expresado en el color, que actúa descarada e insistentemente sobre su sensibilidad" (2001:73).
- Rojo: En el caso de este color Eisenstein también coincide de nuevo en las teorías expuesta por Kandinsky quien señala que este color "da la sensación de fuerza, energía,

impulso, decisión, alegría, triunfo" (2001:79), al tiempo que también señala que este color recuerda el sonido de los metales de la orquesta.

- Negro: En cuanto al negro, el significado que le otorga Eisenstein no puede ser menos amenazador, ya que como recuerda Kandinsky, el negro es el "color de la más profunda tristeza y símbolo de la muerte" (2001:78).

De igual manera que sucediera en *Alexander Nevsky* el realizador concede una importancia capital a la conjunción de la música y las imágenes según su teoría del montaje contrapuntístico, la perfecta unión de planos y temas musicales según un ritmo marcado por el movimiento intrínseco de cada plano, e incluyendo la conexión con los colores que se impone en cada plano. Esta idea la materializa haciendo coincidir el ritmo de la banda sonora, en especial de la música, con el contenido y duración del plano.

Eisenstein encarga una partitura a su habitual colaborador, Prokofiev[95], con la especificación de que tuviera características wagnerianas con la presencia de un motivo continuo (leitmotiv) que pudiera insertar a lo largo del film, influencia nada extraña si se tiene presente que el director había hecho un montaje de la ópera *Die Walküre* en 1941. La importancia que Eisenstein otorgaba a la música era tal que el mismo Prokofiev la señala con estas palabras: "Eisenstein tenía tanto respeto por la música que a veces estaba dispuesto a reducir o prolongar secuencias para no perturbar el equilibrio del episodio musical" (Bordwell, 1999:256).

Pero dicho acompañamiento musical presentará de nuevo similitudes con las teorías expuestas por Kandinsky en cuanto a significado del color y tonalidad,

tal y como se expone en el siguiente cuadro:

COLORES	SIGNIFICADO		TONALIDAD	
	Kandinsky	Eisenstein	Kandinsky	Eisenstein
Dorado	Discordia	Traición	Estridente	Cuerdas
Rojo	Fuerza	Poder	Metales	Viento/Metales
Negro	Muerte	Venganza	Pausa	Percusión

Una serie de motivos sonoros acompañan las diferentes acciones de la película. Así se pueden identificar dos temas principales: una potente fanfarria relacionada con la lucha por el poder encabezada por Iván.

A los que se unen otros de menor presencia, pero no protagonismo, como son: la canción de cuna que entona Efrosinia para calmar a su hijo Vladimir, el baile de la Oprichnina en la que simbólicamente se está presentando las intrigas y luchas por el trono, o la mazurca que acompaña la traición de Kurbsky al rendir homenaje al rey polaco.

En definitiva, en el caso de **Iván el Terrible** la música tiene un protagonismo en igualdad de condiciones que la imagen, al punto de que en ocasiones los primeros acordes que irrumpen en el plano ya están anunciando los acontecimientos que los personajes van a interpretar.

La puesta en práctica de las ideas referidas al color y a la música se sistematiza sobre la pantalla en la escena del baile de la Oprichnina, la primera secuencia en color que filma Eisenstein -y que está llena de sugerencias y lecturas- se caracteriza por la interrelación de cuatro colores que encuentran igualmente su correspondencia musical.

Toda la secuencia se organizó acorde a la música que Prokofiev había grabado con anterioridad –por lo que será en todo momento una música out-, de manera que Eisenstein hace coincidir el movimiento de los danzantes con los acentos musicales, y será precisamente la estructura musical la que marcará la transición del color dominante en cada encuadre y el cambio de plano, estando presente en todo momento la idea del *leitmotiv*, de la repetición insistente –por medios visuales y sonoros- de una idea: el castigo a la conspiración contra el Zar.

La estructura de la escena puede sintetizarse en las siguientes frases audiovisuales:

Primera parte musical:

Se inicia con una melodía que será *leitmotiv* y se deja oír de manera recurrente asociado a los planes de Iván: la eliminación de los boyardos. En el tema musical predominan los sonidos del metal y viento, en plena coincidencia con la tonalidad roja y dorada de los bailarines.

De igual manera la repetitiva música acompaña los planos en los que hay un desplazamiento de los bailarines en tres diferentes movimientos: horizontal, símbolo de las infinitas posibilidades del poder, y circular excéntrico marcado por el color rojo en ambos casos y por uno de los bailarines, con indumentaria dorada, que con movimiento ascendente descendente significa la búsqueda del poder por parte de los boyardos.

La irrupción en el encuadre de la Oprichnina vestida de negro con un movimiento en diagonal que se interpone en la acción de los planos anteriores (que aún se percibe gracias a la profundidad de campo en un segundo plano) se corresponde con el inicio de la

percusión que secciona la melodía principal en diferentes momentos asociados siempre a la Oprichnina, y que alcanza su máxima expresión por la atenuación de la música y el protagonismo de la percusión efectuada por las botas estos últimos danzantes. Precisamente las botas serán un motivo iconográfico al que Eisenstein recurre insistentemente en sus películas asociándolo al carácter opresivo del poder.

El tránsito del rojo y del amarillo al negro están bien fundamentados en la teoría del color de Kandinsky quien manifiesta en una de sus antinomias que el moviendo excéntrico del amarillo llegará a alcanzar el

color negro. En la práctica musical de la banda sonora, la impetuosa melodía que da comienzo a la secuencia es llevada al dominio absoluto del ritmo del taconeo de la Oprichnina anunciando el castigo a quien trata de alcanzar el trono.

Movimiento / Color	Concéntrico		Significado	
	Kandinsky	Eisenstein	Kandinsky	Eisenstein
Amarillo / dorado	Rojo	Rojo	Movilidad	Conspiración
Rojo	Azul	Negro	Inmovilidad	Poder
Negro	Negro			Venganza

Similar esquema se repite con la entrada de Fiodor en escena, ataviado de manera que recuerda a Anastasia (referencia a los papeles femeninos interpretados por actores masculinos en el kabuki), la zarina asesinada, antes de interpretar una canción alusiva a la conspiración de los boyardos.

La entrada de Fiodor desde el lateral izquierdo del encuadre establece una diagonal con respecto a la recargada línea horizontal formada por los hombres de la Oprichnina. Además, su aparición se acompaña por instrumentos de viento marcando una transición dentro del ritmo que ya se ha señalado acompaña cada una de las apariciones de la Oprichnina. Tras la danza que efectúa Fiodor –y unos planos de Iván- entran en escena una serie de bailarines que mantienen el esquema rojo dorado siendo acompañados por la música sinfónica del principio.

El movimiento circular concéntrico, ya que hay diferentes formaciones circulares de bailarines, están remitiendo de nuevo a la tensión interior de los boyardos por alcanzar el poder. Acorde con la estructura que Eisenstein ideara, de nuevo es el color negro el que

acabará adueñándose de la escena, imponiendo de nuevo el ritmo sobre la melodía, en este caso con palmadas.

De igual manera, la ruptura con la acción de los planos anteriores es señalada por el movimiento diagonal que efectúan los danzantes –una ruptura con el baile circular precedente y que al ser filmado desde un punto de vista frontal remarca la horizontalidad - en un primer momento (1 – 2) alejándose de la acción para luego (3 – 4) acercarse de nuevo sobre la escena que se desarrolla, presentando de nuevo la opresión del poder de Iván y su guardia de corps.

Este mismo esquema se repetirá –con una aparición a la inversa de los colores- con la escena de los bailarines saltando sobre la escalera y agrupándose en el suelo en un maremagnun de rojo y oro, como un macabro anuncio de lo que sucederá con los boyardos.

El diálogo entre Iván, Vladimir, Basmanov y

Malyuta.

Tras las imágenes anteriores, Eisenstein efectúa una aproximación a la misma idea que organiza la primera parte musical por medio del diálogo con sus más cercanos colaboradores.

En correspondencia con la parte musical, el protagonismo del color es notorio, ya que Basmanov– jefe de la Oprichnina- viste de negro y en correspondencia con la tensión y el ritmo de la percusión de los bailarines, en el dialogo con él hay una marcada tensión debido a que cuestiona los medios de acción del Zar.

No obstante, sobre todo destaca la composición formal que adoptan los personajes de Iván y Vladimir en un triángulo que muestra la realidad del poder del Zar. Vladimir es el candidato elegido por los conspiradores boyardos para ser elevado al trono. El carácter usurpador y traidor de esta pretensión es puesta en escena por Eisenstein otorgándole al protagonista una vestimenta dorada (amarilla) tonalidad que el mismo reconoce estar asociada con la traición desde época muy remota. Por contraposición, Iván, que aparece en un plano superior está vestido de rojo: color dinámico, vital y asociado al poder exaltado.

Pero Eisenstein otorga además otra lectura al rojo al retomar ideas que están presentes en trabajos psicológicos y recuerda que este color tiene una conexión con patologías de la mente y en especial con la histeria, no en vano durante las dos partes de la película Iván aparece como un ser dominado por sus pasiones y sus miedos a la hora de actuar, y en más de una ocasión demuestra estar dominado por un nerviosismo patológico a la hora de tomar determinadas decisiones. Haciendo referencia a los trabajos del psiquiatra Havelock Ellis, Eisenstein menciona lo siguiente con respecto al rojo: (1999:107): "esta persistencia de la visión del rojo por los histéricos es sólo un ejemplo de la predilección por el rojo que se ha observado como muy frecuente y marcada entre tales enfermos".

La culminación de esta parte no puede ser más perfecta. Iván busca con la mirada a Fiodor, que observa desde las sombras la conversación del Zar. Eisenstein establece así no solo un raccord visual con el eje de las miradas de los personajes, sino además una continuidad en la narración ya que la vestimenta de Fiodor se

corresponde en tonalidad con la de Vladimir, empezando de esta manera la segunda parte musical –en la que se escuchan los acordes del leitmotiv a manera de introducción- donde se anuncia por medio de una canción las intrigas que han llevado a cabo los boyardos y cómo van a recibir el castigo de Iván.

Segunda parte musical:
Todo el tema cantado es, de nuevo, un anuncio del mismo tema que es escenificado al unísono entre Fiodor y los bailarines de la Oprichnina.

Terminada la canción se vuelve a escuchar el tema principal que acompañó a la primera parte, coincidiendo de nuevo con la secuencia de colores rojo, dorado y negro; hasta concluir con una configuración de los personajes formando una pirámide –con Fiodor en la cúspide- que coincide con la fanfarria asociada por el realizador a la máxima expresión de poder.

En los planos finales de la secuencia se aprecia la idea en todo su esplendor: Fiodor rodeado por los demás salta frenéticamente arriba y abajo mientras todos agitan sus brazos y el coro emite un onomatopéyico "¡Schip! ¡Schip" al tiempo que los destellos de dorados y rojos remiten al trabajo del hacha –a la que se alude insistentemente en la canción- cortando los cuellos de los traidores. El mismo Eisenstein (1999:94) se inspiraba en el poema "Chispas emergidas de la rueda" de Walt Whitman para ilustrar sus ideas acerca del color amarillo:

 Contra el borde de la acera, donde terminan las losas,
 un afilador, con un cuchillo entre las manos,
 inclinado sobre la piedra, aplica atentamente el acero contra ella,

en tanto con el pie y la rodilla,
la hace girar rápidamente, con un movimiento igual,
mientras se desprenden, en abundante lluvia de oro,
las chispas que brotan de la rueda.

Curiosamente este mismo poema es fuente de inspiración para el cuadro Malevich: "Afilador de cuchillos"

Iván el Terrible, fue la última realización de Eisenstein. Al final de su carrera, el cineasta que había retratado de manera activa lo mejor de la Revolución fue relegado a un segundo plano por la cúpula de la cultura estalinista. Solo tras el proceso de apertura iniciado con Kruschev la figura del realizador será reivindicada en la Unión Soviética.

En esta secuencia de la película están los esbozos de la nueva teoría en la cual estaba trabajando Eisenstein antes de que falleciera en 1948. Si bien el texto teórico queda inconcluso, en las imágenes se aprecia que este elemento se reviste igualmente de significado dramático complementando o acentuando a los personajes, las acciones, los diálogos, la música. No en vano Eisenstein había manifestado que el cine sería "una maravillosa variedad de arte que fundirá en un todo e incorporará a la pintura y al drama, a la música y a la escultura, la arquitectura y la danza, el paisaje y el hombre, la imagen y la palabra" (Eisenstein, 1990:70), en definitiva, una

obra de arte total como hasta el momento no se había realizado.

REPRESENTACIONES DE LA ANGUSTIA EN EL CINE DE BERGMAN Y DREYER.

En contraposición al cine religioso tradicional, a saber: vida de patriarcas bíblicos, adaptaciones de la Pasión, reflexiones de dogmas doctrinales, etc. hay que señalar un tipo de cinematografía surgida en la reflexión del realizador acerca de Dios y sus manifestaciones. Esta reflexión trataría de liberar estas manifestaciones de la Divinidad de lo mitológico–lo no explicable racionalmente– para interpretarla de manera crítica y racional y ofrecer un significado a la presencia –o no– de Dios en la humanidad.

Este terreno parece haber sido abonado concretamente para dos cineastas nórdicos maestros por excelencia en la reflexión teológica, los cuales se muestran contagiados de unos predicados filosóficos –nacidos en su entorno cultural– que han cuestionado profundamente el papel de la religión, la moral y, en definitiva, de Dios mismo.

Ingmar Bergman: el camino de la angustia.

Se ha repetido hasta la saciedad que el origen del

agnosticismo de Bergman reside en una férrea educación basada en los rígidos principios luteranos de su padre, pastor de dicha iglesia por lo que no vamos a incidir en este punto desde estas líneas. Tampoco nos detendremos de forma pormenorizada en su proceso de llegada a la dirección cinematográfica ni a su vinculación con el mundo teatral.

Al principio de su carrera como cineasta aún manifestaba un cierto interés por Dios (Laurenti, 1976:22-23):

> Yo creo en Dios, pero no en la Iglesia protestante ni en ninguna otra; yo creo en una idea superior que se llama Dios; lo quiero y lo necesito; creo que es absolutamente necesario porque el materialismo integral podrá conducir a la sociedad y a la humanidad toda a un callejón sin salida de vida.

Pero el peso de la experiencia religiosa vivida en su infancia y adolescencia –cargada de prejuicios y normativas de corte fundamentalista– le hace derivar a una desesperación existencial en la que la única visión que puede tener es la de un Dios distraído, término que acuñara su mentor ideológico Strindberg.

Con todo, la figura de Dios es la constante de sus profundos e intelectuales films, figura cuya presencia se manifiesta por medio de su ausencia, sus silencios, sus enigmas incomprensibles para el ser humano. Esta búsqueda de la Divinidad emprendida por Bergman –y en la que se recurre al teatro ideológico de Strinberg, a la filosofía de Kierkegaard, a ciertos aspectos del protestantismo más ortodoxo y a su opuesto encarnado en el existencialismo– obtendría una síntesis satisfactoria recurriendo a palabras de Sartre –otro paladín del existencialismo– a saber: "Que Dios está callado, eso no

puedo negarlo. Que todo dentro de mi clama a Dios, eso no puedo olvidarlo."

El inicio de su carrera en el cine tiene lugar en el año 1944 cuando realiza el guion del film *Hets* (*Tortura*) de Alf Sjöberg. Al año siguiente deriva a la dirección con *Kris* (*Crisis*, 1945). Ya desde los comienzos de su creación fílmica las historias narradas por Bergman sorprenden por ahondar en temas y cuestiones metafísicas y teológicas cuyo centro de gravedad será la finalidad de la existencia del ser humano, así *Fängelse* (*Prisión*, 1948) es un film escatológico en su más puro significado: argumentación acerca de la existencia de Dios, búsqueda del sentido de la vida, el peso de la única certeza posible que es la muerte, liberación de la vida auténtica prisión. Ideas que se continúan en *Sommarnattens leende* (*Sonrisas de una noche de verano*, 1955) bajo la apariencia de la crisis de los valores morales tradicionales, la ausencia de Dios, el problema de lo finito de la existencia humana.

Un hito dentro de su carrera es la película *Det Sjunde Inseglet* (*El séptimo sello*, 1956) basa en su propia pieza teatral *Pintura sobre madera*. El mismo Bergman argumentaba la intencionalidad del film con estas palabras (Laurenti, 1976:77):

> En mi film los protagonistas son unos cruzados que vuelven de la guerra a un mundo atacado por el terror, a la peste, a los bandidos, a la angustia permanente de la muerte, al miedo por sobrevivir. Hoy las gentes viven en el terror de la bomba atómica y también hay soldados que vuelven de distintas guerras, que se confunden en el anonimato de una inmensa masa humana, que se revuelve en una despiadada indiferencia. El séptimo sello quiere ser una alegoría a este tema, con pinceladas fuertes y simples del hombre, en su búsqueda eterna de

Dios, con la muerte como única certidumbre.

Desde la perspectiva de un auto sacramental enraizado en la tradición nórdica medieval, Bergman nos introduce en una dialéctica existencial de marcado pesimismo dentro de un ambiente marcado por la penumbra y cuyos protagonistas serán la Muerte y un caballero que regresa a su tierra después de participar en las Cruzadas, es decir: en una pretendida empresa de filiación religiosa.

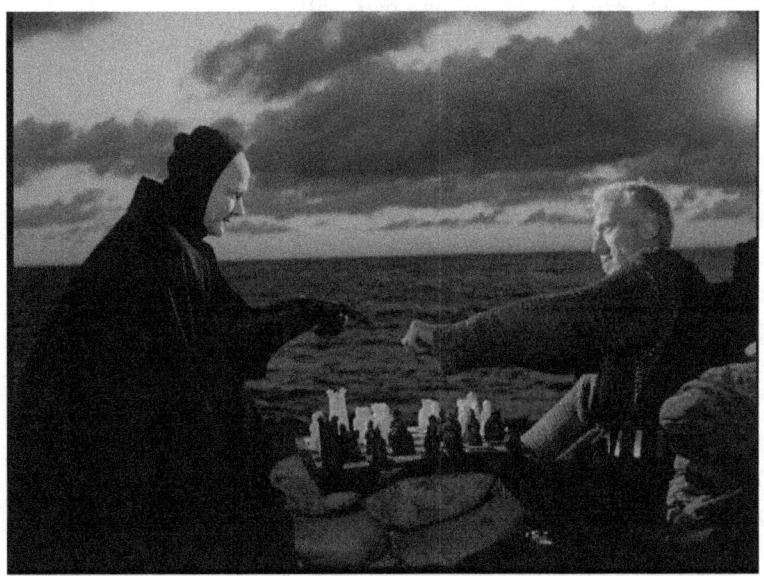

La partida de ajedrez en *Det Sjunde Inseglet*

Bergman parte de la premisa del silencio de Dios. En consecuencia, el hombre se encuentra solo frente a los problemas suscitados por las relaciones humanas y frente al –siempre presente– final de la vida. La gran pregunta del caballero Antonius Block es conocer que se le depara al ser humano tras la muerte. Si existiera Dios,

todas sus dudas tendrían respuestas. Al menos esto se deduce del diálogo entre Block y la Muerte en el confesionario de la iglesia:

> Block: ¿Me oyes?
> Muerte: Si, te oigo.
> Block: Quiero saber, ni fe ni suposiciones, sino saber. Quiero que Dios me tienda la mano, que se revele y me hable.
> Muerte: Pero el permanece callado.
> Block: Clamo a Él en la oscuridad, pero no parece haber nadie.
> Muerte: Quizás no hay nadie allí.
> Block: Entonces la vida es un horror atroz. Nadie puede vivir abocado a la muerte sabiendo que todo es una nada.

Pero éste permanece en silencio, la comunicación entre el individuo y Dios parece haberse quebrado, y la fe, que en definitiva es el único vínculo de unión entre el ser humano y la Divinidad, se torna para Block –alter ego de Bergman– como "¡un tormento... como tener a alguien ahí afuera en la oscuridad pero que nunca aparece, por mucho que se esfuerce uno en llamarle!"

Por medio de los personajes establece Bergman una lucha dualista entre conceptos contrarios y complementarios: amor / muerte, esperanza / desaliento, hombre / Dios.

El caballero y su escudero serían los personajes que se debaten dentro de la dualidad esperanza – desaliento; mientras que el cómico y su mujer representarían la lucha del amor con la muerte, siendo en definitiva la Muerte el leitmotiv del film puesto que extiende la certidumbre de su presencia a todos ellos. El encuentro de Dios es el único punto que queda sin respuesta.

Aunque el caballero entable conversación con la Muerte, aunque entretenga la hora de su final –en el film representado por la partida de ajedrez– de lo único que existe la seguridad es del triunfo de la Muerte. Sin embargo, para Bergman aún existe en este momento una remota posibilidad de encontrar la felicidad en un mundo sobrenatural tal y como sugiere la secuencia final en la que los que mueren lo hacen implorando un perdón de origen celestial.

Este pequeño rayo de esperanza aun brilla tenuemente en *Jungfraukällan* (*El manantial de la doncella*, 1959) film en el cual su búsqueda de la Divinidad le hace plantearse la posibilidad del milagro como respuesta de Dios ante los eternos interrogantes del hombre, pero no obstante el precio previo a pagar es inevitablemente el de la muerte; con todo, la idea que transciende acerca de Dios es la de una especie de señor feudal –representado por el caballero protagonizado por Max von Sydow– en un territorio celeste que castiga el mal de una manera arbitraria: muerte del joven bandido.

En sus films posteriores experimenta un giro hacia un denso sentimiento pesimista motivado por su exacerbado agnosticismo, pues si bien no declara abiertamente el concepto de "muerte de Dios" no abandona esa diatriba acerca de la existencia y naturaleza de la Divinidad. Fruto de ello es la trilogía formada por los siguientes títulos: *Sosom i en spegel* (*Como en un espejo*, 1961); *Nattvardsgästerna* (*Los comulgantes*, 1962) y *Tystnaden* (*El silencio*, 1963).

La contestación propuesta por Bergman en la primera de las películas nos ofrece una imagen y carácter de Dios semejante a un insecto fagocitador tal y como describe Karin, la protagonista:

La puerta se ha abierto, pero el Dios que ha salido era una araña; tenía seis patas y se desplazaba

rápido por el suelo; luego vino hacia mí y he visto su rostro repugnante, lleno de maldad, y se subió sobre mí y trató de entrar en mí, pero yo me he defendido.

Escena, en definitiva, de una lucha entre la conciencia y la voluntad con el resultado del rechazo –previsible– de Dios como sentido o respuesta a la existencia.

En *Nattvardsgästerna* (*Los comulgantes*) vuelve a incidir en este tipo de apariencia divina[104], dándose la paradoja de que quien alberga las dudas y se encuentra sin respuestas ante los dilemas cotidianos y Dios es el pastor de una pequeña comunidad religiosa y que –aún más– no en vano se llama Thomas, como el discípulo de la duda. El protagonista –Thomas– llega a decir: "Cada vez que enfrento a Dios con la realidad que veía, Él se convertía en algo horrible, en un dios–araña, en un monstruo. Fue esta la razón de que le escondiese, apartándole de la luz y la vida."

Su fe inicial se ha transformado en una serie de rituales carentes de significado, repetidos automáticamente una y otra vez lo que genera una total falta de fe e incapacidad para comprender el sufrimiento y el misterio de la vida. Todo ello le lleva a no saber dar respuesta al pescador Jonás –guiño bíblico por excelencia– quien vive atemorizado por la "amenaza china" y la falta de sensibilidad por los sentimientos que por él siente Marta, la maestra local.

El tema que cierra la trilogía es el silencio. En *Tystnaden* (*El silencio*) la silenciosa manifestación de Dios se concreta en problemas tan humanos como son la falta de comunicación, del amor o la incomprensión y que, a en palabras de Rondalino (1978:102) se sintetiza en: "I temi della crisi dei sentimenti, con implicazioni spesso religiose, del dubbio esistenziale, della difficoltà della vita di relazione, della solitudine dell'uomo si

mescolano in una rappresentazione che alterna il dramma alla commedia, la critica di costume all'indagine sociológica."

Fotograma de *Tystnaden*

No obstante, en su raíz ya no puede distinguirse claramente si se trata de una ausencia de Dios o un alejamiento voluntario del hombre. Llegados a este punto de la relación hombre–Dios, la humanidad –bajo la escéptica mirada de Bergman– "está compuesta de seres que no se comprenden, no se aman, no se ven cara a cara, sino como en un espejo oscuro, al sesgo, furtiva y cobardemente" (Bergman, 1975:10).

En conjunto la filmografía de Bergman plantea un deambular que se inicia con la búsqueda de Dios, al que se intuye existe pero que no es fácil encontrar y del que sólo se sabe que las más de las veces se escabulle; el siguiente paso sería certificar la conclusión anterior: la ausencia de Dios se manifiesta por el silencio con el que

responde al hombre ante sus dudas, miedos e incluso amenazas; la conclusión, desde el punto de vista de Bergman, es evidente: el hombre está sólo, desprovisto de cualquier estímulo sobrenatural y condenado a buscar eternamente un sentido a la vida; alcanzándose en última instancia un sentimiento de angustia –en el más puro estilo de Kierkegaard– donde la única certeza es la ambigüedad de la existencia humana y lo absurdo que parece el vivir.

Carl Th. Dreyer: el problema de la fe.

En la producción cinematográfica de Dreyer subyace –al margen de su intencionalidad– un substrato ético–moral de claras raíces religiosas sin definirse por un dogmatismo determinado, sino reivindicando una puesta en práctica de una serie de valores que conectan con el cristianismo en su estado más puro. En consecuencia, Dreyer criticará la religión estandarizada y plagada de rituales y discusiones de alta teología para ofrecer como alternativa la mera relación evangélica del hombre con Dios.

Dreyer contacta con el mundo del cine en 1912, año en el que comienza a redactar rótulos para las películas de la productora Nordisk. En 1920 inicia la realización de films con *Praesidenten* (*El presidente*), revelando ya alguna de las cualidades que le convertirán en uno de los cineastas más grandes de toda la historia del séptimo arte. Así, en pocos años se convierte en un director de gran prestigio llegando a realizar películas en Suecia: *Prästänken* (*La mujer del pastor*, 1920); Alemania: *Mikael* (1924); y Francia: *La passion de Jeanne d'Arc* (1926).

Uno de sus primeros films de reflexión teológica es *Blade af Satans Bog* (*Páginas del libro de Satán*,

1920) película de episodios que sigue la fórmula propuesta por *Satan* (1912) de Luiggi Maggi y sistematizada más adelante por Thomas Ince con *Civilization* (1915) y Griffith en *Intolerance* (1916).

Cuatro son los episodios que configuran el film, presentados cronológicamente: *En Palestina* desarrollado en los últimos días de la vida de Jesús y donde Satán, o la manifestación del Mal, toma cuerpo en la figura de un fariseo que incita a Judas a traicionar a Jesús; *La Inquisición* donde el poder maligno es representado por la Inquisición española; *La Revolución Francesa* en el cual el poder revolucionario es presentado como agente del mal; y por último *La rosa roja de Finlandia* en el cual un comisario bolchevique persigue a los finlandeses que luchan por su independencia.

Se trata, como el film de Griffith, de retratar la intolerancia en su manifestación a lo largo de la historia, si bien Dreyer le concede un toque sobrenatural al apuntar a Satán como el origen de la intolerancia o, en otras palabras: el poder del mal sobre la humanidad.

Estilísticamente en este film, Dreyer ya reveló su estilo de concebir y realizar cine. Le concede una gran importancia a la iluminación que dota a los decorados de una corporeidad sublime y un protagonismo dramático paralelo al de los actores. Junto a ello destaca la minuciosidad del realizador por hacer creíble hasta el más mínimo detalle la historia que muestra en la pantalla: para hacer el episodio español buscó figurantes de aspecto latino; para el último episodio hizo lo propio para encontrar finlandeses.

Un nuevo acercamiento al mundo de la intolerancia –la opresión, la injusticia, o como quiera ser llamada– lo realiza con *La passion de Jeanne d'Arc* (*La pasión de Juana de Arco*, 1928) filmada en Francia con

un guión que adaptaba el proceso original, consiguiendo un film de extraordinaria belleza y profunda carga emocional.

Fotograma de *La passion de Jeanne d'Arc*

En esta obra maestra, Dreyer lleva a extremos inimaginables el concepto de realidad: elimina el maquillaje, filma la dramática historia como un encadenado de primeros planos en el que los actores –a pesar de ser una película muda– tenían que recitar sus papeles, incluso llega a rodar el film siguiendo el orden cronológico de su posterior visión, rompiendo –en definitiva– con la tipología de film histórico realizado hasta el momento. Finalmente se puede decir que la interpretación hecha por Marie Falconetti se resuelve como una especie de reencarnación de Juana.

La injusticia como hilo argumental se va desgranando por el enfrentamiento de los realísticos

primeros planos de Juana –que nos aparecerá como víctima de una injusticia popular, social e histórica– y sus acusadores[107]: rostros que llenan la pantalla y que transmiten estados de santidad y maldad, una lucha, que por las connotaciones del proceso, volvería a incidir en el eterno enfrentamiento entre el Bien y el Mal, con una serie de rasgos pictóricos tomados de El Bosco o Brueghel para acrecentar su dramatismo. Dramatismo que es magistralmente conseguido por el uso de un hábil montaje que en ocasiones nos pueda recordar al – en su momento– reciente *Bronenosets Potiomkin* de Eisenstein. El protagonismo que en el film soviético recaía sobre la masa, los marineros del buque; en Dreyer se encarna en la figura del individuo: Juana; la injusticia política de Eisenstein se reviste de carácter religioso – tomando el término en su acepción de corpus doctrinal– para el caso de la doncella de Orleans. Coincide Dreyer en la importancia de los primeros planos –como se ha visto– para transmitir estados de ánimo, es más para desnudar al hombre de su cuerpo y mostrarnos cuál es su estado espiritual: la lucha interna de su alma por alcanzar, de igual manera que siglos atrás reivindicara El Greco, un estado de liberación por las cargas del mundo terreno, un estado revestido de una parcela de la Divinidad. Como manifestaba Sémoulé (1970:127):

> L'opposition physique des hommes en robe, assis ou gesticulant, ventrus, lippus, coiffés de bonnets, et cette femme en habit de soldat, aux pieds entravés, au "visage un" comme disait Dreyer, retient moins que l'opposition spirituelle des regards, des natures: ches Jeanne, attention et sincérité directe; chez les juges, toutes les formes de la représentation, presque au sens théâtral du terme, de la ruse à la colère, et de la déperdition d'attention, cette autre forme d'insincérité, comme chez ce gros père qui gratouille

son oreille, puis souffle sur sa capture, avant de se rencogner, douillettement replet.

La reivindicación de un ideal lleva a Juana a sufrir el suplicio del juicio y al final su muerte, pero este hecho no significará la victoria del Mal, sino que en Dreyer el sufrimiento último, inherente a la vida, se convierte en victoria de tipo espiritual[108]. Podría decirse que Dreyer ha transmitido por medio de este film su ideario místico de compasión por una humanidad, que no es más que un espejo de Dios, que se desenvuelve en un mundo plagado de escenarios neutros en el que el individuo –la figura humana– aparece como en un fresco de Giotto.

Tras *Vampyr* (*La bruja fantasma*, 1932), film sonoro en el que sobresalían por su valor estético siniestros silencios de origen misterioso, se produce un paréntesis de 11 años en la labor de este genial realizador.

Su siguiente película la realiza en 1943, en plena ocupación alemana, con el título de *Vedrens Dag* (*Dies Irae*), film basado en la pieza teatral *Anne Petersdotter* de Wiers Janssen. Se trata de una historia sombría, ambientada en el siglo XVII, desarrollada en una atmósfera de injusticia religiosa, en el cual la libertad individual está subyugada por el peso de la superstición religiosa, todo ello con una puesta en escena que constantemente recuerda a Vermeer y otros pintores del barroco holandés. Motivado por sus propias inclinaciones, Dreyer denuncia una vez más la intolerancia religiosa, sentimiento que señala muy bien José Aparicio (1991:64): "Dreyer había expresado ya en otros films anteriores el conflicto existente entre una religión que, para él, habría de ser enriquecedora y liberadora y el complejo aparato eclesiástico en que se

materializa, con su intolerancia, sus inclementes dogmas y su rigor opresivo, tendente todo ello a negar cualquier posibilidad para el hombre de ser feliz en la tierra".

La trama de *Dies Irae* gira en torno a la búsqueda del amor por parte de Ana, esposa de un pastor protestante mucho mayor que ella. En esta búsqueda aparece Martín, hijo del pastor con una primera esposa. La unión de estas dos personas no podrá llevarse a cabo por los densos obstáculos morales del mundo en el que viven.

Para complicar aún más el asunto, de forma paralela se efectúa un juicio a una "bruja" lo que hará despertar algunas sospechas sobre Ana, las cuales se volverán en su contra al final del film.

La conclusión del film nos ofrece de nuevo la victoria del mal sobre el individuo y su voluntad, un mal encarnado en toda una serie de valores y prejuicios humanos que nada tienen que ver con el verdadero sentido de lo religioso, pues la religión en su sentido evangélico puro–y este era el único que reivindicaba Dreyer en sus films– no está relacionado con rituales, dogmatismos o servilismos, sino con la libertad individual.

Dies Irae se puede identificar como un drama barroco atendiendo para ello tanto a su forma como a su contenido. En relación con lo primero, estéticamente las imágenes, de gran pictoricismo, están organizadas–a modo de recreaciones de lienzos del XVII– por medio de un austero estilo visual construido por primeros planos, tomas largas y composiciones propias al género de la naturaleza muerta, todo ello bajo una luz tenebrista de gran simbología que por medio de sus contrastes luminosos agudiza el drama interior de los personajes (Sémoulé, 138).

En relación con contenido, el barroquismo de

Dreyer en *Dies Irae* se referiría a una agonía espiritual que sufren los personajes que pugnan por conseguir su libertad sabiendo que están atados por los lazos de los convencionalismos. Dreyer se propone despojar al individuo de su corporeidad para ofrecernos el drama de sus almas. Así cada gesto, cada actitud, cada presencia e incluso cada silencio no es más que un jalón en la resolución de ese dilema de proporciones eternas. Idea que recoge Martin (1986:74) en referencia a la trasmisión de sentimientos y estados anímicos dentro de las artes plásticas de la época: "las miradas y gestos elocuentes no son los únicos medios por los que pueden comunicarse los sentimientos; y a menudo es la radical inmovilidad e inexpresividad de la figura la que deja desnuda la actividad del alma."

La lucha pasional de Ana–que es sobre quien más presiona el intolerante sistema dominante– la llevará a ser acusada tanto de brujería y como de usar poderes malignos para deshacerse de su marido y poder verse libre para emprender su relación con Martin; cuando lo único cierto es que única culpa es la del libre albedrío, la de albergar el deseo de liberarse de la opresión socio-cultural[112]–inherente a ello también la religiosa– representada para ella por Absalón, su marido. Tal y como queda claro en el diálogo previo a la muerte de Absalón (Dreyer, 1970:206):

> ANA: Me has preguntado si te he deseado la muerte. Sí, te la he deseado mil veces. Te he deseado la muerte cuando estabas a mi lado y cuando te alejabas. Sin embargo, nunca te la he deseado con tanta fuerza como desde que Martin... desde que Martin y yo...
> ABSALON: ¿Martin y tú?
> ANA: Sí, yo y Martin. Para que te enteres. Por eso

también quisiera verte muerto... muerto

La liberación final viene precedida –aunque no se nos muestre, únicamente se nos anuncia– por el sufrimiento; apuntado Dreyer, una vez más, por la solución de tipo espiritual a los dilemas humanos tal y como recoge Monty (1980:25): "Dreyer never tried to make us believe that life is a bed of roses. There is much suffering, wickedness, death and torment in his films, but they often conclude in an optimistic convictiion in the victory of spirit over matter. With death comes deliverance. It is beyond the reach of malice".

Tras la experiencia de rodar en Suecia el film *Tvä Människor* (*Dos seres*, 1944), Dreyer no vuelve a rodar un largometraje hasta 1950: *Ordet* (*La palabra*), basándose para ello en un drama teatral del pastor danés Kaj Munk, proyecto que había querido llevar a la pantalla desde los años 30. En *Ordet* describe las costumbres de la vida rural con gran naturalidad y realismo, así como el enfrentamiento social de dos comunidades religiosas.

El preciosismo de las imágenes invita a incorporarse dentro de la acción –construida por largos planos cargados de diálogos y matizadas situaciones– la cual se desarrolla con una esplendorosa lentitud, reflejo de la esencia del ambiente campesino en el que está ambientada la historia; en definitiva, transmite una atmósfera contemplativa para goce del espectador.

Fotograma de *Dies Irae*.

El discurso del film, lejos de identificarse ideológicamente con una u otra práctica religiosa, gira en torno al problema de la fe, cuestión que se resolverá finalmente tras el enfrentamiento de extremos opuestos como señala Rainieri (1978:220): "Dreyer potrebbe indicare nella parabola la vittoria della fede dei semplici contrapposta alle beghe e agli alterchi dei piccolo predicatori delle varie comunita religiose nordiche, dei pastori, degli atei, dei fanatici, degli agnostici".

Así, en esta batalla espiritual de la justificación por la fe, Johanes representa el último remanso de fe dentro de un mundo ligado a unos rituales que han hecho perder el significado de la religión –práctica cuyo único sentido es vincular al humano con Dios– hecho que se revela en toda su magnitud con la figura del pastor escéptico ante la falta de los milagros. En consecuencia, desde el punto de vista del pastor, el camino de la Salvación se ha truncado pues la falta de lo milagroso en

la experiencia espiritual humana haría imposible la conversión –previo acto de fe– y en definitiva la Salvación.

Fotograma de *Ordet*.

Enfrentamiento encontramos de igual manera en el seno de la familia Borgen entre el padre y su hijo Mikael. El primero con una fe de signo optimista sobre la que gira su existencia; y el segundo con un sentimiento escéptico –más bien agnóstico– motivado por el enfrentamiento con la dureza de la existencia cotidiana. Por encima de estas diferencias aparece de nuevo Johanes, quien con sus delirantes palabras reivindica el sentido evangélico de la fe y el significado de la experiencia religiosa.

La lucha por la diferencia en la concepción de la fe se encuentra manifestada entre los patriarcas de las familias Borgen y Petersen, los cuales en su dialéctica

impiden la realización de los sentimientos entre Ana y Anders. Si el primero reivindica que la relación con lo divino ha de producir una suprema alegría por vivir; el segundo y los adeptos a su culto hacen lo propio desde el punto de vista pesimista, optando por una fe que se revela como un estado de penitente amargura perpetua. Sólo en un momento determinado este enfrentamiento doctrinal adquiere sus verdaderas connotaciones al revelarse en plena discusión los reproches que se efectúan estos dos patriarcas por pertenecer a distintos grupos sociales: el campesino y el burgués. De nuevo el punto de inflexión lo representa Johanes con su proximidad a Dios, alejado de las beaterías y reconocedor de que nada es imposible para Dios se le pide con fe. Llegándose a la conclusión de que la "enajenación" de Johanes no es más que la ilusión del primitivo estado de fe sin cargas dogmáticas de ningún tipo.

Hay que señalar que la fe genuina y verdadera que reivindica Dreyer es la que alberga la pequeña Maren, quien confía desde la ingenuidad de su edad en su tío, aunque este llegue un momento en el que tras recuperar la razón parece dudar, en consonancia con el ideal evangélico recogido en Marcos 10:15 y Lucas 18:17. Así Maren incita y espera con más fe que nadie la resurrección de su madre, hecho que, no obstante, se revela artificioso, pues si bien Dreyer había recogido en anteriores films los conflictos espirituales, la presencia de Dios no se había hecho tan palpable como en este caso. Maren, en contraposición al resto de personajes[117], no ha estado tan influenciada por la muerte de su madre pues permanece aferrada a la promesa de Johanes, la promesa de la palabra, como señala Sémolué (142):

> Ce monde de la vie endormie ou figée devient vraiment vivant après l'intervention de la mort. La

mort d'Inger, souhaitée par Peter dans un accès de fanatisme, prèdite par Johannes, révèle à Mikkel que la vie est déchirement; à Peter qu'elle est charité; à Johannes qu'elle est déception, quand il essaye en vain, une première fois, de la ressusciter; au vieux Borgen qu'elle est, jusqu'au bout, souffrance.

Por último, destaca en este film un hecho que es una constante en la producción de Dreyer: la importancia de la mujer en relación, además, con el tema religioso. Tradicionalmente estigmatizada por la praxis religiosa, la mujer ha sido tenida en segundo plano dentro tanto del catolicismo como del protestantismo, sin embargo, Dreyer al apuntar por el contenido – la Idea– del mensaje cristiano nos ofrece una reivindicación del papel femenino dentro de lo espiritual, tema más que cimentado en los escritos evangélicos. Así Juana, Ana o Inger representan esa rehabilitación de igualdad entre el ser humano y Divinidad cuyo contrario no es más que una invención humana.

La suma de todas estas ideas, aparecidas a lo largo de sus films, quiso hacerlas realidad en una película sobre la vida d Cristo, proyecto que albergó durante treinta años. El proyecto de Dreyer no incidía tanto en mostrar el carácter divino de Cristo sino ofrecer la esencia de su mensaje (Rainieri, 1978:222), proyecto que nuca llegaría a realizar debido a la falta de consenso con diferentes productores y con la industria cinematográfica estadounidense que le mantuvo en vilo durante casi todo este tiempo; al menos pudo concretar el film en su parte literaria y acabar el guion.

Con la minuciosidad que lo caracterizaba, Dreyer emprende una serie de viajes para conocer aspectos históricos y arqueológicos sobre la antigua Palestina, otros referidos a la doctrina judaica, y para redondear su

labor comienza a aprender hebreo para así comprender la esencia de los tiempos de Jesús y poder transmitir en la pantalla un toque de máxima realidad tan peculiar en su estilo cinematográfico.

 La intención del realizador era la de presentar a Jesús como un judío dentro de un contexto histórico judío y libre del peso iconográfico tradicional sistematizado desde el Renacimiento. Al mismo tiempo arremetía contra la idea de los judíos como pueblo deicida para señalar que la crucifixión de Jesús fue una medida política cuya responsabilidad recae compartida entre los romanos, en cuanto que representantes de la autoridad sobre un territorio ocupado, y los líderes políticos israelitas, exonerando así de culpa a los representantes del sanedrín religioso.

 El perfil que pretende mostrar de Jesús está también libre de todo dogmatismo, pues el acercamiento que propone Dreyer tiene que ver más con un punto de vista humanista, por lo que el proyecto de *Jesus de Nazareth* sería un capítulo más de denuncia contra la intolerancia y a favor de los derechos humanos. En el Jesús de los evangelios, Dreyer encuentra que éste toma partido por los pobres, los oprimidos, los marginados y las mujeres; en contra de ideologías que, escudadas tras lo espiritual, han coartado la libertad del individuo.

 Esta idea del realizador danés, que no pasó de proyecto, fue, en cierta medida, su testamento ideológico, pues fallecía en Copenhague el año 1968.

LENI RIEFENSTAHL: EL CINE DEL ODIO.

Tradicionalmente las artes plásticas han sido un terreno en el que la participación de la mujer estuvo olvidada por siglos, con excepciones tan espectaculares con el de la pintora holandesa del siglo XVII Judith Leyster. La aparición de la cinematografía como un nuevo medio de expresión, junto a una apertura en las ideas a finales del XIX, permitió a la mujer acceder a esta nueva manifestación artística.

De manera que en la actualidad los diferentes eventos relacionados con la participación femenina en el cine –tales como el Festival Internacional de Cine de Mujeres de Créteil (Francia), el Festival de Mujeres Directoras de Cine y Video (Chicago), Festival Internacional de Cine realizado por Mujeres (Buenos Aires)– deben su existencia a una serie de pioneras, como la española Rosario Pi o las mexicanas Mimi Derba y las hermanas Adriana y Dolores Elhers, que abrieron el camino a la participación cinematográfica más allá de la mera interpretación. Estas pioneras dejaron un legado que ha encontrado su continuidad en directoras de un excelente saber hacer como son Pilar

Miró y Cecilia Bartolomé (España) Jane Campion (Australia), Lina Wertmuller (Italia) o Maria Luisa Bemberg (Alemania) por citar tan solo unos casos.

Pero entre todas las pioneras del cine destaca la controvertida figura de Leni Riefenstahl, cineasta que intentó plasmar sus peculiares concepciones del arte en un marco socio cultural de marcado extremismo como fue el nazismo alemán y en el que el papel de la mujer – desde la política oficial– estaba relegado a un plano inferior y cuyo papel social era *producir* mano de obra y soldados para mantener los frentes de batalla del expansionismo nazi. Pero cualquiera que sea la lectura que se haga de su personalidad y de su obra, cineastas de la talla de Francis Ford Coppola reconocen la importancia de esta creadora de imágenes y de cómo estas pueden transmitir una idea, por irracional que sea.

Breve biografía.

En agosto de 2002 se cumplió el centenario del nacimiento de Leni Riefenstahl, bailarina, actriz, cineasta y fotógrafa.

Coincidiendo con la celebración de su cumpleaños, Riefenstahl presentó su última producción cinematográfica: *Impressionen unter Wasser* (*Impresiones bajo el agua*, 2000) documental realizado entre 1970 y 2000 en las aguas del Pacifico.

Esta película supone la última realización de la directora germana, quien inició sus contactos con el arte en el mundo de la danza a principios del pasado siglo XX, participando de la puesta en escena de coreografías vanguardistas y con el genio y talento del gran nombre del teatro alemán de los años 20 Max Reinhardt.

El tránsito a la cinematografía se produjo por accidente tras sufrir una lesión que la apartó de manera

definitiva de los escenarios teatrales. Pero dicho tránsito se produce en un momento en el que la cinematografía alemana se encuentra en el mejor momento de producción, es por ello obligado reflexionar brevemente sobre este cine de calidad producido en los años 20.

Panorama del cine alemán durante los años 20.

Es interesante señalar que a mediados de los años veinte era general la admiración hacia el cine alemán debido a la gran utilización que de los recursos de esta nueva forma de expresión hacían los germanos. Una sola película alemana venía a significar un alivio para muchos con respecto al bombardeo de films americanos. El cine alemán reinó durante algún tiempo, y tuvo su mejor momento gracias a la labor individual de unos cuantos realizadores, los cuales desarrollaron grandes recursos técnicos y sacaron a la luz nuevas concepciones cinematográficas.

No obstante, el cine alemán no existió con anterioridad a la Gran Guerra. Los intentos por crear una producción nacional fracasaron y las películas alemanas pasaron inadvertidas para el gran público.

La productora UFA (Universum Film Aktiengesellschaft) fue formada en 1917 por resolución de Alto mando alemán (Gral. Ludendorff) con un fin principalmente propagandístico, que sería realizado ya sea en forma directa o indirecta: se realizarían películas características de la cultura alemana y films para la educación nacional. Las principales causas eran el muy bajo nivel de la producción nacional frente a los films extranjeros y el gran poder de influencia que el cine estaba demostrando tener sobre la gente. En 1918, tras la derrota alemana, el Reich renuncia a la participación en la UFA y la mayoría de las acciones son adquiridas por el Deustche Bank, es decir pasa de manos del gobierno a

manos privadas. Con este cambio a los fines propagandísticos se sumaron otros más prácticos: los fines comerciales.

Inmediatamente al fin de la guerra una de las líneas de producción cinematográfica predominante estaba compuesta por films con alto contenido sexual, casi pornográfico, que el pueblo alemán consumía con avidez, principalmente las clases sociales más castigadas. Otra línea de producción era realizada por la UFA, en parte como oposición a la recién mencionada, y consistía en superproducciones pseudo–históricas (uno de cuyos principales directores fue Ernst Lubitsch): tergiversaban la historia, ridiculizando a otros países como Francia (*Madame Dubarry, Danton*) o Gran Bretaña (*Ana Bolena*). A veces se ambientaban en el Oriente u otros lugares exóticos (*La mujer del faraón, Sumurun*).

Un punto aparte será la incursión del expresionismo en la producción cinematográfica cuyo punto de partida –si bien existen antecedentes– es *Das Kabinett des Dr. Caligari* (*El gabinete del Dr. Caligari,*Wiene, 1919). Los temas habituales de los filmes expresionistas, girarán alrededor de lo sobrenatural, lo fantástico, lo desconocido y lo siniestro.

De manera que a finales de los años 20 los estudios de la UFA están en plena actividad compitiendo con Hollywood con directores y films como *Metrópolis* de Fritz Lang o *Tartuff* de Murnau. No obstante los temas de las últimas películas mudas alemanas se repetirán una y otra vez "con toda su glorificación de los trabajadores, la película acentúa y encarece también la unidad familiar, las alegrías del deporte, el aire libre y la comunidad" (VVAA, 1984:82) que aparecen a su vez como reflejo de la difícil época por la que atraviesa este país, pues durante el periodo que supone la República de

Weimar la cinematografía gira en torno a una búsqueda "de los seres queridos, del propio conocimiento, de la supervivencia económica o de información sobre las fuerzas de las tinieblas. Son un reflejo de la Alemania derrotada, donde el papel moneda no tenía valor" (VVAA, 1984:145).

Será en esta etapa final del cine alemán cuando aparezca un subgénero que se conoce como el del film de montaña. Este género de películas es desarrollado por el geólogo Arnold Fanck. Son realizaciones que destacan por los nuevos ángulos de visión que ofrece la cámara, la filmación del movimiento de la naturaleza y la valoración e importancia de la luz natural y en las que –a decir de Román Gubern– el "frenético romanticismo del alma alemana domina el ciclo montañero con su imponente solemnidad, épica y wagneriana" (Gubern, 1979:292).

En esa época Leni Riefenstahl toma contacto con Arnold Fanck y tras ver el film *Der Berg des Schiksals* (*Montaña de destino*, 1923) –película pionera en el género de montañismo– Riefenstahl decide dedicarse al mundo del cine y tras concertar una entrevista con Fanck, éste la propone protagonizar su siguiente película: *Der Heiligenberg* (*Montaña sagrada*, 1926). Para poder dotar de realismo y veracidad a sus personajes aprenderá a escalar y a esquiar. A partir de ese momento y hasta inicios de los años 30, Leni Riefenstahl interpretará numerosos films de Fanck, como *Die weisse Hölle von Piz Pallü* (*Prisioneros de la montaña*, 1929), película rodada en colaboración con G. W. Pabst en el macizo de Morterasch a 28 grados bajo cero; y *Stürme über der Montblanc* (*Tempestad en el Montblanc*, 1930), películas, como manifiesta Gubern, "cuyos rodajes entre los glaciares alpinos eran ya toda una gesta y que constituían a la vez un himno panteísta a

la Naturaleza y un canto prometeico a los héroes que se atrevían a conquistar sus cimas" (Gubern, 1979:292).

La culminación será la dirección de su primer film: *Das blaue Licht* (*La luz azul*, 1931) cuyo guion escribe en colaboración con el teórico y escritor Béla Balázs, presentando una historia de corte legendario y con una fuerte impronta de la pintura del romanticismo alemán. Esto motivó numerosos problemas técnicos a la hora de emprender el rodaje ya que Riefenstahl propugnaba un uso muy especial de la luz capaz de lograr efectos de claroscuro. La solución, como ella misma relata, vino de la industria fotográfica (Riefenstahl, 1991:102): "Me puse en contacto con la AGFA, y pensé en una emulsión de película que fuera insensible para determinados colores, y que en la utilización de filtros especiales hubieran de obtenerse modificaciones cromáticas y efectos de imagen irreales. La AGFA se mostró cooperadora, hizo experimentos y de ahí surgió entonces el Material R".

Apenas un año después de la realización de este film, que fue premiada en la Bienal de Venecia de 1932, no solo la cinematografía sino la cultura y la sociedad alemana al completo se encamina a una estructura que la abocara a un régimen político basado en la sinrazón.

Leni Riefenstahl en *Das blaue Licht*.

Veamos, si fuera escuetamente, algunos rasgos de los cambios que introdujo esta estructura política.

Cultura y cine en la Alemania Nazi.

Tras las elecciones de 1932 el Partido Nazi se ha consolidado como fuerza mayoritaria en el parlamento alemán. En enero de 1933, Adolf Hitler se convierte en

Canciller del Estado y desde los primeros momentos se procede a poner en marcha una política de nazificación de la sociedad. Las medidas puestas en práctica para alcanzar esta meta son muy diversas y se basan en el libro redactado por el Führer: *Mein Kampf*, cuyas ideas son una mezcla de teoría política, la cual oscila entre el nacionalismo conservador pasando por una utopía socialista, y racismo exacerbado.

Todo el periodo de la Primera Posguerra se había caracterizado por la renovación del lenguaje plástico y que deriva con mayor representatividad en el expresionismo, estilo que abarcara todas las manifestaciones artísticas. Tanto grupos organizados como Die Brücke o Der blaue Reiter como pintores más o menos independientes, como Dix, Kandinsky, Kokoschka, vuelven su sensibilidad hacia temas oscuros y atormentados que reflejan los sentimientos desequilibrados de un mundo que se ha precipitado en la ruina.

Esta libertad creatividad quedó truncada en 1933 con la llegada del nacionalsocialismo al poder que impuso una nueva cultura, justificada por Hitler con las siguientes palabras (Clerq y Januzczak, 1993):

> Todo arte verdadero debe imprimir a sus obras el sello de la belleza. Todo lo sano es auténtico y natural. Todo lo auténtico y natural es bello. Por eso, es nuestro cometido encontrar el valor de la belleza verdadera y no dejarnos engañar por los chismes en parte necios y en parte descarados, de los decadentes literatos que intentan difamar lo natural y bello como cursilería.

Inicialmente la política artística nacionalsocialista fue desencadenar agresiones contra el

movimiento artístico moderno. Junto a su eliminación era preciso que un nuevo arte ocupara el puesto vacío, debía ser un arte que plasmara la idea que tenía de sí mismo el estado guiado por el ideal nacionalsocialista.

Siguiendo la planificación estatal, los artistas disponían de cuatro años para adecuarse a los nuevos tiempos, pues con la inauguración de la Casa del Arte Alemán en 1937 las artes figurativas del nuevo estado harían su primera aparición, y para ello en una exposición creada a tal fin: Gran Exposición de Arte Alemán.

El sistema nazi celebró muchos triunfos audiovisuales. Prueba de ello son las numerosas fotografías y documentos cinematográficos que reproducían los acontecimientos de masas. Estas reuniones rituales, que unían masas uniformadas y arquitectura, encontraban su más solemne puesta en escena con motivo del culto a los muertos por el régimen: la celebración del 9 de noviembre de 1923; y con el paso del tiempo, con la glorificación del combatiente caído en los diversos frentes. De esta manera se cerraba el circulo, endogámico, de la propia estética nazi, pues la actividad constructiva nazi había contribuido –económicamente– a preparar la guerra; la guerra, por su parte, realizaba el momento sepulcral y fortificatorio del edificio: producía ruinas y, sobre todo, muertos a los que homenajear.

Características del film nazi.

Con la instauración del régimen nacionalsocialista se cierra la etapa de esplendor del cine alemán. El ministro de propaganda, Joseph Goebbels, no duda en calificar el cine de este periodo –al igual que al resto de las artes– como degenerado y predica un cambio

que ha de producirse desde la propia raíz de la conciencia de la nación alemana (Clerq y Januzczak, 1993): "Hombres y mujeres alemanes, la era del exagerado intelectualismo judío ha llegado a su fin y la victoria de la revolución alemana ha logrado abrir una brecha en el camino alemán".

Así, desde comienzos del régimen nazi Goebbels declara que el "film alemán tiene por misión la conquista del mundo, convertirse en la vanguardia de las tropas nazis". Se aventura pues, un cine de marcado carácter propagandista en el que el mismo Hitler tiene puestas grandes esperanzas. A ello se une el hecho de que la industria cinematográfica alemana (la UFA, junto a industrias ópticas como Zeiss, y químicas como AGFA) era incondicional del estado nazi.

También el ministro de Propaganda repetirá una y otra vez la importancia que el cine tendría para la consolidación de las conciencias en favor de un nuevo estado nacionalsocialista y como modelo a admirar en otras naciones con estas palabras (Jeanne y Ford, 1974:268):

> El cine constituye una posibilidad de recreo para la población civil, que nunca valorara demasiado. Por otra parte, un inmenso campo de acción se abre a los filmes alemanes en todos los países europeos. El filme alemán se encuentra ante una posibilidad política en el mejor sentido de la palabra.

Los temas de las películas giran alrededor de los presupuestos ideológicos del nazismo, contándose títulos como *Ohm Krüger*, film antibritánico; o *Der ewige Jude* de marcado carácter antisemita en el que se presenta a los judíos como "seres primitivos y sucios, estableciendo una comparación directa entre los hebreos y las ratas."

Con el estallido de la guerra en sus distintos frentes, la producción incorpora diversos films propagandísticos relativos a las distintas armas y campañas de la Wehrmacht, prestándose especial atención a las tropas de la Luftwaffe y a los *Lobos grises* –tripulaciones de los U–Boote– que se presentan tanto como paradigma de la técnica bélica alemana, como por la camaradería. También se rodaron documentales como *Sieg in Westen* (Brunsch y Weldan, 1941) y *Sieg im Osten* (1941) de Walter Ruttman, quien murió –en circunstancias poco claras– en el frente oriental.

En toda película, fuera documental o ficticia, se repetirá un mismo discurso: el perfeccionismo moral y físico de la raza aria que castigaba a quienes no seguían los dictados del nacionalsocialismo. En los films del periodo nazi se juntan – paradójicamente– un sentimentalismo dulzón y la glorificación del pueblo alemán representado en nuevos tipos ideales: el soldado, el miembro de las SS o del Partido, los cuales, unidos, configuran un conjunto superior e invencible.

Riefenstahl al servicio del Partido Nazi.

En esta coyuntura y frente a la fuga de los grandes talentos del cine alemán –entre ellos el austriaco Fritz Lang quien se pensó como director de la cinematografía alemana, Leni Riefenstahl significaba un ideal que Hitler utilizó hábilmente para sus fines. Los papeles que ella interpretaba son los que admira el Führer: una heroica *supermujer*, una intrépida y a la vez pura hada de montaña que reside en lo alto de las cumbres, siendo inalcanzable para el resto de los humanos y convirtiéndose en la personificación de un mito. Fruto de esta colaboración realizara tres paradigmáticos documentales del nazismo: *Sieg des*

Glaubens (*Victoria de la fe*, 1933), *Der Triumph des Willens* (*Triunfo de la voluntad*, 1934), *Tag der Freiheit. Unsere Wehrmacht* (*Dia de la libertad, Nuestras fuerzas armadas*, 1935) y *Olimpia* (Olimpiada, 1936).

De entre ellos, los más claros ejemplos de la propaganda audiovisual nazi y del talento de Riefenstahl serán *Triumph des Willens* y *Olimpia*, de los cuales se analizan a continuación algunos aspectos.

Der Triumph des Willens.

Dentro de esta política de nazificación de la sociedad tuvieron gran importancia las demostraciones de adhesión al Führer organizadas por el Partido en la ciudad de Nüremberg. Será precisamente Leni Riefenstahl, la realizadora elegida por la alta jerarquía nazi para inmortalizar en celuloide los fastos del VI Congreso del Partido.

El tema en sí no ofrece estímulo alguno: sucesiones interminables de desfiles y discursos políticos en el típico y recargado lenguaje nazi, dentro de una estética arquitectónica creada por Speer, adornado todo con enormes esvásticas y con una coreografía *wagneriana*.

Precisamente por todo esto, Riefenstahl hace un despliegue enorme y, conocedora de lo estático que resultaban los noticiarios habituales, decide darle movilidad a la cámara y dotarla de numerosos puntos de vista desde donde poder rodar las series de discursos y desfiles; así como emplear de manera profusa el travelling, para dotar más tarde a todo el conjunto de un marcado dinamismo.

El montaje en el cual la realizadora invirtió más de cinco meses. Se articula como una composición musical acentuando diversos momentos en búsqueda de

un aumento constante; y esos momentos culminantes los marcan los propios asistentes al *Parteitag* con sus aplausos, sus vítores y aclamaciones al Führer. La diversidad de puntos de vista le permite conjugar primeros planos de los miembros del Frente del Trabajo, cuyos rostros de recortan, acerados, contra un cielo neutro; con planos medios de las negras filas de las SS descendiendo marcialmente por una escalera –con claras influencias de Eisenstein– con un plano medio en panorámica circular de Hitler en peno discurso, la ascensión entre las astas de las banderas que presiden la tribuna ofreciendo un plano general de las distintas formaciones nazis reunidas en la amplia explanada que los reúne.

Film netamente propagandístico, en opinión de Tchakhotine (1994:166-167): "Estimula pulsiones combativas, cautivando a las masas, atemorizando a los enemigos, despertando la agresividad de los partidarios, por medio de símbolos gráficos, plásticos y sonoros; acciones que actúan sobre los sentidos como los desfiles ostentosos, las concentraciones multitudinarias, la música épica y el despliegue de banderas y uniformes".

Riefenstahl durante el rodaje de Triumph des Willens

Lo cierto es que rompe esquemas con los documentales de este género producidos tanto en regímenes totalitarios como en las democracias. En primer lugar, porque no existe un narrador de lo que sucede ante las cámaras, ya que las imágenes hablan por sí mismas. En segundo término, por la claridad artística de las imágenes, que son inusuales para un cine de este género.

Al margen del mensaje evidente del film, los contemporáneos supieron apreciar el valor de la realización: Riefenstahl recibió la Medalla de Oro otorgada por la cinematografía francesa en 1937. También en Alemania, a pesar de los roces entre Riefenstahl y Goebbels, se recompensó el trabajo siéndole otorgado el Premio Cinematográfico Nacional.

Olympia. Fest des Schonheits – Fest der Volker.

En 1936 Leni Riefenstahl recibe el encargo de filmar los juegos olímpicos de Berlín, acontecimiento con el que la Alemania nacionalsocialista redundaba en esa imagen de nación prospera y pacifica ante el resto de la comunidad internacional.

Fotograma de *Olympia*.

La realizadora, ante el reto de filmar un acontecimiento deportivo en que los cuerpos de los atletas son los verdaderos protagonistas, parte de la cultura griega como modelo a seguir. Así, el film comienza con un prólogo en el que aparecen planos medios –en contrapicado– de atletas desnudos intercalados con planos de las más famosas y perfectas esculturas del clasicismo griego, creándose un efecto de continuidad histórica por el empleo de estas imágenes. Esta vinculación a la Grecia clásica no era involuntaria, ya que "los gobernantes nazis fomentaban la idea de que los griegos que habían creado las Olimpiadas era una

raza de hombres rubios, de ojos azules y extraordinaria fortaleza. Naturalmente los alemanes eran los herederos de aquella tradición, y en los Juegos Olímpicos de Berlín los atletas germanos confirmarían este hecho en medio de un espectáculo majestuoso e impresionante" (Tchakhotine,1994:132).

Riefenstahl durante el rodaje de Olympia.

Los atletas de esta introducción, que filma en situaciones deportivas, irán apareciendo como arquetipos místicos tomados directamente de la escultura griega, sensación que se trasmite al estar filmados en contrapicado y recortadas sus siluetas sobre el cielo. Este tratamiento escultórico del cuerpo se repetirá a lo largo de todo el filme, como señala Eisner (1955:116): "los rostros en primer plano parecen estar esculpidos en granito, con sus vastas superficies fuertemente modeladas y un mentón escultural que ya no tiene nada de común con la cara humana".

Si en *Triumph* el reto era dotar de dinamismo

unas imágenes marcadas por el hieratismo o el marcial y homogéneo movimiento de las masas, en *Olimpia* era todo lo contrario. En esta ocasión, Riefenstahl –y su equipo– debían mostrar una celeridad de reflejos inusual para captar la agilidad del movimiento de los atletas en las diversas competiciones.

Para captar con todo lujo de detalles a los deportistas en el desarrollo de las pruebas, Riefenstahl cuenta con numerosas innovaciones técnicas que, si hoy en día están asumidas para cualquier retransmisión deportiva, en la época se trataba de pasos pioneros en la filmación de acontecimientos de esta índole. Así, en este sentido, se dispuso de una catapulta montada sobre rieles para seguir a los corredores de velocidad –aunque más tarde el artilugio fue prohibido por el Comité Olímpico– un globo con una pequeña cámara para conseguir panorámicas aéreas, fosos a nivel de suelo en las pistas de atletismos, 30 cámaras diseminadas por todos los centros de competición e incluso un objetivo diferente para cada cámara.

La filmación se empieza con tanta precisión como si se tratara de una campaña militar. Riefenstahl busca en todo momento el dramatismo de las escenas, por lo que acude a los entrenamientos donde puede rodar más libremente mezclándose con los atletas. Las imágenes de estos se intercalan con las de la propia competición estableciendo un ritmo en constante aumento y de muy marcado dramatismo donde, según las modalidades deportivas, se podrá apreciar el esfuerzo y el valor de la lucha en equipo, privilegiando la participación de los atletas alemanes y cuya actuación es el reflejo del microcosmos del espíritu nazi.

De los 400 kilómetros de película que se rodaron destacan las secuencias de dos competiciones deportivas:

El maratón:

La prueba de maratón –cinematográficamente hablando– se aventura en principio tediosa para ser filmada en su totalidad, de modo que Riefenstahl de los 42 kilómetros de la carrera pretende resumir en tan solo unos minutos la expresión interior del corredor, mostrando el sufrimiento de su rostro, el esfuerzo de su musculatura, etc. imágenes que montadas con la música apropiada representarán el esfuerzo, la voluntad por no rendirse.

Mostrará con un ritmo martilleante, primeros planos de los rostros de los corredores, el paso del paisaje, los gestos mecánicos de las piernas golpeando contra el suelo, la mirada – por medio de un plano subjetivo no diegético– bañada en sudor en sudor y al final, como un espejismo, la grandiosa puerta del Estadio Olímpico que supone el final de la prueba.

Salto de trampolín:

En la prueba de salto de trampolín hace ingrávido el cuerpo humano. Utilizando tres cámaras –una en el trampolín, otra a nivel de suelo y una tercera subacuática– consigue la sensación de los cuerpos suspendidos en el aire que se recortan de manera muy nítida sobre el cielo.

Filmando la secuencia de saltos para *Olympia*.

Posteriormente, por medio de un montaje dinámico en el que llega a intercalar planos a la inversa, remarca la ingravidez del cuerpo humano.

Tras dos años de arduo montaje, Leni Riefenstahl consigue los mejores galardones y reconocimientos por su labor, comenzando una serie de viajes alrededor del mundo, compromisos que la tendrán alejada de los dramáticos acontecimientos que se desarrollan en Alemania a partir de 1938, así, estará ausente durante los momentos de la Kristallnacht y del Anschluss austriaco.

Desvinculación y ruina.
Un episodio que la alejara del régimen tuvo lugar al comienzo de la guerra.

Riefenstahl con su equipo en la zona de Konskie

Riefenstahl fue enviada a Polonia como corresponsal de guerra para filmar la arrolladora apisonadora bélica de la Wehrmacht. Pero la realidad es más fuerte y regresa horrorizada tras ser testigo de la brutalidad de las tropas alemanas con la población civil. En concreto, Riefenstahl estuvo en la población de Konskie, donde las unidades de las SS, con la aquiescencia de las tropas regulares, efectuaron una de las primeras matanzas de judíos.

Después de esta experiencia decide volver al mundo de las montañas, buscando con ello alejarse de la guerra y evitar realizar films propagandísticos, para rodar una nueva película

El proyecto de Tiefland.

Tiefland (*Tierras bajas*, 1934–1954) fue la última película alemana de Riefenstahl y no será estrenada

hasta después de la guerra. El guión de esta película se basa en la obra teatral del dramaturgo catalán Ángel Guimerá *Terra Baixa* (Tierra Baja) y la adaptación operística que hizo Eugen d'Albert con libreto de Rudolph Lothar resumiendo la realizadora sus intenciones con estas palabras: "En la adaptación utilicé algunos aspectos de la ópera, pero principalmente adapté el texto de Guimerá. Mi película no es una ópera, sino una traducción en imágenes de aquello que en la ópera se cantaba" (Riambau y Torreiro, 1993:51).

El proyecto, que se inicia en 1934, pasara por diversas dificultades que ralentizarán su realización. Así, el primer problema que encuentra la realizadora es la filmación en España, que tras la guerra civil no ofrecía condiciones propicias para efectuar ningún rodaje. Un escollo más importante aún será la enemistad de Goebbels que llegó a expulsar a la realizadora de los estudios UFA, iniciando un periplo por diversas localidades germanas, checas e incluso españolas para tratar de terminar su film.

La intención de la realizadora era concentrarse en lo visual y experimentar con la riqueza expresiva del blanco y negro –en una época en la que el uso del color se estaba imponiendo– para captar la atmósfera y el aire que envuelve a personajes y objetos.

Para conseguir esta percepción, Leni Riefenstahl basa su técnica en dos aspectos. En primer lugar, busca un motivo – paisaje de exterior o interior, incluso un rostro humano– que intrínsecamente tenga composición pictórica, lo cual determinará que el encuadre tenga una estrecha relación con la pintura del romanticismo alemán. En segundo lugar, frente a la técnica habitual de usar el diafragma para regular la entrada de luz en las tomas exteriores, lo que se traduce en una excesiva nitidez en las líneas, Riefenstahl filma con filtros

oscuros, consiguiendo paisajes oscuros de gran intensidad dramática.

A pesar de ser una película ficticia y desligada de toda intencionalidad política, el descrédito cayó sobre Riefenstahl por un hecho, que, si bien ella negó hasta el último día de su vida, no deja de ser un exponente de la política racial y genocida del nacionalsocialismo.

Riefenstahl, con la minuciosidad que caracterizaba su cine, pretendió rodar el film en España, pero la situación del país tras la Guerra Civil, hacía inviable dicho proyecto, lo que la obliga a buscar otra solución. Para contar con extras de aspecto meridional, la productora solicita a la Oficina de Trabajo la presencia de gitanos. La petición es aceptada y estos son enviados al rodaje procedentes del campo de concentración de Leopoldskren, hecho que al concluir el conflicto motivo el veto para Riefenstahl y su cine bajo la acusación de colaboración con la política racial del nazismo.

Cuando la película estaba casi terminada, concluyó la guerra y todo el material fue llevado a Francia, y no le fue devuelto –con ausencia de planos– hasta 1954 después de numerosos pleitos en los que se la acusaba de colaboración con el genocidio nazi.

Conclusión.

Finalizada la guerra y tras conocerse la magnitud de los crímenes del nazismo Leni Riefenstahl es alejada de la producción cinematográfica, algo que no ocurre con otros realizadores como Veidt Harlan responsable de la racista y antisemita *Jude Süss* y que continuó su carrera cinematográfica durante la posguerra.

Paradójicamente en 1948, justo recién terminados los Juicios de Nuremberg, su film *Olimpia* recibe un premio otorgado por el Comité Olímpico Internacional,

Riefenstahl emprende una nueva carrera como fotógrafa. Solo a partir de la década de los 60 vuelve a ponerse tras una cámara para filmar una serie de documentales sobre tribus africanas y el mundo submarino.

Dejando de lado la ideología que emana de sus imágenes –ejercicio que se hace sin esfuerzo con otros realizadores como D. W. Griffith, S. M. Eisenstein o Walt Disney– lo cierto es que el legado de Leni Riefenstahl a la cinematografía no puede ser más brillante ya que por un lado aporta un personal gusto por la belleza, señalado por Susan Sontag de la siguiente manera (1996:267):

> La belleza en las representaciones de la Riefenstahl no es nunca sosa, como en cambio lo es en otras artes visuales nazis. Sabía apreciar la variedad de tipos corporales; en cuestión de belleza no era racista. Y muestra lo que según las más ingenuas normas estéticas nazis se podría considerar una imperfección: el esfuerzo auténtico, como en los cuerpos deformados por el ansia de triunfo y las venas hinchadas y los ojos saltones de los atletas en Olimpiada.

Por otro lado, añade un carácter vanguardista a la imagen con sus efectos de claroscuro, los matices del movimiento de la cámara, los encuadres enfatizados, la profundidad de campo, o el ritmo del montaje. Una unión –entre el clasicismo y la vanguardia– que cinematográficamente no ha sido superado.

BIBLIOGRAFÍA:

"La perestroika en el cine". *Cine y más* Barcelona n° 70 (septiembre, 1990).
APARICIO, J. "Dies Irae" *Nosferatu* (Donostia) n° 5 (enero 1991).
ARNHEIM, R. (1976) *El pensamiento visual*. Buenos Aires: Eudeba.
BRUNETTA, G. P. (1987) *Nacimiento del relato cinematográfico*. Madrid: Cátedra.
BURCH, N. (1995) *El tragaluz del infinito*. Madrid: Cátedra, Madrid.
GIMFERRER, P. (1985) *Cine y literatura*. Barcelona: Planeta.
AUMONT, J – MARIE, M. (1990) *Análisis del film*. Barcelona: Paidós.
AUMONT, J. (1985) *Estética del cine. Espacio fílmico, montaje, narración, lenguaje*. Barcelona: Paidós.
BALLÓ, J. (2000) *Imágenes del silencio. Los motivos visuales en el cine*. Barcelona: Anagrama.
BORDWELL, D. (1999) *El cine de Eisenstein*. Barcelona: Paidós.
BERGMAN, I. (1975) *El silencio*. México: Ed. Era.
BERGMAN, I. (1988): *Linterna mágica*. Barcelona: Tusquets.
BRUNETTA, G. P. (1987) *Nacimiento del relato*

cinematográfico. Madrid: Cátedra.
CASALS, J. (1982) *El expresionismo. Orígenes y desarrollo de una nueva sensibilidad*. Barcelona: Montesinos.
CUELLAR, Carlos A.: "El Golem: Wegener, el gran olvidado" *Banda Aparte*, (Valencia) n° 8 septiembre 1997; pág. 19.
DE MICHELI, M. (2001) *Las vanguardias artísticas del siglo XX*. Madrid: Alianza Editorial.
EISENSTEIN, S. M. (1982) *Film essays and a lecture*. Princeton: Princeton University Press.
EISENSTEIN, S. M. (1999) *El sentido del cine*. México: Siglo XXI.
GOLOMOSTOCK, I. (1991) *L'art totalitaire. Union soviétique- III Reich-Italie fasciste-Chine*. París: Éditions Carré.
DE MIGUEL, C. (1989) *La ciencia ficción, un agujero negro en el cine de género*. Bilbao: Servicio Editorial Universidad del País Vasco.
DREYER, C. Th. (1970) *Juana de Arco. Dies Irae. Algunos apuntes sobre el estilo cinematográfico*. Madrid: Alianza.
EISNER, L. (1955) *La pantalla diabólica*. Buenos Aires: Ed. Losange.
ELGER, D. (1991) *Expresionismo. Una revolución artística alemana*. Colonia: Taschen.
GARCIA MARTINEZ, J.A. (1974) *Arte y pensamiento en el siglo XX*. Buenos Aires: Ed. Universitaria.
GÖSSEL, P. – LEUTHÄUSER, G. (2001) *Arquitectura del siglo XX*. Colonia: Taschen.
GUBERN, R. (1979) *Historia del cine*. Barcelona: Lumen.
HAFTMANN, W. (1975) "Malerei im 20 Jahrhundert", citado en HINZ, B. (1975): *Arte e ideología del nazismo*. Valencia: Fernando Torres.
HEYM, G. (1981) "El dios de la ciudad" en *Poesía expresionista alemana*. Madrid: Hiperión.
HILBERSEIMER, L. (1979) *Groszstadtarchitektur*. Barcelona: Gustavo Gili.
JEANNE – FORD (1974) *Historia ilustrada del cine*. Madrid: Alianza.

KANDINSKY, W. (2001) *De lo espiritual en el arte*. Barcelona: Paidós.
KRACAUER, S. (1989) *De Caligari a Hitler. Historia psicológica del cine alemán*. Barcelona: Paidós.
LAURENTI, R. (1976) *En torno a Ingmar Bergman*. Madrid: Ediciones Sedmay.
LENIN, V. I. (1975) *Sobre arte y literatura*. Madrid: Ed. Júcar.

LUPFER, G. – PAUL, J. (2003) "El siglo XX" en *Teoría de la arquitectura*. Colonia: Taschen.
NIETZSCHE, F. (2004) *Así habló Zaratustra*, Madrid: Alianza.
MARTIN, J. R. (1986) Bilbao: Xarait Ediciones.
MONTY, I. (1984) *The international dictionary of Film and Filmmakers*. Chicago: St. James Press.
ORTIZ, A. – PIQUERAS, M. J. (1995) *La pintura en el cine*. Barcelona: Paidós.
ORTIZ, A. – PIQUERAS, M. J. (1995) *La pintura en el cine*. Barcelona: Paidós.
PUDOVKIN, V. (1961) *La settima arte*. Roma: Editor Riuniti.
RAINIERI, T. (1978) "Dreyer: tecnica e revelazione" en *Storia del cinema*. Venecia: Marsilio Editori.
RAMIREZ, G. *El cine de Griffith*. Madrid: Ed. Era.
RIAMBAU, E. – TORREIRO, M. "Soy una persona extremadamente liberal. Entrevista con Leni Riefenstahl" (*Archivos de la Filmoteca*, num 12, abril / junio 1993).
RIEFENSTAHL, L. (1991) *Memorias*. Barcelona: Lumen.
SONTAG, S.: "La fascinación del fascismo" en *El fascismo en América* Nueva Politica (México) n°1 (enero – marzo, 1996).
RONDALINO, G. (1978) "La fortuna di Ingmar Bergman" en *Storia del cinema*, Venecia: Marsilio Editori.
SADOUL, G. (1967) *Historia del cine mundial*. México: Siglo XXI.
SCHEERBART, P. (1998) *La arquitectura de cristal*. Murcia: Colegio Oficial de Aparejadores y Arquitectos Técnicos de

Murcia.
SÉMOULÉ, J. (1970) *Carl Th. Dreyer*. París: Avant–Scene du Cinema.
SIMMEL, G. (1997) *Filosofía del dinero*. Madrid: IEP.
TAUT, B. (1997) "El constructor del mundo". *Escritos 1919 – 1920*. Madrid: El Croquis Editorial.
VON SIMSON, O. (1988) *La catedral gótica*. Madrid: Alianza.
TCHAKHOTINE, S. (1994) "El secreto del éxito de Hitler" en M. De Moragás *Sociología de la comunicación de masas. Tomo III. Propaganda y opinión pública*. Madrid: Gustavo Gili.
THEODORAKIS, M. "Por un arte al servicio del progreso" *Revista Internacional*, nº 1, 1984, Praga, p. 28.
VÁZQUEZ LIÑAN: "El cine soviético y la creación del héroe" en www.cem.itesmmx/dacs/publicaciones/logos/seduccion/202/septiembre.html
VV. AA. (1984) *Historia del cine. Tomo I*, Madrid: Sarpe.
VV. AA. (1988) *El cine soviético de todos los tiempos (1924 – 1986)*. Valencia: Filmoteca de la Generalitat Valenciana.
VV. AA. (1998) *Historia General del Cine. Vol I*. Madrid: Cátedra.
VV. AA: *Gran historia del cine*. Madrid: Sarpe.
WHITFORD, F. (1991) *La Bauhaus*. Madrid: Destino.

www.ingramcontent.com/pod-product-compliance
Lightning Source LLC
Chambersburg PA
CBHW071432180526
45170CB00001B/312

they need to do during medical school and residency training, however, it also serves as a handicap in making changes. The physician becomes comfortable with a set of routines and uncomfortable with making any changes. Also, there are outside pressures such as, if a specialist changes his routines, he will lose some of his referral resources. Physicians, for many reasons, find it difficult and anxiety-producing, to make changes. In my opinion, this mediates against progress more than any other thing.

"The addition of magnetic therapy to my ecology and infection program became a natural. It had been demonstrated by Albert Roy Davis that a negative (south-seeking) magnetic field both alkalinizes and oxygenates the biological system. I had already determined by my monitoring that symptom-producing reactions to foods or chemicals was acidifying and oxygen-reducing. I used alkalinizing agents such as soda bicarbonate and oxygen to relieve symptoms. I found that a negative (south-seeking) magnetic field was more predictable in relieving symptoms than alkalinization with soda bicarbonate. I had demonstrated that degenerative diseases were simply the extensions in time of the acute reactions in which the disordered chemistry of the acute reaction and of the chronic disease having the same symptoms was identical. It became logical then to extend the time of the application of a negative (south-seeking) magnetic field to reverse and heal degenerative diseases along with avoiding the foods, being well-nourished and treating the viral infections. I was delighted to find that a negative (south-seeking) magnetic field will kill microorganisms whether they are viruses, fungi, bacteria, parasites or cancer cells. Gastrointestinal disorders encompass diseased conditions of the entire gastrointestinal tract (gastrointestinal) from mouth to anus and in organs associated with the gastrointestinal tract such as the gallbladder, liver, and pancreas, emptying excretory contents into the gastrointestinal. The diagnostic classification of these gastrointestinal disorders encompass such as 1) infections, 2) immunologic reactions, 3) the minor gastrointestinal reflux states and irritable bowel disorders as well as the major inflammatory bowel diseases (celiac disease, Crohn's disease and ulcerative colitis).

"Viral infections, especially noted as herpes simplex I with lesions on the lips and mucous membrane of the mouth, chronic

bacterial infections of the mucus membrane of the mouth and the gums around the teeth, and acute bacterial infections of the mouth and throat such as acute streptococcus infection. The esophagus can be acutely or chronically infected the same as the mouth. The stomach and duodenum can be infected with helicobacter pylori producing ulcers. The gall-bladder and pancreas can be acutely or chronically infected with microorganisms. The liver can be acutely or chronically infected with microorganisms, especially noted is viral hepatitis. Cirrhosis of the liver can develop secondary to these infections and or due to the processing of toxins. The anus and adjacent colon can be infected with microorganisms. The small and large colon can be infected with viruses, bacteria, fungi and parasites.

"There are several specific identifiable bacteria that can cause diarrhea and inflammation of the colon. There are specific antibiotics useful in killing these bacteria. My objective observation is that a negative (south-seeking) magnetic field can kill all types of microorganisms (viruses, bacteria, fungi and parasites). This fact is fundamental in understanding the value of magnetic therapy. It is logical to use antibiotics specific for each infection. Magnetic therapy using a negative (south-seeking) static magnetic field and colloidal silver providing a negative (south-seeking) static magnetic field can be used along with the specific antibiotics or used without the antibiotics."

William H. Philpott, M.D.'s Response
Upon Receiving the Linus Pauling Award

"I really thank you a lot for this. I just wanted to say that Linus Pauling was a friend of mine and he wrote the foreword to my book, *Brain Allergies* and I thought I would just read a little bit of this so that you would see his attitude towards my work."

"'The concept that a change in behavior and in mental health can result from changing the concentrations of various substances that are normally present in the brain is an important one. This concept is the basis of orthomolecular psychiatry, a subject that is treated in considerable detail by Dr. William Philpott and Dwight Kalita in their book, *Brain Allergies*. The other general concept, also a closely related one, is that of human ecology. The idea is that substances in our environment can have a profound effect on mental health and behavior. These can be introduced into the environment as a result of our technical culture.'

"I just wanted you to realize that Linus Pauling did appreciate ecology and nutrition both, and said so in this forward to my book. We shared that as a common interest. I have been the one that was responsible for introducing ecology to orthomolecular medicine and the orthomolecular ideas to ecology medicine. I have been a catalyst in getting orthomolecular medicine and environmental toxicology medicine together. This organization needs to, and is, furthering the interest of Linus Pauling and this very important focus in medicine. It will make a difference and I want to congratulate all of you for this interest; keep it growing because it will become a more substantial part of medicine."

Ethics of Magnetic Diagnosis and Therapy

Magnetic instruments that have been cleared by the FDA and can make claims of <u>value</u> within the limits of their clearance -- these FDA cleared instruments include but are not exclusive to MRI, XOMED hearing aid, TENS class of instruments, diapulse, nerve testing instruments, Magneto encephalogram, Magneto cardiogram, etc. Industrial magnets have not been cleared as medical instruments and cannot claim cure for any condition or disease. Research is in process to enlarge the scope of claims of value of magnetic therapy. The person using magnets to treat a disease needs to become party to a medical supervised magnetic research project. The magnets used as described in *The Magnetic Health Quarterly* are industrial magnets for which no claim of cure of disease is made. The application of industrial magnets for sleep and pain is a popular self-help application. The magnetic treatment of diseases demands medical supervised diagnosis and treatment in link with a research institutional review board following FDA guidelines for research. Herein William H Philpott, M.D. presents his observations, theories, research protocols and answers to questions for consideration in the hopes of making progress in the application of Magnetic Therapy. His passing, of course, has interrupted these research goals. Those interested in becoming party to the magnetic research project were at one time advised to contact William H. Philpott, M.D. The goal of research was to firmly establish magnetic therapy as a part of traditional allopathic medicine, which would popularize the application of and provide for insurance coverage for magnetic therapy.

Those choosing to proceed with use of magnets for medical purposes without medical supervision do so on their own responsibility. There is no restriction of the purchase of magnets

for whatever reason they are used. There is no restriction on the writing, releasing, acquiring or purchasing of information about magnets.

Disclaimer

Dr. Philpott has said, "I do not claim a cure for any degenerative disease or even guarantee relief of pain or insomnia by means of magnets. My only claim is that there is evidence justifying a definitive controlled research project following Federal Food and Drug Administration (FDA) guidelines to determine the value and limitations of magnetic therapy. These <u>guidelines require a physician diagnosis and physician monitoring</u> under the supervision of a Scientific Institutional Review Board. The application of magnetic fields to humans has been approved by the FDA, which were based in part on toxicity studies, and has been classified as "not essentially harmful".

How Dr. Philpott Changed His Medical Practice

My work represents my personal focus on health maintenance and disease reversal that has developed from my four years of basic medical school education, specialty training in neurology, psychiatry, allergy-immunology, forty years of medical practice, and my post-retirement research that guides physicians in an examination of the values of static magnetic field application to prevent and reverse degenerative diseases. I am proud to be a medical physician and I am convinced that medical science has a central truth about health maintenance and disease. The improvement in medical practice during my period of practice and observation has been tremendous. Beyond the progress what can and what should we incorporate in established scientific knowledge to the practice of medicine? My work is involved with what I have observed that has been largely ignored or left out in spite of the abundance of information on the respective subjects. I have systematically recorded my observations concerning these neglected areas.

The public, through their congressional representatives have mandated the National Institutes of Health to widen its scope of research to include promising alternative areas beyond the current traditional application of medical science. This is a wise move since there are valuable alternative areas that have been neglected or ignored. To fulfill its mandated obligation, the National Institutes of Health have appointed advisory committees in important scientific areas to provide guidelines

for research. One of the early advisory committees is the Electromagnetic Committee, included five Ph.D. physicists, and two M.D.'s knowledgeable in electromagnetics. The two M.D.'s are Robert 0. Becker, M.D. and myself.

Biochemistry has become more readily understood than biophysics. Biochemistry has developed many promising, symptom-relieving agents and synthetic replacements for the failing human system. Biochemistry has helped us come to understand the role of nutrition, the role of oxygen, and the roles of many, many more necessary biochemical functions of human metabolism. There are great economic rewards for those marketing these valuable biochemicals. Biophysics has more slowly progressed in its medical applications. The current medical horizon holds the promises of biophysics being equal to or even superior to the therapeutic values of biochemistry. This emerging promise of values especially relates to the biological responses to magnetic fields. The values of biological responses to heat and cold have been well incorporated into physical medicine while the biological responses to magnetic fields has been neglected.

The biological response to magnetic fields has been, to a considerable degree, a mystery until recently. Medical science has been using magnetism without knowing it was using magnetism. Examples are such as electro-convulsive therapy used in mental illness. We can now understand that electricity produces magnetic fields. For example when an electric current produces a high neuronal exciting positive (north-seeking) magnetic field it produces a seizure, following which the brain switches its magnetic polarity from a usual positive (north-seeking) to a negative (south-seeking) magnetic field for a few minutes. This electromagnetic-produced general anesthesia calms neuronal functions and relieves mental symptoms. The thousands of enzyme catalytic reactions occurring in human physiology are energy-driven by magnetic fields. By understanding magnetic field energy enzyme catalysis, we no longer assume some mysterious, spontaneous enzyme cataly-sis, but instead, with this new knowledge, magnetic fields can be harnessed to energy-drive specific desired enzyme catalysis. Thus, a static negative (south-seeking) magnetic field can be arranged to produce melatonin and growth hormone during sleep. A static negative (south-seeking) magnetic field can be

harnessed to enzymatically produce adenosine triphosphate (ATP) and reverse the inflammatory consequences of oxidation reduction end-products (free radicals, peroxides, acids, alcohols and aldehydes) in which oxygen is released from its bound state in these inflammatory products.

It is universally true that no one wants to admit that they have symptoms from the favorite foods they are eating. They ask, how could a food that makes me feel good when I eat it, make me sick 3 or 4 hours later? To most people, this is unbelievable. Physicians are, equally with their patients, resistant to accepting maladaptive reactions to foods as a cause of their symptoms. The physician is taught to look everywhere else than foods and also if it is foods there is likely little or nothing that can be done about it, thus, symptoms produced by maladaptive reactions to foods is a grossly neglected area in therapeutic medicine.

A significant aspect of this dilemma of dismissing food reactions as causes of acute symptoms and degenerative diseases is inherent in the change that occurred in the 1920's when antibodies and complement disorders were discovered. Up to that time, an allergic reaction was simply a symptom production by an exposure to a substance. After this discovery of isolatable immune mechanisms as an explanation for allergy, allergic reactions lost their mystery. They went from no known cause to known immunologic causes. In terms of symptoms from food reactions, those without discernable immunologic factors were dismissed as imaginary or psychosomatic and so forth. Only in more recent years, has there emerged evidence of non-immunologic causes of symptoms from foods. These are now being referred to as non-immunologic sensitivities or addictions. The resistance to accept food reactions as the cause of symptoms remains only in the minds of patients and physicians alike.

In the 1940's, Albert Rowe, M.D., Allergist, of San Francisco, observed the relationship of non-immunologic food reactions producing symptoms. He used an initial avoidance followed by a rotation diet to handle these symptoms. In 1950, I attended, along with a dozen other senior medical students, a presentation by Alfred Rouse, M.D., an Allergist. He presented a case of a woman who became anxious when given a specific food. He asked our class, "What is the diagnosis?" I was studying

medicine with the specific intention of becoming a psychiatrist. I answered his question with, "This is an anxiety neurosis." He rejected my diagnosis and to my surprise, maintained pleadingly, that an allergic reaction was involved. At the time, all I obtained from this was that he had ideas that were different than most of my instructors and therefore, I dismissed his hypothesis.

In 1952, while a resident in psychiatry, I read a book written by Walter Alvarez, M.D. entitled, *The Neuroses.* I was interested in what this honored internist at Mayo Clinic was saying about neuroses. Surprisingly, he devoted several pages to describing headaches, dulled brain function and emotional reactions to many different types to food reactions. At the same time in my residency training, all of my instructors were completely ignoring these possibilities. At the time, I thought Dr. Alvarez had made a fool of himself. He wasn't a psychiatrist. Why would he be drawing all of these conclusions that had a bearing on psychiatry?

In 1966, my friend Joseph Wolpe, who is referred to as the father of behaviorism, sent me a paper by Theron G. Randolph, M.D. In this paper, Dr. Randolph described fasting patients for five days and when feeding them meals of single foods, many symptoms emerged including the major symptoms of schizophrenia, manic-depression and neuroses. At the time, I thought this was impossible and I set the paper aside. It was four years before I read this paper again.

In 1970, I was a consultant to a school treating adolescents who were socially and educationally disadvantaged. Saul Klotz, M.D., Allergist, proposed that we do a double-blind study on these patients to see if any of their symptoms related to food reactions. This double-blind study was overwhelmingly positive, and from this I was encouraged to initiate a five-year study into the relationship between reactions to foods, chemicals and inhalants to mental symptoms. This resulted in my book, *Brain Allergies.* I was encouraged to do this project by Theron G. Randolph. I reviewed the writings of Herbert Rinkle, Frederick Spears, Walter Alvarez, Howard Rappaport and others. Marshall Mandell spent one day a week for five years supervising my examination of my patients. I followed Theron G. Randolph's method of fasting for five days followed by test exposures to single foods for the next month. The evidence was overwhelming. This study confirmed the allergists

who had made observations of the emergence of emotionally and even mentally disordered symptoms due to food reactions, chemicals and inhalants.

Quite unexpectedly, I made another observation that resulted in my book, *Victory Over Diabetes*. The maturity-onset diabetic patients among my mental patients, not only had the clearance of their mental symptoms but also the reversal of their diabetes. It became clear that maturity-onset; non-insulin type diabetes mellitus is the product of food addiction. John Potts followed up on this with four excellent statistical studies all of which were published in the abstract issue of the *Jour- nal of Diabetes*. There then followed what to me is a strange phenomenon. Even though this work was done the right way and published in the right place, it had no serious impact on the practice of medicine. Here I had demonstrated conclusively that maturity onset diabetes is due to food addiction and that a 4-Day Diversified Rotation Diet routinely reversed diabetes mellitus and that following such a diet prevented the development of diabetes mellitus. Yet, it was virtually ignored. This again, shows how difficult it is to establish a new system of therapy. You are met with all the resistance of the already established method, even though a new method is demonstrated to be superior.

It is a strange phenomenon that in spite of this knowledge about maladaptive reactions to foods and the role of addiction in these foods, we still have numerous diets to reduce weight or to treat diabetes, which ignore food addiction as the driving force of the compulsion to eat specific foods and overeat. Diets that do not honor and properly treat food addiction drives the person, first of all, into the early stage of the diabetes mellitus disease process such as hypoglycemia and the later stage of hyperglycemia given the diagnostic name of diabetes mellitus type II. Properly engineered, the 4-Day Diversified Rotation Diet with the help of magnets initially relieves the symptoms of addiction so the person is comfortable while overcoming their addiction, help in retraining the compulsion to overeat will not only manage obesity but also prevent or reverse type II diabetes mellitus. It is known that approximately 80% of patients, at the time they are diagnosed as having maturity onset-type diabetes mellitus Type II, are obese. It was interesting for me to observe that the reversal of the diabetes mellitus in my patients was not dependent on weight reduction. The diabetes

mellitus disappeared within five days as soon as the subject had gone through the food addiction withdrawal phase. There was, at that time, no time for weight reduction to have occurred. Obesity is a stress and should be reversed but it is not obesity as such that makes the person diabetic. It is food addiction.

THE THERAPEUTIC SIGNIFICANCE OF NEGATIVE MAGNETIC POLARITY AND NEGATIVE ION POLARITY

HOW NEGATIVE IONS ARE FORMED IN NATURE

The atmosphere, and even within biological systems, is flooded with free static field electrons. There are electromagnetic conditions both in the atmosphere and within biological subjects which turn these static electrons to have either a positive or a negative polarity. In the positive polarity, the electrons are spinning clockwise. In the negative polarity, the electrons are spinning counter-clockwise. The activated electrons attach to particles that are available and produce ions, either positive or negative. Before and during a storm, the atmosphere is flooded with positive ions. The biological response of both animals and people to these positive ions is well-documented as producing tension, anxiety, depression and in cases of predisposed illnesses, physical or mental, the symptoms of the illness are worsened. After a storm is over, then the atmosphere is flooded with negative ions in which both animals and people respond with a sense of comfort and symptom-reduction.

In many parts of the earth, there are waters that have been known for their healing value. A volcanic mountain is a negative magnetic field and is in fact, a magnet. The volcanic mountain is a negative magnetic field and the molten mass beneath the volcano is a positive magnetic field. Water that filters down through the volcanic ash of this negative magnet mountain carries a negative ion charge. Characteristically, there are 70+ minerals that are low atomic weight minerals which become negative ions in which negative counter-clockwise spinning electrons attaches to the minerals. This is a stable situation in which when the water with its minerals is removed from the mountain, it remains composed of negative ions. At this same time, the water is always alkaline and is micro water in which the water is in smaller units than water that does not have negative ions. It is important to observe that a volcano and its molten mass below is indeed a magnet, the same as the magnets that are made industrially with negative and a positive magnet field. It is important to note that this negative magnetic field itself of the negative pole of the volcanic

mountain charges the low atomic weight minerals to be negative ions. In the same order the negative magnetic field of an industrially produced magnet makes negative ions.

HOW NEGATIVE IONS ARE FORMED BY ION GENERATORS AND BY STATIC MAGNET- FIELDS

Electrolysis-type ion generators can be arranged to release into the air only negative ions. Thus a house can be flooded with negative ions with health values. The negative magnetic field of a static field magnet can be used to produce negative ions. The negative magnetic field of a static field magnet activates electrons to be spinning counter-clockwise. Although the magnet field is static, the electrons in the field are activated and thus are not static. Thus, a static negative magnetic field is indeed an energy field with movement spinning of the electrons in that field. A negative magnetic field is a source of electro magnetic energy in terms of a biological response. Thus, sitting a glass of water on the negative magnetic field of a static field magnet will electromagnetically charge up the water to have negative ions of both the mineral content and other particles in the water. Placing nutrients on the negative magnetic field of a static field magnet will charge up the nutrients to be electromagnetic charged negative ions.

THE SIGNIFICANCE OF NEGATIVE MAGNETIC POLARITY OF A STATIC FIELD MAGNET AND NEGATIVE IONS IN WATER, AIR AND NUTRIENTS NEGATIVE ION CHARGED

The biological response to a negative electromagnetic polarity, whether from a static field magnet or negative ions is that of alkaline-hyperoxia. The biological response to a positive static magnetic field and positive ions is acid-hypoxia. Much is known of the significance of alkaline-hyperoxia maintaining health and acid-hypoxia toxicity producing degenerative diseases. It is health-promoting for us to drink water from a natural source such as the volcanic source which has turned the water into alkaline micro negative ion water or the water treated by an electrolysis unit producing alkaline micro negative ion water or placing the water on the negative field of a static field magnet. It is wise to flood the air of our homes with negative ions from a negative ion generator. It is health-promoting and disease-reversing to use all sources of negative magnetic fields and negative ions to keep ourselves well and reverse our acid-hypoxic toxic diseases.

The negative magnetic field of a magnet provides the optimal therapeutic value for body treatment. Treatment of air, water and nutrients are a valuable adjunct to magnet therapy.

Negative electromagnetic polarity is the energizer of oxidoreductase enzymes which make adenosine triphosphate which is the body's central enzyme energizer and the central metabolic detoxifier.

STATIC MAGNETIC FIELD SOURCES FOR PRODUCING NEGATIVE IONS OF WATER AND NUTRIENTS

• One 4" x 6" x 1/2" ceramic block magnet. This is a flat surface static field magnet with positive and negative magnetic polarity on opposite sides. USES: On the negative magnetic pole side, place water (municipal treated or ground water) and nutritional supplements for a minimum of five minutes. The longer, the better. There are many other uses for this 4" x 6" x 1/2" magnet such as heart treatment for atherosclerosis, treating aches and pains, inflammation, spinal treatment, local infections, local cancers and much more.

• Ceramic disc magnets of 1-1/2" x 1/2". These magnets are provided as Soother One which has two 1-12" x 1/2" disc magnets and a band, 2" x 26". These discs have positive and negative magnetic fields on opposite sides.

USES:

The negative magnetic pole of the disc can be used to produce negative ions of water and nutrients.

There are multiple uses for the two discs and wrap such as bitemporal placement for headaches and relief of emotional and mental symptoms, aches and pains, inflammation and small local infections and small local cancers.

THE DEFINITION OF MAGNETIC POLARITY AS USED IN HUMAN PHYSIOLOGY

A magnetometer is used to identify positive (+) and negative (-) magnetic poles. A magnetometer is a scientific instrument, which identifies magnetic polarity in terms of electromagnetic polarity, which is positive (+) and negative (-) rather than the geographic compass needle identification of north and south. When using a compass to identify magnetic poles, a north seeking compass needle identifies a negative magnetic field of a static field permanent magnet. The north-seeking needle of a compass is magnetic positive and therefore points to (seeks) the magnetic

negative north pole of the earth and also the magnetic negative magnetic field of a static field permanent magnet. The south-seeking needle of a compass is magnetic negative and therefore points to (seeks) the magnetic positive south pole of the earth and also the positive magnetic field of a static field permanent magnet.

Static field permanent magnets can properly be characterized as DC magnets because they are magnetized by a direct electric circuit current in which the positive electric pole produces a positive magnetic field and the negative magnetic pole produces a negative magnetic field. Those magnetically charging magnets from a DC electric current understand this relationship. Robert O. Becker, M.D., prefers to use the term DC magnets as applied to static field permanent magnets.

In 1600, William Gilbert (*DE MAGNETE*) was the first to point out that the navigator oriented himself with the compass needle pointing toward north, which he called north, when in fact the compass needle pointed north is a south magnetic field.

Several scientists throughout the years have identified this error in naming the magnetic poles. This error in identifying poles still persists as tradition.

The physicist, B. Belaney (*New Encyclopedia Britannica* 1986. Vol. VIII, pages 274-275) again identified this geographic error in identifying magnetic poles and termed it "semantic confusion". To avoid this semantic confusion, he recommended using the electrical polarity definition of positive (+) and negative (-) as applicable to magnetic poles in which a positive electric pole (+) is also a positive magnetic pole (+qM) and a negative electric pole (-) is also a negative magnetic pole (-qM). "M" stands for magnetism.

The body is an electromagnetic organism with a direct current (DC) central nervous system in which the brain with its neuronal bodies is a positive magnetic field and, also produces a positive electric field. The extensions from the neuronal bodies are a negative magnetic field and also produce a negative electric field. The human body does not have a storage battery from which electricity flows or an electric dynamo from which electricity flows. Rather, by a mechanism comparable to a magneto, the human body turns its magnetic fields into DC electric current. It is also true that each cell of the body has a positive and negative magnetic field in its DNA. Since the human body functions on a DC

electromagnetic circuit, it is especially appropriate to use the positive (+) and negative (-) identification of magnetic polarity when relating magnetism to the human body. The human body does not have a north and south poled field, but rather has positive and negative magnetic fields from which electricity is produced. A geographic definition not applicable to human physiology whereas, an electromagnetic definition of magnetic polarity is essential. If and when the geographic definition of polarity is used, it still requires a translation into usable terminology for application to human physiology.

For the above reasons the definitions of positive (+) and negative (-) magnetic fields are used when applying magnetics to human physiology. The traditional compass needle oriented naming of magnet poles is included in brackets as negative (south-seeking) and positive (north-seeking).

There is a need to understand the navigational error in identifying the magnetic poles as well as the parallel identification in identifying DC electrical current poles and DC static field permanent magnet poles made from the DC current. To those who have examined for and identified the distinctly opposite biological responses to opposite magnetic fields, the separate identification of the magnetic poles is an important must. To those not experienced in the knowledge of separate biological responses to opposite magnetic poles, the magnetic poles and the gauss levels needed for these responses is what is making biophysics become a predictable science parallel to the predictable industrial application of magnetics.

STATUS OF THERAPEUTIC MAGNETISM

Since Ancient times, the beneficial biological response to magnetism has been praised by a few and doubted by a large number. The magnetic force at a distance that could not be seen leads to doubts of magnetism biological responses. The development of the compass produced a general acceptance of the actuality of the existence of magnetism. During the past two hundred years, the interest in the therapeutic value of magnetism has experienced considerable fluctuations.

The physicist, Albert Roy Davis' observations of the opposite biological response to opposite magnetic poles, set the stage for understanding there were two biological responses to magnetism. It is now known biological response to separate magnetic poles can be as predictable for biological responses as the use of

electromagnetism used in our industrial world. It is now understood the magnetism functions at the atomic level with the movement of electrons which influence biological function. The positive magnetic field (traditional north-seeking pole) spins electrons clockwise while the negative magnetic (traditional south-seeking pole) spins electrons counterclockwise. These opposite electron spins from opposite magnetic poles provides predictable opposite biological response. The biological response to the positive magnetic field is acid-hypoxia. The biological response to the negative magnetic field is alkaline-hyperoxia.

Robert O. Becker [2] documented the separateness of the positive (north-seeking) and negative (south-seeking) magnetic fields. The positive (north-seeking) magnetic field is the signal of stress injury. The negative (south-seeking) magnetic field governs healing and normalization of biological functions. In terms of neuronal response, the positive (north-seeking) magnetic field is exciting and when sufficiently high such as during sun flares, can even precipitate psychosis in those so biologically predisposed. The negative (south-seeking) magnetic field is neuron calming and encourages rest, relaxation, sleep and when sufficiently high in gauss strength, can produce general anesthesia. Robert Becker anesthetized his small experimental animals with a negative (south-seeking) magnetic field.

My research has abundantly confirmed these observations of Albert Roy Davis and Robert O. Becker. As a neurologist, I documented by EEG that a positive (north-seeking) magnetic field is neuronally exciting. The higher the gauss strength, the higher the excitement. A sufficiently high positive (north-seeking) magnetic field can evoke seizures in those so predisposed. A negative (south-seeking) magnetic field is neuronal calming. The higher the gauss of the negative (south-seeking) magnetic field, the slower the brain pulsing on the EEG. This information sets the stage in understanding how a negative (south-seeking) magnetic field controls neuronal excitement in neurosis, psychosis, seizure potential, addictive withdrawal and movement disorders. not applicable to human physiology whereas, an electromagnetic definition of magnetic polarity is essential. If and when the geographic definition of polarity is used, it still requires a translation into usable terminology for application to human physiology.

For the above reasons the definitions of positive (+) and negative (-) magnetic fields are used when applying magnetics to human physiology. The traditional compass needle oriented naming of magnet poles is included in brackets as negative (south-seeking) and positive (north-seeking).

There is a need to understand the navigational error in identifying the magnetic poles as well as the parallel identification in identifying DC electrical current poles and DC static field permanent magnet poles made from the DC current. To those who have examined for and identified the distinctly opposite biological responses to opposite magnetic fields, the separate identification of the magnetic poles is an important must. To those not experienced in the knowledge of separate biological responses to opposite magnetic poles, the magnetic poles and the gauss levels needed for these responses is what is making biophysics become a predictable science parallel to the predictable industrial application of magnetics.

SINGULAR BIOLOGICAL RESPONSE TO SINGULAR MAGNETIC POLE FIELDS

There is a classic traditional mechanical magnetic model from which there is a predicted two magnetic pole effect from a single magnetic pole field. In this model, the magnetic field radiates out from the singular magnetic pole of a magnet and turns back to join the opposite pole. The traditional assumption is that when the magnetic field changes direction going backward towards the magnetic field on the other side (other pole) of the magnet that this changed direction is the opposite magnetic pole.

I have prepared magnetic fields honoring this assumption that there are of necessity both magnetic poles on the same side of the flat surfaced plate-type magnet with poles on opposite sides of the flat surface. I have compared this with the assumption that there is a single magnetic field on opposite sides of a magnet. I have not demonstrated by biological responses including brain wave (EEG) responses that there are two opposite magnetic fields on one side of the magnet. Consistently, I have observed a single magnetic pole biological and EEG response to single magnetic fields of flat surfaced magnets with poles on opposite sides of the flat surface.

There is another non-traditional magnetic mechanical model that states that the magnetic poles change at the equator by rotating 180 degrees (minor image). Obviously, in the case of the earth,

the magnetic fields change at the equator producing a northern hemisphere of a negative (south-seeking) magnetic field and a southern hemisphere of a positive (north-seeking) magnetic field. This model indicates that the magnetic field radiating up from the negative (south-seeking) magnetic field of the magnet as well as the magnetic field that buckles back to the opposite side of the magnet are both a negative (south-seeking) magnetic field and only become the opposite magnetic pole field when it enters the half-way point of the magnet (equator).

Even though a static magnetic field does not move, it still is an energy field by virtue of the fact that electrons are moved by the static magnetic field. The negative (south-seeking) static magnetic field rotates (spins) electrons in that field counter-clockwise. A positive (north-seeking) static magnetic field rotates (spins) electrons in that field clockwise. The movement of electrons in a static magnetic field is called the Aharonov-Bohn electromagnetic potential. Akaira Tonomura has also confirmed this. This change in rotation between the positive (north-seeking) and negative (south- seeking) magnetic fields occurs at the equator of the magnets and not at the point where the magnetic field turns back toward the opposite magnetic field. This magnetic mechanical model agrees with the clinical response evidence of the magnetic field being a full individual field on each side of the magnet.

The magnetic field remains the same pole whether directly above the magnet or the magnetic field that is turning back toward the opposite side. If it did become the opposite pole when it turned back, it would then not proceed to the opposite side. This is true since the same poles repels. Therefore, it has to remain the negative (south-seeking) pole that buckles back toward the positive (north-seeking) magnetic field. This being true, the pole cannot change until it reaches the equator in the magnet between the two poles. An example is that in the case of the earth's magnetic field. The south pole (+) goes toward the north pole (-) and changes polarity at the earth's equator.

(See "Depth of Penetration/Gauss Field Strength," Last Page)

MAGNETIC FIELDS BIOLOGICAL RESPONSES UNIVERSAL TRUTHS

Magnetic biological responses are universally the same under any and all sections of the body tested and both of earth's magnetic hemispheres.

1. **Centrad and centrifugal atomic energy expressions.**

At the atomic level, the counter-clockwise rotation pulls electrons toward the center proton (centrad) while the clockwise rotation of electrons pushes outward from the center proton (centrifugal).

Therefore, there are no free radicals in a negative magnetic field with a counter-clockwise spiral spin of electrons pulling toward the center. Thus, a negative magnetic field is a biological anti-stress, anti-inflammatory response.

There are free radicals in a positive magnetic field with a clockwise spiral spin of electrons pushing away from the center. Thus, a positive magnetic field is a biological stress-inflammation response.

2. **Centrad and centrifugal weather energy expressions.**

In the northern magnetic hemisphere of the earth the energy expression of counter-clockwise spiral spinning of electrons is with energy expression being toward the center.

In the southern magnetic hemisphere of the earth the energy expression of the clockwise spiral spinning of electrons is with the energy expression being away from the center.

Varied colliding wind streams with varied temperatures and varied pressures can override the earth's natural occurring hemispheric magnetic polarities and produce a local magnetic field opposite to the earth's hemispheric magnetic field. In any event, wherever it is in the earth's hemispheric magnetic field, a counter-clockwise rotation energy pulls toward the center (centrad) and clockwise rotation energy pushed away from the center (centrifugal).

3. **The Neuronal pulsing frequency relationship to neuronal magnetic field strength.**

The brain's response to a negative magnetic field is a decreasing of the pulsing frequency of the brain relating specifically to the gauss strength of the magnetic field. The higher the gauss strength is the slower the pulsing magnetic field. With a positive magnetic field, the higher the gauss strength, the faster the pulsing field. This reveals that a negative magnetic field is anti-stress and the positive magnetic field is biological stress.

It also holds that the pulsing frequency of the brain can be driven by an external pulsing field using sight, sound, tactile or brain stem with the pulsing field being placed on the upper back of the neck and low occipital. The pulsing field can drive the

magnetic field of the brain. Pulsing fields of 12 cycles per second and less evoke a brain negative magnetic field. The intensity of the pulsing determines the gauss strength of the pulsing field. The pulsing field plus the intensity of the pulsing field determines the magnetic behavioral state of the brain. Eight to twelve cycles per second are relaxation. Six cycles per second is relaxation. Four cycles per second is dissociation. Three cycles per second is lapse states. Two cycles per second is sound sleep. One cycle per two seconds is harmless general anesthesia.

4. A 3-dimension spiral electron spin is provided by magnetic fields.

In electromagnetic physical nature, the 3-dimensional spiral is frequently expressed. This 3- dimensional spiral is present in the light refractory levo (left) substances and dextro (right) sustances. These are 180-degree mirror image isotopes. Magnetism has the same levo (left) and dextro (right) 3-dimensional spiral spin of electrons, the same as the levo and dextro substances in relationship to light. The biological effects are opposite as to the separate energy manifestations. In the case of amino acids and fats, only the levos have nutritional value. in the case of magnetism, the levo (left spiral electron spin) is an anti-stress, healing and normalizing counterstress correction from the biological stress dextro (right spiral electron spin).

5. A positive magnetic field is stressful and therefore, does not heal the human body.

6. A positive magnetic field is biologically stressful, raises endorphins and with frequent use, is addicting.

7. A negative magnetic field is biologically anti-stress, does not raise endorphins and is not addicting.

8. A negative magnetic field is anti-stressful and governs human cellular normalization and healing.

9. A negative magnetic field governs sleep by evoking melatonin production by the pineal gland.

10. A positive magnetic field blocks the production of melatonin by the pineal gland.

11. A positive magnetic field biological response is acid-hypoxia.

This is compatible with the metabolism of microorganisms and cancer and not compatible with human metabolism.

12. A negative magnetic field biological response is alkaline-hyperoxia.

This state is necessary for human metabolism and is not compatible with the metabolism of microorganisms and cancer.

13. A positive magnetic field biological response is vasodilatation and acid-hypoxia.

This makes it unsuited for the treatment of edematous and bleeding areas from acute injuries.

14. A negative magnetic field biological response is alkaline-hyperoxia, and due to the hyperoxia, makes it useful for stopping the bleeding of acute injury, is not vasodilating and resolves the edema of acute injuries.

15. The positive magnetic field acid-hypoxia, in short-term exposure of minutes to a few hours, produces an inflammatory red, raised, edematous area due to the acid-evoked vasodila- tation inflammatory reaction.

16. The positive magnetic field acid-hypoxia continuous long-term exposure of a week to two weeks reveals in fact, an acid-evoked inflammatory vasculitis (acid-burn), which is red, raised, edermatous and itching with bacterial growth pustules.

17. The acid-hypoxia biological response to a positive (north-seeking) magnetic field activates the acid-dependent transferase enzyme catalysis of fermentation production of adenosine triphosphate for microorganisms (viruses, bacteria, fungi, parasites) and cancer cell metabolism which also replaces the **alkaline**-hyperoxia necessary for oxidation-reduction enzyme catalysis production of ATP necessary for human cell metabolism.

18. The alkaline-hyperoxia biological response to a negative (south-seeking) magnetic field activates the alkaline-dependent oxidoreductase enzyme catalysis of oxidation-reduction production of ATP necessary for human cell metabolism which also replaces the acid-hypoxia necessary for microorganisms and cancer cell metabolism.

19. A negative magnetic field activation of alkaline-dependent oxidoreductase enzymes in an alkaline medium processes (detoxifies) the biological inflammatory free radicals, peroxides, acids, alcohols and aldehydes to non-inflammatory water and molecular oxygen.

20. A sustained positive (north-seeking) magnetic field acid-hypoxia sustains the necessary life energy of microorganisms and cancer cells and destroys the necessary life energy of human cells.

21. A sustained negative (south-seeking) magnetic field alkaline-hyperoxia sustains the necessary life energy of human cells and destroys the necessary life energy of microorganisms and cancer cells.

22. Cancer cells have a positive magnetic field charge.

23. Normal human cells have a negative magnetic field charge.

24. Microorganisms have a positive magnetic field charge by virtue of their high mineral content with a high conductance and thus stressful higher pulsing frequency whereas human cells with lower mineral content and lower conductance has a non-stressful low pulsing frequency.

25. The biological response to a magnetic field is determined by the 3-dimensional spiral rotation spin of the electrons in the magnetic field and not by the directional approach of the magnetic field to the biological specimen.

a) Therefore, a flat-surfaced, static field magnet with magnetic poles on opposite sides, has a separate, distinct magnetic field over each side.

b) The directional change of the magnetic field turning back around the sides of the magnet to the opposite pole side, does not change the magnetic polarity electron spin until it reaches the halfway point (equator) between the magnetic fields for the magnet.

c) A unidirectional magnetic field is not necessary to maintain a separation of magnetic fields. The 3-dimensional spiral electron spin and not the direction approach to the biological specimen determines the separate biological response to opposite magnetic fields.

26. IMMUNOLOGIC RESPONSES TO OPPOSITE MAGNETIC FIELDS

A. Substance +
Positive magnetic field>sensitization. Dead or attenuated microorganism+
Positive magnetic field>sensitization.
(vaccination)

B.
Substance to which subject is immunologically reactive +
Negative magnetic field>desensitization.

27. ENZYMATIC RESPONSE TO OPPOSITE MAGNETIC FIELDS

A.
Food substrate +
Oxidoreductase enzymes
+Negative magnetic field> ATP +oxidation
remnant magnetism
(Negative magnetic field)

B.
Food substrate +
Oxidoreductase enzymes +
Positive magnetic field>No ATP production and no oxygen
or water production

C. Substrate
(free radicals, peroxides,
acids, alcohols and aldehydes) +
oxidoreductase enzymes +
negative magnetic field>oxygen and water

D. Substrate
(free radicals, peroxides,
acids, alcohols and aldehydes) +
oxidoreductase enzymes +
No oxygen and no water
positive magnetic field>produced

E.
Food Substrate +
Acid dependant transferase enzyme + ATP by fermentation + Positive magnetic field..............>positive remnant magnetism

28. HEAVY METAL DETOXIFICATION

Heavy metals are all electro-positive. Heavy metals produce acidity and metabolically damaging free radicals and acids. Heavy metals biologically damage by attaching to (complexing) biological macromolecules.

A negative magnetic field replaces the electro-positivity of heavy metals with an electromagnetic negativity and thus blocks, reverses and detoxifies heavy metals, tissue complexing, free radicals, and acid production. In the presence of a maintained static

negative magnetic field heavy metals are dispersed of in the urine in a non-toxic state.

A. Toxic electro-positive heavy metals
(aluminum, mercury, lead and other heavy metals)
+ a sustained static negative magnetic field attached to the heavy metal.......>Dispersed of in the urine as non-toxic electro-negative metal

29. POSITIVE MAGNETIC FIELD NEUROPATHY

The acid-hypoxic response to a positive magnetic field placed over a nerve trunk produces a peripheral neuritis of tingling, numbness, pain, loss of motor function, loss of sense of pressure, etc. This can begin to occur within 3-4 hours of continuous exposure to a positive magnetic field.

30. NEGATIVE MAGNETIC FIELD HEALING OF NEUROPATHY.

The alkaline-hyperoxia response to a negative magnetic field exposure reverses positive magnetic field neuropathy, toxic neuritis, dialectic neuropathy, etc.

31. OPTIMIZING THYMUS GLAND DEFENSE

The biological stress of a positive magnetic field can be used to optimize thymus gland functions against infections and cancer. Due to the acid-hypoxia evoked by the positive magnetic field the external exposure to this magnetic field should not exceed 1/2 hour, periodically. This same principle of short duration exposure to the positive magnetic field applies to increased hormonal production to catabolic hormone glands such as the adrenals.

32. CAN APPLICATION OF THE POSITIVE MAGNETIC FIELD BE HARMFUL?

The FDA has classified magnetic field application to humans as "not essentially harmful." This 'not harmful' classification of magnetic field application to humans is a half-truth. This 'not harmful' classification occurred due to the pre-market testing for the MRI. The short duration of MRI scan exposure to both the positive and negative magnetic fields is not harmful. However, objective observations by several physicians has demonstrated the following:

A. A brief exposure to a positive magnetic field is not harmful and can be used to stimulate the thymus gland function, adrenal-cortical hormone increase, stimulate a return of neuronal function that have been inhibited by pressure, etc.

B. Prolonged exposure to a positive magnetic field can produce a toxic vasculitis, neuritis, and addiction due to evoked endorphins and serotonin, microorganisms and cancer cell replication.

C. A negative magnetic field is never harmful and helps healing, repairs, increases melatonin and growth hormone production and produces biological homeostasis.

33. MAGNETIC FREE ENERGY.

A static magnetic field is the energy essence of magnetic therapy. Oxidoreductase enzyme + alkaline-hyperoxia

Food substrate..>ATP plus electron free energy from static electric catalytic remnant field with movement of electrons between magnetism substrate and enzyme producing a negative (Negative magnetic field) magnetic field (magnetic free energy)

Negative magnetic field therapy provides magnetic free energy from a static negative magnetic field for alkaline-hyperoxia catalytic reactions.

34. Each side of a static field magnet with magnetic fields on opposite sides of a flat surface magnet produces only a single uniform, magnetic field.

From each single side of a flat surface static field magnet, there is a magnetic field of the same magnetic polarity field turning back to enter the opposite magnetic field. This entry into the opposite magnetic field occurs at the edge of the magnet at the equator which is a half-way point between the opposite magnetic fields. Thus, a subject being exposed to the uniform negative magnetic field of a flat surface magnet receives the negative magnetic field only and does not receive a positive magnetic field coming around the edge of the magnet. The entry of the positive magnetic field is at the equator half-way point between the opposite magnetic fields. This is on the edge of the magnet and not on the opposite flat surface side of the magnet.

Albert Roy Davis, Physicist, for several years used flat surface magnets with poles on opposite sides to determine the separateness of the opposite biological response to the positive and negative magnetic fields. This separate biological response to opposite magnetic fields could not have occurred if there was an opposite magnetic field coming around the edge of the magnet.

Robert O. Becker, M.D. understood that a flat surface magnet with opposite magnetic fields on opposite sides provided only a

separate single magnetic field form each side of the flat surface magnet.

Skin tests prove that only a single magnetic field response occurs in response to the single magnetic field on each side of a flat surface magnet. A gauss meter reading documents evidence that only a single magnetic field occurs from a flat surface magnet with poles on opposite sides and that there is not an opposite magnetic field coming around the edge of the magnet. The usefulness of a magnetometer is limited to the reading over the uniform magnetic field over the flat surface of a flat surface magnet with magnetic field poles on opposite sides. The reason for this is that the magnetometer has its own magnetic field which will give an opposite reading when crossing over the edge of the magnet, due to the fact that the bar magnet in the magnetometer reaches beyond the equator at the edge of the magnet.

The erroneous concept model that an opposite magnetic field comes around the edge of a flat surface magnet comes from an incorrect use of a magnetometer, contrary to the manufacturers stated value and limitations of a magnetometer which is "limited to a uniform field".

There is no reason to place mini-block magnets under a 4" mattress pad in order for the surface to receive only a negative magnetic field. When placing mini-block magnets in a bed pad on top of a mattress it is necessary to sufficiently pad between and over the mini-block magnets so the weight of the subject cannot press down between the magnets so as to not reach the equator half-way point between the separate magnetic fields on opposite sides of the mini-block magnets.

The Physiology of Biomagnetics

Humans and all living organisms are electromagnetic. Human life exists as an electromagnetic organism. The central nervous system and the peripheral nervous system function as a direct current circuit with a positive (north-seeking) magnetic field at the positive electric pole and a negative (south-seeking) magnetic field at the negative electric pole. Each cell has its positive (north-seeking) and negative (south-seeking) magnetic fields. The DNA genetic code material of each cell has both positive (north-seeking) and negative (south-seeking) magnetic fields. Magnetic fields govern cell functions and is a necessary functional part of all physiological functions of the human body. Bio- magnetics needs to be understood in order to understand the normal mental and

physiological energy functions of the human body. Biomagnetics needs to be understood in order to understand how handicapping symptoms develop and also how to reverse these handicapping symptoms. Magnetic energy dynamics is the very foundation of normal and abnormal mental and physical human functions. Magnetic therapy employs the basic fundamental energy dynamics of being alive and responding to stimuli whether these are internal brain thoughts or feelings or an external play on sight, sound or tactile senses. Magnetic field energy, due to being the very energy foundation of response, can alter the biological responses to stimuli.

There are distinctly separate fundamental ways in which magnetic fields exert control over responses to stimuli.

Biological Responses to Separate Magnetic Fields:

Positive Magnetic .Field	*Negative Magnetic Field*
Stress response	Anti-stress response
Neurone exciting	Neurone calming
pH acidifying	pH alkalinizing

Human physiology has a homeostatic function between the positive (north-seeking) magnetic field biological governed biological responses and a negative (south-seeking) magnetic field governed biological responses. The necessary biological homeostasis between a positive (north-seeking) and negative (south-seeking) magnetic field is not an equal amount of both of these fields. The negative (south-seeking) magnetic field has a higher gauss strength than the positive (north-seeking) magnetic field in the human body. The presence of a higher negative (south-seeking) magnetic field than a positive (north-seeking) magnetic field provides the human with the ability to exert a control over any possible excessive positive (north-seeking) magnetic field stimulus response. The neuron bodies of the central nervous system are a positive (north-seeking) magnetic field while the neuron axon extensions into the body are a negative (south-seeking) magnetic field.

Robert O. Becker demonstrated that an injury registers as an electromagnetic positive while the healing state of the injury registers electromagnetic negative. Healing-repair can only occur in the presence of a negative (south-seeking) magnetic field. A positive (north-seeking) magnetic field is the signal of injury sent to the brain following which the brain returns a negative (south-seeking) magnetic field necessary for healing-repair. Magnetic

therapy provides an external source of a negative (south-seeking) magnetic field for healing-repair.

The human body can only maintain optimum life function in an alkaline medium. Human life is alkaline-hyperoxia-dependent. The physicist, Albert Roy Davis discovered that a negative (south-seeking) magnetic field biological response is alkaline-hyperoxia while the positive (north-seeking) magnetic field biological response is acid-hypoxia. My observations confirm Davis' observation of an alkaline-hyperoxia response to a negative (south-seeking) magnetic field. The alkaline-hyperoxia biological response to a negative (south-seeking) magnetic field is why a negative (south-seeking) magnetic field relieves symptoms.

There is a parallel between acid-base balance and magnetic field levels. A biological acid state is always a positive (north-seeking) magnetic field. A biological alkaline state is always a negative (south-seeking) magnetic field. My research examined pH before and after test meals of foods and exposure to common environmental chemicals and also, immunologic reactions. When symptoms occurred during these tests of exposures an acidity always developed. These symptoms can be relieved by the negative (south-seeking) magnetic field of a static field magnet because the biological response to the negative (south-seeking) magnetic field is alkaline-hyperoxia.

pH Biological Response to Separate Magnetic Fields

Positive Magnetic Field	Negative Magnetic Field
Acid-hypoxia	Alkaline-hyperoxia

Magnetic Response to Stress Injury

Positive Magnetic Field	Negative Magnetic Field
A positive magnetic field is a signal of injury sent to the brain.	The brain receives the signal of injury as a positive magnetic field and returns the signal of a negative magnetic field
No healing-repair can occur	Healing-repair requires alkaline hyperoxia for oxidative phosphorylation production of ATP. A negative magnetic field biological response to a negative magnetic field is alkaline-hyperoxia.

The production of ATP by oxidative phosphorylation is blocked by the acid-hypoxia of a positive magnetic field.

Chronic stress, from whatever source, produces acidity. Since acidity ties up molecular oxygen, producing acids, the result is acid-hypoxia. Chronic stress resulting from physical injury or psychological stress have the same biological consequences of the production of acid-hypoxia. An injured muscle or over-stressed muscle becomes acidic and thus also hypoxic. This acid-hypoxic state is inflammatory and painful whether the tissue is a muscle, fascia, tendon or other tissues such as an internal organ.

The problem of inflammation and pain production by acidity becomes compounded since the human life energy (ATP) cannot be made in an acid-hypoxic medium since oxidative phosphorylation is alkaline-hyperoxia-dependent. However, human cells have the ability to make ATP by fermentation using transferase enzyme catalysis. The production of ATP by fermentation occurs when acid-hypoxia is present. This is an emergency energy measure and cannot sustain human life for very long. Lactic acid is a by-product of fermentation, which adds further acid-induced inflammation. Cancer cell initiation and growth can only develop in an acid-hypoxic medium since cancer cells use fermentation for the production of ATP. Infectious microorganisms are acid-hypoxic, fermentation-dependent for their production of ATP. A negative (south-seeking) magnetic field with its production of alkaline-hyperoxia canceling out acid-hypoxia is antibiotic, anti-parasitic and anti-cancerous.

Biological Source of Magnetism

Magnetic field energy is essential to biological life energy. Biological life cannot exist without magnetic field energy. The DNA genetic code contains magnetic fields and passes this magnetic field on to the next generation. Magnetic fields are always both positive (north-seeking) and negative (south-seeking) magnetic fields. However, these positive (north-seeking) and negative (south-seeking) magnetic fields do not have to be of equal proportions. In fact, the human magnetism is higher in the negative (south-seeking) magnetic field than the positive (north-seeking) magnetic field. This is how the human organism maintains alkaline-hyperoxia. Microorganisms', parasites' and

cancer cells' magnetic physiology is opposite to the human magnetic physiology in which the positive (north-seeking) magnetic field is higher than the negative (south-seeking) magnetic field.

There are hundreds of enzyme catalytic reactions occurring in the human. A catalytic reaction requires movement of electrons between the substrate and the enzyme. When electrons move, they produce a magnetic field. Thus, alkaline-dependent enzymes are also negative (south-seeking) magnetic field dependent and acid-dependent enzymes are also positive (north-seeking) magnetic field dependent.

Examples of Biological Produced Magnetism
Four Oxidoreductase enzymes

Food Substrate _____>Adenosine triphosphate
 +alkaline-hyperoxia (ATP+ oxidative remnant magnetism; a negative magnetic field)

Food Substrate_____>ATP + a positive
 transferase magnetic field
 enzyme + acid-hypoxia

Secrets of Negative Magnetic Field Therapy

A negative (south-seeking) magnetic field is anti-stressful and thus, neuronal calming. A negative (south-seeking) magnetic field on the brain and spine calms neurones (anti-stress) and aids voluntary relaxation and sleep. It is also true that a negative (south-seeking) magnetic field can be made strong enough to produce involuntary magnetic general anesthesia. Robert O. Becker anesthetized his salamanders with a negative (south-seeking) magnetic field. I have demonstrated the control of seizures by a negative (south-seeking) magnetic field. I have demonstrated the control of movement disorders with a negative (south-seeking) magnetic field. I have observed the control of major mental disorders such as hallucinations, delusions and depression with a negative (south-seeking) magnetic field. The exceptional value of a negative (south-seeking) magnetic field control over neuronal excitation is that

it works whether the neuronal excitation is due to an injured brain from trauma, viral infection, maladaptive food reaction, maladaptive environmental chemical reaction, immunologic reaction or repressed unconscious hostility, anger, anxiety and its associated somatic expression. The secret of a negative (south-seeking) magnetic field therapy is that a negative (south-seeking) magnetic field is neuronal calming, cellular metabolic normalizing, enzymatic processing of all types of inflammatory responses no matter why they are present.

Symptom-producing responses occur due to repeated neuronal excitation paired with a stimulus evoked response. Sensitization is due to neuronal excitation paired with a stimulus. Desensitization results when neurones are held in a calm, anti-stress state while meeting the stimulus that had trained in a maladaptive sensitization response. It is repetition while exposed to a stimulus-producing response that trains in sensitivity and it is repetition while holding the neurones in an anti-stress inhibited state that trains out sensitization. Thus, a negative (south-seeking) magnetic field brain treatment has an immediate cancellation of the maladaptive response and by repetition trains out the maladaptive response. Local inflammation is reversed enzymatically by oxidoreductase enzymes processing of free radicals, peroxides, oxyacids, alcohols and aldehydes.

Oxidoreductase enzyme,

Superoxide disputase enzyme in an alkaline medium

Superoxide Free Radical _____>Hydrogen Peroxide

(H_2O_2)

Catalase enzyme in an alkaline medium
H_2O_2 _ >water + molecular oxygen

Superoxide
free
radical,
peroxides,
oxyacids,
Reductases

Oxidoreductase enzymes
Dehydrogenases, Hydroxylases,
Oxidases Oxygenases,
P e r o x i d a s e s,

alcohols and aldehydes _____>water and oxygen molecules Alkaline-medium electrostatic field or negative magnetic field

The Role of Magnetics In Enzyme Function

All biological enzyme functions (catalysis) in a living biological system are magnetic energized. There is a measurable catalytic remnant magnetism to enzyme function in live biological systems. Four oxidoreductase enzymes are needed to produce adenosine triphosphate (ATP) from foods. During these enzyme processes, there are two energies being made. One is ATP and the other is oxidation remnant magnetism. Both of these energies are used for the energy activation of enzymes. There are thousands of the enzymes, each with its own selective function. These are named according to their functions. Oxidoreductase enzymes are a family of enzymes with specific necessary functions. These enzymes have the following functional values. They produce ATP and catalytic remnant magnetism and they process the end-products of the metabolic process which are initially the free radical called superoxide which is oxygen with an added electron. If not rapidly enzymatically processed, it will produce peroxides, acids, alcohols and aldehydes all of which are enzymatically toxic, that is inflammatory-producing.

In order for us to understand biological life energy, we must understand the starting point of that energy. Thus, we must understand the functions of oxidoreductase enzymes. We have enzymes and the substrates which they are processing. In the case of producing ATP, the substrate is a food. In the case of processing the toxins or inflammatory producing substances, the substrate are the free radicals and the products they produce. There exists a natural tendency for the enzyme and the substrate to join. These areas that have a biological attraction to join are called dipoles. However, this attraction all by itself does not produce enzyme action. These are simply the areas where the enzymes and the substrates do line up and join. Otherwise, there has to be an energy. This characteristically comes from static electrons that are in the body. They help move the enzyme and the substrate together. Once they move, now a magnetic field is created because this is what a magnetic field is all about. It is produced by the movement of electrons. Also, a magnetic field from an external source that is a static magnet field will also produce the movement of electrons.

This is why an external source of a static magnetic field will cause the enzyme and the substrate to join because it is moving electrons.

The essence of static magnetic field therapy is the energy activation of enzymes to join substrates for catalysis. In the case of oxidoreductase enzymes, they are alkaline-hyperoxia dependent and do not require ATP for energy activation but do require a static negative magnetic field energy for catalytic activation.

ATP is an energy activator of many enzymes. In alkaline-hyperoxia, ATP dependent enzyme catalysis, a negative magnetic field is a co-factor with ATP as an enzyme energy activator. This is all human enzymes other than those of the mouth and stomach.

In acid-hypoxia dependent enzymes as well as transferaces, ATP and a positive magnetic field are energy co-factors. Invading microorganisms and cancer cells are acid-hypoxic dependent for making their ATP.

Thus, a static negative magnetic field strengthens the human cell alkaline-hyperoxic dependent energy state and defeats the acid-hypoxic dependent state of cancer cells and invading microorganisms (bacteria, viruses, fungi and parasites).

Magnetic Dynamics of The Degenerative Process

The central disorders of acute maladaptive reactions are: 1) acidity, and 2) oxygen deficit. Monitoring the biochemical disorders of chronic degenerative diseases reveals the same disorders as acute maladaptive reactions which is acid-hypoxia. Chronic degenerative diseases are observed to be acute maladaptive reactions extended in time to a chronic state with the resultant cellular damage. The contrast between the well cells of the healthy, functioning person and the sick cells of degenerative diseases provides valuable clues as to how magnetics can substantially aid in recovery of inflammatory degenerative diseases, infections from microorganisms and cancer.

In the process of oxidative phosphorylation producing adenosine triphosphate (ATP), molecular oxygen accepts an electron and becomes free radical oxygen (superoxide). If not immediately enzymatically reversed, superoxide proceeds to produce other free radicals, peroxides, oxyacids and aldehydes. These are all inflammatory. The oxidoreductase family of enzymes have the assignment of making ATP by oxidative phosphorylation and at the same time, processing the end-products of this oxidation phosphorylation process. This oxidoreductase family of enzymes are alkaline-hyperoxic-negative magnetic field activation

dependent. When these 3 physiologically normal factors are not present, then cellular ATP is made by fermentation. The 3 factors necessary for fermentation to produce ATP are: 1) acidity, 2) lack of oxygen, 3) a positive static magnetic field as an enzyme energy activator. Human cells have the capacity to make ATP by either oxidative phosphorylation or fermentation. Cellular fermentation producing ATP only functions in the abnormal state of acidity and hypoxia. The enzymes catalyzing fermentation production of ATP are transferases which are acid-hypoxic-positive-static magnetic field activation dependent. Sugar is catalyzed by transferase producing ATP, alcohols, acids and carbon dioxide. Hydrolase enzymes catalyzes starches to sugars. Hydrolase also is acid-hypoxic-positive static magnetic field energy activation dependent.

A static magnetic field is the energy activator of all biological catalytic processes. When oxidative phosphorylation catalyzes the production of ATP this catalytic reaction makes negative static field magnetism termed oxidation remnant magnetism. This negative static magnetic field is available to energize oxidoreductase enzyme catalysis and at the same time, block transferase and hydrolase catalysis. Besides the biological available negative static magnetic field from oxidation remnant magnetism, there is an always present electrostatic field (1). In an alkaline medium the electrostatic field produces a negative static magnetic field which energizes oxidoreductase catalysis. In an acid medium, an electrostatic field produces a positive static magnetic field which in turn energizes transferases and hydrolases. Both oxidation phosphorylation and fermentation catalysis are static magnetic field energized. However, they are energized by opposite magnetic poles. Oxidation phosphorylation is energized by a negative static magnetic field in an alkaline-hyperoxic medium. Fermentation is energized by a positive static magnetic field in an acid-hypoxic medium. A static magnetic field is required for the enzyme and the substrate to attach. A static magnetic field present during enzyme catalysis has been documented (2). ATP made by fermentation with its acid-hypoxic medium cannot maintain human biological life energy. ATP made by fermentation can maintain the life energy of microorganisms such as bacteria, fungi, viruses, parasites and cancer cells. The secret to reverse acute maladaptive symptom reactions, prevent and reverse microorganism infections, maintaining human biological health and providing for the reversal of degenerative diseases is to

maintain a normal alkaline body pH, hyperoxia and an adequate negative static magnetic field. The biological response to a negative static magnetic field can maintain these necessary components of healthy human cells. Thus it can be understood that exposure to an external source of a negative static magnetic field supports human health and materially aids in reversal of inflammatory degenerative diseases, cancer and the defense against microorganism invasion. This external negative static magnetic field can be applied to local affected areas as well as applied systemically by such as a negative static magnetic field bed.

1) *Encyclopedia Britannica.* Vol 15, page 1060. 1986 edition

2) Fersht, Alan. *Enzyme Structure and Mechanism*

The Significance of Alkalinity and Acidity in Biological Health and Disease

The human body functions in an alkaline dependent state. Hyperoxia, which is necessary for the production of adenosine triphosphate (ATP), can only be present in an alkaline medium. An acid medium ties up oxygen, which is no longer free for the oxidation-reduction process of producing ATP. A healthy human maintains a blood pH minimum of 7.4. Below 7.4, the numerous necessary enzymes for life function in a human lose their function because they are alkaline-dependent. Alkaline minerals such as sodium, magnesium, potassium, and calcium as bicarbonates are a necessary part of the pH buffer system maintaining alkalinity. Therefore, it is necessary that these nutrients be in adequate supply. Insulin also helps maintain the alkalinity, the production of which rises and falls depending on the need to maintain the alkalinity. This is one of insulin's functions. Endorphins, insulin and nutrients producing bicarbonates are all alkaloids and therefore have a normal physiological level. This normal physiological alkalinity is anti-inflammatory, buffers against infections and cancers that are acid-dependent.

Degenerative diseases such as diabetes mellitus, rheumatoid arthritis, local and systemic infections are all acid states in which local areas of the body are acidic and also there are measurable episodes of systemic acidity in these degenerative diseases.

It is highly significant to understand that sensitivity, symptom-producing reactions to foods and or chemicals are

acid-producing. I have measured thousands of these symptoms occurring during deliberate exposure to foods and chemicals and when symptoms occur there is a measurable acidity occurring in the blood. The local area where the symptom occurred is even more acidic than the blood. Degenerative diseases have been demonstrated to simply be an extension in time of these acute symptom-producing reactions to foods, chemicals and inhalants. It matters not whether these are immunologic with demonstrated antibodies or complement disorders or whether they are non-immunologic. Acidity occurring at the time of either acute symptom production or chronic disease symptoms is the central common denominator. It is true that immunologic reactions are also acidifying but it is also true that there are many times more non-immunologic type reactions that are acidifying and thus, symptom-producing.

Addiction, whether it is to narcotics or other drugs, or to foods has an acidic phase during the withdrawal of that substance. In addictions, the withdrawal begins to occur at 3-4 hours, post-exposure. Addiction to foods turns out to be the most common cause of symptom producing maladaptive sensitivity reactions to foods. The frequently eaten food becomes a stressor, which is beyond the body's biological capacity to optimally process. When first exposed to the food to which the subject is addicted, there is relief of symptoms because the stress evokes a rise in endorphins and serotonin. Some four hours later, when both endorphins and serotonin drop below the normal functional physiological levels, acidity emerges and symptoms occur.

This is why it is so important that all addictions be stopped at the same time. Thus, this includes alcohol, tobacco, caffeine, and all foods to which the person is addicted.

The Role of Oxidoreductase Enzymes in Addiction Including Food Addictions

Members of the Oxidoreductase enzyme family classified by their function are as follows:
1. Dehydrogenases
2. Hydroxylases
3. Oxidases
4. Oxygenases
5. Peroxidases
6. Reductases

Oxidoreductase enzymes are responsible for the production of adenosine triphosphate and oxidation remnant magnetism (negative magnetic field). This is an alkaline-hyperoxia negative (south-seeking) magnetic field dependent enzyme catalytic reaction. When the frequency of a substance exceeds the available functional capacity of oxidoreductase enzymes, then this becomes a stress. The body's response to stress is to raise endorphins and serotonin. This stress more over-produces endorphins and serotonin beyond their normal physiological level, thus providing not just a comfortable feeling, but also a super comfortable, even euphoric feeling. Some 3-4 hours later, the production of endorphins and serotonin drop below physiological level, which is now an acidic, inflammatory, psychologically depressive and anxiety-producing state. When oxidoreductase enzymes can be maintained at a normal physiological level, this addictive state does not occur. We know this is true because when we expose the brain and the symptomatic areas to a negative (south-seeking) magnetic field, it will activate the oxidoreductase enzymes and thus relieve the symptoms. This fact also becomes the center focus for handling the symptoms of addiction in general and food addiction in particular. By the use of a negative (south- seeking) magnetic field applied to symptomatic areas and the brain, the withdrawal from addictive substances including foods can be made comfortable. Maintaining comfort while withdrawing from food addiction is an important part of magnetic therapy of reversing food addiction.

THE ROLE OF ADDICTION IN OBSESSIVE-COMPULSIVENESS

Obsessive-compulsiveness can be a learned response from environmental experiences. However, much of obsessive-compulsiveness is learned from addiction. When contacting the addictive substance, food or otherwise, the subject is super comfortable without body pains and with a mental euphoria. When the addictive withdrawal phase sets in and the discomforts leave and pains, depression, anxiety and tension emerge, there develops first an obsessional wish to obtain relief by contact with the addictive substance again and a compulsion to act on that obsession. Addiction classically trains in obsessive-compulsiveness, which then pervades the entire behavior of the subject. The addict simply, obsessively, can't

wait for relief. They can't accept any imperfection, including waiting for relief. Physical pain can be relieved by placing a negative (south-seeking) magnetic field over the area of pain. Brain symptoms can be relieved by placing the negative (south-seeking) magnetic field over the bitemporal areas of the brain. Bitemporal area placement of the discs relieves depression and tension. Placing a magnetic disc midforehead and left temporal relieves anxiety. Placing a magnetic disc over the left temporal and low occipital area is the most effective for relieving obsessive-compulsiveness.

It is understandable that overeating of calories becomes an obsessional compulsive component of food addiction. The system of magnetic weight reduction is to, first of all, stop all addictions. Secondly, handle all the withdrawal symptoms of stopping all addictions. The third is to decide the number of calories that needs to be consumed to maintain an appropriate weight. Eat this number of calories and stop any compulsion to overeat by placing the magnets appropriately on the head as well as a 4" x 6" x 1/2" magnet on the mid-sternum and over the epigastric area. Also, treat any areas of discomfort at the same time. By this method, the person learns with comfort to eat only the amount of calories that will maintain adequate weight. If there is an urge to eat between meals, then place the magnets on the head, the chest and on the epigastric area. Within 5-10 minutes, this urge will have disappeared. Thus, there is a method of self-help maintenance of comfort and magnetic cancellation of obsessive-compulsiveness.

Grandfather Status of Magnet Therapy

Among early medical practitioners, there are references to the medical uses and self-help uses of static field magnets. This description of static magnetic fields for medical use and self-help application holds a record for being among the longest, if not the longest, held application of medical therapeutics. The application of magnetic therapeutics is world-wide. This worldwide grandfather status of application of static magnetic fields for therapeutic reasons is important in view of the more recent establishment of research practices to prove the value and safety of procedures and products. Among the earliest effort at establishing through scientific means, the value of magnetics is that of the research establishing both the value and safety of the application of magnetic energy for magnetic resonance imagery.

Up to the 1970's, medical practices and sciences had been accepted because of their universal acceptance and application. There now are specific research techniques accepted by the Food and Drug Administration as valuable in establishing a scientific proof of both value and safety. Most medical practices have come to be accepted without this research proof. To this day, a substantial amount of medical practice is grandfathered and proceeds to be used without scientific proof. There is no official list of practices that have been grandfathered. They simply continued to exist without being challenged as to value and safety. Magnet therapy has existed since the early status of the practice of medicine and this has been worldwide. Although, not officially stated as grandfathered, its practice demonstrates that it is grandfathered in the United States and worldwide. In recent years, there has been an increase in the application of magnetics. Years ago, Sears Roebuck used to sell magnets for the relief of pain. In recent years there has been an increase of use of magnets for pain, sleep and other procedures. Magnetic therapy is also, at the same time, undergoing a scientific investigation as to values and limitations. National Institutes of Health is granting funds for this research. There are also privately funded researches in progress.

For many years, biochemistry has been fulfilling its promises of value and of financial rewards for marketing products. Biophysics has been largely ignored in terms of research for years. The times are changing and biophysics is now offering substantial rewards for harnessing magnetic applications.

What is Addiction?

Addiction occurs when there is a production of symptoms occurring on the withdrawal of a narcotic. The classic example is the chronic frequent use of cocaine. When the narcotic is high in the body, there is a mental high with euphoria and disordered judgement. Three to four hours later, when the narcotic is low which has also suppressed the body's own production of narcotics, there is a mental low, depression and again, disordered judgement. Thus, in addiction there is a roller coaster type of mental high without pain, followed by a mental low with pain. Human metabolism has an acute stress response reflex. When an injury or other acute stress is present, there is a rise in serotonin in preparation for action. At the same time, this acute stress raises self-made opiate polypeptides (endorphins) to reduce the physical or mental pain of the stress. When the acute stress state keeps

being frequently evoked so as to be chronic or near chronic, this counter-stress response fatigues and no longer evokes the production of endorphins and serotonin. This sets the stage for food addiction. Foods are eaten which trigger the production of serotonin and self-made narcotics. There develops a roller coaster type of too little, below normal amount of serotonin-opiate response to the fatigue response which is relieved by eating a food which evokes the serotonin-opiate anti-stress reflex, producing more than a normal amount of serotonin and opiates. Thus, the addiction roller coaster state of food addiction is perpetuated. All addiction, whether to exogenous narcotics or endogenous self-made opiates due to a food stress reaction, have biological deteriorating consequences. The symptom producing withdrawal phase characteristically starts at 3-4 hours post-meal and if a food is not eaten to raise the serotonin-opiate complex, the symptoms will worsen through the next three days. By the fourth day, the withdrawal symptoms are diminishing and by the fifth day, they are characteristically gone. There is a percipient rise in body acids during this withdrawal phase which normalizes back to a biologically normal alkaline state by the fifth day. My knowledge of this comes from thousands of patients that I have fasted for a five day period. Blood and saliva is tested for the pH. The addiction phenomena is reversed by the fifth day following a fast after which food maladaptive reactions evoke acute symptoms within the first hour of eating a meal of the single food being tested.

The Sequence of Food Addiction Addictive Withdrawal Phase

Below physiologically normal serotonin-opiate complex. Frequently, blood sugar is below normal. This occurs characteristically, 3-4 hours after the meal. During this withdrawal phase, there develops anxiety, tension, depression, physical and mental symptoms. Pain often develops

Addictive Relief Phase

Food meal relieves symptoms and pH normalizes to a normal alkaline pH. Serotonin-opiate complex rises beyond normal. Anxiety, tension, depression, physical and mental symptoms and pain disappear. Euphoria and impaired judgement develop. Blood sugar normalizes and or sometimes, is higher than normal at 1-2 hours after the meal. Addiction is deteriorating with the end stage being maturity onset type diabetes mellitus and it's numerous physical and mental complications.

Characteristically, before the development of diabetes mellitus Type II, there are several years of food withdrawal symptoms that occur at 3-4 hours, post-meal, associated with hypoglycemia. At 2-3 hours post-meal, there often is a hyperinsulinism, which precedes the hypoglycemia occurring at the 3-4 hour level. This is the compensated stage of maturity-onset type diabetes mellitus. After several years, the hyperinsulinism fatigues and stops at which time the blood sugar stays up overnight. At this stage, when the blood sugar stays up overnight, the diagnosis of clinically significant diabetes mellitus Type II is made. Finally, in the late, late stage, the insulin production drops so low for a few, that insulin is given as a practical management of the diabetic state. This is the sequential story of how maturity onset type diabetes mellitus develops.

The Dimensions of Addiction The Role of Narcotics

There are exogenous narcotics serving a useful purpose in medicine to relieve pain. These are such as morphine, Demerol and others used in medicine. The uses of these are by law used under the judgement of a physician. There are a number of exogenous narcotics used illegally to produce pleasurable euphoria and an altered mental state. Cocaine is an example.

The human body makes endogenous narcotics. These are termed endogenous polypeptide opiates given the name endorphins.

The Role of Symptom Relief

There is a physiological level of endorphins that is not addicting. In case of a stress-injury emergency there is a pain protection of an acute rise in endorphins along with a rise in synaptic junction transmitters (norephrinephrine, ephrinephrine, serotonin) ready for fright, flight or fight. If and when these stress type injury responses occur frequently, there then develops a state of endorphin addiction with a typical physical and mental symptom relief and euphoria phase when endorphins are higher than normal and a symptom (pain, anxiety, depression, weakness) phase when the endorphins are lower than normal.

The endogenous opiates producing a self-made state of addiction can be evoked by numerous non-narcotic physical and chemical stressors. Tobacco, caffeine, alcohol when frequently used can be stressors evoking endorphins producing addiction. Frequently eaten foods can become stressors evoking

the production of endorphins. Alcoholism is addiction to the foods from which the alcohol is made. Alcohol interferes with the selective absorption of foods and thus there is a four times increase in the development of addiction to foods from which the alcohol is made and also the same problem exists when using alcohol with the foods that are eaten. Gambling with its euphoric expectation of winning. Addiction with its disordered metabolism leads to degenerative diseases especially, Type II diabetes mellitus.

The Role of Altered Judgement and Disordered Affect

Addiction with its pleasurable excitement phase followed by its painful withdrawal phase trains in an addict an obsessive-compulsive neurosis. There develops a compulsion to seek a pleasure phase and avoid the painful phase. Thus, there develops a learned compulsion to seek the narcotic, tobacco, alcohol, caffeine, amphetamine, symptom relieving food, pleasurable anticipation of winning while gambling and so forth. Judgement becomes distorted, affect disordered and hostile aggression expressed when the goal of pleasure seeking is interfered with. The addicted person becomes self-centered and incapable of reasonable interpersonal relationships.

The Role of Disordered Metabolism

The withdrawal phase of addiction to narcotics or the self-made endorphins due to nonnarcotic stressors is a state of acid-hypoxia. This is painful and leads to symptoms. Brain function is interfered with by this acid-hypoxic state leading especially to depression and weakness. Target tissues that have either been injured, infected or have otherwise compromised metabolic function are the first to develop symptoms. Most characteristically, pain and soreness. Infections flourish in this state of acid-hypoxia. Carbohydrate metabolism is disordered resulting in hypoglycemia with further symptom production. When the narcotic substance or non-narcotic stressors evoking endorphins produce the euphoric state and symptom relief state, there is a state of alkaline-hyperoxia. Exogenous narcotics and self-made narcotics (endorphins) are alkaloids which produce an alkaline state in which there can be a normal amount of oxygen for biological functions and normal oxidoreductase enzyme function processing the free radicals, peroxides, acids, alcohols and the aldehydes. Thus, there is a seesaw metabolic function including the relief phase followed by a disordered metabolic

function during the withdrawal symptom phase of addiction. The higher than normal exogenous narcotics and endorphins create its own problem in disordered judgement and an unnatural euphoria.

A person who misses a meal and has symptoms emerge is in trouble with food addiction. A person who eats food to relieve physical or mental symptoms is in trouble and is either already or will soon become a food addict. The simple fact is that a person eating foods to remove mental stress symptoms, no matter whether this is protein, carbohydrate or a mixture of these is in trouble. Eating to relieve symptoms is simply an incorrect method of managing symptoms or for that matter, weight reduction or optimum weight maintenance. The result of eating to relieve symptoms is mentally and physically deteriorating.

In 1965, I was referred a schizoaffective patient who had attempted suicide. The referring physician sent me a letter stating the patient had hypoglycemia. At the time, I was unaware of the possible relationship of hypoglycemia and emotional and mental states of the person. On inquiry, I was told of John Tinterra, M.D. of New York City and his Hypoglycemia Foundation. Based on the information I received from Dr. John Tinterra, I did a 6-hour glucose tolerance test on my suicidal patient. At one hour of the six hour glucose tolerance test, she had a blood sugar of 180 mg % at which time she was euphoric and manifested poor judgement. At four hours, her blood sugar was 50 mg % and she was in the depths of depression and again manifesting impaired judgement. I began a routine of 6-hour glucose tolerance tests and found many subjects with euphoria at one hour and depression at four hours often associated with hyperinsulinism preceding the hypoglycemia occurring usually at three to four hours. Dr. Tinterra's answer for this abnormal shift in blood glucose and it's associated symptoms was to have a small protein between meal snack at around two and one-half to three hours post-meal. This materially improved the roller coaster emotional and mental up and down symptoms of my patients. John Tinterra placed me on the board of his Hypoglycemia Foundation. I was the only other doctor on this board. In 1969, John Tinterra died and I became medical director of the Hypoglycemia Foundation.

Between 1970-1975, I did a research project on 500 hospitalized mental patients, most of which were

schizophrenics. From this research, I published two books, *Brain Allergies* (3) and *Victory Over Diabetes* (4). Following the advice of the allergist, Theron G. Randolph, M.D. (5), the patients were fasted on water only for five days. During the first three days of food withdrawal, the patient's mental symptoms increased in intensity and blood and saliva acidity increased. This was demonstrated by both blood and saliva tests. By the fourth day, symptoms were subsiding and by the fifth day, the research subjects were mentally clear and felt physically well or substantially improved. The mental and physical symptoms manifested at four hours while daily using the same foods, now manifested even more pronounced symptoms one hour after a test meal of the same single food. Thus, the symptom reactive foods were separated from the non-symptom reactive foods. The symptom reactive foods were found to be the favorite foods of the subject which were eaten two or more times a week. That is, more than once in four days. This confirmed the observations of Randolph and others that the symptom producing foods were the frequently used foods.

A classic addiction physical, mental, behavioral phenomenon was manifested which included symptom relief on exposure to the frequently eaten food and a symptom emergence after the digestion had occurred and a withdrawal of the food was occurring. This set of symptoms occurred while the subject was eating the foods with their usual frequency of twice a week or more. During the testing phase of single foods, after the five days of avoidance, the symptoms were also compared to antibody studies IgE and IgG and complement studies were being run. This demonstrated IgE reactions to be rare and when present, not to be the frequently used foods. When IgG or complement disorders were present, there was also the addiction phenomenon of relief on contact with the food and symptom emergence on the withdrawal phase occurring at three to four hours later IgG and complement disorders were seldom present. The majority of symptoms produced by foods were demonstrated to be non-immunologic in origin.

During the testing after a five-day avoidance period, blood sugar was tested before the test meal, one hour after the test meal and four hours after the test meal. The picture of the carbohydrate disorder had now changed. There was no more hypoglycemia. There was only hyperglycemia at one hour,

which usually had normalized by the second or third hour, postmeal. The carbohydrate disorder was frequent and did not relate to whether this was a carbohydrate, a protein or a fat. It related to a maladaptive reaction irrespective of which type of food. It related to the frequency with which the food was used.

Because of my role as Medical Director of the Hypoglycemia Foundation, Editor of the *Journal of Metabology* and President of the International Academy of Metabology, I was sent the problem cases of physicians using the frequent between-meal food system. I was in the midst of my research project on mental patients between 1970-1975 and proceeded to submit these problem cases to my research program. I fasted them for five days and proceeded with food testing meals of single foods while recording symptoms evoked by these single food meals, blood sugar before and one hour after meals, symptoms before and one hour after meals, and pH of the blood or saliva before and one hour after meals. With this system of examination the answer emerged.

The same frequently used foods used for between meal snacks had the classic addiction phenomena of relief on contact and symptom on withdrawal from these foods. During the test phase after the fast, the symptoms emerged within an hour instead of four hours later as had been characteristic while they were eating these same foods frequently. The blood sugar was high at one hour and there was no hypoglycemia at three to four hours. This also established the fact that proteins frequently used are just as symptom reactive as carbohydrates or fats. This research study demonstrated that the answer for these symptoms emerging three to four hours post-meal when using these foods frequently was not frequent between meal feedings. The answer was found to be the avoidance of these frequently used foods for a period of three months while setting up a 4-Day Diversified Rotation Diet in which foods were not used any more often than a once in four or five day basis.

An example is a problem case referred to me who had unsteadiness on her feet, headaches and depression. The frequent feeding of between meal snacks had not solved her problem. On the five day fast her symptoms all cleared. When given chicken, which was her favorite high protein food, her symptoms all returned. The unsteadiness on her feet, headaches and the depression emerged. Thus, it was demonstrated that

the very food that she used in an attempt to relieve her symptoms had now become a food that also produced symptoms. Repeatedly, I found that many subjects who had initially obtained considerable relief for anything from one to two years by the frequent feeding in between meal program, had now advanced to a state in which these very foods no longer relieved the symptoms but instead produced symptoms.

Among my patients were a number of maturity onset type II diabetics. When fasted for five days, their blood sugar normalized and on testing of single meals I was able to isolate the foods that produced the hyperglycemia. Thus, maturity onset diabetes mellitus was demonstrated to be caused by maladaptive reactions to foods. They were not different than those patients who were not yet considered diabetics. Thus, clinical significant diabetes was merely an extension in time from the acute carbohydrate disorder reactions that we saw in our non-diabetic patients. These findings are reported in my book, *Victory Over Diabetes*. This fact that maturity onset diabetes mellitus is caused by these maladaptive reactions to foods was confirmed by John Potts (6).

Foods used for the relief of physical, mental or emotional symptoms, no matter whether protein, fat or carbohydrate or a combination of these foods is a mistake. It is more than a mistake. It is the window to addiction. Addiction is the door to degenerative diseases such as diabetes mellitus Type II, rheumatoid diseases, autoimmune diseases, Alzheimer's, arteriosclerosis, cancer and so forth. The safe physiological answer for stress is anti-stress, not a quick fix by low-level stressors evoking the serotonin-opiate complex.

A negative magnetic field provides the non-addictive anti-stress. A negative magnetic field activates the paramagnetic bicarbonates thus producing a normal physiological alkalinity A negative magnetic field energy activates the oxidoreductase enzymes that release oxygen from its bound state in the inflammatory end-products of oxidation-reduction. This inflammatory complex includes free radicals, peroxides, oxyacids, alcohols and aldehydes. The oxidoreductase enzymes not only are responsible for producing ATP, but also for processing all of the inflammatory complex resulting from the oxidation-reduction process producing ATP. All oxidoreductase enzymes are not energized by ATP. Oxidoreductase enzymes are

energized by a static electric field-negative static magnetic field. Oxidoreductase enzymes are all alkaline dependent. Thus, a negative magnetic field becomes the answer for normalizing the pH back to its alkaline state and energizing the oxidoreductase enzymes. This is why a negative magnetic field will characteristically relieve symptoms within a 10-30 minutes period.

When the head is placed in a negative magnetic field, the pineal gland produces melatonin during sleep. This provides for deep, energy restoring sleep. During the fourth stage of non-REM sleep, serotonin, melatonin and opiates are balanced in their production. Thus, a negative magnetic field is the great normalizer. A negative magnetic field acts directly on neurons to control an excessive electromagnetic excitement. Thus, a negative magnetic field provides immediate control over neuronal excitation as well as normalizing the disordered chemistry that is producing the symptoms. This includes the symptoms that are produced during the withdrawal phase of an exogenous narcotic or endogenously produced opiates.

Serotonin is a synaptic junction transmitter making fight or flight possible. Serotonin exerts a control over an undue excitement potential of norephrinephrine and ephrinephrine. Thus, when a stress occurs there is a rise in serotonin. At the same time that serotonin rises, also endogenous opiates rise to protect against the symptoms (pain) produced by stress or injury. Both serotonin and endogenous opiates have a normal level that they have between stress states. When the serotonin-opiate complexes are raised beyond normal, the subject feels good and in fact, feels too good -- even euphoric. There is a compensation mechanism in which the serotonin-opiate complex level drops below normal three to four hours later. At this time, the person feels bad -- in fact, feels too bad, such as being depressed and having impaired judgement. Thus raising the serotonin-opiate complex by arranging for foods to do this, leads to addiction in which a chemical symptom precarious tight rope is being walked during a seesaw, roller coaster type disordered biochemistry. The disordered chemistry of addiction is the development of degenerative diseases with diabetes mellitus and it's complications being the central disease process of addiction. Thus, the answer to addiction and it's resulting degenerative disease is not to raise serotonin-opiates to relieve

the symptoms but instead to relieve the symptoms with a negative magnetic field that normalizes the pH, releases oxygen from its bound state in the inflammatory complex and normalizes the relationship between serotonin, opiates and melatonin by deep energy restoring sleep. Addiction results when exogenous narcotics are used or endogenous narcotics are produced to repeatedly relieve symptoms or for the pleasurable euphoria produced. Exogenous narcotics are such as:

1) Medical use of narcotics for pain relief
2) Various illicit narcotics such as cocaine, morphine, and so forth,
3) Inherent narcotics in foods such as in lettuce
4) Gluten containing cereal grains such as wheat, rye, oats or barley, which becomes a narcotic after the acid dependent proteolytic enzyme digestion in the stomach.

If the duodenal-pancreatic alkaline dependent enzyme proteolytic enzyme digestion does not adequately proceed, then the narcotic from the stomach enters through the mucous membranes of the small intestine. Thus, gluten containing cereal grains are potentially addictive. Gluten containing cereal grains have been noted to provide the highest percentage of maladaptive reactions to foods. Gluten produces the highest percentage of maladaptive reactions of the central nervous system. Several types of maladaptive symptom producing reactions to foods develop from the frequent use of the same food. The biological stress demand made by the frequent exposure to the same food causes these maladaptive symptom producing reactions to develop. There are several identifiable reasons for the symptom producing mal-adaptive reactions including such as:

1. Immunological reaction including the production of antibodies and complement disorders. The IgE reaction produces an acute inflammatory reaction such as hives and so forth and therefore, is avoided and is not significant in terms of food addiction. IgG, and complement disorders have a withdrawal phase occurring three to four hours after exposure. With the prolonged frequent use of these immunologic reactive substances there develops an adaptation in which there is symptom relief when the foods are initially contacted and a withdrawal phase occurring three to four hours after the exposure. If there is as much as a five-day avoidance of these immunologically symptom-producing foods, then there is a change in the timing when the symptoms occur. After a five day avoidance

period on exposure to the food, the symptom will occur within an hour or less rather than a withdrawal phase three or four hours later. This fact is used in deliberate food testing in order to accurately discover the foods that are maladaptively reacting. Thus, we see that these immunologic reactions behave as an addiction and in fact, it is logical to assume that it also is an addiction with an initial rise in self-made narcotics in which the narcotics are beyond normal amounts and thus produce even a euphoric response. When the withdrawal phase occurs the narcotics are less than normal amounts, which in part, produces the symptoms.

2. Oxidoreductase inhibition state. This is produced by acidity. These are alkaline dependent enzymes.

3. Oxidoreductase deficiency state. This is caused by malnutrition of vitamins, minerals and amino acid components of these enzymes.

4. Addiction with a rise of self-made narcotics beyond normal on contact with the substance or addictive food and followed by a drop in self-made narcotics below normal three or four hours later, producing withdrawal symptoms. The relief phase is accompanied by a normal alkalinity. The withdrawal phase is accompanied by an acidity. All of these reactive states such as the immunologic, the oxidoreductase inhibition or the oxidoreductase deficiency all behave the same way with a symptom relief phase on contact and a withdrawal symptom phase three or four hours later. They all behave like an addiction and it is likely true that addiction in terms of self-made narcotics follows through all of these. They also all are relieved with the same process, that is, a negative magnetic field. A low level gauss positive magnetic field can also relieve the symptoms, however, it perpetuates the addiction because the positive magnetic field raises the self-made narcotics whereas, a negative magnetic field normalizes pH and the degree of oxygenation but does not raise self-made narcotics.

5. Some foods contain toxins such as the residues of the pesticide sprays that have been applied to the foods. Some foods contain toxins from fungi. These need not be addictive in their behavior, however, they could develop the same addictive quality with prolonged repeated exposures.

In reversing this food-chemical addictive state, there are procedures that should not be used and procedures that should be used. High protein frequent feeding snacks to handle hypoglycemia should not be used. Carbohydrate frequent

feeding snacks to raise serotonin which also at the same time raises self-made narcotics, should not be used.

The non-addictive symptom relieving method that should be used is that of using a negative magnetic field. The system is to place a negative magnetic field bitemporally with such as disk magnets using either the ceramic disks that are an inch and one-half across and 3/8" thick with a gauss strength of 3,950 (manufacturer's rating) or super neodymium disk magnets that are 1" x 1/4" with a gauss strength of 12,300 (manufacturer's rating). At the same time, place a magnet of suitable size and strength over any area that has symptoms. Suitable magnets for this are such as, the 4" x 6" x 1/2" magnet or magnetic pads that are 5" x 6" or 5" x 12". The effectiveness of these can be reinforced by placing mini-block magnets an inch and one-half apart crosswise on these magnetic pads. Symptoms will usually leave within ten to thirty minutes. Placing a 4 x 6 x 1/2 inch magnet or magnetic pad reinforced by the mini-block magnets on the mid-sternum and epigastric areas is especially useful in relieving withdrawal symptoms since there is a sense of tightness in the chest and also in the epigastric area as a rather universal symptom of withdrawal. It is imperative to set up a 4-Day Diversified Rotation Diet which initially, for the first three months, leaves out the symptom producing foods which are usually among the foods that are used as much as twice a week or more. When medically used narcotics or when illicit hard drugs are being used, handle the symptoms of withdrawal with the negative magnetic field system rather than continuing the use of the narcotic drugs. This also applies to alcoholism, tobacco, and caffeine containing beverages such as coffee, cola drinks, chocolate and so forth. This also applies to amphetamines.

Biological Homeostasis

Raising the serotonin-opioid complex to reduce emotional and physical symptoms of chronic stress (non-acute stress) violates the law of biological homeostasis. Reducing the chronic stress so that there is no demand for raising the serotonin-opioid complex designed only for a temporary symptom reduction in acute stress honors the laws of homeostasis. A static negative magnetic field reduces the excessive electromagnetic excitement of neurons, processes the stressful biological inflammatory complex (superoxides. peroxides. oxyacids. alcohols, and aldehydes

normalizes body pH and processes enzyme toxins) and releases back to oxidative useful molecular oxygen from its bound state. The abundance of molecular oxygen, alkaline pH and the presence of a static negative magnetic field activates the four oxidoreductase enzymes necessary for producing adenosine-triphosphate. Thus, biological energy increases. This provides a true physiological correction of the symptomatic chronic stress state. This static negative magnetic field system of chronic symptom reduction provides a physiologically normalized non-addictive system of handling both acute and chronic

stress symptoms. Thus, the negative magnetic field symptom management reduces the energy output and at the same time raises the biological energy input. The system of raising the serotonin and opioid complex to reduce physical, mental and emotional symptoms is itself a chronic stress with biological consequences leading to chronic deteriorating metabolic degeneration.

Magnetic Protocol For Addiction
Orientation

This magnetic protocol applies to addiction to exogenous narcotics as well as addiction to endogenous opiate-polypeptides (endorphins) evoked by frequently eaten food stressors or frequently used chemical stressors such as alcohol, tobacco, caffeine, amphetamines and so forth. Addiction to gambling can be handled by the same magnetic method. It is highly important that all addictions be handled at the same time. Piecemeal resolution of addiction simply extends the misery and the person is likely never to complete the job. The person abandons any and all exogenous narcotics and stops all chemical stressors such as alcohol, tobacco, caffeine and amphetamines and goes on a five day use of only foods used less than two times a week. This also applies to the entire family of any foods eaten two times a week or more. Gluten containing foods are to be left out of the diet if any of them have been used twice a week or more. These are wheat, rye, oats, barley and corn. A four-day rotation diet based on food families is introduced and maintained as a lifestyle. In six weeks, start re-introducing the frequently used foods back into the rotation diet. Dairy products and gluten containing foods are best to leave out for a twelve- week period before introducing them back into the diet.

If need be, magnets can be used pre-meal to prevent symptom production from food. This can be used where there are *few* foods tolerated.

Minimal Program of Magnets
- Two 1-1/2" x 3/8" ceramic disc magnets
- One 2" x 26" body wrap
- Three 4" x 6" x 1/2" ceramic magnets
- Two 4" x 52" body wraps

Maximum Program of Magnets
Add the following to the minimal program:
- Two 5" x 12" deep penetrating flexible mats
- One 4" x 52" body wrap
- Ten mini-block ceramic magnets that are 1-7/8" x 7/8" x 3/8"
- One magnetic chair pad (composed of mini-block magnets 1-7/8" x 7/8" x 3/8" placed an inch and one-half apart)
- One magnetic mattress pad (composed of mini-block magnets 1-7/8" x 7/8" x 3/8" placed an inch and one-half apart)
- Headboard type sleep enhancer (composed of four 4" x 6" x 1" magnets in a row, 3/4" apart in a wooden carrier that holds them up against the headboard)•

Magnetic eye & sinus unit with additional magnets (composed of one magnetic eye mask, four 1" x 1/8" neodymium discs and four 1/2" x 1/16" neodymium discs).

Non-magnet program
- Alkaline micro water (made with The Singer Electrolysis Unit for the production of alka-line micro water)

Placement and Duration
Symptoms can be relieved by placing ceramic disc magnets bitemporally. That is, in the front of the ears near the top of the ears. Hold these in place with a 2" x 26" band. Place a 4" x 6" X 1/2" magnet on the mid-sternum. This can be held in place with a 4" x 52" body wrap around the chest. This magnet on the sternum is placed lengthwise the body. Below the rib cage directly over the epigastric area, place crosswise the body a 4" x 6" x 1/2" magnet. This can be held in place with a 4" x 52" body wrap. These magnets are to be in place whenever symptoms occur. Symptoms will usually leave within ten minutes, however, for some it may take up to thirty minutes. It would be ideal for the person to be laying down or in a reclining chair. If laying down in a reclining chair there is no need to

place a body wrap around either the chest or the epigastric area. There is no restriction as to the duration of leaving the magnets on the body. The more, the better. Many people will choose, for ambulatory reasons, simply to use the magnets whenever symptoms occur. It is easy however, to leave the magnets on the head continuously, if desired. It is necessary to remove the magnet from the epigastric area when eating a meal and should not be replaced for at least an hour after the meal. If however, there are some symptoms that develop in the epigastric area. it could be replaced until the symptom is relieved and then removed. The reason for removing the magnet from the epigastric area is that these muscles are silent while the magnet is there and the food will not move from the stomach into the intestines. It is important also, to not have a magnet over the right side of the body on the front for an hour to an hour and one-half after a meal. If any symptoms develop in any part of the abdomen, the magnet could be used long enough to relieve the symptoms and then removed allowing for the movement of food through the intestinal tract. The magnets on the head are usually placed bitemporally, however, some people find more relief if they place a magnet on the mid-forehead and one on the left temporal area. This is best for anxiety and tension. For obsessive-compulsiveness, more relief may be obtained by using the left temporal and low occipital area. Some even find it better instead of a disc magnet on the occipital area, to place a 4 x 6 x 1/2 inch magnet on the occipital area and to lean back against this if in a reclining chair or on the back of the head if laying down.

 It is advised that the subject start the food avoidance immediately when handling any other addictions. The foods that are avoided are the ones that are used twice a week or more. Other foods can be eaten. Sometimes it is quite comfortable for the first five days of this avoidance period to use such as a watermelon fast only, if it is watermelon season. In any event, use only foods that are infrequently used. This provides a withdrawal from food addiction. After this five days of avoidance, if foods were introduced to which a person was addicted, there would be an acute symptom production within one hour of exposure to the food. A practical way is to not introduce these foods for at least six weeks and if these were very frequently used foods, such as daily, it would be best

especially for cereal grains containing gluten and dairy products to not be introduced for twelve weeks. However, after six weeks a trial could be made of introducing into the meal or even having a single meal of a food that had been frequently eaten to determine if it now does not produce symptoms. If it does not, it can be introduced back into the diet if kept in rotation as a lifestyle. This is the description of the minimal program. Addiction for water-soluble substances is over in five days. However, fat soluble substances such as nicotine from tobacco requires 21 days to leach out of the cells. Therefore, symptoms may be emerging for as much as 21 days in tobacco addiction. Tobacco, alcohol, and caffeine should never be introduced back into the diet, even on rotation. Even though rotation would make it less likely for symptoms to occur, but for optimum health they should not be introduced back into the diet.

For optimum health, add the following procedures:

When sitting down, sit on the chair pad that has magnets in the seat and the back. Place under the seat of this chair pad a 4" x 6" x 1/2" ceramic magnet. The more hours of sitting on this pad, the better.

When sleeping at night, sleep on the magnetic mattress pad. Sleep also with the magnets up at the crown of the head in the headboard type carrier and the magnetic eye & sinus unit on the face.

It is also wise to sleep with a 4" x 6" x 1/2" ceramic magnet up against the side of the head. If sleeping on the side, then place it on the side of the head that is not on the pillow with the 6 inches length-wise the head or, place it on the back of the head and upper neck. It is well to rotate it from side to side and the back of the head. It is more comfortable to place the 5" x 6" deep penetrating flexible mat on the negative pole side of this ceramic magnet and place this up against the side of the head.

When sleeping, place a 5" x 12" deep penetrating flexible mat across the chest, especially on the left side of the chest so that it is over the heart. Place a minimum of five of the mini-block magnets on

General Information About Magnets

Deep penetrating flexible mats are composed of two stacked plastiform magnet strips measuring 1-1/2" x 7/8" x 1/8". These plastiform magnetic strips are placed in four rows with the 1-1/2" measurement lengthwise in the flexible mat. In a 5" x 6"

flexible mat there are 24 magnetic strips. In a 5" x 12" flexible mat there are 48 magnetic strips. The flexibility of these mats makes them very useful since they will fit around the curves of the body without producing any pressure. The therapeutic level of this flexible mat extends to about two inches. When the flexible mat is reinforced with one row of mini block magnets placed crosswise on the two central rows of magnets in the mat, the therapeutic field extended to three inches. When there are two stacked rows of mini block magnets on the mat, the therapeutic level extends to five inches. This places the mini block magnets an inch and one half apart in which there are three placed on the 5" x 6" flexible mat and six placed on the 5" x 12" flexible mat. The flexible mat can also be reinforced by the 4" x 6" x 1/2" ceramic magnet, this extends the therapeutic value to five inches.

Mini block ceramic magnets are sometimes called Briggs blocks because they are used as the Magneto magnets in a Briggs and Stratton gasoline engine. These magnets measure 1-7/8" x 7/8" x 3/8", and they have many therapeutic uses. They can be used on the head, in such areas as the temporal, frontal or occipital areas, for headaches, management of emotional symptoms or seizures. They can be used on fingers or toes. They can be placed on top of the flexible mats to reinforce the depth of magnetic field penetration. They can be used directly on the joints, under or incorporated into wraps around the joints. They are used in the magnetic slumber pads, the multiple purpose pads, and in the chair cushion pads.

Ceramic discs measure 1-1/2" X 1/2", and have numerous valuable purposes. They can be used around the head to treat headaches or other central nervous system symptoms, around joints, over skin or on subcutaneous lesions. The magnetic field of a ceramic disc extends to eight inches. The magnetic field therapeutic value extends to about two and one half inches. 4" x 6" x 1/2" ceramic magnets have a therapeutic magnetic field value extends for five inches. A ceramic magnet that is 4" x 6" x 1" has a therapeutic value extending to eight inches. The 4" x 6" x 1/2" ceramic magnet has many uses such as around joints or to penetrate deeply into the liver, internal organs, the heart, or into the head such as for treatment of tumors. The 4" x 6" x 1" ceramic magnet are used in the headboard-type magnetic sleep enhancer in order to have a field that penetrates into the

head during sleep. The magnetic sleep enhancer is composed of four 4" x 6" x 1" ceramic magnets placed in a row 3/4" apart. These ceramic magnets are placed upright in a wooden carrier that holds them firmly up against the headboard. They can be raised or lowered depending on the height of the pillow. They are shipped at the top of the carrier and needs to be lowered so that the head is in the magnetic field. They are resting on a wooden dowel. The wooden dowel they are resting on should be at the level of the back of the head when the head is on the pillow. The closer the top of head is to the magnets in the carrier at the head of the bed, the better.

The magnetic slumber pad is composed of ceramic mini block magnets that are placed an inch and one-half apart throughout the pad.

The magnetic chair cushion pad is composed of ceramic mini block magnets placed an inch and one-half apart throughout the seat and back of the pad.

The multiple purpose pads [small (11" x 17") and large (14" x 25")] are and composed of ceramic

Mini Block magnets that are placed an inch and one-half apart throughout the pad. This multiple purpose pad has many uses such as being used on the back, the abdomen, and up over the heart and on the chest area. They can be used directly on the joints, under or incorporated into wraps around joints. They are used in the magnetic mattress pad, the multi-purpose pads and the magnetic chair pads.

Therapeutic Sleep

After the program has been setup, the most important thing to address is sleep. It is optimal to sleep on the 70-magnet bed grid or a magnetic slumber pad.

In maintaining health and reversing degenerative diseases, it is very important that there be deep, energy restoring sleep. It is necessary to sleep a full eight or nine hours in every 24-hour period. Energy is used up during the day and is restored during sleep. The hormone, Melatonin, which is made during sleep, controls the depth of energy restoring sleep. The principle area in which Melatonin is made is the pineal gland, which is at the center of the head. This gland makes Melatonin in response to a negative (south-seeking) magnetic field. This is why it is so important to treat the head to a negative (south-seeking) magnetic field during sleep. The retina of the eyes and the intestinal

walls also make Melatonin. Treating these areas can also raise levels of Melatonin. The hormone Melatonin has the control of the entire energy system of the body including such as the immune system, endocrine system, and respiration. Melatonin is neuronal calming and encourages energy restoring sleep. Melatonin is a powerful antioxidant and thus is anti-inflammatory. Melatonin also has antibiotic and anti-cancer values.

In order to achieve appropriate production of the hormones Melatonin and growth hormone it is necessary to sleep in a completely light-free environment and without any 60 cycles per second electrical pulsing frequencies. Therefore there should not be any night-light, and electric clock, an electric heated blanket, or a heated waterbed. If light cannot be completely excluded from the bedroom, then place over the eyes and the forehead a light shield or mask of some sort. The magnetic eye & sinus mask is a light shield with 1/16" plastiform magnet in it and additional 1" x 1/8" neodymium disc can be added for extra benefit.

The magnetic slumber pad will encourage the production of Melatonin by the gastrointestinal tract. Any magnetic treatment of the abdomen will encourage the production of Melatonin by the walls of the gastrointestinal tract.

Treating the eyes with the eye & sinus mask will also encourage the production of Melatonin by the retina of the eyes. The magnetic headboard type sleep enhancer up against the headboard will have a magnetic field that penetrates into the head and stimulates the pineal gland to produce Melatonin and the hypothalamus to produce growth hormone. Some sleep very well with a 4" x 6" x 1/2" magnet up against the side of the head. It is best to cushion this by placing a double strength flexible mat (5" x 6") up against the side of the head first with the 4" x 6" x 1/2" ceramic magnet over the flexible mat. When lying on the back, this can be leaned up against either side of the head. When lying on the side it can be on the side of the head that is not on the pillow or be placed on the back of the head. Some find it valuable to place a double strength flexible mat under the pillowcase so their head is resting on the flexible mat. If they are on their back it is on the back of their head; if they are on their side, it is on the side of their head. Six mini block ceramic magnets placed on the positive (north-seeking) pole side will further reinforce this flexible

mat. Place these mini block magnets crosswise the flexible mat 1˜1/2" apart. They will magnetically adhere to the flexible mat.

4-Day Diversified Rotation Diet General Information

A local and systemic biological response of acidity is routinely evoked when symptoms develop in response to exposure to foods, chemicals and inhalants. Acidity also produces low oxygen (acid-hypoxia). This is true whether the maladaptive symptom reactions are not immunologic or non-immunologic in origin. Most food symptom reactions are not immunologic. Immunologic and non-immunologic food symptom reactions have a classic addictive seesaw biological response of symptom relief on exposure, with the emergence of symptoms 3-4 hours after the exposure (addictive withdrawal phase). The optimum method of reversing addiction is avoidance. In food addiction, the optimum method of avoidance of the addiction is for there to be a 3-month avoidance followed by an exposure no more often than every fourth day. This is the reason for the 4-Day Diversified Rotation Diet. The short-term management of symptoms can be managed by alkalinization, which can be produced by bicarbonate alkalinization and more optimally, exposure to a negative (south-seeking) magnetic field, which alkalinizes and oxygenates (alkaline- hyperoxia). These alkalinization methods can relieve symptoms after they have occurred from the exposure and can also prevent symptoms from developing when the alkalinization methods are used prior to an exposure to symptom producing foods, chemicals and inhalants.

The Following is the Optimum Method of Preventing Symptoms form Occurring from Foods:

1. A 4-Day Diversified Rotation Diet. This four-day spacing of exposure to specific foods prevents food addiction. The 4-Day Diversified Rotation Diet is described in greater detail in *The Ultimate Diet* (Vol. VI, First Quarter, 2000) by William H. Philpott, M.D.

2. Pre-meal negative magnetic field exposure. One-half hour before the meal place the magnets on the body. Magnetic discs, either ceramic discs (1-1/2" x 1/2") or neodymium discs (1" x 1/8") placed bitemporally. These can be held in place with a 2" x 26" wrap. Place on the sternum, a 4" x 6" x 1/2" ceramic magnet. Hold in place with a 4" x 52" wrap. An added value can result from placing a 4" x 6" x 1/2" ceramic magnet

on the epigastric area, held in place with a 4" x 52" wrap. Place on the thoracic spine a large sized double strength flexible mat; this flexible mat can be held in place with the same 4" x 52" wrap that is supporting the 4" x 6" x 1/2" ceramic on the epigastric area. These can be removed at the beginning of the meal or they can be continued through until the meal is finished. If symptoms emerge after the meal has been eaten, then replace the magnets until the symptoms leave and especially place a suitable sized magnet directly over the symptom area. Also prior to the meal, if there are any symptom areas, treat these with appropriate sized magnets, pre-meal. Always use the negative magnetic field (south-seeking).

3. Post-meal if any symptoms develop then use suitable magnets placed locally for relieving these symptoms.

It could be helpful again, to place the ceramic disc magnets bitemporally. Bicarbonate alkalinization is useful one-half hour after the meal, use multi-element mineral ascorbate powder. Take 1/2 teaspoon of multi-element mineral ascorbate powder and 1/2 teaspoon of soda bicarbonate in 1/2 a glass of water.

The above pre-meal and post-meal alkalization method is recommended for:

• Those with a serious state of symptoms reactions to multiple foods in which food rotation is not entirely satisfactory.

• When of necessity, symptom-evoking foods have to be eaten, such as when eating out at a restaurant, or those that have to use this method instead of waiting three months for the reintroduction of their foods.

In my experience, the above method of basic food rotation diet with the addition when necessary of the magnetic pre-meal exposure and the magnetic post-meal exposure is superior to any neutralization method. Neutralization methods do not honor the fact that the basic problems are addiction and acidity (acid-hypoxia). A food rotation diet is necessary to honor the fact that addiction is the major driving force of food maladaptive reactions and that acid-hypoxia is the immediate cause of symptoms. There is no optimally effective method for the management of maladaptive reactions to foods that is equivalent to food rotation.

Alkaline Micro Water

Alkaline micro water helps materially the body's normal alkaline state. Also, being micro water, it enters into the cells of

the body more readily than the usual water. This also carries negative (south-seeking) magnetic field as well as being alkaline. The Singer Electrolysis Instrument is used for producing the alkaline micro water. At least five glasses of the water should be ingested each day

Polarity
Always use a negative magnetic field.
Beyond Magnetism

An acute maladaptive reaction to foods, chemicals, or inhalants has been documented as producing a brief state of acid-hypoxia. In this state there is a production of acid and a failure to process properly the end products of oxidation phosphorylation metabolism. In this state of acidosis, oxygen content is reduced. Maladaptive reactions to foods are the most frequent cause of bouts of acidosis. Degenerative diseases are noted for their acid-hypoxic state. Therefore every effort should be made to maintain a normal alkalinity and normal oxygen state. of acidosis and reduced oxygen. It is the better part of wisdom to follow a 4-Day Diversified Rotation Diet. This program leaves out foods that are used as frequently as twice a week or more for a period of three months. This is based on the assumption that these foods are being reacted to in some way. It is the frequency of the use that produces the maladaptive reactions. A 4-Day Diversified Rotation Diet is set up to leave out these frequently used foods. After three months, these frequently used foods can be returned to the diet, usually without any symptoms being produced.

All addictive substances should be abandoned such as addictive drugs, alcohol, tobacco and caffeine (coffee, tea with caffeine, chocolate, and soft drinks containing caffeine). Addiction is acidifying.

Carbonated soft drinks are acid producing and should be rarely used. Soft drinks are sweetened with corn sugar (in the US) and if they are ingested they should be limited to the corn rotation day.

In order to maintain an adequate alkaline state, it is necessary that the minerals that are used in the bicarbonate buffer system be in adequate supply. These are the minerals calcium, magnesium, and potassium. There are several proprietary preparations that contain these minerals associated with vitamin C as ascorbates. The preferred source of alkali

minerals is multi-element mineral ascorbates by Klaire Lab. Use 1/2 teaspoon to 1 teaspoon of one of these powders in one-half glass of water, two times a day. The preferred time to take the alkaline minerals is in the morning on arising and again before going to bed at night. When using this mineral alkaline water, place it on the negative magnetic pole of a 4" x 6" x 1/2" magnet for a minimum of five minutes. This will charge up the water and the oxygen in the water with a negative magnetic field, which will help the body maintain its normal alkaline state.

There is a valuable method of electrolysis, which provides alkaline micro water that has an alkaline pH. There is a home electrolysis unit (The Singer Electrolysis Instrument) that provides this alkaline micro water. It is recommended that five glasses of the alkaline micro water be ingested daily.

Magnetic Protocol For Weight Management

Body weight beyond physiological normal is often caused by the urge to overeat due to food addiction. Overeating is a compulsive habit no matter what it's psychological or biological driving force. In any event, magnetic therapy plus calorie reduction can materially help in weight management. Magnetic discs placed bitemporally reduces the electrical excitement of the brain and can handle habit urges whether psychological or physiological thus making it easier for the person to adhere to an assigned calorie reduction.

A 4-Day Diversified Rotation Diet is a must in weight management. This will stop food addiction and make it materially easier to follow a calorie reduction program.

A negative magnetic field placed over a fat area will gradually reduce the fat. This magnet reduction occurs only at night while asleep. A negative magnetic field activates growth hormone's ability for fat cells to release their fat. Growth hormone rises only at night during sleep. However, this magnetic fat reduction has little value in maintaining weight reduction without also associating this with calorie reduction.

Weight Management: The Magnetic Comfort System Components:

a) Magnetic Fat Meltdown.

A negative magnetic pole placed over a fat area at night during sleep will have the biological effect of the fat cells dropping their fat. This happens because a negative magnetic field activates

growth hormone. Growth hormone has the assignment of fat cells dropping their fat. This occurs only at night at which time growth hormone is present. There is not enough growth hormone during the waking hours to be significant. Weight reduction of the fat cells dropping their fat occurs only at night when growth hormone is high. This fat area is usually the abdomen. The optimum magnets for treating the fat areas are ceramic block magnets that are 4" x 6" x 1/2". Two are usually used. Place each block magnet over the fat areas. Hold in place with a 4" x 52" Cool Max band. Some significantly obese subjects may need two of these body wraps. The magnets are placed over the abdomen or other fat areas every night during sleep.

b) Magnet Comfort System of Managing Urges to Overeat and Eat Between Meals.

The magnets used for this are two ceramic discs that are 1-1/2" across and 1/2" thick with Velcro on the positive pole sides. These are held in place on the head with a 2" x 26" Cool Max band. There are three possible placements of these discs. When these discs are placed bitemporally, that is at the level of the top of the ears and about two inches in front of each ear is the first placement to consider. This is particularly noted to handle depression and reduce urges to overeat or eat between meals. The second placement to consider, which is more for tension and anxiety, is a disc on the mid-forehead and left temporal held in place with the band. The third placement to consider, which is maximal for obsessive ideas and compulsive urges, is the left temporal and low occipital (back of the head). When using these discs on the head, the symptoms will usually subside within five minutes. The duration of having magnets on the head can be either just long enough to relieve the symptoms or be continuous. There is no limitation in the time the magnets can be left in place on the head,

A 4" x 6" x 1/2" ceramic block magnet is placed on the sternum (mid-chest) and or also over the epigastric area for the purpose of reducing tension that is often present in these areas based on the discomfort of food addiction withdrawal. This can be placed there at the time there are these urges. It is well to use this to accompany the magnetic placement on the head.

Optimum System of Weight Management: Orientation

This system uses the magnetic fat meltdown, magnetic comfort system of managing urges to over-eat or eat between meals, aversive behavioral training for urges to overeat and eat between meals, the visualization system of food quantity reduction and the 4-Day Diversified Rotation Diet.

Minimum Program of Magnets
- Two ceramic discs that are 1-1/2 " x 1/2 "
- One 2" x 26" body wrap
- Two 4" x 6" x 1-1/2 " ceramic magnets
- Two 4" x 52" body wraps
- Pictures of food quantity initially used for each meal plus pictures of the desired reduction of meal quantity using fixed stages of reduction at six week intervals

Placement and Duration

For 15-30 minutes pre-meal, place the ceramic discs bitemporally or frontal and left temporal or left temporal and occipital based on which of these placements works best for the individual subject. At the same time, pre-meal, place a 4" x 6" x 1/2" magnet on the sternum (mid-chest) with the 6" lengthwise the body and a 4" x 6" x 1/2" ceramic magnet crosswise across the epigastric area (directly over the stomach). Hold these in place with a 4" x 52' body wrap.

When any urges to overeat or eat between meals occur, place the disc magnets on the head and the ceramic block magnets on the mid-chest and epigastric area. Usually these urges will subside within 5-10 minutes.

When these urges occur and the magnets have been placed as described above, with the eyes closed, the urge will pass. While focusing on this in your mind, take a deep breath and hold the breath until the mind goes blank. This can be repeated as many times as is necessary to block the urges.

Prepare photographs of the usual meal sizes that the subject uses. Then make a photograph reducing the quantity by one-third. Place this in front of the plate of food at each meal. At six week intervals, keep reducing the food intake by one-third until the desired weight has been achieved.

It is important that food be rotated to stop food addictions.

Symptomatic Food Reactions General Information

A local and systemic biological response of acidity is routinely evoked when symptoms develop in response to exposure to foods, chemicals and inhalants. Acidity also

produces low oxygen (acid hypoxia). This is true whether the maladaptive symptom reactions are immunologic or non-immunologic in origin. Most food symptom reactions are not immunologic. Immunologic and non-immunologic food symptom reactions have a classic addictive see-saw biological response of symptom relief on exposure with the emergence of symptoms 3-4 hours after the exposure (addictive withdrawal phase). The optimum method of reversing addiction is avoidance. In food addiction, the optimum method of avoidance of the addiction is for there to be a 3- month avoidance followed by an exposure no more often than every fourth day. This is the reason for the 4-Day Diversified Rotation Diet. The optimum long term management of food addiction is the food avoidance period produced by the 4-Day Diversified Rotation Diet. The short term management of symptoms can be managed by alkalinization by exposure to a negative (south-seeking) magnetic field which alkalinizes and oxygenates (alkaline-hyperoxia). These alkalinization methods can relieve symptoms after they have occurred from the exposure and can also prevent symptoms from developing when the alkalinization methods are used prior to an exposure to symptom producing foods, chemicals and inhalants.

Following is the optimum method of preventing symptoms from occurring from foods:

1. A 4-Day Diversified Rotation Diet. This four day spacing of exposure to specific foods prevents food addiction. The 4-Day Diversified Rotation Diet is described in *The Ultimate Diet* quarterly by William H. Philpott, M.D.

2. Pre-meal.

Negative magnetic field (south-seeking) exposure. One-half hour before the meal place the magnets on the body. Magnetic discs, either ceramic, magnetic discs that are 1-1/2" x 1/2" or neodymium discs that are 1" x 1/8" placed bitemporally. These can be held in place with a 2" x 26" band. Place on the sternum, a 4" x 6" x 1/2" ceramic magnet. Hold in place with a 4" x 52" body wrap. An added value can result from placing a 4" x 6" x 1/2" ceramic magnet on the epigastric area. Hold in place with a 4" x 52" body wrap. These can be removed at the beginning of the meal or they can be continued through the meal until it is completed. If symptoms emerge after the meal has been eaten, then replace the magnets until the symptoms leave and

especially place a suitable sized magnet directly over the symptom area. Also prior to the meal, if there are any symptom areas, treat these with appropriate sized magnets, pre-meal. Always use the negative magnetic field (south-seeking).

The above pre-meal and post-meal alkalinization method is recommended for;
* Those with a serious state of symptom reactions to multiple foods in which food rotation is not entirely satisfactory
* When of necessity, symptom-evoking foods have to be eaten, such as when eating out at a restaurant, or those that have to use this method instead of waiting three months for the introduction of their foods.

3. Post-meal. If any symptoms develop, post-meal, then use suitable magnets placed locally for relieving these symptoms. It could be helpful again, to place the disc magnets bitemporally.

A food rotation diet is necessary to honor the fact that addiction is the major driving force of food maladaptive reactions and that acid-hypoxia is the immediate cause of symptoms. There is no optimally effective method for the management of maladaptive reactions to foods that is equivalent to food rotation.

Placing the disc on the head and ceramic block magnets on the sternum and epigastric area for 15-30 minutes before meals will reduce the urge to over eat.

Aversive Behavioral Training for Urges to Overeat or Eat Between Meals

This behavioral training should be accompanied by the placement of the magnets on the head. This consists of, with the eyes closed, placing in mind the urge to overeat or eat between meals. Take a big breath and hold the breath until the mind goes blank. This aversive method says "no — to the urges. This can be repeated as many times as necessary to stop the urges.

Visual System of Food Quantity Reduction

Take a picture of the usual breakfast, noon and evening meals that the subject eats. Take another picture of the same food quantity, reduced by one-third. Have these pictures in front of the plate of food that the subject is going to eat. Have them reduce their quantity intake by one-third. Every six weeks, review this food quantity and keep reducing the quantity by

one-third until the desired weight is achieved and being maintained.

Minimal System of Weight Management

This system does not consider the calorie intake but relies on the magnetic fat meltdown and the magnetic comfort system of managing urges to overeat and eat between meals using the magnets placed bitemporally and the 4" x 6" x 1/2" magnet placed on the sternum.

Magnetic Comfort Method: For Tobacco Addiction Correction and Other Addiction Corrections

Orientation

The secret of stopping an addiction to tobacco or other addiction corrections is that of remaining comfortable while stopping the use of the addictive substance. This comfort during addictive withdrawal can be achieved by the use of magnetic disc magnets placed on the head and magnets placed on the mid-chest and epigastric area. This magnetic application is capable of stopping the urges. An added value can be achieved by placing in mind the urge to use the product and holding the breath until the mind goes blank.

Minimal Program of Magnets

- Two ceramic disc magnets that are 1-1/2" x 1/2"
- One 2" x 26" body wrap
- Two 4" x 6" x 1/2" ceramic magnets
- Two 4" x 52" body wraps

Placement and Duration

A minimal program would use only the disc magnets on the head and the breath holding aversive treatment. A more maximum program will add the ceramic block magnets for the mid-chest and epigastric area.

The most optimal of all is to stop all addictions at the same time -- tobacco, alcohol, caffeine, dextro-amphetamine or any other frequently used, potentially addictive substance. The same system is used for treating narcotic addiction. The secret of correction of addiction is to be comfortable while stopping the use of substances to which the person is addicted. It also is more comfortable if food addiction is handled at the same time. To achieve this, follow the instructions on weight management.

Magnetic Stress Management Protocol: Orientation

First of all, magnetically handle addiction since addiction is a major stressor. Do not use a food to raise the serotonin-opiate

complex as this either is addiction or will soon become addiction. Use a negative magnetic field to relieve the symptoms. Sleeping at night in a negative magnetic field will normalize the serotonin and opiate balance. Symptoms can be relieved within ten to thirty minutes with a negative magnetic field appropriately placed on the head and the symptom area. This magnetic treatment normalizes biological function and never leads to addiction or any side effects.

Minimal Program of Magnets:
- Two ceramic disc magnets that are 1-7/8" x 7/8"
- One 2" x 26" headband/body wrap
- Mega-field magnetic bed pad (composed of mini block magnets that are 1-7/8" x 7/8" x 3/8" placed 1-1/2" apart throughout the bed pad)
- Headboard type sleep enhancer (composed of four 4" x 6" x 1" magnets in a row, 3/4" apart in a wooden carrier that holds them up against the headboard)

Optimum Program of Magnets:
Add the following to the above magnets:
- Three 5" x 12" deep penetrating flexible mats
- One 5" x 6" deep penetrating flexible mat
- Two 4" x 52" body wraps
- One 4" x 6" x 1/2" ceramic magnet
- Fifteen mini-block ceramic magnets that are 1-7/8" x 7/8" x 3/4"
- A magnetic chair pad (composed of mini-block magnets 1-7/8" x 7/8" x 3/8" placed an inch and one-half apart)
- A 14" x 25" multi-purpose pad (composed of mini-block magnets 1-7/8" x 7/8" x 3/8" placed an inch and one-half apart)

Placement and Duration

The ceramic disc magnets that are 1-1/2" x 3/8" can be used bitemporally placed, that is, in front of the ears near the top of the ears. These can be held in place with a 2" x 26" headband/body wrap. This works well for depression and most other symptoms. Anxiety is sometimes best relieved by placing a disc on the mid-forehead and the left temporal area. Obsessive-compulsiveness may be best handled by placing a disc on the left temporal and low occipital area. Any discomforts can be treated with either the disc magnets. the 4" x 6" x 1/2" inch magnet or the flexible mats. Placing mini-block magnets on the mats will increase the depth of penetration. Placing the 4" x 6" x 1/2"

magnet on a flexible mat will increase the depth of penetration such as when treating an internal organ or the necessity of treating deeply into a muscle or joint.

When sitting down, sit on the magnetic chair pad and place under the seat of this pad the 4" x 6" x 1/2" magnet. The more hours of exposure to the chair pad, the better. This can also be used in the car when driving.

The multi-purpose pad is provided which can be leaned back against treating either the lower back and thoracic spine or the thoracic spine and the cervical spine and back of the head when leaning back against this in a chair or when laying down. It can also be used beneficially by placing it over the abdomen and up across the heart and the chest. The more hours of exposure to a negative magnetic field, the greater the anti-stress value.

Much of the value is achieved at night during sleep. Sleep on the magnetic mattress pad. Sleep with the magnets in the carrier up against the headboard.

It is well to sleep with a 5" x 12" deep penetrating flexible mat across the chest, especially over the heart. Place the mini-block magnets on this pad. These magnets are placed crosswise the mat an inch and one-half apart. They magnetically attach to the two inner rows of magnets on the pad. Especially place three of these on this pad over the heart. Treating the heart will markedly reduce tension. It will prophylactically prevent the development of atherosclerosis. It can treat inflammation of the heart such as following a viral or bacterial infection. It is wise to have the treatment of the heart as a lifestyle routine.

It is wise to sleep with a 4" x 6" x 1/2" inch magnet up against the side of the head. If lying on the back it could be placed up against either side of the head. When lying on the side, it can be on the side of the head not on the pillow or placed on the back of the head and the upper neck.

It is also highly useful to treat the low abdomen during sleep. This can be achieved by placing a 5" x 12" deep penetrating flexible mat across the low abdomen-pubic area. Place on top of this, six of the mini-block magnets. Hold this in place with a 4" x 52" body wrap.

The eyes can be treated with the magnetic eye & sinus unit.

Beyond Magnetism

An acute maladaptive reaction to foods, chemicals, or inhalants has been documented as producing a brief state of

acid-hypoxia. In this state there is a production of acid and a failure to process properly the end products of oxidation phosphorylation metabolism. In this state of acidosis, oxygen content is reduced. Maladaptive reactions to foods are the most frequent cause of bouts of acidosis. Degenerative diseases are noted for their acid-hypoxic state. Therefore every effort should be made to maintain a normal alkalinity and normal oxygen state.

Majorities of people are maladaptively reacting to foods in one or more ways, thus producing bouts of acidosis and reduced oxygen. It is the better part of wisdom to follow a 4-Day Diversified Rotation Diet. This program leaves out foods that are used as frequently as twice a week or more for a period of three months. This is based on the assumption that these foods are being reacted to in some way. It is the frequency of the use that produces the maladaptive reactions. A 4-Day Diversified Rotation Diet is set up to leave out these frequently used foods. After three months, these frequently used foods can be returned to the diet, usually without any symptoms being produced.

All addictive substances should be abandoned such as addictive drugs, alcohol, tobacco and caffeine (coffee, tea with caffeine, chocolate, and soft drinks containing caffeine). Addiction is acidifying.

Carbonated soft drinks are acid producing and should be rarely used. Soft drinks are sweetened with corn sugar (in the US) and if they are ingested they should be limited to the corn rotation day.

In order to maintain an adequate alkaline state, it is necessary that the minerals that are used in the bicarbonate buffer system be in adequate supply. These are the minerals calcium, magnesium, potassium, and zinc. There are several proprietary preparations that contain these minerals associated with vitamin C as ascorbates. The preferred source of alkali minerals is multi-element mineral ascorbates by Klaire Lab. Use 1/2 teaspoon to 1 teaspoon of one of these powders in one-half glass of water, two times a day. The preferred time to take the alkaline minerals is in the morning on arising and again before going to bed at night. When using this mineral alkaline water, place it on the negative magnetic pole of a 4" x 6" x $^1/2$" magnet for a minimum of five minutes. This will charge up the

water and the oxygen in the water with a negative magnetic field, which will help the body maintain its normal alkaline state.

There is a valuable method of electrolysis, which provides alkaline micro water that has an alkaline pH. There is a home electrolysis unit (The Singer Electrolysis Instrument) that provides this alkaline micro water. It is recommended that five glasses of the alkaline micro water be ingested daily.

Four-Day Rotation Diet
Day I
Meat
Bovidae: Lamb, Beef, Goat, Deer, Cheese, Milk and Yogurt
Fish
Fish and/or shellfish can be on any or all days by keeping the type of fish or shellfish different for each day.
Vegetables
Potatoes: Potato, Tomato, Eggplant, Red/Green Peppers and Pimento, Goosefoot: Beet, Spinach, Swiss chard and Lamb's quarters

Composites: Lettuce, Chicory, Endive, Escarole, Artichoke, Dandelion and Safflower

Corn: Fresh Corn as a fresh vegetable
Fruits
Mulberry: Mulberry, Figs and Breadfruit

Rose: Strawberry, Raspberry, Blackberry, Dewberry, Loganberry, Young-berry, Boysenberry and
Rose Hip

Grape: Grapes and Raisins

Cashew: Mango
Nuts:
Sunflower: Sunflower Seeds Cashew: Cashew and Pistachio Protea: Macadamia Nut
Thickening
Tapioca
Seasonings
Grape: Cream of Tarter
Potato: Chili Pepper, Paprika and Cayenne
Composites: Tarragon Nutmeg: Nutmeg and Mace
Sweetener
Beet Sugar
Tea Rose Hips, Chicory and Dandelion
Sprouts

Legumes, Bean Sprouts, Alfalfa Sprouts and Sunflower Sprouts
Fresh Vegetable
Green Bean Sprouts, Alfalfa Sprouts and Sunflower Sprouts
Day II
Meat
Bird: *All fowl – Chicken, Turkey, Duck, Goose, Guinea, Pigeon, Quail and Pheasant
Eggs
 Eggs
Fish
Fish and/or Shellfish can be on any or all days by keeping the type of fish or shellfish different for each day.
Vegetables
Myrtle: Pimento Grass: Millet
Parsley: Carrot, Parsnip and Celery
Mushroom: Mushroom and Yeast (Brewer's or Baker's) Mallow: Okra
Fruits
Plum: Plum, Cherry, Peach, Apricot, Nectarine and Wild Cherry, Pineapple: Pineapple
Pawpaw: Pawpaw, papaya and papain
Grains:
Gluten: Wheat, Oats, Barley, Rye and mature Corn, Non-gluten: Millet, Sorghum, Bamboo shoot and Malt
Nuts:
Plum: Almond Beech: Chestnut Brazil nut: Brazil nut Flaxseed: Flaxseed
Thickening
Wheat flour, Agar-agar (vegetable gelatin from sea algae)
Seasonings
Myrtle: Guava, Clover, Allspice and Clove
Parsley: Celery seed, Celeriac, Anise, Dill, Fennel, Cumin, Coriander and Caraway
Pedalium: Sesame
Orchid: Vanilla
Oil
Cottonseed, Flaxseed and Sesame
Sweetener
Corn sugar, Clover honey and Molasses
Tea

Sterculia: Papaya tea
Day III Meat
Suidae: Pork
Fish
Fish and or Shellfish can be on any or all days by keeping the type of fish or shellfish different for each day.
Vegetable
Mature Legumes: Pea, Black-eyed Pea, Soybean, Lentil, Peanut, Lima Bean, Navy Bean, Garbanzo Bean, Great Northern Bean, Pinto Bean and Kidney Bean

Laurel: Avocado, Lily: Onion, Garlic, Asparagus, Chive and Leek
Fruits
Apple: Apple, Pear and Quince, Banana: Banana and Plantain

Heath: Blueberry, Huckleberry and Cranberry

Gooseberry: Currant and Gooseberry

Ebony: Persimmon Buckwheat: Rhubarb **Grains**
Buckwheat: Buckwheat and Rice
Nuts
Legume: Peanuts

Birch: Filbert (Hazelnut) Conifer: Pine Nut (Pinon)
Thickening
Arrowroot: Arrowroot Flour
Seasonings
Arrowroot: Arrowroot Heath: Wintergreen Legume: Licorice

Laurel: Cinnamon, Bay leaf, Sassafras and Cassia bud/bark

Pepper: Black & White Pepper

Oil Soybean, Peanut and Avocado
Sweetener
Fructose, Carob syrup, Maple sugar, Tupelo honey and Cane sugar
Tea
Alfalfa, Sassafras, Garlic and Apple cider/tea
Day IV Meat
Meat: Rabbit, Fowl not used on Day II (Chicken, Turkey, Duck)

Fish Fish and/or Shellfish can be on any or all days by keeping the type of fish or shellfish different for each day.
Vegetables
Morning Glory: Sweet Potato

Gourd: Cucumber, Pumpkin, Squash, Acorn and Squash seeds

Mustard: Mustard, Turnip, Radish, Horseradish, Watercress, Cabbage, Kraut, Chinese Cabbage, Broccoli, Cauliflower, Brussel Sprouts, Collard, Kale, Kohlrabi and Rutabaga

Olive: Black/Green Olives

Fresh Grain Vegetables

Sprouts: Wheat, Rye, Barley and Oat

Fruits

Gourd: Watermelon, Cantaloupe and Honeydew

Citrus: Lemon, Orange, Grapefruit, Lime, Tangerine, Kumquat and Citron

Honeysuckle: Elderberry Palm: Coconut and Date **Nuts**

Seeds: Pumpkin seeds, Squash seeds and Coconut

Walnut: English walnut, Black walnut, Pecan, Hickory and Butternut

Thickening

Cornstarch

Seasonings

Mustard: Mustard

Mint: Basil, Sage, Oregano, Savory, Horehound, Catnip, Spearmint, Peppermint, Thyme, Marjoram and Lemon Balm

Oil:

Coconut, Olive, Pecan and Corn

Sweetner:

Date sugar, Honey (other than Tupelo or Clover)

Tea:

Kaffer

How to Use the Four-Day Diversified Rotation Diet Without Deliberate Food Testing

Many people find it practical to go directly to a four day diversified rotation diet without food testing. First, the person assumes that he or she is reacting to any food eaten as frequently a twice a week, or to any members of that food family. The person leaves these frequently used foods out of the diet for three months. At the initiation of the rotation diet, stop all use of caffeine (coffee, teas with caffeine, cola drinks, chocolate), tobacco and all alcoholic drinks. **Do Not Reintroduce These Into The Diet.**

For the next three to four days, there will be withdrawal symptoms. Handle these symptoms as described in the section, **How To Initiate This Program.**

Three months later, these foods are reintroduced back into the diet. Nearly always (95% of the time), these foods will no longer be reactive as long as they are kept on a once-in-four-day basis in this diet. When reintroducing foods into the diet, simply add the food to the established rotation and observe whether or not symptoms occur. If no symptoms occur, then this food can be rotated. If symptoms occur, wait another three months before trying this food again.

One way to expand the use of foods is to sprout cereal grains and legumes. A person should be certain that the grain or bean is sprouted with approximately 1/4" or more of a sprout. The foods that have been sprouted will no longer carry the same reactive capacity that the non-sprouted foods do. Thus, once sprouted, grains and legumes can be introduced into the diet immediately.

A potential reaction to chemicals can be determined by sniffing the product. These products include clothes, carpet, car exhaust, or anything to which a person has frequent exposure.

Gluten is the most frequent and severe symptom reactor of all foods. Thus, gluten is the most likely food substance to continue evoking symptoms. Common physical reactions to gluten include: gastrointestinal problems such as celiac disease and Crohn's disease (gluten enteropathy); jerking muscles (Tourette's syndrome); and headache. Emotional and mental symptoms caused by reactions to gluten range from mild (tension, anxiety, phobias, depression, obsessions, compulsion) to severe (psychotic depression, hallucinations, delusions). There is genetically determined immunologic reaction to gluten occurring at a ratio of 1 in 200 Irish people and 1 in 2,000 non-Irish. These immunologically reactive people should leave gluten out of their diet. Wheat, rye, oats, barley and mature corn all contain gluten. If gluten is introduced, only a small amount should be used, and then avoided for months.

In addition to being the most reactive food substance in terms of immunologic and non-immunologic maladaptive reactions, gluten is the most addictive of all food substances. Gluten is split in half during the first stage of digestion, which occurs in the stomach by a combination of hydrochloric acid with the enzyme pepsin. This splitting of gluten produces an active narcotic (exorphin). This narcotic becomes addicting when it is absorbed through the small intestine without further

digestion by pancreatic enzymes and their normal alkaline medium. Many people do not produce adequate pancreatic enzymes or associated sodium and potassium bicarbonate. Thus, these people are subject to gluten addiction if they use gluten frequently. Alcoholics using alcohol prepared from wheat, rye, oats, barley or corn will have symptoms emerge on deliberate food testing for these gluten-containing foods. Vodka addicts have symptoms to provocative food testing for white potatoes. Wine addicts have symptoms to a provocative test meal of either grapes or the substance from which the wine is made. This applies to wine vinegar as well. Beer addicts have symptoms with test meals to brewer's yeast or any gluten-containing cereal or rice used in the beer-making process.

Dairy products and beef are the second most symptom reactive foods. Characteristically, the person who reacts to dairy products also reacts to beef, and vice versa. In terms of the frequency of symptoms, corn products are approximately equal to dairy products and beef.

People with homocystinuria have symptoms from dairy products and meats. Homocystinuria is an infrequent genetic error. It is caused by a deficiency of cystathionine 8-synthase enzyme, in which methionine cannot be processed properly. Occasionally, homocystinuria is due to a nutritional deficiency of the B complex vitamins, especially B_{12} or folic acid. In these nutritional deficiency cases, B complex supplementation solves the problem of food reactions to high methionine containing foods. People with genetic homocystinuria must rely on avoidance of foods high in methionine. They must also supplement cystine, which comes from methionine. In addition, they should also supplement taurine, which is made from cystine. Taurine is important in keeping the central nervous system calm.

Another rare genetic enzyme disorder is carnosinuria. This is caused by a deficiency of the enzyme carnosinase. This enzyme processes carnosine and anserine. If not enzymatically processed, carnosine and anserine are toxic to humans. People with this genetic enzyme disorder must avoid foods containing carnosine and anserine. Carnosine is found in all land animals. Anserine is found in tuna and salmon. Carnosinase is a zinc-dependent enzyme. Therefore, carnosinuria is occasionally caused by zinc deficiency. Zinc deficiency can be determined by a

laboratory assessment. Physical symptoms of zinc deficiency include: white spots in the fingernails and toenails; ridged or easily splitting fingernails, and stretch marks on the skin, especially on the abdomen or breasts. When carnosinuria is caused by a nutritional deficiency, zinc supplementation can solve the problem. A carnosinase enzyme deficiency can produce a wide range of symptoms. The most prominent symptoms I have observed are attention deficit and hyperactivity. For example, a ten-year-old boy with attention deficit and hyperactivity on laboratory testing was demonstrated to have both carnosinuria and zinc deficiency. Neither supplementation with zinc nor rotation of foods solved his problem. However, upon removal of meats, tuna and salmon from his diet, he was free of symptoms. Thus, he had a genetic enzyme deficiency.

I have explained these genetic and nutritional enzyme disorders in order to point out that although rotation diet solves most food reaction symptoms, these other causes of food reactions must some-times be considered. Laboratory tests can make the determination People who try to help themselves without medical supervision can make this determination only through trial and error.

For twenty years I deliberately food tested my patients. This consisted of five days of avoidance of any food used with the frequency of two or more times a week, followed by food tests of single food per test-meal. In my original five-year research study, a five-day food fast was used. Classically, it is the foods eaten with a frequency of two or more times a week that produces acute symptoms and is responsible for the symptoms of degenerative diseases. This is true of degenerative diseases such as diabetes mellitus II, arthritis of various types, inflammatory reactions such as tendonitis, myositis, fibrositis, and many pains such as headaches and pains elsewhere in the body. Secondarily, these maladaptive reactions are most important in major mental disorders, multiple sclerosis, lupus, etc. These diseases classically start with a viral infection, which disorders the immune system and injures target tissues where symptoms are produced.

Stress factors such as injury, frequency of use, local infection, etc., often serve to prepare a specific area of the body to be the area selected as the target tissue area in food reaction. An example is carpel tunnel syndrome classically occurring in the wrist that is used most frequently. I have examined numerous carpel tunnel

syndrome cases and found them all to be due to food maladaptive reactions. The stress of use associated with the food reaction combine to produce the inflammatory reaction of the specific area. In major mental illness, there exists a primary chronic viral infection of the brain, which prepares the brain to be the target organ for a maladaptive food reaction. Malnutrition can also be a factor predisposing to maladaptive reactions to foods, chemicals, and inhalants and to the selection of particular tissue areas for the maladaptive reaction.

Years of experience of deliberate food testing has provided convincing evidence that it is the stress of the frequency of contact that produces the maladaptive reactions to foods, chemicals, and inhalants. This is true, whether these are IgG immunological reactions or non-immunological reactions. The frequency needs to be more than two times per week. A practical food rotation diet can be set up, avoiding any food eaten as frequently as two times a week or more. Initially, avoid these foods for three months. Ninety-five percent of the time, after three months of avoidance, these initial foods left out of the diet can be introduced back into the four-day diversified rotation diet without symptoms being produced. Gluten from wheat, rye, oats, barley or corn is the most frequent and most serious food producing reactions. Dairy foods come in for a good second. Any food used frequently can become a reactive substance. The same principle of frequent contact producing maladaptive symptoms applies also to chemicals and inhalants.

The four-day diversified rotation diet and avoidance of symptom of frequently used foods is initiated at the same time. Furthermore, to be discontinued at the same time is the use of any tobacco, alcohol, and caffeine beverages. The first three days will be the most serious symptom-evoking period. By the fifth day, usually the symptoms have materially subsided and have become manageable. To handle the acute withdrawal symptoms, the person needs to have available the following magnets:

- Two 1-1/2" x' 1/2" ceramic disc magnets
- Two 4" x 6" x 1/2" ceramic magnets
- For some people, it would be well for them to also have a 5" x 12" deep penetrating flexible mat

These magnets can be used either continuously during this withdrawal phase or used just at the time the withdrawal symptoms emerge. It usually requires 10 to 30 minutes for

magnetic management of the symptoms. First, place the ceramic disc magnets on each temple area, that is, in front and at the level of the top of the ears. These can be held in place with a 2 x 26 inch self-fastening band. Other placements that may be found to be profitable are a left temple and low occipital area or a left temple and frontal area. The left temple is used in a right-handed person, and the right temple is used in the left-handed person. At the same time, place a 5" x 6" x 1/2" ceramic block magnet on the mid-sternum, that is, the middle of the chest, on the front. Also, a 4" x 6" x 1/2" thick magnet should be placed directly over the epigastric area, which is just below the sternum. These can be held in place by a 4" x 52" body wrap or an Ace bandage, or if the person is lying down, these magnets can just rest on these areas. Some may find it profitable or even necessary to use the 5" x 12" multi-magnet flexible mats on the lumbar and thoracic spine. The person would need to be lying down to do this. To use this magnet, always use the negative magnetic field. After this acute phase is over, the person uses these magnets to relieve symptoms if and when they reoccur. The rotation diet should become a life style. The subject also should sleep on a magnetic bed pad and with magnets at the crown of the head. This system is described elsewhere in more detail. Also, the subject would do well to be supplementing specific nutrients such as vitamin C as mineral ascorbates, B complex vitamins and minerals (especially calcium and magnesium).

Self-Help Food Testing

There is no practical reason to do self-help food testing. It is best to proceed without food testing

Deliberate food testing should not be done without medical supervision on the following.
1) Diabetics on insulin
2) Seizure cases
3) Dangerously aggressive cases such as in some psychotics

Even though I am not recommending self-help food testing, the principles of self-help food testing are as follows:
1) Five day avoidance of foods used as frequently as two or more times a week. Wait five days before using any of these foods in a single meal food test.
2) Use test meals of single foods.

3) Monitor for the emergence of physical and emotional symptoms as well as blood pressure before the meal and one hour after the meal. The pulse should be taken before, and one hour after the test meal. In a non-insulin dependent diabetic (Type II), test the blood sugar before the meal and one hour after the meal. It is also well for anyone to test the blood sugar. There are many high blood sugars (beyond 160) in patients who have not been diagnosed as diabetics. When the blood sugar is beyond 160 in a non-diabetic, it demonstrates that this person is in a pre-diabetic state.

4) Symptoms can be relieved by bitemporal placement of ceramic disc magnets which are 1-1/2" x 3/8" held in place with a 2" x 26" headband.

5) Stop all tobacco, alcohol and caffeine when the program starts.

Final Word

Addiction leads to degenerative diseases, especially maturity onset diabetes mellitus. Food addiction is very real and the most frequent addiction. A 4-Day Diversified Rotation Diet is optimal to prevent and or reverse food addiction. Do not use food as a symptom reliever or for weight management such as has been advised. Some weight reduction medications using the serotonin-opiate complex produced so many symptoms, they have been withdrawn from the market. The tranquilizer-antidepressants using a method of raising the serotonin-opiate complex produce serious, devastating side effect symptoms and therefore, cannot be recommended. A negative magnetic field properly placed relieves symptoms, produces melatonin, produces normal energy restoring sleep and normalizes the serotonin-opiate ratio and has no side effects. A negative magnetic field associated with a non-addictive state is markedly superior to tranquilizers, antidepressants and weight management medications.

<u>Warning</u>

The system described in this write-up uses the negative magnetic pole field only. The positive magnetic field or the mixed positive-negative magnetic fields will not achieve the necessary results. A negative magnetic field calms neurons and normalizes biological functions. A negative magnetic field does not evoke the production of serotonin or endorphins. A negative magnetic field has a biological response of alkaline-hyperoxia. A negative magnetic field activates oxidoreductase enzymes that process

free radicals, peroxides, acids, alcohols and aldehydes and releases oxygen which is bound in these substances thus making oxygen available for producing ATP in the oxidation phosphorylation process.

A positive magnetic field, whether singly or mixed with a negative magnetic field, excites neurons, produces acid-hypoxia, and blocks oxidoreductase enzyme function. The positive magnetic field on the heart increases the pulse rate and can evoke tachycardia in a subject predisposed to tachycardia. A positive magnetic field excites neurons and can evoke a seizure in a subject predisposed to seizures. A positive magnetic field evokes the production of serotonin and endorphins and for this reason can produce magnetic addiction. Positive magnetic field addiction produces pleasurable euphoria, disorders judgement, and has a painful withdrawal phase. Positive magnetic field addiction can lead to the frequent use of the magnet to relieve pain and when used on the head can be misused to produce pleasurable euphoria. A positive magnetic field addiction is a true addiction with all the features of addiction.

My reason for presenting this subject of a positive magnetic field addiction is because there are magnets marketed for pain that use both positive and negative pole fields. These are not suitable for treatment of addiction, weight management or for stress management.

References

1. Davis, A.R. and Rawls, W. The Magnetic Blueprint of Life (Acres USA: Kansas City, MO. 1979)

 Davis, A.R. and Rawls, W. The Magnetic Effect (Acres USA: Kansas City, MO. 1975) Davis, A.R. The Anatomy of Biomagnetism (Acres USA: Kansas City, MO. 1975)

2. Becker, Robert O., Cross Currents (Jeremy P. Tarcher, Inc.: Los Angeles, CA. 1990) Becker, Robert O. and Marino, A.A. Electromagnetism & Life. (State University of New York Press; Albany, NY 1982)

 Becker, 0 and Selden, G. The Body Electric: Electromagnetism & the Foundation of Life. (William Morrow & Co: New York, NY. 1985)

3. Philpott, WH. and Kalita, D.K. Brain Allergies: The Psychonutnent and Magnetic Connections. (Keats Publishing. New Canaan, CT. 1981)

Philpott, WH. and Kalita, Dwight K. Victory Over Diabetes. (Keats Publishing: New Canaan, CT. 1983)

4. Randolph, T.G. The Enzymatic and Hypoxia. Endocrine Concept of Allergic Clinical Ecology. (Charles C. Thomas Publisher: Springfield, IL. 1976)

5. Potts, John. Journal of Diabetes. 'Avoidance Provocative Food Testing in Assessing Diabetes Responsiveness". 26: Supplement 1,1977.

Potts, John. Journal of Diabetes, "Value of Specific Testing for Assessing Insulin Resistance." 29: Supplement 2, 1980.

Potts, John. Journal of Diabetes, "Blood Sugar-Insulin Responses to Specific Foods Versus GTT." 30: Supplement 1,1981.

Potts, John. Journal of Diabetes. "Insulin Resistance Related to Specific Food Sensitivity." 35: Supplement 1, 1986.

6. Wurtman, J. "The Involvement of Brain Serotonin in Excessive Carbohydrate Snacking by Obese Carbohydrate Cravers". Journal of the American Diet Association (1894). 84:1004-1007.

Wurtman, R. and Wurtman, J. "Nutrition Control of Central Neurotransmitters". *The Psy- chology of Anorexia Nervosa,* ed. By K.M. Pirke and D. Ploog, pp. 4-11. (Berlin: Springer Verlag, 1984)

Wurtman, R., and Wurtman, J. *Nutrition and the Brain. Vol.* 7. (New York: Raven Press, 1986) Wurtman, J. and Suffes, Susan. *The Serotonin Solution.* (Columbine: Fawcett **Press,** 1996)

References concerning raising serotonin for its tranquilizer, antidepressant and weight management effect:

7, Fernstrom, J.D. and Wurtman, R.J. *Brain Serotonin Content: Physiological Regulation by Plasma Neutral Amino Acids.* Science (1972), 178:414-416.

8. Lieberman, H., Wurtman J., and Chew, B. "Changes in Mood After Carbohydrate Consump- tion Among Obese Individuals". American Journal of Clinical Nutrition (1987), Volume 44.

9. Desmaisons, Kathleen Ph.D., *Potatoes not Prozac.* (NY, NY: Simon & Schuster, 1998)

10. Pomeranz, B: *Recent Advances in Acupuncture Research.* Temple Univ. Center for Frontier Sciences Symposium. April 26, 1994.

[*Magnetic Health Quarterly* "Magnetic Management of Addiction" Vol. IV, 1st Qtr, 1998 (2003Revision)]

Alzheimer's Disease and Amyloidsis

Preview: Revealing Facts About Alzheimer's

As a quick, educational primer, here is a valuable list of pertinent facts about Alzheimer's.

• There are over 4 million Americans suffering with Alzheimer's. The number will increase to 14 million people in the next generation or two. There are 20 million Americans directly affected by it, and this will progress to 70 million.

• The combined expenses to treat Alzheimer's in the United States exceed $100 billion annually.

• Approximately 50 percent of the population will develop Alzheimer's if they survive past the age of eighty-five.

• Twenty percent of all Alzheimer's cases are related to genetic inheritance.

• Alzheimer's can be prevented. Even moderately advanced stages can be delayed. Early recognition is the key to treatment and prevention.

• The larger the brain, the greater the reserve that remains throughout the course of this developing dementia. Larger brains show better performance during the downhill spiral of Alzheimer's.

• It is now generally accepted that the course of Alzheimer's disease might start as early as the fetal stage and will intermittently traverse several decades. It can have slow and sporadic periods of development, as well as acute phases, depending upon the underlying causes, the individual's physiologic status, and genetic mutations.

• Short-term memory loss is the most prominent early symptom of Alzheimer's. It can be very subtle in onset, and initially it is cleverly hidden by the patient.

• Little-known fingerprint patterns can predict the development of Alzheimer's years before its clinical onset, and with such accuracy that they have been proven an excellent marker. A simple home test will reveal it.

• The sense of smell is lost approximately two years prior to other symptoms. It is an early marker for disease. Its onset is so gradual over such a prolonged period of time that the patient is often totally unaware. Simple home testing can expose it.

• Hearing loss is extraordinarily high in Alzheimer's and occurs earlier than other symptoms. It is an early marker for identifying disease and easy to detect.

- Depression is a very early marker. It is encountered in 50 percent of all patients suffering with dementias. In Alzheimer's, its onset is seen earlier than other dementias, setting it apart from them. It can present itself more than two years before the disease is recognized.
- Survival is generally six to eight years after diagnosis. However, death can occur as soon as two years after the diagnosis has been established.
- Seventy percent of all deaths due to dementias are of the Alzheimer's type. There are many dementias that mimic Alzheimer's, of which vascular dementia is the most frequently encountered.
- Individuals with low blood sugar (hypoglycemia) have nearly twice the chance of developing Alzheimer's dementia because their brain cells are deprived of the sugar required for energy and survival.
- Diabetics have only one-half the risk of developing Alzheimer's disease.
- Prolonged psychological stress can induce Alzheimer's.
- Prolonged use of the antihistamine type of nerve medicine, chlorpromazine (Thorazine), can contribute to Alzheimer's disease.
- Prolonged use of stomach medicines such as Donnatal and Bentyl might play a significant role causing, or at least aggravating, Alzheimer's.
- Electromagnetic fields are now implicated as a cause of Alzheimer's.
- Exposure to several groups of organic solvents such as toluene is implicated as a possible cause of Alzheimer's.
- Several anti-inflammatory agents such as ibuprofen are able to reduce the risk of developing Alzheimer's as much as 55 to 60 percent by their ability to counteract the inflammatory processes in the brain that are responsible for the death of brain cells that cause Alzheimer's.
- Shingles, a very painful skin rash caused by a virus, can produce a dementia identical to Alzheimer's.
- Autopsy reveals that Alzheimer's patients are deficient in thiamine (vitamin B_1). Correcting this deficiency with vitamin supplements has been shown to improve cognition.
- Estrogen replacement therapy provides a 55 percent reduction in the risk of developing Alzheimer's disease.

- Aluminum has been alleged to be a major cause of Alzheimer's disease.
- Zinc is now a primary suspect among the heavy metals suspected as a potential cause of Alzheimer's.
- Iron deposits in the brain are prominent in Alzheimer's and may possibly evolve as a cause of dementia.
- The lack of circulation with a corresponding loss of oxygen and glucose (sugar) to the brain is highly suspected to be a contributing cause of Alzheimer's disease, even as early as the fetal stage.
- Children of affected mothers have a significantly higher rate of Alzheimer's (9:1) compared to children of affected fathers.
- Several genes have been identified that cause Alzheimer's, and the earlier its onset the more likely the cause is genetic.
- Apolipoprotein E 4 (APOE 4) is a harmful inherited gene, carried by 30 percent of the population, but fortunately only 10 percent of those who carry it will ever develop Alzheimer's.
- Head trauma, particularly accompanied by loss of consciousness, doubles the risk of Alzheimer's. Head trauma with possession of the abnormal hereditary gene APOE 4 increases the risk of Alzheimer's tenfold.
- Alzheimer's dementia has been documented in individuals as young as age twenty-nine, representing an inherited genetic subset of the disease.
- The Cherokee Nation of Native Americans exhibits a natural immunity to Alzheimer's.
- African-Americans and Hispanics are both at higher risk than whites for developing Alzheimer's.
- AD 7 C has to date proven to be a most significant test and it closely matches autopsy findings for diagnostic accuracy.
- The PET scan is unique for measuring blood flow and metabolism in the brain. It is reported to have the potential to predict Alzheimer's as many as twenty years before clinical symptoms evolve.
- Nicotine improves learning and slows the progression of Alzheimer's, although this is not an excuse for smoking.
- Vitamin E is 55 percent effective against Alzheimer's. It can help to prevent the disease if started early in the course of treatment.

- Haldol, a nerve medicine initially marketed for the treatment of schizophrenia and other psychoses and now used for other nervous disorders, can significantly retard the progression of Alzheimer's.
- Certain ulcer medications such as Tagament provide significant delay in both onset and progression of Alzheimer's.
- Fish oils (omega-3) are protective against Alzheimer's and help prevent depression.
- Levels of vitamin B_{12} normally decrease with aging, but Alzheimer's patients have lower levels of vitamin B_{12} than their normal counterparts and this deficiency requires replacement.
- Sundowner's syndrome refers to wandering and roaming when the sun goes down. Melatonin may help to alleviate sundowner's syndrome and help regulate and normalize sleep patterns.
- Epileptic-type seizures can be a very early marker of a rare genetic subset of Alzheimer's and can occur even before the early onset of disease at ages as early as twenty-nine.

Understanding Magnetic Therapy
What is a static field magnet?

A static field magnet is surrounded by a magnetic field that moves electrons in the field. Even though the magnetic field is static the movement of electrons makes this an energy field. Therapeutic magnets are flat surfaced ranging in thickness from 1/16 to 1 inch and in diameter from 1/2 inch to 4" x 6" x 1". The magnetic fields are on opposite sides of a flat surface. There is a positive magnetic field (+) and a negative magnetic field (-) on opposite surfaces of these static field magnets. The positive and negative magnetic fields correspond to the positive and negative magnetic field of a direct current electric circuit. In fact the magnetic field of a magnet are produced by an electric exposure to the electric fields direct current circuit.

One half of the thickness of the magnet is a positive and the other half is a negative field. These are opposite sides of the static field magnet. Iron oxide or neodymium is the usual materials used. These metals are impregnated in a hard material such as ceramic or neoprene form.

Magnets used for treating Alzheimer and other types of Amyloidosis

For the purpose of treating Amyloidosis the magnets used are:

1. Four 4" x 6" x 1" thick stacked magnets on both sides and top of the head. A total of twelve 4" x 6" x 1" magnets surrounding the head. This super magnetic head unit is used during sleep at night and when napping during the day.

2. Thirty-four 1" x 1/8" stacked neodymium disc magnets strategically placed on the hat around the head exposing the entire head to an optimum magnetic field.

3. When a single organ such as the liver is involved in Amyloidosis then a 4" x 6" x 1/2" thick magnet is used over this organ.

The duration of exposing the target organ with Amyloidosis to a negative magnet field for the resolution of Amyloidosis is yet to be statistically determined. The objectively observed immediate effect of symptom relief in the early stages of Alzheimer's is obvious. The percentage values are yet to be experimentally determined. It is the better part of wisdom for the treatment to be used daily as a lifestyle.

Beyond the local treatment of the amyloid deposits such as the brain for Alzheimer or other selective organs such as the liver, pancreas, heart, kidneys, spleen and so forth, it would be well for general health reasons to have a systemic exposure to a negative field. This can be achieved by sleeping on a negative magnetic field bed composed of mini block magnets (1-7/8" x 7/8") placed one and one half inch apart, or even more optimal, a single bed size composed of seventy magnets (4"x 6" x 1") placed one inch apart.

The Patho-Physiology of Alzheimer's Disease

Amyloid deposits can develop anywhere in the body, and are often in the liver and pancreas. Alzheimer's disease is amyloidosis of the brain. Beta-Amyloid is a neuro-toxic amyloid. Amyloid is composed of insoluble amino acids plus minerals, heavy metals (especially aluminum and mercury) and remnants of dead neurons and their appendages.

Amino Acids are soluble in an alkaline pH, such as the physiologically normal 7.4 pH of the blood and body fluids[4]. Amino acids form insoluble gel precipitates in an acid medium[4]. Therefore we know of a certainty the starting point of the formation of local amyloid deposits is a local acidity. Furthermore, the change of insoluble amino acids back to soluble amino acids requires the reversal of the local acidity to a local alkalinity (i.e. a change in pH). The local application of a negative magnetic field achieves

the replacement of acid-hypoxia with alkaline-hyperoxia. For this reason, the most fundamental starting point is the local application of the negative magnetic field to the brain.

Any acidifying source is important to consider and reverse. Deliberate test exposure to foods, chemicals and inhalants demonstrates that when symptoms occur there is measurable blood acidity. The body area where a symptom develops has the highest local acidity. In Alzheimer's disease the brain is the local area of highest acidity, which precipitates the local amino acids into insoluble gels. All the early stage symptoms of Alzheimer's have been observed to be evoked with deliberate test exposures to foods, chemicals and inhalants to which the subject is addicted, immunologically reactive or otherwise evoking an inflammatory reaction due to a hypersensitivity to that substance. These maladaptive symptom evoking brain reactions demonstrate that these maladaptive reactions are the fundamental building blocks for Alzheimer's disease. Each time a brain maladaptive reaction from an environmental substance occurs a layer (plaque) of insoluble amino acids occurs. Alzheimer's disease is the extension in time of acute cerebral symptom reactions to environmental substances. Percentage wise these symptoms mostly occur to foods by the mechanism of addictions, immunologic allergies and otherwise oxidoreductase enzyme inhibitions producing hypersensitivity reactions.

All sources of acidification are important; the following need to be considered:

- Addiction reactions. The withdrawal phase of addiction is acidification. Hypoglycemia is a manifestation of the withdrawal phase of food addiction. The reduced supply of glucose to the brain further damages neurons and compounds the damage forms acidity.
- Immunologic reactions. These types of reactions are acidifying as well.
- Hypersensitive reactions that are neither addictions nor immunologic reactions. These occur due to several reasons such as; malnutrition or an oxidoreductase trained inhibition.
- Infections. Infections are acidifying, it is wise to examine for chronic infections such as Epstein-Barr, cytomegalo, and Human Herpes VI.
- Heavy metals. These are acidifying by virtue of the formation of free radicals and its production of a chain of inflammatory

substances (especially including oxyacids). Heavy metals are electropositive; therefore free radicals and acids are formed. A negative magnetic field reverses the electromagnetic positivity of heavy metals, which in turn stops free radicals and acid formations.

• Nutritional deficiencies. Oxidoreductase enzymes and in fact all other enzymes are formed from amino acids, B complex vitamins and mineral. A nutritional deficiency can produce a decreased efficiency of the oxidoreductase enzymes. The assignment of the oxidoreductase enzymes is to produce ATP and also detoxify and process any end products of the oxidation-reduction metabolism starting with free radicals and their end products.

Further facts observed by William H. Philpott:

• Alzheimer's is amyloidosis of the brain.

• Amyloid plaques consist of amino acid gels with whatever else was present and caught up with this amino acid gel. This includes heavy metals (especially calcium, aluminum and mercury), dead neurons and their appendages.

• Amino acids are soluble in the physiological pH (in the brain) of 7.4 and are insoluble in an acid medium. Therefore, amyloidosis can only develop when there is a local acidity to the brain.

• The biological response to a negative magnetic field is alkaline-hyperoxia; therefore a negative magnetic field is capable of reversing the amyloid plaques.

• The major reason for precipitating amino acid gels is maladaptive reactions to foods, chemical and inhalants in the form of food addictions and immunologic reactions.

• Heavy metals compound the problem by their electromagnetic positivity forming free radicals and acids. This is reversible by a negative magnetic field, replacing the electromagnetic positivity of heavy metals.

The specific symptoms that develop are a reflection of the area of the brain that is involved and sometimes maybe rather limited to that area with the rest of the function being reasonably intact. There are five such discreet areas of brain malfunction that are observed in Alzheimer's:

1. Karsakoff amnesic state. This amnesic state consists of an inability to remember recent events. The memory may be so impaired that the subject cannot remember what occurred a minute

or two previously. Yet the area of most important learned functions may still remain intact.

2. Dysnomia. This is the forgetting of words especially proper names.

3. Viseo-spatial disorientations. The parietal-occipital functions sometimes become disarranged and fail while other areas of function are preserved. Losing ones way even in familiar surroundings is an example of this.

4. Paranoia and other personality changes.

5. Gait disorders. In most cases of Alzheimer's the gait disorder is only observed in the last stage of the disease, but in some cases it occurs early in the disease process.

WHAT IS AMYLOID?

Amyloid is composed of the precipitate of insolvable amino acids along with fibrous material from dead neurons and their extensions. Successive layers of Amyloid precipitate are laid down in intercellular space. This growth of Amyloid precipitate is increasingly space occupying between cells and is toxic and thus injurious. Amyloid is an abnormal protein precipitate of insolvable amino acids which have no biological value in human metabolism. Amyloid is toxic because it is acidic, is a positive magnetic field and has heavy metals attached to the Amyloid. Heavy metals are not necessary for the production of Amyloid. All that is needed is acidity to precipitate the amino acids into an insolvable gel. Heavy metals complex with this Amyloid resulting in an increased toxicity of the Amyloid thus the higher amount of toxic heavy metals the more toxic the Amyloid. Also the presence of the toxic heavy metals is acidifying thus can have a secondary role in increasing the amount of Amyloid.

WHAT PRECIPITATES AMYLOID?

Amyloid develops because of an insolvable precipitate of amino acids. Amino acids are solvable in the physiological normal in the pH of 7.4 and beyond and as such are available to be incorporated into enzymes and useful tissues. Amino acids are known to be insolvable in an acid medium in which condition amino acids become an insolvable gel. Amyloid is amino acid gel, which has incorporated fibrous elements of dead neurons and their extensions.

Understanding that amino acids are solvable in an alkaline medium of 7.4 and beyond and insoluble in an acid medium

explains why there are so many factors that influence the development of Amyloidosis in general and Alzheimer Amyloidosis in particular. The goal of prevention is to maintain a physiological alkaline pH in the blood and tissues. The goal of treatment is to stop the input of acidification and provide a sustained alkalinity not just of the blood but also of the tissues, where the Arnyloid is deposited in any system that maintains alkaline-hyperoxia is helpful. Amyloid is not vascular and thus is resistant to a reversal from blood alkaline-hyperoxia. Ideal is a magnetic field that has no dependence on diffusion because it is all the same everywhere in the magnetic field. The biological response to a negative magnetic field is alkaline-hyperoxia. Thus a sustained, static, negative magnetic field can reverse Amyloidosis. The higher the magnetic gauss strength and the more sustained the magnetic field exposure the more efficient the process of Amyloid absorbance. The insolvable acid Amyloid becomes solvable in the alkaline-hyperoxia produced by a negative magnetic field.

Amyloidosis is a systemic disease despite the fact it has high concentrations in local areas giving it the appearance of being only a local disease. The brain (Alzheimer Disease), liver, kidneys, pancreas, heart, around blood vessels and around nerves, frequently have heavy precipitates of insolvable Amyloid. There are frequent skin and subcutaneous deposits of Amyloid. Even the fingerprints change due to Amyloidosis. Indeed Amyloidosis is a serious incapacitating disease both mentally and physically.

INFECTIONS

All biologically invading microorganisms (viruses, bacteria, fungus and parasites) are acidifying.

Viruses particularly may be involved in a local infection but also toxins from local bacterial and viral infections are also inflammatory, and may well be a part of the acidification where the Amyloid is deposited. A search should be made for infectious agents especially including latent and slow virus infections. Special consideration should be given for the isolation of any of the herpes viruses.

All invading microorganisms can be successfully treated with a negative magnetic field. Toxins from microorganisms can be detoxified by a negative magnetic field. When indicated, which is especially true of such as Epstein-Barr,

Cytomegalovirus, and Human Herpes #VI, the magnetic treatment should be systemic. Ideal for this is a seventy magnetic bed composed of ceramic block magnets that are 6" x 4" x 1" thick placed 1" apart. Seventy of these are needed for a single bed size. Any treatment that can rid the body of a microorganism infection state is useful in the prevention or advancement of Amyloidosis. Amyloidosis frequently has episodes that undoubtedly related to infections or other periodic inflammatory responses.

RHEUMATOID INFLAMMATORY REACTIONS

Amyloidosis is frequently associated with rheumatoid inflammatory reactions. Inflammation is acidic and any inflammation no matter how produced is significant in the production of Amyloidosis.

IMMUNOLOGIC REACTIONS

Immunologic reactions are always acidifying and should be appropriately treated. Treating local systemic immunologic reactions with magnets is very profitable. Avoidance and spacing of contact with agents precipitating allergies is a significant part of management of allergies.

ADDICTIONS

The withdrawal phase of addiction to anything whether it be narcotics, foods, alcohol, tobacco, caffeine and so forth are acidifying and can be a major cause of Amyloidosis.

NUTRITIONAL DEFICENCIES

Nutritional deficiencies lead to inflammatory reactions. Special consideration should be given to deficiencies in thiamin, vitamin E, folic acid and B_{12}.

Trauma is known to aid in precipitating a development of Amyloidosis. In Alzheimer disease, head trauma can precipitate or markedly increase the production of Alzheimer disease.

STRESS:

Prolonged stress can precipitate Amyloidosis in the specific area that is being stressed.

HEAVY METAL TOXICITY

Most common heavy metal toxicity's are to aluminum, mercury, and lead[6]. All heavy metals are Electro-magnetic positive[7] and thus are free radical producing and acid producing. Heavy metals are known to complex with specific elements in tissues. For example, mercury complexes with sulfur in amino acids and tissues. Heavy metals produce acidity and add

Electromagnetic positivity to Amyloid where they attach (complex). Heavy metals are not necessarily for the production of Amyloidosis however when present they will increase the toxicity and the production of Amyloidosis. Therefore, to rid the body of heavy metals of any type is very important. There are specific chelating agents for specific metals.

Also, a negative magnetic field detoxifies heavy metals by replacing their electro-magnetic positivity with electro-magnetic negativity. While in this detoxified state the heavy metals are dispensed of in the urine.

Alzheimer's with Arteriosclerosis

Cerebral symptoms are indicative of the specific area of the involved but does not reveal why. Sophisticated techniques of visualization are necessary to reveal with certainty the cause. The diagnosis of Alzheimer's is a matter of excluding all other causes and also visualizing the presence of amyloid deposits. The most common differential diagnosis is between amyloid deposits of the brain and vascular abnormalities secondary to arteriosclerosis. Compounding the differential diagnosis is the fact that both amyloid deposits and cerebral arteriosclerosis are frequently present together in which both can produce the same symptoms. Furthermore, toxic beta-amyloid can erode blood vessels and produce bleeding in the brain.

An examination of amyloidosis should equally include an examination for vascular disorders of the brain. Also the examinations should include the entire body, examining for amyloid deposits and vascular disorders. Insoluble calcium deposits should also be included in the bodily survey of insoluble deposits.

The common denominator of insoluble of amino acids and insoluble calcium is the repeated evoking of local acidity. Arthromatous plaques in the arteries are composed of a combination of amino acid and calcium insoluble deposits plus other local cellular elements caught up in these deposits. Arteriosclerosis including the entire arterial wall and surrounding soft tissue is the same process of local acidity as that of arthromatous plaque formation. There are several potential causes for this local acidity. The major cause is maladaptive reactions (addiction and immunologic allergies to foods), which are ingested with such a frequency that they become a biological stressor. All inflammatory reactions are acidifying. The goal of

magnetic therapy is to stop all inflammatory, acidifying responses and thus stopping these insoluble deposits. Magnetic therapy has the goal to stop the cause of these insoluble deposits and also by the alkaline-hyperoxia response to the magnetic field resolve these deposits.

The Role of pH

Theron G. Randolph was the first to observe that biological acidity emerged when symptoms developed in response to deliberate test exposure to foods, chemicals and inhalants. He also observed that enzyme inhibition was involved in this acid reaction. The majority of enzymes involved in human function are alkaline dependant and thus acidity blocks the enzyme response. I have examined many thousands of symptom producing reactions on deliberate exposure to foods, chemicals and inhalants. It has been my routine to test pH as well as blood sugar. My work has abundantly confirmed that Dr. Randolph was right. Acidity does emerge when symptoms do develop, it matters not whether these symptoms can be demonstrated to be addictive withdrawal symptoms, immunologic allergies or otherwise symptom producing sensitivity. Acidity is there when symptoms emerge. This is a very important key to understanding how Alzheimer's disease can develop. It is well established that amino acids are soluble in an alkaline pH, and form insoluble gels in an acid pH[4]. The same is true of calcium, which is soluble in an alkaline pH and insoluble in an acid medium[4]. We see these calcium deposits develop wherever there is inflammation, such as around joints and muscles. Amyloid is obviously insoluble amino acid gels that have developed because of acidity. Therefore now, based on this understanding, these insoluble amyloid deposits developing in the brain in Alzheimer's disease is due to acidity. There are many sources of acidity. Even biological stress is acidifying. Most important of all are maladaptive symptom reactions to foods mostly, and also to chemicals and inhalants. These acidity states keep being evoked because of the frequent exposure to these foods, chemicals and inhalants. My observation is that when a symptom develops in response to an exposure to a substance the acidity is systemically measurable such as in the blood or the saliva. However, the area where the symptom develops is the most acidic of all. Thus in Alzheimer's disease

the acidity is in the brain and where this acidity specifically occurs amino acids become insoluble gels.

This knowledge of amino acids becoming insoluble in an acid medium gives us also the queue for treatment. It is known that a negative magnetic field alkalinizes. Therefore the treatment of Alzheimer's is to maintain an alkalinization of the brain so that the amino acids go back into solution.

The Role of Oxidoreductase Enzymes

The families of oxidoreductase enzymes have two major responsibilities, which are

1. The production of adenosine triphosphate (ATP) and
2. Oxidation remnant magnetism (a negative magnetic field)

It requires four of these oxidoreductase enzymes to make ATP. Whenever there is an enzyme catalytic reaction there is always a magnetic field produced. The magnetism produced is called oxidative remnant magnetism[10]. Thus there are two sources of energy made by this process of oxidation phosphorylation, which are ATP and a negative magnetic field. These energies are used in producing enzyme catalytic reactions. The human body must maintain an alkaline pH in order for these enzymes to work. They are alkaline dependant.

The second function of oxidoreductase enzymes is to process free radicals. Free radicals are a spin off of the oxidation phosphorylation process. Free radicals, if they are not processed immediately, will proceed to produce acids, alcohols and aldehydes, which are inflammatory products. There is a specific member of the oxidoreductase enzyme family that have the job of processing any and all toxic substances, either the end product of oxidation-reduction or any other toxins to which the body may be exposed. These enzymes have nutritional precursors of amino acids, B complexes and an assortment of minerals. Thus maintaining optimum nutrition is an important component of being healthy. No one can have health without adequate nutrition.

As important as nutrition is, nutrition alone with the presence of adequate enzymes does not cause the enzymes to function. The function of enzymes is a matter of an energizer. The source of energizing oxidoreductase enzymes is the harnessing of available static electrons to move between the enzyme and the substrate, thus making the enzymes and the

substrate join so that a catalytic reaction can take place. When this movement of electrons occurs between the enzyme and the substrate a magnetic field is formed. It is known that the movement of electrons produces a magnetic field. It is also equally known that a magnetic field can be harnessed to move electrons. The magnetic field formed when oxidoreductase enzyme catalysis occurs is a negative magnetic field. For this reason a static negative magnetic field rather than a static electric field can be used for enzymes to join with substrates. This use of free electron energy, which becomes free magnetic energy, is in essence what magnetic therapy is all about. Magnetic therapy is the energizing of oxidoreductase enzymes, which have the task of producing ATP plus a negative magnetic field and also the assignment of detoxifying all toxins whether from the end products of metabolism or from external source of toxins. No matter what these may be, from bacteria, microorganisms, physical injury, petrochemical hydrocarbons or heavy metals, oxidoreductase enzymes detoxify them.

The International functional classification of oxidoreductase is as follows:
1. Dehydrogenases
2. Hydroxylases
3. Oxidases
4. Oxygenases
5. Peroxidases
6. Reductases

Heavy Metal Detoxification

Aluminum and mercury especially as heavy metals have been considered as a likely source of producing Alzheimer's disease. This is assumed because of the measurable presence of these heavy metals in Alzheimer's autopsies. I think the evidence is that the heavy metals are not the cause of Alzheimer's disease but rather the precipitating of amino acid gels is due to the maladaptive reactions of foods, chemicals and inhalants. However, the heavy metals become an important contaminant. Due to the fact that the heavy metals are simply caught up in the amyloid, and because the amyloid is not live tissue, it remains as a deposit in the amyloid. This makes the amyloid more toxic because the heavy metals are electromagnetic positive, which produces free radicals, which in turn produces acidity. Therefore, the heavy metals are an

important contaminant though they are not the original cause. It is important to process the metals out of the body. There are chelation techniques that can be used both intravenously as well as orally that will aid in removing these heavy metal contaminants from the body. These should be used as optimally as possible. It should also be understood that a negative magnetic field exposure cancels the toxicity of the heavy metals by replacing the electromagnetic positivity of these heavy metals with an electromagnetic negativity.

Therefore they are no longer producing free radicals and acids when exposed to a static negative magnetic field. As long as the area containing these heavy metals is in the presence of a negative magnetic field their toxicity is cancelled; and in this non-toxic state they will be processed out of the body, especially in the urine. Therefore it is important from a standpoint of toxicity to expose more than just the brain to a negative magnetic field. The entire body should be exposed to a negative magnetic field so that these toxins can be processed out of the body through the urine in a non-toxic state. In terms of mercury, one of the methods of removing this metal is through the lungs, such at the body temperature to some degree making mercury volatile.

Static Magnetic Field Therapy
Vs.
Pulsing Magnetic Field Therapy
Why I Use Static Magnetic Field Therapy
Why I Do Not Use Pulsing Magnetic Field Therapy

I use static magnetic field therapy in preference to magnetic field pulsing therapy because there are advantages to using a static field over using a pulsing magnetic field. Robert O. Becker, M.D. and I agree that there are no advantages and only disadvantages when using a pulsing magnetic field versus a static magnetic field. In 1993, at the NIH Electromagnetic Advisory Committee, I presented my research program using the static magnetic field. Robert O. Becker responded by seconding my research and added, "We should be doing as Dr. Philpott is doing, using a static magnetic field. I am a co-inventor of the Bassett Instrument with a pulsing magnetic field used for healing bones. However, I can state that a pulsing magnetic field has no advantage over a static magnetic field. There is nothing a pulsing magnetic

field can do that cannot also be produced by a static magnetic field."

Understanding the biological response in general and cerebral response, in particular, to separate negative and positive magnetic fields has taught me a valuable lesson. The lesson is that you do not need to go through biological stress to arrive at biological anti-stress as a reflex compensation to the biological stress. The magnetic stress I was using for my mental patients was electro-convulsive therapy and non-seizure electromagnetic brain stimulation. These treatments produce a positive magnetic field stressor for which there is a post-stress, anti-stress reflex compensation of a negative magnetic field replacing the positive magnetic field's stress. By going directly to the negative magnetic field anti-stress, the symptoms of brain malfunction are more predictably reduced than going through stress to achieve a reflex compensative anti-stress. The head placed in an anti-stress negative magnetic field predictably stops psychotic ideas (hallucinations, delusions, perceptual distortion, judgement disorders, depression and mania) as well as non-psychotic (tension, anxiety, depression, other emotional symptoms and also including seizures) without the stress of a seizure of electromagnetic stimulation of the brain. From an electromagnetic standpoint, there is no reason to go through electromagnetic stress to arrive at a reflex compensated electromagnetic anti-stress state. This negative magnetic field anti-stress can be achieved with two 1-1/2" x 1/2" ceramic disc magnets placed bitemporally; and even more optimally achieved with a Super Magnetic Hat that permeates the entire brain with a negative magnetic field.

My practice of neurology and especially my extensive experience with EEG has provided me guide-lines in applying magnetic therapy and especially isolates the errors being made in the current popular application of pulsing magnetic field therapy.

The EEG reveals that the electromagnetic pulsing of the brain at 8-12 cycles per second is an anti-stress relaxed brain.

Sleep runs as low as 2 cycles per second. Any pulsing frequency of 12 cycles per second or less is a negative magnetic field, non-stress state. Any pulsing field beyond 12 cycles per second is the expression of a positive magnetic field stress state. Imagery and thinking produce 22 cycles per second and in a few, 18

cycles per second, which is a sufficient stress that can only be maintained for three minutes without a relaxed anti-stress period when the pulsing frequency of the brain cuts the stress pulsing frequency in half, thus producing a period of anti-stress.

An anti-stress pulsing frequency needs to be below 13 cycles per second. A stress pulsing frequency, when used, should be no more than 18-22 cycles per second and not sustained for more than three minutes at a time.

Information from the EEG must not be known by those enthusiastic about magnetic pulsing therapy. One instrument advises no more than 8 minutes for their magnetic stress pulsing frequency. Some advise no more than 20 minutes for their magnetic stress pulsing instrument. Classically, pulsing frequencies beyond 22 cycles per second are being used by these magnetic stress pulsing instruments with 50-100 Hz being frequently used. This is all contrary to our understanding of human electromagnetic physiology. Magnetic pulsing therapy has not been using proper guidelines for its investigation.

The essential truth emerges when the brain is exposed to separate positive and negative static magnetic fields during an EEG. A negative magnetic field produces an anti-stress EEG. The higher the gauss strength, the slower the brain pulsing field. Thus, there is a direct relationship to a negative magnetic field gauss strength and anti-stress value. A positive magnetic field produces a stress EEG. The higher the gauss strength, the more frequency the pulsing field. Thus, there is a direct relationship between positive magnetic field gauss strength and the degree of stress. The stress of a positive magnetic field with its increasing in frequency of pulsation can extend up to 35 cycles per second at which a grand mal seizure occurs. Even at low gauss strength, a positive magnetic field can evoke a seizure in a subject predisposed to seizures. On the other hand a negative magnetic field will prevent seizures in a subject predisposed to seizures. Thus, again, we see the stress factor of a positive magnetic field and the anti-stress factor of a negative magnetic field.

The separate skin response to a positive magnetic field and to a negative magnetic field needs to be understood. The skin response to a positive magnetic field is that of vasodilation with a visible reddening of the skin. When this positive magnetic field is extended over a week or more, it turns out that the vasodilation is an inflammatory vasculitis caused by

the acid-hypoxia produced by the positive tic field. Infection sets in on this inflammatory vasculitis. The short-term response of vasodilation is bleeding from cuts, arteries and veins. This acid-produced vasculitis decreases oxygen supply to the area under the positive magnetic field. The negative magnetic field releases oxygen from its bound state in free radicals, peroxides, acids, alcohols and aldehydes and due to the abundance of molecular oxygen is vasoconstricting and thus stops bleeding. The negative magnetic field is suitable to treat acute as well as chronic injury conditions. A positive magnetic field cannot be used in an acute bruise or cut injury but only in chronic injuries.

Robert O. Becker, M.D. made a most valuable observation which is that a positive magnetic field is the signal of injury and that a negative magnetic field is of necessity present during healing. Thus a negative magnetic field heals and a positive magnetic field does not heal and can prevent healing.

If a magnetic pulsing field is used, these are the rules to follow:

1) For any healing effect, the pulsing field needs to be below 13 cycles per second. There is no limit in the time exposure when within the anti-stress field below 13 cycles per second.

2) For sleep induction, the pulsing field is best at 2 cycles per second. There is no limit in the time exposure to the anti-stress level of the 2 cycles per second.

3) A pulsing field of 22 cycles per second can activate neurons in the brain and spinal cord which have lost their functional response due to "functional extinction of disuse" due to such as pressure from edema after an accident or after the acute swelling of myelin during an acute attack of multiple sclerosis or anything that puts pressure on without killing the neurons. Don't exceed three minutes exposure of 22 cycles per second. It is useful to use runs of three-minute intervals for 22 cycles per second followed by 10 cycles per second. This alternating from 22 cycles to 10 cycles could be used for up to 30 minutes.

4) A pulsing frequency of 22 cycles per second can be used to stimulate glandular function such as adrenocortical function activating the production of adrenocortical hormone or the thymus for activation of its immune-hormonal responses. Do not exceed thirty minutes exposure because prolonged application will block response by producing a stress fatigue.

The rules to be followed for static magnetic field therapy are as follows:

1) Use a static negative magnetic field for all healing, cuts, bruises, insect stings, infections (bacterial, viral, fungal or parasitic), cancers and any inflammation.

2) Use a static negative magnetic field as a detoxifier of free radicals, peroxides, acids, alcohols and aldehydes and exogenous toxins.

3) Use static magnetic field to control mental, emotional and seizure symptoms.

4) Use a static negative magnetic field to control weight.

5) Use a static negative magnetic field to enhance sleep.

6) Use a static negative magnetic field to counter immune and autoimmune reactions.

7) Use a static negative magnetic field to control symptoms of addiction withdrawal.

8) Use a brief exposure to a static positive magnetic field to activate neurons and stimulate glandular function.

Summary

Human cells pulsate in response to magnetic fields. A positive magnetic field is stressful and pulsates cells in the stress range beyond 13 cycles per second. The higher the gauss strength, the higher the pulsing field. A negative magnetic field pulsates the cells in the anti-stress range of 12 cycles per second and below. An exogenous pulsing field can be used to produce magnetic fields in human cells. 13 cycles per second and beyond is a positive magnetic stress field and below 13 is a negative magnetic field anti-stress. Pulsing fields have no advantage over static magnetic fields. To go through stress by a pulsing field to achieve a reflex correction, producing anti-stress, is inefficient and the results are not as predictable as producing anti-stress with a static negative magnetic field. Efficiency and predictability is on the side of using a static magnetic field rather than a pulsing field.

In terms of detoxification, a static negative magnetic field using long term application is a masterful detoxifier while a pulsing magnetic field going through stress to achieve a brief period of anti-stress is a low level inefficient detoxifier.

I use a static magnetic field because I know of no good reason not to use a static magnetic field. I do not use pulsing magnetic fields because I know of no good reason to replace a

static magnetic field with a pulsing magnetic field. A pulsing magnetic field simply does not qualify for the sustained alkaline-hyperoxia response required to reverse atherosclerosis, arteriosclerosis, amyloidosis including Alzheimer's disease, infections, cancer and other conditions requiring sustained alkaline-hyperoxia, whereas a static negative magnetic field predictably treats these same conditions and does so without any side effects.

Alzheimer's Disease
Orientation

Alzheimer's disease is amyloidosis of the brain. Amyloid is composed of acid produced insoluble amino acids. Amino acids are soluble in an alkaline medium and insoluble in an acid medium. Any mechanism that produces a local acidity can initiate the production of amyloid deposits. Common sources of acidity are such as:

- Addictive reactions to foods, chemicals or inhalants
- Immunologic allergies to foods, chemical or inhalants
- Otherwise hypersensitive reactions to foods, chemical or inhalants
- Inflammations (for whatever reason they may occur)
- Infections
- Cancer

Beyond that of the brain other common areas of amyloid deposits are:

- Spleen
- Liver
- Kidneys
- Pancreas
- Tendons (producing tendonitis)
- Around inflamed nerves

Fifty-nine percent of diabetics have amyloidosis of the pancreas. There is an amyloid neuropathy which is symptomatically indistinguishable from diabetic neuropathy. There should be a systemic laboratory evaluation of amyloid deposits anywhere in the body, not just the brain. All of these amyloid deposits should be treated with a negative magnetic field. If it is quite wide-spread, than a seventy-magnet bed (composed of seventy 4" x 6" x 1" ceramic magnets) should be used as well as the local treatment of the head. The entire body should be surveyed for vascular disorders, arthromatous plaques

and arteriosclerosis. The brain, heart and carotids will frequently have the vascular abnormalities. Alzheimer's disease is frequently a mixture of amyloid deposits and vascular disorders. Amyloid deposits, arthromatous plaques and arteriosclerosis are caused by local acidity. All are treated and reversed by the alkaline-hyperoxia produced by the negative magnetic field.

Calcium is soluble in an alkaline medium and insoluble in an acid medium. The entire body needs to be studied for calcium deposits. The calcium deposits produce stenotic areas; the lumbar and cervical areas are most common. These calcium deposits need to be treated with a negative magnetic field so as to reverse the calcium deposits.

Magnet Therapy
Minimum Program of Magnets:
- Super magnetic hat (composed of 34 neodymium disc magnets that are 1" x 1/8")
- Super magnetic head unit (composed of twelve 4" x 6" x 1" ceramic magnets equally distributed to the sides and top of the head)
- One 4" x 6" X 1/2" ceramic magnet
- One 5" x 12" deep penetrating flexible mat
- Five mini block magnets that are 1-7/8" x 7/8" x 3/8"
- One 4" x 52" body wrap

Maximum Program of Magnets
- Magnetic mattress pad (composed of mini block magnets that are 1-7/8" x 7/8" x 3/8" placed an inch and a half apart throughout the pad)
- One chair pad (composed of mini block magnets that are an inch and a half apart in both the back and the seat)

For Viral Infections:

If viral infections have been isolated, especially from lab work, indicating an infection of Epstein-Barr, cytomegalo, or Human Herpes VI virus, then replace the regular magnetic mattress pad with the seventy-magnet bed (composed of seventy 4" x 6" x 1" ceramic magnets which are placed an inch apart in two wooden carrier grids). Furthermore, go back on the bed 1 hour four times a day for the first three months. Optimize thymus gland function by using the positive pole (the side with hook Velcro) of a 2" x 5" x 1/2" ceramic at one-half hour periods four times per day for the first three months.

For Calcium Deposits:

Magnets that are suitable for treating the calcium deposits are given above, the most useful will be the 4" x 6" x 1/2" ceramic magnets.

For Vascular Disorders:

Special consideration should be given to treat these vascular disorders. Most of the time the magnets used for this will be the 4" x 6" x 1/2" ceramic magnet.

For Amyloid Deposits:

Magnets suitable for treating these amyloid deposits need to be arranged. Most of the time they will be the 4" x 6" x 1/2" ceramic magnet.

Placement and Duration

Most of the treatment occurs at night. Sleep with the head in the super magnetic head unit. Go back to this unit for one hour four times a day if possible. During the day, when not in the super magnetic head unit, wear the super magnetic hat. Also the super magnetic hat is worn for the reduction of symptoms when there is a reaction. When out in public it is best to wear the hat to keep the brain oxygenated and alkalinized. This will reduce symptoms and make the subject more functional in society.

The heart is routinely treated with magnetic therapy even if and when there is no cardiac condition. This negative magnetic field attachment to the water and oxygen in the blood will circulate this negative magnetic field to the entire body. There are two choices for treating the heart, one is the 4" x 6" x 1/2" ceramic magnet placed over the heart with the 6" lengthwise the body. This is held in place with a 4" x 52" body wrap. This is part of the nightly treatment, however if there is a cardiac problem then this can be extended to the daytime. In that event, suspenders would need to be attached to this body wrap in order to keep it in place. The alternative that some people prefer is to take a 5" x 12" deep penetrating flexible mat and place it crosswise the length of the body, and on top of this flexible mat place five mini block magnets. These mini block magnets are placed crosswise the two inner rows of magnets (inside the flexible mat), this places them an inch and a half apart and provides a deeper penetration to treat both heart and lungs.

In case of infections use the seventy-magnet bed. For one to three months also go back on the bed for 1 hour four times per day. Also use the positive magnetic field of a 2" x 5" x 1/2" ceramic magnet on the thymus gland for four half-hour periods during the day.

Calcium deposits are treated with suitable magnets that will penetrate deep enough. Most of the time this will require a ceramic magnet or three to four plastiform magnets stacked together.

Amyloid deposits are treated with magnets that are suitable to penetrate to tissues. Most of the time a minimum of 1/2" thick ceramic magnets will need to be used. Specific magnets would have to be arranged depending on the depth of the deposits.

Nutrients Recommended

- Vital Life Multi-Element Buffered Vitamin C Powder. This powder contains vitamin C, calcium, magnesium, zinc, manganese, copper, quercetin potassium and reduced L-glutathione. A minimum of one-half teaspoon, or a maximum of one teaspoon twice a day is quite useful.
- Vital Life Multi-Vitamin with Chelated Minerals. This provides a broad-spectrum supply of vitamins and chelated minerals. Take one tablet, twice daily.
- Vital Life Chromium Picolinate Plus. One daily is the recommended dosage.
- It is recommended that the monitoring physician be responsible for the nutrition. It is very important that B complex vitamins be evaluated, especially thiamin, B_{12} and folic acid. Vitamins, minerals and amino acids should be assessed and treated according to the deficiency.

Alkaline Micro Water

Alkaline micro water helps materially to maintain the body's normal alkaline state. Also, being micro water, it enters into the cells of the body more readily than the usual water. This also carries a negative magnetic field as well as being alkaline. The Singer Electrolysis Instrument is used for producing the alkaline micro water. At least five glasses of the water should be ingested each day.

4-Day Diversified Rotation Diet General Information

A local and systemic biological response of acidity is routinely evoked when symptoms develop in response to

exposure to foods, chemicals and inhalants. Acidity also produces low oxygen (acid-hypoxia). This is true whether the maladaptive symptom reactions are immunologic or non-immunologic in origin. Most food symptom reactions are not immunologic. Immunologic and non-immunologic food symptom reactions have a classic addictive seesaw biologi- cal response of symptom relief on exposure, with the emergence of symptoms 3-4 hours after the exposure (addictive withdrawal phase). The optimum method of reversing addiction is avoidance. In food addiction, the optimum method of avoidance of the addiction is for there to be a 3-month avoidance followed by an exposure no more often than every fifth day. This is the reason for the 4-Day Diversified Rotation Diet. The short-term management of symptoms can be managed by alkalinization, which can be produced by bicarbonate alkalinization and more optimally, exposure to a negative magnetic field, which alkalinizes and oxygenates (alkaline- hyperoxia). These alkalinization methods can relieve symptoms after they have occurred from the exposure and can also prevent symptoms from developing when the alkalinization methods are used prior to an exposure to symptom producing foods, chemicals and inhalants.

The Following is the Optimum Method of Preventing Symptoms form Occurring from Foods:

1. **A 4-Day Diversified Rotation Diet.** This four-day spacing of exposure to specific foods prevents food addiction.

2. **Pre-meal negative magnetic field exposure.** One-half hour before the meal place the magnets on the body. Magnetic discs, either ceramic discs (1-1/2" x 1/2") or neodymium discs (1" x 1/8") placed bitemporally. These can be held in place with a 2" x 26" wrap. Place on the sternum, a 4" x 6" x 1/2" ceramic magnet. Hold in place with a 4" x 52" wrap. An added value can result from placing a 4" x 6" x 1/2" ceramic magnet on the epigastric area, held in place with a 4" x 52" wrap. Place on the thoracic spine a large sized double strength flexible mat; this flexible mat can be held in place with the same 4" x 52" wrap that is supporting the 4" x 6" x 1/2" ceramic on the epigastric area. These can be removed at the beginning of the meal or they can be continued through until the meal is finished. If symptoms emerge after the meal has been eaten, then replace the magnets until the symptoms leave. Especially place a suitable sized

magnet directly over the symptom area. Also prior to the meal, if there are any symptom areas, treat these with appropriate sized magnets, pre-meal. Always use the negative magnetic field.

3. **Post-meal, if any symptoms develop then use suitable magnets placed locally for relieving these symptoms.** It could be helpful again, to place the ceramic disc magnets bitemporally. Bicarbonate alkalinization is useful one-half hour after the meal, use multi-element mineral ascorbate powder. Take 1/2 teaspoon of multi-element mineral ascorbate powder and 1/2 teaspoon of soda bicarbonate in 1/2 a glass of water. The bicarbonate alkalinization is not likely to be needed when the magnets are used.

The above pre-meal and post-meal alkalization method is recommended for:

• Those with a serious state of symptoms reactions to multiple foods in which food rotation is not entirely satisfactory.

• When of necessity, symptom-evoking foods have to be eaten, such as when eating out at a restaurant, or those that have to use this method instead of waiting three months for the reintroduction of their foods.

In my experience, the above method of basic food rotation diet with the addition when necessary of the magnetic pre-meal exposure and the magnetic post-meal exposure is superior to any neutralization method. Neutralization methods do not honor the fact that the basic problems are addiction and acidity (acid-hypoxia). A food rotation diet is necessary to honor the fact that addiction is the major driving force of food maladaptive reactions and that acid-hypoxia is the immediate cause of symptoms. There is no optimally effective method for the management of maladaptive reactions to foods that is equivalent to food rotation.

General Information About Magnets

Double strength flexible mats are composed of two stacked plastiform magnet strips measuring 1 x 7/8" x 1/8". These plastiform magnetic strips are placed in four rows with the 1-1/2" measurement lengthwise in the flexible mat. In a 5" x 6" flexible mat there are 24 magnetic strips. In a 5" x 12" flexible mat there are 48 magnetic strips. The flexibility of these mats makes them very useful since they will fit around the curves of the body without producing any pressure. The therapeutic level of this

flexible mat extends to about two inches. When the flexible mat is reinforced with one row of mini block magnets placed crosswise on the two central rows of magnets in the mat, the therapeutic field extends to three inches. This places the mini block magnets an inch and one half apart in which there are three placed on the 5" x 6" flexible mat and six placed on the 5" x 12" flexible mat. The flexible mat can also be reinforced by the 4" x 6" x 1/2" ceramic magnet, this extends the therapeutic value to five inches.

Mini block ceramic magnets are sometimes called Briggs blocks because they are used as the Magneto magnets in a Briggs and Stratton gasoline engine. These magnets measure 1-7/8" x 7/8" x 3/8", and they have many therapeutic uses. They can be used on the head, in such areas as the temporal, frontal or occipital areas, for headaches, management of emotional symptoms or seizures. They can be used on fingers or toes. They can be placed on top of the flexible mats to reinforce the depth of magnetic field penetration. They can be used directly on the joints, under or incorporated into wraps around the joints. They are used in the magnetic slumber pads, the multiple purpose pads, and in the chair cushion pads.

Ceramic discs measure 1-1/2" x 1/2", and have numerous valuable purposes. They can be used around the head to treat headaches or other central nervous system symptoms, around joints, over skin or on subcutaneous lesions. The magnetic field of a ceramic disc extends to eight inches. The magnetic field therapeutic value extends to about two and one half inches. 4" x 6" x 1/2" ceramic magnets have a therapeutic magnetic field value that extends for five inches. A ceramic magnet that is 4" x 6" x 1" has a therapeutic value extending to eight inches. The 4" x 6" x 1/2" ceramic magnet has many uses such as around joints or to penetrate deeply into the liver, internal organs, the heart, or into the head such as for treatment of tumors. The 4" x 6" x 1" ceramic magnet are used in the headboard-type magnetic sleep enhancer in order to have a field that penetrates into the head during sleep. The magnetic sleep enhancer is composed of four 4" x 6" x 1" ceramic magnets placed in a row 3/4" apart. These ceramic magnets are placed upright in a wooden carrier that holds them firmly up against the headboard. They can be raised or lowered depending on the height of the pillow. They are shipped at the top of the carrier and needs to

be lowered so that the head is in the magnetic field. They are resting on a wooden dowel. The wooden dowel they are resting on should be at the level of the back of the head when the head is on the pillow. The closer the top of head is to the magnets in the carrier at the head of the bed, the better.

The magnetic slumber pad is composed of ceramic mini block magnets that are placed an inch and one-half apart throughout the pad.

The magnetic chair cushion pad is composed of ceramic mini block magnets placed an inch and one-half apart throughout the seat and back of the pad.

The multiple purpose pads [small (11" x 17") and large (14" x 25")] are composed of ceramic Mini Block magnets that are placed an inch and one-half apart throughout the pad. This multiple purpose pad has many uses such as being used on the back, the abdomen, and up over the heart and on the chest area.

Polarity

Always use the negative magnetic field only. With one exception, when infections or cancer are present a positive magnetic field treatment using the 2" x 5" x 1/2" ceramic magnet for one half hour four times during the day. This is used in order to optimize thymus function. This would be used for the first three months of treatment only.

Beyond Magnetism

An acute maladaptive reaction to foods, chemicals, or inhalants has been documented as producing a brief state of acid-hypoxia. In this state there is a production of acid and a failure to process properly the end products of oxidation phosphorylation metabolism. In this state of acidosis, oxygen content is reduced. Maladaptive reactions to foods are the most frequent cause of bouts of acidosis. Degenerative diseases are noted for their acid-hypoxic state. Therefore every effort should be made to maintain a normal alkalinity and normal oxygen state.

Majorities of people are maladaptively reacting to foods in one or more ways, thus producing bouts of acidosis and reduced oxygen. It is the better part of wisdom to follow a 4-Day Diversified Rotation Diet. This program leaves out foods that are used as frequently as twice a week or more for a period of three months. This is based on the assumption that these foods are being reacted to in some way. It is the frequency of the use

that produces the maladaptive reactions. A 4-Day Diversified Rotation Diet is set up to leave out these frequently used foods. After three months, these frequently used foods can be returned to the diet, usually without any symptoms being produced.

All addictive substances should be abandoned such as addictive drugs, alcohol, tobacco and caffeine (coffee, tea with caffeine, chocolate, and soft drinks containing caffeine). Addiction is acidifying.

Carbonated soft drinks are acid producing and should be rarely used. Soft drinks are sweetened with corn sugar (in the US) and if they are ingested they should be limited to the corn rotation day.

In order to maintain an adequate alkaline state, it is necessary that the minerals that are used in the bicarbonate buffer system be in adequate supply. These are the minerals calcium, magnesium, potassium, and zinc. There are several proprietary preparations that contain these minerals associated with vitamin C as ascorbates. The preferred source of alkali minerals is multi-element mineral ascorbates by Klaire Lab. Use 1/2 teaspoon to 1 teaspoon of one of these powders in one-half glass of water, two times a day. The preferred time to take the alkaline minerals is in the morning on arising and again before going to bed at night. When using this mineral alkaline water, place it on the negative magnetic pole of a 4" x 6" x 1/2" magnet for a minimum of five minutes. This will charge up the water and the oxygen in the water with a negative magnetic field, which will help the body maintain its normal alkaline state.

There is a valuable method of electrolysis, which provides alkaline micro water that has an alkaline pH. There is a home electrolysis unit (The Singer Electrolysis Instrument) that provides this alkaline micro water. It is recommended that five glasses of the alkaline micro water be ingested daily.

How to Find Help
Medical Supervised Research

The objective Observations of the value of magnetic therapy for numerous medical conditions demonstrates what is usually considered to be "too good to be true". Indeed, magnetic therapy deserves definitive, controlled research following all the guidelines of the FDA. This research has been in process under the supervision of William H Philpott, M.D. and other independent research organizations as well as NIH grant-

sponsored researches. The research under William H. Philpott, M.D. requires a local physician to be following the patient. A physician and patient provided Dr. Philpott with a definitive diagnosis and the physician and patient both agreed to be reporting at least 3 times a year to Dr. Philpott. Dr. Philpott provided a magnetic research protocol giving the details of the magnets used. This was a home treatment. The information obtained was part of a statistical study in preparation for publication in peer reviewed medical journals.

Self-Help Magnetic Therapy

William H. Philpott, M.D. had since 1995 prepared The *Magnetic Health Quarterly* that range widely on specific subjects. These quarterlies described magnetic treatment that can be adapted to self-help. Also, there is a series of magnetic protocols describing in general terms treatment of specific conditions but not for a specific person. It is ethical to obtain this information that lends itself to self-help use. There is no restriction in the purchase of magnets. When a person does self-help it is his/her responsibility. The application of magnets has been classified by the FDA as not being harmful. There is misuse of the magnets that can be made, such as using the positive magnetic pole for an extended period of time. Although this does not injure cells, it is acidifying and would not be healthy for long-term use. The cost of self-help is the purchase of self-help information on the appropriate subject. Self-help materials by W.H. Philpott, M.D. that are available are:

1. The book *Magnet Therapy* by AlternativeMedicine.com
2. The book *Brain Allergies* by Keats Publishing
3. The book *Cancer: The Magnetic/Oxygen Answer*
4. Magnetic Health Quarterlies
5. Individual magnetic protocols

Otherwise, the cost of self-help is the cost of the magnets. In doing self-help, the person obtains the general information and decides without any coaching from anyone, what magnets they want to use and how they want to apply them based on the general information they have received. Many people are admirably helping themselves. It is always wise that major illnesses be under the supervision of the medical research program.

Many of the specialized alternative medicine physicians that examine broadly for maladaptive reactions to foods,

chemicals and inhalants as well as examining for toxicities and nutritional needs belong to the American Academy of Environmental Medicine Society and American College for Advancement of Medicine. Magnetic therapy as outlined in this quarterly needs to be incorporated into the environmental medicine-toxicology-nutritional program in order to achieve optimum results. Some of the physicians upon referral from W.H. Philpott, M.D. served as monitors for Dr. Philpott's magnetic research project. If possible first engage your local physician to monitor the magnetic research project.

American Academy of Environmental Medicine
http://www.aaemonline.org/referral.php
American College for Advancement in Medicine
http://www.acam.org/

Final Word

The valuable information that my observations contribute to the cause and treatment of Alzheimer's is that the deposits of insoluble amino acids forming amyloid plaques as an acid process. Thus also the resolution of amyloid plaques can be achieved by a negative magnetic field alkaline-hyperoxia response inherent as a biological response to a negative magnetic field. This is indeed good news as this sets the stage for a logical prevention and treatment of Alzheimer's. The prevention of Alzheimer's includes the stopping of any source of acidification. The most prominent source of acidification is maladaptive food reactions. Maladaptive reactions to chemicals and inhalants are also acidifying. Addictions to foods and allergies to foods are the major source of the episodic acidification that leads to the formation of insoluble amino acid gels.

Beyond stopping these sources of acidification the treatment is that of a sustained negative magnetic field in which the amino acids will become soluble and the other toxic substances including heavy metals will be detoxified and also processed out of the body.

It has been abundantly, objectively, observed that any symptoms of Alzheimer's can be observed in deliberate test exposures to foods, chemicals and inhalants in susceptible subjects. The cause of the maladaptive reactions are such as addictions, immunologic reactions, and hypersensitive reactions or some other basis (some of which are not now

understood). It has been found that some of these maladaptive reactions simply mimic Alzheimer's disease. When in fact this is more than mimicking Alzheimer's disease this is a demonstration of the cause of Alzheimer's disease. Whenever an area is acidic due to a maladaptive reaction symptoms are produced which cause harm to that area of the brain. When these symptoms do occur there is laid down some insoluble amino acids due to the acidity. Therefore, these observable reactions that mimic Alzheimer's are in fact why Alzheimer's exists in the first place. These reactions are simply the reason why Alzheimer's develops.

The good news is that the cause of amino acid insoluble gelling is known. It is frequently repeated local brain acidity. The sources of acidity can be stopped. The most frequent source of acidity is maladaptive reactions to foods. Amino acid insoluble gels will become soluble in an alkaline medium. A negative magnetic field with its biological response of alkaline-hyperoxia can reverse the insoluble amino acid gel.

The observation of a negative magnetic field exposure to the brain with its production of alkaline-hyperoxia is observed to materially reverse the early symptoms of Alzheimer's disease. Long-term studies will be needed to demonstrate the degree of reversibility of the chronic late stage of Alzheimer's disease.

A remarkable book *Beating Alzheimer's: A Step Towards Unlocking the Mysteries of Brain Diseases*[11] is a required read for everybody dealing with this disease. This is the fascinating story of recovery from an early stage of Alzheimer's. The necessity of assessing and therapeutic honoring of maladaptive reactions (immunologic, non-immunologic, and toxic) to environmental substances is objectively depicted. The reversibility of Alzheimer's disease, especially the early stage, is obvious.

References

1. Davis, A.R. and Rawls, W. *The Magnetic Effect* (Kansas City, MO: Acres USA, 1975

 Davis, A.R. and Rawls, W. *Magnetism and Its Effect on the Living System* (Kansas City, MO: Acres USA, 1976)

 Davis, A.R. and Rawls, W. *The Magnetic Blueprint of Life* (Kansas City, MO: Acres USA, 1979)

2. Becker, Robert O. and Marino, A. *Electromagnetism and Life* (Albany, N.Y.: State University of New York Press, 1982)

Becker, Robert O. and Seldon, G. *The Body Electric (N.Y.:* William Morrow and Co., 1986) Becker, Robert O. *Cross Currents* (Los Angeles, CA: Jeremy P. Tarcher Inc., 1990)

3. Cohen, Elwood. *Alzheimer's Disease* (Los Angeles: Keats Publishing, 1999)

4. Klonowski, W. and Klonowski, M. "Aging Process **and** Enzymic Proteins." *Journal of Bioelectricity* Vol. 4, Issue 1, 1985, pp. 93-102.

5. Adams, Raymond; Victor, Maurice and Ropper, Allan. *Principles of Neurology, Sixth Edition (N.Y.:* McGraw-Hill Publishers, 1997), pp. 1049-1057.

6. Casdorph, Richard and Walker, Morton. *Toxic Metal Syndrome* (Garden City Park, N.Y.: Avery Publishing Group, 1995), pp. 41-50.

7. Harbison, Raymond. *Industrial Toxicology* (St. Louis: Mosby, 1998), pp. 17.

8. Randolph, T.G. "The Enzymic and Hypoxia, Endocrine Concept of Allergic Inflammation" *Clinical Ecology* (Springfield, IL.: Charles C. Thomas Publisher, 1976) pp. 577-596.

9. Philpott, William H. and Kalita, Dwight K. *Brain Allergies: The Psychonutrient and Magnetic Connections, Second Edition* (Los Angeles: Keats Publishing, 2000)

Philpott, William H. and Kalita, Dwight K. *Magnet Therapy* (Tiburon, CA.: AlternativeMedicine.com, 2000)

10. Fyfe, William S. "Oxidative Remnant Magnetism." (Chicago: Encyclopedia Britannica, Inc., 1986) Vol. 24, pp. 200.

11. Warren, Tom. *Beating Alzheimer's* (Garden City Park, N.Y.: Avery Publishing Group, 1991)

Other References

Fersht, Alan. *Enzyme Structure and Mechanism, Second Edition (N.Y.C.:* W.H. Freeman and Co., 1994)

"Magnetic Fields in Enzyme Catalysis." (Chicago: Encyclopedia Britannica, Inc. 1986) Vol. 15, pp. 1068.

Perlmutter, David. *BrainRecovery.com* (Naples, Florida: The Perlmutter Health Center, 2000) Stein, Jay, etal. *Internal Medicine, Fourth Edition* (St. Louis: Mosby, 1994) pp. 968-969, 1060-1062, 2511, 2835-2836. [*Magnetic Health Quarterly* "Alzheimer's Disease and Amyloidsis," Vol. VII, 1st Qtr, 2001]

CANCER : THE CAUSE, PREVENTION AND REVERSAL

THE CANCER SCOURGE

Cancer is a major cause of death in the United States. Cancer is the leading cause of death in the United States under the age of 54. Cancer incidence increases with age. So far, there has been no completely effective method of preventing or controlling cancer incidence. In the past 36 years, cancer has increased 36%. Two leading contributing factors to cancer are smoking and diet. Colorectal cancers are the most common cause of cancer in the industrial world. Less than one-third of the patients with colorectal cancer will survive five years. Surgery is the most effective treatment for colorectal cancer while chemotherapy is disappointing. Breast cancer was the leading cause of death in women until recently when it was surpassed by lung cancer. Lung cancer is the leading cause of death of both men and women in the United States. Cigarette smoking is the major cause of lung cancer. Skin cancer is the most common type of malignancy. Seventy-three percent of deaths from skin cancer are from melanomas. Prostate cancer has a high incidence in men.

CANCER PREVENTION MEASURES

There are methods that are under voluntary control which can reduce the risk factors of developing cancer. They include such as 1) no use of tobacco, 2) no use, or moderate use of alcohol, 3) optimum nutrition associated with a high fiber diet, 4) optimum exercise, 5) prevention of sunburn or even prolonged exposure to sunshine, 6) prevent, and or, reverse symptom maladaptive reactions to foods, chemicals or inhalants.

Prevention and reversal of maladaptive reactions to foods, chemicals and inhalants has, up to the present, been a neglected area. The reason for this neglect is that knowledge of the mechanism of disordered physiology has not been widely documented in medical research and therefore physicians remain largely uninformed on the subject. I have observed that these maladaptive reactions consist of 1) immunologic reactions, 2) oxidoreductase enzyme inhibition state, 3) oxidoreductase enzyme deficiencies, 4) addiction withdrawal reactions, 5) reactions to toxins. The common denominator biological response to all of these maladaptive reactions is observed to be the production of acid and the reduction of oxygen (acid-hypoxia). This is highly significant since cancer can only develop in a tissue state of acid-hypoxia. Tissue injuries are also acid-hypoxic. Insect sting and reptile bites are also acid-hypoxic. Microorganism infections (viral, fungal, bacterial, parasitic) are also acid-hypoxic. Since cancer can only develop in acid-hypoxic tissues, any state producing acid-hypoxia is cancer-promoting.

IS CANCER MULTIPLE DISEASES OR A SINGLE DISEASE?

Traditionally cancer is viewed as multiple diseases with multiple causes and requiring multiple types of treatment for reversal. The reason for this is that there are multiple known carcinogens, multiple promoting causes, multiple tissue types of cancer and no single therapy (chemotherapy, hormone or surgery) effective in all cancers.

The view that I have been lead to accept is that cancer is a single disease with a single common denominator cause and a single effective treatment. The single common denominator cause is acid-hypoxia and the single correction of acid-hypoxia is its replacement with alkaline-hyperoxia. Otto Warburg (1) was given a Nobel prize for demonstrating that acid-hypoxia is the condition necessary for cancer to develop and grow. Others have confirmed this (2, 3). Otto Warburg considered that there was no disease whose cause was better known. Despite the fact that his findings are well-published and that he considered the correct treatment for cancer was the reversal of acid-hypoxia and that these presentations were made at well-established cancer research organizations such as the National Institute of Cancer, his findings have not substantially influenced medical cancer research. This research continues to look for the toxic agents that can kill cancer before it kills other human cells and to otherwise destroy the cancer by physical means or surgically remove it.

M. Rose (4) observed that the energy concentrated by the body to heal or regenerate a limb in a small animal is the energy that heals cancer. This was discovered by implanting cancer at the joint of the limb of a small animal that is known to regenerate a limb and cutting this area. When the regeneration of that area occurred, the cancer died.

Arthur Trappier, etal (5) demonstrated that cancer cells exposed to a negative (south-seeking) magnetic field discourages the growth of cancer. Cancer cells exposed to the positive (north-seeking) magnetic field encourages the growth of cancer.

Robert O. Becker (6) demonstrated that it is a negative electromagnetic field (negative magnetic field) that is necessary for healing to occur. The body concentrates a negative (south-seeking) magnetic field at the site of injury for healing. An external field from a static field permanent magnet or a static field from an electromagnet of this same negative (south-seeking) magnetic field will produce

the same results as the body concentrating the negative (south-seeking) magnetic field at the site for healing.

A negative (south-seeking) magnetic field acts directly on the bicarbonate buffer system by which a normal alkaline state can be maintained. A negative (south-seeking) magnetic field serves as an energy activator for the oxidoreductase enzyme system which processes free radicals, peroxides, acids, alcohols and aldehydes. A negative (south-seeking) magnetic field releases oxygen from its bound state in these products. A negative (south-seeking) magnetic field provides the necessary alkaline-hyperoxia that is required to reverse cancer.

The normal human cell produces its adenosine-triphosphate (ATP) energy bond by oxidative phosphorylation which is alkaline and molecular oxygen (alkaline-hyperoxia) dependent.

The cancer cells, no matter what type of tissue cells these may be, produce their ATP by fermentation which is acid-hypoxic dependent. Furthermore, fermentation cannot function in the presence of alkaline-hyperoxia. Thus, the answer for the reversal of cancer is the replacement of acid-hypoxia with alkaline-hyperoxia. This is what Otto Warburg says has to occur in order for cancer to be reversed.

The biological response to a static negative (south-seeking) magnetic field is the production of alkaline-hyperoxia. Thus, a continuous exposure of the static negative (south-seeking) magnetic field to a cancerous lesion reverses cancer. This is irrespective of the type of cancer this might be or what its initiating carcinogenic cause may be. This singular fact of replacing acid-hypoxia with alkaline-hyperoxia reverses cancer. My observations are that the cancer cells do not revert back to normal cells but instead they die. Tumors that are still present after treatment with the negative (south-seeking) magnetic field have been microscopically examined and found to be no longer neoplastic. If the tumor is a surface lesion, such as a melanoma, as the cancer tumor dies new skin will grow under the tumor and it will fall off. When microscopically examined, it is no longer carcinogenic.

GENERAL PRINCIPLE OF MAGNETIC THERAPY

Always use a negative (south-seeking) magnetic field. The higher the gauss strength, the better. The more continuous the magnetic exposure, the better. The longer the duration of exposure, the better.. Neodymium (ceramic or plastiform) magnets have higher gauss strength than the iron oxide plastiform magnets. The plastiform iron-

oxide or neodymium materials can be stacked to increase the gauss strength.

The size of the magnetic field needs to be larger than the lesion being treated. The larger the magnetic field, the deeper its penetration.

PLACEMENT AND DURATION:

Place the negative poled field of a static field permanent magnet directly over the cancerous lesion. The magnetic field needs to be larger than the lesion being treated. The 4" x 6" x 1/2" ceramic magnetic field penetrates deep enough to treat internal organs. The duration is 24-hours a day for a minimum of three months and in some cases may need to be longer. There can be brief periods of removal for taking a bath, etc. When the cancerous lesion is in the upper abdomen, the magnetic field needs to be removed from the upper abdomen for 1 to 1-1/2 hours post-meal in order to allow for food to pass from the stomach to the small intestine and from the small intestine to the large intestine.

When sitting down, sit on a magnetic chair pad that has magnets in the seat and the back. Place under this seat a 4" x 6" x 1/2" magnet far enough back to radiate into the rectal/genital/pelvic area. During the waking period, place a 5" x 6" double magnet, multi-magnet flexible mat over the heart. This can be held in place by pinning it to the underwear or by placing two super neodymium disc magnets in separate places over the outer wear which would magnetically hold the mat in place.

At night, use the same pad placed across the face with the 5" extending from the forehead to the tip of the nose. This is held in place with a 2" x 26" headband. Place on top of this, directly over each eye, a super neodymium disc magnet which is "1 x 1/4". This will stimulate the retina of the eyes to produce melatonin. If there is any pressure in the eyes (glaucoma) then use a 5" x 12" double magnet, multi-magnet flexible mat with the super neodymium disc magnets placed on the side of this mat to the side of each eye.

It is wise to sleep with a magnetic multi-purpose pad which is 14" x 25" up over the abdomen, heart and chest. The wall of the intestinal tract is known to produce melatonin. Thus, this will encourage the production of melatonin.

At night during sleep, sleep on a negative poled magnetic bed pad. This magnetic bed pad is composed of mini-block magnets 1-7/8" x 7/8" x 3/8" placed an inch and one-half apart. Place on top of this an egg crate type foam pad. Also when asleep at night, have the head in a negative (south-seeking) magnetic field from a wooden

carrier that holds the magnets up against the headboard. There are four of these magnets that are 6" long, 4" wide and 1" thick placed in a row 3/4" apart. These magnets will not only provide deep, energy-restoring sleep but will stimulate the pineal gland to produce melatonin. Melatonin is very important in the prevention of cancer. The hormone melatonin is known to have anticancer values. Thus, we are encouraging the production of melatonin by the pineal gland, the retina of the eyes and the wall of the intestinal tract.

At night when asleep, also place a 5" x 12" double magnet, multi-magnet flexible mat across the low abdomen-pubic area. Center on top of this mat, a 4" x 6" x 1/2" magnet with the 6" lengthwise the body. This can be held in place with the 4" x 52" body wrap.

BEYOND MAGNETISM:

There should be no use of tobacco. No use of caffeine. No use of alcohol. The food should be rotated on a four day basis. This leaves out of the diet foods that have been eaten with a frequency of two or more times a week. These can usually be returned to the diet after three months if they are kept in this diet with a frequency of no more than once in four days. My booklet, *Health Strategies* describes the details of the 4 Day Diversified Rotation Diet and should serve as the guide for this diet. The reason for this diet is to stop episodes of acid-hypoxia that may be occurring in specific tissue which would encourage the development or spread of cancer. These maladaptive reactions also have a systemic acid-hypoxic affect. The goal is to keep the body, both local and systemically, in a state of normal alkaline hyperoxia in which cancer will not only be prevented but will die and be prevented from spreading.

GENERAL PRINCIPLES OF CANCER PREVENTION ORIENTATION:

All known substances that lead to cancer such as tobacco, alcohol, pesticides and industrial contaminants that are known to be carcinogenic are to be avoided as near as possible. No tobacco, alcohol or caffeine should be used. Many of the non-steroidal anti-inflammatory agents that are used for pain or inflammation suppress the production of melatonin and should not be used. They especially should not be taken at night before going to bed since this would suppress the production of melatonin. As near as possible, pains, inflammatory reactions and infections should be appropriately treated with a negative (south-seeking) magnetic field . Nutrition should be made optimum and it would especially be valuable to rotate into the diet essential and unsaturated fatty acids from a variety of sources.

Not only should there be a systemic treatment that keeps the body in its normal alkaline-hyperoxic state, but also especially treat the most vulnerable areas of the body known to develop cancer.

Local treatment for vulnerable areas:

During the waking state, it would be wise to sit on a magnetic chair pad that has magnets in the seat as well as the back. During the waking state, it would be wise to wear a 5" x 6" double magnet, multi-magnet flexible mat over the heart.

Sleep is the most convenient time to treat local areas for a period of hours. It is also the most logical time to treat these areas since this is the time when melatonin is raised. Melatonin is only made at night in the dark where there is no 60 cycle per second electric pulsation. Therefore, there should be total darkness. If this cannot be provided then place a pad over the forehead and the eyes to prevent light from entering the eyes or being on the forehead. There are three areas where melatonin is made. One is the pineal gland in the center of the head. Another is the retina of the eyes and a third is the wall of the intestinal tract. These can all be treated at night during sleep. The pineal gland is treated by having magnets in a carrier up against the headboard, thus providing radiation of a negative (south-seeking) magnetic field into the head which is known to stimulate the pineal gland to produce melatonin. Treating the eyes with a magnetic eye treatment unit will also encourage the production of melatonin by the retina of the eyes. The Vitality Sleeper up against the headboard will have a magnetic field that penetrates into the head and stimulates the pineal gland to produce melatonin and the hypothalamus to produce growth hormone. Some sleep very well with a 4" x 6" x 1/2" magnet up against the side of the head. It is best to cushion this by placing a 5" x 6" double magnet, multi-magnet flexible mat up against the side of the head first with the 4" x 6" x 1/2" magnet over the mat. When laying on the back, this can be leaned up against either side of the head. When laying on the side it can be on the side of the head that is not on the pillow or be placed on the back of the head. Some find it valuable to place a 5" x 12" double magnet, multi-magnet flexible mat under the pillowcase so that their head is resting on this mat. If they are on their back it is on the back of the head. If they are on their side, it is on the side of their head. The value can be further increased by reinforcing this mat with six mini-block magnets placed on the positive (north-seeking) pole side. Place these mini-block magnets crosswise the mat 1-1/2" apart. They will magnetically adhere to the mat. The intestinal tract

can be stimulated to produce melatonin by two methods. One is to place over the abdomen a 14" x 25" magnetic multi-purpose pad. It can thus cover the pelvic area, the abdominal area, the lungs, breasts and heart. It is well to sleep with this over these areas. Even when turning on the side, it can still be kept near to these areas. The subject should also sleep on a magnetic bed pad. Over this bed pad should be placed an egg crate type foam pad. If the breasts have any sore areas, they should also be treated during the daytime by using a 5" x 6" or a 5" x 12" double magnet, multi-magnet flexible mat. It would be well to place a super neodymium disc magnet on top of this mat directly over the sore area or a ceramic disc which is 1-1/2" x 3/8" on top of the mat directly over the sore area.

THEY WERE RIGHT

Otto Warburg was right in his assessment that cancer requires fermentation in an acid-hypoxic medium in order to develop. Otto Warburg was right in stating research in cancer prevention and reversal should focus on alkaline-hyperoxia replacing acid-hypoxia. This is the same as saying that the biological abnormal production of ATP by fermentation needs to be replaced by the normal production of ATP by oxidative phosphorylation. Otto Warburg was right in assuming that fats could increase oxidation and thus reverse cancer.

Dr. Johanna Budwig was right in following up on Otto Warburg's work using cis levofats and levosulphur containing amino acids to increase oxidation.

M. Rose was right in observing that the magnetic energy concentrated in the body to heal and regenerate a limb in a small animal is the energy that heals cancer.

Robert Becker was right in observing that the positive electromagnetic field is the biological signal of injury and that the electromagnetic negative field governs healing. This magnetic negative (south-seeking) field healing effect also applies to cancer reversal (healing).

Albert Roy Davis was right in observing that the biological response of exposure to a negative (south-seeking) magnetic field is the production of alkaline-hyperoxia. Albert Roy Davis was right when he observed the reversal of cancer by exposure to a negative (south-seeking) magnetic field.

Kenneth McClain was right 22 years ago when he described to me the reversal of cancer with the use of magnetic field therapy. He phoned me stating he had some amazing findings he wished to describe to me. I was passing through New York City with a layover

between planes. He came to the airport and enthusiastically described to me the reversing of cancer using static field magnetics. I was not researching cancer at the time and had no idea I would later be researching the application of magnetics to cancer. I treated his information with curiosity but also with indifference. Thus, I can appreciate those scientific researchers and lay persons who respond to hearing about magnetic therapy as an interesting curiosity but only worthy of indifference. We have all been wrong and Otto Warburg was right. The cure for cancer is the replacement of acid-hypoxia with alkaline-hyperoxia.

Arthur Trappier, etal, were right when they demonstrated that cancer cells exposed to a negative (south-seeking) magnetic field discourages the growth of cancer and that cancer cells exposed to a positive (north-seeking) magnetic field encourages the growth of cancer. This is a peer reviewed medical journal article and thus a scientifically acceptable objective observation. Thus, we do have a peer review medical journal article indicating that a negative (south-seeking) magnetic field is capable of reversing cancer. A negative (south-seeking) magnetic field has been proven to reverse cancer. My objective observations confirm this.

NEGATIVE STATIC MAGNETIC FIELD FORMULATION FOR TREATING CANCER

1) The biological response to a negative static magnetic field activates the bicarbonate buffer system as well as energy actives oxidoreductase enzymes to release molecular oxygen from its bound state in free radicals, peroxides, acids, alcohols and aldehydes thus, producing alkaline-hyperoxia which in turn inhibits acid-hypoxia fermentation production of ATP with alkaline-hyperoxia production of ATP by oxidative phosphorylation.

2) Under the biological conditions of alkaline-hyperoxia, the acid-hypoxia dependent cancer cells die. My observation microscopically confirmed that cancer cells do not revert back to normal, but instead, die.

3) The direct application of a static negative (south-seeking) magnetic field from either a static field permanent magnet or an electromagnet kills cancer cells. This treatment produces no toxicity and in fact processes toxins and does not produce any symptoms.

4) The negative (south-seeking) magnetic field has to be larger than the lesion being treated.

5) The negative (south-seeking) magnetic field needs to be near continuous exposure.

6) The minimal time for cancer reversal under treatment with a negative (south-seeking) magnetic field is three months. Some require longer. This has especially been noted after injury from x-ray treatment.

7) Cancerous tumors that have been killed by a negative (south-seeking) magnetic field are not always absorbed and may show on MRI or x-ray tests. These tumors are dead and there is no need to remove them surgically. Several have been removed after magnetic therapy and found to be non-malignant.

8) The use of cis levofats and levosulphur containing amino acids can complement negative (south-seeking) magnetic field therapy for cancer.

The 4 Day Diversified Rotation Diet provides an assortment of sources of essential unsaturated fatty acids. These unsaturated fatty acids should be either cold-pressed or unprocessed. Some of these sources include flax seed oil (linseed oil), walnut oil, pumpkin oil, soy oil, fish oils, evening primrose oil, and so forth. These cis unsaturated fatty oils refract light counterclockwise, the same as a negative (south-seek-ing) magnetic field. Therefore, cis essential fats provide the same oxidation value as a negative (south-seeking) magnetic field. Cis fats and a negative (south-seeking) magnetic field complement each other. To achieve their optimum value, these essential fats also need sulphur-containing proteins. Some of the most valuable sources are cottage cheese, yogurt, and ricotta cheese. Whenever the rotation day calls for these, one or the other of these should be used if they are tolerated. Ricotta cheese is the most tolerated of these dairy products.

9) Any system or combination of systems that a) replace acid-hypoxia with alkaline-hyperoxia, b) optimizes nutrition, and c) detoxifies toxins is capable of killing cancer. Negative static magnetic field therapy alkalinizes, oxygenates, reverses the reduced end-products of oxidation production of superoxides, peroxides, acids, alcohols and aldehydes, detoxifies and thus kills cancer. Beyond magnetic therapy, nutrition needs to be optimized.

CASE HISTORY EVIDENCE OF VALUE

An M.D., anesthesiologist, knew he had chronic hepatitis from an accidental needle stick from a patient with hepatitis. His abdomen was rapidly enlarging and he was becoming weak. An oncologist diagnosed him as having cancer of the liver and spleen. The lesions were so large they were meeting in the middle. Fetoprotein was

present with a high titer. He was offered no help due to the extent of liver involvement. He was given an estimated 5-6 months of life.

He read the chapter on magnetics in the book, *Alternative Medicine,* by Future Medicine Publishers (1993). He called my office but I was out of town. He proceeded on his own to purchase two 4" x 6" x 1/2" ceramic magnets . He placed one over the liver and one over the spleen. I had no contact with him until several months later when he called to thank me for the information on magnetics which reversed his cancer. The liver and spleen had receded. The fetoprotein had completely disappeared. His energy had returned and he had not missed as much as a day of work. His comment was, "my fellow physicians will have a hard time believing this". This occurred seven years ago. Being a physician, he proceeded to help himself with no more than information on magnetics in a chapter in a book. I advise all cancer patients to be under medical supervision and be a party to a research project following FDA guidelines.

WHERE DO WE GO FROM HERE?

1. I am convinced that magnetic therapy for cancer will become established as a first choice. This will require sufficient, tightly controlled research statistics which are published in peer review journals. This is a prolonged and costly endeavor which is in process. Current studies provide convincing information giving the rational for direction but have too many variables to satisfy critics.

2. Single isolated (non-metastatic) lesions are easily treatable with a high degree of success.

3. Obstructional lesions and metastatic lesions limit success.

4. Does a higher gauss strength than available from static field permanent magnets reduce the time and or frequency of the treatments? There are studies in progress using a higher gauss strength produced by an electromagnetic to determine if an hourly, daily, several times a day or week, or an all night treatment can be used to successfully treat cancer.

5. I fondly hope that the degree of understanding that we have and its success we have observed will inspire multiple efforts by multiple well-funded research projects to venture into magnetic research for the prevention and reversal of cancer.

6. A 4 Day Diversified Rotation Diet leaving out foods used as often as twice a week for the first three months will materially reduce maladaptive food reactions. This will support the immune

system. See *The Ultimate Diet* Quarterly by William H. Philpott, M.D.

7. Nutrition should be optimized by supplementation.

8. Brain tumors can be treated with the Magnetic Brain Tumor Unit.

9. Multiple metastasis can be treated with the 70 magnet bed.

WHAT MAGNETIC THERAPY IS

Magnetic therapy is magnetic-electron-enzyme catalysis therapy. Static magnetic fields move electrons which rotate resulting in a magnetic-electron energy field. Static negative magnetic field electrons spin in a 3-dimensional spiral counterclockwise rotation. In a static positive magnetic field, electrons spin in a 3-dimensional spiral clockwise rotation. A positive magnetic field energizes acid-dependent enzymes. A negative magnetic field energizes alkaline-dependent enzymes. Biological response to a positive magnetic field is acid-hypoxia. Biological response to a negative magnetic field is alkaline-hyperoxia. Alkalinity maintains calcium and amino acid solubility and reverses insoluble deposits of calcium and amino acids in such as arteriosclerosis, spinal stenosis, around joints, amyloidosis, Alzheimer's, etc.

The energy activation of biological enzymes is magnetic therapy.

WHAT MAGNETIC THERAPY DOES

The biological response to a static positive magnetic field is acid-hypoxia. The biological response to the static negative magnetic field is alkaline-hyperoxia. Positive magnetic field therapy is limited to brief exposure to stimulate neuronal and catabolic glandular functions. Positive magnetic field therapy should be under medical supervision due to the danger of prolonged application, producing acid-hypoxia.

Negative magnetic field therapy has a wide application in such as cell differentiation, healing, production of adenosine triphosphate by oxidative phosphorylation and processing of toxins by oxidoreductase enzymes and resolution of calcium and amino acid insoluble deposits. Negative magnetic field therapy is not harmful and can effectively be used both under medical supervision and self-help application.

Some of the values of magnetic therapy are:

• Enhanced sleep with its health-promoting value by production of melatonin.

- Enhanced healing by production of growth hormone.
- Energy production by virtue of oxidoreductase enzyme production of adenosine triphosphate and catalytic remnant magnetism.
- Detoxification by activation of oxidoreductase enzymes processing free radicals, acids, peroxides, alcohols and aldehydes.
- Pain resolution by replacing acid-hypoxia with alkaline-hyperoxia.
- Reversal of acid-hypoxia degenerative diseases by replacement of acid-hypoxia with alkaline-hyperoxia.
- Antibiotic effect for all types of human-invading microorganisms.
- Cancer remission by virtue of blocking the acid-dependent enzyme function producing ATP by fermentation.
- Resolution of calcium and amino acid insoluble deposits by maintaining alkalinization.
- Neuronal calming providing control over emotional, mental and seizure disorders.

"Magnetic therapy has been observed to have the highest predictable results of any therapy I have observed in 40 years of medical practice." William H. Philpott, M.D.

THE ROLE OF MAGNETICS IN THE ENZYME FUNCTION

All biological enzyme functions (catalysis) in a living biological system are magnetic energized. There is a measurable catalytic remnant magnetism to enzyme function in live biological systems. Four oxidoreductase enzymes are needed to produce adenosine triphosphate (ATP) from foods. During these enzyme processes, there are two energies being made. One is ATP and the other is oxidation remnant magnetism. Both of these energies are used for the energy activation of enzymes. There are thousands of the enzymes, each with its own selective function. These are named according to their functions. Oxidoreductase enzymes are a family of enzymes with specific necessary functions. These enzymes have the following functional values. They produce ATP and catalytic remnant magnetism and they process the end-products of the metabolic process which are initially the free radical called superoxide which is oxygen with an added electron. If not rapidly enzymatically processed, it will produce peroxides, acids, alcohols

and aldehydes all of which are enzymatically toxic, that is inflammatory-producing.

In order for us to understand biological life energy, we must understand the starting point of that energy. Thus, we must understand the functions of oxidoreductase enzymes. We have enzymes and the substrates which they are processing. In the case of producing ATP, the substrate is a food. In the case of processing the toxins or inflammatory producing substances, the substrate are the free radicals and the products they produce. There exists a natural tendency for the enzyme and the substrate to join. These areas that have a biological attraction to join are called dipoles. However, this attraction all by itself does not produce enzyme action. These are simply the areas where the enzymes and the substrates do line up and join. Otherwise, there has to be an energy. This characteristically comes from static electrons that are in the body. They help move the enzyme and the substrate together. Once they move, now a magnetic field is created because this is what a magnetic field is all about. It is produced by the movement of electrons. Also, a magnetic field from an external source that is a static magnet field will also produce the movement of electrons. This is why an external source of a static magnetic field will cause the enzyme and the substrate to join because it is moving electrons.

The essence of static magnetic field therapy is the energy activation of enzymes to join substrates for catalysis. In the case of oxidoreductase enzymes, they are alkaline-hyperoxia dependent and do not require ATP for energy activation but do require a static negative magnetic field energy for catalytic activation.

ATP is an energy activator of many enzymes. In alkaline-hyperoxia, ATP dependent enzyme catalysis, a negative magnetic field is a co-factor with ATP as an enzyme energy activator. This is true for all human enzymes other than those of the mouth and stomach.

In acid-hypoxia dependent enzymes as well as transferaces, ATP and a positive magnetic field are energy co-factors. Invading microorganisms and cancer cells are acid-hypoxic dependent for making their ATP.

Thus, a static negative magnetic field strengthens the human cell alkaline-hyperoxic dependent energy state and defeats the acid-hypoxic dependent state of cancer cells and invading microorganisms (bacteria, viruses, fungi and parasites).

MAGNETIC DYNAMICS OF THE DEGENERATIVE DISEASE PROCESS

The central disorders of acute maladaptive reactions are: 1) acidity, and 2) oxygen deficit. Monitoring the biochemical disorders of chronic degenerative diseases reveals the same disorders as acute maladaptive reactions which is acid-hypoxia. Chronic degenerative diseases are observed to be acute maladaptive reactions extended in time to a chronic state with the resultant cellular damage. The contrast between the well cells of the healthy, functioning person and the sick cells of degenerative diseases provides valuable clues as to how magnetics can substantially aid in recovery of inflammatory degenerative diseases, infections from microorganisms and cancer.

In the process of oxidative phosphorylation producing adenosine triphosphate (ATP), molecular oxygen accepts an electron and becomes free radical oxygen (superoxide). If not immediately enzymatically reversed, superoxide proceeds to produce other free radicals, peroxides, oxyacids and aldehydes. These are all inflammatory. The oxidoreductase family of enzymes have the assignment of making ATP by oxidative phosphorylation and at the same time, processing the end-products of this oxidation phosphorylation process. This oxidoreductase family of enzymes are alkaline-hyperoxic-negative magnetic field activation dependent. When these 3 physiologically normal factors are not present, then cellular ATP is made by fermentation. The 3 factors necessary for fermentation to produce ATP are: 1) acidity, 2) lack of oxygen, 3) a positive static magnetic field as an enzyme energy activator. Human cells have the capacity to make ATP by either oxidative phosphorylation or fermentation. Cellular fermentation producing ATP only functions in the abnormal state of acidity and hypoxia. The enzymes catalyzing fermentation production of ATP are transferases which are acid-hypoxic-positive-static magnetic field activation dependent. Sugar is catalyzed by transferase producing ATP, alcohols, acids and carbon dioxide. Hydrolase enzymes catalyzes starches to sugars. Hydrolase also is acid-hypoxic-positive static magnetic field energy activation dependent.

A static magnetic field is the energy activator of all biological catalytic processes. When oxidative phosphorylation catalyzes the production of ATP this catalytic reaction makes negative static field magnetism termed oxidation remnant magnetism. This negative static magnetic field is available to energize

oxidoreductase enzyme catalysis and at the same time, block transferase and hydrolase catalysis. Besides the biological available negative static magnetic field from oxidation remnant magnetism, there is an always present electrostatic field (1). In an alkaline medium the electrostatic field produces a negative static magnetic field which energizes oxidoreductase catalysis. In an acid medium, an electrostatic field produces a positive static magnetic field which in turn energizes transferases and hydrolases. Both oxidation phosphorylation and fermentation catalysis are static magnetic field energized. However, they are energized by opposite magnetic poles. Oxidation phosphorylation is energized by a negative static magnetic field in an alkaline-hyperoxic medium. Fermentation is energized by a positive static magnetic field in an acid-hypoxic medium. A static magnetic field is required for the enzyme and the substrate to attach. A static magnetic field present during enzyme catalysis has been documented (2).

ATP made by fermentation with its acid-hypoxic medium cannot maintain human biological life energy. ATP made by fermentation can maintain the life energy of microorganisms such as bacteria, fungi, viruses, parasites and cancer cells. The secret to reverse acute maladaptive symptom reactions, prevent and reverse microorganism infections, maintaining human biological health and providing for the reversal of degenerative diseases is to maintain a normal alkaline body pH, hyperoxia and an adequate negative static magnetic field. The biological response to a negative static magnetic field can maintain these necessary components of healthy human cells. Thus it can be understood that exposure to an external source of a negative static magnetic field supports human health and materially aids in reversal of inflammatory degenerative diseases, cancer and the defense against microorganism invasion. This external negative static magnetic field can be applied to local affected areas as well as applied systemically by such as a negative static magnetic field bed.

1) *Encyclopedia Britannica*. Vol 15, page 1060. 1986 edition

2) Fersht, Alan. *Enzyme Structure and Mechanism*

ECOLOGY OF DIABETES MELLITUS TYPE II

Non-insulin dependent type II diabetes mellitus is caused by maladaptive reactions to foods. These maladaptive reactions to foods are IgG allergies and addictions. To a less extent, there are toxic reactions to environmental substances. These maladaptive

reactions to foods are determined by deliberate test meal exposures to single foods. Food allergy and food addictions are central to the cause of diabetes mellitus type II. The allergic or addictive reactions to foods cause cellular swelling in which insulin cannot do its job of transporting the sugar into the cells. The deliberate single test meal exposures to foods is preceded by five days of avoidance. The hyperglycemic reaction occurs within an hour of test exposure to a single food. When these hyperglycemic foods are removed, the diabetes no longer exists. After avoiding these foods for a period of three months, they can be placed in a four or seven day rotation diet. Ninety-five percent of the time, there will be no hyperglycemic or other symptom reactions occurring as long as the rotation diet is maintained. It is surprisingly easy and highly effective to manage type II diabetes mellitus with a four or seven day rotation diet. Diabetes mellitus is a systemic disease and therefore needs to be treated systemically with a strong negative magnetic field. To this systemic treatment, a local magnetic treatment is used for symptom management and local disease injury areas.

There is a magnetic method of treating the heart, liver and head for 30 minutes before a meal which prevents the maladaptive food reactions. With this pre-meal and during the meal magnetic exposure, the subjects start the rotation diet without a three month period of avoidance of hyperglycemic reactions to foods.

MAGNETIC CARDIAC RHYTHM PACER

Case History

An 83-year-old man with an irregular heart rhythm. There were two or more skipped beats per minute and runs of skipping every other beat. It required three months of 24 hour a day treatment of a negative magnetic field from a 4" x 6" x 1/2" magnet to permanently reverse the irregular pulse.

After reversing the irregular pulse, he wore a 4" x 6" x 1/2" magnet over his heart at night only. Occasionally, by the end of the day, his heart rhythm became irregular. Replacing the magnet over his heart would usually normalize the heart rhythm within 30 minutes. However, on occasion, it required up to three hours of continuous negative magnetic field treatment of the heart before it would nor-malize its rhythm.

FUNCTIONS:

The biological response to a negative magnetic field is alkaline-hyperoxia. A negative magnetic field attached to bicarbonates activates their alkalinity response. A negative magnetic field

activation of oxidoreductase enzymes releases oxygen from free radicals, peroxides, acids, alcohols, aldehydes and other enzyme toxins. Calcium and amino acids are soluble at the physiological alkalinity of the blood in body tissues and becomes insoluble deposits in an acid medium (Klonowski, W. and Klonowski, M. "Aging Process and Enzymatic Proteins," *Journal of Bio-Electricity*, Vol IV, Issue 1, 1985, pages 93-102). Atherosclerosis and arteriosclerosis are composed, among other things, as deposits of insoluble amino acid gels and insoluble calcium deposits. A negative magnetic field treatment of the heart achieves two goals, 1) the immediate response of replacing the symptom-producing acid-hypoxia with symptom-relieving alkaline-hyperoxia and, 2) with prolonged exposure of the heart to a negative magnetic field, resolving the acid-hypoxia produced insoluble residues of calcium, amino acids and other compounds. The sustained negative magnetic field with its alkaline-hyperoxia biological response, slowly reverses the insoluble deposits in arteries so that they are clear of obstructive deposits. Mechanisms of a negative magnetic field biological response of alkaline-hyperoxia reversing acid-produced insoluble deposits is an observed objective fact. The negative magnetic field reversal of calcium insoluble deposits also apply to spinal stenosis, deposits of calcium around arthritic and injured joints, calcium deposits in infected tissues and so forth. The negative magnetic field reversal of amino acids and insoluble deposits also apply to amyloid deposits of organs and body tissues including amyloid deposits in the brain (Alzheimer's disease).

RESOLUTION OF CARDIAC ATHEROSCLEROSIS

A 71-year-old physician had cardiac surgery of seven bypassed arteries. One artery not bypassed was 50% occluded. For nine months, he wore a 4" x 6" x 1/2" ceramic block magnet over his heart 24 hours a day with the negative magnetic field facing his body. Nine months later, a study of his heart revealed that the artery that was 50% occluded is now 100% open. He was also sleeping on a bed of 4" x 6" x 1" magnets with the negative pole facing his body. A leg that had lost all feeling has now regained normal feeling.

PLACEMENT AND DURATION:

Place the negative magnetic field of the 4" x 6" x 1/2" magnet over the heart with its 6" length-wise the body. Hold in place with a 4" x 52" wrap. Place a 2" x 26" band across the left shoulder

with Velcro fastened to the body wrap. Mild cases will treat only at night during sleep. Severe cases should treat 24 hours a day.

NEGATIVE MAGNETIC FIELD ANTIBIOTIC EFFECT

A woman with severe gastrointestinal symptoms was stool cultured for pathological bacteria and fungi as well as normal bacteria flora. Three months after sleeping on a bed composed of seventy 4" x 6" x 1" magnets, the gastrointestinal flora was again cultured. The pathological bacteria and fungi flora were absent and a normal friendly bacteria flora was flourishing.

CONCLUSIONS

A negative magnetic field strengthens the human body's antibiotic value against invading pathological microorganisms.

MAGNETS USED:

Two 1-1/2" x 1/2" ceramic disc magnets with a 2" x 26" band

PLACEMENT AND DURATION:

The ceramic disc is useful for local infections that are no more than 1-1/2" across.

FOR SYSTEMIC INFECTIONS such as the herpes family of viruses such as Epstein-Barr, cytomegalo, human herpes virus #6 or other diseases of either virus origin, bacterial or fungal origin which are systemic in nature, use the following:

A 70-magnet bed composed of magnets that are 4" x 6" x 1". Thirty-five of these are placed in a wooden grid, 36" square which weighs 200 pounds. Two of these grids are placed end to end producing a bed 36" x 72".

A super magnetic head unit composed of twelve 4" x 6" x 1" magnets.

*These items are over 400 pounds of weight. Shipping cost is determined by the distance that it is shipped.

PLACEMENT AND DURATION:

Sleep on this 70-magnet bed all night and preferably return to the bed one hour, four times during the day for the first three months of treatment. Place a 2" egg crate type foam pad over the magnetic bed. After the three months are completed, continue to sleep on this bed. At this time it could be placed under a 4" mattress pad if desired. Sleeping nightly on this bed should be a contin- ued lifestyle.

SUCCESS STORY
SCHIZOPHRENIA

A schizophrenic in his 20's was depressed and anxious with visual and auditory hallucinations and delusions which were not managed by tranquilizers and antidepressants. He slept on a super magnetic bed composed of 70 magnets 4" x 6" x 1" with a negative pole facing his body. He also slept with his head in the super magnetic head unit composed of twelve magnets, 4" x 6" x 1". He managed his foods by using disc magnets on his head and a 4" x 6" x 1/2" magnet on his chest and epigastric area for 30 minutes before each meal. He sat up a 4 day diversified rotation diet. In this, he also used no caffeine, no tobacco and no alcohol and was not on tranquilizers or antidepressants. He used the 1-1/2" x 1/2" disc magnets placed bitemporally for any immediate symptoms.

Three months later, his mother reported to me that he was symptom-free. She proceeded to order the super magnetic bed for other members of the family.

SUCCESS STORY
SCHIZOPHRENIA

This is a 23-year-old man diagnosed with schizophrenia having symptoms of depression and auditory hallucinations. At age 11, he was diagnosed as having attention-deficit disorder. This has now progressed to the point of major mental symptoms. He has been under treatment for better than one year. He sleeps on a bed of 70 magnets that are 4" x 6" x 1". He sleeps with his head in a magnetic head unit composed of 12 magnets that are 4" x 6" x 1". He uses ceramic disc magnets that are 1-1/2" x 1/2" placed bitemporally for any symptoms. He has an apartment separate from the family which is near the university he attends. He is making excellent grades.

MAGNET THERAPY SUCCESSES
SLEEP APNEA INSOMNIA
MIGRAINE HEADACHES PAIN, ACHES AND CRAMPS
Dear Dr. Philpott,

I am writing to let you know the results from the use of the magnets you prescribed. I have also rotated my diet for 8 years. I use alkaline micro negative ionized water with an alkaline pH which I get from an electrolysis machine I purchased about 2 years ago. I do not use drugs, alcohol, tobacco, caffeine or carbonated soft drinks.

My husband had a bad case of sleep apnea and insomnia for years. After sleeping on the magnet mattress pad and headboard system for a week, almost all of his symptoms are gone. He rarely

wakes up until morning and his breathing is much more normal with little snoring or other noises he used to make. He is so happy about it!

My results are also exciting. I followed your instruction to wear the 4" x 6" x 1/2" magnets over my liver and heart as well as the disc magnets over my temples 15 minutes before mealtimes and during the meals. As long as I do this, I am able to eat anything and suffer no horrendous migraine headache. There were at least 39 foods containing tyramine which caused my headaches. I forgot to wear the magnets several times and got migraines as a result. Your magnet prescription is a Blessing of God and a Miracle to me to be able to keep the migraines away.

The result of wearing the magnets before mealtimes is that I am now able to take vitamin E that I was allergic to before. I was having awful hot flashes multiple times a day for 8 years and felt bad when one took me down for 5 minutes each time. I am rarely having the hot flashes now. It is wonderful!

Another nice benefit is the pain relief from minor pains such as cramps, stomach aches, ear aches, etc. We have found that pain is often relieved by placing a magnet over the pain for a short while.

With Gratefulness,

ACID-HYPOXIC FACTORS IN CANCER

Otto Warburg was given a Nobel prize for the discovery that cancer makes its adenosine triphosphate by the process of fermentation. Fermentation requires acidity and hypoxia in order to function in making ATP. Since acid-hypoxia is required for cancer to make its ATP, it is also observed to be the vulnerable point for the death of cancer. Cancer cannot survive in an alkaline-hyperoxia medium. It can't make its energy in an alkaline-hyperoxia medium. Therefore the answer for the reversal of cancer is a sustained alkaline-hyperoxia. This can be achieved with the use of a negative magnetic field since the biological response to a negative magnetic field is alkaline-hyperoxia.

Cancer dies 100% of the time in a sustained alkaline-hyperoxic medium. Since this is true, why is it that we cannot achieve 100% results of the reversal of cancer with the application of a negative magnetic field? The reason for this is not that cancer can survive in an alkaline-hyperoxic medium produced by a negative magnetic field, but that the subject sometimes brings to the therapy a state of non-survival. Important are nutritional needs, hydration needs,

and functional level of survival for critical tissues such as bowel function, absorption of nutrients, liver function, respiratory function and obstructions of vital areas are important deterrents to success in any program. Pressure on the aqueduct for fluid flow between the ventricles in the brain and spinal fluid is a must. A person cannot survive with hydrocephalus. Bowel obstruction is a great deterrent and some of those with bowel obstruction cannot survive the necessary surgery for the removal of this bowel obstruction. The attempt to keep the bowel open when it is largely closed with a tumor is a battle that most of the time is not won. Liver function depleted and obstruction of the bile flow are serious deterrents to survival. Obstruction of respiration with tumors in specific areas that compromise the amount of oxygen being received by the lungs is a serious deterrent which sometimes cannot be reversed fast enough for survival. Some of these are so obstructive that they would not survive surgery for the removal of the obstruction. So in spite of the fact that cancer dies 100% of the time in the presence of alkaline-hyperoxia produced by a negative magnetic field, the survival rate cannot be 100% since the subject does not bring to the therapy a biological survival capacity irrespective of what the treatment may be.

CANCER REMISSION

Henry Thompson is a 78-year-old man with cancer of the prostate with multiple metastasis to bones. He slept on a 70-magnet bed composed of magnets that are 4" x 6" x 1". The AMAS blood test was originally positive for cancer. After sleeping on a 70-magnet bed for several months, the AMAS tests have all been normal, showing no evidence of cancer.

BRAIN TUMOR REMISSION

An 88-year-old woman lost much of the function of her left arm. She staggered when she walked. She is a musician and could no longer play the piano. CT scan revealed a tumor on the right side of her head. She was treated with a super magnetic head unit composed of twelve 4" x 6" x 1" ceramic magnets in a wooden frame surrounding her head. She slept all night with her head in this super magnetic head unit and returned for one hour, four times a day during her waking period. At three months, all her functions had returned to normal. With enthusiasm, she played the piano while I listened on the phone. At six months, a CT scan documented that there was no longer a tumor in her brain. No

surgery was done and thus there was no pathological cellular report of the tumor.

NORTH OAKLAND MEDICAL CENTERS RADIOLOGY SERVICES

461 WEST HURON PONTIAC, MI 48341 CT OF BRAIN WITHOUT AND WITH CONTRAST EXAM DATE: 6/11/02 CLINICAL INFORMATION: Memory loss, confusion, headaches.

IMPRESSION: VAGUE AREA OF VASOGENIC EDEMA WITHIN THE RIGHT POSTERIOR TEMPORAL PARIETAL LOBE WITH FAINT PATHOLOGIC ENHANCEMENT REPRESENTS AN INTRA-AXIAL MALIGNANT NEOPLASM. MRI EXAMINATION IS RECOMMENDED FOR ADDITIONAL EVALUATION. THESE RESULTS WERE RELAYED DIRECTLY VIA TELEPHONE CONVERSATION TO DR. IMAD MANBOOR AT THE TIME OF THIS DICTATION.

Providence Hospital and Medical Centers (12-19-02) Patient returns in follow-up. She underwent a CT scan of the head on 12-13-02 that revealed no evidence of enhancing mass or extra-axial fluid collection. There is an old infarct versus an area of volume averaging involving the superior left cerebellum that appears to be new from prior exam. There is also a right posterior parietal encephalomalasia. She has been on magnetic therapy since diagnosis. Per her daughter, who is present with her, the patient's mental status has improved. She has no difficulty communicating thoughts or ideas. Her short-term and long-term memory has improved. She denies any balance problems or weakness.

Patrick W. McLaughlin, M.D. Department of Radiation Oncology

KATHERINE'S FRIGHTENING DILEMMA

Katherine, age 75, is my "Sweety-Pie" of fifty-three years of marriage. She is the mother of three healthy, successful children, and grandmother of six smart and healthy grandchildren. Suddenly, virtually overnight, a mole developed on her forehead from the deep layers of the skin. The mole was black and red combined with a jagged periphery and a very sore base. It grew to 1" across and 1/2 " in height in one week. It had penetrated into the subcutaneous fat with fingers spreading more than 1". What shall we do? Shall we do a biopsy and risk metastatic spread? At age 34, a breast cancer was successfully surgically treated. At age 44, a basal cell carcinoma was successfully surgically treated. At age

71, a skin lesion with the characteristic appearance of a basal cell carcinoma was successfully treated with a negative magnetic field. With intensity born of necessity, we studied the traditional and alternative medical treatment options for a malignant melanoma. Shall we have surgical removal, which would remove half of her forehead down to the bone and require a graft?

The rapidly growing mole had suddenly developed on her forehead where no mole had been before. It's appearance was that of a classic nodular malignant melanoma with invasion of the subcutaneous tissue. This gave the evidence of being a very malignant and potentially metastatic lesion. X-ray and chemotherapy reportedly have poor results. Is Dr. Robert O. Becker's observation that a biologically produced negative electromagnetic field governs all healing true? Does this principle of a negative magnetic field governing healing also apply to cancer and not just to cuts, bruises and broken bones? Can we use the negative (south-seeking) magnetic pole field of a static field magnet, which is the magnetic field polarity equivalent of the electromagnetic negative field concentrated by the body at injured areas for healing, to control or actually heal cancer? Can we trust the maverick physician, Kenneth Maclean's reports of 40 years ago that he observed cancers controlled in animals and humans by a magnetic field? How much faith can we put in an observation made on myself of a fast growing, multi-colored, sore mole which dried up and peeled off under the influence of a negative magnetic field? This was the dilemma and crisis Katherine and I found ourselves suddenly thrust into. We cried. Our children cried. The decision was for her to enter a research program that had qualified itself for FDA approval with it's appropriate institutional review board and appropriate monitoring of cases being treated with a negative magnetic field. For the first week, she was treated with a neodymium disc magnet which was 1" across and 1/4" thick of 12,300 gauss. She was treated only when asleep at night. The mole continued to grow and the edge became wider and more notched than originally. The magnet was barely the size of the surface of the tumor. A more vigorous time exposure was obviously needed and the magnetic field needed to be larger. The tumor was then exposed to a ceramic disc magnet that was 1-1/2" across and 3/8" thick of 3,950 gauss. She was then treated 24 hours a day. The tumor stopped growing with 24-hour-a-day exposure to a negative (south-seeking) magnetic field. It took one month of 24-hour-a-

day treatment before the soreness at the base of the tumor disappeared. After the soreness disappeared, the tumor gradually began to recede and dry up. Ten weeks after daily treatment, the tumor had dried up and skin had grown under the tumor.

Lessons that were learned during this research:

1. A negative magnetic field can reverse a fast growing melanoma with the classic appearance of a malignant melanoma.

2. It requires 24-hour-a-day exposure to inhibit the tumor growth in contrast to having observed night treatment only while sleeping for reversal of a basal cell carcinoma in six weeks.

Single cases such as this have provided the inspiration of a mission for me to find out how consistently a negative magnetic field will reverse cancer. Surely, these single cases justify the large scale definitive and expensive studies necessary to find out if indeed a negative magnetic field energy is capable of curing cancer.

We desperately need the definitive studies making it both scientific and ethical to claim that a negative (south-seeking) magnetic field can and does cure cancer. My only claim is that we are abundantly justified in doing definitive research to find out if a negative (south-seeking) magnetic field can indeed cure cancer.

Without promise of a cure, magnetics is worth a try!

SKIN DISORDERS: WARTS, SCARS NON-MALIGNANT MOLES; MALIGNANT MELANOMA; BASAL CELL CARCINOMA; SQUAMOUS CELL CARCINOMA ORIENTATION:

Small moles may become malignant melanomas. Malignant melanomas usually develop as single lesions on the skin. Injury from the sun is a common cause for the development of malignant melanoma, basal cell carcinoma, or squamous cell carcinoma. Skin cancers are all treated the same way. Many scars will disappear when treated with a negative magnetic field.

MAGNETS USED:

The size of the lesion determines the size of the magnet used. Available magnets are such as: Neodymium discs, 1" x 1/8". Ceramic disc magnets, 1-1/2" x 1/2".

Ceramic mini-block magnets that are 1-7/8" x 7/8" x 3/8".

Plastiform magnets that are 1/8" thick and can be obtained in any size such as 2" x 2", 3" x 3", 4" x 4", 4" x 6" and so forth.

PLACEMENT AND DURATION:

The magnetic field needs to be larger than the lesion being treated. The duration needs to be two to four weeks for non-

malignant moles and twelve weeks or more for malignant melanoma or any cancerous skin lesion. Pre-cancerous skin lesions should be treated like a cancer. Scars are treated like a cancer. Pre-cancerous lesions and basal cell carcinoma are best treated 24-hours-a-day, but 8-hours-a-day during sleep has been observed to suffice. Malignant melanoma and squamous cell is best treated 24-hours-a-day with no more than one or two hours a day without the magnetic field on the cancerous lesion. A cushion padding such as a corn pad can be placed over raised lesions to avoid pressure on the lesion. Tape the magnet over the lesion using a hypo-allergic tape. The best tape is HY-Tape. It is skin colored and can be purchased at medical supply stores. Magnetic fields can be made stronger by stacking the magnets. This can especially be used to increase the gauss strength of the neodymium discs or plastiform magnets. Place a Band-Aid over the lesion with the magnet on top of the Band-Aid. Hold in place with another Band-Aid or HY tape.

POLARITY:
Always use a negative (south-seeking) magnetic field.

SUPER MAGNETIC BED OF 70 MAGNETS
Composed of:
Seventy ceramic block static field magnets, 4" x 6" x 1".

A sealed wood frame that places the ceramic block magnets 1" apart. Each wood frame holds 35 magnets. The wood frame comes in two sections for ease of shipping. The wood frames holding the magnets are 36" x 36". Placed end to end, they make a bed 36" x 72".

Cover the bed with a 2" foam pad.

Placement:
Place the wood frames holding the magnets end to end for a single bed. Place on a twin size box spring.

Uses:
- Cancer metastasis
- Systemic infections
- Detoxification
- Increased energy
- Autoimmune Disorders
- Degenerative Diseases

Treatment:
Systemic infections are treated for 4-6 weeks. Sleep on the bed grid all night and for four, one hour periods during the day.

Metastatic cancer, systemic infections, immune and autoimmune disorders requires a minimum of 3 months of all night treatment plus one hour, four times a day during the waking period. When not on the bed, local cancerous lesions, inflammation or infections will be treated with suitable magnets which usually are 4" x 6" x 1/2" ceramic block magnets. A 4" x 52" KOOL MAX body wrap can be used to hold the block magnets in place. It is sometimes preferable to make a garment of non-stretchable material with pockets for the ceramic block magnets that are directly over the cancerous lesions.

This is good for anyone as a life style.

SUPER MAGNETIC HAT

The super magnetic hat is composed of thirty-four 1" x 1/8" neodymium disc magnets. The manufacturer's rating is 12,300 gauss. Surface gauss strength measured by a gauss meter is 1,250.

The gauss reading of the super magnetic hat at center of hat 3" from the top of the hat is 65 gauss. The closer one is to the magnets, the higher the gauss strength.

Weight: 1.06 tbs. Shipping weigh: 7 lbs.

*Shipping weight includes plastic head for holding hat in shape, handy storage/carrying case and packaging for shipping.

<u>USES:</u>
- Brain Tumor

Brain disorders such as:
- Alzheimer's and cerebral arteriosclerosis
- Post-stroke recovery and senility
- Brain infection
- Emotional Disorders (anxiety, phobias, obsessions-compulsions)
- Major mental disorders (schizophrenia, manic depressive, psychotic depression)
- Seizures and movement disorders
- Autoimmune Diseases

This is worn during the day when ambulatory. At night and during the day, when resting on the bed, the super head unit is used.

SUPER MAGNETIC HEAD UNIT Dimensions of the super magnetic head unit: Length - 19"; Height - 7.5"

Headspace in the unit 9.25" and contains only a negative magnetic field, made of twelve 4" x 6" x 1" ceramic block magnets. Starts at 900 gauss and extends to 150 gauss at the center.

Weight: 59 lbs.
Shipping weight: 65 lbs.

Four 4" x 6" x 1" ceramic block magnets are placed on either side of the head and at the top of the head. The magnets are placed in a wooden carrier. It has a space for the head that is sufficient for either lying on the back or turning from side to side. This unit sets on top of the pillow so the head is on the pillow inside of the space. This is used to sleep at night or rest in during the day.

USES:
- Tumors of the brain and cerebral arteriosclerosis
- Cerebral vascular spasm and post-stroke
- Alzheimer's and Parkinsonism
- Headache and seizures
- Movement disorders
- Autoimmune diseases
- Emotional disorders (anxiety, phobias, obsessive compulsion)
- Major mental disorders (schizophrenia, manic-depression, psychotic depression)

Placement and Duration:

For brain tumors, infections, autoimmune disorders or multiple sclerosis follow the instructions which have been provided for each condition. For cerebral arteriosclerosis, cerebral vascular spasm, post-stroke or Alzheimer's, sleep with the head in this unit, preferably nine or more hours a day. When resting or napping during the day, the unit should also be used. A good rule of thumb is, the more hours of exposure, the better.

MAGNETIC BRAIN TUMOR RESEARCH

Essentials of Magnetic Research protocol

I. Twenty-four hour duration exposure to a negative magnetic field for twelve weeks.

II. Observed progression.

Observed progression of tumors during continuous exposure to a negative magnetic field:
a) stops growing immediately.
b) edema surrounding tumor recedes quickly, within hours to a week or less.
c) stops being sore by the fourth week. This indicates that acid is no longer being produced by the tumor.
d) at 12 weeks, tumor may not be present in some cases, depending on the size of the tumor or it may be one-half the size

in larger tumors. In another 3-4 months of nightly treatment, the tumor absorbs and thus is no longer present. The exception to this is a meningioma still present and of the original size without any growth at one year. This was observed to be a fast-growing meningioma before magnetic treatment. Surface lesions (malignant melanomas, skin squamous cell and basal cell) have dried up and fallen off by the third month with new skin having grown under the tumor. No scar is present after healing skin lesions. All skin cancers have healed within the three month period.

e) it would be a mistake to treat less than twelve weeks.

EQUIPMENT:

I. Magnetic Head Unit: Sleep all night with head in the magnetic head unit and during the waking period a minimum of one hour, four times during the day. The more hours, the better.

II. Super II Magnetic Hat: Place on head when not in magnetic head unit.

THE SECRET OF SUCCESSFUL MAGNETIC CANCER REMISSION By William H. Philpott, M.D.

SCIENTIFIC PEER-REVIEWED DOCUMENTATION

A static magnetic field is an energy field by virtue of the movement of electrons. AHARONOV, Y. and BOHN, D. "Significance of Electromagnetic Potentials in Quantum Theory." *The Physical Revision.* 115, 485. (1959).

It is an accepted fact that a negative magnetic field spins electrons counter clockwise and a positive magnetic field spins electrons clockwise.

A gauss meter, magnetometer or compass identify the positive (+) and negative (-) magnetic fields of the earth's magnetic fields and also of a static field magnet.

A positive (north-seeking) static magnetic field blocks melatonin production by the pineal gland and the negative (south-seeking) magnetic field stimulates production of melatonin by the pineal gland. SEMM, P, SCHNEIDER, T & VOLLRATH, L. "The Effects of an Earth Strength Magnetic Field on the Electrical Activity of Pineal Cells". *Nature,* 1980; 288: 607-608.

Cancer cells ATP production by transferase enzymes is acid-hypoxic dependent. WARBURG, O., "On the Origin of Cancer Cells." *Science* 123 (1956) 309-315.

Cancer results from a disorder of cell proliferation regulators such as occurs in hypoxia and oxidoreductase enzyme inhibition.

SZENT-Gyorgyi, ALBERT. *Electronic Biology and Cancer. A New Theory of Cancer.* 1976. Marcel Dekker, Inc. NY, NY 10016

Lack of oxygen induces a malignant transformation in cell culture. GOLDBLATT, H., and CAMERON, G. (1953), *J. Exp. Med.*, 97:525-552; GOLDBLATT, H., FRIEDMAN, L., and CECHNER, R.L. (1973), *Biochem. Med.*, 7:241-252

There is published peer reviewed evidence that a static magnetic field inhibits cancer proliferative replication.

Six prior studies have shown that a brief static magnetic field exposure resulted in reduction of cancer cell proliferation growth. Nine prior brief static magnetic field studies revealed no effect on cancer cell proliferation growth. This study was designed to determine if a strong static magnetic field with a prolonged exposure would result in cancer cell proliferation growth. Three malignant cell lines; melanoma, ovarian cancer and lymphoma were exposed to a seven tesla uniform static magnetic field for 64 hours. Conclusion: "We have determined that extended exposure to a strong static magnetic field retards the growth of three human tumor cell lines. Further investigations of this phenomena may have a significant impact on the future understanding and treatment of cancer." In this study, the cell culture plate was placed iso-center in the static magnetic field. This study was not intended to isolate separate responses to separate positive and negative magnetic fields, however, the placement of the culture in the iso-center of the static magnetic field exposed one-half of the culture to the negative magnetic field and one-half of the culture to the positive magnetic field. RAYLMAN, RAYMOND R., CLAVO, ANAIRA C., WAHL, RICHARD L. *Bioelectromagnetics* 17:358-363. Wiley-Liss, Inc. 1996.

The positive magnetic field encourages cancer growth. The negative magnetic field inhibits cancer growth. TRAPPIER, ARTHUR, et al. "Evaluating Perspectives on the Exposure Risks from Magnetic Fields", *Journal of the National Medical Association,* 82:9, September 1990.

NON-PEER REVIEWED OBSERVATIONS CONFIRMING PEER REVIEWED DOCUMENTATIONS

The biological response to a static positive magnetic field is acid-hypoxia. The biological response to a negative magnetic field is alkaline-hyperoxia. Cancer implanted on the skin dies in response to a static negative magnetic field. DAVIS, A.R. and

RAWLS, W. *The Magnetic Blueprint of Life*. Acres USA, Kansas City, MO, 1979.

Confirmation of Davis' work by W.H. Philpott, M.D., PHILPOTT, W.H., M.D. and KALITA, Dwight, Ph.D., *Magnet Therapy.* (Tiburon, CA: Alternative Medicine. cam, 2000); PHILPOTT, W.H., M.D. *Cancer. The Magnetic/Oxygen Answer.* 2001 edition. Published, by W.H. Philpott. 17171 S.E. 29th Street, Choctaw, OK 73020.

A positive magnetic field is the signal present in response to injury. A negative magnetic field is present during healing. BECKER, ROBERT O. and SELDON, G. *The Body Electric. Electromagnetism and the Foundation of Life*. William Morrow and Company. NY. 1986.

DISCUSSION

The documentation that a static positive magnetic field free energy is a human biological stressor, disorganizer and thus, the signal of injury and that a static negative magnetic field free energy is a human biological anti-stressor, organizer-regulator and thus the signal present during biological normalization and healing is one of the great documented discoveries of the 20th century.

Starting in the 1930's and spanning a period of over 50 years, Albert Roy Davis documented the acid-hypoxia biological response to a static positive magnetic field and the alkaline-hyperoxia response to a static negative magnetic field. He documented cancer remission to a negative magnetic field application.

In 1982, Robert O. Becker documented that a static positive magnetic field is the signal of injury and a static negative magnetic field is present during healing. BECKER, ROBERT O. and SELDON, G. *The Body Electric. Electromagnetism and the Foundation of Life.*" William Morrow and Company. NY. 1986.

In the 1930's, Otto Warburg documented the acid-hypoxia fermentation transferase enzyme function as the energy drive of cancer for which he won a Nobel prize.

In 1996, Raymond Raylman documented that a strong, prolonged magnetic field killed cancer. Arthur Trappier, in 1990, documented that it is the negative magnetic field that kills cancer. Albert Szent-Gyorgi documented that oxygen as an electron receiver and oxidoreductase enzymes moving electrons was necessary to kill cancer. He knew that an energy was needed but in 1970 did not know that a negative magnetic field is the energizer.

We now know the answer for which he was seeking is alkaline-hyperoxia plus a negative magnetic field energizer controlling human cell proliferation.

In 1953, H. Goldblatt documented that lack of oxygen induces a malignant transformation in cell culture.

In 1972, W. Joklik observed "Among the goals that should be within reach in the foreseeable future are an understanding of the fundamental control mechanisms that operate in both normal and abnormal cell differentiation, including cancer. JOKLIK, WOLFGANG K., D. Phil. *Zinsser Microbiology.* 20th edition. Appleton & Lange, Norwalk, CT. 1992. We now have achieved the goal Joklik was seeking. It is negative magnetic field free energy regulating cell proliferation and thus regulating growth and healing and also control over invading microorganisms and cancer.

CONCLUSION

Magnetic therapy of cancer replaces the acid-hypoxia-dependent transferase enzyme catalysis (fermentation) producing ATP with alkaline-hyperoxia oxidoreductase enzyme catalysis (oxidation reduction) of producing ATP. Cancer cells are thus robbed of their ability to produce ATP by fermentation. Cancer cells die because they cannot produce ATP in an alkaline-hyperoxia medium.

Acid-hypoxia is the central causal factor in degenerative diseases in general and cancer development in particular.

The initiating causes of acid-hypoxia are many, such as, immunologic reactions, addictive reactions, toxic reactions, physical injury, local or systemic stress, prolonged emotional stress, nutritional deficiencies and so forth.

Cancer cells die in the presence of a continuous static negative magnetic field. Both peer reviewed publications and non-peer reviewed publications confirm the death of cancer cells from a static negative magnetic field of sufficient gauss strength and sufficient prolonged duration. A static negative magnetic field is the breath of life for human cells and the kiss of death for invading microorganisms and cancer cells. Definitive negative magnetic field therapy for the treatment of cancer is justified and recommended by both peer reviewed and non-peer reviewed evidence.

IT IS AN ESTABLISHED SCIENTIFIC FACT THAT A PROLONGED SUSTAINED STATIC NEGATIVE

MAGNETIC FIELD PRODUCES CANCER CELL REMISSION.
HORSE AND BUGGY ENERGY MEDICINE VERSUS ELECTROMAGNETIC FREE ENERGY MEDICINE

The invention of the wheel was a great invention in its day. Mankind now had wheel barrels and scooters. Harnessing the energy of a horse to a wagon was another great invention which served mankind well for thousands of years. It is true that our grandparents moved west by horse and buggy. Two generations later, we fly all over the world. Transportation has advanced from an original wonderful achievement to a new marvelous achievement.

This marvelous achievement of the electromagnetic industrial age has occurred because of the achievement of harnessing the movement of electrons. We no longer just wonder at the electromagnetic energy of lightning, tornados, cyclones and anti-cyclones which, in the northern hemisphere spin counter-clockwise and in the southern hemisphere spin clockwise. Mankind has learned to harness the energy of movement of electrons. We make magnets with the flow of electrons and we give direction to the flow of electrons with magnets. We have learned to trust the predictableness of the movement of electrons with magnetic fields. We live in a virtual sea of electrons in the space around us as well as the space within us. Mankind is an electromagnetic organism. The magnetic movement of free energy electrons within us is an integral aspect of biological life energy. Human life does not exist apart from magnetism. Have we missed something in medicine that the electromagnetic industry has captured? Yes, we have! We have failed to capture the free magnetic energy available to us. The same degree of predictableness exists in biological systems exposed to magnetic fields as it does in electric non-biological systems.

Therapeutic medicine is barely entering the threshold of free magnetic energy use. We nourish our bodies but we still wait for some mysterious life energy to spontaneously heal us. Magnetic therapy can change the speed of healing from the horse and buggy level to an equivalent level of flying. The movement of electrons between enzymes and substrates produces a magnetic field which attaches the enzyme and the substrate. With the magnetic energy medicine, electrons are magnetically harnessed to move between

enzymes and substrates. The secret of magnetic therapy is that this free magnetic energy can be supplied from a static field magnet providing the energy activation of the enzymes so that a catalytic reaction occurs. A static negative magnetic field alkalinizes and energizes, such as the alkaline-dependent oxidoreductase enzymes family of enzymes. These oxidoreductase enzymes are responsible for producing some of life's energy (ATP and catalytic remnant magnetism) as well as processing inflammatory toxic substances that threaten life energy. A positive magnetic field energy blocks these enzymes from functioning. The essence of magnetic therapy is the predictable movement of free energy field static electrons by a free energy static magnetic field in a biological system producing predictable biological responses.

Magnetic therapy is at this threshold of moving therapeutic medicine from the horse and buggy low level efficiency, slow speed energy function into a high efficiency speed energy function equivalent to flying and computer efficiency functions.

TREATMENT OF LOCAL NON-METASTATIC CANCER LESIONS MAGNETIC TREATMENT OF LOCAL CANCER

The most likely single, non-metastatic lesions are such as brain cancer, bronchiogenic lung cancer, liver cancer secondary to a chronic viral infection, bowel cancer, ovarian cancer, bone sarcoma, pancreatic cancer, prostate cancer and melanoma. It must always be considered that any of these single lesions can and frequently do metastasize. Liver cancer is more frequently metastatic from some other primary source. Cancer of the breast usually metastasizes even if you can't initially find the metastatic lesions. They may show up even years later. Therefore, breast cancer should always be treated as metastatic and should have the systemic magnetic treatment.

Single, non-metastatic lesions are treated with magnets of suitable size and strength for each type of cancer. For small lesions, the 1" x 1/8" neodymium disc magnet in which two of these are stacked, are used. The 1-1/2" x 1/2" disc magnets can be used for lesions that are more than 1" across. Skin lesions such as melanomas, basal cell and squamous cell skin lesions are usually treatable with these magnets. Plastiform magnet material is available and can be cut in any size such as 2" x 3" x 1/8", 4" x 4" x 1/8" or 4" x 6" x 1/8". At least two of these 1/8" thick magnets are stacked for treating a superficial skin lesion or a lesion within 2" of the skin surface. A 4" x 6" x 1/2"

magnet is the most usable magnet for such as bronchiogenic lung cancer, liver cancer, pancreatic cancer, prostate cancer, or bone sarcoma. It is most likely that ovarian cancer or bowel cancer will have been resected before treatment begins. Treat right over the area of surgery with a 4" x 6" x 1/2" magnet. The rule is that the lesion must be kept under the influence of a negative magnetic field for as near to 24 hours a day as possible for at least a minimum of the first three months. For skin lesions, the magnets can be taped to the skin. For internal lesions, use a 4" x 52" body wrap to hold the magnet in place. It is wise to make a garment with pockets in it which supports the weight from the shoulders. The pocket is to be right over the lesion with a 4" x 6" x 1/2" magnet placed in the pocket.

The negative magnetic field must always be used for a cancer lesion. The positive magnetic field would make the cancer grow. A negative magnetic field of sufficient strength and duration will routinely kill cancer.

METASTATIC CANCER
ORIENTATION:

This magnetic research protocol is for any type or degree of metastatic cancer. Every metastatic cancer patient needs a physician to monitor their condition (see the section on Complementary Treatments Associated with Magnet Therapy). Magnet therapy all by itself will kill cancer. Complementary therapies are valuable and in certain circumstances such as a life-threatening metastatic cancer, intravenous vitamin C should be used along with magnetic therapy. Metastatic cancer requires a systemic treatment which is provided by the 70-magnet bed and the super magnetic head unit. Also, the local areas need to be also treated with a negative magnetic field beyond that of the general treatment provided by the 70-magnet bed.

MAGNETS USED:

Super magnetic bed composed of seventy 4" x 6" x 1" magnets. Thirty-five of these are placed in a wooden carrier 36" square. Two of these wooden carriers are placed end to end providing a bed 36" x 72" weighing 400 pounds. Over this place a 2" foam pad.

A 2" thick memory foam pad or other suitable pad or futon for a single sized bed.

Super magnetic head unit composed of twelve 4" x 6" x 1" magnets in a wooden frame with a place for the head surrounded by these magnets.

Suspension magnetic unit. This can be either four 4" x 6" x 1" magnets or six 4" x 6" x 1" magnets depending on the area that

needs to be covered. This is used when there is a seeding of cancer throughout the abdomen. It is also used on the lungs where there is a seeding of multiple lesions throughout the lungs.

Two 4" x 6" x 1/2" ceramic block magnets with Velcro on the positive pole side. Two is the minimum that is needed because this is used pre-meal to treat the heart and the liver. Also, there should be other ceramic block magnets available to treat local areas when appropriate such as a single lesion in the bronchi or a single lesion such as a sarcoma in a bone or metastatic liver, gall bladder or pancreatic cancer.

Two or more of the 4" x 52" body wraps which are used to hold the magnets in place. Two 1 1/2" x 1/2" ceramic disc magnets with Velcro on the positive pole side. One 2" x 26" band.

PLACEMENT AND DURATION:

The suspension unit is used in special cases such as the seeding of cancer throughout the abdomen or multiple lung lesions.

A super magnetic bed is used in all metastatic cancer cases. This will treat every cell in the body. The cell makes its own ATP. This raises the energy of the body to fight the cancer.

The super magnetic head unit is routinely used to accompany the super magnetic bed. The super magnetic head unit treats the pineal gland to raise melatonin which itself is anticancerous.

It is recommended that avoidance of substances to which the subject is demonstrated to be reacting to should be avoided. The most frequent substances to which people react to are to foods. The reactions could be in the nature of addictions, allergies and toxicities. A food rotation does much to avoid these reactions. A seven day rotation is recommended. Even though cancer can be successfully treated without rotation, it is still best to rotate the foods so that the acidity reactions that occur due to these reactions is avoided. This acidic reaction can be handled by treating magnetically ahead of meals of foods. This places the disc magnets bitemporally, a 4" x 6" x 1/2" magnet over the heart and one over the liver for approximately 30 minutes ahead of a meal and preferably even kept on during the meal. However, there can be reactions so severe that they would override this magnetic protection. When that happens, these foods should be left out of the diet for a period of three months before they are reintroduced into the rotation diet.

HOW TO USE THE FOUR DAY OR SEVEN DAY DIVERSIFIED ROTATION DIET

The essence of the Diversified Rotation Diet is that foods are rotated on a four or seven day basis, thus preventing their maladaptive reactions, be these allergies or addictions. Also, this rotation diet will correct hypoglycemia and non-insulin dependent diabetes mellitus.

One method is to avoid food eaten twice a week or more for a period of three months, rotating all other foods. At the end of three months, then place these frequently used foods back into the diet, rotated once in four or seven days. This method is outlined in my *Metabolic Syndrome* quarterly and also in my book, *Magnet Therapy*.

Another method that is preferred by some is to start rotating all foods, even those that are eaten frequently. This can be achieved if the subjects will treat themselves to magnets for 15-30 minutes ahead of the meal. To achieve this, place the ceramic disc magnets bitemporally, that is in the front of the ears at the level of the top of the ears. These are held in place with a 2" x 26" band. The discs are ceramic discs that are 1-1/2" x 1/2". The negative magnetic field is always placed toward the body. On the positive magnetic field side, there is hook Velcro that will hook to the band around the head and hold these in place. At the same time, place a 4" x 6" x 1/2" magnet on the heart with the 6" lengthwise the body. Hold this in place with a 4" x 52" body wrap. Also, place a 4" x 6" x 1/2" magnet with the 6" lengthwise the body over the liver area which is on the right side of the body with half of the magnet over the rib cage and half below the rib cage. Hold this in place with a 4" x 52" body wrap. The minimum time of exposure should be 15 to 30 minutes or more before each meal. With this method, there is no avoidance period of the commonly used foods.

After three months of rotation, there is little likelihood of a maladaptive reaction to a food without the magnets before the meal. Whenever purposely violating the rotation diet such as eating out, then use the magnets ahead of a meal.

The 4-day diversified rotation diet is in the quarterly, *The Ultimate Non-Addiction, Non-Stress Diet.*

The 7-day rotation diet is in the quarterly, *Metabolic Syndrome.*

NEGATIVE ION HOUSEHOLD AIR TREATMENT

The biological response to negative ions and negative magnetic fields are the same. The biological response to negative ions and a negative magnetic field is alkaline-hyperoxia. Alkaline-hyperoxia is anti-inflammatory, anti-stress, antibiotic, energizing and aids in

healing. Negative air ions plus a small amount of ozone in the air cleans the air from dust, microorganisms, pollen, smoke, chemicals, odors and so forth. Negative ions in the air clean up the environment whereas a negative magnetic field is used on the body to achieve the same values inside the body. Thus, negative air ions, negative water ions and a negative magnetic field are complementary and should be used together to achieve optimum results.

AIR NEGATIVE ION GENERATORS LIVING AIR CLASSIC

Covers up to 3,000 square feet. Useful for living room size areas. ECOHELP LIVING AIR CLASSIC with air filter. Especially useful for respiratory disorders. LIVING BREEZE

Covers 1,200 square feet. Useful for small rooms such as bedrooms.

Air negative ions are absorbed through the mucus membrane of the nasopharynx and lungs as well as the skin. Water negative ions from electronic produced negative ion-micro water and naturally occurring negative ion water such as Nariwa water are absorbed through the mucus membrane of the gastrointestinal tract. Colloidal silver antibiotic negative ions are absorbed through the mucus membrane of the mouth and gastrointestinal tract.

ALKALINE MICRO NEGATIVE ION WATER:

Alkaline micro negative ion water helps materially to maintain the body's normal alkaline state. Also, being micro water, it enters into the cells of the body more readily than the usual water. This also carries negative ions as well as being alkaline. The AKAI Electrolysis Instrument is used for producing the alkaline micro negative ion water. At least five glasses of this water should be used each day.

NARIWA WATER:

Nariwa water is a negative ion water from Japan's magnetic mountain. This comes in a bottle containing 500 cc. A minimum of one of these bottles should be used a day and preferably, two. The total amount of water used during a day should be a minimum of eight glasses of water and preferably as much as a total of ten glasses of fluid intake.

COLLOIDAL SILVER THERAPY:

Magnetic therapy does not require colloidal silver to be effective. However, colloidal silver are negative ions and also the silver itself is antibiotic.

Colloidal silver is made by an electrolysis method that produces a particle size of 0.0001 micron. These small silver particles are charged to a negative magnetic field by the electrolysis method. This solution of colloidal silver is placed in the mouth, especially under the tongue for absorption. This provides quick absorption into the blood stream. These fine silver particles go throughout the entire body. The negative magnetic field magnetically attaches to microorganisms, parasites and cancer cells which are positive magnetic poled. Silver, in its own right beyond that of the negative magnetic field, inhibits the replication of these cells. The small silver particles do not interfere in any way with human cell function. It is recommended to use 40 parts per million starting for the first week with 1/2 teaspoon four times a day and followed for the next three months with 1 teaspoon four times a day. In the case of acute infections, two weeks of treatment of 1 teaspoon four times a day usually suffices. There is also an aloe vera silver salve which can treat local skin infections.

POLARITY:
Always use a negative magnetic field facing the body.

BEYOND MAGNETISM:
Acute maladaptive reactions to foods, chemicals, inhalants or stress frequency pulsing fields has been documented as producing a brief state of acid-hypoxia. In this state, there is a production of acid and a failure to process properly the end-products of oxidation phosphorylation metabolism. In this state of acidosis, oxygen content is reduced. Maladaptive reactions to foods are the most frequent cause of bouts of acidosis. Degenerative diseases are noted for their acid-hypoxic state. Therefore, every effort should be made to maintain a normal alkaline and normal oxygen state.

A majority of people are maladaptively reacting in one or more ways to foods, thus producing bouts of acidosis and reduced oxygen. It is the better part of wisdom to follow a 4-Day or 7-Day Diversified Rotation Diet. This program leaves out foods that are used as frequently as twice a week or more for a period of three months. This is based on the assumption that these foods are being reacted to in some maladaptive way. It is the frequency of the use that produces the maladaptive reactions. A 4-Day or 7-Day Diversified Rotation Diet is set up to leave out these frequently used foods. After three months, these frequently used foods can be returned to the diet, usually without any symptoms being produced.

All addictive substances should be abandoned such as addictive drugs, alcohol, tobacco and caffeine (coffee, tea with caffeine, chocolate, and soft drinks containing caffeine). Addiction is acidifying.

Carbonated soft drinks are acid and should be rarely used. Soft drinks are sweetened with corn sugar (in the US) and if and when used should be limited to the corn rotation day.

There is a valuable method of electrolysis which provides an alkaline micro negative ionized water that has an alkaline pH. There is a home electrolysis unit (AKAI instrument) that provides this alkaline micro water. It is recommended that five glasses of this alkaline micro water be used a day.

Nariwa water is a naturally negative ionized water from Japan's magnetic mountain and is the optimum alkaline micro water available. This comes in a bottle containing 500 cc. A minimum of one of these bottles should be used a day and preferably, two. The total amount of water used during a day should be a minimum of eight glasses of water and preferably as much as a total of ten glasses of fluid intake.

A copy is provided for the subject undergoing magnetic therapy and a copy for the monitoring physician.

COMPLEMENTARY TREATMENTS ASSOCIATED WITH MAGNET THERAPY NUTRITIONAL STATUS

Cancer will die in the presence of a negative magnetic field irrespective of the nutritional state of the patient. Single skin lesions such as melanoma, basal cell or squamous cell are easily treated without concern of the subject's nutritional state. It is recommended that every subject receiving magnet therapy in general and particularly for cancer, be under the care of a physician or nutritionist responsible for the nutritional state of the patient. A laboratory evaluation of the nutritional state of the patient is ideal. Since my focus is the use of the magnets and within this narrow focus the availability of lab work in terms of the nutritional state of the patient is not available. Therefore, it is recommended that everyone be under the care of a physician and that especially their nutritional state be considered.

VITAMIN C

Vitamin C is of special concern in cases of metastasis especially as when the abdominal cavity has been seeded with metastatic cancer from such as endometriosis, bowel cancer, ovarian cancer and so forth. There always remains the threat that the cancer may cause bowel obstruction. Multiple lung lesions are of special concern in

which the respiration can be interfered with. Brain cancer that is causing hydrocephalus is also of concern. In these precarious cases, it is advised that vitamin C be given in substantial doses such as 50 grams, three or more times a week for the first 6 weeks. Vitamin C intravenously can very rapidly prevent the cancer from growing and reduce the size of the cancer and the edema around the cancer. I have had considerable experience in using intravenous vitamin C. I find that it can quickly put a lid on the cancer however, in spite of the cancer remission, the intravenous vitamin C has to be continued every 2-4 weeks. Otherwise, the cancer returns. Oral vitamin C does not adequately place cancer in remission. Even bowel tolerated doses does not produce cancer remission. However, intravenous vitamin C does produce cancer remission but intravenous vitamin C has to be periodically continued in order to control the cancer. In these precarious life-threatening cases, it is well to start the intravenous vitamin C at the same time that you start magnet therapy. Vitamin C places the cancer in remission and the magnet therapy comes in for the kill of the cancer.

HYDRATION

Adequate hydration is very important and is an absolute necessity. Adequate hydration will help stop the pain. Hydration is necessary for magnet therapy and conduction therapy to work. It is not just water that is necessary but is also minerals in the water. There are available in health food stores, special waters that come from volcanic sources such as springs at the base of volcanic mountains or water from hot springs volcanic sources. These contain minerals that are negative ions. The water is also alkaline and micronized so that it has an increased value in hydration. The special water that I recommend is Nariwa water which comes from a spring at the base of a volcanic mountain in Japan. This is a micronized negative ion alkaline water. It should be understood that caffeine such as in coffee and cola drinks is a diuretic and that the fluid used in these drinks cannot be used as the fluid intake because the diuresis flushes more water out of the body than is being taken in with the drinks. Therefore, the hydration has to come from other fluid sources. Ideal are the mineral waters from these volcanic sources. Eight glasses of water should be used as a minimum. It is recommended that caffeine beverages not be used due to their dehydrating affect. Five or more glasses of this mineral water should be used daily. The total fluid intake should be 8-10 glasses

a day. A subject should keep a record of the amount of water he is drinking in order to be sure he is are being properly hydrated.

SPECIFIC MINERAL NUTRIENTS

There are specific minerals that help maintain the adequate continuous alkalinity. They are such as cesium, lithium and vanadium. These are being used with a reasonable degree of success in treating cancer. There is an added value in using these minerals along with magnet therapy and conduction therapy.

CHEMOTHERAPY

Negative magnetic field is a natural energy for the body and is compatible to be used with chemotherapy.

RADIATION THERAPY

Radiation therapy is compatible with magnetic therapy and in fact, magnetic therapy will help to alleviate the damage that radiation therapy does.

FINAL WORD

Human biology is electromagnetic. Magnetism is the energy of biological life and as such can predictably influence metabolism by an exogenous static magnetic field. There are two magnetic energies. Positive magnetic field energy controls wakefulness, mental and physical activity and when chronically maintained is stressful, producing unprocessed free radicals which can then produce peroxides, acids, alcohols and aldehydes, the state of which encourages the growth of invading microorganisms and cancer. Negative magnetic field energy controls rest, relaxation, sleep, cell replication, tissue healing and repair, is anti-stressful, antibiotic and anti-cancerous. The biological response to a positive magnetic field is acid-hypoxia. The biological response to a static negative magnetic field is alkaline-hyperoxia which is necessary for human metabolism. Microorganisms (viruses, bacteria, fungi and parasites) that invade the human body produce and need to maintain acid-hypoxia. Cancer, like invading microorganisms, produces and needs acid-hypoxia. The human organism can defeat invading microorganisms and cancer to the extent that it can maintain a constant high level of alkaline-hyperoxia. An exogenous source of static negative magnetic field can, with its alkaline-hyperoxia, support human physiology capacity to destroy invading microorganisms and cancer.

WHAT CAUSES CANCER?

I Cancer is caused by acid-hypoxia. Cancer growth requires an acid-hypoxia medium. There are many environmental carcinogenic substances. Maladaptive reactions to foods is a common cause of

acid- hypoxia. These maladaptive reactions to foods are in the nature of addictions, allergies and toxicities.

II What is the treatment for cancer?

The carcinogenic state of acid-hypoxia can be changed to alkaline-hyperoxia with the application of a negative magnetic field. Local cancer that has not metastasized can be treated with the negative magnetic field of a suitable size and suitable strength magnet. For skin lesions such as melanoma, basal cell and squamous cell cancers, the magnets used are a neodymium disc of 1" x 1/8". Two of these are stacked together. Or use a ceramic disc of 1-1/2" x 1/2" or for larger skin lesion, ceramic magnets of sufficient size to cover the lesion. The treatment is 24 hours a day for a minimum period of three months. For metastatic lesions, the local treatment is also used plus a systemic treatment of a 70-magnet bed. These magnets are 4" x 6" x 1". It takes seventy of these to make a single sized bed. The minimum treatment is three months of near continuous exposure. The subject sleeps all night on this bed and one hour, four times during the waking period. Some, in a very serious state, sleep on the bed all the time and get up for one hour at a time, three or four times a day.

III Ancillary treatment for general health.

1. Intravenous vitamin C. This is particularly useful for serious cases, to put a lid on the cancer growth and follow this with the magnet and at the same time, use the negative magnetic field to kill the cancer.

2. Nutrition should be optimized under the supervision of a physician.

3. Negative ion treatment: The home air can be treated producing a negative ion field with the negative ion generator.

4. Negative ion water: Alkaline-negative ion water can be obtained from springs at the base of a volcano or a volcanic water source such as from a volcanic hot springs.

THE GOOD NEWS IS THAT AN EXOGENOUS STATIC NEGATIVE MAGNETIC FIELD OF SUFFICIENT GAUSS STRENGTH AND SUFFICIENT DURATION SUPPORTS THE HUMAN BIOLOGY'S NATURAL NEGATIVE MAGNETIC FIELD, EFFECTIVELY AND NON-TOXICALLY, KILLING CANCER

REFERENCES

AHARONOV, Y. and BOHN, D. Significance of Electromagnetic Potentials in Quantum Theory. The Physical Revision. 115, 485. (1959).

SEMM, P, SCHNEIDER, T & VOLLRATH, L. "The Effects of an Earth Strength Magnetic Field on the Electrical Activity of Pineal Cells". Nature, 1980; 288: 607-608.

WARBURG, O., On the Origin of Cancer Cells. Science 123 (1956) 309-315.

SZENT-Gyorgyi, ALBERT. *Electronic Biology and Cancer. A New Theory of Cancer.* 1976. Marcel Dekker, Inc. NY, NY 10016

GOLDBLATT, H., and CAMERON, G. (1953), J. Exp. Med., 97:525-552; GOLDBLATT, H., FRIEDMAN, L., and CECHNER, R.L. (1973), Biochem. Med., 7:241-252

RAYLMAN, RAYMOND R., CLAVO, ANAIRA C., WAHL, RICHARD L. Bioelectromagnetics 17:358-363. Wiley-Liss, Inc. 1996.

TRAPPIER, ARTHUR, et al. "Evaluating Perspectives on the Exposure Risks from Magnetic Fields", Journal of the National Medical Association, 82:9, September 1990.

DAVIS, A.R. and RAWLS, W. "The Magnetic Blueprint of Life.". Acres USA, Kansas City, MO, 1979.

W.H. Philpott, M.D., PHILPOTT, W.H., M.D. and KALITA, Dwight, Ph.D., *Magnet Therapy.* (Tiburon, CA: Alternative Medicine. corn, 2000); PHILPOTT, W.H., M.D. *Cancer. The Magnetic/Oxygen Answer.* 2001 edition. Published by W.H. Philpott. 17171 S.E. 29th Street, Choctaw, OK 73020.

BECKER, ROBERT 0. and SELDON, G. "The Body Electric. Electromagnetism and the Foundation of Life." William Morrow and Company. NY. 1986.

JOKLIK, WOLFGANG K, D. Phil. Zinsser Microbiology. 20th edition. Appleton & Lange,

Norwalk, CT. 1992. *[*"Cancer Prevention & Reversal," ***Magnetic Health Quarterly, Vol.II, 4th Qtr, 1996 (Revision Update 2000, Revision Update 2004)] Detoxification***
MAGNETIC PROTOCOL
Acid Toxicity, Chemical Toxicity, Heavy Metal Toxicity
MAGNETIC FREE ENERGY DETOXIFICATION
Theron G. Randolph, M.D. was the first to observe that when symptoms develop on deliberate exposure after a five-day period of avoidance, acidity develops. He postulated that this acidity disordered enzyme functions (1). My research of fasting

patients for five days, followed by deliberate test exposure to foods while monitoring blood or saliva pH before and one hour after post-test meal demonstrated consistently that acidity developed when symptom reactions occurred (2).

We are now prepared to identify the enzymes involved and their functions. They are the family of oxidoreductase enzymes (3). They have the assignment of making ATP and oxidation remnant magnetism (a negative magnetic field) by the process of oxidation reduction (4). These enzymes are alkaline-dependent and therefore do not function in an acid medium. When acidity develops due to a maladaptive reaction, these enzymes do not function. These maladaptive reactions have several sources, principally of which are addictions, true immunologic allergies and otherwise hypersensitive reactions. In making ATP, both alkalinity and hyper-oxygenation is necessary. Furthermore, these enzymes also have the assignment of processing toxins and free radicals. Superoxide is a biological product of oxidation-reduction when ATP is made. Superoxide must be processed quickly or it develops into other toxic substances such as peroxides, oxyacids, alcohols and aldehydes. When the oxidoreductase enzymes do their job properly, the end product of these toxins is molecular oxygen and water. Also, exogenous toxins from environmental substances are processed by these same oxidoreductase enzymes. These exogenous toxins include any sources and also such as petrochemical hydrocarbons which are processed by cytochrome P450. This also includes heavy metal toxins. Heavy metal toxins are toxic because they are electromagnetic positive, which forms free radicals and the chain of inflammatory reactions from free radicals. A negative magnetic field replaces the electromagnetic positivity of the heavy metals and cancels out their toxicity. In this non-toxic state, they are processed out of the body as non-toxic.

The way that a negative magnetic field functions is to, first of all, attach to the bicarbonate and increase their alkalinity and secondly, to energy activate oxidoreductase enzymes. In the natural course of biological catalytic function of these enzymes, they use static field electrons to move between the enzyme and the substrate, which then produces the catalytic reaction with an end result of molecular oxygen and water. When electrons move, a magnetic field is produced. The

magnetic field produced by the oxidoreductase enzymes is a negative magnetic field. These static electrons activating enzyme catalysis is termed free energy since it comes from the environment of the sea of electrons we are in and not from energy produced by the food we eat. In fact, oxidoreductase enzymes are not ATP dependent and do not use ATP as an activator. Since the movement of electrons produces a magnetic field, then ultimately the energy activator is a negative magnetic field. This is why an exogenous source of negative magnetic field will energy activate oxidoreductase enzymes. The stronger the magnetic field, the stronger the catalytic reaction. This use of free magnetic energy from a static field magnet is why magnetic therapy works.

Theron G. Randolph was right that acidity develops when maladaptive reactions occur and in fact the acidity is the cause of the reaction. We now understand the enzymes involved which are the family of oxidoreductase enzymes that are alkaline dependent and therefore their catalytic reaction function is blocked by acidity. A negative magnetic field will, first of all, alkalinize, and second, energy activates oxidoreductase enzymes thus rapidly relieving symptoms. This is magnet therapy.

There are several valuable lessons that we learned out of my research. The custom was to fast the patient for five days, using water only. In later years, we learned the trick of using foods that were seldom used, such as watermelon, for a fast that worked the same way. I did some monitoring that had not been done before. I had been interested for some time in hypoglycemia and diabetes. Therefore, I monitored the blood sugar before and an hour after each test meal of single foods. Dr. Theron Randolph had stated that his observations were that when symptoms emerged there was acidity with swollen cells that emerged that caused the symptoms. So, I monitored the pH of the blood and or saliva before the test meal and after the test meal. I also was looking for infections so we originally did a broad-spectrum study of bacteria cultures, viral antibody studies and cultures for fungi. Out of this came some valuable information. Blood sugar was disordered about half of the time. A number of my patients were also diabetic and their diabetes cleared when we removed the foods that gave them the hyperglycemic reaction. These foods could be returned after

three months without this occurring. This resulted in me writing a book called *Victory Over Diabetes*. We found that common among our mental patients were antibodies to Epstein-Barr, cytomegalo and Human Herpes #6 (one or more of these). We also found that most of the patients had Candida in their vaginal or stool samples. The pH studies were very important because we did find that indeed acidity emerged at the time symptoms occurred which was one hour after the test meal. These pH studies had never been done before. We were also running immunology studies and we found out that the majority of the symptom producing foods were not caused by immunologic reactions but by another mechanism which we isolated to be food addiction. It was also Theron G. Randolph that found that food addiction was an important cause of symptoms. We found the common denominator to symptom production was that of acidity whether or not their reactions were associated with immunologic phenomena or no evidence of immunologic disorder. Allergy today would be quite a different science had it been known that a common denominator of symptom production was acidity and not antibodies or complement disorder. You can only know this if you are doing deliberate food or chemical exposure testing while monitoring the pH changes. As far as infections are concerned it seemed apparent that my mental patients had an infection of one of the lymphotrophic viruses (Epstein-Barr, cytomegalo and Human Herpes #6) and that this had injured their brain. They had this infection while their brain was in the developmental stage and it had injured the brain. This is why the brain is the target organ for symptoms due to food reactions. The actual central illness is the viral infection and the reactions to foods, chemicals and inhalants giving mental symptoms was a secondary phenomena. This was important of course, because avoidance and spacing of contact can handle symptoms. A 4-Day Diversified Rotation Diet became a very important tool. In fact, I have had to conclude that there is no substitute for a 4—Day Diversified Rotation Diet. Neutralization and desensitization for foods simply does not match the value of a 4-Day Diversified Rotation Diet.

 Since I had observed that acidity emerges at the time symptoms emerge, I was using the method of soda bicarbonate given orally or sometimes intravenously along with breathing

oxygen. Of course, when there is an acid pH there is always an oxygen deficit because molecular oxygen cannot remain free in an acid medium. This is where my utilization of magnets occurred. I was in practice in St. Petersburg, Florida. Albert Roy Davis was in St. Petersburg, Florida. I heard of his work in which he stated that a negative magnetic field alkalinized and oxygenated. This is what I was doing, providing baking soda and also oxygen. For this reason, I tested out to see if I could relieve symptoms with a negative magnetic field placement over the area where the symptoms were occurring. It is true that using a negative magnetic field is more predictable than the use of soda bicarbonate and the breathing of oxygen. I had come to realize that chronic diseases are simply extensions in time of acute reactions. Therefore, I began to treat the symptoms of degenerative *diseases* with magnets. I began this study 18 years ago and by this time have considerable experience in treating not just acute symptoms, but chronic diseases with magnetic therapy.

The Role of Enzymes in Detoxification

Oxidoreductase enzymes are the only enzymes metabolically, specifically assigned the job of detoxification. This is why it is so important to understand their role in detoxification as well as their role in energy activation by a static negative magnetic field.

Proteolytic enzymes have a partial role in detoxification due to their ability to reverse inflammation. It is the oxidoreductase enzymes that have the broad-spectrum detoxification capacity. It is amazing how quickly and efficiently a wasp sting, bee sting, ant bite or other insect bite or sting will detoxify without any residual with the application of a negative magnetic field to the injury. When a person experiences the efficiency of detoxification, there is no longer a wonder of how effective a negative magnetic field is in activating oxidoreductase enzymes for detoxification.

Enzymes are energy-driven biological entities that constitute the many components necessary for the making of life-energy production and all of its entities in turning raw food elements into living structures and functions of these structures. Toxicity is in essence the poisoning of enzyme functions. There are thousands of enzymes with thousands of functions in the human organism. The oxidoreductase enzyme family is a

specific set of enzymes with two essential life functions. Their first function is to make foods into energy that drives specific enzymes and their functions. The second function is to process the toxic spin-off of the food being processed to adenosine triphosphate energy (ATP). The capturing of life energy from foods is termed oxidation-phosphorylation. Thus oxidation phosphorylation processes by virtue of four oxidoreductase enzymes makes ATP and catalytic remnant magnetism called oxidation remnant magnetism. This catalytic produced magnetic energy is a negative magnetic field. In this process molecular oxygen (O_2) accepts an extra electron and is now superoxide (O_2) which is toxic. If not processed immediately, it generates other toxic substances such as peroxides, oxyacids, alcohols and aldehydes. These are self-made (endogenous) toxins. These oxidoreductase enzymes can add electrons or subtract electrons as the case may be in processing these toxic substances to harmless pure water (H_2O) and molecular oxygen (O_2).

These oxidoreductase enzymes classified according to their functions are dehydrogenases, hydrolases, oxidases, oxygenases, peroxidases and reductases. These enzymes are alkaline-dependent. It is a negative magnetic field that makes and maintains alkalinity. Furthermore, it is a negative magnetic field that energizes these alkaline-dependent oxidoreductase enzymes. The movement of electrons between enzyme and substrate from a static electron field in an alkaline medium produces a negative magnetic field when the enzyme and the substrate join. Furthermore, a static magnetic field separate from a static electric field can energize the catalysis joining of a substrate and oxidoreductase enzyme. The substrates referenced to are foods in the first catalytic reaction and toxins in the second catalytic reaction.

Magnetic therapy is the energizing of oxidoreductase enzymes to join substrates such as foods for the production of ATP plus catalytic magnetism and also toxic substrate to join oxidoreductase enzymes to produce water and molecular oxygen. Thus, it can be understood that a negative magnetic field energizing oxidoreductase enzymes is central to the human body's capacity to detoxify toxins whether these are endogenous toxins or exogenous toxins. The catalysis of oxidoreductase enzymes is the process by which all toxins, whether endogenous

or exogenous, are enzymatically detoxified. A static negative magnetic field is the activator of oxidoreductase enzymes. Thus, a static negative magnetic field is the central energy source of biological detoxification.

Oxidoreductase enzymes are the only enzymes metabolically, specifically assigned the job of detoxification. This is why it is so important to understand their role in detoxification as well as their role of oxidoreductase enzyme energy activation by a static negative magnetic field.

The rapid detoxification of a burn provides convincing evidence of the ability of a negative magnetic field to detoxify and normalize human biological functions. The immediate observable state of a superficial burn is a white avascular color of the skin plus excruciating pain. The end result of a superficial burn is blistering followed by sloughing of the skin. When a negative magnetic field is immediately placed over the burn, the pain and white blanching dissipates in about five minutes and there is no blistering or sloughing of the skin. The skin shows no evidence of injury. The negative magnetic field activation of the oxidoreductase enzymes recovers the biological functions as soon as the acid hypoxic state is replaced with an alkaline-hyperoxia state.

The value of avoidance of the symptom-producing foods or substances is observed in which a five-day fast produces recovery from symptoms. There are cases in which enzyme function is not adequately activated by avoidance in which case a negative magnetic field energizing oxidoreductase enzymes is required for a functional return.

Karl recovered from his psychosis with five days of avoidance of foods and the petrochemical hydrocarbons he was reacting to. He remained well for 19 years on an avoidance of pesticides and food reaction. With a mass of prolonged exposure to petrochemical hydrocarbons, he again became psychotic. He did not recover from his psychosis after several weeks of avoidance of exposure to petrochemicals. Within five minutes of bitemporal exposure to a negative magnetic field, his symptoms vanished. In this case it required a negative magnetic field to energize the oxidoreductase enzymes to restore normal function. This case reveals that we should not rely on avoidance as our only answer of recovery but instead provide a negative

magnetic field for the reinstatement of oxidoreductase enzyme function by a negative magnetic field.

Many human metabolic enzymes are ATP-dependent as well as alkaline-dependent. These ATP and alkaline-dependent enzymes are also energized by a negative magnetic field. Thus, a negative magnetic field has a central energizing function for all alkaline dependent enzymes and for their ability to detoxify, that is, their ability to have a reinstated function after an enzyme inhibiting substance has poisoned them.

Oxidoreductase enzymes are in every cell and all fluids in the body but are more concentrated in the liver along with numerous other enzymes. Thus the liver is the central organ that processes toxins that have not been adequately processed at the local cellular level. The P450 oxidoreductase enzymes are of special importance in that they process petrochemical hydrocarbons. Placing a 4" x 6" x 1/2" or 4" x 6" x 1" static field magnet energy activates the oxidoreductase enzymes including the P450 enzymes to process these toxins that poisoned these enzymes and thus block their function. As long as they are in the state of being poisoned, these enzymes cannot function. Under these normal circumstances, these enzymes are not functional because they are poisoned. However, a negative magnetic field will so energize these enzymes so as to override their poison state and now they can process the very substances that had poisoned them.

A man in his 40's developed a serious toxic liver injury from a medicine he had been provided. His only chance of survival was a liver transplant. While waiting for a liver transplant, his liver was treated with the negative magnetic field of a 4" x 6" x 1/2" ceramic block magnet.

This was a 24-hour a day treatment. From all observable appearances, he became well. One year passed before a liver was available for transplantation. When examined, his liver function tests were all normal and he was in good health. The liver transplant was not needed. He decided he was well and therefore, stopped using the magnet over his liver and abandoned the rotation diet that he was on. He shortly became ill and promptly died due to liver failure. This case demonstrates the value of treating the liver with a negative magnetic field. This case also demonstrated that his liver could only

function in the presence of a continuous exposure to a negative magnetic field.

Endogenous Toxins

There are two major endogenous toxins. One is superoxide (O_2') and the other is lactic acid. Super oxide (O_2') is a spin-off of oxidation-reduction producing ATP and oxidation remnant magnetism in which molecular oxygen (O_2) receives an extra electron producing super oxide (O_2'). This superoxide must be enzymatically processed immediately or it becomes organic peroxides, oxyacids, alcohols or aldehydes. These are all enzyme toxins and inflammatory substances.

$$O_2' \xrightarrow[\text{Alkaline medium plus negative magnetic field}]{\text{Superoxide dismutase}} H_2O_2$$

$$H_2O_2 \xrightarrow[\text{Alkaline medium plus negative magnetic field}]{\text{Catalase}} H_2O \text{ and } O_2$$

Lactic acid is a byproduct of anaerobic muscle metabolism. When the available ATP is used up, muscles resort temporarily, to maintain their functional capacity, by fermentation, to produce ATP. Fermentation occurs in the presence of an acid medium with transferase enzymes producing ATP in this anaerobic state. The by-product of this fermentation process is lactic acid. This is what makes the muscles sore. Oxidoreductase enzymes process this lactic acid and then turn it back to water and molecular oxygen. ATP made by fermentation is only a temporary measure to sustain muscle function. It cannot sustain human life energy. Fermentation can sustain the life energy of microorganisms and cancer cells.

Exogenous Toxins

Exogenous enzyme toxins are such as microorganism toxins, cancer cell toxins, heavy metals, petrochemicals including such as pesticides and other products of fossil fuels and so forth, and formaldehyde, which is a toxic product of petrochemicals. There are many useful industrial products made from petrochemicals. There is a continual need for us to be

processing these industrial toxins and also a need to avoid them as much as possible. These enzyme toxins inhibit enzyme functions and their ability to process these toxins. This enzyme toxic state can be overridden by energy activation of bicarbonates producing alkalinity and energy activation of oxidoreductase enzymes.

Heavy metals are toxic by virtue of forming free radicals and conjugation with specific elements in tissues and enzymes including the oxidoreductase enzymes. Heavy metals are toxic because they are electromagnetic positive and thus attach to electromagnetic negative elements in tissues and enzymes. A negative magnetic field attaches to the electromagnetic positivity of heavy metals and blocks their toxicity plus enzymatic processing of free radicals that have been formed by the heavy metals. Thus, while the heavy metal is in a negative magnetic field, it is non-toxic. While in this non-toxic state, heavy metals are being dispensed of in the urine and feces and in the case of mercury also being discharged in the breath.

Other sources of exogenous toxins are such as toxins from plants and toxins from insect stings and bites. All of these toxins inhibit oxidoreductase enzymes. However, when these oxidoreductase enzymes are energized by a negative magnetic field, then they process these toxins. An example of this is the remarkable reversal of the toxic effect of a bee sting or a wasp sting. When an negative magnetic field is placed immediately over the insect sting, it will effectively process these toxins in which no harmful effects will occur. This evidence is a remarkable and readily observable evidence of a negative magnetic field activating oxidoreductase enzymes and detoxifying the acids and other components of the insect sting. There is also one report of a snakebite having been handled with a negative magnetic field exposure.

Non-Enzyme Detoxification: Sweating Detoxification

Toxins can be processed out of the body by sweating; infrared sauna treatments are ideal for discharging toxins through the skin. Thirty minutes, two or three times a week or even daily, is remarkably beneficial. A sauna treatment is alkalinizing and thus oxidoreductase enzyme stimulating. The increased temperature also helps in activating oxidoreductase enzymes.

Infrared Sauna:

Far infrared is a good, non-injurious heat source with several valuable health promoting values including alkalization, oxygenation and detoxification.

1. Alkalinization

The human body functions in an alkaline medium. Enzymes in the human body are dependent on alkalinization and on temperature range. Increasing the temperature increases the enzyme function.

2. Oxygenation

The human body makes it's energy by the oxidation process requiring the presence of molecular oxygen. As the temperature rises, the oxidation process increases. Thus, this will aid in producing more energy.

3. Detoxification

The human body processes toxins, some by being exhaled from the lungs, others passed out through the urine or the stool. Sweating from the skin is another process of detoxification. The far-infrared sauna is ideal in that it penetrates through the layers of the skin and into the subcutaneous fat throughout the skin and then detoxifies all types of toxicity including heavy metal toxicity. Therefore, this is ideal for heavy metal toxicity such as mercury, lead or other heavy metals. It also processes the enzyme inhibiting acids such as in degenerating diseases. Especially noted is the value in processing the toxins from cancer. Therefore, this is also a valuable treatment for degenerative diseases, including cancer.

Far-infrared sauna is markedly complementary to negative magnetic field therapy which is also alkalinizing, oxygenating and detoxifying.

Infrared hand-held Lumiscope: The Infralume Hand-held Lumiscope is an ideal instrument. This is obtainable from medical supply stores and drug stores. When using the Infralume, the magnet can be placed on the area immediately after heating. There can be 30 minutes of heating one or more times a day.

Hyperbaric Oxygen Therapy Detoxification:

Oxygen under pressure is detoxifying. I have measured the presence of pesticides in a subject before and after a series of hyperbaric oxygen treatments. There was a remarkable processing of the pesticides out of the body.

Colon Detoxification:

Dispensing of toxins through the colon is a natural process of detoxification and of ridding the body of the toxins by their spillage into the bowel. The wall of the intestinal tract has a special capacity to make melatonin, which is anti-free radical and also has the capacity to tie up the hydroxyl radical.

Flushing the bowel with enemas and colonics has an established value. A good self-help method of cleansing the bowel is that of a vitamin C flush. Use sodium ascorbate. There are 4 grams in each teaspoon. Place 2 teaspoons in a glass of water. Drink a glass of water every half hour or every hour. Start in the morning before having eaten any foods. Keep drinking this sodium ascorbate water until there is a diarrhea flush. Not only is the vitamin C detoxifying, but also the vitamin C flush will discharge the colon content. This could be repeated as needed once a week or less.

Sufficient vitamin C should be taken beyond the ability of absorption, which would be sufficient to maintain a soft but formed stool. This has to be completely individualized. In a series of urine spillage of vitamin C, I have found that many toxic patients will have to have as much as 25 grams of vitamin C before they spill any in the urine. Many will do well with 10 grams of vitamin C a day. This should be individualized according to the need of the subject. I have noted some cancer patients to be taking as much as 50 grams of vitamin C orally a day, and still have formed stools. It is very important for cancer patients, especially when the cancer is in the abdomen, to keep a soft stool to prevent, if possible, blockage from the cancer within the colon or pressure on the colon from a cancer outside of the colon. Each subject with abdominal cancer should maintain a soft stool. Even then, it needs to be understood that vitamin C and a negative magnetic field will not always be the answer. If a blockage develops, then surgery may be the only answer.

Detoxification of Immune Reactions:

Allergic immune reactions are themselves toxic and need to be detoxified. Immune reactions are always acidic. The negative magnetic field can change this acidity to alkalinity, which in itself has considerable effect on relieving the symptoms. It is evident that immune reactions are not the primary defense of the body, instead the level of the negative magnetic field is the primary defense of the body and when the

negative magnetic field is sufficiently high, an immune reaction will not develop. Once the immune reaction has developed it can be reversed with a negative magnetic field of sufficient gauss strength and duration. Local treatment involves the placement of a strong negative magnetic field over the local area. A systemic treatment would require a magnetic bed of 70-magnets that are 4" x 6" x 1" placed one inch apart. Seventy of these will cover a single bed of 36" x 72". Immune responses will be enhanced by a positive magnetic field and can be blocked by a negative magnetic field. A positive magnetic field can be used to purposely enhance immune responses to such as bacteria and viruses (positive magnetic fields reinforce vaccination). A negative magnetic field is used to desensitize responses to these microorganisms.

Nutritional Detoxification:

Enzymes are made from nutrients, especially amino acids, minerals and vitamins. Nutrition should be adequate to supply these needs. It is well to supplement these needs.

It is well to take a general vitamin and mineral supplement. The only way to know for sure what the need is, is for a medical practitioner to examine these in human tissue or quantity in the blood and so forth. B_{12} and folic acid are of special importance and should be periodically checked and supplied either orally or sometimes of necessity, intramuscularly. Only a physician can discover these particular needs. There should be an abundance of green leafy and fibrous vegetables. Any person interested in health should be examining the literature on nutrients. One special nutrient can be quite beneficial for its detoxifying effect. That is chlorella. A number of heavy metals have specific nutrients to which they would attach and can thus be removed from the body. For example, mercury attaches to sulphur and an abundance of sulphur containing foods can help remove mercury and other metals that attach to sulphur or other components of the food from the body.

It should be understood that adequate food intake is necessary as building blocks for enzymes. However, it should be equally understood that enzymes do not function just because they are present in adequate or even super adequate supply. Enzymes require energy activation. The negative magnetic field is the energy activator of oxidoreductase enzymes and thus the energy activator of detoxification. We must have adequate

enzymes. We must have the energy activator of these enzymes. It has been an error made in medicine that the enzymes provided in adequate supply functioned spontaneously. This is why orthomolecular medicine made the assumption that by raising these enzymes; by such as megadoses of B_3, this would spontaneously result in the increased function of these detoxifying enzymes. This was in error. It is true that a higher amount than is usually used may be needed but not the massive doses of B_3. The energy activator has by error been missed through the years. You need not just nutrition but you need a negative magnetic field to activate these detoxifying enzymes.

There are a number of nutrients that can serve as absorbents for free radicals. It is well to use these antioxidants. However, it should be understood that a negative magnetic field is the greatest of all antioxidants. Superoxide, which is oxygen with an extra electron is what a free radical is. In the presence of a negative magnetic field, this extra electron which is spinning clockwise and thus free because it is a free radical which is positive magnetic charged the same as the proton in the center of the atom. Therefore, this free radical is pushing out from the center. In the presence of a negative magnetic field, the free electron spins counterclockwise and is thus pulled toward the center and is not free. At the same time, the negative magnetic field energizes the enzymes superoxide, dismutase and catalyse that processes this free radical to water and molecular oxygen. Thus it can be understood that there are no free radicals in the presence of a negative magnetic field.

Chelation Detoxification:

Chelation is a process of providing orally, or especially intravenously, substances to which a heavy metal attaches and thus can be processed out of the body in a non-toxic state. It is beyond the scope of this quarterly to describe the details of chelation therapy. It is accepted as the most efficient method of detoxifying and removing heavy metals from the body.

The Detoxifying Role of Hydration:

Seventy percent of the human body is water. With a 5% loss of water, symptoms of toxicity develop. Adults, even though they have symptoms from the dehydration of 5% loss of water, can survive. However, infants with 5% dehydration would die. Water is lost from the body by urine, feces, sweating

and with breathing. Toxins are removed from the body through the urine, feces, sweating and through the breath.

With dehydration, body fluids (blood, extra cellular fluid and fluids within the cells) become acidic. A pH of 7.4 (7.35-7.45) must be maintained for necessary life-sustaining enzymes to function. Most enzyme-sustaining life functions are alkaline-dependent. Among other enzymes, acidity from any source including dehydration, inhibits by it's toxic effect, the functions of the oxidoreductase enzymes that have the assignment of making adenosinetriphosphate which is an aspect of human life energy along with catalytic remnant magnetism (a negative magnetic field). Furthermore, these oxidoreductase enzymes have the assignment of processing endogenous inflammatory toxins (free radicals, peroxides, oxyacids, alcohols and aldehydes) and also exogenous toxins (petrochemical hydrocarbons, heavy metals, acids, toxins from invading microorganisms, cancer, insect stings and reptile bites and so forth). This detoxification by oxidoreductase enzymes occurs by either adding or subtracting electrons as the need may be. The end result of oxidoreductase enzyme detoxification is pure water and molecular oxygen.

The necessary maintenance of an optimum alkaline pH (7.4) is a magnetic field mechanism. A negative magnetic field attaches to calcium, magnesium and potassium minerals in solution producing the alkaline bicarbonates of these minerals. Only the negative magnetic field produces alkaline mineral bicarbonate. A positive magnetic field blocks the production of alkaline bicarbonates and instead produces acids. Since only the negative magnetic field is capable of producing alkaline bicarbonates, it is understood that the human body of necessity, has to maintain a greater amount of a negative magnetic field than a positive magnetic field. The battle of maintaining health is of necessity that of maintaining a higher negative magnetic field over that of a positive magnetic field. Understandably, magnetic therapy is mostly the application of an exogenous static negative magnetic field.

It has been determined that a negative magnetic field structures the water in small units of 3-5 water molecules. In a positive magnetic field, acidity water has clusters of 50-60 water molecules. The energy from a negative magnetic field is necessary to break down the 50-60 molecules of water to 3-5

molecules of water before the water can be hydrating to the cells. Methods of restructuring the water with a static negative magnetic field are as follows: 1) placing the water and fluid foods over the negative magnetic field of a 4" x 6" x 1/2" ceramic block magnet for a minimum of five minutes, 2) sleeping on a negative magnetic field mattress pad, 3) treating the heart to a negative magnetic field during sleep by placing a 4 x 6" x 1/2" magnet on the heart and holding in place with a 4" x 52" Cool Max body wrap, 4) treat any specific symptom area with a negative magnetic field, 5) use electrolysis-produced alkaline micro water, 6) structured alkaline water from a spring with "healing alkaline micro water".

It is likely that the best of all these methods is to treat the water with electrolysis, producing alkaline micro water. There are several companies with electrolysis instruments for the production of alkaline micro water. I recommend the Singer Electrolysis Instrument for the production of alkaline micro water.

There are, throughout the world, springs that naturally contain structured alkaline micro water. France, Tibet and Japan are known for "healing water springs". These mineral waters have passed through a negative magnetic field, which has structured and alkalinized the water. OHNO Institutes of Cleveland, Ohio has demonstrated the value of an alkaline-structured water from a volcanic spring in Japan.

The minimum amount of pure water, preferably alkaline micro-structured water, per day is eight glasses for adults. The more toxic the subject, the more water that is needed for its detoxifying value. I have known of some toxic individuals to feel their best with 16 glasses of water a day.

Another useful detoxifying water is the use of ascorbate water. Mineral ascorbates are readily available since several companies have marketed mineral ascorbates. I recommend Vital Life Multi-Element Buffered C Powder, one teaspoon per day. This provides ascorbates of calcium, magnesium and potassium. The rest of the ascorbates should be sodium ascorbates. I have examined the urine spillage of a series of ill subjects and found that a sizable number needed 25 grams before there was any spillage of vitamin C in the urine The best method to determine the amount of vitamin C needed for

each individual toxic subject is to determine the amount needed by the consistency of the stool.

The amount of vitamin C taken by a toxic subject should be sufficient to have a soft-formed stool. This will detoxify the colon and have sufficient vitamin C for detoxification of the blood, intra-cellular fluid and intercellular fluid. Each teaspoon of sodium ascorbate powder has four grams of vitamin C. Place the sodium ascorbate powder in water.

An ascorbate flush is an ideal colon detoxifier and preferred to colonics. Starting with an empty stomach, add two teaspoons of sodium ascorbate powder to a glass of water. Drink one glass of water with two teaspoons of sodium ascorbate each half hour until a diarrhea flush occurs. This can be repeated as often as needed. Once a week or once every two weeks is a reasonable frequency for an ascorbate flush for a toxic subject.

Hydration is so important that the amount of water used on a daily basis should not be guessed at but instead, counted. There should be a minimum of eight glasses of water and more is better. The more toxic, the more water needed. This should be pure water, preferably electrolysis-produced alkaline-micro water. This provides not only alkalinity, but also small clumps of water instead of large clumps of water. It also carries a negative magnetic field. If this water is not available, then it should be magnetic negative poled by placing, each glass of water on the negative pole of a 4" x 6" x 1/2 magnet for a minimum of five minutes before drinking.

Water is paramagnetic. A negative magnetic field is necessary for all healing water, which carries a healing negative magnetic field to the human cells. Blood is 90% water, whereas the total human organism is 70% water. The blood must maintain a pH of 7.4 in order for healing to occur. Alkalinization of water is by means of a negative magnetic field activating the mineral bicarbonates such as calcium bicarbonate, magnesium bicarbonate and potassium bicarbonate. Human life energy, making adenosine triphosphate plus a negative magnetic field catalytic magnetism of oxidative phosphorylation and the magnetic activation of the detoxification by oxidation remnant magnetism family of the enzymes cannot exist separate from a negative magnetic field. Furthermore, an alkaline pH cannot be maintained without the negative magnetic field being higher than the positive magnetic field. Human life is not a balance between positive and negative

magnetic fields but in-stead is an imbalance in favor of a negative magnetic field. For microorganisms, parasites and cancer cells it is with a positive magnetic field being higher than a negative magnetic field. Toxins are a positive magnetic field. A negative magnetic field cancels and enzymatically processes toxins and kills invading microorganisms.

The Characteristics of Light Metallic Mineral Elements

Sodium, magnesium, potassium and calcium minerals are light atomic weight metallic elements. These are soluble and form bicarbonate in neutral pH water. A negative magnetic field energizes the production of and maintenance of their soluble bicarbonate alkaline state in biological systems. Thus, a negative magnetic field is responsible for maintaining alkalinity in biologic systems. These alkali minerals are soluble in an alkaline medium and precipitate into insoluble mineral salts in an acid medium. Calcium is especially noted for its insoluble state in an acid medium which forms deposits in human tissues.

Characteristics of Heavy Atomic Weight Metals

Heavy metal toxicity is proportional to the electropositive and the solubility of metals cations in water or in liquids.

Varying degrees of solubility in a neutral and alkali medium. Metals have freely moving electrons (conduction electrons).

Toxicity is in proportion to their electromagnetic positivity and solubility. Electromagnetic positivity is toxic while electromagnetic negativity is not toxic. A static negative magnetic field can produce an electromagnetic negativity and thus counter the toxic electromagnetic positivity. The electromagnetic positivity produces free radicals.

The detoxification of heavy metals in solution is achieved by a negative magnetic field biological response of alkalinity and electromagnetic negativity. As long as the soluble metal ions are soluble and in a negative magnetic field, there is no toxicity. In essence, there is no formation of free radicals and damage from the free radicals. In this state of negative magnetic field, soluble heavy metals do not proceed to produce free radicals in biological systems. Furthermore, a negative magnetic field energizes oxidoreductase enzymes, which rapidly detoxify free radicals and their end products such as peroxides, oxyacids, alcohols and aldehydes.

Heavy metals are (known to be) rapidly dispensed in the urine and feces and in the case of mercury, also from the lungs

while in a negative magnetic field. These heavy metals are excreted from the body in a non-toxic state. A strong negative magnetic field bed is ideal for the detoxifying of heavy metals.

Heretofore, medicine has been dependent on chelation of heavy metals. EDTA is ideal for the chelation of lead and some other heavy metals whereas sulfur-containing compounds serve best as chelating agents for mercury. The negative magnetic field detoxification method applies to all heavy metals. Furthermore, the negative magnetic field detoxification method equally applies to petrochemical hydrocarbons through the energy activation of oxidoreductase enzymes in the subclass of P450. In the case of microorganisms, not only are the toxins produced by these organisms detoxified, but also the organisms themselves die in the presence of a negative magnetic field, there is a common denominator to the usefulness of a negative magnetic field in all of these cases which is conductivity. A negative magnetic field supports the human level of conductivity and inhibits the level of conductivity of heavy metal, microorganisms and cancer cells. A common biological response by-product of a negative magnetic field is alkaline-hyperoxia. This in itself can explain some of the corrections. Furthermore, the degree of conductivity is also a central important factor.

Heavy metals are electropositive and have a higher conductance than the electronegative human cells. Electromagnetic positive, due to their degree of conductance, have a vibrational pulsing frequency beyond twelve cycles per second. This is stressful to human cells. Microorganisms have a higher conductance than human cells and thus vibrate beyond the twelve cycles per second. Therefore, they are stressful to human cells and also are electromagnetic positive. Cancer cells behave like invading microorganisms.

Case History

A man in his 40's had severe ringing in both ears that was so severe that it interfered with the attention that he could give to someone speaking to him. At the time of initial examination, I placed a 4" x 6" x 1/2" magnet up against his right ear. The ringing stopped in his right ear but was still present in the left ear. I then removed the magnet. The ringing returned. I placed the magnet over the left ear and the ringing stopped in the left ear. When the magnet was removed, the ringing returned. I told him that in my opinion the problem was the dozen amalgams he had in his teeth

and that a current was flowing between the teeth due to the conductivity of the minerals. The dentist removed the amalgams on one side of his mouth and the ringing stopped on that side. (Should be removed by a biological dentist for safety. Ed.) He came directly from the dentist's office to my office for chelation. The ringing in the side of the mouth where these amalgams had been removed was no longer there. He still complained of feeling weak, which was an original complaint of his. The next day, the amalgams were removed in the other side of the mouth, which then had removed all of the amalgams. The ringing stopped and his energy returned. This is an illustration of the conductivity of heavy metals, in this case, mercury and silver. Fortunately in this case, the source could be removed. This case does illustrate that a negative magnetic field can change the conductivity from electromagnetic positive to electromagnetic negative. In this case, the symptoms could be immediately removed. However, the point to be understood is that electromagnetic positive produces symptoms and electromagnetic negative blocks the symptoms. It also stops any production of free radicals and in fact, the free radicals are blocked immediately in the presence of a negative magnetic field. Furthermore, any free radicals that are present are processed to water and oxygen. Any further production of inflammatory producing end products such as peroxides, oxyacids, alcohols and aldehydes are no longer made since there are no free radicals and those that are present are processed to water and oxygen. Therefore, they are not symptom producing. Further-more, heavy metals are being rapidly processed through the body and dispensed through urine and feces. They can be carried to their area of excretion while not being toxic as long as they are in the presence of a negative magnetic field.

Magnetic Detoxification of Heavy Metals

Heavy metals are termed heavy by virtue of their atomic weights. There is a long list of toxic heavy metals; the most common heavy metals contacted by non-industrial workers are mercury, lead and aluminum. Heavy metals are toxic by virtue of their electropositivity. The higher their atomic weight, the greater their toxicity. Heavy metals are toxic because they produce free radicals and complex with essential tissue elements of biological life.

To understand free radical toxicity, we need to understand how free radicals are toxic. An atom is described as having an

electropositive proton in the center with electronegative electrons rotating around the electropositive proton. There is an electromagnetic attraction between the electropositive proton in the center and the electromagnetic negative electrons, which magnetically hold these together. These are in an electromagnetic stable balance. The electrons around the proton are spinning counter clockwise and the proton in the center is spinning clockwise. A free radical is formed when an extra electron is loosely attached to the outer ring of electrons surrounding the atom. This free electron is spinning clockwise, opposite of the other electrons and the same as the proton in the center. This extra electron renders the atom electromagnetic unstable in favor of the positive electromagnetic energy. Electrons spinning counterclockwise are magnetically pulled toward the proton, which is spinning clockwise. The extra electrons is an unstable free radical which is spinning clockwise the same as the proton and is thus pushed magnetically away from the center and thus it is a loose electron. When this free radical atom is placed in a negative magnetic field, it changes the spin of the outer free electron, which now pulls toward the center. Thus, there are no free radicals in a negative magnetic field. However, if this free radical is placed in a positive magnetic field it becomes freer than ever and thus, more toxic than ever.

Toxic heavy metals have in common the ability of electrons to flow freely through their crystalline structure. These are used for conductors of an electric current. For example, a copper wire is used as a conductor in an electric circuit. All toxic heavy metals are electropositive since there are more free electrons spinning clockwise than there are electrons spinning counterclockwise. The higher the atomic weight, the higher the electropositive electrons spinning clockwise and thus, the more toxic by virtue of free radical formation.

Free radicals are toxic by virtue of:

1) Metal complexes forming with essential tissue elements and formation of inflammatory substances, which are peroxides, oxyacids, alcohols and aldehydes. Thus heavy metal toxicity is always acid forming in biological systems.

2) Low atomic weight metallic minerals such as sodium, potassium, magnesium and calcium form alkalinizing bicarbonates. A negative magnetic field strengthens the electronegativity and also thus their alkalinization whereas a

positive magnetic field blocks their alkalinization. Toxic heavy metals in solution behave the same in solution as when not in solution by increasing conductivity and free radical formation. The presence of heavy metals in solution in body fluids changes conduction from low conduction to higher conductance and increases free radical formation and thus also, the inflammatory end-products of free radicals such as peroxides, oxyacids, alcohols and aldehydes.

Placing the human body in a negative magnetic field containing heavy metal tissue complexes and heavy metal ions in body fluids detoxifies by virtue of reversing the heavy metal tissue complexes and reversing the electropositivity of the metal ions and also preventing the formation of free radicals with their inflammatory end-products. If there are any already formed inflammatory end-products, they are rapidly processed by oxidoreductase enzymes that are energized by a negative magnetic field. The higher the magnetic field and the longer the duration of exposure, the more efficient the magnetic detoxification of heavy metals. A strong negative magnetic field that treats the entire body is ideal for this detoxification. Again, the more hours of exposure, the better such as sleeping all night on this strong magnetic bed and going back on the bed for one hour, three or four times during the day, keeps the process of detoxification going. It is also wise to treat local areas of deposits of these heavy metals to a negative magnetic field. These are such as the liver, the kidneys, the heart, brain and the fat tissues. It is highly important to treat the kidneys because they have the brunt of handling the toxicity of these heavy metals as they pass through the kidneys into the urine. Keeping the kidneys in a negative magnetic field keeps the kidneys from being toxic while processing these heavy metals out of the body through the urine

Heretofore, using chelating agents have been the usual method of detoxification. EDTA is particularly noted for its value in detoxifying lead. Mercury is best detoxified by sulfur containing agents that can be given either intravenously or orally. Combining these methods of chelation with magnetic detoxification obviously has an advantage. In terms of heavy metals, magnetic detoxification is especially useful because it applies to all heavy metals.

Magnetized Oxygen Detoxification

Oxygen is paramagnetic, water is paramagnetic and bicarbonates are paramagnetic. All of these can be charged up

with a magnetic field. Negative poled oxygen is a detoxifier, antibiotic as well as a valuable sleep aid. This is achieved by having the oxygen tubing pass through the negative magnetic field of a static field magnet. I have invented the magnet oxygen magnetizer which is made of a wooden box containing a 4" x 6" x 1" ceramic magnet. Breathing should be through a canula in the nose with a 2 L flow of oxygen. There is no limit to the duration.

A bronchiectasis subject requiring a continuous oxygen found magnetized oxygen to liquefy bronchial secretions better than any medicines and sleep was markedly enhanced.

A cancer subject with loss of appetite due to toxicity from the cancer had her appetite return after breathing magnetized oxygen.

Colloidal Silver Ion Magnetic Therapy

Through the process of electrolysis, colloidal silver ions are electromagnetically charged with a negative magnetic field. This negative magnetic field charged colloidal silver ion suspension solution can be applied locally or systemically. Systemic application is by absorption through the mucus membrane of the mouth, especially under the tongue. Local treatment can be by application to skin or mucus membranes (nose, nasopharynx, sinuses, eyes, ears, vagina, colon and so forth) by appropriate types of application. Application of a negative magnetic field from a static field magnet has been observed to be the most efficient method while colloidal silver magnetic field therapy is sometimes more convenient. Optimum treatment can combine the values of both a negative magnetic field from a static field magnet and a negative magnetic field from colloidal silver. Combining these two methods for systemic infections or cancer is ideal, as colloidal silver therapy and negative magnetic field therapy is complementary.

Concentration used: 10-40 ppm or more can be used.

Local treatment: Skin

Rub into the lesion a 10-40 ppm suspension solution three or more times a day. Drops, sprays or salve can be used.

Upper respiratory infection: nose, nasopharynx, sinuses or mouth and throat

Use drops or sprays of a 10-40 ppm three or more times a day.

Any lesion below the surface layer of the skin and mucus membrane requires the penetrating magnetic field from a static field magnet.

Systemic treatment:

Use a 40-ppm colloidal suspension solution. Adult dose is as follows.

Child dose is the percentage of the weight of the child divided into 130 lbs. (though there is no harm no matter how large the dose)

Acute Systemic Infection, Such as Influenza:

One teaspoon four times a day for two weeks absorbed in the mucus membrane of the mouth and especially under the tongue.

At the same time the systemic treatment is taking place, local treatment should be taking place such as spraying the nose and the throat and purposefully inhaling some of this **spray** into the lungs. This spraying should take place three times a day.

Chronic Systemic Infection and Cancer with Metastasis:

Use one tsp. 4 times per day for a minimum of three months.

Use colloidal silver therapy associated with appropriate local or systemic magnetic therapy. The colloidal silver therapy can be used as complementary therapy with magnetic therapy because it may penetrate some areas missed by the magnetic therapy.

Magnetic Detoxification

<u>Orientation</u>

A negative magnetic field activates mineral bicarbonates providing alkaline-hyperoxia and at the same time energizes oxidoreductase enzymes. Most enzyme toxins are processed by negative magnetic field energy activation of these enzymes that have been inhibited by toxins.

Heavy metals are detoxified by a negative magnetic field reversing the heavy metal electropositivity.

<u>**Minimum Program of Magnets**</u>

Local toxic states such as in insect stings and bites and skin contact with toxins:

Use a magnet of suitable size over the lesion.

The most frequently used magnet is a 4" x 6" x 1/2" ceramic magnet. Place the negative magnetic field over the lesion.

Minutes, hours or days may be required for treatment. Use continuous treatment until all toxicity as well as healing is complete

Local symptoms can be treated locally.

Systemic toxic states such as chronic systemic infections, heavy metal toxicity, autoimmune reactions and otherwise systemic immune toxic states:

The local treatment for any local symptoms needs to be continued.

Sleeping at night on a negative magnetic sleep mattress pad can be very useful.

The most optimal systemic treatment is to sleep on a Seventy-magnet bed (composed of magnets that are 4" x 6" x 1" placed 1" apart. Thirty-Five of theses magnets are placed in two wooden carriers that are 36" square. When placed end-to-end they make a single bed of 36" x 72").

It is best to go back on this bed for 1/2 to 1 hour, three or four times during the day for the first three months.

Joint, Muscle and Fascia Treatment:

Use a 4" x 6" x 1/2" ceramic magnet, magnet pads such as the 5" x 6" or 5" x 12" flexible pads or the 11" x 17" or 14" x 25" Multi-purpose pads.

Eye and Sinus Treatment:

Use the eye & sinus unit at night during sleep.

This unit places 1" x 1/8" neodymium discs over each eye for eye treatment, or over each sinus for sinus treatment.

Head:

Use the Super magnetic head unit (composed of twelve 4" x 6" x 1" ceramic magnets evenly distributed to the top and sides of the head in a wooden carrier).

This is used during sleep.

The Super magnetic hat (composed of thirty-four neodymium disc magnets that are 1" x 1/8") can be used during the ambulatory state.

- Ingest a minimum of eight glasses of water a day, more if need be. Preferably using alkaline micro water which is produced by electrolysis.
- Infrared sauna treatment as frequently as needed.
- Ascorbate flush as often as indicated.
- Optimize nutrition.
- Rotate foods on a four day basis.

Sharon's Success Story
Chronic Fatigue Syndrome

I wrote a magnetic research protocol for a woman who, for the past 20 years or more had been having a chronic fatigue syndrome episodically in response to petrochemicals, other chemical exposures or to common allergens. She had extreme episodes of weakness when she was unable to stand or even talk. She had described these as catatonic episodes although they did not have the mental disorder that is sometimes seen with catatonic episodes. A study in 1991 revealed a high titer to human herpes viruses #6, Epstein-Barr virus and rubella. I believed that her problems stemmed from these viral infections and that her reactions to foods, chemicals and inhalants were secondary to the injury that had occurred from these viral infections. Of course, it was very important for her to avoid whatever she was reacting to. It was imperative that she follow a 4-Day Diversified Rotation Diet and that she also treat herself with magnets prior to eating foods. When she did have a symptom, she would treat her brain or any other area of her body that may have had a pain or malfunction with magnets.

Treatment Results

She sleeps on a 70-magnet bed composed of magnets that are 4" x 6" x 1" placed 1" apart. Thirty-five of these magnets are placed in two wooden carriers that are 36" square. When placed end-to-end, they make a single bed of 36" x 72". She rotates her foods. She uses Far Infrared sauna treatments also.

Her response to Far Infrared Sauna treatment has been most remarkable. Before the treatment, she was so weak that she could only whimper and was too weak to walk. Within 2 minutes of exposure to the infrared sauna, her strength returned. Using the magnet bed combined with the Far Infrared sauna treatments, she has made a remarkable recovery.

Ann's Success Story

Ann has a chronic severe multiple chemical sensitivity. Marked weakness is a major symptom. She has faithfully pursued the systems of several expert environmental and toxicological specialists. She has found Far Infrared Sauna therapy to be of appreciable value. When she added magnetic therapy there was marked improvement in symptom reduction. A more optimal value is increased strength and reduced

symptoms even when exposed to an assortment of chemicals when she sleeps on the negative field of a 70-magnet bed.

When on vacation away from her 70-magnet bed her weakness and symptoms returned. Upon returning to the magnet bed her strength promptly returned and the symptoms faded. Her health requires the nightly use of the 70-magnet bed.

Ann's story is a case of chronic oxidoreductase enzyme toxin inhibition that cannot be managed by mere avoidance of the initiating chemical enzyme toxins but can be managed by a nightly negative magnetic field activation of her oxidoreductase enzymes.

The following is a letter that Ann wrote to me. Re: The 70-Magnet Bed

To Whom it may concern,

My chemical sensitivities began back in 1983 and by the time I located Dr. Philpott for help in 1985 I had become a 'universal reactor'. After one year, eighty ozone IV's, a strict rotation diet, along with removal of my silicon breast implants, I still was very chemically reactive. The ozone had brought down my pesticide level considerably, as had EDTA chelation which removed much of the lead poisoning in my body, but still I could not function at all in 'the real world'.

This is when Dr. Philpott realized a new approach was needed and he began to investigate the possible use of magnets. I had instant success wearing them in the head band of my hat.

From then on I was at all times wearing magnets on various parts of my body as well as sleeping on twenty 4" x 6" x 1/2" magnets at night -- not too comfortable but definitely symptom relieving.

For many years I managed to survive in this manner until Dr. Philpott invented the 70-magnet bed which changed my while life, as now my entire body is captured nightly in a strong, healing magnetic field.

After three months I was almost symptom free of chemical and electromagnetic field sensitivities. However, I am still cautious about my diet -- an all organic rotation diet, and walk three miles on the beach everyday.

There is only one drawback to this treatment. When I leave the 70-magnet bed to stay at my house in the Bahamas, I do not do so well after a few weeks and must return early to rejuvenate myself again with strong, negative magnetic therapy. It works!

Ann Lloyd
Deerfield Beach, Fl.
Final Word

The oxidoreductase family of enzymes are the great detoxifiers. Toxicity consists of poisoning the oxidoreductase enzyme family. A negative magnetic field can reverse this enzyme poison state by energy activation of the enzymes in which the activated enzymes are now capable of processing these enzyme poisons.

A negative magnetic field reverses the electro-positivity of heavy metals and processes enzymatically the free radicals formed by heavy metals

There are no free radicals in a negative magnetic field.

The good news is that a negative magnetic field has a major role in detoxification and also that a static negative magnetic field is readily available from a static field magnet.

The sad news is that the many biological normalizing values of a static negative magnetic field are not common knowledge.

STATIC NEGATIVE MAGNETIC FIELD FREE ENERGY BY VIRTUE OF ENERGY ACTIVATION OF OXIDOREDUCTASE ENZYMES IS HUMAN METABOLISMS MOST CENTRAL AND MOST POWERFUL DETOXICANT.

Prediction of Therapeutic Application of
Magnetic Free Energy

Magnetic fields move electrons and the movement of the electrons produce magnetic fields. Modern industrial progress could not have been made without the predictability of electromagnetism.

The human body is an electromagnetic organism. In fact, all biological life is electromagnetic and can only exist due to the electromagnetic, both exogenous and endogenous, sources of magnetism. Exogenous sources of magnetism influences the functions of bio-magnetic life in the same way as endogenous static magnetic fields. Deduced from the universal truths of biological responses to magnetic fields, I predict the following roles in medical therapeutics. These are all worthy of statistical definitive research verification.

Enzymes are a compound of nutrients, and therefore optimum nutrition is needed for functions of enzymes energized by exogenous and endogenous magnetic fields.

A negative magnetic field will become the most used antibiotic against invading disease producing microorganisms.

Predictions

A negative magnetic field will have a major role in both treatment and prevention of cancer. A negative magnetic field will be the major treatment for insomnia.

A negative magnetic field will become the central treatment of addictions of all types. A negative magnetic field will essentially replace tranquilizers.

A negative magnetic field will essentially replace anti-psychotic medications and electric shock treatment.

A negative magnetic field will become the major treatment for headaches of all types.

A negative magnetic field will become the central treatment for Alzheimer's and otherwise, amyloidosis.

A negative magnetic field will become the major treatment for movement disorders. A negative magnetic field will become the major anti-stress treatment.

A negative magnetic field will become the major treatment for inflammatory reactions. A negative magnetic field will become the major detoxifier.

A negative magnetic field will become the major treatment for immune disorders. A negative magnetic field will become the major anti-aging treatment.

A negative magnetic field will become the major anti-seizure treatment.

A negative magnetic field will become the major anti-rheumatoid treatment. A negative magnetic field will become a major treatment for osteoporosis.

A negative magnetic field will become a major healing agent.

A negative magnetic field will be used to optimally maintain pH.

A negative magnetic field will become a major treatment for diabetes mellitus, both type I and II.

A negative magnetic field will become the major treatment for vascular disorders of the heart, brain and carotids.

A negative magnetic field will become a major treatment for stenosis of the spine and the carotids.

A negative magnetic field will be used for immunologic desensitization without the need to break the skin.

Brief positive magnetic field exposure will be used for sensitized vaccination without the need to break the skin.

Brief positive magnetic field exposure will be used to reinstate neuronal functions that have been inhibited by "neuronal response extinction by misuse" such as after trauma or after an acute bout of multiple sclerosis.

Brief positive magnetic field exposure will be used to stimulate catalytic glandular functions of the thymus gland, adrenal glands and the thyroid gland.

Prolonged (during sleep) negative magnetic field exposure will be used to stimulate anabolic functions of the pineal gland (melatonin) and the hypothalamus (growth hormone).

References

1. Randolph, T.G. "The Enzymic and Hypoxia, Endocrine Concept of Allergic Inflamma- tion" *Clinical Ecology* (Springfield, IL.: Charles C. Thomas Publisher, 1976) pp. 577-596.

2. Philpott, William H. and Kalita, Dwight K. *Brain Allergies: The Psychonutrient and Mag- netic Connections, Second Edition* (Los Angeles: Keats Publishing, 2000)

3. Fersht, Alan. *Envzme Structure and Mechanism*, Second Edition (N.Y.C.: W.H. Freeman and Co., 1994)

4. "Magnetic Fields in Enzyme Catalysis." (Chicago: Encyclopedia Britannica, Inc. 1986) Vol. 15, pp. 1068.

5. Lee, Richard. *Hamilton and Hardy's Toxicology, 5th ed.* (Mosby, 1998) pg. 17.

6. Leclair, J.A. and Quig, D.W. "Toxic Metal Exposure and Children's Behavior" *Journal of Orthomolecular Medicine.* First Quarter, 2001, vol. 16, num 1. [*Magnetic Health Quarterly* "Detoxification" Vol. VII, 2nd Qtr, 2001]

Emotional Disorders

Psychoneurosis are composed of maladaptive responses to a variety of emotional stimuli. In a person with a normal functioning, non-injured brain these stimuli that evoke the symptoms may be from traumatic stimuli, or from stimuli evoking anxiety and tension from interpersonal relationships. Tension-anxiety may take many forms of maladaptive reactions such as tension, anxiety, depression, phobias, hysterical reactions, panic, disassociation, obsessive-compulsive behavior, learning disorders and so forth. There are mind/body symptoms such as tension myalgia syndrome from such as subconsciously

repressed hostilities, anger, fear and so forth. Tension and anxiety is biologically stressful and can therefore produce acid-hypoxia in any area of the body predisposed for the reaction. The magnetic treatment is the same whether there is a biological reason or psychlogical reason for the selection of the symptoms and the somatic expression. Both the brain response and when present, the somatic response, need to be treated simultaneously with a negative (south-seeking) magnetic field. The usual treatment of the brain is with a bitemporal placement of discs (either neodymium discs or ceramic discs). The somatic symptom is treated with appropriate magnets for the size and depth of the symptom. Suitable magnets for somatic symptom treatment are, such as, the ceramic disc, the neodymium disc, the double magnet, multi-magnet flexible mats, or the reinforcement of these flexible mats with mini-block magnets, various sizes of plastiform magnets, 4" x 6" x 1/2" ceramic block magnets and so forth. The duration of exposure to a negative (south-seeking) magnetic field ranges from 10-30 minutes for acute symptom relief. For chronic symptoms, the duration should be prolonged to aid in healing. The longer the duration of exposure to a negative (south-seeking) magnetic field, the better.

Training out of the symptoms is achieved by a reviewing of the symptom-evoking stimuli while magnetically maintaining a calm central nervous system. This may be achieved by a live meeting of the stimuli or by an image review of the stimuli.

Obsessive-compulsive treatment requires special techniques that inhibit the obsessional thoughts or compulsive acts. Breath holding to the point of the mind going blank is one aversive way to block out obsessive-compulsiveness. This practice of imaging the obsession or the compulsion and blanking it out by breath-holding should proceed under the circumstances of maximum relaxation and the maintenance of neuronal inhibition by exposure to a negative (south-seeking) magnetic field. Obsessive-compulsiveness deserves special consideration since it can run through the gauntlet of neuroses, personality disorders, somatic disorders, tension/muscle disor- ders, learning disorders and psychoses. Obsessive-compulsiveness can be produced by a non-organic brain response or by an organically injured brain such as schizophrenia, manic-depressive, initially injured by a viral infection (Epstein-Barr, cytomegalovirus and/or human herpes virus #6).

Three or more months of one-half hour per day of behavioral training will be useful for all stages, ranging from neurosis to psychosis. Although, acute symptoms in all categories can be managed with exposure to a negative (south-seeking) magnetic field, there should be a search for organic factors such as maladaptive reactions to foods, chemicals and inhalants. Behavioral training while relaxed and while optimally exposed to a negative (south-seeking) magnetic field should proceed for one-half hour daily for three or more months.

Magnets Used in Magnetic Therapy
Ceramic disc:

These are available as 1 x 1/2 " or 1 " x 1/4 ". They are frequently used on the head, held in place with a 2" x 26" elastic band. On the head they are used for headaches, anxiety, depression, obsessive-compulsiveness, seizures and sleep encouragement. They are also used on lesions anywhere on the body that are no larger than 1-1/2" across.

Neodymium disc:

These are 1" x 1/8". They are frequently used on the head with one on the inside of the band and one on the outside of the band. They are popular because they weigh about one-fourth of the weight of the ceramic disc. These discs are also used in the magnetic eye unit. They can be easily taped to any area of the body that has a lesion that is no larger than 1" across.

Flexible mats:

Flexible mats are made of strips of plastiform material that are 1-1/2 x 7/8" x 1/8". These are placed in four rows. A mat which is 5" x 6" contains twelve of these magnets. A 5" x 12" mat contains twenty-four. It is more common to use double magnet, multi-magnet flexible mats in which the magnet strips are stacked in two's with twenty-four in a 5" x 6" mat and forty-eight in a 5" x 12" mat. These have many uses, particularly for surface lesions where we are effectively treating within two inches of the magnet with a penetration of 2" from the magnet.

Plastiform magnets:

Plastiform magnetic material is 1/8" thick and comes in rolls that are 2, 3 or 4 inches wide. The length can be whatever length is needed. Popular sizes are 2" x 2", 3" x 3", 4" x 4" and 4" x 6". A single plastiform magnet would effectively treat a depth of 1". If two of these are stacked together it will effectively treat 2" deep. These magnets can be stacked as many as needed to provide the

depth of penetration desired. Two stacked of the 4" x 6" plastiform magnets is popular for the treatment of the heart. Plastiform material can be cut into any size or length as needed as stacked as many together as needed to provide the adequate depth of penetration for therapy.

Ceramic blocks:

The most popular ceramic block is 4" x 6" x 1/2 ". This will have a therapeutic depth of penetration of 4-1/2 ", therefore this is suitable for treatment of internal organs and joints that are deep in the body such as the hip joint or the spine. This magnet weighs two pounds and is not too heavy to be held on the body with a wrap of suitable size. This magnet is used up around the head to resolve atheromatous plaques in the cerebral arteries. It is used on the head to encourage sleep or to treat brain tumors. The 4" x 6" x 1" magnet has an effective penetration of 8". It does weigh four pounds and therefore, is not too suitable to fasten on the body. A Super Magnetic Bed is made from this magnet where seventy of these are placed an inch apart on a steel plate that is the size of a single bed. It is used to treat systemic infections, and multiple metastatic lesions.

A 2" x 5" x 1/2" ceramic magnet is suitable for treating lesions that are no more than 2" wide and as long as 5". This is especially suited for treating the carpal tunnel syndrome in the wrist.

Ceramic mini-block magnets are 1-7/8" x 7/8" x 3/8". These can be used the same as disc magnets on any part of the body. They are used as reinforcements to the magnetic mats. They can be placed crosswise the two inner rows of magnets in the magnetic mats. This places them 1/2" apart. A 5" x 6" mat uses three of these. A 5" x 12" uses six of these mini-blocks. This still leaves this mat flexible and yet with a good depth of penetration. These are useful for treating the joints, injuries of fingers and toes or fastened on the face to treat an infected tooth or gum.

Mini-blocks are used in the preparation of the magnetic mattress pads and also the multipurpose pad that is 14" x 25". These are placed an inch and one-half apart. Also, they are used in the chair pad that has magnets in the back and the seat.

Body wraps:

There are wraps for numerous placements. There is a 2" x 17", a 2" x 26", a 4" x 31", a 4" x 40" and a 4" x 52" wrap.

Obsessions-Compulsions, Depression, Anxieties, Phobias and other Maladaptive Responses

Preparation for Drill:

Fill out the tension response inventory. Select three of the items to work on during the drill.

Content of Behavioral Corrective Practice Drill:

A. Progressive Relaxation

B. Systematic Desensitization While relaxed, reproach through imagery, fears and phobias. This trains down anxieties and phobias.

C. Inhibition of Obsessions and Compulsions

Relaxation does not train out obsessions and compulsions. Holding the breath until the image of the obsession or compulsion disappears effectively says "no" to the symptoms and is capable of training out obsessions and compulsions.

D. Positive Reinforcement

This positive imagery is capable of training in a new, socially useful behavior. After each imagery inhibition of a maladaptive response, picture yourself behaving acceptably with correction.

Magnetic Facilitated Behavioral Training Therapy

Understanding Magnets and their Therapeutic Application

The magnets used have magnetic poles on opposite sides of flat surfaces so that exposure can be made to one pole at a time. The negative pole is identified with the word "Negative".

The positive magnetic field excites cellular function including neurones while a negative (south-seeking) magnetic field calms down and controls cellular excitement, including neurons of the brain and spine. The secret is to have the brain and spinal cord exposed to a sufficient negative (south-seeking) magnetic energy field to cancel out symptoms while re-approaching situations, which have been evoking symptoms. The essence of desensitization corrective training is to meet the stimuli usually evoking symptoms while not experiencing symptoms. Adequate relaxation while re-approaching stimuli through imagery is adequate for some people to train out their anxieties and pho- bias. However, using magnets appropriately placed and of proper gauss strength can calm down the brain, spinal cord, muscles and abdominal organs which materially increases the effectiveness of behavioral therapy training sessions.

Inhibiting an image by holding the breath until the image is blanked out of the mind is especially effective in training out obsessive-compulsive behavior.

Placement of Magnets:

A. Head:

Bitemporal placement of ceramic disc magnets that are 1-1/2" x 1/2" held in place by a suitable band, such as a 2" x 26" KOOL MAX band or sweat band, etc. An alternative to ceramic disc magnets are neodymium disc magnets that are 1" x 1/8". One is placed inside the head band and a second one is placed outside the head band directly over the inner magnet. The temporal areas are in front of and at the level of the top of the ears. An alternative placements that some people may find to be most effective are to place a disc magnet on the forehead and the left temporal area or on the left temporal and low occipital.

B. Chest: Place a 4" x 6" x 1/2" ceramic magnet on the mid-sternum.

C. Back: Place a 14" x 25" multi-purpose magnetic pad on the upper back, neck and back of the head.

D. Magnetic Eye Treatment Unit: The magnetic eye unit is composed of a magnetic light shield covering the eyes and forehead with two 1" x 1/8" neodymium disc magnets on the light shield over each eye.

Therapeutic Sleep

Therapy can be materially enhanced by having a good night's sleep. For improved sleep and therapeutic dreaming at night, use a magnetic sleep system composed of four 4" x 6" x 1" ceramic magnets placed 3/4" apart in a carrier which is placed up against the headboard. An additional value can be achieved by placing the negative (south-seeking) magnetic field of a 4" x 6" x 1/2" magnet on the side, front or back of the head. This 4" x 6" x 1/2" ceramic magnet should be placed on a 5" x 6" double magnet, multi-magnet flexible mat. Place the 6" front to back on the side of the head which is not on the pillow when laying on a side or lean it up against the side of the head if laying on the back.

With the sleeper system up against the headboard, the head is in a magnetic field 19" across and 6" high. This not only produces improved sleep, but increases dreaming while relaxed during the night. Dreaming is nature's own desensitization technique, which again fulfills the re-approach to situations while being

relaxed. Many anxieties and phobias can be trained out simply by therapeutic dreaming with the use of magnets. The closer the top of the head is to the magnets, the better.

An additional value can be obtained by using a magnetic bed pad which improves sleep. This consists of negative poled magnets throughout the bed pad.

Progressive Relaxation Drill

Slowly proceed with the following relaxing practice. Place both thoughts and feelings in the mind as a picture. The eyes are closed. The magnetic eye unit is across the eyes and all the magnets are to be in place as have been described. Progressively, proceed slowly as follows:

Think of the right foot. Let every muscle go. Heavy, heavy, heavy. Warm, warm, warm.

Heavy, warm, relaxed. Proceed the same way to the lower leg, the upper leg and then proceed to each section of the left leg. Proceed the same way to the right arm, the left arm, the abdomen, the low back, the front of the chest, the upper back, the back of the neck, the front of the neck, eyes, forehead, scalp. This will require about ten minutes.

Imagery Corrective Drill

While maintaining relaxation, place in mind an image of a troubled thought or feeling. Stay relaxed. Place again the troubled thought or feeling as a picture in your mind. Stay relaxed while holding the breath until the mind goes blank.

Again, think and feel the right leg; heavy, warm, relaxed. Then proceed over the entire body. After again achieving maximum relaxation, continue the practice on other troubled thoughts and feelings. Practice 3, 4 or more different imagery pictures during these sessions. Include for sure, one or more obsessive thoughts and compulsive acts each session.

The advice is to have 30-minute behavioral training sessions daily until all tension, anxiety, phobias, troubled thoughts, troubled feelings, anger, hostility, obsessions and compulsions have been trained out.

Tension Response Inventory

The items in this questionnaire refer to fears, concerns, hostile feelings, compulsions, moods and any response that shifts above an even keel, socially acceptable feeling or behavior. The degree of response is judged on a scale of 0-100, with 100 being an overwhelming response. 0 represents no response. Up to 30

represents awareness of a symptom but feelings of being in adequate control and therefore not bothered. Between 30-100 are symptoms that are uncomfortable to varying degrees with 100 being the state of necessity to act out on the feeling.

List your own individual feared words/situations, obsessions, compulsions, anger, and memories evoking these. Each day of practice, try to add to this list.

Magnetic Therapy For Emotional and Mental Symptom Management and Corrective Behavioral Training

Orientation:

Magnetic therapy can be used in two ways;

1) magnetic relief of symptoms in a day to day live stimulus response situation. This symptom management can result not only in the immediate management of neurotic symptoms, it can have the effect of training out neurotic symptoms because they are always canceled in the pres- ence of the stimulus that -- evokes them. Some neurotic symptoms can be precipitated or exacerbated by food maladaptive reactions. A 4-Day Diversified Rotation Diet food rotation program will prevent neurotic symptoms from precipitating or being exacerbated by maladaptive food reactions.

2) in severely handicapping neurotic symptoms, add to this live situation of magnetic symptom relief, that of magnetic behavioral corrective training practice sessions. These are usually 30 minutes a day until the symptoms have been trained out. In both types of approaches, suitable magnets are used on the brain and the body to relieve symptoms.

In psychoses, food rotation is a must, whereas in neuroses, food rotation may or may not be useful.

Placement and Duration:

For Acute Situational Evoked Symptoms: Ceramic or neodymium disc magnets:

Place either ceramic discs which are 1-1/2" x 1/2" or 1-1/2" x 1/4" on the head to relieve symptoms. These can be held in place with a 2" x 26" KOOL MAX band. Place the negative pole towards the head with the positive pole which has hook Velcro on it covered by the band which will hold this in place. Due to less weight, many prefer neodymium disc magnets over ceramic disc magnets. The neodymium disc magnets are 1" x 1/8". Place one of these on the inside of the band with the negative pole facing the head and a second one on the outside

of the band directly over the first magnet under the band. The following placements can be used:

Bitemporal, which is at the level of the top of the ears about 1" in front of the ears. This relieves most symptoms, especially depression.

A placement on the mid-forehead and left temporal is the best treatment for anxiety.

A placement of the left temporal and low occipital is best for obsessive-compulsiveness. Some need to place a 4" x 6" x 1/2" magnet on the back of the head to handle obsessive-compulsiveness.

There is no limit to the duration of exposure. The more, the better. Bitemporal placement also encourages relaxation and sleep.

While treating the brain for the relief of emotional and mental symptoms, it is also wise to treat the body for any pain or other discomfort that may be isolated in the body. Suitable magnets for his are such as a 4" x 6" x 1/2" ceramic magnet, a 2" x 5" x 1/2" ceramic magnet, magnetic flexible mats -- either 5" x 6" or 5" x 12", magnetic flexible mats reinforced with mini-block magnets, or plastiform magnets of various suitable sizes. Both emotional and mental symptoms, as well as sematic symptoms, are characteristically relieved within ten to thirty minutes. It is best to leave the magnets on for longer periods of time. The more the better. A negative magnetic field is the energy field that is necessary for healing beyond that of just symptom relief.

Magnetic Placement During Corrective Behavioral Training Sessions:

Follow the instructions in the section on behavioral training.

Minimum Program of Magnets:

- One 14" x 25" multi-purpose pad placed on the thoracic spine, cervical spine and back of the head.
- A 4" x 6" x 1/2" ceramic magnet placed on the sternum.
- A 4" x 6" x 1/2" ceramic magnet placed on the epigastric area.
- Neodymium discs or plastiform discs placed bitemporally.
- A magnetic eye unit placed over the eyes.
- For many people, it is advised to sleep on a magnetic mattress pad composed of mini-block magnets that are 1-7/8" x 7/8" x 3/8". These are placed an inch and one-half apart throughout the mattress pad. It is also best to accompany this with a Vitality Sleeper that holds the magnets in a carrier up against the headboard. There

are four 4" x 6" x 1" magnets placed 3/4" apart in a wooden carrier that holds them up against the headboard. They can be raised or lowered depending on the height of the pillow. The closer the top of the head is to these magnets, the better.

- For more severe, chronic cases that have chronic microorganism infections (viral, bacterial or fungal) it is best, for at least 3-4 months, to sleep every night on the Super Magnetic Bed which is composed of seventy magnets. These are 4" x 6" x 1" placed an inch apart on a steel plate that is the size of a single bed. Over this is placed a feather comforter, thin mattress or suitable futon. The subject sleeps all night on this bed and goes back on the bed four times during the waking period. This bed was made for metastatic cancer. It is also suitable for such diseases as Lyme disease, AIDS, lupus, multiple sclerosis, infectious mononucleosis for its extension into chronic fatigue and fibromyalgia. After the initial three months it is well to sleep on this bed two or more nights a week for a prophylactic treatment against further infections.

Alkaline Micro Water:

Alkaline micro water helps materially the body's normal alkaline state. Also, being micro water, it enters into the cells of the body more readily than the usual water. This also carries negative (south-seeking) magnetic field as well as being alkaline. The Singer Electrolysis Instrument is used for producing the alkaline micro water. At least five glasses of the water should be ingested each day.

Therapeutic Sleep:

After the program has been setup, the most important thing to address is sleep. It is optimal to sleep on the 70-magnet bed grid or a magnetic slumber pad.

In maintaining health and reversing degenerative diseases, it is very important that there be deep, energy restoring sleep. It is necessary to sleep a full eight or nine hours in every 24-hour period. Energy is used up during the day and is restored during sleep. The hormone, Melatonin, which is made during sleep, controls the depth of energy restoring sleep. The principle area in which Melatonin is made is the pineal gland, which is at the center of the head. This gland makes Melatonin in response to a negative (south-seeking) magnetic field. This is why it is so important to treat the head to a negative (south-seeking) magnetic field during sleep. The retina of the eyes and the intestinal walls also make Melatonin.

Treating these areas can also raise levels of Melatonin. The hormone Melatonin has the control of the entire energy system of the body including such as the immune system, endocrine system, and respiration. Melatonin is neuronal calming and encourages energy restoring sleep. Melatonin is a powerful antioxidant and thus is anti-inflammatory. Melatonin also has antibiotic and anti-cancer values.

In order to achieve appropriate production of the hormones Melatonin and growth hormone it is necessary to sleep in a completely light-free environment and without any 60 cycles per second electrical pulsing frequencies. Therefore there should not be any night-light, and electric clock, an electric heated blanket, or a heated waterbed. If light cannot be completely excluded from the bedroom, then place over the eyes and the forehead a light shield/mask of some sort. The magnetic eye & sinus mask is a light shield with 1/16" plastiform magnet in it and additional 1" x 1/8" neodymium disc can be added for extra benefit. The magnetic slumber pad will encourage the production of Melatonin by the gastrointestinal tract. Any magnetic treatment of the abdomen will encourage the production of Melatonin by the walls of the gastrointestinal tract.

Treating the eyes with the eye & sinus mask will also encourage the production of Melatonin by the retina of the eyes. The magnetic headboard type sleep enhancer up against the headboard will have a magnetic field that penetrates into the head and stimulates the pineal gland to produce Melatonin and the hypothalamus to produce growth hormone. Some sleep very well with a 4" x 6" x 1/2" magnet up against the side of the head. It is best to cushion this by placing a double strength flexible mat (5" x 6") up against the side of the head first with the 4" x 6" x 1/2" ceramic magnet over the flexible mat. When lying on the back, this can be leaned up against either side of the head. When lying on the side it can be on the side of the head that is not on the pillow or be placed on the back of the head. Some find it valuable to place a double strength flexible mat under the pillowcase so their head is resting on the flexible mat. If they are on their back it is on the back of their head; if they are on their side, it is on the side of their head. Six mini block ceramic magnets placed on the positive (north-seeking) pole side will further reinforce this flexible mat. Place these mini block magnets crosswise the flexible mat 1-1/2" apart. They will magnetically adhere to the flexible mat.

General Information About Magnets:

Double strength flexible mats are composed of two stacked plastiform magnet strips measuring 1-1/2" x 7/8" x 1/8". These plastiform magnetic strips are placed in four rows with the 1-1/2" measurement lengthwise in the flexible mat. In a 5" x 6" flexible mat there are 24 magnetic strips. In a 5" x 12" flexible mat there are 48 magnetic strips. The flexibility of these mats makes them very useful since they will fit around the curves of the body without producing any pressure. The therapeutic level of this flexible mat extends to about two inches. When the flexible mat is reinforced with one row of mini block magnets placed crosswise on the two central rows of magnets in the mat, the therapeutic field extended to three inches. When there are two stacked rows of mini block magnets on the mat, the therapeutic level extends to five inches. This places the mini block magnets an inch and one half apart in which there are three placed on the 5" x 6" flexible mat and six placed on the 5" x 12" flexible mat. The flexible mat can also be reinforced by the 4" x 6" x 1/2" ceramic magnet, this extends the therapeutic value to five inches.

Mini block ceramic magnets are sometimes called Briggs blocks because they are used as the Magneto magnets in a Briggs and Stratton gasoline engine. These magnets measure 1-7/8" x 7/8" x 3/8", and they have many therapeutic uses. They can be used on the head, in such areas as the temporal, frontal or occipital areas, for headaches, management of emotional symptoms or seizures. They can be used on fingers or toes. They can be placed on top of the flexible mats to reinforce the depth of magnetic field penetration. They can be used directly on the joints, under or incorporated into wraps around the joints. They are used in the magnetic slumber pads, the multiple purpose pads, and in the chair cushion pads.

Ceramic discs measure 1-1/2" x 1/2", and have numerous valuable purposes. They can be used around the head to treat headaches or other central nervous system symptoms, around joints, over skin or on subcutaneous lesions. The magnetic field of a ceramic disc extends to eight inches. The magnetic field therapeutic value extends to about two and one half inches. The 4" x 6" x 1/2" ce- ramic magnets have a therapeutic magnetic field value extends for five inches. A ceramic magnet that is 4" x 6" x 1" has a therapeutic value extending to eight inches. The 4" x 6" x 1/2" ceramic magnet has many uses such as around joints or

to penetrate deeply into the liver, internal organs, the heart, or into the head such as for treatment of tumors. The 4" x 6" x 1" ceramic magnet are used in the headboard-type magnetic sleep enhancer in order to have a field that penetrates into the head during sleep. The magnetic sleep enhancer is composed of four 4" x 6" x 1" ceramic magnets placed in a row 3/4" apart. These ceramic magnets are placed upright in a wooden carrier that holds them firmly up against the headboard. They can be raised or lowered depending on the height of the pillow. They are shipped at the top of the carrier and needs to be lowered so that the head is in the magnetic field. They are resting on a wooden dowel. The wooden dowel they are resting on should be at the level of the back of the head when the head is on the pillow. The closer the top of head is to the magnets in the carrier at the head of the bed, the better.

The magnetic slumber pad is composed of ceramic mini block magnets that are placed an inch and one-half apart throughout the pad.

The magnetic chair cushion pad is composed of ceramic mini block magnets placed an inch and one-half apart throughout the seat and back of the pad.

The multiple purpose pads [small (11" x 17") and large (14" x 25")] are and composed of ceramic Mini Block magnets that are placed an inch and one-half apart throughout the pad. This multiple purpose pad has many uses such as being used on the back, the abdomen, and up over the heart and on the chest area.

Polarity:
Always use a negative magnetic field.

Beyond Magnetism:
An acute maladaptive reaction to foods, chemicals, or inhalants has been documented as producing a brief state of acid-hypoxia. In this state there is a production of acid and a failure to process properly the end products of oxidation phosphorylation metabolism. In this state of acidosis, oxygen content is reduced. Maladaptive reactions to foods are the most frequent cause of bouts of acidosis. Degenerative diseases are noted for their acid-hypoxic state. Therefore every effort should be made to maintain a normal alkalinity and normal oxygen state.

Majorities of people are maladaptively reacting to foods in one or more ways, thus producing bouts of acidosis and reduced oxygen. It is the better part of wisdom to follow a 4-Day Diversified Rotation Diet. This program leaves out foods that are used as

frequently as twice a week or more for a period of three months. This is based on the assumption that these foods are being reacted to i some way. It is the frequency of the use that produces the maladaptive reactions. A 4-Day Diversified Rotation Diet is set up to leave out these frequently used foods. After three months, these frequently used foods can be returned to the diet, usually without any symptoms being produced.

All addictive substances should be abandoned such as addictive drugs, alcohol, tobacco and caffeine (coffee, tea with caffeine, chocolate, and soft drinks containing caffeine). Addiction is acidifying.

Carbonated soft drinks are acid producing and should be rarely used. Soft drinks are sweetened with corn sugar (in the US) and if they are ingested they should be limited to the corn rotation day.

In order to maintain an adequate alkaline state, it is necessary that the minerals that are used in the bicarbonate buffer system be in adequate supply. These are the minerals calcium, magnesium, potassium, and zinc. There are several proprietary preparations that contain these minerals associated with vitamin C as ascorbates. The preferred source of alkali minerals is multi-element mineral ascorbates by Klaire Lab. Use 1/2 teaspoon to 1 teaspoon of one of these powders in one-half glass of water, two times a day. The preferred time to take the alkaline minerals is in the morning on arising and again before going to bed at night. When using this mineral alkaline water, place it on the negative magnetic pole of a 4" x 6" x 1/2" magnet for a minimum of five minutes. This will charge up the water and the oxygen in the water with a negative magnetic field, which will help the body maintain its normal alkaline state.

There is a valuable method of electrolysis, which provides alkaline micro water that has an alkaline pH. There is a home electrolysis unit (The Singer Electrolysis Instrument) that provides this alkaline micro water. It is recommended that five glasses of the alkaline micro water be ingested daily.

Magnetic Health Maintenance
Orientation:

For those without serious handicapping symptoms, the following general health magnetic protocol is provided. This provides a magnetic lifestyle format for health.

Minimum Program of Magnets:
- One 5" x 6" double magnet, multi-magnet flexible mat

- One 5" x 12" double magnet, multi-magnet flexible mat
- Ten ceramic mini-blocks that are 1-7/8" x 7/8" x 3/8" with Velcro on the positive pole side.
- Two ceramic discs that are 1-1/2 " x 1/2" with Velcro on the positive pole side.
- A magnetic eye unit composed of a magnetic light shield and four 1" x 1/8" neodymium disc magnets.
- One magnetic chair pad composed of mini-block magnets that are 1-7/8" x 7/8" x 3/8". These are placed an inch and one-half apart throughout the back and seat of this chair pad.
- A 14" x 25" multi-purpose pad composed of mini-block magnets that are 1-7/8" x 7/8" x 3/8". These are placed an inch and one-half apart throughout the pad.
- One 4" x 6" x 1/2" ceramic magnet
- One 2" x 5" x 1/2 " ceramic block magnet
- One 2" x 26" band
- One 4" x 52" body wrap
- One 4" x 31" band
- A magnetic mattress pad composed of mini-block magnets that are 1-7/8" x 7/8" x 3/8". These are placed an inch and one-half apart throughout the bed pad.
- A Vitality Sleeper composed of four 4" x 6" x 1" ceramic block magnets placed in a wooden carrier 3/4" apart. These are held in this carrier up against the headboard.
- Colloidal silver: Four 16 oz bottles of 40 parts per million colloidal silver.
- Alkaline micro water: The Singer Electrolysis Instrument for the production of alkaline micro water.

Placement and Duration:

When sitting down, sit on the chair pad.

When sleeping at night, sleep on the magnetic mattress pad. Sleep with the magnets in the Vitality

Sleeper up against the headboard. Sleep with the magnetic eye unit across the eyes.

For any acute infection, take one teaspoon, four times a day of colloidal silver for two weeks. It is well to drink the alkaline micro water.

General Information About Magnets:

Double strength flexible mats are composed of two stacked plastiform magnet strips measuring 1-1/2" x 7/8" x 1/8". These plastiform magnetic strips are placed in four rows with the 1-1/2"

measurement lengthwise in the flexible mat. In a 5" x 6" flexible mat there are 24 magnetic strips. In a 5" x 12" flexible mat there are 48 magnetic strips. The flexibility of these mats makes them very useful since they will fit around the curves of the body without producing any pressure. The therapeutic level of this flexible mat extends to about two inches. When the flexible mat is reinforced with one row of mini block magnets placed crosswise on the two central rows of magnets in the mat, the therapeutic field extended to three inches. When there are two stacked rows of mini block magnets on the mat, the therapeutic level extends to five inches. This places the mini block magnets an inch and one half apart in which there are three placed on the 5" x 6" flexible mat and six placed on the 5" x 12" flexible mat. The flexible mat can also be reinforced by the 4" x 6" x $1/2$" ceramic magnet, this extends the therapeutic value to five inches.

Mini block ceramic magnets are sometimes called Briggs blocks because they are used as the Magneto magnets in a Briggs and Stratton gasoline engine. These magnets measure 1-7/8" x 7/8" x 3/8", and they have many therapeutic uses. They can be used on the head, in such areas as the temporal, frontal or occipital areas, for headaches, management of emotional symptoms or seizures. They can be used on fingers or toes. They can be placed on top of the flexible mats to reinforce the depth of magnetic field penetration. They can be used directly on the joints, under or incorporated into wraps around the joints. They are used in the magnetic slumber pads, the multiple purpose pads, and in the chair cushion pads.

Ceramic discs measure 1-1/2" x 1/2", and have numerous valuable purposes. They can be used around the head to treat headaches or other central nervous system symptoms, around joints, over skin or on subcutaneous lesions. The magnetic field of a ceramic disc extends to eight inches. The magnetic field therapeutic value extends to about two and one half inches. 4" x 6" x 1/2" ceramic magnets have a therapeutic magnetic field value extends for five inches. A ceramic magnet that is 4" x 6" x 1" has a therapeutic value extending to eight inches. The 4" x 6" x 1/2" ceramic magnet has many uses such as around joints or to penetrate deeply into the liver, internal organs, the heart, or into the head such as for treatment of tumors. The 4" x 6" x 1" ceramic magnet are used in the headboard-type magnetic sleep enhancer in order to have a field that penetrates into the head during sleep. The

magnetic sleep enhancer is composed of four 4" x 6" x 1" ceramic magnets placed in a row 3/4" apart. These ceramic magnets are placed upright in a wooden carrier that holds them firmly up against the headboard. They can be raised or lowered depending on the height of the pillow. They are shipped at the top of the carrier and needs to be lowered so that the head is in the magnetic field. They are resting on a wooden dowel The wooden dowel they are resting on should be at the level of the back of the head when the head is on the pillow. The closer the top of head is to the magnets in the carrier at the head of the bed, the better.

The magnetic slumber pad is composed of ceramic mini block magnets that are placed an inch and one-half apart throughout the pad.

The magnetic chair cushion pad is composed of ceramic mini block magnets placed an inch and one-half apart throughout the seat and back of the pad.

The multiple purpose pads [small (11" x 17") and large (14" x 25")] are composed of ceramic Mini Block magnets that are placed an inch and one-half apart throughout the pad. This multiple purpose pad has many uses such as being used on the back, the abdomen, and up over the heart and on the chest area.

Therapeutic Sleep:

After the program has been setup, the most important thing to address is sleep. It is optimal to sleep on the 70-magnet bed grid or a magnetic slumber pad.

In maintaining health and reversing degenerative diseases, it is very important that there be deep, energy restoring sleep. It is necessary to sleep a full eight or nine hours in every 24-hour period. Energy is used up during the day and is restored during sleep. The hormone, Melatonin, which is made during sleep, controls the depth of energy restoring sleep. The principle area in which Melatonin is made is the pineal gland, which is at the center of the head. This gland makes Melatonin in response to a negative (south-seeking) magnetic field. This is why it is so important to treat the head to a negative (south-seeking) magnetic field during sleep. The retina of the eyes and the intestinal walls also make Melatonin. Treating these areas can also raise levels of Melatonin. The hormone Melatonin has the control of the entire energy system of the body including such as the immune system, endocrine system, and respiration. Melatonin is neuronal calming and encourages energy restoring sleep. Melatonin is a powerful antioxidant and

thus is anti-inflammatory. Melatonin also has antibiotic and anti-cancer values.

In order to achieve appropriate production of the hormones Melatonin and growth hormone it is necessary to sleep in a completely light-free environment and without any 60 cycles per second electrical pulsing frequencies. Therefore there should not be any night-light, and electric clock, an electric heated blanket, or a heated waterbed. If light cannot be completely excluded from the bedroom, then place over the eyes and the forehead a light shield / mask of some sort. The magnetic eye & sinus mask is a light shield with 1/16" plastiform magnet in it and additional 1" x 1/8" neodymium disc can be added for extra benefit.

The magnetic slumber pad will encourage the production of Melatonin by the gastrointestinal tract. Any magnetic treatment of the abdomen will encourage the production of Melatonin by the walls of the gastrointestinal tract.

Treating the eyes with the eye & sinus mask will also encourage the production of Melatonin by the retina of the eyes. The magnetic headboard type sleep enhancer up against the headboard will have a magnetic filed that penetrates into the head and stimulates the pineal gland to produce Melatonin and the hypothalamus to produce growth hormone. Some sleep very well with a 4" x 6" x 1/2" magnet up against the side of the head. It is best to cushion this by placing a double strength flexible mat (5" x 6") up against the side of the head first with the 4" x 6" x 1/2" ceramic magnet over the flexible mat. When lying on the back, this can be leaned up against either side of the head. When lying on the side it can be on the side of the head that is not on the pillow or be placed on the back of the head. Some find it valuable to place a double strength flexible mat under the pillowcase so their head is resting on the flexible mat. If they are on their back it is on the back of their head; if they are on their side, it is on the side of their head. Six mini block ceramic magnets placed on the positive (north-seeking) pole side will further reinforce this flexible mat. Place these mini block magnets crosswise the flexible mat 1-1/2" apart. They will magnetically adhere to the flexible mat.

Magnetic Eye Unit:

The magnetic eye unit is composed of a magnetic light shield that covers the eyes and much of the face. Two 1" x 0.125" neodymium disc magnets are placed over each eye. The following placement of the neodymium discs can be used:

1) The first choice is to stack two of the discs together and place these directly over the eye. Place two of the stacked magnetic discs over each eye. The negative magnetic field is to face the eyes. These disc magnets will magnetically adhere to the magnetic light shield. If need be, the first disc can be held more firmly in place by taping it to the magnetic light shield. The second disc can be stacked on top of the disc that is taped to the light shield.

2) The second choice is to place one disc on the inside of the light shield and the second disc on the outside of the light shield directly over the first disc that is on the inside of the light shield. These are to be placed directly over each eye. It is important that there be no pressure on the eye from the edge of the disc on any part of the face around the eye. This can be achieved by using the foam padding provided at appropriate places to raise the light shield sufficiently above the face to avoid any pressure on the eye or contact with the edge of the disc on any part of the face around the eye.

This system of placement of disc magnets on the inside and outside of the magnetic light shield will need to be used when strong magnets are being used about the head. With this placement, the disc will not jump over to a nearby magnet.

4-Day Diversified Rotation Diet General Information

A local and systemic biological response of acidity is routinely evoked when symptoms develop in response to exposure to foods, chemicals and inhalants. Acidity also produces low oxygen (acid-hypoxia). This is true whether the maladaptive symptom reactions are not immunologic or non-immunologic in origin. Most food symptom reactions are not immunologic. Immunologic and non-immunologic food symptom reactions have a classic addictive seesaw biological response of symptom relief on exposure, with the emergence of symptoms 3-4 hours after the exposure (addictive withdrawal phase). The optimum method of reversing addiction is avoidance. In food addiction, the optimum method of avoidance of the addiction is for there to be a 3-month avoidance followed by an exposure no more often than every fourth day. This is the reason for the 4-Day Diversified Rotation Diet. The short-term management of symptoms can be managed by alkalinization, which can be produced by bicarbonate alkalinization and more optimally, exposure to a negative (south-seeking) magnetic field, which alkalinizes and oxygenates (alkaline-hyperoxia). These alkalinization methods can relieve symptoms after they have

occurred from the exposure and can also prevent symptoms from developing when the alkalinization methods are used prior to an exposure to symptom producing foods, chemicals and inhalants.

The Following is the Optimum Method of Preventing Symptoms form Occurring from Foods:

1. **A 4-Day Diversified Rotation Diet.** This four-day spacing of exposure to specific foods prevents food addiction.

2. **Pre-meal negative magnetic field exposure.** One-half hour before the meal place the magnets on the body. Magnetic discs, either ceramic discs (1-1/2" x 1/2") or neodymium discs (1" x 1/8") placed bitemporally. These can be held in place with a 2" x 26" wrap. Place on the sternum, a 4" x 6" x 1/2" ceramic magnet. Hold in place with a 4" x 52" wrap. An added value can result from placing a 4" x 6" x 1/2" ceramic magnet on the epigastric area, held in place with a 4" x 52" wrap. Place on the thoracic spine a large sized double strength flexible mat; this flexible mat can be held in place with the same 4" x 52" wrap that is supporting the 4" x 6" x 1/2" ceramic on the epigastric area. These can be removed at the beginning of the meal or they can be continued through until the meal is finished.

If symptoms emerge after the meal has been eaten, then replace the magnets until the symptoms leave and especially place a suitable sized magnet directly over the symptom area. Also prior to the meal, if there are any symptom areas, treat these with magnets bitemporally. Bicarbonate alkalinization is useful one-half hour after the meal, use multi element mineral ascorbate powder. Take 1/2 teaspoon of multi-element mineral ascorbate powder and 1/2 teaspoon of soda bicarbonate in 1/2 a glass of water.

The above pre-meal and post-meal alkalization method is recommended for

• Those with a serious state of symptoms reactions to multiple foods in which food rotation is not entirely satisfactory.

• When of necessity, symptom-evoking foods have to be eaten, such as when eating out at a restaurant, or those that have to use this method instead of waiting three months for the reintroduction of their foods.

In my experience, the above method of basic food rotation diet with the addition when necessary of the magnetic pre-meal exposure and the magnetic post-meal exposure is superior to any neutralization method. Neutralization methods do not honor the fact that the basic problems are addiction and acidity (acid-

hypoxia). A food rotation diet is necessary to honor the fact that addiction is the major driving force of food maladaptive reactions and that acid-hypoxia is the immediate cause of symptoms. There is no optimally effective method for the management of maladaptive reactions to foods that is equivalent to food rotation.

Colloidal Silver Therapy:

Colloidal Silver is made by an electrolysis method that produces a particle size of 0.0001 micron. These small silver particles are charged to a negative (south-seeking) magnetic field by the electrolysis method. This solution of colloidal silver is placed in the mouth, especially under the tongue for absorption. This provides quick absorption into the blood stream. These fine silver particles go throughout the entire body. The negative magnetic field magnetically attaches to microorganisms, parasites and cancer cells, which are positive (north-seeking) magnetic poled. Silver, in its own right beyond that of the negative magnetic field, inhibits the replication of these cells. The small silver particles do not interfere in any way with human cell function. It is recommended to use 40 parts per million starting for the first week with 1/2 teaspoon four times a day, then followed the next three months by 1 teaspoon four times a day. Aloe salve may also help in the treatment of local skin infections.

Alkaline Micro Water:

Alkaline micro water helps materially the body's normal alkaline state. Also, being micro water, it enters into the cells of the body more readily than the usual water. This also carries negative (south-seeking) magnetic field as well as being alkaline. The Singer Electrolysis Instrument is used for producing the alkaline micro water. At least five glasses of the water should be ingested each day.

Infrared Sauna:

FAR-INFRARED is a good, non-injurious heat source with several valuable health promoting values including alkalization, oxygenation and detoxification.

1. **Alkalinization**

The human body functions in an alkaline medium. Enzymes in the human body are dependent on alkalinization and on temperature range. Increasing the temperature increases the enzyme function.

2. **Oxygenation**

The human body makes it's energy by the oxidation process requiring the presence of molecular oxygen. As the temperature rises, the oxidation process increases. Thus, this will aid in producing more energy.

3. Detoxification

The human body processes toxins, some by being exhaled from the lungs, others passed out through the urine or the stool. Sweating from the skin is another process of detoxification. The far-infrared sauna is ideal in that it penetrates through the layers of the skin and into the subcutaneous fat throughout the skin and then detoxifies all types of toxicity including heavy metal toxicity. Therefore, this is ideal for heavy metal toxicity such as mercury, lead or other heavy metals. It also processes the enzyme inhibiting acids such as in degenerating diseases. Especially noted is the value in processing the toxins from cancer. Therefore, this is also a valuable treatment for degenerative diseases, including cancer.

Far-infrared sauna is markedly complementary to negative magnetic field therapy which is also alkalinizing, oxygenating and detoxifying.

Polarity:

Always use a negative magnetic field.

Active H:

Active H is a super free radical scavenger. It also normalizes the pH. Active H is an excellent adjunct to magnetic therapy.

Active H is the most powerful known antioxidant. A well person uses 1-2 capsules a day. An ill person uses up to two capsules 3 times a day for a period of three months. Any quantity has no ill side effects. (New Vision International, Scottsdale, AZ 85255.)

Beyond Magnetism:

An acute rnaladaptive reaction to foods, chemicals, or inhalants has been documented as producing a brief state of acid-hypoxia. In this state there is a production of acid and a failure to process properly the end products of oxidation phosphorylation metabolism. In this state of acidosis, oxygen content is reduced. Maladaptive reactions to foods are the most frequent cause of bouts of acidosis. Degenerative diseases are noted for their acid-hypoxic state. Therefore every effort should be made to maintain a normal alkalinity and normal oxygen state.

Majorities of people are maladaptively reacting to foods in one or more ways, thus producing bouts of acidosis and reduced

oxygen. It is the better part of wisdom to follow a 4-Day Diversified Rotation Diet. This program leaves out foods that are used as frequently as twice a week or more for a period of three months. This is based on the assumption that these foods are being reacted to in some way. It is the frequency of the use that produces the maladaptive reactions. A 4-Day Diversified Rotation Diet is set up to leave out these frequently used foods. After three months, these frequently used foods can be returned to the diet, usually 'without any symptoms being produced.

All addictive substances should be abandoned such as addictive drugs, alcohol, tobacco and caffeine (coffee, tea with caffeine, chocolate, and soft drinks containing caffeine). Addiction is acidifying.

Carbonated soft drinks are acid producing and should be rarely used. Soft drinks are sweet- ened with corn sugar and if they are ingested they should be limited to the corn rotation day.

In order to maintain an adequate alkaline state, it is necessary that the minerals that are used in the bicarbonate buffer system be in adequate supply. These are the minerals calcium, magnesium, potassium, and zinc. There are several proprietary preparations that contain these minerals associated with vitamin C as ascorbates. The preferred source of alkali minerals is multi-element mineral ascorbates by Klaire Lab. Use 2 teaspoon to 1 teaspoon of one of these powders in one-half glass of water, two times a day. The preferred time to take the alkaline minerals is in the morning on arising and again before going to bed at night. When using this mineral alkaline water, place it on the negative magnetic pole of a 4" x 6" x 1/2" magnet for a minimum of five minutes. This will charge up the water and the oxygen in the water with a negative magnetic field, which will help the body maintain its normal alkaline state.

There is a valuable method of electrolysis, which provides alkaline micro water that has an alkaline pH. There is a home electrolysis unit (The Singer Electrolysis Instrument) that provides this alkaline micro water. It is recommended that five glasses of the alkaline micro water be ingested daily.

Colds, Minor Flu, Bronchitis or Sinusitis
Orientation:

For minor infections such as cold, minor flu, bronchitis or sinusitis, treat the local areas such as the sinuses with the magnetic

discs and magnetic light shield. For bronchitis, place the 4" x 6" x 1/2" magnet on the sternum.

General Information About Magnets:

Double strength flexible mats are composed of two stacked plastiform magnet strips measuring 1-1/2" x 7/8" x 1/8". These plastiform magnetic strips are placed in four rows with the 1-1/2" measurement lengthwise in the flexible mat. In a 5" x 6" flexible mat there are 24 magnetic strips. In a 5" x 12" flexible mat there are 48 magnetic strips. The flexibility of these mats makes them very useful since they will fit around the curves of the body without producing any pressure. The therapeutic level of this flexible mat extends to about two inches. When the flexible mat is reinforced with one row of mini block magnets placed crosswise on the two central rows of magnets in the mat, the therapeutic field extended to three inches. When there are two stacked rows of mini block magnets on the mat, the therapeutic level extends to five inches. This places the mini block magnets an inch and one half apart in which there are three placed on the 5" x 6" flexible mat and six placed on the 5" x 12" flexible mat. The flexible mat can also be reinforced by the 4" x 6" x 1/2" ceramic magnet, this extends the therapeutic value to five inches.

Mini block ceramic magnets are sometimes called Briggs blocks because they are used as the Magneto magnets in a Briggs and Stratton gasoline engine. These magnets measure 1-7/8" x 7/8" x 3/8", and they have many therapeutic uses. They can be used on the head, in such areas as the temporal, frontal or occipital areas, for headaches, management of emotional symptoms or seizures. They can be used on fingers or toes. They can be placed on top of the flexible mats to reinforce the depth of magnetic field penetration. They can be used directly on the joints, under or incorporated into wraps around the joints. They are used in the magnetic slumber pads, the multiple purpose pads, and in the chair cushion pads.

Ceramic discs measure 1-1/2" x 1/2", and have numerous valuable purposes. They can be used around the head to treat headaches or other central nervous system symptoms, around joints, over skin or on subcutaneous lesions. The magnetic field of a ceramic disc extends to eight inches. The magnetic field therapeutic value extends to about two and one half inches. 4" x 6" x 1/2" ceramic magnets have a therapeutic magnetic field value extends for five inches. A ceramic magnet that is 4" x 6" x 1" has a

therapeutic value extending to eight inches. The 4" x 6" x 1/2" ceramic magnet has many uses such as around joints or to penetrate deeply into the liver, internal organs, the heart, or into the head such as for treatment of tumors. The 4" x 6" x 1" ceramic magnet are used in the headboard-type magnetic sleep enhancer in order to have a field that penetrates into the head during sleep. The magnetic sleep en- hancer is composed of four 4" x 6" x 1" ceramic magnets placed in a row 3/4" apart. These ceramic magnets are placed upright in a wooden carrier that holds them firmly up against the headboard. They can be raised or lowered depending on the height of the pillow. They are shipped at the top of the carrier and needs to be lowered so that the head is in the magnetic field. They are resting on a wooden dowel. The wooden dowel they are resting on should be at the level of the back of the head when the head is on the pillow. The closer the top of head is to the magnets in the carrier at the head of the bed, the better.

The magnetic slumber pad is composed of ceramic mini block magnets that are placed an inch and one-half apart throughout the pad.

The magnetic chair cushion pad is composed of ceramic mini block magnets placed an inch and one-half apart throughout the seat and back of the pad.

The multiple purpose pads [small (11" x 17") and large (14" x 25") are and composed of ceramic Mini Block magnets that are placed an inch and one-half apart throughout the pad. This multiple purpose pad has many uses such as being used on the back, the abdomen, and up over the heart and on the chest area.

Therapeutic Sleep:

After the program has been setup, the most important thing to address is sleep. It is optimal to sleep on the 70-magnet bed grid or a magnetic slumber pad.

In maintaining health and reversing degenerative diseases, it is very important that there be deep, energy restoring sleep. It is necessary to sleep a full eight or nine hours in every 24-hour period. Energy is used up during the day and is restored during sleep. The hormone, Melatonin, which is made during sleep, controls the depth of energy restoring sleep. The principle area in which Melatonin is made is the pineal gland, which is at the center of the head. This gland makes Melatonin in response to a negative (south-seeking) magnetic field. This is why it is so important to treat the head to a negative (south-seeking) magnetic field during sleep.

The retina of the eyes and the intestinal walls also make Melatonin. Treating these areas can also raise levels of Melatonin. The hormone Melatonin has the control of the entire energy system of the body including such as the immune system, endocrine system, and respiration. Melatonin is neuronal calming and encourages energy restoring sleep. Melatonin is a powerful antioxidant and thus is anti-inflammatory. Melatonin also has antibiotic and anti-cancer values.

In order to achieve appropriate production of the hormones Melatonin and growth hormone it is necessary to sleep in a completely light-free environment and without any 60 cycles per second electrical pulsing frequencies. Therefore there should not be any night-light, and electric clock, an electric heated blanket, or a heated waterbed. If light cannot be completely excluded from the bed-room, then place over the eyes and the forehead a light shield/mask of some sort. The magnetic eye & sinus mask is a light shield with 1/16" plastiform magnet in it and additional 1" x 1/8" neodymium disc can be added for extra benefit.

The magnetic slumber pad will encourage the production of Melatonin by the gastrointestinal tract. Any magnetic treatment of the abdomen will encourage the production of Melatonin by the walls of the gastrointestinal tract.

Treating the eyes with the eye & sinus mask will also encourage the production of Melatonin by the retina of the eyes. The magnetic headboard type sleep enhancer up against the headboard will have a magnetic field that penetrates into the head and stimulates the pineal gland to produce Melatonin and the hypothalamus to produce growth hormone. Some sleep very well with a 4" x 6" x 1/2" magnet up against the side of the head. It is best to cushion this by placing a double strength flexible mat (5" x 6") up against the side of the head first with the 4" x 6" x 1/2" ceramic magnet over the flexible mat. When lying on the back, this can be leaned up against either side of the head. When lying on the side it can be on the side of the head that is not on the pillow or be placed on the back of the head. Some find it valuable to place a double strength flexible mat under the pillowcase so their head is resting on the flexible mat. If they are on their back it is on the back of their head; if they are on their side, it is on the side of their head. Six mini block ceramic magnets placed on the positive (north-seeking) pole side will further reinforce this flexible mat. Place

these mini block magnets crosswise the flexible mat 1-1/2" apart. They will magnetically adhere to the flexible mat.

Magnetic Eye Unit

The magnetic eye unit is composed of a magnetic light shield that covers the eyes and much of the face. Two 1" x .125" neodymium disc magnets are placed over each eye. The following placement of the neodymium discs can be used:

1) The first choice is to stack two of the discs together and place these directly over the eye. Place two of the stacked magnetic discs over each eye. The negative magnetic field is to face the eyes. These disc magnets will magnetically adhere to the magnetic light shield. If need be, the first disc can be held more firmly in place by taping it to the magnetic light shield. The second disc can be stacked on top of the disc that is taped to the light shield.

2) The second choice is to place one disc on the inside of the light shield and the second disc on the outside of the light shield directly over the first disc that is on the inside of the light shield. These are to be placed directly over each eye. It is important that there be no pressure on the eye or that there be no pressure from the edge of the disc on any part of the face around the eye. This can be achieved by using the foam padding provided at appropriate places to raise the light shield sufficiently above the face to avoid any pressure on the eye or contact with the edge of the disc on any part of the face around the eye.

This system of placement of disc magnets on the inside and outside of the magnetic light shield will need to be used when strong magnets are being used about the head. With this placement, the disc will not jump over to a nearby magnet.

The 4-Day Diversified Rotation Diet

The Significant Role of Symptom-Evoking Reactions to Foods, Chemicals and Inhalants

A 17-year-old schizophrenic boy was compulsively, rhythmically, at 3 second intervals, repeating the word, "circle, circle, circle". I placed the negative magnetic field of a 4" x 6" x 1/2" ceramic magnet on the back of his head and he stopped saying, "circle". A fast of five days on water only, rendered him symptom-free. On his test meal of wheat, his compulsion to rhythmically repeat the word "circle" returned. After The completion of one month of test meals of single foods, he was placed on a 4-Day Diversified Rotation Diet leaving out symptom-producing foods. Three months later, the initial symptom-evoking foods were returned to his

rotation diet. This included wheat to which he had responded with the compulsive, rhythmic word "circle". After this three months of avoidance of wheat, he no longer reacted to wheat and did not have the compulsion to say the word "circle". In this case, I had demonstrated that; 1) a negative magnetic field could control the brain's neuronal excitation causing him to compulsively, rhythmically say the word "circle", 2) gluten in wheat produced the neuronal excitation driving his compulsion, 3) the final correction was the removal of wheat from his diet for three months. In three months, there was no longer a neuronal excitation from gluten as long as he kept it rotated on a four day basis.

A neurosis is a learned habit response to a stimulus in which the symptoms are interfering with normal social, educational and work life. It is the maladaptive reaction that results in it being termed a neurosis. The response of body tension and mental anxiety is a driving neuronal excitement, training in maladaptive symptom behaviors. The symptoms can take the form of tension, anxiety, phobias, disassociation, depression, elation, anger, hostility, hysteria, panic, somatic symptoms, hyperkinesis, lethargy, tics, obsessions, compulsions, personality disorders, learning disorders and any other physical or mental symptom driven by tension-anxiety. These occur in an organically intact brain.

These learned responses in an organically intact brain can, and often are, episodically precipitated by neuronal excitation factors. These precipitating factors can be and often are allergies to many environmental allergens, non-immunologic maladaptive reactions to foods which takes the form of an addictive withdrawal phase, hypoglycemia as the withdrawal phase of food addiction, or maladaptive non-immunologic reactions to an assortment of common environmental chemicals. Petro-chemicals such as from car exhaust, propane or natural gas, cosmetics (perfumes, lipstick, rouge), out-gassing of rugs, draperies and so forth. All of the above need to be considered as possible precipitants in neurotic, somatic reactions, learning disorders, personality disorders and psychosis. Maladaptive, addictive type reactions to foods are the most common causes precipitating maladaptive reactions.

The difference between neurosis and psychosis is that neurosis occur in an organically intact brain while psychosis (schizophrenia, manic-depression) occur in an organically injured brain. The brain is injured by viral infections such as Epstein-Barr, cytomegalo and human herpes virus #6.

Psychotics can and often do have neurotic-learned responses the same as non-psychotic neurotics. Beyond neurotic-learned responses, the psychotic has also a set of symptoms such as hallucinations, delusions, disassociation, catatonia or marked mood swings (high is mania and low is depression).

Obsessive-compulsiveness needs special consideration since it can occur as a neurotic-learned response in an organically intact brain or can also be a manifestation of an organically injured brain.

Hyperkinesis, lethargy, attention-deficit and other learning disorders are, by-and-large, due to an organically injured brain, the same as schizophrenia and manic depressive. The brain in these cases is less injured than psychosis. It has been my observation that these lesser injured brains predispose to the development of psychosis in the twenties and thirties. The viral infection is an ongoing encephalitis which continues to injure the brain and this is why these lesser illnesses predispose to psychosis 10-15 years later. The evidence is that the viral infections occur when the child is small and it is believed that a sizable number are passed on from the mother having the infection for which she has had a flare-up during gestation and passes this virus on to the fetus. The lymphotropic viruses (Epstein-Barr, cytomegalo. human herpes virus #6) are the cause of infectious mononucleosis. The chronic state of infectious mononucleosis often has the symptoms given the diagnosis of chronic fatigue and fibromyalgia. These viruses, once present, do not die out but continue to injure the person. However, when these viral infections occur after the brain has been fully developed, it does not produce psychosis but does produce weakness and pains. The viral infected person can develop neurotic symptoms beyond their chronic weakness, pains and depression produced by the viral infection.

Autism occurs in children with a viral injured brain, the same as schizophrenia and manic depression.

The Four-Day Diversified Rotation Diet

The following are observed facts about maladaptive reactions to foods:

1) IgG immune food reactions are acute inflammatory reactions in which spacing of contact has no significance. Therefore, a four day rotation diet has no significance in IgG mediated immune reactions. Fortunately, IgG food reactions are scarce.

2) IgG immune food reactions quiet down after three months of avoidance. After three months of avoidance an IgG immune reaction is calmed and suitable for a contact spacing of a 4-Day Diversified Rotation Diet. Food IgG reactions have the same relief phase on contact and withdrawal phase 3-4 hours later, which is characteristic of addiction.

3) Food addiction with relief on contact of the food and a withdrawal phase 3-4 hours later is characteristic of the majority of maladaptive symptom-producing food reactions.

4) A five-day avoidance breaks the addiction cycle following which, for 4-6 weeks; there is an acute symptom reaction within the first hour of exposure to the addictive food. This is the basis of single food testing meals after five days of avoidance.

5) There are toxic reactions without an addictive withdrawal phase. These toxic reactions are infrequent.

6) The biological response to the addictive withdrawal phase of symptom production is acid-hypoxia.

7) The acute symptom phase after a five day avoidance period is acid-hypoxia. Acid-hypoxia produces cellular edema.

8) Acid-hypoxia produces the symptoms of the addictive withdrawal phase.

9) A carbohydrate disorder is produced by addiction. This has the characteristics of hyperinsulinism after exposure to the addictive food followed by hypoglycemia 3-4 hours later during the withdrawal phase.

10) After five days of avoidance there is no hyperinsulinism and no hypoglycemia. These are replaced by a hyperglycemia within one hour of eating the addictive food.

11) Food addiction is a state of metabolic compensation response to the stress leading to the addiction.

12) After five days of avoidance there is no metabolic compensation and in fact, there is a metabolic decompensation.

13) Diabetes Type II is the decompensated state of food addiction with its acid-hypoxia and hyperglycemia.

14) Acute symptom-producing maladaptive food reactions when extended in time are identified as chronic diseases with the same symptoms.

15) Diabetes mellitus type II is the final decompensated state of the earlier compensated state of food addiction. The metabolic disordered chemistry of food addiction is the same as clinically

significant diabetes mellitus type II. The common denominator of disordered metabolism of food addiction and maturity-onset diabetes mellitus type II is acid-hypoxia and hyperglycemia.

16) The only way to prevent, and or reverse, maturity-onset type II diabetes mellitus is to reverse food addiction by initial avoidance and later spacing of the formerly addictive food.

17) Addiction to non-food items also advances the diabetes mellitus disease process. Examples are such as the use of narcotics, tobacco, alcohol and so forth.

18) Toxic, non-food, chemical stressors also advance the diabetes mellitus disease process.

19) Definitive food testing to determine maladaptive reactions to foods can only effectively proceed when all foods reacted to are avoided for five days preceding test meals of single foods. Remaining addicted to even one food will interfere with test results.

Characteristically, physicians are taught to test food immunologic or non-immunologic sensitivity reactions as a secondary rather than a primary cause of illness and to test foods while leaving the subject addictively or otherwise maladaptively responding to multiple other foods. Even when there is a five day avoidance of that single suspected food, the re-testing of that food is unreliable since they are in the process of reacting to so many other foods. Characteristically, no attempt is made to clear all food reactions by a five day fast before testing begins. This method of not clearing the subject of all food reactions before testing begins gives spurious results. This leads to conflicting data as to the significance of food reactions. This conflict in data is used by some physicians to justify discarding food reactions as causes of diseases in general or specifically with the disease they are dealing with at the time. Good food testing also requires examination of blood pH and blood sugar before and after the food test meal.

20) Ignoring the food maladaptive reaction as critical to the cause of degenerative diseases whether brain, gut or other biological systems, advances the central primary degenerative disease of type II diabetes mellitus.

21) Ignoring the food maladaptive inflammatory reactions and resorting to steroids, non-steroidal anti-inflammatory agents, tranquilizers and antidepressants to handle the symptoms of inflammation further accelerates the diabetes mellitus disease process with the end result being clinically significant type II diabetes mellitus.

The above observations provide the significance of maladaptive food reactions and the relationship of the 4-Day Diversified Rotation Diet to food reactions.

How to Food Test

Five days of avoidance of all foods using a water fast only or another system of using a single infrequent food such as watermelon during the five days of avoiding foods.

During the five days avoidance, use one-half to one teaspoon of soda bicarbonate, three times a day to help offset the acid-hypoxia that develops during the food addiction withdrawal phase.

A negative (south-seeking) magnetic field therapy can materially aid in reducing the food addiction withdrawal symptoms during the five days of avoidance. Placing magnetic disc magnets bitemporally, which is in front of the ears, near the top of the front of the ears, under a band can reduce head symptoms such as headache or depression. It will also help to reduce the local symptoms otherwise by stopping the message to the brain from the local area of symptoms elsewhere in the body. Treating the brain should be accompanied at the same time by treating any other area of the body that has discomfort. The best magnet for treating local areas of the body that have pain or other discomfort is the 4" x 6" x 1/2 " ceramic magnet. This can be placed directly over the area of discomfort. The magnets bitemporally placed on the head are disc magnets that are 1-1/2" x 1/2 " ceramic magnets. An alternative to this that provides lighter magnets that are just as effective are 1" x 1/8" neodymium disc magnets. Place one on the inside of the band around the head and another one on the outside. This will magnetically hold these in place. That would be two on each side of the head, placed temporally. Anxiety is best handled by mid-forehead and left temporal placement. Obsessive-compulsiveness is best handled by left temporal and low occipital. Use either the ceramic discs or the neodymium disc magnets. The best band for this is a 2" x 26" body wrap. During the withdrawal phase of addiction whether this be to food or to other addictants, there is an uncomfortable tightness in the chest and in the epigastric areas. This discomfort can be handled by placing a 4" x 6" x 1/2 " magnet lengthwise on the sternum and or the epigastric area, crosswise the epigastric area. These can be held in place with a 4" x 52" body wrap. In terms of duration,

these magnets can be held in place until symptoms are relieved which is usually within five, ten to fifteen minutes or they can be continuously held in place during the withdrawal phase to maximize comfort. It should be understood that a negative (south-seeking) magnetic field alkalinizes and oxygenates the body area that is within that negative (south-seeking) magnetic field.

Record blood pH before the five days of avoidance begins and immediately before and one hour after each test meal. A normal blood pH is 7.4. This test is achieved by blood plasma on litmus paper. It is best to use one with a pH of 6 to 8. I have characteristically used pHydron litmus paper.

Test blood sugar before the fasting begins and before and one hour after each test meal of a single food. There are home blood test units for diabetics which are adequate for this purpose. This requires a drop of blood from a lance prick of a finger. Normal fasting blood sugar ranges from 80-120. One hour after a test meal, the normal blood sugar can range up to 140. From 140-160 is suspect. From 160 on, is definitely an abnormal hyperglycemia.

Symptom-survey the entire body for symptoms before and one hour after each test meal.

Test the pulse before and one hour after each test meal. The heart is very sensitive to stress. Skipped beats in response to maladaptive food reactions are common. Some people have a vulnerability to set off a tachycardia. Tachycardia could be handled by placing a 4" x 6" x 1/2" magnet with a negative (south-seeking) magnetic pole over the heart. Hypertension is frequently a manifestation of food maladaptive reactions.

When food testing Crohn's disease or ulcerative colitis cases, it is best to have the suspected foods tested the last meal of the day. This provides for an overnight period of recovery from the reaction. The most suspected foods are the frequently used foods. They are often in the area of cereal grains, such as wheat, rye, oats, barley, corn or dairy products. However, it can be any food that is eaten with a frequency of two times a week or more including even salads. I have known some people who ate the same salad every day who maladaptively react to all the foods in their salads that they use daily.

It is wise not to use caffeine or alcohol in any form. However, it should be understood that it is possible that infrequently used

caffeine such as a cup of coffee or chocolate candy or an occasional beer or alcohol otherwise will not necessarily set off the addiction. Addiction requires more than twice a week exposure. Even though it is not recommended that these items be used, it can be understood that an infrequent use on a single occasion will not reinstate addiction. It should however, be understood that subjects with mental symptoms should not really toy with the use of caffeine because it is a central nervous system excitant or with alcohol in any form. Those who have seizures should follow the same rules.

Those who choose a very limited diet such as strict vegetarians who are not using meat or any animal products, even fish, do find it more difficult to follow the 4-Day Diversified Rotation Diet. One way to get around this is to sprout the cereal grains such as wheat, rye, oats and barley and also sprout the beans. Sprouts of grains and beans are really a different food than the mature product and can be used on a different day than the mature product such as eating the cereal grains on rotation, two days later eating the cereal grains that have been sprouted. The same thing can occur with beans. Fresh corn such as corn on the cob is not the same food as mature corn and can be used on a different day than mature corn. When sprouting the grains or beans be sure that there is about 1/4" sprout and only use those beans or grains that have sprouted. These sprouts can be prepared in many different ways such as ground for bread or used as a cooked cereal. Sprouted beans or grains can be used as a fresh vegetable and in salads.

Four-Day Rotation Diet
Day I Meat
Bovidae:Lamb, Beef, Goat, Deer, Cheese, Milk and Yogurt
Fish
Fish and/or shellfish can be on any or all days by keeping the type of fish or shellfish different for each day.

Vegetables
Potatoes: Potato, Tomato, Eggplant, Red/Green Peppers and Pimento
Goosefoot: Beet, Spinach, Swiss chard and Lamb's quarters
Composites: Lettuce, Chicory, Endive, Escarole, Artichoke, Dandelion and Safflower
Corn: Fresh Corn as a fresh vegetable
Fruits
Mulberry: Mulberry, Figs and Breadfruit

Rose: Strawberry, Raspberry, Blackberry, Dewberry, Loganberry, Young-berry, Boysenberry and Rose Hip
Grape: Grapes and Raisins
Cashew: Mango
Nuts:
Sunflower: Sunflower Seeds Cashew: Cashew and Pistachio Protea: Macadamia Nut
Thickening
Tapioca
Seasonings
Grape: Cream of Tarter
Potato: Chili Pepper, Paprika and Cayenne
Composites: Tarragon Nutmeg: Nutmeg and Mace **Sweetener**
Beet Sugar
Tea : Rose Hips, Chicory and Dandelion
Sprouts Legumes, Bean Sprouts, Alfalfa Sprouts and Sunflower, Sprouts
Fresh Vegetable
Green Bean Sprouts, Alfalfa Sprouts and Sunflower Sprouts
Day II
Meat
Bird: *All fowl: Chicken, Turkey, Duck, Goose, Guinea, Pigeon, Quail and Pheasant
Eggs
Eggs
Fish
Fish and/or Shellfish can be on any or all days by keeping the type of fish or shellfish different for each day.
Vegetables
Myrtle: Pimento Grass: Millet
Parsley: Carrot, Parsnip and Celery
Mushroom: Mushroom and Yeast (Brewer's or Baker's)
Mallow: Okra
Fruits
Plum: Plum, Cherry, Peach, Apricot, Nectarine and Wild Cherry
Pineapple: Pineapple
Pawpaw: Pawpaw, papaya and papain
Grains:
Gluten: Wheat, Oats, Barley, Rye and mature Corn Non-gluten: Millet, Sorghum, Bamboo shoot and Malt

Nuts:
Plum: Almond Beech: Chestnut Brazil nut: Brazil nut Flaxseed: Flaxseed

Thickening
Wheat flour, Agar-agar (vegetable gelatin from sea algae)

Seasonings
Myrtle: Guava, Clover, Allspice and Clove
Parsley: Celery seed, Celeriac, Anise, Dill, Fennel, Cumin, Coriander and Caraway
Pedalium: Sesame
Orchid: Vanilla

Oil
Cottonseed, Flaxseed and Sesame

Sweetener
Corn sugar, Clover honey and Molasses

Tea
Sterculia: Papaya tea

Day III

Meat
Suidae: Pork

Fish
Fish and or Shellfish can be on any or all days by keeping the type of fish or shellfish different for each day.

Vegetable
Mature Legumes: Pea, Black-eyed Pea, Soybean, Lentil, Peanut, Lima Bean, Navy Bean, Garbanzo Bean, Great Northern Bean, Pinto Bean and Kidney Bean
Laurel: Avocado
Lily: Onion, Garlic, Asparagus, Chive and Leek

Fruits
Apple: Apple, Pear and Quince
Banana: Banana and Plantain
Heath: Blueberry, Huckleberry and Cranberry
Gooseberry: Currant and Gooseberry
Ebony: Persimmon Buckwheat: Rhubarb

Grains
Buckwheat: Buckwheat and Rice

Nuts
Legume: Peanuts
Birch: Filbert (Hazelnut) Conifer: Pine Nut (Pinon)

Thickening
Arrowroot: Arrowroot Flour
Seasonings
Arrowroot: Arrowroot Heath: Wintergreen Legume: Licorice
Laurel: Cinnamon, Bay leaf, Sassafras and Cassia bud/bark
Pepper: Black & Whit Pepper
Oil Soybean, Peanut and Avocado
Sweetener
Fructose, Carob syrup, Maple sugar, Tupelo honey and Cane sugar
Tea Alfalfa, Sassafras, Garlic and Apple cider/tea
Day IV
Meat
Meat: Rabbit, Fowl not used on Day II (Chicken, Turkey, Duck)
Fish
Fish and/or Shellfish can be on any or all days by keeping the type of fish or shellfish different for each day.
Vegetables
Morning Glory: Sweet Potato
Gourd: Cucumber, Pumpkin, Squash, Acorn and Squash seeds
Mustard: Mustard, Turnip, Radish, Horseradish, Watercress, Cabbage, Kraut, Chinese Cabbage, Broccoli, Cauliflower, Brussel Sprouts, Collard, Kale, Kohlrabi and Rutabaga
Olive: Black/Green Olives
Fresh Grain Vegetables
Sprouts: Wheat, Rye, Barley and Oat
Fruits
Gourd: Watermelon, Cantaloupe and Honeydew
Citrus: Lemon, Orange, Grapefruit, Lime, Tangerine, Kumquat and Citron
Honeysuckle: Elderberry Palm: Coconut and Date **Nuts**
Seeds: Pumpkin seeds, Squash seeds and Coconut
Walnut: English walnut, Black walnut, Pecan, Hickory and Butternut
Thickening
Cornstarch
Seasonings
Mustard: Mustard
Mint:

Basil, Sage, Oregano, Savory, Horehound, Catnip, Spearmint, Peppermint, Thyme, Marjoram and Lemon Balm

Oil: Coconut, Olive, Pecan and Corn

Sweetner:
Date sugar, Honey (other than Tupelo or Clover)

Tea:
Kaffer

How to Use a Four-Day Diversified Rotation Diet Without Deliberate Food Testing

Many people find it practical to go directly to a four day diversified rotation diet without food testing. First, the person assumes that he or she is reacting to any food eaten as frequently as twice a week, or to any members of that food family. The person leaves these frequently used foods out of the diet for three months. At the initiation of the rotation diet, stop all use of caffeine (coffee, teas with caffeine, cola drinks, chocolate), tobacco and all alcoholic drinks. Do not reintroduce these into the diet.

For the next three to four days, there will be withdrawal symptoms. Handle these symptoms as described in the section, How To Initiate This Program.

Three months later, these foods are reintroduced back into the diet. Nearly always (95% of the time), these foods will no longer be reactive as long as they are kept on a once-in-four-day basis in this diet. When reintroducing foods into the diet, simply add the food to the established rotation and observe whether or not symptoms occur. If no symptoms occur, then this food can be rotated. If symptoms occur, wait another three months before trying this food again.

One way to expand the use of foods is to sprout cereal grains and legumes. A person should be certain that the grain or bean is sprouted with approximately 1/4" or more of a sprout. The foods that have been sprouted will no longer carry the same reactive capacity that the non-sprouted foods do. Thus, once sprouted, grains and legumes can be introduced into the diet immediately.

Selective Four-Day Rotation Diet

This diet selectively rotates on a four-day basis, the foods that have been demonstrated by deliberate food testing to evoke symptoms. Foods not demonstrated to produce symptoms or hypoglycemia reactions are used freely at any time desired. There is a particular problem with this diet in which the person may become addicted to some of the food that they are eating with

frequency. This can easily escape them unless they test out. This diet starts either with a full month of testing of foods in which only the foods that gave symptoms, acid reaction or hypoglycemic reactions are initially left out for two more months beyond the month of testing food reactions and then placed into the rotation diet. Foods not producing these symptoms are eaten freely. This makes it easier to prepare combinations of foods.

The other system, which would relate itself largely to self-help without a physician monitoring, would be to leave out all the foods that are eaten twice a week or more. This also includes all the family members of those foods. Set up a rotation diet of other foods, however, there would be no need to pay strict attention to rotation on these foods that have not been eaten frequently. After five days on this program, then start testing foods. This would start testing the foods and the family members of the foods that have been left out the diet. These can be placed back in the diet if no symptoms, acid reactions or high blood sugar is demonstrated. After having gone through all these foods that were left out of the diet originally, then start on the other foods, testing one meal once a month. It is suggested that in the case of gastrointestinal reactions, especially Crohn's disease and ulcerative colitis, have the test meal in the evening so that if there is a reaction, there is time for recovery from the reaction before the next meal in the morning.

Systematically, the food should be tested as outlined in the section on food testing. This involves that a food or a family member of this food should not be used for five days prior to the test meal. The test meal should be a single food test meal There should be a symptom survey recorded before the test meal begins and again repeated one hour after the test meal. The blood pH should be taken before the meal and one hour after the meal. The blood sugar should be taken before the meal and one hour after the meal.

FINAL WORD

A negative magnetic field has been documented as capable of doing the following:

1. Can relieve all types of neurotic symptoms
2. Can train out neurotic symptoms
3. Can relieve psychotic symptoms
4. Can relieve maladaptive reactions to foods, chemicals and inhalants whether immunologic or non-immunologic hypersensitive reactions.

5. Can prevent seizures
6. Can reverse some movement disorders

The good news is that a negative magnetic field can relieve neurotic symptoms and also be used as a neuronal calming agent during behavioral corrective training sessions. Furthermore, a negative magnetic field does not have symptom side-effects, is not a stressor and cannot lead to any degenerative disease. A negative magnetic field is necessary for not only symptom correction, but also for healing.

Do's

Do use a negative magnetic field to relieve neurotic symptoms.

Do use the negative magnetic field to relieve neurotic symptoms. The negative magnetic field is an anti-stressor and relieves all the degenerative disease consequences of stressors. A negative magnetic field along with a four-day diversified rotation diet reverses diabetes mellitus type II.

Do use the negative magnetic field to relieve neurotic symptoms. It is an anti-stress and does not raise serotonin and endorphins beyond physiological levels.

Do use a negative magnetic field to relieve psychotic symptoms and a four-day rotation diet to stop food addictions. A negative magnetic field is an anti-stressor reversing and aiding in healing and the complications of de-generative diseases.

Don'ts

Don't use tranquilizers and anti-depressants to relieve neurotic symptoms.

Don't use tranquilizers and anti-depressants to relieve neurotic symptoms because these are chemical stressors with complicating stress side-effects leading to degenerative diseases, especially diabetes mellitus type II.

Don't use St. John's Wort to relieve neurotic symptoms since it is a chemical stressor raising serotonin and endorphins.

Don't use tranquilizers and anti-depressants to relieve psychotic symptoms since this leads to further degenerative disease. [*Magnetic Health Quarterly* "Emotional Disorders" Vol. V, 4th Qtr, 1999, (2001 Revision)]

Causes and Corrections of Fibromyalgia The Single Simple Cause and Correction of Fibromyalgia Pain

The single simple cause of fibromyalgia pain is acid-hypoxia produced by a local positive magnetic field. The single simple answer for fibromyalgia pain is the replacement of local acid-hypoxia with alkaline-hyperoxia by virtue of the alkaline-hyperoxia biological response to a negative magnetic field. Regardless of the initiating causes of the presence of a positive magnetic field with its associated acid-hypoxia, the correction is all the same which is the replacement of a positive magnetic field and its acid-hypoxia biological response with a negative magnetic field with its alkaline-hyperoxia biological response.

Robert 0. Becker[1] materially helped us understand the magnetics of symptom production and the corrective magnetic healing process. A positive magnetic field is the signal of biological injury while the negative magnetic field is the signal present during healing. Albert Roy Davis[2] established the evidence of the acid-hypoxia biological response to a positive magnetic field and the alkaline-hyperoxia biological response to a negative magnetic field. Theron G. Randolph[3] was the first to establish acid-hypoxia as the cause of symptoms to allergic, addictive or otherwise hyper-sensitive reactions to foods, chemicals and inhalants. My method of monitoring blood and saliva pH during deliberate food, chemical and inhalant testing, after five days of fasting in an environment free of common chemicals and inhalants has confirmed the acid-hypoxia symptom association and the alkaline-hyperoxia negative magnetic field relief of symptoms as well as the healing of physically injured areas and chronic stress-injury areas[4,5].

Originally, I followed Theron G. Randolph's symptom relief of oral bicarbonate plus inhalation of oxygen when a subject developed symptoms during testing procedures. This would alkalinize and oxygenate and thus relieve symptoms. By chance, I heard of the physicist Albert Roy Davis' observations that the biological response to a negative magnetic field is alkaline-hyperoxia. I tested this out and found that Albert Roy Davis was right. Symptoms evoked during testing are predictably relieved by placing the negative magnetic field of a static field magnet over the symptom area. Furthermore, placing the negative magnetic field bi-temporally over the amygdala area relieved pain, weakness, depression, tension, obsessive-compulsiveness and in major mental patients, also relieved

depression, delusions, hallucinations and other mental symptoms. Chronic diseases were observed to be time extensions of acute symptoms observed during testing procedures. Chronic diseases have further injured areas by the chronic acid-hypoxia. Thus, I demonstrated that the acute symptoms of reactions to environmental substances plus chronic diseases with the same symptoms as acute reactions are both treatable with a negative magnetic field.

A logical question is, why do symptoms occur where they do? I observed that any area that has sustained an injury in the past is likely to develop a symptom during deliberate exposure testing to a food, chemical or inhalant to which they have now developed these symptoms. I have worked up a lot of carpal tunnel syndromes. The immediate cause is due to the stress of the chronic use of that wrist, however, I have always found that there was a food or substance to which the subject was reacting, making them more vulnerable to the stress of the chronic use. Thus, in this case there were two causes, one is a reaction to a substance producing a general inflammatory reaction but showing up at the area of greatest stress. Thus it can be understood that the areas where symptoms develop are the most biologically compromised areas for some reason. In my mental patients, I found the reason why they have mental symptoms is that their brain has been injured by viruses of the herpes family such as Epstein-Barr, cytomegalovirus or human herpes virus VI. These injuries occurred early in life so that the brain did not fully develop because the infection was in the brain as well as otherwise in the body. So the brain became the target organ for reactions when they did react to foods plus the fact that their immune system has been disordered by these viruses which like the lymphocytes. The B-lymphocytes make antibodies and have become disordered. Plus the fact that many of these patients are addicted, not showing any antibodies, but addicted having a disordered metabolism in which there was an initial rise in endorphins and a later symptom withdrawal phase. They would not have the mental symptoms if they hadn't had a brain injury from the viruses.

In my experience in diagnosing and treating fibromyalgia, I have concluded that quite routinely these cases have viral infections of the herpes family, especially Epstein-Barr and cytomegalo. Therefore, I have had to conclude that these viral

infections set the stage for most of the fibromyalgia cases. Not only should we treat the local symptoms with a negative magnetic field for the immediate relief of symptoms but it is also logical and best to treat the subject systemically with the negative magnetic field to kill the viruses.

My observations during the diagnosis and treatment of fibromyalgia has demonstrated that virtually routinely, reactions to foods particularly and also to chemicals and inhalants, can and do evoke the pain symptoms of fibromyalgia. Therefore, fibromyalgia patients should rotate foods on a four day diversified basis. The details of this are in my writings which should be referred to for the details of implementing the 4-Day Diversified Non-Stress, Non-Addiction Rotation Diet. Most fibromyalgia patients can be kept symptom-free by following this rotation diet.

What about the remarkable relief of the painful symptoms of fibromyalgia by a cognitive-behavioral therapy approach as outlined by Nancy Selfridge, M.D.(6). This system focuses on the stress-injury of chronic stress such as occurs from an obsessional dwelling on anger or other unsolved problems.

The subject may not even be conscious of the source of this stress injury. In any event, ultimately, the focus on this stress injury, including the focus on the pain itself, can through practice, switch the local polarity of a positive magnetic field provoking acid-hypoxia into that of a negative magnetic field evoking alkaline-hyperoxia. Any practice that leads to this change of polarity at the site of injury will reduce symptoms. This is true even if the content is not true. The very attempt itself can harness the brain to send a negative magnetic field to the site of stress-injury. This is why Robert 0. Becker's work is so important. He demonstrated that a positive magnetic field is present at the site of injury.

This is true even if it is a stress injury and not an initial trauma injury. The brain can respond to this and change the positive magnetic field with its acid-hypoxia to that of a negative magnetic field with alkaline-hyperoxia. A subject can, through practice, develop cues that will signal the brain to send the correct message to the trauma-injured or stress-injured areas. It is necessary for the negative magnetic field to be there in order for correction of the disordered physiology and for healing to occur. There are any number of systems; relaxation,

cognitive therapy, behavioral therapy, or meditation that can signal the brain to normalize the pH of the symptom area and this is done through magnetism where a positive magnetic field is replaced with a negative magnetic field. Thus, it is understood that the simplest way to do this is simply place a negative magnetic field over the symptom area. This will replace acid-hypoxia with alkaline-hyperoxia and thus relieve the symptom. I have included a section in this quarterly demonstrating how to use behaviorism to magnetically normalize biological function. In this practice, I use the negative magnetic field placed on the brain and on the body in order to facilitate the behavioral practice.

Human Biological Stress Injury State Versus Human Biological Non-Stress Healing State

The non-stress state is the baseline of normal human physiology. In this non-stress state, the pH of the body is alkaline and a negative magnetic field. The negative magnetic field is maintained at a higher level than the positive magnetic field. There is a direct relationship between an alkaline body pH and a negative magnetic field. This non-stress normal base physiology occurs during relaxation and during sleep. During this time, the cells are producing more adenosine-triphosphate than they are using. This is the growth repair-healing mode. Alkaline-hyperoxia is present in this non-stress mode. This is the mode that relieves fibromyalgia pain.

Human biological stress-injured state occurs with prolonged biological activity. Biological activity has an end-product that is acidifying. Humans make brief excursions from the non-stress state over to the stress state. Thinking and movement are all biological stress states. During this stress state, we are using more adenosine triphosphate than is being produced, therefore, the human has to go back to the non-stressed state such as relaxation during the day with cessation of mental and physical activity and at night, the necessity of sound sleep which makes more ATP than is being used and makes melatonin and growth hormone that are anabolic hormones.

Fibromyalgia pain results from a chronic maintained stress injury state. The answer for fibromyalgia pain and its associated fatigue is biological non-stress which is alkaline-hyperoxia and a negative magnetic field which relieves the biological acid-hypoxia positive magnetic field state.

Sources of biological acidity include:
1) reduced processing of free radical oxygen by-products
2) products from physical injury
3) accumulated end-products of physical and mental biological metabolism
4) addictive reactions to foods and or chemicals
5) allergic-immunologic reactions

Acid is painful. Acid also produces hypoxia. Thus, acid-hypoxia is the cause of tissue pain not caused by specific nerve injury. The tissue pain of fibromyalgia is due to acid-hypoxia. This explains why fibromyalgia pain is relieved by a negative magnetic field producing alkaline-hyperoxia.

Cues, such as thoughts, words and ideas can, by practice, switch the brain (limbic system) and local tissue areas from a pain-producing acid-hypoxia positive magnetic field stress injury to alka-line-hyperoxia negative magnetic field non-stress state.

Thus, it is understood that there are systems of meditation, self-hypnosis, relaxation and cognitive methods of isolating either real or supposed causes which has trained in a chronic obsessional stress-injury hostility or anger. Relief of pain occurs when any method is capable of switching the polarity of the brain and tissues from positive magnetic field acid-hypoxia to a negative magnetic field non-stress alkaline-hyperoxia negative magnetic field. Relaxation relieves the chronic tension which is often expressed as anxiety or phobias. However, obsession requires a second mechanism. It requires a cancellation of the obsession which relaxation alone will not do. Cognitive conscious focus on the pain and its probable causes from learned experiences can lead to the capacity to set aside the obsession and thus relieve the pain. This is one way of achieving the goal. Another is to effectively block this obsession by holding the breath until the mind goes blank. In any event, what has to develop is the ability to repeatedly block the obsession until it no longer is cued by some thought or environmental experience.

As a neurologist, I have been intrigued by the accuracy of an electroencephalogram revealing the difference between the stress-injury state and the non-stress state. When a subject is relaxed and not thinking, there is a brain pulsing frequency ranging from 8-12 cycles per second. In sleep, the pulsing frequencies of the brain can be as low as 2 cycles per second. When a person is thinking, the pulsing frequency is 22 cycles

per second. The higher the pulsing frequency, the more biological stress the subject is experiencing. Thirty-five cycles per second with sufficient intensity can produce a seizure. Exposing the brain to a negative magnetic field produces the non-stress levels of brain activity. The higher the gauss strength, the slower the pulsing field. On the other hand, exposure of the brain to a positive magnetic field -- the higher the gauss strength, the faster the pulsing field. Also, the brain pulsing field can be driven by sensory inputs -- sight, sound, tactile -- thus the sensory inputs can drive the brain either in a negative magnetic field or a positive magnetic field.

Static Magnetic Field Free Energy

How can it be that a static (non-moving) magnetic field is an energy? Energy is defined as being evidenced by movement. A static magnetic field does not move. This lack of movement of a static magnetic field has caused some physicists to picture magnetic therapy as a hoax in which subjects are imagining they are favorably influenced by a magnetic field.

The answer to this criticism about a solid state static magnetic field not being an energy field has been answered by Y. Abaronav and D. Bohn(7). In 1986, the Abaronav-Bohn effect was confirmed by Akaira Tonomura at Hitachi, Ltd. in Tokyo. Thus, movements of electrons do occur in response to a static magnetic field. A static magnetic field is an energy field by virtue of the movement of electrons in the magnetic field. Thus, the engineer, physicist, or biochemist claiming that a static magnetic field doesn't influence human physiology are exposing their lack of information. They may have a Ph.D. in a science field and still have never heard of the Abaronav-Bohn effect. The energy is the movement of electrons which affect human metabolism. Some scientists without any experience of observing human responses to magnetic fields are bold to declare magnetic therapy a hoax. It is a strange phenomena that a scientist holding a Ph.D. or M.D. can be so uninformed as to boldly declare himself an expert in a field that he has no knowledge or expertise.

On Naming Magnetic Fields

The original naming of magnetic poles related to the navigator's use of a compass. The compass needle that pointed north was named north pole and the compass needle that pointed south was named south pole.

In 1600, William Gilbert (DE Magnete) was the first to point out that the navigator oriented himself with a compass needle pointing toward north which he called north which in fact the compass needle pointing north is a south poled magnetic field. Several scientists throughout the years have identified this error in naming the magnetic pole. This error in identifying magnetic poles still persists as a tradition.

The physicist, B. Belaney(8) again identified the geographic error in identifying magnetic poles and termed it "semantic confusion." To avoid this semantic confusion, he recommended using the electrical polarity definition of positive (+) and negative (-) as applicable to magnetic poles in which the positive electric pole (+) is also a positive magnetic pole (+qM) and a negative pole (-) is also a negative magnetic pole (-qM). M stands for magnetism.

Where Do Electrons Come From?

Space around the earth and inside our bodies is filled with static field electrons. Magnetic fields move (spin) these electrons. We don't need any more than the fact of a static magnetic field moving electrons in us to justify magnetic therapy application to influence human metabolism. However, there likely is something more as to why these electrons are in a magnetic field. It is probable that some of these electrons come from space free energy with the magnetic field serving as a space free energy-to-electron converter.

"The magnet is a window to free space energy of the universe". Bruce D. Palma, Free space energy inventor(9).

"The challenge is not to decide whether or not "free energy" is real. It is. Instead the challenge is to our collective will to break free of our ignorance, the electric jail, the ecocide, the gridlock, the Newtorin recidity, the greed and the vested interest." (Brian O'Leary, Ph.D. Physicist and former astronaut)(9).

Researchers have observed space energy consists of spirals of energy in constant motion. Whirlpools, tornados, cyclones, anti-cyclones and wide storms are examples of weather spiraling energy. The positive magnetic field clockwise spiral spin is an energy from the center outward. The negative magnetic field counterclockwise spiral spin energy is from outward to the center.

In the outward motion, matter and energy are dissipated. In the motion toward the center, energy is created.

Researchers believe that space energy follows an inward spiral path and are in constant motion. Whirlpools, tornados, cyclones, anti-cyclones and wide rotating storms are examples of weather spiraling energy produced by magnetic fields.

[Modern phycists have found that wherever a dipole (plus and minus) are set up energy pours freely from "virtual space" sometimes called "the vacuum." Do an internet search for Ret. Lt. Col. Thomas Bearden and/or John Bedini: Ed.}

The Magnetics Of Spiraling Electrons In Human Physiology

There is a parallel between industrial use of the explosive fossil fuels and atomic energy and the effect of the positive magnetic field biological toxicity. The positive magnetic field spins electrons clockwise. This is explosive. The negative magnetic field response to human physiology is energizing and without toxic damage. This is equivalent to the implosive space free energy source. The negative magnetic field spins electrons counterclockwise and is implosive.

Industrial Use Of Energies

Fossil fuels and atomic energy is an expanding energy from combustion. This is equivalent to the positive magnetic field spinning electrons clockwise. This explosive energy has many toxic spin offs. We are seriously contaminating our earth s atmosphere and producing human diseases. The space energy inward spiral has no toxic end products and when used as our source of electron energy will not contaminate our environment.

Biological Regulators

Human biological life consists of the circadian rhythm which consists of two phases 1) an awake, alert, conscious period of physical and mental activity, and 2) a relax and sleep phase. The wakeful active phase is driven by the positive magnetic field. The sleep phase is driven by the negative magnetic field. The wake-active phase, if chronically maintained, becomes toxic, depletes energy and if continued, could lead to death. The sleep phase is necessary for restoring life-energy, detoxification and healing-repair.

Each biological response has a counter-regulatory response to prevent an over-response biological injury. For example, there are chemical regulators to inflammation, blood clotting,

immune reactions, toxins produced during metabolism and so forth. These counter regulators are chemicals, hormones and enzymes. The regulators are negative magnetic field energized. Metabolism has two expressions of energy which are catabolism and anabolism. Adrenaline, steroid hormones, insulin, endorphins and serotonin are catabolic hormones. Melatonin and growth hormone are examples of anabolic hormone regulators. Ultimately, a negative magnetic field and biological responses to a negative magnetic field are regulators over the harmful effects of prolonged over-expression of catabolism's potential injuries.

The famous biochemist, Albert Szent-Gyorgya, was seeking to discover the cell proliferation regulators because he has stated that cancer results from a disorder of cell proliferation regulators. He knew that this occurred in hypoxia. His book on this subject is titled *Electronic Biology and Cancer*(10). He knew that this had to be electronic however, he had not discovered that the negative magnetic field is a regulator over the positive magnetic field and energizes all the biological regulators of the body. We now know that it is the negative magnetic field that he was seeking. He said, "when we find this, we will have an answer to the reversal of cancer." Now, we have the evidence that it is the negative magnetic field that he was seeking.

Negative Magnetic Field Energized: Oxidoreductase Enzymes

Human energy coming from oxidation of foods is dependent on alkaline-hyperoxia. A negative magnetic field, with its counterclockwise rotation of electrons makes oxidation reduction possible. Four oxidoreductase enzymes are involved in producing human life energy (ATP) and oxidation remnant magnetism. In this process, oxygen accepts an extra electron which is now a free radical (superoxide, O_2'). This free radical must be quickly detoxified or it develops a series of toxic substances. Again, the oxidoreductase enzymes come to the rescue of reversing the free radical electrons with the end product of a non-inflammatory molecular oxygen and water. If, by chance, inflammatory substances have been already produced, there are specific oxidoreductase enzymes available to process these inflammatory products (peroxides, acids, alcohols and aldehydes) to non-toxic molecular oxygen and

water. All of these oxidoreductase enzymes are energy activated by a negative magnetic field.

Both oxidoreductase enzymes and substrates (foods, O_2', hydrogen peroxide, acids, alcohols and aldehydes) have dipoles that provide an attraction between the enzyme and the substrate. However, beyond this attraction, there has to be an energy source. This energy source is static electrons. These environmental available electrons move between the enzyme and the substrate dipoles. This movement of electrons produces a measurable magnetic field (negative magnetic field). Thus, the final step of enzyme and substrate joining so the enzyme can do its catalysis is a negative magnetic field. Magnet therapy consists of exposing the area containing enzymes and substrates to a negative magnetic field so they join and enzyme catalysis occurs.

Magnetic Antibiotics

Microorganisms have a high metabolic rate whereas human cells have a low metabolic rate. Microorganisms have an inefficient mechanism of producing ATP whereas human cells have a highly efficient mechanism of making ATP with oxidation phosphorylation. Microorganisms preferentially use fermentation and also other respiratory mechanisms not using oxygen. Oxidative phosphorylation has the highest efficiency of producing ATP. Even when there are human-invading microorganisms using oxidative phosphorylation, they still have this mechanism of a positive magnetic field cell membrane. Microorganisms can invade human tissue because they have this opposite positive magnetic field in contrast to the human negative magnetic field. If microorganisms can outwit and thus override the cellular negative magnetic field of the human, they can win. If human cells can maintain a higher negative magnetic field with all of its protection against invasion, then they can win. The battle is between the positive magnetic field reinforcing the invading microorganisms and the negative magnetic field reinforcing the human organism. It is not the negative magnetic field all by itself that is so significant. It is the biological support of the human cells from a negative magnetic field that can fight the battle and win against the invading microorganisms. Therefore, in vitro, techniques of trying to determine this battle between the positive and negative magnetic field is an inappropriate and inefficient way of making

any determination. The determination must be made in vivo, while the human cells and microorganisms having this battle are exposed to each other. It is the negative magnetic field support of the human metabolism that makes a negative magnetic field antimicrobial. This only exists in an in vivo situation.

Microorganisms (bacteria, fungi, viruses and parasites) infected areas are sore and painful because of the presence of acid-hypoxia produced by the infection of microorganisms producing add and a positive magnetic field. A negative magnetic field relieves the pain and soreness of microorganism infections. The good news is that microorganism infections of any type, (bacterial, fungal, viral or parasites) will die in the presence of a sufficient negative magnetic field gauss strength of sufficient duration.

Cancer production of ATP by transferase enzymes is acid-hypoxia-dependent the same as invading microorganisms. Cancer is sore and painful due to the presence of acid-hypoxia. A negative magnetic field relieves the pain and soreness of cancer. The good news is that cancer of any cell type or cause will die in the presence of a negative magnetic field of sufficient gauss strength and sufficient duration.

There are non-invasive bacteria, such as friendly bacteria in the gut, to which the above described battle between the magnetic pole fields does not apply. A negative magnetic field does not destroy these non-invasive, friendly bacteria.

Acid Hypoxia

Common Denominator Of Addictions, Allergies, Immunologic Reactions, Infections and Cancer

Addictive reactions constitute inflammatory symptoms precipitated by an adaptation to a frequently used substance (food, tobacco, caffeine, alcohol or narcotics) to which there are no immune components, such as cellular or humeral, to the symptom production. Symptoms may be precipitated by constitutive defenses such as vasoactive agents (histamine, serotonin, kinines and complement disorders). The central mechanism of addictive adaptation is a see-saw of too much and too little endorphins and serotonin. This is a hypersensitive reaction developed by the biological stress of frequent contact with the same food. On contact, there is a hypersensitive defense response of a rise in self-made narcotic polypeptides

(endorphins). This rise in alkaloid endorphins produces an alkaline state in which oxygen and oxidoreductase enzymes function with efficiency. At the same time, the endorphins rise beyond normal. Serotonin also, as a defense against biological stress, rises beyond normal. This alkaline-hyperoxia, high narcotic, high serotonin state is super comfortable in which pain leaves, energy is present and oxidoreductase enzymes are highly functional and the beyond normal narcotic level produces a mental euphoria and disordered judgment. Three to four hours later, there is a switch to acid-hypoxia, a drop below normal of endorphins and serotonin with the emergence of pain and the euphoria is replaced with depression. Again, judgment is impaired due to the depression. In this acid-hypoxia state, histamine and other inflammatory constitutive reactions develop, producing symptoms. The frequency association of IgG immune reactions to foods and addictive reactions to food suggests that at least in some cases, IgG immune reactions develop secondary to addictive reactions.

The essence of allergic hypersensitive reactions is inflammation associated with substance exposure. Food addiction and food allergy, as separate mechanisms, can exist to the same substance. In my writings, I have specifically referred to food allergies since it is classically regarded in the medical literature as being the same as immunologic reactions. Theron G. Randolph, M.D.(3), has taught us the significance of addiction and its relationship to allergies. My research as described in my book, *Brain Allergies,* agrees with and compliments the observations of T.G. Randolph. My observations have demonstrated that acid-hypoxia is the common denominator in symptom production even when there is no evidence of immune reactions. Immune reactions are also and always acidifying. Thus there are many reactions that immunologists have dismissed as being psychosomatic when in fact, they were addictions. Acid-hypoxia is the common denominator between addictive reactions and allergic-immune reactions. The withdrawal phase of addiction explains the symptoms of addiction. Fortunately, avoidance of the IgG allergen and or the addiction withdrawal reaction can be reversed with three months of avoidance following which, 95% of the time, a single exposure to the food will not produce symptoms. The re-exposure at the frequency of once in four

days classically does not reinstate either the immunologic reaction or the addictive reaction. Furthermore, food addiction cannot be adequately handled by desensitization type treatments. Both IgG, complement disorders and addiction can be adequately handled with the initial three months avoidance followed by an exposure once in four days.

There are a dozen or more constitutive defenses against invasion of antigens, be these non-alive antigens or alive microorganisms. The constitutive defense mechanisms are not immune mechanisms as such but set the stage for the cascade of humeral and cellular immune mechanisms. For a review of the significance of these constitutive defenses, refer to text in these fields(11). The goal of this treatise is to recognize and emphasize neglected⁻ and even ignored electromagnetic and energy factors which are a party to and impinging on allergy, immunology and microbiology sciences.

The value of avoidance and spacing of contact with the offending agent compared to neutralization and desensitization techniques is that avoidance and spacing is most efficient. All too often, the avoidance and spacing of contact is ignored in preference to neutralization. If the offending agent is dander from a cat or dog, the best policy is to remove the cat or dog and clean up the house especially with filtration and ozone. If it is a food, then avoid the food for a period of three months and then space the contact to no more than once in four days. In my judgement, after an extensive trial period, I regarded food desensitization or neutralization as a disaster, whereas food rotation turned out to be a great health promoter for the majority.

The Role Of Magnetic Energy

The anti-inflammatory, anti-microbial role of the endogenous level and exogenous level of a static negative magnetic field has been ignored and as such has not been assessed in classic allergy immunology and microbiology. These sciences need to assess this magnetic energy factor in relationship to the enormous valuable contribution these magnetic fields can contribute to these sciences. This assessment requires an in vivo assessment and cannot be adequately made in an in vitro assessment.

All biological life is an electro magnetic energy system. Live biological cells have both positive and negative magnetic fields. Invading microorganisms have higher positive magnetic

fields than negative magnetic fields. Human cells have higher negative magnetic fields than positive magnetic fields. Invading microorganisms have a higher mineral content and thus a higher conductance and a higher pulsing frequency than human cells. Thus, opposite magnetic fields between human and invading microorganisms and other antigens is a critical difference between the biological energy systems. Any antigen, whether a live microorganism or a non-live antigen that evokes symptoms does so by virtue of either being a positive magnetic field or evoking a positive magnetic field in the human biological system.

Human biological energy has two factors: 1) the production of ATP which is an energizer to many necessary enzymes, and 2) catalytic remnant magnetism which is a negative magnetic field. The oxidoreductase enzyme family identified by function are as follows; dehyrogenases, reductases, oxidases, peroxidases, hydroxylases and oxygenases. They are not ATP-dependent but rather are energized by a static electric field or a negative magnetic field. They are also alkaline-hyperoxia-dependent. When electrons move between dipoles of the enzyme and the substrate, a magnetic field is formed. Alkaline-dependent enzymes, such as the oxidoreductase enzymes, produce a catalytic remnant negative magnetic field. Acid-dependent enzymes used by invading microorganisms produce a positive catalytic remnant field. In humans, it requires four oxidoreductase enzymes to produce ATP which, at the same time, produces catalytic remnant magnetism of a negative magnetic field. All catalytic reactions have a measurable magnetic field produced which of course, also includes those that are ATP-dependent. Physiological texts have ignored or have not considered the magnetic fields that are always present in catalytic reactions. This is a serious mistake since the level of this inherent magnetism varies with the metabolic state of the subject. The exogenous source of magnetism can be varied with the gauss strength of exposure. The efficiency of a catalytic reaction is dependent on the level of endogenous or exogenous magnetism available.

Oxidoreductase enzymes have two functions; 1) to make ATP and catalytic remnant magnetism and 2) detoxification of inherent endogenous toxic species of oxidoreductase metabolism such as free radicals, peroxides, acids, alcohols

and aldehydes as well as the numerous environmental exotoxins. The efficiency of catalytic reactions producing ATP and detoxification of toxins is dependent on the level of magnetism available from both endogenous and exogenous magnetism sources.

The greatest area or neglect, avoidance and even ignorance is in the area of magnetism's free-energy biological response. A negative static magnetic field is anti-stressful, anti-inflammatory and anti-microbial with a biological response of health promoting alkaline-hyperoxia. On the contrary, a positive magnetic field is biologically stressful, inflammatory, and microbial supportive with a metabolic disorganizing disease-producing acid-hypoxia.

The Pathology Of Herpes Family Viruses: Facts about Herpes Family Viruses

Herpes simplex I is characteristically around the face, cervical spine or also in the head and brain itself.

Herpes simplex II is characteristically in the genital area.

Herpes simplex I or II can be either around the head or the genital area.

Varicella-zoster causes chicken-pox. Most children have had chicken-pox. Years later, the manifestation can be observed as shingles which is caused by the latent viruses of chicken pox.

Epstein-Barr is a highly frequent infection. It particularly likes lymphocytes. It also is neurotrophic. It not uncommonly becomes disseminated into any organs of the body such as the liver, spleen, thyroid or the brain.

Cytomegalovirus is particularly neurotrophic affecting the brain and the entire nervous system. Human herpes virus VI has been implicated as being consistently present in multiple sclerosis.

Human herpes virus VII is a recently discovered human herpes virus. Little is known of its significance.

Herpes B virus is a virus that is carried by some Old World monkeys. There are 18 well documented human cases. Thirteen of these were fatal.

Almost all adult subjects have one or more of these types of herpes family viruses. Epstein-Barr virus is positive in about 90-95% of adults. Herpes viruses do not die. Instead they estab-

lish a latency and survive. The only way they can be killed is with a human biological response to a negative magnetic field.

Herpes viruses establish latency in the body after primary infection despite the presence of anti-bodies.(11)

Antibodies to herpes viruses are not protective against subsequent outbreaks. "Reoccurrences are common and represent reactivation of latent viruses".(11).

None of the antiviral agents eradicate latent viruses. (11).

Congenital herpes has been established as a fact. A reasonable theoretical postulation is that Epstein-Barr, cytomegalovirus or human herpes virus VI is congenitally passed to the fetus during a recurrent symptom infection from a latent infection. This is most likely to occur during the 2nd half of pregnancy. An acquired infection during gestation, infancy or childhood, while the brain is still in its formative development, injures the brain so that it does not fully develop. Herpes viruses have the ability of stealth adaptation in which they are able to drop out their antigen to which the human immune system is responding. Thus, they skirt around the immune defense of the human system. They can latently dwell in the lymphocytes, particularly the B-lymphocytes and the neurons. They can continue to damage the human physiology without evoking a human immune response. Infections of these viruses are even known to exist when there were no antibodies against the virus.

In my extensive studies of learning disordered, attention-deficit and hyperactive children, I discovered that they have one or more of these herpes viruses, usually Epstein-Barr or cytomegalovirus. They have these early in life which injures the brain. Mental cases like schizophrenia and manic depressive are cases that have more injury to the brain than these attention-deficit, learning disordered and hyperactive children. The illness is progressive and adolescents with these infections are all candidates to progress to schizophrenia or manic depressive illness. It is also my conclusion that adults who develop an Epstein-Barr or cytomegalovirus infection after the brain is developed do not develop psychosis but they do develop depression, pains and weakness and are frequently given the clinical diagnosis of fibromyalgia, chronic fatigue and neurotic depression. Weakness is a characteristic of these chronic infections, be they present congenitally, after birth or developed

even as an adult after the brain has developed. Ninety-five percent of the adult population do have antibodies to Epstein-Barr or cytomegalovirus. It seems evident from literature that human herpes virus #6 is the single cause of multiple sclerosis. Anyone who has these infections are suffering to some degree. Even though they may think themselves in reasonable health, they are fighting a serious battle with a wicked enemy. Anyone who has symptoms, mental or physical, should consider the possibility that these herpes viral infections are adversely affecting their health. There are no antibiotics that can eradicate the human body of these latent viruses. There is only one way these viruses can be killed and that is the human biological response to the support of a negative magnetic field.

Behavioral Therapy For Fibromyalgia
Body, Brain and Emotional Disorders
Psychoneurosis are composed of maladaptive responses to a variety of emotional stimuli.

In a person with a normal functioning, non-injured brain these stimuli that evoke the symptoms may be from traumatic stimuli, or from stimuli evoking anxiety and tension from interpersonal relationships. Tension-anxiety may take many forms of maladaptive reactions such as tension, anxiety, depression, phobias, hysterical reactions, panic, disassociation, obsessive-compulsive behavior, learning disorders and so forth. There are mind/body symptoms such as tension myalgia syndrome from such as subconsciously repressed hostilities, anger, fear and so forth. Tension and anxiety is biologically stressful and can therefore produce acid-hypoxia in any area of the body predisposed for the reaction. The magnetic treatment is the same whether there is a biological reason or psychological reason for the selection of the symptoms and the somatic expression. Both the brain response and when present, the somatic response, need to be treated simultaneously with a negative (south-seeking) magnetic field. The usual treatment of the brain is with a bitemporal placement of discs (either neodymium discs or ceramic discs).

The somatic symptom is treated with appropriate magnets for the size and depth of the symptom. Suitable magnets for somatic symptom treatment are, such as, the ceramic disc, the neodymium disc, the double magnet multi-magnet flexible mats, or the reinforcement of these flexible mats with mini-block

magnets, various sizes of plastiform magnets, 4" x 6" x 1/2" ceramic block magnets and so forth. The duration of exposure to a negative (south-seeking) magnetic field ranges from 10-30 minutes for acute symptom relief. For chronic symptoms, the duration should be prolonged to aid in healing. The longer the duration of exposure to a negative (south-seeking) magnetic field, the better.

Training out of the symptoms is achieved by a reviewing of the symptom-evoking stimuli while magnetically maintaining a calm central nervous system. This may be achieved by a live meeting of the stimuli or by an image review of the stimuli.

Fibromyalgia pain and obsessive-compulsive treatment requires special, techniques that inhibit the pain and obsessional thoughts or compulsive acts. Breath-holding to the point of the mind going blank is one aversive way to block out obsessive-compulsiveness. This practice of imaging the obsession or the compulsion and blanking it out by breath-holding should proceed under the circumstances of maximum relaxation and the maintenance of neuronal inhibition by exposure to a negative (south-seeking) magnetic field. Obsessive-compulsiveness deserves special consideration since it can run through the gauntlet of neuroses, personality disorders, somatic disorders, tension/muscle disorders, learning disorders and psychoses. Obsessive-compulsiveness can be produced by a non-organic brain response or by an organically injured brain such as schizophrenia, manic-depressive, initially injured by a viral infection (Epstein-Barr, cytomegalovirus and/or human herpes virus VI).

Three or more months of one-half hour per day of behavioral training will be useful for all stages, ranging from Fibromyalgia to neurosis to psychosis. Although, acute symptoms in all categories can be managed with exposure to a negative (south-seeking) magnetic field, there should be a search for organic factors such as maladaptive reactions to foods, chemicals and inhalants. Behavioral training while relaxed and while optimally exposed to a negative (south-seeking) magnetic field should proceed for one-half hour daily for three or more months.

Pains, Anger, Hostilities, Corrective Behavioral Training Drill For Obsessions-Compulsions, Depression, Anxieties, Phobias and Other Maladaptive Responses

Preparation For Drill

Fill out the tension response inventory. Select three of the items to work on during the drill. Content of Behavioral Corrective Practice Drill:

A. Progressive Relaxation

B. Systematic Desensitization

While relaxed with eyes closed, reproach through imagery, fears and phobias. This trains down anxieties and phobias.

C. Inhibition of Obsessions, compulsions and fibromyalgia pains

Relaxation does not train out obsessions, compulsions and fibromyalgia pains.

Holding the breath until the image of the obsession or compulsion disappears effectively says "no" to the symptoms and is capable of training out obsessions and compulsions and fibromyalgia pains.

D. Positive Reinforcement

This positive imagery is capable of training in a new, socially useful behavior. After each imagery inhibition of a maladaptive response, picture yourself behaving acceptably with correction.

Magnetic Facilitated Behavioral Training Therapy

Understanding Magnets and Their Therapeutic Application

The magnets used have magnetic poles on opposite sides of flat surfaces so that exposure can be made to one pole at a time. The negative pole is identified with the word "Negative" or "N".

The positive magnetic field excites cellular function including neurons while a negative (south-seeking) magnetic field calms down and controls cellular excitement, including neurons of the brain and spine. The secret is to have the brain and spinal cord exposed to a sufficient negative (south-seeking) magnetic energy field to cancel out symptoms while re-approaching situations which have been evoking symptoms. The essence of desensitization corrective training is to meet the stimuli usually evoking symptoms while not experiencing symptoms. Adequate relaxation while re-approaching stimuli through imagery is adequate for some people to train out their anxieties and phobias. However, using magnets appropriately placed and of proper gauss strength can calm down the brain, spinal cord, muscles and abdominal organs which materially increases the effectiveness of behavioral therapy training sessions.

Inhibiting an image by holding the breath until the image is blanked out of the mind is especially effective in training out obsessive-compulsive behavior.

Placement Of Magnets:

A. Head:

Bitemporal placement of ceramic disc magnets that are 1-1/2" X 12" x 1/2" held in place by a suitable band, such as a 2" x 26" wrap or sweat band, etc. An alternative to ceramic disc magnets are neodymium disc magnets that are 1" x 1/8". One is placed inside the head band and a second one is placed outside the head band directly over the inner magnet. The temporal areas are in front of and at the level of the top of the ears. Alternative placements that some people may find to be most effective are to place a disc magnet on the forehead and the left temporal area or on the left temporal and low occipital.

B. Chest: Place a 4" x 6" x 1/2" ceramic magnet on the mid-sternum.

C. Back: Place a 14" x 25" multi-purpose magnetic pad on the upper back, neck and back of the head.

D. Magnetic Eye Treatment Unit: The magnetic eye unit is composed of a magnetic light shield covering the eyes and forehead with two 1" x 1/8" neodymium disc magnets on the light shield over each eye.

E. Those with the seventy magnet super bed and twelve magnet super head unit will use the bed and head unit rather an items A, B, C and D. This system provides the optimum setup for behavioral practice.

Therapeutic Sleep

Therapy can be materially enhanced by having a good night's sleep. For improved sleep and therapeutic dreaming at night, use a magnetic sleep system composed of four 4" x 6" x 1" ceramic magnets placed 3/4" apart in a carrier which is placed up against the headboard. An additional value can be achieved by placing the negative (south-seeking) magnetic field of a 4" x 6" x 1/2" magnet on the side, front or back of the head. This 4" x 6" x 1/2" ceramic magnet should be placed on a 5" x 6" double magnet, multi-magnet flexible mat. Place the 6" front to back on the side of the head which is not on the pillow when laying on a side or lean it up against the side of the head if laying on the back.

With the sleeper system up against the headboard, the head is in a magnetic field 19" across and 6" high. This not only produces improved sleep, but increases dreaming white relaxed during the night. Dreaming is nature's own desensitization technique, which again fulfills the re-approach to situations while being relaxed. Many anxieties and phobias can be trained out simply by therapeutic dreaming with the use of magnets. The closer the top of the head is to the magnets, the better.

An additional value can be obtained by using a magnetic bed pad which improves sleep. This consists of negative poled magnets throughout the bed pad.

A 70-magnet super bed and twelve magnet super head unit provides the optimum deep therapeutic sleep system.

Progressive Relaxation Drill

Slowly proceed with the following relaxing practice. Place both thoughts and feelings in the mind as a picture. The eyes are closed. The magnetic eye unit is across the eyes and all the magnets are to be in place as have been described. Progressively, proceed slowly as follows:

Think of the right foot. Let every muscle go. Heavy, heavy, heavy. Warm, warm, warm. Heavy, warm, relaxed. Proceed the same way to the lower leg, the upper leg and then proceed to each section of the left leg. Proceed the same way to the right arm, the left arm, the abdomen, the low back, the front of the chest, the upper back, the back of the neck, the front of the neck, eyes, forehead, scalp. This will require about ten minutes.

Imagery Corrective Drill

While maintaining relaxation, place in mind an image of a troubled thought, feeling or pain. Stay relaxed. Place again the troubled thought, feeling or pain as a picture in your mind. Stay relaxed while holding the breath until the mind goes blank.

Again, think and feel the right leg; heavy, warm, relaxed. Then proceed over the entire body. After again achieving maximum relaxation, continue the practice on other troubled thoughts and feelings. Practice 3, 4 or more different imagery pictures during these sessions. Include for sure, one or more obsessive thoughts and compulsive acts each session.

The advice is to have 30-minute behavioral training sessions daily until all tension, anxiety, phobias, troubled thoughts, troubled feelings, anger, hostility, fibromyalgia pains, obsessions and compulsions have been trained out.

Magnetic Protocol for Fibromyalgia: Static Magnetic Field Systemic Therapy and Local Therapy Magnetic Field
Systemic negative magnetic field magnetic therapy is optimally suited for:

1) Systemic or local allergic reactions.
2) Systemic or local immune reactions.
3) Systemic or local microbial infection of any and all types of invading microorganisms.
4) Any and all inflammatory reactions including addictive withdrawal inflammatory reactions, autoimmune reactions or organ transplant rejection reactions and enzyme toxic reactions.
5) Fibromyalgia.

All inflammatory reactions, no matter how produced are benefitted materially by an application of a negative magnetic field to the inflamed area. There can be local, inflamed areas that have evoked only the mechanisms of the constitutive barriers. Once these constitutive barriers have been bridged, then the immune reaction, be it humeral, cellular or both is at that point, systemic. Therefore, it is wise that all inflammatory reactions should use the systemic approach. When not being systemically exposed to a negative magnetic field then the known local areas of inflammation should be locally treated. The inflammatory reaction of addictive withdrawal is also benefited, however the final part of the treatment must be also avoidance of the addictant. In a case of foods, three months avoidance usually suffices for control over the inflammatory reaction when exposure to the original addictant is no more often than once in four days. Narcotics, alcohol and caffeine should be avoided completely and never reintroduced. The biological response to a negative magnetic field exerts a control over the immune system. Therefore negative magnetic field systemic therapy should be used to assure the optimum function of the immune system. Much of the time a negative magnetic field stopping the invasion of microorganisms at the constitutive barrier level will prevent even the necessity of evoking the humeral and cellular immune defenses. But if this is breached, and it often is before treatment begins, then the negative magnetic field has a control over the function of the immune system including its production of inflammation.

A positive magnetic field can be used to stimulate thymus function. These periods of thymus positive magnetic field

exposure should be brief such as 15-20 minutes and spaced several hours apart so that there is not an over-stress of the thymus gland produced by the development of local acidity in the thymus gland. For all other aspects of treating the immune systems, the negative magnetic field should be used because it is anti-stressful, anti-inflammatory and controlling over the normal functions of the immune system.

Negative Magnetic Field Systemic Therapy

Magnets for systemic therapy:
- Seventy-magnet bed (composed of magnets that are 4" x 6" x 1" placed 1" apart. Thirty- Five of theses magnets are placed in two wooden carriers that are 36" square. When placed end-to-end they make a single bed of 36" x 72")
- Super magnetic hat (composed of thirty-six neodymium disc magnets that are 1" x 1/8")
- Super magnetic head unit (composed of twelve 4" x 6" x 1" ceramic magnets evenly distributed to the top and sides of the head in a wooden carrier)

Local Magnetic Therapy

The magnets used for local magnetic therapy will vary considerably depending on the size or the need for the depth of penetration.

Ceramic Magnets
- 4" x 6" x 1/2" ceramic block magnet
- 2" x 5" x 1/2" ceramic block magnet
- 1-1/2" x 1/2" ceramic disc magnet

Neodymium Disc Magnets
- 1/2" x 1/16" neodymium disc magnet
- 1" x 1/8" neodymium disc magnet
- 1" x 1/4" neodymium disc magnet

Plastiform Flexible Magnets

These come in strips 2", 3" and 4" wide. They can be cut to any dimension desired. They can be stacked to produce a stronger field. Common plastiform magnets available are:
- 2" x 3" x 1/8"
- 3" x 3" x 1/8"
- 4" x 6" x 1/8" Four of these stacked together will produce the same strength as a 1/2" ceramic magnet.

Flexible Mats

These are composed of plastiform magnets set into foam. These flexible mats are 5" x 6" or 5" x 12". They are composed

of plastiform material that is 1-1/2" long, 7/8" wide and 1/8" thick. They are provided with one or two layers of these magnets.

Multi-Purpose Pads

These are flexible foam mats composed of mini-block magnets that are 1-7/8" x 7/8" x 3/8" placed 1-1/2" apart. These pads are 11" x 17" or 18" x 24".

Body Wraps

These hold the single magnets in place. The sizes are 2" x 12", 2" x 17", 2" x 26", 3" x 31", 3" x 40" and 4" x 52".

Placement and Duration

The central purpose of systemic treatment is achieved by sleeping on a super magnetic bed. Those with acute infections or systemic cancer, should not only sleep on the magnetic bed at night but also 1/2 to one hour, four times during the day. The initial treatment should extend to twelve weeks. In achieving this, they should be as close to the magnets as possible. An eggcratetype foam pad or a suitable futon that is approximately two inches thick is suitable. After the 3 months, the critical phase is over and the subject can continue to sleep on the bed as is or can place the magnets between the mattress and the springs.

Severe chronic cases are best served by returning to the bed and super magnetic head unit two to four times a day for 1/2 hour to 1 hours sessions. This is especially true of chronic viral infections and chronic toxic states.

Fibromyalgia subjects characteristically have chronic infections of one or more of the herpes family viruses (Epstein-Barr, cytomegalovirus or Human Herpes Virus #6) and do best on the super magnet bed all night and for one hour, four times during the day for a minimum of 3 months. Use the super magnetic hat when not on the bed.

Local treatment can be used during the time that the subject is not on the bed. When on the bed, the subject will also have his head in the super magnetic head unit. When not on the bed, the super magnetic hat can be used. In treating a tumor of the brain, it is necessary to treat the head during the period when not on the bed at which time the head is in the super magnetic head unit. For any serious condition of the brain such as a tumor of the brain, Alzheimer's disease or a vascular disorder it would be wise to use the super magnetic hat with thirty-four of the

neodymium disc magnets when not on the bed and super magnetic head unit.

The 1-1/2" x 1/2" ceramic disc magnets can be used anywhere on the body with a local lesion that is no larger than 1-1/2" across. These discs are especially useful when placed on the head. The magnets are placed bitemporally and held in place with a 2" x 26" band. This is used to handle any emotional or mental symptoms associated with the illness. Suitable magnets, be they ceramic, neodymium discs or flexible pads or mats can be used. In treating areas that are more than 1-1/2" deep, a larger ceramic magnet should be used. Suitable is the 4" x 6" x 1/2" magnet. This can be placed over the liver, spleen, heart, stomach, intestines or wherever the local lesion is. This ceramic block magnet can be held in place with a 4" x 52" body wrap. This should be used locally when not on the bed.

For very serious conditions such as invasion by microorganisms of the lungs, intestines, liver or any other place, the most optimum treatment would be that of a suspension of magnets which is four of the 4" x 6" x 1" magnets suspended above the subject without any weight on the subject. This can be used at the same time the super magnetic bed is being used, thus there is an approach from the back side as well as the front side of the body.

It can be useful to maximize the response of the thymus gland by placing a positive magnetic field of a 2" x 5" x 1/2" ceramic block magnet on the sternum. Beneath the sternum is the thymus gland. This uses a positive magnetic field for 15 minutes three times a day.

It could be further beneficial to drink alkaline microwater to help keep the body in an alkaline state.

There are many cases in which a far-infrared sauna would add a detoxifying value as well as an oxidoreductase enzyme stimulating value.

A 4-Day Diversified Rotation Diet can handle food addiction. Alcohol addiction is food addiction to the food in alcohol production.

4-Day Diversified Rotation Diet General Information

A local and systemic biological response of acidity is routinely evoked when symptoms develop in response to exposure to foods, chemicals and inhalants. Acidity also produces low oxygen (acid-hypoxia). This is true whether the maladaptive symptom reactions

are not immunologic or non-immunologic in origin. Most food symptom reactions are not immunologic. Immunologic and non-immunologic food symptom reactions have a classic addictive seesaw biological response of symptom relief on exposure, with the emergence of symptoms 3-4 hours after the exposure (addictive withdrawal phase). The optimum method of reversing addiction is avoidance. In food addiction, the optimum method of avoidance of the addiction is for there to be a 3-month avoidance followed by an exposure no more often than every fourth day. This is the reason for the 4-Day Diversified Rotation Diet. The short-term management of symptoms can be managed by alkalinization, which can be produced by bicarbonate alkalinization and more optimally, exposure to a negative (south-seeking) magnetic field, which alkalinizes and oxygenates (alkaline-hyperoxia). These alkalinization methods can relieve symptoms after they have occurred from the exposure and can also prevent symptoms from developing when the alkalinization methods are used prior to an exposure to symptom producing foods, chemicals and inhalants.

The Following is the Optimum Method of Preventing Symptoms form Occurring from Foods:

1. A 4-Day Diversified Rotation Diet. This four-day spacing of exposure to specific foods prevents food addiction. The 4-Day Diversified Rotation Diet is described in greater detail in *The Ultimate Diet* (Vol. VI, First Quarter, 2000) by William H. Philpott, M.D.

2. Pre-meal negative magnetic field exposure. One-half hour before the meal place the magnets on the body. Magnetic discs, either ceramic discs (1-1/2" x 1/2") or neodymium discs (1" x 1/8") placed bitemporally. These can be held in place with a 2" x 26" wrap.

1. Place on the sternum, a 4" x 6" x 1/2" ceramic magnet. Hold in place with a 4" x 52" wrap. An added value can result from placing a 4" x 6" x 1/2" ceramic magnet on the epigastric area, held in place with a 4" x 52" wrap. Place on the thoracic spine a large sized double strength flexible mat; this flexible mat can be held in place with the same 4" x 52" wrap that is supporting the 4" x 6" x 1/2" ceramic on the epigastric area. These can be removed at the beginning of the meal or they can be continued through until the meal is finished. If symptoms emerge after the meal has been eaten, then replace the magnets until the symptoms leave and especially place a suitable sized

magnet directly over the symptom area. Also prior to the meal, if there are any symptom areas, treat these with appropriate sized magnets, pre-meal. Always use the negative magnetic field (south-seeking).

3. Post-meal, if any symptoms develop then use suitable magnets placed locally for relieving these symptoms. It could be helpful again, to place the ceramic disc magnets bitemporally. Bicarbonate alkalinization is useful one-half hour after the meal, use multi-element mineral ascorbate powder. Take 1/2 teaspoon of multi-element mineral ascorbate powder and 1/2 teaspoon of soda bicarbonate in 1/2 a glass of water.

The above pre-meal and post-meal alkalization method is recommended for:

• Those with a serious state of symptoms reactions to multiple foods in which food rotation is not entirely satisfactory.

• When of necessity, symptom-evoking foods have to be eaten, such as when eating out at a restaurant, or those that have to use this method instead of waiting three months for the reintroduction of their foods.

In my experience, the above method of basic food rotation diet with the addition when necessary of the magnetic pre-meal exposure and the magnetic post-meal exposure is superior to any neutralization method. Neutralization methods do not honor the fact that the basic problems are addiction and acidity (acid-hypoxia). A food rotation diet is necessary to honor the fact that addiction is the major driving force of food maladaptive reactions and that acid-hypoxia is the immediate cause of symptoms. There is no optimally effective method for the management of maladaptive reactions to foods that is equivalent to food rotation.

Infrared Sauna

Far Infrared is a good, non-injurious heat source with several valuable health promoting values including alkalinization, oxygenation and detoxification.

1. Alkalinization

The human body functions in an alkaline medium. Enzymes in the human body are dependant on alkalinization and on temperature range. Increasing the temperature increases the enzyme function.

2. Oxygenenation

The human body makes it's energy by the oxidation process requiring the presence of molecular oxygen. As the temperature rises, the oxidation process increases. Thus, this will aid in producing more energy.

3. Detoxification

The human body processes toxins, some by being exhaled from the lungs, others passed out through the urine or the stool. Sweating from the skin is another process of detoxification. The far infrared sauna is ideal in that it penetrates through the layers of the skin and into the subcutaneous fat throughout the skin and then detoxifies all types of toxicity including heavy metals. Therefore, this is ideal for heavy metal toxicity such as mercury, lead or other heavy metals. It also processes the enzyme inhibiting acids such as in degenerating diseases. Especially noted is the value in processing the toxins from cancer.

Far infrared sauna is markedly complementary to negative magnetic field therapy which is also alkalinizing, oxygenating and detoxifying.

The Infralume Hand-Held Lumiscope is an ideal instrument. This is obtainable from medical supply stores and drug stores. When using the Infralume, the magnet can be placed on the area immediately after heating. There can be 30 minutes of heating one or more times a day.

Magnetic Alkaline Micro Water

Magnetic alkaline micro water helps materially to maintain the body's normal alkaline state. Also, being micro water, it enters into the cells of the body more readily than the usual water. This also carries negative (south-seeking) magnetic field as well as being alkaline. There are electrolysis instruments used for producing the magnetic alkaline micro water. At least five glasses of the water should be ingested each day.

The most optimum alkaline microwater comes from a natural spring water from Japan's magnetic mountain. This water contains many minerals that hold a permanent negative magnetic field and micronized water. This is marketed in the U.S. under the name of Nariwa water. One 500 ml or more of this water are advised a day. This is detoxifying and energizing. There is a minimum value in exposing water to the negative magnetic field of a static field magnet. Water and oxygen are magnetizable.

Hydration

A minimum of eight glasses a day of pure water should be ingested, and ten glasses can be even better. Magnetic alkaline microwater is the most hydrating and most detoxifying.

Optimized Nutrition

It is recommended that a local physician be responsible for optimizing nutrition.

Bowel Function

It is very important to keep bowel movement optimal. Sleeping on the magnetic bed will help retain some fluid in the stool and make for a softer bowel movement. Vitamin C particularly as a sodium ascorbate can be used in adequate amounts to provide a soft-formed stool. It is generally good to take minerals of calcium, magnesium and potassium as ascorbates. The rest of the Vitamin C can be taken as a sodium ascorbate.

Colloidal Silver Therapy

Colloidal Silver is made by an electrolysis method that produces a particle size of 0.0001 micron. These small silver particles are charged to a negative (south-seeking) magnetic field by the electrolysis method. This solution of colloidal silver is placed in the mouth, especially under the tongue for absorption. This provides quick absorption into the blood stream. These fine silver particles go throughout the entire body. The negative magnetic field magnetically attaches to microorganisms, parasites and cancer cells, which are positive (north-seeking) magnetic poled. Silver, in its own right beyond that of the negative magnetic field, inhibits the replication of these cells. The small silver particles do not interfere in any way with human cell function. It is recommended to use 40 parts per million starting for the first week with 1/2 teaspoon four times a day, then followed the next three months by 1 teaspoon four times a day. Aloe salve may also help in the treatment of local skin infections.

Polarity

Always use the negative (south-seeking) magnetic field facing the body at all times other than the brief exposure of the thymus gland to the positive magnetic field as has been described.

Final Word

Fibromyalgia pain management is achieved by treating the head and the painful area of the body at the same time. Optimum for treating the head is the ceramic disc magnets (1-1/2" x

1/2") placed bitemporally for depression or headache, frontal and left temporal for anxiety or left temporal and occipital for obsessive-compulsiveness. These ceramic mini-block magnets that are 1-7/8" x 7/8" x 3/8" can serve the same value as the ceramic disc magnets. The magnetic super hat composed of thirty-four ceramic disc magnets that are 1" x 1/8" is the most optimal for head treatment. Local pain areas can be treated with magnets of sufficient suitable size for the area involved such as the 4" x 6" x 1/2" magnet which is the one that is used most, ceramic discs, mini-blocks, neodymium discs, flexible mats, multi-purpose pads made from the mini-blocks or a magnetic chair made from the mini-blocks.

Usually, fibromyalgia subjects are infected with one or more of the herpes family viruses as well as candidiasis of the colon and vagina. Due to these infections, a basic magnetic systemic treatment with a 70 magnet (4" x 6" x 1") bed is optimal.

A negative magnetic field spins electrons counterclockwise and is anti-stressful, neuronal-calming, cellular function-regulating and thus, healing.

The negative magnetic field of a static field magnet is a space free energy converter to electrons. A negative magnetic field has the biological regulatory control over a positive magnetic field. A negative magnetic field is the anabolic control over the harmful effects of prolonged catabolism.

The present and future battle over toxic explosion fossil fuel and atomic energy and non-toxic implosive space free energy in industry and the medical application of potentially toxic pharmaceuticals replacement with the development of non-toxic magnetic free energy therapy will evoke resistance to change from vested interests.

Furthermore, physicians will need to learn a new dimension in maintaining health, reversing disease and producing healing. It is not easy for a physician highly skilled and justly rewarded for his special skills to change to even a more successful therapy.

FIBROMYALGIA INFLAMMATION AND PAIN ARE CAUSED BY A POSITIVE MAGNETIC FIELD ACID-HYPOXIA STRESS BIOLOGICAL RESPONSE AND REVERSED BY NEGATIVE MAGNETIC FIELD ALKALINE-HYPEROXIA ANTI-STRESS BIOLOGICAL RESPONSE.

Fibromyaglia Pain Do's & Don't

DO's

Do relieve pain with a static negative magnetic field over the painful area while also treating bitemporally with negative magnetic field discs.

Do relieve pain with a static negative magnetic field over the painful area while also treating bitemporally with negative magnetic field discs. Rotate the foods on a 4-Day Diversified Rota- tion basis. Rotate the foods on a 4-Day Diversified Rotation basis.

Do avoid addiction withdrawal symptoms by rotating foods on a four day rotation basis.

Do clean up your home or work place so that you do not have chronic exposure to chemicals to which you are known to be reactive.

Do behavioral training to train out any obsessions, compulsions, anger or other symptoms including pain.

Do behavioral training to train out any obsessions, compulsions, anger or other symptoms including pain.

Optimize nutrition with appropriate supplementation, preferably under medical supervision. Do use the super magnetic bed and a super magnetic head unit to treat infections.

Don'ts

Don't relieve pain with narcotics. Don't relieve pain with steroids.

Don't relieve pain with non-steroidal analgesics. Don't relieve pain with tranquilizers.

Don't relieve pain with antidepressants. Don't relieve pain with St. John's Wort.

Don't relieve pain with between-meal feedings.

Don't continue to daily eat foods to which you are symptom-reacting (addicted, allergic) Don't eat between meals to relieve food addiction withdrawal symptoms.

Don't continue exposure to chemicals to which you are symptom-reactive. Don't obsessively dwell on pain.

Don't obsessively dwell on anger or hostility. Don't be malnourished.

Don't use antibiotics for the treatment of viral infections.

References

1) BECKER, ROBERT 0. "Cross Currents". Jeremy P. Tarcher, Inc. Los Angeles, CA, 1990. BECKER, ROBERT 0. and SELDON, G. "The Body Electric. Electromagnetism and

the Foundation of Life." William Morrow and Company. NY. 1986.

2) DAVIS, A.R. and RAWLS, W. "The Magnetic Blueprint of Life.". Acres USA, Kansas City, MO, 1979.

3) RANDOLPH, T.G. *The Enzymatic and Hypoxia, Endocrine Concept of Allergic Inflammation.*
Clinical Ecology, pp. 577-596. Charles C. Thomas, Publisher, Springfield, Illinois. (1976).

4) PHILPOTT, W.H., M.D. and KALITA, Dwight, Ph.D., *BrainAlletgiec. The Psycho-Nutrient and Magnetic Connections.* Updated second edition. Keats Publishing NTC/Contemporary Pub- lishing Group. Los Angeles, CA , 2000.

5) PHILPOTT, W.H., M.D. and KALITA, Dwight, Ph.D., *Magnet Therapy.* (Tiburon, CA: Alternative Medicine, corn, 2000)

6) SELFRIDGE, NANCY, M.D. and PETERSON, Franklynn. *Freedom Fmm Fibromyalgia.*
The 5 Week Program Proven to Conquer Pain. Three Rivers Press, New York, New York. 2001.

7) AHARONOV, Y. and BOHN, D. Significance of Electromagnetic Potentials in Quantum Theory. The Physical Revision. 115, 485. (1959).

8) BELANEY, B. The New Encyclopedia Britannica. 1986. Vol. 18, pp 274-275.

9) MANNING, Jean. *The Coming Energy Revolution.* Avery Publishing Group 1996.

10) SZENT-GYORGYA, ALBERT. *Electronic Biology and Cancer. A New 1 Theory of Cancer.* 1976. Marcel Dekker, Inc. NY, NY 10016

11) ZINSSER, JOKLIK . *Zinsser Microbiology,* 20th Edition, Appleton & Lange, Norwalk, CT, 1992. Pg 955, 956, 958.

Other References

FYFE, William S. New Encyclopedia. Vol. 24, pg 200. Oxidative Remnant Magnetism Encyclopedia Britannica, Inc. Chicago. 1986.

FERSHT, Alan., *Enzyme Structure and Mechanism.* Second Edition. W.11. Freeman and Co. New York, New York. 1994

McGILVERY, R.W. *Magnetic Fields in Enzyme Catalysis. Functional Approach.* W.B. Saunders Company, 1983. Philadelphia, PA. USA.

BISHOP, *ML Clinical Chemistry*. Second Edition. 1992. J.B. Lippincott Company. Philadelphia, PA. USA. [*Magnetic Health Quarterly* "Fibromyalgia " Vol. VII, 4th Qtr, 2001]

MAGNETIC PROTOCOL

Ulcers, Polyps, Cancer, Diverticulitis, Diverticulosis, Gastric Reflux, Celiac Disease, Crohn's Disease, Ulcerative Colitis, Brain/Gut Syndrome, Irritable Bowel Disorders Gastrointestinal Disorders

Celiac disease (non-tropical sprue) attacks the lower area of the small intestine and has been documented to be due to an inherited immunologic reaction (gluten enteropathy). Irish inherit gluten enteropathy at a rate of 1 in 200. Non-Irish inherit gluten enteropathy at a rate of 1 in 2000.

The minor gastrointestinal reflux states and irritable bowel disorders as well as major inflammatory bowel diseases (Crohn s disease and ulcerative colitis) are classically said to have no specific causes. There is a mixed bag of immunologic, non-immunologic, food sensitivities and intolerances with superimposed infections. It is classically concluded in the medical literature that there is no specific known cause for inflammatory bowel disease (IBD).

This is where my research observations challenge the "no specific known cause" of traditional medicine for IBD. I have observed a specific, isolated, known cause for IBD with a specific isolated common denominator. This common denominator had not been documented before my research although it had been postulated. This common denominator is the emergence of systemic acidity sufficient to be measurable in the blood at the emergence of symptoms. This is in the nature of food addiction. It matters not whether these are immunologic reactions or non-immunologic reactions. There is always acidity. Acidity always reduces molecular oxygen and therefore, this biological response is characterized as acid-hypoxia. All cells, including single cell organisms, swell (edema) in a state of acidity when the acid is sufficient to override their tolerance for acidity. Human cells optimally function in an alkaline medium of 7.4 below which edema develops. This edematous hypoxia is inflammatory and encourages microorganisms (viruses, bacteria, fungi, parasites) and cancer cells to flourish. These microorganisms and cancer cells have a higher tolerance for acid-hypoxia than the human cells. In fact, the microor-

ganisms and cancer cells make their adenosine triphosphate (ATP) by fermentation using the catalysis of transferase enzymes that are acid-hypoxic-dependent. Human cells make their ATP by the catalysis of four oxidoreductase enzymes which are alkaline-hyperoxia-dependent.

Theron G. Randolph, M.D., Allergist, was the first to postulate that acid-hypoxia was the common denominator of symptom-producing food reactions. He also identified this as food addiction with a characteristic withdrawal phase. The value of my research is that by monitoring thousands of patients over a twenty year period in which I monitored for the emergence of acid with symptoms, I proved by this large statistical study that Dr. Randolph was right. Dr. Randolph also postulated that enzyme catalysis was involved. My observations proved that enzyme catalysis is present. It is my research with biological responses to separate positive (north-seeking) and negative (south-seeking) magnetic fields that identified the enzyme factor in illness, health and healing.

This quarterly (former publication) provides a systematic way to do an examination that brings out the evidence of the relationship between food maladaptive reactions and chronic degenerative diseases. This quarterly especially addresses gastrointestinal disorders.

The Crucial Role of Maladaptive Symptom Producing Food Reactions in Degenerative Diseases in General and Gastrointestinal Diseases in Particular

The term maladaptive food reaction will be used in this treatise to designate foods that produce acute symptoms which can also, in time, progress to degenerative diseases with the same symptoms. These have been termed "hypersensitive reactions" and often the loose term "allergy" has been used. In my experience, which will be described later in this article, I have observed that only a few of these symptom-producing food reactions are immunologic in origin as determined by the assessment of immunologic mechanisms. The majority are symptom-producing, but not immunologic in origin. It has been determined that the common denominator between all these immunologic and non-immunologic, symptom-producing food reactions is that of acidity. Addiction with the symptom-producing withdrawal phase occurring 3-4 hours after contact

with the addictant is characteristic of these maladaptive food reactions.

What is the significance of maladaptive, symptom-producing reactions in gastrointestinal diseases?

John F. Johanson and Associates reported in the Gastrointestinal Diseases Risk Factors and Prevention list food sensitivity reactions among risk factors in gastrointestinal diseases. The food sensitivity (maladaptive) reactions are referred to in a non-systematized way such as in history-taking if the subject has observed any relationship between foods and symptoms. The subject is supported in self-help observations about food-producing symptoms. There is no physician monitored systematic examination of the possibility of foods producing the gastrointestinal symptoms. John F. Johnson and his associates at examination of risk factors and from this, deductions made for a formulation for prevention is grossly faltered by lacking a systematic, physician-monitored examination of maladaptive reactions to foods. The excuse is given that there is conflicting data on the subject. If conflicting data exists, obviously an examination of these articles reveal that the conflicting data exist because of a lack of standardized physician-monitored techniques in examining for food reactions precipitating gastrointestinal symptoms.

The honored gastroenterologist specialist, W. Grant Thompson, has provided an information guide for patients and physicians entitled, *THE ANGRY GUT*. He admits to the role of gluten enteropathy in celiac disease which affects the small intestine but denies that this applies to Crohn s disease which can affect any segment of the gastrointestinal tract from the mouth to the anus or to ulcerative colitis affecting the colon. He refers to Cambridge doctors who systematically test for maladaptive reactions to wheat, eggs and milk, but he is personally doubtful of its significance. He is concerned about "quack" diets, the proponents of which have timidity to the claim of a cure. He regards the claims of a diet cure of Inflammatory Bowel Disease (IBD) as a cruel hoax. He despairingly refers to clinical ecologists "goading patients on" to use a diet as a cure for inflammatory bowel disease. Grant Thompson relies on a tight-rope balancing act with a trade-off between the limited values and injury limitations between steroid therapy, non-steroidal anti-inflammatory agents and

sulfonamide antibiotic values. He ignores and even has an expressed bias against considering food reactions as a possibility of inflammatory bowel disease.

My experience tells me that it is a travesty of medical therapeutic errors to relegate food maladaptive reactions to a relative low value or ignore or even have a bias against the relative significance of maladaptive reactions to foods as being in fact, central as cause to Crohn s disease, ulcerative colitis or the less injurious irritable bowel syndrome.

What is my experience that justifies my conclusion that symptom-producing, maladaptive food reactions are central to minor gastrointestinal reactions such as imtable bowel syndrome to major tissue injury reactions,including celiac disease, inflammatory bowel disease (IBD), Crohn s disease and ulcerative colitis?

My initial specialty training was in neurology and psychiatry. By the eighth year in my specialty practice, I observed the relationship between hyperinsulinism and its production of hypoglycemia in my psychiatric patients. In my twelfth year of clinical specialty practice, Saul Klotz, M.D, Allergist and I did a double-blind study on behavioral and psychiatric disordered adolescents which demonstrated a causal relationship between food reactions and their symptoms. Between 1970-1975, I devoted this time to a research program systematically examining the relationship between maladaptive reactions to foods, chemicals, inhalants and toxins and the symptoms of mental patients. These were all mental patients whose symptoms were sufficient to require hospitalization. Marshall Mandel, M.D, Allergist, spent one day a month for five years guiding this program. Theron G. Randolph, M.D, Allergist, with his system of food testing after a five day fast, was followed. Dr. Randolph was an advisor to this research program. Martin Rubin, Ph.D., Biochemist, guided the laboratory assessment.

The patients were placed in an environmentally clean environment in a hospital. They were fasted on pure water only -- for five days. Test meals of single foods proceeded from the sixth day to the thirtieth day of hospitalization. Blood sugar and blood or saliva pH was tested before each test meal and one hour after each test meal. An entire body symptom system survey was made before each test meal and one hour after the

test meal. This testing included a pulse and blood pressure test. Food antibodies and complement disorders was made on each subject. An assortment of anti-body studies to common infectious diseases, especially viruses, was made. Basic vitamin and mineral studies were made. Later, after this five year initial research study, essential fats and amino acids were added to the nutritional survey. A study for porphyria and for heavy metal toxicity was added. I have had twenty years of experience in systematically examining thousands of patients for maladaptive food reactions.

Among my mental patients in the original research examination, there was a spread of gastrointestinal disorders from minor to major. It is of interest to note that there is documentation that schizophrenics have, percentage-wise, more gastrointestinal symptoms than they have mental symptoms. Autistic also have the same Brain/Gut association as schizophrenics.

There is evidence of a common cause between these mental and gastrointestinal symptoms. This common cause is a viral infection. Consistently, in our mental patients, we found evidence of brain injury from a chronically, ongoing, viral infection of Epstein-Barr, cytomegalo and or, human herpes virus #6. These same viruses, especially cytomegalovirus and others, have been isolated as infecting the enteric nerves and sacral nerves. The mechanism is that the viruses have injured selective tissues or nerves which predispose these maladaptive food reactions to manifest symptoms in these injured or metabolically compromised tissues.

Surprisingly, my research demonstrated that the common denominator of maladaptive reactions to foods, chemicals and inhalants is acidity. For years, the immunologists had assumed that antibodies and complement disorders were the common denominator of maladaptive, symptom-producing reactions. This proved not to be true. Most of the reactions did not manifest antibodies or complement disorders, but whether immunologic or non-immunologic, the common denominator was the emergence of acidity at the time of the symptom. This was demonstrated with both blood and saliva tests before the test meal and after the test meal when symptoms emerged. The following types of maladaptive reactions were isolated:

1) Immunologic disorders

2) Oxidoreductase enzyme deficiencies
3) Oxidoreductase enzyme inhibition
4) Addictive reactions
5) Reactions to toxins

The addictive reactions, with a classical relief on exposure and a withdrawal phase 3-4 hours after the exposure, ran through all types of observed reactions other than the reactions to toxins. Anti-bodies to foods were seldom an IgE reaction which does give an immediate reaction and does not have an addictive withdrawal phase. IgG reactions, of which the majority of immunologic food reactions were composed, has the same addictive quality of relief on contact and a withdrawal phase 3-4 hours after the initial contact.

Therefore, food addiction is really central as the usual initiating cause of whether this is mental or physical symptoms including gastrointestinal symptoms. Another observation we made is that there is classically no such thing as a single symptom occurring at the time of a maladaptive food reaction. You have to examine all systems of the body. By doing so, you discover that there are multiple systems involved at the same time when a food reaction occurs. The gastroenterologist looks at this and refers to non-intestinal reactions, such as a skin Crohn disease reaction. In fact, there are over 100 non-intestinal system reactions documented as associated with the intestinal reactions.

Therefore, we understand this is not simply a gastrointestinal reaction. This is a total body reaction with the systems that have, for some predisposing reason, a compromised metabolism of those tissues which manifest symptoms at the time of the reaction. It helps us understand that our treatment must focus on a central cause, such as the maladaptive reaction to food rather than centering all our attention on the inflammatory reaction occurring in only the gastrointestinal symptom. We must treat appropriately, the central cause, which in the case of mental as well as gastrointestinal reactions, is maladaptive reactions to foods. In a lesser degree, there can be maladaptive reactions to toxins or infections. In order for the tissues to be selected for reaction, there has to be some preceding tissue injury. During food testing, a person who has previously sprained an ankle will likely have some discomfort in that ankle that may have been

injured years before. It is simply that any tissues that have a compromised metabolism for any reason, will be the tissues that show up as symptom-producing when a food reaction occurs or when an acute reaction to a chemical, a mold, a cat or dog, the chemicals from the rug on the floor or the petrochemicals from car exhaust occurs, and so forth. Thus, the focus of John F. Johnson and his associates on risk factors is quite significant because these risk factors pave the way for the final, common pathway of food reactions or acute reactions to other environmental factors precipitating symptoms. Foods simply are our most common frequent exposure to environmental substances.

It is very important to understand that frequency of exposure relates to the potential of maladaptive reactions. The central reason for this is that addiction is an adaptation reaction to the stress of frequent exposure to a specific food. In a somewhat indirect way, nutrition also relates to this although, nutrition all in its own right, may reduce the chance of addiction but will not totally prevent addiction from occurring. Addiction is based on frequency of exposure. This is true whether this is tobacco, alcohol, caffeine or any food.

The understanding of food addiction becomes the central kingpin of how to prevent symptoms. To stop symptoms, addiction must be stopped. Addiction relates to frequency of exposure. This is why a 4-Day Diversified Rotation Diet is established. First, stop the addiction by five days of avoidance. The testing will demonstrate the foods to which the person is reacting with symptoms. Avoid these foods for a period of three months. Ninety-five percent of the time, the person can return to these foods as long as they are kept henceforth on a five day rotation basis. Addiction does not exist unless a person makes contact with the addictant more often than every five days. This is simply an observed fact about addiction, whether this be tobacco, alcohol, a narcotic or a food. You have to understand addiction and its necessity for frequent contact in order to understand maladaptive food reactions and how you can arrange for a rotation diet that will prevent these food reactions. The exception to this of course, is that of genetic disorders such as celiac disease in which there is an inflammatory reaction in the small intestine. One out of 200 with an Irish ancestry have a genetic disorder that will produce symptoms on contact with

gluten. In the non-Irish population, the frequency is 1 in 2,000. In these cases, foods containing gluten should be avoided all the time and cannot be successfully rotated. Otherwise, gluten reactions which we found to be the highest (64%) among our patients, can return to gluten in their rotation diet after three months of avoidance.

How to do an Ecologic Examination

1. Complete physical and mental examination.

2. Five day food avoidance. No smoking. This is best achieved by a fast on water only. Use pure water that has no chlorine. Theron G. Randolph, M.D. is the inventor of this system of five days of avoidance. By doing this, all substances to which the person is reactive will have gone through a withdrawal phase. The withdrawal phase is for the first 3-4 days. After the fifth day, the withdrawal phase of addiction has been broken. For best results, this should be in an environmentally controlled unit away from any chemicals to which the person may be frequently exposed. A less valuable, but more practical way would be to feed the subject one food during this five days that they do not use frequently (or any member of the family of foods to which they are not likely to have any type of reaction). Such a food that is most appropriate is watermelon. The person can eat all the watermelon they want for the five day period. This will provide them fluids and also minerals. This provides for an ideal withdrawal phase from any addictive substances. Less ideal, but often satisfactory, is to simply leave out all foods and members of the family of that food that is used twice a week or more and then immediately proceed with a 4-Day Diversified Rotation Diet leaving out these frequently used foods and their families. It is also possible at this point to begin food testing. It is easier with self-help, to simply make the evening meal a single food meal and proceed with food testing in this manner. In any event, the foods that are used with a frequency of twice a week or more should be left out for a period of three months unless it is proved by the food testing that they are not symptom-reactive foods.

3. Systemic system survey examines every organ of their body. Is there any pain? Is there any kind of discomfort? Is there any specific or general symptom? The pulse is taken and recorded. The blood pressure is taken and recorded. Due to the fact that the subject has gone through the five days of avoidance,

it is very unlikely that there will be any symptoms before the food is tested. If there are, these are recorded because even an increase in these symptoms, if present, will be a significant evidence of reaction. It would undoubtedly come as a surprise to many people that my mental patients were clear of their symptoms after a five day fast. Their delusions, hallucinations, depressions, and gastrointestinal symptoms, of which they have in abundance, have simply, classically disappeared by the fifth day of a five day avoidance. It should be understood that during the first three days of a fast, symptoms can and usually do, become worse. They begin to subside by the fourth day. I have demonstrated that the reason why the symptoms during this withdrawal phase increase is that acidity increases. Therefore, to make the patient more comfortable during the withdrawal phase, you can alkalinize them. This can be done by sodium bicarbonate or a combination of two-thirds sodium and one-third potassium bicarbonate. Use a teaspoon, three times a day. An added value can be to have the subject breathe oxygen several times during the day. The acid state ties up oxygen and the person is essentially in a acid-hypoxic state.

Therefore, you should alkalinize them and have them breathe oxygen for the relief of symptoms. A further substantial value can be obtained by using a negative (south-seeking) magnetic field.

You should have ceramic disc magnets available that are 1-1/2" x 1/2" and a band that can hold these on the head. Another method is to use 1" x 1/8" neodymium discs. Use a 2" x 26" head band with one disc on the inside and one on the outside for magnetic attachment. Place in front of the ears at the level of the top of the ears (bitemporally). Headaches and other discomforts of the head, delusions, hallucinations, catatonia and so forth may occur during this withdrawal phase. Placing these magnets bitemporally, that is in front of the ears at the level of the top of the ears, can relieve these symptoms. It is well to also have a 4" x 6" x 1/2" magnet that can be used anywhere on the body where there may be discomfort. Place this magnet over the area. Usually the symptoms will be gone within a ten minute period. It matters not whether these magnets are left continuously on this area or whether they are removed as soon as the symptom disappears. Always use a negative (south-seeking) magnetic field since the biological response

to the negative (south-seeking) magnetic field is alkaline-hyperoxia which cancels out the acid- hypoxia producing the symptom.

4) pH monitoring.

The most reliable pH monitoring is that of the blood. Litmus paper is used to determine the pH. The litmus paper should range from a pH range of 6-8. Prick the finger and a drop of blood can determine the pH. The plasma from the blood can be absorbed into the litmus paper or place the blood on the litmus paper and wipe off cellular elements. The normal pH is 7.4 or more. Any pH below 7.4 is acidic. During the withdrawal phase the pH will drop. During the five day withdrawal phase, for the first three days, the pH will drop below 7.4 usually to 7.0 or less. This will recover by the fifth day. The food testing should always start with a normal pH. If the pH has not normalized between test meals, then it is best to alkalinize the body, skip that meal and wait for another meal. This rarely occurs. Even if a food reaction occurs, it is classically true that the pH returns to normal by the next test meal. Saliva can be used. Place a drop of saliva on the pH paper. Do not place the pH paper on the tongue. After the one hour of the test meal in which the observation has been made for any symptoms and the pH of the saliva has been taken, then rinse the mouth thoroughly so that the next test meal saliva will be normal. The saliva will not necessarily read 7.4 but more likely will read around 7.0. Saliva pH is not significant until below a pH of 7.0. It is easy to test the blood since a drop of blood will be taken anyway for monitoring the blood sugar. The saliva pH, if it is being used, will at least indicate that there was a drop in pH from the starting point before the test meal to an hour after the test meal.

It is very important that pH be monitored. By monitoring the pH, my research project discovered that the common denominator between the various types or reasons for food reactions have one common denominator which is an evidence of acid reaction. Immunologists had assumed for many years that the common denominator was antibodies. Therefore, when known immunological mechanism was not isolated, they often dismissed as insignificant or even psychosomatic, symptoms that did not show antibodies. It has taken medicine a long time to reverse that error. Most symptom-producing food reactions are not immunologic and therefore cannot be logically termed

"allergy" since the term allergy has become synonymous with immunology. There are reactions that can be described as maladaptive because the symptoms are produced or some prefer the term "hypersensitive reactions" or "sensitivity reactions".

5) Blood sugar.

Blood sugar beyond normal occurring one hour after the test meat is fairly frequent and is characteristically there in more than one food. The blood sugar is tested before the test meal. This is achieved by a drop of blood and a monitoring instrument such as a diabetic uses for self-testing of blood sugar. Testing of blood sugar before and after each food test meal revealed that a diabetic disease process existed in food addiction.

There is an early stage of disordered carbohydrate metabolism that is sometimes called chemical diabetes. I prefer to call this the compensated stage of the diabetes mellitus disease process. During this time, there is no overnight fasting high blood sugar. However, there is a demonstrated carbohydrate metabolism disorder. Before the five day fast occurs, tills is usually manifested as hypoglycemia. The subject eats the food to which they are addicted and there is a hyperinsulin response which in turn drops the blood sugar down. The blood sugar will be below normal — normal being around 80 — at the 3 or 4 hour level. This in itself can be symptom-producing and is simply a manifestation of the withdrawal phase of food addiction. After the five days of fast, there is no hyperinsulin phase and therefore, no hypoglycemic phase. Instead, what the food testing shows is that the blood sugar will be beyond normal in one hour. Normal is 140, however, due to the literature we allow this to be 160. However, between 140-160 is suspicious because after we have the subjects on their rotation diet and they are stabilized, they never have a blood sugar one hour after meals any higher than 140. It is not uncommon to see blood sugars at the time of the symptom production at one hour of 200 or more. When testing a maturity onset diabetic, they will have their high blood sugar at whatever level which may be 200-300 or more an hour after the test meal. In the test meal, high blood sugar has no relationship to whether this was a meal of sugar or not. It can be a fat, a protein, a complex carbohydrate, a free carbohydrate — it doesn't matter. The high blood sugar happens because the subject has reacted

to that food. The cause of this is that when there is a symptom reaction to a food, there are many cells in the body that swell. When a cell is swollen, it is the acidity that causes the cell to swell. When cells swell, the insulin cannot do its job of carrying the blood sugar into the cell. The height of the blood sugar will be determined by how many cells are swollen. A non-insulin diabetic will not show a high blood sugar to a sugar unless they are reacting to the parent substance from which that sugar comes. They will react to non-sugar foods as well as a toxic reaction to a chemical. The reason why the blood sugar rises is that the cells are swollen and the sugar cannot be carried into the swollen cells by insulin. As soon as you reverse the state of acidity, the blood sugar normalizes because the cells can now receive sugar carried by insulin into the cell.

Diabetes, maturity-onset type II, is purely and simply the product of food reactions. There is the early stage that we call the compensated stage in which the blood sugar only temporarily will rise but it does not stay up overnight. In the decompensated stage, the blood sugar will stay up above normal overnight. So, this person has a fasting high blood sugar. In both the compensated and early decompensated stages, diabetes is very reversible by simply sorting out the foods that the person is symptomatically addicted to. In the late stage of the decompensated stage, the pancreas is in a state of fatigue and will not be producing adequate amounts of insulin. At that point, many physicians will resort to the use of insulin to maintain a normal blood sugar. However, it has been demonstrated that even in this late stage, if you sort the foods out that the person is reacting to, three-fourths of these will not need insulin and the ones who do will only use 1/3 as much as long as the foods are kept rotated. Therefore, it has been documented that the majority of maturity-onset diabetics are readily reversible by a program of a four day diversified rotation diet in which the foods are initially removed from the diet that produce the high blood sugar. These can be returned to the diet at three months without the high blood sugar reaction occurring and it will not occur unless these foods are eaten with a frequency greater than every fifth day.

The diabetic end-result of food addiction is very important because it doesn't matter whether this is a person with major mental symptoms due to their food reactions or gastrointestinal

reactions. It is all the same. The end result will be diabetes mellitus if the person lives long enough to have arrived at the decompensated stage of the diabetes mellitus disease process. Thus, the diabetes mellitus disease process is seen as the central disease process of food addiction with many symptoms in many different systems of the body along the way as a person moves toward that final stage of clinically significant diabetes mellitus. It is very important to understand this because if you manage this gastrointestinal reaction, whether it is minor or major, by simply reducing the inflammation by steroids or non-steroidal, anti-inflammatory agents, you simply continue on the process towards the final stage of diabetes mellitus. It is known that steroids will increase the chance of the development of diabetes mellitus. It is well known that the non-steroid, anti-inflammatory reactions have serious side effects such as interstitial cystitis, interstitial disorder of the kidneys, encouragement of gastric ulcers and so forth. The use of non-steroidal, anti-inflammatory substances or chemicals should be a last resort or even a most temporary measure while you are arranging for the more fundamental management with the goal of managing food reactions, essentially food addiction. Do not settle for this tight rope balance of a game of using steroids and non-steroid, anti-inflammatory substances, tranquhizers or antidepressants. Tranquilizers and antidepressants also are documented as increasing the development of diabetes mellitus. The most fundamental thing a person can do is sort out the foods and arrange for a rotation diet to prevent addiction. Never treat foods as some incidental potential reactor, but treat foods as central to the disease process whether this is mental or physical and this includes gastrointestinal reactions from minor to major.

6) Symptom reactions to chemicals beyond foods.

The survey of reactive substances needs to also include common environmental chemicals. Various types of petrochemical hydrocarbons are the most prevalent such as petrochemical hydrocarbon fuels and their combustion products, perfumes, food colorings, synthetic fabrics, resins, insecticides, formaldehyde and so forth. These can be tested by sniffing or by sublingual extract testing.

These chemicals inhibit oxidoreductase enzyme catalysis. The application of a negative (south-seeking) magnetic field placed bitemporally will characteristically relieve these symptom

reactions to an assortment of reactive substances within 5-10 minutes. A negative (south-seeking) magnetic field activates oxidoreductase enzyme catalysis and by this method detoxifies these chemicals. Avoidance of these symptom-evoking chemicals is a necessary part of environmental and toxi- cology therapy.

7) Test for antibodies.

I have gone through a series of thousands of patients testing for a wide spectrum of antibodies to infectious agents. What I discovered was that the central infectious agents that relate to degenerative diseases, whether these are mental or physical, are Epstein-Barr, cytomegalovirus and human herpes virus #6. One or more of these are frequently found. This has been determined to be an ongoing infection with a fluctuation of the antibodies relating to the exacerbation of the diseases. These viruses infect lymphocytes. They are called lymphotropic viruses and they infect B-lymphocytes that make antibodies. They disorder the immune system. They like neurons and nerves and infect both neurons in the brain and nerves. In our mental patients we discovered that the infections occur early in their life. It is quite possible that many of these are passed on through the mother who has the infection to the child and the child is born infected. It is also easy to pass this from one child to another or from an adult that is infected to a child. It is passed by saliva. It has been called the "kissing disease" since many college or high school students will pass this between themselves as they engage in kissing. If an adult gets this disease, it is called infectious mononucleosis. In its more smoldering stage, it is often called chronic fatigue syndrome. In our mental patients and learning disordered children, hyperactive children, attention-deficit children and so forth, they obtain this infection early in life which injures the brain so that it does not achieve its fully developed form. The brain doesn t mature until late adolescence. By this time, the brain has been injured. The symptoms the patient has relates to the area of the brain that has been injured. In a schizophrenic, the pre-frontal, frontal and even to the temporal areas are affected. Occasionally, it is even further back in the motor area and can produce seizures.

8) Infections.

Fungal infections should be examined for in the vagina. Stool contents should be examined for *Candida albicans* since

the altered immune system from the viral infection will allow the fungal infections to flourish. Fungal infections are easily treatable with negative (south-seeking) magnetic field therapy. Viral infections are readily treatable with a negative (south-seeking) magnetic field therapy.

9) Nutritional status.

The food rotation diet and magnetic therapy can never substitute for adequate nutrition. In my work, I assessed vitamins, minerals, amino acids and essential fats. This is not possible under some circumstances where there is not research. Supplementation of vitamins, minerals and essential fats should be encouraged. There are selective amino acids that should be supplemented if they are demonstrated to be deficient, but that are quite useful, such as cysteine and taurine.

It is no wonder that we have a discrepancy as to the significance of foods since these researchers have not followed a standard program. Particularly, most of them did not go through the five day avoidance period to start making their determinations. You cannot rely on the patient s history of what they think they reacted to or even on testing that has been done without having gone through the initial five day avoidance period. This is why there is a discrepancy in the reports. There is no discrepancy in those that have followed the proper rules to make such a determination. Food reactions are the central cause of gastrointestinal disorders. It is a disservice to the patient to ignore this. Most important of all is that if food reactions are ignored as the central cause of gastrointestinal disorders, you end up unnecessarily with clinically significant diabetes mellitus. Many physicians are responsible for producing clinically significant diabetes mellitus by ignoring maladaptive food reactions and proceeding with long term use of steroids, non-steroidal anti-inflammatory substances, tranquilizers and antidepressants. Some have voiced the concern that if their patients start eliminating foods to which they are reacting, they are going to end up with such a narrow spectrum of foods that they will be malnourished. Of course, adequate nutrition is extremely important. However, the rotation diet does not eliminate the foods that are causing the symptoms. It only eliminates them long enough (6-12 weeks) so that the addictive reaction is completely reversed. Then these foods are placed back in the diet. Actually, the person ends up

understanding foods and food values and enjoying their foods. They have a broad spectrum of foods. Much broader than they would have if they were not rotating their foods. Therefore, they are much better nourished. Only infrequently are there genetic errors to which the person cannot return to certain foods such as celiac intestinal reactions caused by gluten enteropathy. They should not return to the use of gluten foods (wheat, rye, oats and barley). However, these grains can be sprouted making a very nutritious food. There is no gluten present when the grains have been sprouted. Therefore, a celiac case can eat these cereal grains, only they have to eat them sprouted. In cases of homocystinuria, first of all, the nutritional survey will rule out whether this is due to a B_{12} or folic acid deficiency. If it is, supplementing these will handle the homocysteneria. In a small number of cases, there is a genetic homocysteneria. Methionine does not have to be used as a food. The need for methionine to produce cysteine and taurine can be bypassed by supplementing cysteine and taurine and not using methionine. There has been a misunderstanding on the part of some gastroenterologists about what a 4-Day Diversified Rotation Diet was all about and the fear they have expressed that somehow their patient would become malnourished is completely unfounded. In fact, beyond that of providing a highly nutritious rotation diet, it is also recommended that supplementation of essential vitamins, minerals, amino acids and fats be supplemented even beyond the specific laboratory demonstratable special needs that subject may have in terms of nutrition.

The Gut-Brain Axis

Statistically reported schizophrenics have, percentage-wise, more gut symptoms than brain symptoms. My research observations confirm this. Autistic children have the same gut-brain axis symptoms as a schizophrenic. My research observations confirm this. What is the most likely causes of these gut-brain symptom relationships?

Maladaptive reactions to foods are the major cause of these gut-brain symptoms with symptom reactions to environmental chemicals present to a much lesser degree. Maladaptive reactions can occur to any frequently contacted substance, whether ingested, inhaled or topical. The big question is why do these symptom reactions select specific tissues for their

manifestation? What common denominator between brain and gut could be responsible for this gut-brain relationship?

My research isolated evidence of a lymphotropic virus infection (Epstein-Barr, cytomegalovirus and human herpes virus #6) in major mental patients (schizophrenia, manic-depressive) as well as lesser brain disorders (hyperkinesis, attention-deficit, dyslexia, autism). These lymphotropic virus infections initially are diagnosed as infectious mononucleosis. This occurs in adults who have not had the infection before. Mental, learning disordered and also behavioral disordered subjects have this viral infection starting either at gestation having received this from the mother, or at least, early in the childhood. These infections produce a smoldering encephalitis in the brain and a smoldering infection in the lymph tissue surrounding the gut. The brain infection interferes with brain development, particularly in the pre-frontal, frontal and temporal areas.

It is characteristic that these lymphotropic viruses and in-general viruses, do not die after the initial infection but instead hide from oxygen which they cannot tolerate and from the immune system defenses. The tissues they hide in are neurons and lymph node tissue. Thus, the brain neurons are chronically infected and the lymph tissues surrounding the gut are also infected. The gut is lined with lymph nodes. Thus, in my research I isolated the common denominator of gut-brain symptom reactions to be due to Epstein-Barr, cytomegalovirus and human herpes #6.

These viruses injure the brain and the gut and cause these areas to be the selected tissues in maladaptive reactions to foods, chemicals and inhalants. Any tissue that is injured for any reason can also be selected as the tissues that respond to maladaptive reactions to foods, chemicals and inhalants. Certain it is also that other types of viruses can be involved. The measles virus is a good candidate and has often been observed as being present. The herpes and measles viruses are also known for their infection of nerves, beyond neurons and lymph node tissue. In fact, the nerves supplying the bowel have been noted as virally infected.

An effective treatment must have the following qualities:

1) Stop the immediate precipitation of symptoms by avoiding the substances that evoke these symptoms or spacing

the contact, that is, infrequent exposure, so that the symptoms are not produced.

2) Reverse the inflammatory reactions of the gut and the brain.

3) Kill the viruses.

4) Repair the tissues.

A negative (south-seeking) magnetic field is more anti-inflammatory than steroids and has no injurious side effects. A negative (south-seeking) magnetic field can and should replace the use of steroids to reverse inflammation. A negative (south-seeking) magnetic field regulates the immune responses and is more effective than immunosuppressant drugs in the management of adverse immunologic, inflammatory responses. A negative (south-seeking) magnetic field is an effective antibiotic for viruses, bacterial, fungi as well as parasites.

Certain it is that the gastroenterologists and psychiatrists should be experts in examining for and treating food addictions and toxic reactions.

Medications that calm down the inflammatory reaction of the gut and brain is not adequate treatment. We must also kill the microorganisms producing or associated with the inflammatory reaction. A negative (south-seeking) magnetic field achieves this goal. We must reverse the free radicals, peroxides, acids, alcohols and aldehydes that are part and parcel of the inflammatory reaction. A negative (south-seeking) magnetic field reverses these inflammatory substances through activation of the oxidoreductase enzymes catalysis. We must alkalinize the affected area. A negative (south-seeking) magnetic field alkalinizes the area through magnetic activation of the bicarbonates.

Magnetic Placement for Specific Conditions of the Gastrointestinal Tract

Orientation

This treatise is selectively specific for gastrointestinal disorders. Gastrointestinal disorders encompass the entire elementary system from the lips to the anus. Symptoms of the gastrointestinal tract are frequently manifestations of a systemic disease. The appropriate treatment for the systemic disease including magnetic therapy should be instituted -- not just local magnetic treatment.

Viral, bacterial, fungal and parasitic infections can occur selectively in any segment of the gastrointestinal system. These microorganisms and infections can be adequately eradicated with a negative (south-seeking) magnetic field of sufficient gauss strength and adequate duration. A negative (south-seeking) magnetic field can kill these infectious agents. The gauss strength needs to be a minimum of 25 gauss at the site of the infection. The higher the gauss strength, the better. Duration needs to be continuous, or near so, for a minimum of two weeks. The longer, the better. There needs to be time for tissue healing-repair after the infection has been eradicated. This could require 2-4 or more weeks after the infection is killed. This healing-repair can be achieved by magnetic treatment to the local area while sleeping at night.

Cancer of the gastrointestinal tract is dealt with in a separate section of this writing. The duration of treating cancer is different than microorganisms. Cancer requires three months of continuous or near-continuous magnetic treatment. The cancer may have died in four weeks, but we never rely on four weeks of treatment. Tissue healing-repair and reabsorption of the dead tumor may require several months. Usually at three months, the tumor will be about half its original size. If the tumor is a skin surface lesion, such as a melanoma, it will fall off by the end of three months. New skin will have grown under the tumor. It may take several more weeks of nightly treatment for the area where the tumor was to fill in. There will be no scar where the tumor was.

Cuts, infections or blisters on the lips should be treated immediately to prevent scarring. Scars develop because there is not sufficient oxygen present during the healing process. A negative (south-seeking) magnetic field alkalinizes and oxygenates the area which prevents scar formation during healing. Scars already formed will soften up and characteristically disappear with prolonged treatment. Also, a negative (south-seeking) magnetic field is mildly vasoconstricting, reducing bleeding potential. The negative (south-seeking) magnetic field using magnets that are treating the lips are neodymium discs such as 1, x 1/8 discs, ceramic mini-blocks that are 1-7/8 x 7/8 x 3/8 or plastiform magnets that are 1 x 1/8" and whatever length is needed. When using the plastiform magnets cover the negative (south-seeking) magnetic pole side

with HY tape since plastiform magnets contain lead. The size of the magnet should be larger than the lesion being treated. The 1" x 1/8" neodymium disc is ideal. Tape the magnet over the lip lesion with HY tape. HY tape is skin colored, hypoallergenic and will not loosen up by the skin sweating.

In terms of treating infection, the duration needs to be continuous for two weeks and then could be at night for healing. More than two weeks may be needed for healing. Scars that are already formed could be treated at night. It would take several weeks or months for the scar to disappear.

Herpes simplex I viral infection of the lips require special attention since the entire nerve from the neuron nerve trunk and local blister is infected. Treat the local blister with a 1" x 1/8" neodymium disc or suitable size plastiform magnet taped to the lip plus a 5" x 12" double magnet, multi-magnet flexible mat across the side of the face and cervical spine. Hold the flexible magnet in place with a 2" x 26" or 4" x 31" body wrap.

Infections of the mouth in general, gums and teeth can be treated with a negative (south-seeking) magnetic field. Teeth and gums can be treated with a 1" x 1/8" neodymium disc, mini-block magnets that are 1-7/8" x 7/8" x 3/8" or a suitable 1/8" thick plastiform magnet. Tape these over the affected area. It is well to place another neodymium disc on top of the one that is taped down or do the same with the plastiform magnet. The purpose of this is to increase the depth of magnetic gauss penetration. The stronger the magnetic field, the more effective the treatment. Two 3" x 3" x 1/8" or two 2" x 2" x 1/8" plastiform magnets can be taped on the side of the face. At night during sleep, place on top of the magnets that are already on the face, a 4" x 6" x 1/2" ceramic block magnet on the side of the face.

Esophagus

Treatment of the upper esophagus may be achieved with a 4" x 6" x 1/2" magnet on the side of the face and neck. A 5" x 6" double magnet, multi-magnet flexible mat is suited for upper esophagus lesions. Even better is to add to this flexible mat, one or more 3" x 6" x 1/8" or 4" x 6" x 1/8" thick plastiform magnets. These can be bent sufficiently to fit the curve of the neck. It is well to place these in the shape that you need them and then put duct tape on both negative and positive pole sides to hold the magnet bent in place. Hold these in place with a 4" x 31" body wrap. When treating the neck, it is necessary to put

one of the rows of the magnets that are in the mat up under the chin so as not to have the positive (north-seeking) magnetic pole from the magnets that are on the neck radiating a positive (north-seeking) magnetic field into the mouth. The esophageal area below the neck and under the sternum can be best treated with a 4″ x 6″ x 1/2″ magnet. If a hiatal hernia is present, it would be best to use a 4″ x 12″ x 1/8″ plastiform magnet placed from the top down the sternum across the stomach. A second one can be placed on top of this to provide a depth of penetration or place the 4″ x 6″ x 1/2" magnet at the top if the esophagus under the sternum is involved or down over the hiatal area if a hiatal hernia or infection of the hiatal area is involved.

Stomach
Gastritis or gastric ulcer can be treated with a 4″ x 6″ x 1/2″ magnet placed crosswise across the stomach area. Two weeks continuous treatment for gastric ulcer. Remove magnet for one hour, post-meal.

Duodenum
Duodenal ulcer or duodenitis can be treated with a 4″ x 6″ x 1/2" magnet directly over the duodenal area. Even better for either the stomach or duodena is to place a 5″ x 12″ double magnet, multi-magnet flexible mat across the stomach and duodenum and place on top of this a 4″ x 6″ x 1/2″ magnet. Hold this in place with a 4″ x 52″ body wrap or a non-stretchable garment that has pockets in it. The garment supports the weight from the shoulders and makes it easy for the magnet to be removed since this needs to be removed during and for at least an hour after the completion of the meal.

Small Intestine
The small intestine is treated with a 5″ x 12″ double magnet, multi-magnet flexible mat length-wise the small intestine with a 4″ x 6″ x 1/2" magnet directly over the most affected area.

Large Intestine
The large intestine is treated the same way as the small intestine. Place a 5″ x 12″ double magnet, multi-magnet flexible mat across the affected area with a 4″ x 6″ x 1/2" magnet on top of the flexible mat.

When treating any of the intestinal tract it has to be kept in mind that while the intestinal tract is in the magnetic field, it is virtually silent in terms of peristaltic movement. Therefore, the magnets need to be removed for at least one hour after the

meal is completed or up to an hour and one-half after the completion of the meal.

Diverticulitis

This is an acute state of small abscesses making pouching diverticuli sacks in the colon. This is magnetically treated as an acute infection using the negative (south-seeking) magnetic field continuously, or near so, for a minimum of two weeks. After this initial two weeks, there should follow a nightly magnetic treatment for another two weeks. The infection is usually in the descending colon. Wherever the infection is in the colon, it should be treated with a negative magnetic field. The most fundamental magnet to use is a 4 x 6 x 1/2" magnet. It works best to place a 5 x 12 double magnet, multi-magnet flexible mat crosswise the abdomen-pubic area and a second one further up on the abdomen adjacent to the first mat. Place a 4 x 6 x 1/2" ceramic magnet crosswise and on top of the mat. A second 4 x 6 x 1/2 magnet is also placed crosswise the second flexible mat. These are to be placed directly over the area of the colon which is sore.

Hold these in place with 4" x 52" body wraps or a garment with pockets in it to hold the mag- nets. Thus, the weight can be supported from the shoulders. If body wraps are used, then use suspenders to hold these in place.

Diverticulosis

Diverticulosis is a chronic state of infected diverticuli. Diverticulosis is treated the same as diverticulitis but continues as a lifestyle. Use a negative magnetic field abdominal treatment. Sleeping on a negative poled magnetic mattress pad can also be useful.

Low colon

The low colon and rectal area should have the 5" x 12" mat placed crosswise the body on the low abdomen-pubic area with a 4 x 6 x 1/2" magnet placed lengthwise the body directly over the affected area.

Colon polyps

Polyps characteristically occur in the low colon or colorectal area. These are caused by viral infections of the mucous membrane comparable to viral infections of the skin causing moles. These should be surgically removed, usually by a wire snare, and examined for possible cancer. After the removal of the polyp, the magnetic treatment should be the same as for

cancer whether or not the polyps are cancerous. The chances that the remaining base of the polyp will become cancerous is too high to risk. Magnetic treatment must proceed so as to kill the viruses producing the polyps or to treat the cancer if already present. Use the double magnet, multi-magnet flexible mats plus the 4 x 6 x 1/2" ceramic magnets as described for diverticulitis. Extend the continuous or near continuous treatment for three months. For colorectal polyps, add a magnetic super seat composed of three 4 x6 x 1 ceramic block magnets placed 3/4 apart in a wooden carrier. Place a thin pillow over this when sitting down. The more hours of exposure to this strong magnetic field, the better.

Colorectal area

Treat the colorectal area the same as the low colon but also use a 4 x 6 x 1/2 magnet across the rectal area. It is best to have a garment of non-stretchable material that is supported from the shoulders with a pocket in it. This could be moved aside or pulled up when sitting down. When standing, it can drape down across the rectal area. When sitting down, sit on a special wooden magnetic carrier made with three of the 4" x 6 x 1 magnets placed 3/4" apart. Place a suitable pillow on top of this. This is a strong magnetic field that will radiate into the rectal area and low colon. At night during sleep, have the magnets on the front of the body on the low colon and also arrange to hold a 4 x 6 x 1/2" magnet over the rectal area. In case of infection, treatment needs to be for a minimum of two weeks. Cancer is dealt with in another section of this presentation.

Constipation and its complications

Constipation represents a spectrum of disorders ranging from a minor disorder such as hard stool or straining at the stool, increasing all the way to serious conditions such as a megacolon and valvulitis which can become a surgical condition.

Damage to the nerves that supply the colon (enteric) nerves or the nerves from the sacral area that supply the muscles of the floor of the pelvis have been documented as a frequent cause of chronic constipation. This nerve damage can have several sources such as exogenous toxin from bacteria, viruses, or heavy metal toxicity (lead, mercury, arsenic). Viral infections of the enteric nerves is often involved. The most potentially

likely viruses are the lymphotrophic herpes viruses (Epstein-Barr, cytomegalovirus and human herpes virus #6) and the measles virus.

The goal of this treatise is to add to the known values and limitations, the values that environmental medicine-toxicology and magnetic therapy can add.

Fluid intake should include 8-12 glasses of water a day. Electrolysis-produced alkaline micro water is the most optimum water. Avoid carbonated soft drinks for their acid production and especially avoid those that contain caffeine. Do not drink coffee or teas containing caffeine, thinking that they will supply adequate fluid. The four day diversified rotation diet or the selective four day diversified rotation diet is recommended and in fact, a necessary component of management of chronic constipation. In this rotation diet, vegetables and fruit should be eaten.

Vitamin C and its ascorbates of magnesium, calcium, potassium and sodium should be used as a stool softener. Beyond the optimum supplementation levels of magnesium, potassium, and calcium use sodium ascorbate in quantities sufficient to produce and maintain a soft stool. This will vary considerably for each person from 6-20 or more grams of ascorbates daily. This system of a soft stool by providing more ascorbates than can be absorbed is much preferred over chronic laxative use. Constipation, other than the more severe states such as megacolon, impaction or valvulitis can be relieved by an ascorbate flush. An ascorbate flush consists of 1-2 teaspoons of sodium ascorbate in a glass of water each 15 minutes until a diarrhea flush occurs. After the ascorbate flush, then experimentally determine the amount of ascorbate that will provide a soft stool and thus reduce the hard stool constipation condition.

Magnetic Treatment for Constipation and its Complications

Sleeping with a 5" x 12" double magnet, multi-magnet flexible mat on the low abdomen-pelvic area plus a 4" x 6" x 1/2" ceramic magnet centered on this pad and placed lengthwise the body is adequate to satisfy minor uncomplicated constipation cases. The negative (south-seek-ing) magnetic field will pull the fecal matter with its associated water content

into the low colon-rectal area. This provides for a normal stool evacuation reflex upon awakening in the morning.

Sleeping with a 5 x 12 double magnet, multi-magnet flexible mat across the low abdomen-pubic area with another one higher up on the abdomen and adjacent to this magnetic pad can provide treatment of the entire abdomen. In order to provide for a greater depth of penetration, place a 4 x 12" x 1/8" plastiform magnet on top of each mat. If need be, two or more of these plastiform magnets can be stacked on top of the mat in order to provide a depth sufficient to relieve any pain and sufficient to treat viral infections. The minimum would be a magnetic flexible pad with a 4 x 12 x 1/8 flexible plastiform magnet on top of this. In more serious cases, place two of these magnets stacked together on top of the pad. Sometimes, a 4 x 6 x 1/2" magnet is needed on top of the magnets in order to have a depth of penetration and sufficient gauss strength to relieve the pain. After the pain is relieved, then the larger 4 x 6 x 1/2 magnet can be removed. When sleeping all night with these pads on the abdomen, remove the magnets on the upper part of the abdomen for the last three hours of the night. By doing so, this will allow fecal matter and fluid with the fecal matter to be pulled into the low colon providing for an evacuation reflex upon awakening in the morning.

Hemorrhoidal Disease

Approximately ten million Americans have hemorrhoidal disease. Increased pressure in the anal sphincter is the central cause of hemorrhoidal disease. Conditions increasing anal sphincter pressure are such as a sedative occupation, obesity and diarrhea. The common complaint of hemorrhoidal disease are such as bleeding, prolapse and thrombosis of hemorrhoidal veins. A chronic irritation of the squamous cell and mucosal cells can lead to cellular degeneration and in a few cases, to cancer of the rectal tissues. The cause of the diarrhea should be assessed and treated. The cause of diarrhea also includes an examination of food addiction and food sensitivity reactions. Weight reduction should proceed in obese individuals. Again, this weight reduction involves the examination of food addiction with its management by a rotation diet which must be also associated with a reduction in calorie intake and increased exercise. Exercise can, in its own right, reduce anal sphincter hypertension.

Magnetic therapy for anal sphincter disease consists of sitting on a negative (south-seeking) pole magnetic chair pad. The magnetic chair cushion has mini-block magnets that are 1-7/8 x 7/8 x 3/8 placed an inch and one-half apart throughout the seat as well as the back of this chair pad. A further value can be achieved by placing a 4 x 6 x 1/2" ceramic block magnet under the chair seat, directly under the rectal area. Always use a negative (south-seeking) magnetic field facing the person. The negative (south-seeking) magnetic field is mildly vasoconstricting and has been observed to be sufficient to stop hemorrhoidal bleeding. At the same time that the negative (south-seeking) magnetic field is vasoconstricting, it is also alkalinizing and oxygenating. The alkalinization occurs because a negative (south-seeking) magnetic field attaches to the bicarbonates in the blood, making them more active and thus, alkalinizing the area. The extra oxygen is supplied by an enzymatic action of oxidoreductase enzymes on free radicals, peroxides, acids, alcohols and aldehydes thus releasing oxygen from its bound state in these products. Thus, alkaline-hyperoxia is produced. This is necessary for any healing to occur.

Further value can be achieved by proceeding with the general magnetic health measures as has been outlined such as sleeping on a magnetic bed pad.

Cancer

All inflammatory areas, no matter how produced, such as food symptom reaction areas, chemical reaction areas and microorganism infected areas are predisposed to cancer development. The reason for this is the common denominator of acid-hypoxia. Acid-hypoxia is the medium in which cancer can thrive by producing ATP by transferase enzyme catalysis during fermentation.

The principle of treating cancer is to stop the acidifying maladaptive reaction to foods, chemicals and infections. The most optimum part of the treatment is to maintain alkaline-hyperoxia, replacing acid-hypoxia locally, involving the entire cancer and adjacent tissues. A magnet of sufficient size, depth and gauss strength needs to be used. The magnetic field should be a minimum of 25 gauss. The higher the gauss strength, the more effective the treatment. The magnetic field must be all negative (south-seeking) . The duration needs to be as near to 24 hours a day as possible and extended for a minimum period

of three months. Peristalsis is relatively silent when exposed to a negative (south-seeking) magnetic field sufficiently strong enough to treat cancer. For this reason of reduced peristalsis, the magnet should be removed for an hour and one-half, post-meal, when the stomach, duodenum, small intestine, upper large intestine, gall bladder, liver or pancreatic area is being treated.

Mouth Cancer will encompass the entire mouth. This needs to be held up against either side of the face that will include the mouth in the field. It needs to be kept in place as near to 24 hours a day as possible. It could be removed while eating. A suitable way to hold this in place is to use a sports cap fastening this to the bill of the cap and letting it drape over the side of the face. It would be well to hold it snug up against the side of the face with a band around the head and under the chin.

Esophagus Cancer

A 4 x 6 x 1/2" magnet held on either side of the neck so as to involve the esophageal lesion if it is high in the neck, would be suitable. Again, this can be held on the visor of a sports cap or a soft-brimmed sports hat. Hold this firmly up against the side of the neck. If the esophageal lesion is lower than the neck, then treat from the front of the sternum. This can be held in place with a 4 x 52 body wrap or a pocket in a garment that supports the weight from the shoulders. A 4 x 6 x 1/2" magnet is most suitable for this.

Stomach Cancer

A 4 x 6 x 1/2" magnet is placed directly over the lesion and held in place with a pocket in a garment that is supported from the shoulders or a 4 x 52 body wrap. It should be removed during meals since this will allow the stomach to make its normal acid. Also remove the magnet for one hour, post-meal, for emptying of the stomach into the duodenum.

Duodenal Cancer

Place a 4 x 6 x 1/2" magnet directly over the duodenal area which is just to the right side of the stomach. It would be best to remove this for an hour and one-half after meals. It can be held in place with a 4 x 52" body wrap or a pocket in a garment that supports the weight from the shoulders.

Gallbladder Cancer

The gallbladder can be treated which is slightly below the duodenum on the right side of the abdomen using the 4 x 6 x 1/2" magnet held in place with a 4 x 52 body wrap that has

shoulder straps on it or a pocket in a garment that holds it in place.

Pancreatic Cancer

Use a 4" x 6" x 1/2" magnet directly over the pancreas. It is wise to use a 5" x 12" double magnet, multi-magnet flexible mat across the pancreatic/gallbladder area and then place a 4 x 6 x 1/2" magnet on top of this.

Liver Cancer

Place a 5" x 12" double magnet, multi-magnet flexible mat across the front and right side, directly over the liver. Place a 4 x 6 x 1/2" magnet either on the front of the abdomen over the liver or on the side of the abdomen. It would be well to rotate these. This can, again, be held in place with a 4" x 52" body wrap or a garment that has a pocket in it that supports the weight from the shoulders.

Small Intestine Cancer

Place a 5" x 12" double magnet, multi-magnet flexible mat lengthwise the body on the right side of the abdomen, directly over the small intestine. Place a 4 x 6 x 1/2" magnet directly over the area of the small intestine that is affected. Hold this in place with two of the 4" x 52" body wraps with shoulder straps or a garment that has a pocket in it that supports the weight from the shoulders.

Colon Cancer

The magnetic field must be directly over the colon. It may require two 4 x 6 x 1/2" magnets placed adjacent to each other. To do this, it would be preferred to use a 5" x 12" double magnet, multi-magnet flexible mat first, directly over the lesion with one or two of the 4 x 6 x 1/2" magnets directly over the area on top of this mat. It would be well to have a garment with pockets in it that would support the weight from the shoulders. Otherwise, two of the 4" x 52" body wraps can be used. Suspenders or otherwise, shoulder straps need to be attached to these wraps to hold them in place.

Colorectal Cancer

This would require a 5" x 12" double magnet, multi-magnet flexible mat directly over the area with a 4 x 6 x 1/2" magnet on top of this. When sitting down, sit on a special wooden carrier that holds three of the 4 x 6 x 1" magnets 3/4 of an inch apart. Sit on this to radiate directly into the rectal and low colon areas. The more hours of sitting down on this, the better.

Rectal Cancer

When sitting down, sit on the special wooden carrier that has three of the 4„ x 6„ x 1;" magnets an inch apart. When standing, have a 4 x 6 x 1 magnet draped over the rectal area. This can be held in place with a 4 x 52 body wrap with a pocket containing the magnet attached to this body wrap. A terry-cloth pot holder is the ideal size to hold this 4 x 6 x 1/2 magnet.

Magnetic Protocol for Gastrointestinal Diseases
Orientation

This program presumes that the person has already been through the assessment of food testing under medical supervision and has set up a selective four day rotation diet or a four day diversified rotation diet under medical supervision. The alternative is self-help rotation diet using either the selective four day rotation diet or the strict four day diversified rotation diet. The irritable bowel syndrome, celiac disease, Crohn s disease and ulcerative colitis are all viewed as a systemic acid-hypoxia reaction with multiple system symptoms evoked by maladaptive reactions to foods in which the gastrointestinal symptoms are the most prominent. The orientation is that the systemic acid-hypoxia central to the generalized degenerative disease process is being treated. Food addiction is accepted as the cause with either the compensated or decompensated stages of diabetes mellitus disease process being present. The only exception to this is that celiac disease is a genetic disorder evoking inflammatory symptoms in the small intestine. Even in celiac disease, other symptoms are also present in other systems in response to this genetic disorder to gluten.

It is necessary to understand the gastrointestinal reactions are only one manifestation of the systemic, reactive condition. The intestinal tract is selected for some reason that has altered the metabolic function of that area. Other areas of the body will also be involved and should be assessed. The skin is often involved and the treatment needs to be systemic but also local. Wherever there is a lesion, the local lesion should be treated whether it is the gastrointestinal tract, the skin, or an organ of the body and at the same time, the treatment should be systemic such as sleeping on a magnetic bed pad being a good idea and sleeping with magnets over the eyes with these magnets

attached to a light shield and sleeping with magnets in a carrier up against the headboard. The more magnetic treatment, the better. It should be understood that treating at right angles is quite acceptable. Treating with a negative (south-seeking) magnetic field of the same strength on each side of the body is not preferred because there will be a blank, area where the magnetic fields join. However, if the field on one side of the body is much stronger than the field on the other side of the body, it will push against the weaker magnetic field and treat the body successfully. This is true such as when sleeping on a magnetic bed that will have a low gauss strength compared to the strong gauss strength of a 4 x 6 x 1/2 magnet placed on the body. So, sleeping on a magnetic bed pad with magnets on the abdomen on the opposite side of the body is not a concern because the stronger magnetic field will still reach into the body adequately. It is very important to treat the eyes and the brain, since the retina of the eyes and the pineal gland in the brain make melatonin. It is also true that the wall of the intestinal tract makes melatonin. The higher the melatonin is, the greater defense against inflammation, infection and cancer.

In terms of treating viruses, it would take several weeks to adequately treat for these viral, bacterial, fungal and parasitic infections. A negative (south-seeking) magnetic field will kill viruses, bacteria, fungi and all types of parasites. It is recommended that this treatment proceed continuously, nightly for one to two months. It is well to have a lifestyle of treating the low abdomen-pubic area regularly at night. Treating the abdomen as has been described above, has these established values:

1) Processing exogenous and endogenous toxins,

2) Magnetic killing of infecting agents such as viruses, bacteria, fungi and parasites,

3) Healing of diabetic neuropathy of the enteric nerves. The treatment of diabetes must also include the systemic treatment of diabetes described elsewhere in this treaties,

4) Reversal and healing of atheromatous plaques in the blood vessels supplying enteric nerves. A negative (south-seeking) magnetic field is known to resolve atheromatous plaques,

5) Reversal of free radicals and free radical end-product damage. A negative (south-seeking) magnetic field is a free

radical scavenger and also, will through enzymatic actions, resolve the damaging end-products of free radicals.

Magnetic Therapy

Magnets used:
- Two 5" x 12" double magnet, multi-magnet flexible mats
- One 5" x 6" double magnet, multi-magnet flexible mat
- Two 4" x 12" x 1/8" plastiform magnets
- Two 1-1/2" x 1/2" ceramic disc magnets
- One eye unit consisting of a light shield with two 1" x 1/8" ceramic disc magnets over each eye
- Two 4" x 6" x 1/2" ceramic block magnets with Velcro on the positive pole sides
- Two 4" x 52" body wraps
- One 2" x 26" band
- One 4" x 31" band
- A magnetic mattress pad composed of mini-block magnets that are 1-7/8" x 7/8" x 3/8" placed an inch and one-half apart throughout the bed pad
- Headboard type sleep enhancer (composed of four 4" x 6" x 1" magnets in a row, 3/4" apart in a wooden carrier that holds them up against the headboard)
- One magnetic chair pad (composed of mini-block magnets that are 1-7/8" x 7/8" x 3/8". These are placed an inch and one-half apart throughout the seat and back of this magnetic chair pad)

Non-Magnetic Products:

Alkaline micro water. The Singer Electrolysis Instrument for the production of alkaline micro water.

Colloidal silver: Four 16 oz bottles of 40 parts per million colloidal silver. For Additional Value: Infrared sauna home unit.

Placement and Duration

During the five day withdrawal phase before food testing begins or before the rotation diet is instituted, magnets can be used to reduce symptoms. The ceramic disc magnets can be placed bitemporally, that is in front of and at the level of the top of the ears. These are held in place with a 2" x 26" band. An alternative is to use two neodymium discs on both temporal areas with one disc inside the band and one on the outside of the band directly over the disc inside the band. This will magnetically hold the disc in place. These can relieve head symptoms and also can be used without head symptoms when

there are other areas of the body with symptoms. Any area of the body can produce symptoms. Treating the brain will help relieve the local symptom. The local symptoms should be treated with a 4 x 6 x 1/2" magnet with the negative (south-seeking) pole held directly over this area until the symptoms leave. The symptoms will usually be relieved within ten minutes but occasionally require thirty minutes.

Specific Magnetic Treatment For Inflammatory Bowel Diseases

Inflammatory bowel diseases include celiac disease, Crohn's disease and ulcerative colitis. Celiac disease is specific for the small intestine and is known to be a genetic inflammatory reaction to gluten. Wheat, rye, oats, barley and mature corn contain gluten. The treatment involves avoidance of gluten foods. A negative (south-seeking) magnetic field reverses the inflammatory reaction and heals the mucous membrane of the small intestine. The magnetic treatment for celiac disease is the same as for Crohn's disease and ulcerative colitis. Crohn's disease and ulcerative colitis are also due to maladaptive reactions to foods but not to a genetically determined food such as in celiac disease. These inflammatory reactions occasionally are immunologic (IgG) with the majority being non-immunologic addictions to frequently used foods. The foods involved in the inflammatory bowel disease needs to be determined by single food test meals after a five day fast on water only or from any food used two times a week or more. A food fast on watermelon only is ideal. Magnetic therapy is involved from the beginning of the treatment including the fasting period.

At the beginning of the fast, use the following placement of magnets:

Place a 5" x 12" double magnet, multi-magnet flexible mat across the low abdomen-pubic area with a 4" x 6 x 1/2" magnet placed crosswise the mat over the sore area. Place another 5 x 12 flexible mat higher up on the abdomen but adjacent to the mat on the lower abdomen.

Place another 4 x 6 x 1/2" magnet crosswise over the flexible mat over the sore area. Remove these magnets for one and one-half hours, three times a day. If watermelon or other infrequently used foods are used during this fast, then leave the magnets off the abdomen for one and one-half hours after eating. The reason for leaving the magnets off the abdomen for

a period of time is to allow for peristaltic movement to occur since peristalsis is virtually silent while the abdomen is covered with the negative (south-seeking) magnetic field. If severe pain occurs during the period while the magnets are off of the abdomen, then replace the magnets over the painful area to relieve the pain.

The pain is usually relieved within 5-10 minutes. Hold these in place with 4 x 52 body wraps. It would be necessary to have shoulder straps or suspenders to hold these in place. Even better is to have a non-stretchable garment that is supported from the shoulders with pockets in it so the weight is supported from the shoulders. The magnets are held firmly up against the abdomen, but not held in place by pressure. Also, during this withdrawal phase, place ceramic disc magnets that are 1-1/2" x 1/2" or use the neodymium disc magnets that are 1 x 1/8" on each temporal area (bitemporally) with one on the inside and one on the outside of the band. Hold these in place with a 2 x 26 band. The pain of food addictive withdrawal can further be relieved by a 4 x 6 x 1/2, magnets placed on the sternum and epigastric area. This 4 x 6 x 1/2" magnet is placed lengthwise on the sternum and on the epigastric area, it is placed crosswise. Hold these in place with a 4 x 52 body wrap or preferably a garment that has pockets in it that holds the weight from the shoulders. Treat any painful areas occurring during the withdrawal phase with a 4 x 6 x 1/2" magnet. The duration of exposing the magnets to the head, sternum, epigastric or painful areas can be for the duration needed to relieve the discomfort. The longer, the better.

The five day food addictive withdrawal phase is acidifying. Acidification produces an oxygen deficit state. Thus, acid-hypoxia is present during the first three to four days of the withdrawal phase and characteristically clears by the fifth day. A negative (south-seeking) magnetic field produces a biological response of alkaline-hyperoxia and thus relieves the acid-hypoxia. One teaspoon of sodium bicarbonate, three times a day, can aid in relieving the food addictive withdrawal symptoms.

After the five days of avoiding food, testing can proceed using meals of single foods or proceed with a 4-Day Diversified Rotation Diet leaving out the person s frequently used foods for three months before returning these foods to the 4-Day

Diversified Rotation Diet. The details of the 4-Day Diversified Rotation Diet and also how to do food testing is described in more detail else-where.

Essential magnetic treatment after the withdrawal phase or after the food testing is to treat at night during sleep and also periodically as needed to relieve pain.

However, since infections are imposed on the inflammatory bowel disease food reactions, it is best to eat infrequent foods for a period of two weeks after the five day fast period while continuing to treat the abdomen. Treat the upper and lower areas of the abdomen continuously except for the hour and one-half post-meal. If treating for infection, then postpone food testing until after the two weeks of infectious period treatment is completed. Start the food rotation diet after the five day rotation using only single, infrequently used foods. Food testing cannot proceed as long as the magnets are being used nearly continuously to treat the infections.

The Role of Infection in Inflammatory Bowel Diseases

There are known infections that cause an irritable bowel disease reaction. It is anticipated that these known colon infections will be treated with antibiotics known to be specific for these infections. However, it should be understood that a negative (south-seeking) magnetic field is an antibiotic and can replace the established antibiotic treatment for these known microorganisms. Two weeks minimum magnetic therapy, as near continuous treatment as possible, is necessary for the magnetic antibiotic value. Longer than two weeks is valuable and necessary for healing-repair.

Inflammatory bowel diseases have superimposed bacterial and fungal infections due to the impaired intestinal mucous membrane. Magnetic treatment for two or more weeks, as near continuous as possible can clear the colon of these infections. It is best to clear these colon infections before starting food testing.

My research indicates that there are classically chronic viral infections in inflammatory bowel diseases. There is also chronic viral infections in major mental disorders. Frequently both the mental disorders and the inflammatory bowel disease of minor to major degree is also involved at the same time. The viruses that my research has isolated as being consistently present are Epstein-Barr, cytomegalovirus and human herpes virus #6.

These are lymphotropic viruses of the herpes family. Once infected, these viruses do not die, but hide from oxygen in neurons and lymph tissues. Major mental disorders have a smoldering encephalitis of the brain as well as infected neurons in the spine. The spinal infection can flair when the oxygen is low and the immune system defense is low at which time the spinal neurons supplying the gastrointestinal tract are infected and produce symptoms. This is comparable to shingles from the herpes zoster virus residual from an initial chicken pox infection. The viruses survive through the years and flourish when the immune system and the low oxygen supply allow this to happen. Measles viruses have been observed to be able to behave the same way as lymphotropic viruses. Furthermore, the lymph tissue lining the gut can be infected by the lymphotropic viruses. The gut is lined with lymph tissue where these viruses reside which can chronically and or episodically produce gastrointestinal symptoms. Maladaptive food reactions with their acidity encourage the viral infection episodes. It is important to stop the food reactions in order to stop the viral infection episodes.

When sitting down, sit on the chair pad. Place a 4" x 6" x 1/2" ceramic block magnet under the chair seat sufficiently far enough back to radiate a magnetic field into the rectal area.

It is well to have a routine of having the 5" x 12" double magnet, multi-magnet flexible mat across the low abdomen-pubic area. On top of this and centered on this pad place a 4" x 6" x 1/2" magnet which is placed lengthwise the body and crosswise the mat. Hold this in place with a 4" x 52" body wrap. This will treat the low colon. It will treat for fungal infections such as candidiasis or any infection in the pelvic area. It will pull the fecal matter and fluid associated with the fecal matter into the low colon so there will be an urge for a bowel movement the first thing in the morning on awakening. If there is still a need for healing of the gastrointestinal tract, place another 5" x 12" double magnet, multi-magnet flexible mat crosswise the abdomen, adjacent to the one that is on the lower abdomen. There may be a need to place one or two of the 4" x 12" x 1/8" plastiform magnets on top of this to provide a sufficient depth of penetration to the abdomen. If there is any particularly painful area above this, a 4" x 6" x 1/2" magnet could be placed on this area. It is well to remove the magnets in the middle to upper

abdomen at least three hours before A.M. arriving, while leaving the magnets on the lower abdomen for the sake of pulling the fluid and fecal matter down into the low colon. It is well for one or two months, or even longer, to wear these magnets on both the lower, middle or even upper section of the abdomen in order to provide for proper healing in the gastrointestinal reactions. There is no limitation as to how long these magnets could be used on the abdomen.

There should be an initial three month course of colloidal silver. Colloidal silver are small particles that carry a negative (south-seeking) magnetic field. Because bacteria, viruses, fungi and parasites have a positive (north-seeking) magnetic field, the colloidal silver will attach to them. Colloidal silver is known to kill bacteria, fungi, viruses, parasites and cancer cells.

Five to eight glasses of alkaline micro water should be ingested per day. The alkaline water will have a pH of 8 or more.

General Information About Magnets

Double strength flexible mats are composed of two stacked plastiform magnet strips measuring 1-1/2 x 7/8" x 1/8". These plastiform magnetic strips are placed in four rows with the 1-1/2" measurement lengthwise in the flexible mat. In a 5" x 6" flexible mat there are 24 magnetic strips. In a 5" x 12" flexible mat there are 48 magnetic strips. The flexibility of these mats makes them very useful since they will fit around the curves of the body without producing any pressure. The therapeutic level of this flexible mat extends to about two inches. When the flexible mat is reinforced with one row of mini block magnets placed crosswise on the two central rows of magnets in the mat, the therapeutic field extends to three inches. When there are two stacked rows of mini block magnets on the mat, the therapeutic level extends to five inches. This places the mini block magnets an inch and one half apart in which there are three placed on the 5" x 6" flexible mat and six placed on the 5" x 12" flexible mat. The flexible mat can also be reinforced by the 4" x 6" x 1/2" ceramic magnet, this extends the therapeutic value to five inches.

Mini block ceramic magnets are sometimes called Briggs blocks because they are used as the Magneto magnets in a Briggs and Stratton gasoline engine. These magnets measure 1-7/8" x 7/8" x 3/8", and they have many therapeutic uses. They

can be used on the head, in such areas as the temporal, frontal or occipital areas, for headaches, management of emotional symptoms or seizures. They can be used on fingers or toes. They can be placed on top of the flexible mats to reinforce the depth of magnetic field penetration. They can be used directly on the joints, under or incorporated into wraps around the joints. They are used in the magnetic slumber pads, the multiple purpose pads, and in the chair cushion pads.

Ceramic discs measure 1-1/2" x 1/2", and have numerous valuable purposes. They can be used around the head to treat headaches or other central nervous system symptoms, around joints, over skin or on subcutaneous lesions. The magnetic field of a ceramic disc extends to eight inches. The magnetic field therapeutic value extends to about two and one half inches. 4" x 6" x 1/2" ceramic magnets have a therapeutic magnetic field value extends for five inches. A ceramic magnet that is 4" x 6" x 1" has a therapeutic value extending to eight inches.

The 4" x 6" x 1" ceramic magnet has many uses such as around joints or to penetrate deeply into the liver, internal organs, the heart, or into the head such as for treatment of tumors. The 4" x 6" x 1" ceramic magnet are used in the headboard-type magnetic sleep enhancer in order to have a field that penetrates into the head during sleep. The magnetic sleep enhancer is composed of four 4" x 6" x 1" ceramic magnets placed in a row 3/4" apart. These ceramic magnets are placed upright in a wooden carrier that holds them firmly up against the headboard. They can be raised or lowered depending on the height of the pillow. They are shipped at the top of the carrier and needs to be lowered so that the head is in the magnetic field. They are resting on a wooden dowel. The wooden dowel they are resting on should be at the level of the back of the head when the head is on the pillow. The closer the top of head is to the magnets in the carrier at the head of the bed, the better.

The magnetic slumber pad is composed of ceramic mini block magnets that are placed an inch and one-half apart throughout the pad.

The magnetic chair cushion pad is composed of ceramic mini block magnets placed an inch and one-half apart throughout the seat and back of the pad.

The multiple purpose pads [small (11" x 17") and large (14" x 25")] are composed of ceramic Mini Block magnets that are

placed an inch and one-half apart throughout the pad. This multiple purpose pad has many uses such as being used on the back, the abdomen, and up over the heart and on the chest area.

Therapeutic Sleep

After the program has been setup, the most important thing to address is sleep. It is optimal to sleep on the 70-magnet bed grid or a magnetic slumber pad.

In maintaining health and reversing degenerative diseases, it is very important that there be deep, energy restoring sleep. It is necessary to sleep a full eight or nine hours in every 24-hour period. Energy is used up during the day and is restored during sleep. The hormone, Melatonin, which is made during sleep, controls the depth of energy-restoring sleep. The principle area in which Melatonin is made is the pineal gland, which is at the center of the head. This gland makes Melatonin in response to a negative (south-seeking) magnetic field. This is why it is so important to treat the head to a negative (south-seeking) magnetic field during sleep. The retina of the eyes and the intestinal walls also make Melatonin. Treating these areas can also raise levels of Melatonin. The hormone Melatonin has the control of the entire energy system of the body including such as the immune system, endocrine system, and respiration. Melatonin is neuronal calming and encourages energy restoring sleep. Melatonin is a powerful antioxidant and thus is anti-inflammatory. Melatonin also has antibiotic and anti-cancer values.

In order to achieve appropriate production of the hormones Melatonin and growth hormone it is necessary to sleep in a completely light-free environment and without any 60 cycles per second electrical pulsing frequencies. Therefore there should not be any night-light, and electric clock, an electric heated blanket, or a heated waterbed. If light cannot be completely excluded from the bed-room, then place over the eyes and the forehead a light shield/mask of some sort. The magnetic eye & sinus mask is a light shield with 1/16" plastiform magnet in it and additional 1" x 1/8" neodymium disc can be added for extra benefit.

The magnetic slumber pad will encourage the production of Melatonin by the gastrointestinal tract. Any magnetic treatment of the abdomen will encourage the production of Melatonin by the walls of the gastrointestinal tract.

Treating the eyes with the eye & sinus mask will also encourage the production of Melatonin by the retina of the eyes. The magnetic headboard type sleep enhancer up against the headboard will have a magnetic field that penetrates into the head and stimulates the pineal gland to produce Melatonin and the hypothalamus to produce growth hormone. Some sleep very well with a 4" x 6" x 1/2" magnet up against the side of the head. It is best to cushion this by placing a double strength flexible mat (5" x 6") up against the side of the head first with the 4" x 6" x 1/2" ceramic magnet over the flexible mat. When lying on the back, this can be leaned up against either side of the head. When lying on the side it can be on the side of the head that is not on the pillow or be placed on the back of the head. Some find it valuable to place a double strength flexible mat under the pillowcase so their head is resting on the flexible mat. If they are on their back it is on the back of their head; if they are on their side, it is on the side of their head. Six mini block ceramic magnets placed on the positive (north-seeking) pole side will further reinforce this flexible mat. Place these mini block magnets crosswise the flexible mat 1-1/2" apart. They will magnetically adhere to the flexible mat.

Magnetic Eye & Sinus Mask

One eye & sinus mask
Two neodymium dot discs (1/2" x 1/16") Two neodymium discs (1" x 1/8")

Placement of Magnets for Eye & Sinus Mask

The eye & sinus mask is magnetic which has special value for producing healthy skin under the magnetic shield and also for the eyes. Placing neodymium disc magnets over the eyes increases this magnetic value. Place the 1/2" neodymium dot discs on the inside as a holder for the 1" neodymium disc on the outside, both of which are directly over the eyes. It works equally well to place the discs to the sides of the eyes. This side of the eyes placement of the discs can be used in glaucoma to release the pressure in the eyes. Once the correct placement of the discs is over the eyes, then firmly tape down the magnets on the outside of the magnetic eye & sinus mask.

Uses for the Eye & Sinus Mask

This magnetic eye treatment is arranged for the treatment of cataracts, glaucoma, infection, floaters, macular degeneration and degeneration of other areas of the eye.

Magnetic treatment of the eye is not harmful and has the potential of being beneficial to most all eye conditions.

Cataract Treatment - Place the magnets directly over the eyes. Use nightly. Treat nightly for several months and, preferably, it is best to use it nightly as a lifestyle.

Glaucoma Treatment - Glaucoma is due to an abnormally high pressure in the eye. Treating with the magnetic field directly over the eyes is anti-inflammatory and is likely to solve the glaucoma problem. If and when treating directly over the eye and within a month to six weeks, the pressure in the eye has not resolved, then treat from the side of the eye. If glaucoma is present, the eye pressure should be monitored and the magnets moved to the side of the eye if the pressure is not being resolved by treating directly over the eye.

Macular Degeneration Treatment - Wear the magnetic eye unit over the eye every night as a life-style. It may require a year or more to achieve measurable value. Some people are reporting success when treated less than a year.

Eye Infection Treatment - Place the magnetic eye unit over the eyes as near to 24 hours a day as possible. To achieve a 24-hour a day treatment, a set of glasses could be used; place two of the 1" x 1/8" neodymium disc magnets on opposite sides of the earpiece adjacent to the eye. Tape the inner disc to the earpiece of the glasses. Ideal for this treatment are safety glasses or sunglasses that have a flange on the earpiece adjacent to the side of the eye. In treating infection it is important to extend the treatment to 24 hours a day for a minimum of two weeks. In some cases it would be best to draw this out to a month. The duration needs to be long enough to completely kill the infection. Extend the time to whatever is necessary to handle the infection and heal the tissues.

Cancer of the Eye Treatment - Cancer requires a 24-hour a day treatment for a minimum of three months. If necessary, extend it as long as is necessary to handle the cancer.

Diabetic Retinopathy Treatment - Diabetes will lead to vascular disorders of the heart, the brain and the eyes. These all should be treated at the same time and a 4-day Diversified Rotation Diet is mandatory for the reversal of the diabetes disease process. This is true whether this is Type I or Type II diabetes mellitus. The eyes should be treated at night, and preferably, during the daytime also.

4-Day Diversified Rotation Diet General Information

A local and systemic biological response of acidity is routinely evoked when symptoms develop in response to exposure to foods, chemicals and inhalants. Acidity also produces low oxygen (acid-hypoxia). This is true whether the maladaptive symptom reactions are not immunologic or non-immunologic in origin. Most food symptom reactions are not immunologic. Immunologic and non-immunologic food symptom reactions have a classic addictive seesaw biological response of symptom relief on exposure, with the emergence of symptoms 3-4 hours after the exposure (addictive withdrawal phase). The optimum method of reversing addiction is avoidance. In food addiction, the optimum method of avoidance of the addiction is for there to be a 3-month avoidance followed by an exposure no more often than every fourth day. This is the reason for the 4-Day Diversified Rotation Diet. The short-term management of symptoms can be managed by alkalinization, which can be produced by bicarbonate alkalinization and more optimally, exposure to a negative (south-seeking) magnetic field, which alkalinizes and oxygenates (alkaline-hyperoxia). These alkalinization methods can relieve symptoms after they have occurred from the exposure and can also prevent symptoms from developing when the alkalinization methods are used prior to an exposure to symptom producing foods, chemicals and inhalants.

The Following is the Optimum Method of Preventing Symptoms form Occurring from Foods:

1. A 4-Day Diversified Rotation Diet. This four-day spacing of exposure to specific foods prevents food addiction.

2. Pre-meal negative magnetic field exposure. One-half hour before the meal place the magnets on the body. Magnetic discs, either ceramic discs (1-1/2"x 1/2") or neodymium discs (1" x 1/8") placed bitemporally. These can be held in place with a 2" x 26" wrap. Place on the sternum, a 4" x 6" x 1/2" ceramic magnet. Hold in place with a 4" x 52" wrap. An added value can result from placing a 4" x 6" x 1/2"ceramic magnet on the epigastric area, held in place with a 4" x 52" wrap. Place on the thoracic spine a large sized double strength flexible mat; this flexible mat can be held in place with the same 4" x 52" wrap that is supporting the 4" x 6" X 1/2" ceramic on the epigastric area. These can be removed at the beginning of the

meal or they can be continued through until the meal is finished. If symptoms emerge after the meal has been eaten, then replace the magnets until the symptoms leave and especially place a suitable sized magnet directly over the symptom area. Also prior to the meal, if there are any symptom areas, treat these with appropriate sized magnets, pre-meal. Always use the negative magnetic field (south-seeking).

3. **Post-meal, if any symptoms develop then use suitable magnets placed locally for relieving these symptoms.** It could be helpful again, to place the ceramic disc magnets bitemporally. Bicarbonate alkalinization is useful one-half hour after the meal, use multi-element mineral ascorbate powder. Take 1/2 teaspoon of multi-element mineral ascorbate powder and 1/2 teaspoon of soda bicarbonate in 1/2 a glass of water.

The above pre-meal and post-meal alkalization method is recommended for:

• Those with a serious state of symptoms reactions to multiple foods in which food rotation is not entirely satisfactory.

• When of necessity, symptom-evoking foods have to be eaten, such as when eating out at a restaurant, or those that have to use this method instead of waiting three months for the reintroduction of their foods.

In my experience, the above method of basic food rotation diet with the addition when necessary of the magnetic pre-meal exposure and the magnetic post-meal exposure is superior to any neutralization method. Neutralization methods do not honor the fact that the basic problems are addiction and acidity (acid-hypoxia). A food rotation diet is necessary to honor the fact that addiction is the major driving force of food maladaptive reactions and that acid-hypoxia is the immediate cause of symptoms. There is no optimally effective method for the management of maladaptive reactions to foods that is equivalent to food rotation.

Colloidal Silver Therapy

Colloidal Silver is made by an electrolysis method that produces a particle size of 0.0001 micron. These small silver particles are charged to a negative (south-seeking) magnetic field by the electrolysis method. This solution of colloidal silver is placed in the mouth, especially under the tongue for absorption. This provides quick absorption into the blood stream. These fine silver particles go throughout the entire body.

The negative magnetic field magnetically attaches to microorganisms, parasites and cancer cells, which are positive (north-seeking) magnetic poled. Silver, in its own right beyond that of the negative magnetic field, inhibits the replication of these cells. The small silver particles do not interfere in any way with human cell function. It is recommended to use 40 parts per million starting for the first week with 1/2 teaspoon four times a day, then followed the next three months by 1 teaspoon four times a day. Aloe salve may also help in the treatment of local skin infections.

Alkaline Micro Water

Alkaline micro water helps materially the body's normal alkaline state. Also, being micro water, it enters into the cells of the body more readily than the usual water. This also carries negative (south-seeking) magnetic field as well as being alkaline. The Singer Electrolysis Instrument is used for producing the alkaline micro water. At least five glasses of the water should be ingested each day.

Polarity

Always use a negative magnetic field.

Beyond Magnetism

An acute maladaptive reaction to foods, chemicals, or inhalants has been documented as producing a brief state of acid-hypoxia. In this state there is a production of acid and a failure to process properly the end products of oxidation phosphorylation metabolism. In this state of acidosis, oxygen content is reduced. Maladaptive reactions to foods are the most frequent cause of bouts of acidosis. Degenerative diseases are noted for their acid-hypoxic state. Therefore every effort should be made to maintain a normal alkalinity and normal oxygen state.

Majorities of people are maladaptively reacting to foods in one or more ways, thus producing bouts of acidosis and reduced oxygen. It is the better part of wisdom to follow a 4-Day Diversified Rotation Diet. This program leaves out foods that are used as frequently as twice a week or more for a period of three months. This is based on the assumption that these foods are being reacted to in some way. It is the frequency of the use that produces the maladaptive reactions. A 4-Day Diversified Rotation Diet is set up to leave out these frequently used foods.

After three months, these frequently used foods can be returned to the diet, usually without any symptoms being produced.

All addictive substances should be abandoned such as addictive drugs, alcohol, tobacco and caffeine (coffee, tea with caffeine, chocolate, and soft drinks containing caffeine). Addiction is acidifying.

Carbonated soft drinks are acid producing and should be rarely used. Soft drinks are sweetened with corn sugar (in he US) and if they are ingested they should be limited to the corn rotation day.

In order to maintain an adequate alkaline state, it is necessary that the minerals that are used in the bicarbonate buffer system be in adequate supply. These are the minerals calcium, magnesium, potassium, and zinc. There are several proprietary preparations that contain these minerals associated with vitamin C as ascorbates. The preferred source of alkali minerals is multi-element mineral ascorbates by Klaire Lab. Use 1/2 teaspoon to 1 teaspoon of one of these powders in one-half glass of water, two times a day. The preferred time to take the alkaline minerals is in the morning on arising and again before going to bed at night. When using this mineral alkaline water, place it on the negative magnetic pole of a 4" x 6" x 1/2 magnet for a minimum of five minutes. This will charge up the water and the oxygen in the water with a negative magnetic field, which will help the body maintain its normal alkaline state.

There is a valuable method of electrolysis, which provides alkaline micro water that has an alkaline pH. There is a home electrolysis unit (The Singer Electrolysis Instrument) that provides this alkaline micro water. It is recommended that five glasses of the alkaline micro water be ingested daily.

Infrared Sauna

Far Infrared is a good, non-injurious heat source with several valuable health promoting values including alkalinization, oxygenation and detoxification.

1. **Alkalinization**

The human body functions in an alkaline medium. Enzymes in the human body are dependant on alkalinization and on temperature range. Increasing the temperature increases the enzyme function.

2. **Oxygenenation**

The human body makes it's energy by the oxidation process requiring the presence of molecular oxygen. As the temperature rises, the oxidation process increases. Thus, this will aid in producing more energy.

3. Detoxification

The human body processes toxins, some by being exhaled from the lungs, others passed out through the urine or the stool. Sweating from the skin is another process of detoxification. The far infrared sauna is ideal in that it penetrates through the layers of the skin and into the subcutaneous fat throughout the skin and then detoxifies all types of toxicity including heavy metals. Therefore, this is ideal for heavy metal toxicity such as mercury, lead or other heavy metals. It also processes the enzyme inhibiting acids such as in degenerating diseases. Especially noted is the value in processing the toxins from cancer.

Far infrared sauna is markedly complementary to negative magnetic field therapy which is also alkalinizing, oxygenating and detoxifying.

The Infralume Hand-Held Lumiscope is an ideal instrument. This is obtainable from medical sup-ply stores and drug stores. When using the Infralume, the magnet can be placed on the area immediately after heating. There can be 30 minutes of heating one or more times a day.

The 4-Day Diversified Rotation Diet

The following are observed facts about maladaptive reactions to foods:

1) IgE immune food reactions are acute inflammatory reactions in which spacing of contact has no significance. Therefore, a four day rotation diet has no significance in IgE mediated immune reactions. Fortunately, IgE food reactions are scarce.

2) IgG immune food reactions quiet down after three months of avoidance. After three months of avoidance an IgG immune reaction is calmed and suitable for a contact spacing of a 4-Day Diversified Rotation Diet. Food IgG reactions have the same relief phase on contact and withdrawal phase 3-4 hours later which is characteristic of addiction.

3) Food addiction with relief on contact of the food and a withdrawal phase 3-4 hours later is characteristic of the majority of maladaptive symptom-producing food reactions.

4) A five day avoidance breaks the addiction cycle following which, for 4-6 weeks, there is an acute symptom reaction within the first hour of exposure to the addictive food. This is the basis of single food testing meals after five days of avoidance.

5) There are toxic reactions without an addictive withdrawal phase. These toxic reactions are infrequent.

6) The biological response to the addictive withdrawal phase of symptom production is acid-hypoxia.

7) The acute symptom phase after a five day avoidance period is acid-hypoxia. Acid-hypoxia produces cellular edema.

8) Acid-hypoxia produces the symptoms of the addictive withdrawal phase.

9) A carbohydrate disorder is produced by addiction. This has the characteristics of hyperinsulinism after exposure to the addictive food followed by hypoglycemia 3-4 hours later during the withdrawal phase.

10) After five days of avoidance there is no hyperinsulinism and no hypoglycemia. These are replaced by a hyperglycemia within one hour of eating the addictive food.

11) Food addiction is a state of metabolic compensation response to the stress leading to the addiction.

12) After five days or avoidance there is no metabolic compensation and in fact, there is a metabolic decompensation.

13) Diabetes type II is the decompensated state of food addiction with its acid-hypoxia and hyperglycemia.

14) Acute symptom-producing maladaptive food reactions when extended in time are identi- fied as chronic diseases with the same symptoms.

15) Diabetes mellitus type II is the final decompensated state of the earlier compensated state of food addiction. The metabolic disordered chemistry of food addiction is the same as clinically significant diabetes mellitus type II. The common denominator of disordered metabolism of food addiction and maturity-onset diabetes mellitus type II is acid-hypoxia and hyperglycemia.

16) The only way to prevent, and or reverse, maturity-onset type II diabetes mellitus is to reverse food addiction by initial avoidance and later spacing of the formerly addictive food.

17) Addiction to non-food items also advances the diabetes mellitus disease process. Examples are such as the use of narcotics, tobacco, alcohol and so forth.

18) Toxic, non-food, chemical stressors also advance the diabetes mellitus disease process.

19) Definitive food testing to determine maladaptive reactions to foods can only effectively proceed when all foods reacted to are avoided for five days preceding test meals of single foods. Remaining addicted to even one food will interfere with test results. Characteristically, physicians are taught to test food immunologic or non-immunologic sensitivity reactions as a secondary rather than a primary cause of illness and to test foods while leaving the subject addictively or otherwise maladaptively responding to multiple other foods. Even when there is a five day avoidance of that single suspected food, the re-testing of that food is unreliable since they are in the process of reacting to so many other foods. Characteristically, no attempt is made to clear all food reactions by a five day fast before testing begins. This method of not clearing the subject of all food reactions before testing begins gives spurious results. This leads to conflicting data as to the significance of food reactions. This conflict in data is used by some physicians to justify discarding food reactions as causes of diseases in general or specifically with the disease they are dealing with at the time. Good food testing also requires examination of blood pH and blood sugar before and after the food test meal.

20) Ignoring the food maladaptive reaction as critical to the cause of degenerative diseases whether brain, gut or other biological systems, advances the central primary degenerative disease of type II diabetes mellitus.

21) Ignoring the food maladaptive inflammatory reactions and resorting to steroids, non-steroidal anti-inflammatory agents, tranquilizers and antidepressants to handle the symptoms of inflammation further accelerates the diabetes mellitus disease process with the end result being clinically significant type II diabetes mellitus. The above observations provide the significance of maladaptive food reactions and the relationship of the 4-Day Diversified Rotation Diet to food reactions

How to Food Test

Five days of avoidance of all foods using a water fast only or another system of using a single infrequent food such as watermelon during the five days of avoiding foods.

During the five days avoidance, use one-half to one teaspoon of soda bicarbonate, three times a day to help offset the acid-hypoxia that develops during the food addiction withdrawal phase.

A negative (south-seeking) magnetic field therapy can materially aid in reducing the food addiction withdrawal symptoms during the five days of avoidance. Placing magnetic disc magnets bitemporally, that is in front of the ears, near the top of the front of the ears, under a band can reduce head symptoms such as headache or depression. It will also help to reduce the local symptoms otherwise by stopping the message to the brain from the local area of symptoms elsewhere in the body. Treating the brain should be accompanied at the same time by treating any other area of the body that has discomfort. The best magnet for treating local areas of the body that have pain or other discomfort is the 4" x 6 x 1/2" magnet. This can be placed directly over the area of discomfort. The magnets bitemporally placed on the head are disc magnets that are 1-1/2" x 1/2". These are ceramic magnets. An alternative to this that provides lighter magnets that are just as effective are 1" x 1/8" neodymium disc magnets. Place one on the inside of the band around the head and another one on the outside. This will magnetically hold these in place. That would be two on each side of the head, placed temporally. Anxiety is best handled by mid-forehead and left temporal placement. Obsessive-compulsiveness is best handled by left tempo-ral and low occipital. Use either the ceramic discs or the neodymium disc magnets. The best band for this is a 2" x 26" band. During the withdrawal phase of addiction whether this be to food or to other addictants, there is an uncomfortable tightness in the chest and in the epigastric areas. This discomfort can be handled by placing a 4" x 6" x 1/2" magnet lengthwise on the sternum and or the epigastric area, crosswise the epigastric area. These can be held in place with a 4" x 52" body wrap. In terms of duration, these magnets can be held in place until symptoms are relieved which is usually within five, ten to fifteen minutes or they can be continuously held in place during the withdrawal phase to maximize comfort. It should be understood that a negative (south-seeking) magnetic field alkalinizes and oxygenates the

body area that is within that negative (south-seeking) magnetic field.

Record blood pH before the five days of avoidance begins and immediately before and one hour after each test meal. A normal blood pH is 7.4. This test is achieved by blood plasma on litmus paper. It is best to use one with a pH of 6 to 8. I have characteristically used pHydron litmus paper.

Test blood sugar before the fasting begins and before and one hour after each test meal of a single food. There are home blood test units for diabetics which are adequate for this purpose. This requires a drop of blood from a lance prick of a finger. Normal fasting blood sugar ranges from 80-120. One hour after a test meal, the normal blood sugar can range up to 140. From 140-160 is suspect. From 160 on, is definitely an abnormal hyperglycemia.

Symptom-survey the entire body for symptoms before and one hour after each test meal. Test the pulse before and one hour after each test meal. The heart is very sensitive to stress.

Skipped beats in response to maladaptive food reactions are common. Some people have a vulnerability to set off a tachycardia. Tachycardia could be handled by placing a 4" x 6" x 1/2" magnet with a negative (south-seeking) magnetic pole over the heart. Hypertension is frequently a manifestation of food maladaptive reactions.

When food testing Crohn's disease or ulcerative colitis cases, it is best to have the suspected foods tested the last meal of the day. This provides for an overnight period of recovery from the reaction. The most suspected foods are the frequently used foods. They are often in the area of cereal grains, such as wheat, rye, oats, barley, corn or dairy products. However, it can be any food that is eaten with a frequency of two times a week or more including even salads. I have known some people who ate the same salad every day who maladaptively react to all the foods in their salads that they use daily. It is wise not to use caffeine or alcohol in any form. However, it should be understood that it is possible that infrequently used caffeine such as a cup of coffee or chocolate candy or an occasional beer or alcohol otherwise will not necessarily set off the addiction. Addiction requires more than twice a week exposure. Even though it is not recommended that these items be used, it can be understood that an infrequent use on a single occasion

will not reinstate addiction. It should however, be understood that subjects with mental symptoms should not really toy with the use of caffeine because it is a central nervous system excitant or with alcohol in any form. Those who have seizures should follow the same rules.

Those who choose a very limited diet such as strict vegetarians who are not using meat or any animal products, even fish, do find it more difficult to follow the 4-Day Diversified Rota- tion Diet. One way to get around this is to sprout the cereal grains such as wheat, rye, oats and barley and also sprout the beans. Sprouts of grains and beans are really a different food than the mature product and can be used on a different day than the mature product such as eating the cereal grains on rotation, two days later eating the cereal grains that have been sprouted. The same thing can occur with beans. Fresh corn such as corn on the cob is not the same food as mature corn and can be used on a different day than mature corn. When sprouting the grains or beans be sure that there is about 1/4" sprout and only use those beans or grains that have sprouted. These sprouts can be prepared in many different ways such as ground for bread or used as a cooked cereal. Sprouted beans or grains can be used as a fresh vegetable and in salads.

Four-Day Rotation Diet
Day I
Meat
Bovidae: Lamb, Beef, Goat, Deer, Cheese, Milk and Yogurt
Fish
Fish and/or shellfish can be on any or all days by keeping the type of fish or shellfish different for each day.
Vegetables
Potatoes: Potato, Tomato, Eggplant, Red/Green Peppers and Pimento
Goosefoot: Beet, Spinach, Swiss chard and Lamb's quarters
Composites: Lettuce, Chicory, Endive, Escarole, Artichoke, Dandelion and Safflower
Corn: Fresh Corn as a fresh vegetable
Fruits
Mulberry: Mulberry, Figs and Breadfruit
Rose: Strawberry, Raspberry, Blackberry, Dewberry, Loganberry, Young-berry, Boysenberry and Rose Hip
Grape: Grapes and Raisins

Cashew: Mango
Nuts:
Sunflower: Sunflower Seeds Cashew: Cashew and Pistachio
Protea: Macadamia Nut
Thickening
Tapioca
Seasonings
Grape: Cream of Tarter
Potato: Chili Pepper, Paprika and Cayenne
Composites: Tarragon Nutmeg: Nutmeg and Mace
Sweetener
Beet Sugar
Tea Rose Hips, Chicory and Dandelion
Sprouts
Legumes, Bean Sprouts, Alfalfa Sprouts and Sunflower Sprouts
Fresh Vegetable
Green Bean Sprouts, Alfalfa Sprouts and Sunflower Sprouts

Day II
Meat
Bird: *All fowl – Chicken, Turkey, Duck, Goose, Guinea, Pigeon, Quail and Pheasant
Eggs
Eggs
Fish
Fish and/or Shellfish can be on any or all days by keeping the type of fish or shellfish different for each day.
Vegetables
Myrtle: Pimento
Grass: Millet
Parsley: Carrot, Parsnip and Celery
Mushroom: Mushroom and Yeast (Brewer's or Baker's)
Mallow: Okra
Fruits
Plum: Plum, Cherry, Peach, Apricot, Nectarine and Wild Cherry
Pineapple: Pineapple
Pawpaw: Pawpaw, papaya and papain
Grains:
Gluten: Wheat, Oats, Barley, Rye and mature Corn
Non-gluten: Millet, Sorghum, Bamboo shoot and Malt

Nuts:
Plum: Almond Beech: Chestnut Brazil nut: Brazil nut Flaxseed: Flaxseed
Thickening
Wheat flour, Agar-agar (vegetable gelatin from sea algae)
Seasonings
Myrtle: Guava, Clover, Allspice and Clove
Parsley: Celery seed, Celeriac, Anise, Dill, Fennel, Cumin, Coriander and Caraway
Pedalium: Sesame
Orchid: Vanilla
Oil
Cottonseed, Flaxseed and Sesame
Sweetener
Corn sugar, Clover honey and Molasses
Tea
Sterculia: Papaya tea

Day III
Meat
Suidae: Pork
Fish
Fish and or Shellfish can be on any or all days by keeping the type of fish or shellfish different for each day.
Vegetable
Mature Legumes: Pea, Black-eyed Pea, Soybean, Lentil, Peanut, Lima Bean, Navy Bean, Garbanzo Bean, Great Northern Bean, Pinto Bean and Kidney Bean
Laurel: Avocado
Lily: Onion, Garlic, Asparagus, Chive and Leek
Fruits
Apple: Apple, Pear and Quince
Banana: Banana and Plantain
Heath: Blueberry, Huckleberry and Cranberry
Gooseberry: Currant and Gooseberry
Ebony: Persimmon Buckwheat: Rhubarb **Grains**
Buckwheat: Buckwheat and Rice
Nuts
Legume: Peanuts
Birch: Filbert (Hazelnut) Conifer: Pine Nut (Pinon)
Thickening
Arrowroot: Arrowroot Flour

Seasonings
Arrowroot: Arrowroot Heath: Wintergreen Legume: Licorice
Laurel: Cinnamon, Bay leaf, Sassafras and Cassia bud/bark
Pepper: Black & White Pepper
Oil Soybean, Peanut and Avocado

Sweetener
Fructose, Carob syrup, Maple sugar, Tupelo honey and Cane sugar

Tea
Alfalfa, Sassafras, Garlic and Apple cider/tea

Day IV

Meat
Meat: Rabbit, Fowl not used on Day II (Chicken, Turkey, Duck)

Fish Fish and/or Shellfish can be on any or all days by keeping the type of fish or shellfish different for each day.

Vegetables
Morning Glory: Sweet Potato
Gourd: Cucumber, Pumpkin, Squash, Acorn and Squash seeds
Mustard: Mustard, Turnip, Radish, Horseradish, Watercress, Cabbage, Kraut, Chinese Cabbage, Broccoli, Cauliflower, Brussel Sprouts, Collard, Kale, Kohl- rabi and Rutabaga
Olive: Black/Green Olives

Fresh Grain Vegetables
Sprouts: Wheat, Rye, Barley and Oat

Fruits
Gourd: Watermelon, Cantaloupe and Honeydew
Citrus: Lemon, Orange, Grapefruit, Lime, Tangerine, Kumquat and Citron
Honeysuckle: Elderberry Palm: Coconut and Date **Nuts**
Seeds: Pumpkin seeds, Squash seeds and Coconut
Walnut: English walnut, Black walnut, Pecan, Hickory and Butternut

Thickening
Cornstarch

Seasonings
Mustard: Mustard
Mint: Basil, Sage, Oregano, Savory, Horehound, Catnip, Spearmint, Peppermint, Thyme, Marjoram and Lemon Balm

Oil:
Coconut, Olive, Pecan and Corn

Sweetner:
Date sugar, Honey (other than Tupelo or Clover)
Tea:
Kaffer

How to Use Four-Day diversified rotation diet without food testing.

Many people find it practical to go directly to a four day diversified rotation diet without food testing. First, the person assumes that he or she is reacting to any food eaten as frequently as twice a week, or to any members of that food family. The person leaves these frequently used foods out of the diet for three months. At the initiation of the rotation diet, stop all use of caf-feine (coffee, teas with caffeine, cola drinks, chocolate), tobacco and all alcoholic drinks. **Do Not Reintroduce These Into The Diet.**

For the next three to four days, there will be withdrawal symptoms. Handle these symptoms as described in the section, "How To Initiate This Program."

Three months later, these foods are reintroduced back into the diet. Nearly always (95% of the time), these foods will no longer be reactive as long as they are kept on a once-in-four-day basis in this diet. When reintroducing foods into the diet, simply add the food to the established rotation and observe whether or not symptoms occur. If no symptoms occur, then this food can be rotated. If symptoms occur, wait another three months before trying this food again.

One way to expand the use of foods is to sprout cereal grains and legumes. A person should be certain that the grain or bean is sprouted with approximately 1/4" or more of a sprout. The foods that have been sprouted will no longer carry the same reactive capacity that the non-sprouted foods do. Thus, once sprouted, grains and legumes can be introduced into the diet immediately.

Selective 4-Day Rotation Diet

This diet selectively rotates on a four-day basis, the foods that have been demonstrated by deliberate food testing to evoke symptoms. Foods not demonstrated to produce symptoms or hypoglycemia reactions are used freely at any time desired. There is a particular problem with this diet in which the person may become addicted to some of the foods that they are eating

with frequency. This can easily escape them unless they test out these foods periodically.

This diet starts either with a full month of testing of foods in which only the foods that gave symptoms, acid reaction or hypoglycemic reactions are initially left out for two more months beyond the month of testing food reactions and then placed into the rotation diet. Foods not producing these symptoms are eaten freely. This makes it easier to prepare combinations of foods.

The other system, which would relate itself largely to self-help without a physician monitoring, would be to leave out all the foods that are eaten twice a week or more. This also includes all the family members of those foods. Set up a rotation diet of other foods, however, there would be no need to pay strict attention to rotation on these foods that have not been eaten frequently. After five days on this program, then start testing foods. This would start testing the foods and the family members of the foods that have been left out the diet. These can be placed back in the diet if no symptoms, acid reactions or high blood sugar is demonstrated. After having gone through all these foods that were left out of the diet originally, then start on the other foods, testing one meal once a month. It is suggested that in the case of gastrointestinal reactions, especially Crohn s disease and ulcerative colitis, have the test meal in the evening so that if there is a reaction, there is time for recovery from the reaction before the next meal in the morning.

Systematically, the food should be tested as outlined in the section on food testing. This involves that a food or a family member of this food should not be used for five days prior to the test meal. The test meal should be a single food test meal. There should be a symptom survey recorded before the test meal begins and again repeated one hour after the test meal. The blood pH should be taken before the meal and one hour after the meal. The blood sugar should be taken before the meal and one hour after the meal.

Final Word

Maladaptive inflammatory symptom-producing reactions of the gastrointestinal tract, whether diagnosed as a low level irritable bowel syndrome or more severe inflammatory tissue injury reaction diagnosed as inflammatory bowel disease are

systemic diseases with numerous other organ tissues involved in the reactions. It is characteristic of medical literature to state the cause of these gastrointestinal inflammatory reactions as unknown. My findings are that the cause is known. It is due to maladaptive reactions to foods. Addiction to the individual person,s frequently eaten foods is the central cause. Each subject s reactions relate to their personally, frequently eaten foods. Addiction with a characteristic symptom producing withdrawal phase is present whether this is isolated as an immunologic (IgG or complement disorder) or non-immunologic reaction. IgG antibodies to foods does relate to a few of the reactions, but even with this, there is the addiction phenomenon present. Oxidoreductase enzyme deficiency and or enzyme inhibition has been isolated as frequent in these symptom-reacting foods but again, the addictive phenomenon with its withdrawal phase is always present. Acid-hypoxia is always present during the addictive withdrawal phase occurring 3-4 hours after contact with the addictive substance. This is true whether this is a drug or a food.

Celiac disease, affecting the small intestine, is known to be due to a reaction to gluten. This is a genetic disorder affecting 1 in 200 of Irish descent and 1 in 2,000 of non-Irish descent. Most gastrointestinal inflammatory reactions are not due to gluten, but rather due to maladaptive addiction to foods eaten with a frequency of two times a week or more. It can be any food eaten by an individual at a frequency of two times a week or more.

The essence of gastrointestinal Treatment of these inflammatory gut reactions is to initially avoid the frequently eaten, symptom-producing foods for three months while rotating on a four day basis, the non-symptom producing foods. After three months, it is safe 95% of the time, to return to these initially, symptom-producing foods as long as they are kept on a four day rotation basis.

Some find it safe to follow a selective four day rotation diet in which only the initial symptom-producing foods are rotated on a four day basis. To safely achieve this selective food rotation, these frequently eaten foods need to be periodically tested after five days of avoidance to make sure that addiction has not developed to these frequently eaten foods.

It is also true that after a non-symptom stability has been achieved, it is safe to eat a single meal without concern of rotation. This can usually be done a minimum of once a month and sometimes even more frequently, such as twice a month. It is safest to not use any caffeine beverages or alcohol beverages as a lifestyle. However, it is also true that if these are rotated on an infrequent basis, no known harm would result.

Maturity onset diabetes mellitus Type II is the end result of addiction to foods or addiction to any other substance. Handling the inflammation from food maladaptive reactions by steroids, non-steroidal anti-inflammatory agents, tranquilizers or antidepressants, further enhances the diabetes mellitus disease process. Stopping the food addiction by a 4-Day Diversified Rotation Diet is the only way to prevent and or reverse maturity-onset diabetes mellitus Type II. Type I diabetes mellitus characteristically has two reasons for the diabetic state; 1) an injured pancreas by viral infections or an autoimmune reaction secondary to an immunologic reaction to foods and, 2) food addiction. A rotation diet characteristically reduces the insulin requirement.

Psychiatrists and their patients are caught up in a serious medical dilemma in which the tranquilizer-antidepressants used have serious chronic, disease-producing complications. The complications of phenothiazines are a disaster. The SSRI serotonin-endorphin complex causes chronic raising of stress response chemistry beyond a physiological normal. It is simply riding the crest of disordered addictive chemistry in which the consequences are serious, damaging side effects. Prozac, as a prototype of the SSRI tranquillizer- antidepressants, has over 100 side effects including such as producing psychosis and so forth.

There is a remarkably effective answer to this medical dilemma in which the psychiatrist and his patients are caught up in. The answer is a four day rotation diet, optimized nutrition and a negative (south-seeking) magnetic field to cancel out acute and chronic symptoms, establish sound, energy-restoring sleep, kill viral infections and heat-repair injured tissues.

Gastroenterologists and their patients are caught up in a serious medical dilemma in which the steroid and non-steroid, anti-inflammatory agents produce serious chronic disease-producing complications.

There is a remarkably effective answer to this medical dilemma in which the gastroenterologist and his patients are caught up in . The answer is a four day rotation diet, optimized nutrition and a negative (south-seeking) magnetic field to cancel out acute and chronic symptoms, establish sound, energy-restoring sleep, kill microorganism infections and heal-repair injured tissues.

My observation that maturity-onset, non-insulin dependent diabetes mellitus type II is caused by maladaptive reactions to foods (essentially, addiction) and is reversible by a four day rotation diet was confirmed by John Potts, M.D. This confirmation was published in abstract supplement issues of *The Journal of Diabetes..*

Don'ts

Don't disregard foods as a primary cause of minor gastrointestinal reactions to major inflammatory bowel diseases.

Don't use steroids to suppress inflammation in inflammatory bowel disease.

Don't use non-steroidal, anti-inflammatory chemicals to suppress inflammation in inflammatory bowel diseases.

Don't' use tranquilizers or antidepressants to suppress mental, and emotional symptoms in the brain/gut syndrome.

Do s

Do systematically examine for maladaptive food reactions.

Do use food avoidance plus a negative magnetic field to reduce inflammation in inflammatory bowel disease.

Do use food avoidance plus a negative magnetic field to reduce inflammation in inflammatory bowel disease.

Do use food avoidance and food rotation plus a negative magnetic field to reduce mental, emotional and intestinal symptoms in the brain/gut syndrome.

References

Davis, A.R. and Rawls, W. "The Magnetic Blueprint of Life. ". Acres USA, Kansas City, MO, 1979. Davis, A.R. and Rawls, W. "The Magnetic Effect". Acres USA, Kansas City, MO 1975

Davis, A.R, and Rawls, W. "Magnetism and Its Effect on the Living System . Acres USA, Kansas City, MO 1976.

Harrison's Principles of Internal Medicine, 11th Edition. 1987. P. 1223-1307 McGraw-Mill Book Company.

Johanson, John F. *Gastrointestinal Diseases. Risk Factors and Prevention.* Lippincott-Raven Publishers. Philadelphia and NY 1997.

Klotz, Saul, M.D., Internist-Allergist. Double-blind study on food reactions. In *Clinical Ecology edited* by Lawrence D. Dickey. Springfield: Charles C. Thomas, 1976.

Philpott, William H. M.D,, *Cancer. The Magnetic/ Oxygen Answer.* 1999. Published by W.H. Philpott. 17171 S.E. 29th Street, Choctaw, OK 73020.

Philpott, W.H. and Kalita, D. *Brain Allergies. The Psycho-Nutrient Connection.* Keats Publishing Company, Inc. New Canaan, CT 1980, Updated Edition, 1999.

Philpott, W.H. and Kalita, D. *Victory Over Diabetes: A Bio-Electric Triumph.* Keats Publishing Company, Inc. New Canaan, CT. 1993.

Philpott, W.H., M.D. *Critical Review of Currently Practiced Magnetic Therapy.* 1998. Published by W.H. Philpott. 17171 S.E. 29th Street, Choctaw, OK 73020.

Potts, John. Journal of Diabetes. "Avoidance Provocative Food Testing in Assessing Diabetes Responsiveness." 26: Supplement 1, 1977.

Potts, John. Journal of Diabetes. "Value of Specific Testing for Assessing Insulin Resistance." 29: Supplement 2, 1980.

Potts, John, Journal of Diabetes. "Blood Sugar-Insulin Responses to Specific Foods Versus GTT." 30: Supplement 1,1981.

Potts, John, Journal of Diabetes. "Insulin Resistance Related to Specific Food Sensitivity." 35: Supplement 1, 1986.

Stein, J.H. *Internal Medicine*, 4th Edition. 1994. P. 340-524. Mosby Publishers. Thompson, W. Grant. *The Angry Gut. Coping with Colitis and Crohn's Disease.* Plenum Press. 1993. NY and London.

Wolf, S. and Berl, B. *The Biology of the Schizophrenic Process.* Plenum Press. NY, 1976. [*Magnetic Health Quarterly* "Gastrointinal Diseases" Vol. V, 3rd Qtr, 1999]

Book Review

The Inflammation Cure by William Joel Meggs, M.D., Ph.D. with Carol Svec. Publisher, Contemporary Books, McGraw-Hill Books. 2003.

William Meggs, M.D. has selected the central fact of degenerative diseases which is inflammation. The current

publication of research concerning the central role of inflammation in degenerative disease is having a wholesome effect on medicine. This centers the focus on prevention since inflammation can be there at even a very early stage of a disease process. So often, the physician is called to do the most minimal, least costly approach. Often, the patient asks the doctor for relief and not information about their disease or how to stop its progression. The doctor becomes a physician of the subject's economic limitations. It is easy for the doctor to fall into the state of serving the patient's request and not offering preventive information. The information about inflammation being central to the degenerative disease process is reminding the doctor of his role in education of the prevention of degenerative diseases. Inflammation involves hundreds of different biological and chemical processes. The best test to determine the presence of inflammation is the C-reactive protein test.

Seven inflammation-fighting guidelines:

1) Eat lots of fruits and vegetables, at least five servings each day.

2) Eat fish 3-5 times a week.

3) Add olive oil to your diet.

4) Eat very little meat, poultry, cheese, butter or other animal products - or become a vegetarian.

5) Take recommended supplements daily.

6) Eat less.

7) Identify and avoid personal problem foods.

The detailed justification for each of these seven guidelines is provided and referenced.

In our industrial age, we are subjected to many chemicals used in building materials, cleaning agents and farming. As near as possible, we should identify these and avoid the contact. Smoking of tobacco or any source of smoke is injurious. As near as possible, each person should take charge of their health to provide a healthy lifestyle. The book is recommended as a valuable guide to taking personal charge of avoiding inflammation by their own lifestyle, avoidance of inflammatory substances and the addition to the diet of anti-inflammatory foods -- particularly noted is supplementation with Omega-3 oils. Omega-3 oils are abundant in fish oils and several vegetable oils but not the usual vegetable oils used in cooking.

Book Review

The Inflammatory Syndrome by Jack Challem. Published by John Wiley and Sons, Inc. 2003. Jack Challem's book, *The Inflammatory Syndrome. The Complete Nutritional Program to Prevent and Reverse Heart Disease, Arthritis, Diabetes, Allergies and Asthma* is a serious compilation of what is known today about inflammation and how it relates to degenerative disease. The C-reactive protein test has spun a lot of research about inflammation and its relation to degenerative diseases. This book describes how to hunt for the triggers of inflammation, the background diet encouraging inflammation, as well as the specific nutrients that discourage inflammation.

THE ANTI-INFLAMMATION SYNDROME DIET STEPS:

1) Eat a variety of fresh and whole foods.
2) Eat more fish, especially cold water varieties.
3) Eat lean meats (not corn-fed) from free range chickens and turkeys, grass-fed cattle and buffalo and game meats such as duck and ostrich.
4) Eat a lot of vegetables, the more colorful, the better.
5) Use spices and herbs to flavor foods and limit your use of salt and pepper.
6) Use olive oil as your primary cooking oil.
7) Avoid commercial cooking oils such as corn, sunflower, safflower and soybean oil as well as vegetable shortening, margarine and partially hydrogenated oils.
8) Identify and avoid food allergies.
9) Avoid or strictly limit your intake of food products that contain sugars, such as sucrose or high fructose corn syrup.
10) Avoid or limit your intake of refined grains.
11) Limit your intake of dairy products.
12) Snack on nuts and seeds.
13) When thirsty, drink water.
14) Whenever possible, buy and eat organically raised foods.
15) To lose weight, reduce both carbohydrates and calories.

The book needs to be read to fill in the details of the significance of these anti-inflammatory food steps.

Book Review

Breaking the Food Seduction by Neal Barnard, M.D. St. Martins Press, **NY**, 2003. Dr. Neal Barnard in his book, *Breaking the Food Seduction* provides seven steps:

Step one: Start with a healthy breakfast. Be sure to have breakfast. Fiber rich foods are essential. Choose healthy protein sources.

Step two: Choose foods that hold your blood sugar steady. Be sure to eat enough foods. Use high fiber foods. He recommends using the glycemic index to keep your glycemic foods low in amount.

Step three: Use appetite-taming leptin. Leptin is in fruits and vegetables. By eating more fruits and vegetables in abundance, as compared to meats, will increase leptins and their function and reduce the urges to eat particular foods.

Step four: Break craving cycles. Avoidance of the foods that produce cravings in each individual is a major method of stopping the craving.

Step five: Exercise and rest.

Step six: Call in reinforcements. This describes techniques of having other people help you stop the action of your urges to eat specific foods or between meals.

Step seven: Use extra motivators.

The significance of specific nutrients, meal planning and recipes are provided.

WHAT IS MISSING?

These two books on inflammation and the book on breaking the food seduction are a reflection of the current status of research and all three are valuable. The central theme that I have discovered in my research is that there is both an allergic (IgG) and addiction state. Dr. Theron G. Randolph was the first one to call this, allergy-addiction. IgG has a delayed reaction. IgE is an immediate reaction. IgG has a delayed reaction in which the symptoms occur at 3-4 hours post-contact with the allergen. Whereas, food addiction is not an allergy but is caused by the stress of the food, raising endorphins. When the food is first contacted, due to the stress, the endorphins rise and along with this, serotonin also rises and at about 3 hours, the withdrawal phase begins and symptoms now develop with a drop in endorphins, serotonin and adrenal hormone. IgG food allergy and food addiction behaviorally look alike. The only difference is that in food addiction, there are no antibodies formed. Theron G. Randolph, M.D., Allergist, who is the father of clinical ecology, called this condition allergy-addiction. He also observed that cellular edema occurred at the time of the reaction and the cause of that was acidity. I had been published that cells in an acid

medium would become edematous. He developed a way to relieve symptoms by using sodium and potassium bicarbonate and if need be, having them breathe oxygen also. In a state of acidity, oxygen becomes tied up and in fact makes oxyacids. Of course, it has been a popular self-help program to use calcium, magnesium as alkalies to relieve gastritis and gastric reflux symptoms. He used it to relieve symptoms in general and it has considerable value. I used this extensively in my practice and if the symptoms were severe enough, I would give intravenous alkali in the form of calcium and magnesium.

Albert Roy Davis had observed that the biological response to a negative magnetic field is alkaline-hyperoxia and the biological response to a positive magnetic field is acid-hypoxia. Robert O. Becker had observed that when an injury occurs, a positive magnetic field was registered. When the healing was taking place, a negative magnetic field was registered. Based on this information, I replaced oral alkalinizing agents with a negative magnetic field. It was observed that this was more consistent in its symptom relief response than that of alkalinization. I also observed that not only could I relieve the symptoms after they had been evoked by a deliberate food test, but I could also provide the magnets ahead of a meal and prevent the reaction from occurring to a test meal.

Thus, all three of these books have failed to understand fully food allergy-addiction and that avoidance was central and of course, they all used avoidance. But they didn't understand that avoidance wouldn't have to be continuous. In fact, they advised once you reacted to a food, just not use it again. The fact is that you can return to the foods under the condition of three months of avoidance or of treating with the magnets ahead of each meal while rotating the food. Of course, there is nothing in the peer review literature at this time that tells you the significance of magnet therapy so therefore they completely missed the significance of magnet therapy in management of symptoms and in reversal of disease processes.

COMPONENTS OF MAGNETIC FIELD THERAPY:

1) pH. The normal human pH is from 7.35 to 7.45. When the pH drops into the acid range, then the enzymes of the human body are inhibited. This acidity is toxic to human enzymes other than the digestive enzymes in the mouth and the stomach. All the rest of the enzymes in the body, which are many hundreds, are all alkaline-dependent. The oxidoreductase enzymes are alkaline-hyperoxic dependent. These enzymes make human energy

(adenosine-triphosphate (ATP) and when this oxidoreduction process making ATP occurs, it also makes a static oxidation remnant negative magnetic field magnetism which the body then uses in activation of other enzymes along with the ATP.

The *Encyclopedia Britannica* states that there are two ways to determine if a catalytic reaction occurred. One is to measure the end product of that catabolism, the other is to measure the evidence that a magnetic field was created by the catalytic reaction. The second major use of oxidoreductase enzymes is that of detoxification. An end product of oxidative phosphorylation is the free radical, super oxide. Super oxide is rapidly enzymatically processed by oxidoreductase enzymes, in this case its free radical is processed to hydrogen peroxide by super oxide dismutase. Then hydrogen peroxide is processed to oxygen and water by catalase. If this process does not rapidly occur, then the super oxide produces other free radicals, ties up oxygen into oxyacids and proceeds to produce alcohols and aldehydes all of which are inflammatory. Therefore, in considering inflammation, we first of all consider the oxidoreductase enzymes that have the job of processing enzyme toxins. A catalytic reaction occurs when a substrate joins an enzyme. This occurs because of dipoles on both the enzyme and the substrate. For the catalytic reaction to occur, electrons have to move between the enzyme and the substrate. There are available, static electrons that are all around us and in us. Vitamin C serves as an enzyme co-factor, providing either the giving or receiving of electrons. When electrons move, a magnetic field is produced. There is a natural attraction between the dipoles of the enzyme and the substrate, however that attraction is not sufficient to cause catalysis. It requires the movement of electrons which ultimately are a magnetic field in order to make the catalysis occur. In the case of the oxidoreductase enzymes, which are alkaline-hyperoxia dependent, the magnetic field produced by the catalysis is always a negative magnetic field. The accumulation of this negative magnetic field is part of the energy system along with ATP that drives other enzyme catalysis that is also alkaline-hyperoxic dependent. Thus it can be seen that since the final step of catalysis is magnetic, then supplying an external source of negative magnetism will energy-activate oxidoreductase catalysis and other alkaline-hyperoxia dependent catalysis. This is why when these enzymes are inhibited by any substance that supplies this energy

activation of a negative magnetic field they can override this enzyme toxicity and the enzymes then can process the toxins.

Thus, supplying an external negative magnetic field is the most important of the detoxifying process of the human body. It has been well established and confirmed by my observations that the biological response to a negative magnetic field is alkaline-hyperoxia. The oxygen in this case doesn't come from the oxygen that we breathe, but comes from the release of oxygen and water from toxic substances. This is easily observable. If you are stung by an insect, placing the area immediately over a negative magnetic field will process the toxins injected into the human body and will do so rapidly within a matter of minutes or at most, hours and there will be no evidence of injury at all. A finger is burned and the area blanches and is acutely painful. Placing this area over a negative magnetic field will reverse this within minutes. The area will turn pink and will not blister. A bruised area that is turning dark-colored will quickly loose its color and become a normal color within a matter of minutes of exposing the area to a negative magnetic field. An area that has been cut and bleeding will stop its bleeding by placing the area on a negative magnetic field. It does this by virtue of the release of oxygen from acids caused by the injury. Oxygen is vaso-constricting and will stop the bleeding. Furthermore, leaving the magnet on the area, it will heal without any infection occurring and there will not be a scar. The biological response to a sustained positive magnetic field is acid-hypoxia and will make the cuts, bruises, insect stings and so forth, worse. This is easy for anyone to observe. Another proof of the separateness of the positive and negative magnetic field can be observed by using a 1" x 1/8" neodymium disc magnet by placing the positive magnetic field on the skin. Within four days it will begin to hurt. Within two weeks, there will be a vasculitis which is now infected with pustules. Using a negative magnetic field, there will be no harmful effect at all to the skin. The essence of magnet therapy is the energy activation of enzymes. The negative magnetic field is the correction for disordered metabolism. The positive magnetic field can be used for a brief period to activate neurones that have been inhibited by the extinction of disuse from an accident or an acute swelling that has caused pressure on neurones after a bout of multiple sclerosis. This would have to be used while associating this energy activation of neurones with a practice of return function. The positive magnetic field must not

be used as a chronic exposure due to its harmful disordering of metabolic function. All healing occurs under the influence of the negative magnetic field. A positive magnetic field is always present at the site of injury, infection or cancer.

2) MAGNET POLES. It is observed that a biological response to a negative magnetic field is alkaline-hyperoxia which drives normal physiological functions. The positive magnetic field is the signal of injury.

Both the positive and negative magnetic fields are part and parcel of human physiological function. The positive magnetic field awakens the subject, drives the ability to think and to act, however it cannot be sustained for a long period of time without injury. The basic function of the human body is that of alkaline-hyperoxia with a pH in the alkaline range. Relaxation and particularly sleep maintains the alkaline state.

3) STRESS AND ANTI-STRESS. Life is composed of both stress and anti-stress. Being awake, mental function and biological function area all in the stress range. Relaxation and sleep are in the anti-stress range. This is all easily demonstrated by the EEG. A pulsing field of 13 and more is stress. A pulsing field of 12 or less is anti-stress. Our base line is anti-stress. We make excursions over into stress but do not sustain this for a long period of time. If we do, there is a buildup of harmful metabolic products starting especially with super oxide and all the damage that it can do in the event that it is not processed rapidly. There are many chemicals from the environment that if in sufficient quantity are enzyme toxic. Allergies and other immunologic reactions are enzyme toxic. The withdrawal phase from addiction is toxic. The combustion by-products of fossil fuels is enzyme toxic. There are many environmental enzyme toxins that we have to be processing and if our quantity is too great, then they overwhelm our enzyme system and disease results. In order to survive, we must relax and we must sleep soundly in order to re-charge our electromagnetic bodies and process all the toxins and maintain alkaline-hyperoxia so that our enzymes that have many functions can function.

NO SIDE EFFECTS FROM NEGATIVE MAGNETIC FIELD THERAPY

Negative magnetic field therapy is an ordering of disordered physiology. A negative magnetic field therapy is not a narcotic and does not evoke a narcotic biological response. A negative magnetic field is not an analgesic like the array of non-steroidal

analgesics all of which have potential side effects which can be serious. A negative magnetic field is not an anesthetic. A negative magnetic field is not a statin drug which can have serious side effects, some of which have been removed from the market because of deaths occurring. A negative magnetic field relieves symptoms because it corrects the disordered physiology of disease processes. The acid-hypoxia and other disordered chemistries of the disease process are changed to alkaline-hyperoxia. A negative magnetic field cures the symptoms by curing the disease. Human health is an ordered electromagnetic state. Human disease is a disordered electromagnetic state. The biological response to a negative magnetic field does not mask the symptoms by analgesics, anesthetics, steroids, narcotics, statin drugs tranquilizers, anti-depressants or anti-seizure medications. A negative magnetic field is a universal ordering of the disordered chemistries of diseases no matter whether this disease is identified as an allergy, an autoimmune disease, a toxicity, an addiction, an infection, cancer, depression, psychosis, behavior disorder, learning disorder and so forth. Magnetic therapy cures the disease. Magnet therapy is the only universal ordering of the disordered metabolism of diseases.

GLYCEMIC INDEX MYTH

Glycemic substances are identified as foods that quickly evoke blood sugar but still do so within the range of normal, that is below 140 mg/dl. These, by and large, have a quantity of free carbohydrates such as sugars. The assumption is made that hyperglycemia, that is a blood sugar beyond 140, will result out of an accumulation of glycemic foods. This is a false assumption but based on this assumption, then it is considered that diabetes mellitus type II can be managed by reducing the glycemic foods. This concept is erroneous because there is no such thing as a generalization as to the production of hyperglycemic foods by the accumulation of glycemic foods. This however, is not published in the peer review literature and it was not known until I did my research starting in 1970. One of the factors of this research, besides examining for symptoms produced, was to examine blood sugar before and after each single food test meal. The subjects were fasted on water only for five days. This changes the reaction timing from delayed, such as 3-4 hours after contact with the food, to that of the symptoms being acute within the first hour. Thus, **we** were looking at hyperglycemia, that is beyond 140 mg/dl, at one hour after the test

meal, not at the fasting blood sugar on a morning specimen. This technique revealed conclusively what foods evoked hyperglycemia. There was no way to make a generalization. These foods were specific for each individual and the reaction was based on the fact that the subject frequently, that is, daily, several times a day or at least several times within a week, used the same food. Thus, the glycemic index which is just a generalization is really a myth whereas when you do a test meal of a single food after a five day fast, you know exactly which foods are hyperglycemic and which foods are not. Interestingly, this individuality bears no relationship as to whether the food is glycemic or not. The foods can even be proteins and glutena and it was conclusively demonstrated that clinically significant diabetics had sugars that they never used that they did not react to. For example, I have never found a diabetic type II reacting to maple sugar even though we give them a full meal of maple sugar. They will react only to the sugars that they use and they will also react to the parent substance from which that sugar is made such as beet sugar from beets. They react to beets. Whereas there are lots of diabetics that don't react to sorghum or to cane sugar or to honey. Some will react to honey that is taken from their local neighborhood and not react to honey that is taken from a neighborhood that they do not visit with any frequency. Diabetes mellitus type II is not a reaction to sugars or glycemic foods. Diabetes mellitus type II is due to food allergy and food addiction. When you remove the foods evoking hyperglycemia and they can come from any category of carbohydrates, complex carbohydrates, free carbohydrates, fats or proteins, there is no diabetic reaction. There is no hyperglycemia. Fortunately, if you remove these foods for three months, the body will have desensitized to these foods and 95% of the time, the food can be returned to a diet that rotates the foods either on a four or seven day basis without hyperglycemic reactions occurring. This return to the foods can be achieved at a 95% rate. Therefore, the treatment of diabetes is an initial avoidance of hyperglycemic foods, followed by a reinstatement of these foods into the rotation diet three months later. There is a shortcut to this and that is if you supply a negative magnetic field to the brain, heart and liver for 30 minutes ahead of a meal, most of the time, there will not be any hyperglycemic reaction. If the exposure to this food does override the negative magnetic field, that food needs to be left out for three months before reintroducing it into the rotation diet.

EXCHANGE DIET MYTH

This is a myth because it does not recognize the individuality of the reactions and makes the generalized assumption that there are foods that are equivalent to each other that can be used in this exchange diet. Hyperglycemic reactions to foods is completely individualized and cannot be generalized, therefore the exchange diet is a myth.

HYPOGLYCEMIA AND HYPERGLYCEMIA.

The stages of the diabetes mellitus type II disease process.

In the early stage of the diabetes mellitus type II disease process, the maladaptive reactions to a specific food is that of hyperinsulinism that rushes the glucose into the cells. By the third or fourth hour, the blood sugar and cellular glucose is now low and symptoms are produced. These symptoms can be brain symptoms or physical symptoms and weakness of course is characteristic. Mental symptoms of dizziness is common. Soon after eating the food, the subject is usually euphoric. When the blood sugar drops into hypoglycemic levels, then the subject is depressed. I have observed hypoglycemia to be the symptoms of the withdrawal of food allergy-addiction. It lasts usually several years before the hyperglycemic phase develops. The hyperglycemic phase develops when the pancreas function of producing hyperinsulinism is fatigued. Then there is only hyperglycemia because there is not that extra insulin to drive the glucose into the swollen cells.

The treatment for hypoglycemia and hyperglycemia are one and the same. That is, isolate the foods that evoke the condition. Remove the foods and neither hypoglycemia or hyperglycemia exists. These foods are specific for each individual and no generalization can be made as to what the foods will be. The only generalization we can make is that the foods that evoke the symptoms will be foods that are frequently used and it will not bear any relationship as to whether it is a free carbohydrate, a complex carbohydrate, a protein or a fat. It will bear relationship to frequency of use for that individual.

Diabetes mellitus type II is caused by cellular edema in response to an allergic, addictive or toxic response to a specific food and it does not relate only to foods. Toxic chemicals can also produce the same problem but foods are also always and basically the offending substances. An interesting example is a teenager who was type I diabetic and had been receiving insulin since

childhood. The examination of his reactions to foods and chemicals occurred out in the country in Oklahoma. It was demonstrated that he had sufficient insulin and was not even insulin-dependent. However, when he moved back to New York City with the abundance of car exhaust, he had to take insulin because of his reaction to car exhaust.

WHAT IS THE CAUSE OF INSULIN RESISTANCE?

Much is being made today of insulin resistance however, the cause of insulin resistance is being escaped. Insulin resistance exists only when the subject is maladaptively reacting to foods or chemicals. The cause of this is that during these reactions, cellular edema occurs and the insulin cannot do its job of transferring the glucose from the blood into the cells. Insulin resistance completely disappears when these foods are removed. Insulin resistance is nothing more than the cellular edema. The more cells that are edematous, the higher the insulin resistance. The real problem is cellular edema.

THE CAUSE AND CURE OF OBESITY

Obesity exists because too many calories are eaten. Obesity is cured by eating less calories. There is a balance between the caloric intake and the exercise output. Exercise more and eat less is the cure for obesity. The urge to eat too much and to eat specific satisfying foods is an addiction. An IgG allergy has a delayed reaction the same as addiction. Theron G. Randolph coined the term allergy-addiction. Since addiction has a withdrawal phase and IgG allergy has a delayed reaction phase, these two correlate. The real issue for addiction is how to be comfortable while reducing the calories. The easiest way to achieve this is to stop eating all frequently used foods, some of which will be addictions or allergies but if the subject stops eating all frequently used foods, those that are used twice a week or more, it will encompass the allergy-addiction foods. Then start rotating all other foods on a four or seven day basis. All other addictions or potential addictions should be stopped at the same time, that is, alcohol in any form, caffeine in any form and tobacco in any form. Comfort is achieved by stopping all addictions at once. The discomfort will be only for the first 3-4 days. This discomfort can also be managed by using ceramic disc magnets that are 1/2" x 1-1/2" placed bitemporally and held in place with a 2" x 26" band. Place a 4" x 6" x 1/2" magnet over the heart with the 6" lengthwise the body. Hold in place with a 4" x 52" body wrap. Place a 2" x 26" band with Velcro

on each end over the left shoulder to hold this magnet in place over the heart. Place a 4" x 6" x 1/2" magnet over the liver with the 6" lengthwise the body. Hold in place with a 4" x 52" body wrap. All these magnets should have the negative pole facing the body. These can be used to manage the withdrawal symptoms and can be used continuously if symptoms indicate. This only needs to be applied for the first five days and then whenever there is an urge that develops, either to eat a specific food for satisfaction or to eat between meals, apply the magnets again and it will handle the symptoms within 5-10 minutes. Drink an abundance of water, at least 8 glasses or more a day. The best water is alkaline micro negative ion water. The source of this water is volcanic water. There are several sources on the market. Nariwa water is such a water. Also, this water can be made by an electrolysis instrument. Such an instrument is available for home use.

Take pictures of the meal size for the breakfast, noon and evening meal. The first picture is to be the size the subject usually eats. Then make another picture, reducing the quantity by one-third. Every month make a new set of pictures, reducing the quantity of food by one-third of that which is being used. Continue this until the desired weight is achieved.

An additional method which can help reduce the fat, usually by about one pound a day, is to place magnets over the fat area. For example, to reduce abdominal fat, place a 4" x 6" x 1/2" magnet lengthwise of the body, one on the left side of the abdomen and one on the right side, placing these a couple of inches apart. Hold these in place with a 4" x 52" band. Do this only at night during sleep.

There are two methods of starting the rotation diet and one is to leave out foods eaten twice a week or more while using the magnets for comfort while setting up a four or seven day rotation diet. Another method is to use magnets ahead of and during each meal, setting up the rotation diet, but with this method, not leaving any foods out. The magnets are to treat the bitemporal area, heart and liver 30 minutes before a meal and during a meal. This will serve the same purpose of desensitizing to foods as avoidance of those frequently used foods for three months.

The secret of weight reduction is to be comfortable while achieving calorie reduction. The use of negative magnetic field therapy can keep the subject comfortable.

THE CAUSE AND CURE OF FOOD ADDICTION

Frequently eating the same food is a biological stress in which addiction can occur. Addiction is caused by a rise in self-made endorphins and is truly an addiction. IgG allergy has a delayed reaction where the symptoms appear between 3-4 four hours, post-meal. This behaves the same way as the withdrawal phase of addiction, therefore allergy-addiction is very much a reality. A negative magnetic field can handle the symptoms of allergy-addiction. The wise way to do this is to fast for five days, drinking an abundance of water for this five days and using magnets to relieve symptoms whenever they occur or the magnets could even be used continuously during that phase. These magnets are ceramic disc magnets placed bitemporally, held in place with a band. A 4" x 6" x 1/2" magnet is placed over the heart and over the liver. These are held in place with a 4" x 52" body wrap or other suitable band or pockets in a garment. All addictions should be stopped at the same time, therefore tobacco or pot smoking should be stopped and caffeine beverages should be stopped all at the same time. There should never be any consideration of piece-meal stopping addictions. Stop all addictions at once and use magnets to be comfortable during the withdrawal phase. By the 5th day of withdrawal, addiction is over except tobacco addiction is not over for 21 days since tobacco contains fat soluble substances, whereas the foods contain water soluble substances. Keeping the food rotated prevents addiction from reoccurring. After stability is present, which is about three months, then a single meal can be used about every two weeks, that pays no attention to rotation. It would be wise but not necessary to treat with magnets ahead of this purposely rotation-violated program. It is wise to never return to the use of alcohol or caffeine beverages. However, it is also true that if alcohol is used only once on the four day rotation diet or once on the seven day rotation diet, the addiction would not be re-established. This is also true of caffeine beverages. If coffee is to be reinstated, then use only one and no more than two cups of coffee every seven days. This would also apply to cola drinks containing caffeine. This would also apply to chocolate containing caffeine. The secret is to not eat the foods or the treats frequently enough to re-establish the addiction or the allergy.

THE CAUSE AND CURE OF DIABETES MELLITUS TYPE II

Diabetes mellitus type II has been determined as being due to food reactions. These maladaptive reactions are allergies,

addictions or toxicities. Following a 4 day diversified rotation diet or a 7 day rotation diet reverses diabetes mellitus type II.

The foods evoking hyperglycemia will be frequently used foods and will be individualized as to the subject and how frequently the food is used. There is no such thing as a generalization about hyperglycemia. It all is individualized for each subject and depends on the frequency to which they use the foods. Maladaptive reactions evoking hyperglycemia can occur in any category of foods -- free carbohydrates, complex carbohydrates, proteins or fats. It cannot be predicted ahead of time but can be proved by deliberate food testing. To achieve this, the subject would need to fast for a period of five days. The fasting can be water only or can be such as watermelon or associated with this, a protein food, especially such as a fish that is not commonly used. Following this, deliberate food testing occurs with meals of single foods testing the blood sugar before each meal and one hour after each meal as well as testing for symptom development. This will determine which foods are hyperg- lycemic. Hyperglycemia is whenever a food evokes a blood sugar beyond 140. Removing these foods there is no hyperglycemic reaction therefore, there is no diabetes that we know by a diabetic reaction. Leaving these foods out for a period of three months, they can be returned to the diet with at least 95% of them being returned to the diet. The best rotation diet is a 7 day rotation diet. Another method that is satisfactory to most people is to fast for 5 days or at least until the blood sugar is normal. Then start eating meals of multiple foods as is usually used, testing the blood sugar before and one hour after each meal. Use the disc magnets placed bitemporally and the 4" x 6" x 1/2" magnet over the heart and over the liver. If, in any meal, the blood sugar is beyond 140, then the next go-round for these foods, test them singly and find out which food produced the hyperglycemia. This is judged only if the food overrides the application of the magnets. If this occurs, then remove that particular food out of the diet for the next three months and try again to re-introduce this into the rotation diet.

This system which has been described applies only the diabetes mellitus type II.

Diabetes mellitus type I is an insulin-dependent diabetes. For diabetes type I, do not fast the patient but start treating with magnets for 30 minutes ahead of each meal. It has been observed that this system of magnets ahead of each meal and avoiding the frequently

eaten foods, reduces the insulin requirements down to one-third and brings the diabetes into good control.

THE CAUSE AND CURE OF CANCER

The human body requires the maintenance of alkaline-hyperoxia which will maintain an alkaline pH. Human cells have the capacity to make adenosine triphosphate (ATP) either by oxidative phosphorylation or by fermentation. The fermentation process is only used in an emergency. For example, if a subject exercises to the point of having used up their ATP which of course has been made by oxidative phosphorylation, then the muscle cells will go into making ATP by fermentation. This of course, produces soreness, because fermentation has an acid by-product. The human cannot survive long on making their ATP by fermentation. They must resort to relaxation and sleep to produce their ATP by oxidative phosphorylation. However, the type of bacteria, viruses and parasites that invade the human body can survive on making their ATP by fermentation. There are many reasons why acid-hypoxia develops on which fermentation is dependent. This acid-hypoxic producing reactions are such as prolonged stress of any kind, physical or mental, allergic reactions, autoimmune reactions, addictive reactions or toxic reactions and all produce acid-hypoxia. Microorganisms and infections all produce acid-hypoxia. Therefore, all of these are carcinogenic if chronically maintained. Cancer makes its ATP by fermentation. Otto Warburg received a Nobel prize by demonstrating this.

The cure for cancer is to replace acid-hypoxic fermentation with alkaline-hyperoxia oxidative phosphorylation. All human cells are capable of becoming cancer cells if acid-hypoxia is chronically maintained and the cell is forced to make its ATP by fermentation. New generations of cells that are forced to make their ATP by fermentation become incapable of returning to making their ATP by alkaline-dependent oxidative phosphorylation. Therefore they continue to multiply unregulated and make their ATP by fermentation. Also, alkaline-hyperoxia is the necessary state for the control of replication of cells. Cancer cells are out of control and no longer fit into their normal cell place of the human body and therefore, a tumor develops which has no relationship to the human need of cell function.

A negative magnetic field biological response is that of alkaline-hyperoxia. Therefore, treating the cancer with a continuous negative magnetic field stops the cancer cells from

replicating. Furthermore, the dead cancer cells are reabsorbed in most cases. Occasionally, for some unknown reason, certain cancers, even though dead, do not reabsorb.

THE CAUSE AND CURE OF INFLAMMATION

First of all, inflammation can fill the role of aid in preventing the body from bleeding and make a bridge against invasion of infectious microorganisms. Under these protective situations in which the body function is normal including its maintained alkaline-hyperoxia, the inflammation is short-termed and is resolved by the normal functions of physiology. However, if the body condition such as acid-hypoxia are present, then this initial inflammation does not resolve and becomes itself a party to the disease process. A negative magnetic field with its response of alkaline-hyperoxia and other unexplained values, resolves inflammation no matter where it is or why it was initially evoked. Of course, avoidance of substances and situations that evoke inflammation should be the first consideration. The second consideration is to use a negative magnetic field to resolve the inflammation. Inflammation is caused by many conditions such as a cut, bruise, invading microorganism, an allergy, an addiction or toxicity. All of these should be considered in reversing inflammation. But of prime importance is using a negative magnetic field to reverse the inflammation no matter how it is caused.

THE CAUSE AND CURE OF INFECTION

Infection refers to the invasion of the human body with microorganisms that injure. These microorganisms themselves, by and large, produce their ATP by the fermentation process which is dependent on acid-hypoxia. The human cells are negative magnetic field oriented and this to a large degree is their defense against microorganisms which are positive magnetic field oriented. Whichever has the strongest field will win. This is why supporting the human cells with a negative magnetic field will defeat the energy of the organisms that are positive magnetic field oriented. This robs these organisms of their ability to make their ATP and therefore, they die. For a local infection, local treatment is all that is necessary. For a systemic infection, the treatment needs to be systemic and can be supplied by such as a bed composed of 70 magnets that are 4" x 6" x 1".

THE PATHOLOGY OF HERPES FAMILY VIRUSES

Facts about Herpes Family Viruses

The following are members of the herpes family virus:

Herpes simplex 1 which is characteristically around the face, cervical spine or also in the head and brain itself.

Herpes simplex II which is characteristically in the genital area.

Herpes simplex I or II can be either around the head or the genital area.

Varicella-zoster causes chicken-pox. Most children have had chicken-pox. Years later, the manifestation can be observed as shingles which is caused by the latent viruses of chicken pox.

Epstein-Barr is a highly frequent infection. It particularly likes lymphocytes. It also is neurotrophic. It not uncommonly becomes disseminated into any organs of the body such as the liver, spleen, thyroid or the brain.

Cytomegalovirus is particularly neurotrophic affecting the brain and the entire nervous system. Human herpes virus # 6 has been implicated as being consistently present in multiple sclerosis. Human herpes virus # 7 is a recently discovered human herpes virus. Little is known of its significance.

Herpes B virus is a virus that is carried by some Old World monkeys. There are 18 well-documented human cases. Thirteen of these were fatal.

Almost all adult subjects have one or more of these types of herpes family viruses. Epstein-Barr virus is positive in about 90-95% of adults. Herpes viruses do not die. Instead they establish a latency and survive. The only way they can be killed is with a human biological response to a negative magnetic field.

Herpes viruses "establish latency in the body after primary infection despite the presence of antibodies".

Antibodies to herpes viruses are not protective against subsequent outbreaks. "Reoccurrences are common and represent reactivation of latent viruses"

None of the antiviral agents eradicate latent viruses.

Congenital herpes has been established as a fact. A reasonable theoretical postulation is that Epstein-Barr, cytomegalo or human herpes virus #6 is congenitally passed to the fetus during a recurrent symptom infection from a latent infection. This is most likely to occur during the 2nd half of pregnancy. An acquired infection during gestation, infancy or childhood, while the brain is still in its formative development, injures the brain so that it does not fully develop. Herpes viruses have the ability of stealth adaptation in which they are able to drop out their antigen to which the human

immune system is responding. Thus, they skirt around the immune defense of the human system. They can latently dwell in the lymphocytes, particularly the B-lymphocytes and the neurones. They can continue to damage the human physiology without evoking a human immune response. Infections of these viruses are even known to exist when there were no antibodies against the virus.

In my extensive studies of learning and behavioral disorders including autism, attention deficit, obsessive compulsiveness, hyperactive, lethargic and dyslexic children, I discovered that they have one or more of these herpes viruses, usually Epstein-Barr or cytomegalo. They have these early in life which injures the brain. Mental cases like schizophrenia and manic depressive are cases that have more injury to the brain than these attention-deficit, learning disordered, hyperactive and autistic children. The illness is progressive in children and adolescents with these infections are all candidates to progress to schizophrenia or manic depressive illness. It is also my conclusion that adults who develop an Epstein-Barr or cytomegalo infection after the brain is developed do not develop psychosis but they do develop depression, pains and weakness and are frequently given the clinical diagnosis of fibromyalgia, chronic fatigue and neurotic depression. Weakness is a characteristic of these chronic infections, be they present congenitally, after birth or developed even as an adult after the brain has developed. Ninety-five percent of the adult population do have antibodies to Epstein-Barr or cytomegalo virus. It seems evident from literature that human herpes virus #6 is the single cause of multiple sclerosis. Anyone who has these infections are suffering to some degree. Even though they may think themselves in reasonable health, they are fighting a serious battle with a wicked enemy. Anyone who has symptoms, mental or physical, should consider the possibility that these herpes viral infections are adversely affecting their health. There are no antibiotics that can eradicate the human body of these latent viruses. There is only one way these viruses can be killed and that is the human biological response to the support of a negative magnetic field.

VIRAL ENCEPHALITIS SYNDROME CAUSE

The viral encephalitis syndrome is caused by members of the herpes family viruses. These are lymphotropic and neurotrophic viruses. They can cause varying degrees of encephalitis. These herpes family viruses consist of Epstein-Barr, cytomegalovirus or

human herpes virus #6, herpes zoster, or herpes complex viruses 1 and 2.

The viral encephalitis syndrome is in the following conditions:

Schizophrenia, manic depressive, autism, Tourette's syndrome, attention deficit disorder, obsessive-compulsive disorder, hyperactivity, lethargy, dyslexia, mirror-imaging and some seizures.

CAUSE OF SYMPTOMS

The symptoms expressed are dependent on the area and extent of viral encephalitis injury to the brain. Trigger mechanisms that are secondary to the original injury are such as maladaptive reactions (allergies, addictions and toxicities) especially to frequently used foods and to a lesser extent, environmental chemicals. A cure consists of determining the foods or chemicals that evoke symptoms which can then be controlled by avoidance and later spacing of the foods on a 7 day rotation diet and also avoiding chemicals that evoke symptoms. Negative magnetic field therapy with exposure to the negative magnetic field of the brain, heart and the liver before a meal can, to a high degree, prevent these symptoms from developing. The combination of a rotation diet and negative magnetic field pre-meal treatment is quite effective. These herpes family viruses do not die and the human immune system cannot kill them. There are no reasonably effective antibiotics to kill these viruses. A systemic treatment with a strong negative magnetic field will kill these viruses.

THE CAUSE AND CURE OF NEURITIS

Neuritis is inflammation of peripheral nerves. Neuritis has many causes, such as trauma, infection, toxicities, allergies, addictions and nutritional deficiencies.

A negative magnetic field will reverse the inflammation of neuritis no matter how it has been caused. The negative magnetic field therapy treatment of neuritis is as varied as its causes. The necessity is to place the affected area in a strong negative magnetic field and maintain this until all symptoms are gone and healing has occurred. This may take several weeks of continuous treatment. Any food that is frequently eaten can become a source of either allergy, addiction or toxicity. There are certain foods that are more likely to be a causative factor. They are gluten foods (wheat, rye, oats, barley and corn) and the nightshade family foods which are potatoes, tomatoes, eggplant and peppers. The answer to management of these food precipitating factors is to avoid the foods that evoke symptoms or treat with magnets ahead of a meal.

Avoidance of the foods does not usually have to be permanent but, after three months of avoidance, most of the time the food can be returned to either a 4 or 7 day rotation diet. Magnet therapy applied ahead of meals will, most of the time, prevent the neuritis symptoms from occurring. This pre-meal magnetic exposure is ideally associated with a four or seven day rotation diet.

TREATMENT PROGRAMS THAT EMERGED FROM MY ORIGINAL RESEARCH

My original program was that of setting up either a 4 day or 7 day diversified rotation diet leaving out foods that evoke symptoms and or hyperglycemia. If these are left out of the rotation diet for a period of three months, a desensitization had occurred in which the allergy-addiction symptoms did not emerge as long as they kept these original symptom-producing foods to that of once every four or seven days. Occasionally, there was a patient who would still react to gluten. These no doubt are patients who have a genetic predisposition to react to gluten, likely as an allergy. These patients were to leave gluten out all the time.

In the mid-80's, I had discovered the observations of Albert Roy Davis, Ph.D. which was that of the biological response to a negative magnetic field being that of alkaline-hyperoxia. I confirmed that he was right and used a negative magnetic field as a relieving agent for patients who had symptoms on deliberate food testing. This proved to be more substantial than baking soda and oxygen given when the patient had symptoms during food testing. Not only did I discover that a negative magnetic field was very efficient in relieving symptoms evoked during food testing or chemical testing, but I also discovered that the magnets could be provided ahead of a test meal of a food that had been established as being symptom reactive and that it would prevent the symptom from occurring. With this information, I then found I could start a patient on a rotation diet and have them expose themselves to magnets for 30 minutes ahead of a meal and prevent them from reacting. Therefore, we didn't have to wait for three months before reintroducing these reactive foods. If it was found, which occasionally happened that a person still overrides the magnets, then those foods should be left out for three months before trying it again. This system makes it easier for the subject to enter into the rotation diet right away. We treat the head with the ceramic disc magnets that are 1-1/2" x 1/2".

These are placed bitemporally. Treat the heart with a 4" x 6" x 1/2" magnet with the 6" lengthwise the body and held in place with a 4" x 52" body wrap. Then we treat the liver with a 4" x 6" x 1/2" magnet with the 6" lengthwise the body held in place with a 4" x 52" body wrap. This is started 30 minutes or even 15 minutes ahead of a meal and preferably kept in place until the meal was completed. This was found to be very effective in preventing symptoms from occurring. Always use the negative magnetic field, of course. If perhaps symptoms do occur after the magnets are removed, then place the magnets over the area where symptoms occurred and the symptoms will quickly leave. Also, using the magnets placed on the body can help a person ride through their addictive withdrawal phase and be reasonably comfortable. Thus, it is fairly easy to stop tobacco or alcohol and use the magnets to stop the withdrawal phase symptoms. Magnets are also used during the five days of withdrawal. However, it is easy for a lot of people to not go through any five day fast but go directly to the rotation diet using the magnets. In this case, there would not be testing of the foods to which a person reacts to. There would be the assumption that the reactive foods are among the most frequently used foods that they use more than once a week. However, you do not have to prove it. You can make the assumption and immediately start treating the patient and find relief without going through the food testing.

One aspect of my study was to examine the nutritional needs. We therefore surveyed for vitamins, minerals, amino acids and toxins especially including heavy metals. We added to our ecology program that of nutrition which was justified by our laboratory testing. However, we found that the subject would become symptom-free before we even gave them the nutrients. The symptoms of the illness was precipitated by maladaptive reactions to foods, chemicals and inhalants.

Another aspect of my study was to examine the infected state of the patient. We ran cultures from all the body orifices and the skin. Stool cultures were sometimes run and a series of antibodies to a wide assortment of viruses. I made vaccines from the bacteria and fungi that we grew. We found that vaccination was not an appreciable answer for turning the illness around. Avoidance and spacing was the central way of reversing the illness. We found vitamin C to be very important. We gave it in 50 gram doses intravenously along with appropriate minerals and B complex

vitamins. We often used this intravenous vitamin C each day during the five days of withdrawal. We found this to be substantial in relieving the symptoms. We could relieve symptoms with magnets or with this intravenous vitamin C or combine the two. What we found in our antibody survey was that in schizophrenics, manic depressives and the learning and behavioral disordered children, either Epstein-Barr, cytomegalovirus or human herpes virus #6 was consistently present. Epstein-Barr had the highest percentage and it was consistent in these psychotics and these lesser, non-psychotic symptoms of producing learning disorders, attention deficit disorders, obsessive-compulsive disorders and autism of chil- dren. Therefore, because of this we centered our focus on the herpes family viruses. They don't die. The human immune system cannot kill them. They have the ability to establish a latency. They have a stealth ability so that they can avoid the immune system. The injury from the infection is progressive through the years. All of these learning and behavior disordered children are candidates for schizophrenia in their 20's. All the schizophrenics describe their learning and behavioral disorders when they were children. The next question is, can we kill these viruses with a negative magnetic field? Herpes zoster which causes chicken pox also develops a latency, most often in the neurones of the thoracic spine and years later, will develop shingles along the rib cage. When this is treated with a negative magnetic field treating both the thoracic spine and the nerves along the rib cage, it completely kills these shingles and they never come back and there is also not that painful neuralgia that the subject experiences even when there are not any blisters. Thus, it was demonstrated that we can effectively kill the herpes family viruses. We also proved this with herpes simplex 1 and 2 as well as herpes zoster. Out of this, we have developed the bed of 70 magnets.

The subject sleeps on this bed and with a head unit that has twelve of the 4" x 6" x 1" magnets.

We kill the viruses that are the starting point of the development of schizophrenia, manic depressive and these lesser behavioral and learning disorders. With this, it has become remarkably simple and effective to reverse schizophrenia and manic depressive. We do need to continue a system that prevents them from reacting to foods and toxins and occasionally to chemicals. Toxins are quickly processed by the oxidoreductase enzymes which have the job of detoxification as well as making ATP. A negative magnetic field

energy-activates oxidoreductase enzymes. Nutrition should be optimized for general health but not depend on nutrition to manage the psychosis, the learning or behavioral disorders of the children.

OPTIMIZED NUTRITION

It is recommended to be under the care of a professional nutritionist. It is wise to assess the nutritional state of vitamins, minerals, amino acids and essential fats. It is well to have a survey of toxic heavy metals.

The following optimized nutritional program is for those who are helping themselves without professional supervision.

1. The 7 day rotation diet as outlined herein.
2. Pre-meal and during meal, magnet placement as outlined herein.
3. Take one tablet, twice a day, of a vitamin/mineral tablet or capsule designed for a one-a-day.
4. Take vitamin C 1 gram (1000 milligrams), four times a day.
5. Eat lots of fruits and vegetables.
6. Eat fish as a major source of protein. Lacto-ovo-vegetarians and veggie vegetarians can arrange for adequate protein.
7. Eat very little meat, poultry or animal products.
8. Eat three meals a day and do not eat between meals.
9. If overweight, reduce calories and exercise.
10. Cook with olive oil.

HEAVY METAL TOXICITY

The common heavy metals producing toxicity are such as mercury, lead, aluminum and there are also rare heavy metals that cause toxicity. Atomic weight heavy metals have a positive magnetic field. When the body is placed in a negative magnetic field, it cancels out the positive magnetic field of the heavy metals. These are then processed out of the body as non-toxic heavy metals charged with a negative magnetic field. Therefore, processing these metals out of the body with magnetics does not injure kidney function. Heavy metal toxicity should always be considered. It can behave similarly to a viral infection. There are special techniques for both intravenous and oral chelation of metals. It is useful to use these but it should also be understood that a negative magnetic field also processes these metals out of the body. To do this, a 70 magnet bed should be used.

AUTOIMMUNITY

Autoimmunity is when the immune system attacks itself. Cells that are infected with viruses are often the cause of autoimmunity in which the immune system cannot react to viruses properly but responds to the cells that are affected because of their abnormal state such as their acidity. Toxins also cause the same abnormal cellular response to which the immune system responds with autoimmunity. The answer to autoimmunity is to use the 70 magnet bed as well as local treatment to stop the autoimmunity and first of all, hunt for precipitating factors, particularly viruses and other cellular toxins. It must be understood that any acid produced even by reactions to foods, chemical or inhalants is a toxin and can set the stage for autoimmunity. An example is children who develop an autoimmunity to the islet cells in the pancreas start out with milk allergy and end up with an autoimmunity of the islet cells of the pancreas.

PHYSICAL THERAPY FOR INFLAMMATION

Cold can reduce inflammation. Heat can increase circulation, helping to resolve the inflammation. It is common to use alternately cold and heat in treating inflammation.

Massage can be used to treat inflammation. When pressure is made on an inflamed area, it sends a message to the brain that this is an acute situation. The brain sends back a negative magnetic field. So pressure on sore areas prompts the brain to send a negative magnetic field to the area for healing. It is wise to use a conducting substance while massaging the hand over a painful lesion. It can serve as a conductor, especially if a conduction substance such as aloe vera or conducting gel are used during a massage. The current flowing through the conducted hand can reduce pain thus, massage with pressure on the sore area and a massage with the hand crossing over the conduction block decreases pain.

CONDUCTION DISORDER

An inflamed area is the positive magnetic field. The brain receives the message that this is an area of acute injury and sends back a negative magnetic field. However, the conduction disorder itself is painful. The area of the inflamed conduction disorder is painful because it is lacking oxygen and is acid. The nerve areas peripheral to this conduction block are also painful. When you bypass the conduction disorder with a suitable tape that carries a conduction, it can materially reduce the pain and make the area peripheral to the conduction block have reduced pain. It is easy to make your own conducting tape by placing an electron gel strip

down a 2" wide tape and place this tape with the conduction gel over the conduction block.

INFLAMMATION MAGNETIC PROTOCOL:
ORIENTATION:

This magnetic protocol is for the magnetic reversal of the inflammatory process. For local inflammation, a single magnet can be placed over the inflamed area. The surface of the magnet needs to be larger than the lesion being treated. The depth of penetration of the negative magnetic field needs to be a minimum of 25 gauss at the site of inflammation.

The larger the magnet, the deeper the penetration. The thicker the magnet, the stronger the magnetic field.

MAGNETS USED: For <u>local treatment:</u>

Neodymium disc magnet that is 1"x 1/8". This is suitable for treating small surface lesions that are less than 1" such as infections, warts, moles, basal cell carcinoma, squamous cell carcinoma and malignant melanoma. These magnets are often stacked two together to increase the strength. Their strength doesn't extend more than about 1/2" to 1".

Ceramic disc magnets are 1-1/2" x 1/2". They can be used on small lesions the same as the neodymium discs. However, they weigh several times more and the neodymium disc magnet is more optimum for the small skin lesions. But if the lesion is larger than 1", then use this larger magnet. These magnets can be taped on the skin or held with a band. The ceramic disc magnet is also used for headaches by placing these bitemporally or for anxiety, tension, depression or the control of seizures or even the control of psychotic ideas and or behavior. These are held in place with a 2" x 26" band. They can also be used on joints that are sore, painful or inflamed for any reason. The longer duration of application, the more effective the treatment.

Eye sinus unit neodymium disc magnets are placed on a light shield. They can be placed directly over the frontal or maxillary sinuses or over the eyes.

A 4" x 6" x 1/2" ceramic block magnet. This magnet is ideal for treating lesions that are below the skin or in an organ. They will penetrate effectively into the liver, stomach, urinary bladder, the prostate, cervix or other organ. These can be held in place with a band or with pockets in a garment. The longer the duration, the better. Always use a negative magnetic field. 4" x 6" x 1" magnets are used to make the 70 magnet bed. This provides 25

gauss as far away as 18" from the bed. This is suitable for systemic infections and metastatic cancer. This is a frequently used magnet. There is a 4" x 52" KOOL MAX body wrap that is frequently used with this magnet. Even when treating systemically, this magnet is used to treat local organs such as the liver if it has metastasis and so forth.

Super magnetic head unit is composed of twelve 4" x 6" x 1" magnets. This can be used for local treatment of the head such as brain tumors, post-stroke, post-cerebral spasms or the prevention of cerebral spasms, or for sleep and so forth.

Magnets for <u>systemic treatment:</u>

Super magnetic bed composed of seventy 4" x 6" x 1" magnets. Thirty-five of these are placed in a wooden carrier 36" square. Two of these wooden carriers are placed end to end providing a bed 36" x 72". The total weight of this is 400 pounds.

A 2" thick memory foam pad for a single sized bed.

Super magnetic head unit composed of twelve 4" x 6" x 1" magnets.

Two 4" x 6" x 1/2" ceramic block magnets with Velcro on the positive pole side. Two 4" x 52" body wraps.

Two 1-1/2" x 1/2" ceramic disc magnets with Velcro on the positive pole side. One 2" x 26" band.

PLACEMENT AND DURATION:

Sleep all night on the super magnetic bed and the super magnetic head unit. In cases of metastatic cancer and systemic infections, return to the bed and head unit one hour, four times during the day for the first three months. After three months, continue this nightly as a lifestyle.

I strongly recommend a rotation diet. The 7 day rotation diet is the most convenient. Follow the instructions on the 7 day rotation diet described herein.

HOW TO USE THE FOUR DAY OR SEVEN DAY DIVERSIFIED ROTATION DIET

The essence of the Diversified Rotation Diet is that foods are rotated on a four or seven day basis, thus preventing their maladaptive reactions, be these allergies or addictions. Also, this rotation diet will correct hypoglycemia and non-insulin dependent diabetes mellitus.

One method is to avoid food eaten twice a week or more for a period of three months, rotating all other foods. At the end of three

months, then place these frequently used foods back into the diet, rotated once in four or seven days. This method is outlined herein.

Another method that is preferred by some is to start rotating all foods, even those that are eaten frequently. This can be achieved if the subjects will treat themselves to magnets for 15-30 minutes ahead of the meal. To achieve this, place the ceramic disc magnets bitemporally, that is in the front of the ears at the level of the top of the ears. These are held in place with a 2" x 26" band. The discs are ceramic discs that are 1-1/2" x 1/2". The negative magnetic field is always placed toward the body.

On the positive magnetic field side, there is hook Velcro that will hook to the band around the head and hold these in place. At the same time, place a 4" x 6" x 1/2" magnet on the heart with the 6" lengthwise the body. Hold this in place with a 4" x 52" body wrap. Also, place a 4" x 6" x 1/2" magnet with the 6" lengthwise the body over the liver area which is on the right side of the body with half of the magnet over the rib cage and half below the rib cage. Hold this in place with a 4" x 52" body wrap. The minimum time of exposure should be 15 to 30 minutes or more before each meal. With this method, there is no avoidance period of the commonly used foods.

After three months of rotation, there is little likelihood of a maladaptive reaction to a food without the magnets before the meal. Whenever purposely violating the rotation diet such as eating out, then use the magnets ahead of a meal.

The 4-day and 7-day diversified rotation diet is described herein.

NEGATIVE ION HOUSEHOLD AIR TREATMENT

The biological response to negative ions and negative magnetic fields are the same. The biological response to negative ions and a negative magnetic field is alkaline-hyperoxia. Alkaline-hyperoxia is anti-inflammatory, anti-stress, antibiotic, energizing and aids in healing. Negative air ions plus a small amount of ozone in the air cleans the air from dust, microorganisms, pollen, smoke, chemicals, odors and so forth. Negative ions in the air clean up the environment whereas a negative magnetic field is used on the body to achieve the same values inside the body. Thus, negative air ions, negative water ions and a negative magnetic field are complementary and should be used together to achieve optimum results.

AIR NEGATIVE ION GENERATORS <u>LIVING AIR CLASSIC</u>

Covers up to 3,000 square feet. Useful for living room size areas.

ECOHELP: **LIVING AIR CLASSIC** with air filter. Especially useful for respiratory disorders.

LIVING BREEZE

Covers 1,200 square feet. Useful for small rooms such as bedrooms.

Air negative ions are absorbed through the mucus membrane of the nasopharynx and lungs as well as the skin. Water negative ions from electronic produced negative ion micro water and naturally occurring negative ion water such as Nariwa water are absorbed through the mucus membrane of the gastrointestinal tract. Colloidal silver antibiotic negative ions are absorbed through the mucus membrane of the mouth and gastrointestinal tract.

Alkaline micro negative ion water helps materially to maintain the body's normal alkaline state. Also, being micro water, it enters into the cells of the body more readily than the usual water. This also carries negative ions as well as being alkaline. The AKAI Electrolysis Instrument is used for producing the alkaline micro negative ion water. At least five glasses of this water should be used each day.

NARIWA WATER:

Nariwa water is a negative ion water from Japan's magnetic mountain. This comes in a bottle containing 500 cc. A minimum of one of these bottles should be used a day and preferably, two. The total amount of water used during a day should be a minimum of eight glasses of water and prefer- ably as much as a total of ten glasses of fluid intake.

POLARITY:

Always use a negative magnetic field facing the body.

BEYOND MAGNETISM:

Acute maladaptive reactions to foods, chemicals, inhalants or stress frequency pulsing fields has been documented as producing a brief state of acid-hypoxia. In this state, there is a production of acid and a failure to process properly the end-products of oxidation phosphorylation metabolism. In this state of acidosis, oxygen content is reduced. Maladaptive reactions to foods are the most frequent cause of bouts of acidosis. Degenerative diseases are noted

for their acid-hypoxic state. Therefore, every effort should be made to maintain a normal alkaline and normal oxygen state.

A majority of people are maladaptively reacting in one or more ways to foods, thus producing bouts of acidosis and reduced oxygen. It is the better part of wisdom to follow a 4-Day or 7-Day Diversified Rotation Diet. This program leaves out foods that are used as frequently as twice a week or more for a period of three months. This is based on the assumption that these foods are being reacted to in some maladaptive way. It is the frequency of the use that produces the maladaptive reactions. A 4-Day or 7-Day Diversified Rotation Diet is set up to leave out these frequently used foods. After three months, these frequently used foods can be returned to the diet, usually without any symptoms being produced.

All addictive substances should be abandoned such as addictive drugs, alcohol, tobacco and caffeine (coffee, tea with caffeine, chocolate, and soft drinks containing caffeine). Addiction is acidifying.

Carbonated soft drinks are acid and should be rarely used. Soft drinks are sweetened with corn sugar (in the US) and if and when used should be limited to the corn rotation day.

There is a valuable method of electrolysis which provides an alkaline micro negative ionized water that has an alkaline pH. There is a home electrolysis unit (AKAI instrument) that provides this alkaline micro water. It is recommended that five glasses of this alkaline micro water be used a day.

Nariwa water is a naturally negative ionized water from Japan's magnetic mountain and is the optimum alkaline micro water available. This comes in a bottle containing 500 cc. A minimum of one of these bottles should be used a day and preferably, two. The total amount of water used during a day should be a minimum of eight glasses of water and preferably as much as a total of ten glasses of fluid intake.

FINAL WORD

Acute inflammation protects against microorganism invasion and against excessive bleeding. Acute inflammation is a primary defense of the human metabolism. However, chronic inflammation becomes part and parcel of chronic degenerative diseases. There are foods that are pro-inflammatory and also foods that are anti-inflammatory. Anti-inflammatory food intake should be greater than pro-inflammatory food intake.

Maladaptive inflammatory symptom-producing reactions to foods, chemicals and inhalants are in the nature of allergies, addictions or toxins. These conditions should be appropriately treated with avoidance and spacing of contact and desensitization and detoxification. All inflammation is acid-hypoxic. The biological response to a negative magnetic field is alkaline-hyperoxia. Therefore, treating inflammation with a negative magnetic field replaces the acid-hypoxia with alkaline-hyperoxia and thus relieves the symptoms. The most effective treatment for inflammation, no matter what its cause, is that of magnet therapy using a static negative magnetic field.

The human body is a bioelectric organism. Therefore, it responds to an external magnetic field. Magnetism with its separate positive and negative energies is the energy field of life which is measurable during life and is absent at death. Magnet therapy uses magnetic fields to give direction to biological responses. This is a natural supplemental energy which drives the human electromagnetic energy. To understand the separate biological responses to positive and negative magnetic fields sets the stage for the use of these separate fields to achieve separate biological responses. A positive magnetic field is neuronal and other cells energizing their function. Wakefulness, any use of the brain for thought, energy or motor function is all positive and in fact the EEG indicates that in all these conditions the EEG is beyond 13 cycles per second. For example, imagery of the brain is 22 cycles per second. The positive magnetic field can be used for reinstatement of inhibited functions such as have occurred after an accident or a bout of multiple sclerosis which has created a neuronal extinction of disuse. In this case where the neurones are not dead, the positive magnetic field can be used during a practice to return function. However, prolonged application of the positive magnetic field is acidifying and hypoxic. Therefore, the positive magnetic field when used at all, is only used briefly. The negative magnetic field is the anti-stress field. It is the healing field. It is the anti-cancer field. The antibiotic field. The field that encourages sleep. The negative magnetic field is needed for the production of adenosine triphosphate which is the energy used for energy-activating alkaline-dependent enzymes. The oxidoreductase enzymes produce the ATP and also handle the toxic end-products of metabolism and all the other enzyme environmental toxins.

The greatest need for using magnetic fields is its anti-stress fields produced by a negative magnetic field. Therefore, most of the use of magnetism is that of a negative magnetic field and its alkaline-hyperoxia response.

Ultimately, a negative magnetic field accompanied with its biological response of alkaline-hyperoxia heals inflammation. The inflammation is a positive magnetic field signal of injury. This positive magnetic field signal is relayed to the brain neurones through the peripheral nervous system. The brain neurones return a negative magnetic field to the inflammation which produces an alkaline-hyperoxia healing response. The application of an external source from a static field magnet of a negative magnetic field markedly reinforces the body's own neurone negative magnetic field for healing. Magnet therapy is the application of the negative magnetic field reinforcing the body's own negative magnetic field healing response.

REFERENCES

BECKER, ROBERT O. "Cross Currents". Jeremy P. Tarcher, Inc. Los Angeles, CA, 1990. BECKER, ROBERT O. and SELDON, G. "The Body Electric. Electromagnetism and the Foundation of Life." William Morrow and Company. NY. 1986.

BECKER, ROBERT O. and MARINO, A. "Electromagnetism and Life". State University of New York Press; Albany, NY 1982.

BELANEY, B. The New Encyclopedia Britannica, 1986. Vol VIII, pp 274-275.

BRAUNWALD, Eugene. Harrison's Principles of Internal Medicine. 11th edition 1987. McGraw-Hill Book Company, NY.

CHALLEM, Jack. *The Inflammatory Syndrome. The Complete Nutritional Program to Prevent and Reverse Heart Disease, Arthritis, Diabetes, Allergies and Asthma.* John Wiley and Sons, Inc. 2003.

BARNARD, Neal, M. D. *Breaking the Food Seduction.* St Martins Press, NY 2003.

DAVIS, A.R. and RAWLS, W. "The Magnetic Blueprint of Life.". Acres USA, KansasCity, MO, 1979.

DAVIS, A.R. and RAWLS, W. "The Magnetic Effect". Acres USA, Kansas City, MO 1975

DAVIS, A.R. and RAWLS, W. "Magnetism and Its Effect on the Living System". Acres USA, Kansas City, MO 1976.

FLANIGAN, PATRICK and FLANIGAN, GAEL AND CRYSTAL. Earthpulse Press New Test Number One.

FRESHT, Alan., *Enzyme Structure and Mechanism,* Second Edition. W.H. Freeman and Co. New York, New York. 1994

KLONOWSKI, W and KLONOWSKI, M. Journal of BioElectricity. Aging Process and Enzy- matic Proteins. 4(1), 93-102 (1985).

LEVY, THOMAS E, M.D., J.D. *Vitamin C, Infectious Diseases, & Toxins. Curing The Incurable.* Xlibris Corporation.

Magnetic Fields in Enzyme Catalysis. Encyclopedia Britannica. Vol 15. Pg 1068. Chicago, 1986. MEGGS, William Joel, M.D., Ph.D. with SVEC, Carol. Contemporary Books, McGraw-Hill Books, 2003.

NORDENSTROM, BEW, Biologically Closed Electric Circuits. Stockholm, Sweden: Nordic Medical Publications, 1983.

NORDENSTROM, BEW, "Electrochemical treatment of cancer; variable response to anodic and cathodic fields". Am J. Clin Oncol, 1989: 12:530-536.

NORDENSTROM, BEW, "Survey of mechanisms in electrochemical treatment (ECT) of cancer". Europ J. Surg. Suppl. 1994: 574:93-109.

NORDENSTROM, BEW, "Biokinetic impacts on structure and imaging of the lung: the concept of biologically closed electric circuits". Am J Roentgenol, 1985; 145:447-467.

O'CLOCK, G.D., "Studies of the effects of in vitro electrical stimulation on eukaryotic cell proliferation". MA Thesis (Biological Sciences), Mankato State University, Mankato, MN, 1991

O'CLOCK Jr G.D., & Lyle, M., "Potential uses of low-level direct current electrotherapy for the treatment of cancer". Proceedings of the 15th Annual International Conference of the IEEE Engineering in Medicine and Biology Society, San Diego, CA, Part 3: 1993; 1515-1516.

PHILPOTT, W.H., M.D. and KALITA, Dwight, Ph.D., *Victory Over Diabetes: A Bio-Electric Triumph.* Keats Publishing Company, Inc. New Canaan, CT. 1982 (1991 paperback with new chapter on Medical Magnetics).

PHILPOTT, W.H., M.D. *Diabetes Mellitus. A Reversible Disease.* Vol III, Second Quarter, 1997. W.H. Philpott Publication. 17171 S.E. 29th Street, Choctaw, OK 73020.

PHILPOTT, W.H., M.D. and KALITA, Dwight, Ph.D., *Brain Allergies. The Psycho-nutrient and Magnetic Connections.*

Updated second edition. Keats PublishingNTC/Contemporary Publishing Group. Los Angeles, CA, 2000.

PHILPOTT, W.H., M.D. and KALITA, Dwight, Ph.D., *Magnet Therapy*. (Tiburon, CA: Alternative Medicine. com, 2000)

POTTS, JOHN, Journal of Diabetes. Avoidance Provocative Food Testing in Assessing Diabetes Responsiveness." 26:Supplement 1, 1977.

POTTS, JOHN, Journal of Diabetes. "Value of Specific Testing for Assessing Insulin Resis- tance." 29: Supplement 2, 1980.

POTTS, JOHN, Journal of Diabetes. "Blood Sugar-Insulin Responses to Specific Foods Versus GTT." 30:Supplement 1, 1981.

POTTS, JOHN, Journal of Diabetes. "Insulin Resistance Related to Specific Food Sensitivity." 35: Supplement 1, 1986.

RANDOLPH, T.G. *The Enzymatic and Hypoxia, Endoctrine Concept of Allergic Inflammation*
Clinical Ecology. pp 577-596. Charles C. Thomas, Publisher, Springfield, Illinois. (1976).

STEIN, Jay H. *Internal Medicine*. 4th Edition. 1994. P. 340-524. Mosby Publishers. St. Louis.

TRAPPER, ARTHUR, et al. "Evaluating Perspectives on the Exposure Risks from Magnetic Fields", Journal of the National Medical Association, 82:9, September 1990.

WARBURG, O., The Metabolism of Tumors. F. Dickens (Trans) London: Arnold Constable: 1930.

WARBURG, O., On the Origin of Cancer Cells. Science 123 (1956) 309-315. WARBURG, O. " The Prime Cause and Prevention of Cancer". Revised lecture at the meeting of the Nobel laureates on June 30, 1966. National Cancer Institute Bethesda, MD.1967

[*Magnetic Health Quarterly* "Inflammation," Vol. X, 2nd Qtr, 2004] Viral Hepatitis Chemical Hepatitis Addictive Hepatitis

LIVER DETOXIFICATION

The liver has many vital functions such as nutritional food substances processed into biological life-needs values. All blood passes through the liver for processing such as transformation and detoxification as needed. Thus also, the liver can become the target organ for having its detoxification ability become overwhelmed by the quantity of toxins and itself become intoxicated with the overwhelming load of toxins (hepatitis). The liver can also become the focal organ for infections, especially viral infections and their toxins (viral hepatitis).

Human biological cells use hundreds of enzymes for specific specialized functions of biological life. There are acid-dependent enzymes and there are alkaline-dependent enzymes. There are hypoxic-dependent enzymes and hyperoxic-dependent enzymes. Negative magnetic field dependent enzymes and positive magnetic field dependent enzymes. ATP dependent enzymes and non-ATP dependent enzymes. The enzymes we are especially interested in in this consideration of liver functions are the family of oxidoreductase enzymes. As enzymes were in the process of being discovered, they were named by their discoverers. This contained confusion and therefore there has developed an international classification based on function. The oxidoreductase enzymes based on function are; dehydrogenase, reductase, oxidase, oxygenase, peroxidase, catalase and hydroxylase.

The oxidoreductase enzymes are alkaline-dependent, non-ATP dependent, hyperoxic-dependent and negative magnetic field-dependent.

The oxidoreductase enzymes have two principle functions which are processing of foods, producing immediate enzyme energy activators of ATP and the enzyme activator oxidation remnant magnetism (negative magnetic field). It requires four oxidoreductase enzymes to produce ATP and a negative magnetic field catalytic remnant magnetism. This initial process of processing foods to ATP and a negative magnetic field catalytic oxidation remnant magnetic field magnetism, there is produced super oxygen which is oxide that has taken on an extra electron. This is a free radical which is inflammatory and damages tissues. If not processed rapidly by enzyme action to water and oxygen, it becomes other inflammatory substance which are peroxides, oxyacids, alcohols and formaldyhydes. There are a set of oxidoreductase enzymes for the processing of any of these inflammatory substances. These oxidoreductase enzymes also have not only a process by which endogenous toxins which are a product of metabolism but also exogenous toxins which come from sources external to the human metabolism. Every cell in the body has these oxidoreductase enzymes and is itself a manufacturer not only of ATP and a negative magnetic field but also a processor of both endogenous and exogenous toxins. The liver is a special organ with a super amount of these enzymes for processing toxins. The liver is a great guardian against enzyme toxification. When

we refer to being toxic, we really are referring to toxins that tie up enzyme functions.

The oxidoreductase enzymes are great detoxifiers and can also become overwhelmed by the quantity of toxins and can themselves become non-functional because they are overwhelmed by the quantity of toxins which they could process. This is where an external negative magnetic field beyond that of the internal negative magnetic field can activate these inhibited enzymes to process these toxins. Therefore, a negative magnetic field through the catalytic reaction of oxidoreductase enzymes becomes the great fundamental detoxifier of toxins. This is true of each cell in the body but especially true of the oxidoreductase enzymes in the liver. By placing the liver in a negative magnetic field such as from a 4" x 6" x 1/2 " ceramic magnet, the liver is **aided in its** detoxifying process. This local treatment is highly significant however, even beyond the local treatment, when the subject is exposed to a super magnetic bed such as composed of seventy 4" x 6" x 1" magnets and the super magnetic head unit composed of twelve 4" x 6" x 1" magnets, all cells of the body are in this negative magnetic field and now are energy activated to process toxins anywhere they are in the body. Furthermore, this same process of enzyme energy activation maintains a strong negative magnetic field for each biological cell which has the capacity to energy out-maneuver the positive magnetic field of invading microorganisms. Therefore, the same process of exposure to a negative magnetic field not only is energy activating of enzymes but it is also an antibiotic to viruses, fungi, bacteria and invading parasitic organisms.

VIRAL HEPATITIS

Ninety-five percent of viral hepatitis is encompassed in the viral type A, B, C, D and E. Other viruses that are documented as producing hepatitis are herpes family viruses (Epstein-Barr, cytome- galovirus, herpes simples and herpes zoster), yellow fever virus, rubella virus, Coxsackie virus and adeno virus. Other uncommon viruses may infect the liver such as Marburg, Ebola and Lassa. Thus, the liver is frequently subjected to virtually any virus infecting the subject. The hepatitis evoked by viruses ranges from minor infections which are quickly managed by the autoimmune system to that of dangerous chronicity and even death.

HEPATITIS A

Hepatitis A is the most common, world-wide hepatitis viral infection. It is most prevalent in areas of the world with poor hygiene in which areas have up to 95% of the population with hepatitis A antibodies. However, in the United States with the best hygiene of the world, up to 6% of the population has antibodies to hepatitis A virus by age 50. In poor sanitation areas of the world, children by the age of 10 have hepatitis A antibodies. In areas where sanitation is improved, the age of infection does not occur until adulthood. Unfortunately, an adult who gets hepatitis A has a more serious illness than children.

Hepatitis A virus belongs to the enteric virus genus to which polio virus, Coxsackie virus and ECAO virus. Infections occur by the intestinal tract. Liver damage occurs by cell-mediated destruction of infected hepatocytes. The diagnosis is made by IgM/IgE antibodies to the hepatic A virus.

Most cases do not develop jaundice. Rarely, there is a fatal case (1 in 1000).

HEPATITIS B

Hepatitis B is a major public health problem with three hundred million chronic cases worldwide. It is responsible for much of the liver cancer cases and is implicated in up to 90% of primary hepato cellular liver carcinomas such as in epidemic areas with only 25% in the United States. It is the most common visceral malignancy worldwide causing up to one million deaths a year.

Hepatitis B virus belongs to the atpadna genus which is known to affect small rodents, ducks and herons which can be carriers of the virus. It is diagnosed by serological tests. It is spread by close contact with an infected individual caused also by parenteral exposure.

Twenty to twenty-five percent of hepatitis B virus cases recover completely, one-percent die and ten-percent become chronic carriers. Some cases are asymptomatic carriers while an appreciable number progress to chronic liver disease including liver cirrhosis. All chronic carriers are at risk for developing liver cancer.

The transmission is usually by blood from needles, the splashing of blood on the skin where there is a break or the mucous membrane of the mouth where there may be a break in the mucous membrane. It can be sexually transmitted.

HEPATITIS E

Hepatitis E virus is a RNA virus relating to the calici viruses. The diagnosis is by specific serological test with epidemics occurring throughout the world. Mortality is about 2% in the general population but about 20% in pregnant women. It is transmitted by gastrointestinal exposure.

NON A - NON B HEPATITIS

This is a class of improperly identified viruses producing hepatitis. They are especially noted as having resulted from transfusion.

HEPATITIS C

This virus is a RNA virus. It's usual transmission is by transfusion or accidental needle prick from a carrier. It can be sexually transmitted. Liver failure necessitating liver transplantation is common.

HEPATITIS D

This is caused by an incomplete RNA virus which requires an associated virus for replication. Hepatitis B virus is usually the "helper" associated virus. Infection of hepatitis D virus associated with hepatits B virus can be a serious fulminant hepatitis. It is diagnosed by an antibody assay.

ACUTE VIRAL INFECTIONS

Most acute viral hepatitis are of short duration with no jaundice, slight malaise and gastrointestinal flu-like symptoms. Transaminate liver enzymes are elevated but due to minor symptoms the liver is not likely to have been damaged.

A less likely, more severe, acute viral liver hepatitis will have jaundice for several days or weeks, anorexia, nausea and sometimes vomiting. Characteristically there is loss of appetite, general ill feelings, fatigue, low grade fever and aching in the right upper abdominal quadrant. Painful swollen joints may develop. The liver and sometimes also the spleen are enlarged. Elevated liver enzyme transaminases are present. Multiple remissions and exacerbations is characteristic of acute viral hepatitis. These episodes can usually be managed at home with the traditional treatment being bed rest and a low fat, high carbohydrate diet. There is no effective antibiotic, corticoid steroids or interferon therapy. A negative magnetic field of sufficient gauss strength and of sufficient duration kills viruses. The minimum gauss strength to kill viruses is 25 gauss. The duration should be continuous or as near to continuous as possible. The minimal duration is two weeks to kill viruses. The more optimum treatment extends to even three or four months.

For liver magnetic therapy:

The negative magnetic field of a 4" x 6" x 1/2 " ceramic magnet is ideal. Place one on the front of the body over the liver and for even more optimum therapy, place another 4" x 6" x 1/2 " over the right side of the body over the liver.

Acute viral hepatitis is often mistreated since it may not cause jaundice and has only flu-like symptoms and gastrointestinal symptoms such as nausea with or without vomiting.

A twelve-year-old girl was brought to me with the symptoms of nausea and vomiting. The mother had taken her to several physicians without finding a cause for her nausea and vomiting. She finally took her to a psychiatrist who decided that the mother wanted her child to be sick and was causing the nausea and vomiting based on a dependency relationship. She decided the only way for the child to become symptom-free was to separate the child from her mother. She obtained a court order to remove the child from her mother. The mother was under court order to deliver the child to the hospital and not to see the child during psychiatric therapy. She escaped from the state of New York with her child and brought the child to me in Oklahoma. I knew nothing of this court order.

My laboratory survey revealed an elevated blood transaminase. I saw no evidence of a psychiatric disorder. Since a mild hepatitis may produce nausea and vomiting and an elevated transaminase, I decided she likely had a mild hepatitis. I proceeded to give her intravenous vitamin C which is known to kill viruses. After six intravenous vitamin C infusions, she was symptom-free. At this time, I received an order from the Oklahoma juvenile authorities to deliver the child to them for transport to New York State. I provided my write-up indicating a viral hepatitis and the results of the IV infusion relieving her symptoms. Two weeks after being taken into custody, her nausea and vomiting returned. For one year, she was hospitalized under psychiatric care, during which time there was no communication between her and her mother. Her symptoms continued and due to this she was referred to numerous specialists trying to find out why her nausea and vomiting continued. All these specialty examinations and treatment did not change her symptoms of nausea and vomiting. At the end of this year, she was returned to the court. The judge returned her to her mother saying to the psychiatrist who had said it was the mother's fault, "she has seen more specialists during the last year

than her mother had taken her to during her entire lifetime. I am returning her to her mother." The mother took her to a physician friend of mine who proceeded to give her intravenous vitamin C. She promptly became symptom-free and the family made a trip to Europe.

I tell this case to illustrate how easy it is to miss a mild case of viral hepatitis. All these specialists ignored my diagnosis of viral hepatitis. My report was in her chart all this time. With my present knowledge of a negative magnetic field killing viruses, I would have treated her with a negative magnetic field as being optimum treatment for hepatitis.

FULMINATE HEPATITIS

Fulminate hepatitis is a state of rapid liver failure. Viral hepatitis is the primary cause in the United States. Within four to eight weeks of infection, rapid liver failure develops. Symptoms de- velop including disordered coagulation, resulting in bleeding. Hepatitis viruses A, B, C, D and non-A and non-B can all cause acute life-threatening hepatitis. Other viruses that less frequently cause an acute life-threatening hepatitis are herpes simplex, Epstein-Barr, cytomegalovirus and occasionally other viruses. Drugs cause 5% of hepatitis in the United States. In Great Britain, drugs ingested for suicide such as massive doses of non-steroidal analgesics, especially acetaminophen, are a frequent cause of life-threatening hepatitis. A major cause of life-threatening hepatitis in Europe is mushroom poisoning from amanita phalloid mushroom.

The clinical course of fulminate hepatitis is rapid deterioration with the development of ascites, pulmonary complications, renal failure, brain swelling, systemic infection and bleeding. With supportive measures, 30-40% survive. The supportive measures are intravenous nutrients, fluids, steroids and blood transfusions. There is no specific medication that will reverse life-threatening hepatitis. There is no specific treatment that will reverse life-threatening hepatitis.

A 2" x 4" x 1/2 " magnet should be placed on the front of the abdomen over the liver and on the side of the abdomen over the liver. Besides this local treatment, the 70-magnet bed and a super magnetic head unit composed of twelve 4" x 6" x 1" magnets should be used.

Magnet therapy is a new treatment that justifies statistical evaluation for life-threatening hepatitis.

SUBACUTE HEPATIC NECROSIS

Subacute hepatic necrosis is between fulminate hepatitis and chronic active hepatitis in which 20% is fatal and 30% proceed to develop chronic active hepatitis. Liver transplantation is the necessary answer for survival for some.

BENIGN VARIANTS OF ACUTE VIRAL HEPATITIS

Cholestatic hepatitis has an unusually high bilirubin and is hard to differentiate from gall bladder disease.

Prolonged viral hepatitis is a slowly resolving case lasting a year or so. Relapsing hepatitis has relapsing episodes. This is usually due to hepatitis C.

There is chronic persistent and chronic active hepatitis forms. Liver cirrhosis can result from chronic viral hepatitis. There is a chronic active hepatitis of undetermined origin which most likely is an aspect of an autoimmune disease that can also widely affect varied tissues. Symptoms often are progressive jaundice, severe anorexia, malaise and fatigue. The liver and the spleen may both be enlarged and there often is abdominal pain. Occasionally, there are symptoms of nose bleeds, acne, persistent fever or a tender liver. Antiviral therapy has been disappointing due to limited benefits and unacceptable side effects.

CHEMICAL TOXIC PRODUCED LIVER DISEASE

There are numerous liver toxic substances used in traditional medicine. There are numerous industrial chemicals that are liver toxic. There are plant and food toxins. Exposure to toxic substances can occur in the home, the workplace as well as in clinical medicine.

There are over 300 drugs used in traditional medicine treatment and diagnosis that are known to be toxic to which sensitivities and allergic reactions are known to occur. These reactions may relate to dosage, frequency and duration of use or to idiosyncratic, unpredictable individual responses that are toxic. These liver toxic reactions of substances occur in commonly used chemical substances such as tranquilizers, antidepressants, anti-seizure medications, steroids used for anti-inflammation, contraceptive hormones, non-steroid anti-inflammatory agents, antibiotics used for infection, contrast media used in x-ray diagnosis and so forth. Virtually all areas of therapeutic medicine and diagnosis have the potential of the development of toxic liver reactions.

There are numerous household cleaning agents, chemical products and chemical by-products in industry that are toxic.

Numerous disinfectants used in homes have the potential for liver toxicity. Insecticides used in agriculture have liver toxicity potential.

The liver is the principle detoxifying agent of the body. All chemicals entering the body by any route are processed through the liver. The liver detoxifies but can itself become the organ that is intoxicated because it is overwhelmed by the amount of toxin beyond which it can process.

Enzymes used by the body in general and the liver in particular for detoxification are members of the family of oxidoreductase enzymes. These enzymes can add or subtract electrons as required for detoxification process. Cytochrome P450 and their isozymes belong to the oxidoreductase enzyme family. They have special ability to process enzyme toxins such as belonging to the petrochemical hydrocarbon class of toxins which are so prevalent in our industrialized world environment. Chemical hepatitis can range from mild to life-threatening. Chronic states can develop such as fatty acid liver, cell death (necrosis), benign tumors and primary liver carcinoma tumors. The mushroom Phalloides and related species are common causes of liver toxicity in Europe. Fungi can grow in the food producing liver toxins. Methotrexate used as a chemotherapy agent against cancer and against the inflammation of rheumatoid disease conditions and cirrhosis can produce fatty acid liver and liver sclerosis.

The diagnosis of chemical-produced hepatitis requires a thorough examination of toxins and environmental factors. Improved liver function when avoiding specific environmental toxins con- firms the diagnosis.

The treatment of chemical hepatitis centers around the values of avoidance of the offending agents. There are no specific values other than nutritional support.

The non-nutritional treatment of chemical toxic hepatitis would be appropriate chelation agents if a heavy metal is involved and vitamin C has great detoxifying value and can be used even up to bowel tolerated doses. Intravenous sodium ascorbate is quite valuable. Most important of all is that of magnetic therapy. The liver must be specifically treated with 4" x 6" x 1/2 " magnets placed on the front of the body and on the right side of the body. Most important of all is a systemic treatment. The toxins are influencing all areas of the body. Although the liver is the main detoxifying organ, every cell in the body has the capacity to use

oxidoreductase enzymes and a detoxifying agent of toxins. Therefore, this treatment should also be systemic with the use of the 70-magnet bed and the twelve magnets treating the head. These magnets are 4" x 6" x 1" magnets. The magnets treating the liver locally are 4" x 6" x 1/2 " magnets. The negative magnetic field energizes the oxidoreductase enzymes to process toxins.

It is so unnecessary to use toxic mediums when they can be avoided by the use of a negative magnetic field. For example, a negative magnetic field is anti-inflammatory no matter why that inflammation may be there. A negative magnetic field should be used as an anti-inflammatory agent instead of steroids or non-steroidal anti-inflammatory agents. It seems such a shame and really saddening that women are being injured by hormonal contraceptives. Certainly there are other effective non-injurious, contraceptive measures and it is so sad that there is such a broad advertising of the injurious hormonal contraceptives. A negative magnetic field is an antibiotic and therefore with this we could avoid the injury from chemical antibiotics. A negative magnetic field can control emotions, depression, delusions and hallucinations. We should optimally learn how to use magnets rather than tranquilizers and antidepressants. Seizures can be controlled by a negative magnetic field. We should be learning the optimum use of controlling seizures with a negative magnetic field. Many of the injurious chemicals would not need to be used when we learn to optimally use a negative magnetic field.

Success Story

CHEMICAL HEPATITIS REVERSAL WITH A NEGATIVE MAGNETIC FIELD

A young man was given a medication by his doctor to which he reacted with an acute, life-threatening hepatitis. It was so severe that a liver transplant was the only answer. While waiting for the liver transplant, he wore a 4" x 6" x 1/2 " magnet over his liver, 24 hours a day, with the negative magnetic field facing his body. Soon he began to feel well. One year later, a liver was available for transplantation. In preparation for the liver transplant, his liver function tests were done and were all found to be normal. He gave evidence of being physically and emotionally well. He decided he was well and abandoned the use of the magnet over his liver. In a few weeks, he developed acute liver failure and died.

As long as he had the liver under the negative magnetic field, his liver functioned normally without evidence of chemical

hepatitis. Withdrawal of the negative magnetic field over the liver produced such a severe liver failure from chemical hepatitis that he died.

ALCOHOLIC LIVER DISEASE ADDICTION HEPATITIS

ALCOHOLIC LIVER DISEASE

In countries where alcoholic beverages are extensively consumed, alcoholism is the most common cause of chronic liver disease. Alcohol is a liver toxin. This is true of all sources of alcohol such as beer, wine, whiskey and so forth. Alcohol is directly hepatotoxic even in the presence of adequate nutrition.

Stages of alcohol liver disease are:

1. Alcoholic fatty liver. There is interference with fat metabolism causing a deposit of fat in the liver, particularly around the arteries.

2. Acute alcoholic hepatitis with its complications of portal hypertension, ascites, spontaneous bacterial peritonitis, or hepatic encephalopathy which is a serious mental reaction.

3. Hepatic renal syndrome.

4. Liver cirrhosis often develops.

Severe alcoholic hepatitis has a high death rate. Progression to chronic liver disease is common. Abstinence from alcohol is essential for any reasonable achievement in the treatment of alcohol liver disease. Alcoholism is an addiction to which the alcoholic is highly motivated to maintain even if the alcoholism kills him.

Magnetic therapy can be used as an effective deterrent to addiction by using a negative magnetic field to block the compulsive urge to act out the addiction. Furthermore, the negative magnetic field treating the liver directly provides the optimum physiological state for healing. It should be understood and has been abundantly confirmed that alcoholism is addiction to the foods from which the alcohol is made. Therefore it is not just the avoidance of alcohol, it is the avoidance of the food such as wheat, rye, oats, barley, corn or rice from which the alcohol is made. Avoiding all foods and alcohol for a period of five days prepares the subject for testing of single foods. When the alcoholic eats a food from which his favorite alcohol is made, he experiences a "dry drunk," yet he had no alcohol at all. Alcohol itself is toxic. However, to make a correction of alcoholism we need to understand that there is addiction to the foods from which the alcohol is made and that this addiction is also physiologically damaging

as well as psychologically damaging. Both aspects need to be appropriately handled. Stopping the urge to drink alcohol is an essential aspect of the treatment of the alcoholic. The use of a negative magnetic field applied to the bitemporal areas of the brain has a remarkable value in blocking the compulsive urge to drink the alcohol.

THE ROLE OF ADDICTION IN LIVER DISORDERS

The subject of alcohol addiction is very important. Alcohol is a toxin and must be rapidly processed as a toxin. It is easy to exceed the liver's detoxifying capacity for alcohol. Several liver functions are interfered with. The final end stage can be cirrhosis of the liver.

Alcohol addiction is, in essence, a food addiction. Addiction itself with its acidic withdrawal phase is toxic even separate from the alcohol. Since oxidoreductase enzymes are alkaline dependent, acidity itself below the physiological level is enzyme toxic. Blood pH ranges from 7.35 - 7.45 or even beyond. The lowest functional tissue pH is 6.9. Any pH below the physiological functional level has the consequences of insoluble calcium deposits, amino acids and fat deposits. One significant fact is that addiction to anything, whether it is a hard drug, a food or alcohol, is itself acidifying. It is the withdrawal phase that occurs 3-4 hours after the initial exposure producing a withdrawal phase which is acidifying. I have abundantly demonstrated with deliberate food testing that after a five day fast, the alcoholic will react with a "dry drunk" to the foods from which the alcohol is made such as, wheat, rye, barley, yeast, corn or rice. The subject will selectively react symptomatically to the foods from which the alcohol is made. Therefore, alcohol addiction is not just the toxicity of the alcohol, but the toxicity of the acidic state occurring during the withdrawal phase. This is important because you don't have to drink any alcohol at all to have the consequences of the acidity of the withdrawal phase. Therefore, liver disorders can develop out of the acidity of the withdrawal phase of addiction. This is why it is so important to rotate the foods on a four day basis and thus stop all addictions. It is the frequency to which a food is used that produces the state of addiction. The rotation diet reverses addiction and thus prevents development of the degenerative diseases resulting from addiction. The addict, during the withdrawal phase particularly, is weak because ATP cannot be made during the acid state. The oxidoreductase enzymes that make ATP and for also

processing the end products of metabolism will not function during the acidic withdrawal phase. The oxidoreductase enzymes are alkaline-dependent enzymes.

Oxidoreductase enzymes are also negative magnetic field dependent. The human body is an electromagnetic organism. It maintains a higher negative magnetic field than it does a positive magnetic field. It requires at least eight hours sleep out of twenty-four to maintain the negative magnetic field and the alkaline-pH associated with the negative magnetic field. The function of the oxidoreductase enzymes demand a negative magnetic field. They are indeed negative magnetic field dependent. The body is making and maintaining a negative magnetic field as a by-product of oxidoreductase catalysis. Thus, it is understood that externally, the body's own negative magnetic field will activate oxidoreductase enzymes. There is no oxidoreductase enzyme catalysis without a negative magnetic field being present. A significant method by which the negative magnetic field is formed is the movement of electrons from a static magnetic field with the movement of electrons between the enzyme and the substrate. Whenever electrons move, a negative magnetic field is permitted. Therefore, it can be said that a negative magnetic field is necessary for the catalysis of oxidoreductase enzymes.

Each human cell is a manufacturing plant for ATP and a negative magnetic field. Therefore, the more cells of the body involved in that negative magnetic field, more efficient the production of life-energy. Treating the liver with a negative magnetic field from such as the 4" x 6" x 1/2 " magnet is highly significant but even more significant is sleeping on the super magnetic bed of 4" x 6" x 1" magnets with the super head unit of twelve 4" x 6" x 1" magnets. Thus, every cell in the body is being energized to produce ATP and its associated negative magnetic fields of catalysis. It has been objectively observed that sleeping on the 70-magnet bed and with the super magnetic head unit with twelve magnets, is markedly superior to local treatment in terms of the energy threshold the person feels and the reduction in any symptoms. The heart is a very sensitive organ and thus reflects the energy state of the subject. When fatigue sets in, the heart will begin skipping beats. Placing the negative magnetic field of a 4" x 6" x 1/2 " magnet over the heart will routinely correct the beats of normal of heart pulsations. However, there are some subjects who, in spite of the local treatment of the negative magnetic field over

the heart, will still have some skipped beats. It has been observed that those same subjects, placed on the super magnetic bed of 70 magnets and the head unit, will develop a normal cardiac rhythm. Therefore, the systemic treatment is observed to be superior to the local treatment whether we are observing the behavior of the heart or the liver. Therefore, the systemic magnetic treatment becomes the optimal treatment under any and all conditions. This super magnetic bed was invented to treat cancer which it successfully does but it has been found to be the answer for systemic infections, weakness, cardiac arrhythmias, liver detoxification and control over allergies and autoimmunity. The super magnetic head unit of twelve magnets was invented to treat brain tumors or brain cancer which it can do. It is found to be the optimal treatment for mental and emotional disorders, infections, Alzheimer's, cerebral arteriosclerosis and so forth.

MAGNETIC MANAGEMENT OF ADDICTIVE WITHDRAWAL SYMPTOMS

The addiction, whether it be to alcohol, tobacco or a food, without associating it with alcohol, is an uncomfortable situation. Acidity sets in during the withdrawal phase for 3-4 hours after the contact with the addictant. This shuts down the oxidoreductase enzyme process. Weakness results. Pains and other discomforts begin to develop. There is a magnetic way to handle these withdrawal symptoms. The symptoms are based on the development of acidity. A negative magnetic field counters the acidity that is alkaline-hyperoxia biological response-producing. The local treatment for the symptoms is the two ceramic discs that are 1-1/2" x 1/2" placed bitemporally. Place a 4" x 6" x 1/2" magnet over the heart. Another 4" x 6" x 1/2" magnet is over the epigastric area and it is wise to place another 4" x 6" x 1/2" magnet over the liver. Hold these in place with 4" x 6" x 1/2" body wraps. It is characteristic that from 5 minutes to 15 minutes to 30 minutes, the withdrawal symptoms will have disappeared and anytime withdrawal symptoms develop again these magnets can be placed and the symptoms will leave. Of course, more optimum than ever would be that of adding to these local areas of treatment that of a 70-magnet bed and twelve magnet head unit. With this method, the addiction can be stopped immediately and the subject can maintain comfort by this negative magnetic field treatment. The alcoholic, tobacco addict and food addict should stop immediately the addictive substances. Food addiction, not associated with

alcoholism can be managed differently than alcohol and cigarette addiction. Alcohol and cigarette addiction must be stopped immediately, whereas food addiction can be managed differently in that with exposure to the negative magnetic field of these magnets for fifteen to thirty minutes ahead of the meal, the addictive foods need not be avoided but can be placed in a rotation diet preventing the symptoms from developing. The rotation diet is a 4 day diversified rotation diet. Initially, we always use avoidance of the symptom-producing food for a period of three months before returning it to the diet, however negative magnetic field treatment ahead of each meal can prevent this reaction from occurring. By the end of three months, desensitization will have developed whether it is by avoidance initially for three months or magnetic treatment during that three months. Therefore, after three months, the rotation diet can proceed without the magnet treatment ahead of a meal. However, it should always be kept in mind that if the subject is going to be eating out in a restaurant or eating a special holiday meal, treating with the negative magnetic field ahead of the meal can prevent a symptom reaction from occurring.

MAGNETIC COMFORT METHOD FOR ADDICTION CORRECTIONS: ORIENTATION:

The secret of stopping an addiction to tobacco or other addiction corrections is that of remaining comfortable while stopping the use of the addictive substance. This comfort during addictive withdrawal can be achieved by the use of magnetic disc magnets placed on the head and magnets placed on the heart and liver area. This magnetic application is capable of stopping the urges. An added value can be achieved by placing in mind the urge to use the product and holding the breath until the mind goes blank.

Minimum program of magnets:

Two ceramic disc magnets that are a 1-1/2 " x 1/2 ". One 2" x 26" body wrap.

Two 4" x 6" x 1/2 " ceramic magnets. Two 4" x 52" body wraps.

PLACEMENT AND DURATION:

A minimal program would use only the disc magnets on the head and the breath-holding aversive treatment. A more maximum program will add the ceramic block magnets for the heart and liver area.

The most optimal of all is to stop all addictions at the same time -- tobacco, alcohol, caffeine, dextro-amphetamine or any other frequently used, potentially addictive substance. The same system is used for treating narcotic addiction. The secret of correction of addiction is to be comfortable while stopping the use of substances to which the person is addicted. It also is more comfortable if food addiction is handled at the same time. To achieve this, follow the instructions on weight management.

WEIGHT MANAGEMENT MAGNETIC PROTOCOL FOR WEIGHT MANAGEMENT: ORIENTATION:

Body weight beyond physiological normal is often caused by the urge to overeat due to food addiction. Overeating is a compulsive habit no matter what it's psychological or biological driving force. In any event, magnetic therapy plus calorie reduction can materially help in weight manage- ment. The negative (south-seeking) magnetic field of magnetic discs placed bitemporally reduces the electrical excitement of the brain and can handle habit urges whether psychological or physiological thus making it easier for the person to adhere to an assigned calorie reduction.

A 4-Day Diversified Rotation Diet is a must in weight management. This will stop food addiction and make it materially easier to follow a calorie reduction program.

A negative (south-seeking) magnetic field placed over a fat area will gradually reduce the fat. This magnet reduction occurs only at night while asleep. A negative (south-seeking) magnetic field activates growth hormone's ability for fat cells to release their fat. Growth hormone rises only at night during sleep. However, this magnetic fat reduction has little value in maintaining weight reduction without also associating this with calorie reduction.

COMPONENTS:

a) Magnetic Fat Meltdown.

A negative magnetic pole placed over a fat area at night during sleep will have the biological effect of the fat cells dropping their fat. This happens because a negative magnetic field activates growth hormone. Growth hormone has the assignment of fat cells dropping their fat. This occurs only at night at which time growth hormone is present. There is not enough growth hormone during the waking hours to be significant. Weight reduction of the fat cells dropping their fat occurs only at night when growth hormone is high. This fat area is usually the abdomen. The optimum magnets

for treating the fat areas are ceramic block magnets that are 4" x 6" x 1/2 ". Two are usually used. Place each block magnet over the fat areas. Hold in place with a 4" x 52" Cool Max band. Some significantly obese subjects may need two of these body wraps. The magnets are placed over the abdomen or other fat areas every night during sleep.

b) Magnet Comfort System of Managing Urges to Overeat, Eat Between Meals or Use Addictant. The magnets used for this are two ceramic discs that are 1-1/2" across and 1/2" thick with Velcro on the positive pole sides. These are held in place on the head with a 2" x 26" Cool Max band. There are three possible placements of these discs. When these discs are placed bitemporally, that is at the level of the top of the ears and about two inches in front of each ear is the first placement to consider. This is particularly noted to handle depression and reduce urges to overeat or eat between meals. The second placement to consider, which is more for tension and anxiety, is a disc on the mid-forehead and left temporal held in place with the band. The third placement to consider, which is maximal for obsessive ideas and compulsive urges, is the left temporal and low occipital (back of the head).

When using these discs on the head, the symptoms will usually subside within five minutes. The duration of having magnets on the head can be either just long enough to relieve the symptoms or be continuous. There is no limitation in the time the magnets can be left in place on the head.

A 4" x 6" x 1/2 " ceramic block magnet is placed on the heart and or also over the liver area for the purpose of reducing tension that is often present in these areas based on the discomfort of food addiction withdrawal. This can be placed there at the time there are these urges. It is well to use this to accompany the magnetic placement on the head.

OPTIMUM SYSTEM OF WEIGHT MANAGEMENT: ORIENTATION:

This system uses the magnetic fat meltdown, magnetic comfort system of managing urges to overeat or eat between meals, aversive behavioral training for urges to overeat and eat between meals, the visualization system of food quantity reduction and the 4 day diversified rotation diet.

MINIMUM PROGRAM OF MAGNETS:

Two ceramic discs that are 1-1/2 " x 1/2 ". One 2" x 26" body wrap. Two 4" x 6" x 1/2 " ceramic magnets. Two 4" x 52" body wraps.

Pictures of food quantity initially used for each meal plus pictures of the desired reduction of meal quantity using fixed stages of reduction at six week intervals.

PLACEMENT AND DURATION:

For 15-30 minutes pre-meal, place the ceramic discs bitemporally, frontal and left temporal or left temporal and occipital based on which of these placements works best for the individual subject. At the same time, pre-meal, place a 4" x 6" x 1/2 " magnet on the heart with the 6" lengthwise the body and a 4" x 6" x 1/2 " magnet crosswise over the liver. Hold these in place with a 4" x 52" body wrap.

When any urges to overeat or eat between meals occur, place the disc magnets on the head and the ceramic block magnets on the heart and liver area. Usually these urges will subside within 5-10 minutes.

When these urges occur and the magnets have been placed as described above, place in mind, with the eyes closed, the urge. While focusing on this in your mind, take a deep breath and hold the breath until the mind goes blank. This can be repeated as many times as is necessary to block the urges.

Prepare photographs of the usual meal sizes that the subject uses. Then make a photograph reducing the quantity by one-third. Place this in front of the plate of food at each meal. At six week intervals, keep reducing the food intake by one-third until the desired weight has been achieved.

It is important that the food be rotated to stop food addictions.

SYMPTOMATIC FOOD REACTIONS: GENERAL INFORMATION

A local and systemic biological response of acidity is routinely evoked when symptoms develop in response to exposure to foods, chemicals and inhalants. Acidity also produces low oxygen (acid-hypoxia). This is true whether the maladaptive symptoms reactions are immunologic or non-immunologic in origin. Most food symptom reactions are not immunologic. Immunologic and non-immunologic food symptom reactions have a classic addictive see-saw biological response of symptom relief on exposure with the emergence of symptoms 3-4 hours after the exposure (addictive withdrawal phase). The optimum method of reversing addiction

is avoidance. In food addiction, the optimum method of avoidance of the addiction is for there to be a 3-month avoidance followed by an exposure no more often than every fourth day. This is the reason for the 4 day diversified rotation diet. The optimum long term management of food addiction is the food avoidance period produced by the 4 day diversified rotation diet. The short term management of symptoms can be managed by alkalinization by exposure to a negative magnetic field which alkalinizes and oxygenates (alkaline-hyperoxia). These alkalinization methods can relieve symptoms after they have occurred from the exposure and can also prevent symptoms from developing when the alkalinization methods are used prior to an exposure to symptom producing foods, chemicals and inhalants.

Following is the optimum method of preventing symptoms from occurring from foods:

1. A 4 day diversified rotation diet. This four day spacing of exposure to specific foods prevents food addiction. The 4 day diversified rotation diet is described in *The Ultimate Non-Addiction, Non- Stress Diet* quarterly by William H. Philpott, M.D.

2. Pre-meal.

Negative magnetic field exposure. One-half hour before the meal, place the magnets on the body. Magnetic discs, either ceramic, magnetic discs that are 1-1/2 " x 1/2" or neodymium discs that are 1" x 1/8" are placed bitemporally. These can be held in place with a 2" x 26" band. Place on the heart, a 4" x 6" x 1/2" magnet. Hold in place with a 4" x 52" body wrap. An added value can result from placing a 4" x 6" x 1/2 " ceramic magnet on the liver area. Hold in place with a 4" x 52" body wrap. These can be removed at the beginning of the meal or they can be continued through the meal until it is completed. If symptoms emerge after the meal has been eaten, then replace the magnets until the symptoms leave and especially place a suitable sized magnet directly over the symptom area. Also, prior to the meal, if there are any symptom areas, treat these with appropriate sized magnets, pre- meal. Always use the negative magnetic field facing the body.

The above pre-meal and post-meal alkalinization method is recommended for:

• Those with a serious state of symptom reactions to multiple foods in which food rotation is not entirely satisfactory.

• When of necessity, symptom-evoking foods have to be eaten, such as when eating out at a restaurant, or those that have to use

the method instead of waiting three months for the introduction of their foods.

3. Post-meal. If any symptoms develop, post-meal, then use suitable magnets placed locally for relieving these symptoms. It could be helpful again, to place the disc magnets bitemporally.

A food rotation diet is necessary to honor the fact that addiction is the major driving force of food maladaptive reactions and that acid-hypoxia is the immediate cause of symptoms. There is no optimally effective method for the management of maladaptive reactions to foods that is equivalent to food rotation.

Placing the disc on the head and ceramic block magnets on the heart and liver area for 15-30 minutes before meals will reduce the urge to overeat.

AVERSIVE BEHAVIORAL TRAINING FOR URGES TO OVEREAT OR EAT BETWEEN MEALS

This behavioral training should be accompanied by the placement of the magnets on the head. This consists of, with the eyes closed, placing in mind the urge to overeat, eat between meals or use addictive substances. Take a big breath and hold the breath until the mind goes blank. This aversive method says, "NO" to the urges. This can be repeated as many times as necessary to stop the urges.

VISUAL SYSTEM OF FOOD QUANTITY REDUCTION

Take a picture of the usual breakfast, noon and evening meals that the subject eats. Take another picture of the same food quantity, reduced by one-third. Have these pictures in front of the plate of food that the subject is going to eat. Have them reduce their quantity intake by one-third. Every six weeks, review this food quantity and keep reducing the quantity by one-third until the desired weight is achieved and being maintained.

MINIMAL SYSTEM OF WEIGHT MANAGEMENT

This system does not consider the calorie intake but relies on the magnetic fat meltdown and the magnetic comfort system of managing urges to overeat and eat between meals using the magnets placed bitemporally and the 4" x 6" x 1/2 " magnet placed over the heart.

Magnetic Protocol for Hepatitis LIVER DISORDERS ORIENTATION:

This protocol applies to viral infections of the liver, alcohol addiction and in fact, all addictions whether to hard drugs or food addictions. It applies to chemical toxicity hepatitis.

MINIMAL TREATMENT:

A 4" x 6" x 1/2" magnet is placed over the liver either on the front of the body or on the right side of the body. This magnet should have the 6" lengthwise the body. It can be held in place with a 4" x 52" (or longer, if need be) COOL MAX band. It is even preferred that there be one of these magnets over the front of the liver and one over the side of the liver. These magnets should be worn 24 hours a day until reversal of the condition has developed and then after that, wear one of these magnets over the liver at night during sleep as a lifestyle.

OPTIMAL TREATMENT:

The optimal treatment is to add to the local treatment that of the 70-magnet bed composed of magnets that are 4" x 6" x 1". This bed is composed of two wooden grids with 35 magnets each which is a 36" square grid. Two of these are placed end to end producing a bed 36" x 72". This is essentially the size of a single bed. It can be placed on top of the bed or on top of the box springs by removing the mattress. It is recommended that a 2 or 3 inch foam pad be placed over this bed. The most comfortable foam pad is a memory type foam pad. It is possible to use a 4" thick mattress pad however, it is best for at least the first three months to be as close to the magnets as possible, therefore a 2" foam pad is recommended for at least the first three months.

The super head unit composed of twelve 4" x 6" x 1" magnets is also associated with the bed. In acute cases of viral hepatitis or of alcohol hepatitis, it would be wise to return to the bed for one hour, four times during the day for the first three months.

There are other additional values that can be obtained such as:
- Drinking negative ionized water.

ALKALINE MICRO NEGATIVE ION WATER:

Alkaline micro negative ion water helps materially to maintain the body's normal alkaline state. Also, being micro water, it enters into the cells of the body more readily than the usual water. This also carries a negative magnetic field as well as being alkaline. The AKAI Electrolysis Instrument is used for producing the alkaline micro water. At least five glasses of this water should be used each day.

NARIWA WATER:

Nariwa water is a negative ionized water from Japan's magnetic mountain. This comes in a bottle containing 500 cc. A minimum of one of these bottles should be used a day and preferably, two.

The total amount of water used during a day should be a minimum of eight glasses of water and preferably as much as a total of ten glasses of fluid intake.
 • Cleaning the air in the home with a negative ionizer.

NEGATIVE ION HOUSEHOLD AIR TREATMENT

The biological response to negative ions and negative magnetic fields are the same. The biological response to negative ions and a negative magnetic field is alkaline-hyperoxia. Alkaline-hyperoxia is anti-inflammatory, anti-stress, antibiotic, energizing and aids in healing. Negative air ions plus a small amount of ozone in the air cleans the air from dust, microorganisms, pollen, smoke, chemicals, odors and so forth. Negative ions in the air clean up the environment whereas a negative magnetic field is used on the body to achieve the same values inside the body. Thus, negative air ions, negative water ions and a negative magnetic field are complementary and should be used together to achieve optimum results.

AIR ION GENERATORS LIVING AIR CLASSIC

Covers up to 3,000 square feet. Useful for living room size areas.

ECOHELP LIVING AIR CLASSIC with air filter. Especially useful for respiratory disorders. LIVING BREEZE

Covers 1,200 square feet. Useful for small rooms such as bedrooms.

Air negative ions are absorbed through the mucus membrane of the nasopharynx and lungs as well as the skin. Water negative ions from electronic produced negative ion micro water and naturally occurring negative ion water such as Nariwa water are absorbed through the mucus membrane of the gastrointestinal tract. Colloidal silver antibiotic negative ions are absorbed through the mucus membrane of the mouth and gastrointestinal tract.

Air negative ions are absorbed through the mucus membrane of the nasopharynx and lungs as well as the skin. Water negative ions from electronic produced negative ion micro water and naturally occurring negative ion water such as Nariwa water are absorbed through the mucus membrane of the gastrointestinal tract. Colloidal silver antibiotic negative ions are absorbed through the mucus membrane of the mouth and gastrointestinal tract.

 • A 4 day diversified rotation diet.

GENERAL INFORMATION ABOUT THE 4-DAY DIVERSIFIED ROTATION DIET

The essence of the 4-Day Diversified Rotation Diet is that foods are rotated on a four day basis, thus preventing their maladaptive reactions, be these allergies or addictions.

One method is to avoid food eaten twice a week or more for a period of three months, rotating all other foods. At the end of three months, then place these frequently used foods back into the diet, rotated once in four days.

Another method that is preferred by some is to start rotating all foods, even those that are eaten frequently. This can be achieved if the subject will treat themselves to magnets for 15-30 minutes ahead of the meal. To achieve this, place the ceramic disc magnets bitemporally, that is in the front of the ears at the level of the top of the ears. These are held in place with a 2" x 26" band. The discs are ceramic discs that are 1-1/2 " x 1/2 ". The negative magnetic field is always placed toward the body. On the positive magnetic field side, there is hook Velcro that will hook to the band around the head and hold these in place. At the same time, place a 4" x 6" x 1/2 " magnet on the sternum with the 6" lengthwise the body. Hold this in place with a 4" x 52" body wrap. Also, place a 4" x 6" x 1/2 " magnet with the 6" lengthwise the body over the liver area which is on the right side of the body with half of the magnet over the rib cage and half below the rib cage. Hold this in place with a 4" x 52" body wrap. The minimum time of exposure should be 15 to 30 minutes or more before each meal. With this method, there is no avoidance period of the commonly used foods.

OPTIMIZED NUTRITION:

It is best for this to be under medical supervision under which a test has been made as to the possible deficiencies of vitamins, minerals, amino acids and the supplementation based on this information. Some would choose to proceed empirically. They should be using a vitamin, mineral, amino acid daily dose with preferably twice the daily dose.

POLARITY:

Always use a negative magnetic field.

BEYOND MAGNETISM:

Acute maladaptive reactions to foods, chemicals or inhalants has been documented as producing a brief state of acid-hypoxia. In this state, there is a production of acid and a failure to process properly the end-products of oxidation phosphorylation metabolism. In this state of acidosis, oxygen content is reduced. Maladaptive reactions to foods are the most frequent cause of bouts

of acidosis. Degenerative diseases are noted for their acid-hypoxic state. Therefore, every effort should be made to maintain a normal alkaline and normal oxygen state.

A majority of people are maladaptively reacting in one or more ways to foods, thus producing bouts of acidosis and reduced oxygen. It is the better part of wisdom to follow a 4-Day Diversified Rotation Diet. This program leaves out foods that are used as frequently as twice a week or more for a period of three months. This is based on the assumption that these foods are being reacted to in some maladaptive way. It is the frequency of the use that produces the maladaptive reactions. A 4- Day Diversified Rotation Diet is set up to leave out these frequently used foods. After three months, these frequently used foods can be returned to the diet, usually without any symptoms being produced.

All addictive substances should be abandoned such as addictive drugs, alcohol, tobacco and caffeine (coffee, tea with caffeine, chocolate, and soft drinks containing caffeine). Addiction is acidifying.

Carbonated soft drinks are acid and should be rarely used. Soft drinks are sweetened with corn sugar and if and when used should be limited to the corn rotation day.

There is a valuable method of electrolysis which provides an alkaline micro negative ionized water that has an alkaline pH, negative charged ions and negatively magnetically charged oxygen and water. There is a home electrolysis unit (The AKAI Electrolysis Instrument) that provides this alkaline micro water. It is recommended that five glasses of this alkaline micro water be used a day. Nariwa water is a naturally negative ionized water from Japan's magnetic mountain and is the optimum alkaline micro water available. This comes in a bottle containing 500 cc. A minimum of one of these bottles should be used a day and preferably, two. The total amount of water used during a day should be a minimum of eight glasses of water and preferably as much as a total of ten glasses of fluid intake.

In order to maintain an adequate alkaline state, it is necessary that the minerals that are used in the bicarbonate buffer system be in adequate supply. These are the minerals calcium, magnesium, potassium and zinc. There are several proprietary preparations that contain these minerals associated with vitamin C as ascorbates. Use 1/2 teaspoon to 1 teaspoon of one of these powders in one-half glass of water, two times a day. The preferred time to take the

alkaline minerals is in the morning on arising and before going to bed. Before using this mineral alkaline water, place it on the negative magnetic field of a 4" x 6" x 1/2 " magnet for a minimum of five minutes or more. This will charge up the water and the oxygen in the water with a negative magnetic field which will help the body maintain its normal alkaline state. When using micro alkaline water, the mineral water need not be placed on a magnet since it is already magnetically charged.

FINAL WORD
Success Story
REVERSAL OF HEPATITIS C VIRUS INFECTION AND CANCER OF THE LIVER WITH METASTASIS TO THE SPLEEN

A physician anesthesiologist with hepatitis C had received his viral infection by an accidental needle prick. This was a chronic state of hepatitis C for several years.

His liver and spleen began to enlarge and he was weak. His abdomen was very large. An oncologist who examined him determined that he had cancer of the liver with metastatic spread to the spleen. Both the liver and the spleen were so large as to be meeting in the middle of his abdomen. Lab tests revealed a high titer for fetoprotein. This high fetoprotein is known to be possible both from hepatitis C and or liver cancer. The oncologist judged him to be so advanced with cancer that there was no traditional treatment for him.

In casting about for a possible answer, he came across the book, *A Definitive Guide to Alternative Medicine* in which he read of my treatment of cancer with a negative magnetic field. He purchased and used a 4" x 6" x 1/2 " magnet over both the liver and the spleen. The negative magnetic field was facing the body. He applied the negative magnetic field 24 hours a day. He proceeded to treat himself with the magnets without any medical supervision other than his own. He called me six months later to thank me for his recovery from viral hepatitis C and cancer of the liver with metastasis to the spleen. Both the liver and the spleen had returned to normal size and the fetoprotein had completely disappeared. This was ten years ago. He remains well and hasn't missed a days work as an anesthesiologist.

The liver is the detoxifying organ. A negative magnetic field can activate oxidoreductase enzymes to optimally process toxins specifically by the liver and in general by all cells of the body.

The biological response to a negative magnetic field which is alkalinity, hyperoxia, ATP production and catalytic remnant magnetism (negative magnetic field), reinforce cellular negative magnetic field and renders the cellular response to be an effective antibiotic against invading microorganisms (bacteria, viruses, fungi and parasites).

THE GOOD NEWS IS THAT SYMPTOMS WILL DISAPPEAR WITH AVOIDANCE OF THE SYMPTOM-EVOKING SUBSTANCES.

THE GOOD NEWS IS THAT A NEGATIVE MAGNETIC FIELD IS A VALUABLE HARMLESS, ANTI-INFLAMMATORY AGENT AND A BIOLOGICAL HEALER.

A NEGATIVE MAGNETIC FIELD IS HUMAN NATURE'S OWN HIGHLY EFFICIENT, HARMLESS, ANTI-INFLAMMATORY AGENT, DETOXIFIER, ANTIBIOTIC, BIOLOGICAL ENERGIZER AND BIOLOGICAL REGULATOR OVER HARMFUL, PROLONGED STRESS STATES.

The good news is that a negative magnetic field therapy can therapeutically replace most of the therapeutic drugs used which produce liver toxicity and can along with avoidance of the toxic substances, effectively treat chemical toxicity and with proper use can prevent chemical liver toxicity.

The sad news is that there are numerous sources used in therapeutic traditional medicine to which there are direct liver toxic effects, allergic toxic effects and non-predictable individualized sensitivity toxic effects.

The fact is the liver is the central detoxifying organ that bears the brunt of endogenous and exogenous toxins. The liver is the detoxifying agent but can also be overwhelmed by the quantity of the toxins.

The oxidoreductase enzyme family of enzymes are the detoxifying enzymes used by the body in general and the liver in particular for detoxification.

The good news is that a negative magnetic field is an oxidoreductase enzyme activator of alkaline dependent hyper-oxygenation-negative magnetic field dependent oxidoreductase enzymes. The oxidoreductase enzymes can be energized by a negative magnetic field from a static field magnet and from negative ions in air and water.

The good news is that the cellular biological response to a negative magnetic field renders it to be an effective antibiotic to all invading microorganisms (viruses, fungi, bacteria and parasites).

The sad news is that traditional medicine does not know of the life energy (ATP and magnetic fields) producing detoxification and antibiotic values of a negative magnetic field. This vital knowledge of magnetics is dependent on acceptable statistical validated publication in peer reviewed medical literature.

References

Books by William H. Philpott, M.D.

Brain Allergies. The Psycho-nutrient and Magnetic Connections. PHILPOTT, W.H., M.D. and KALITA, Dwight, Ph.D., Updated second edition. Keats Publishing NTC/ Contemporary Publishing Group. Los Angeles, CA , 2000.

Magnet Therapy. PHILPOTT, W.H., M.D. and KALITA, Dwight, Ph.D.,(Tiburon, CA: Alterna- tive Medicine. cam, 2000)

REFERENCES

SZENT-GYORGYA, ALBERT. *Electronic Biology and Cancer. A New Theory of Cancer.* 1976. Marcel Dekker, Inc. NY, NY 10016

BELANEY, B. New Encyclopedia Britannica. 1986. Vol VIII. pg. 274-275.

LIVINGSTON, JAMES D. "Driving Force. The Natural Magic of Magnetics". Harvard University Press. Cambridge, MA. 1996.

TRAPPIER, ARTHUR, et al. "Evaluating Perspectives on the Exposure Risks from Magnetic Fields", Journal of the National Medical Association , 82:9, September 1990.

NORDENSTROM, BEW, Biologically Closed Electric Circuits. Stockholm, Sweden: Nordic Medical Publications, 1983.

NORDENSTROM, BEW, "Electrochemical treatment of cancer; variable response to anodic and cathodic fields". Am J. Clin Oncol, 1989: 12:530-536.

NORDENSTROM, BEW, "Survey of mechanisms in electrochemical treatment (ECT) of cancer". Europ J. Surg. Suppl. 1994: 574:93-109.

NORDENSTROM, BEW, "Biokinetic impacts on structure and imaging of the lung: the concept of biologically closed electric circuits". Am J Roentgenol, 1985; 145:447-467.

O'CLOCK, G.D., "Studies of the effects of in vitro electrical stimulation on eukaryotic cell proliferation". MA Thesis

(Biological Sciences), Mankato State University, Mankato, MN, 1991

O'CLOCK Jr G.D., & Lyte, M., "Potential uses of low-level direct current electrotherapy for the treatment of cancer". Proceedings of the 15th Annual International Conference of the IEEE Engineer- ing in Medicine and Biolociy Society, San Diego, CA, Part 3: 1993; 1515-1516.

SEMM, P, SCHNEIDER, T & VOLLRATH, L. "The Effects of an Earth Strength Magnetic Field on the Electrical Activity of Pineal Cells". Nature , 1980; 288: 607-608.

DAVIS, A.R. and RAWLS, W. The Magnetic Blueprint of Life. Acres USA, Kansas City, MO, 1979.

DAVIS, A.R. and RAWLS, W. The Magnetic Effect. Acres USA, Kansas City, MO 1975 DAVIS, A.R. and RAWLS, W. Magnetism and Its Effect on the Living System. Acres USA, Kansas City, MO 1976.

BECKER, ROBERT 0. Cross Currents. Jeremy P. Tarcher, Inc. Los Angeles, CA, 1990. BECKER, ROBERT 0. and SELDON, G. The Body Electric. Electromagnetism and the Foundation of Life. William Marrow and Company. NY. 1986.

WARBURG, O., The Metabolism of Tumors. F. Dickens (Trans) London: Arnold Constable: 1930.

WARBURG, O., On the Origin of Cancer Cells. Science 123 (1956) 309-315. WARBURG, O. " The Prime Cause and Prevention of Cancer". Revised lecture at the meeting of the Nobel laureates on June 30, 1966. National Cancer Institute Bethesda, MD.1967

FRESHT, Alan., *Enzyme Structure and Mechanism* Second Edition. W.H. Freeman and Co. New York, New York. 1994

BERRY, R. Stephen. New Encyclopedia Britannica. Vol 15, pg 1060. Encyclopedia Britannica, Inc. Chicago. 1986. (There is a measurable magnetic field produced during enzyme catalysis).

FYFE, William S. New Encyclopedia Britannica. Vol 24, pp 200. Encyclopedia Britannica, Inc Chicago. 1986. (Oxidative Remnant Magnetism).

KLONOWSKI, W and KLONOWSKI, M. Journal of BioElectricity. Aging Process and Enzy- matic Proteins. 4(1), 93-102 (1985).

BAREFOOT, R.R. and REICH, C.J. The Calcium Factor. 1991 Bokar Consultants, P.O. Box 201270, Wickenburg, AZ 85358.

RANDOLPH, T.G. *The Enzymatic and Hypoxia, Endoctrine Concept of Allergic Inflammation*
Clinical Ecology.. pp 577-596. Charles C. Thomas, Publisher, Springfield, Illinois. (1976).

LEE, RICHARD, page 17 in Hamilton and Hardy's Industrial Toxicology 5th Edition, 1998. Mosby, publisher.

Magnetic Fields in Enzyme Catalysis. Encyclopedia Britannica. Vol 15. Pg 1068. Chicago, IL 1986.

BRAUNWALD, Eugene. Harrison's Principles of Internal Medicine. 11th edition 1987. McGraw-Hill Book Company, NY.

STEIN, Jay H. *Internal Medicine*. 4th Edition. 1994. P. 340-524. Mosby Publishers. St. Louis. [*Magnetic Health Quarterly* "Liver Disorderx" Vol. VIII, 4th Qtr, 2002 (2002 Revision)]

The good news is that the liver is a reparable organ and when provided with appropriate alkalinity, oxygenation and nutrition, can frequently repair to a functional level. A negative magnetic field can materially aid in maintaining liver function. Some with an injured liver have to have a negative magnetic field over the liver as a lifestyle to maintain its function.

Liver Disorders

Cancer, Metabolic Diseases, Transplantation, Cirrhosis, Gallbladder, Bile Ducts

CANCER OF THE LIVER

There are two types of cells that develop into cancer of the liver. Hepatocellular cells which are the liver cells and the cholangio cellular which are the bile duct cells. These two types of cells compose 80-90% of the liver carcinomas. Primary liver cancer accounts for only 2% of malignant tumors in the United States whereas in Asia and Africa, this percentage can be as high as 30%. Cancer of the liver is four times more frequent in men than in women.

Known causes of cancer of the liver are such as:

1. Chronic liver disease. Any chronic liver inflammation can predispose to cancer of the liver.

2. Viral hepatitis. Hepatitis B is common in Africa and Asia and can lead to cancer of the liver.

3. Micro toxins. Saprophytic fungi toxins such as aflatoxins can lead to carcinoma of the liver. These toxins are especially noted to be present in the foods of Africa and Asia.

4. The male hormone predisposes to cancer significantly. Hepatocellular carcinoma has been reported in some patients on long-term androgenic therapy.

5. Iatrogenic factors. Toxic reactions to chemicals used in medical treatment can lead to cancer. For some years, up to the 1950's, thorium dioxide was used during radiation imaging. This was toxic to the liver providing a continuous lower level radiation injury.

Cancer liver is often hard to detect because it is so often associated with cirrhosis of the liver. Pain on palpitation and the physical presence of an enlarged area of the liver are of special importance. Cancer of the liver is often associated with a wide array of metabolic disorders.

Alphafetoprotein is found in the serum of almost all patients with hepatocellular carcinoma. High levels such as 500ng/ml occurs in around 90% of the patients with carcinoma of the liver. Liver biopsy is the ultimate proof of liver cancer. The course of liver carcinoma is fatal and rapid. Chemotherapy has poor results.

Hepatonomas are rare but have been particularly in women taking oral contraceptives for long periods. Hepatoblastomas is a rare malignancy in infancy and early childhood. Hemangioma is the most common benign tumor.

METASTATIC TUMORS

Metastatic tumors of the liver are common and is second only to cirrhosis as a cause of fatal liver disease. Metastatic carcinoma of the liver is twenty times greater than that of primary cancer. This is true in the United States but not true in Africa and Europe. Metastatic spread has its highest incidence in lymph nodes. Metastatic spread to the liver comes in for a good second in frequency. Most common sources of liver metastasis are gastrointestinal, lung, breast and melanomas. Less frequent are spread from the thyroid, prostate and skin.

Characteristically, metastatic carcinoma of the liver responds poorly to all forms of traditional treatment including chemotherapy.

The magnet therapy for cancer of the liver, be it primary or metastatic, is to treat the liver with a strong magnetic field. This can be achieved with a 4" x 6" x 1/2 " magnet placed directly over the liver. Place the 6" lengthwise the body. It can be placed over the front of the body over the liver or on the right side of the body over the liver. Or it can be placed on the front of the body as well as the side of the liver. The magnet should be in place 24 hours a

day. In metastatic cancer, the subject should be treated systemically with a bed composed of 70 magnets, 4" x 6" x 1". This bed is used all night and a minimum of an hour, four times during the day. This intense treatment should continue for a minimum of three months.

INFILTRATIVE AND METABOLIC DISEASES EFFECTING THE LIVER

The liver is the great detoxifying organ, therefore toxins are concentrated in the liver for processing. Fatty infiltration, especially from triglycerides, can become deposited in the hepatocytes,

Kupffer cells and other elements of the reticuloendothelial system. Common causes for fatty infiltration of the liver is chronic alcoholism, protein malnutrition, diabetes mellitus type 2 (especially those who are overweight and poorly controlled), obesity, jejunoileal bypass and chronic illnesses, especially those that impair nutrition. Patients with ulcerative colitis, chronic pancreatitis, or prolonged heart failure often develop fatty livers. Those maintained on intravenous hyperalimentation may develop fatty livers. Pregnancies in the third trimester can develop fatty livers. Massive tetracycline therapy may develop a fatty liver. The treatment is to adequately treat the underlying cause. With such treatment, fatty livers are reversible. The contribution that magnet therapy can make is to place a 4" x 6" x 1/2 " magnet over the liver, either on the front side of the body or on the right side of the body and maintain this 24 hours a day. This alkalinizes and oxygenates the liver and with the help of growth hormone, causes the fat to become soluble and come out of the cells in its soluble form. Fatty deposits occur in the presence of acid-hypoxia and leaves the cells as a soluble form in the presence of alkaline-hyperoxia.

There are ten or more genetic diseases involving enzyme deficiencies which cause infiltration deposits in the liver. These inherited types of enzyme deficiencies have not been subjected to magnet therapy. It would seem logical to assume that magnet therapy would not be of benefit in genetic disorders because magnet therapy cannot in any way correct the defect of genetically determined enzyme deficiencies.

Granulomatous infiltrates can occur in the liver from systemic diseases such as sarcoidosis, miliary tuberculosis, histophlesmosis, brucellosis, schistosomiasis, berylliosis and drug reactions.

Amyloidosis is an important and frequent infiltrate in the liver. This does not involve the liver cells but is between the cells. Amyloidosis is toxic to the liver cells. Amyloidosis consists of insoluble deposits of amino acids. This occurs because of acidity such as occurs in systemic diseases and infectious diseases. Diabetes will encourage deposits of amyloid, not just in the liver but in the pancreas, even in the skin, around the nerves and around blood vessels. The answer for amyloidosis is to treat the systemic disease that is maintaining the acidity and in the case of the liver, treat the liver specifically with a 4" x 6" x 1/2 " magnet on the front of the body over the liver or on the side of the body. This should be maintained while treating the systemic disease also. It requires a number of months for a resolution of amyloidosis. The resolution occurs because amyloid can go back into solution in the presence of sustained alkaline-hyperoxia. It is acidity that makes the amyloid deposits occur in the first place. Therefore, alkalinity maintained can help amyloid go back into solution. Since amyloid is characteristically a systemic disease it is the better part of wisdom that the subject be treated systemically with a 70-magnet bed. These magnets are 4" x 6" x 1" providing a strong negative magnetic field that engulfs the entire individual. At the same time the bed is used, the brain should be treated with twelve of the 4" x 6" x 1" magnets in a wooden carrier. Amyloidosis of the brain is Alzheimer's disease. Amyloidosis of the brain is a systemic disease that even biopsy of the skin can determine its presence.

LIVER TRANSPLANTATION

When liver transplantation is used, it should be treated immediately, post-surgery, with a negative magnetic field. To do this, magnets that are 4" x 6" x 1 /2 " are used, placed directly over the liver, either on the front or the side of the body or both. This system of magnet treatment for the liver should have the effect of preventing rejection and would also kill any viruses that may have been in the liver. This is being recommended as an obviously logical treatment. No statistics have been gathered on the results of liver transplantation treated with a negative magnetic field magnet therapy. Theoretically, it should be quite effective.

CIRRHOSIS

Cirrhosis of the liver is a final, common pathway of many types of chronic liver injury. In the final stages, the liver shrinks in size. Liver cells die. There are patchy nodules where the liver cells retain their function and show evidence of attempted repair.

Substantial use of high quantity amounts of alcohol of any type such as whiskey, wine or beer characteristically requires about ten years of heavy chronic use of alcohol. The pathology that develops is in progressive stages such as a fatty liver, hepatitis and finally the development of cirrhosis in which the liver shrinks in size and has nodules of functional liver cells which develop because of attempts at repair. In the early stages, with complete absence of alcohol, a significant amount of repair and metabolic recovery occurs. The late stage may result in varied forms of mental disorder and final death in a coma state.

The causes are markedly variable beyond that of alcoholism. There are infectious diseases which are characteristically also systemic. There are at least five known viruses and also systemic bacterial infections. There are at least nine inherited disorders that can produce cirrhosis. Drugs that are used to treat specific diseases to which there can be a toxic reaction may be important such as the treatments for Parkinsonism, chemotherapy and even oral contraceptives. There are at least a half-dozen other systemic diseases that are associated with cirrhosis such as diabetes mellitus, jejunoileal by-pass, chronic inflammatory bowel disease and other chronic diseases.

Congestive heart failure can lead to cirrhosis.

The metabolic answer for cirrhosis in both its early and late stage is that of treating the liver with a negative magnetic field. When possible, this should also be accompanied by systemic treatment. The local treatment is that of using a 4" x 6" x 1/2 " magnet placed with the negative magnetic field over the liver with the 6" lengthwise the body. This can be placed over the front of the body, the right side of the body or even the front and the side of the body. If the spleen is enlarged, it should also be treated the same way as the liver is being treated. For heart failure cases, the heart should be treated with a 4" x 6" x 1/2 " magnet. Toxins should be removed. Viruses are often systemic and therefore a systemic treatment should be used. The systemic treatment would be that of a super magnetic bed composed of seventy 4" x 6" x 1" magnets. This should be associated with a head unit composed of twelve 4" x 6" x 1" magnets. The subject should sleep on the bed and head unit at night and for the first three months, preferably go back on the bed for one hour, four times during the day. In severely acute cases, it is wise for the subject to sleep on the bed except for an hour at a time, three or four times during the day in which they

exercise and eat a meal. The combined local and systemic treatment will provide the optimum chance of recovery. After the recovery period, the minimum of which should be three months, then sleep on the bed and head unit as a lifestyle.

DISEASES OF THE GALLBLADDER AND BILE DUCTS

The liver and gallbladder are intimately associated. Most of the time, the bile remains soluble however a number of conditions causes the cholesterol, calcium and the pigment present to become insoluble. Consideration should be given to any condition producing acidity which makes these products become insoluble. Any disease condition producing acidity has the capacity to do this. When stones develop they can also produce a congestion and resulting in inflammation. The magnetic answer for gallstones or any inflammation of the gallbladder is that of maintaining a high alkalinity that can resolve these insoluble deposits. The treatment would be that of placing a 4" x 6" x 1/2 " magnet over the liver area using the negative magnetic field. Place the 4" x 6" x 1/2 " magnet lengthwise the body. Hold in place with a 4" x 52" body wrap. The front of the body over the liver/gallbladder area or the right side of the body over the liver area can be used. Both can be used at the same time. Suspenders would be needed to hold these magnets in place. Fasten the suspenders to the band that goes around the body. Another easy method is to place the magnet in a pocket such as a towel-type pot holder. Fasten this to a shirt over the appropriate areas of the liver. This method supports the weight from the shoulders. Systemic diseases such as diabetes or alcoholism needs to be treated systemically. Therefore, the 70-magnet bed is ideal for systemic treatment. In any event, a negative magnetic field sustained for weeks or months has the capacity of reversing these insoluble products occurring in the gallbladder and to reverse the inflammation or infection that has occurred also.

MAGNETIC LIVER THERAPY: ORIENTATION:

Magnetic therapy is applicable for local liver treatment and also for systemic conditions leading to liver disorders.

MAGNETS USED: Local treatment:

Two 4" x 6" x 1/2 " ceramic block magnets with Velcro on the positive pole side. Two 4" x 52" body wraps.

Two ceramic disc magnets that are 1-1/2 " x 1/2 " with Velcro on the positive pole side. One 2" x 26" band.

For systemic treatment, add the following:

One 70-magnet bed. These magnets are 4" x 6" x 1" and weigh four pounds each. Thirty-five of these are placed in a 36" square wooden frame which weighs 200 pounds. Two of these wooden frames with magnets are placed end to end producing a bed 36" x 72". Over this, place a 2" memory foam pad.

One 2" memory foam pad suitable for a single sized bed.

Super magnetic head unit composed of twelve 4" x 6" x 1" magnets.

PLACEMENT AND DURATION:

For the local treatment of the liver, place a 4" x 6" x 1/2 " magnet on the front of the body with the 6" lengthwise the body or place it on the side of the body over the liver. In acute cases, treat both the side and the front of the body. It will take a number of weeks to resolve liver conditions. It would also be wise to place a 4" x 6" x 1/2 " magnet with the negative magnetic field facing the body over the liver as a nightly lifestyle to keep the liver and the gallbladder healthy. Any systemic diseases present should be appropriately treated with the use of the super magnetic bed and super magnetic head unit. The head unit can be quite important because often liver function disorders also affect the brain.

It is the better part of wisdom to rotate the food on either a four or a seven day basis. The four day basis is in the quarterly, *The Ultimate Non-Addiction, Non-Stress Diet* and the seven day rotation is in the *Metabolic Syndrome* quarterly. It is wise to treat the brain, liver and the heart with magnets ahead of each meal while using the rotation diet.

HOW TO USE THE FOUR DAY OR SEVEN DAY DIVERSIFIED ROTATION DIET

The essence of the Diversified Rotation Diet is that foods are rotated on a four or seven day basis, thus preventing their maladaptive reactions, be these allergies or addictions. Also, this rotation diet will correct hypoglycemia and non-insulin dependent diabetes mellitus.

One method is to avoid food eaten twice a week or more for a period of three months, rotating all other foods. At the end of three months, then place these frequently used foods back into the diet, rotated once in four or seven days.

Another method that is preferred by some is to start rotating all foods, even those that are eaten frequently. This can be achieved if the subjects will treat themselves to magnets for 15-30 minutes

ahead of the meal. To achieve this, place the ceramic disc magnets bitemporally, that is in the front of the ears at the level of the top of the ears. These are held in place with a 2" x 26" band. The discs are ceramic discs that are 1-1/2 " x 1/2 ". The negative magnetic field is always placed toward the body. On the positive magnetic field side, there is hook Velcro that will hook to the band around the head and hold these in place. At the same time, place a 4" x 6" x 1/2 " magnet on the heart with the 6" lengthwise the body. Hold this in place with a 4" x 52" body wrap. Also, place a 4" x 6" x 1/2 " magnet with the 6" lengthwise the body over the liver area which is on the right side of the body with half of the magnet over the rib cage and half below the rib cage. Hold this in place with a 4" x 52" body wrap. The minimum time of exposure should be 15 to 30 minutes or more before each meal. With this method, there is no avoidance period of the commonly used foods.

After three months of rotation, there is little likelihood of a maladaptive reaction to a food without the magnets before the meal. Whenever purposely violating the rotation diet such as eating out, then use the magnets ahead of a meal.

NEGATIVE ION HOUSEHOLD AIR TREATMENT

The biological response to negative ions and negative magnetic fields are the same. The biologi-cal response to negative ions and a negative magnetic field is alkaline-hyperoxia. Alkaline-hyperoxia is anti-inflammatory, anti-stress, antibiotic, energizing and aids in healing. Negative air ions plus a small amount of ozone in the air cleans the air from dust, microorganisms, pollen, smoke, chemicals, odors and so forth. Negative ions in the air clean up the environment whereas a negative magnetic field is used on the body to achieve the same values inside the body. Thus, negative air ions, negative water ions and a negative magnetic field are complementary and should be used together to achieve optimum results.

AIR NEGATIVE ION GENERATORS LIVING AIR CLASSIC

Covers up to 3,000 square feet. Useful for living room size areas.

ECOHELP

LIVING AIR CLASSIC with air filter. Especially useful for respiratory disorders. LIVING BREEZE

Covers 1,200 square feet. Useful for small rooms such as bedrooms.

Air negative ions are absorbed through the mucus membrane of the nasopharynx and lungs as well as the skin. Water negative ions from electronic produced negative ion micro water and naturally occurring negative ion water such as Nariwa water are absorbed through the mucus membrane of the gastrointestinal tract. Colloidal silver antibiotic negative ions are absorbed through the mucus membrane of the mouth and gastrointestinal tract.

ALKALINE MICRO NEGATIVE ION WATER:

Alkaline micro negative ion water helps materially to maintain the body's normal alkaline state. Also, being micro water, it enters into the cells of the body more readily than the usual water. This also carries negative ions as well as being alkaline. The AKAI Electrolysis Instrument is used for producing the alkaline micro water. At least five glasses of this water should be used each day.

NARIWA WATER:

Nariwa water is a negative ion water from Japan's magnetic mountain. This comes in a bottle containing 500 cc. A minimum of one of these bottles should be used a day and preferably, two. The total amount of water used during a day should be a minimum of eight glasses of water and preferably as much as a total of ten glasses of fluid intake.

POLARITY:

Always use a negative magnetic field.

BEYOND MAGNETISM:

Acute maladaptive reactions to foods, chemicals, inhalants or stress frequency pulsing fields has been documented as producing a brief state of acid-hypoxia. In this state, there is a production of acid and a failure to process properly the end-products of oxidation phosphorylation metabolism. In this state of acidosis, oxygen content is reduced. Maladaptive reactions to foods are the most frequent cause of bouts of acidosis. Degenerative diseases are noted for their acid-hypoxic state. Therefore, every effort should be made to maintain a normal alkaline and normal oxygen state.

A majority of people are maladaptively reacting in one or more ways to foods, thus producing bouts of acidosis and reduced oxygen. It is the better part of wisdom to follow a 4-Day or 7-Day Diversified Rotation Diet. This program leaves out foods that are used as frequently as twice a week or more for a period of three months. This is based on the assumption that these foods are being reacted to in some maladaptive way. It is the frequency of the use that produces the maladaptive reactions. A 4-Day or 7-Day

Diversified Rotation Diet is set up to leave out these frequently used foods. After three months, these frequently used foods can be returned to the diet, usually without any symptoms being produced. Another method is to treat the head, heart and liver ahead of food rotation meals.

All addictive substances should be abandoned such as addictive drugs, alcohol, tobacco and caffeine (coffee, tea with caffeine, chocolate, and soft drinks containing caffeine). Addiction is acidifying.

Carbonated soft drinks are acid and should be rarely used. Soft drinks are sweetened with corn sugar (in the US) and if and when used should be limited to the corn rotation day.

There is a valuable method of electrolysis which provides an alkaline micro negative ionized water that has an alkaline pH. There is a home electrolysis unit (AKAI instrument) that provides this alkaline micro water. It is recommended that five glasses of this alkaline micro water be used a day. Nariwa water is a naturally negative ionized water from Japan's magnetic mountain and is the optimum alkaline micro water available. This comes in a bottle containing 500 cc. A minimum of one of these bottles should be used a day and preferably, two. The total amount of water used during a day should be a minimum of eight glasses of water and preferably as much as a total of ten glasses of fluid intake.

FINAL WORD

The liver is the human body's central detoxifying organ. It can be overwhelmed by the quantity of toxins being processed. It can be overwhelmed by infections. Its function can be overwhelmed by systemic diseases. The liver can develop primary cancers and is often an aspect of metastatic spread of tumors, starting primary in other areas of the body. The liver and gallbladder are influenced by acidity with insoluble deposits and gallstones.

The good news is that the liver is a reparable organ and when provided with appropriate alkalinity, oxygenation and nutrition, can frequently repair to a functional level. A negative magnetic field can materially aid in maintaining liver function. Some with an injured liver have to have a negative magnetic field over the liver as a lifestyle to maintain its function.

REFERENCES

SZENT-GYORGYA, ALBERT. *Electronic Biology and Cancer. A New Theory of Cancer.* 1976. Marcel Dekker, Inc. NY, NY 10016

BELANEY, B. New Encyclopedia Britannica. 1986. Vol VIII. pg. 274-275.

LIVINGSTON, JAMES D. "Driving Force. The Natural Magic of Magnetics". Harvard University Press. Cambridge, MA. 1996.

TRAPPIER, ARTHUR, et al. "Evaluating Perspectives on the Exposure Risks from Magnetic Fields", Journal of the National Medical Association, 82:9, September 1990.

NORDENSTROM, BEW, Biologically Closed Electric Circuits. Stockholm, Sweden: Nordic Medical Publications, 1983.

NORDENSTROM, BEW, "Electrochemical treatment of cancer; variable response to anodic and cathodic fields". Am J. Clin Oncol, 1989: 12:530-536.

NORDENSTROM, BEW, "Survey of mechanisms in electrochemical treatment (ECT) of cancer". Europ J. Surg. Suppl. 1994: 574:93-109.

NORDENSTROM, BEW, "Biokinetic impacts on structure and imaging of the lung: the concept of biologically closed electric circuits". Am J Roentgenol. 1985; 145:447-467.

O'CLOCK, G.D., "Studies of the effects of in vitro electrical stimulation on eukaryotic cell proliferation". MA Thesis (Biological Sciences), Mankato State University, Mankato, MN, 1991

O'CLOCK Jr G.D., & Lyte, M., "Potential uses of low-level direct current electrotherapy for the treatment of cancer". Proceedings of the 15th Annual International Conference of the IEEE Engineer- ing in Medicine and Biology Society, San Diego, CA, Part 3: 1993; 1515-1516.

SEMM, P, SCHNEIDER, T & VOLLRATH, L. "The Effects of an Earth Strength Magnetic Field on the Electrical Activity of Pineal Cells". Nature, 1980; 288: 607-608.

DAVIS, A.R. and RAWLS, W. The Magnetic Blueprint of Life. Acres USA, Kansas City, MO, 1979.

DAVIS, A.R. and RAWLS, W. The Magnetic Effect. Acres USA, Kansas City, MO 1975 DAVIS, A.R. and RAWLS, W. Magnetism and Its Effect on the Living System. Acres USA, Kansas City, MO, 1976.

BECKER, ROBERT 0. Cross Currents. Jeremy P. Tarcher, Inc. Los Angeles, CA, 1990. BECKER, ROBERT O. and SELDON, G. The Body Electric. Electromagnetism and the Foundation of Life. William Marrow and Company. NY. 1986.

WARBURG, O., The Metabolism of Tumors. F. Dickens (Trans) London: Arnold Constable:, 1930.

WARBURG, O., On the Origin of Cancer Cells. Science 123 (1956) 309-315. WARBURG, 0. "The Prime Cause and Prevention of Cancer". Revised lecture at the meeting of the Nobel laureates on June 30, 1966. National Cancer Institute Bethesda, MD.1967

FRESHT, Alan., *Enzyme Structure and Mechanism* Second Edition. W.H. Freeman and Co. New York, New York. 1994

BERRY, R. Stephen. New Encyclopedia Britannica. Vol 15, pg 1060. Encyclopedia Britannica, Inc. Chicago. 1986. (There is a measurable magnetic field produced during enzyme catalysis).

FYFE, William S. New Encyclopedia Britannica. Vol 24, pp 200. Encyclopedia Britannica, Inc, Chicago. 1986. (Oxidative Remnant Magnetism).

KLONOWSKI, W and KLONOWSKI, M. Journal of BioElectricity. Aging Process and Enzy- matic Proteins. 4(1), 93-102 (1985).

BAREFOOT, R.R. and REICH, C.J. The Calcium Factor. 1991 Bokar Consultants, P.O. Box 201270, Wickenburg, AZ 85358.

RANDOLPH, T.G. *The Enzymatic and Hypoxia, Endoctrine Concept of Allergic Inflammation*
Clinical Ecology. pp 577-596. Charles C. Thomas, Publisher, Springfield, Illinois. (1976).

LEE, RICHARD, page 17 in Hamilton and Hardy's Industrial Toxicology 5th Edition, 1998. Mosby, publisher.

Magnetic Fields in Enzyme Catalysis. Encyclopedia Britannica. Vol 15. Pg 1068. Chicago, IL 1986.

BRAUNWALD, Eugene. Harrison's Principles of Internal Medicine. 11th edition 1987. McGraw-Hill Book Company, NY.

STEIN, Jay H. *Internal Medicine.* 4th Edition. 1994. P. 340-524. Mosby Publishers. St. Louis.

Books by William H. Philpott, M.D.

Brain Allergies. The Psycho-nutrient and Magnetic Connections. PHILPOTT, W.H., M.D. and KALITA, Dwight, Ph.D., Updated second edition. Keats Publishing NTC/ Contemporary Publishing Group. Los Angeles, CA , 2000.

Magnet Therapy. PHILPOTT, W.H., M.D. and KALITA, Dwight, Ph.D., (Tiburon, CA: Alterna- tive Medicine. corn, 2000)

[*Magnetic Health Quarterly* "Liver Disorderx" Vol. IX, 2nd Qtr, 2003]

MAGNET THERAPY Grandfather Status

Among early medical practitioners, there are references to the medical uses and self-help uses of static field magnets. This description of static magnetic fields for medical use and self-help application holds a record for being among the longest, if not the longest, held application of medical therapeutics. The application of magnetic therapeutics is world-wide. This worldwide grandfather status of application of static magnetic fields for therapeutic reasons is important in view of the more recent establishment of research practices to prove the value and safety of procedures and products. Among the earliest effort at establishing through scientific means, the value of magnetics is that of the research establishing both the value and safety of the application of magnetic energy for magnetic resonance imagery.

Up to the 1970's, medical practices and sciences had been accepted because of their universal acceptance and application. There now are specific research techniques accepted by the Food and Drug Administration as valuable in establishing a scientific proof of both value and safety. Most medical practices have come to be accepted without this research proof. To this day, a substantial amount of medical practice is grandfathered and proceeds to be used without scientific proof. There is no official list of practices that have been grandfathered. They simply continued to exist without being challenged as to value and safety. Magnet therapy has existed since the early status of the practice of medicine and this has been worldwide. Although, not officially stated as grandfathered, its practice demonstrates that it is grandfathered in the United States and worldwide. In recent years, there has been an increase in the application of magnetics. Years ago, Sears Roebuck used to sell magnets for the relief of pain. In recent years there has been an increase of use of magnets for pain, sleep and other procedures. Magnetic therapy is also, at the same time, undergoing a scientific investigation as to values and limitations. National Institutes of Health is granting funds for this research. There are also privately funded researches in progress.

For many years, biochemistry has been fulfilling its promises of value and of financial rewards for marketing products. Biophysics has been largely ignored in terms of research for years. The times are changing and biophysics is now offering substantial rewards for harnessing magnetic applications.

LAST WORD

Magnetic therapeutic application to humans, be it medical-ordered or self-help, holds a grandfather status worldwide. Beyond this grandfather status, there now exists a growing research application of magnetic therapy which is establishing the values and limitations of static magnetic field therapy and pulsing magnetic therapy.

It is recommended that multiple institutional review boards be established by medical practitioners. This status should be gathered under the institutional review board as outlined by the FDA. Accumulative values and confirmations from these numerous institutional review boards will have a great value in maintaining and further establishing magnetics as a substantial part of traditional medicine as well as its self-help role in maintaining health and aiding in reversing degenerative disease.

CELL PHONE SPEAKER INJURY; TELEPHONE SPEAKER INJURY; HEAD PHONE SPEAKER INJURY

All cell phone speakers are magnetic positive static field poled facing the ear. With rare exceptions, telephone speakers and head phone speakers are magnetic positive static field poled facing the ear. Thus, users of these personalized specific speaker systems are receiving a positive static magnetic field with its stressful injury.

The biological response to a positive magnetic field is acid-hypoxia which is stressful with the consequences of encouraging pathological growth of microorganisms and encouragement of the development of cancer including brain tumors. The biological response to a negative magnetic field is alkaline-hyperoxia which is non-stressful and also anti-stressful with the consequences of being relaxing, antidepressive, antibacterial and anti-cancer. Correction of this magnetic positive exposure can be achieved by taping a 1" x 1/8" neodymium disc magnet over the earphone speaker in which the negative magnetic field is facing the ear.

Cell phones have a double problem -- not only the damage of the positive magnetic field facing the ear, but also a pulsing frequency of 900 MHZ. Any frequency beyond twelve cycles per second is stressful to the human body. Fastening the neodymium disc magnet over the speaker will, with the static negative magnetic field facing the ear, counter the static positive magnetic field of the instrument and also counter the high frequency pulsing field of a cell phone.

MAGNETIC THERAPY: DELAYED SPEECH CORRECTION

A 7-year-old boy was not talking.

He slept with his head in a super magnetic head unit which is composed of twelve 4" x 6" x 1" magnets in a wooden frame which surrounds his head. He was instructed to rotate his foods on a four day diversified basis. Within three months of sleeping with his head surrounded by these twelve magnets and following the rotation diet, his speech was normal. He now speaks freely and distinctly.

Possible Causes

Viral infection of the brain from herpes family viruses such as Epstein-Barr, cytomegalo or human herpes virus # 6. A negative magnetic field kills viruses.

Heavy metal toxicity such as mercury from vaccinations. A negative magnetic field processes heavy metal toxins.

NEGATIVE ION HOUSEHOLD AIR TREATMENT

The biological response to negative ions and negative magnetic fields are the same. The biological response to negative ions and a negative magnetic field is alkaline-hyperoxia. Alkaline-hyperoxia is anti-inflammatory, anti-stress, antibiotic, energizing and aids in healing. Negative air ions plus a small amount of ozone in the air cleans the air from dust, microorganisms, pollen, smoke, chemicals, odors and so forth. Negative ions in the air clean up the environment whereas a negative magnetic field is used on the body to achieve the same values inside the body. Thus, negative air ions, negative water ions and a negative magnetic field are complementary and should be used together to achieve optimum results.

Air negative ions are absorbed through the mucus membrane of the nasopharynx and lungs as well as the skin. Water negative ions from electronic produced negative ion micro water and naturally occurring negative ion water such as Nariwa water are absorbed through the mucus membrane of the gastrointestinal tract. Colloidal silver antibiotic negative ions are absorbed through the mucus membrane of the mouth and gastrointestinal tract.

AIR ION GENERATORS LIVING AIR CLASSIC

Covers up to 3,000 square feet. Useful for living room size areas. ECOHELP

LIVING AIR CLASSIC with air filter. Especially useful for respiratory disorders.

LIVING BREEZE

Covers 1,200 square feet. Useful for small rooms such as bedrooms.

RESOLUTION OF CARDIAC ATHEROSCLEROSIS

A 71-year-old physician had cardiac surgery of seven bypassed arteries. One artery not bypassed was 50% occluded. For nine months, he wore a 4" x 6" x 1/2 " ceramic block magnet over his heart 24 hours a day with the negative magnetic field facing his body. Nine months later, a study of his heart revealed that the artery that was 50% occluded is now 100% open. He was also sleeping on a bed of 4" x 6" x 1" magnets with the negative pole facing his body. A leg that had lost all feeling has now regained normal feeling.

MAGNETS USED FOR CARDIAC TREATMENT:

A 4" x 6" x 1/2 " ceramic block magnet
One 4" x 52" body wrap
One 2" x 26" shoulder strap

PLACEMENT AND DURATION:

Place the negative magnetic field of the 4" x 6" x 1/2 " magnet over the heart with its 6" length-wise the body. Hold in place with a 4" x 52" wrap. Place a 2" x 26" band across the left shoulder with Velcro fastened to the body wrap. Mild cases will treat only at night during sleep. Severe cases should treat 24 hours a day.

MAGNETIC REVERSAL OF ADDICTION

ORIENTATION:

Addiction has a symptom relief phase when the addictive substance is taken into the body and also has a symptom production withdrawal phase some 3-4 hours after the initial relief phase. Addiction can be to a narcotic substance or to frequently used non-narcotic substances. The biological stress of the frequent use of non-addictive substances can evoke self-made narcotics (endorphins). In non-narcotic addiction, these endorphins are raised above the needed normal physiological level and the biological response to these endogenous narcotics is the same as to exogenous narcotics. These endorphin addictions from non-narcotic substances can be due to frequently contacted substances such as tobacco, alcohol, caffeine, foods and other chemicals. Acidity and lack of oxygen (acid-hypoxia) develops as a part of the disordered chemistry of addiction withdrawal.

The secret of reversal of addiction consists of avoidance of the addictive substance. The biological response to a negative magnetic field is the production of alkaline-hyperoxia, which

relieves the acid-hypoxia that produces the symptoms. The first four days of withdrawal from water-soluble substances is the critical symptom withdrawal period. For fat-soluble substances, such as nicotine from tobacco, the symptom withdrawal phase is 21 days.

Magnetic treatment consists of relieving the withdrawal symptoms by exposure to a negative magnetic field. The most important areas for magnetic field exposure are:

1) The temporal areas of the head, which is in front of the ears and near the top of the ears. For depression, place the ceramic disc magnets that are 1-1/2 " x 3/8" in front of the ears. Hold these i place with a 2" x 26" band. Always place the negative magnetic field facing the body. For anxiety, place a ceramic disc on the mid-forehead and left temporal area (in a right-handed person), and on the mid-forehead and right temporal area (in a left-handed person). For obsessive thoughts and compulsive acts, place a disc on the left temporal area and low occipital area.

2) To relieve the tension in the chest, which is common as a withdrawal symptom, place a 4" x 6" x 1/2 " ceramic magnet on the front of the chest on the mid-sternum area. Place this magnet with the 6" lengthwise the body.

3) To relieve the tension that is classic of withdrawal symptoms in the epigastric area, place a 4" x 6" x 1/2 " magnet directly over the stomach which is just below the rib cage (sternum area). Place this magnet with the 6" crosswise the body.

4) To relieve the tension in the spine that occurs during withdrawal, place a 5" x 12" multi-magnet flexible mat on the thoracic spine. This is on the back between the shoulder blades. If the neck has more tension, then place it on the neck. If the low back has more tension, place on the low back. Hold these magnets on the epigastric area of the chest and on the back with 4" x 52" body wraps.

5) On any area that has symptoms during the withdrawal phase, place a 4" x 6" x 1/2 " magnet or a 5" x 12" multi-magnet flexible mat over the area until the symptoms are relieved.

DURATION OF MAGNETIC EXPOSURE:

There is no limitation to the duration of exposure to the negative magnetic field. The magnetic field facing the body should always be a negative magnetic field. Usually the symptoms are relieved within 10 minutes and rarely, 30 minutes may be needed.

FOR MINIMAL TREATMENT:

Two ceramic disc magnets that are 1-1/2 " x 3/8" One 2" x 26" headband

One 4" x 6" x 1/2 " magnet

One 4" x 52" body wrap

FOR OPTIMAL TREATMENT, ADD THE FOLLOWING: One 4" x 6" x 1/2 " magnet

One 5" x 12" multi-magnet flexible mat

One 4" x 52" body wrap

SUCCESS STORY: SCHIZOPHRENIA

A schizophrenic in his 20's was depressed and anxious with visual and auditory hallucinations and delusions which were not managed by tranquilizers and antidepressants. He slept on a super magnetic bed composed of 70 magnets 4" x 6" x 1" with a negative pole facing his body. He also slept with his head in the super magnetic head unit composed of twelve magnets, 4" x 6" x 1". He managed his foods by using disc magnets on his head and a 4" x 6" x 1/2 " magnet on his chest and epigastric area for 30 minutes before each meal. He sat up a 4 day diversified rotation diet. In this, he also used no caffeine, no tobacco and no alcohol and was not on tranquilizers or antidepressants. He used the 1-1/2 " x 1/2 " disc magnets placed bitemporally for any immediate symptoms.

Three months later, his mother reported to me that he was symptom-free. She proceeded to order the super magnetic bed for other members of the family.

MAGNET USED:

70 magnet bed

Super magnetic head unit

Soother One, consisting of:

Two 1-1/2" x 1/2 " ceramic discs and one 2" x 26" band Two 4" x 6" x 1/2 " ceramic magnets

Two 4" x 52" body wraps

NEGATIVE MAGNETIC FIELD ANTIBIOTIC EFFECT

A woman with severe gastrointestinal symptoms was stool cultured for pathological bacteria and fungi as well as normal bacteria flora. Three months after sleeping on a bed composed of seventy 4" x 6" x 1" magnets, the gastrointestinal flora was again cultured. The bacteria and fungi flora were absent and a normal friendly bacteria flora was flourishing.

CONCLUSIONS

A negative magnetic field strengthens the human body's antibiotic value against invading patho- logical microorganisms.

MAGNETS USED:
Two 1-1/2 " x 1/2 " ceramic disc magnets with a 2" x 26" band

PLACEMENT AND DURATION:
The ceramic disc is useful for local infections that are no more than 1-1/2 " across.

FOR SYSTEMIC INFECTIONS such as the herpes family of viruses such as Epstein-Barr, cytomegalo, human herpes virus #6 or other diseases of either virus origin, bacterial or fungal origin which are systemic in nature, use the following:

A 70-magnet bed composed of magnets that are 4" x 6" x 1". Thirty-five of these are placed in a wooden grid, 36" square which weighs 200 pounds. Two of these grids are placed end to end produc- ing a bed 36" x 72".

A super magnetic head unit composed of twelve 4" x 6" x 1" magnets.

PLACEMENT AND DURATION:
Sleep on this 70-magnet bed all night and preferably return to the bed one hour, four times during the day for the first three months of treatment. Place a 2" eggcrate type foam pad over the magnetic bed. After the three months are completed, continue to sleep on this bed. At this time it could be placed under a 4" mattress pad if desired. Sleeping nightly on this bed should be a continued lifestyle.

BRAIN TUMOR REMISSION
An 88-year-old woman lost much of the function of her left arm. She staggered when she walked. She is a musician and could no longer play the piano. CT scan revealed a tumor on the right side of her head. She was treated with a super magnetic head unit composed of twelve 4" x 6" x 1" ceramic magnets in a wooden frame surrounding her head. She slept all night with her head in this super magnetic head unit and returned for one hour, four times a day during her waking period. At three months, all her functions had returned to normal. With enthusiasm, she played the piano while I listened on the phone. At six months, a CT scan documented that there was no longer a tumor in her brain. No surgery was done and thus there was no pathological cellular report of the tumor.

Cost: Super magnetic head unit $ 629.95 (Shipping to be determined)

Evaluation from: NORTH OAKLAND MEDICAL CENTERS RADIOLOGY SERVICES

461 WEST HURON PONTIAC, MI 48341
CT OF BRAIN WITHOUT AND WITH CONTRAST
EXAM DATE: 06/11/02

CLINICAL INFORMATION: Memory loss, confusion, headaches.

Impression: VAGUE AREA OF VASOGENIC EDEMA WITHIN THE RIGHT POSTERIOR TEMPORAL PARIETAL LOBE WITH FAINT PATHOLOGIC ENHANCEMENT REPRESENTS AN INTRA-AXIAL MALIGNANT NEOPLASM. MRI EXAMINATION IS RECOMMENDED FOR ADDITIONAL EVALUATION. THESE RESULTS WERE RELAYED DIRECTLY VIA TELEPHONE CONVERSATION TO DR. IMAD MANBOOR AT THE TIME OF THIS DICTATION.

PROVIDENCE HOSPITAL AND MEDICAL CENTERS (12-19-02):

Mr returns in follow up. She underwent a CT scan of the head on 12-13-02 that revealed no evidence of enhancing mass or extra-axial fluid collection. There is an old infarct versus an area of volume averaging involving the superior left cerebellum that appears to be new from prior exam. There is also a right posterior parietal encephalomalasia. She has been on magnetic therapy since diagnosis. Per her daughter, who is present with her, the patient's mental status has improved. She has no difficulty communicating thoughts or ideas. Her short-term and long-term memory has improved. She denies any balance problems or weakness.

Patrick W. McLaughlin, M.D. Department of Radiation Oncology

CANCER REMISSION

Henry Thompson (phone number 940-327-4845) is a 78-year-old man with cancer of the prostate with multiple metastasis to bones. He slept on a 70-magnet bed composed of magnets that are 4" x 6" x 1". The AMAS blood test was originally positive for cancer. After sleeping on a 70-magnet bed for several months, the AMAS tests have all been normal, showing no evidence of cancer.

MAGNETS USED:

Super magnetic bed of 70 magnets with wood grid holders
Super magnetic head unit
Two 4" x 6" x 1/2" ceramic block magnets
Two 4" x 52" body wraps

Soother One composed of two 1-1/2" x 1/2" ceeramic block magnets with one 2" x 26" band

MAGNETIC CANCER REMISSION
SCIENTIFIC PEER-REVIEWED DOCUMENTATION

A static magnetic field is an energy field by virtue of the movement of electrons. AHARONOV, Y. and BOHN, D. Significance of Electromagnetic Potentials in Quantum Theory. The Physical Revision. 115, 485. (1959).

It is an accepted fact that a negative magnetic field spins electrons counter clockwise and a positive magnetic field spins electrons clockwise.

A gauss meter, magnetometer or compass identify the positive (+) and negative (-) magnetic fields of the earth's magnetic fields and also of a static field magnet.

A positive (north-seeking) static magnetic field blocks melatonin production by the pineal gland and the negative (south-seeking) magnetic field stimulates production of melatonin by the pineal gland. SEMM, P, SCHNEIDER, T & VOLLRATH, L. "The Effects of an Earth Strength Magnetic Field on the Electrical Activity of Pineal Cells". Nature, 1980; 288: 607-608.

Cancer cells ATP production by transferase enzymes is acid-hypoxic dependent. WARBURG, O., On the Origin of Cancer Cells. Science 123 (1956) 309-315.

Cancer results from a disorder of cell proliferation regulators such as occurs in hypoxia and oxidoreductase enzyme inhibition. SZENT-Gyorgyi, ALBERT. *Electronic Biology and 25 Cancer. A New Theory of Cancer.* 1976. Marcel Dekker, Inc. **NY, NY** 10016

Lack of oxygen induces a malignant transformation in cell culture. GOLDBLATT, H., and CAMERON, G. (1953), J. Exp. Med., 97:525-552; GOLDBLATT, H., FRIEDMAN, L., and CECHNER, R.L. (1973), Biochem. Med., 7:241-252

There is published peer reviewed evidence that a static magnetic field inhibits cancer proliferative replication.

Six prior studies have shown that a brief static magnetic field exposure resulted in reduction of cancer cell proliferation growth. Nine prior brief static magnetic field studies revealed no effect on cancer cell proliferation growth. This study was designed to determine if a strong static magnetic field with a prolonged exposure would result in cancer cell proliferation growth. Three malignant cell lines; melanoma, ovarian cancer and lymphoma were exposed to a seven tesla uniform static magnetic field for 64

hours. Conclusion: "We have determined that extended exposure to a strong static magnetic field retards the growth of three human tumor cell lines. Further investigations of this phenomena may have a significant impact on the future understanding and treatment of cancer." In this study, the cell culture plate was placed iso-center in the static magnetic field. This study was not intended to isolate separate responses to separate positive and negative magnetic fields, however, the placement of the culture in the iso-center of the static magnetic field exposed one-half of the culture to the negative magnetic field and one-half of the culture to the positive magnetic field. RAYLMAN, RAYMOND R., CLAVO, ANAIRA C., WAHL, RICHARD L. *Bioelectromagnetics* 17:358-363. Wiley-Liss, Inc. 1996.

The positive magnetic field encourages cancer growth. The negative magnetic field inhibits cancer growth. TRAPPIER, ARTHUR, et al. "Evaluating Perspectives on the Exposure Risks from Magnetic Fields", *Journal of the National Medical Association,* 82:9, September 1990.

NON-PEER REVIEWED OBSERVATIONS CONFIRMING PEER REVIEWED DOCUMENTATIONS

The biological response to a static positive magnetic field is acid-hypoxia. The biological response to a negative magnetic field is alkaline-hyperoxia. Cancer implanted on the skin dies in response to a static negative magnetic field. DAVIS, A.R. and RAWLS, W. "The Magnetic Blueprint of Life.". Acres USA, Kansas City, MO, 1979.

Confirmation of Davis' work by W.H. Philpott, M.D., PHILPOTT, W.H., M.D. and KALITA, Dwight, Ph.D., *Magnet Therapy.* (Tiburon, CA: Alternative Medicine. corn, 2000); PHILPOTT, W.H., M.D. *Cancer. The Magnetic/Oxygen Answer.* 2001 edition. Published by W.H. Philpott. 17171 S.E. 29th Street, Choctaw, OK 73020.

A positive magnetic field is the signal present in response to injury. A negative magnetic field is present during healing. BECKER, ROBERT 0. and SELDON, G. "The Body Electric. Electromagnetism and the Foundation of Life." William Morrow and Company. NY. 1986.

DISCUSSION

The documentation that a static positive magnetic field free energy is a human biological stressor, disorganizer and thus, the signal of injury and that a static negative magnetic field free energy

is a human biological anti-stressor, organizer-regulator and thus the signal present during biological normalization and healing is one of the great documented discoveries of the 20th century.

Starting in the 1930's and spanning a period of over 50 years, Albert Roy Davis documented the acid-hypoxia biological response to a static positive magnetic field and the alkaline-hyperoxia response to a static negative magnetic field. He documented cancer remission to a negative magnetic field application.

In 1982, Robert O. Becker documented that a static positive magnetic field is the signal of injury and a static negative magnetic field is present during healing. BECKER, ROBERT 0. and SELDON, G. "The Body Electric. Electromagnetism and the Foundation of Life." William Morrow and Company. NY. 1986.

In the 1930's, Otto Warburg documented the acid-hypoxia fermentation transferase enzyme function as the energy drive of cancer for which he won a Nobel prize.

In 1996, Raymond Raylman documented that a strong, prolonged magnetic field killed cancer. Arthur Trappier, in 1990, documented that it is the negative magnetic field that kills cancer. Albert Szent-Gyorgi documented that oxygen as an electron receiver and oxidoreductase enzymes moving electrons was necessary to kill cancer. He knew that an energy was needed but in 1970 did not know that a negative magnetic field is the energizer. We now know the answer for which he was seeking is alkaline-hyperoxia plus a negative magnetic field energizer controlling human cell proliferation.

In 1953, H. Goldblatt documented that lack of oxygen induces a malignant transformation in cell culture.

In 1972, W. Joklik observed "Among the goals that should be within reach in the foreseeable future are an understanding of the fundamental control mechanisms that operate in both normal and abnormal cell differentiation, including cancer. JOKLIK, WOLFGANG K., D. Phil. Zinsser *Microbiology*. 20th edition. Appleton & Lange, Norwalk, CT. 1992. We now have achieved the goal Joklik was seeking. It is negative magnetic field free energy regulating cell proliferation and thus regulating growth and healing and also control over invading microorganisms and cancer.

CONCLUSION magnetic therapy of cancer replaces the acid-hypoxia-dependent transferase enzyme catalysis (fermentation) producing ATP with alkaline-hyperoxia oxidoreductase enzyme

catalysis (oxidation reduction) of producing ATP. Cancer cells are thus robbed of their ability to produce ATP by fermentation. Cancer cells die because they cannot produce ATP in an alkaline-hyperoxia medium.

Acid-hypoxia is the central causal factor in degenerative diseases in general and cancer develop- ment in particular.

The initiating causes of acid-hypoxia are many, such as, immunologic reactions, addictive reac- tions, toxic reactions, physical injury, local or systemic stress, prolonged emotional stress, nutritional deficiencies and so forth.

Cancer cells die in the presence of a continuous static negative magnetic field. Both peer reviewed publications and non-peer reviewed publications confirm the death of cancer cells from a static negative magnetic field of sufficient gauss strength and sufficient prolonged duration. A static negative magnetic field is the breath of life for human cells and the kiss of death for invading microorganisms and cancer cells. Definitive negative magnetic field therapy for the treatment of cancer is justified and recommended by both peer reviewed and non-peer reviewed evidence.

IT IS AN ESTABLISHED SCIENTIFIC FACT THAT A PROLONGED SUSTAINED STATIC NEGATIVE MAGNETIC FIELD PRODUCES CANCER CELL REMISSION.

HORSE AND BUGGY ENERGY MEDICINE VERSUS ELECTROMAGNETIC FREE ENERGY MEDICINE

The invention of the wheel was a great invention in its day. Mankind now had wheel barrels and scooters. Harnessing the energy of a horse to a wagon was another great invention which served mankind well for thousands of years. It is true that our grandparents moved west by horse and buggy. Two generations later, we fly all over the world. Transportation has advanced from an original wonderful achievement to a new marvelous achievement.

This marvelous achievement of the electromagnetic industrial age has occurred because of the achievement of harnessing the movement of electrons. We no longer just wonder at the electromagnetic energy of lightning, tornados, cyclones and anti-cyclones which, in the northern hemisphere spin counter-clockwise and in the southern hemisphere spin clock-wise. Mankind has learned to harness the energy of movement of electrons. We make

magnets with the flow of electrons and we give direction to the flow of electrons with magnets. We have learned to trust the predictableness of the movement of electrons with magnetic fields. We live in a virtual sea of electrons in the space around us as well as the space within us. Mankind is an electromagnetic organism. The magnetic movement of free energy electrons within us is an integral aspect of biological life energy. Human life does not exist apart from magnetism. Have we missed something in medicine that the electromagnetic industry has captured? Yes, we have! We have failed to capture the free magnetic energy available to us. The same degree of predictableness exists in biological systems exposed to magnetic fields as it does in electric non-biological systems.

Therapeutic medicine is barely entering the threshold of free magnetic energy use. We nourish our bodies but we still wait for some mysterious life energy to spontaneously heal us. Magnetic therapy can change the speed of healing from the horse and buggy level to an equivalent level of flying. The movement of electrons between enzymes and substrates produces a magnetic field which attaches the enzyme and the substrate. With the magnetic energy medicine, electrons are magnetically harnessed to move between enzymes and substrates. The secret of magnetic therapy is that this free magnetic energy can be supplied from a static field magnet providing the energy activation of the enzymes so that a catalytic reaction occurs. A static negative magnetic field alkalinizes and energizes, such as the alkaline-dependent oxidoreductase enzymes family of enzymes. These oxidoreductase enzymes are responsible for producing some of life's energy (ATP and catalytic remnant magnetism) as well as processing inflammatory toxic substances that threaten life energy. A positive magnetic field energy blocks these enzymes from functioning. The essence of magnetic therapy is the predictable movement of free energy field static electrons by a free energy static magnetic field in a biological system producing predictable biological responses.

Magnetic therapy is at this threshold of moving therapeutic medicine from the horse and buggy low level efficiency, slow speed energy function into a high efficiency speed energy function equivalent to flying and computer efficiency functions.

THE ROLE OF INSOLUBLE DEPOSITS IN DEGENERATIVE DISEASES OSTEOPOROSIS

The insoluble deposits in degenerative diseases are:

1. Insoluble calcium deposits.
2. Insoluble amino acid deposits (amyloid).
3. Insoluble fat deposits.
4. Insoluble glycation deposits.
5. Insoluble pigment deposits.

There is a central cause for these insoluble tissue deposits. In acid-hypoxia tissue state, these substances become insoluble. Acid-hypoxia is central to degenerative diseases. Biological health is dependent on a tissue state of alkaline-hyperoxia. The biological response to a static negative magnetic field is that of alkaline-hyperoxia. The biological response to a static positive magnetic field is acid-hypoxia. The human organism is an electromagnetic organism and of necessity, must maintain alkaline-hyperoxia. Much is known about the damage of acid-hypoxia and the necessary maintenance of alkaline-hyperoxia. It is characteristic of degenerative diseases that there will be both local and to some degree, systemic acid-hypoxia. There are many known causes for the development of acid-hypoxia, such as allergic reactions, addictive reactions, reactions to toxicity, heavy metal toxicity, infections of all types of invading organisms which are acidifying and so forth. To therapeutically prevent and treat degenerative diseases, each of these causes of acid-hypoxia must be assessed and appropriately treated.

INSOLUBLE CALCIUM DEPOSITS

It is documented that calcium is soluble at the normal alkaline pH of body fluids. It is documented that calcium becomes insoluble in an acid medium. Thus, it is observed that calcium can deposit around inflamed joints. Calcium becomes deposited in areas of stress where free radicals are not being processed rapidly such as in the lumbar spine where spinal stenosis develops with calcium depositing around the spinal cord and the nerves. Insoluble calcium becomes a part of the plaques in arteries. In any case, local or systemic, where acidity develops, calcium deposits occur.

AMYLOID DEPOSITS

It is documented that amino acids are soluble at the physiologically normal alkaline pH of blood and other body tissues. It is documented that amino acids become insoluble in an acid medium. These insoluble amino acids can be deposited anywhere the tissues are acidic. A fair percentage of diabetics have amyloidosis of the pancreas. It can deposit around nerves producing

neuropathies. Insoluble deposits of amino acids occur in the brain which is given the title of Alzheimer's disease.

INSOLUBLE FAT DEPOSITS

Fat is soluble at the normal physiological alkaline pH of body tissues. It becomes deposited as insoluble fat deposits in an acid medium. Obesity is caused by insoluble fat deposits.

INSOLUBLE GLYCATION PRODUCTS

Glycation is a joining of glucose and other reducing sugars to protein. This is made possible by the presence of an aldehyde. The development of aldehydes are one of the products that develop if free radicals are not quickly processed by oxidoreductase enzymes. Oxidoreductase enzymes function only in an alkaline medium. In the presence of an acid medium, peroxides, oxyacids, alcohols and aldehydes are formed. The presence of the aldehyde makes possible the joining of sugars to protein. This insoluble product can occur anywhere in the body. Arteriosclerosis is due to glycation products and calcium deposits.

INSOLUBLE PIGMENT DEPOSITS

Insoluble pigment deposits occur in acid-hypoxic tissues. They can occur in response to damage which of course is maintaining acidity. The skin and the retina of the eyes are classic tissues where these insoluble deposits occur.

TOXICITY OF INSOLUBLE PRODUCTS

Not only are these insoluble products produced by acidity, but they also are toxic, producing free radicals.

SOLUBILITY OF INSOLUBLE PRODUCTS

The answer to the reversal of these acid-produced insoluble products is that of maintaining a continuous alkaline-hyperoxia. This is achieved by a sustained exposure to a sufficiently strong and of a sufficient duration negative magnetic field with its biological response of alkaline-hyperoxia. Thus, all of these insoluble deposits are made soluble by the application of a static negative magnetic field.

OSTEOPOROSIS

The calcium being deposited as insoluble deposits is drawn from the blood plasma. Calcium is drawn from the bones in order to maintain optimum serum calcium for metabolic functions. Thus, all the reasons for developing insoluble deposits due to acid-hypoxia also apply to osteoporosis. The answer to osteoporosis is to stop all these acid-hypoxic conditions and then treat the body systemically so that all bones are involved in a negative magnetic

field. The optimum treatment for this is a 70-magnet bed of 4" x 6" x 1" magnets and also with a super magnetic head unit composed of twelve of these 4" x 6" x 1" magnets. Of course, nutrition must be optimized and it is wise to include in this specific supplementation of the nutrients needed for bone growth and repair. The maintenance of a negative magnetic field with the use of a negative magnetic bed is central to the repair of osteoporo- sis. Bone density studies should be repeated at yearly intervals until the desired bone density is achieved.

ECOLOGY OF DIABETES MELLITUS TYPE II

Non-insulin dependent type II diabetes mellitus is caused by maladaptive reactions to foods. These maladaptive reactions to foods are IgG allergies and addictions. To a less extent, there are toxic reactions to environmental substances. These maladaptive reactions to foods are determined by deliberate test meal exposures to single foods. Food allergy and food addictions are central to the cause of diabetes mellitus type II. The allergic or addictive reactions to foods cause cellular swelling in which insulin cannot do its job of transporting the sugar into the cells. The deliberate single test meal exposures to foods is preceded by five days of avoidance. The hyperglycemic reaction occurs within an hour of test exposure to a single food. When these hyperglycemic foods are removed, the diabetes no longer exists. After avoiding these foods for a period of three months, they can be placed in a four or seven day rotation diet. Ninety-five percent of the time, there will be no hyperglycemic or other symptom reactions occurring as long as the rotation diet is maintained. It is surprisingly easy and highly effective to manage type II diabetes mellitus with a four or seven day rotation diet. Diabetes mellitus is a systemic disease and therefore needs to be treated systemically with a strong negative magnetic field. To this systemic treatment, a local magnetic treatment is used for symptom management and local disease injury areas.

There is a magnetic method of treating the heart, liver and head for 30 minutes before a meal which prevents the maladaptive food reactions. With this pre-meal and during the meal magnetic exposure, the subjects start the rotation diet without a three month period of avoidance of hyperglycemic reactions to foods.

Schizophrenia, Manic Depressive, Autism, Obsessive-Compulsive Disorder, Dyslexia, Hyperkinesis, Tourette's Syndrome

INTRODUCTION

My research work in psychiatry and neurology, extending over a 25 year period, provides convincing evidence of the initial organicity of major mental disorders. There is a continuum of brain disorders of varying degrees depending on the extent of the brain injury. Attention deficit disorders, dyslexia, autism, childhood schizophrenia, Tourette's syndrome, hyperkinesis and lethargy are simply organic brain states that are on a continuum with schizophrenia and manic depressive disorders, caused by the same process. This is a chronic progressive process and therefore these minor types of conditions predispose to the major disorders. In taking the histories of schizophrenics, it is characteristic that they will describe their learning disorders as a child.

There is a common starting point for these varying degrees of organic brain disorders. This common denominator is a viral infection from the herpes family lymphotrophic viruses. These are Epstein-Barr, cytomegallo and human herpes virus #6. The infection has it's inception in early childhood before the brain has reached its maturity in late adolescence. There literally is a chronic smoldering viral encephalitis progressively injuring the brain, especially in the areas that deal with emotion, judgement, perception and also some in the motor area producing Tourette's syndrome, hyperkinesis and or, lethargy. For a sizeable number there is evidence that the mother, before the child's gestation, had infectious mononucleosis caused by one or more of these lymphotrophic herpes viruses. When the mother, under the stress of gestation, has an exacerbation of her viral infection this can then infect the fetus. It is equally significant when saliva from an infected adult or child is passed to a child. Kissing on the mouth is the most common way of passing these viruses. The infection is progressive and can start as a minor brain disorder in childhood and end up in late adolescence or early 20's as a major psychosis. Antibody studies have revealed that these viral infections are chronic and fluctuating.

Secondarily to the stress of these viral infections, there develops a state of maladaptive reactions to foods, chemical or inhalants as well as nutritional deficiencies. These disorders compound the problem with further symptom development. Further complicating the problem is the development of interpersonal disorders and social inappropriate disorders secondary to the brain disorder. An optimum therapeutic approach must consider all these factors and treat them simultaneously.

If the following factors were considered and treated appropriately and simultaneously, there would be little use made of tranquilizers or antidepressants or shock treatment. Following are the factors that need to be functional simultaneously:

1) Control symptoms with a negative (south-seeking) magnetic field and not with tranquilizers or antidepressants.

2) Produce sound, energy restoring sleep with a negative (south-seeking) magnetic field treatment to the brain. This can be achieved by sleeping on a negative (south-seeking) magnetic field mattress pad, and the head being in a negative (south-seeking) magnetic field from static field magnets.

3) Kill the viruses with a negative (south-seeking) magnetic field from a static field magnet and colloidal silver carrying a negative (south-seeking) magnetic field.

4) Follow a 4 Day Diversified Rotation Diet as a lifestyle. This is for the purpose of avoiding maladaptive symptoms from foods.

5) Avoid chemicals to which the person is symptomatically reactive.

6) Avoid all potentials of addiction such as caffeine, tobacco, alcohol or addictive drugs.

7) An optimum nutritional supplement program based on laboratory evidence of need for vitamins, minerals, amino acids and essential fats.

8) Corrective behavioral training for social adaptation and learning.

My original research extending from 1970 through 1975 was based on reactions to foods and laboratory evidence of nutritional needs provided a 75% success rate determined by no need to return to the hospital during a 3 year period. This compared to five other traditional psychiatric practices in the same hospital who had a 75% return in the hospital in the same three years. The success rate is much higher now that we have the magnets available to handle symptoms.

CASE HISTORIES

A teenage girl was brought to me because in her psychotic state she had attempted suicide. My diagnosis was that of a schizoaffective illness. The mother described that when she ate wheat she would become depressed and would socially withdraw and have a flat affect. I had her go through 5 days of avoiding any food that she ate with a frequency of as much as twice a week. Then I

began to food test her with meals of single foods. When we came to wheat, she asked to leave the test room where other patients were because she had a headache. I took her to a room by herself. Her affect was flat. I placed the negative (south-seeking) pole of a 4" x 12" x 1/8" strip magnet down her spine for her to lay on and placed the negative (south-seeking) pole of ceramic disc magnets bitemporally. Within 5 minutes, she was asleep. I let her sleep for 45 minutes then awoke her and asked her how she felt. She was symptom-free. She did not have a headache, her affect was normal and she was happy to be out in the test room with other patients. A few days later, I followed the procedure of exposing her to the magnets on her spine and bitemporally for 30 minutes before she ate a meal of a symptom producing food. No symptoms were produced. Not only had we demonstrated that we could relieve the symptoms of a known food to which she was reactive, but we could also prevent the symptoms from developing by treating her ahead of time.

John is a man whom I first diagnosed as psychotic because he had the delusion that he was Jesus Christ. By avoiding foods that he frequently used, and avoiding exposure to chemicals, he became mentally clear within a period of 5 days. Exposing him to petrochemical hydrocarbons such as an extract of car exhaust or pesticides, he would again be delusional, thinking he was Jesus Christ. His illness developed because he sprayed an apple orchard with a pesticide. He also had an apple warehouse which was also an enclosed cooler. He used a propane operated fork-lift truck to move the apples within the warehouse. One day he became so weak he fell off the fork-lift. He was taken to the emergency room of a hospital where he was discovered to be psychotic. This is the point where he became my patient. I found him not only reactive to an assortment of petrochemicals, but also to a number of foods. He was hospitalized for a period of two months at a cost of $30,000. He rotated his foods on a four-day basis. He avoided exposure to petrochemicals including car exhaust. He was sane for a period of 18 years. Suddenly, he was again psychotic which developed when his neighbor tarred his roof with a hot, smelly tar. This petrochemical cross-reacted with the other petrochemicals such as the propane gas, the car exhaust, the pesticides that he had used. This time he was treated with two neodymium disc magnets. These were placed bitemporally. Within 10 minutes, he had dropped his delusional state. The cost of these magnets

was $110. There is quite a contrast between this $110 and the $30,000 of his initial treatment. He continues to sleep on a magnetic bed pad and with magnets at the crown of his head. He keeps the neodymium disc magnets with him and if he does by chance have exposure to any petrochemical hydrocarbons and feels tension arising, he places the magnets bitemporally and within 10 minutes the anxiety and tension leaves and he does not go psychotic. He does not use any tranquilizers or antidepressants.

Tim became my patient when he was seventeen years old. At age five, he was correctly diagnosed as autistic. This diagnosis was made at the Children's Hospital division of the medical school in his local community. Both of his parents were M.D. physicians. He was given every therapeutic, medical and educational opportunity available. At 17, he was floridly schizophrenic. He could only speak in grunts accompanied by bizarre facial and arm movements. Much of the time, even his mother could not understand what he was trying to say. He was covered with acne from head to foot. No antibiotic had helped his generalized acne. Episodically, he had periods of saying the word, "circle" at three second intervals. With the placement of the negative (south-seeking) pole of the 4" x 6" x 1/2" magnet on the back of his head and upper neck, he would stop his compulsive three-second repetitive verbalization of the word, "circle". Deliberate food testing demonstrated that any gluten bearing cereal grain would evoke the symptom of three per-second rhythmic compulsive saying of the word, "circle". His acne cleared on the withdrawal from his frequently eaten foods and emerged with the test meal of cows milk. His psychosis cleared by the fifth day of avoidance of these commonly used foods. When his psychotic symptom-evoking foods, which had been determined by deliberate food tests of single foods, were returned to his 4-Day Diversified Rotation Diet after three months of avoidance, they no longer produced symptoms when kept at that four day interval exposure. With behavioral training by temporal-placed magnets used to hold symptoms in abeyance during practice sessions, he was taught to speak clearly without his former bizarre facial and arm gesturing. He was taught to drive a car. He attended the Christian University of Arts and Sciences as a special student in the art department. He has his own apartment apart from his parents, prepares his own food for his 4-Day Diversified Rotation Diet, draws and sells his excellent artwork. This autistic child at age five, schizophrenic

adolescent, became socially and economically functional and even an art genius.

He was found to have the genetic disorder of homocystinuria. He was instructed to eat no more than one-third of a meal as protein. Cystine and taurine were supplemented. In homocystinuria, cystine and taurine are deficient since they are made from methionine which is not being adequately processed. Taurine has a calming effect on neuron function.

This case illustrates the organic continuum that I have observed between lesser organic brain disorders and full-blown psychosis. This case illustrates the ability of learning disabled children, autistic children, psychotics and so forth to have the symptoms of their brain disorder reversed and also after this reversal of the symptoms, to learn both social and economic appropriate behavior. I have many patients, both of the lesser organic brain disorders and the major organic disorders that have achieved these goals. They are not on Ritalin, tranquilizers or antidepressants. They sleep soundly when exposed to a negative (south-seeking) magnetic field during sleep. Magnetic discs are available in the case of an occasional accidental exposure to something that evokes symptoms. They can quickly relieve these symptoms with the magnetic discs. These patients have no side effects from their treatment.

Dr. S., a Ph.D., sociologist and chairman of the sociology department of a university, developed a psychotic depression. He would not drink or eat. Tranquillizers and antidepressants did not change his symptoms. After 6 weeks in the medical school university hospital, his wife was informed that the only therapy left with potential value was electric shock treatment. She declined EST and asked me to take him as a patient. His psychiatrist called me with great concern about his being signed out of the hospital against medical advice. I assured him I was a psychiatrist and had treated patients who would not eat or drink. I told him the EST produced a magnetic general anesthesia which would work but that there was also a magnetic treatment without EST that would work. I had my initial interview with him and then described to him that I would have him lay on a massage table with 4" x 6" x 1/2" magnets covering this table. Under his head, there would be a stack of eight, 4" x 6" x 1/2" magnets. Above his head there would be a magnet about a foot above his forehead. The magnets under his body and under his head would all be negative (south-

seeking) magnetic field facing his body. The magnet above his forehead had the positive (north-seeking) magnetic field facing him. His head would be only in the negative (south-seeking) magnetic field coming from the magnets from the back of his head in which the equator between the magnetic negative pole at the back of his head and the positive (north-seeking) magnetic pole from the magnet at his forehead would be above his forehead, thus he would be receiving only a negative (south-seeking) magnetic field in his head. I proceeded to give an intravenous for hydration and nutrients containing intravenous vitamin C, B_6, calcium and magnesium. He was asleep within five minutes. At one hour, I awakened him and removed the IV. I asked him to go downtown with his wife and eat a meal in a restaurant. He agreed. With this magnetic treatment, his psychotic depression was reversed in one hour. It would have taken a dozen or more electric shock treatments to achieve this same goal. This is just one example. The same value has been achieved with other patients. Since I have given in excess of 70,000 electric shock treatments, I am prepared to make an objective assessment between non-EST magnetic therapy and EST. The value of EST is the post EST magnetic general anesthesia which has been electrically produced. Dr. S. returned to his post as chairman of the sociology department of a university. He wrote me a letter thanking me for my service. He states, "Someone might think I became well because I had confidence in you. I had no confidence in anyone. You simply did the right thing".

Harold has temporal lobe seizures, during which he is confused, disoriented and disassociated. A deliberate food test meal of eggs produced a temporal lobe seizure. One week later, the negative (south-seeking) magnetic field of ceramic disc magnets were placed bitemporally for 30 minutes before and during a test meal of eggs. No seizure occurred. This case demonstrates the control of seizures with a negative (south-seeking) magnetic field.

Jim developed grand mal seizures after a head injury from a car accident. He had grand mal seizures every two hours, day and night. No medication controlled his seizures. He was on three anti-seizure medications when he became my patient and there was no control of the seizures. The frequent seizures made him a zombie. He could not talk. He could not understand what you told him.

He could not walk without help. Two 2" x 2" x 1/8" plastiform magnets with a gauss strength of 2,450 were placed bitemporally.

There were no more seizures, except when one night the magnets fell off of his head he had a seizure. This case illustrates the control of seizures in a medicine refractory subject. Brain electro-magnetic excitement can be controlled by a negative (south-seeking) magnetic field of appropriate gauss strength and appropriate duration. This includes emotional reactions such as anxiety, depression, phobias, obsessions and compulsions on to organic brain disorders including psychosis, and seizures.

CONFIRMING EVIDENCE OF THE VALUE OF NEURONAL CONTROL OF CENTRAL NERVOUS SYSTEM EXCITATION WITH A NEGATIVE (SOUTH-SEEKING) MAGNETIC FIELD POSITIVE (NORTH-SEEKING) MAGNETIC FIELD EEG STRESS EXAMINATION FOR THE DETERMINATION OF AN EPILEPTIC FOCI

I devised a positive (north-seeking) magnetic field stress test for the isolation of epileptic foci. Donald Dudley, M.D., Neurologist confirmed the value of this positive (north-seeking) magnetic field EEG Stress Test for the determination of epileptic foci.

With the EEG running, and starting from the eight to twelve cycles per second alpha rhythm, slowly move a ceramic disc magnet that is 1-1/2" x 3/8" with a gauss strength of 3,950 or a super neodymium disc magnet that is 1" x 1/4" with a gauss strength of 12,300, over the head. When the EEG evokes a seizure pattern, a foci has been demonstrated. The disc magnet exposing the brain to a positive (north-seeking) magnetic field must be immediately turned over and thus stop the seizure pattern. If the positive (north-seeking) magnetic field continues beyond a brief exposure, a seizure will be evoked. The seizure foci area is used as the best placement for the negative (south-seeking) magnetic field disc exposure to control seizures. This foci is the most sensitive area for placing the negative (south-seeking) magnetic field. If no specific seizure focus can be demonstrated then use bitemporal placement. Beyond the therapeutic value of this test, it demonstrates conclusively that a positive (north-seeking) magnetic field produces neuronal and other cellular excitement and that a negative (south-seeking) magnetic field has a calming, normalizing, excitement control over neurones and other cells.

Magnetic Therapy:

Magnetic therapy has had a checkered past with claims being made through the years of value. Those who experienced the value, accepted the value. But those looking on as critics had no scientific way by which they could verify the significance of this "force at a distance". For this reason, the claims have been relegated to psychosomatic, placebo or even claims of charlatans. James Livingston(1) makes a statement that reflects the uncertainty that surrounds magnetic therapy. He states that "Much of magnetic healing and magnetic therapy was and is pure hokum". He softens this a bit by proceeding to say that there is a lot yet to learn about the electro-chemical processes of the body and that it could be expected that magnetic fields would influence those electro-chemical processes.

As judged by the available reports in peer review scientific journals, James Livingston is right. This reveals how important the systematic gathering of objective data is in order for advancement in magnetic therapy. Here are some of the things we do know:

1) There is a peer review journal article establishing the fact that a positive (north seeking) magnetic field encourages the growth of cancer cells and that the negative (south-seeking) magnetic field discourages the growth of cancer cells(2).

2) Robert Becker demonstrated that a positive (north-seeking) magnetic field is the sign of injury and a negative (south-seeking) magnetic field is needed for healing.(3)

3) the widespread use of electricity in diagnosis and therapeutic instruments is being systematically replaced by magnetic instruments.

The human body is an electro-magnetic organism with a direct current circuit in which the neurons are positive (north-seeking) electro-magnetic poled and their extensions are electro-magnetic negative (south-seeking) poled. All human cells, including neurons, are electromagnetic responsive. The positive (north-seeking) magnetic field from a static field magnet is cellularly exciting which include neuronal excitation. A static positive (north-seeking) magnetic field governs central nervous system excitation including wakefulness, motor function, sensory function, mental activity and so forth. A static negative (south-seeking) magnetic field governs control over excitation, relaxation, sleep and general anesthesia. All general anesthetics, no matter how produced, have been demonstrated to be a switch of the brain from a magnetic

positive to a magnetic negative.(3). This switch of the brain's polarity from magnetic positive to magnetic negative also includes post electric shock therapy. The seizure phase is the excitation phase of the positive (north-seeking) magnetic pole. As soon as this is over, the brain switches to a negative (south-seeking) magnetic field for a few minutes. The value of electric shock is the production of this negative (south-seeking) magnetic field general anesthesia.

A positive (north-seeking) magnetic field is the signal of injury and a negative (south-seeking) magnetic field is always present during healing.(3) There were 39,000 admissions to mental hospitals that were examined and were found to correlate with sun flares. Also, the "disturbed" days in mental institutions correlated with sun flares(3). Sun flares are a positive (north-seeking) magnetic field that break through the earth's magnetosphere shield producing a higher than normal positive (north-seeking) magnetic field exposure to humans. Under normal conditions, the sun's sky shines produce a low level positive (north-seeking) magnetic field during the day, while a negative (south-seeking) magnetic field is produced during the night. The earth's crust is a negative (south-seeking) magnetic field and the molten mass below the earth's crust is a positive (north-seeking) magnetic field.

There are several companies marketing positive magnetic poled (traditional north-seeking pole) or mixed positive and negative (south-seeking) magnetic poled magnets. These are used as a mild stressor, evoking a counter-irritant reflex essentially the same as a liniment achieves. These are used to relieve pain. The testimonials of pain relief are true. However, a negative (south-seeking) magnetic field works just as well or better for pain and does not have the limitations of the fatiguing stress response reflex. Limitations consist of the reflex fatiguing in about eight weeks and also the fact that the stress can evoke self-made narcotics (endorphins and enkephalins) and thus are addictive. The positive (north-seeking) magnetic or mixed positive/negative poles applied to the central nervous system runs the risk of an increased excitation of the central nervous system which can increase the potential for psychosis and seizures. I have received hundreds of calls about this problem. I have had to deal with this problem of positive (north-seeking) magnetic field addictions. One physicist died because he was so euphoric from treating his brain with a positive (north-

seeking) magnetic field that he refused medical treatment for pneumonia. The fact that this time limitation of using this system of either positive or mixed positive/negative (south-seeking) magnetic poles exists has been published in the Japanese Medical Journal(4). This has been confirmed many times over by my observations and other physician's observations. It is the ethical responsibility of those selling positive (north-seeking) magnetic poled or mixed positive/negative poled magnets to inform their clients of the time limitation of the system and also its addictive potential.

A physician called me about how wonderful he felt using a 4" x 6" x 1/2" magnet on his head at night during sleep. He was excited, talking fast, euphoric, and sleeping 5 hours at night. The sales person had told him which side of the magnet to use which he described to me. He was using the positive (north-seeking) magnetic field. I told him he was using the wrong side of the magnet. This positive (north-seeking) magnetic field would have the following effects: 1) speeding up his thinking faster than he could speak (pressure of speech), 2) euphoria by evoking self-made narcotics, 3) produce a sleep deficient state by reducing the needed hours of sleep, 4) activate any latent microorganisms in his brain and, 5) reduce his life span.

A month later, he called me. He was calm and without pressured speech. He was not euphoric. He was sleeping a full eight hours a night. He was energetic without tension. He stated his thinking, which initially was faster than he could speak, had now slowed down to no pressure of speech. He thanked me for alerting him to the problem that was developing with the use of the positive (north-seeking) magnetic field.

THE BODY MAGNETIC

The human body is electromagnetic. The bodies of the neurones of the brain and spinal cord are magnetic positive (north-seeking) with the axon and dendrite extensions being magnetic negative (south-seeking).

The magnetic positive (north-seeking) magnetic negative (south-seeking) aspects of neurones and their extensions produce electricity, much as a magneto produces an electric spark by the friction of movement between opposite magnetic poles. This electricity flows through the nerves. Movement of electrons through the nerve synaptic junction transmitters is a magnetic chemical process. A magnetic field is produced by electron flow

and also a magnetic field is necessary for an electric current to flow. Thus, an electric current is a flow of electrons in the magnetic field. Industry makes masterful use of magnetic fields controlling electron flow making such as, TV's, computers and so forth, possible. All the laws of physics that are known to govern electromagnetics equally applies to human physiology the same as the marvelous uses of the science of physics applied to industry. In classic human physiology text, the role of magnetism is ignored and in its place a spontaneity of reactions is assumed. The closest that classic physiological text come to identifying magnetics is couched under the title of electro-chemical. The presence of an electrostatic field and the presence of chemicals (hormones, enzymes, synaptic junction transporters and so forth) are identified but the necessary presence of a magnetic field for any of the biological functions to occur is not classically identified. The assumption of spontaneity of function is assumed by just the fact of getting the chemicals together. However, there is no enzyme function and no synaptic junction transmission or other biological responses without the presence of a magnetic field. By recognizing the fact of the necessity of the presence of a magnetic field for biological function, we are now prepared to use magnetic fields to control biological functions in the same way that industry controls and directs electron flow in our marvelous new industrialized world. There are equally marvelous results when applying magnetics to human physiology as we now have in our non-biology industry. Based on this increased understanding of the role of magnetism in physiology there is occurring a gradual, yet steadily increasing application of magnetism in medicine such as magnetic resonance imagery replacing x-ray, magnetic encephalography replacing electroencephalography, magneto-cardiology replacing electrocardiology, magnetic tests replacing electric tests, magnetic application replacing TENS instruments, magnetic placement on the head replacing electro-convulsive therapy for depression and major mental disorders as well as magnetic application replacing tranquilizers and antidepressants and also the use of magnetics replacing anti-seizure medication. We are now at the threshold of demonstrating the marvelous control magnetics can have over brain and spinal cord function in the areas of psychiatry and neurology. This article reports my findings to date. The minor symptoms of anxiety, tension, depression, obsessions and compulsion can be controlled by a negative (south-

seeking) magnetic field application to the brain or spinal cord. Major mental symptoms of depression, psychotic symptoms (delusions, hallucinations, catatonia and so forth) can be controlled with a negative (south-seeking) magnetic field applied to the brain and spine. Seizures can be controlled by a negative (south-seeking) magnetic field applied to the brain. All this is marvelous news for the specialties of psychiatry and neurology. The problem is that magnetic application in the specialties of psychiatry and neurology is yet in it's experimental phase with no one in these specialties being systematically trained in these areas. These marvelous results I have objectively observed are not as yet reflected in articles in peer review scientific journals. There is still a long way to go before these observations will be reflected in traditional medicine.

I have given 70,000+ electric shock treatments, along with bushels of tranquilizers and antidepressants and seizure medication and I can state by objective observed comparison that magnetics is superior to any of these and is also without harmful side effects. The future for magnetic application in the fields of psychiatry and neurology is illuminatingly bright.

ON ACHIEVING THE REDOX GOAL OF ORTHOMOLECULAR MEDICINE: INTRODUCTION:

In the 1960's several physician researchers began searching for the answer to "Why are schizophrenics unusually fatigued?" By 1970, this focus led to the establishment of the Orthomolecular Psychiatric Association and the *Journal of Orthomolecular Medicine*. This research produced leads and therapeutic systems in several directions such as:

1) Megavitamin therapy of B_3 as a precursor to oxidoreductase enzymes with the goal of a hopeful stimulation of their catalysis.

2) A study of nutritional deficiencies and supplementation based on laboratory evidence of need.

3) An examination of and treatment of toxic states.

4) An examination of genetic errors.

5) An examination of microorganism infected states.

6) An examination of maladaptive symptom producing reactions to foods, chemicals and inhalants.

7) An examination of body pH when symptoms occurred evoked by maladaptive symptom reaction to foods, chemicals or inhalants.

8) An examination of blood sugar shifts when symptoms occurred evoked by maladaptive symptom reactions to foods, chemicals and inhalants.

9) An examination of alkaline negative (south-seeking) magnetic field dependent enzymes and alkaline -- ATP dependent enzymes.

VALUES AND LIMITATIONS OF ORTHOMOLECULAR MEDICINE

Nutrition functioning under the auspices of orthomolecular medicine has made valuable contributions to nutritional needs but also sometimes has functioned with what my research has judged as four limiting factors.

These limitations are as follows:

1) The assumption that mega-nutrients beyond nutritional needs of the B-complex vitamins, especially B_3 will energy activate or otherwise stimulate oxidoreductase enzyme function (redox).

The facts:

There is little evidence that this is so and clinical evidence shows that this has only low level value. The missing link in nutritional medicine and orthomolecular nutritional medicines format for prevention and reversal of degenerative diseases both mental and physical appears to be the known need for a magnetic energy activator for redox catalysis. A negative (south-seeking) magnetic field is observed to be the energy activator for oxidoreductase enzyme catalysis.

2) The assumption that anti-oxidant type vitamins and minerals beyond nutritional needs is the most valuable way to "absorb" free radicals.

The facts:

The facts are this method does not address the biological need for maintaining alkalinity and enzymatically processing acids and aldehydes for the release of bound oxygen back to oxidative reactive molecular oxygen. A negative (south-seeking) magnetic field activates the bicarbonate buffer system and energy activates the family of oxidoreductase enzymes which process and thus release oxygen back to oxidatively active molecular oxygen from superoxide, peroxides and other free radicals, oxyacids, alcohols and aldehydes. The most optimum answer is not megadoses of free radical absorbents but magnetic energy activation of oxidoreductase enzymes and activation of the bicarbonate buffer system.

3) The assumption that immunologic and non-immunologic maladaptive symptoms evoking reactions to foods, chemicals and inhalants comprises only a subset type of major mental disorders. Other subset types are low histamine, high histamine and a porphyrin metabolism disorder.

The facts:

In my research of thousands of mental patients over a twenty year period provides convincing evidence that 100% of major mental disorders have their major symptoms comprising the justification for their diagnosis as caused by maladaptive symptom reactions to foods mostly, a lesser extent to chemicals, occasionally to common inhalants and occasionally to inherent genetic disorders. The subtype of identifiable metabolic disorders are demonstrated to be caused secondarily by the maladaptive symptom producing reactions. Furthermore, there is evidence in the mentally ill, of a chronic viral infection of the herpes family viruses (Epstein-Barr, cytomegalovirus, and human herpes virus #6). There is evidence that this viral infection starts in either infancy or early childhood and injures the brain and immune system. The brain injury predisposes the brain to be the target organ of symptom production from maladaptive symptom evoking reactions to foods and chemicals.

4) The assumption that oxidoreductase enzyme catalysis is solely dependent on the adequacy of specific selective amino acids, specific selective vitamin precursors to products incorporated in the enzyme and specific selective mineral activators and does not need an energy activator.

The facts:

Beyond the need of being adequate in supply of enzymes, oxidoreductase enzyme catalysis requires a non-phosphorous energy activator. This energy activator can be an electrostatic field that forms a negative (south-seeking) magnetic field at the moment of catalysis or can be an exogenous negative (south-seeking) magnetic field . Varying the gauss strength correspondingly varies the degree of oxidoreductase catalysis. Oxidoreductase enzyme to substrate binding requires a static negative (south-seeking) magnetic field.

THE INFLUENCE OF A VARIABLE GAUSS STRENGTH MAGNETIC ENZYME ACTIVATOR ON OXIDOREDUCTASE ENZYME CATALYSIS

The roles of variable pH, temperature, enzyme concentration, substrate concentration, attractive forces between enzyme and substrate are routinely dealt with in biochemistry text. The magnetic enzyme energy activator is considered as a constant. The fact that a non-phosphorous energy activator is necessary for oxidoreductase enzyme catalysis is known. The fact that this enzyme activator is a magnetic field is known. The fact that the magnetic activator of the oxidoreductase enzymes is a negative (south-seeking) magnetic field is known. The sources of magnetism considered to be a constant come from:

1) endogenous magnetism -- oxidation remnant magnetism.
2) exogenous -- the earth's magnetic field.
3) exogenous magnetism -- a static electric field that can form a magnetic field.

It is a mistake to not consider the influences of varied gauss strengths of magnetic endogenous and exogenous sources of magnetism in enzyme catalysis.

The secret of the biological response to an exogenous source of magnetism from a static field permanent magnet or static field electromagnet is that of increasing enzyme catalysis by increasing gauss strength. The biological response to a negative (south-seeking) magnetic field activates oxidoreductase enzyme catalysis which includes oxidation phosphorylation producing ATP plus oxidative remnant magnetism as well as reversing reduced end-products of metabolism and also maintaining an alkaline pH.

A positive (north-seeking) magnetic field biological response produces acidity and energy activates the enzymes transferase and hydrolase catalyzing fermentation.

Electrostatic binding between enzyme and substrate as a non-phosphorus energy activator of oxidoreductive catalysis produces a measurable magnetic field (oxidative remnant magnetism) and therefore, logically can be termed electrostatic-magnetic binding of enzyme to substrate. Thus, it can be understood that a negative (south-seeking) magnetic field apart from an electrostatic field can energy activate oxidoreductase catalysis. It has to be a negative (south-seeking) magnetic field in order to maintain alkalinity on which oxidoreductase enzymes are dependent.

SUMMARY CONCLUSIONS

The answer for major mental illness is **a 4** Day Diversified Rotation Diet initially leaving out for three months the foods that evoke symptoms. The symptom reactive foods turn out to be those

eaten by the subject two or more times a week. This diet is the immediate (within five days of avoidance) reducer of symptoms. Nutrition needs to be made adequate by supplementation but does not of itself provide immediate or even long term optimum symptom reversal. A locally placed negative (south-seeking) magnetic field over the symptom area provides immediate control (within 10-30 minutes) of symptoms. A lifestyle of sleeping on a magnetic mattress pad with magnets at the crown of the head does much to stabilize the body pH, oxygenate tissues and provides for energy restoring sleep.

THE ROLE OF GENETIC ENZYME DISORDERS, NUTRITIONAL DEFICIENCY SIMULATING ENZYME GENETIC DISORDER AND TOXICITIES IN MAJOR MENTAL DISORDERS

The central reason for developing major mental disorders is, as I have already described, initially a viral infection involving both the neurones of the brain and lymphocytes of the immune system. Associated with this, secondarily are nutritional disorders. However, there are infrequent instances when specific genetic enzyme disorders give the same or similar set of symptoms as nutritional deficiencies. There are nutritional deficiencies which involve the same enzymes in a non-genetic functional disorder. There are also toxins that interfere with the enzyme function. Even though I have geared this presentation toward self-help without medical supervision, I must say that in my practice I considered all the possibilities that I am describing in this section. Organic brain disorders, whether this influences learning, motor activity or produces a psychosis or seizures, deserve to have the study which I am describing in this section. If the initial program that I have outlined does not provide ready results then consider a further medically supervised study of what is outlined in this section.

Carnosinuria

This is a spillage of carnosine in the urine. The carnosinase enzyme processes carnosine and anserine, both of which are toxic to the human central nervous system. I have especially noted carnosinuria in hyperkinetic and attention-deficit cases although this is rare. carnosine is in all land animals such as beef and fowl. Anserine is in tuna, salmon and geese. The carnosinase enzyme may be genetically deficient in which case carnosine and anserine containing animal muscle meat, tuna and salmon will have to be excluded from the diet. The carnosinase enzyme is zinc dependent

and therefore, carnosinuria will be present in zinc deficiency. The level of zinc needs to be determined. The physical manifestations of zinc deficiency is ridged fingernails and toenails, splitting of the nails, white spots in the nails and stretch marks on the skin. The non-genetic cases of carnosinuria which are due to zinc deficiency are solved by supplementing zinc.

Homocystinuria

Homocystinuria can exist due to genetic enzyme deficiencies or nutritional deficiencies of B_{12} and or folic acid and or pyridoxine. Homocystine spillage in the urine can be determined by a 24- hour urine examination. During this day, an 80% protein meal should be taken plus a supplemental methionine load. A 24-hour methylmalonic acid urine spillage should also be examined during this high protein stress day since this is specific for B_{12} genetic disorder or nutritionally deficient B_{12}.

Either an enzyme genetic disorder or a nutritional deficiency can produce this homocystinuria or methylmalonic acid spillage in the urine. B_{12} has a special condition in which there may be a relative functional deficiency rather than an absolute nutritional deficiency which can only be handled by intramuscular injection of 1,000 micrograms of B_{12} once or twice a week.

A five year old child suddenly stopped talking. A pediatrician diagnosed her as having autism even though the only symptom characteristic of autism was that of not speaking. Otherwise, the child was normal. The mother was quite dissatisfied with this diagnosis and sought my service. My study demonstrated a B_{12} deficiency. Two hours after an injection of 1,000 micrograms of B_{12} she was talking.

Porphyria

Either genetic porphyria or acquired toxic porphyria can produce organic brain symptoms. My routine for testing for porphyria has included thousands of patients. I found it to be present in about one-third of the cases. Very rarely was it genetic in origin. Most of the porphyria cases were toxic coproporphyria and related to the toxicity of maladaptive reactions to foods and sometimes to lead toxicity. Lead and mercury need to be examined because of their potential toxicity.

The toxic coproporphyria would usually disappear with the 4-Day Diversified Rotation Diet. Otherwise, it can be due to lead. The lead and mercury cases should be chelated with EDTA or other more specific chelating agents. All organic mental disorders

should have silver-mercury amalgams removed from their teeth (by a biological dentist: ed).

Hyperammonemia

The diabetic disease process, both the compensated and decompensated phase, can produce hyperammonemia. Hyperammonemia results from the necessary removal of ammonia from proteins (amino acids) in order for the human body to reconstitute these amino acids into useable tissues in the body. Ammonia is known to be severely neurotoxic. The urea cycle that processes ammonia into urea has several phases. In my clinical work with Jon Pangborn, Ph.D., biochemist as a consultant, we were able to isolate the development of the enzyme disorder that results in hyperammonemia in the last step of the urea cycle. This enzyme (arginase) is dependent on the mineral, manganese and the amino acid, arginine. These become deficient out of demand and hyperammonemia results. Although the initial problem is that of maladaptive reactions to foods, chemicals and inhalants, this secondarily developed nutritional deficiency needs to be supplemented with arginine and manganese. The neuro-toxic effect of ammonia is to injure neurones both in the spine and the brain. Usually, it is first manifested in the spine resulting in amyotrophy which is a known complication of diabetes mellitus. The first manifestation is the legs become weak and as the neuronal injury increases up the spine the next step is a respiratory problem from injury to the neurones regulating respiration. The same process occurs in the compensated phase of the diabetes mellitus disease process in which stage there is not the classic morning specimen fasting hyperglycemia as seen in the decompensated stage of the diabetes mellitus disease process. Therefore, this disease of amyotrophy in the compensated stage of the diabetes mellitus disease process is given a different name which is amyotrophic lateral sclerosis (ALS). I have examined a number of ALS cases and found them all to have this hyperammonemia. Amyotrophy cases of diabetes mellitus also have the hyperammonemia and so do Alzheimer's cases have hyperammonemia(5).

An institution devoted to the custodial care of Alzheimer's and senile cases asked me what I thought the basic problem was with Alzheimer's. I told them to feed an 80% protein meal and two hours later take venous and arterial ammonia. They called me back stating that they had tested 20 Alzheimer's cases and 20 senile cases, all of which had been diagnosed by a neurologist. All 20 of

the Alzheimer's cases had high ammonia after an 80% protein meal and none of the senile cases had hyperammonemia after an 80% protein stress meal. Within a month of this report to me there was a report in the *American Journal of Psychiatry* that hyperammonemia had been demonstrated in Alzheimer's cases.(5).

There is another factor that has to be considered in Alzheimer's cases and that is the deposits of amyloid. Amyloid consists of insoluble amino acid gels. It can occur in any part of the body. It is known to be accelerated in diabetes mellitus. When it occurs in the brain, the diagnosis of Alzheimer's disease is made. Amino acids are soluble in the normal alkaline media of the body but insoluble in acid media. This gives evidence that the maladaptive food reactions producing bouts of acidosis is the cause of these deposits of insoluble amino acid gels. Also, the same process is functional in atherosclerosis with the deposits of insoluble amino acid gels on the wall of the arteries. It is also true that calcium is soluble in the normal alkaline medium of the human body but insoluble in acid mediums. Again, when these maladaptive reactions to foods occur and acidity is present, then you have insoluble crystallized calcium and you have insoluble amino acid gels(6).

Gluten enteropathy is a genetic disorder present at a rate of 1 in 200 of Irish descent and 1 in 2000 in the non-Irish descent. There are many gluten reactors that are not genetic in origin. In fact, I found gluten to be producing the highest percentage of maladaptive reactions. It was 64% in my schizophrenic population. The genetic gluten disorder cannot only produce mental disorders but also celiac disease and Crohn's disease. Celiac disease affects the small intestine and Crohn's disease affects any part of the gastrointestinal tract. Crohn's disease can also be caused by foods other than gluten. Both of these can also be present due to a non-genetic reaction to gluten. Gluten can also be addicting. It is the only food that has this problem in which the first step of digestion in the stomach splits the gluten in half which then is a narcotic. If and when the second stage of digestion does not occur appropriately from the bicarbonate and digestive enzymes from the pancreas then the narcotic goes through the intestinal tract unchanged and is as addicting as all other narcotics. When alcohol is made from the gluten cereal grains, it carries this addictive quality. I have tested numerous alcoholics and find that when they

used alcohol made from gluten bearing cereal grains, they would have dry drunks when tested for gluten.

Testing Procedure

It has been my policy to have one day of an 80% protein day in which beef, chicken, tuna or salmon in particular was used. I also added a supplement of methionine. Two hours after the first 80% protein meal, both the arterial and venous blood was drawn for the examination of hyperammonemia. The 24-hour urine was saved during this day and tested for homocysteine, methylmalonic acid and porphyria. I was taught to do this food stress testing by Martin Rubin, Ph.D., Professor of Biochemistry at Georgetown University Medical School. I have discovered a number of genetic errors and or nutritional deficiencies that simulated genetic errors by doing this stress testing whereas, they had already had had a single morning urine specimen genetic screening test without food stress testing which was negative. Stress testing both for genetic errors and nutritional deficiencies and for the reactions to specific foods by a single food test meal has been the hallmark of my examination. This stress testing provided the ability to discover these problems of genetic errors and nutritional deficiencies and maladaptive reactions to foods which had been missed by the classic examination of the physicians. This technique gave me the ability to discover and appropriately treat many of the failures of traditional medical practice. In my judgement, all organic brain disorders whether these are in children with learning disabilities, hyperkinesis, Tourette's syndrome or adults with psychosis or any child or adult with seizures would do well to have this comprehensive study of genetic errors, nutritional deficiencies, toxic states and maladaptive reactions to foods, chemicals and inhalants. This comprehensive study should also include antibody studies for Epstein-Barr, cytomegalo and human herpes virus #6. A culture should be run on vaginal and anal swabs and stool for Candida. If there is a cough culture material coughed up for Candida. There should be a surve for parasites. From this information, a detailed plan of treatment can proceed. Genetic errors can be to some degree bypassed by supplementation. An example is that in genetic homocystinuria not only would the person need to have a low methionine intake, but they can also be supplemented with cystine and taurine which are end-products of methionine metabolism which are necessary for human function.

Gluten Enteropathy

Sixty-four percent of my adult schizophrenics had symptoms when fed a single test meal of gluten bearing cereal grains such as wheat, rye, oats and barley. I have examined quite a number of Tourette's syndrome cases and all of them had their major muscle jerking symptoms when fed gluten. Gluten is the most serious reactor of any foods and should always be considered in any organic brain disorder such as in learning disabled children, hyperkinetic children, autistic children, Tourette's syndrome or adults with psychosis. Gluten is a high reacting substance because when it is frequently used, it's nature causes it to become a narcotic when it is first digested in the stomach. When passed to the small intestine, if it is not rapidly handled by the alkalinization and pancreatic enzymes and processed to a nutritional value substance, it will pass through the small intestine as a narcotic. Thus, under these circumstances, gluten can be addicting because it has this narcotic quality. This also becomes a serious problem in relation to alcoholism since gluten's narcotic response is passed through the alcohol made from sugar grains containing gluten. From a genetic standpoint, gluten is also a serious problem. One out of 200 Irish, have a genetic gluten enteropathy. This can manifest itself as celiac disease or Crohn's disease. We observed cases that do not have the small intestine or large intestine response to gluten but have only the neuronal irritated response to gluten. The possibility of gastrointestinal reactions to gluten should always be considered. It is an observed fact that schizophrenics have more stomach aches, in terms of frequency than they have delusions. If it is determined that the reaction to gluten is genetic in origin, then gluten cereal grains must be avoided. If it is not genetic, then usually within three months of avoidance it can be rotated on once in four days without either a gastrointestinal or brain reaction occurring. In non-Irish subjects, the genetic rate of gluten enteropathy is one in 2,000.

John was an adolescent with Tourette's syndrome. His symptoms were most bizarre in that his arms and legs would both flail during his symptoms. With five days of fasting on water only, his symptoms of Tourette's syndrome completely disappeared. When fed any gluten-bearing cereal grains, his feet would sharply extend and he would fling his legs in the air and at the same time both arms would fling in the air. I have worked up a number of Tourette's syndrome cases and found all of them to have their major symptoms based on a response to gluten.

Subliminal Nutritional Syndrome

Pellagra which is a B_3 deficiency can cause major mental disorders, both overt classical pellagra and subclinical cases should be considered.

Scurvy, which is vitamin C deficiency can cause major mental disorders. Both overt and subclini-cal cases should be considered. I found some schizophrenics who required 30 grams of vitamin C before any spillage of vitamin C in the urine. This is during their reactive state. I provided a minimum of 12 grams of vitamin C a day for my mental patients.

MAGNETIC PROTOCOL FOR MAJOR MENTAL ILLNESSES: ORIENTATION:

This protocol refers to schizophrenia, manic-depressive and psychotic depression. The treatment described here is also applicable for autism, childhood schizophrenia, hyperkinesis, attention deficit disorder, dyslexia and all types of learning disorders. These psychiatric illnesses are organic in origin with secondary super-imposed maladaptive learned responses. The symptoms of the major mental disorders are delusions, hallucinations, mania, depression, disordered perception and disordered judgement. Hyperkinesis, attention-deficit, Tourette's syndrome and learning disorders give evidence of being the same illness only to a lesser degree.

From several years of study as to the cause of schizophrenia I've concluded it's origin is a viral infection which was acquired early in life, often during gestation. The immune system (B lymphocytes) and the brain neurones are infected. The viruses involved are Epstein-Barr, cytomegalo, and human herpes virus #6. I have run antibodies for these viruses on thousands of patients. The antibody level will fluctuate with the activity of the illness. The brain cannot properly develop when it is infected. This disorders judgement, affect and perception. Early in life the child often experiences learning difficulties and or hyperkinesis. In later adolescents or early 20's, the subject develops fullblown schizophrenia, manic-depressive reaction or psychotic depression. I conclude that these major mental illnesses are all of the same origin. The disorder depends on the area of the brain most affected. These viruses are lymphotropic viruses. They infect the lymphocytes. The B-lymphocytes make antibodies. Therefore the person has a disordered immune system. The brain, being infected, has a smoldering encephalitis and has a neuron infection.

Particularly involved are the pre-frontal, frontal and back as far as the temporal areas. Even the size of the brains of schizophrenics is smaller than normal and the architectural structure of the brain as viewed microscopically is disordered. This viral infection injury to the brain makes it the symptom reactive target tissue for symptoms produced by foods, chemicals and inhalants.

There are a lot of secondary disordered interpersonal relationships and symptoms that are the same as the neuroses. It is particularly noted that obsessive-compulsiveness runs through all of these major illnesses. It is sometimes hard to know whether an obsessive-compulsive reaction is organic in origin or learned in origin.

It is very important to address the evidence of the maladaptive reactions to foods, chemicals and inhalants. These reactions have six sources; 1) immune reactions in which antibodies are formed or complement function is disordered, or 2) oxidoreductase enzyme inhibition, or 3) oxidoreductase enzyme deficiency based on nutritional deficiency of enzyme building blocks (amino acids, vitamins, minerals), or 4) a deficiency of endogenous (self) produced negative (south-seeking) magnetic field resulting from reduced quantity of oxidoreductase enzyme catalytic reactions, or 5) addictive reactions from excessive production of opiate polypeptides (endorphins and enkephalins) resulting from the stress of frequently eaten foods, or 6) reactions to toxins. All of these behave alike in terms of symptom production on exposure to a substance. Foods are the most important of the substances to which a person might react. Therefore, a 4-Day Diversified Rotation Diet is a must in these cases. Nutrition needs to be made adequate in order to have available adequate oxidoreductase enzymes and adequate minerals for the pH buffer system to maintain an adequate alkaline pH. This is true even though the nutrition disorder is secondary to the illness and not the primary cause of the illness.

It is very important that the person not use tobacco, alcohol, caffeine or be addicted to anything including foods.

A negative (south-seeking) magnetic field can usually control symptoms within 10 minutes. Usually, the ceramic or neodymium discs are used, placed bitemporally to control mental symptoms. These mental patients often have systematic symptoms that can also be treated appropriately with the magnet over the area where symptoms occur.

MAGNETIC TREATMENT:

The baseline treatment is to sleep on a magnetic bed pad and sleep with magnets at the crown of the head. The magnets in the pad are mini-block magnets 1-7/8" x 7/8" x 3/8" placed an inch and one-half apart. They have a manufacturers rating of 3,950 gauss. A foam pad or other pad is placed over this magnetic mattress pad.

The magnets at the crown of the head are composed of four magnets placed 3/4 inch apart. They are 4" x 6" x 1". They have a manufacturers rating of 3,950 gauss. They can be raised or lowered depending on the height of the pillow. The top of the head should be no closer than 3 inches to these magnets which provides a full negative (south-seeking) magnetic field. This is usually automatically achieved by keeping the head on the pillow which places it no closer than 3 inches.

A magnet should be worn over the heart at night during sleep. This is best achieved with a 5" x 12" multi-magnet flexible mat over the heart, crosswise the body. This magnet has a manufacturers rating of 2,450 gauss. This mat can be best be held in place by a 4" x 52" body wrap. Place on top of this mat, lengthwise the body and directly over the heart, a 4" x 6" x 1/2" ceramic magnet with hook Velcro on both sides. Place a second 4" x 52" body wrap around the body and over this 4" x 6" x 1-1/2" magnet. Hook Velcro on both sides of the magnet adheres to the body wraps. It is important to treat the heart because the water and the oxygen flowing through the heart will be magnetized and carried to the entire body. This also helps to maintain the body's normal pH.

When sitting down the subject should sit on a comfort chair pad that has magnets in the seat and in the back. It is wise to slip a 4 x 6 x 1/2" inch thick magnet under the seat as far back as the rectal/ genital area. This will allow the magnetic field to penetrate deeply into the pelvic area. The magnet used has hook Velcro on both sides.

At night the subject should sleep with a 5" x 12" multi-magnet flexible mat crosswise on the lower abdomen-pubic area. Place on top of this a 4" x 6" x 1/2" thick magnet lengthwise the body.

Place this in the center of this magnetic mat. This can be held in place with a 4" x 52" body wrap. The magnet has hook Velcro on both sides. This will treat the pelvic area and in the event that there is any viral, fungal or parasitic infection, it will help rid the body of these anywhere in the pelvic area including the vagina or

the low colon and rectal area. This will also have the effect of encouraging the production of melatonin by the intestinal wall. This also aids in producing deep, energy restoring sleep.

Also at night, it is wise for the person to sleep with a 5" x 12" multi-magnet flexible mat across the face and onto the sides of the head. This can be held in place with a 2" x 26" self-fastening band around the head. This extends from the forehead which would cover the frontal sinuses and down across the face over the maxillary sinuses and over the nose and nasopharynx and includes the eyes.

Optimum value can be achieved by using a 4" x 6" x 1/2" thick magnet on top of the mat covering the sides of the head. This magnet has hook Velcro on both sides. This has a gauss strength of 3,950 placed up against the side, back or front of the head. Some learn to place this up onto the side of their head that is not on the pillow if they are on their side. Usually they will sleep 3 or 4 hours without turning over with this magnet placed on the side of the head.

It is important to have ceramic disc and neodymium disc magnets. Ceramic disc magnets are 1-1/2" x 3/8". Hook Velcro is placed on the positive poled side of the ceramic disc magnet so that when a band is placed around the head, when placed bitemporally, the hook Velcro will hold them in place.

A 2" x 26" self-adjusting band is used to hold the magnets. These magnets will be the most used when treating mental symptoms. They should be used freely. It usually requires about 10 minutes to relieve major symptoms. The more hours of exposure to the magnets the better. The neodymium magnets weigh approximately one-fourth of the weight of the ceramic disc magnets and are more convenient and as effective. When using the neodymium disc magnet it is best to place a 2" x 3" or 3" x 3" plastiform magnet first against the temporal area and the neodymium disc on the outside of the plastiform magnet. This spreads the magnetic field. A small disc magnet is provided as a holder by placing it on the outside of the head band.

Depression, delusions, and hallucinations are usually best handled by bitemporal placement. The bitemporal area to be treated is in front of, and near the top of the ears. Centered in the temporal areas are the amygdala which are small walnut sized areas that are the center of the electro-activity of the brain. The entire brain can be calmed down by treating the amygdala. Other areas to consider

testing is the left temporal area and the mid-forehead in right handed persons. That is the most anxiety relieving placement. For treating obsessive-compulsiveness, treat the left temporal area and the low occipital area.

Mental patients often have systematic symptoms also. An appropriately sized magnet that is larger than the symptom area being treated should be used and at the same time, discs should be placed bitemporally. The brain receives messages from the body and also sends messages to the body. While treating a symptom of the body, the brain should also be treated at the same time.

COLLOIDAL SILVER THERAPY:

Colloidal silver is made by an electrolysis method that produces a particle size of 0.0001 micron. These small silver particles are charged to a negative (south-seeking) magnetic field by the electrolysis method. This solution of colloidal silver is placed in the mouth, especially under the tongue for absorption. This provides quick absorption into the blood stream. These fine silver particles go throughout the entire body. The negative (south-seeking) magnetic field magnetically attaches to microorganisms, parasites and cancer cells which are positive (north-seeking) magnetic poled. Silver, in its own right beyond that of the negative (south-seeking) magnetic field, inhibits the replication of these cells. The small silver particles do not interfere in any way with human cell function. It is recommended to use 40 parts per million starting for the first week with 1/2 teaspoon four times a day and followed for the next three months with 1 teaspoon four times a day. In the case of acute infections, two weeks of treatment of 1 teaspoon four times a day usually suffices. There is also an aloe vera silver salve which can treat local skin infections.

ACTIVE H:

Active H is a super free radical scavenger. It also normalizes the pH. Active H is an excellent adjunct to magnetic therapy.

Active H is the most powerful known antioxidant. A well person uses 1-2 capsules a day. An ill person uses up to two capsules 3 times a day for a period of three months. Any quantity has no ill side effects.

ALKALINE MICRO WATER:

Alkaline micro water helps materially to maintain the body's normal alkaline state. Also, being micro water, it enters into the cells of the body more readily than the usual water. This also carries a negative (south-seeking) magnetic field as well as being alkaline.

The Singer Electrolysis Instrument is used for producing the alkaline micro water. At least five glasses of this water should be used each day.

GENERAL INFORMATION ABOUT MAGNETS:

Multi-magnet flexible mats are composed of plastiform magnet strips 1-1/2" x 7/8" x 1/8" with a manufacturers gauss rating of 2,450. These plastiform magnetic strips are placed in four rows with the 1-1/2 inches lengthwise the pad. These strips are stacked in two's. In a 5" x 6" mat, there are 24 magnetic strips. In a 5" x 12" mat, there are 48 magnetic strips. The flexibility of these mats makes them very useful since they will fit around the curves of the body without producing any pressure. With the multi-magnet flexible mats, the magnetic field extends to 7 inches. However, the therapeutic level extends about 2 inches. When the flexible mat is reinforced with one row of mini-block magnets placed on the two central rows of magnets in the mat, the magnetic field extends to 10 inches with the therapeutic field extending to 4 inches. When there are two rows of mini-block magnets on the mat, the therapeutic level extends to 5 inches. The flexible mat can be reinforced with mini-block magnets placed crosswise the two inner rows of plastiform magnets in the flexible mat. This places the mini-block magnets an inch and one half apart in which there are three placed on the 5" x 6" mat and six placed on the 5" x 12" mat. The flexible mat can also be reinforced by the 4" x 6" x 1/2" ceramic block magnet. This extends the therapeutic value to 6 inches.

Mini-block ceramic magnets are called Briggs blocks because they are used as the MAGNETO magnets in Briggs and Stratton gasoline motors. They are 1-7/8" x 7/8" x 3/8" with a manufacturers gauss rating of 3,950. These are cast mini-blocks. They have many therapeutic uses. They can be used on the head such as the temporal areas, frontal or occipital areas for headaches or management of emotional symptoms or seizures. They can be used on fingers or toes. They can be placed on top of the flexible mats to reinforce the depth of magnetic field penetration. They can be used directly on the joints, under or incorporated into wraps around joints. They are used in the magnetic mattress pad, the multi-purpose pads and the magnetic chair pads.

Ceramic disc magnets are 1-1/2" x 3/8" with a manufacturers gauss rating of 3,950. These ceramic discs are cut from the larger 4" x 6" x 1/2" magnets. They serve numerous valuable purposes

such as around the head to treat headaches or other central nervous system symptoms, around joints, over skin or subcutaneous lesions. The magnetic field of a ceramic disc extends to eight inches. The therapeutic value extends to about three inches.

Ceramic block magnets which are 4" x 6" x 1/2" have a manufacturers gauss rating of 3,950. The magnetic field extends to 12 inches. The therapeutic value extends for 6-7 inches. A ceramic block magnet that is 4" x 6" x 1" has a magnetic field extending to 19 inches with a therapeutic value extending to 9 inches. The 4" x 6" x 1/2" ceramic block has many uses such as around joints or to penetrate deeply into the liver, internal organs, the heart or into the head such as for treatment of tumors. The 4" x 6" x 1" ceramic block magnets are used in the Vitality Sleeper to have a field that penetrates into the head during sleep. The Vitality Sleeper is composed of four ceramic blocks that are 4" x 6" x 1" placed in a row 3/4 inch apart. These ceramic blocks are placed upright in a wooden carrier that holds them firmly up against the headboard. They can be raised or lowered depending on the height of the pillow. They are shipped at the top of the carrier and need to be lowered so that the head is in the magnetic field. They are resting on a wooden dowel. The wooden dowel they are resting on should be slightly below the back of the head when the head is on the pillow. It is designed that the top of the head should be approximately three inches from these magnets. By doing so, it provides a full negative (south-seeking) magnetic field.

A magnetic mattress pad is composed of mini-block magnets that are placed an inch and one-half apart throughout the pad. An eggcrate type foam pad or other suitable futon should be placed over this mattress pad. By doing so, it provides a full negative (south-seeking) magnetic field.

The magnetic chair pad is composed of mini-block magnets placed an inch and one-half apart throughout the seat and the back of the pad.

The multi-purpose pad is 14" x 25" and composed of mini-block magnets that are placed an inch and one-half apart throughout the pad. This multi-purpose pad has many uses such as being used on the back, the abdomen and up over the heart and the chest.

THERAPEUTIC SLEEP:

In maintaining health and reversing degenerative diseases, it is very important that there be deep, energy restoring sleep. It is necessary to sleep a full eight hours in every 24 hour period. Energy

is used up during the day and is restored during sleep. The depth of energy restoring sleep is controlled by the hormone, melatonin, that is made during sleep. The principle area in which melatonin is made is the pineal gland which is in the center of the head. This gland makes melatonin in response to a negative (south-seeking) magnetic field. This is why it is so important to treat the head to a negative (south-seeking) magnetic field during sleep. The retina of the eyes also make melatonin and the intestinal wall makes melatonin. Treating these areas also raises melatonin. The hormone melatonin has the control of the entire energy system of the body including such as the immune system and the endocrine system.

Another hormone that is made during sleep is growth hormone which is made by the hypothalamus in the brain. Growth hormone has control over the health of skin, nails, cellular replication and also, respiration.

In order to achieve appropriate production of the hormones melatonin and growth hormone it is necessary to sleep in a completely light-free environment and without any 60 cycle per second electrical pulsing frequency. Therefore, there should not be a night light, an electric clock, an electric heated blanket or a heated waterbed. If light cannot be completely excluded from the bedroom, then place over the eyes and the forehead a light shield.

The magnetic mattress pad will encourage the production of melatonin by the gastrointestinal tract. Any magnetic treatment of the abdomen will encourage the production of melatonin by the wall of the gastrointestinal tract.

Treating the eyes with a magnetic flexible pad will also encourage the production of melatonin by the retina of the eyes. The Vitality Sleeper up against the headboard will have a magnetic field that penetrates into the head and stimulates the pineal gland to produce melatonin and the hypothalamus to produce growth hormone. This can be further encouraged by a flexible mat over the eyes and or up against the sides or back of the head. This can be further enhanced by reinforcing the flexible mat with mini-block magnets. Some sleep very well with a 4" x 6" x 1/2" magnet up against the side of the head. It is best to cushion this by placing a 5" x 6" mat up against the side of the head first with the 4" x 6" x 1/2" magnet over the mat. When laying on the back, this can be leaned up against either side of the head. When laying on the side it can be on the side of the head that is not on the pillow or be placed on the back of the head. Some find it valuable to place a 5"

x 12" multi-magnet flexible mat on the pillow or under the pillowcase so that their head is resting on this mat. If they are on their back it is on the back of the head. If they are on their side, it is on the side of their head. The value can be further increased by reinforcing this mat with six mini-block magnets placed on the positive (north-seeking) pole side. Place these nine mini-block magnets crosswise the mat, one and one-half inches apart. They will magnetically adhere to the mat.

SYMPTOMATIC FOOD REACTIONS GENERAL INFORMATION:

A local and systemic biological response of acidity is routinely evoked when symptoms develop in response to exposure to foods, chemicals and inhalants. Acidity also produces low oxygen (acid-hypoxia). This is true whether the maladaptive symptom reactions are immunologic or non-immunologic in origin. Most food symptom reactions are not immunologic. Immunologic and non-immunologic food symptom reactions have a classic addictive see-saw biological response of symptom relief on exposure with the emergence of symptoms 3-4 hours after the exposure (addictive withdrawal phase). The optimum method of reversing addiction is avoidance. In food addiction, the optimum method of avoidance of the addiction is for there to be a 3-month avoidance followed by an exposure no more often than every fourth day. This is the reason for the 4-Day Diversified Rotation Diet. The optimum long term management of food addiction is the food avoidance period produced by the 4- Day Diversified Rotation Diet. The short term management of symptoms can be managed by alkalinization which can be produced by bicarbonate alkalinization and more optimally, exposure to a negative (south-seeking) magnetic field which alkalinizes and oxygenates (alkaline-hyperoxia).

These alkalinization methods can relieve symptoms after they have occurred from the exposure and can also prevent symptoms from developing when the alkalinization methods are used prior to an exposure to symptom producing foods, chemicals and inhalants.

Following is the optimum method of preventing symptoms from occurring from foods:

1. A 4-Day Diversified Rotation Diet. This four day spacing of exposure to specific foods prevents food addiction.

a) Bicarbonate alkalinization. One-half hour before the meal, use Electro-C powder (by Nutri-Biotic). Use 1/2 teaspoon of

Electro-C powder and 1/2 teaspoon of soda bicarbonate in 1/2 glass of water.

b) Negative magnetic field (south-seeking) exposure. One-half hour before the meal place the magnets on the body. Magnetic discs, either ceramic, magnetic discs that are 1-1/2" x 3/8" or super neodymium discs that are 1" x 1/4" placed bitemporally. These can be held in place with a 2" x 26" band. Place on the sternum, a 4" x 6" x 1/2" ceramic magnet. Place on the thoracic spine, a 5" x 12" multi-magnet flexible mat. Hold the magnet on the sternum and the magnetic mat on the thoracic spine in place with a 4" x 52" body wrap. These can be removed at the beginning of the meal or they can be continued through the meal until it is completed. If symptoms emerge after the meal has been eaten, then replace the magnets until the symptoms leave and especially place a suitable sized magnet directly over the symptom area. Also prior to the meal, if there are any symptom areas, treat these with appropriate sized magnets, pre-meal. Always use the negative magnetic field (south-seeking).

The above pre-meal alkalinization method is recommended for;

a) those with a serious state of symptom reactions to multiple foods in which food rotation is not entirely satisfactory

b) when of necessity, symptom evoking foods have to be eaten. Such as when eating out at a restaurant, or those that have to use this method instead of waiting three months for the introduction of their foods.

3. Post-meal. If any symptoms develop, post-meal, then use suitable magnets placed locally for relieving these symptoms. It could be helpful again, to place the disc magnets bitemporally.

In my experience, the above method of basic food rotation diet with the addition when necessary of the magnetic pre-meal exposure and the magnetic post-meal exposure is superior to any neutralization method. Neutralization methods do not honor the fact that the basic problem is that of addiction. A food rotation diet is necessary to honor the fact that addiction is the major driving force of food maladaptive reactions. There is no optimally effective method for the management of maladaptive reactions to foods that is equivalent to food rotation.

POLARITY:

Always use a negative (south-seeking) magnetic field. The positive (north-seeking) magnetic field would excite the brain. The negative (south-seeking) magnetic field calms the brain.

Four-Day Rotation Diet
Day I
Meat
Bovidae: Lamb, Beef, Goat, Deer, Cheese, Milk and Yogurt
Fish
Fish and/or shellfish can be on any or all days by keeping the type of fish or shellfish different for each day.
Vegetables
Potatoes: Potato, Tomato, Eggplant, Red/Green Peppers and Pimento

Goosefoot: Beet, Spinach, Swiss chard and Lamb's quarters

Composites Lettuce, Chicory, Endive, Escarole, Artichoke, Dandelion and Safflower

Corn: Fresh Corn as a fresh vegetable
Fruits
Mulberry: Mulberry, Figs and Breadfruit

Rose: Strawberry, Raspberry, Blackberry, Dewberry, Loganberry, Young-berry, Boysenberry and

Rose Hip

Grape: Grapes and Raisins

Cashew: Mango
Nuts:
Sunflower: Sunflower Seeds Cashew: Cashew and Pistachio Protea: Macadamia Nut
Thickening
Tapioca
Seasonings
Grape: Cream of Tarter

Potato: Chili Pepper, Paprika and Cayenne

Composites: Tarragon Nutmeg: Nutmeg and Mace
Sweetener
Beet Sugar

<u>Tea</u> Rose Hips, Chicory and Dandelion

Sprouts Legumes, Bean Sprouts, Alfalfa Sprouts and Sunflower, Sprouts
Fresh Vegetable
Green Bean Sprouts, Alfalfa Sprouts and Sunflower Sprouts
Day II

Meat
Bird: *All fowl – Chicken, Turkey, Duck, Goose, Guinea, Pigeon, Quail and Pheasant
Eggs
Eggs
Fish
Fish and/or Shellfish can be on any or all days by keeping the type of fish or shellfish different for each day.
Vegetables
Myrtle: Pimento Grass: Millet
Parsley: Carrot, Parsnip and Celery
Mushroom: Mushroom and Yeast (Brewer's or Baker's)
Mallow: Okra
Fruits
Plum: Plum, Cherry, Peach, Apricot, Nectarine and Wild Cherry, Pineapple: Pineapple, Pawpaw: Pawpaw, papaya and papain
Grains:
Gluten: Wheat, Oats, Barley, Rye and mature Corn Non-gluten: Millet, Sorghum, Bamboo shoot and Malt
Nuts:
Plum: Almond Beech: Chestnut Brazil nut: Brazil nut Flaxseed: Flaxseed
Thickening
Wheat flour, Agar-agar (vegetable gelatin from sea algae)
Seasonings
Myrtle: Guava, Clover, Allspice and Clove
Parsley: Celery seed, Celeriac, Anise, Dill, Fennel, Cumin, Coriander and Caraway, Pedalium: Sesame, Orchid: Vanilla
Oil
Cottonseed, Flaxseed and Sesame
Sweetener
Corn sugar, Clover honey and Molasses
Tea
Sterculia: Papaya tea
Day III
Meat
Suidae: Pork
Fish

Fish and or Shellfish can be on any or all days by keeping the type of fish or shellfish different for each day.

Vegetable

Mature Legumes: Pea, Black-eyed Pea, Soybean, Lentil, Peanut, Lima Bean, Navy Bean, Garbanzo Bean, Great Northern Bean, Pinto Bean and Kidney Bean

Laurel: Avocado

Lily: Onion, Garlic, Asparagus, Chive and Leek

Fruits

Apple: Apple, Pear and Quince

Banana: Banana and Plantain

Heath: Blueberry, Huckleberry and Cranberry

Gooseberry: Currant and Gooseberry

Ebony: Persimmon Buckwheat: Rhubarb

Grains

Buckwheat: Buckwheat and Rice

Nuts

Legume: Peanuts

Birch: Filbert (Hazelnut) Conifer: Pine Nut (Pinon)

Thickening

Arrowroot: Arrowroot Flour

Seasonings

Arrowroot: Arrowroot Heath: Wintergreen Legume: Licorice

Laurel: Cinnamon, Bay leaf, Sassafras and Cassia bud/bark

Pepper: Black & Whit Pepper

Oil Soybean, Peanut and Avocado

Sweetener

Fructose, Carob syrup, Maple sugar, Tupelo honey and Cane sugar

Tea

Alfalfa, Sassafras, Garlic and Apple cider/tea

Day IV

Meat

Meat: Rabbit, Fowl not used on Day II (Chicken, Turkey, Duck)

Fish

Fish and/or Shellfish can be on any or all days by keeping the type of fish or shellfish different for each day.

Vegetables

Morning Glory: Sweet Potato

Gourd: Cucumber, Pumpkin, Squash, Acorn and Squash seeds

Mustard: Mustard, Turnip, Radish, Horseradish, Watercress, Cabbage, Kraut, Chinese Cabbage, Broccoli, Cauliflower, Brussel Sprouts, Collard, Kale, Kohlrabi and Rutabaga

Olive: Black/Green Olives

Fresh Grain Vegetables

Sprouts: Wheat, Rye, Barley and Oat

Fruits

Gourd: Watermelon, Cantaloupe and Honeydew

Citrus: Lemon, Orange, Grapefruit, Lime, Tangerine, Kumquat and Citron

Honeysuckle: Elderberry Palm: Coconut and Date

Nuts

Seeds: Pumpkin seeds, Squash seeds and Coconut

Walnut: English walnut, Black walnut, Pecan, Hickory and Butternut

Thickening

Cornstarch

Seasonings

Mustard: Mustard

Mint: Basil, Sage, Oregano, Savory, Horehound, Catnip, Spearmint, Peppermint, Thyme, Marjoram and Lemon Balm

Oil:

Coconut, Olive, Pecan and Corn

Sweetner:

Date sugar, Honey (other than Tupelo or Clover)

Tea:

Kaffer

HOW TO USE A FOUR DAY DIVERSIFIED ROTATION DIET WITHOUT DELIBERATE FOOD TESTING

Many people find it practical to go directly to a four day diversified rotation diet without food testing. First, the person assumes that he or she is reacting to any food eaten as frequently as twice a week, or to any members of that food family. The person leaves these frequently used foods out of the diet for three months. At the initiation of the rotation diet, stop all use of caffeine (coffee, teas with caffeine, cola drinks, chocolate), tobacco and all alcoholic drinks. DO NOT REINTRODUCE THESE INTO THE DIET.

For the next three to four days, there will be withdrawal symptoms. Handle these symptoms as described in the section, How To Initiate This Program.

Three months later, these foods are reintroduced back into the diet. Nearly always (95% of the time), these foods will no longer be reactive as long as they are kept on a once-in-four-day basis in this diet. When reintroducing foods into the diet, simply add the food to the established rotation and observe whether or not symptoms occur. If no symptoms occur, then this food can be rotated. If symptoms occur, wait another three months before trying this food again.

One way to expand the use of foods is to sprout cereal grains and legumes. A person should be certain that the grain or bean is sprouted with approximately 1/4" or more of a sprout. The foods that have been sprouted will no longer carry the same reactive capacity that the non-sprouted foods do. Thus, once sprouted, grains and legumes can be introduced into the diet immediately. A potential reaction to chemicals can be determined by sniffing the product. These products included clothes, carpet, car exhaust, or anything to which a person has frequent exposure.

Gluten is the most frequent and severe symptom reactor of all foods. Thus, gluten is the most likely food substance to continue evoking symptoms. Common physical reactions to gluten include: gastrointestinal problems such as celiac disease and Crohn's disease (gluten enteropathy); jerking muscles (Tourette's syndrome); and headache. Emotional and mental symptoms caused by reactions to gluten range from mild (tension, anxiety, phobias, depression, obsessions, compulsion) to severe (psychotic depression, hallucinations, delusions). There is genetically determined immunologic reaction to gluten occurring at a ratio of 1 in 200 Irish people and 1 in 2,000 non-Irish. These immunologically reactive people should leave gluten out of their diet. Wheat, rye, oats and barley all contain gluten. If gluten is introduced, only a small amount should be used, and then avoided for months.

In addition to being the most reactive food substance in terms of immunologic and non-immunologic maladaptive reactions, gluten is the most addictive of all food substances. Gluten is split in half during the first stage of digestion, which occurs in the stomach by a combination of hydrochloric acid with the enzyme pepsin. This splitting of gluten produces an active narcotic (exorphin). This narcotic becomes addicting when it is absorbed through the small intestine without further digestion by pancreatic enzymes and their normal alkaline medium. Many people do not produce adequate pancreatic enzymes or associated sodium and

potassium bicarbonate. Thus, these people are subject to gluten addiction if they use gluten frequently. Alcoholics using alcohol prepared from wheat, rye, oats or barley will have symptoms emerge on deliberate food testing for these gluten-containing foods. Vodka addicts have symptoms to provocative food testing for white potatoes. Wine addicts have symptoms to a provocative test meal of either grapes or the substance from which the wine is made. This applies to wine vinegar as well. Beer addicts have symptoms with test meals to brewer's yeast or any gluten-containing cereal or rice used in the beer-making process.

Dairy products and beef are the second most symptom reactive foods. Characteristically, the person who reacts to dairy products also reacts to beef, and vice versa. In terms of the frequency of symptoms, corn products are approximately equal to dairy products and beef.

People with homocystinuria have symptoms from dairy products and meats. Homocystinuria is an infrequent genetic error. It is caused by a deficiency of cystathionine B-synthase enzyme, in which methionine cannot be processed properly. Occasionally, homocystinuria is due to a nutritional deficiency of the B complex vitamins, especially B_{12} or folic acid. In these nutritional deficiency cases, B complex supplementation solves the problem of food reactions to high methionine containing foods. People with genetic homocystinuria must rely on avoidance of foods high in methionine. They must also supplement cystine, which comes from methionine. In addition, they should also supplement taurine, which is made from cystine. Taurine is important in keeping the central nervous system calm.

Another rare genetic enzyme disorder is carnosinuria. This is caused by a deficiency of the enzyme carnosinase. This enzyme processes carnosine and anserine. If not enzymatically processed, carnosine and anserine are toxic to humans. People with this genetic enzyme disorder must avoid foods containing carnosine and anserine. Carnosine is found in all land animals. Anserine is found in tuna and salmon. carnosinase is a zinc-dependent enzyme. Therefore, carnosinuria is occasionally caused by zinc deficiency. Zinc deficiency can be determined by a laboratory assessment. Physical symptoms of zinc deficiency include: white spots in the fingernails and toenails; ridged or easily splitting fingernails, and stretch marks on the skin, especially on the abdomen or breasts. When carnosinuria is caused by a nutritional deficiency, zinc

supplementation can solve the problem. A carnosinase enzyme deficiency can produce a wide range of symptoms. The most prominent symptoms I have observed are attention deficit and hyperactivity. For example, a ten-year-old boy with attention deficit and hyperactivity on laboratory testing was demonstrated to have both carnosinura and zinc deficiency. Neither supplementation with zinc nor rotation of foods solved his problem. However, upon removal of meats, tuna, and salmon from his diet, he was free of symptoms. although rotation diet solves most food reaction symptoms, these other causes of food reactions must some- times be considered. Laboratory tests can make the determination. People who try to help themselves without medical supervision can make this determination only through trial and error.

For twenty years I deliberately food tested my patients. This consisted of five days of avoidance of any food used with the frequency of two or more times a week, followed by food tests of single food per test meal. Classically, it is the foods eaten with a frequency of two or more times a week that produce acute symptoms and are also responsible for the symptoms of degenerative diseases. This is true of degenerative diseases such as diabetes mellitus type II, arthritis of various types inflammatory reactions such as tendinitis, myositis, fibrositis, and many pains such as headaches and pains elsewhere in the body. Secondarily, these maladaptive reactions are important in major mental disorders, multiple sclerosis, lupus, etc. These diseases classically initially start with a viral infection which disorders the immune system and injures target tissues where symptoms are produced.

Stress factors such as injury, frequency of use, local infection, etc., often serve to prepare a specific area of the body to be the area selected as the target tissue area in food reaction. An example is carpel tunnel syndrome classically occurring in the wrist that is used most frequently. I have examined numerous carpel tunnel syndrome cases and found them all to be due to food maladaptive reactions. The stress of use associated with the food reaction combine to produce the inflammatory reaction of the specific area. In major mental illness, there exists a primary chronic viral infection of the brain which prepares the brain to be the target organ for a maladaptive food reaction. Malnutrition can also be a factor predisposing to maladaptive reactions to foods, chemicals, and inhalants and to the selection of particular tissue areas for the maladaptive reaction.

Years of experience of deliberate food testing has provided convincing evidence that it is the stress of the frequency of contact that produces the maladaptive reactions to foods, chemicals, and inhalants. This is true, whether these are IgG immunological reactions or non-immunological reactions. The frequency needs to be more than two times per week. A practical food rotation diet can be set up, avoiding any food eaten as frequently as two times a week or more. Initially, avoid these foods for three months. Ninety-five percent of the time, after three months of avoidance, these initial foods left out of the diet can be introduced back into the four-day diversified rotation diet without symptoms being produced. Gluten from wheat, rye, oats, or barley is the most frequent and most serious food producing reactions. Dairy foods and corn products come in for a good second. Any food used frequently can become a reactive substance. The same principle of frequent contact pro- ducing maladaptive symptoms applies also to chemicals and inhalants.

HOW TO INITIATE THIS PROGRAM

The Four-day diversified rotation diet and avoidance of symptom of frequently used foods is initiated at the same time. Furthermore, to be discontinued at the same time is the use of any tobacco, alcohol, and caffeine beverages. The first three days will be the most serious symptom-evoking period. By the fifth day, usually the symptoms have materially subsided and have become manageable. To handle the acute withdrawal symptoms, the person needs to have available the following magnets:

Two 1-1/2" x 3/8" ceramic disc magnets. These have a gauss strength of 3,950. Two 4" x 6" x 1/2" ceramic block magnets with a gauss strength of 3,950.

For some people, it would be well for them to also have two 5" x 12" multi-magnet flexible mats with a gauss strength of 2,450.

These magnets can be used either continuously during this withdrawal phase or used just at the time the withdrawal symptoms emerge. It usually requires 10 to 30 minutes for magnetic management of the symptoms. First, place the ceramic disc magnets on each temple area, that is, in front and at the level of the top of the ears. These can be held in place with a 2" x 26" self-fastening band. Other placements that may be found to be profitable, are a left temple and low occipital area or a left temple and frontal area. The left temple is used in a right-handed person, and the right temple is used in the left-handed person. At the same time, place a

4" x 6" x 1/2" ceramic block magnet on the mid-sternum, that is, the middle of the chest, on the front. Also, a 4" x 6" x 1/2" thick magnet should be placed directly over the epigastric area, which is just below the sternum. These can be held in place by a 4" x 52" body wrap or an Ace bandage, or if the person is lying down, these magnets can just rest on these areas. Some may find it profitable or even necessary to use the 5" x 12" multi-magnet flexible mat on the thoracic and or lumbar spine. The person would need to be lying down to do this or hold the magnetic mats with a 4" x 52" body wrap. To use this magnet, always use the negative (south-seeking) magnetic field. After this acute phase is over, the person uses these magnets to relieve symptoms if and when they reoccur. The rotation diet should become a life style. The subject also should sleep on a magnetic bed pad and with magnets at the crown of the head. Also, the subject would do well to be supplementing specific nutrients. This, also, is described in more detail elsewhere.

. SELF-HELP FOOD TESTING

There is no practical reason to do self-help food testing. It is best to proceed as described in the section, "How to use the four day diversified rotation diet without deliberate food testing."

Deliberate food testing should not be done without medical supervision on the following: 1) diabetics on insulin, 2) seizure cases, 3) dangerously aggressive cases such as in some psychotics. All of these cases can proceed to the rotation diet without food testing.

Even though I am not recommending self-help food testing, the principles of self-help food testing are as follows:

1) Five day avoidance of foods used as frequently as two or more times a week. Wait five days before using any of these foods in a single meal food test.

2) Use test meals of single foods.

3) Monitor for the emergence of physical and emotional symptoms as well as blood pressure before the meal and one hour after the meal. The pulse should be taken before, and one hour after the test meal. In a non-insulin dependent diabetic (Type II), test the blood sugar before the meal and one hour after the meal. It is also well for anyone to test the blood sugar. There are many high blood sugars (beyond 160) in patients who have not been diagnosed as diabetics. When the blood sugar is beyond 160, it demonstrates that this person is in a pre-diabetic state.

4) Symptoms can be relieved by bitemporal placement of ceramic disc magnets which are 1-1/2" x 3/8" held in place with a 2" x 26" headband.

5) Stop all tobacco, alcohol and caffeine when the program starts.

FOUR-DAY DIVERSIFIED ROTATION DIET REVERSAL OF THE DEGENERATIVE DISEASE PROCESS

Classically, maladaptive reaction to foods, chemicals, and inhalants are part of and central to degenerative diseases whether physical or mental. Maladaptive reaction to foods composed a major- ity of these acute symptoms produced, as well as the longer term degenerative disease symptoms. Comparing acute symptoms with the chronic symptoms of degenerative diseases reveals that the symptoms of chronic diseases are simply a time extension of acute maladaptive reactions. The metabolic mechanisms of acute maladaptive reactions are the same as the chronic symptoms of degeneration. Central to this biological disorder producing symptoms is the production of acidity with its associated reduction of oxygen (acid-hypoxia).

There have been isolated six types of maladaptive reactions, producing both acute symptoms and the chronic symptoms of degenerative diseases.

(1) Immunological reactions. This produces antibodies and complement complexes which are inflammatory. This comprises a minor percentage of maladaptive reactions. The specialty of allergy/immunology focuses on this reason for maladaptive reactions.

(2) Oxidoreductase enzyme deficiency. The oxidoreductase enzymes are necessary to produce biological life energy by oxidation phosphorylation producing ATP and oxidation remnant negative poled magnetism. The biological life energy consists of enzyme catalytic production of: (a) adenosine triphosphate (ATP), (b) oxidative remnant magnetism [a negative (south-seeking) magnetic field]. This oxidation/reduction enzymatic response is dependent upon alkalinity and molecular oxygen (alkaline-hyperoxia). These oxidoreductase enzymes also process the end products and by-products of oxidation reduction metabolism which are free radical oxygen and further production of either free radicals, peroxides, oxyacids or aldehydes. These inflammatory

substances are enzymatically processed by oxidoreductase enzymes releasing oxygen back to its oxidative molecular state.

These oxidoreductase enzymes are all alkaline dependent. The enzyme activator can be either a static electric field or a negative (south-seeking) magnetic field. The movement of electrons between the enzyme and the substrate (free radicals, peroxides, oxyacids, and aldehydes), during the catalytic reaction, produces a negative (south-seeking) magnetic field. This production of the negative (south- seeking) magnetic field due to this catalytic reaction occurs with all oxidoreductase enzyme catalytic reactions. The production of this magnetic field is measurable. Furthermore, a negative (south-seeking) magnetic field can magnetically cause the enzyme and the substrate to join, thus serving as the energy activator of oxidoreductase enzymes.

The nutritional precursor of oxidoreductase enzymes of necessity needs to be present. However, an excessive amount of these nutrient enzyme precursors have no ability to serve as an energy activator of these enzymes. The conditions necessary for the catalytic response of the oxidoreductase enzymes are: 1) Adequate amounts of enzymes made from the nutrient precursors, 2) An alkaline medium since these enzymes are alkaline dependent, 3) An energy activator which can be either a) a static electric field, or b) a negative (south-seeking) magnetic field. Clinical observations provide convincing evidence that a negative (south-seeking) magnetic field can activate oxidoreductase enzymes even in the present of a moderately malnourished state.

(3) Oxidoreductase enzyme inhibition. This is a state in which there are adequate oxidoreductase enzymes whose response capacity has been trained down. This enzyme inhibition state develops because of repeated and prolonged development of acidity due to maladaptive reaction to foods, chemicals, or inhalants. This acidity is largely a result of maladaptive reactions to frequently used foods. The frequency of eating a food more often than each four days is central to the development of oxidoreductase enzyme inhibition. It matters not whether these maladaptive reactions are immunologic or non-immunologic in origin, the reaction is always the same, and that is, the production of an acid-hypoxia. I have tested thousands of these maladaptive symptom-producing reactions of all types and have found them all to be acid-producing. It is the acidity that produces the

symptoms. Acidity causes the cells to swell and reduces the availability of oxygen.

There is good clinical evidence that oxidoreductase enzyme inhibition is the major cause of maladaptive symptom-producing reactions. Furthermore, since all types of maladaptive reactions are acidifying and since acidity inhibits oxidoreductase enzyme function, there exists oxidoreductase inhibition in all types of maladaptive reactions.

The answer to this state of oxidoreductase enzyme inhibition is to 1) provide an alkaline medium in which the enzymes can function, and 2) provide a negative (south-seeking) magnetic field to energy-activate these enzymes. Of interest to note is that a negative (south-seeking) magnetic field provides for both the alkalinity by direct action on. the bicarbonate buffer system and also the energy activation of the oxidoreductase enzymes.

(4) A deficiency of endogenous (self) produced negative (south-seeking) magnetic field resulting from reduced quantity of oxidoreductase enzyme catalytic reactions.

(5) Addiction. It is the acidifying addictive withdrawal phase of an addiction that is the culprit. This occurs three to four hours after exposure to the addictive substance. There are two types of addictions (a) from an external narcotic source, and (b) self-made narcotics (endorphins and enkephalins) produced by the stress of frequent exposure to non-narcotic substances. Thus frequently used foods, alcohol, tobacco, caffeine, etc., which in themselves are not narcotics, but addicting when frequently (two or more times a week) used. Narcotics, both external and internally self-made, are symptom relieving, since all narcotics are alkaloids, and thus alkalizing. Thus, while under the alkalizing influence of the narcotic, the oxidoreductase enzymes are adequately functional. When the narcotic is metabolically used up, and therefore not present, then a state of acidity develops and oxidoreductase enzyme inhibition sets in. Thus, in the acid-hypoxic addictive withdrawal state with its free radicals, peroxides, oxyacids, and aldehydes, symptoms develop. The type of symptoms depend upon the specific tissue involved in the maladaptive reaction. The answer to reversal of the acute symptom reactive tissue state is to expose this area to an external source negative (south-seeking) magnetic field.

(6) Toxins. Toxins are enzyme poisons which are a complete block of oxidoreductase enzyme function. Many toxins are strong

acids or evoke acid production in the human body. Insect stings and reptile bites are powerful acids. Pesticides are toxic to humans as well as insects. Our industrialized civilization produces toxins such as petrochemical exhaust from combustion, formaldehyde, etc. The major necessary measure of handling reaction to toxins is avoidance. The second most important method of handling toxins is to provide a negative (south-seeking) magnetic field for the production of an alkaline medium and the activation of the oxidoreductase enzymes, thus oxidatively processing these toxins out of the body and activating the enzymes that will reverse the acid-hypoxic state.

REVISITING THE MAGNETIC DYNAMICS OF THE DEGENERATIVE DISEASE PROCESS

The central disorders of acute maladaptive reactions are: 1) acidity, and 2) oxygen deficit. Monitoring the biochemical disorders of chronic degenerative diseases reveals the same disorders as acute maladaptive reactions which are acid-hypoxia. Chronic degenerative diseases are observed to be acute maladaptive reactions extended in time to a chronic state with the resultant cellular damage. The contrast between the well cells of the healthy, functioning person and the sick cells of degenerative diseases provides valuable clues as to how magnetics can substantially aid in recovery of inflammatory degenerative diseases, infections from microorganisms and cancer.

In the process of oxidative phosphorylation producing adenosine triphosphate (ATP), molecular oxygen accepts an electron and becomes free radical oxygen (superoxide). If not immediately enzy- matically reversed, superoxide proceeds to produce other free radicals, peroxides, oxyacids, alcohols and aldehydes. These are all inflammatory. The oxidoreductase family of enzymes have the assignment of making ATP by oxidative phosphorylation and at the same time, processing the reduced end-products of this oxidation phosphorylation process. This oxidoreductase family of enzymes are alkaline-hyperoxic- negative (south-seeking) magnetic field activation dependent. When these 3 physiologically normal factors are not present, then cellular ATP is made by fermentation. The 3 factors necessary for fermentation to produce ATP are: 1) acidity, 2) lack of oxygen, 3) a positive static magnetic field as an enzyme energy activator. Human cells have the capacity to make ATP by either oxidative phosphorylation or fermentation. Cellular fermentation producing ATP only

functions in the abnormal state of acidity and hypoxia. The enzymes catalyzing fermentation production of ATP are transferases which are acid-hypoxic-positive static magnetic field activation dependent. Sugar is catalyzed by transferase producing ATP, alcohols, acids and carbon dioxide. Hydrolase enzymes catalyzes starches to sugars. Hydrolase also is acid-hypoxic-positive static magnetic field energy activation dependent.

There are specific (oxidoreductase enzymes) non-phosphorus (non ATP) static magnetic field enzyme energy activation and specific ATP energy activated enzymes. When oxidative phosphorylation catalyzes the production of ATP this catalytic reaction makes negative static field magnetism termed oxidation remnant magnetism. This negative static magnetic field is available to energize oxidoreductase enzyme catalysis and at the same time, block transferase and hydrolase catalysis. Besides the biological available negative static magnetic field from oxidation remnant magnetism, there is an always present electrostatic field(7). In an alkaline medium the electrostatic field produces a negative static magnetic field which energizes oxidoreductase catalysis. In an acid medium, an electrostatic field produces a positive static magnetic field which in turn energizes transferases and hydrolases. Both oxidation phosphorylation and fermentation catalysis are static magnetic field energized. However, they are energized by opposite magnetic poles. Oxidation phosphorylation is energized by a negative static magnetic field in an alkaline-hyperoxic medium. Fermentation is energized by a positive static magnetic field in an acid-hypoxic medium. A static magnetic field is required for the enzyme and the substrate to attach. A static magnetic field present during enzyme catalysis has been documented(8).

ATP made by fermentation with its acid-hypoxic medium cannot maintain human biological life energy. ATP made by fermentation can maintain the life energy of microorganisms such as bacteria, fungi, viruses, parasites and cancer cells. The secret to reverse acute maladaptive symptom reactions, prevent and reverse microorganism infections, maintaining human biological health and providing for the reversal of degenerative diseases is to maintain a normal alkaline body pH, hyperoxia and an adequate negative static magnetic field. The biological response to a negative static magnetic field can maintain these necessary components of healthy human cells . Thus it can be understood that exposure to an external source of a negative static magnetic field supports

human health and materially aids in reversal of inflammatory degenerative diseases, cancer and the defense against microorganism invasion. This external negative static magnetic field can be applied to local affected areas as well as applied systemically by such as a negative static magnetic field bed pad.

ANTIOXIDANT "ABSORBENT" THERAPY COMPARED TO ENZYME "ELECTRON SINK" THERAPY

Much significant information is being presented in the scientific literature concerning the role of free radicals in relationship to acute cellular injury in acute inflammation, and cellular injury in chronic degenerative diseases. It is evident that free radicals play a major role in the development of degenerative diseases, as well as in acute inflammatory reactions. It has become popular to offer megadoses of vitamin A, beta-carotene, bioflavonoids, selenium, vitamin E and vitamin C for their absorbent value of the extra electron present in free radicals. There is a serious limitation in this therapy in that the hydroxyl free radical, which is the most damaging of all free radicals, will not give up its extra electron to be absorbed by these nutrients antioxidants.

At best, megadoses of antioxidant nutrients is only a secondary stopgap measure supplementing the assigned job of the body's oxidoreductase enzymes.

Oxidoreductase enzymes have the biological assignment of processing free radicals and when optimally functional, process these in a split second. The oxidoreductase family of enzymes has been appropriately described as an "electron sink". These enzymes remove the extra electrons from free radicals, oxyacids, and aldehydes. This enzymatic reversal of the extra electron from free radicals, oxyacids, and aldehydes returns the bound oxygen back to its molecular oxidatively functional state. Therefore, preferred and most profitable focus should be not on megadose nutrient antioxidant absorbent therapy, but on how to maintain optimal oxidoreductase enzyme "electron sink" function.

Optimal available oxidoreductase enzymes require optimal precursor nutrients of amino acids, vitamins and minerals from which these enzymes are constructed in cellular mitochondria metabo- lism. However, the adequate availability of oxidoreductase enzymes does not of itself produce function.

There are two factors which must be present in order for oxidoreductase enzymes to function: 1) an alkaline medium — since these are alkaline-dependent enzymes, 2) an energy activator, which is always a negative (south-seeking) magnetic field. The negative (south-seeking) magnetic field producing a catalytic reaction (enzyme joining the substrate) can come from two sources: 1) a static electric field which produces a negative (south-seeking) magnetic field, or 2) an external applied negative (south-seeking) magnetic field.

An externally applied negative (south-seeking) magnetic field has two values: 1) activation of the bicarbonate buffer system producing alkalinity, and 2) activation of the oxidoreductase enzymes. A negative static magnetic field exposure of the pineal gland, the retina of the eyes, and the intestinal wall stimulates the production of the hormone melatonin. Melatonin, in it's own right, is a free radical reverser, including the hydroxyl radical. The application of a negative static magnetic field over an area of cellular inflammation, or cellular degeneration produces: 1) a normal alkaline pH, and 2) reversal of all free radicals, peroxides, oxyacids and aldehydes.

The efficiency of a magnetic negative static field oxidoreductase enzyme "electron sink" therapy is far superior to mega-nutrient antioxidant absorption therapy. Magnetic therapy classically reduces acute inflammation in 10-30 minutes. Magnetic therapy reverses chronic metabolic disorders, and proceeds with governing healing. Thus, magnetic therapy is observed to have a major role in the reversal of both acute and chronic metabolic disorders. Comparatively, mega-nutrient antioxidant absorption therapy has a measurable but minor role in correcting disordered metabolism.

NUTRITIONAL SUPPLEMENTATION

Enclosed is a partial list of supplemental nutrition as judged by my 35 years of experience of using both laboratory assessment and empirical application to the area of nutrition:

1) Vitamin C as ascorbates. There are four grams of vitamin C per teaspoon. There should be 3 teaspoons a day, or even preferably 4 teaspoons a day, which give a range from 12-16 grams of vitamin C per day. Vitamin C is best taken as ascorbates of calcium, magnesium, zinc, selenium, manganese, and copper. Supplemental calcium intake should be around 1,000 milligrams per day. Magnesium supplement should be around 500 milligrams

per day. Zinc should range from 15-30 milligrams per day. A small amount of selenium and copper per day. Laboratory assessment may change these ratios.

2) Niacin, 1000-3000 milligrams per day. Supplemental NADH (coenzyme I), coenzyme 10 and lipoic acid is well to consider since these bypass changing the B-complex vitamins to these necessary pre-enzyme products by the mitochondria of cells.

3) B-6, 50-100 milligrams per day.

4) B-12, 1,000 milligrams per day.

5) Other B-complex vitamins in small amounts.

6) Antioxidant therapy other than vitamin C; vitamin A, vitamin E, beta-carotene.

7) Essential fats: fish oils, primrose oil, flaxseed oil.

8) Amino acids, especially cystine, 500 milligrams and taurine, 500 milligrams. Laboratory assessment is necessary to determine other amino acid needs.

Optimum application of nutritional magnetic therapy can only be achieved by keeping abreast of the progress in this area. It is recommended that periodically there be a laboratory assessment of the nutritional state.

FINAL WORD

I have treated many major mental illnesses with magnetics. Delusions, hallucinations, manic states, depressive states all have been successfully handled with magnetic therapy. I have treated many learning disabled children, hyperactive children and autistic children with a remarkable degree of success. Magnetic application has controlled seizures of all types including seizures not controllable with medication. Magnetic therapy does not produce side effects and does not produce any kind of secondary illness. I can say this with confidence, that during 40 years of medical practice, most of which has been in the area of psychiatry and neurology, I have never found any treatment that equals that of magnetic therapy. It is imperative that we do this type of research and record it properly and published it in the right journals so that Magnetic Resonance Bioxidative Therapy becomes an integral part of traditional medicine.

References

(1) LIVINGSTON, JAMES, Driving Force, Harvard University Press, Cambridge, MA 1996.

(2) TRAPPIER, ARTHUR et al. Evaluating Perspectives on the Exposure Risks From Magnetic Fields. Journal of the National Medical Association. 82:9 September 1990.

(3) BECKER, R.O. and SELDON, G. The Body Electric. Electro-Magnetism and the Founda- tion of Life. William Marrow & Company, New York, 1986.

BECKER, R.O. Cross Currents, Jeremy P. Tarcher, Inc., Los Angeles, CA 1990.

(4) NAKAGAWA, KYCICHI, "Magnetic Field Efficiency Syndrome & Magnetic Treatment", Japanese Medical Journal No.2745, December 4, 1976.

(5) FISMAN, M. et al., American Journal of Psychiatry., 142-71-73, 1985.

(6) KLONOWSKI, E. and KLONOWSKI, M., Journal of Bio-electricity Aging Processes and Enzymatic Proteins. 4 (1), 93-102 (1985).

(7) FERSHT, ALAN, Enzyme Structure and Mechanism. Second Edition., W.H. Freeman and Company, New York, New York. 1994.

(8) BERRY, R. STEPHEN, New Encyclopedia Britannica, Vol 15, pg 1060. Encyclopedia Britannica, Inc., Chicago. 1986.

Additional References

PHILPOTT, W. H., M.D. Brain Allergies: The Psycho-Nutrient Connection. Keats Publishing Co., New Canaan, CT. 1980.

PHILPOTT, WILLIAM H. M.D. Victory Over Diabetes. Keats Publishing Co., New Canaan, CT. 1982. (1991 paperback with new chapter on medical magnetics).

PHILPOTT, WILLIAM H., M.D. Diabetes Mellitus: The Secret of Prevention and Reversal. The Magnetic Health Quarterly, Vol III, Second Quarter, 1997. Published by W.H.Philpott. 17171 SE 29th St. Choctaw, OK 73020

PHILPOTT, WILLIAM H., M.D. Secret of the Magnetic Field of Youth, The Magnetic Health Quarterly, Vol III, First Quarter, 1997. Published by W.H.Philpott. 17171 SE 29th St. Choctaw, OK 73020

PHILPOTT, WILLIAM H., M.D. The Magnetics of the Anti-inflammatory Oxidoreductase Enzyme System. The Magnetic Health Quarterly, Vol I, Third Quarter, 1995. Published by W.H. Philpott. 17171 SE 29th St. Choctaw, OK 73020 [*Magnetic Health Quarterly* "Major Mental Disorders" Vol. III, 3rd Qtr, 1997 (2002Revision)]

OPTIMUM SYSTEMIC MAGNETIC THERAPY:
ORIENTATION:

This magnetic protocol features systemic therapy which is applicable for any person with a systemic disease such as viral infections, metastatic cancer, lupus, Lyme's disease, chronic fatigue, fibromyalgia, multiple sclerosis and major mental or emotional disorders. This systemic magnetic therapy is the optimal therapy for anyone. This is superior to the usual sleep magnetic beds using mini-blocks. The therapy is composed of two features. One is 70 magnets that are 4" x 6" x 1". These are placed in two wooden grids with 35 magnets each. These two grids are placed end to end making a bed 36" wide and 72" long. This bed radiates a magnetic field of 25 gauss at 18". 25 gauss is the level at which infections and cancer will die out. The second feature is twelve of these 4" x 6" x 1" magnets surrounding the head. This produces deep sleep and is suitable for treating brain cancer, cerebral arteriosclerosis and Alzheimer's. It is the maximum treatment for producing deep sleep for anyone.

MAGNETS USED:

Two wooden grids containing 35 magnets that are 4" x 6" x 1" placed 1" apart. These grids are 36" square. Two grids are placed end to end producing a bed 36" x 72".

A super magnetic head unit composed of twelve 4" x 6" x 1" magnets. These magnets surround the head.

PLACEMENT AND DURATION:

For initial treatment of three months or more, sleep as close to the magnets in the bed as pos- sible. This can be achieved by using an eggcrate-type foam pad that is 2" thick or other suitable futon that is about 2" thick. After the initial treatment of three months or more, if desired, it can be placed under a 4" thick mattress.

The super magnetic head unit is composed of twelve 4" x 6" x 1" magnets. This is placed on the pillow. There may need to be a small child's pillow to raise the head a couple of inches beyond the pillow that this unit is sitting on. This is provided, if necessary, for comfort. The magnets are 6" long and are standing upright. The head needs to be within that 6". This is used nightly for sleep.

For infections in the head or for Alzheimer's or cerebral arteriosclerosis, it is wise to go back on the bed and this head unit for one hour, four times during the day. There also can be a hat provided that is composed of neodymium disc magnets that can

be used when not on this bed for such cases as brain tumor, cerebral arteriosclerosis, cerebral spasm, Alzheimer's and so forth.

This bed and head unit can be used daily as a lifestyle. It is the optimum magnetic therapy provided for any condition and essential for certain systemic and chronic conditions.

It is wise for this therapeutic bed to be accompanied with optimization of nutrition by use of supplemental nutrients. Optimization of hydration should be considered with 8 or more glasses of pure water each day.

Metabolic Risk Factors for Metabolic Degenerative Diseases

THE METABOLIC SYNDROME RISK FACTORS

The metabolic syndrome has stated the risk factors for developing two major clinically significant degenerative diseases. These are diabetes mellitus type II and cardiovascular disease. Besides these two degenerative diseases, these risk factors also relate to all causes of mortality. Reversal of these degenerative disease risk factors is a major challenge for health professionals and for everyone seeking a healthy lifestyle system.

These degenerative disease risk factors are:
1. Overweight and especially with abdominal fat distribution.
2. A mild degree of disordered glucose - insulin metabolism.
3. A mild degree of dyslipodemia.
4. A mild degree of hypertension.

PURPOSEFUL, NARROW FOCUS AND LIMITATIONS OF THIS TREATISE

This treatise is purposely limited in focus for emphasis of highly important factors often neglected as causes of and appropriate effective treatment for metabolic syndrome risk factors. The neglected causes and the neglected treatment of risk factors are;

1. The role of maladaptive (allergic and or addictive) food reactions.
2. Non-food, environmental antigens and toxins.
3. Toxins, both endogenous and exogenous.
4. The role of obesity as a risk factor for degenerative diseases.
5. The role of infections.
6. The role of a negative magnetic field in reversal of these degenerative disease risk factors. The significant roles of nutrition and exercise are equally important and are amply stated in scientific medical literature such as books on internal medicine.

For additional alternative medicine information, consider the information in the books;

Alternative Medicine. The Definitive Guide. Celestial Arts, Berkeley, CA and Toronto, Ontario Canada. 2002.

Disease Prevention and Treatment, Third Edition. Life Extension Media. PO Box 22912 Holly- wood, Florida 33022-9120.

There are a number of other alternative medicine treatise of equal value.

OBESITY AND ABDOMINAL FAT

An average-sized woman should weigh approximately 130 pounds or less. An average-sized man should weigh 160 pounds or less. Tall men 6' and taller can weigh up to 180 pounds. For more exact details on average weight, see pages 827 in *Alternative Medicine. The Definitive Guide.*

Obesity is caused by eating more calories than is being metabolically used which results in body fat deposits. Exercise is a major use of calories, thus reduced calories and increased exercise is a logical therapy for weight reduction. The question is how to remain comfortable and satisfied while reducing calories.

Obesity is a significant risk factor for the development of degenerative diseases, especially diabetes mellitus type II, cardiovascular disease, cerebral-vascular disease, hypertension and cancer.

Thus, the disease prevention goal is normalization of weight while maintaining adequate nutrition. Supplementation of nutrients can help maintain nutrition while reducing calories. The problem is how to reduce calories and still be comfortable and satisfied.

The subject who, when missing a meal, develops symptoms of any physical, mental or emotional type is a food addict. The symptoms are a manifestation of addictive withdrawal. Food addiction is a very real addiction. Alcohol addiction is to the food from which the alcohol is made. Deliberate food testing of the alcohol addict after a five day fast reveals dry-drunk symptoms when given a meal of a single food from which this alcohol is made. There need be no alcohol present for the development of food addiction. Non-alcoholic food addiction is just as damaging as alcohol-food addiction. All addiction leads to degenerative diseases, especially diabetes mellitus type II, cardiovascular and cerebral vascular diseases. These diseases are purely and simply

the consequences of food addiction and allergies and do not exist separately from food/alcohol addiction and IgG food allergies.

THE ROLE OF FOOD ALLERGIES

IgE allergy produces an acute and often life-threatening symptom. This seldom occurs. IgG food allergy behaves the same as an addiction. Upon contact with the food, the symptoms are relieved and only three or four hours later, withdrawal symptoms emerge. This is a delayed allergy symptom reaction and is either also an addiction withdrawal or behaves as an addiction withdrawal. Food addiction, separate from an allergy, does not have antibodies to the food.

WHAT IS ADDICTION?

Addiction develops to the chronic streess of a frequently used food. On initial contact with the food or drug there is a rise in self-made narcotics (endorphins) or else the drug itself is a narcotic. There is also a rise in seratonin at this time. Seratonin rises due to the stress. This is a biologically comfortable state. Three or four hours later however, there is a withdrawal producing weakness, depression, pain and so forth. The symptoms are relieved when the subject eats the addictive food or takes the addictive drug. Thus, both frequency of eating the food, coupled with the satisfying quanti- ties appears to be the answer since this relieves symptoms. This however, is not the answer since it leads to increased calorie intake. The answer for any addiction is avoidance of the addictant whether this is a food or a drug. Fortunately however, a food will desensitize in three months of avoidance following which the food could be used on a once in four day basis without reinstating either the allergy or the addiction. The negative magnetic field method of desensitization does not have to proceed with a 3-month avoidance but only the four day avoidance. Thus, a 4 day diversified rotation diet can be set up immediately with a negative magnetic field exposure before each meal. Within three months, the foods will have desensitized and can be rotated on a four day basis without symp- toms developing.

MAGNETIC FAT MELTDOWN

Growth hormone is necessary for fat cells to drop their fat and turn the insoluble fat into a soluble fat. Growth hormone, along with melatonin, is made at night under the influence of a negative magnetic field. Since growth hormone is not made during the waking period, this fat reduction would be at a time when growth hormone is available at night so not only should growth hormone

be stimulated to be made by a negative magnetic field but it also would be used in turning insoluble fat into soluble fat which is then dispensed with. A negative magnetic field placed over an obese pot belly causes the fat in the omentum to go back into solution and thus be dispensed with.

METABOLIC SYNDROME DIMENSIONS

The significance of the metabolic syndrome as a diagnostic precursor to cardiovascular disease and maturity onset diabetes as stated in the *AMA Journal,* December 4, 2002 is a wholesome look at early stage metabolic disease processes. This is a welcome focus on preventive medicine. All too often, both patient and physician do not consider the early stage of metabolic diseases. Giving a diagnosis to early stages of degenerative diseases warrants both the patient and his physician to start early treatment for prevention of the late stage metabolic degenerative diseases. Identification and treatment of degenerative disease risk factor components of the metabolic syndrome is a major challenge to health professionals and their patients facing an epidemic of overweight, addiction, immunological reactions and sedentary lifestyle. Roughly one-third of middle age men and women in the United States have the metabolic syndrome.

COMPONENTS OF THE METABOLIC SYNDROME

Fasting plasma glucose of at least 110 mg/DL.

Serum triglycerides of at least 150 mg/DL.

Serum HDL cholesterol of less than 40 mg/DL. Blood pressure of at least 130/85.

Waist girth of more than 102 cm.

Waist girth of more than 94 cm was suggested for men genetically susceptible to insulin resis- tance. A waist girth of 40" is the upper limit of normal.

METABOLIC FACTORS AND METABOLIC SYNDROME

The metabolic syndrome is based on a combination of symptoms and laboratory evidence of a mild degree of an assortment of metabolic disorders which are the early risk factors of chronic diseases especially that of maturity onset type diabetes type II and cardiovascular disorders.

My experience of fasting subjects for five days while also removing their environmental chemi- cals followed by deliberate food exposures of test meals of single foods accompanied by sniff testing and sublingual testing to their environmental chemicals

reveals remarkable relief of symptoms and disordered metabolism. The subjects were tested for blood pH and glucose before the fast and before each test meal. They were again tested for blood sugar and blood pH an hour after each test meal. In a small number, insulin was also tested before and after each test meal. Fat metabolism was not a part of the original testing, except pre-testing. Five hundred hospitalized patients were in the original group. These were all mental patients. Degenerative diseases exist in essentially the same degree in mental patients as in the general population. Thus, the examination applied to physical diseases as well as to mental diseases.

It was observed that the acute reactive symptoms and laboratory findings of acute reactions are the same as the symptoms and laboratory test disorders of chronic degenerative diseases. Thus, chronic disease are simply a time extension of the acute reactions. These findings are recorded in my books, *Brain Allergies* and *Victory Over Diabetes.*

The observations are that a measurable acidity emerged with symptoms and with hyperglycemia. This documented the fact that degenerative diseases are acidic as well as the acute reactions being acidic. The majority of these subjects revealed a carbohydrate disorder with the glucose at or beyond 140/160 mg/DL. This was true in all that had been diagnosed with maturity onset diabetes and also a large number that had not yet been diagnosed as maturity onset diabetics. This revealed that we were tapping into the early stage of the diabetes mellitus disease process and could tell which foods or chemicals were causing the carbohydrate disorder.

Human metabolism has the physiologically normal pH which must be maintained in order for health to proceed. What my research demonstrated is that the main reason for disordered pH is that of maladaptive reactions, mostly to foods and less frequently to chemicals or other inhalants. The pH must be maintained at a minimum of 7.35 to an optimum of 7.45 or beyond.

The fact is that calcium, amino acids and fats are soluble at the normal physiological pH of the blood but become insoluble with a pH below the physiologically normal. A central fact of cardiovascular disorders are the deposits of calcium, amino acids and fats on the cell wall of the arteries of the heart, the carotids and brain as well as these deposits also developing in the arteries themselves to a lesser degree. It requires an acidity for these insoluble deposits to occur. We now know that the major cause of

acidity are reactions to foods mainly, and to a lesser degree, chemicals and inhalants. Amyloid which is due to the development of insoluble amino acids is a part of the problem that develops out of these insoluble deposits. Amyloid can become deposited in the brain, producing Alzheimer's.

It can be deposited anywhere in the body and it is frequently deposited in the pancreas and around nerves, producing a neuropathy. Calcium becomes deposited in stressful areas where acidity is maintained. Especially, this is noted in the lumbar spine producing spinal stenosis. It develops in inflamed joints or any inflamed tissues because they are also acidic. All of these calciums and amino acid deposits are reversible by placing a negative magnetic field over the area and maintaining this continuously for a period necessary to resolve these insoluble deposits. This occurs because the biological response to the negative magnetic field is that of alkaline-hyperoxia.

Infections are acidifying. Cancer is acidifying. Therefore, a negative magnetic field of sufficient strength and sufficient continuous duration can reverse infections and cancer.

Oxidoreductase enzymes have the responsibility of making the human ATP energy by oxidative phosphorylation and also of processing the toxic end products of metabolism including free radicals. The oxidoreductase enzymes detoxify. The inflammatory substances they make such as acids, peroxides, alcohols and aldehydes are all alkaline-hyperoxic dependent. Therefore, a negative magnetic field is necessary for the function of these enzymes. They also serve as the immediate energy activator of these oxidoreductase enzymes. Magnet therapy has the characteristic of activation of oxidoreductase enzymes and the resolution of calcium, amino acids and fat deposits which are an aspect of the degenerative disease process.

Negative ions have the same biological response of alkaline-hyperoxia as a negative magnetic field and should wisely be used as complementary to negative magnetic field therapy.

MAGNETIC PROTOCOL FOR OBESITY AND WEIGHT MANAGEMENT: ORIENTATION:

Start with a determined ideal weight goal.

Measure the girth of the abdomen. The goal is to be less than 40".

MAGNETS USED:
<u>Minimal program:</u>

Four 4" x 6" x 1/2 " ceramic block magnets with Velcro on the positive pole side.

Three bands, 4" wide and as long as is necessary to reach around the abdomen. The length of a COOL MAX band should be ten inches longer that the girth around the abdomen.

Two ceramic discs that are 1-1/2 " x 1/2 " magnets with Velcro on the positive pole side. One 2" x 26" headband.

Optimal program, add the following:

A super magnetic bed composed of 70 magnets that are 4" x 6" x 1". Thirty-five of these are placed an inch apart, sealed in a wooden grid 36" square. Two of these wooden grids are placed end to end producing a bed 36" x 72". Over this is placed a 2" foam pad, preferably a memory-type foam pad.

Super magnetic head unit composed of twelve 4" x 6" x 1" magnets.

CALORIE REDUCTION

Take a picture of the meal that is characteristically consumed. Estimate the number of calories. Then take a picture of a meal that is one-third less than the original picture and count the calories. Set up a rotation diet following the pattern as outlined herein. For a minimum of 15 minutes and preferably 30 minutes before a meal, place the disc magnets bitemporally and hold in place with a band. Place a 4" x 6" x 1/2 " magnet over the heart with the 6" lengthwise the body. Place another 4" x 6" x 1/2 " magnet over the liver. This can be either on the front of the body or the right side of the body. Hold in place with a 4" x 52" body wrap or whatever the length needs to be for that wrap. Eat the size of the meal that has been determined which is one-third less than the original meal that has previously been used. Do not eat anything between meals. If and when there is a desire to eat be- tween meals, then place the discs back on the head bitemporally and if need be, place a 4" x 6" x 1/2 " magnet over the heart and a second one wherever there is discomfort which may be in the epigastric area. It may be that the discs alone can solve the urge to eat between meals or to overeat. Leave the magnets on the head, the heart and the liver during the meal.

PLACEMENT AND DURATION: Minimal program:

At night, place two magnets a couple of inches apart over the obese abdomen. Hold in place with a body wrap. Place another magnet on the right side of the body over the liver, either on the

front of the body or the right side of the body. Hold in place with a body wrap.

Pre-meal:

Place a 4" x 6" x 1/2 " over the heart with the 6" lengthwise the body. Hold in place with a body wrap. Optimum is 30 minutes before and during the meal.

Each month, reduce the size of the meal by one-third. Continue this until the desired weight has been achieved. The discs can be kept in a pocket so that they can be used at any time there is an urge to eat between meals. The subject should have a goal of keeping her or himself comfortable during this calorie reduction and reversal of food addiction.

Optimum program, add the following:

Sleep all night on the 70 magnet bed and with the head in the super magnetic head unit.

MAGNETIC PROTOCOL FOR HYPERTENSION:
ORIENTATION:

My years of experience with deliberate food testing after a five day fast, has revealed that classically, hypertension is caused by maladaptive reactions, either allergic or addictive, to foods that are being used on a virtually daily basis. Usually the subject will also be obese but not necessarily so. A five day fast on water only or a single, infrequently used food such as watermelon reveals that most hypertensive subjects will have a normal blood pressure by the 5th day of this fast. Then feeding meals of single foods will determine which foods are causing the hypertension.

MAGNETS USED: Minimal program:

Four 4" x 6" x 1 /2 " ceramic block magnets with Velcro on the positive pole side.

Three bands, 4" wide and as long as is necessary to reach around the abdomen. The length of a COOL MAX band should be ten inches longer that the girth around the abdomen.

Two ceramic discs that are 1-1 /2 " x 1 /2 " magnets with Velcro on the positive pole side. One 2" x 26" headband.

Optimal program, add the following:

A super magnetic bed composed of 70 magnets that are 4" x 6" x 1". Thirty-five of these are placed an inch apart, sealed in a wooden grid 36" square. Two of these wooden grids are placed end to end producing a bed 36" x 72". Over this is placed a 2" foam pad, preferably a memory-type foam pad.

Super magnetic head unit composed of twelve 4" x 6" x 1" magnets.

PLACEMENT AND DURATION:
Minimal program:

At night, place two magnets a couple of inches apart over the obese abdomen. Hold in place with a body wrap. Place another magnet on the right side of the body over the liver, either on the front of the body or the right side of the body. Hold in place with a body wrap.

Pre-meal:

Place a 4" x 6" x 1/2 " over the heart with the 6" lengthwise the body. Hold in place with a body wrap. Optimum is 30 minutes before and during the meal.

Optimum program, add the following:

Sleep all night on the 70 magnet bed and with the head in the super magnetic head unit.

If obesity is present, then follow the magnetic protocol as outlined for obesity and add to that the following:

One 4" x 6" x 1/2 " magnet over each kidney on the back side of the body which are held in place with a body wrap. This is to be before and during the meals. The more hours of exposure, the better. Always use a negative magnetic field.

SUCCESS STORY

A 40-year-old woman had severe headaches that could only be managed with narcotics. She had a hypertension of 180/110. She was fasted for five days on water only at which time there was no headache and her hypertension was gone. When she ate a meal of soy, both her headache and her hypertension returned. She was a strict vegetarian and used soy every day as her source of protein.

SUCCESS STORY

An 18-year-old juvenile diabetic taking 60 units of insulin was not in control of his diabetes. He had had laser treatment on his eyes. His blood pressure was 180/110. He had 4+ protein in the urine. He was placed on a rotation diet which took away all the foods that he used with a frequency of twice a week or more. Within a two week period, his insulin requirements were 20 units and his blood sugar was in control. His blood pressure was normal and there was no protein in the urine.

SUCCESS STORY

An 80-year-old man weighing 185 pounds with an abdominal girth of 41" placed two of the 4" x 6" x 1/2 " magnets two inches

apart on his abdomen. He held them in place with a 4" x 52" body wrap. He lost a pound a day until he reached 160 pounds. Following this, there was no more weight loss. He had emptied the fat from his omentum and there was no more fat loss after this had occurred. He was already on a 4 day diversified rotation diet. He lost this weight without any reduction in his calorie intake.

ECOLOGIC SYMPTOM EXAMINATION PLUS BIOCHEMICAL MONITORING

From 1970 through 1975, I did a research project at the psychiatric hospital, Fuller Memorial Hospital in South Attleboro, MA. Two books were published giving the details of the results of the research. They were *Brain Allergies* and *Victory Over Diabetes*. Five hundred mental patients were examined. Most were schizophrenics, a few were bipolar and thirty were severely depressed neurotics. All of these individuals required hospitalization. Among these patients was an assortment of chronic degenerative diseases. A number were maturity onset diabetics. Many qualified as metabolic syndrome.

The research system included the following:

A psychiatric and physical examination and bio-chem screen before the research was instituted. Five days of a water only fast.

There was a series of antibody studies which included Epstein-Barr, cytomegalovirus and human herpes virus #6. Starting on the 6th day after the five day fast, single food meal tests began and continued for the next month. Before each meal and one hour after each meal, the following was done.

1. Symptom severity test with symptom present and severity was placed on a 1-10 intensity.
2. Blood sugar test.
3. Blood pressure test.
4. Pulse test.
5. pH of blood and/or saliva.

Theron G. Randolph, M.D., allergist, had observed the fact that acidity was present when symptoms occurred. Blood sugar and blood pH an hour before and after each meal had never been done before. Dr. Randolph's observation of acidity associated with symptom production proved to be correct. Blood sugar had never been tested before. In maturity onset diabetes type II, specific foods which evoked the blood sugar beyond 140 were in evidence. When these foods were withdrawn from the diet, there was no diabetes. This was so even in patients who were obese and had not yet had

the opportunity to reduce their weight. After three months of avoidance, the foods that were evoking hyperglycemia could be reintroduced and would not produce hyperglycemia as long as they were used only once in four days.

My friend, John Potts, M.D., had many diabetic patients. He systematically examined these patients and published in the abstract issue of the *Journal of Diabetes*, four research projects. This confirmed that diabetes was caused by these food reactions and even in those late stage diabetics where insulin was not in adequate supply, two-thirds of these did not need insulin when their foods were sorted out. Between 1976-1990, I was in private practice with a ten bed environmental controlled unit. I also had a large outpatient department. With this, I had a wide assortment of degenerative diseases and numerous diabetics. It was easy to reverse maturity onset type II diabetes. Most hypertensions also were reversed by honoring the food reactions. In my original research and in later years, I found many patients that would satisfy the criteria of metabolic syndrome in which there was a mild hypertension, a mild disordered glucose metabolism and a mild disordered lipid metabolism. These all reversed when honoring the fact that foods, chemicals and sometimes other environmental substances such as toxins were the precipitating cause of this metabolic syndrome.

CONCLUSIONS FROM MY RESEARCH

1. Mental patients routinely became clear of their mental symptoms when fasted for five days. This was indeed an unexpected, shocking revelation.

2. Mental symptoms emerged when exposed to single test meals of foods, chemicals or inhalants and the patient remained mentally clear when these were removed.

3. 95% of the time, foods that had originally produced symptoms, either mental or physical, would not be present if you avoided those foods for three months. After three months, they could be re-introduced into the rotation diet as long as the exposure is no more than once in four days. Only occasionally were there genetic reasons, such as genetic reactions to gluten.

4. The cause of diabetes mellitus type II was reactions to foods, chemicals or inhalants and was not caused by glucose as such. In fact, each sugar, corn, beet, cane, sorghum molasses and honey - had to all be tested separately. Among my patients, I never found a diabetic that would react to maple sugar. The reactions are to the

substances from which the sugar is made. For example, you may react to beet sugar but not to cane sugar or maple sugar. Even exposure to honey had an interesting phenomena. The honey gathered from the local area where the subject lives may cause a reaction. Honey from an area where the subject does not live characteristically did not cause a reaction.

5. pH dropped below the physiological normal when symptoms and/or high blood sugar occurred.

6. It was determined that the patients -- schizophrenics, manic depressives, hyperkinetic, obsessive compulsive, learning disordered and autistic children -- showed the same characteristics of being infected with herpes family viruses, either Epstein-Barr, cytomegalovirus or human herpes virus #6 as the adult schizophrenics and manic depressives. Also it was determined that all the behavioral and learning disordered children were candidates to become schizophrenics in their 20's. The history of schizophrenics included these learning disorders, attention deficit disorders and obsessive compulsive disorders quite routinely. Thus, it was determined there is a spectrum of organic brain disorders having the same source and that is a childhood infection with one of the herpes family viruses. Reactions to foods, chemicals and inhalants is a secondary phenomena. These lymphotropic viruses do infect the lymph system including the B-lymphocytes that make antibodies. They also are neurotrophic and invade the neurones of the central nervous system, especially the pre-frontal, frontal and temporal areas of the brain. Thus the person is more allergic and becomes addicted more easily to these foods. When a food reaction does occur, the organ selected for reaction is the injured area which in this case is the central nervous system, especially the brain.

During the past twenty years from 1983 to 2003, I have been involved in research examining the value of magnetic therapy. I have determined that if you expose the person magnetically before a meal, the reaction does not occur. For this, two ceramic disc magnets that are 1-1/2 " x 1/2 " are placed bitemporally. A 4" x 6" x 1/2" magnet is placed over the heart and one over the liver. All of these have the negative pole facing the body. With 15-30 minutes exposure pre-meal, symptoms do not develop. Thus a person can go on a rotation diet immediately without an avoidance period of three months of the reactive foods.

A negative magnetic field is an effective antibiotic. Therefore, the infections that are so prone to develop in diabetes can be

prevented and reversed with a negative magnetic field. Also, diabetic neuropathy and other toxic neuropathies can be effectively treated with the negative magnetic field.

MAGNETIC PROTOCOL FOR METABOLIC SYNDROM: ORIENTATION:

This protocol can function for a physician-monitored magnetic protocol for the metabolic syndrome or self-help magnetic protocol for the metabolic syndrome. The metabolic syndrome is diagnosed by three or more of the following:

1. Mild degree of abnormal level fasting blood sugar.
2. Hyperinsulinism-hypoglycemia syndrome precipitating weakness, headaches, depression, increase in neurotic symptoms, major mental symptoms, hypertension or hypotension.
3. Mild degree of disordered lipid metabolism.
4 Mild degree of hypertension.
5 Obesity with waistline of 40" or more.
6. Disordered pulse.

EQUIPMENT FOR SELF-HELP

1. Stethoscope for monitoring hypertension.
2. Glucometer for monitoring blood sugar.

MAGNETS USED:

Minimal program:

Two 1-1/2 " x 1/2 " ceramic disc magnets with Velcro on the positive pole side. One 2" x 26" headband.

Two 4" x 6" x 1 /2 " ceramic block magnets with Velcro on the positive pole side. Two 4" x 52" body wraps.

Mega-field slumber pad composed of mini-block magnets 1-7/8" x 7/8" x 3/8" placed 1-1/2" apart. The sizes are single bed, queen and two of the single beds are used for a king bed.

Vitality Sleeper. This is composed of four 4" x 6" x 1" magnets placed in a row in a wooden carrier up against the headboard.

Optimal program:

A 70-magnet bed composed of ceramic block magnets that are 4" x 6" x 1" placed 1" apart. Thirty-five of these are placed in a wooden carrier, 36" square. This weighs 200 pounds. Two of these wooden frames are placed end to end producing a bed 36" x 72" with a total weight of 400 pounds.

Super magnetic head unit composed of twelve 4" x 6" x 1" magnets that surround the head. The mega-field slumber pad with the Vitality Sleeper is replaced by the 70-magnet bed and super mag- netic head unit.

Two 1" x 1/8" neodymium discs.
PLACEMENT AND DURATION
For the minimal program:
Sleep on the mega-field slumber pad with the Vitality Sleeper up at the headboard so as to provide a strong negative magnetic field at the top of the head.

The ceramic discs are used pre-meal or whenever there are any symptoms such as headache, anxiety, tension and so forth.

The 4" x 6" x 1/2" magnets are used pre-meal as described below and a 4" x 6" x 1/2" magnet is worn over the heart at night.

For the optimal program:
Use the super magnetic bed of 70 magnets. Place over this a foam pad. The best is a memory foam pad, 2" thick. The Vitality Sleeper is replaced with the super magnetic head unit of twelve magnets. Sleep every night on this 70-magnet bed and super magnetic head unit. Use the ceramic discs and the ceramic block magnets pre-meal and also use the 4" x 6" x 1 /2 " magnet over the heart at night during sleep.

For infected areas, (skin or teeth), use two 1" x 1/8" neodymium discs taped over the infected area.

GENERAL INFORMATION ABOUT THE 4-DAY DIVERSIFIED ROTATION DIET

The essence of the 4-Day or 7-Day Diversified Rotation Diet is that foods are rotated on a four or seven day basis, thus preventing their maladaptive reactions, be these allergies or addictions.

One method is to avoid food eaten twice a week or more for a period of three months, rotating all other foods. At the end of three months, then place these frequently used foods back into the diet, rotated once in four days.

Another method that is preferred by some is to start rotating all foods, even those that are eaten frequently. This can be achieved if the subjects will treat themselves to magnets for 15-30 minutes ahead of the meal. To achieve this, place the ceramic disc magnets bitemporally, that is in the front of the ears at the level of the top of the ears. These are held in place with a 2" x 26" band. The discs are ceramic discs that are 1-1 /2 " x 1 /2 ". The negative magnetic field is always placed facing the body.

On the positive magnetic field side, there is hook Velcro that will hook to the band around the head and hold these in place. At the same time, place a 4" x 6" x 1/2 " magnet on the heart with the 6" lengthwise the body. Hold this in place with a 4" x 52" body

wrap. Also, place a 4" x 6" x 1/2 " magnet with the 6" lengthwise the body over the liver area which is on the right side of the body with half of the magnet over the rib cage and half below the rib cage. Hold this in place with a 4" x 52" body wrap. The minimum time of exposure should be 15 to 30 minutes or more before each meal. With this method, there is no avoidance period of the commonly used foods.

NEGATIVE ION HOUSEHOLD AIR TREATMENT

The biological response to negative ions and negative magnetic fields are the same. The biological response to negative ions and a negative magnetic field is alkaline-hyperoxia. Alkaline-hyperoxia is anti-inflammatory, anti-stress, antibiotic, energizing and aids in healing. Negative air ions plus a small amount of ozone in the air cleans the air from dust, microorganisms, pollen, smoke, chemicals, odors and so forth. Negative ions in the air clean up the environment whereas a negative magnetic field is used on the body to achieve the same values inside the body. Thus, negative air ions, negative water ions and a negative magnetic field are complementary and should be used together to achieve optimum results.

AIR NEGATIVE ION GENERATORS
LIVING AIR CLASSIC

. Covers up to 3,000 square feet. Useful for living room size areas.

ECOHELP

LIVING AIR CLASSIC with air filter. Especially useful for respiratory disorders.

LIVING BREEZE

Covers 1,200 square feet. Useful for small rooms such as bedrooms.

Air negative ions are absorbed through the mucus membrane of the nasopharynx and lungs as well as the skin. Water negative ions from electronic produced negative ion micro water and/or naturally occurring negative ion water such as Nariwa water are absorbed through the mucus membrane of the gastrointestinal tract. Colloidal silver antibiotic negative ions are absorbed through the mucus membrane of the mouth and gastrointestinal tract.

ALKALINE MICRO NEGATIVE ION WATER:

Alkaline micro negative ion water helps materially to maintain the body's normal alkaline state. Also, being micro water, it enters into the cells of the body more readily than the usual water. This

also carries negative ions as well as being alkaline. The AKAI Electrolysis Instrument is used for producing the alkaline micro water. At least five glasses of this water should be used each day.

NARIWA WATER:

Nariwa water is a negative ion water from Japan's magnetic mountain. This comes in a bottle containing 500 cc. A minimum of one of these bottles should be used a day and preferably, two or more. The total amount of water used during a day should be a minimum of eight glasses of water and preferably as much as a total of ten glasses of fluid intake.

POLARITY:

Always use a negative magnetic field.

BEYOND MAGNETISM:

Acute maladaptive reactions to foods, chemicals, inhalants or stress frequency pulsing fields has been documented as producing a brief state of acid-hypoxia. In this state, there is a production of acid and a failure to process properly the end-products of oxidation phosphorylation metabolism. In this state of acidosis, oxygen content is reduced. Maladaptive reactions to foods are the most fre- quent cause of bouts of acidosis. Degenerative diseases are noted for their acid-hypoxic state. Therefore, every effort should be made to maintain a normal alkaline and normal oxygen state.

A majority of people are maladaptively reacting in one or more ways to foods, thus producing bouts of acidosis and reduced oxygen. It is the better part of wisdom to follow a 4-Day or 7-Day Diversified Rotation Diet. This program leaves out foods that are used as frequently as twice a week or more for a period of three months. This is based on the assumption that these foods are being reacted to in some maladaptive way. It is the frequency of the use that produces the maladaptive reactions. A 4-Day or 7-Day Diversified Rotation Diet is set up to leave out these frequently used foods. After three months, these frequently used foods can be returned to the diet, usually without any symptoms being produced.

All addictive substances should be abandoned such as addictive drugs, alcohol, tobacco and caffeine (coffee, tea with caffeine, chocolate, and soft drinks containing caffeine). Addiction is acidifying.

Carbonated soft drinks are acid and should be rarely used. Soft drinks are sweetened with corn sugar and if and when used should be limited to the corn rotation day.

There is a valuable method of electrolysis which provides an alkaline micro negative ionized water that has an alkaline pH, negative charged ions and negatively magnetically charged oxygen and water. There is a home electrolysis unit (The AKAI Electrolysis Instrument) that provides this alkaline micro water. It is recommended that five glasses of this alkaline micro water be used a day.

Nariwa water is a naturally negative ionized water from Japan's magnetic mountain and is the optimum alkaline micro water available. This comes in a bottle containing 500 cc. A minimum of one of these bottles should be used a day and preferably, two or more. The total amount of water used during a day should be a minimum of eight glasses of water and preferably as much as a total of ten glasses of fluid intake.

In order to maintain an adequate alkaline state, it is necessary that the minerals that are used in the bicarbonate buffer system be in adequate supply. These are the minerals calcium, magnesium, potassium and zinc. There are several proprietary preparations that contain these minerals associated with vitamin C as ascorbates. Use 1/2 teaspoon to 1 teaspoon of one of these powders in one-half glass of water, two times a day. The preferred time to take the alkaline minerals is in the morning on arising and before going to bed. Before using this mineral alkaline water, place it on the negative magnetic field of a 4" x 6" x 1/2 " magnet for a minimum of five minutes or more. This will charge up the water and the oxygen in the water with a negative magnetic field which will help the body maintain its normal alkaline state. When using micro alkaline water, the mineral water need not be placed on a magnet since it is already magnetically charged.

TREATMENT OF COMPLICATIONS

There are vascular complications of the emerging diabetes mellitus process either in its early stage of the metabolic syndrome or its late stage of clinically significant diabetes mellitus. It is wise to wear a 4" x 6" x 1/2 " magnet over the heart at night during sleep, held in place with a 4" x 52" body wrap. Always use a negative magnetic field facing the body.

Another complication is neuropathy pains. These are especially noted in the feet as sharp, fleeting pains. Place the feet on the 4" x 6" x 1/2 " magnets with the negative magnetic field facing the feet. This has been observed to correct diabetic neuropathy.

Infections develop with poor defense against the infection. These are often mixed fungal and bacterial. Place the 4" x 6" x 1/2 " magnet over this area and keep it in place as many hours as you can until the infection heals. A negative magnetic field is an effective antibiotic whether it is a bacteria, fungus or a virus. It will also materially aid healing. The teeth are often infected in diabetes mellitus. A 1" x 1/8" neodymium disc magnet can be placed on the face over the affected tooth and be used thus as an antibiotic. Tape this on the face over the affected tooth move the enzyme and the substrate together. Once they move, now a magnetic field is created because this is what a magnetic field is all about. It is produced by the movement of electrons. Also, a magnetic field from an external source that is a static magnet field will also produce the movement of electrons. This is why an extemal source of a static magnetic field will cause the enzyme and the substrate to join because it is moving electrons.

SUCCESS STORY

A 45-year-old man with paranoid schizophrenia and diabetes mellitus type II in poor control had a delusion that he killed a man. He spent many hours obsessing with overwhelming guilt and depression. The circumstances was that of driving on a narrow mountain road. He met another car and took the inside road, forcing the other car to be on the outside road next to a steep cliff. The delusion was that the car had fallen off of the road and killed the driver. He was fasted for five days and his obsessional concern about this mountain road experience disappeared. Also, his blood sugar was normal by the 5th day. When he was food tested for wheat, he had a blood sugar within an hour of 200. At the same time, his obsessional delusion returned. Several other foods gave minor blood sugars beyond normal. He was placed on a rotation diet which left out, for three months, the foods that showed symptoms or hyperglycemia.

I returned him to his internist with the full account of his food testing. He now was in complete control of the diabetic state. The internist observed that the evidence was that the diabetes had disappeared but he commented, "I can tell you one thing. Food allergy and food addiction have nothing to do with the cause of diabetes. This doctor just by chance found a better diet for you".

This was the first diabetic patient I had treated with the ecologic examination while monitoring for blood sugar and pH. I was thrilled over the discovery of the connection between food reactions

and diabetes. It was with a degree of enthusiasm that I presented this to his internist. It was disappointing when the internist rejected any relationship between the food test and his patient's diabetes. How could he dare to deny the relationship when it was presented to him and therefore could not be denied.

A Mexican woman with diabetes mellitus type II out of control was fasted for five days at which time her blood sugar was normal. When given a whole meal of maple sugar, she did not show any hyperglycemia. When given a meal of pinto beans, there was her hyperglycemia. It is the maladaptive reaction (allergic, addictive, toxic) to specific foods, be they carbohydrates, proteins or fats and not to glucose as such that causes diabetes mellitus.

I was making a presentation at a medical meeting and I made the statement that the disordered biochemistry of food addiction and maturity onset diabetes are one and the same. A physician spoke up, declaring, "that is not so." I told him that I could understand his remark, since he had not monitored the evidence. I invited him to my office. He spent five days watching me monitor the blood sugar of patients, some of which would justifiably be diagnosed as clinically significant diabetes. Many others could justifiably be diagnosed as metabolic syndrome disorder. He observed the evidence of the reaction to foods producing hyperglycemia in both types of cases. At the end of five days, he came to me and explained that he had objectively observed that I was right, that you could tell specifically which foods evoked hyperglycemia. He told me that he was a specialist in diabetes, that he had just completed the best residency that he could find in New York City. From his residency training, he knew nothing about maladaptive reactions to specific foods causing hyperglycemia. His statement was "you are right. You have changed the way I will practice medicine."

At 54 years of age, I became dizzy. A chem strip test demonstrated a fasting blood sugar of 250. This was a big surprise to me. I had no idea that I had diabetes mellitus. I was in the midst of my research of testing foods on patients and had discovered these high blood sugars are in response to specific foods and/or of hyperglycemia response to some chemicals to which the subject was symptomatically reacting. I fasted for five days at which time my blood sugar was normal. Meals of single foods demonstrated that all foods that contained gluten gave me a high blood sugar. In response to cow's milk, I had bursitis, sore elbows and

tenosynovitis in my right wrist. I proceeded to follow the rules of leaving these reactive foods out for a period of three months and then returning them to a 4 day diversified rotation diet. That was 30 years ago. I am now 84 and have had no evidence of diabetes mellitus and no evidence of rheumatoid symptoms during these 30 years.

I have reversed diabetes in large numbers of maturity onset diabetes cases. I reversed the metabolic syndrome in even larger numbers of cases. The answer is a rotation diet.

A patient with a temporal lobe seizure state when fed eggs became disoriented. A week later, I placed 1-1/2 " x 1/2 " disc magnets with the negative pole facing the temples. One half hour later, I fed the subject eggs and no symptoms develop.

A teenage schizophrenia-affective patient who had attempted suicide was examined with deliberate food testing. She was symptom-free after five days of a fast. When given wheat, her affect became flat. She had a headache. She couldn't tolerate being in the same room with other patients who were being tested. I took her to a room where she was by herself. I placed ceramic disc magnets bitemporally and a strip magnet down the spine. She promptly fell asleep. I let her sleep for 45 minutes. When I woke her up she was completely symptom-free and went back to the test room with the other patients. A week later, I placed magnets bitemporally and on her spine for 1/2 hour before feeding her a test meal of the food that had evoked her psychotic symptoms. No symptoms emerged. Thus I demonstrated that not only could I relieve symptoms with a negative magnetic field of a magnet, but I could also prevent symptoms from occurring even in the face of feeding the food that was known to evoke these symptoms.

A negative magnetic field prevents symptoms from developing. If used for self-help, this allows a subject to go directly to a rotation diet preventing symptoms from occurring. There does not have to be a 3-month wait before the food is introduced back into the diet. A negative magnetic field is desensitizing to these reactions.

I have helped many diabetics reverse their poorly controlled diabetes by the simple fact of leaving out their most common foods while doing a 4 day or 7 day diversified rotation diet. There can be an avoidance of three months before introducing these foods back into the rotation diet or even an easier way to do this is to treat the subject to magnets for 15-30 minutes pre-meal while instituting a rotation diet including all foods.

I tested large numbers of subjects that fit the criteria of the metabolic syndrome. This syndrome is easily reversed with a 4 day or 7 day diversified rotation diet. Thus, the subject is prevented from developing chronic degenerative diseases which are the end stage of the metabolic syndrome.

SEVEN-DAY ROTATION DIET

This rotation diet is to be used by those who have many allergies. By having less frequent contacts with food, the system should clear faster, making the diet better tolerated.

The recommended usage to clear the system is to have only one contact with each food in seven days, still rotating the foods in family groups. Any of the foods listed for that day may be used, but only one contact with each food. This is best accomplished by using two to four foods at one meal, and not repeating these foods at a following meal. Do not repeat any food the second time.

Rarely is there a person who can eat only one food with each meal since combinations of any type give symptoms. In this case, six meals a day can be used keeping them on a seven-day rotation program.

Heating foods in oils reduces the absorption rate and reduces symptoms. Oils should be rotated. Use corn, safflower, peanut, olive, soy and cottonseed oils, butter, lard and other animal fats, and others. Heating in a Chinese wok is ideal. For these very sensitive persons requiring foods heated in oils, a seven-day rotation diet is preferred.

This 7-Day rotation diet is also useful for subjects in good control for its convenience. One day of the week can be designed where cereal grains containing gluten can be combined with dairy products, making available foods containing both. Some find that one day a week, they can eat anything without reinstating their maladaptive reactions. Some even find that they can eat the same food two days in a row without developing symptoms.

Sprouting cereal grains and legumes, makes it possible to eat these same foods twice in a week in which one day they are using the non-sprouted foods and another day they are using the sprouted foods.

The 4 day diversified rotation diet, which is commonly used, as described herein.

SEVEN DAY ROTATION DIET
Seven Day Rotation diet
Day 1 — Sunday

FOOD FAMILIES

Apple: apple, pear, quince Mulberry: mulberry, figs, breadfruit Honeysuckle: elderberry

Olive: black, green or stuffed with pimento

Gooseberry: currant, gooseberry

Potatoe: potato, tomato, eggplant, peppers (red and green), chili pepper, paprika, cayenne

Lily: onions, garlic, asparagus, chives, leeks

Grass: wheat, corn, rice, oats, barley, rye, wild rice, cane, millet, sorghum, bamboo sprouts

Bovid: milk products, butter, cheese, yogurt, beefand pure beef products, lamb

Herb: basil, savory, sage, oregano, horehound, catnip, spearmint, peppermint, thyme, marjoram, lemon balm

Tea: elder, mint, catnip

Oil: olive, corn, 100% corn oil margarine, butter

Juices: juices may be made and used without added sweeteners from the following: Fruits - any listed above in any combination desired

Vegetables -- any listed above in any combination desired

Seven-Day Rotation Day 1 - Sunday

<u>Breakfast</u>

Apples applesauce and juice

American cheese, Mint tea, Potato, Currants

<u>Lunch</u>

Potato, Asparagus, Beef, Figs, Onions, Olives (Black), Gooseberries

<u>Dinner</u>

Olives (Green) Tomato, Lamb (or beef), Tomato Juice, Eggplant, Pears, sauces & Juice

*This menu is prepared for the no-milk and no-cereal grain program. Most can eat these after a three-month abstinence.

Seven-Day Rotation Day II - Monday

FOOD FAMILIES

Citrus: lemon, orange, kumquat, citron, grapefruit, lime, tangerine

Parsley: carrot, celeriac, parsley, anise, parsnip, celery, celery seed, dill, cumin, coriander, caraway, fennel

Pepper: white pepper

Herbs: mace

Walnut: English walnut, black walnut, pecan, hickory nut, butternut

Bird: chicken, goose, quail and their eggs

Tea: Comfrey tea, comfrey greens, fennel Oil: fat from any bird listed above Sweetener: orange honey - use sparingly

Juices: juices may be made and used without adding sweeteners from the following: Fruits - any listed above in any combination

Vegetables -- any listed above in any combination

Seven-Day Rotation Day II- Monday

<u>Breakfast</u>

Grapefruit, Walnuts, Eggs, Comfrey tea,

<u>Lunch</u> Carrots, Parsley, Chicken Eggs, Parnips

<u>Dinner</u> Orange, Pecans, Chicken or other fowl listed, Celery, Celeriac

Seven-Day Rotation Day III -- Tuesday

FOOD FAMILIES

Grape: all varieties of grapes and raisins

Rose: strawberry, raspberry, blackberry, dewberry, loganberry, youngberry, boysenberry, rose hips Peas: pea, black-eyed pea, dry beans, string beans, carob, soy beans, lentils, licorice, peanut, alfalfa Flaxseed: flaxseed

Tea: alfalfa tea, rose hip tea

Oil: peanut or soy

Sweetner: carob syrup (use sparingly), clover honey (if honey isn't used on any other day) Swine: all pork products arrowroot

Arrowroot: arrowroot

Juices: juices may be made and used without adding sweeteners, from the following:

Fruits -- any listed above in any combination

Vegetables -- any listed above in any combination

Seven-Day Rotation Day III - Tuesday

<u>Breakfast</u>

Raisins, Alfalfa, tea, Limas Grapes

<u>Lunch</u>

Shell Beans, Strawberries, Boysenberry, Peas, Pork, Boysenberry

<u>Dinner</u>

Lentils or other beans, String Beans, Blackberry, Peanut Butter, Pork

Seven-Day Rotation Day IV -- Wednesday

FOOD FAMILIES

Blueberry: blueberry, huckleberry, cranberry, wintergreen
May apple: may apple
Aster: lettuce, chicory, endive, escarole, artichoke, dandelion, sunflower seeds, tarragon, oyster plant (salsify) celluse
Morning Glory: Sweet potato (not yam)
Laurel: avacado, cinnamon, bay leaf, sassafras, cassia buds or bark
Protea: macadamia nut
Beech: chestnut
Orchid: vanilla
Fungus: mushrooms and yeast
Salt water fish: Sea herring, anchovy, cod, sea bass, sea trout, mackerel, tuna, swordfish, flounder, sole
Fresh Water Fish: sturgeon, herring, salmon, pike, white fish, bass, perch, sunfish, bluegill
Oil: avocado
Tea: sassafras tea, papaya
Spurge: tapioca
Juices: juices may be made and used without adding sweeteners, from the following: Fruits - any listed above in any combination
Vegetables -- any listed above in any combination
Seven-Day Rotation Day IV -- Wednesday
Breakfast
Blueberry, Huckleberry, Sunflower seeds, Fish
Lunch
Cranberry Juice (dietetic), Lettuce and others in family for a salad, Fish, Salsify or Oyster Plant, Sweet Potato (light yellow flesh)
Dinner
Avocado, Chestnuts, Mushrooms, Fish
*Vary the types of fish with each meal
Seven Day Rotation Day V - Thursday
FOOD FAMILIES
Pineapple: (juicepack, waterpack or fresh and frozen without added sugar)
Melon (gourd): watermelon, cucumber, cantaloupe, pumpkin, squash (all varieties), other melons, zucchini, summer squash
Pursulane: pursulane, New Zealand spinich greens
Mallow: okra, cottonseed
Cashew: cashew, pistachio, mango

Tea: fenugreek
Pedalium: sesame
Oil: cottonseed, sesame
Mollusks: abalone, snail, squid, clam, mussel, oyster, scallop
Crustaceans: crab, crayfish, lobster, prawn, shrimp
Juices: juices may be made and used without adding sweeteners, from the following: Fruits - any listed above in combination

Vegetables — any listed above in combination

Seven-Day Rotation Diet V - Thursday

Breakfast
Cantaloupe, Zucchini and/or pumpkin, Cashews

Lunch
Watermelon, Pistachios, Winter squash, Shellfish

Dinner Pineapple, Shellfish, Okra Cucumber, Summer Squash, Sesame Seeds, Sesame seed milk

*Vary the types of shellfish with each meal

Seven-Day Rotation Diet VI - Friday

Banana: banana, plantain, arrowroot (musa) Pomegranate: pomegranate

Ebony: persimmon
Palm: coconut, dates, date sugar, sago, palm cabbage
Pepper: black pepper, peppercorn
Herbs: nutmeg
Beet: beet, chard, spinach, lambs quarters (greens) Birch: filbert, hazelnut

Bird: turkey, duck, pigeon, pheasant and their eggs
Tea: lemon verbena
Oil: coconut oil and fat from any bird listed above
Sweetener: date sugar or beet sugar (use sparingly)
Juices: juices may be made and used without adding sweeteners, from the following:

Fruits -- any listed above in combination
Vegetables -- any listed above in combination

Seven-Day Rotation Diet VI - Friday

Breakfast
Hazel nuts or Filberts, Banana, Duck eggs

Lunch
Beets, Beet greens, Lambs quarteers (greens), Turkey, Pomegranate, Fresh coconut, Coconut milk

Dinner Spinach, Dates, Turkey or Duck, Persimmons

Seven-Day Rotation Diet VII -- Saturday

FOOD FAMILIES

Plum: plum, cherry, peach, apricot, nectarine, almond, wild cherry, also small amounts of any natural dried fruit listed above

Mustard: mustard, turnip, radish, horse radish, wateercress, cabbage, kraut, chinese cabbage, broc- coli, cauliflower, brussel sprouts, collards, kale, kohlrabi, rutabaga

Buckwheat: buckwheat, rhubarb Yam: yam, chinese potato Subucaya: Brazil nut

Conifer: pine nut

Oil: safflower

Tea: safflower, ate

Bovid: lamb

Sweeteners: buckwheat, safflower, sage, if honey — not used on any other day

Juices: juices may be made and used without adding sweeteners, from the following:

Fruits: any listed above in any combination

Vegetables: any listed above in any combination

Seven-Day Rotation Diet VII -- Saturday

Breakfast

Apricots, Buckwheat, Grits, Almonds, Cherries, Nectarine, Juices of either fruit or mixed

Lunch

Plums, Watercress, Yam (dark yellow - pink flesh), Broccoli, Turnips, Turnip Greens, Prunes, Cabbage or Sauerkraut, Lamb Radishes, Mustard Greens

Dinner

Peaches, Brussel Sprouts, Cauliflower, Lamb, Rhubarb, Collards, Kale, Yam, Brazil nuts

*May need to use lamb only once

FINAL WORD

The metabolic syndrome is composed of metabolic risk factors for developing diabetes mellitus type II and cardiovascular disease. Appropriate treatment of these degenerative disease risk factors is a major preventive medicine challenge for both medical science and personal health.

Metabolic degenerative disease risk factors can be assessed by a system of avoidance for five days of the common stress factors followed by a single, deliberate exposure to each stress factor, monitored for the emergence of symptoms and laboratory assessed

disordered metabolism such as hyperglycemia, hypertension, cardiac irregularities, disordered lipid metabolism and obesity. These common stress risk factors are allergies especially to foods, addictions especially to foods and with also any addiction being a significant risk factor, toxicities and infections. Initial avoidance and later, spacing of contact with food allergies and food addictions and reversing all addictions is a major step in solving the chronic stress leading to degenerative diseases. Toxicity can be processed out of the body. It is important that nutrition be optimized.

The good news is that a negative magnetic field provides biological anti-stress and the maintenance of the necessary alkaline-hyperoxia for the maintenance of the defense against the development of early stage degenerative disease risk factors as well as reversal of established clinically significant metabolic degenerative diseases.

A rotation diet relieves the stress of food allergies and food addiction.

A negative magnetic field producing an alkaline-hyperoxia biological response reverses the acid-hypoxic produced insoluble deposits of calcium, fats amino acids (amyloid), advanced glycosylation end-products (AGES) (toxic chemical compound of amino acids -- glucose from hyperglycemia), wherever they have occurred in the body.

A negative magnetic field is an effective antibiotic and anti-cancer agent.

References

BECKER, ROBERT O. "Cross Currents". Jeremy P. Tarcher, Inc. Los Angeles, CA, 1990. BECKER, ROBERT O. and SELDON, G. "The Body Electric. Electromagnetism and the Foundation of Life." William Morrow and Company. NY. 1986.

BECKER, ROBERT O. and MARINO, A. "Electromagnetism and Life". State University of New York Press; Albany, NY 1982.

DAVIS, A.R. and RAWLS, W. "The Magnetic Blueprint of Life.". Acres USA, Kansas City, MO, 1979.

DAVIS, A.R. and RAWLS, W. "The Magnetic Effect". Acres USA, Kansas City, MO 1975

DAVIS, A.R. and RAWLS, W. "Magnetism and Its Effect on the Living System". Acres USA, Kansas City, MO 1976.

Encyclopedia Britannica. Vol 15, page 1060. 1986 edition.

FERSHT, Alan., *Enzyme Structure and Mechanism*

Second Edition. W.H. Freeman and Co. New York, New York. 1994

KLONOWSKI, W and KLONOWSKI, M. Journal of BioElectricity. Aging Process and Enzy- matic Proteins. 4(I), 93-102 (1985).

LAKKA, HANNA-MAARIA, M.D., Ph.D., et al JAMA , December 4, 2002. Vol 288, No. 21, Pg 2709

PHILPOTT, W.H., M.D. and KALITA, Dwight, Ph.D., *Victory Over Diabetes: A Bio-Electric Triumph.* Keats Publishing Company, Inc. New Canaan, CT. 1982 (1991 paperback with new chapter on Medical Magnetics).

PHILPOTT, W.H., M.D., Magnetic Health Quarterly, *Diabetes Mellitus,* Vol III, Second quarter, 1997

PHILPOTT, W.H., M.D. and KALITA, Dwight, Ph.D., *Brain Allergies. The Psycho-nutrient and Magnetic Connections.* Updated second edition. Keats Publishing NTC/Contemporary Publishing Group. Los Angeles, CA , 2000.

PHILPOTT, W.H., M.D. and KALITA, Dwight, Ph.D., *Brain Allergies,* updated second edition. Keats Publishing NTC/ Contemporary Publishing Group, Los Angeles, CA 2000

PHILPOTT, W.H., M.D. and KALITA, Dwight, Ph.D., *Magnet Therapy.* (Tiburon, CA: alternativemedicine. corn, 2000)

POTTS, JOHN, Journal of Diabetes. Avoidance Provocative Food Testing in Assessing Diabe- tes Responsiveness." 26:Supplement 1, 1977.

POTTS, JOHN, Journal of Diabetes. 'Value of Specific Testing for Assessing Insulin Resistance." 29: Supplement 2, 1980.

POTTS, JOHN, Journal of Diabetes. "Blood Sugar-Insulin Responses to Specific Foods Versus GTT." 30:Supplement 1, 1981.

POTTS, JOHN, Journal of Diabetes. "Insulin Resistance Related to Specific Food Sensitivity." 35: Supplement 1, 1986.

BRAUNWALD, Eugene. Harrison's Principles of Internal Medicine. 11th edition 1987. McGraw-Hill Book Company, NY.

STEIN, Jay H. *Internal Medicine.* 4th Edition. 1994. P. 340-524. Mosby Publishers. St. Louis. [*Magnetic Health Quarterly* "Metabolic Syndrome Risk Factors" Vol. IX, 1st Qtr, 2003 (2002 Revision)]

MULTIPLE SCLEROSIS

Multiple sclerosis classically occurs as repeated episodes with progressive central nervous system function deterioration. In a lesser number, the illness is steadily progressive from the start. In

it's early stage, the diagnosis of multiple sclerosis is uncertain in most cases and only after several flare-ups and with multiple locations of central nervous system myelin destruction is the diagnosis confirmed. Classic features are impaired vision, impaired speech, unsteadiness on the feet, intention tremor, weakness and paralysis (either local or general), spasticity and loss of control of urine. Specific local symptoms reflect the area of the brain or spinal area involved in the inflammatory and demyelin rating lesions. This varies considerably from person to person.

PATHOLOGY

There are numerous scattered discreet areas of demyelination consisting of microscopically gray-pink areas in the normal myelin white matter. Classically, the neurones are preserved. However, there is some degree of axonal damage but demyelination predominates. These demyelin plaques are scattered throughout the brain and spinal cord areas. Myelin is the fatty material that surrounds neurones and their extensions (axons). In multiple sclerosis, the myelin is inflamed and swells putting pressure on the neurones and their axons. This pressure blocks the function of neurones resulting in a functional loss even without destruction of neurones or their axons. This loss of neuronal function is termed the "functional extinction of disuse".

EPIDEMIOLOGY

Classically, multiple sclerosis occurs in the age group of 30-40 years and only occasionally occurs in children. Sixty percent of cases are female. Northern Europe, Northern United States and Canada has the largest incidence. Multiple sclerosis is rare in Japan and the Orient. Whites are more likely than blacks, living in the same area, to have multiple sclerosis. Identical twins are more likely to have multiple sclerosis than non-identical twins. The data is consistent with a viral infection. The data is consistent with a genetic predisposition to succumb to the same viral infection.

AUTOIMMUNITY

The inflammatory attacks on myelin as a specific tissue is consistent with autoimmunity. Viral infections are known to be capable of setting the stage for a selective tissue autoimmune disease. A viral infection can set off a specific tissue sensitivity. The virus may or may not be present in the affected autoimmune reactive tissue. The observation of excessive antibodies in multiple sclerosis is an important fact. Immunologic reactions to foods are usually IgG mediated.

PRECIPITATING FACTORS

Various stressors, such as infections of various types, injuries and even mental upset have been claimed to precipitate the first attack of multiple sclerosis. It seems evident that these precipitating factors are only stressors in an already existing viral disease. The most important immediate symptom evoking fact has been observed to be maladaptive reactions to foods and environmental chemicals. Food maladaptive reactions are not the initiating cause of multiple sclerosis but can precipitate the symptoms of an already injured tissue.

THE ROLE OF MALADAPTIVE FOOD REACTIONS

The viral infection (especially human herpes virus #6) sensitizes to myelin and thus produces an autoimmune disease in which the immune system produces an autoimmune destructive inflammatory attack of myelin. This injured myelin tissue sets the stage for any process that produces cellular edema to select this injured tissue area with it's compromised metabolic function to react to cellular edema first, and more than normal cells and normal tissues.

The observed causes of maladaptive symptom producing, acid-hypoxic producing, cellular edema producing reactions are observed to be:

1) Immunologic IgG reactions to foods are observed to be the most frequent immunologic cause of reactions with IgE mediated reactions to be infrequent. IgG antibodies are observed to be high in multiple sclerosis. Antibodies are produced by B-lymphocytes. The lymphotropic viruses are Epstein-Barr, cytomegalo and human herpes virus #6. Thus, the lymphotropic viral infection with the infected lymphocytes include the B-lymphocytes to make antibodies. This viral infection immune disorder produces IgG antibodies to the stress of frequently used foods and commonly contacted environmental chemicals. This IgG immune response to foods and chemicals is a reason for an initial avoidance period of commonly eaten foods which are demonstrated to be symptom producing, and later, spacing the contact on a four day basis after the immunological response has calmed down. The symptom reactive IgG foods and chemicals evoke cellular edema and thus aggravate the already damaged myelin tissues. Exposure to the symptom producing foods evoke the multiple sclerosis symptoms into the already damaged myelin.

2) Non-immunologic reactions are (a) addiction, (b) oxidoreductase enzyme deficiency, (c) oxidoreductase enzyme inhibition, (d) enzyme toxins.

The common denominator of both the immunologic and non-immunologic reactions is acid-hypoxia. Thus, it can be understood that eating a food or exposure to a chemical to which the subject has a maladaptive reaction can aggravate the symptoms of multiple sclerosis. Initial avoidance of these symptom producing foods or chemicals and a later spacing the contact below symptom production can materially aid in the management of multiple sclerosis and appears to help prevent further episodes.

The best way to demonstrate this relationship to maladaptive reactions to foods and multiple sclerosis is to fast for a period of five days and at the same time avoid common environmental chemicals. Under this circumstance, the subject is observed to have a lessening of their multiple sclerosis symptoms. After this five days, feeding foods of single test meals or exposure by sniffing common chemicals can demonstrate which foods and which chemicals are exacerbating the symptoms of multiple sclerosis. Cumulatively, those physicians who have been using this procedure have demonstrated large numbers of multiple sclerotic patients in which this procedure does precipitate symptoms in multiple sclerosis and the management of those symptoms are materially aided by a four day diversified rotation diet after initial avoidance of environmental chemicals demonstrated to precipitate symptoms of multiple sclerosis.

The role of enzyme toxins in multiple sclerosis is significant. Viruses produce toxins. Fungi, such as *Candida albicans* produces toxins. Bacterial infection produces toxins. There are numerous common environmental chemicals such as petrochemicals and formaldehyde that are enzymatic toxic. Lead is enzymatic toxic. Mercury is enzymatic toxic. Acidity is enzymatic inhibiting for the numerous alkaline dependent enzymes necessary for human biological function. Maladaptive reactions to foods, chemicals and inhalants produces acidity, thus, inhibiting necessary biological enzyme function.

Silver-mercury amalgams are a common source of mercury toxicity. Amalgams should be removed [by a Biological Dentist]. Immediately after the removal of the amalgams, the subject should receive EDTA chelation intravenously. 12,000 mcg of B_{12} should be given intravenously. Continue 12,000 mcg of B_{12}

intramuscularly or intravenously weekly for two or three months and then reduce to 4,000 mcg of B_{12} intravenously or intramuscularly weekly as a protection and healing factor. B_{12} is necessary as a protection against neuronal damage from toxins (1,2,3). Cerebral spinal fluid of multiple sclerotic subjects has a lower B_{12} level than a control group.

HOW MAGNETIC THERAPY HELPS MULTIPLE SCLEROTIC SUBJECTS

A negative magnetic field is an antibiotic.

I repeatedly, objectively observed that a negative (south-seeking) magnetic field kills bacteria, viruses, fungi and parasites. This is not common knowledge and needs statistical validation and therefore, is subject to doubts by those not experienced in this fact. Consistently, I have observed the general antibiotic effect of a negative (south-seeking) magnetic field. A negative (south-seeking) magnetic field alkalinizes by magnetic activation of the bicarbonate buffer system and oxygenates by magnetic activation of the oxidoreductase enzyme system thus, relieving oxygen from it's bound state in free radicals, peroxides, oxyacids, alcohols and aldehydes. This alkaline-hyperoxia blocks the acid-hypoxia necessary for the replication of most human invading microorganisms. Most microorganisms make their ATP by fermentation. Fermentation is acid-hypoxic dependent. Alkaline-hyperoxia inhibits fermentation and thus blocks microorganism replication. This mechanism can explain the antibiotic effect for most microorganisms, however, even the aerobic organisms are killed by a negative (south-seeking) magnetic field. The mechanism of a negative (south-seeking) magnetic field antibiotic effect against aerobic organisms is not known.

A NEGATIVE (SOUTH-SEEKING) MAGNETIC FIELD ALKALINIZES

Bicarbonates are slightly imbalanced in their valence and thus are paramagnetic. When a negative (south-seeking) magnetic field attaches to a bicarbonate, it activates the alkalinity of the bicarbonate. When a positive (north-seeking) magnetic field attaches to a bicarbonate, it inactivates the alkalinity.

A NEGATIVE (SOUTH-SEEKING) MAGNETIC FIELD OXYGENATES

Oxidoreductase enzymes that process free radicals, peroxides, oxyacids, alcohols and aldehydes are activated by a negative (south-seeking) magnetic field and inactivated by a positive (north-

seeking) magnetic field. A negative (south-seeking) magnetic field energy activation of oxidoreductase enzymes frees oxygen from it's bound state in free radicals, peroxides, oxyacids, alcohols and aldehydes and thus provides for an abundance of oxygen.

A negative (south-seeking) magnetic field governs healing. Alkaline-hyperoxia is necessary for the production of ATP by human cells. This also governs the entire healing process. Thus, a negative (south-seeking) magnetic field is calculated to heal myelin. It is known that myelin attempts to heal, but only does so partially because of the ongoing inflammatory autoimmune process. Once the autoimmune process is stopped, then theoretically, myelin can heal. There is an urgent need to prove that myelin will repair once the autoimmune reaction is stopped and there is an exposure to the negative (south-seeking) magnetic field. Theoretically, this is what would happen and therefore, deserves verification. The application of magnetic fields should not be just to stop the inflammatory autoimmune reaction, but to also proceed as a lifestyle so the repair of the myelin occurs.

Therefore, it is recommended that a person with multiple sclerosis continue the use of the magnets, which does not need to be quite as intense as initially, but can be easily achieved by sleeping with magnets on the back, on a magnetic bed pad and with magnets up against the head at night. During sleep is also the time when growth hormone rises and therefore, the healing process occurs at night during sleep.

A POSITIVE (NORTH-SEEKING) MAGNETIC FIELD STIMULATES NEURONAL FUNCTION

A negative (south-seeking) magnetic field alkalinizes and heals. A positive (north-seeking) magnetic field is energy activating to neurones but does not heal. A positive (north-seeking) magnetic field expresses the use of biological energy but does not produce biological energy. Therefore, a positive (north-seeking) magnetic field for brief periods, such as 3-5 minutes, can be used during practice sessions to stimulate a return of function. This neuronal stimulation needs to be associated with the person's voluntary effort for the return of function. Even if the subject is paralyzed in a limb, the limb could be passively moved by another person and at the same time the multiple sclerotic subject would be signaling by thought for the limb to move. Sometimes, this combination of a static positive (north-seeking) magnetic field with the effort of moving the paralyzed part of the body works so

well that it looks like a miracle has occurred. Through the years, an electrical stimulus has been used to energy activate neurones for the return of function. A positive (north-seeking) magnetic field works the same way that an electric current works in energy activating neurones.

DIETARY FACTORS

Viral infections of the lymphotropic type (Epstein-Barr, cytomegalo, human herpes virus #6) have been observed to reduce the body's level of essential fatty acids (4,5,6,7). Thus, it is in order to use primrose oil, cod liver oil or other sources of unsaturated fatty acids in multiple sclerosis.

The stress of a viral infection makes great demand for vitamins, minerals and amino acids. Folic acid and B_{12}, especially, can become deficient and need replacing. B_{12} should be provided in large doses for the reinstatement of neuronal function. Magnesium is especially important because of the spasticity that accompanies multiple sclerosis. Adequate magnesium helps to some degree to ally the spasticity. It is well for multiple sclerosis subject to take two or three times the usual daily requirement of necessary vitamins which also includes the antioxidant vitamins.

Pancreatic bicarbonates of sodium and potassium and the production of pancreatic enzymes are observed to be low in chronic, degenerative diseases. These should be replaced in ample amounts.

IDENTIFICATION OF CAUSES

The need to identify the cause of multiple sclerosis and the difficulty in identifying the cause of multiple sclerosis has spawned numerous studies and even more numerous theoretical discussions. Summaries of these studies and theoretical discussions are in numerous scientific journals and textbooks (8,9,10). The consensus is that viral infections are involved. Some viral infections are known to produce massive generalized demyelination. However, in multiple sclerosis the demyelination is scattered spottily through the central nervous system. The most convincing observations contain the following:

1. Human herpes virus #6 is present throughout the brain tissue of multiple sclerotic subjects.

2. Oligodendroglia cells surround the multiple sclerosis plaques. Antibodies to human herpes virus #6 are in these oligodendrogliacytes. Oligodendroglia have the assignment of making myelin. The plaques are composed of dead myelin cells

incidental to the initial inflammatory process. Is this inflammatory process secondary to an autoimmune disorder? No one knows for sure.

3. There is evidence of abortive attempts at re-myelination but in the face of the continued infection, this cannot be completed.

4. Most neurones and their axons are not destroyed by the inflammatory process.

5. Neurones undergo a functional "extinction of disuse" due to the pressure from the edema of the acute inflammatory attacks.

6. Neurones and axons, robbed of their myelin insulation, cross-circuit the messages.

THE GOAL OF TREATMENT FOR MULTIPLE SCLEROSIS

1) Kill the viral infection.

2) Repair the myelin.

3) Stop the reactions to environmental substances (foods, chemicals and inhalants).

4) Optimize nutrition.

5) Reinstate function through magnetic or electrical neuronal excitation paired with functional movement and sensory practice.

A negative (south-seeking) magnetic field kills viruses. The ability of a negative (south-seeking) magnetic field to kill viruses has been objectively observed in relationship to shingles, herpes sim- plex I and II and influenza. These are objective observations that I have made. A negative (south-seeking) magnetic field governs healing. Robert O. Becker established this fact. I have objectively confirmed the fact that a negative (south-seeking) magnetic field governs healing. The positive (north-seeking) magnetic field stimulates neurones to function and when paired with a functional practice, can often seemingly, miraculously reinstate function in a multiple sclerotic.

MULTIPLE SCLEROSIS PROTOCOL OPTIMUM SYSTEMIC MAGNETIC THERAPY: ORIENTATION:

This magnetic protocol features systemic therapy which is applicable for any person with a systemic disease such as viral infections, metastatic cancer, lupus, Lyme's disease, chronic fatigue, fibromyalgia, multiple sclerosis and major mental or emotional disorders. This systemic magnetic therapy is the optimal therapy for anyone. This is superior to the usual sleep magnetic beds using mini-blocks. The therapy is composed of two features. One is 70 magnets that are 4" x 6" x 1". These are placed in two

wooden grids with 35 magnets each. These two grids are placed end to end making a bed 36" wide and 72" long. This bed radiates a magnetic field of 25 gauss at 18". 25 gauss is the level at which infections and cancer will die out. The second feature is twelve of these 4" x 6" x 1" magnets surrounding the head. This produces deep sleep and is suitable for treating brain cancer, cerebral arteriosclerosis and Alzheimer's. It is the maximum treatment for producing deep sleep for anyone.

Multiple sclerosis is initially caused by a systemic viral infection. The most, recent information implicates human herpes virus #6 to be the virus consistently found in multiple sclerotics (11). There also appears to be an immunologic autoimmune reaction specific against myelin initiated by and also, superimposed on the viral infection. The viral infection and superimposed myelin immunologic reaction is chronic and thus has exacerbations. The therapeutic need is to 1) isolate and stop the exacerbation precipitating factors, 2) kill the viruses, 3) reverse the immunologic autoimmune reaction, 4) repair the injured and destroyed myelin, 5) practice a return of function of neurones inhibited by, but not killed by, the acute inflammatory autoimmune disorder.

Maladaptive reactions to foods, chemicals and inhalants needs to be appropriately handled since the maladaptive reactions have been demonstrated to evoke acute multiple sclerosis symptoms and thus, also precipitate exacerbation episodes(3). A negative (south-seeking) magnetic field can kill the viruses. A negative (south-seeking) magnetic field can reverse the autoimmune reaction. A negative (south-seeking) magnetic field theoretically can repair the myelin. A positive (north-seeking) magnetic field activates the neurones and can be used during functional return practice sessions to stimulate neurones to reverse the neuronal functional extinction of disuse.

MAGNETS USED:

Two wooden grids containing 35 magnets that are 4" x 6" x 1" placed 1" apart. These grids are 36" square. Two grids are placed end to end producing a bed 36" x 72".

A super magnetic head unit composed of twelve 4" x 6" x 1" magnets. These magnets surround the head.

Super magnetic hat composed of thirty-four 1" x 1/8" neodymium discs.

PLACEMENT AND DURATION:

For initial treatment of three months or more, sleep as close to the magnets in the bed as possible. This can be achieved by using an eggcrate-type foam pad that is 2" thick or other suitable futon that is about 2" thick. After the initial treatment of three months or more, if desired, it can be placed under a 4" thick mattress.

The super magnetic head unit is composed of twelve 4" x 6" x 1" magnets. This is placed on the pillow. There may need to be a small child's pillow to raise the head a couple of inches beyond the pillow that this unit is sitting on. This is provided, if necessary, for comfort. The magnets are 6" long and are standing upright. The head needs to be within that 6". This is used nightly for sleep.

For infections in the head, multiple sclerosis or for Alzheimer's or cerebral arteriosclerosis, it is wise to go back on the bed and this head unit for one hour, four times during the day. There also can be a hat provided that is composed of neodymium disc magnets that can be used when not on this bed for such cases as brain tumor, cerebral arteriosclerosis, cerebral spasm, Alzheimer's and so forth.

This bed, super magnetic hat and magnetic head unit needs to be used daily as a lifestyle. It is the optimum magnetic therapy provided for multiple sclerosis, many other conditions and is essential for certain systemic and chronic conditions.

It is wise for this therapeutic bed to be accompanied with optimization of nutrition by use of supplemental nutrients. Optimization of hydration should be considered with 8 or more glasses of pure water each day.

A rotation diet is necessary for multiple sclerosis. Follow the instructions as described herein.

FUNCTIONAL RETURN PRACTICE SESSIONS

After the acute symptoms of inflammation are over, which would require more than a month and more likely up to three months, then start a functional practice for return of function. During this practice, place the 4" x 24" plastiform magnet on the spine with the positive (north-seeking) magnetic field facing the spine. An alternative would be to use the 5" x 12" multi-magnet flexible mats, one on the lumbar spine and one on the thoracic spine. Also, place a 4" x 6" x 1/2" magnet with the positive (north-seeking) pole facing the head (either the top, side or back of the head or the fore- head). The positive (north-seeking) pole is to be facing the body for a minimum of three minutes and a maximum

of five minutes. During this time, a practice for functional return is being performed. This can be motor movement or speech. Whatever the deficits are, an effort is made to practice a return of function. There is no need to do this more than five minutes since a maximum neuronal excitation is achieved in three minutes. It would especially be wise not to extend this beyond five minutes. After removing the magnets, then the practice can be continued for another five minutes then put the magnets back on with the positive (north-seeking) pole facing the body. This can be repeated over and over for a period of twenty minutes. It needs to be understood that if a seizure has occurred due to the multiple sclerosis, the 4" x 6" x 1/2" magnet on the head may not be able to be used. Instead, it may have to be replaced with a 4" x 6" x 1/8" plastiform magnet. A positive (north-seeking) magnetic field on the head can precipitate a seizure in any subjects that are seizure-prone. Multiple sclerosis can sometimes lead to seizures. This needs to be understood. There should be one to three practice sessions daily, lasting from 20-30 minutes for return of function. Neurones become inhibited in function without being killed. This is termed the "extinction of disuse". Stimulating the neurones with a positive (north-seeking) magnetic field while at the same time practicing the effort of a return function can help the function to return. The negative (south-seeking) magnetic field calms down the neurones, calms down the acute inflammatory reaction, calms down the autoimmune reaction, kills the viruses but it does not stimulate neuronal functional return. Only the positive (north-seeking) magnetic field can do this. There is no need, however, to take this practice to the extent of exhaustion. Exhaustion will not achieve any particular value.

POLARITY

Use the negative (south-seeking) magnetic field for inflammation and viral infection. Use a positive (north-seeking) magnetic field for functional return practice sessions.

MULTIPLE SCLEROSIS: ORIENTATION:

Multiple sclerosis is a demyelinating disease of the myelin around the brain and the spinal cord. This is caused by a viral infection. Consistently, human herpes virus # 6 has been isolated from multiple sclerotic cases. Therefore, it is assumed that this is the virus involved in the demyelinating process. The first goal is to kill the viruses. The process for doing this is to sleep on a strong magnetic bed composed of seventy 4" x 6" x 1" magnets and sleep

with the head in a strong negative magnetic field composed of twelve of the 4" x 6" x 1" magnets. There needs to be a practice of return function. Nutrition needs to be optimized under medical supervision.

MAGNETS USED:

Two wooden grids contain 35 magnets each that are 4" x 6" x 1", placed 1" apart and firmly held in the wooden grid. Two of these are placed end to end producing a bed 36" x 72". Over this bed, an eggcrate-type foam pad that is about 2" thick or other suitable thin futon is used.

Two 5" x 12" double-magnet flexible mats. Three 4" x 52" body wraps.

One 4" x 6" x 1/2" ceramic block magnet.

Two 1-1/2" x 1/2" ceramic disc magnets with Velcro on the positive pole side. One 2" x 26" band.

Super magnetic head unit composed of twelve 4" x 6" x 1" magnets with a space for the head to be surrounded by these magnets.

PLACEMENT AND DURATION:

Sleep all night on the magnetic bed with a thin pad over this bed and the head in the magnetic head unit. This super magnetic head unit is placed on a pillow. For the first three months, the subject should return to the bed and the head unit for an hour, four times during the day. The bed and the head unit is used nightly as a lifestyle after the three months, and it is preferred that there be an hour or so during the day when the bed and the head unit is returned to as a lifestyle as treatment after three months.

A practice session for return function is entered into. This consists of placing the flexible 5" x 12" mats on the spine. One on the lower spine and one on the upper spine and neck. Place the positive magnetic field that has the Velcro on it next to the body for about five minutes while practicing motor functional return of the arms and legs and walking. These can be held in place with a 4" x 52" body wrap. After five minutes, turn it over and still continue to practice for another five minutes. Use the positive magnetic field for five minutes, the negative magnetic field for five minutes, back and forth for about twenty minutes. The minimum should be once a day - twice a day would be better.

Another practice at another time would be to practice return function of the brain. This uses a 4" x 6" x 1/2" magnet. First of all, wrap a 4" x 52" body wrap around the back of the head and

forehead. Place this 4" x 6" x 1/2" in the folds of this wrap at various positions during the practice time -- that is, the back of the head, the sides of the head and the forehead. Again, this should be only five minutes at a time on the positive pole. The practice should consist of all mental functions such as reading, listening, visual, pictures of objects and of people should be seen and have the subject name these people in the pictures and historical information. All mental functions need to be practiced -- visual, auditory, memory, historical events and so forth. There is a remote danger that a grand mal seizure could occur while practicing with this positive magnetic field on the head. It is very important that exposure to the brain be no more than five minutes at a time on the positive pole and then turn the magnet over to the negative pole for another five minutes. There is not likely to be a seizure unless the person is seizure-prone. If they have had seizures and are therefore known to be seizure-prone, practice could be no more than 2-3 minutes which is likely then to prevent the development of a seizure. The positive magnetic field is an excitement field to the neurones of the brain. We need this to activate the neurones to a return function.

Discs that are 1-1/2" x 1/2" are provided. These are placed under the 2" x 26" band and placed about one inch in front of each ear. This can relieve many symptoms and can be used in two ways. One is just to relieve symptoms when they occur such as depression or memory problems or it can be used quite continuously. There are no limits of the application of the negative magnetic field to the brain with these discs. The nature of multiple sclerosis is such that the magnets can improve the injury and improve the energy and the function, however it has to be kept up as a daily practice. After reinstating function, there will be a lapse back to reduced function after a few hours and the function needs to be reinstated again. This is simply the nature of multiple sclerosis.

NUTRITION:

Nutrition should be optimized, preferably under the direction of a physician.

4-DAY DIVERSIFIED ROTATION DIET:

It is imperative to use a 4-Day Diversified Rotation Diet. The instructions should be followed in *The Ultimate Diet* quarterly. Essentially, foods that are eaten twice a week or more are left out for three months while starting the 4-Day Diversified Rotation Diet. After three months, the foods that had been used frequently

can be returned to the diet. It is important to use the 4-Day Diversified Rotation Diet as a lifestyle.

HYDRATION:

It is important to drink pure water with a minimum of eight glasses and preferably even ten glasses of water daily. We need this water for hydration and also for detoxification.

ALKALINE MICRO NEGATIVE-POLED WATER:

There are two systems that can be used. There are electrolysis instruments that will alkaline micro negative magnetic pole the water. The more of this that is used in the course of the day, the better. A minimum should be five glasses a day.

The most studied, and thus documented value, is from NARIWA water. This is from a natural spring from Japan's magnetic mountain. 500cc of this a day should be used as a minimum. 1000cc would be even better.

Alkaline micro water negative magnetic poled water is optional but is preferred.

POLARITY:

The basic treatment is that of a negative magnetic field that will calm neurones, kill viruses and repair myelin. The exception to the use of the negative magnetic field is that of the practice sessions for return function as have been described which uses the positive magnetic field for brief periods of 3-5 minutes.

FINAL WORD

There is convincing evidence that multiple sclerosis is caused by a general brain infection of herpes virus #6. The focal white matter myelin areas of infection result in cellular injury producing plaque formation. This is caused by an infection of herpes virus #6 and immune response of oligodendrogliacytes to the viral infection. Oligodendrogliacytes are the cells that make myelin. In this immune response to the viral infection, the oligodendrogliacytes cannot effectively repair myelin although there are evidences of abortive attempts at myelin repair. The therapeutic goal for the reversal of multiple sclerosis is:

1) Kill the viral infection.
2) Repair the myelin.
3) Reinstate function while exciting neuronal function.

The bad news is that the initial cause of multiple sclerosis is a viral infection of human herpes virus #6. The good news is that a negative (south-seeking) magnetic field can kill viruses.

The bad news is that the myelin is destroyed by the immune response to the viral infection. The good news is that a negative (south-seeking) magnetic field can repair the myelin after the infection has been killed.

The bad news is that in multiple sclerosis, the viral infection and the immunologic reaction resulting from the viral infection and the edema caused by the inflammatory reaction block neuronal function resulting in symptoms reflecting the functional "extinction of disuse" of neurones. This interference with axon function is due to the destruction of the myelin insulation. The good news is that after the acute edematous phase is over and myelin is repaired or being repaired, the positive (north-seeking) magnetic field can reinstate function by the excitement of neurones while paired with a functional return practice.

GLOSSARY

AUTOIMMUNE DISORDER: When the immune mechanism attacks specific, selective cells or tissues. This is secondary to a viral infection or other immunologic reactions.

KININS: Polypeptides produced by tissue damage. Kinins produce tissue inflammation.

MALADAPTIVE REACTIONS: Any symptom producing response when exposed to a food, chemical or inhalant. These can be immunologic such as antibody formation, complement disorders, etc. Non-immunologic maladaptive disorders can result from addictions, enzyme deficiencies, enzyme inhibition or from enzyme toxins. Non-immunologic maladaptive symptom reactions make up the majority of maladaptive reactions.

MYELIN: The fatty, insulating, cushioning material around the neurons and their axon and extensions.

OLIGODENDROGLIACYTES: These make myelin.

REFERENCES

(1)REYNOLDS, E.H.; LINNELL, J.C.; and FALUDY, J.E. "Multiple Sclerosis Associated with Vitamin B_{12} Deficiency" *Archives of Neurology* 48 no. 8 (Aug, 1991) pages 808-811. (2)NIJIST, T.Q.; et al. "Vitamin B12 and Folate Concentrations in Serum and Cerebro Fluid of Neurological Patients with Special Reference to Multiple Sclerosis and Dementia." *Journal of Neurology, Neurosurgery, and Psychiatry* 53 no.11 (Nov, 1990): pages 951-954.

(3)*Alternative Medicine. The Definitive Guide.* Future Medicine Publishing, Inc. Puyallup, Washington, 1993. Pages 755-761.

(4)AGRANOFF, B.W.; and GOLDBERG, D. "Diet and the Geographical Distribution of Mul- tiple Sclerosis." *Lancet 2* no. 7888 (Nov, 1974): pages 1061-1066.

(5)SWANK, R.L. "Multiple Sclerosis: Chronicle of its Incidence with Dietary Fat." *American Journal of Science* 220 no.2 (Oct, 1950): pages 421-430.

(6)ALTER, M.; YAMOOR, M.; and HARSHE, M. "Multiple Sclerosis and Nutrition. *Archives of Neurology 31* no. 4 (Oct, 1974): pages 267-272.

(7)CRAWFORD, M.A.; BUDOWSKI, P.; and HASSAM, A.G. "Dietary Management in Multiple Sclerosis." *Proceedings of the Nutritional Society 38* no. 3 (Dec, 1979): pages 373-379.

(8)ADAMS, R.D., RICHARDSON, E. P. Jr. *Chemical Pathology of the Nervous System,* New York, Pergamon Press (1961) pages 162-196.

(9)Stein's *Internal Medicine.* 4th Edition. Mosby-Year Book, Inc. St. Louis, MO 63146. (1994). (10) *Harrison's Internal Medicine.* 11th Edition. McGraw Hill, Inc. (1987).

(11) *Proc. Natl. Acad. Sci. USA.* Vol.92, pages 7440-7444, August, 1995.

References by William H. Philpott, M.D. concerning maladaptive symptom responses to foods, chemicals and inhalants:

PHILPOTT, W.H. and KALITA, D. *Brain Allergies. The Psycho-Nutrient Connection.* Keats Publishing Company, Inc. New Canaan, CT 1981, Update Edition, 1987.

PHILPOTT, W.H. and KALITA, D. *Victory Over Diabetes: A Bio-Electric Triumph.* Keats Publishing Company, Inc. New Canaan, CT. 1983.

[*Magnetic Health Quarterly* "Multiple Sclerosis," Vol. IV, 4th Qtr, 1998 (2002 Revision)]

References by William H. Philpott, M.D. concerning biological responses to magnetic fields:

Cancer. The Magnetic Oxygen Answer.

The Secret of the Magnetic Treatment of Cancer. Magnetic Health Quarterlies:

Volume I-The Magnetics of Sleep, Pain. The Magnetic Answer.

The Magnetics of the Anti-inflammatory Oxidoreductase Enzyme System. The Negative Magnetic Field Antibiotic Effect. Volume II-Negative Magnetic Field Production of Melatonin. Bone and Cartilage Injuries. Soft Tissue Injuries. The Magnetic Answer. Rheumatoid Degenerative Diseases. The Magnetic Answer. Cancer Prevention and Reversal. The Magnetic Answer. Volume III-Secrets of the Magnetic Field of Youth Diabetes Mellitus. The Secret of Prevention and Reversal. The Magnetic Answer Major Mental Disorders. The Magnetic Answer. Vascular Diseases. The Magnetic Answer Volume IV-Addiction. The Magnetic Answer. Movement Disorders. The Magnetic Answer. Seizure Disorders. The Magnetic Answer. Vascular Disorders. The Magnetic Answer Volume V-Eye Disorders. The Magnetic Answer Pelvic Disorders. The Magnetic Answer Intestinal Disorders. The Magnetic Answer Emotional Disorders. The Magnetic Answer Volume VI-The Ultimate Non-Stress, Non-Addiction Diet. The Four Day Rotation Diet Answer Skin Disorders. The Magnetic Answer Respiratory Disorders. The Magnetic Answer Menopause. The Magnetic Answer Volume VII-Alzheimer's Disease and Amyloidosis. The Magnetic Answer Detoxification. The Magnetic Answer Immune Disorders. The Magnetic Answer Chronic Fatigue and Fibromyalgia. The Magnetic Answer Volume VIII-Spinal Disorders. The Magnetic Answer. Sources and Functions of Biological Energy. The Magnetic Answer. Ear Disorders. The Magnetic Answer. Liver Disorders. The Magnetic Answer.
SUCCESS STORY

SCHIZOPHRENIA

A schizophrenic in his 20's was depressed and anxious with visual and auditory hallucinations and delusions which were not managed by tranquilizers and antidepressants. He slept on a super magnetic bed composed of 70 magnets 4" x 6" x 1" with a negative pole facing his body. He also slept with his head in the super magnetic head unit composed of twelve magnets, 4" x 6" x 1". He managed his foods by using disc magnets on his head and a 4" x 6" x 1/2" magnet on his chest and epigastric area for 30 minutes before each meal. He sat up a 4 day diversified rotation diet. In this, he also used no caffeine, no tobacco and no alcohol and was not on tranquilizers or antidepressants. He used the 1-1/2" x 1/2" disc magnets placed bitemporally for any immediate symptoms. Three months later, his mother reported to me that he

was symptom-free. She proceeded to order the super magnetic bed for other members of the family.

MAGNETIC REVERSAL OF ADDICTION Updated 2002: ORIENTATION:

Addiction has a symptom relief phase when the addictive substance is taken into the body and also has a symptom production withdrawal phase some 3-4 hours after the initial relief phase. Addiction can be to a narcotic substance or to frequently used non-narcotic substances. The biological stress of the frequent use of non-addictive substances can evoke self-made narcotics (endorphins). In non-narcotic addiction, these endorphins are raised above the needed normal physiological level and the biological response to these endogenous narcotics is the same as to exogenous narcotics. These endorphin addictions from non-narcotic substances can be due to frequently contacted substances such as tobacco, alcohol, caffeine, foods and other chemicals. Acidity and lack of oxygen (acid-hypoxia) develops as a part of the disordered chemistry of addiction withdrawal.

The secret of reversal of addiction consists of avoidance of the addictive substance. The biological response to a negative (south-seeking) magnetic field is the production of alkaline-hyperoxia, which relieves the acid-hypoxia that produces the symptoms. The first four days of withdrawal from water-soluble substances is the critical symptom withdrawal period. For fat-soluble substances, such as nicotine from tobacco, the symptom withdrawal phase is 21 days.

Magnetic treatment consists of relieving the withdrawal symptoms by exposure to a negative (south-seeking) magnetic field. The most important areas for magnetic field exposure are:

1) The temporal areas of the head, which is in front of the ears and near the top of the ears. For depression, place the ceramic disc magnets that are 1-1/2" x 3/8" in front of the ears. Hold these in place with a 2" x 26" band. Always place the negative magnetic field facing the body. For anxiety, place a ceramic disc on the mid-forehead and left temporal area (in a right-handed person), and on the mid-forehead and right temporal area On a left-handed person). For obsessive thoughts and compulsive acts, place a disc on the left temporal area and low occipital area.

2) To relieve the tension in the chest, which is common as a withdrawal symptom, place a 4" x 6" x 1/2" ceramic magnet on

the front of the chest on the mid-sternum area. Place this magnet with the 6" lengthwise the body.

3) To relieve the tension that is classic of withdrawal symptoms in the epigastric area, place a 4" x 6" x 1/2" magnet directly over the stomach which is just below the rib cage (sternum area). Place this magnet with the 6" crosswise the body.

4) To relieve the tension in the spine that occurs during withdrawal, place a 5" x 12" multi-magnet flexible mat on the thoracic spine. This is on the back between the shoulder blades. If the neck has more tension, then place it on the neck. If the low back has more tension, place on the low back. Hold these magnets on the epigastric area of the chest and on the back with 4" x 52" body wraps.

5) On any area that has symptoms during the withdrawal phase, place a 4" x 6" x 1/2" magnet or a 5" x 12" multi-magnet flexible mat over the area until the symptoms are relieved.

DURATION OF MAGNETIC EXPOSURE:

There is no limitation to the duration of exposure to the negative magnetic field. The magnetic field facing the body should always be a negative magnetic field. Usually the symptoms are relieved within 10 minutes and rarely, 30 minutes may be needed.

SUCCESS STORY
SCHIZOPHRENIA

A schizophrenic in his 20's was depressed and anxious with visual and auditory hallucinations and delusions which were not managed by. tranquilizers and antidepressants. He slept on a super magnetic bed composed of 70 magnets 4" x 6" x 1" with a negative pole facing his body. He also slept with his head in the super magnetic head unit composed of twelve magnets, 4" x 6" x 1". He managed his foods by using disc magnets on his head and a 4" x 6" x 1/2" magnet on his chest and epigastric area for 30 minutes before each meal. He sat up a 4 day diversified rotation diet. In this, he also used no caffeine, no tobacco and no alcohol and was not on tranquilizers or antidepressants. He used the 1-1/2" x 1/2" disc magnets placed bitemporally for any immediate symptoms.

Three months later, his mother reported to me that he was symptom-free. She proceeded to order the super magnetic bed for other members of the family.

BRAIN TUMOR REMISSION

An 88-year-old woman lost much of the function of her left arm. She staggered when she walked.

She is a musician and could no longer play the piano. CT scan revealed a tumor on the right side of her head. She was treated with a super magnetic head unit composed of twelve 4" x 6" x 1" ceramic magnets in a wooden frame surrounding her head. She slept all night with her head in this super magnetic head unit and returned for one hour, four times a day during her waking period. At three months, all her functions had returned to normal. With enthusiasm, she played the piano while I listened on the phone. At six months, a CT scan documented that there was no longer a tumor in her brain. No surgery was done and thus there was no pathological cellular report of the tumor.

NORTH OAKLAND MEDICAL CENTERS RADIOLOGY SERVICES, 461 WEST HURON PONTIAC, MI 48341 CT OF BRAIN WITHOUT AND WITH CONTRAST EXAM DATE: 06/11/02 CLINICAL INFORMATION:

MEMORY LOSS, CONFUSION, HEADACHES.

IMPRESSION: VAGUE AREA OF VASOGENIC EDEMA WITHIN THE RIGHT POSTERIOR TEMPORAL PARIETAL LOBE WITH FAINT PATHOLOGIC ENHANCEMENT REPRESENTS AN INTRA-AXIAL MALIGNANT NEOPLASM. MRI EXAMINATION IS RECOMMENDED FOR ADDITIONAL EVALUATION. THESE RESULTS WERE RELAYED DIRECTLY VIA TELEPHONE CONVERSATION TO DR. IMAD MANSOOR AT THE TIME OF THIS DICTATION.

PROVIDENCE HOSPITAL AND MEDICAL CENTERS (12-19-02): **MrS.**—— returns in follow up. She underwent a CT scan of the head on 12-13-02 that revealed no evidence of enhancing mass or extra-axial fluid collection. There is an old infarct versus an area of volume averaging involving the superior left cerebellum that appears to be new from prior exam. There is also a right posterior parietal encephalomalasia. She has been on magnetic therapy since diagnosis. Per her daughter, who is present with her, the patient's mental status has improved. She has no difficulty communicating thoughts or ideas. Her short-term and long-term memory has improved. She denies any balance problems or weakness.

Patrick W. McLaughlin, M.D. Department of Radiation Oncology

CANCER REMISSION

Henry Thompson (phone number 409/ 625-3183) is a 78-year-old man with cancer of the prostate with multiple metastasis to bones. He slept on a 70-magnet bed composed of magnets that are 4" x 6" x 1". The AMAS blood test was originally positive for cancer. After sleeping on a 70-magnet bed for several months, the AMAS tests have all been normal, showing no evidence of cancer.

NEGATIVE MAGNETIC FIELD ANTIBIOTIC EFFECT

A woman with severe gastrointestinal symptoms was stool cultured for pathological bacteria and fungi as well as normal bacteria flora. Three months after sleeping on a bed composed of seventy 4" x 6" x 1" magnets, the gastrointestinal flora was again cultured. The bacteria and fungi flora were absent and a normal friendly bacteria flora was flourishing.

CONCLUSIONS

A negative magnetic field strengthens the human body's antibiotic value against invading pathological microorganisms.

MAGNETS USED:

Two 1 1/2" x 1/2" ceramic disc magnets with a 2" x 26" .

PLACEMENT AND DURATION:

The ceramic disc is useful for local infections that are no more than 1-1/2" across.

FOR SYSTEMIC INFECTIONS such as the herpes family of viruses such as Epstein-Barr, cytomegalo, human herpes virus #6 or other diseases of either virus origin, bacterial or fungal origin which are systemic in nature, use the following:

A 70-magnet bed composed of magnets that are 4" x 6" x 1". Thirty-five of these are placed in a wooden grid, 36" square which weighs 200 pounds. Two of these grids are placed end to end produc- ing a bed 36" x 72".

A super magnetic head unit composed of twelve 4" x 6" x 1" magnets.

PLACEMENT AND DURATION:

Sleep on this 70-magnet bed all night and preferably return to the bed one hour, four times during the day for the first three months of treatment. Place a 2" eggcrate type foam pad over the magnetic bed. After the three months are completed, continue to sleep on this bed. At this time it could be placed under a 4" mattress pad if desired. Sleeping nightly on this bed should be a continued lifestyle.

RESOLUTION OF CARDIAC ATHEROSCLEROSIS

A 71-year-old physician had cardiac surgery of seven bypassed arteries. One artery not bypassed was 50% occluded. For nine

months, he wore a 4" x 6" x 1/2" ceramic block magnet over his heart 24 hours a day with the negative magnetic field facing his body. Nine months later, a study of his heart revealed that the artery that was 50% occluded is now 100% open. He was also sleeping on a bed of 4" x 6" x 1" magnets with the negative pole facing his body. A leg that had lost all feeling has now regained normal feeling.

MAGNETS USED FOR CARDIAC TREATMENT:
A 4" x 6" x 1/2" ceramic block magnet.
One 4" x 52" body wrap. One 2" x 26" shoulder strap.

PLACEMENT AND DURATION:
Place the negative magnetic field of the 4" x 6" x 1/2" magnet over the heart with its 6" length- wise the body. Hold in place with a 4" x 52" wrap. Place a 2" x 26" band across the left shoulder with Velcro fastened to the body wrap. Mild cases will treat only at night during sleep. Severe cases should treat 24 hours a day.

WHAT MAGNETIC THERAPY IS
Magnetic therapy is magnetic-electron-enzyme catalysis therapy. Static magnetic fields move electrons which rotate resulting in a magnetic-electron energy field. Static negative magnetic field electrons spin in a 3-dimensional spiral counterclockwise rotation. In a static positive magnetic field, electrons spin in a 3-dimensional spiral clockwise rotation. A positive magnetic field energizes acid- dependent enzymes. A negative magnetic field energizes alkaline-dependent enzymes. Biological response to a positive magnetic field is acid-hypoxia. Biological response to a negative magnetic field is alkaline-hyperoxia. Alkalinity maintains calcium and amino acid solubility and reverses insoluble deposits of calcium and amino acids in such as arteriosclerosis, spinal stenosis, around joints, amyloidosis, Alzheimer's, etc.

The energy activation of biological enzymes is magnetic therapy

WHAT MAGNETIC THERAPY DOES
The biological response to a static positive magnetic field is acid-hypoxia. The biological response to the static negative magnetic field is alkaline-hyperoxia. Positive magnetic field therapy is limited to brief exposure to stimulate neuronal and catabolic glandular functions. Positive magnetic field therapy should be under medical supervision due to the danger of prolonged application, producing acid-hypoxia.

Negative magnetic field therapy has a wide application in such as cell differentiation, healing, production of adenosine triphosphate by oxidative phosphorylation and processing of toxins by oxidoreductase enzymes and resolution of calcium and amino acid insoluble deposits. Negative magnetic field therapy is not harmful and can effectively be used both under medical supervision and self-help application.

Some of the values of magnetic therapy are:

• Enhanced sleep with its health-promoting value by production of melatonin.

• Enhanced healing by production of growth hormone.

• Energy production by virtue of oxidoreductase enzyme production of adenosine triphosphate and catalytic remnant magnetism.

• Detoxification by activation of oxidoreductase enzymes processing free radicals, acids, peroxides, alcohols and aldehydes.

• Pain resolution by replacing acid-hypoxia with alkaline-hyperoxia.

• Reversal of acid-hypoxia degenerative diseases by replacement of acid-hypoxia with alkaline-hyperoxia.

• Antibiotic effect for all types of human-invading microorganisms.

• Cancer remission by virtue of blocking the acid-dependent enzyme function producing ATP by fermentation.

• Resolution of calcium and amino acid insoluble deposits by maintaining alkalinization.

• Neuronal calming providing control over emotional, mental and seizure disorders.

"Magnetic therapy has been observed to have the highest predictable results of any therapy I have observed in 40 years of medical practice." William H. Philpott, M.

Endometriosis, Pelvic Inflammatory Disease, Uterus Disorders, Ovarian Disorders, Vulvovaginal Disorders, Conditions of the Vagina, Cancer of the Female Pelvic, Genital Organs, Meopause

PELVIC DISORDERS INTRODUCTION

Men and women have their own special pelvic disorders based on their own specialized tissues. Infections and cancer are common denominators of pelvic disorders for both men and women. Fortunately, this common denominator for infections (bacterial, viral, fungal and parasitic), cancer and inflammation is the

replacement of acid-hypoxia with alkaline-hyperoxia. This is achieved by a local exposure to a negative (south-seeking) magnetic field. Therefore, the local application of a negative (south-seeking) magnetic field turns out to be the basic treatment for pelvic disorders. A negative (south-seeking) magnetic field is human cellular function normalizing and healing, whereas a positive (north-seeking) magnetic field interferes with human cell normal functions and on the other hand, stimulates microorganism and cancer cell replication. Fortunately, a positive (north-seeking) magnetic field can also stimulate sexual function. The rules of limitations of application of a positive (north-seeking) magnetic field needs to be followed. These limitations are spelled out in detail in this quarterly.

ENDOMETRIOSIS: ORIENTATION:

Approximately 15% of American women (5 million +) have endometriosis. Endometriosis consists of endometrial tissue normally lining the inside of the uterus, which is sloughed off during the menstrual period, being in places other than inside the uterus. Endometrial tissue may occur any place lining the abdominal cavity (peritoneal cavity). Endometrial tissue often is found on the outside of the uterus, on the ovaries, on the intestines and sometimes invading abdominal organs such as the liver, intestines and even the uterine musculature (adenomyosis). Much like cancer, endometriosis consists of metastatic spread of endometrial tissue beyond its normal place lining the uterus (endometrionia). Endometriosis has been dubbed as benign cancer, however, only about 1% actually becomes malignant cancer (adenoacanthoma).

The most serious symptom of endometriosis is pain at the site of the endometrioma or adenomyosis. At the time of menstruation, endometrial tissue in the uterus is bleeding and being sloughed off and the endometrioma also bleeds. This bleeding sets up inflammation due to local reduced oxygen, local acidity, free radical production, and the local rise in histamines and prostaglandins. Both histamines and prostaglandins evoke inflammation. The chain consequences to these inflammatory insults can be such as scar tissue producing adhesions and cysts which can produce painful symptoms even between menstrual periods.

There are several theories as to why endometriosis develops such as the concept of aberrantly placed endometrial tissue. The

endometrial tissue is undifferentiated embryonic tissue. The most popular and seemingly most likely theory is retrograde transportation caused by some type of obstruction of the menstrual flow in which the menstrual flow is forced up the fallopian tubes and thus, into the abdominal peritoneal cavity where it implants.

The diagnosis of endometriosis is difficult since the common denominator of pain is shared by several other conditions such as adenomyosis, appendicitis, benign ovarian cysts, bowel obstruction, colon and ovarian cancers, diverticulitis, ectopic pregnancy, fibroid tumors of the uterus, gonorrhea, inflammatory bowel disease, irritable bowel syndrome, pelvic inflammatory disease and other in- flammatory conditions.

HOW MAGNETICS RELIEVES ENDOMETRIAL PAIN

The biological response to a negative (south-seeking) magnetic field is the production of alkaline-hyperoxia. Acid-hypoxia is a central aspect of any state of inflammation. Therefore, the negative (south-seeking) magnetic field can replace acid-hypoxia producing pain with alkaline-hyperoxia which will relieve pain. Furthermore, a negative (south-seeking) magnetic field is mildly vasoconstricting which reduces the bleeding of endometriosis. A negative (south-seeking) magnetic field blocks the production of histamine and prostaglandins which are inflammatory irritants. The negative (south-seeking) magnetic field stimulates oxidoreductase enzymes which will process both histamines and prostaglandins, thus canceling their inflammatory response. The negative (south-seeking) magnetic field has been noted to soften and even reverse scar tissue. Adhesions are scar tissue. These can be initially softened and reversed by treatment with a negative (south-seeking) magnetic field.

The magnetic field needs to be large enough to cover the affected area and thick enough to penetrate into the affected area and strong enough to deliver a therapeutic effect. The most frequently used magnet achieving all these values is a 4" x 6" x 1/2" ceramic block magnet. This is a static field magnet with opposite magnetic poles on opposite sides of a flat surface. This 4" x 6" x 1/2" static field ceramic block magnet weighs two pounds. The semi-flexible plastiform magnets which are 1/8" thick and requires four of these to be stacked together to be equivalent to a 1/2" ceramic block magnet. The weight of these stacked magnets is approximately the same as the 1/2" thick ceramic magnet. Whatever amount of magnetic field energy is needed to produce

this depth can be used. One plastiform magnet may do the job or they can be stacked together for a deeper penetration. The plastiform magnets can be cut into any desirable size. They come 2", 3" or 4" wide and can be made as long as is needed. A common size is 4" x 6" x 1/8" or a 4" x 12" x 18". Plastiform magnets are semi-flexible, but when bent a few times, they will crack. When cracking or breaking, they can be held together with duct tape.

Flexible magnet pads have been made from plastiform magnets by cutting them into strips 1-1/2" x 1/2" and placing these 1/4" apart throughout the pad. The magnets can also be doubled by stacking them on top of each other. These could serve the purpose of treating pain that is caused by an area that is within 2" of the surface of the skin. If the pain is much deeper than 2" then the ceramic magnets need to be used or stacking the plastiform magnets would work. The flexible, double magnet pads are convenient.

The duration of application of the negative (south-seeking) magnetic field over the painful area can be as long as is necessary. It is convenient to wear magnets over these painful areas all night long. They can be placed during the day as needed. There is a 4" x 52" body wrap that can be used to hold these magnets in place. In order to hold them, there needs to be suspenders that would keep them in place. A better method is to make a garment of non-stretchable material which supports the weight from the shoulders. Pockets could be placed in this garment, directly over the area where it is needed so the magnet can be in place for whatever duration is needed for relief.

PELVIC INFLAMMATORY DISEASE

There is a dozen or more types of bacteria and mycoplasma which produce pelvic inflammatory disease of any or all areas of the female pelvis. Naming these is not significant in terms of magnetic therapy since all of these will die in the presence of a continuous negative (south-seeking) magnetic field. The secret is to have the field large enough and the strength of the field capable of penetrating into the infected area. This can usually be provided with a 5" x 12" double magnet, multi-magnet flexible mat and with one or more of the 4" x 6" x 1/2" magnets. These are held in place with a 4" x 52" body wrap. The treatment is as near to 24 hours a day as possible for a minimum of two weeks and preferably, longer. After the two weeks treatment, then treat nightly for an extended period of time. Treating the pelvic area nightly is a good prophylaxis also against infection.

CYSTITIS

There are around 8.9 million visits a year to medical practitioners due to cystitis. Cystitis is the most common cause of women seeking medical assistance. There is a common erroneous belief that a woman may never be cured of cystitis.

INFECTIOUS CYSTITIS

Various types of bacterial infections of the urinary bladder is the most common cause of infectious cystitis. Lumbar pain may be a reflection of infectious cystitis or lumbar disorders such as lumbar strain or degenerative discs may produce urinary bladder symptoms and predispose to microorganism infections of the bladder. Due to the lumbar-urinary bladder connection, it is well to magnetically treat both the lumbar spine and urinary bladder. It is well at the same time to also treat the brain. The brain receives messages from the body and sends messages to the body. Treating the brain to a negative (south-seeking) magnetic field can aid in breaking this cycle of message connections between the body and the brain. Disc magnets (ceramic discs 1" x 1/2", or super neodymium disc magnets 1" x 1/4") placed bitemporally (in front of, and at the level of the top of the ears) for depression; forehead and left temporal for anxiety; and left temporal and low occipital for obsessive- compulsiveness. The longer the duration of treatment, the better.

Treat the lumbar disc spine with a 5" x 12" double magnet, multi-magnet flexible mat and some need to place on top of this a 4" x 6" x 1/2" ceramic magnet to penetrate a negative (south-seeking) magnetic field deeply into the spine. The urinary bladder is best treated with a 5" x 12" double magnet, multi-magnet flexible mat with a 4" x 6" x 1/2" magnet on top of this. These are placed directly over the urinary bladder. A 4" x 52" COOL MAX body wrap can be used to hold the magnets over the urinary bladder or over the lumbar spine. Another method is to have a garment of non-stretchable material that supports the weight from the shoulders. Make pockets in this garment so the magnets can be slipped in to these pockets over the lumbar spine and the urinary bladder.

It is important to understand that an infection needs to be treated continuously 24 hours a day for a minimum period of two weeks. After this, there needs to continue to be a treatment for another 2, 3 or 4 weeks in which the magnets are used nightly. This is for the purpose of healing. In case of a lumbar disc spine disorder, it will

take a number of months, such as 10-12 months, to heal the lumbar disc. There are on record those who have healed a lumbar disc with a negative (south-seeking) magnetic field and thus, avoided surgery. This is particularly applicable for those who have a type of lumbar disc which is not operable. The more hours of exposure, the better. The minimum should be at night during sleep. To understand better how a negative (south-seeking) magnetic field is an antibiotic, refer to the area of this article that is specifically on the antibiotic effect of a negative (south-seeking) magnetic field.

INTERSTITIAL CYSTITIS

Interstitial cystitis is a chronic, non-infectious inflammation of the space between the bladder lining and the bladder muscle. Any inflammatory cause affecting the urinary bladder can predispose to the development of this chronic, non-infected, inflammatory reaction of the interstitial tissues in the urinary bladder. Bacterial infections are acidifying and, even separate from the infection itself, can set the stage for the development of interstitial cystitis. A neuronal message from the low spine can so disorder interstitial tissues as to set the stage for the non-infected, interstitial cystitis. There are drugs, particularly the non-steroidal anti-inflammatory drugs, that can so irritate the interstitial tissues as to set a stage for this development.

From my experience, I judge that it is likely true that the most prominent and frequent cause of interstitial cystitis is the process of the diabetes mellitus disease process. This is acidifying. It can be noted that particular foods to which a person is symptom-producing, maladaptive reacting to will evoke a non-infectious, inflammatory interstitial reaction of the urinary bladder. In my extensive experience with food testing, the symptoms referable to the bladder frequently occur demonstrating that these maladaptive reactions to foods are very important. These maladaptive reactions to foods is what produces diabetes mellitus, both the compensated and decompensated stages. (For more information on this, see the section of the diabetes mellitus disease process). The interstitial tissues of the kidneys behave the same way as the interstitial tissues of the urinary bladder and have common causes such as infections precipitating these inflammatory reactions, the diabetes mellitus disease process with its acidifying reactions to foods and chemicals is also a major contributor. The magnetic treatment of interstitial inflammatory

disorder of the urinary bladder or kidneys is to stop the input such as, the food or chemical reactions or the non-steroid anti-inflammatory agents that are being frequently used. Certainly, infections should be promptly treated. Infections of any type; bacterial, viral, fungal or parasitic can be effectively treated with a negative (south-seeking) magnetic field.

The healing of the interstitial tissues of either the bladder or the kidney can be healed with a negative (south-seeking) magnetic field. It requires several weeks of as near to 24 hour a day exposure as is possible. Especially, the exposure to the negative (south-seeking) magnetic field should be at night during sleep. The most important magnet to be used is one that will cover the entire field and will also have a depth of penetration which is the 4" x 6" x 1/2" ceramic block magnet. This can be placed over the urinary bladder or over the kidneys and held there either with a body wrap or with a garment that has pockets in it over these areas.

Of course, it is also important to be sure to reverse the diabetes mellitus disease process with initial avoidance of symptom-producing foods which turn out to be the foods that are used with a frequency of twice a week or more. After three months, these foods can be returned to the diet as long as they are kept rotated. There is a 95% chance there will not be any further reaction to these foods as long as they are kept rotated on a four day basis.

If a person wishes to prove which foods these are, the process is to fast for a period of five days or eat foods that are infrequently used such as a watermelon fast or a single food fast. On the sixth day, start eating meals of single foods as test meals. If the food is involved in symptom-production, the symptoms will emerge within an hour. Three test meals can proceed during a single day. The method of relieving the symptoms when they do occur is to put the negative field of a magnet directly over the area until the symptoms disappear which is usually within 10-30 minutes. The symptoms are relieved because the negative (south-seeking) magnetic field is alkalinizing and hyper-oxygenating which replaces the acid-hypoxia which causes the symptoms. To test in this way would require about a month of eating three test meals a day of single foods.

A practical answer for most people is to assume that they are symptom-maladaptively reacting to foods that they use with a frequency of twice a week or more or members of the family of those foods. By leaving these foods out and immediately starting

the rotation of foods that are used less frequently than twice a week, in a practical way, solves this problem for many people. After three months, they can put these frequently used foods back into their rotation diet. The rotation diet should be a lifestyle diet. It is well also to have a lifestyle of sleeping on a magnetic mattress pad and also sleeping with magnets over the most vulnerable areas. In this case, it would be for chronic cystitis, that of the urinary bladder area. This exposure can occur during night when asleep.

SIGNIFICANCE OF ACID-HYPOXIA

Prior to my examination of maladaptive reactions to foods and chemicals, I applied the principle of avoiding acid-forming foods. I found this to have a low level efficiency whereas, using the principle of initial avoidance and later spacing of test foods demonstrated symptom-producing, maladaptive reactions to foods and chemicals has a high level, predictable value. In a symptom-producing, maladaptive reaction, acidity develops, whether the food is an acid or alkaline-forming food. Acid-forming food did not produce systemic acidity unless eaten with a frequency producing addiction. I also found that testing urine pH is unreliable, whereas testing blood pH and saliva pH are reliable. Blood pH is the most reliable test. My research involved these reliable methods of examining for pH and abandoning any attempt at using urine pH in drawing a judgement as to the systemic state of pH.

THE SIGNIFICANCE OF THE DIABETES DEGENERATIVE DISEASE PROCESS IN PELVIC DISORDERS AND KIDNEY DISORDERS

Diabetes Mellitus, non-insulin type II, has the characteristic of acidity. Type II diabetes mellitus is diagnosed as clinically significant diabetes when the blood sugar is abnormally high on an a.m. fasting specimen. However, the diabetes disease process exists for several years before the clinically significant phase is diagnosed. The diabetes mellitus compensated phase exists for several years before the hyperglycemic clinically significant phase. Hyperinsulin-hypoglycemia exists during the compensated stage of the diabetes mellitus disease process. Generalized acidity with resulting tissue hypoxia exists both in the compensated and decompensated stages. All the known complications of decompensated diabetes mellitus can occur in the compensated stage.

In the diabetes mellitus disease process, there is a chain of inflammatory substances starting with superoxide free radical

proceeding to peroxides, oxyacids, alcohols and aldehydes. Of these inflammatory substances, the easiest to monitor is the development of acidity. My research used the acidity as the indicator of the existence of this chain of inflammatory substances. My research demonstrated that acidity emerges in response to maladaptive reactions mostly to foods and less frequently to chemicals, inhalants and toxins. A small number of these acid-producing maladaptive reactions to foods are immunologic. The most frequent cause of maladaptive reactions to foods is addiction. The stress of frequently eaten foods produces addiction by evoking self-made narcotics (endorphins).

The acidity of the diabetes mellitus disease process both during the compensated and decompensated stage sets the stage for infectious invasion and replication of opportunist microorganisms. A chronic acid-hypoxia results in organ deterioration like chronic interstitial cystitis, tubulointerstitial kidney disease and fibrosis of the uterus. This chronic acid-hypoxia sets the stage for the development of cancer. Cancer makes its energy bond (adenosine triphosphate) by fermentation which is acid-hypoxic dependent.

My research has demonstrated that the answer to both the compensated and decompensated stages of maturity onset type II diabetes mellitus is a 4-Day Diversified Rotation Diet. Insulin-dependent type I diabetes mellitus also has the acid-hypoxia disorder and also requires a 4-Day Diversified Rotation Diet. Using the 4-Day Diversified Rotation Diet characteristically reduces the requirement of insulin by two-thirds as compared to not using this diet. Details of the 4-Day Diversified Rotation Diet described herein.

NEGATIVE MAGNETIC FIELD ANTIBIOTIC EFFECT

Human cells make biological energy by oxidative phosphorylation which is alkaline-hyperoxic- dependent. Alkaline-hyperoxic-dependent oxidative phosphorylation requires four oxidoreductase enzymes that drive enzyme catalysis in producing two energies which are; 1) adenosine triphosphate (ATP), and 2) oxidative remnant magnetism which is a negative (south-seeking) magnetic field. Human cells also have the capacity to produce ATP by fermentation which uses enzymes which are acid-hypoxic-dependent. The human cell activation of fermentation to produce ATP is an energy survival technique which can only briefly sustain human cell life. Fermentation is acid-hypoxic-dependent and also produces acids, especially lactic acid. An example is that of

prolonged stressful exercise in which muscle cells resort to fermentation to produce ATP after the oxidative phosphorylation ATP has been depleted. The muscles are sore due to the lactic acid produced by fermentation. This same process of fermentation exists in the urinary bladder producing interstitial cystitis and in the kidneys producing interstitial kidney disease.

All microorganisms, parasites and cancer cells produce their ATP by fermentation and therefore, are acid-hypoxic-dependent. Cancer cells only use fermentation to produce ATP and are thus killed by a negative (south-seeking) magnetic field which produces a biological response of alkaline-hyperoxia. Some bacteria are capable of producing ATP by both fermentation and oxidative phosphorylation and thus, can survive in an alkaline-hyperoxic medium. It is understandable how a negative (south-seeking) magnetic field with its biological response of alkaline-hyperoxia can kill cancer cells and other microorganisms that are acid-hypoxic-dependent for the production of their ATP.

What about the microorganisms tolerant of alkaline-hyperoxia? How are they killed by a negative (south-seeking) magnetic field? All microorganisms and cancer cells have electromagnetic positive cellular membrane. Human cells have an electromagnetic negative membrane. A negative (south- seeking) magnetic field supports the physiological function of the human electromagnetic negative membrane whereas, a negative (south-seeking) magnetic field interferes with the physiological function of the electromagnetic positive membrane of bacteria, fungi, viruses, parasites and cancer cells.

The good news is that a negative (south-seeking) magnetic field is an antibiotic for all types of microorganisms (bacteria, fungi, viruses, parasites) and cancer cells. The mechanisms by which a negative (south-seeking) magnetic field is an antibiotic to microorganisms and cancers is its interference with the microorganism and cancer cells in making their ATP and also interference with their electromagnetic positive cell membrane. Therefore, microorganism adaptation, tolerance and cancer cell adaptation tolerance to a negative (south-seeking) magnetic field does not exist. The frantic search for antibiotics to which microorganisms have not developed a resistance can stop. The frantic search for toxic substances capable of killing specific types of cancer cells can stop. What we need to concentrate our research

energies on include the following variables of a static negative (south-seeking) magnetic field such as;
1) Gauss strength
2) Duration of exposure
3) Field of exposure
4) Duration of exposure for tissue repair after the death of microorganisms and cancer. There is no human cellular damage to exposure to a static negative (south-seeking) magnetic field. A static negative (south-seeking) magnetic field controls all aspects of healing repair whether this is endogenously concentrated by the human body at the site of tissue repair or exogenously supplied from a static magnetic field.

PELVIC DISORDERS: ORIENTATION:

This magnetic protocol is for pelvic disorders. The principle of magnetic treatment is to use a magnetic field that is larger than the lesion being treated and is sufficiently strong in gauss strength to penetrate sufficiently deep into the tissues for the particular condition that is being treated. The most important magnet for the treatment of pelvic disorders is a 4" x 6" x 1/2" magnet. This will penetrate deeply into the pelvic organs. The second most important magnet is a 5" x 12" double magnet, multi-magnet flexible mat. This covers a wide space but does not penetrate as far as the 4" x 6" x 12" magnet. It has Velcro on the positive pole side. The 4" x 6" x 1/2" ceramic block is often placed on top of this mat. Another method which weighs less and approaches that of the 4" x 6" x 1/2" magnet is that of mini-block magnets that are 1-7/8" x 7/8" x 3/8" which can be placed on the flexible mat. These are placed crosswise the flexible mat on the two inner rows. This places them an inch and one-half apart. Six magnets can be placed on the 5" x 12" double magnet, multi-magnet flexible mat.

A magnetic chair pad is quite useful. It has mini-block magnets in the back as well as the seat. These are placed an inch and one-half apart throughout the chair pad. These can be magnetically strengthened by placing a 4" x 6" x 1/2" magnet under the seat directly under the affected area.

Infections, bacteria, fungi, viruses and parasites will generally require a minimum of two weeks continuous treatment. It is well to extend this more than two weeks by wearing the magnets over the area for another four weeks for the purpose of healing the damage that has been done by the infection.

Cancer requires special treatment that is continuous, as near to 24 hour a day treatment as possible, for a minimum of three months. Treatment of cancer of the pelvic organs can also best be treated by using the magnetic chair pad with three of the 4" x 6" x 1" magnets placed 1" apart in a row in a wooden carrier and placed under the seat of the magnetic chair pad. Sit on this as many hours as is conveniently possible. magnetic field. The positive (north-seeking) magnetic field would actually make these worse since it acidifies and all of these microorganisms and cancer flourish in an acid-hypoxic medium. The secret of why a negative (south-seeking) magnetic field will be so helpful in destroying microorganisms, cancer and parasites is that it is alkaline-hyperoxic producing which defeats these microorganisms and cancer cells in making their energy. At the same time, this mag- netically negative produced alkaline-hyperoxia reinforces the human cells in producing their adenosine-triphosphate by oxidative phosphorylation which is alkaline-hyperoxic-dependent.

MAGNETIC TREATMENT:

The following is suitable for cervicitis, vulval vaginitis, urethritis or infectious cystitis. Place a 5" x 12" double magnet, multi-magnet flexible mat on the low abdomen-pubic area. Extend this a couple of inches below the pelvic bone in the case of vulval vaginitis and urethritis. Place on top of this, centered and crosswise this mat, the 4" x 6" x 1/2" magnet. In the case of vulval vaginitis and urethritis, make sure it is extended a couple of inches below the pelvic bone. In the case of infectious cystitis, be sure that this is over the urinary bladder which is above the pelvic bone. Hold these magnets in place with a 4" x 52" body wrap.

When sitting down, sit on a chair pad that has magnets both in the back and the seat. Place under the seat of this chair pad, a 4" x 6" x 1/2" magnet placed back far enough to cover the affected area.

INTERSTITIAL CYSTITIS:

Interstitial cystitis is an inflammation of the urinary bladder tissues that are below the mucous membrane. This is not usually caused by an infection even though an infection may start the process, but so can several other situations including a heavy use of non-steroid analgesics or food reactions or reactions to chemicals. Use the same system that has been described above for infectious cystitis. Treat 24 hours a day for the first couple of weeks and then treat nightly for the next month. It may even require

longer for the healing of interstitial cystitis. Keep the treatment going as long as there is any symptoms. The person should hunt for factors that can be precipitating this, such as a heavy use of anti-steroid analgesics and particularly reactions to foods. A 4-Day Diversified Rotation Diet is often necessary. This diet is described in the booklet, *Health Strategies*.

CANCER OF THE CERVIX, VULVA VAGINAL AREA, URETHRA AND URINARY BLADDER:

Use the same system of the double magnet, multi-magnet flexible mat, the 4" x 6" x 1/2" mag- nets, the 4" x 52" body wrap and the chair pad. However, in this case, underneath the seat of the chair pad, the wooden carrier holding the three 4" x 6" x 1" magnets should be placed. The treatment for cancer is to be as near 24 hours a day treatment as is possible for a period of three months.

URETER DISORDERS:

The ureters can be infected and they can be cancerous. For ureter disorders, place the 4" x 6" x 1/2" magnets over the ureters. This is halfway between the pelvic bone and the umbilicus. These should be placed at an angle because the ureters extend from the urinary bladder to the kidneys. Infections require the two weeks treatment and cancer requires a three month treatment. However, seldom will the ureters be treated when treating the urinary bladder or the kidneys.

KIDNEY INFECTION AND INTERSTITIAL DISORDERS OF THE KIDNEY:

These can be treated with the 4" x 6" x 1/2" magnet. Again, treat an infection for a minimum of two weeks and preferably more, particularly for healing. Treat cancer for three months of continuous treatment. The kidney is treated from the back, about two inches from each side of the vertebrae of the lumbar spine. The upper third of the magnet should be over the rib cage and two-thirds below the rib cage. These can be held in place with a 4" x 52" body wrap. It would be necessary to have suspenders to hold this in place. Another method is to have a garment of non-stretchable material which supports the weight from the shoulders. Place pockets in these areas as needed.

When treating the kidney area on the right side, the magnet should be left off for about an hour to an hour and one-half after meals since this will slow down the movement of food through the intestinal tract. The left side does not matter. The right side is over the small intestine where peristalsis is most important.

UTERUS DISORDERS:

The uterus can be infected and can develop fibrosis. The same pelvic treatment as has been described for other pelvic disorders would be used. In addition to this, the 4" x 6" x 1/2" magnet would be placed on top of the pad directly over the uterus which is behind the urinary bladder.

TREATMENT OF LUMBAR SPINE:

Disorders in the pelvic area can cause a disorder in the lumbar spine. In turn, a disorder in the lumbar spine such as a state of chronic stress or even a disc can also disorder pelvic function. Therefore, when treating pelvic function it is often wise and even sometimes even necessary to treat the lumbar spine. This can be treated in two ways. One is with the 5" x 12" double magnet, multi-magnet flexible mat or with a 4" x 6" x 1/2" magnet. Often, this magnetic block is placed on top of the flexible mat. This can be held in place with a 4" x 52" body wrap or a garment that has a pocket in it that holds this in place. Suspenders may be needed to hold the body wrap in place.

OVARIAN DISORDERS:

Place a 4" x 6" x 1/2" magnet directly over the affected ovary. Approach the ovaries from the front of the body. The ovaries are about two inches from the center of the body. Start the edge of the magnet two inches from the center of the body, halfway between the pelvic bone and the umbilicus. Single ovaries can be treated on either the right or the left, or both can be treated at the same time. Infections and cysts should be treated for two weeks continually followed by nightly treatment for the next month. Cancer would need to be treated 24 hours a day for three months followed then by nightly treatment as a lifestyle. It is well to follow any cancer treatment with nightly treatment as a lifestyle after the initial three month treatment is over.

CANDIDIASIS:

The fungus, Candida, is a frequent invader of the female vagina. This can again be treated as an infection with as near as possible a 24 hour a day treatment for two weeks followed by a nightly treatment of the pelvic area. This would involve the standard treatment for the pelvic area of the 4" x 6" x 1/2" blocks, the 5" x 12" double magnet, multi-magnet flexible mats, the 4" x 52" body wraps and the magnetic chair pad.

ENDOMETRIOSIS:

This condition has been described in more detail in a different section of this book. The principle of treating endometriosis is to use a 4" x 6" x 1/2" magnet over the uterus and over the endometrial areas that are causing pain. The more hours of treatment, the better. A 5" x 12" double magnet, multi- magnet flexible mat may suffice, however, a 4" x 6" x 1/2" magnet will be more often the magnet that is needed. It would be well to have an undergarment made of non-stretchable material that is supported from the shoulders and place the 4" x 6" x 1/2" magnet in pockets directly over the areas that are painful or sore to pressure.

PROSTATIC DISORDERS OF MEN
PROSTATIC HYPERTROPHY AND PROSTATITIS:

These can be treated with a 4" x 6" x 1/2" magnet. It is best to use the 5" x 12" double magnet, multi-magnet flexible mat with this 4" x 6" x 1/2" magnet placed crosswise the mat. For the first two weeks, wear this as near continuous as possible. It would even be best to extend this to four weeks. Hypertrophy of the prostate and prostatitis should be treated the same way. After the initial months' treatment is over, then use the same system nightly. It would also be well to be sitting on the chair pad when sitting down with a 4" x 6" x 1/2" magnet under the chair pad.

CANCER OF THE PROSTATE:

Cancer of the prostate is treated with a 5" x 12" double magnet, multi-magnet flexible mat placed across the low abdomen-pubic area with a 4" x 6" x 1/2" magnet centered in the middle of this, crosswise the mat. Hold this in place with a 4" x 52" body wrap. Some men have preferred using two pair of tight-fitting jockey shorts and slip these magnets in the top of the jockey shorts.

When sitting down, sit on the chair pad with a 4" x 6" x 1/2" magnet under the seat of this chair pad, sufficiently far enough back to radiate into the rectal/genital area. Three months' treatment is required for the treatment of cancer of the prostate. Following this, it should be a lifestyle to sleep with these magnets on the pubic area.

URINARY BLADDER, URETHRAL INFECTIONS AND INTERSTITIAL CYSTITIS, AND KIDNEY DISORDERS:

These conditions in men should be treated the same as in women.

GENITAL INFECTIONS:

Genital Infections are treated the same in men as in women.

HEMORRHOIDS:

Sit on the magnetic chair pad with a 4" x 6" x 1/2" magnet under the chair pad as many hours as possible.

RECTAL AND LOW COLON CANCER:

Treat with a 5" x 12" double magnet, multi-magnet flexible mat across the low abdomen-pubic area. Place the 4" x 6" x 1/2" magnet centered on top and crosswise this mat. When sitting down, sit on the chair pad with the wooden carrier holding three of the 4" x 6" x 1" magnets. It is necessary to treat cancer for three months as near to 24 hours a day as possible.

POLYPS:

Polyps in the colon should be treated the same way as cancer and should be considered precancerous. The rectal and low colon areas are treated the same in both men and women.

GENITAL HERPES

Herpes Simplex II viral infection is the cause of genital herpes. This is a sexually transmitted disease.

Virus infections start in the peripheral area of a nerve and extends all the way through the nerve to the neuron. The neurones are in the low lumbar spine-sacral area. It is necessary to treat the entire length of the nerve from the periphery to the neurones in the low spine. Therefore, the treatment should be a 4" x 6" x 1/2" magnet on the local area and a 4" x 6" x 1/2" magnet on the low lumbar-sacral area. The duration should be as it is for any other infection, a minimum of two weeks and preferably longer. The infection in the genital area may be in an awkward area to place a magnet. Placing a magnet on the pubic bone and extending 1-2" below the pubic bone will radiate a magnetic field into the genital area without the magnet having been placed directly on the genital area. When it is convenient, it would be well to have the 4" x 6" x 12" magnet directly on the genital area.

PEYRONIE'S DISEASE

Peyronie's disease results from a lack of blood filling the cavernous sinus of the penis which is necessary for the production of an erection. This results in a crooked penis because of a lack of filling of a cavernous sinus. The cause is secondary to some type of inflammatory reaction or the development of a vascular stricture due to atherosclerosis of arteries leading to the penis. A negative (south-seeking) magnetic field can resolve the inflammation, any scar tissue resulting from inflammation and can resolve atheromatous plaques.

The treatment is that of placing a 4" x 6" x 1/2" ceramic block magnet on the pubic bone, extending about 2-3" beyond the bone so as to cover the penis. If an infection is present, this would need to be worn 24 hours a day for two weeks. Most of these problems are solved simply by sleeping at night with this 4" x 6" x 1/2" magnet on the pubic bone and extending below the pubic bone. It would take several weeks or even months to solve this problem.

SEXUAL DISORDERS

Male impotency and female frigidity have many causes for which there is no single adequate treatment. The limited value of magnetic stimulation is based on the following:

A. Biological responses to a positive (north-seeking) magnetic field:

1) Increased blood supply to the genital area.
2) Increased testosterone for the male.
3) Increased estrogen for the female.

B. Biological responses to a negative (south-seeking) magnetic field:

Reduced emotional components; a) anxiety, b) depression, c) obsessive-compulsiveness.

The positive (north-seeking) magnetic field; 1) increases local genital blood supply with application to the local area, 2) increases testosterone with a positive (north-seeking) magnetic field application to the testicles, 3) increases estrogen with positive (north-seeking) magnetic field application to the ovaries.

The negative (south-seeking) magnetic field 1) reduces anxiety and tension with a negative (south-seeking) magnetic field application to the frontal-temporal areas of the brain, 2) reduces depression with a negative (south-seeking) magnetic field application bitemporally, and 3) reduces obsessive-compulsiveness with a negative (south-seeking) magnetic field application to the left temporal and occipital areas of the brain. Increased biological energy by oxidoreductase enzyme catalytic response producing human life energy adenosine triphosphate.

The principle of magnetic treatment for sexual disorders consists of using the positive (north- seeking) magnetic field of a 4" x 6" x 1/2" placed over the necessary areas.

For the male, place the positive (north-seeking) magnetic pole side of a 4" x 6" x 1/2" magnet under the genital area to stimulate testosterone production by the testicles and at the same time

increase the blood supply to the genital area. The duration should be 15-30 minutes prior to sexual intercourse.

Place the negative (south-seeking) magnetic field of a 1-1/2" x 1/2" ceramic disc magnet on the head, a) bitemporally, that is, in front of the ears near the top of the front of the ears, for depression, b) mid-forehead and left temporal for anxiety, c) left temporal and low occipital for obsessive-compulsiveness. These discs are held in place with a 2" x 26" band. The duration should be 15-30 minutes before and even during sexual intercourse.

For the female, place the positive (north-seeking) magnetic field of a 4" x 6" x 1/2" ceramic block magnet under the genital area to increase blood supply to the genital area. The duration should be 15-30 minutes. Estrogen production by the ovaries can be enhanced by treating the ovaries with a positive (north-seeking) magnetic field. Use the positive (north-seeking) magnetic field of a 4" x 6" x 1/2" magnet over each ovary. This is placed on the front of the body about two inches from the mid-line and with the 6" lengthwise the body and halfway between the umbilicus and the inguinal area. The duration should be 15-30 minutes prior to sexual intercourse.

There are limitations to the use of the positive (north-seeking) magnetic pole that should be understood. The positive (north-seeking) magnetic field; 1) stimulates replication of microorganisms that may by chance be present, 2) stimulates replication of cancer cells that may by chance be present, 3) raises the serotonin-opiate complex and if used with a frequency exceeding a four day frequency, can produce magnetic addiction in which a person feels exceptionally good with this and has a compulsion to keep using this frequently.

Appropriate rules to follow when using the positive (north-seeking) magnetic field is;

1) soon after sexual intercourse, use the negative (south-seeking) magnetic field over the area where the positive (north-seeking) magnetic field had been used for the same length of time or more than the positive (north-seeking) magnetic field had been applied.

2) do not use the positive (north-seeking) magnetic field more than every 4th day.

3) do not use the positive (north-seeking) magnetic field on the head. It will produce a sense of euphoria and if frequently used, can lead to magnetic positive (north-seeking) field addiction.

Since this also excites the brain, it can lead to seizures in those that are so predisposed or can increase mental disorders in those that are so predisposed. In any event, the use of a positive (north-seeking) magnetic field on the head can lead to euphoria and disordered judgement due to the euphoria. Therefore, it is not advised to use a positive (north-seeking) magnetic field on the head.

MENOPAUSE

During the ten year span from age 45-55, both men and women undergo physical changes. Work and social stress add to the physical complications. A lifestyle, including the use of magnets for energy-restoring sleep and relief of any discomfort is in order. The lifestyle should be a non-addicted, well-nourished state. Excessive uterine bleeding that some women experience can be managed with the application of a negative magnetic field over the uterus. Depression can be managed with magnetic discs placed bitemporally. Maladaptive symptom producing reactions to foods, chemicals and inhalants and mostly to foods, is observed to make the classic symptoms of menopause in a menopausal person. The endocrine changes set the stage for the symptom food reaction. An example is hot flashes evoked by a symptom reaction to milk in a menopausal woman. It is wiser to manage menopausal symptoms with a magnetic field than to resort to supplemental hormones.

The above information relates to specific pelvic areas. The following is information that is useful as a backup for increasing general health.

Sleep on a magnetic bed pad that is composed of mini-block magnets that are 1-7/8" x 7/8" x 3/8". Place on top of this bed pad an eggcrate-type foam pad or other suitable futon that would raise the subject approximately an inch above the mattress pad. Sleep with magnets in the carrier up against the headboard. This consists of four magnets that are 4" x 6" x 1". They are placed 3/4" apart in a wooden carrier. They can be raised or lowered depending on the height of the pillow. They come shipped at the top of the carrier and need to be lowered so that the wooden dowel they are resting on is level with the back of the head when the head is on the pillow. The closer the top of the head is to these magnets, the better. This should be used nightly as a lifestyle.

It is also well to treat the eyes with an Eye-Sinus Unit. This is composed of a light shield, two neo-dots that are 1/2" across and

1/16" thick and two super neodymium disc magnets that are 1" x 1/4". This can treat the eyes by placing these magnets directly over the eyes. If there is a sinus infection, the magnets can be moved to the sinus areas. If necessary, two more super neodymium disc magnets can be added so that all four sinuses can be treated at the same time. Treating the eyes at night raises melatonin since the retina of the eyes produce melatonin. It also signals the pineal gland in the brain to make melatonin.

It is also wise to sleep with a 4" x 6" x 1/2" magnet up against the side of the head when laying on the back. When laying on the side, treat the back of the head and upper neck or the side of the head that is not on the pillow. Another useful method encouraging sleep is to use a 5" x 12" double magnet, multi-magnet flexible mat. Place on top of the pillow, between the pillow and the pillow-case. This will treat the back of the head when laying on the back or the side of the head when laying on the side. All of these methods of treating the head with a negative (south-seeking) magnetic field from the top of the head, the side of the head, the back of the head and the eyes will have the effect of raising melatonin. Melatonin governs the human energy system. It is anti-inflammatory, anti-cancerous and anti-infectious. The more we can raise melatonin, the deeper our sleep will be, the more energy we will recover during that night's sleep and the more defense we have against microorganisms and cancer.

GENERAL INFORMATION ABOUT MAGNETS:

Double magnet, multi-magnet flexible mats are composed of two stacked plastiform magnet strips 1-1/2" x 7/8" x 1/8". These plastiform magnetic strips are placed in four rows with the 1-1/2 inches lengthwise the pad. In a 5" x 6" mat, there are 12 magnetic strips. In a 5" x 12" mat, there are 24 magnetic strips. The flexibility of these mats makes them very useful since they will fit around the curves of the body without producing any pressure. With the multi-magnet flexible mats, the magnetic field extends to seven inches. However, the therapeutic level extends about two inches. When the flexible mat is reinforced with one row of mini-block magnets placed crosswise on the two central rows of magnets in the mat, the magnetic field extends to ten inches with the therapeutic field extending to four inches. When there are two stacked rows of mini-block magnets on the mat, the therapeutic level extends to five inches. The flexible mat can be reinforced with mini-block magnets placed crosswise the inner two rows of

plastiform magnets in the flexible mat. This places the mini- block magnets an inch and one half apart in which there are three placed on the 5" x 6" mat and six placed on the 5" x 12" mat. The flexible mat can also be reinforced by the 4" x 6" x 1/2" ceramic block magnet. This extends the therapeutic value to six inches.

Mini-block ceramic magnets are called Briggs blocks because they are used as the MAGNETO magnets in Briggs and Stratton gasoline motors. They are 1-7/8" x 7/8" x 3/8". These are cast mini-blocks. They have many therapeutic uses. They can be used on the head such as the temporal areas, frontal or occipital areas for headaches or management of emotional symptoms or seizures. They can be used on fingers or toes. They can be placed on top of the flexible mats to reinforce the depth of magnetic field penetration. They can be used directly on the joints, under or incorporated into wraps around joints. They are used in the magnetic mattress pad, the multi-purpose pads and the magnetic chair pads.

Ceramic disc magnets are 1-1/2" x 1/2". These ceramic discs are cut from the larger 4" x 6" x 1/2" magnets. They serve numerous valuable purposes such as around the head to treat headaches or other central nervous system symptoms, around joints, over skin or subcutaneous lesions. The magnetic field of a ceramic disc extends to eight inches. The therapeutic value extends to about three inches.

Ceramic block magnets are 4" x 6" x 1/2". The magnetic field extends to twelve inches. The therapeutic value extends for 6-7 inches. A ceramic block magnet that is 4" x 6" x 1" has a magnetic field extending to 19 inches with a therapeutic value extending to nine inches. The 4" x 6" x 1/2" ceramic block has many uses such as around joints or to penetrate deeply into the liver, internal organs, the heart or into the head such as for treatment of tumors. The 4" x 6" x 1" ceramic block magnets are used in the Vitality Sleeper to have a field that penetrates into the head during sleep. The Vitality Sleeper is composed of four ceramic blocks that are 4" x 6" x 1" placed in a row 3/4 inch apart. These ceramic blocks are placed upright in a wooden carrier that holds them firmly up against the headboard. They can be raised or lowered depending on the height of the pillow. They are shipped at the top of the carrier and need to be lowered so that the head is in the magnetic field. They are resting on a wooden dowel. The wooden dowel they are resting on should be slightly below the back of the head when the head is on the

pillow. The closer the top of the head is to the magnets in the carrier at the head of the bed, the better. By doing so, it provides a full negative (south-seeking) magnetic field.

A magnetic mattress pad is composed of mini-block magnets that are placed an inch and one-half apart throughout the pad. An eggcrate type foam pad or other suitable futon should be placed over this mattress pad. By doing so, it provides a full negative (south-seeking) magnetic field.

The magnetic chair pad is composed of mini-block magnets placed an inch and one-half apart throughout the seat and the back of the pad.

The multi-purpose pad is 14" x 25" and composed of mini-block magnets that are placed an inch and one-half apart throughout the pad. This multi-purpose pad has many uses such as being used on the back, the abdomen and up over the heart and the chest.

SYMPTOMATIC FOOD REACTIONS GENERAL INFORMATION:

A local and systemic biological response of acidity is routinely evoked when symptoms develop in response to exposure to foods, chemicals and inhalants. Acidity also produces low oxygen (acid-hypoxia). This is true whether the maladaptive symptom reactions are immunologic or non-immunologic in origin. Most food symptom reactions are not immunologic. Immunologic and non-immunologic food symptom reactions have a classic addictive see-saw biological response of symptom relief on exposure with the emergence of symptoms 3-4 hours after the exposure (addictive withdrawal phase). The optimum method of reversing addiction is avoidance. In food addiction, the optimum method of avoidance of the addiction is for there to be a 3-month avoidance followed by an exposure no more often than every fourth day. This is the reason for the 4-Day Diversified Rotation Diet. The optimum long term management of food addiction is the food avoidance period produced by the 4- Day Diversified Rotation Diet. The short term management of symptoms can be managed by alkalinization which can be produced by bicarbonate alkalinization and more optimally, exposure to a negative (south-seeking) magnetic field which alkalinizes and oxygenates (alkaline-hyperoxia).

These alkalinization methods can relieve symptoms after they have occurred from the exposure and can also prevent symptoms from developing when the alkalinization methods are used prior

to an exposure to symptom producing foods, chemicals and inhalants.

Following is the optimum method of preventing symptoms from occurring from foods:

1. A 4-Day Diversified Rotation Diet. This four day spacing of exposure to specific foods prevents food addiction. The 4-Day Diversified Rotation Diet is described herein.

The book, *Brain Allergies*
The book, *Victory Over Diabetes*
The book, *Magnet Therapy*

2. Pre-meal.

Negative magnetic field (south-seeking) exposure. One-half hour before the meal place the magnets on the body. Magnetic discs, either ceramic, magnetic discs that are 1-1/2" x 3/8" or super neodymium discs that are 1" x 1/4" placed bitemporally. These can be held in place with a 2" x 26" band. Place on the sternum, a 4" x 6" x 1/2" ceramic magnet. An added value can result from placing a 4" x 6" x 1/2" ceramic magnet on the epigastric area. Hold in place with a 4" x 52" body wrap. Place on the thoracic spine, a 5" x 12" double magnet, multi-magnet flexible mat. Hold the magnet on the sternum and the magnetic mat on the thoracic spine in place with a 4" x 52" body wrap. These can be removed at the beginning of the meal or they can be continued through the meal until it is completed. If symptoms emerge after the meal has been eaten, then replace the magnets until the symptoms leave and especially place a suitable sized magnet directly over the symptom area. Also prior to the meal, if there are any symptom areas, treat these with appropriate sized magnets, pre-meal. Always use the negative magnetic field (south-seeking).

The above pre-meal and post-meal alkalinization method is recommended for;

a) those with a serious state of symptom reactions to multiple foods in which food rotation is not entirely satisfactory

b) when of necessity, symptom-evoking foods have to be eaten, such as when eating out at a restaurant, or those that have to use this method instead of waiting three months for the introduction of their foods.

3. Post-meal. If any symptoms develop, post-meal, then use suitable magnets placed locally for relieving these symptoms. It could be helpful again, to place the disc magnets bitemporally.

In my experience, the above method of basic food rotation diet with the addition when necessary of the magnetic pre-meal exposure and the magnetic post-meal exposure is superior to any neutral- ization method. Neutralization methods do not honor the fact that the basic problem is that of addiction. A food rotation diet is necessary to honor the fact that addiction is the major driving force of food maladaptive reactions. There is no optimally effective method for the management of maladaptive reactions to foods that is equivalent to food rotation.

COLLOIDAL SILVER THERAPY:

Colloidal silver is made by an electrolysis method that produces a particle size of 0.0001 micron. These small silver particles are charged to a negative (south-seeking) magnetic field by the electrolysis method. This solution of colloidal silver is placed in the mouth, especially under the tongue for absorption. This provides quick absorption into the blood stream. These fine silver particles go throughout the entire body. The negative (south-seeking) magnetic field magnetically attaches to microorganisms, parasites and cancer cells which are positive (north-seeking) magnetic poled. Silver, in its own right beyond that of the negative (south-seeking) magnetic field, inhibits the replication of these cells. The small silver particles do not interfere in any way with human cell function. It is recommended to use 40 parts per million starting for the first week with 1/2 teaspoon four times a day and followed for the next three months with 1 teaspoon four times a day. In the case of acute infections, two weeks of treatment of 1 teaspoon four times a day usually suffices. There is also an aloe vera silver salve which can treat local skin infections.

ALKALINE MICRO WATER:

Alkaline micro water helps materially to maintain the body's normal alkaline state. Also, being micro water, it enters into the cells of the body more readily than the usual water. This also carries a negative (south-seeking) magnetic field as well as being alkaline. At least five glasses of this water should be used each day.

Nariwa water is the optimum alkaline negative magnetic field micro water. This comes from a Japanese volcanic magnetic mountain.

INFRARED SAUNA: promoting values including alkalization, oxygenation and detoxification. One half hour (or more) daily infrared sauna is recommended.

1. **ALKALINIZATION**

The human body functions in an alkaline medium. Enzymes in the human body are dependent on alkalinization and on temperature range. Increasing the temperature increases the enzyme function.

2. OXYGENATION

The human body makes it's energy by the oxidation process requiring the presence of molecular oxygen. As the temperature rises, the oxidation process increases. Thus, this will aid in producing more energy.

3. DETOXIFICATION

The human body processes toxins, some by being exhaled from the lungs, others passed out through the urine or the stool. Sweating from the skin is another process of detoxification. The far-infrared sauna is ideal in that it penetrates through the layers of the skin and into the subcutaneous fat throughout the skin and then detoxifies all types of toxicity including heavy metal toxicity. Therefore, this is ideal for heavy metal toxicity such as mercury, lead or other heavy metals. It also processes the enzyme inhibiting acids such as in degenerating diseases. Especially noted is the value in processing the toxins from cancer. Therefore, this is also a valuable treatment for degenerative diseases, including cancer.

Far-infrared sauna is markedly complementary to negative (south-seeking) magnetic field therapy which is also alkalinizing, oxygenating and detoxifying.

POLARITY:

Always use a negative (south-seeking) magnetic field.

BEYOND MAGNETISM:

Acute maladaptive reactions to foods, chemicals or inhalants has been documented as producing a brief state of acid-hypoxia. In this state, there is a production of acid and a failure to process properly the end-products of oxidation phosphorylation metabolism. In this state of acidosis, oxygen content is reduced. Maladaptive reactions to foods are the most frequent cause of bouts of acidosis. Degenerative diseases are noted for their acid-hypoxic state. Therefore, every effort should be made to maintain a normal alkaline and normal oxygen state. producing bouts of acidosis and reduced oxygen. It is the better part of wisdom to follow a 4-Day Diversified Rotation Diet. This program leaves out foods that are used as frequently as twice a week or more for a period of three months. This is based on the assumption that these foods are being reacted to in some maladaptive way. It is the frequency of the use

that produces the maladaptive reactions. A 4-Day Diversified Rotation Diet is set up to leave out these frequently used foods. After three months, these frequently used foods can be returned to the diet, usually without any symptoms being produced. The details of this rotation diet are in the quarterly, *The Ultimate Diet.*

All addictive substances should be abandoned such as addictive drugs, alcohol, tobacco and caffeine (coffee, tea with caffeine, chocolate, and soft drinks containing caffeine). Addiction is acidifying.

Carbonated soft drinks are acid and should be rarely used. Soft drinks are sweetened with corn sugar (in the US) and if and when used should be limited to the corn rotation day.

In order to maintain an adequate alkaline state, it is necessary that the minerals that are used in the bicarbonate buffer system be in adequate supply. These are the minerals calcium, magnesium, potassium and zinc. There are several proprietary preparations that contain these minerals associated with vitamin C as ascorbates. Use 1/2 teaspoon to 1 teaspoon of one of these powders plus one-half teaspoon of soda bicarbonate in one-half glass of water three times a day. Some have loose stools with 1 teaspoon, 3 times a day and should therefore, take 1/2 teaspoon, 3 times a day. The preferred time to take the alkaline minerals is thirty minutes after meals. If using alkaline micro water, the soda bicarbonate need not be used. Before using this mineral alkaline water, place it on the negative (south-seeking) magnetic field of a 4" x 6" x 1/2" magnet for a minimum of five minutes or more. This will charge up the water and the oxygen in the water with a negative (south-seeking) magnetic field which again will help the body maintain its normal alkaline state. When using micro alkaline water, soda bicarbonate need not be used when mixing the mineral water.

There is a valuable method of electrolysis which provides an alkaline micro water that has an alkaline pH. There is a home electrolysis unit that provides this alkaline micro water. It is recommended that five glasses of this alkaline micro water be used a day.

FINAL WORD

The good news is that a negative magnetic field will kill invading microorganisms and cancer cells. This fact effectively treats a high percentage of pelvic disorders.

The good news is that a negative magnetic field energy source makes available the human response of alkaline-hyperoxia,

magnetic energy for human cellular oxidation phosphorylation producing adenosine triphosphate human life energy, necessary pH and magnetic energy for growth-healing-repair of human cells and tissue and detoxification of endogenous inflammatory substances (free radicals, peroxides, acids, alcohols and aldehydes) and exogenous toxins.

The positive magnetic field has a limited value in sexual drive responses. The limitations of applying a positive magnetic field needs to be followed to prevent 1) microorganism and cancer cell replication, and 2) magnetic positive field addiction.

Dont's

Don't use chemical analgesics to relieve kidney pain. Chronic use of non-steroidal, analgesics can cause urinary bladder interstitial disease.

Don't allow an infection (bacterial, fungal, viral, parasitic) in any area of the pelvis or kidneys to be chronic.

Don't be addicted to foods or chemicals. The withdrawal phase of addiction is acidifying.

Don't use caffeine any more frequently than once in four days. Do not use caffeine twice a week as it can be addictive when used with that frequency. Many should never use caffeine.

Don't use carbonated beverages as often as twice a week. Carbonated beverages are acidic and can further acidify you

Don't postpone treatment of cancer.

Dos

Do use a negative magnetic field to relieve pelvic and kidney pain. There is no damage to the pelvic area or the kidneys to the negative magnetic field no matter how long the application or how strong the field is.

Do kill infections (bacterial, fungal, viral, parasitic) in the pelvic area and kidneys with a negative magnetic field.

Do rotate foods on a four day diversified basis as addiction cannot exit unless the food is used twice a week or more.

Do drink pure water. Five to ten glasses a day depending upon body weight.

Do use pure water. The preferred water has undergone electrolysis and is an alkaline micronegative magnetically charged water. Drink a minimum of five glasses a day and preferably, eight glasses a day.

Do use a negative magnetic field to treat cancer. A negative magnetic field is compatible with any other treatment of cancer.

THE GOOD NEWS IS THAT THE ALKALINE-HYPEROXIA NEGATIVE MAGNETIC FIELD HUMAN CELLULAR RESPONSE THAT IS THE BREATH OF LIFE FOR HUMAN CELLS IS THE KISS OF DEATH FOR ACID-HYPOXIC-DEPENDENT MICROORGANISMS, CANCER CELLS AND INFLAMMATION.

REFERENCES

GILLESPIE, LARRIAN, M.D., *You Don't Have To Live With Cystitis.* Avon Books, 1350 Avenue of the Americas, NY, NY 10019, 1996.

PHILPOTT, W.H. and KALITA, D. *Victory Over Diabetes: A Bio-Electric Triumph.* Keats Publishing Company, Inc. New Canaan, CT. 1983.

Harrison's Principles of Internal Medicine. 11th Edition. McGraw-Hill Book Company, NY 1997.

STEIN, *JAY, Mosby Internal Medicine.* 4th Edition, 1994. St. Louis, MO [*Magnetic Health Quarterly* "Pelvic Disorders" Vol. V, 2nd Qtr, 1999 (2002 Revision)]

The Enzyme Factor, The Solubility Factor, The Infectious Factor, The Environmental Factor

THE pH FACTOR IN DIABETES MELLITUS TYPE II

Diabetes mellitus type II, non-insulin dependent diabetes, is an acid-hypoxia disease condition. The diabetes mellitus disease process develops due to maladaptive reactions to foods. The biological response to these symptom-producing and hyperglycemia-producing responses is acid-hypoxia during which cellular edema occurs. These swollen cells block insulin from transporting glucose into the cells. This blocking of insulin from its function is called INSULIN RESISTANCE.

These maladaptive reactions to foods can be of several sources, such as IgG immunologic-type reactions, addictions without antibody formation and a response to toxins which are either endogenous or exogenous to the foods. IgG food reactions have a delayed reaction whereas IgE food reactions have immediate inflammatory reactions. This IgG delayed reaction is such that relief of symptoms is initially experienced in contact with the food but three to four hours later, the IgG antibodies that have attacked the foods are now, after digestion, free to attach to tissues and now produce a tissue inflammatory reaction. An addictive reaction is when food has become a stressor such that it evokes the production of self-made narcotics (endorphins) and serotonin.

There is this delayed withdrawal phase to addiction. Both IgG antibody reactions and addictions behave the same way in which there is this delayed reaction. After five days of a fast, the reaction is within an hour rather than delayed to 3-4 hours, post-exposure. This is why a fast is important when testing for the food reaction causes of diabetes mellitus type II.

The early stage of the diabetes mellitus disease process has the swelling of cells in which the insulin cannot do its job. The pancreas responds to that with hyperinsulinism. As soon as the swelling goes down, which is some 3 hours or so after the contact, then the hyperinsulinism sends the glucose into the cells and the blood now has low insulin. The glucose is quickly used by the cells and then we have low glucose, not only in the blood but also in the cells. At that time, numerous symptoms emerge. Dizziness, weakness, alteration in blood pressure and the precipitation of any other symptoms that are potential such as anxiety and phobias. Hypoglycemia serves as a trigger mechanism for emotional, mental and physical symptoms. This hypoglycemic phase of the diabetes mellitus disease process can last for several years before the final development of clinically significant diabetes mellitus.

In the clinically significant diabetes mellitus disease phase of the diabetes mellitus disease process, the hyperinsulinism has ceased to exist so there no longer is hypoglycemia but now there is hyperglycemia. This is because the cells stay swollen much longer in this second phase of the diabetes mellitus disease process. There is an acidity reaction in both the early stage and the second stage of diabetes mellitus. The cells simply cannot function correctly in a state of acidity. Insulin resistance is present both in the early stage and the late stage of the diabetes mellitus disease process. The difference is, there is no hyperinsulinism in the second stage. Therefore, there is no hypoglycemia, only hyperglycemia.

The diagnosis of diabetes mellitus type II is that of fasting the patient for five days. This can be a water fast or a food fast using a food that the subject seldom uses. Watermelon is a good food for this five days of fasting. Any other foods, fish or vegetables that are not ordinarily used could be used during this fast. The secret of this fast is that it changes the delayed reaction of these maladaptive reactions to foods to that of an acute reaction within an hour. Before the fast, the height of the symptoms was 3-4 hours after eating whereas after a fast, the height of the symptoms is

within one hour. It is easy to document that maturity onset diabetes mellitus type II is caused by these food reactions.

The blood sugar will normalize by the 4th or 5th day of the fast. Test meals of single foods are used. The blood sugar is taken before the meal is eaten and one hour after the meal is eaten. The foods that cause symptoms and hyperglycemic reactions will reveal that these are the causes of the diabetes mellitus. When these foods are left out, there is no diabetes mellitus. There simply is no hyperglycemic reactions when these foods are removed. If these symptom and hyperglycemic and acid-producing foods are removed from the diet for three months, 95% of the time, they can be returned to the diet as long as they are eaten no more often than once in four days or seven days. The subject sets up a four or seven day rotating diet program. The diabetes mellitus has simply disappeared into thin air. This provides a 100% proof that maturity onset diabetes mellitus is caused by food reactions. It is also true that there can be reactions to environmental chemicals that can also cause this swelling of cells and be a party to this diabetes mellitus disease process. I have especially noted this to be petrochemical hydrocarbons such as car exhaust, natural gas or propane.

It is very important to examine the subject for reaction to environmental chemicals because these need to be avoided too if they are part of why the person is diabetic. An example is a teenage boy diagnosed as having type I insulin-dependent diabetes. When removed from his chemical environment of New York City, which has lots of car exhaust fumes, he did not need insulin. However, when moving back to New York, he had to have insulin. His body was producing a marginal amount of insulin and in a clinically clean environment, he did not need extra insulin. In a chemically contaminated environment, he had to have insulin. Thus, I have found several type I diabetics who did not have to have insulin if their food or chemical reactions were removed. I have routinely found that type I diabetics also have the same problems of reactions to foods that type II diabetics have. It is just as important that a type I diabetic rotate the foods and avoid chemicals they are reacting to as it is type II. However, the type I usually does have to have insulin but in my experience the insulin requirement is cut to one-third if you honor the reactions to foods and chemicals. Type I diabetics are not fasted since they could develop an acute acidosis. Treatment is dependent on former reactions to frequently used foods. Fortunately, I have discovered that there is a way to proceed

without going through a fast and without having three months of avoidance of foods they are reacting to. This method achieves its goal by exposure to the negative magnetic field ahead of the food. Place two ceramic disc magnets that are 1-1/2" x 1/2" bitemporally. Hold these in place with a 2" x 26" band. Use the negative magnetic field facing the body. Place the negative magnetic field of a 4" x 6" x 1/2" magnet over the heart. Hold this in place with a 4" x 52" body wrap. Place a 4" x 6" x 1/2" magnet over the liver.

Hold this in place with a 4" x 52" body wrap. These ceramic block magnets should have the negative magnetic field facing the body and the 6" should be lengthwise the body. Exposing the head, heart and the liver to these magnets for 15 minutes, or preferably 30 minutes before a meal, there is little chance that there will be any reaction at all, be it either symptomatic or hyperglycemic. This system will so help to alkalinize the body that it blocks the acidic reaction which causes the cells to swell. With this system the subject sets up a rotation diet of either a four or seven day length, whichever they choose and does not go through any type of food testing. Experience has taught that there are foods that are frequently eaten that are producing the hyperglycemia due to the acidity of cells. When that acidity is blocked from occurring then there is no reaction. The biological response to a negative magnetic field is alkaline-hyperoxia. After three months of pre-meal exposure to a negative magnetic field, desensitization has occurred. The allergy-addiction has been reversed and the magnets do not have to be used ahead of a meal. The subject can continue the rotation as a lifestyle. It is wise if a person is going to eat out at a restaurant and purposely violate the rotation program, to use this magnetic exposure pre-meal as a protection against a reaction.

THE ROLE OF pH IN HEALTH AND DISEASE

Blood pH provides the biological window to the electromagnetic health and the electromagnetic pathology of metabolic diseases. There are parallel metabolic conditions that are always present at the same time, any one of which will provide you the evidence that the others will be present. These parallels are alkaline pH, hyperoxia, magnetic cellular anti-stress state, cellular pulsing frequency below 13 cycles per second, cellular negative magnetic state. The other set of parallels are acid pH, hypoxia, cellular magnetic stress state, cellular pulsing frequency beyond 12 cycles per second, cellular positive magnetic state. These are so fundamentally interrelated so that when one is present, the others are also present. Thus, the presence of a blood

acid pH indicates acid-hypoxia, cellular stress state, cellular pulsing fre- quency above 12 cycles per second, cellular positive magnetic state. This set of parallels associated with an acid pH is the condition in which symptoms occur. This set of parallels when alkaline-hyperoxia is present is symptom relief. I was fortunate to have done an experiment in which I was monitoring blood pH in relationship to symptom production. A brief blood acidity is present when symptoms are produced. My knowledge of electroencephalography with specific frequency relating to specific behavioral expression established the cellular electromagnetic state of both non-stress pulsing frequencies compared to stress pulsing frequencies of diseased conditions. Theron G. Randolph, M.D., Allergist was the first to observe acidity present during maladaptive reactions (allergies, addictions, toxicity reactions). Based on this evidence, he used sodium bicarbonate plus breathing oxygen as a relieving agent for symptoms. That occurred during deliberate test exposures. Acidity incorporates oxygen into the acid thus the chemistry of the maladaptive reaction is that of acid-hypoxia. I confirmed his observation of acid-hypoxia as being consistently present during maladaptive reactions to foods, chemical compounds and inhalants. Accordingly, I used bicarbonate plus breathing of oxygen as a symptom relieving agent. Albert Roy Davis, Physicist, was the first to observe that the biological response to a static positive magnetic field is acid-hypoxia and that in contrast the biological response to a static negative magnetic field is alkaline-hyperoxia. I confirmed his findings and found that the application of a negative magnetic field to the area of symptom production was more consistently present with a static negative magnetic field than with oral bicarbonate plus breathing oxygen. I was evoking these symptoms by stress testing by the method of five days of avoidance before this stress testing exposure. This initial avoidance plus single substance exposure during this stress testing revealed consistently which substances evoked which symptoms. These acute symptoms were the same symptoms as chronic diseases. Thus a static magnetic field therapy developed with the dimensions of:

1) identification of symptom-evoking substances.

2) demonstration of acid-hypoxia present when maladaptive symptoms occurred.

3) relief of symptoms and normalization of pH with exposure to a negative magnetic field.

4) healing of degenerative diseases with the prolonged use of an alkaline-hyperoxia response to a static negative magnetic field. Robert

O. Becker, M. D. also observed that healing only occurs in the cellular condition of a negative magnetic field and that healing does not occur in a cellular positive magnetic field state. He observed a cellular positive magnetic field to be the signal of injury.

The essence of magnetic therapy is production of negative ion charges at the cellular level which not only provides the alkaline-hyperoxia necessary for oxidoreductase enzymes to function but also energizes these enzymes for catalysis. This goal of negative ion charges at the cellular level can be achieved by:

1) a static negative magnetic field exposure.

2) negative ion charges in the air with absorption of these negative ions through the skin.

3) negative magnetic pulsing field at an anti-stress frequency which are below 13 cycles per second.

4) sensory pulsing fields at anti-stress levels below 13 cycles per second. This can be any sen- sory input such as sight, sound or tactile.

Acute symptoms produced by stress test exposure are measurably acid-hypoxic. Chronic metabolic diseases are also acid-hypoxic and are simply the time extension of acute maladaptive reactions. Thus, with diabetes mellitus type II, stress testing identifies the hyperglycemic and otherwise symptom-producing foods, chemicals and inhalants. The withdrawal of these symptom reacting substances versus the diabetes mellitus disease process fortunately three months of non-exposure provides a reversal of these responses and these foods can usually be reintroduced and kept on a four or seven day rotation basis without hypoglycemia or symptoms reemerging. Furthermore, exposing the brain, heart and the liver to a negative magnetic field for 15-30 minutes ahead of an exposure to the offending agents, food or otherwise, consistently prevents the hyperglycemia or symptoms from emerging. Thus, a subject can set up a four or seven day rotation diet without the usual 5 days of avoidance and proceed immediately with a rotation diet with a negative magnetic exposure ahead of each meal. This same principle applies to vascular disorders, rheumatoid disorders, allergy and autoimmune disorders thus exposure to a negative magnetic field becomes a central and fundamental therapy for either acute symptoms or degenerative disease symptoms. Magnetic therapy is the most predictable symptom reliever whether these are acute reactions or symptoms

of chronic disease that I have observed in forty years of medical practice.

DIABETES MELLITUS DIAGNOSIS

Diabetes mellitus is diagnosed by a hyperglycemic fasting blood sugar higher than 140 mg/dL. It's earliest symptom is usually that of frequency of urination based on an osmotic diuresis. It is characterized by deterioration abnormalities of the eyes, kidneys, nerves and blood vessels.

Classification of Diabetes: <u>Primary</u>
1) Insulin-dependent diabetes mellitus (IDDM, type I)
2) Non-insulin-dependent diabetes mellitus (NIDDM, type II) <u>Secondary:</u>
Pancreatic disease
Hormonal abnormalities
Drug and chemical induced insulin receptor abnormalities
Genetic syndromes

The insulin-dependent diabetes mellitus is characteristically found to be an autoimmune process that destroys islet cells. This can be a viral infection. It has also been demonstrated to be secondary to cow milk allergy. In any event, there is an inflammatory process in which the islet cells are destroyed. With 90% of the destruction of the islet cells, then insulin is required. Concerning the non-insulin-dependent diabetes mellitus -- "little progress has been made in understanding the genesis of non-insulin-dependent diabetes mellitus". (Page 1781 in *Harrison's Principles of Internal Medicine*, 11th Edition) Characteristic of this primary type non-insulin-dependent diabetes mellitus, there are mechanisms that are isolatable apart from the initiating cause which are abnormal insulin secretion and a resistance to insulin action.

DISCOVERY OF THE CAUSE OF PRIMARY DIABETES MELLITUS, TYPE II

After ruling out isolatable secondary causes of diabetes mellitus type II, there remains the majority of type II diabetes with an unidentifiable cause. This is where my research into diabetes mellitus has come into play. Fasting the subject for five days, following test meals of single foods as well as test meals of exposure to single chemicals and inhalants has demonstrated that there is an isolatable cause for primary diabetes mellitus type II. What it is are maladaptive reactions to mostly foods, but to less extent to chemicals and inhalants. This environmental type testing

demonstrates what the specific substances are in specific individuals. This is entirely a personal cause and does not have the general characteristics of it being a particular type of food or particular type of chemical or inhalant but rather the substances are isolated as an individual maladaptive response of each subject. Therefore, the testing has to be on each individual to discover what the cause of diabetes mellitus for that particular subject. It cannot be generalized. The reason why medical science has not understood what the cause of primary diabetes mellitus type II was is that this type of ecologic examination regarding single substances after a five day fast is not a part of medical education. I discovered this cause of diabetes mellitus type II by accident. I was doing a research study on mental patients, some of which of course are diabetic. This consisted of fasting five days, followed by stress test meals of single foods and single chemicals and inhalants. In all my patients, including the maturity-onset type diabetes mellitus, all had a normal blood sugar by the fifth day of fasting. The blood sugar was then taken before each test meal and at one hour after completing the meal which was an hour and one-half after the beginning of the meal. I was looking for symptoms to emerge which would determine for me which foods and substances evoked the mental and physical symptoms characteristic of mental patients. At the same time, I was monitoring pH before and after each meal based on information provided by Theron G. Randolph that these reactions to foods and chemicals produced an acidity. I confirmed that he was right. I also was testing blood sugar before and an hour and one half after each meal. About half of my patients did have hyperglycemia. Only a small number however were diabetics. When the foods that produced hyperglycemia were removed, there was no diabetes. Thus, primary diabetes mellitus type II considered as having an unknown cause was established as having known causes. Furthermore, it was isolated that these maladaptive reactions were allergic with IgG antibodies or addictive without IgG antibodies or toxic reactions to toxins that may be in the food or otherwise that may be in the environment of that particular subject.

John Potts confirmed my cause of maturity-onset diabetes mellitus and published this data in the abstract issues of *The Journal of Diabetes*.

DISCOVERY OF THE CORRECT TREATMENT OF DIABETES MELLITUS, TYPE II

The cause of diabetes mellitus, type II is maladaptive reactions to foods and chemicals, to foods mainly but also to chemicals and inhalants to a lesser degree. Thus, the correct treatment for maturity-onset diabetes mellitus is that of avoidance of these substances evoking maladaptive reactions including hyperglycemia. Feeding foods that do not produce hyperglycemia and avoiding chemicals and inhalants that evoke hyperglycemia for that specific person corrects the insulin resistance. Fortunately, avoiding these foods and other substances for a period of three months reverses these reactions 95% of the time. The answer is a diversified rotation diet, either four or seven day. With the initial three months of avoidance of the offending foods or other substances, after which these can be placed into the diet and only occasionally is there a food that evokes symptoms and or hyperglycemia which should then be avoided completely. The insulin resistance is caused by the cells that are swollen by the maladaptive reactions. When the reactions are not present, the cells are not swollen, the pH is normal and there is no hyperglycemia and there is no insulin resistance. Under these conditions, I have found no reason to provide medication that will raise insulin. Only occasionally will there be a subject who has advanced to a stage of sufficiently low insulin as to require insulin. John Potts found that of those maturity-onset type diabetics that have been judged as needing insulin, that 2/3 of these did not need insulin when their foods were rotated.

There is a technique that has a high percentage chance of being successful without a three month period of avoidance. This consists of treating the brain with ceramic discs placed bitemporally and a 4" x 6" x 1/2" magnet over the heart and another one over the liver for 15-30 minutes pre-meal which prevents the maladaptive reactions from occurring. Monitoring the blood sugar before and after each meal will prove whether this is true for each individual food.

THE ROLE OF pH AND HYPOXIA IN THE DIABETES MELLITUS DISEASE PROCESS

The metabolic response common denominator to allergies, addictions and toxicities is acid-hypoxia. This emergence of the acid-hypoxia biological response to specific biologic stressors is demonstrated by an ecological examination which consists of five days of avoidance of foods, chemicals and inhalants followed by single, stress test exposures to foods, chemicals and inhalants. Before these single test meals of foods, the blood sugar and blood

pH is taken. One hour after the end of the test meal which is usually an hour and one-half after the beginning of the meal, there is again a survey of symptoms that may have emerged and of blood sugar and blood pH. Non-insulin dependent diabetes mellitus type II is demonstrated to be caused by a biological acid-hypoxia reaction specific for isolatable single foods and to a lesser extent, to chemicals and inhalants. Acid-hypoxia is the common denominator of these maladaptive reactions whether these are allergies with IgG antibodies, addictions or toxicities. Cells swell in this acid-hypoxic medium of a maladaptive reaction to the food. This produces insulin resistance. When these symptom-producing foods are removed there is no insulin resistance and there is no longer a diabetic reaction. Avoiding glycemic foods such as free carbohydrates rapidly evoking a glycemic reaction does not reverse diabetes mellitus. Eating alkaline-forming foods as the major foods does not reverse the acid-hypoxia of diabetes mellitus and therefore does not reverse diabetes. Any diet that does not honor these maladaptive reactions to foods does not adequately manage diabetes mellitus type II.

THE ACID-HYPOXIC FACTOR IN CARDIOVASCULAR DISEASES

The cause of cardiovascular diseases is acid-hypoxia evoked by maladaptive reactions to foods, chemicals and inhalants. These reactions are principally caused by addictions and allergies to foods. Cardiovascular diseases are reversed by initial avoidance and later, spacing of these maladaptive reactions. In diabetes mellitus, which is an acid-hypoxic disease, cardiovascular disorders rapidly advance. The question is, is diabetes mellitus the central disease of degeneration and even though the subject has a normal fasting blood sugar, do they still have an earlier stage of the diabetes mellitus disease process or can this develop separate from diabetes mellitus? The ecologic examination of a five day fast followed by test meals of single foods is as applicable to cardiovascular disorders as it is to diabetes mellitus. A part of this ecologic test is to always test the pulse before and after each test meal. Many times, an abnormal pulse is evoked by these maladaptive reactions.

THE ACID-HYPOXIC FACTOR IN ESSENTIAL HYPERTENSION

Most hypertensions are caused by maladaptive reactions to foods and occasionally to chemicals or inhalants. The ecologic examination in which there is a five day fast demonstrates that

most hypertensions will have cleared by the 5th day. Stress testing of the foods then demonstrates which foods specifically are evoking hypertension. Is it possible that essential hypertension is simply a complication of the diabetes mellitus disease process? It appears that this may well be so. It is possible that the kidneys have been so damaged that the hypertension still remains after the 5 day fast. However, this is not usual even in subjects that have damaged kidneys to the point of protein spillage in the urine.

THE ACID-HYPOXIC FACTOR IS LIPID METABOLISM

Disordered lipid metabolism is caused by maladaptive reactions to foods mostly and to a lesser extent, chemicals and inhalants. Honoring these maladaptive reactions by avoidance and spacing of contacts reverses the disordered lipid metabolism.

INTERESTING FACTS AND CASE HISTORIES

Sugar as such is not the cause of diabetes mellitus. Maladaptive reactions to foods, chemicals and inhalants is the cause of diabetes mellitus type II. Sugar of course, can be one food to which subjects develop addictions. These are to specific foods, specific sources of sugar such as cane, beet, corn, honey, sorghum and so forth. The reaction is to a sugar, it is not to glucose. It is to the parent substance from which the glucose comes thus a subject may react to beet sugar but not to any other sugar. A subject may react to honey that comes from their own locality and not to honey that comes from another locality. I have not found any diabetics that reacted to maple sugar. This is likely due to the fact that maple sugar is seldom used. Corn sugar is a special problem since cornstarch undergoes a reaction to an acid to produce corn sugar. The reaction can be to not only the corn, but to the carrier that has been used to turn the cornstarch into sugar.

A fifty-year-old man, when tested for corn syrup, developed a cough because of the development of an acute bronchitis. No other sugar gave him any symptoms.

A Mexican woman with maturity-onset diabetes mellitus type II was out of control with her diabetes. By five days of a fast, her blood sugar and her blood pH were normal. She was fed maple sugar and there was no reaction. She was fed all other sugars with no reactions. When given pinto beans, she had a serious hyperglycemic reaction. Pinto beans were the only food that evoked her diabetic hyperglycemia and acid-hypoxia.

An insulin dependent type I, eighteen year old, who had had diabetes mellitus since early childhood was in serious, poor control. He was using 60 units of insulin a day and still not in control. Twice, he had had laser treatment for his eyes due to retinal bleeding. There was 4+ protein in his urine. He had a hypertension of 180/110 which was unmanaged by medication. Because he was insulin dependent, he was not fasted. Instead, any foods that he used twice a week or more were removed from his diet. A four day rotation diet was set up. Within a week, his blood pressure was normal. There was no protein in his urine and he was being managed on 20 units of insulin. In a sizable series of insulin-dependent diabetics, this same process has been followed with the result of characteristically, the blood sugar will be managed on an insulin level that is approximately 1/3 of the insulin level they were using before treatment. This gives evidence that these maladaptive reactions to foods are also occurring in these insulin-dependent diabetics but that there is damage to the pancreas sufficient that insulin is required. I have also found that also insulin-dependent and non-insulin-dependent diabetics can be reacting to chemicals -- the petrochemical of car exhaust are common reactors to diabetics. I have placed diabetics behind the car, breathing the car exhaust and demonstrated a hyperglycemic reaction. One of my insulin-dependent diabetics who had received insulin for years was proved not to be insulin-dependent. However, when he returned to New York City in which he lived, he had to use insulin due to the car exhaust.

THE PATHOLOGICAL ELECTROMAGNETIC MISSING DIAGNOSIS

It is understood that live biological systems are electromagnetic. Magnetic and electric poles cannot be separated. Electric fields produce magnetic fields and magnetic fields produce electricity. They cannot be separated. Live biological cells pulse as an expression of their magnetic state. Live biological cells respond to a static magnetic field by pulsing. The pulsing magnetic state of cells which express their magnetic state can be driven by:

1. A static magnetic field, or
2. A pulsing magnetic field
3. Pulsing sensory (sight, sound, tactal inputs)

Despite the fact that the always present electromagnetic phenomena of living cells is basic knowledge, it is ignored in medical diagnosis and treatment. Medical texts do not have

chapters or even paragraphs on the electromagnetic diagnosis of each disease compared to the normal electromagnetic functions of live biological cells. This electromagnetic pathology diagnosis would include magnetic polarity (positive or negative) magnetic gauss strength, pulsing frequency and pH, both local and systemic.

Understanding the electromagnetic diagnosis provides a major clue as to treatment. Immediate treatment for symptom relief would involve a correction of the electromagnetic pathology by appropriate exposure to a static or pulsing magnetic field. Longer term would be providing for appropriate nutrition and detoxification as well as avoidance of the environmental inputs that are evoking the pathology. The environmental inputs are such as allergies, especially to foods, addictions, especially to foods, and the identification of environmental enzyme toxins.

The value of the electromagnetic pathology diagnosis is that there are emerging a new energy medicine both from a diagnostic and a therapeutic standpoint in which there is more immediate symptom relief and an expanded version of what causes disease. Current technology makes it possible to proceed with an electromagnetic diagnosis. We need to focus on current technology capacity to provide us an electromagnetic pathology diagnosis. To achieve this, we need to access with instruments magnetic polarity, gauss strength, pulsing frequencies, pH (both local and systemic) and oxygen content (both local and systemic.) The sciences of electroencephalography and magnetic encephalography are providing valuable clues as to the relationship between electromagnetism and the disease state. It has been objectively observed that a negative magnetic field is anti-stress with pulsing fields below thirteen cycles per second. The higher the gauss strength, the slower the pulsing field. 8-12 is a relaxing, anti-stress state. A pulsing field of 2 cycles per second is deep, energy- restoring sleep. A pulsing brain field can be driven by a pulsing input. Sensory input such as sight and sound and tactiles can be used in driving the specific pulsing frequencies that are desired to be achieved. In any event, either a static field exposure or a pulsing field exposure or a sensory pulsing input can achieve the same results of driving the brain as specific magnetic states that relate to behavioral consequences. A static positive magnetic field will drive the brain beyond 12 cycles per second. The higher the gauss strength, the higher the frequency of the brain response. In pathological states, the pulsing frequencies are in the stress

level beyond that of 12 cycles per second. These pathological states can be corrected by either a static or pulsing anti-stress level. Based on our current knowledge of the electromagnetic diagnosis of pathological states, we can deduce an anti-stress level of magnetism whether this be pulsing fields or static fields, to achieve our results of anti-stress reversal of the biological stress pathologies. It would be a considerable boon to therapeutic medicine to note specifically the electromagnetic diagnosis of specific conditions and reverse this with a corrective electromagnetic anti-stress input for immediate relief of symptoms. We need to also be able to repeat this electromagnetic diagnosis as a biofeedback mechanism demonstrating that we have indeed achieved an electromagnetic correction of the pathological state.

ACID-HYPOXIC FACTORS IN CANCER

Otto Warburg was given a Nobel prize for the discovery that cancer makes its adenosine triphosphate by the process of fermentation. Fermentation requires acidity and hypoxia in order to function in making ATP. Since acid-hypoxia is required for cancer to make its ATP, it is also observed to be the vulnerable point for the death of cancer. Cancer cannot survive in an alkaline-hyperoxia medium. It can't make its energy in an alkaline-hyperoxia medium. Therefore the answer for the reversal of cancer is a sustained alkaline-hyperoxia. This can be achieved with the use of a negative magnetic field since the biological response to a negative magnetic field is alkaline-hyperoxia.

Cancer dies 100% of the time in a sustained alkaline-hyperoxic medium. Since this is true, why is it that we cannot achieve 100% results of the reversal of cancer with the application of a negative magnetic field? The reason for this is not that cancer can survive in an alkaline-hyperoxic medium produced by a negative magnetic field, but that the subject sometimes brings to the therapy a state of non-survival. Important are nutritional needs, hydration needs, and functional level of survival for critical tissues such as bowel function, absorption of nutrients, liver function, respiratory function and obstructions of vital areas are important deterrents to success in any program. Pressure on the aqueduct for fluid flow between the ventricles in the brain and spinal fluid is a must. A person cannot survive with hydrocephalus. Bowel obstruction is a great deterrent and some of those with bowel obstruction cannot survive the necessary surgery for the removal of this bowel obstruction. The attempt to keep the bowel open when it is largely

closed with a tumor is a battle that most of the time is not won. Liver function depleted and obstruction of the bile flow are serious deterrents to survival. Obstruction of respiration with tumors in specific areas that compromise the amount of oxygen being received by the lungs is a serious deterrent which sometimes cannot be reversed fast enough for survival. Some of these are so obstructive that they would not survive surgery for the removal of the obstruction. So in spite of the fact that cancer dies 100% of the time in the presence of alkaline-hyperoxia produced by a negative magnetic field, the survival rate cannot be 100% since the subject does not bring to the therapy a biological survival capacity irrespective of what the treatment may be.

THE ACID-HYPOXIC FACTOR IN LOCAL AND SYSTEMIC INFECTIONS

Bacterial, viral, fungal, parasitic infections thrive in a slightly acid-hypoxic medium. A high acid state such as a pH of 2 will kill all cells whether bacterial, fungal, viral or parasitic. Therefore, the treatment with the high acid is not possible. Sustained alkaline-hyperoxia is itself a defense against invading microorganisms. There are other antibiotic factors not clearly understood, however, it is observed that infections will die in the presence of a sustained alkaline-hyperoxia response to a negative magnetic field. However, it is also observed that in an in vitro culture study, there is only a small antibiotic effect of a negative magnetic field. However, invivo, in which the human body is responding to the negative magnetic field, there is a high level of antibiotic efficiency. Local infections can be treated locally with a magnet of suitable size and strength. A neodymium disc, 1" x 1/8" is ideal for the treatment of small skin lesions. A ceramic disc magnet 1-1/2" x 1/2" is ideal for the treatment of small skin infected lesions. Systemic infection requires systemic treatment using the bed composed of seventy 4" x 6" x 1" magnets and the super head unit composed of twelve 4" x 6" x 1" magnets.

THE ACID pH OF DEHYDRATION

Water is the great solvent and also makes it possible for soluble bicarbonates to maintain alkalin- ity. Furthermore, oxygen and water both are magnetizable and ionizable. They can both hold a negative magnetic field charge and a negative ion charge which has the common denominator of alkaline-hyperoxia. Frequently, ill people do not drink enough pure water. Water should also be without contaminants and it is preferred that it be water that has

been charged up with a negative magnetic field and with negative ions. Eight glasses of pure water are a minimum. Ten glasses and sometimes more are needed to process the toxins out of the body. An ill person should count the number of glasses of water they drink a day. They cannot depend on thirst as the indicator of need of water. A human subject will die in the state of dehydration.

ACID pH FACTOR IN MAJOR MENTAL ILLNESSES

Symptoms of schizophrenia and manic depressive disorders calm down with 5 days of a fast and then emerge with stress tests of single foods. An acid blood pH will accompany the emergence of symptom production. These major mental disorders are found to be caused by brain injury by viral infections. Especially noted is Epstein-Barr, cytomegalovirus and human herpes virus #6. The acidity that is evoked by food allergies, addictions and toxicities attack the brain's viral injured areas. The type of symptoms relate to the specific areas of the brain that have been injured.

There are a spectrum of a lesser brain injuries which produce symptoms in the same way. These are such as learning disabilities, hyperkinesis, lethargy, attention-deficit disorders, autism and so forth. All of these viral injured brain disorders are effectively treatable with a 4 or 7 day food rotation and avoidance of environmental chemicals to which they are found to be symptom reacting. Immediate symptoms can be managed by bitemporal placement of either ceramic or neodymium disc magnets. The viral infection can be killed by a super magnetic bed and a super magnetic head unit composed of four 4" x 6" x 1" ceramic magnets.

THE ACID HYPOXIC FACTOR IN INFLAMMATORY REACTIONS

Five days of avoidance will demonstrate that many inflammatory reactions will have either considerably calmed down or disappeared by the fifth day of a fast and again emerge when testing single foods or single exposure to environmental chemicals to which they have developed either an allergy addiction or a toxic reaction. This is true of neuritis, tendinitis, arthritis or any inflammatory reaction.

The treatment for inflammatory reactions is local negative magnetic field treatment for the local state of inflammation. When bacterial infections or viral infections are involved, the treatment should be a negative magnetic field systemic treatment of the super magnetic bed and super magnetic head unit. These microorganisms can be killed and their toxins can be enzymatically processed by the energy of a negative magnetic field.

THE ACID pH FACTOR IN AUTOIMMUNITY

Autoimmunities are customarily extensions of an initial allergy which extends the reaction to autoimmunity. Lupus is a good example. Five days of fasting and the lupus will considerably calm down. Usually by the 5th day of a fast, the butterfly affect across the face is now a brown color. Ecological testing of foods, chemical and inhalants will reveal which items are evoking the lupus symptoms. I have worked up a number of these cases. They have always responded to several items but they have all responded to gluten foods. The butterfly lesions on the face of a lupus patient become bright red when exposed to gluten foods. Other foods and chemicals can do this also but a reaction to gluten so far appears to be universal. Lupus patients should all be treated systemically as well as locally. Viral infections are suspected in lupus cases.

ACID REFLUX DISORDER

Acid reflux disorder exists because of maladaptive reactions to specific foods. These are in the nature of allergies, addictions and toxicity reactions. The important thing to understand is that this relates to specific isolatable substances and when these substances are removed, there is no acid reflux disease. To achieve this, there needs to be five days of a fast with test exposure to single foods. When these foods are withdrawn, the acid reflux disorder does not exist. Fortunately, they do not have to be withheld forever. Usually, there will be no reaction if the foods are rotated after three months of avoidance. The other method is to start the rotation immediately and treat magnetically ahead of each meal. A 4" x 6" x 1/2" magnet needs to be placed over the epigastric area pre-meal, for at least 30 minutes. For healing, a 4" x 6" x 1/2" magnet needs to be placed over the epigastric area. This should be held in place with a 4" x 52" body wrap. The more hours of exposure, the better. The negative pole facing the body will heal the injured mucous membrane of the stomach and low esophagus.

THE ROLE OF INSOLUBLE DEPOSITS IN DEGENERATIVE DISEASES

The insoluble deposits in degenerative diseases are:
1. Insoluble calcium deposits.
2. Insoluble amino acid deposits (amyloid).
3. Insoluble fat deposits.
4. Insoluble glycation deposits.
5. Insoluble pigment deposits.
6. Insoluble carbonates containing hydroxyapatite deposits.

There is a central cause for these insoluble tissue deposits. In acid-hypoxia tissue state, these substances become insoluble. Acid-hypoxia is central to degenerative diseases. Biological health is dependent on a tissue state of alkaline-hyperoxia. The biological response to a static negative magnetic field is that of alkaline-hyperoxia. The biological response to a static positive magnetic field is acid-hypoxia. The human organism is an electromagnetic organism and of necessity, must maintain alkaline-hyperoxia. Much is known about the damage of acid-hypoxia and the necessary maintenance of alkaline-hyperoxia. It is characteristic of degenerative diseases that there will be both local and to some degree, systemic acid-hypoxia. There are many known causes for the development of acid-hypoxia, such as allergic reactions, addictive reactions, reactions to toxicity, heavy metal toxicity, infections of all types of invading organisms which are acidifying and so forth. To therapeutically prevent and treat degenerative diseases, each of these causes of acid-hypoxia must be assessed and appropriately treated.

INSOLUBLE CALCIUM DEPOSITS

It is documented that calcium is soluble at the normal alkaline pH of body fluids. It is documented that calcium becomes insoluble in an acid medium. Thus, it is observed that calcium can deposit around inflamed joints. Calcium becomes deposited in areas of stress where free radicals are not being processed rapidly such as in the lumbar spine where spinal stenosis develops with calcium depositing around the spinal cord and the nerves. Insoluble calcium becomes a part of the plaques in arteries. In any case, local or systemic, where acidity develops, calcium deposits occur.

AMYLOID DEPOSITS

It is documented that amino acids are soluble at the physiologically normal alkaline pH of blood and other body tissues. It is documented that amino acids become insoluble in an acid medium. These insoluble amino acids can be deposited anywhere the tissues are acidic. A fair percentage of diabetics have amyloidosis of the pancreas. It can deposit around nerves producing neuropathies. Insoluble deposits of amino acids occur in the brain which is given the title of Alzheimer's disease.

INSOLUBLE FAT DEPOSITS

Fat is soluble at the normal physiological alkaline pH of body tissues. It becomes deposited as insoluble fat deposits in an acid medium. Obesity is caused by insoluble fat deposits.

INSOLUBLE GLYCATION PRODUCTS

Glycation is a joining of glucose and other reducing sugars to protein. This is made possible by the presence of an aldehyde. The development of aldehydes are one of the products that develop if free radicals are not quickly processed by oxidoreductase enzymes. Oxidoreductase enzymes function only in an alkaline medium. In the presence of an acid medium, peroxides, oxyacids, alcohols and aldehydes are formed. The presence of the aldehyde makes possible the joining of sugars to protein. This insoluble product can occur anywhere in the body. Arteriosclerosis is due to glycation products and calcium deposits.

INSOLUBLE PIGMENT DEPOSITS

Insoluble pigment deposits occur in acid-hypoxic tissues. They can occur in response to damage which of course is maintaining acidity. The skin and the retina of the eyes are classic tissues where these insoluble deposits occur.

HYDROXYAPATITE INSOLUBLE DEPOSITS

With acidification of the aging process, the pineal gland accumulates concentrated deposits. These insoluble deposits have been determined to consist of carbonate-containing hydroxy apatite concretions These insoluble concretions are the product of acidity and are reversible by a sustained alkaline-hyperoxia produced by a negative magnetic field. Apnea caused by reduced melatonin production due to this insoluble concretion of the pineal gland is reversible after several months of nightly exposures of the pineal gland of a negative magnetic field.

TOXICITY OF INSOLUBLE PRODUCTS

Not only are these insoluble products produced by acidity, but they also are toxic, producing free radicals.

SOLUBILITY OF INSOLUBLE PRODUCTS

The answer to the reversal of these acid-produced insoluble products is that of maintaining a continuous alkaline-hyperoxia. This is achieved by a sustained exposure to a sufficiently strong and of a sufficient duration negative magnetic field with its biological response of alkaline-hyperoxia. Thus, all of these insoluble deposits are made soluble by the application of a static negative magnetic field.

THE ROLE OF ACID pH IN OSTEOPOROSIS

Osteoporosis is the most common of metabolic bone diseases. The most common forms of osteoporosis has an unknown cause. There are ten or more chronic metabolic diseases in which

osteoporosis is present. There are four genetic disorders in which osteoporosis is present. There are seven common metabolic disorders with associated osteoporosis. These are all states of acidosis such as rheumatoid arthritis, diabetes mellitus, alcoholism, malnutrition and so forth. It is understood that in all these conditions, that acidosis is the common denominator. The human body is alkaline-hyperoxic dependent. It is understandable that osteoporosis will develop when acid-hypoxia is present. Robert O. Becker, M.D, Orthopedic Surgeon has demonstration that bone healing will not occur in the presence of a positive magnetic field but will occur only in the presence of a negative magnetic field. The biological response to a positive magnetic field is acid-hypoxia and to a negative magnetic field is alkaline-hyperoxia. Thus again, it is observed that bone healing only occurs in the presence of alkaline-hyperoxia.

The calcium being deposited as insoluble deposits is drawn from the blood plasma. Calcium is drawn from the bones in order to maintain optimum serum calcium for metabolic functions. Thus, all the reasons for developing insoluble deposits due to acid-hypoxia also apply to osteoporosis. The answer to osteoporosis is to stop all these acid-hypoxic conditions and then treat the body systemically so that all bones are involved in a negative magnetic field. The optimum treatment for this is a 70-magnet bed of 4" x 6" x 1" magnets and also with a super magnetic head unit composed of twelve of these 4" x 6" x 1" magnets. Of course, nutrition must be optimized and it is wise to include in this specific supplementation of the nutrients needed for bone growth and repair. The maintenance of a negative magnetic field with the use of a negative magnetic bed is central to the repair of osteoporo- sis. Bone density studies should be repeated at yearly intervals until the desired bone density is achieved.

MAGNETIC PROTOCOL FOR MAINTAINING OPTIMUM ALKALINE-HYPEROXIA: ORIENTATION:

Maladaptive reactions to foods, chemicals and inhalants evokes a physiological response of acid-hypoxia. This acid-hypoxia state produces an array of physical, emotional and mental symptoms depending on the area of the body where the acid-hypoxia is the highest. A period of five days avoidance of foods and chemicals to which the subject is exposed to reverses the chronic symptoms and acute symptoms occurring upon exposure to the offending substance. Within the five days, there is a clearance of symptoms

that emerge when exposed to specific substances. This ecology examination discovers the specific substances evoking specific symptoms. Thus, it can be determined which substances evoke a hyperglycemia diabetic reaction, which evokes symptoms in muscles, joints, skin or other body systems. These maladaptive reactions are in the nature of allergies, addictions and enzyme toxic reactions. Acute symptom reactions are the precursors of chronic symptom reactions identified as chronic degenerative diseases. Initial avoidance of the foods or other substances evoking symptoms reverses the disease process. Tolerance increases as avoidance is continued and at three months, substances can be tolerated if rotated on a four or seven day basis.

The metabolic degenerative diseases are diabetes mellitus type II, cardiovascular disorders, essential hypertension and disordered lipid metabolism. In the early stage of these metabolic diseases, the term metabolic syndrome is used which consists of minimal evidence of these metabolic disorders occurring years before the diseases have progressed to the stage of clinical significance. Long term studies demonstrate that the early stage evidences of these metabolic diseases are significant and are indeed the hallmark of the metabolic degenerative diseases which will in time develop. The best treatment is to start ecologic and magnetic treatment at the early stages of these diseases thus preventing the development of these metabolic degenerative diseases. This treatment must combine both ecologic factors of maladaptive reactions from specific substances producing acid-hypoxia and the magnetic treatment that reverses these diseases.

TREATMENT FORMAT

A minimal treatment of having diagnosed these maladaptive reactions by an ecologic examination involving a fast and test exposure of stress testing to single substances. Both foods and chemicals can produce symptoms in many people. If they will honor these maladaptive reactions by avoidance and spacing, they will not develop a metabolic degenerative diseases.

<u>Minimal treatment</u> using magnets:

In the early stage of the metabolic syndrome disorder, magnets can be used to reverse these minor metabolic disorders by adding magnetic treatment to the four or seven day rotation diet along with adequate nutrition, even if need be, by supplementation. This could be determined by specific testing as to the nutritional state of the subject. The subject could sleep on a magnetic bed composed

of mini-block magnets that are 1-7/8" x 7/8" x 3/8" placed an inch and one-half apart. Along with this, use the Vitality Sleeper which is magnets placed in a wooden carrier up against the headboard. These magnets are 4" x 6" x 1" placed one inch apart. These magnets can be raised or lowered as the case may be. The most fundamental way of reversing any of these maladaptive reactions is to treat the brain, the heart and the liver pre-meal.

PLACEMENT AND DURATION:

For the minimal program, rotate the foods on either a four or seven day basis. Provide adequate nutrition as demonstrated by laboratory testing. The 4-day diversified rotation diet is described herein.

The minimal program plus minimal magnet therapy consists of the rotation diet, appropriate supplements plus sleeping on a magnetic bed composed of mini-block magnets and a Vitality Sleeper head unit which supplies a magnetic field to the crown of the head.

The optimal program which should routinely be used if the disease has progressed to a clinically significant stage are composed of the super magnetic bed and the super magnetic head unit. The rotation diet and appropriate supplements need to be continued as a lifestyle. This super magnetic bed is needed to reverse lipid metabolism and aid in the repair of tissues such as kidneys, heart, liver, eyes and so forth. When the heart is involved in any dysrhythmia, plaque formation or arteriosclerosis, then place a 4" x 6" x 1/2" magnet over the heart 24 hours a day if needed to reduce symptoms but especially at night. Hold this in place with a 4" x 52" body wrap. Always use a negative magnetic field facing the body. Place the 6" lengthwise the body over the heart. For carotid stenosis, use the 1-1/2" x 1/2" disc magnets -- each one over a carotid artery. Hold in place with a 2" x 26" band. The more hours of exposure, the better. The 4" x 6" x 1/2" magnets can be used anywhere on the body that has symptoms. Always use the negative magnetic field. The more time of exposure, the more efficient the treatment. The 4" x 6" x 1/2" magnets can be placed over the kidneys for healing. Hold in place with a 4" x 52" body wrap. The brain with arteriosclerosis will be treated with the super magnetic head unit.

HOW TO USE THE FOUR DAY OR SEVEN DAY DIVERSIFIED ROTATION DIET

The essence of the Diversified Rotation Diet is that foods are rotated on a four or seven day basis, thus preventing their maladaptive reactions, be these allergies or addictions. Also, this rotation diet will correct hypoglycemia and non-insulin dependent diabetes mellitus.

One method is to avoid food eaten twice a week or more for a period of three months, rotating all other foods. At the end of three months, then place these frequently used foods back into the diet, rotated once in four or seven days. This method is outlined in my quarterly, *The Ultimate Non-Addiction, Non-Stress Diet* and also in my book, *Magnet Therapy*. The seven day rotation diet is in my quarterly, *Metabolic Syndrome*.

Another method that is preferred by some is to start rotating all foods, even those that are eaten frequently. This can be achieved if the subjects will treat themselves to magnets for 15-30 minutes ahead of the meal. To achieve this, place the ceramic disc magnets bitemporally, that is in the front of the ears at the level of the top of the ears. These are held in place with a 2" x 26" band. The discs are ceramic discs that are 1-1/2" x 1/2". The negative magnetic field is always placed toward the body.

On the positive magnetic field side, there is hook Velcro that will hook to the band around the head and hold these in place. At the same time, place a 4" x 6" x 1/2" magnet on the heart with the 6" lengthwise the body. Hold this in place with a 4" x 52" body wrap. Also, place a 4" x 6" x 1/2" magnet with the 6" lengthwise the body over the liver area which is on the right side of the body with half of the magnet over the rib cage and half below the rib cage. Hold this in place with a 4" x 52" body wrap. The minimum time of exposure should be 15 to 30 minutes or more before each meal and best even during the meal. With this method, there is no avoidance period of the commonly used foods.

After three months of rotation, there is little likelihood of a maladaptive reaction to a food without the magnets before the meal. Whenever purposely violating the rotation diet such as eating out, then use the magnets ahead of a meal.

The 4-day diversified rotation diet is in the quarterly, *The Ultimate Non-Addiction, Non-Stress Diet*. The 7-day rotation diet is in the quarterly, *Metabolic Syndrome*

FINAL WORD

The human body is dependent on maintaining alkaline-hyperoxia. All the enzymes of the human body are alkaline-

dependent except those of the mouth and the stomach. A negative magnetic field is an enzyme energy activator of oxidoreductase enzymes in particular and other enzymes along with ATP as an energy activator. The biological response of acid-hypoxia is present as the pervading common denominator of maladaptive reactions to foods, chemicals, inhalants and toxins. The maintenance of alkaline-hyperoxia is necessary for the reversal of allergies, addictions and toxicities. Fortunately, the biological response to a negative magnetic field and negative ions is that of alkaline-hyperoxia. Furthermore, it is fortunate that the chronic exposure to a negative magnetic field and negative ions can be maintained. The reason for the development of primary diabetes mellitus type II was unknown until I did a project of a 5 day fast followed by stress single exposure to foods, chemicals and inhalants while at the same time, monitoring before and after exposure, that of blood sugar and blood pH. The cause of maturity onset type II diabetes mellitus is demonstrated to be maladaptive reactions to foods, chemicals and inhalants, but especially to foods. When these maladaptive hyperglycemic and pH acidifying reacting substances are removed there is no diabetic reaction. A 4 or 7 day diversified rotation diet has been demonstrated to be the central reversal technique of primary diabetes mellitus type II. This is easy enough that a well-oriented subject can do their own testing. Unfortunately, doctors, including specialists in diabetes, are not taught the technique of demonstrating the foods and substances that evoke the diabetes mellitus. Diets leaving out glycemic foods, eating largely of alkaline-forming foods or relying on some zone theory about foods, does not reverse diabetes mellitus, type II. However, avoidance, spacing and magnetic treatment with its alkaline-hyperoxic production does reverse diabetes mellitus. Furthermore, a negative magnetic field producing a sustained alkaline-hyperoxia, effectively treats arteriosclerosis, atherosclerosis, neuropathy, amyloidosis and reverses other insoluble deposits produced by a local acid state. A negative magnetic field kills local and systemic invading microorganisms. A negative magnetic field with its alkaline-hyperoxic response can reverse the mental and emotional symptoms of major mental and emotional disorders. A negative magnetic field reverses biological stress states so that symptoms are relieved. Appropriate therapy requires the stopping of the inputs producing acid-hypoxia and replacing the acid-hypoxia with the alkaline-hyperoxia produced by a response to a negative magnetic

field. This is universally true of inflammations, infections, metabolic degenerative diseases and mental and emotional states. A negative magnetic field has universal value in not only immediately relieving symptoms but also in reversing the chronic degenerative disease process. The biological response to a negative magnetic field is that of alkaline-hyperoxia which is needed for the maintenance of health and the reversal of metabolic degenerative diseases, infections, inflammations, physical injuries and tissue deposits of insoluble substances.

REFERENCES

BECKER, ROBERT O. "Cross Currents". Jeremy P. Tarcher, Inc. Los Angeles, CA, 1990. BECKER, ROBERT 0. and SELDON, G. "The Body Electric. Electromagnetism and the Foundation of Life." William Morrow and Company. NY. 1986.

BECKER, ROBERT O. and MARINO, A. "Electromagnetism and Life". State University of New York Press; Albany, NY 1982.

BELANEY, B. The New Encyclopedia Britannica, 1986. Vol VIII, pp 274-275. BRAUNWALD, Eugene. Harrison's Principles of Internal Medicine. 11th edition 1987. McGraw-Hill Book Company, NY.

DAVIS, A.R. and RAWLS, W. "The Magnetic Blueprint of Life.". Acres USA, Kansas City,MO, 1979.

DAVIS, A.R. and RAWLS, W. "The Magnetic Effect". Acres USA, Kansas City, MO 1975

DAVIS, A.R. and RAWLS, W. "Magnetism and Its Effect on the Living System". Acres USA, Kansas City, MO 1976.

FLANIGAN, PATRICK and FLANIGAN, GAEL AND CRYSTAL. Earthpulse Press New Test Number One.

FRESHT, Alan., *Enzyme Structure and Mechanism* Second Edition. W.H. Freeman and Co. New York, New York. 1994

KLONOWSKI, W and KLONOWSKI, M. Journal of BioElectricity. Aging Process and Enzy- matic Proteins. 4(I), 93-102 (1985).

Magnetic Fields in Enzyme Catalysis. Encyclopedia Britannica. Vol 15. Pg 1068. Chicago, IL 1986.

NORDENSTROM, BEW, Biologically Closed Electric Circuits. Stockholm, Sweden: Nordic Medical Publications, 1983.

NORDENSTROM, BEW, "Electrochemical treatment of cancer; variable response to anodic and cathodic fields". Am J. Clin Oncol, 1989: 12:530-536.

NORDENSTROM, BEW, "Survey of mechanisms in electrochemical treatment (ECT) of cancer". Europ J. Surg. Suppi. 1994: 574:93-109.

NORDENSTROM, BEW, "Biokinetic impacts on structure and imaging of the lung: the concept of biologically closed electric circuits". Am J Roentgenol, 1985; 145:447-467.

O'CLOCK, G.D., "Studies of the effects of in vitro electrical stimulation on eukaryotic cell proliferation". MA Thesis (Biological Sciences), Mankato State University, Mankato, MN, 1991.

O'CLOCK Jr G.D., & Lyte, M., "Potential uses of low-level direct current electrotherapy for the treatment of cancer". Proceedings of the 15th Annual International Conference of the IEEE Engineering in Medicine and Biology Society, San Diego, CA, Part 3: 1993; 1515-1516.

PHILPOTT, W.H., M.D. and KALITA, Dwight, Ph.D., *Victory Over Diabetes: A Bio-Electric Triumph.* Keats Publishing Company, Inc. New Canaan, CT. 1982

PHILPOTT, W.H., M.D. Magnetic Health Quarterly, *Diabetes Mellitus,* Vol III, Second Quarter, 1997.

PHILPOTT, W.H., M.D. and KALITA, Dwight, Ph.D., *Brain Allergies. The Psycho-nutrient and Magnetic Connections.* Updated second edition. Keats Publishing NTC/Contemporary Publishing Group. Los Angeles, CA , 2000.

PHILPOTT, W.H., M.D. and KALITA, Dwight, Ph.D., *Brain Allergies,* updated second edition. Keats Publishing NTC/ Contemporary Publishing Group, Los Angeles, CA 2000
PHILPOTT, W.H., M.D. and KALITA, Dwight, Ph.D., *Magnet Therapy.* (Tiburon, CA: Alternative Medicine. corn, 2000)

POTTS, JOHN, Journal of Diabetes. Avoidance Provocative Food Testing in Assessing Diabetes Responsiveness." 26:Supplement 1, 1977.

POTTS, JOHN, Journal of Diabetes. 'Value of Specific Testing for Assessing Insulin Resistance." 29: Supplement 2, 1980.

POTTS, JOHN, Journal of Diabetes. "Blood Sugar-Insulin Responses to Specific Foods Versus GTT." 30: Supplement 1, 1981.

POTTS, JOHN, Journal of Diabetes. "Insulin Resistance Related to Specific Food Sensitivity." 35: Supplement 1, 1986.

RANDOLPH, T.G. *The Enzymatic and Hypoxia, Endoctrine Concept of Allergic Inflammation* Clinical Ecology. pp 577-596. Charles C. Thomas, Publisher, Springfield, Illinois. (1976).

STEIN, Jay H. *Internal Medicine.* 4th Edition. 1994. P. 340-524. Mosby Publishers. St. Louis. TRAPPER, ARTHUR, et al. "Evaluating Perspectives on the Exposure Risks from Magnetic Fields", Journal of the National Medical Association, 82:9, September 1990.

WARBURG, O., The Metabolism of Tumors. F. Dickens (Trans) London: Arnold Constable: 1930.

WARBURG, O., On the Origin of Cancer Cells. Science 123 (1956) 309-315. WARBURG, O. " The Prime Cause and Prevention of Cancer". Revised lecture at the meeting of the Nobellaureates on June 30, 1966. National Cancer Institute Bethesda, MD.196

[*Magnetic Health Quarterly* "The pH Factor in Health & Disease" Vol. XI, 3rd Qtr, 2003]

THE MAGNETICS OF SLEEP DOUBLE AUDIENCE

The Magnetic Health Quarterlies are designed for both scientist and lay audiences. To maintain lay audience interest, scientific terms are kept at a minimum.

The identification of magnetic poles will follow the recommendations of B. Belaney in the Encyclopedia Britannica using the term electromagnetic definition of negative and positive. A magnetometer using negative (-) and positive (+) for magnetic pole identification is used for pole identification. For those used to and comfortable with the traditional compass needle geographic naming of the magnetic poles as north-seeking and south-seeking, the traditional identification of magnetic poles will be placed in brackets as negative (south-seeking) and positive (north-seeking).

Sleep and Health

Sleep is the great restorer of biological energy. Without adequate sleep, humans become weak, toxic, invaded by microorganisms with an increase in the development of degenerative diseases and aging. Certain it is that sleep is absolutely necessary for the maintenance of health and happiness. Following are some of the major factors involved in sleep and interference with sleep.

Circadian Rhythm

Human physiology has a wakeful period and a sleep period. The wakeful period is driven by environmental factors which excite

the brain such as light and a positive (north-seeking) magnetic field coming from the sun. The sleep period is governed by the lack of light and the sunshine and skyshine having disappeared and the crust of the earth which is a negative (south-seeking) magnetic field, encourages rest, relaxation and sleep. Thus, we see the wakefulness governed by a positive (north-seeking) magnetic field and the sleep governed by a negative (south-seeking) magnetic field. It is important to understand this since we use this fact of a negative (south-seeking) magnetic field governing sleep to produce sound sleep. This sleep period also controls the expression of hormonal production. The wakeful period activates the production of catabolic hormones such as thyroid, adrenocortical hormones and some others. The sleep period activates the production of anabolic hormones such as melatonin and growth hormone. It has been demonstrated that melatonin can be produced at will by exposure to an anti-stress magnetic field. The optimum anti-stress magnetic field is that of a negative (south-seeking) magnetic field placed at the top of the head so the pineal gland, which produces melatonin, and the hypothalamic area of the brain, which produces growth hormone, are in the magnetic field. It is also of interest to note that the most optimum time for the production of melatonin and growth hormone are in the late P.M. such as 11:00 P.M. and early A.M. such as up to 1:00 A.M. or 2:00 A.M. There are external factors that interfere with this circadian rhythm such as sun flares which are a positive (north-seeking) magnetic field that can excessively activate the

human brain and other areas of the body. It has been particularly noted that subjects predisposed to mental illness have been noted in substantial numbers to develop an acute exacerbation of their illness at the time of sun flares. It also would encourage the growth of microorganisms and help produce epidemics of these human-invading microorganisms. In the far northern hemisphere, there are the long night periods and the long light periods. This also disturbs the circadian rhythm. On the other hand, many people work at night which disturbs the circadian rhythm. It is important to set up artificial magnetic fields. This can be done by sleeping at night on a magnetic negative (south-seeking) poled bed pad and with the negative (south-seeking) pole of magnets at the crown of the head so that no matter what the external circumstances (such as long periods of light or night or working at night) all be handled by setting up an artificial sleep/wake cycle. Bright light has been

used to offset the depression that occurs during the long periods without light. However, what we have observed is that if you sleep with magnets at the crown of the head you will be governing the sleep/wake cycle and the bright light serves no particular purpose. Therefore, it is understood that you could drive the circadian rhythm either by waking up to bright light or using magnets to sleep soundly. It is a matter of driving the circadian rhythm. The more practical solution to this is to sleep at night with the negative (south-seeking) pole of magnets at the crown of the head and on a negative (south-seeking) poled magnetic bed pad because this has the optimum potential of raising melatonin and growth hormone.

MAGNETS USED

The magnets used are permanent and flat-surfaced, thus providing the ability of separation of the positive (north-seeking) and negative (south-seeking) magnetic fields. A static magnetic field is an energy field by virtue of it's movement of electrons in the magnetic field. There are single negative (south-seeking) and single positive (north-seeking) magnetic fields. The most useful application is achieved by separating the magnetic poles by use of flat-surfaced magnets with opposite poles on opposite sides of the flat surface. The magnetic polarity is purposely identified as positive and negative rather than north-seeking or south-seeking. The human body functions as a direct current circuit with the body of the neurons in the brain and spinal cord being positive and their extensions into the periphery of the body being negative. Therefore, by using the medical definition of electromagnetic polarity, we have a direct parallel without any necessity of translation in applying magnetic fields to the human body. A positive electric field produces a positive magnetic field and a negative electric field produces a negative magnetic field and this is why both electricity and magnetism can use the same sign.

THE MELATONIN HORMONE FACTOR

Melatonin is made by the pineal gland which is centered in the head. It has been documented to be responsive to a magnetic field. A negative (south-seeking) magnetic field evokes melatonin and a positive (north-seeking) magnetic field stops the production of melatonin. A 60-cycle per second cuts the production of melatonin and therefore, it is important not to sleep in a 60-cycle per second electric field. There should not be an electric clock, water bed heater, electric blanket, etc. in the bedroom. Light stops the production of melatonin, therefore, it is important to sleep in

total darkness. If total darkness cannot be arranged, then cover the eyes and forehead to prevent a response to light. Melatonin governs the production of sound sleep. Melatonin has been documented as having anti- cancer values, anti-aging value, control of endocrine function, control of immune function, control of respiration and in fact, control of all body energy systems.

GROWTH HORMONE FACTOR

Growth hormone is also produced at night when asleep, as is melatonin. Growth hormone is also under the control of melatonin. Growth hormone has to do with growth and therefore, also with healing. It is the hormone that makes it possible for amino acids to be turned into proteins which then are used as building blocks in the growth and healing process of the human body. Growth hormone has the control over the health of skin, nails, hair and also muscle mass. With growth hormone, the skin should maintain it's normal thickness. Growth hormone has control over fat cells and is necessary for fat cells to be able to drop their fat. Interestingly enough, the growth hormone rises at night and very little is present during the day. It is interesting to note that fat cells drop their fat at night when we are asleep. Maybe there is such a thing as a beauty sleep.

THE pH FACTOR

Acid-base balance is controlled by a magnetic field. A positive (north-seeking) magnetic field is acidifying and a negative (south-seeking) magnetic field is alkalinizing. When sleeping at night in a negative (south-seeking) magnetic field, the human body becomes more alkaline. The alkaline factor is very essential since oxygen can only be available in an alkaline medium otherwise, in an acid medium the oxygen becomes tied up and not effective as an oxidizing agent. If we are reacting to a food, either immunologically with the production of antibodies, allergic-like maladaptive reaction, produced by oxidoreductase enzyme inhibition, addictive reactions or toxic reactions we become acidic and this would disturb our sleep. Therefore, it is important that the person not be addicted or maladaptively reactive to foods, chemicals, inhalants or toxins. It is important that these factors be handled so that sound sleep can be achieved. The magnets can do much to offset these acidifying factors and provide sound sleep. Logically, we should function at the levels of stopping these acidifying reactions and at the same time, sleeping in a negative

(south-seeking) magnetic field from a magnetic bed pad and with magnets at the crown of the head.

THE PAIN FACTOR

The discomforts of pain keep people awake. The pain is often caused by the acidic state caused by the reactions to foods, chemicals and inhalants or toxic state. Placing the negative (south-seeking) pole of a static field magnet over the area of pain is a great reliever of the pain produced by these acid states that reduce oxygen in local areas. Therefore, it is important to treat local areas that may be painful in order to obtain sound sleep. The magnets need to be larger than the painful area being treated. Some years ago, a man was involved in an accident which resulted in the removal of both legs above the knees. There was constant pain in both stumps for which no appreciable relief had been achieved. He fastened the negative pole of a 1-1/2" x 1/2" ceramic magnet over the painful area of each stump. He called the next day enthusiastically stating that the pain was relieved and he had a sound, refreshing sleep for the first time in years.

THE EDEMA FACTOR

When cells are swollen they are painful because they are lacking oxygen and are acidic. Cells that are swollen also cannot make their energy by the normal process of oxidation phosphorylation of adenosine triphosphate and oxidation remnant magnetism. It is important to treat any area of local edema with a negative (south-seeking) magnetic field in order to provide for the conditions of sound sleep.

HOW TO HAVE SOUND, DEEP, HEALING, ENERGY RESTORING SLEEP

The person should sleep in total darkness. If total darkness cannot be arranged, a pad should be placed over the eyes and forehead which will not admit light. It is the response of the eyes and forehead to light that cuts off the production of melatonin and growth hormone when asleep at night. Therefore, if a person has light coming through a window or if sleeping in the daytime because of their work schedule, they should put a pad over their eyes and forehead during sleep.

It is important not to have any 60-cycle per second pulsing frequency such as comes from electric currents in the room. There should not be an electric clock, night light or any other electrical instru- ment in the room where a person sleeps. It has been shown that 60-cycle per second quickly cuts off the production of

melatonin. To achieve the optimum help from a magnetic field, the subject can best sleep on a magnetic bed pad composed of mini-block magnets placed sufficiently close together so the magnetic field is a full negative (south-seeking) magnetic field. It is best to accompany this with magnets at the crown of the head. In fact, we have found magnets at the crown of the head to be even more effective in producing sound sleep than the bed pad itself. These magnets at the crown of the head are composed of four 4" x 6" x 1" magnets placed 3/4" apart in a carrier holding them firmly against the headboard. These magnets can be raised or lowered depending on the height of the pillow. The bottom of the magnets resting on the wooden dowel should be slightly below the back of the head when the head is on the pillow. The maximum magnetic sleep instrument is the super magnetic head unit composed of twelve 4" x 6" x 1" magnets in a wooden carrier surrounding the head.

GENERAL INFORMATION ABOUT MAGNETS:

Plastiform flexible magnets come in long strips. They can be obtained 2" wide, 3" wide and 4" wide. They can be cut whatever length is desired. They are 1/8" thick. They are frequently stacked together as two, to make them stronger for depth of penetration.

Common sizes are 4" x 4" x 1/8", 2" x 3" x 1/8" and a 4" x 6" x 1/8". They can be as long as is needed such as 12" long or 24" long. These longer ones can be used to cover the entire spine. When they are bent a few times, they break. If these magnets have broken, then they can be fastened together with duct tape and will still have the same magnetic value. Because they tend to break, they are cut in strips, 1-1/2" x 3/8". Four rows of these are placed in mats. The mats are 5" x 6" or 5" x 12". Usually they are placed double for the depth of penetration. A double flexible mat will have a therapeutic penetration of about 2". They are only useful for depth of penetration of 2". Ceramic block magnets can be placed on top of these to increase their depth. Large ceramic block magnets, such as 4" x 6" can be placed over these flexible mats to increase their strength considerably. For example, a double-magnet flexible mat with a 4" x 6" x 1/2" ceramic block magnet has a therapeutic penetration of 5".

Mini-block ceramic magnets are called Briggs blocks because they are used as the MAGNETO magnets in Briggs and Stratton gasoline motors. They are 1-7/8" x 7/8" x 3/8". These are cast mini-blocks. They have many therapeutic uses. They can be used on the

head such as the temporal areas, frontal or occipital areas for headaches or management of emotional symptoms or seizures. They can be used on fingers or toes. They can be placed on top of the flexible mats to reinforce the depth of magnetic field penetration. They can be used directly on the joints, under or incorporated into wraps around joints. They are used in the magnetic mattress pad, the multi-purpose pads and the magnetic chair pads.

Ceramic disc magnets are 1-1/2" x 1/2". These ceramic discs are cut from the larger 4" x 6" x 1 12" magnets. They serve numerous valuable purposes such as around the head to treat headaches or other central nervous system symptoms, around joints, over skin or subcutaneous lesions. The therapeutic value extends to about two inches.

Ceramic block magnets are 4" x 6" x 1/2". The therapeutic value extends for 6-7 inches. A ceramic block magnet that is 4" x 6" x 1" with a therapeutic value extending to 8 inches. The 4" x 6" x 1/2" ceramic block has many uses such as around joints or to penetrate deeply into the liver, internal organs, the heart or into the head such as for treatment of tumors. The 4" x 6" x 1" ceramic block magnets are used in the Vitality Sleeper to have a field that penetrates into the head during sleep. The Vitality Sleeper is composed of four ceramic blocks that are 4" x 6" x 1" placed in a row 3/4 inch apart. These ceramic blocks are placed upright in a wooden carrier that holds them firmly up against the headboard. They can be raised or lowered depending on the height of the pillow. They are shipped at the top of the carrier and need to be lowered so that the head is in the magnetic field. They are resting on a wooden dowel. The wooden dowel they are resting on should be slightly below the back of the head when the head is on the pillow.

A magnetic mattress pad is composed of mini-block magnets that are placed an inch and one-half apart throughout the pad.

The magnetic chair pad is composed of mini-block magnets placed an inch and one-half apart throughout the seat and the back of the pad.

The large multi-purpose pad is 14" x 25" and the small multi-purpose pad is 11" x 17". The pads are composed of mini-block magnets that are placed an inch and one-half apart throughout the pad. These multi-purpose pads have many uses such as being used on the back, the abdomen and up over the heart and the chest.

Optimum therapeutic value is obtained from a bed made of seventy 4" x 6" x 1" ceramic block magnets. Thirty-five magnets are placed in a wooden grid, 36" square. This grid of 35 magnets weighs 200 pounds. Two of these grids are placed end to end producing a bed 36" x 72". This bed can be placed on the floor, the bed spring or on top of the mattress. It will raise the bed about 2 or more inches high. Place a 2" eggcrate-type foam pad or other suitable futon over the magnet bed. Use this thin pad when treating metastatic cancer or systemic infections. When the bed is used for sleep, place it under a 4" mattress. The therapeutic value of this 70-magnet bed extends to 18".

A super magnetic head unit is composed of twelve 4" x 6" x 1" magnets in a wooden carrier surrounding the head. This provides an optimum negative magnetic field to the head for sleep. It is especially used for brain tumors, Alzheimer's, arteriosclerosis, post-stroke, brain infections and so forth.

The super magnetic hat is composed of thirty-four 1" x 1/8" neodymium disc magnets. This is for daytime use for any disorder of the brain. It is especially designed for brain tumors.

THERAPEUTIC SLEEP:

In maintaining health and reversing degenerative diseases, it is very important that there be deep, energy restoring sleep. It is necessary to sleep a full eight hours in every 24 hour period. Energy is used up during the day and is restored during sleep. The depth of energy restoring sleep is controlled by the hormone, melatonin, that is made during sleep. The principle area in which melatonin is made is the pineal gland which is in the center of the head. This gland makes melatonin in response to a negative (south-seeking) magnetic field. This is why it is so important to treat the head to a negative (south-seeking) magnetic field during sleep. The retina of the eyes also make melatonin and the intestinal wall makes melatonin. Treating these areas also raises melatonin. The hormone melatonin has the control of the entire energy system of the body including such as the immune system and the endocrine system.

Another hormone that is made during sleep is growth hormone which is made by the hypothalamus in the brain. Growth hormone has control over the health of skin, nails, cellular replication and also, respiration.

In order to achieve appropriate production of the hormones melatonin and growth hormone it is necessary to sleep in a completely light-free environment and without any 60 cycle per

second electrical pulsing frequency. Therefore, there should not be a night light, an electric clock, an electric heated blanket or a heated waterbed. If light cannot be completely excluded from the bedroom, then place over the eyes and the forehead a light shield.

The magnetic mattress pad will encourage the production of melatonin by the gastrointestinal tract. Any magnetic treatment of the abdomen will encourage the production of melatonin by the wall of the gastrointestinal tract.

The eyes make melatonin, therefore it is important to treat the eyes to maximize sleep. Melatonin offers therapeutic protection against eye injury because melatonin is a scavenger for free radicals. When sleeping with the magnets in the Vitality Sleeper where the magnets are placed in a carrier up against the headboard, this does treat the eyes. However, this can be materially increased by using a light shield with magnets attached to the light shield. The magnetic eye unit has a 1/2" x 1/16" small neodymium disc on the inside of the light shield directly over the eyes. On the outside of the light shield, two of the 1" x 1/8" neodymium disc magnets are attached. It is best to tape these down o the light shield. This same light shield is used to place magnets over the sinuses, both the maxillary sinuses and the frontal sinuses. The optimum treatment of the eyes occurs when the super magnetic head unit is used which contains twelve 4" x 6" x 1" magnets surrounding the head.

QUESTIONS AND ANSWERS
Q-WHAT IS THE DIFFERENCE BETWEEN A BAR MAGNET AND A FLAT PLATE MAGNET?

A bar magnet is a bar in which the magnetic poles are on opposite ends of the bar. This may be a straight bar or curved like a horseshoe but the essence is that the poles are on the opposite ends of a bar. Horseshoe magnets have been very popular because when you have both poles adjacent to each other you have a stronger holding force. Bar magnets are used to pick up metals and have a strong holding force. A flat plate magnet could be the same way if half of the magnet has separate poles on the same side. The magnets used to hold items on a refrigerator door are usually flat magnets with both poles on the same side. This is used because this is a stronger holding magnet than a single magnetic pole. The bar magnets are not used in therapy because you do not wish to have both magnetic poles on the same side. A

flat plate magnet has the magnetic poles on opposite sides of flat surfaces.

If you want to treat the head to improve sleep it is important to have a magnetic field that is a complete negative (south-seeking) field. This can be provided by having the negative (south-seeking) pole of magnets only facing the head and have them close enough together that when you are within two or three inches from this magnetic field, you have only the negative pole. A good way of providing this complete negative (south-seeking) magnetic field is to have four, 4" x 6" x 1" magnets placed 3/4" apart. It is important to have the magnets close enough together so when you are 1" or more away from the magnets you are in a complete negative (south-seeking) field. When treating a lesion, like a bruise, cut, infection, cancer, inflamed area, and so forth, it is important that the magnetic field be larger than the lesion being treated.

Q-WHAT IS THE RATIONALE FOR USING THE ELECTRICAL TERMS POSITIVE AND NEGATIVE RATHER THAN THE TRADITIONAL MAGNETIC POLE TERMS OF NORTH OR NORTH-SEEKING OR SOUTH OR SOUTH-SEEKING?

Navigators use small bar magnets as a compass. The end of the magnet that pointed toward the geographic north pole of the earth was designated as "North" and the compass needle that pointed to the geographic south pole of the earth was designated "South". Note that the orientation of naming the poles was that of the compass needle not that of the geographic north pole of the earth. This is confusing and was really named wrong since opposites attract and the compass needle pole that points to the north pole of he earth is, in actuality, south pole and the compass needle that points to the south pole of the earth is actually north pole. An attempt at correction of this fact was introduced years later in which the compass needle pointing to the north pole of the earth was called north-seeking pole and the compass needle pointing to the south pole of the earth was called south-seeking pole. These definitions serve their purpose well in terms of navigation and industry, however, when trying to relate this polarity to the physiology of the human body a translation of terms had to occur in which a parallel between the direct current circuits as used in the human body parallel these traditionally used terms defining magnetic polarity. A magnetometer is an instrument that can be used to identify the positive and negative pole of a direct

current circuit, the magnetic poles of the earth or a magnet. The magnetometer uses the electrical polarity definition of positive and negative. When you train the magnetometer on the north pole of the earth, it registers negative. When you train it on the south pole of the earth, it registers positive. The scientific literature does justify the use of the electrical definitions of poles as applied to static magnetic poles of a permanent magnet. In fact, a permanent magnet is made by a direct current circuit. The negative pole (-) passing through this magnetizable material produces a negative magnetic field (-qm, where "m" stands for magnetism). Some physicists not used to dealing with human physiology, are uncomfortable in this translation of terms simply because it is not the way they have usually made reference to magnetic poles. In my writings, I have purposefully used the electrical polarity terms of positive and negative rather than north-seeking and south-seeking so no translation is required when applying the magnetic fields to the human body.

Q-HOW CAN ONE DETERMINE THE NEGATIVE MAGNETIC FIELD OF A STATIC FIELD INDUSTRIAL MAGNET?

The recommended magnets are flat surfaced with magnets on opposite sides of the flat surface. The scientific instrument magnetometer is the ideal way to determine the magnetic poles. The magnetometer reads positive or negative. This is the electromagnetic definition of polarity and is equally applicable to the magnetic poles in an electric circuit and to the magnetic poles of a static field magnet, A compass can be used to make this determination. The compass needle that points to the north pole of the earth is the compass needle that identifies the negative field of a magnet. In terms of a navigational definition, this is the south-seeking pole since the true north pole of the earth seeks the south pole of the earth. The compass needle that points to the north pole of the earth is a south pole needle. It is termed the north-seeking pole of the compass needle. I advise that the deter- mination of magnetic poles be made by the use of a magnetometer.

Q-HOW CAN WE PROVIDE A FLEXIBLE MAGNET FOR USE ON CURVED OR IRREGULAR AREAS OF THE BODY?

The multi-magnet flexible mat is composed of small plastiform magnets. These are placed close together throughout the mat. This makes for a very flexible mat. The mats come in 5" x 6" or 5" x

12". The flexibility allows the mat to be placed around joints, shoulders, across the bridge of the nose, over the female breast and so forth. The magnets are padded which provides on the surface, a full negative magnetic field of 25 gauss. This can be reinforced by placing an iron oxide ceramic disc magnet or neodymium disc magnet on the mat, directly over the lesion. The disc should be placed with the negative pole placed on the positive pole of the magnetic mat. This provides for a large spread of the magnetic field around the lesion with a more specific, stronger field directly over the lesion. A 2" x 26" body wrap is provided which can hold this mat in place anywhere around the head, smaller joints or across the eyes. A 4" x 52" body wrap is provided for holding the magnets in place in larger areas such as across the abdomen, breast or heart. Shoulder straps can be placed on this body wrap when the mat is being held on the chest, across the breast or heart. The flexibility of this magnetic mat makes it valuable for placement anywhere on the body. The mat has Velcro on the positive pole side which will hook to the body wraps, which also have Velcro so the mat and body wraps will fasten together.

Q-WHAT ABOUT USING THE POSITIVE MAGNETIC POLE (TRADITIONAL NORTH-SEEKING MAGNETIC POLE) RATHER THAN THE NEGATIVE MAGNETIC POLE (TRADITIONAL SOUTH-SEEKING MAGNETIC POLE) AS HAS BEEN RECOMMENDED IN THIS WRITE-UP?

The entrance of energy medicine into medical science has initially been reflexology with acupuncture being a classic example. Magnetics (especially in Japan) has been used as a reflexology method using the positive (north-seeking) magnetic field or combined positive (north-seeking) and negative (south-seeking) magnetic field. This low level positive magnetic field evokes the brain to reflexly send a negative magnetic field to the area to counter the stress of the low gauss positive magnetic field. There are two limiting factors to the counter irritant (stress) reflex method such as 1) the symptom corrective response is dependent on the subject's internal energy and 2) counter irritant reflex fatigues on an average of about eight weeks at which time symptoms reemerge. On the other hand, a negative (south-seeking) magnetic field is always anti-stressful no matter how long the contact or how high the gauss strength and therefore, the response to the negative magnetic field is always predictably consistent.

MAGNETIC SLEEP PROTOCOL: ORIENTATION:

Sleep is a necessary aspect of biological life energy. The pineal gland response to a negative magnetic field is the production of melatonin. Melatonin drives sleep and governs the entire energy system of the body.

MAGNETS USED: Minimal sleep program:

Two ceramic discs, 1-1/2" x 1/2" with Velcro on the positive pole side. One 2" x 26" band.

Optimal sleep program:

Magnetic mattress pad composed of mini-block magnets that are 1-7/8" x 7/8" x 3/8" placed 1-1/2" apart throughout the bed pad.

Vitality Sleeper composed of four 4" x 6" x 1" magnets placed 3/4" apart in a wooden carrier that is up against the headboard. The magnets can be raised or lowered depending on the height of the pillow.

Maximal sleep program:

A 70-magnet bed. These magnets are 4" x 6" x 1". Each one weighs four pounds. Thirty-five of these are placed in a wooden grid that is 36" square. Two of these are placed end to end producing a bed 36" x 72". Each wooden grid with 35 magnets weighs 200 pounds, thus the total bed is 400 pounds.

Super Magnetic Head Unit. This is composed of twelve 4" X 6" X 1" magnetis in a wooden holder. There is a space for the head. The head is surrounded by these magnets.

PLACEMENT AND DURATION:

For the minimal sleep program, place the two discs on the head. These are placed bitemporally, that is at the front of the ears at the level of the front of the ears. This is held in place with the 2" x 26" band. This can be worn at night during sleep. It also can relieve symptoms during the day. The more hours of exposure, the better.

Optimum sleep program. The mattress pad is made of mini-block magnets that are 1-7/8" x 7/8" x 3/8" placed 1-1/2" apart. There are single and queen size beds. For the king-size bed use two of the singles. Sleep every night on this bed pad. Associated with this is sleeping with the Vitality Sleeper which has four 4" x 6" x 1" magnets in a carrier up against the headboard. They can be raised or lowered depending on the height of the pillow.

Maximal sleep program: Sleep on the 70-magnet bed pad. Place a 2" eggcrate-type foam pad over the mattress or other suitable

thin futon. Not only does this bed provide for optimum sleep but also it can treat metastatic cancer or viral infections. If it is not treating major illness, then it can be placed under a 4" mattress. At the same time that this bed is used, sleep with the super magnetic head unit. This super magnetic head unit, beyond encouraging sleep, is capable of treating brain tumors, brain infections, Alzheimer's and cerebral arteriosclerosis.

FINAL WORD

Human energy is restored at night during sleep and used up during wakefulness. Human life is composed of a wakeful period and a sleep period. The sleep period is necessary to make the wakeful period available. During the sleep/no light period, the adenosine triphosphate (ATP) is being made in excess of its use in metabolic functions. Each catalytic reaction producing ATP from food also produces a negative magnetic field. This cumulative negative magnetic field energizes enzyme catalysis.

Sleep raises growth hormone which controls many metabolic functions. Sleep is energy-driven by a negative magnetic field. Melatonin is produced by a negative magnetic field response of the pineal gland. Melatonin drives sleep.

SLEEP IS PRODUCED BY A RISE IN MELATONIN. THE PINEAL GLAND PRODUCES MELATONIN AS A RESPONSE TO A NEGATIVE MAGNETIC FIELD. HUMAN BIOLOGY LIFE ENERGY IS USED UP DURING THE WAKING PERIOD AND MADE DURING THE SLEEPING PERIOD.

The Interface Between Vitamin C & Magnetic Fields

Vitamin C facilitates the maintenance of a negative magnetic energy pool

ANN'S SUCCESS STORY

Ann has a chronic severe multiple chemical sensitivity. Marked weakness is a major symptom. She has faithfully pursued the systems of several expert environmental and toxicological specialists. She has found Far-Infrared Sauna therapy to be of appreciable value. When she added magnetic therapy, there was marked improvement in symptom reduction. A more optimal value is increased strength and reduced symptoms even when exposed to an assortment of chemicals when she sleeps on the negative field of a 70-magnet bed.

When on vacation away from her 70-magnet bed, her weakness and symptoms returned. Upon returning to the magnet bed, her

strength promptly returned and the symptoms faded. Her health requires the nightly use of the 70-magnet bed.

Ann's story is a case of chronic oxidoreductase enzyme toxin inhibition that cannot be managed by mere avoidance of the initiating chemical enzyme toxins but can be managed by a nightly negative magnetic field activation of her oxidoreductase enzymes.

The following is a letter that Ann wrote to me.

Re: The 70-Magnet Bed To whom it may concern,

My chemical sensitivities began back in 1983 and by the time I located Dr. Philpott for help in 1985, I had become a 'universal reactor'. After one year, eighty ozone IV's, a strict rotation diet, along with removal of my silicone breast implants, I still was very chemically reactive. The ozone had brought down my pesticide level considerably, as had EDTA chelation which removed much of the lead poisoning in my body, but still I could not function at all in 'the real world'.

This is when Dr. Philpott realized a new approach was needed and he began to investigate the possible use of magnets. I had instant success wearing them in the head band of my hat. From then on, I was at all times wearing magnets on various parts of my body as well as sleeping on twenty 4" x 6" x 1/2" magnets at night -- not too comfortable, but definitely symptom-relieving.

For many years, I managed to survive in this manner until Dr. Philpott invented the 70-magnet bed which changed my whole life, as now my entire body is captured nightly in a strong, healing magnetic field.

After three months, I was almost symptom-free of chemical and electromagnetic field sensitivities. However, I am still cautious about my diet -- an all organic rotation diet -- and walk three miles on the beach every day.

There is only one drawback to this treatment. When I leave the 70-magnet bed to stay at my house in the Bahamas, I do not do so well after a few weeks and must return early to rejuvenate myself again with strong, negative magnetic therapy. It works!

Ann Lloyd
Deerfield Beach, Florida

KARL'S SUCCESS STORY

Karl was a young man with the delusion that he was Jesus Christ and that his father was God, the Father. These delusions consistently developed when operating a propane fueled forklift in an en- closed apple cooler warehouse. In his psychotic state, he

was hospitalized in a psychiatric hospital where he became a party to a research program examining mental patient's development of symptoms on exposure to environmental substances such as foods, chemicals and inhalants. By the fourth day of avoidance of foods, chemicals and inhalants, he was mentally normal. A systematic blind exposure to car exhaust fumes and an array of other petrochemical sources all evoked his delusion of being Jesus Christ and of his father being God. Deliberate food testing of single foods evoked physical symptoms. Wheat evoked depression but only petrochemicals evoked his delusions.

His program consisted of avoidance exposure to petrochemical hydrocarbon sources and a four day diversified rotation of his foods along with optimization of his nutrition. He was symptom-free for a period of 18 years. When his neighbor tarred his roof with a hot, smelly tar, he again became psychotic. This time, he thought someone was trying to kill him and he was going to find them first. For several weeks, he was kept at home with two male attendants around the clock. The hope was that the symptoms would clear from his massive exposure to the petrochemicals in the tar from the neighbor's roof. He did not clear. Super neodymium disc magnets which are 1" x 1/4" were placed bitemporally. Within 10 minutes, his mental symptoms cleared. He carries these magnets with him and whenever he is exposed to petrochemicals such as car exhaust and feels himself becoming tense,

he places these disc magnets bitemporally and his symptoms disappear. His psychotic symptoms have never returned. It has now been eight years that he has been symptom-free.

His original hospitalization which reversed his original psychotic state cost $30,000. These two magnets cost $55 each. This time, his psychosis was reversed for $110.

Sharon's Success Story
Chronic Fatigue Syndrome

I wrote a magnetic research protocol for a woman who, for the past 20 years or more had been having a chronic fatigue syndrome episodically in response to petrochemicals, other chemical exposures or to common allergens. She had extreme episodes of weakness when she was unable to stand or even talk. She had described these as catatonic episodes although they did not have the mental disorder that is sometimes seen with catatonic episodes. A study in 1991 revealed a high titer to human herpes viruses #6, Epstein-Barr virus and rubella. I believed that her problems

stemmed from these viral infections and that her reactions to foods, chemicals and inhalants were secondary to the injury that had occurred from these viral infections. Of course, it was very important for her to avoid whatever she was reacting to. It was imperative that she follow a 4-Day Diversified Rotation Diet and that she also treat herself with magnets prior to eating foods. When she did have a symptom, she would treat her brain or any other area of her body that may have had a pain or malfunction with magnets.

Treatment Results

She sleeps on a 70-magnet bed composed of magnets that are 4" x 6" x 1" placed 1" apart. Thirty-five of these magnets are placed in two wooden carriers that are 36" square. When placed end-to-end, they make a single bed of 36" x 72". She rotates her foods. She uses Far Infrared sauna treatments also.

Her response to Far Infrared Sauna treatment has been most remarkable. Before the treatment, she was so weak that she could only whimper and was too weak to walk. Within 2 minutes of exposure to the infrared sauna, her strength returned. Using the magnet bed combined with the Far Infrared sauna treatments, she has made a remarkable recovery.

DYNAMIC FUNCTION OF ENZYMES
What Magnetic Therapy Is
What Magnetic Therapy Does

Magnetic therapy is the energy activation of enzymes. What Are Enzymes?

There are thousands of enzymes in the human body, each with a specific function. We digest our foods with enzymes. Enzymes are used to process the food as nutrition for the production of biological energy. Enzymes are composed of vitamins, minerals, amino acids and fats. When we are deficient in these building blocks of enzymes, diseases result. This is why nutrition is so important and has taken a central role in health maintenance and reversal of degenerative diseases.

What Are the Functions of Enzymes?

Enzymes have the ability to add electrons or subtract electrons without injury to the enzyme. Enzymes are either acid-dependent or alkaline-dependent. Most of the enzymes in the human body are alkaline-dependent. Only those in the mouth and the stomach are acid-dependent. Alkaline- dependent enzymes will not function in an acid medium. The acid is a toxin to alkaline-dependent

enzymes. Many of the toxins that inhibit enzyme function in the human body are acids. Examples are insect stings and reptile bites. Free radicals produce acids. Heavy metals produce free radicals. Many of the agricultural and industrial chemicals that we are exposed to form free radicals and thus form acids. Many enzymes in the human body are activated by adenosine triphosphates (ATP). Thus, they are designated as ATP-dependent enzymes. There are other enzymes in the human body that are not ATP-dependent. These are called oxidoreductase enzymes. The oxidoreductase enzymes are categorized according to their specific function. They are 1) dehydrogenases, 2) hydroxylases, 3) oxydases, 4) oxygenases, 5) peroxidases, and 6) reductases. The end result of these oxidoreductase enzymes is molecular oxygen and water. Four of these oxidoreductase enzymes are necessary for the production of ATP from food sources. These oxidoreductase enzymes process free radicals, acids, alcohols, aldehydes and peroxides. They not only produce energy in terms of ATP, they also handle the metabolic process of the end results of oxidation reduction. Their product is molecular oxygen and water which is not inflammatory.

How Enzymes Are Activated

Many enzymes in the body are activated by ATP which is made by oxidoreductase enzymes which are not ATP-dependent. Thus, oxidoreductase enzymes become the source of the ATP energy activation of many enzymes in the body. This ATP is not the only activator of enzymes but is a main source. A negative magnetic field will activate these enzymes and even these ATP-dependent en- zymes are activated by a negative magnetic field associated with the ATP. The substrate is identified as the substance that is being changed by the enzyme. There is an electromagnetic attraction between substrates and enzymes. However, this attraction is at areas termed dipoles. This attraction is not in itself capable of making the enzyme and the substrate join for the catalytic reaction. The mechanism by which oxidoreductase enzyme joins the substrate is through this dipole attraction moving static electrons that are inherently in us and around us. When the movement of electrons occur, a magnetic field is produced. In the case of oxidoreductase enzymes, this is a negative magnetic field. These are alkaline-dependent enzymes and in an alkaline medium it is a negative magnetic field that is formed. Magnetic therapy is that of providing an external source of a negative magnetic field which provides for the movement of electrons between the

enzymes and substrate so that a catalytic reaction occurs. This catalytic reaction can be the production of ATP from food sources. It can be the detoxifying value of free radicals and their product of peroxides, oxyacids, alcohols and aldehydes or external source of toxins which can be acids or any other substance that can turn into a free radical or an acid and thus become an enzyme toxin. The oxidoreductase enzymes process all of these enzyme toxins. When the toxic substances are in a heavy amount, they will block the oxidoreductase enzyme detoxifying capacity. By adding an external source of a negative magnetic field, this will activate the oxidoreductase to do their energy production of ATP and also activate their detoxification process. This is essentially what magnet therapy is. That is, it is activation of oxidoreductase enzymes to do their job of making ATP and detoxification. A negative magnetic field can activate an oxidoreductase enzyme that otherwise is overwhelmed, thus inhibited by the toxin.

There are enzymes that are acid-dependent. These acid-dependent enzymes are termed transferases. They are present in cancer, microorganism infections and inflammation. A negative magnetic field not only activates the oxidoreductase enzymes to make ATP and detoxify but also they block the acid-dependent transferase enzymes that are present in cancer, infections and inflammation. Thi is why a negative magnetic field application is so valuable in such a broad spectrum way which can reduce soreness, inflammation from any source, kill microorganisms that invade the body and kill cancer. The application of a negative magnetic field is a most remarkable therapy. A negative magnetic field is anti-stressful as shown by the electroencephalogram. Placing a negative magnetic field on the head can calm the brain down, stop major mental disorder symptoms, minor emotional symp- toms and reverse the brain response to toxins.

Unfortunately, for many years, medicine has ignored the fact that oxidoreductase enzymes need an activator. They considered if the enzymes were in adequate supply through nutrition that they would automatically function. This is not true. They have to have an energy activator. An external source of a negative magnetic field is the energy activator of oxidoreductase enzymes. We do not have to wait for the chance of the use of static electrons in the environment to activate these enzymes. We can do this with a negative magnetic field. Magnetic therapy is so effective in such a broad spectrum of situations that initially it sounds to most people

like a cure all. But, the fact is, it works in this broad spectrum of cases.

Magnetic Therapy, Pre-meal

The biological response to a negative magnetic field is that of alkaline-hyperoxia. The oxygen comes from the release of the oxygen that is bound in the many toxic substances. Thus, the application of a negative magnetic field is completely non-toxic and never produces any side effects. For years, I used soda bicarb and the breathing of oxygen to relieve symptoms when I had evoked them by deliberate food testing. Albert Roy Davis, Physicist, had demonstrated that the biological response to a negative magnetic field is alkaline-hyperoxia. This is what I was doing. I was alkalinizing the patient and providing them oxygen to breathe. Oxygen is always deficient in an acid medium. The symptom reactions to foods and chemicals were always associated with a demonstrated acidity in the blood. I found that using a negative magnetic field was even more predictable than the use of alkalinizing agents and the breathing of oxygen. Therefore, I changed from that of providing alkalinization and oxygenation to that of relieving the symptoms of a negative magnetic field. The symptoms of degenerative diseases are the same as the acute symptoms evoked during deliberate food testing. It is simply an extension in time of these same symptoms into a chronic state. I demonstrated that I could relieve the symptoms of acute maladaptive reactions during deliberate exposure testing. I then extended this to the relief of chronic diseases. Furthermore, I not only could relieve the acute symptoms evoked during testing exposure, but I could also put the same magnets on the head or other parts of the body for one-half hour before the exposure test and there would be no symptoms produced. Therefore, I have come up with a technique of exposing the subject to a negative magnetic field using discs for the brain and larger magnets for the heart and the liver. I do this negative magnetic field exposure before the foods are eaten on a rotation basis and thus symptoms are prevented. Originally, I would leave the symptom reactive foods out for a period of three months. 95% of the time, these could be returned to the diet on either a four or seven day basis without symptoms occurring. However, with the magnets, I can provide these magnets ahead of a meal and prevent the symptom from occurring, therefore, we go directly to a rotation diet of either a four or seven day basis with magnets ahead of the meals. By three

months, the desensitization has occurred and the foods can continue to be rotated without the magnets ahead of meals. However, if a person is going to eat a meal out and not pay attention to the rotation diet by using the magnets ahead of the meal, they can proceed without symptom production. This is really a very remarkable discovery.

SOURCES OF UNIVERSAL REACTIONS

A universal maladaptive reactor is a most miserable person, seemingly maladaptive reacting with symptoms to a large assortment of environmental contacts such as foods, environmental chemicals, environmental allergens, autoimmune reactions, infectious agents and so forth. They often present with multiple neurotic and physical symptoms. They present with overwhelming weakness, anxiety and fears that they will react as well as muscle, tendon, facial and joint pains. They have reacted so frequently, and often violently falling to the floor, that they live in a fear that they will react to some chemical or allergen. This is a most miserable state. The reactions are so universal that the physician doesn't know where to start to discover what he can do for his patient's relief. Instead of being dismissed as neurotic or sometimes even psychotic, this universal reactor deserves a broad spectrum study of the multiple factors that may enter into their miserable state.

A LIST OF DIFFERENTIAL DIAGNOSIS CONSIDERATIONS

Multiple food allergies
Multiple food addictions
Reactions to multiple foods, cosmetics and house heating systems
Car exhaust Pesticides Fabrics
Multiple infections, especially Epstein-Barr, cytomegalovirus or human herpes virus #6, Candida,
Lyme's disease
Low thyroid function with low temperature
Low adrenal function Autoimmunity Insomnia
Dehydration
Imbalance of essential fats Diabetes mellitus disease process

MALADAPTIVE FOOD REACTIONS

Allergic reactions to foods of the IgG type are frequent and often unsuspected. IgG has a delayed type of reaction in which when first contacting this food there is a relief state. Three or more

hours later, there is a symptom state. Because the very food to which they are allergic can give relief, it is unsuspected as the cause. I have run antibodies on thousands of cases demonstrating that these allergic food reactions are present, not just from the fact that we can isolate these food reactions after a five day fast but also the antibodies are there.

Food addiction without antibodies is very common. Both the food allergies and the food addic- tions are based on the frequency of contact so that either antibodies are formed or addiction without antibodies is formed. An addiction has the quality of initial relief followed by a withdrawal phase three to four hours later. There is no good way for the differentiation between food allergies and food addictions since they behave alike. It is quite likely that both qualities are present in allergies and addictions to the same foods, although we know you can have the addictive reactions without anti-bodies. The traditional allergy specialty has errored in missing the subject of food addiction and unfortunately even food allergies are often treated lightly. A desensitization process using injection therapy has little value in either food allergy or food addiction. Avoidance always works and should be the main treatment for consideration of food allergy and food addiction. Five days of avoidance of foods, or the five days could be only foods that are seldom used such as watermelon, fish or otherwise, reverses both food allergy and food addiction so that within an hour there is the emergence of symptoms when feeding this food as a single test meal. Associated with this is the emergence of acidity both demonstrated in the blood and saliva when symptoms occur. Therefore, we know this is an acidic state which would also be a low oxygen state. Acid-hypoxia is the result of a maladaptive reaction, be these allergies, addictions or toxicities. The treatment of choice is initial avoidance for three months and the setting up of either a four or seven day rotation of foods. In three months, 95% of the time, the foods can be returned to the rotation diet without symptoms emerging. Fortunately, I have discovered that treating the subject with a negative magnetic field ahead of the food used on a rotation basis can block the symptoms. In varying degrees, there emerges hyperglycemia with the food reactions.

Toxins are frequently in the foods. With our present day agricultural program, residual insecticide sprays can be in the foods. Certain foods inherently contain inflammatory reactions. The nightshade family which are tomatoes, potatoes and eggplant

contain inflammatory chemicals that when frequently used can set off inflammation. Foods containing fatty acids, some of which are inflammatory such as omega 6 or hydrogenated fats. It is easy to have an inflammation because of the imbalance of inflammatory omega 6 and anti-inflammatory omega 3 and omega 9.

MULTIPLE REACTIONS TO CHEMICALS Low Thyroid

Frequently, the subject with multiple reactions has a low thyroid with a resulting low temperature. Enzymes are not only pH-dependent, they are also temperature-dependent. Therefore, the person with low thyroid does not have optimum enzyme function. Often, there is no particular problem with the thyroid gland itself but it is a non-specific low thyroid function which relates to the chronic stress that the subject is under. Sometimes there is evidence of autoimmune reaction to this thyroid which is most likely based on a viral infection such as Epstein-Barr, cytomegalovirus, human herpes virus #6 or other infections. What we have interestingly observed is that when a total magnetic treatment is used, the thyroid would sometimes return to normal and the subject would have to go off of thyroid medication that they had been taking.

Low Adrenal Function

This is not classically Addison's disease but a stress reaction in which the adrenals become exhausted. This is secondary to, but a part of the universal symptom response syndrome. When the stress of the responses are reduced, adrenals have a chance to return to normal function. Also, adrenal function can be an autoimmune reaction. The magnetic treatment for this is a total body treatment of the super magnetic bed and super magnetic head unit. The adrenals can profitably be treated from anywhere from 5-15 minutes, not to exceed 30 minutes at a time. Place a 4" x 6" x 1/2" over each kidney/adrenal area using the positive magnetic pole. Do this in the morning before starting the day's work. Do this again in the early afternoon, if need be. The use of the positive magnetic field will stimulate the adrenals to pour out hormones and reinstate their function.

Infections

The universal reactor characteristically is carrying infections which is part of the problem. Not only the infections, but their toxins. The human herpes family of viruses is commonly present -- this is Epstein-Barr, cytomegalovirus or human herpes virus #6. These infect the immune system. These are lymphotropic

viruses and like lymphocytes. The B-lymphocytes make antibodies, therefore there is a disordered immune system in the presence of these infections. They are also neurotrophic and like neurones, therefore they affect the neurone system, both central and peripheral. These viruses do not die. Approximately 80% of the adult public have these viruses and many are suffering from the effects of these viruses. Even lymphoma cancers are known to be initiated by these viruses. They do make stealth adaptation in which the immune system no longer responds to them. They can be present and cultured even when the body has no antibodies. These viruses will die in the presence of a negative magnetic field. An example of this is shingles caused by herpes zoster which are the viruses that continue to survive after having chickenpox as a child. Often shingles does not appear until a person is in later years and the immune system is lagging. Treating directly over these viruses, wherever they are, such as on the rib cage and at the same time treating the thoracic spine where the viruses have been hiding in the neurones will kill these viruses and there is then no longer episodes of shingles occurring and there is no lingering neuralgia symptoms. Also, herpes simplex 1 occurring on the lips and herpes simplex 2 in the genital area can be treated the same way and once treated for about two weeks with magnets, there is no longer any more episodes of these viruses. To treat these viruses systemically, a super magnetic bed composed of the 4" x 6" x 1" magnets is used. These subjects frequently have Candida — women in the vagina and men or women in the low colon. Sometimes they invade the sinuses, sometimes the mouth and occasionally the lungs. These are all effectively treatable with a negative magnetic field. This is so effective there is no need for any medication to treat this or other fungal infection. We should always consider Lyme's disease. It gives multiple symptoms including weakness. There are other infections to con- sider.

Autoimmune Reactions

Autoimmune reactions should be considered. An ANA test is wise to do. Autoimmunity may affect the body in general but also, specific tissues may be affected. Sometimes the tissue involvement such as in lupus is not too prominent and even though they have the disease it cannot be particularly related to a classic tissue disorder. The treatment for autoimmunity is that of the super magnetic bed and head unit plus stopping the input of what may trigger the autoimmunity, particularly considering foods or

maladaptive reactions to chemicals and toxins, particularly chemical toxins.

Insomnia

Insomnia is often present in this general multiple maladaptive reactor. The treatment for insom- nia is of course, treating the disorder that may be isolated first of all, but also sleeping on the super magnetic bed and the super magnetic head unit.

Aches and Pains

Fibromyalgia symptoms are common. They are usually an expression of the infected state of the patient. Rheumatoid arthritis is often an expression of the infected state of the patient and the autoimmune state of the patient.

THE ROLE OF SYMPTOM REACTIONS TO CHEMICALS

My observations are that maladaptive reactions to environmental chemicals have a major role in producing the universal symptom reactor syndrome. It is necessary to have an ecological examination to consider all the possible exposures to chemicals. First, we look within the home itself. The rugs on the floor, the drapes on the windows, the paint on the walls, how the house is heated, and so forth. Many homes are heated with fossil fuels such as propane and natural gas. The furnaces are sometimes not properly vented. Our cars are fueled by gasoline and oils. Sometimes we have found a faulty exhaust system as a cause of a universal reaction to multiple chemicals. Petrochemicals are a major source of chemicals in our industrial world. We are now exposed to thousands of chemicals that our ancestors were not exposed to. Some of these being used in agriculture are not sufficiently biodegradable and they enter into the soils, polluting our water system. It is frightening to think of how many chemicals we are exposed to that our body has to process. These chemicals are enzyme toxins so it is easy to develop enzyme inhibited and enzyme hypersensitivity toxic states to these numerous chemicals. For years, formaldehyde has been a common source. In recent years, many of the foam pad products are now without formaldehyde. These sensitive reactors react to the resin of pine and cedar and sometimes other woods. We have to clean up our house, filtration of water is part of the answer, also the use of negative ions is an important method of cleaning up the chemicals i the house. Many of these chemicals are fat soluble and are not depleted in the body immediately. Appropriate nutrients, especially

large amounts of vitamin C can help clean the body of these chemical contaminants. A negative magnetic field is a major source of activating oxidoreductase enzymes so that these enzyme toxins are processed to non-toxic substances such as water and molecular oxygen.

THE ROLE OF TOXIC METALS

Toxic metals such as lead, aluminum and mercury needs to be considered. A hair test can indicate the body's load of toxic metals. There are appropriate chelating agents for removal of these toxic metals from the body. A negative magnetic field of the super magnetic bed of seventy 4" x 6" x 1" magnets has a powerful detoxifying effect for toxic metals.

LOCAL MAGNETIC THERAPY

The first use I made of negative magnetic field therapy is that of the treatment of local symptoms. My original treatment of local symptoms was that of baking soda for alkalinization and oxygenation.

I had demonstrated that maladaptive reactions to foods, chemicals and inhalants were particularly documented and, in relationship to foods, was that of acidity. This was demonstrated during deliber- ate food testing in which there had been a fasting period of water only for five days followed by deliberate exposure to single foods or single chemicals. Theron G. Randolph, M.D., Allergist had stated that these maladaptive reactions were acidifying. I confirmed that this was true. Albert Roy Davis, Physicist, had documented that the biological response to a negative magnetic field was that of alkaline-hyperoxia and the biological response to the positive magnetic field was acid-hypoxia. When I tested this out, I confirmed that this was true, therefore, I used a negative magnetic field to relieve the symptoms that had been evoked by deliberate exposure to a substance such as a food. I found this to be more predictable than the baking soda and the breathing of oxygen. Furthermore, I also documented that when you expose a subject to the magnets ahead of a test meal of a food to which the subject is known to respond, that they will not respond. Therefore, we could relieve the symptoms after they occurred but we could also prevent the symptoms from occurring.

A teenager who had attempted suicide, was diagnosed as schizo affective. Five days of fasting, her symptoms all cleared. When given a test meal of wheat, her affect became flat, she said she couldn't stand it in the test room with other patients, she had a

headache and was seriously depressed. Her suicide attempt had occurred after eating wheat. I took her to a room by herself, placed disc magnets on her head and a magnet down her spine. She fell asleep. Forty-five minutes later I woke her up and her symptoms were all gone. She returned to the test room with the other patients with comfort and her affect was normal. A week later, I placed the magnets on her head and the magnet down her spine as I had done to relieve the symptoms, then fed her the meal of her reactive food and she didn't have any symptoms.

A teenage boy with temporal lobe seizures in which he would become disoriented became disoriented when he was fed eggs. I relieved his symptoms with the disc magnets placed on his head. A week later, I placed the disc magnets bitemporally and fed him a meal of eggs and no symptoms occurred.

Originally, my use of magnets was to relieve or prevent acute symptoms in a test exposure situation. However, the symptoms of degenerative diseases are the same symptoms as the acute symptoms evoked during a test situation. The subject with a chronic degenerative disease was fasted. Their symptoms would either markedly abate or even disappear. Then the meals of single foods were given and the symptoms would emerge with specific foods. Therefore, the symptoms of acute reac- tions and of chronic diseases are the same. In the chronic diseases, the symptoms become chronic due to the chronic frequency of exposure. This could be pain, soreness, skin eruptions or hyperglycemia. I also determined that these foods could be due to IgG reactions. We always ran antibody studies on our subjects. There could also be addiction without antibodies. There could also be enzyme toxic reactions without antibodies. By this means, we found that there were many reactions missed by the allergists who were insisting on antibodies as evidence of a reaction. We had to look broader at reactions than the allergist-immunologist was doing. These non-immunologic reactions were just as serious as the immunologic reactions. The area of clinical ecology developed because the specialty of allergy and immunology was ignoring these non-antibody reactions. I now had established that acute symptoms could be relieved with a negative magnetic field and the chronic symptoms of degenerative disease could also be relieved with a negative magnetic field. I had developed the fact that symptoms could be prevented by treating with magnets ahead of exposure to the reactive substances. This changed the whole inability to prevent

a symptom ahead of time by exposure to a negative magnetic field and changed dramatically how we could proceed with setting up a rotation diet. Initially, we had left the symptom-producing foods out for a period of three months. By tha time, a desensitization had occurred whether this was allergy, addiction or toxicity. These foods could be returned to the diet on a 4 or 7 day rotation basis. Ninety-five percent of the time, the foods could be returned and the subject would remain symptom-free as long as they were rotated. By exposing the subject to the disc magnets placed bitemporally and the heart with the exposure to a 4" x 6" x 1/2" magnet and the liver to a 4" x 6" x 1/2" magnet prevents the subject from developing symptoms. Providing these magnets for 30 minutes ahead of a meal and preferably even also during the meal will characteristically stop the reaction. If per chance, which is infrequent, the exposure to the foods or chemicals did override the negative magnetic field, then these foods or chemical exposures should be left out of the diet for three months before reintroducing them. This has made it a lot easier for people at home helping themselves to set up a rotation diet. Many people prefer the 7 day rotation diet. This is outlined in my quarterly, *Metabolic Syndrome*.

SYSTEMIC EXPOSURE

Besides the local treatment where symptoms developed, we proceeded to develop a systemic treatment. First of all, this was a bed made of mini-block magnets that are 1-7/8" x 7/8" x 3/8" placed 1-1/2" apart. We also developed a head unit composed of four 4" x 6" x 1" magnets called a Vitality Sleeper. This was very useful in encouraging relaxation and sleep. However, it was not adequate to treat systemic infections or cancer.

The super magnetic bed composed of 4" x 6" x 1" magnets placed an inch apart making a single bed of 70 magnets was developed to treat systemic infections and metastatic cancer. I found this bed made of these large 4" x 6" x 1" magnets to be ideal for the universal symptom reactor. This bed treats every cell in the body. The energy system of the body is made by each cell, therefore exposing all the cells of the body which materially increases the energy production of each cell rendering the subject capable of outwitting their universal reactors. We still continue to treat locally as well as systemically. For example, if the person has sinusitis, it should be treated locally with the sinus/eye unit or with the super magnetic head unit.

The super magnetic head unit is composed of twelve 4" x 6" x 1" magnets. Four are stacked together on each side of the head and four are at the crown of the head. This is a wooden carrier with a space for the head. This space is such that the person can be either on their back or on their side. The head unit is very important as a part of this. It is such that it will treat the eyes and will treat the sinuses and upper part of the neck. These magnets are all negative pole facing the head. At first, we were concerned that maybe negative poles facing each other on each side of the head would cancel each other out. We found this not to be true and with many different trials of many different posi- tions, we found that this provided the most optimum treatment. This was originally invented to treat brain tumors but we found it to be optimal for anyone, especially including the universal symptom reactor.

The super magnetic hat unit is composed of thirty-four 1"x 1/8" neodymium disc magnets.

One layer of these magnets are sewn into the fabric of the hat. Extra magnets are attached to these that are sewn into the fabric. At night, they would sleep with their head in the super magnetic head unit of twelve of the 4" x 6" x 1" magnets and during the day they would wear this super magnetic head unit on their head. It is also being used for any other cerebral problems including Alzheimer's disease.

SUCCESS STORIES

Numerous subjects have been treated with the magnets ahead of a meal or ahead of an exposure to chemicals and have found it to be a highly successful method of preventing symptoms.

OPTIMIZED NUTRITION

The human organism is an electromagnetic organism functional in an alkaline-hyperoxic medium. The human body is an energy machine with each cell of the body making its own energy from nutrients. An external source of magnetism is necessary for this human metabolic energy machine to function. A reasonable nutritionally intact human organism will respond to an external negative magnetic field with a biological response of alkaline-hyperoxia capable of preventing and reversing inflammation, govern- ing tissue repair/healing, destroying invading microorganisms, destroying cancer and much, much more. Magnetism provides the energy for turning food into adenotriphosphate energy as well as detoxification of internal metabolic toxic products of metabolism and processing of exogenous

toxins from the environment. Magnetism provides the energy of life and thus acts on the framework of the human body. Magne- tism does not provide the human body biological frame. Only nutrition can be incorporated into the human body energy machine. When I describe the role of magnetic energy in the human body function, I am telling only half of the necessary story for optimum human function. The necessary other half is nutrition.

SOURCES OF NUTRITIONAL INFORMATION
Professional nutritionist.

The guidance of optimal nutrition by a professional nutritionist provides the greatest chance of optimal nutrition being provided. Scientific nutrition information is rapidly advancing and it is hard to keep up with all of this information for self-help alone. Everyone is ultimately responsible for gathering the knowledge from scientific information necessary for good health and reversal of diseases if and when they have developed. In some areas of nutrition your doctor will require a laboratory assessment to deter- mine if a nutritional disorder is present, particularly, such as B_{12} deficiency.

UNIVERSAL SYMPTOM REACTOR: ORIENTATION:

This magnetic protocol is for the treatment of the universal symptom reactor. These subjects have many allergies, addictions and toxicities to chemicals to which they are especially sensitive, even just a whiff of a chemical that they are reactive to can produce major symptoms such as marked weakness or even falling to the floor. It is hard for them to live in this world because there are so many chemicals in the environment. Exposure to petrochemicals is a major symptom producer for these universal symptom reactors. They often react to the fumes from the colors in fabrics, clothing, rugs or draperies. Avoidance should be as optimal as possible. Beyond this, use the magnets to relieve the symptoms. They need to sleep all night on the super magnetic bed and head unit. They need disc magnets that they can place bitemporally when needed. They should always carry with them these disc magnets and the band that holds them. As soon as they sense a reaction, they place these magnets on their head bitemporally.

MAGNETS USED:

Super magnetic bed composed of seventy 4" x 6" x 1" magnets. Thirty-five of these are placed in a wooden grid 36" square. Two of these wooden grids are placed end to end providing a bed 36" x 72". This is the size of a single bed. The total weight of this is 400 pounds. Over this place a 2" pad.

A 2" thick memory foam pad for a single sized bed.

Super magnetic head unit composed of twelve 4" x 6" x 1" magnets.

Two 4" x 6" x 112" ceramic block magnets with Velcro on the positive pole side. Two 4" x 52" body wraps.

Two 1-1/2" x 1/2" ceramic disc magnets with Velcro on the positive pole side. One 2" x 26" band.

PLACEMENT AND DURATION:

Sleep all night on the super magnetic bed and super magnetic head unit. For the first three months, it is wise for them to go back on this bed for one hour, four times a day during the waking period. The reason for this is to kill any viruses, bacteria or fungi.

Some with adrenal exhaustion benefit by placing the positive magnetic pole of a 4" x 6" x 1/2" magnet over each adrenal. This is usually placed on the backside over the kidneys. The duration is a minimal of five minutes and an optimum of thirty minutes. This could be done in the morning on awakening and may need to be repeated in the afternoon. The positive magnetic pole is a stress field which will activate the adrenals to produce their hormones.

Many of these subjects are overrun by Candida in the vagina or the low colon. It is wise to place a 4" x 6" x 1/2" magnet over the pubic area with the 6" lengthwise the body. Hold this in place with a 4" x 52" body wrap. Treat this area 24 hours a day for the first month of treatment.

Sinusitis is common and with this, the super magnetic head unit may suffice, otherwise, use the sinus/eye unit composed of a light shield with 1" x 1/8" neodymium disc magnets attached to this light shield. If this is used, treat the sinuses as many hours a day as possible until the sinusitis has been corrected.

Individual magnets are used wherever there are symptoms. These local areas could also be treated with a 4" x 6" x 1/2" ceramic block magnet while still on the bed.

It is imperative that they rotate their foods on a four or seven day basis. The 4-day and 7-day diversified rotation diet is described herein. The body is treated with magnets ahead of the meal as described below.

HOW TO USE THE FOUR DAY OR SEVEN DAY DIVERSIFIED ROTATION DIET

The essence of the Diversified Rotation Diet is that foods are rotated on a four or seven day basis, thus preventing their maladaptive reactions, be these allergies or addictions. Also, this

rotation diet will correct hypoglycemia and non-insulin dependent diabetes mellitus.

One method is to avoid food eaten twice a week or more for a period of three months, rotating all other foods. At the end of three months, then place these frequently used foods back into the diet, rotated once in four or seven days. This method is outlined in my quarterly, *The Ultimate Non- Addiction, Non-Stress Diet* and also in my book, *Magnet Therapy*.

Another method that is preferred by some is to start rotating all foods, even those that are eaten frequently. This can be achieved if the subjects will treat themselves to magnets for 15-30 minutes ahead of the meal. To achieve this, place the ceramic disc magnets bitemporally, that is in the front of the ears at the level of the top of the ears. These are held in place with a 2" x 26" band. The discs are ceramic discs that are 1-1/2" x 1/2". The negative magnetic field is always placed toward the body.

On the positive magnetic field side, there is hook Velcro that will hook to the band around the head and hold these in place. At the same time, place a 4" x 6" x 1/2" magnet on the heart with the 6" lengthwise the body. Hold this in place with a 4" x 52" body wrap. Also, place a 4" x 6" **x 1/2"** magnet with the 6" lengthwise the body over the liver area which is on the right side of the body with half of the magnet over the rib cage and half below the rib cage. Hold this in place with a 4" x 52" body wrap. The minimum time of exposure should be 15 to 30 minutes or more before each meal. With this method, there is no avoidance period of the commonly used foods.

After three months of rotation, there is little likelihood of a maladaptive reaction to a food without the magnets before the meal. Whenever purposely violating the rotation diet such as eating out , then use the magnets ahead of a meal.

. BEYOND MAGNETISM:

Acute maladaptive reactions to foods, chemicals, inhalants or stress frequency pulsing fields has been documented as producing a brief state of acid-hypoxia. In this state, there is a production of acid and a failure to process properly the end-products of oxidation phosphorylation metabolism. In this state of acidosis, oxygen content is reduced. Maladaptive reactions to foods are the most fre- quent cause of bouts of acidosis. Degenerative diseases are noted for their acid-hypoxic state. Therefore, every effort should be made to maintain a normal alkaline and normal oxygen state.

A majority of people are maladaptively reacting in one or more ways to foods, thus producing bouts of acidosis and reduced oxygen. It is the better part of wisdom to follow a 4-Day or 7-Day Diversified Rotation Diet. This program leaves out foods that are used as frequently as twice a week or more for a period of three months. This is based on the assumption that these foods are being reacted to in some maladaptive way. It is the frequency of the use that produces the maladaptive reactions. A 4-Day or 7-Day Diversified Rotation Diet is set up to leave out these frequently used foods. After three months, these frequently used foods can

UNIVERSAL SYMPTOM REACTOR TO AN ASSORTMENT OF ENVIRONMENTAL CHEMICALS AND STRESS-LEVEL PULSING MAGNETIC FIELDS ORIENTATION:

This protocol is for exquisitely sensitive subjects to both an assortment of environmental chemi- cals and environmental stress-level pulsing frequencies. Thirteen cycles per second is the dividing line, dividing pulsing frequency between stress and non-stress. Below 13 cycles per second is a non- stress and anti-stress level of pulsing frequency. Above 13 cycles per second is a stress pulsing field. The EEG demonstrates this. A base line is a non-stress base line below the 13 cycles per second. In thinking and motor activity and so forth, we make excursions into the higher stress level pulsing fields and then revert back to the non-stress level and in fact at night, we maintain this non-stress level even with a brain pulsing frequency of 2 cycles per second in deep sleep. Thinking and motor activity is 22 cycles per second. We make excursions into this but always revert back below the 13 cycles per second and we have to maintain this at night in order to get our energy back. It is the non-stress level that makes adenosine triphosphate and a negative magnetic field termed oxidative rem- nant magnetism. We have to not maintain for long periods of time, the stress level frequency, but we have to revert back to the non-stress level in order to recover our energy. These oxidoreductase enzymes also have the assignment of processing all the toxins. When they are functioning low, we cannot process all our toxins or we cannot offset the stress of the chronic stress-level pulsing fields that we are exposed to. The answer for this is to maintain a high level of non-stress during sleep or at any other time that we may need this during the day.

MAGNETS USED:

Super magnetic bed composed of 70 magnets 4" x 6" x 1". Thirty-five of these are placed in a wooden carrier, 36" square. Two of these wooden carriers are placed end to end producing a bed 36" x 72". Place over this a 2" pad. The memory foam pad is best for comfort.

A, super magnetic head unit composed of twelve 4" x 6" x 1" magnets in a wooden carrier. Two ceramic block magnets that are 1-1/2" x 1/2". These are ceramic block magnets. One 2" x 26" band.

Two 4" x 6" x 1/2" ceramic block magnets with Velcro on the positive pole side. Two 4" x 52" body wraps.

An additional value can be obtained from negative ions in both water and air.

PLACEMENT AND DURATION:

Sleep all night on the super magnetic bed and the super magnetic head unit.

For the management of any symptoms occurring during the waking period, place the ceramic disc magnets bitemporally. Hold in place with the 2" x 26" band.

GENERAL INFORMATION ABOUT THE 4-DAY DIVERSIFIED ROTATION DIET

The essence of the 4-Day Diversified Rotation Diet is that foods are rotated on a four or seven day basis, thus preventing their maladaptive reactions, be these allergies or addictions.

One method is to avoid food eaten twice a week or more for a period of three months, rotating all other foods. At the end of three months, then place these frequently used foods back into the diet, rotated once in four or seven days.

Another method that is preferred by some is to start rotating all foods, even those that are eaten frequently. This can be achieved if the subject will treat themselves to magnets for 15-30 minutes ahead of the meal. To achieve this, place the ceramic disc magnets bitemporally, that is in the front of the ears at the level of the top of the ears. These are held in place with a 2" x 26" band. The discs are ceramic discs that are 1-1/2" x 1/2". The negative magnetic field is always placed toward the body. On the positive magnetic field side, there is hook Velcro that will hook to the band around the head and hold these in place. At the same time, place a 4" x 6" x 1/2" magnet on the sternum with the 6" lengthwise the body. Hold this in place with a 4" x 52" body wrap. Also, place a 4" x 6" x 1/2" magnet with the 6" lengthwise the body

over the liver area which is on the right side of the body with half of the magnet over the rib cage and half below the rib cage. Hold this in place with a 4" x 52" body wrap. The minimum time of exposure should be 15 to 30 minutes or more before each meal and are to be continued during the meal. With this method, there is no avoidance period of the commonly used foods.

NEGATIVE ION HOUSEHOLD AIR TREATMENT

The biological response to negative ions and negative magnetic fields are the same. The biological response to negative ions and a negative magnetic field is alkaline-hyperoxia. Alkaline-hyperoxia is anti-inflammatory, anti-stress, antibiotic, energizing and aids in healing. Negative air ions plus a small amount of ozone in the air cleans the air from dust, microorganisms, pollen, smoke, chemicals, odors and so forth. Negative ions in the air clean up the environment whereas a negative magnetic field is used on the body to achieve the same values inside the body. Thus, negative air ions, negative water ions and a negative magnetic field are complementary and should be used together to achieve optimum results.

ELECTROMAGNETIC STRESS PULSING FREQUENCY SUCCESS STORY

A woman had multiple emotional and physical symptoms. She lived next to a transformer. When placed on a magnetic bed and with magnets treating her head, all her emotional and physical symptoms disappeared.

FINAL WORD

Universal reactions to foods, environmental chemicals and inhalants is a most miserable state. The universal reactor can hardly exist in this world. The symptoms are so numerous and pervasive that the physician doesn't know where or how to start helping his patient. The good news is that a negative magnetic field energy activates enzymes that have a universal value in symptom relief of the universal symptom reactor.

HORSE AND BUGGY ENERGY MEDICINE VERSUS ELECTROMAGNETIC FREE ENERGY MEDICINE

The invention of the wheel was a great invention in its day. Mankind now had wheel barrels and scooters. Harnessing the energy of a horse to a wagon was another great invention which served mankind well for thousands of years. It is true that our grandparents moved west by horse and buggy. Two generations later, *we* fly all over the world. Transportation has advanced from

an original wonderful achievement to a new marvelous achievement.

This marvelous achievement of the electromagnetic industrial age has occurred because of the achievement of harnessing the movement of electrons. We no longer just wonder at the electromagnetic energy of lightening, tornados, cyclones and anti-cyclones which, in the northern hemisphere spin counter-clockwise and in the southern hemisphere spin clock-wise. Mankind has learned to harness the energy of movement of electrons. We make magnets with the flow of electrons and we give direction to the flow of electrons with magnets. We have learned to trust the predictableness of the movement of electrons with magnetic fields. We live in a virtual sea of electrons in the space around us as well as the space within us. Mankind is an electromagnetic organism. The magnetic movement of free energy electrons within us is an integral aspect of biological life energy. Human life does not exist apart from magnetism. Have we missed something in medicine that the electromagnetic industry has captured? Yes, we have! We have failed to capture the free magnetic energy available to us. The same degree of predictableness exists in biological systems exposed to magnetic fields as it does in electric non-biological systems.

Therapeutic medicine is barely entering the threshold of free magnetic energy use. We nourish our bodies but we still wait for some mysterious life energy to spontaneously heal us. Magnetic therapy can change the speed of healing from the horse and buggy level to an equivalent level of flying. The movement of electrons between enzymes and substrates produces a magnetic field which attaches the enzyme and the substrate. With the magnetic energy medicine, electrons are magnetically harnessed to move between enzymes and substrates. The secret of magnetic therapy is that this free magnetic energy can be supplied from a static field magnet providing the energy activation of the enzymes so that a catalytic reaction occurs. A static negative magnetic field alkalinizes and energizes, such as the alkaline-dependent oxidoreductase enzymes family of enzymes. These oxidoreductase enzymes are responsible for producing some of life's energy (ATP and catalytic remnant magnetism) as well as processing inflammatory toxic substances that threaten life energy. A positive magnetic field energy blocks these enzymes from functioning. The essence of magnetic therapy is the predictable movement of free energy field static electrons

by a free energy static magnetic field in a biological system producing predictable biological responses.

Magnetic therapy is at this threshold of moving therapeutic medicine from the horse and buggy low level efficiency, slow speed energy function into a high efficiency speed energy function equivalent to flying and computer efficiency functions.

REFERENCES

BECKER, ROBERT 0. "Cross Currents". Jeremy P. Tarcher, Inc. Los Angeles, CA, 1990. BECKER, ROBERT O. and SELDON, G. "The Body Electric. Electromagnetism and the Foundation of Life." William Morrow and Company. NY. 1986.

BECKER, ROBERT O. and MARINO, A. "Electromagnetism and Life". State University of New York Press; Albany, NY 1982.

BELANEY, B. The New Encyclopedia Britannica, 1986. Vol VIII, pp 274-275. BRAUNWALD, Eugene. Harrison's Principles of Internal Medicine. 11th edition 1987. McGraw-Hill Book Company, NY.

DAVIS, A.R. and RAWLS, W. "The Magnetic Blueprint of Life.". Acres USA, Kansas City,MO, 1979.

DAVIS, A.R. and RAWLS, W. "The Magnetic Effect". Acres USA, Kansas City, MO 1975

DAVIS, A. R. and RAWLS, W. "Magnetism and Its Effect on the Living System". Acres USA, Kansas City, MO 1976.

FLANIGAN, PATRICK and FLANIGAN, GAEL AND CRYSTAL. Earthpulse Press New Test Number One.

FRESHT, Alan., *Enzyme Structure and Mechanism* Second Edition. W.H. Freeman and Co. New York, New York. 1994

KLONOWSKI, W and KLONOWSKI, M. Journal of BioElectricity. Aging Process and Enzymatic Proteins. 4(1), 93-102 (1985).

LEVY, THOMAS E, M.D., J.D. *Vitamin C, Infectious Diseases, & Toxins. Curing The Incurable.* Xlibris Corporation.

Magnetic Fields in Enzyme Catalysis. Encyclopedia Britannica. Vol 15. Pg 1068. Chicago, IL 1986.

NORDENSTROM, BEW, Biologically Closed Electric Circuits. Stockholm, Sweden: Nordic Medical Publications, 1983.

NORDENSTROM, BEW, "Electrochemical treatment of cancer; variable response to anodic and cathodic fields". Am J. Clin Oncol, 1989: 12:530-536.

NORDENSTROM, BEW, "Survey of mechanisms in electrochemical treatment (ECT) of cancer". Europ J. Surg. Suppl. 1994: 574:93-109.

NORDENSTROM, BEW, "Biokinetic impacts on structure and imaging of the lung: the concept of biologically closed electric circuits". Am J Roentgenol. 1985; 145:447-467.

O'CLOCK, G.D., "Studies of the effects of in vitro electrical stimulation on eukaryotic cell proliferation".MA Thesis (Biological Sciences) Mankato State Univ, Mankato, MN 1991.

O'CLOCK Jr G.D., & Lyte, M., "Potential uses of low-level direct current electrotherapy for the treatment of cancer". Proceedings of the 15th Annual International Conference of the IEEE Engineering in Medicine and Biology Society, San Diego, CA, Part 3: 1993; 1515-1516.

PHILPOTT, W.H., M.D. and KALITA, Dwight, Ph.D., *Victory Over Diabetes: A Bio-Electric Triumph.* Keats Publishing Company, Inc. New Canaan, CT. 1982

PHILPOTT, W.H., M.D. Magnetic Health Quarterly, *Diabetes Mellitus, Vol* III, Second Quarter, 1997.

PHILPOTT, W.H., M.D. and KALITA, Dwight, Ph.D., *Brain Allergies. The Psycho-nutrient and Magnetic Connections.* Updated second edition. Keats Publishing NTC/Contemporary Publishing Group. Los Angeles, CA , 2000.

PHILPOTT, W.H., M.D. and KALITA, Dwight, Ph.D., *Brain Allergies,* updated second edition. Keats Publishing NTC/Contemporary Publishing Group, Los Angeles, CA 2000 PHILPOTT, W.H., M.D. and KALITA, Dwight, Ph.D., *Magnet Therapy.* (Tiburon, CA: Alternative Medicine. corn, 2000)

POTTS, JOHN, Journal of Diabetes. Avoidance Provocative Food Testing in Assessing Diabetes Responsiveness." 26:Supplement 1, 1977.

POTTS, JOHN, Journal of Diabetes. 'Value of Specific Testing for Assessing Insulin Resistance." 29: Supplement 2, 1980.

POTTS, JOHN, Journal of Diabetes. "Blood Sugar-Insulin Responses to Specific Foods Versus GTT." 30:Supplement 1, 1981.

POTTS, JOHN, Journal of Diabetes. "Insulin Resistance Related to Specific Food Sensitivity." 35: Supplement 1, 1986.

RANDOLPH, T.G. *The Enzymatic and Hypoxia, Endoctrine Concept of Allergic Inflammation*
Clinical Ecology. pp 577-596. Charles C. Thomas, Publisher, Springfield, Illinois. (1976).

STEIN, Jay H. *Internal Medicine.* 4th Edition. 1994. P. 340-524. Mosby Publishers. St. Louis. TRAPPER, ARTHUR, et al. "Evaluating Perspectives on the Exposure Risks from Magnetic Fields",
Journal of the National Medical Association, 82:9, September 1990.
WARBURG, O., The Metabolism of Tumors. F. Dickens (Trans) London: Arnold Constable: 1930. WARBURG, O., On the Origin of Cancer Cells. Science 123 (1956) 309-315. WARBURG, O. " The Prime Cause and Prevention of Cancer". Revised lecture at the meeting of the Nobel laureates on June 30, 1966. National Cancer Institute Bethesda, MD.1967
[*Magnetic Health Quarterly* "Universal Sensitivity Reactions" Vol. IX, 4th Qtr, 2003]

THE INTERFACE BETWEEN ASCORBIC ACID AND MAGNETIC FIELDS

Catalytic reactions occur when dipoles of a substrate and the enzyme join so the enzyme can transfer electrons in the substrate by either adding or subtracting electrons from the substrate. Enzymes can either receive or give electrons without destroying the enzyme. Adenosine triphosphate (ATP) is an energy activator for ATP-dependent enzymes which are a substantial number of human metabolic enzymes for their numerous jobs. Oxidoreductase enzymes are not ATP-dependent in oxidoreductase enzyme catalysis static electrons are activated between the dipoles of enzyme and substrate. Ascorbic acid is also an available source of electrons beyond that of static electrons for catalysis. Therefore, the quantity of ascorbic acid helps determine the speed of the catalytic reaction. When electrons move between the enzyme and the substrate, a magnetic field is produced. This magnetic field is called oxidative remnant magnetism and is measurable as evidence of a catalytic reaction. In an alkaline medium, alkaline-dependent enzyme catalysis produces a negative magnetic field. In an acid medium, acid-dependent enzyme catalysis produces a positive magnetic field. A magnetic field is always present as the final state of enzymes and substrate joining for catalysis. This is why an external magnet force can be used to produce a catalysis. A negative magnetic field produces alkaline-hyperoxia. The positive magnetic field produces acid-hypoxia. Human metabolism requires alkaline-hyperoxia. Invading microorganisms and cancer require acid-hypoxia. Ascorbic acid supports the alkaline-

dependent oxidoreductase enzyme functions and stops the acid-dependent fermentation function. Ascorbic acid and a negative magnetic field are complementary and should be used together. The higher the quantity of vitamin C, the more available the electrons are for catalysis of alkaline-dependent enzymes.

It is recommended that ascorbic acid be taken as an ascorbate. In an ascorbate, ascorbic acid is joined to an alkalinizing mineral such as sodium, potassium, phosphorus and so forth. Six to eight grams should be considered. 4000 mg equals one gram. The higher the quantity of ascorbic acid, the better. Intravenous ascorbates function more optimally than oral ascorbates. Ascorbates and negative magnetic fields independently can often achieve the same goal in some instances. However, combin- ing ascorbates and a negative magnetic field provides optimal catalytic function and therefore, should be combined for the complementary effect.

ASCORBIC ACID AS A VITAMIN AND AS A COFACTOR ENZYME

1. It is a vitamin preventing or effectively treating scurvy.

2. As a coenzyme, it can receive electrons or give electrons without destroying its value.

3. It makes available electrons along with available static field electrons for enzyme catalysis of oxidoreductase enzymes and other alkaline-dependent enzymes.

4. Through the method of electron contribution to alkaline-dependent enzyme catalysis, it becomes a party producing the negative magnetic field's final step in the catalytic reaction.

5. It's electron movement in alkaline-dependent enzyme catalysis contributes to the necessary reservoir of a negative magnetic field.

6. When it contributes an electron to alkaline-dependent enzyme catalysis, producing a negative magnetic field, it contributes to the maintenance of the biologically necessary alkalinity due to the fact that alkaline-hyperoxia is the biological response to a negative magnetic field.

7. As an antioxidant it prevents the development of toxic chemical species such as peroxides, oxyacids, alcohols and aldehydes.

8. Thus, it contributes to alkalinity whether ingested as an acid (ascorbate acid) or an alkali mineral ascorbate.

9. It is an anabolic regulator of over-expressed catabolism.

BOWEL TOLERANCE OPTIDOSING OF ASCORBATE

Multiple mineral ascorbate. There are several multiple mineral ascorbates available. They contain ascorbates with calcium, magnesium and potassium and some also have chelates of zinc, manganese and copper. These are used to provide multiple minerals as well as ascorbate of the minerals.

Sodium ascorbate

Calcium ascorbate

1 teaspoon of calcium or sodium ascorbate equals 4000 milligrams (1 gram). Method:

Start with 1 teaspoon of multiple ascorbates two times per day. Add to this, calcium ascorbate at one teaspoon doses. Calcium ascorbate can be given up to a total of six teaspoons a day. Beyond this, use sodium ascorbate in teaspoon doses until there is a soft-formed stool. Provide this in four doses a day. This can be either given before or 30 minutes after a meal. Each day, keep adding two teaspoons of ascorbate until the desired dose of a soft-formed stool occurs. When the stress of an acute infection occurs, there would be a need to increase the ascorbate to handle the toxicity of the stress of the infection. Cancer patients would require substantial doses, sometimes even up to 30, 40 or 50 grams a day. Oral ascorbates can do much to handle the toxicity of cancer but are not capable of maintaining a cancer remission.

ASCORBATE FLUSH

Ascorbate flush is preferred to an enema, a colonic or a coffee enema. This is achieved by using sodium ascorbate. Using three teaspoons in 1/4 to 1/2 glass of water every 15 minutes until a colon flush occurs. Do this on an empty stomach the first thing in the morning before breakfast.

VALUES OF VITAMIN C INTRAVENOUSLY

Vitamin C intravenously achieves a significant value beyond that of oral vitamin C. This can be given in either small or substantial doses of 50 grams or more a day or even more than once a day. This has been shown to work quite effectively for an acute infection with a fever. Often the fever will be normalized within 3-4 days and the acute infection has evidence of stopping. For chronic infections or cancer, this should be given daily in substantial doses for 6-8 weeks. I have extensive experience in the use of Vitamin C, both orally and intravenously. My finding is that intravenous vitamin C did cause cancer to go into remission. However, vitamin C intravenously at 50 gram doses had to continue at 50 gram doses every two weeks in order to

maintain the remission. When the vitamin C was stopped at two week intervals and bowel tolerated doses continued, the subjects still had a return of their cancer from which they died. My experience with negative magnetic field treatment of cancer is quite different. Cancer will die and no return will occur. Combining vitamin C and the negative magnetic field therapy are complementary.

"Everybody requires an optidosing of vitamin C on a daily basis to reach and maintain optimum health." Thomas E. Levy, M.D.

Vitamin C Infectious Diseases & Toxins by Thomas E. Levy, M.D. Xlibris Corporation, 1-888- 795-4274

THE ROLE OF VITAMIN C IN MAINTAINING LIFE'S ENERGY MAGNETIC FIELD

Albert Szent-Gyorgyi confirms Otto Warburg's observation of cancer being a fermentation process and H. Goldblatt's observation that lack of oxygen induces a malignant transformation cell. The movement of electrons in the biological body is a necessity for biological health. The enzymatic role of vitamin C is the facilitation of movement of electrons in the biological body. Vitamin C both receives and gives electrons as the need may be. Thus, vitamin C helps maintain the necessary magnetic field of life energy. The movement of electrons produce a magnetic field. Magnetic fields in turn, give direction to the movement of electrons. The human body as a reservoir of magnetism produced by catalysis. Since the catalytic reaction moves electrons, its final step is magnetic. Magnetic field movement of electrons is the final common pathway of life energy. This is why an exogenous negative magnetic field is a universal energy, maintaining health and a reversal of degenerative diseases, infections and cancer.

Albert Szent-Gyorgyi was seeking to discover the cell proliferation regulators because he had discovered that cancer results from a disorder of cell proliferation regulators. He knew this occurred in hypoxia. He knew that this had to be electronic however he had not discovered that the negative magnetic field is a regulator over the positive magnetic field and energizes all the biological regulators of the body. We now know that this is the negative magnetic field that he was seeking. "When we find this, we will have an answer to the reversal of cancer". Now, we have the evidence that it is the negative magnetic field that he was seeking.

Cancer cells ATP production by transferase enzymes is acid-hypoxic dependent. WARBURG, O., On the Origin of Cancer Cells. Science 123 (1956) 309-315.

Cancer results from a disorder of cell proliferation regulators such as occurs in hypoxia and oxidoreductase enzyme inhibition. SZENT-Gyorgyi, ALBERT. *Electronic Biology and Cancer. A New Theory of Cancer.* 1976. Marcel Dekker, Inc. NY, NY 10016

Vitamin C contribution to the maintenance of a magnetic field in living biological systems. Szent-Gyorgyi, A. 1980. The living state and cancer, *Physiological Chemistry and Physics.* 12(2): 99-110.

Lack of oxygen induces a malignant transformation in cell culture. GOLDBLATT, H., and CAMERON, G. (1953), J. Exp. Med., 97:525-552; GOLDBLATT, H., FRIEDMAN, L., and CECHNER, R.L. (1973), Biochem. Med.. 7:241-252

Chronic Progressive, Insidious, Low-Intensity Epstein-Barr Virus and/or Cytomegalovirus Encephalitis as causes of childhood: Autism, Attention Deficient Disorder, Hyperactive Disorder, Lethargy Disorder, Obsessive-Compul- sive Disorder, Tourettes Syndrome Disorder, Mirror Imaging Disorder, Some Seizure Disorders, Some Development Disorders, Progressive to Adult: Schizophrenia Disorders, Bipolar Disorders, Non-Psychotic Depression Disorder, ;with Chronic Fatigue & Fibromyalgia Pain.

I HAVE DOCUMENTED A CHRONIC, INSIDIOUS, SLOWLY PROGRESSIVE VIRAL ENCEPHALITIS SYNDROME AS A CENTRAL CAUSE OF CHILDHOOD AUTISM AND LEARNING AND BEHAVIORAL DISORDERS, PROGRESSING TO ADULT SCHIZOPHRENIA AND BI- POLAR DISORDERS.

THE GOOD NEWS IS THAT A NEGATIVE MAGNETIC FIELD WILL KILL VIRUSES, BACTERIA, FUNGI AND PARASITES AND THUS STOP THE PROGRESSION OF BRAIN INJURY FROM THESE INVADING MICROORGANISMS. THE GOOD NEWS IS THAT ONCE THE ORGANISMS ARE KILLED AND THE IMMUNOLOGIC REACTIONS, ADDICTIVE REACTIONS AND TOXICITIES ADEQUATELY TREATED, THE SUBJECT IS THEN TRAINABLE WITH NEW APPROPRIATE SOCIAL, BEHAVIORAL AND LEARNING SKILLS. THIS PROGRAM IS HIGHLY EFFICIENT.

From Autism to Artistic Genius

Larry was diagnosed at the University of Oklahoma in Oklahoma City as autistic when he was age 5. His father and mother are both physicians. Larry had every possible advantage of both medical science and education. He came to me at age 18. What I have found is that there is a spectrum of organic brain disorders from minor such as attention-deficit, hyperkinesis, dyslexia, autism, to major mental symptoms such as schizophrenia and manic depressive. These are all simply degrees of the same brain disorder. I have found all of these brain disorders to be infected with viruses. The viruses that we have consistently found are the herpes family viruses such as Epstein-Barr, cytomegalo and human herpes virus #6. These viruses do not die spontaneously. There are not any antibiotics that will kill them. These viruses injure the brain and the illness is progressive. All children infected with these viruses are candidates for the development of schizophrenia or bipolar disorder in their 20's. Maladaptive reactions to foods and to a lesser degree, inhalants, is a secondary phenomena in which when a reaction occurs, the brain is the target organ for symptom production because it has a state of injury.

This case demonstrated:

1) The progression from autism from age 5 to schizophrenia by age 18.

2) Evoked symptoms cleared with a five day fast while learned symptoms continued.

3) Symptoms were precipitation by maladaptive reactions (allergies, addictions and toxicities) to foods during deliberate food and chemical testing.

4) Symptom relief by avoidance of symptom-evoking foods.

5) A return of initial symptom-evoking foods without symptoms after three months of avoidance.

6) All foods rotated.

7) Negative magnetic field relief of symptoms.

8) Use of a negative magnetic field brain placement along with relaxation to train out learned responses that have developed out of this symptom-evoking viral infection. This demonstrates the capacity to learn new social and learning new behaviors after the symptoms have been relieved by initial avoidance and later spacing and magnet therapy treatment during the behavioral training sessions.

Viral Encephalitis Syndrome

MY DISCOVERY OF CHRONIC PROGRESSIVE HERPES FAMILY VIRAL ENCEPHALITIS SYNDROME

Starting in 1970 through to 1990, I did a research project on my mental patients which were largely schizophrenics with a few manic-depressives as well as non-psychotic depression and obsessive-compul- siveness. I examined them broadly for their nutritional needs, their toxic state and their infected state. I did cultures on my patients and did antibody studies for systemic infections. I found a wide assortment of candidates for brain injury to my patients. However, the most striking evidence was the presence of antibodies to Epstein-Barr, cytomegalovirus and sometimes also to human herpes virus #6. Consistently, my patients with psychosis and the children with attention deficit disorder, hyperkinetic disorders, obsessive compulsive disorders, autism, Tourette's syndrome, dyslexia and mirror imaging had antibodies to these herpes family viruses. This was consistent no matter what their age. Whereas in the non-psychotic and those without behavioral and learning disordered children the antibodies to Epstein-Barr came in later life, usually in their late teens and early twenties. This alerted me to a consistent presence of these herpes family viruses in these psychiatric conditions, behavioral disordered and learning disordered children. Furthermore, these herpes family viruses don't die. The body is unable to immunologically kill them because they make stealth adaptation and thus establish a latency in the body. They are both lympotropic and neurotropic and have the capacity to produce an encephalitis.

For years, the specialty of psychiatry has had an ego satisfaction out of grouping mental, behavioral and learning symptoms into specific categories of symptoms. The causes of these reactions were only speculative. The separate naming of mental, behavioral and learning disorders is in contrast to usual medicines identification which is to a common cause with multiple symptoms. Based on my research, I concluded that we should look for a common cause even though the symptoms varied. Isolating a common cause. encourages also the examination of a common treatment. The common treatment that my research has indication of is to, first of all, kill the viruses. Secondly, stop the maladaptive reactions by initial avoidance and later spacing of contacts with the symptom evoking substances. These maladaptive reactions are food allergies with antibodies, food addiction without antibodies and toxins without antibodies. The third consideration of treatment is to examine for nutritional needs and optimize nutritional supplementation. The conditions that have been

isolated as justifying the conclusion of a viral encephalitis in childhood are; attention deficit, hyperkinetic disorder (ADHD), obsessive-compulsive disorder (OCD), autism, Tourette's syndrome, dyslexia and mirror imaging.

The herpes family virus encephalitis is progressive and all of these childhood conditions are subject to progression to schizophrenia, or bipolar disorder. The histories demonstrate the symptoms' progression of this viral encephalitis. Diagnostic categories of the adult condition are a progression of these symptoms which often then add hallucinations and delusions justifying the conclusion of the diagnosis of schizo- phrenia and manic-depressive disorder.

I participated with Saul Klotz, Allergist, in a double-blind study on adolescents. The learning disorders, behavioral disorders and schizophrenia in which we used food extracts sublingually placed and compared with pure water. The evidence was overwhelmingly convincing that food reactions did enter into these learning and behavioral and psychotic disorders. From this, I launched a systematic study of reactions to foods, chemicals and inhalants.

Theron G.. Randolph had developed a system of fasting for five days followed by meals of single foods and monitoring for the development of symptoms . I followed his lead under the supervision of Marshall Mandell, M.D., Allergist and Martin Rubin, Ph.D, Biochemist in which we were looking for food symptom reactions nutritional deficiencies, toxic states and infected states.

Five days of a fast was most amazingly revealing. Psychotic patients, no matter what their category, showed either a total or marked clearance of their symptoms. After five days of a fast, they were given meals of single foods and this revealed that there were reactions to foods that evoked symptoms. We also, at the same time, were running food allergies. We found that not all of the reactions had antibodies. They were addictive in quality, that is, when chronically using the foods, the foods relieved the symptoms and the symptoms were a withdrawal phase occurring four hours or more after eating a food and again, would be relieved by eating the symptom-producing foods. There is a smaller number of reactions to toxins from various sources that evoke symptoms also. This was tested by sniffing or sublingual application of the toxic substances. Foods themselves contain toxic substances which, when eaten frequently, overwhelm the enzyme system of the body. There is nothing in my training as a psychiatrist or in text books in

psychiatry that told us that a mental patient would markedly improve with a 5 day fast. It simply is not common knowledge in psychiatry. The fact that eating test meals of single foods will reveal which foods or which chemicals evoke these symptoms simply is again, not common knowledge. Understanding this makes it possible to bring the patient quickly into control of their symptoms and will do so without any nutritional supplements, tranquilizers, anti-depressants or shock treatments.

COMMON DIAGNOSIS AND COMMON TREATMENT FOR CHRONIC PROGRESSIVE HERPES FAMILY VIRAL ENCEPHALITIS SYNDROME

The viral encephalitis syndrome is a final conclusion of a central cause of a viral infection of the brain from the herpes family viruses (Epstein-Barr, cytomegalovirus and occasionally, human herpes virus #6) plus the viral injured brain symptoms precipitated by maladaptive reactions (allergies, addictions and toxins) to environmental substances. The components of the diagnosis are:

1) identification of viruses by antibody culture or immunologic identification of the presence of viruses.

2) identification of allergies by the presence of antibodies or other cytotoxic evidences, identification of autoimmune reactions.

3) identification of addictions, especially food addictions.

4) identification of toxins, especially heavy metal toxins such as mercury and lead.

THE ROLE OF A FAST AND DELIBERATE SYMPTOM TEST EXPOSURE

Five days of avoidance frequently produces a symptom-free, or relatively symptom-free state. This avoidance period can be achieved by a 5 day fast. For adolescents or children over ten years of age a water fast can achieve the goal. Children can develop a state of acidosis with a water fast only. A five day avoidance can be achieved by feeding the subject selective infrequent foods during the fasting period. Ideally, foods for the five day fast are watermelon and a fish or a legume such as lima or butter beans. Use foods infrequently used by the subject. Classically foods that precipitate symptoms are foods that are used twice a week or more. Five days of avoidance changes the symptoms from the chronic state in which the foods cannot be identified to an acute state in which on single exposure to a food or chemical symptoms are precipitated. Thus, the foods or chemicals can be individually identified. It takes about a month to go through this type of test. Before each test meal of a single food or

substance, a record is made of any symptoms and these are graded on a 1-10 scale. Between an hour to an hour and one-half of the test meal, the symptoms will emerge. And again a record is made of the development of symptoms or a change in intensity of the symptoms. Thus, from this, you can learn what foods or chemicals can be avoided in order to be symptom-free.

There are two major conditions that can be assessed and give valuable information. The pH of the blood or saliva, but especially the blood can be made before the test meal and an hour after the test meal. Litmus paper can be used for this. Just moisten this litmus paper with blood and wipe off the cellular elements. You need a litmus paper which gives you a reading between 6-8. The name of the litmus paper that we use most commonly is called Phydron. This can be obtainable from a laboratory supply. The other most common test is blood sugar before and one hour after each test meal. For this, use the standard instrumentation that diabetics use for monitoring their blood sugar. Any blood sugar beyond 140 is consid- ered hyperglycemia which is a diabetic reaction. The blood pH below 7.35 is acidic. Characteristically, whenever symptoms develop, also evidence of acidosis is also present. Saliva can be used for this test, however, it is not that reliable. There must be no particles of food in the mouth and it must be the saliva, not testing on the tongue itself. If saliva testing is going to be used, then you would have to rinse the mouth after the test meal and wait one hour before you test the saliva. What I have described above is convincing evidence, both to the subject and the observer of the significance of the reaction to foods, chemicals or inhalants. Chemicals or other volitable substances can be tested by sniff testing or sublingual testing.

HOW TO PROCEED WITHOUT FOOD TESTING

What I have observed and documented is that foods that are reacted to are foods that are used frequently. Therefore, a person can assume that they are reacting to frequently used foods and leave these out of the diet for three months before reintroducing them. In the meantime, go on a 7 day rotation diet. I have also worked out another method since it has been observed that symptoms that are evoked during testing can be relieved with a negative magnetic field. This would involve using two discs placed bitemporally. These discs are 1-1/2" x 1/2" ceramic disc magnets that are held in place with a 2" x 26" band and also place a 4" x 6" x 1/2" magnet directly over where the symptoms are that developed. I have worked out a system that works very well and that is, if you will treat the head, heart and

the liver ahead of meals, chances are that there will be no reaction. If there is a reaction, and say you have eaten three foods, then you would need on the next go round, to test those foods singly and see which food it is that overrides the magnetic application ahead of the meal. That food then should be left out for three months before reintroducing it into the rotation diet. In this system, you immediately rotate everything including the foods used frequently but only leave out those that override the magnetic pre-meal exposure. The heart is treated with a 4" x 6" x 1/2" magnet with the 6" placed lengthwise the body. Hold this in place with a 4" x 52" body wrap. The liver is also treated with a 4" x 6" x 1/2" magnet with the 6" lengthwise the body. Hold in place with a 4" x 52" body wrap. The minimum should be 15 minutes, more optimally would be 30 minutes. The magnets can remain in place during the meal also, if desired, and it would be best to do so.

THE COMMON TREATMENT FOR VIRAL ENCEPHALITIS SYNDROME IS:

1. First of all, kill the viruses. This can be done by sleeping on a 70 magnet bed. These magnets are 4" x 6" x 1". Thirty-five are placed in a wooden carrier 38" square. Two of these wooden carriers are placed end to end making a bed 76" x 38". Over this, place a 2" memory foam pad. Sleep also with the head surrounded by twelve of these 4" x 6" x 1" magnets. These are placed in a wooden carrier. There is space for the head surrounded by these magnets and the person can turn from side to side if desired. It is wise to go back on this bed for one hour, four times during the day for the first three months. After three months, then sleep on the bed and the head unit nightly as a lifestyle.

2. Use one of the methods that has been described to prevent symptoms from developing. Optimize the nutrition. It is wise to be tested broadly for vitamin, mineral, amino acids and essential fats to deter- mine if indeed there are any deficiencies or genetic errors relating to nutrition such as homocystineria. The initial plan is to take vitamin-mineral mixtures that are intended for one-a-day and take it instead, twice a day. If a specific deficiency has been identified, then treat accordingly.

3. Treat appropriately any identified toxins, especially mercury and lead toxins. There are specific chelation treatments for these toxic metals that can be given intravenously or orally. The super magnetic bed is itself a very strong detoxifier of any kind of toxins including heavy metal toxicity. Therefore, sleeping on this super

magnetic bed will in itself resolve the problems of toxicity. However, it also works well with other established methods of detoxification.

THE ROLE OF GLUTEN

In my research, I have discovered that gluten is the highest reactive food substance. There were 64% of my mental patients that reacted to gluten. Gluten is easily addictive. In the first stage of digestion, gluten splits in half. It now is a narcotic and unless the second phase of digestion occurring in the small intestine occurs normally, then it can enter the blood stream as a narcotic and thus become addicting. Gluten also has a genetic component in some people. This is 1 in 200 in the Irish and 1 in 2,000 in non- Irish. We should always be aware of this genetic possibility of reaction to gluten. The classic intestinal symptoms are celiac disease which is an irritable inflammatory reaction of the small intestine or Crohn's disease which is in the large intestine or irritable bowel syndrome. If these physical symptoms or the mental symptoms continue in spite of rotation and in spite of the use of the magnets, then it can be as- sumed to be genetic and gluten foods should be left out. Gluten foods are wheat, rye, oats, barley, millet and the gliadin of mature corn. Gluten is a good food if you are not reacting to it and should be a part of the rotation diet but only left out in cases of continued maladaptive reactions. Sprouting the grain removes the gluten. Sprouting the grain makes it possible to use these valuable nutritious grains.

ANTIBIOTIC NEGATIVE MAGNETIC FIELD

The good news is that a negative magnetic field is an antibiotic across the board for all types of human invading microorganisms. It matters not the type of invading microorganism such as viruses, bacteria, fungi or parasites. If and when the human body comes up with a strong enough negative magnetic field, it will itself kill invading microorganisms. Invading microorganisms are a positive magnetic field and when they can come up with a stronger positive magnetic field than the human body's negative magnetic field, then the invading microorganism will win. It is of further interest to observe that microorganism plate cultures are not appreciably influenced by exposure to a negative magnetic field. There is something in the human response to a negative magnetic field that makes it an antibiotic. We know what some of these values are but there must be a number that we do not as of yet, understand. The human organism is an alkaline-hyperoxic negative magnetic field organism, whereas, microorganisms that invade the human body are acid-hypoxia positive magnetic field organisms. They have the ability

to tolerate an acid that the humans cells cannot tolerate and also, their cells cannot tolerate the necessary alkaline-hyperoxia that the human body requires. Unfortunately, we cannot use the common culture methods to determine the antibiotic value of a negative magnetic field. We are dependent in this case on the body's response to the separate magnetic fields as a reinforcer of its own antibiotic capacity.

SUCCESS STORY

A physician sent a patient to me with multiple gastrointestinal symptoms. He had run a stool culture on her which contained numerous pathological bacteria and fungi. After three months on the super mag- netic bed of 70 magnets, a stool culture was run. The pathological bacteria and fungi had all died out and the good non-invading bacteria were flourishing. The non-invading bacteria are a negative magnetic field, the same as the human cells and they make their ATP by the oxidation reduction method as human cells. Being a negative magnetic field, they cannot invade because the human negative magnetic field would repel the negative magnetic field of the microorganism. They can live in the gastrointestinal tract but they cannot invade the tissues. A negative magnetic field reinforces the already existing negative magnetic field of the human cell and this is why a negative magnetic field is an antibiotic, the details of which are yet to be fully explained.

POLARITY SIGNIFICANCE

The human body is an electromagnetic organism. Magnet polarity decides the direction of biological responses. Both positive and negative magnetic polarities are of equal importance for life, health and happiness. A positive magnetic polarity is a biological stress with a cellular pulsing frequency beyond 12 cycles per second. Brief excursions of a positive magnetic field is responsible for all wakefulness, mental and motor activity. The toxic free radicals and acids of biological stress are quickly processed to water and oxygen by oxidoreductase enzymes. Chronic stress beyond the capacity of the oxidoreductase enzymes to process toxic end products of metabolism leads to disease. The anti-stress negative magnetic field has a pulsing field below 13 cycles per second. The magnetic negative anti-stress biological field prevents and reverses these diseased states. Deep sleep is 2 cycles per second. 8-12 cycles per second is relaxation. The alkaline-hyperoxic anti-stress state rapidly, enzymatically processes toxic end products of metabolism and also is responsible for enzymatically making adenosine triphosphate which is the central

driving force in human enzyme catalysis. Any method that helps maintain the base line of alkaline-hyperoxia, cellular pulsing frequency below 13 cycles per second, is anti-stress negative magnetic polarity and helps maintain biological health. Optimal sources of maintaining anti-stress negative magnetic field polarity are such as:

1. External negative magnet field which the body uses as a source of energy beyond that of nutrition.

2. Negative polarity ions. Negative ion air. Negative ion drinking water. Negative silver ion solution. Negative ions in the air and water along with negative magnetic fields is an important ancillary therapy to that of a negative magnetic field provided from static field magnets.

CONCLUSIONS FROM MY RESEARCH

1. Mental patients routinely became clear of their mental symptoms when fasted for five days. This was indeed an unexpected, shocking revelation.

2. Mental symptoms emerged when exposed to single test meals of foods, chemicals or inhalants and the patient remained mentally clear when these were removed.

3. 95% of the time, foods that had originally produced symptoms, either mental or physical, would not be present if you avoided those foods for three months. After three months, they could be re-introduced into the rotation diet as long as the exposure is no more than once in four days. Only occasionally were there genetic reasons, such as genetic reactions to gluten.

4. The cause of diabetes mellitus type II was reactions to foods, chemicals or inhalants and was not caused by glucose as such. In fact, each sugar -- corn, beet, cane, sorghum molasses and honey -- had to all be tested separately. Among my patients, I never found a diabetic that would react to maple sugar. The reactions are to the substances from which the sugar is made. For example, you may react to beet sugar but not to cane sugar or maple sugar. Even exposure to honey had an interesting phenomena. The honey gathered from the local area where the subject lives may cause a reaction. Honey from an area where the subject does not live characteristically did not cause a reaction.

5. pH dropped below the physiological normal when symptoms and/or high blood sugar occurred.

6. It was determined that the patients -- schizophrenics, manic depressives, hyperkinetic, obsessive compulsive, learning disordered and autistic children -- showed the same characteristics of being infected with herpes family viruses, either Epstein-Barr,

cytomegalovirus or human herpes virus #6 as the adult schizophrenics and manic depressives. Also it was determined that all the behavioral and learning disordered children were candidates to become schizophrenics in their 20's. The history of schizophrenics included these learning disorders, attention deficit disorders and obsessive compulsive disorders quite routinely. Thus, it was determined there is a spectrum of organic brain disorders having the same source and that is a childhood infection with one of the herpes family viruses. Reactions to foods, chemicals and inhalants is a secondary phenomena. These lymphotropic viruses do infect the lymph system including the B-lymphocytes that make antibodies. They also are neurotrophic and invade the neurones of the central nervous system, especially the pre-frontal, frontal and temporal areas of the brain. Thus the person is more allergic and becomes addicted more easily to these foods. When a food reaction does occur, the organ selected for reaction is the injured area which in this case is the central nervous system, especially the brain.

Since 1983, I have been involved in research examining the value of magnetic therapy. I have determined that if you expose the person magnetically before a meal, the reaction does not occur. For this, two ceramic disc magnets that are 1-1/2" x 1/2" are placed bitemporally. A 4" x 6" x 1/2" magnet is placed over the heart and one over the liver. All of these have the negative pole facing the body. With 15-30 minutes exposure pre-meal, symptoms do not develop. Thus a person can go on a rotation diet immedi- ately without an avoidance period of three months of the reactive foods.

A negative magnetic field is an effective antibiotic. Therefore, the infections that are so prone to develop in diabetes can be prevented and reversed with a negative magnetic field. Also, diabetic neuropathy and other toxic neuropathies can be effectively treated with the negative magnetic field.

ECOLOGIC SYMPTOM EXAMINATION PLUS BIOCHEMICAL MONITORING

From 1970 through 1975, I did a research project at the psychiatric hospital, Fuller Memorial Hospital in South Attleboro, MA. Two books were published giving the details of the results of the research. They were *Brain Allergies* and *Victory Over Diabetes*. Five hundred mental patients were examined. Most were schizophrenics, a few were bipolar and thirty were severely depressed neurotics. All of these individuals required hospitalization. Among these patients was an assortment of chronic

degenerative diseases. A number were maturity onset diabetics. Many qualified as metabolic syndrome.

The research system included the following:

A psychiatric and physical examination and bio-chem screen before the research was instituted. Five days of a water only fast.

There was a series of antibody studies which included Epstein-Barr, cytomegalovirus and human herpes virus #6. Starting on the 6th day after the five day fast, single food meal tests began and continued for the next month. Before each meal and one hour after each meal, the following was done.

1. Symptom severity test with symptom present and severity was placed on a 1-10 intensity.
2. Blood sugar test.
3. Blood pressure test.
4. Pulse test.
5. pH of blood and/or saliva.

Theron G. Randolph, M.D., allergist, had observed the fact that acidity was present when symptoms occurred. Blood sugar and blood pH an hour before and after each meal had never been done before. Dr. Randolph's observation of acidity associated with symptom production proved to be correct. Blood sugar had never been tested before. In maturity onset diabetes type II, specific foods which evoked the blood sugar beyond 140 were in evidence. When these foods were withdrawn from the diet, there was no diabetes. This was even in patients who were obese and had not yet had the opportunity to reduce their weight. After three months of avoidance, the foods that were revoking hyperglycemia could be reintroduced and would not produce hyperglycemia as long as they were used only once in four days.

My friend, John Potts, M.D., had many diabetic patients. He systematically examined these patients and published in the abstract issue of the *Journal of Diabetes*, four research projects. This confirmed that diabetes was caused by these food reactions and even in those late stage diabetics where insulin was not in adequate supply, two-thirds of these did not need insulin when their foods were sorted out. Between 1976-1990, I was in private practice with a ten bed environmental controlled unit. I also had a large outpatient department. With this, I had a wide assortment of degenerative diseases and numerous diabetics. It was easy to reverse maturity onset type II diabetes. Most hypertensions also were reversed by honoring the food reactions. In my original research and in later

years, I found many patients that would satisfy the criteria of metabolic syndrome in which there was a mild hypertension, a mild disordered glucose metabolism and a mild disordered lipid metabolism. These all reversed when honoring the fact that foods, chemicals and sometimes other environmental substances such as toxins were the precipitating cause of this metabolic syndrome.

THE PATHOLOGY OF HERPES FAMILY VIRUSES

Facts about Herpes Family Viruses

The following are members of the herpes family virus:

Herpes simplex I which is characteristically around the face, cervical spine or also in the head and brain itself.

Herpes simplex II which is characteristically in the genital area.

Herpes simplex I or II can be either around the head or the genital area.

Varicella-zoster causes chicken-pox. Most children have had chicken-pox. Years later, the manifestation can be observed as shingles which is caused by the latent viruses of chicken pox.

Epstein-Barr is a highly frequent infection. It particularly likes lymphocytes. It also is neurotrophic. It not uncommonly becomes disseminated into any organs of the body such as the liver, spleen, thyroid or the brain.

Cytomegalovirus is particularly neurotrophic affecting the brain and the entire nervous system. Human herpes virus # 6 has been implicated as being consistently present in multiple sclerosis. Human herpes virus # 7 is a recently discovered human herpes virus. Little is known of its significance.

Herpes B virus is a virus that is carried by some Old World monkeys. There are 18 well-documented human cases. Thirteen of these were fatal.

Almost all adult subjects have one or more of these types of herpes family viruses. Epstein-Barr virus is positive in about 90-95% of adults. Herpes viruses do not die. Instead they establish a latency and survive. The only way they can be killed is with a human biological response to a negative magnetic field.

Herpes viruses "establish latency in the body after primary infection despite the presence of antibod- ies".

Antibodies to herpes viruses are not protective against subsequent outbreaks. "Reoccurrences are common and represent reactivation of latent viruses"

None of the antiviral agents eradicate latent viruses.

Congenital herpes has been established as a fact. A reasonable theoretical postulation is that Epstein-Barr, cytomegalo or human herpes virus #6 is congenitally passed to the fetus during a recurrent symp- tom infection from a latent infection. This is most likely to occur during the 2nd half of pregnancy. An acquired infection during gestation, infancy or childhood, while the brain is still in its formative development, injures the brain so that it does not fully develop. Herpes viruses have the ability of stealth adaptation in which they are able to drop out their antigen to which the human immune system is responding. Thus, they skirt around the immune defense of the human system. They can latently dwell in the lymphocytes, particularly the B-lymphocytes and the neurones. They can continue to damage the human physiology without evoking a human immune response. Infections of these viruses are even known to exist when there were no antibodies against the virus.

In my extensive studies of learning and behavioral disorders including autism, attention deficit, obsessive compulsiveness, hyperactive, lethargic and dyslexic children, I discovered that they have one or more of these herpes viruses, usually Epstein-Barr or cytomegalo. They have these early in life which injures the brain. Mental cases like schizophrenia and manic depressive are cases that have more injury to the brain than these attention-deficit, learning disordered, hyperactive and autistic children. The illness is progressive in children and adolescents with these infections are all candidates to progress to schizophrenia or manic depressive illness. It is also my conclusion that adults who develop an Epstein-Barr or cytomegalo infection after the brain is developed do not develop psychosis but they do develop depression, pains and weakness and are frequently given the clinical diagnosis of fibromyalgia, chronic fatigue and neurotic depression. Weakness is a characteristic of these chronic infections, be they present congenitally, after birth or developed even as an adult after the brain has developed. Ninety-five percent of the adult population do have antibodies to Epstein-Barr or cytomegalo virus. It seems evident from literature that human herpes virus #6 is the single cause of multiple sclerosis. Anyone who has these infections are suffering to some degree. Even though they may think themselves in reasonable health, they are fighting a serious battle with a wicked enemy. Anyone who has symptoms, mental or physical, should consider the possibility that these herpes viral infections are adversely affecting their health. There are no antibiotics that can

eradicate the human body of these latent viruses. There is only one way these viruses can be killed and that is the human biological response to the support of a negative magnetic field.

CHRONIC PROGRESSIVE HERPES FAMILY VIRUS
Encephalitis Syndrome of Adulthood
1) Multiple sclerosis
Human herpes virus #6 as cause
2) Fibromyalgia with weakness and depression Epstein-Barr virus and or cytomegalo virus as cause.

WHAT PROOF IS THERE THAT THE NEGATIVE MAGNETIC FIELD KILLS VIRUSES?
With magnet treatment, shingles, herpes simplex 1 and 2 can be completely reversed and never return.

NEGATIVE MAGNETIC THERAPY:
Place the negative field of a plastiform magnet that is 3" or 4" wide and 1/8" thick, the length of the infected nerve clear back to the spine. Place a 4" x 6" x 1/2" negative magnetic field over the spine at the insertion of the affected nerve. Hold these in place for a minimum of two weeks. The viruses will die both in the nerve and in the spinal nerve and never return. The neuralgia so often experienced by the infected person is no longer present and the episodes of acute activity with blisters ceases. The treatment of herpes simplex 1 and 2 responds the same way as shingles to magnet therapy. This has proved that the viruses have been killed.

Epstein-Barr, cytomegalovirus and human herpes virus #6 are hiding in specific tissues of the body and can be cultured from the blood or identified as present by an immunologic response to their presence. The evidence of infection can be determined by antibody studies. However, antibody studies are not completely reliable because of the capacity of these herpes family viruses to stealth adapt in which the human body no longer is making antibodies to these viruses even though they are present and causing disease.

Beyond that of viruses, we have been able to document that the body's biological response to a negative magnetic field kills invading microorganisms, whether these are bacteria, viruses, fungi or parasites. Thus, there is documented evidence that a sufficiently strong negative magnetic field such as our strong 70-magnet bed will clear the body *of* its invading microorganisms no matter what type of organism they are:

EPSTEIN-BARR INFECTION
Mental Problems Linked

"In recent years, scientists have tentatively linked several infectious agents to psychiatric symptoms. New research suggest that Epstein-Barr, the common virus that causes mononucleosis, should be added to this list.

"June Caruso and colleagues identified five children who developed cognitive and neurological problems after contracting Epstein-Barr. Their symptoms included seizures, obsessive-compulsive behavior, cognitive deterioration, loss of speech and language skills, impulsiveness, and inappropri- ate behavior. Magnetic resonance imaging (MRI) scans of the children revealed abnormalities in all cases.

"The researchers say that individuals who develop Epstein-Barr encephalitis may not present with typical symptoms of mononucleosis, and that serum tests may be negative. They recommend that patients who present with sudden symptoms of perseveration, impulsivity, seizures, abnormal emotional changes, and obsessive-compulsive behavior be evaluated for Epstein-Barr infection.

"In earlier research, investigators linked strep infections to a disorder they have named pediatric autoimmune neurological disorders, or PANDAS. In addition to causing hyperactivity, tics and obsessive-compulsive behaviors, PANDAS has been associated with some cases of autism. Boma virus, also being investigated as a possible cause of autism, is associated with depression."

Abstract quoted from *Autism Research Review International*, Vol 15 No. 1, 2001.

METHYLATION: the link between thimerosal and autism?
[Autism Research Review Volume 18, No. 1 2004]

Rates of autism have climbed dramatically over the past three decades, a trend paralleled by the escalating numbers of thimerosal-laden vaccines given to children since the 1970's. A possible explanation of this link comes from new research by Richard Deth and colleagues, who report that exposure to even low levels of thimerosal, a vaccine preservative that is nearly 50 percent mercury, can drastically alter a critical process called methylation.

Methylation occurs when methyl groups (molecules consisting of one carbon atom and three hydro- gen atoms) are added to or subtracted from other molecules. Because this process regulates DNA function and gene expression, proper methylation is critical to normal neurological development.

Deth et al. found that methylation is stimulated by insulin-like growth factor-1 (IGF-1) and the neurotransmitter dopamine. The researchers discovered that thimerosal inhibits these pathways, even at concentrations typically found following vaccination. They also found that ethanol and lead inhibit methylation, but Deth says that thimerosal "was the far the most potent" inhibitor. Thimerosal, he says, disrupted the methylation process at doses 100 times lower than a child would receive after a single dose of a thimerosal-containing vaccine.

"Scientists certainly acknowledge that exposure to neurotoxins like ethanol and heavy metals can cause developmental disorders, but until now, the precise mechanisms underlying their toxicity have not been known," Deth says. "The recent increase in the incidence of autism led us to speculate that environmental exposures, including vaccine additives, might contribute to the triggering of this disorder."

The researchers say thimerosal appears to interfere with methylation by inhibiting the biosynthesis of methyl cobalamin, the active form of vitamin of B_{12}.

Deth says thimerosal may also play a role in attention deficit hyperactivity disorder (ADHD), another behavioral problem that is on the rise. "During the first years of life, networks of neurons that represent the matrix for learning are being developed in the brain," he says. "Methylation and the development of neuronal cells to create these networks are critical during this time. If the process is interrupted, the ability to learn and pay attention would naturally be impaired."

Reports that autism rates have not dropped since drug companies started phasing out thimerosal from some vaccines do not disprove the thimerosal-autism link, Deth says.

"The epidemiological studies are looking at whole populations," he comments, "and we are trying to determine what it is about an individual kid that might make him more susceptible to this exposure."

Deth cautions that his research group's findings are preliminary, but calls for more research into the possible link between autism and thimerosal. "Up to now, people have said the cause or causes of autism are unknown," Deth says. "Our work isn't final in any sense at all, but it seems to point to this biochemistry as a potential, or even primary, cause of autism."

In 1999, the FDA requested that manufacturers eventually reduce or eliminate the mercury in vaccines, but thimerosal-containing vaccines are still being used.

"Activation of methionine synthase by insulin-like growth factor-1 and dopamine: a target for neurodevelopmental toxins and thimerosal," M. Waly, H. Olteanu, R. Banerjee, S.W. Choi, J.B. Mason, B.S. Parker, S. Sukamar, S. Shim, A. Sharma, J.M. Benzecry, V.A. Power-Charnitsky, and R.C. Deth, *Molecular Psychiatry,* January 27, 2004 (epub). Address: Richard C. Deth, Dept. Of Pharmaceutical Sciences, Northeastern University, Boston, MA 01225.

Methylation: The Link Between Thimerosal and Autism. Autistic Research Review, vol 18, No 1,2004

INVOLVEMENT OF DIFFERENT SYSTEMS IN AUTISM

"Genetic and environmental factors are implicated in the pathogenesis of autism. The effects of environmental factors such as infections and toxic chemicals on gene expression result in biochemical, immunological and neurological disorders found in children with autism.

"Similar to many complex diseases, genetic and environmental factors including infections, xenobiotics, dietary proteins and peptides, play a critical role in the development of autism. The effects of environmental factors on genetic makeup result in immune, gastrointestinal, neurological, biochemical and neuroimmunological abnormalities. Based on extensive research, which led to publications of three different manuscripts and two review articles, we postulated that autism is induced by infectious agent antigens, toxic chemicals and dietary proteins. This process begins in the gastrointestinal tract but manifests itself in the brain.

"Edelson and Cantor demonstrated that neurotoxicants play a possible role in more than 90% of autistic children. These authors presented evidence for genetic and environmental aspects of a proposed process involving immune system injury and autoimmune responses secondary to exposure to immunotoxins. They believe that activation of the immune system is caused by toxicants leading to the production of autoantibodies against haptens, i.e., the toxic chemicals attached to brain proteins. The subsequent damage may be considered a component in the etiologic process of neurotoxicity in the autistic spectrum.

"We and other authors were able to present viable evidence in support of the genetic and environmental aspects of a hypothetical process believed to cause immune system toxicant, leading to the production of autoantibodies against haptens - the toxic chemicals attached to brain proteins. The resulting damage may be considered a component in the etiologic process of neurotoxicity in the autistic spectrum.

"Opioid peptides are available from a variety of food sources. These dietary proteins and peptides, including casein, casomorphins, gluten (GLU) and gluteomorphins, can stimulate T-cells, induce peptide-specific T-Cell responses, and abnormal levels of cytokine production, which may result in inflammation, autoimmune reactions and disruption of neuroimmune communications.

"Infectious agents, toxic chemicals, and dietary peptides are triggers for autoimmunity in autism."

Immunoscience Lab, Inc., 822 S. Robertson Blvd., Ste. 312, Los Angeles, CA 90035. Tel: (310) 657-1077. Fax: (310) 57-1053.

MAGNETIC ANTIBIOTICS

There are numerous evidences that microorganisms capable of infecting humans will die in a negative magnetic field of sufficient gauss strength and sufficient duration. This is true whether the infectious agent is a virus, bacteria, fungus, parasite or other invading microorganism.

A man with a culture identification of a tuberculosis lesion on the back of his hand, having been unsuccessfully treated with various antibiotics, was treated with a plastiform magnet 4" square and 1/8" thick with the negative magnetic field facing the lesion and kept on continuously for six weeks. This negative magnetic field completely killed the tuberculosis skin lesion. Thus, we know there is a magnetic answer for tuberculosis no matter where it is on or in the body.

A man with viral C hepatitis with a positive fetoprotein test was treated with the negative magnetic field of a 4" x 6" x 1/2" magnet 24 hours a day for several weeks. The viral infection died out and the fetoprotein test became zero.

A woman with a stool culture of several pathogenic bacteria along with *Candida albicans* plus the usual normal, harmless colon bacteria slept on a negative magnetic pole bed of 70 magnets. These mag- nets are 4" x 6" x 1". The total weight of the 70 magnets in two wooden grids 36" square, with two of these placed end to end, is 400 pounds. The therapeutic gauss strength of 25 gauss extends 18" above the bed. Thus, the entire body is engulfed in a therapeutic

level negative magnetic field. Three months after sleeping on this 70 magnet bed nightly, a stool culture demonstrated the absence of the bacterial and fungal pathogen. The normal non-invading, non-harmful bacterial flora of the colon was flourishing.

An elderly man with diabetes mellitus type II that was out of control had a large, non-healing ulcer of a mixed bacterial and fungal culture was scheduled for surgical removal of his foot. The negative mag- netic field of a 4" x 6" x 1/2" ceramic block magnet was placed over the non-healing infected ulcer. Within a week, the ulcer started healing. The ulcer healed and the foot was not surgically removed. This occurred despite his uncontrolled state of type II diabetes mellitus.

CONCLUSION FROM CURRENT OBSERVATIONS

The death of invading type microorganisms cannot be demonstrated by invitro culture outside of the human body. The death of these invading microorganisms is dependent on invivo infection. The static negative magnetic field strengthens the human cell's response such that the human cells can kill invading microorganisms. All invading microorganisms of viruses, bacteria, fungi, parasites and others have all responded with death of the microorganism from a sufficiently strong static negative magnetic field of sufficient duration. There is no adaptation capacity of these microorganisms to a static negative magnetic field.

The good news is that in addition to the life saving value of currently used antibiotics, we now have a static negative magnetic field with universal antibiotic value to which no human invading microorganisms can adapt. The sad news is that this universal antibiotic value of a static negative magnetic field is not common knowledge and therefore is not being used by traditional scientific medicine. Surely, it can safely be predicted that the day will come when hospitals will be equipped with negative magnetic field beds of sufficient gauss strength to produce an antibiotic value which will be used with or without currently well- established values of known chemical antibiotics.

VIRAL ENCEPHALITIS SYNDROME

My observations are that a chronic, progressive, insidious, low intensity Epstein-Barr virus and or cytomegalovirus encephalitis produces learning disorders, behavioral disorders and autism in childhood and progresses to schizophrenia and bipolar disorders in adulthood. If the viral infection occurs in adult- hood after the brain is fully matured, then psychosis does not develop. The symptoms in

adults with Epstein-Barr and or cytomegalovirus is that of fibromyalgia with depression and chronic fatigue. Also, autoimmune reactions such as lupus erythematosus and rheumatoid arthritis can be precipitated by these viruses. The development of lymphoma cancer can result from the herpes family viruses. Commonly, anyone with Epstein-Barr or cytomegalovirus suffers in varying degrees. The majority of adults do have antibodies to the herpes family viruses. Infections of these herpes family viruses sets the stage for opportunist bacteria and fungi (Candida) to flourish. The human immune system cannot kill these viruses. Once infected, they are latent in the human body. There is no antibiotic that effectively kills these viruses. Zyclovir has a suppressive effect on these viruses however no claims are being made that they can effectively kill the virus. Fortunately, there is evidence that a negative magnetic field of sufficient gauss strength and of sufficient duration will kill these viruses and all human invading microorganisms. At the same time a negative magnetic field activates oxidoreductase enzymes to process toxins of these microorganisms.

MAGNETIC DETOXIFICATION OF TOXIC METALS

All atomic weight heavy metals are electromagnetic positive and in the human body, produce free radicals which in turn damage human metabolism. These heavy metals such as mercury and lead in the human body are changed to non-toxic in the presence of a sufficiently strong negative magnetic field. Not only are the metals themselves rendered non-toxic by the attachment of a negative magnetic field to their positive magnetic field, also they are processed out of the body by the negative magnetic field. The free radicals that have been formed by the presence of these atomic weight heavy metals are quickly processed by the negative magnetic field activation of the oxidoreductase enzymes, the non-toxic results being molecular oxygen and water.

THE ROLE OF pH IN HEALTH AND DISEASE

Blood pH provides the biological window to the electromagnetic health and the electromagnetic pathology of metabolic diseases. There are parallel metabolic conditions that are always present at the same time, any one of which will provide you the evidence that the others will be present. These parallels are alkaline pH, hyperoxia, magnetic cellular anti-stress state, cellular pulsing frequency below 13 cycles per second, cellular negative magnetic state. The other set of parallels are acid pH, hypoxia, cellular magnetic stress state, cellular pulsing frequency beyond 12 cycles

per second, cellular positive magnetic state. These are so fundamentally interrelated so that when one is present, the others are also present. Thus, the presence of a blood acid pH indicates acid-hypoxia, cellular stress state, cellular pulsing frequency above 12 cycles per second, cellular positive magnetic state. This set of parallels associated with an acid pH is the condition in which symptoms occur. This set of parallels when alkaline-hyperoxia is present is symptom relief. I was fortunate to have done an experiment in which I was monitoring blood pH in relationship to symptom production. A brief blood acidity is present when symptoms are produced. My knowledge of electroencephalography with specific frequency relating to specific behavioral expression established the cellular electromagnetic state of both non- stress pulsing frequencies compared to stress pulsing frequencies of diseased conditions. Theron G. Randolph, M.D., Allergist was the first to observe acidity present during maladaptive reactions (allergies, addictions, toxicity reactions). Based on this evidence, he used sodium bicarbonate plus breathing oxygen as a relieving agent for symptoms. That occurred during deliberate test exposures. Acidity incorporates oxygen into the acid thus the chemistry of the maladaptive reaction is that of acid-hypoxia. I confirmed his observation of acid-hypoxia as being consistently present during maladaptive reactions to foods, chemical compounds and inhalants. Accordingly, I used bicarbonate plus breathing of oxygen as a symptom relieving agent. Albert Roy Davis, Physicist, was the first to observe that the biological response to a static positive magnetic field is acid-hypoxia and that in contrast the biological response to a static negative magnetic field is alkaline-hyperoxia. I confirmed his findings and found that the application of a negative magnetic field to the area of symptom production was more consistently present with a static negative magnetic field than with oral bicarbonate plus breathing oxygen. I was evoking these symptoms by stress testing by the method of five days of avoidance before this stress testing exposure. This initial avoidance plus single substance exposure during this stress testing revealed consistently which substances evoked which symptoms. These acute symptoms were the same symptoms as chronic diseases. Thus a static magnetic field therapy developed with the dimensions of:

 1) identification of symptom-evoking substances.

 2) demonstration of acid-hypoxia present when maladaptive symptoms occurred.

3) relief of symptoms and normalization of pH with exposure to a negative magnetic field.

4) healing of degenerative diseases with the prolonged use of an alkaline-hyperoxia response to a static negative magnetic field. Robert 0. Becker, M.D. also observed that healing only occurs in the cellular condition of a negative magnetic field and that healing does not occur in a cellular positive magnetic field state. He observed a cellular positive magnetic field to be the signal of injury.

The essence of magnetic therapy is production of negative ion charges at the cellular level which not only provides the alkaline-hyperoxia necessary for oxidoreductase enzymes to function but also energizes these enzymes for catalysis. This goal of negative ion charges at the cellular level can be achieved by:

1) a static negative magnetic field exposure.

2) negative ion charges in the air with absorption of these negative ions through the skin.

3) negative magnetic pulsing field at an anti-stress frequency which are below 13 cycles per second.

4) sensory pulsing fields at anti-stress levels below 13 cycles per second. This can be any sensory input such as sight, sound or tactile.

Acute symptoms produced by stress test exposure are measurably acid-hypoxic. Chronic metabolic diseases are also acid-hypoxic and are simply the time extension of acute maladaptive reactions. Thus, with diabetes mellitus type II, stress testing identifies the hyperglycemic and otherwise symptom-producing foods, chemicals and inhalants. The withdrawal of these symptom reacting sub- stances versus the diabetes mellitus disease process fortunately three months of non-exposure provides a reversal of these responses and these foods can usually be reintroduced and kept on a four or seven day rotation basis without hypoglycemia or symptoms reemerging. Furthermore, exposing the brain, heart and the liver to a negative magnetic field for 15-30 minutes ahead of an exposure to the offending agents, food or otherwise, consistently prevents the hyperglycemia or symptoms from emerging. Thus, a subject can set up a four or seven day rotation diet without the usual 5 days of avoidance and proceed immediately with a rotation diet with a negative magnetic exposure ahead of each meal. This same principle applies to vascular disorders, rheumatoid disorders, allergy and autoimmune disorders thus exposure to a negative magnetic field becomes a central and fundamental therapy for

either acute symptoms or degenerative disease symptoms. Magnetic therapy is the most predictable symptom reliever whether these are acute reactions or symptoms of chronic disease that I have observed in forty years of medical practice.

COMPONENTS OF MAGNETIC FIELD THERAPY:

1) pH. The normal human pH is from 7.35 to 7.45. When the pH drops into the acid range, then the enzymes of the human body are inhibited. This acidity is toxic to human enzymes other than the digestive enzymes in the mouth and the stomach. All the rest of the enzymes in the body, which are many hundreds, are all alkaline-dependent. The oxidoreductase enzymes are alkaline-hyperoxic dependent. These enzymes make human energy (adenosine-triphosphate (ATP) and when this oxidoreduction process making ATP occurs, it also makes a static oxidation remnant negative magnetic field magnetism which the body then uses in activation of other enzymes along with the ATP. The *Encyclopedia Britannica* states that there are two ways to determine if a catalytic reaction occurred. One is to measure the end product of that catabolism, the other is to measure the evidence that a magnetic field was created by the catalytic reaction. The second major use of oxidoreductase enzymes is that of detoxification. An end product of oxidative phosphorylation is the free radical, super oxide. Super oxide is rapidly enzymatically processed by oxidoreduc- tase enzymes, in this case its free radical is processed to hydrogen peroxide by super oxide dismutase.

Then hydrogen peroxide is processed to oxygen and water by catalase. If this process does not rapidly occur, then the super oxide produces other free radicals, ties up oxygen into oxyacids and proceeds to produce alcohols and aldehydes all of which are inflammatory. Therefore, in considering inflammation, we first of all consider the oxidoreductase enzymes that have the job of processing enzyme toxins. A catalytic reaction occurs when a substrate joins an enzyme. This occurs because of dipoles on both the enzyme and the substrate. For the catalytic reaction to occur, electrons have to move between the enzyme and the substrate. There are available, static electrons that are all around us and in us. Vitamin C serves as an enzyme co-factor, providing either the giving or receiving of electrons. When electrons move, a mag- netic field is produced. There is a natural attraction between the dipoles of the enzyme and the substrate, however that attraction is not sufficient to cause catalysis. It requires the movement of electrons which

ultimately are a magnetic field in order to make the catalysis occur. In the case of the oxidoreductase enzymes, which are alkaline-hyperoxia dependent, the magnetic field produced by the catalysis is always a negative magnetic field. The accumulation of this negative magnetic field is part of the energy system along with ATP that drives other enzyme catalysis that is also alkaline-hyperoxic dependent. Thus it can be seen that since the final step of catalysis is magnetic, then supplying an external source of negative magnetism will energy activate oxidoreductase catalysis and other alkaline-hyperoxia dependent catalysis. This is why when these enzymes are inhibited by any substance that supplies this energy activation of a negative magnetic field they can override this enzyme toxicity and the enzymes then can process the toxins.

Thus, supplying an external negative magnetic field is the most important of the detoxifying process of the human body. It has been well established and confirmed by my observations that the biological response to a negative magnetic field is alkaline-hyperoxia. The oxygen in this case doesn't come from the oxygen that we breathe, but comes from the release of oxygen and water from toxic substances. This is easily observable. If you are stung by an insect, placing the area immediately over a negative magnetic field will process the toxins injected into the human body and will do so rapidly within a matter of minutes or at most, hours and there will be no evidence of injury at all. A finger is burned and the area blanches and is acutely painful. Placing this area over a negative magnetic field will reverse this within minutes. The area will turn pink and will not blister. A bruised area that is turning dark colored will quickly loose its color and become a normal color within a matter of minutes of exposing the area to a negative magnetic field. An area that has been cut and bleeding will stop its bleeding by placing the area on a negative magnetic field. It does this by virtue of the release of oxygen from acids caused by the injury. Oxygen is vaso-constricting and will stop the bleeding. Furthermore, leaving the magnet on the area, it will heal without any infection occurring and there will not be a scar. The biological response to a sustained positive magnetic field is acid-hypoxia and will make the cuts, bruises, insect stings and so forth, worse. This is easy for anyone to observe. Another proof of the separateness of the positive and negative magnetic field can be observed by using a 1" x 1/8" neodymium disc magnet by placing the positive magnetic field on the skin. Within four days it will begin to hurt. Within two weeks,

there will be a vasculitis which is now infected with pustules. Using a negative magnetic field, there will be no harmful effect at all to the skin. The essence of magnet therapy is the energy activation of enzymes. The negative magnetic field is the correction for disordered metabolism. The positive magnetic field can be used for a brief period to activate neurones that have been inhibited by the extinction of disuse from an accident or an acute swelling that has caused pressure on neurones after a bout of multiple sclerosis. This would have to be used while associating this energy activation of neurones with a practice of return function. The positive magnetic field must not be used as a chronic exposure due to its harmful disordering of metabolic function. All healing occurs under the influence of the negative magnetic field. A positive magnetic field is always present at the site of injury, infection or cancer.

2) MAGNET POLES. It is observed that a biological response to a negative magnetic field is alkaline-hyperoxia which drives normal physiological functions. The positive magnetic field is the signal of injury.

Both the positive and negative magnetic fields are part and parcel of human physiological function. The positive magnetic field awakens the subject, drives the ability to think and to act, however it cannot be sustained for a long period of time without injury. The basic function of the human body is that of alkaline-hyperoxia with a pH in the alkaline range. Relaxation and particularly sleep main- tains the alkaline state.

3) STRESS AND ANTI-STRESS. Life is composed of both stress and anti-stress. Being awake, mental function and biological function area all in the stress range. Relaxation and sleep are in the anti-stress range. This is all easily demonstrated by the EEG. A pulsing field of 13 and more is stress. A pulsing field of 12 or less is anti-stress. Our base line is anti-stress. We make excursions over into stress but do not sustain this for a long period of time. If we do, there is a buildup of harmful metabolic products starting especially with super oxide and all the damage that it can do in the event that it is not processed rapidly. There are many chemicals from the environment that if in sufficient quantity, enzyme toxic. Allergies and other immunologic reactions are enzyme toxic. The withdrawal phase from addiction is toxic. The combustion by-products of fossil fuels is enzyme toxic. There are many environmental enzyme toxins that we have to be processing and if our quantity is too great, then

they overwhelm our enzyme system and disease results. In order to survive, we must relax and we must sleep soundly in order to recharge our electromagnetic bodies and process all the toxins and maintain alkaline-hyperoxia so that our enzymes that have many functions can function.

NO SIDE EFFECTS FROM NEGATIVE MAGNETIC FIELD THERAPY

Negative magnetic field therapy is an ordering of disordered physiology. A negative magnetic field therapy is not a narcotic and does not evoke a narcotic biological response. A negative magnetic field is not an analgesic like the array of non-steroidal analgesics all of which have potential side effects which can be serious. A negative magnetic field is not an anesthetic. A negative magnetic field is not a statin drug which can have serious side effects, some of which have been removed from the market because of deaths occurring. A negative magnetic field relieves symptoms because it corrects the disordered physiology of disease processes. The acid-hypoxia and other disordered chemistries of the disease process are changed to alkaline-hyperoxia. A negative magnetic field cures the symptoms by curing the disease. Human health is an ordered electromagnetic state. Human disease is a disordered electromagnetic state. The biological response to a negative magnetic field does not mask the symptoms by analgesics, anesthetics, steroids, narcotics, statin drugs tranquilizers, anti-depressants or anti-seizure medications. A negative magnetic field is a universal ordering of the disordered chemistries of diseases no matter whether this disease is identified as an allergy, an autoimmune disease, a toxicity, an addiction, an infection, cancer, depression, psychosis, behavior disorder, learning disorder and so forth. Magnetic therapy cures the disease. Magnet therapy is the only universal ordering of the disordered metabolism of diseases.

GLYCEMIC INDEX MYTH

Glycemic substances are identified as foods that quickly evoke blood sugar but still do so within the range of normal, that is below 140 mg/dl. These, by and large, have a quantity of free carbohydrates such as sugars. The assumption is made that hyperglycemia, that is a blood sugar beyond 140, will result out of an accumulation of glycemic foods. This is a false assumption but based on this assumption, then it is considered that diabetes mellitus type II can be managed by reducing the glycemic foods. This concept is erroneous because there is no such thing as a generalization as to the production of hyperglycemic foods by the accumulation of glycemic

foods. This however, is not published in the peer review literature and it was not known until I did my research starting in 1970. One of the factors of this research, besides examining for symptoms produced, was to examine blood sugar before and after each single food test meal.

The subjects were fasted on water only for five days. This changes the reaction timing from delayed, such as 3-4 hours after contact with the food, to that of the symptoms being acute within the first hour. Thus, we were looking at hyperglycemia, that is beyond 140 mg/dl, at one hour after the test meal, not at the fasting blood sugar on a morning specimen. This technique revealed conclusively what foods evoked hyperglycemia. There was no way to make a generalization. These foods were specific for each individual and the reaction was based on the fact that the subject frequently, that is, daily, several times a day or at least several times within a week, used the same food. Thus, the glycemic index which is just a generalization is really a myth whereas when you do a test meal of a single food after a five day fast, you know exactly which foods are hyperglycemic and which foods are not. Interestingly, this individuality bears no relationship as to whether the food is glycemic or not. The foods are often even proteins, such as gluten and it was conclusively demonstrated that clinically significant diabetics had sugars that they never used that they did not react to. For example, I have never found a diabetic type II reacting to maple sugar even though we give them a full meal of maple sugar. They will react only to the sugars that they use and they will also react to the parent substance from which that sugar is made such as beet sugar from beets. They react to beets. Whereas there are lots of diabetics that don't react to sorghum or to cane sugar or to honey. Some will react to honey that is taken from their local neighborhood and not react to honey that is taken from a neighborhood that they do not visit with any frequency. Diabetes mellitus type II is not a reaction to sugars or glycemic foods. Diabetes mellitus type II is due to food allergy and food addiction. When you remove the foods evoking hyperglycemia and they can come from any category of carbohydrates, complex carbohydrates, free carbohydrates, fats or proteins, there is no diabetic reaction. There is no hyperglycemia. Fortunately, if you remove these foods for three months, the body will have desensitized to these foods and 95% of the time, the food can be returned to a diet that rotates the foods either on a four or seven day basis without hyperglycemic reactions occurring. This

return to the foods can be achieved at a 95% rate. Therefore, the treatment of diabetes is an initial avoidance of hyperglycemic foods, followed by a reinstatement of these foods into the rotation diet three months later. There is a shortcut to this and that is if you supply a negative magnetic field to the brain, heart and liver for 30 minutes ahead of a meal, most of the time, there will not be any hyperglycemic reaction. If the exposure to this food does override the negative magnetic field, that food needs to be left out for three months before reintroducing it into the rotation diet.

OPTIMIZED NUTRITION

The human organism is an electromagnetic organism functional in an alkaline-hyperoxic medium. The human body is an energy machine with each cell of the body making its own energy from nutrients. An external source of magnetism is necessary for this human metabolic energy machine to function. A reasonable nutritionally intact human organism will respond to an external negative magnetic field with a biological response of alkaline-hyperoxia capable of preventing and reversing inflammation, governing tissue repair/healing, destroying invading microorganisms, destroying cancer and much, much more. Magnetism provides the energy for turning food into adenotriphosphate energy as well as detoxification of internal metabolic toxic products of metabolism and processing of exogenous toxins from the environment. Magnetism provides the energy of life and thus acts on the framework of the human body. Magnetism does not provide the human body biological frame. Only nutrition can be incorporated into the human body energy machine. When I describe the role of magnetic energy in the human body function, I am telling only half of the necessary story for optimum human function. The necessary other half is nutrition.

SOURCES OF NUTRITIONAL INFORMATION

1. Professional nutritionist.

The guidance of optimal nutrition by a professional nutritionist provides the greatest chance of optimal nutrition being provided. Scientific nutrition information is rapidly advancing and it is hard to keep up with all of this information for self-help alone. Everyone is ultimately responsible for gathering the knowledge from scientific information necessary for good health and reversal of diseases if and when they have developed. Some areas of nutrition require a laboratory assessment to determine if a nutritional disorder is present, particularly, such as B_{12} deficiency or folic acid deficiency.

2. Health food stores and book stores.

There is an abundance of new scientific information occurring and published in book stores and health food stores. It is the responsibility of each person seeking help for the reversal of disease to seek information from these sources. Health food stores have an abundance of supplementations that the health-minded person needs to understand and use. Health food stores have special foods for special problems. The health-minded person should be knowledgeable about the source of information, supplements and specialty foods.

3. Jonathan Wright, M. D. *Nutrition and Healing* http://wrightnewsletter.com/ Dr. J. Wright provides a valuable update of nutritional information and nutrients.

4. Life Extension Foundation PO Box 229120 Hollywood, Florida 33022-9120 This is a good source of information and supply of nutrients.

6. W. H. Philpott, M.D. *Magnetic Health Quarterlies* (This book contains the quarterlies.)

Each quarterly is on a single subject. There are many books on diets. Any diet system that does not honor food allergies, food addictions and food toxicities is missing a very essential need for diet consider- ations. The Magnetic Health Quarterlies emphasize the rotation diet. The quarterly entitled, *The Ultimate Non-Addiction, Non-Stress Diet* outlines a four day rotation diet. The quarterly entitled *Metabolic Syndrome* describes the seven day rotation diet. The quarterly entitled *Addiction and Weight Management* describes the magnetic meltdown in which magnets are used directly over the fatty areas, especially the abdomen for weight loss. It also describes how to reduce the calories using a visual method of training and the acceptance of the reduction of calories.

Optimum nutrition is a must along with magnet therapy. Professional guidance for optimum nutrition is recommended. For those not under professional guidance, then following a minimal nutrition program is recommended.

1. One a day type vitamin-mineral capsule. Take one, 2 x a day.
2. Ascorbate minerals, 1 tsp a day
3. At least 2 or more grams of vitamin C a day in divided doses, 2 x a day.
4. Fish oils. Consider emulsified cod liver oil 1 tsp, 3 x a day.

5. Abraham Hoffer, M.D. 2727 Quadra St #3A Victoria, BC, Canada V8T4E5 Dr. A. Hoffer provides an excellent source of nutritional information.

6. Hugh Riordan, M. D. 3100 North Hillside Wichita, KS 67219 316/ 682-3100 Dr. H. Riodan provides an excellent source of nutrition. He has especially studied the value of vitamin C IV.

7. Bernard Rimland, Ph.D. Autistic Research Institute 4182 Adams Ave San Diego, CA 92116 619/563-6840

HEAVY METAL TOXICITY

The common heavy metals producing toxicity are such as mercury, lead, aluminum and there are also rare heavy metals that cause toxicity. Atomic weight heavy metals have a positive magnetic field. When the body is placed in a negative magnetic field, it cancels out the positive magnetic field of the heavy metals. These are then processed out of the body as non-toxic heavy metals charged with a negative magnetic field. Therefore, processing these metals out of the body with magnetics does not injure kidney function. Heavy metal toxicity should always be considered. It can behave similarly to a viral infection. There are special techniques for both intravenous and oral chelation of metals. It is useful to use these but it should also be understood that a negative magnetic field also processes these metals out of the body. To do this, a 70 magnet bed should be used.

AUTOIMMUNITY

Autoimmunity is when the immune system attacks itself. Cells that are infected with viruses are often the cause of autoimmunity in which the immune system cannot react to viruses properly but responds to the cells that are affected because of their abnormal state such as their acidity. Toxins also cause the same abnormal cellular response to which the immune system responds with autoimmunity. The answer to autoimmunity is to use the 70 magnet bed as well as local treatment to stop the autoimmunity and first of all, hunt for precipitating factors, particularly viruses and other cellular toxins. It must be understood that any acid produced even by reactions to foods, chemical or inhalants is a toxin and can set the stage for autoimmunity. An example is children who develop an autoimmunity to the islet cells in the pancreas start out with milk allergy and end up with an autoimmunity of the islet cells of the pancreas.

THE PATHOLOGICAL ELECTROMAGNETIC MISSING DIAGNOSIS

It is understood that live biological systems are electromagnetic. Magnetic and electric poles cannot be separated. Electric fields

produce magnetic fields and magnetic fields produce electricity. They cannot be separated. Live biological cells pulse as an expression of their magnetic state. Live biological cells re- spond to a static magnetic field by pulsing. The pulsing magnetic state of cells which express their magnetic state can be driven by:

1. A static magnetic field, or
2. A pulsing magnetic field
3. Pulsing sensory (sight, sound, tactal inputs)

Despite the fact that the always present electromagnetic phenomena of living cells is basic knowledge, it is ignored in medical diagnosis and treatment. Medical texts do not have chapters or even paragraphs on the electromagnetic diagnosis of each disease compared to the normal electromagnetic functions of live biological cells. This electromagnetic pathology diagnosis would include magnetic polarity (positive or negative) magnetic gauss strength, pulsing frequency and pH, both local and systemic.

Understanding the electromagnetic diagnosis provides a major clue as to treatment. Immediate treatment for symptom relief would involve a correction of the electromagnetic pathology by appropriate exposure to a static or pulsing magnetic field. Longer term would be providing for appropriate nutrition and detoxification as well as avoidance of the environmental inputs that are evoking the pathology. The environmental inputs are such as allergies, especially to foods, addictions, especially to foods, and the identification of environmental enzyme toxins.

The value of the electromagnetic pathology diagnosis is that there are emerging a new energy medicine both from a diagnostic and a therapeutic standpoint in which there is more immediate symptom relief and an expanded version of what causes disease. Current technology makes it possible to proceed with an electromagnetic diagnosis. We need to focus on current technology capacity to provide us an electromagnetic pathology diagnosis. To achieve this, we need to access with instruments magnetic polarity, gauss strength, pulsing frequencies, pH (both local and systemic) and oxygen content (both local and systemic.) The sciences of electroencephalography and magnetic encephalography are providing valuable clues as to the relationship between electromagnetism and the disease state. It has been objectively observed that a negative magnetic field is anti-stress with pulsing fields below thirteen cycles per second. The higher the gauss strength, the slower the pulsing field. 8-12 is a relaxing, anti-stress state. A pulsing field of 2 cycles per second is deep, energy-

restoring sleep. A pulsing brain field can be driven by a pulsing input. Sensory input such as sight and sound and tactiles can be used in driving the specific pulsing frequencies that are desired to be achieved. In any event, either a static field exposure or a pulsing field exposure or a sensory pulsing input can achieve the same results of driving the brain as specific magnetic states that relate to behavioral consequences. A static positive magnetic field will drive the brain beyond 12 cycles per second. The higher the gauss strength, the higher the frequency of the brain response. In pathological states, the pulsing frequencies are in the stress level beyond that of 12 cycles per second. These patho- logical states can be corrected by either a static or pulsing anti-stress level. Based on our current knowledge of the electromagnetic diagnosis of pathological states, we can deduce an anti-stress level of magnetism whether this be pulsing fields or static fields, to achieve our results of anti-stress reversal of the biological stress pathologies. It would be a considerable boon to therapeutic medicine to note specifically the electromagnetic diagnosis of specific conditions and reverse this with a corrective electro- magnetic anti-stress input for immediate relief of symptoms. We need to also be able to repeat this electromagnetic diagnosis as a biofeedback mechanism demonstrating that we have indeed achieved an electromagnetic correction of the pathological state.

THEORETICAL MAGNETIC IMMUNOLOGY

Humans are an electromagnetic organism. Both positive and negative magnetic fields are an inherent aspect of life energy. Biological life does not exist apart from magnetism. Magnetism is always a positive and negative pole. However, these do not have to be at the same gauss strength and obviously in humans they are not at the same gauss strength. The fact that human metabolism functions in an alkaline medium is evidence that the positive and negative magnetic poles are not equal in humans and in fact, a negative pole is higher than the positive pole. This has to be in order to maintain the alkalinity. Movement of a static electric field source of electrons produces magnetic fields. This biological production of magnetic fields develops with each catalytic joining of enzymes and substrates. When electrons move between enzyme and substrate, a magnetic field is produced. Likewise, an external static magnetic field moves electrons, producing a joining of enzyme and substrate (catalysis). The stronger the gauss strength, the stronger the catalytic reaction. Magnetism is two opposite energies that are mirror images. The static

negative magnetic field spins electrons counterclockwise. This is a three dimensional spin. The higher the negative magnetic gauss strength, the faster the electrons spin and the higher the biological expressed energy. The positive magnetic field spins electrons clockwise in a three dimensional spin. The higher the positive magnetic field gauss strength, the faster the spin of the electrons.

The EEG provides evidence of the biological response to positive and negative magnetic fields and demonstrates that this is an opposite energy. A brain exposed to a static negative magnetic field reveals that the higher the gauss strength, the slower the pulsing field. This ranges all the way from 8 cycles per second for relaxation to 12 cycles per second for relaxation and 2 cycles per second for sleep to 1 cycle every two seconds for anesthesia.

The brain exposed to a static positive magnetic field pulses beyond 12 cycles per second. The higher the gauss strength, the faster the pulsing field. This positive magnetic field exposure to the brain is beyond 12 cycles per second and ranges to 22 cycles per second during mental activity to 35 cycles per second during a grand mal seizure.

Thus the EEG response establishes conclusively the separate biological energy systems produced by separate positive and negative magnetic fields. It can also be understood that pulsing sensory inputs can evoke specific magnetic field energy expression of the brain. The EEG tells us that the pulsing frequency is such as the non-stress (stress-controlling), 8-12 cycles per second for relaxation, the 2 cycles per second for sleep and 1 cycle very two seconds for anesthesia. Thus we have two ways to drive the magnetic field of the brain, such as positive and negative magnetic fields and sensory and low gauss pulsing magnetic fields.

The natural pulsing of the brain, and thus also all cells of the body is dependent on cellular conductance. Cellular conductance is dependent on cellular mineral content. The higher the cellular mineral content, the greater the conductance. Conductance produces a vibrational pulsing frequency. The higher the mineral content, the higher the inherent vibrational pulsing frequencies. Microorganisms (viruses, bacteria, fungi and parasites) and cancer cells have a higher mineral content and thus a higher pulsing frequency than human cells which have a lower mineral content and thus a lower vibrational pulsing frequency.

There is a battle of electromagnetic energies between human cells, microorganisms and cancer cells. The one with the highest

energy will win the battle between electromagnetic positives and electromag- netic negatives. Human cells are electromagnetic negative. Supplying exposure to a negative magnetic field supports the human negative electromagnetic field energy and blocks the microorganisms and cancer cells that are electromagnetic positive.

Human cell function is alkaline-dependent. Most human enzymes are alkaline-dependent and some, such as those producing ATP, are alkaline-hyperoxia-dependent. Oxidoreductase enzymes have the assignment of producing ATP and catalytic remnant magnetism (negative magnetic field) as well as processing inflammatory end-products of metabolism (free radicals, peroxides, oxyacids, alcohols and aldehydes) and all endotoxins and exotoxins. It is very important to understand enzyme dependence on pH and cellular energy as an expression of conductance since the understanding of the minutia of immunology has ignored both pH and conductance. This seems very strange because there is an enormous amount of detailed understanding about immunologic reactions. Understanding these two factors gives immunology a new therapeutic life-energy dimension. The understanding of the two diametrically opposed magnetic fields of negative and positive is precisely where magnetic therapy makes its contribution to immunology and the therapeutic use of the25 immunologic mechanisms.

Some serious questions need to be asked and answered about pH and immunologic reactions: Are both hormonal and cellular immunologic defense reactions acidic-dependent? Does the acidity precede the immunologic response or is the acidity the product of the immune defense response? It is possible that either can be true. It is certain that all immune responses are inflammatory and acidic and that all immune inflammatory responses are favorably influenced by alkalinization.

Is it possible that a strong and evenly maintained alkaline pH can defeat microorganism invasion? Many patients report that while sleeping on a negative magnetic field bed that they no longer have colds, flu or other evidences of infection.

Can we optimize systemic exposure to an external negative magnetic field and thus prevent infectious invasions? We can successfully treat microorganism infections with a strong and sustained negative magnetic field and kill the microorganisms and kill cancer cells.

Is it possible that understanding the separate roles of conductance between the human cells and microorganisms can lead to understanding why a negative magnetic field is an antibiotic?

A static negative magnetic field biological response is alkaline-hyperoxia. A negative magnetic field attaches to bicarbonates, supporting their alkalinity. A negative magnetic field enzymatically pro- cesses inflammatory byproducts of oxidation reduction metabolism (free radicals, peroxides, oxyacids, alcohols and aldehydes) to molecular oxygen and water. Also, endogenous and exogenous toxins are likewise processed to molecular oxygen and water. Thus, alkaline-hyperoxia is a product of a negative magnetic field exposure to human metabolism.

A negative magnetic field biological response is anti-stress and thus controlling of all normal human cellular functions including the control over cellular replication, tissue growth and healing. On the contrary a positive magnetic biological response is stress and if sustained for any period of time, interferes with human cellular functions including cellular replication, tissue growth and healing. Robert O. Becker, M.D. has determined that healing only occurs in the presence of a negative mag- netic field and is equally blocked by the presence of a positive magnetic field.

Microorganism cultures and blood cell cultures (virus and cancer) ignores pH as maintained by human metabolism and especially ignores conductance deficiencies between human cells and micro- organisms. Even though there is some value in these cultures, the results can never be equated to an intact biological organism with these two defenses (pH and conductance) intact. All immune responses are biological stress responses and thus are measurably acid-hypoxic. A negative magnetic field biological response of the alkaline-hyperoxia can initially block and if present already, replace acid- hypoxia with alkaline-hyperoxia.

Infections invading microorganisms are acid-producing and thus the constitutive defenses against invasion are inflammatory acid-producing as well as the immune defense against the invading microorganism is acidifying. Cancer fermentation process is acid-dependent and also produces lactic acid.

MAGNETIC IMMUNOLOGIC PROJECT
Principle of Functions

A negative magnetic field, by virtue of a biological response of alkaline-hyperoxia, is anti-inflammatory and can be used to train out an immunological inflammatory allergic reaction to an antigen.

A positive magnetic field is inflammatory by virtue of a biological response of acid-hypoxia and can be used to train in an inflammatory (vaccination) response to an antigen.

Desensitization Methodology

Use a patch skin test or intradermal skin test that is positive to an antigen. Place over this positive skin test, a 1" x 1/8" neodymium disc magnet. Leave in place for one week. Repeat the exposure to the antigen and immediately place on this the negative magnetic field for another week. On the third time, test to determine if the test is still positive. Keep repeating this procedure unit the test is negative at which time desensitization has developed and is demonstrated.

Sensitization (Vaccination) Methodology

Do an intradermal skin test to determine a negative response. Place the antigen between two glass slides. Secure these glass slides so that they cannot move. Place the glass slides on the skin. Place over this a 1" x 1/8" neodymium disc magnet. Tape this to the skin. Hold this in place for four days. Four days are required to maximize the cellular immune response. Do not exceed four days since the positive magnetic field is inflammatory. A mild degree of vasodilation, producing soreness, will be present by four days. If it is extended to as much as two weeks, there will be a florid infection on top of this inflammatory vasculitis. Therefore, do not exceed four days. Move the antigen to another area of the skin every four days. A positive vaccine response will be manifest when an inflammatory reaction with soreness is present within the first day of exposure.

This method of vaccination would not expose the person to an infection. Therefore, it would be a protection against the damage that does occasionally occur from vaccination. A magnetic representation of a substance is known to be capable of producing a biological response. This is the principle of homeopathy. It would be a great blessing to be able to vaccinate and not run the risk of an infection, a massive immune response to some component of the vaccine, contamination of viruses in the vaccine material or of toxic heavy metal contamination. The magnetic method of vaccination using a magnetic representation of the antigen rather than the antigen substance itself is urgently needed and should be vigorously pursued.

AMAS TEST
(666)

The AMAS immune assay is the most reliable test for early cancer detection of all types of cancer except leukemia. This is a blood test approved by the FDA. The AMAS test can also be used after magnetic therapy to determine if cancer has been successfully eradicated.

My observations justify the evidence of a progressive, insidious herpes family viral encephalitis as a central cause of autism. Attention-deficit hyperactive disorder, obsessive-compulsive syndrome, dyslexia, mirror-imaging and some developmental delay and seizure disorders in childhood that in some will progress into adulthood with the development of schizophrenia and bipolar disorder. Furthermore, there are numerous other candidates for brain disorder concerning the childhood and adult central nervous system injuries. Some of them are such as measles from the attenuated measles vaccine, several other viruses, bacteria such as streptovirus and Lyme's disease, mercury toxicity from vaccines containing thimerosal lead toxicity and so forth.

I have isolated a single central treatment to chronic progressive herpes family viral encephalitis syndrome. This central treatment system is equally applicable to other possible and or probable causes and that is a strong negative magnet gauss strength of sufficient duration to kill viruses and all invading microorganisms as well as processing heavy metal toxicities out of the body.

Specific supplemental nutrition should be optimized, preferably after a survey of the nutritional needs. B-complex, especially B_6, minerals especially magnesium, calcium, zinc, potassium, selenium, as well as cysteine and taurine to bypass a metabolic disorder. The viral injured brain has set the stage for maladaptive reactions to allergies, addictions and toxic food reactions. Avoidance and spacing by food rotation is needed for symptom management. Gluten-containing foods have the highest frequency of symptom reactions. There are usually six or more food reactions. When gluten foods continue to produce symptoms, despite rotation and or treatment with magnets ahead of each meal, then the gluten reaction is considered to be genetic. In this case, gluten grains should be sprouted. Gluten-containing foods are such a central source of nutrition that these foods should be used by sprouting the grains.

Viral encephalitis of herpes family viruses has been confirmed with MRI evidence of brain damage (CARUSO and colleagues). This report by June Caruso and Colleagues describes viral

encephalitis caused by Epstein-Barr virus. Also, strep infection encephalitis is referenced. My findings, based on antibody evidence, are consistent with viral encephalitis of the mononucleosis viruses, Epstein-Barr virus or cytomegalovirus. Children with this viral encephalitis have learning disorders, behaviora disorders and autism.

This viral encephalitis interferes with brain development. The history of schizophrenics reveal characteristically, the behavioral disorders, learning disabilities and or features of autism occurring in their childhood.

My observation is that children with chronic progressive viral encephalitis are candidates for the development of schizophrenia or bipolar disorder. Furthermore, my observations are that adults who get these mononucleosis viruses after their brain development, do not go psychotic but develop fibromyalgia with weakness and depression.

Bernard Remland, Ph.D., Autistic Research Institute, 4182 Adams Avenue, San Diego, CA 92116.

Bernard Remland keeps research on autism updated in his *Autism Research Review International Journal.* He has, in conjunction with physicians, developed the DAN program which emphasizes the nutritional value of improved brain function stability especially using B complex vitamins and B_{12}.

The frequent maladaptive reaction to gluten is emphasized. The toxic effects of mercury in vaccines is emphasized and considered in the treatment.

William H. Philpott, M.D. Viral Research Project

All with a chronic progressive herpes viral encephalitis are invited to be a party to a statistical study and treatment. The viruses in the blood are identified by the polymerase chain reaction (PCR) before magnetic treatment begins and after three months of magnetic treatment. This, first of all, identifies the live viruses and the fact that three months later, they are not present. It is very important this study be done and published in peer review scientific journals.

The laboratory that does the PCR identification of the virus and proof of their absence after treatment is: 822 S. Robertson Blvd., Ste. 312, Los Angeles, CA 90035. Tel: (310) 657-1077. Fax: (310) 57-1053.

MAKING VACCINATIONS SAFE RESEARCH PROJECT

Vaccination has two major problems:
1. The fact that measles vaccine is a live attenuated virus.
2. The fact that mercury is used in some vaccines.

Measles has been a devastating disease. Serious side effects are including encephalo myelitis, subacute sclerosing panencephalitis, pneumonia, seizures and death. The production of a vaccine that would prevent these serious complications is well justified and has achieved a very high degree of suc- cess, however, occasionally and in small amounts, there still are the complications of measles even with the attenuated virus used as a vaccine. A dead virus was tried but did not achieve the goal. Any time when the immune system is suppressed, this virus can start flourishing and damaging the central nervous system. The human immune system cannot kill the measles virus, not even the attenuated type used for vaccination. The goal is to kill the virus after it has had a sufficient opportunity to mount the immunologic reaction, building antibodies. A negative magnetic field is known to be capable of killing viruses. It is a matter of using a sufficiently strong gauss of sufficient duration of exposure. A strong negative magnetic bed and head unit make this possible. We need also to gather data for publication in scientific peer review literature that the viruses are killed and that the mercury has been processed out of the body. After three months of magnetic treatment on the super magnetic bed and super magnetic head unit, then test the blood to determine if the presence of the measles virus can be detected. This is done by a immune identification process. Spillage in the urine of mercury during the special process of chelation should be done after three months of treatment. Treatment is complete when the evidence of the viruses have died and the mercury is no longer spilled in the urine. However, this magnetic bed and magnetic head unit are continued nightly as a lifestyle.

SUCCESS STORIES
SCHIZOPHRENIA

A schizophrenic in his 20's was depressed and anxious with visual and auditory hallucinations and delusions which were not managed by tranquilizers and antidepressants. He slept on a super magnetic bed composed of 70 magnets, 4" x 6" x 1", with the negative pole facing his body. He also slept with his head in the super magnetic head unit composed of twelve magnets, 4" x 6" x 1" . He managed his foods by using disc magnets on his head and a 4" x 6" x 1/2" magnet on his chest and epigastric area for 30 minutes before each

meal. He sat up a four day rotation diet. In this, he also used no caffeine, no tobacco and no alcohol and was not on tranquilizers or antidepressants. He used the 1-1/2" x 1/2" disc magnets placed bitemporally for any immediate symptoms.

Three months later, his mother reported to me that he was symptom-free. She proceeded to order the super magnetic bed for other members of the family.

SCHIZOPHRENIA

This is a 23-year-old man diagnosed with schizophrenia having symptoms of depression and auditory hallucinations. At age 11, he was diagnosed as having attention-deficit disorder. This has now progressed to the point of major mental symptoms. He has been under treatment for better than one year. He sleeps on a bed of 70 magnets that are 4" x 6" x 1". He sleeps with his head in a magnetic head unit composed of 12 magnets that are 4" x 6" x 1". He uses ceramic disc magnets that are 1-1/2" x 1/2" placed bitemporally for any symptoms. He has an apartment separate from the family which is near the university he attends. He is making excellent grades.

This case illustrates the progression from attention-deficit as a child to schizophrenia as an adult.

SLEEP APNEA: INSOMNIA: MIGRAINE HEADACHES PAIN, ACHES AND CRAMPS

Dear Dr. Philpott,

I am writing to let you know the results from the use of the magnets you prescribed. I have also rotated my diet for 8 years. I use alkaline micro negative ionized water with an alkaline pH which I get from an electrolysis machine I purchased about 2 years ago. I do not use drugs, alcohol, tobacco, caffeine or carbonated soft drinks.

My husband had a bad case of sleep apnea and insomnia for years. After sleeping on the magnet mattress pad and headboard system for a week, almost all of his symptoms are gone. He rarely wakes up until morning and his breathing is much more normal with little snoring or other noises he used to make. He is so happy about it!

My results are also exciting. I followed your instruction to wear the 4" x 6" x 1/2" magnets over my liver and heart as well as the disc magnets over my temples 15 minutes before mealtimes and during the meals. As long as I do this, I am able to eat anything and suffer no horrendous migraine headache. There were at least 39 foods containing tyramine which caused my headaches. I forgot to wear the magnets several times and got migraines as a result. Your magnet

prescription is a Blessing of God and a Miracle to me to be able to keep the migraines away.

The result of wearing the magnets before mealtimes is that I am now able to take vitamin E that I was allergic to before. I was having awful hot flashes multiple times a day for 8 years and felt bad when one took me down for 5 minutes each time. I am rarely having the hot flashes now. It is wonderful!

Another nice benefit is the pain relief from minor pains such as cramps, stomach aches, ear aches, etc. We have found that pain is often relieved by placing a magnet over the pain for a short while.

With Gratefulness,

A 5-year-old girl suddenly was not talking. Her development was normal up to her loss of speech. She otherwise had no markers of autism. A nutritional survey demonstrated B_{12} deficiency. Two hours after a B_{12} injection, she resumed talking.

MAGNET THERAPY: DELAYED SPEECH CORRECTION

A 7-year-old boy was not talking.

He slept with his head in a super magnetic unit which is composed of twelve 4" x 6" x 1" magnets in a wooden frame which surrounds his head. He as instructed to rotate his foods on a four day basis. Within three months of sleeping with his head surrounded by these twelve magnets and following the rotation diet, his speech was normal. He now speaks freely and distinctly.

Possible causes:

A viral infection of the brain from herpes family viruses such as Epstein-Barr, cytomegalovirus or human herpes virus #6. A negative magnetic field kills viruses.

Heavy metal toxicity such as mercury from vaccinations. A negative magnetic field processes heavy metal toxicity.

CHRONIC PROGRESSIVE HERPES FAMILY VIRAL ENCEPHALITIS SYNDROME: ORIENTATION:

Viral encephalitis syndrome includes a spectrum of organic brain syndrome disorders which occurred because of the development of a viral infection in childhood. Some of these develop during gestation or are passed on by the mother who had these viruses. There are any number of candidates that can produce an encephalitis. However, in my large study, I isolated that consistently the herpes family viruses are present which are Epstein-Barr, cytomegalovirus and occasionally human herpes virus #6. Heavy metal toxicity such as mercury or lead can also

cause an encephalitis. This needs to always be considered as a possibility. If present, these can be appropriately treated with the super magnetic bed as provided by this magnetic protocol. It is capable of processing these heavy metals out of the body. There are other useful chelating methods of getting the heavy metals out of the body. The encephalitis syndrome, which is basically a viral encephalitis, are schizophrenia and its numerous symptom manifestations, manic depressive disorder, a spectrum of childhood organic brain disorders secondary to the encephalitis which are obsessive-compulsive disorder, attention-deficit disorder, hyperactive disorder, dyslexia, mirror-imaging, Tourette's syndrome and autism. The magnetic protocol as outlined will kill the viruses and will process toxins including heavy metals. After reversing the basic infection or toxic disorder, the subject then is capable of being retrained with behavior therapy. Symptoms that are evoked by such as an allergy, addiction or toxicity to foods also, because of their repetition, become learned behaviors and after stopping the driving force behind these reactions, then the subject is capable of being retrained for social and learning achievements. Maladaptive reactions to foods, chemicals and inhalants, especially foods, is an important secondary aspect of this encephalitis syndrome. When a maladaptive reaction occurs, whether it is an allergy, addiction or toxicity, the brain is the reacting organ because of its state of injury. Therefore, it is highly important to stop these maladaptive reactions even though they are not the initiating cause of the illness. This can be achieved by spacing the contact with the substances that cause maladaptive reactions. A rotation diet of either a four or seven day is very much in order. The subject should not settle on a single food such as gluten, even though it has a high frequency, because on an average, these subjects react to a half a dozen or more foods. When treating the head, heart and the liver with magnets ahead of a meal, this simplifies the food rotation diet. Symptoms can effectively be managed with disc magnets placed bitemporally. These should always be available so that if the subjects meet up with a food or substance that they react to, they could place the magnets bitemporally and within minutes, relieve their symp- toms. No tranquilizers or antidepressants are used in this magnetic treatment system. Nutrition is optimized especially by laboratory assessments of vitamin, mineral and amino acid needs. Genetic states should be considered, especially homocystinemia.

MAGNETS USED:

Super magnetic bed composed of seventy 4" x 6" x 1" magnets. Thirty-five of these are placed an inch apart in a wooden carrier 36" square. Two of these wooden carriers are placed end to end pro- viding a bed 36" x 72". This is the size of a single bed.

A 2" thick memory foam pad for a single sized bed.

Super magnetic head unit composed of twelve 4" x 6" x 1" magnets.

Two 4" x 6" x 1/2" ceramic block magnets with Velcro on the positive pole side. Two 4" x 52" body wraps.

Two 1-1/2" x 1/2" ceramic disc magnets with Velcro on the positive pole side. One 2" x 26" band.

PLACEMENT AND DURATION:

Sleep all night on the super magnetic bed and the super magnetic head unit. Go back on the bed and the head unit one hour, four times during the day for the first three months. This is for the purpose of killing any virus, bacteria or fungi. After three months, sleep on the bed and the head unit nightly as a lifestyle. This is energizing but also protective against the development of infections.

Pre-meal, treat the head, heart and the liver for 30 minutes ahead of meals. Follow the instructions in the *Metabolic Syndrome* quarterly. It is highly important to rotate the foods in all of these cases. There usually are a half dozen foods reacted to with symptoms. The most frequent food reacted to was foods that contain gluten such as wheat, rye, oats and barley. Corn does contain a gliadin which is a special type of gluten to which some also react. Millet has been considered a question mark by some. Rice and buck-wheat do no contain gluten. Grains that have been sprouted do not contain gluten. Since the subjects react to several foods, it is not wise to select just gluten to leave out of the diet and in fact, there should always be a return to the gluten containing foods after a period of avoidance or treating the body ahead of each meal. There are only a few who will continue to react to gluten on a genetic basis. This is 1 in 200 of Irish and 1 in 2000 in the non-Irish. Foods containing gluten are very nourishing foods and should be used if at all possible or even in those who have a genetic disorder, sprout the grains before using them.

It is very useful to use other factors that provide a negative polarity such as keeping the air in the house cleaned by a negative ion generator. This will keep the infections down. Also the breathing of these ions are healthful. The negative ions, whether this is in the air, the water or in colloidal silver, have the same effect as the negative

magnetic field and should be used as supplementation to the negative magnetic field.

It is wise for the first three months to have a course of colloidal silver. Colloidal silver is a negative ion and its treatment is a part of this negative magnetic field treatment. Negative ions have an antibiotic effect on viruses, bacteria, fungi and parasites. Negative silver ions do not remain in the body and do not produce any kind of symptoms or injury.

FINAL WORD

The discovery of a common viral encephalitis in children with behavioral disorders, learning disabilities and autism and adults with major mental illness has also lead to a common denominator treatment. The human immune system cannot kill these herpes family viruses. The herpes family viral encephalitis is a progressive brain injury. Minor brain injury in childhood causing behavioral, learning disorders and autism can and frequently does progress to more brain injury resulting in adult psychosis in the 20's. Adults with these herpes family viruses are diagnosed as infectious mononucleosis. This does not result in psychosis but can and often does result in a chronic illness diagnosed as fibromyalgia with weakness and depression. The observation is that adult psychotics had these viral infections during the brain's developmental period which prevented the full maturity of the brain. Human herpes virus #6 has been consistently indicated in multiple sclerosis, which is a progressive viral en- cephalitis.

The common treatment for children with behavioral disorders, learning disabilities and autism and adults with psychosis and also adults who have developed fibromyalgia with weakness and depression and multiple sclerosis is as follows:

1. Kill the viruses.

2. Stop the maladaptive (allergies, addictions and toxicities) symptoms including chemicals and inhalants.

3. The negative magnetic field can kill the herpes family viruses and invading bacteria, fungi and parasites.

4. A negative magnetic field can reverse the allergies, toxicities and addictions.

5. Stabilize brain function by optimum nutrition, especially B complex vitamins, vitamin C, essential minerals and essential fats.

6. After managing the symptoms and killing the viruses, then proceed with behavioral therapy, training out learned inappropriate

social and disordered learning symptoms and train in useful social and learning skills.

REFERENCES

ADAMS, Raymond D.; VICTOR, M.; ROPPER, A.H., *Principles of Neurology,* Sixth Edition, The McGraw-Hill Companies

BECKER, ROBERT O. "Cross Currents". Jeremy P. Tarcher, Inc. Los Angeles, CA, 1990. BECKER, ROBERT O. and SELDON, G. "The Body Electric. Electromagnetism and the Foundation of Life." William Morrow and Company. NY. 1986.

BECKER, ROBERT O. and MARINO, A. "Electromagnetism and Life". State University of New York Press; Albany, NY 1982.

BELANEY, B. The New Encyclopedia Britannica, 1986. Vol VIII, pp 274-275. BRAUNWALD, Eugene. Harrison's Principles of Internal Medicine. 11th edition 1987. McGraw-Hill Book Company, NY.

CHALLEM, Jack. *The Inflammatory Syndrome. The Complete Nutritional Program to Prevent and Reverse Heart Disease, Arthritis, Diabetes, Allergies and Asthma.* John Wiley and Sons, Inc. 2003.

BARNARD, Neal, M.D. *Breaking the Food Seduction.* St Martins Press, NY 2003.

DAVIS, A. R. and RAWLS, W. "The Magnetic Blueprint of Life.". Acres USA, KansasCity,MO, 1979.

DAVIS, AR. and RAWLS, W. "The Magnetic Effect". Acres USA, Kansas City, **MO** 1975

DAVIS, A.R. and RAWLS, W. "Magnetism and Its Effect on the Living System". Acres USA, Kan- sas City, MO 1976.

FLANIGAN, PATRICK and FLANIGAN, GAEL AND CRYSTAL. Earthpulse Press New Test Number One.

FRESHT, Alan., *Enzyme Structure and Mechanism,* Second Edition. W.H. Freeman and Co. New York, New York. 1994.

KLONOWSKI, W and KLONOWSKI, M. Journal of BioElectricity. Aging Process and Enzy- matic Proteins. 4(I), 93-102 (1985).

LEVY, THOMAS E, M. D., J.D. *Vitamin C, Infectious Diseases, & Toxins. Curing The Incur- able.* Xlibris Corporation.

Magnetic Fields in Enzyme Catalysis. Encyclopedia Britannica. Vol 15. Pg 1068. Chicago, 1986. MEGGS, William Joel, M.D., Ph.D. with SVEC, Carol. Contemporary Books, McGraw-Hill Books, *2003.*

NORDENSTROM, BEW, Biologically Closed Electric Circuits. Stockholm, Sweden: Nordic Medical Publications, *1983*.

NORDENSTROM, BEW, "Electrochemical treatment of cancer; variable response to anodic and cathodic fields". Am J. Clin Oncol, 1989: *12:530-536.*

NORDENSTROM, BEW, "Survey of mechanisms in electrochemical treatment (ECT) of cancer". Europ J. Surg. Suppl. *1994: 574:93-109.*

NORDENSTROM, BEW, "Biokinetic impacts on structure and imaging of the lung: the concept of biologically closed electric circuits". Am J Roentgenol. *1985;* 145:447-467.

O'CLOCK, G.D., "Studies of the effects of in vitro electrical stimulation on eukaryotic cell proliferation". MA Thesis (Biological Sciences), Mankato State University, Mankato, MN, *1991.*

O'CLOCK Jr G.D., & Lyte, M., "Potential uses of low-level direct current electrotherapy for the treatment of cancer". Proceedings of the 15th Annual International Conference of the IEEE Engineering in Medicine and Biology Society, San Diego, CA, Part *3: 1993;* 1515-1516.

PHILPOTT, W.H., M.D. and KALITA, Dwight, Ph.D., *Victory Over Diabetes: A Bio-Electric Triumph.* Keats Publishing Company, Inc. New Canaan, CT. 1982 (1991 paperback with new chapter on Medical Magnetics).

PHILPOTT, W.H., M.D. *Diabetes Mellitus. A Reversible Disease.* Vol III, Second Quarter, 1997. W.H. Philpott Publication. 17171 S.E. 29th Street, Choctaw, OK 73020. PHILPOTT, W.H., M.D. and KALITA, Dwight, Ph.D., *Brain Allergies. The Psycho-nutrient and Magnetic Connections.* Updated second edition. Keats Publishing NTC/Contemporary Publishing Group. Los Angeles, CA , *2000*

PHILPOTT, W.H., M.D. and KALITA, Dwight, Ph.D., *Magnet Therapy.* (Tiburon, CA: Alternative Medicine. corn, *2000)*

POTTS, JOHN, Journal of Diabetes. Avoidance Provocative Food Testing in Assessing Diabetes Responsiveness." 26:Supplement 1, 1977.

POTTS, JOHN, Journal of Diabetes. 'Value of Specific Testing for Assessing Insulin Resistance." *29:* Supplement 2, 1980.

POTTS, JOHN, Journal of Diabetes. "Blood Sugar-Insulin Responses to Specific Foods Versus GTT." 30: Supplement 1, 1981.

POTTS, JOHN, Journal of Diabetes. "Insulin Resistance Related to Specific Food Sensitivity." 35: Supplement 1, 1986.

PROC. NATL. READ. SCI USA. Vol *92* p 2440-2444. August 1995. About HHV6 as cause of multiple sclerosis.

RANDOLPH, T.G. *The Enzymatic and Hypoxia, Endoctrine Concept of Allergic Inflammation* Clinical Ecology. pp 577-596. Charles C. Thomas, Publisher, Springfield, Illinois. (1976).

STEIN, Jay *H. Internal Medicine.* 4th Edition. 1994. P. 340-524. Mosby Publishers. St. Louis. TRAPPER, ARTHUR, et al. "Evaluating Perspectives on the Exposure Risks from Magnetic Fields", Journal of the National Medical Association, 82:9, September 1990.

WARBURG, O., The Metabolism of Tumors. F. Dickens (Trans) London: Arnold Constable: 1930. WARBURG, O., On the Origin of Cancer Cells. Science 123 (1956) 309-315. WARBURG, O. " The Prime Cause and Prevention of Cancer". Revised lecture at the meeting of the Nobel laureates on June 30, 1966. National Cancer Institute Bethesda, MD.1967

ZINSSER, JOKLIK . *Zinsser Microbiology,* 20th Edition, Appleton & Lange, Norwalk, CT, 1992. [*Magnetic Health Quarterly* "Viral Encephalitis Syndrome" Vol. X, 3rd Qtr, 2004] "Intestinal lymphocyte populations in children with regressive autism: evidence for extensive mucosal immunopathology," Paul Ashwood, Simon H. Murch, Andrew Anthony, Alicia A. Pellicer, Franco Torrente, Michael A. Thompson, John A. Walker-Smith, and Andrew J. Wakefield, *Journal of Clinical Immunology,* Vol 23, No 6, November 2003, 504-17. Address: Paul Ashwood, Inflammatory Bowel Disease Study Group, Royal Free and University College Medical School, London, UK, p.ashwood@rfc.ucl.ac.uk.

"Bowel virus found in autistic children who had MMR jab," Beezy Marsh, *Daily Mail, (UK),* Janu- ary 13, 2004.

"Effect of thimerosal, a preservative in vaccines, on intracellular Ca(2+) concentration of rat cerebellar neurons," T. Ueha-Ishibashi, Y. Oyama, H. Nakao, C. Umebayashi, Y. Nishizaki, T. Tatsuishi, K. Iwase, K. Murao, and H. Seo, *Toxicology,* Vol 195, No. 1, January 15, 2004, 77-84. "Increased prevalence of familial autoimmunity in probands with pervasive developmental disorders," Mayne L. Sweeten, Suzanne L. Bowyer, David J. Posey, Gary M. Halberstadt, and Christopher J. McDougle, *Pediatrics,* Vol 112, No. 5, November 2003, e420 (electronic publication). Address: Christo- pher J. McDougle, Department of Psychiatry, Indiana University School of Medicine, Psychiatry Building A305, 111 W. 10th Street, Indianapolis,

IN 46202-4800. cmcdoug@jupui.edu "An assessment of the impact of thimerosal on childhood neurodevelopmental disorders," David A. Geier and Mark R. Geier, *Pediatric Rehabilitation*, Vol 6, No 2, April-June *2003*, 97-102. Address: Mark R. Geier, Genetic Centers of America, 14 Redgate Court, Silver Spring, MD 20905, mgeier@erols.com. *"Activation of methionine synthase by insulin-like growth factor-I and dopamine: a target for neurodevelopmental toxins and thimerosal,"* M. Waly, H. Olteanu, R. Banerjee, S. W. Choi, J.B. Mason, B.S. Parker, S. Sukamar, S. Shim, A. Sharma, J.M. Benzecry, V.A. Power-Chamitsky, and R.C. Deth, *Molecular Psychiatry*, January 27, 2004 (epub). Address: Richard C. Deth, Dept. Of Pharmaceutical Sciences, Northeastern University, Boston, MA 01225. *Methylation: The Link Between Thimerosal and Autism.* Autistic Research Review, vol 18, No 1, 2004. "Persistent preceding focal neurologic deficits in children with chronic Epstein-Barr virus encephali- tis". J.M. Caruso, G.A. Tung, G.G. Gascon, J. Rogg, L. Davis and W.D. Brown, *Journal of Child Neurol- ogy. Vol 15*, NO 12, December 2000, pp 791-796. Address: J. M. Caruso, Department of Pediatric Neurology, Children's National Medical Center, Washington, D.C. 20010.

MAGNETIC THERAPY: PSYCHIATRY AND PSYCHOLOGIES' BRIGHT NEW HORIZON

Magnet therapy has set the stage for a new highly efficient, predictable promising future. Imagine no tranquilizers, no antidepressants or electric shock or their deleterious side effects. Imagine symptom relief of minor and major emotional or organic mental symptoms relieved within minutes of exposing the brain to a negative magnetic field. Imagine all invading microorganisms killed. Imagine no more allergies, addictions or toxic reactions to foods, chemicals or inhalants. Imagine trainableness by behavioral therapy once the organic factors are appropriately handled.

The day of these values is already here!

The sad news is that the values of magnetic therapy is not common knowledge and that psychiatrists and psychologists are not being oriented to use it.

The good news is that the values of magnetic therapy are predictable and reproducible. The good news is that magnet therapy does not require a medical prescription and is thus available for self-help application. Application of magnet fields to humans is classified by the FDA as not being harmful. The efficiency of magnet therapy

is such as to predict that it will be a substantial part of tomorrows clinical psychiatry and clinical psychology.

THE ROLE OF WATER IN MAGNET THERAPY

The biological life including of course, humans, is as dependent on water as it is on oxygen. Water is on the inside and the outside of every cell. Water is a solvent carrying nutrients to cells and carrying away metabolic end-products that have to be dispensed with. The free radical, super oxide, is toxic and unless processed rapidly, enzymatically by the oxidoreductase enzymes to oxygen and molecular water is en- zyme toxic to the body. All free radicals as end-products of metabolism are toxic to enzymes. The basic enzyme function of the body is alkaline-dependent and if acidity develops, which will happen with dehy- dration, then these enzymes cannot function. Water is necessary to keep alkalinity present. Acidity is a product of dehydration. Acidity evokes histamine and evokes autoimmune reactions. The metabolic function of the body simply cannot continue to function without adequate water. The end result of dehydration are metabolic degenerative diseases. At least, this is a major source of degenerative diseases and water should be used adequately for its preventive value. I have found that acid-hypoxia is central to the degenerative disease process and that when a subject reacts to a food, chemical or a toxin, their reaction always is associated with acidity. I found that there are predisposing causes such as infections, particularly viral infections in our mental patients that sets the stage for these reactions. The reactions are maladaptive and are based on the condition of the tissues involved. For example, when the brain is infected by a virus and has been injured, the reaction will manifest itself as a mental reaction based on the brain's injury. However, to managing the reaction itself by maintaining adequate water and thus maintaining adequate alkalinity is a very significant part of therapy. Killing the viruses, the bacteria or the parasites is another necessary component of therapy.

In my original work, I fasted patients on water only. I did not tell them how much water. I simply said to drink an abundance of water and this was not any special water but it was water that was not contami- nated. It was tap water from the city. Surprisingly, and even shockingly, my mental patients with schizophrenia and manic depressive were sane within five days. Feeding them meals of single foods revealed to us which foods produced which symptoms. Avoiding these foods avoided their symptoms. Usually, with three months of avoidance, these foods could be returned as long as they

kept them rotated on either a 4 or 7 day basis. We were testing blood pH as well as blood sugar. We found that routinely, when a symptom developed, the blood became temporarily acidic. Our first use of relieving symptoms was to give them baking soda or sodium and potassium combination adequate to relieve the symptoms which would be anywhere from 1/2 teaspoon to 1 teaspoon. We also, at the same time, had them breathe oxygen because in any acidic state, there is an oxygen deficit because the oxygen becomes tied up into acids in an acidic state. Later, we found that the physicist, Albert Roy Davis, was right when he said that the biological response to a negative magnetic field was that of alkaline-hyperoxia. Therefore, we began to use a negative magnetic field over the area of symptom production as a relieving agent. I also demonstrated that if we provide the exposure to the magnetic field ahead of a meal of a food that they have been demonstrated to be symptom reactive to, that they will not react. Thus, we found that local alkalinity prevented the development of the symptoms. At that point, early in my discovery of these values, I was not paying any attention to the quantity of water. Now that Dr. Bateman has helped us understand that often these symptoms develop because there is a basic dehydration with an evoked histamine reaction, we now pay close attention to the amount of water that the subject takes in. Of course, when we gave them soda bicarb as a relief of symptoms, they did drink a quantity of water at the time. I was not aware of course, that the water itself was part of the relieving agent. However, we did demonstrate that a negative magnetic field without any addition of water also relieved the symptoms. We do know that water is pulled into the magnetic field. Thus, we are hydrating that local area of which we are relieving symptoms. Now we understand that drinking extra water will itself, help maintain alkalinity and provide the extra fluid necessary for the kidneys to dispense with the acids and other toxins. The most minimal amount of water should be eight, 8 fluid ounces of water a day and this is really even too minimal. For many people, ten glasses of water would be better and for some, it takes twelve or more glasses of water, especially initially, to rid their body of toxins and acidity.

Fortunately, there has developed a knowledge of the value of some special waters. Water that comes from a volcanic source where the water is filtered through volcanic ash, has 70 or more low atomic weight minerals that have become negative ions and the water is always alkaline. Volcanic source waters are health waters because they are alkaline and also contain negative ion minerals. Negative

ions have the same biological value as a negative magnetic field. That is, alkaline-hyperoxia biological response. Also, water through electrolysis can be made into alkaline negative ion water using the minerals that are naturally, inherently present such as calcium, magnesium, sodium and potassium. There are home units that can turn your tap water into alkaline micro negative ion water. This is especially useful in maintaining hydration and its necessary alkalinity. There is a water that I have helped get on the market called Polarity Water. This water is from Alaskan glacier water with minerals from coral buds. Thus, there are the minerals that are inherently in the ocean in this water. This is then treated by electrolysis so that the minerals all become negative ions and the water is alkaline.

MAGNETIC PROTOCOL FOR HEALTH MAINTENANCE AND DISEASE REVERSAL:
ORIENTATION:

This magnetic protocol is for the purpose of maintaining health and when disease has already developed, for the reversal of the disease. Maintaining optimum hydration is one of the essentials of maintaining health or reversing diseases that are already present. Meeting adequate nutritional needs are another essential. Ridding the body of any invasion by microorganisms is another essential. Healing the body of damaged areas from degeneration or invading microorganisms is another essential. Magnet therapy materially aids in maintaining health by maintaining a normal physiological alkaline-hyperoxia, killing any microorganisms and healing any injured tissues. It is absolutely necessary to start with a baseline of adequate hydration. This hydration is best achieved with special waters such as from volcanic source with minerals. These are negative ions with its natural alkalinity. The more of these special waters that are used, the better. These waters can be prepared also for home use using tap water or ground water containing minerals such as sodium, potassium, calcium and magnesium. These can, through electrolysis, be turned into negative ions thus helping maintain the body's needed alkalinity. Although there are magnetic bed pads which help encourage sleep, they do not totally treat the cells of the body. You have to go to a strong enough magnet field in order to treat each cell of the body. This is available by using strong ceramic block magnets placed in a bed so that every cell of the body is treated with a negative magnetic field during sleep. This not only maintains the normal alkalinity, if of course there is adequate hydration, but it also provides the negative magnetic field that is necessary for healing of injured

tissues, the reversal of immunologic and autoimmune reactions and the killing of invading microorganisms. This super magnetic bed of 70 magnets and a head unit containing twelve of these 4" x 6" x 1" magnets is used as a lifestyle for maintaining health. It is also used for the reversal of diseases including invasion by disease producing microorganisms and also the reversal of cancer.

MAGNETS USED:

Super magnetic bed composed of seventy 4" x 6" x 1" magnets. Thirty-five of these are placed in a wooden carrier 38" square. This is 200 pounds of magnets and is half of the bed. Two of these wooden carriers are placed end to end producing a bed 76" x 38" which is the size of a single bed. This is 400 pounds of magnets.

A 2" thick memory foam pad or other suitable foam pad or futon for a single sized bed. A king-size bed uses two of these single-sized beds.

Super magnetic head unit composed of twelve 4" x 6" x 1" magnets.

Two 4" x 6" x 1/2" ceramic block magnets with Velcro on the positive pole side. Two 4" x 52" body wraps.

Two 1-1/2" x 1/2" ceramic disc magnets with Velcro on the positive pole side. One 2" x 26" band.

PLACEMENT AND DURATION:

Sleep on the bed and the head unit as a lifestyle. In treating diseases, it is necessary to return to the bed and the head unit one hour, four times during the day for at least the first three months. This is capable of killing invading microorganisms and is also capable of killing cancer.

It is wise to rotate the foods on a 7 day basis and also treat the head, heart and the liver with magnets ahead of each meal.

A suggested program is to drink two glasses of water. if this is tap water, ground water, reverse osmosis water or water from steam inhalation which doesn't even contain minerals, it would be wise to place a pinch of sea salt in two of the glasses of water. Before eating, drink two glasses of water with a pinch of sea salt, then place the disc magnets bitemporally on the head held in place with the 2" x 26" band. A 4" x 6" x 1/2" magnet is placed over the heart with the 6" lengthwise the body held in place with the 4" x 52" body wrap. Also place a 4" x 6" x 1/2" magnet over the liver with the 6" lengthwise the body held in place with a 4" x 52" body wrap. During this 30 minutes is the ideal time to exercise. Walking of course is ideal. Any other kind of exercise is useful also. The magnets can

either be removed or preferably left on during the meal. Each meal - breakfast, noon meal and evening meal, would be treated the same way. In-between meals, there would be a glass of water used. This provides eight glasses of water which is the minimal.

Ten are much better. So at the time of going to bed at night, drink two more glasses of water. If awakened for urination, drink another glass of water.

FINAL WORD

Water is as much of a necessity for human metabolic function as oxygen. All too often, we take our water intake for granted and don't pay attention. Equally, we don't pay attention to the body's signals of the need for water which are often pains in various parts of the body. We shouldn't consider the presence of a disease until we have demonstrated that adequate hydration with water will solve the problem first. Invasion of the body with microorganisms is a serious problem which often is ignored. This sets the stage for an acidity since all these invading microorganisms not only make acids but they thrive best in an acid medium. We can reverse all this with the alkalinity response to a negative magnetic field. We can also kill the microorganisms and kill the cancer with an appropriate sustained negative magnetic field.

It is wise to rotate the foods on either a 4 or 7 day basis and it is also wise to treat the head, heart and the liver ahead of meals with magnets. This can solve many problems of maladaptive reactions to foods.

Our water should be free of contaminants and it is preferred to have negative ion water which is alkaline. Negative ions have the same biological response as a negative magnetic field which is alkaline-hyperoxia. We should keep track of the amount of water we use. We should not consider that coffee, tea or cola drinks will satisfy hydration needs. In fact, they will interfere with good hydration and if used at all, should be used as a rare treat and not daily. It should not be assumed that this fluid is hydrating, because instead of being hydrating, it is dehydrating.

REFERENCES

BATMANGHELIDJ, F., M.D. *Your Body's Many Cries for Water.* Global Health Solutions, Inc. 8472- A Tyco Road, Vienna, VA 22182. 703-848-2333 phone / 703-848-0028 fax. 1997.

DAVIS, A.R. and RAWLS, W. "The Magnetic Blueprint of Life". Acres USA, KansasCity, MO, 1979. DAVIS, AR. and RAWLS, W. "The Magnetic Effect". Acres USA, Kansas City, MO 1975 DAVIS,

A.R. and RAWLS, W. "Magnetism and Its Effect on the Living System". Acres USA, Kansas City, MO 1976.

HUNTER, BEATRICE TRUM. Water and Your Health. Basic Health Publications, Inc. North Bergen, N. J. 07047. 2003.

PHILPOTT, W.H., M.D. and KALITA, Dwight, Ph.D., *Victory Over Diabetes: A Bio-Electric Triumph.* Keats Publishing Company, Inc. New Canaan, CT. 1982 (1991 paperback with new chapter on Medical Magnetics).

PHILPOTT, W.H., M.D. and KALITA, Dwight, Ph.D., *Brain Allergies,* updated second edition. Keats Publishing NTC/Contemporary Publishing Group, Los Angeles, CA 2000 PHILPOTT, W.H., M.D. and KALITA, Dwight, Ph.D., *Magnet Therapy.* (Tiburon, CA: Alternative Medicine. corn, 2000) [*Magnetic Health Quarterly* "Water" Vol. X, 4th Qtr, 2004]

TWO METHODS OF USING A 4-DAY DIVERSIFIED ROTATION DIET

The essence of the 4-Day Diversified Rotation Diet is that foods are rotated on a four day basis, thus preventing their maladaptive reactions, be these allergies or addictions. Also, this rotation diet will correct hypoglycemia and non-insulin dependent diabetes mellitus. The food families for rota- tion are arranged in this article.

One method is to avoid food eaten twice a week or more for a period of three months, rotating all other foods. At the end of three months, then place these frequently used foods back into the diet, rotated once in four days. This method is also outlined in my book, *Magnet Therapy.*

Another method that is preferred by some is to start rotating all foods, even those that are eaten frequently. This can be achieved if the subject will treat themselves to magnets for 15-30 minutes ahead of the meal. To achieve this, place the ceramic disc magnets bitemporally, that is in the front of the ears at the level of the top of the ears. These are held in place with a 2" x 26" band. The discs are ceramic discs that are 1-1/2" x 1/2". The negative magnetic field is always placed toward the body.

On the positive magnetic field side, there is hook Velcro that will hook to the band around the head and hold these in place. At the same time, place the negative magnetic field of a 4" x 6" x 1/2" magnet over the heart with the 6" lengthwise the body. Hold this in place with a 4" x 52" body wrap. Also, place a 4" x 6" x 1/2" magnet with the 6" lengthwise the body over the liver area

which is on the right side of the body with half of the magnet over the rib cage and half below the rib cage. Hold this in place with a 4" x 52" body wrap. The minimum time of exposure should be 15 to 30 minutes or more before each meal. With this method, there is no avoidance period of the commonly used foods.

After three months of rotation, there is little likelihood of a maladaptive reaction to a food with- out the magnets before the meal. Whenever purposely violating the rotation diet such as eating out , then use the magnets ahead of a meal.

ABDOMINAL FAT MAGNETIC MELTDOWN

Nightly, place two 4" x 6" x 1/2" ceramic block magnets, 2" apart on the fatty abdomen. Use the negative magnetic field. Hold in place with a 4" x 52" body wrap. Some may need two of these body wraps. Some report losing one pound a day.

The Non-Addiction Ultimate Diet
The Biochemistry of Addiction

A physician uses narcotics such as Demerol, morphine and so forth to relieve pain. When non-narcotic pain substances do not relieve pain, then a physician can legally use his professional judgment as to the necessity of using a narcotic to relieve pain or even to perpetuate an addictive state in such as a terminally ill patient. This ability of a narcotic to relieve pain is a great blessing but can be equally a serious curse if self-administered.

Narcotics do more than relieve pain. They act on the brain, relieving depressions, anxieties and producing euphoria, which in turn, disorders judgment. This euphoria and altered judgment produces a state of risk-taking, which seriously and adversely handicaps behavior. Thus, due to the altered judgment, addicts will risk socially disruptive behavior, which they would not do unless addicted.

Addiction has two phases, which are:

1) Pain relief and euphoria from contact with the narcotic.

2) Withdrawal symptoms emerging 3-4 hours after taking the narcotic. By this time, the narcotic has been processed and the level of normal narcotic (self-made endorphins) drops below normal. This addictive withdrawal state is acid producing and thus also oxygen reducing (acid-hypoxia). This acid-hypoxia is inflammatory producing (cellular edema). Inflammation is pain producing. Thus, pain emerges, the brain responds to this addictive withdrawal state with depression and

again, altered judgment with the emergence of fears. The addict keeps taking frequently (on a 3-4 hours schedule) his narcotic so as to avoid the pain and depression of the addictive withdrawal phase. He seeks the pain relief and euphoria of taking the narcotic.

This addictive seesaw, euphoria/pain-free state on exposure to the narcotic with its swing to pain/ depression on withdrawal, results in an obsessive-compulsive personality or neurosis with intolerance for discomfort along with pleasure seeking to relieve discomfort.

The human body makes self-made polypeptide narcotics called endorphins. There is a non-addictive, normal physiological level for these endorphins. They serve a valuable function in human physiology even beyond that of handling pain or stress. Acute stress evokes these endor- phins beyond physiological level. If stressors on a frequent 3-4 hour nature evoke the above physiological normal levels of endorphins, then addiction to the self-made narcotic develops. The exposure to narcotics, whether externally supplied such as illicit narcotics, ethical narcotics supplied by physicians or internally-made (endorphins) has to be more frequent than twice in four days in order for the addictive withdrawal phase to develop.

Frequently eaten foods can become biological stressors. Adequate nutrition is necessary but adequate nutrition cannot be depended on to prevent food addiction from developing. Thus, daily use of a food carries the potential of becoming a stressor evoking endorphins beyond the physiological level. It is a common practice to eat wheat bread at each meal and use dairy products at each meal. Thus, these foods have a high percentage chance of developing food addiction. Food addiction is a narcotic addiction in which the frequently eaten food is a stressor evoking self-made narcotics beyond physiological levels. Alcohol addiction is more than addic- tion to the alcohol itself but is also an addiction to the food that the alcohol is made of. I proved this many times by deliberate food testing of a meal from which the alcohol is made. A vodka drinker reacts to potatoes. The cereal grains from which the alcohol is made such as wheat, barley, corn and rice on a single food test meal evokes symptoms in the alcohol addict who uses alcohol made from these foods. Deliberate exposure to these foods without

any alcohol present, characteristically can produce a "dry drunk".

Tobacco addiction occurs because tobacco serves as a stressor evoking self-made narcotics. Caffeine addiction exists because frequent use can evoke self-made narcotics producing caffeine addiction. Amphetamine addiction can develop because of a frequent use of amphetamines as a stressor evoking self-made narcotics. A positive (north-seeking) magnetic field is a stressor and magnetic addiction can develop because of frequent use of a positive (north-seeking) magnetic field as a stressor evoking self-made narcotics.

Alkaline Diet

George Watson invented the alkaline diet in which alkaline-forming foods are eaten with frequency and in a percentage greater than acid-forming foods. It is true that reactions to foods are acid forming. What this diet fails to perceive is that a maladaptive addictive type reaction to foods is acidifying whether this is an alkaline-forming food or an acid-forming food. All mal-adaptive reactions to foods are acidifying. This system fails to recognize that food addiction occurs and therefore, there is a continuation of frequently eating the same foods and maintaining food addiction. This is why this system has a measurable value but a low level efficiency. The person following this diet proceeds down the road to developing maturity-onset type diabetes mellitus.

Frequently Eaten Protein Between Meals Diet

John Tinterra, M.D., was an internist who had observed that protein would buffer against hypoglycemia. This system has the subject eat a protein snack between meals to buffer against hypoglycemia. This diet has a measurable value. It uses the same foods frequently, and therefore does not honor food addiction and can produce food addition to these frequently eaten foods. The person following this diet proceeds down the road to developing maturity-onset type diabetes mellitus.

Protein-Carbohydrate Frequent Feeding Diet

Judith Wurtman improved on John Tinterra's protein between meal feedings by having a combination of complex carbohydrate with proteins. This again provides a degree of relief of symptom production of both the hyper-insulinism phase and hypoglycemia phase. This diet does not recognize food addiction as a symptom-producing agent. Therefore, it

has a limited value in symptom amelioration. The person following this diet proceeds down the road to develop maturity onset type diabetes mellitus.

Zone Diet

Barry Spear's Zone diet does not recognize food addiction. The person following this diet proceeds down the road to developing maturity-onset type diabetes mellitus.

Food Addiction: Primrose Path to Diabetes Mellitus Type II

The primrose path to diabetes mellitus is paved by food addiction. The path has numerous pot-holes composed of food addiction, acid-hypoxia, inflammation and degenerative diseases. The disordered chemistry of acute symptom maladaptive reactions observed during deliberate single meal food testing after an initial five days of food avoidance has been demonstrated to be the same as degenerative diseases manifesting chronically the same symptoms. The chronic diseases are named according to the tissues involved in the reaction such as muscles, fascia, joints, liver, spleen, intestines, pelvic organs, lungs, nasopharynx, skin, specific areas of the brain and so forth. Maladaptive, symptom producing food reactions can affect any tissues of the body. The target tissue selected for the symptoms are in some way metabolically compromised. There are many different ways of compromising selective tissues such as trauma, current infection or injury from infection, examples are my observations concerning tendonitis such as carpal tunnel syndrome in which the stress of the hand and wrist causes this wrist tendon sheath to produce tendonitis. I have routinely been able to demonstrate a maladaptive reaction to a food as a basic cause of the tendonitis, which is evoked during deliberate food testing. This is also true of fibromyalgia and often of inflamed joints in rheumatoid arthritis. Another example is schizophrenia in which the selective areas of the brain have been injured by a viral infection causing the brain to be the selective tissues for maladaptive food reactions. All major mental disorders are precipitated by addictive food reactions. Non-addictive reactions to other substances such as petrochemicals, molds and other inhalants can also selectively produce mental symptoms.

The pre-clinical diabetes mellitus state, sometimes called chemical diabetes and identified by me as a compensated stage

of the diabetes mellitus disease process is caused by maladaptive reactions to foods. This is the state of hyperinsulinism followed by hypoglycemia.

Any and all complications known to occur during clinical diabetes can and do occur during this compensated diabetes mellitus disease process, pre-clinical diabetes mellitus. They are identified as separate diseases simply because the person has not yet progressed to the chronic high blood sugar stage of clinically significant diabetes mellitus. Examples of naming degenera- tive diseases occurring during this compensated stage of the diabetes mellitus disease process separate from clinical diabetes are:

1) Toxic neuritis identified during the pre-diabetic stage which is called diabetic neuropathy when the subject is known to have clinically significant diabetes,

2) Hypertension

3) Amyotrophic lateral sclerosis named separately from amyotrophy, which is identical to the amyotrophy of the known clinically significant diabetes mellitus.

PRIMROSES

The primroses on the food addiction path to diabetes mellitus type II are the methods of temporary reduction of addiction symptoms, which include all the diets that provide frequent meals of the same foods without rotation. These include George Watson's Alkaline Food Diet, John Tinterra's High Protein Between-Meal Snacks, Judith Wurtman's Carbohydrate-Protein Between-Meal Snacks and Barry Spear's Zone Diet providing a 40% carbohydrate-30% protein- 30% fat on a four-hour schedule feedings. These methods of symptoms relief perpetuate the diabetes mellitus compensated stage of degenerative diseases and clinical diabetes mellitus as the end-stage of food addiction. Other methods of relieving the symptom of food addiction such as non-steroid anti-inflammatory chemicals, steroid anti-inflammatory chemicals, food neutralization, homeopathy, acupuncture or other reflexologies do not reverse food addiction but only perpetuate the progression of food addiction to the end-stage diabetes mellitus type II. There is no combination of any of the non-rotation proposed diets that will reverse food addiction.

With the 4-Day Diversified Rotation Diet, there is no hyperinsulinism to buffer against and there is no hypoglycemia for which

symptoms need to be relieved. There is no symptom-producing acid- hypoxia resulting from a withdrawal addiction stage. A 4-Day Diversified Rotation Diet is the only, and therefore, ultimate diet to reverse food addiction thus preventing the many symptoms emerging during the compensated state of the diabetes mellitus disease process. It will also prevent the development of the final stage of addiction, which is diabetes mellitus type II. Fortunately, food addiction is also reversible with a 4-Day Diversified Rotation Diet. This is true at any stage including the final stage of clinically significant diabetes mellitus type II.

The Broad Spectrum Values of a 4-Day Diversified Rotation Diet

Maladaptive symptom-producing food reactions are acidifying. In an acid medium, oxygen is processed and becomes a party to acids. This symptom-producing state is characterized as acid-hypoxia. Acid-hypoxia is inflammatory-producing and thus, symptom- producing. The target tissues for symptom production are target tissues due to some reason for compromised metabolism. Physical traumas, past injury or present infections are such predisposing causes of symptom production from the acid-hypoxia produced by food reactions. The heart and brain are frequent symptom target tissues due to their inherent need to maintain an optimum alkaline pH and an optimum amount of oxygen.

Acid-hypoxia from food maladaptive reactions occurs no matter why the reaction occurs. Maladaptive reactions can occur for the following reasons:

1) An immunologic reaction in which antibodies are made and or complement is disordered

2) Oxidoreductase enzyme deficiencies due to nutritional deficiencies

3) Oxidoreductase enzyme inhibition due to evoked states of acidity. Oxidoreductase enzymes are alkaline-dependent and therefore can only function in a normal physiological alkaline state

4) Addiction. Addiction has the quality of first evoking a rise in serotonin and endorphins on contact with the food which is, at that time, symptom-relieving, and later a symptom-producing withdrawal phase when a drop below physiological normal of endorphins and serotonin occurs

5) Toxicity. There are toxicities that are either inherent in or contaminants in the food supply. These can become addictions

but can function also by inhibiting enzymes without addiction having developed.

The following disease states need the spacing of foods so that symptoms do not develop. A 4-Day Diversified Rotation Diet is the ideal way to maintain a spacing of the foods below the level of addiction and also in IgG immunologic reactions, the spacing of the foods also prevents the immuno- logical reaction from occurring. Also, in toxicities, the body has time to process the toxins before it receives more toxins in the next meal.

Diabetes mellitus - I have observed diabetes mellitus, non-insulin-dependent, type II, to be the direct result of food addiction. The process of diabetes mellitus is present for many years before the final stage of clinically significant diabetes mellitus. The development of diabetes mellitus can be prevented and also reversed by a 4-Day Diversified Rotation Diet.

Rheumatoid conditions - This involves not only rheumatoid arthritis, but also fibromyalgia and many other inflammatory rheumatoid conditions. Characteristically, these inflammatory conditions are more often caused by maladaptive reactions to foods than to any other cause.

Pain -- Pains are most frequency caused by a state of acid-hypoxia evoked by food reactions.

Mental disorders -- This refers to major mental disorders such as schizophrenia, and manic-depressive. This is also involved in most learning disorders and attention deficit disorders. Maladaptive food reactions are nearly always associated with these disorders. Originally, the brain has been disordered by a viral infection such as Epstein-Barr, cytomegalo or human herpes virus #6.

Emotional disorders - It is frequently true that emotional disorders are also evoked by the acid-hypoxia of food reactions.

Movement disorders - Movement disorders can be caused sometimes solely by the maladaptive food reactions. An example of this is Tourette's syndrome, which is managed by avoiding the foods that are evoking the symptoms. Classically, the symptom-evoking foods are gluten-bearing cereal grains; wheat, rye, oats, barley and corn.

Sleep disorders - Sleep disorders are often produced by maladaptive food reactions.

Addiction -- Food addiction is the most common of all types of addiction.

Seizures -- Seizures are frequently precipitated by maladaptive food reactions acting on an injured brain.

Multiple sclerosis -- Maladaptive food reactions can precipitate symptoms in multiple sclerosis.

Gastrointestinal Disorders -- Maladaptive food reactions are frequently a party to gas- trointestinal symptoms.

Sleep -- The addictive withdrawal phase of food addiction is a frequent cause of sleep disorders.

How to have energy-restoring sleep:

1. Do not be addicted to anything, including foods.

2. Sleep in a totally light-free environment. Any light inhibits the production of melatonin by the pineal gland.

3. Eliminate all electrical instruments from the room. The 60-cycle per second frequency of the electric current prohibits the production of melatonin by the pineal gland.

4. Sleep on a negative (south-seeking) magnetic field mattress pad. This is provided by a magnetic mattress pad composed of mini-block magnets that are 1-7/8" x 7/8" x 3/8" placed an inch and one-half apart and padded so that only a negative (south-seeking) magnetic field is received.

5. Sleep with a negative (south-seeking) magnetic field facing the top of the head. This is provided by a carrier holding four 4" x 6" x 1" ceramic block magnets placed 3/4" apart.

6. Sleep with a magnetic light shield over the eyes. This magnetic light shield has magnetic neodymium disc magnets placed over the eyes. The retina of the eyes makes melatonin.

Magnetic Fat Dissolution

A negative (south-seeking) magnetic field placed over a fat area will cause the fat cells to release their fat into the blood circulation. Some have lost as much as a pound a day by placing a negative (south-seeking) magnetic field over a body fat area. Also, fatty tumors have been demonstrated to dissolve when treated with a negative (south-seeking) magnetic field. The fat deposits in arteries will dissolve in the presence of a negative (south-seeking) magnetic field. Fatty deposits, whether in fat cells or not in fat cells, such as in arteries or organs like the heart or liver are a positive (north-seeking) magnetic field, which maintains an acid medium.

Fat, amino acids, calcium and other minerals are soluble in an alkaline medium such as the normal alkaline pH of 7.4 and insoluble in an acid medium. The biological response to a nega-

tive (south-seeking) magnetic field is alkalinity. The insoluble deposits of fat, both outside of fat cells such as in arteries, liver and heart and other organs as well as inside of fat cells goes back into solution by a negative (south-seeking) magnetic field turning the area alkaline. A second mechanism is also functional in which growth hormone has the assignment of causing fat cells to release their fat. Growth hormone is an anabolic hormone made during sleep. A negative (south-seeking) magnetic field produces growth hormone by the hypothalamus which aids in fat cells dropping their fat which then enters the blood as soluble fat. Growth hormone requires a hormonal activator made by the pancreas. A negative (south-seeking) magnetic field serves the function of an activator of growth hormone either directly or indirectly by raising the pancreatic growth hormone activator. Placing a negative (south-seeking) magnetic field over the epigastric area at night during sleep is calculated to raise the growth hormone activator.

Suitable magnets for fat dissolution are such as a 14" x 25" multi-purpose magnetic pad or an 11" x 17" multi-purpose magnetic pad. These pads are composed of mini-block magnets that are 1-7/8" x 7/8" x 3/8" placed an inch and one-half apart in this pad. Their magnetic field can be further reinforced for a deeper penetrating magnetic field by placing a 4" x 6" x 1/2" magnet over the pad. These 4" x 6" x 1/2" ceramic block magnets can be placed 2" apart on the pad. Place the pad and the ceramic blocks over the area needed to have fat dissolution such as the abdomen, thighs, buttocks, breasts and so forth. The treatment need be only during sleep when growth hormone and its hormone activator are present.

Although this method of magnetic fat dissolution has been demonstrated to function without calorie reduction, I can only recommend it as an aspect of weight reduction associated with calorie reduction and food addiction management by a rotation diet.

The Stress of Sleep Deprivation
The Circadian Rhythm

Adequate sleep is necessary for energy restoration with its numerous homeostatic functions. Inadequate sleep, along with addiction, infection and other stressors is one of the stress building blocks leading to degenerative diseases including obesity itself. Nine or more hours of sleep in total darkness is

necessary to maintain anti-stress metabolic homeostasis. In the book, *Lights Out,* T.S. Wiley and Bent Formby, PhD, have provided the evidence of the stress consequences of not having adequate energy restoring sleep.

A rhythmic exposure to light is also necessary for metabolic homeostasis. In the far northern and far southern hemispheres of the earth, where there are months of continuous light alternating with months of continuous darkness, a development of the disordering of the sleep-wake cycle results in stress symptoms, especially depression. I used to provide a morning exposure to light to maintain the circadian rhythm in order to prevent depression. What I observed when using an exposure of the body, including the head during sleep, to a negative (south-seeking) magnetic field is that it adequately drives a circadian rhythm without the need for light exposure during the long, sustained dark periods. Thus, I have observed that the negative (south-seeking) magnetic field during sleep is adequate without light for driving the circadian rhythm.

The Non-Stress, Non-Addiction Food Rotation Diet
Orientation

This non-stress, non-addiction rotation diet is for food addicts whether overweight or not over- weight. This is the optimum degenerative disease reversal and disease prevention diet.

Overweight exists because the subject is eating too many calories. The answer for being over-weight is to reduce the calories. The desire to overeat is a learned compulsion secondary to the initial food addiction. The compulsive urge to eat a specific food, to eat between meals or to overeat is stopped by magnetic treatment to the head. The subject carries magnetic discs with him at all times so that he can stop his compulsive urge with magnetic discs placed on his head when need be.

The subject can decide to immediately start the 4-Day Diversified Rotation Diet leaving out the foods and the other members of the family of the foods that are eaten twice a week or more with all other foods rotated on a four day basis. Three months later, the foods that are left out of the diet initially can be reintroduced back into the diet.

Another method is to prove which foods the person is addicted to or otherwise maladaptively reacting to. This requires a five day fast either of water only or of a single food such as watermelon, following which the subject eats meals of single foods to determine

if symptoms emerge. After having tested out all the foods, then set up the rotation diet initially leaving out the foods that gave symptoms. These foods would be left out of the diet for a period of three months before reintro- ducing them into the diet.

After initiating the rotation diet, then assess the calories being eaten with comfort which still maintains overweight. Reduce the calorie intake by one-third. Re-assess every three months and continue to reduce calories by one-third until optimum weight is maintained.

Minimum Program of Magnets
- Two 1" x 1/2" ceramic disc magnets
- Four 1" x 1/8" neodymium disc magnets
- Two 2" x 26" body wrap
- Two 4" x 6" x 1/2" ceramic block magnets

Maximum Program of Magnets
For more optimal general health, add the following:

• One 14" x 25" multi-purpose pad (composed of mini-block magnets that are 1-7/8" x 7/8" x 3/8". These are placed an inch and one-half apart throughout the pad)

• One 11" x 17" multi-purpose pad (composed of mini-block magnets that are 1-7/8" x 7/8" x 3/8". These are placed an inch and one-half apart throughout the pad)

- Two 4" x 52" body wraps.

• One magnetic chair pad (composed of mini-block magnets that are 1-7/8" x 7/8" x 3/8". These are placed an inch and one-half apart throughout the back and seat of this chair pad)

• A magnetic mattress pad (composed of mini-block magnets that are 1-7/8" x 7/8" x 3/8". These are placed an inch and one-half apart throughout the mattress pad)

• A Vitality sleeper (composed of four 4" x 6" x 1" magnets placed in a carrier that holds them up against the headboard. These are 3/4" apart. They come shipped at the top of the carrier and need to be lowered so that the wooden dowel they are resting on is level with the back of the head when the head is on the pillow)

• A magnetic eye unit (composed of a magnetic light shield with a 1/2" x 1/16" neodymium disc placed over each eye on the inside of the light shield and on the outside, directly over this magnet and over each eye, place a 1" x 1/8" neodymium disc magnet)

Placement and Duration

For addictive withdrawal during the five days avoidance or whenever symptoms emerge after the initial withdrawal phase, use the following:

- A 4" x 6" x 1/2" magnet placed on the mid-sternum
- A 4" x 6" x 1/2" magnet placed on the epigastric area
- On the sternum place the magnet lengthwise and on the epigastric area crosswise the body. These can be held in place with 4" x 52" body wraps. Place disc magnets on the head, either the ceramic disc magnets or the neodymium disc magnets.

The ceramic disc magnet is placed on the inside of the band next to the head. There is Velcro on the positive pole side that will attach to the 2" x 26" wrap placed around the head. When using the neodymium disc magnets, place one 1" x 1/8" neodymium disc on the inside of the band and one on the outside of the band. These are placed directly over the area of the head that is being treated. Depression is characteristically best reduced by bitemporal placement that is at the level of the ears and in front of the ears. These are placed over the amygdala, which is a walnut-sized area in the temporal lobes. This can calm the entire brain down. Anxiety and tension is best handled by placing a disc on the mid-forehead and one on the left temporal area. Obsessions and compulsions are sometimes best handled by placement on the left temporal and low occipital area. The duration should be whatever is needed. Often five minutes will stop the urge. It may take up to 30 minutes. There is no limit in how long the magnets can be left on. This system will be very useful during the five days of withdrawal. However, obsessive-compulsiveness is a learned response and will require training. Whenever an obsessional idea of eating a particular food or eating between meals or over- eating occurs, then place the magnet on the head that most appropriately relieves the symptoms.

Five, ten, fifteen, sometimes thirty minutes are required to handle the obsession. The subject needs to agree with himself so that when these obsessive-compulsive urges occur, he will use the magnets instead of acting on the compulsion. Use the magnets for the relief of the obsession-compulsion and its associated feelings of tension and depression rather than by relieving the symptoms by acting out the compulsion. This method of training out the obsessive-compulsiveness relates to more that just foods. It relates to the personality behavior, so whenever these urges occur, cancel them with the magnetic fields. The system also stops all addictions

including tobacco, alcohol and caffeine. Tobacco particularly is fat soluble and therefore the urge to return to the tobacco lasts longer than the water soluble foods. It takes approximately one month to get over the urges to smoke. The answer is to always cancel this urge with the placement of the magnetic fields, particularly over the head, but if need be, also over the sternum and epigastric area. Also, the 4" x 6" x 1/2" magnet can be used anywhere on the body where it is needed to relieve any pain or other discomfort. For optimum health, the subject should sleep on a magnetic bed pad and with magnets in the carrier up against the headboard. It is also wise to sleep at night with an eye unit across the face and eyes. The retina of the eyes makes melatonin and also the eyes through a nerve pathway will encourage the pineal gland to make melatonin. Sound sleep is necessary for energy restoration and for all the homeostatic functions between serotonin and endorphins to be optimally functional. When sleeping at night, it would be best to put the 11" x 17" multi-purpose pad across the abdomen. This is especially useful when the omentum has fat. The omentum is over the intestines. This fills up with fat. By placing the 11" x 17" multi-purpose pad across the abdomen will help to cause the fat to leave the cells of the omentum as well as the fat in the layer of skin. It is important that the areas where magnets are placed for processing the fat be done at night. Only at night is when growth hormone is high enough to perform the function of helping fat cells release their fat. The magnets can be placed on any area that needs to have fat reduction. The 4" x 6" x 1/2" magnets are ideal because they penetrate deep enough. The multi-purpose pads can be reinforced by placing the 4" x 6" x 1/2" magnets on top of these pads.

When sitting down, sit on the chair pad. It is useful to place a 4" x 6" x magnet under the seat of the chair pad. This particularly is useful where there is Candida either in the colon of a man or in the vagina or colon of a woman. The smaller multi-purpose pad can be used anywhere around the body and the larger 14" x 25" multi-purpose pad can be used on the thoracic area, cervical area and back of the head. It is especially useful to have these magnets in place while resting in a reclining chair.

General Information About Magnets

Double strength flexible mats are composed of two stacked plastiform magnet strips measuring 1-1/2" x 7/8" x 1/8". These plastiform magnetic strips are placed in four rows with the 1-1/2"

mea- surement lengthwise in the flexible mat. In a 5" x 6" flexible mat there are 24 magnetic strips. In a 5" x 12" flexible mat there are 48 magnetic strips. The flexibility of these mats makes them very useful since they will fit around the curves of the body without producing any pressure. The therapeutic level of this flexible mat extends to about two inches. When the flexible mat is reinforced with one row of mini block magnets placed crosswise on the two central rows of magnets in the mat, the therapeutic field extended to three inches. When there are two stacked rows of mini block magnets on the mat, the therapeutic level extends to five inches. This places the mini block magnets an inch and one half apart in which there are three placed on the 5" x 6" flexible mat and six placed on the 5" x 12" flexible mat. The flexible mat can also be reinforced by the 4" x 6" x 1/2" ceramic magnet, this extends the therapeutic value to five inches.

Mini block ceramic magnets are sometimes called Briggs blocks because they are used as the Magneto magnets in a Briggs and Stratton gasoline engine. These magnets measure 1-7/8" x 7/8" x 3/8", and they have many therapeutic uses. They can be used on the head, in such areas as the temporal, frontal or occipital areas, for headaches, management of emotional symptoms or seizures. They can be used on fingers or toes. They can be placed on top of the flexible mats to reinforce the depth of magnetic field penetration. They can be used directly on the joints, under or incorporated into wraps around the joints. They are used in the magnetic slumber pads, the multiple purpose pads, and in the chair cushion pads.

Ceramic discs measure 1-1/2" x 1/2", and have numerous valuable purposes. They can be used around the head to treat headaches or other central nervous system symptoms, around joints, over skin or on subcutaneous lesions. The magnetic field of a ceramic disc extends to eight inches. The magnetic field therapeutic value extends to about two and one half inches. 4" x 6" x 1/2" ceramic magnets have a therapeutic magnetic field value extends for five inches. A ceramic magnet that is 4" x 6" x 1" has a therapeutic value extending to eight inches. The 4" x 6" x 1" ceramic magnet has many uses such as around joints or to penetrate deeply into the liver, internal organs, the heart, or into the head such as for treatment of tumors. The 4" x 6" x 1" ceramic magnet are used in the headboard- type magnetic sleep enhancer in order to have a field that penetrates into the head during sleep. The

magnetic sleep enhancer is composed of four 4" x 6" x 1" ceramic magnets placed in a row 3/4" apart. These ceramic magnets are placed upright in a wooden carrier that holds them firmly up against the headboard. They can be raised or lowered depending on the height of the pillow. They are shipped at the top of the carrier and needs to be lowered so that the head is in the magnetic field. They are resting on a wooden dowel. The wooden dowel they are resting on should be at the level of the back of the head when the head is on the pillow. The closer the top of head is to the magnets in the carrier at the head of the bed, the better.

The magnetic slumber pad is composed of ceramic mini block magnets that are placed an inch and one-half apart throughout the pad.

The magnetic chair cushion pad is composed of ceramic mini block magnets placed an inch and one-half apart throughout the seat and back of the pad.

The multiple purpose pads [small (11" x 17") and large (14" x 25")] are composed of ceramic Mini Block magnets that are placed an inch and one-half apart throughout the pad. This multiple purpose pad has many uses such as being used on the back, the abdomen, and up over the heart and on the chest area.

Therapeutic Sleep

After the program has been setup, the most important thing to address is sleep. It is optimal to sleep on the 70-magnet bed grid or a magnetic slumber pad.

In maintaining health and reversing degenerative diseases, it is very important that there be deep, energy restoring sleep. It is necessary to sleep a full eight or nine hours in every 24-hour period. Energy is used up during the day and is restored during sleep. The hormone, Melatonin, which is made during sleep, controls the depth of energy restoring sleep. The principle area in which Melatonin is made is the pineal gland, which is at the center of the head. This gland makes Melatonin in response to a negative (south-seeking) magnetic field. This is why it is so important to treat the head to a negative (south-seeking) magnetic field during sleep. The retina of the eyes and the intestinal walls also make Melatonin. Treating these areas can also raise levels of Melatonin. The hormone Melatonin has the control of the entire energy system of the body including such as the immune system, endocrine system, and respiration. Melatonin is neuronal calming and encourages energy restoring sleep. Melatonin is a powerful antioxidant and

thus is anti-inflammatory. Melatonin also has antibiotic and anti-cancer values.

In order to achieve appropriate production of the hormones Melatonin and growth hormone it is necessary to sleep in a completely light-free environment and without any 60 cycles per second electrical pulsing frequencies. Therefore there should not be any night-light, and electric clock, an electric heated blanket, or a heated waterbed. If light cannot be completely excluded from the bed- room, then place over the eyes and the forehead a light shield/ mask of some sort. The magnetic eye & sinus mask is a light shield with 1/16" plastiform magnet in it and additional 1" x 1/8" neodymium disc can be added for extra benefit.

The magnetic slumber pad will encourage the production of Melatonin by the gastrointestinal tract. Any magnetic treatment of the abdomen will encourage the production of Melatonin by the walls of the gastrointestinal tract.

Treating the eyes with the eye & sinus mask will also encourage the production of Melatonin by the retina of the eyes. The magnetic headboard type sleep enhancer up against the head-board will have a magnetic filed that penetrates into the head and stimulates the pineal gland to produce Melatonin and the hypothalamus to produce growth hormone. Some sleep very well with a 4" x 6" x 1/2" magnet up against the side of the head. It is best to cushion this by placing a double strength flexible mat (5" x 6") up against the side of the head first with the 4" x 6" x 1/2" ceramic magnet over the flexible mat. When lying on the back, this can be leaned up against either side of the head. When lying on the side it can be on the side of the head that is not on the pillow or be placed on the back of the head. Some find it valuable to place a double strength flexible mat under the pillowcase so their head is resting on the flexible mat. If they are on their back it is on the back of their head; if they are on their side, it is on the side of their head. Six mini block ceramic magnets placed on the positive (north-seeking) pole side will further reinforce this flexible mat. Place these mini block magnets crosswise the flexible mat 1-1/2" apart. They will magnetically adhere to the flexible mat.

Magnetic Eye & Sinus Mask

One eye & sinus mask

Two neodymium dot discs (1/2" x 1/16") Two neodymium discs (1" x 1/8")

Placement of Magnets for Eye & Sinus Mask

The eye & sinus mask is magnetic which has special value for producing healthy skin under the
magnetic shield and also for the eyes. Placing neodymium disc magnets over the eyes increases this magnetic value. Place the 1/2" neodymium dot discs on the inside as a holder for the 1" neodymium disc on the outside, both of which are directly over the eyes. It works equally well to place the discs to the sides of the eyes. This side of the eyes placement of the discs can be used in glaucoma to release the pressure in the eyes. Once the correct placement of the discs is over the eyes, then firmly tape down the magnets on the outside of the magnetic eye & sinus mask.

Uses for the Eye & Sinus Mask

This magnetic eye treatment is arranged for the treatment of cataracts, glaucoma, infection, floaters, macular degeneration and degeneration of other areas of the eye. Magnetic treatment of the eye is not harmful and has the potential of being beneficial to most all eye conditions.

Cataract Treatment -- Place the magnets directly over the eyes. Use nightly. Treat nightly for several months and, preferably, it is best to use it nightly as a lifestyle.

Glaucoma Treatment -- Glaucoma is due to an abnormally high pressure in the eye. Treating with the magnetic field directly over the eyes is anti-inflammatory and is likely to solve the glaucoma problem. If and when treating directly over the eye and within a month to six weeks, the pressure in the eye has not resolved, then treat from the side of the eye. If glaucoma is present, the eye pressure should be monitored and the magnets moved to the side of the eye if the pressure is not being resolved by treating directly over the eye.

Macular Degeneration Treatment -- Wear the magnetic eye unit over the eye every night as a life-style. It may require a year or more to achieve measurable value. Some people are reporting success when treated less than a year.

Eye Infection Treatment -- Place the magnetic eye unit over the eyes as near to 24 hours a day as possible. To achieve a 24-hour a day treatment, a set of glasses could be used; place two of the 1" x 1/8" neodymium disc magnets on opposite sides of the earpiece adjacent to the eye. Tape the inner disc to the earpiece of the glasses. Ideal for this treatment are safety glasses or sunglasses that have a flange on the earpiece adjacent to the side of the eye. In treating infection it is important to extend

the treatment to 24 hours a day for a minimum of two weeks. In some cases it would be best to draw this out to a month. The duration needs to be long enough to completely kill the infection. Extend the time to whatever is necessary to handle the infection and heal the tissues.

Cancer of the Eye Treatment -- Cancer requires a 24-hour a day treatment for a minimum of three months. If necessary, extend it as long as is necessary to handle the cancer.

Diabetic Retinopathy Treatment -- These all should be treated at the same time and a 4-day Diversified Rotation Diet is mandatory for the reversal of the diabetes disease process. This is true whether this is Type I or Type II diabetes mellitus. The eyes should be treated at night, and preferably, during the daytime also.

Alkaline Micro Water

Alkaline micro water helps materially the body's normal alkaline state. Also, being micro water, it enters into the cells of the body more readily than the usual water. This also carries negative (south-seeking) magnetic field as well as being alkaline. The Singer Electrolysis Instru- ment is used for producing the alkaline micro water. At least five glasses of the water should be ingested each day.

Nutrients Recommended

- Vital Life Multi-Element Buffered Vitamin C Powder. This powder contains vitamin C, calcium, magnesium, zinc, manganese, copper, quercetin, potassium and reduced L-glutathione. A minimum of one-half teaspoon, or a maximum of one teaspoon twice a day is quite useful.

- Vital Life Multi-Vitamin with Chelated Minerals. This provides a broad-spectrum supply of vitamins and chelated minerals. Take one tablet, twice daily.

- Vital Life Chromium Picolinate Plus. One daily is the recommended dosage.

<u>Polarity</u> Always use a negative (south-seeking) magnetic field.

Beyond Magnesium

An acute maladaptive reaction to foods, chemicals, or inhalants has been documented as producing a brief state of acid-hypoxia. In this state there is a production of acid and a failure to process properly the end products of oxidation phosphorylation metabolism. In this state of acidosis, oxygen

content is reduced. Maladaptive reactions to foods are the most frequent cause of bouts of acidosis. Degenerative diseases are noted for their acid-hypoxic state. Therefore every effort should be made to maintain a normal alkalinity and normal oxygen state.

Majorities of people are maladaptively reacting to foods in one or more ways, thus producing bouts of acidosis and reduced oxygen. It is the better part of wisdom to follow a 4-Day Diversified Rotation Diet. This program leaves out foods that are used as frequently as twice a week or more for a period of three months. This is based on the assumption that these foods are being reacted to in some way. It is the frequency of the use that produces the maladaptive reactions. A 4-Day Diversified Rotation Diet is set up to leave out these frequently used foods. After three months, these frequently used foods can be returned to the diet, usually without any symptoms being produced.

All addictive substances should be abandoned such as addictive drugs, alcohol, tobacco and caffeine (coffee, tea with caffeine, chocolate, and soft drinks containing caffeine). Addiction is acidifying.

Carbonated soft drinks are acid producing and should be rarely used. Soft drinks are sweetened with corn sugar (in the US) and if they are ingested they should be limited to the corn rotation day.

In order to maintain an adequate alkaline state, it is necessary that the minerals that are used in the bicarbonate buffer system be in adequate supply. These are the minerals calcium, magnesium, potassium, and zinc. There are several proprietary preparations that contain these minerals associated with vitamin C as ascorbates. The preferred source of alkali minerals is multi-element mineral ascorbates by Klaire Lab. Use 1/2 teaspoon to 1 teaspoon of one of these powders in one-half glass of water, two times a day. The preferred time to take the alkaline minerals is in the morning on arising and again before going to bed at night. When using this mineral alkaline water, place it on the negative magnetic pole of a 4" x 6" x 1/2" magnet for a minimum of five minutes. This will charge up the water and the oxygen in the water with a negative magnetic field, which will help the body maintain its normal alkaline state.

There is a valuable method of electrolysis, which provides alkaline micro water that has an alkaline pH. There is a home

The following are observed facts about maladaptive reactions to foods:

1) IgG immune food reactions are acute inflammatory reactions in which spacing of contact has no significance. Therefore, a four day rotation diet has no significance in IgG mediated immune reactions. Fortunately, IgG food reactions are scarce.

2) IgG immune food reactions quiet down after three months of avoidance. After three months of avoidance an IgG immune reaction is calmed and suitable for a contact spacing of a 4-Day Diversified Rotation Diet. Food IgG reactions have the same relief phase on contact and withdrawal phase 3-4 hours later, which is characteristic of addiction.

3) Food addiction with relief on contact of the food and a withdrawal phase 3-4 hours later is characteristic of the majority of maladaptive symptom-producing food reactions.

4) A five-day avoidance breaks the addiction cycle following which, for 4-6 weeks, there is an acute symptom reaction within the first hour of exposure to the addictive food. This is the basis of single food testing meals after five days of avoidance.

5) There are toxic reactions without an addictive withdrawal phase. These toxic reactions are infrequent.

6) The biological response to the addictive withdrawal phase of symptom production is acid-hypoxia.

7) The acute symptom phase after a five day avoidance period is acid-hypoxia. Acid-hypoxia produces cellular edema.

8) Acid-hypoxia produces the symptoms of the addictive withdrawal phase.

9) A carbohydrate disorder is produced by addiction. This has the characteristics of hyper-insulinism after exposure to the addictive food followed by hypoglycemia 3-4 hours later during the withdrawal phase.

10) After five days of avoidance there is no hyperinsulinism and no hypoglycemia. These are replaced by a hyperglycemia within one hour of eating the addictive food.

11) Food addiction is a state of metabolic compensation response to the stress leading to the addiction.

12) After five days of avoidance there is no metabolic compensation and in fact, there is a metabolic decompensation.

13) Diabetes type II is the decompensated state of food addiction with its acid-hypoxia and hypglycemia.

14) Acute symptom-producing maladaptive food reactions when extended in time are iden- tified as chronic diseases with the same symptoms.

15) Diabetes mellitus type II is the final decompensated state of the earlier compensated state of food addiction. The metabolic disordered chemistry of food addiction is the same as clinically significant diabetes mellitus type II. The common denominator of disordered metabo- lism of food addiction and maturity-onset diabetes mellitus type II is acid-hypoxia and hyperglycemia.

16) The only way to prevent, and or reverse, maturity-onset type II diabetes mellitus is to reverse food addiction by initial avoidance and later spacing of the formerly addictive food.

17) Addiction to non-food items also advances the diabetes mellitus disease process. Exam- ples are such as the use of narcotics, tobacco, alcohol and so forth.

18) Toxic, non-food, chemical stressors also advance the diabetes mellitus disease process.

19) Definitive food testing to determine maladaptive reactions to foods can only effectively proceed when all foods reacted to are avoided for five days preceding test meals of single foods. Remaining addicted to even one food will interfere with test results.

Characteristically, physicians are taught to test food immunologic or non-immunologic sensitivity reactions as a secondary rather than a primary cause of illness and to test foods while leaving the subject addictively or otherwise maladaptively responding to multiple other foods. Even when there is a five day avoidance of that single suspected food, the re-testing of that food is unreliable since they are in the process of reacting to so many other foods. Characteristically, no attempt is made to clear all food reactions by a five day fast before testing begins. This method of not clearing the subject of all food reactions before testing begins gives spurious results. This leads to conflicting data as to the significance of food reactions. This conflict in data is used by some physicians to justify discarding food reactions as causes of diseases in general or

specifically with the disease they are dealing with at the time. Good food testing also requires examination of blood pH and blood sugar before and after the food test meal.

20) Ignoring the food maladaptive reaction as critical to the cause of degenerative diseases whether brain, gut or other biological systems, advances the central primary degenerative dis- ease of type II diabetes mellitus.

21) Ignoring the food maladaptive inflammatory reactions and resorting to steroids, non-steroidal anti-inflammatory agents, tranquilizers and antidepressants to handle the symptoms of inflammation further accelerates the diabetes mellitus disease process with the end result being clinically significant type II diabetes mellitus.

The above observations provide the significance of maladaptive food reactions and the relationship of the 4-Day Diversified Rotation Diet to food reactions.

HOW TO FOOD TEST

Five days of avoidance of all foods using a water fast only or another system of using a single infrequent food such as watermelon during the five days of avoiding foods.

During the five days avoidance, use one-half to one teaspoon of soda bicarbonate, three times a day to help offset the acid-hypoxia that develops during the food addiction withdrawal phase.

A negative (south-seeking) magnetic field therapy can materially aid in reducing the food addiction withdrawal symptoms during the five days of avoidance. Placing magnetic disc mag- nets bitemporally, which is in front of the ears, near the top of the front of the ears, under a band can reduce head symptoms such as headache or depression. It will also help to reduce the local symptoms otherwise by stopping the message to the brain from the local area of symptoms elsewhere in the body. Treating the brain should be accompanied at the same time by treating any other area of the body that has discomfort. The best magnet for treating local areas of the body that have pain or other discomfort is the 4" x 6" x 1/2 " ceramic magnet. This can be placed directly over the area of discomfort. The magnets bitemporally placed on the head are disc magnets that are 1-1/2 " x 1/2 " ceramic magnets. An alternative to this that provides lighter magnets that are just as effective are 1" x 1/8" neodymium disc magnets. Place one on the inside of the band

around the head and another one on the outside. This will magnetically hold these in place. That would be two on each side of the head, placed temporally. Anxiety is best handled by mid-forehead and left temporal placement. Obsessive-compulsiveness is best handled by left temporal and low occipital. Use either the ceramic discs or the neodymium disc magnets. The best band for this is a 2" x 26" body wrap. During the withdrawal phase of addiction whether this be to food or to other addictants, there is an uncomfortable tightness in the chest and in the epigastric areas. This discomfort can be handled by placing a 4" x 6" x 1/2 " magnet lengthwise on the sternum and or the epigastric area, crosswise the epigastric area. These can be held in place with a 4" x 52" body wrap. In terms of duration, these magnets can be held in place until symptoms are relieved which is usually within five, ten to fifteen minutes or they can be con- tinuously held in place during the withdrawal phase to maximize comfort. It should be under- stood that a negative (south-seeking) magnetic field alkalinizes and oxygenates the body area that is within that negative (south-seeking) magnetic field.

Record blood pH before the five days of avoidance begins and immediately before and one hour after each test meal. A normal blood pH is 7.4. This test is achieved by blood plasma on litmus pa-per. It is best to use one with a pH of 6 to 8. I have characteristically used pHydron litmus paper.

Test blood sugar before the fasting begins and before and one hour after each test meal of a single food. There are home blood test units for diabetics which are adequate for this purpose. This requires a drop of blood from a lance prick of a finger. Normal fasting blood sugar ranges from 80-120. One hour after a test meal, the normal blood sugar can range up to 140. From 140-160 is suspect. From 160 on, is definitely an abnormal hyperglycemia.

Symptom-survey the entire body for symptoms before and one hour after each test meal. Test the pulse before and one hour after each test meal. The heart is very sensitive to stress.

Skipped beats in response to maladaptive food reactions are common. Some people have a vulnerability to set off a tachycardia. Tachycardia could be handled by placing a 4" x 6" x 1/2" magnet with a negative (south-seeking) magnetic pole

over the heart. Hypertension is frequently a manifestation of food maladaptive reactions.

When food testing Crohn's disease or ulcerative colitis cases, it is best to have the suspected foods tested the last meal of the day. This provides for an overnight period of recovery from the reaction. The most suspected foods are the frequently used foods. They are often in the area of cereal grains, such as wheat, rye, oats, barley, corn or dairy products. However, it can be any food that is eaten with a frequency of two times a week or more including even salads. I have known some people who ate the same salad every day who maladaptively react to all the foods in their salads that they use daily.

It is wise not to use caffeine or alcohol in any form. However, it should be understood that it is possible that infrequently used caffeine such as a cup of coffee or chocolate candy or an occasional beer or alcohol otherwise will not necessarily set off the addiction. Addiction re- quires more than twice a week exposure. Even though it is not recommended that these items be used, it can be understood that an infrequent use on a single occasion will not reinstate addiction. It should however, be understood that subjects with mental symptoms should not really toy with the use of caffeine because it is a central nervous system excitant or with alcohol in any form. Those who have seizures should follow the same rules.

Those who choose a very limited diet such as strict vegetarians who are not using meat or any animal products, even fish, do find it more difficult to follow the 4-Day Diversified Rota- tion Diet. One way to get around this is to sprout the cereal grains such as wheat, rye, oats and barley and also sprout the beans. Sprouts of grains and beans are really a different food than the mature product and can be used on a different day than the mature product such as eating the cereal grains on rotation, two days later eating the cereal grains that have been sprouted. The same thing can occur with beans. Fresh corn such as corn on the cob is not the same food as mature corn and can be used on a different day than mature corn. When sprouting the grains or beans be sure that there is about 1/4" sprout and only use those beans or grains that have sprouted. These sprouts can be prepared in many different ways such as ground for bread orused as a cooked cereal. Sprouted beans or grains can be used as a fresh vegetable and in salads.

HOW TO USE A FOUR DAY DIVERSIFIED ROTATION DIET WITHOUT DELIBERATE FOOD TESTING

Many people find it practical to go directly to a four day diversified rotation diet without food testing. First, the person assumes that he or she is reacting to any food eaten as frequently as twice a week, or to any members of that food family. The person leaves these frequently used foods out of the diet for three months. At the initiation of the rotation diet, stop all use of caf- feine (coffee, teas with caffeine, cola drinks, chocolate), tobacco and all alcoholic drinks. <u>Do not reintroduce these</u> into the diet.

For the next three to four days, there will be withdrawal symptoms. Handle these symptoms as described in the section, "How To Initiate This Program."

Three months later, these foods are reintroduced back into the diet. Nearly always (95% of the time), these foods will no longer be reactive as long as they are kept on a once-in-four-day basis in this diet. When reintroducing foods into the diet, simply add the food to the established rotation and observe whether or not symptoms occur. If no symptoms occur, then this food can be rotated. If symptoms occur, wait another three months before trying this food again.

One way to expand the use of foods is to sprout cereal grains and legumes. A person should be certain that the grain or bean is sprouted with approximately 1/4" or more of a sprout. The foods that have been sprouted will no longer carry the same reactive capacity that the non- sprouted foods do. Thus, once sprouted, grains and legumes can be introduced into the diet immediately.

SELECTIVE 4-DAY ROTATION DIET

This diet selectively rotates on a four-day basis, the foods that have been demonstrated by deliberate food testing to evoke symptoms. Foods not demonstrated to produce symptoms or hypoglycemia reactions are used freely at any time desired. There is a particular problem with this diet in which the person may become addicted to some of the food that they are eating with fre- quency. This can easily escape them unless they test out. This diet starts either with a full month of testing of foods in which only the foods that gave symptoms, acid reaction or hypoglycemic reactions are initially left out for two more months beyond the month of testing food reactions and then placed into the rotation diet. Foods

not producing these symptoms are eaten freely. This makes it easier to prepare combinations of foods.

The other system, which would relate itself largely to self-help without a physician monitoring, would be to leave out all the foods that are eaten twice a week or more. This also includes all the family members of those foods. Set up a rotation diet of other foods, however, there would be no need to pay strict attention to rotation on these foods that have not been eaten frequently. After five days on this program, then start testing foods. This would start testing the foods and the family members of the foods that have been left out the diet. These can be placed back in the diet if no symptoms, acid reactions or high blood sugar is demonstrated. After having gone through all these foods that were left out of the diet originally, then start on the other foods, testing one meal once a month. It is suggested that in the case of gastrointestinal reactions, especially Crohn's disease and ulcerative colitis, have the test meal in the evening so that if there is a reaction, there is time for recovery from the reaction before the next meal in the morning.

Systematically, the food should be tested as outlined in the section on food testing. This involves that a food or a family member of this food should not be used for five days prior to the test meal.

The test meal should be a single food test meal. There should be a symptom survey recorded before the test meal begins and again repeated one hour after the test meal. The blood pH should be taken before the meal and one hour after the meal. The blood sugar should be taken before the meal and one hour after the meal.

Chronic Stress Chemistry Degenerative Diseases the Magnetic Anti-Stress Answer

The chemistry of acute stress, whether physical, chemical or psychic is an acute rise in serotonin needed for action as well as control over excessive response and at the same time, an acute rise in self-made polypeptide opiates (endorphins) for the relief of the pain of physical injury or psychic stress. Thus, a serotonin-endorphin complex is the chemistry of acute stress. Furthermore, the serotonin-endorphin complex is also the chemistry of chronic stress with alternating swings above and below physiological homeostasis levels for serotonin and endorphins. After the acute stress is over, the serotonin-endorphin complex returns to a normal physi- ological level in a few hours.

There are methods of chronically raising the serotonin-endorphin complex in which the subject has a sense of well-being and readiness for action. These methods are:

1. Providing chemicals that block the normal breakdown of serotonin, thus maintaining a chronic state of high serotonin, and

2. Frequently eaten, between meal snacks of carbohydrate-protein.

Chemicals classified as selective serotonin re-uptake inhibitors (SSRI) that raise serotonin to the stress level by the process of preventing serotonin's normal re-uptake are floxetine (Prozac), sertaline (Zoloft), paroxetine (Paxil), metazodone (Serzone), Luvox, venlafaxine (Effexor) and remoron. These are used as antidepressants, anti-obsessive-compulsive disorder and anti-anxi- ety. Dexfenfluramine (Redox) has been used as an appetite suppressant for weight control.

Redox has now been removed from the market due to the severity of its side effects. Carbohydrate is known for its ability to raise serotonin. Protein is known for its ability to buffer against the food addictive withdrawal symptom of hypoglycemia. It has been recommended that between meals snacks of carbohydrate-protein be used for appetite suppression, weight reduction and a sense of maintaining well-being by sustaining a chronic state of serotonin-endorphins. All of these methods that raise serotonin and thus raise to a chronic stress level the serotonin-endorphin complex has serious side effects, sometimes life-threatening. Prozac, as an example, has many symptoms, some of which are dangerous to the health of the subject. Redox has so many serious side effects that it has been removed from the market. Primary pulmonary hypertension, which is life threatening and kidney function deterioration are among the injuries that can develop from maintaining a high level of serotonin-endorphins. The serotonin syndrome consists of a complex of symptoms produced by a chronic state of serotonin levels beyond physiological homeostatic levels. The symptom side effects of the method of chronically raising serotonin-endorphins are such that it is a mystery that they are still maintained on the market. It is an injustice to both the physician and his patients for these chemicals, leading to degenerative diseases, to still be on the market. St. John's Wort is known to raise serotonin and the frequent use of St. John's

Wort carries the same chronic disease potential as SSRI stress chemicals. I cannot recommend St. John's Wort due to this chronic stress disease potential.

Instead of St. John's Wort as a chemical stressor, use a negative (south-seeking) magnetic field for symptom relief.

My studies in environmental medicine and toxicology have demonstrated that chronic dis- eases are the extension in time of acute maladaptive reactions, whether to foods, chemicals or inhalants.

Thus, the acute maladaptive symptom producing reactions produced by these medications that raise serotonin beyond homeostatic levels or between meal feedings to sustain a high level of serotonin-endorphins, is not to be treated lightly. To sustain these reactions by chronic admin- istration of these methods of raising serotonin/endorphins is to produce chronic diseases. My monitoring of chemistry of both acute reactions and chronic diseases that have the same symptom is that the disordered chemistry is the same for the chronic disease as it is for the acute symptom-producing reaction.

The Role of Food Addiction

There is a normal, necessary physiological homeostatic level for both serotonin and endorphins. Homeostatic normal level of serotonin and endorphins does not lead to any degenerative disease. Sleep is a great normalizer of this homeostatic level of serotonin and endorphins.

Addiction is a state of too much with a feedback mechanism of too little. Addiction is a stress response adaptation. The initial response to the stressor is over production beyond a base need of serotonin, endorphins (self-made narcotics), cortisol, insulin (hyper-insulinism) and other factors. The biofeedback response to the initial stress response is too little (below homeostasis) of the same serotonin, endorphins, cortisol, and other functions including acidity (acid-hypoxia) and hypoglycemia secondary to the initial hyper-insulinism. Addiction adaptation develops only after repeated and frequent stress responses to the same stressor. In the case of food addiction, the frequency must be more frequent than once in four days. My studies have demonstrated conclusively that maturity onset type diabetes mellitus is an end product of addic- tion and its numerous symptomatic complications. Therefore, it has been observed

that diabetes mellitus Type II is the degenerative disease end product of addiction.

Any person who has symptoms because they missed a meal is a food addict -- any person eating food to relieve symptoms is a food addict. Any person who has withdrawal symptoms while withdrawing from a chemical is addicted to that chemical. Addiction is an adaptation to a frequently contacted stressor. Therefore, this is proof that serotonin and endorphins are being raised beyond the normal needed homeostatic levels. All of these serotonin-raising chemicals are stressful and make a physiological addiction adaptation. The immediate maladaptive symp- toms are a demonstration of that stress. The long-term (not immediately evident) development of diabetes mellitus Type II and its associated complications of degenerative disease is the most serious of all even though it is largely ignored because it is not immediate.

Addiction is the cause of diabetes mellitus Type II (*Victory Over Diabetes: A Bio-Electric Triumph,* W. H. Philpott and Dwight Kalita. Keats Publishing Company, Inc. New Canaan, CT. 1983). Food addiction is the major source of addiction producing non-insulin diabetes mellitus.

The pH Factor in the Serotonin-Endorphin Complex and Acute Maladaptive Reactions and Degenerative Diseases

The human physiology functions as an alkaline-dependent state. Normal pH of the blood and cells is 7.4, and can be higher. It cannot be lower than 7.4 without inhibiting enzyme functions. All enzymes in the human body are alkaline-dependent. Also, the production of enzymes by the mitochondria in the cells is alkaline-dependent. The production of ATP by oxidative phosphorylation and the resulting enzyme catalysis spin-off of negative (south-seeking) magnetic field (oxidative remnant magnetism) are all alkaline-dependent and oxygen-dependent (alkaline- hyperoxia dependent). The only exception to the general rule that all enzymes in the body are alkaline-dependent is that of digestive enzymes in the stomach. The normal biological homeostatic functions of the human body are alkaline-hyperoxia dependent. An acid state, due to the free hydrogen ions, ties up oxygen and produces more acids. Any acid state is automatically acid-hypoxic. This is true of acute symptoms produced by exposure to symptom-producing foods,

chemicals and inhalants. It is equally true of the chronic degenerative diseases that are the end result of the accumulation extended in time from these acute symptom-producing reactions. The serotonin-narcotic complex, when raised beyond normal, is the chemistry of stress. Whichever one you raise, the other one rises also. The behavioral consequences justify this conclusion. Taking into the body an exogenous narcotic also raises serotonin. The narcotic has the biological consequences of making the subject pain-free and also feeling euphoric and distorting judgment so that risks are taken that would not otherwise be taken if not on the narcotic. Stimulating drugs that serve as a stress evoke the body's self-made narcotics (endorphins) and produce the same situation of euphoria and distorted judgment and a lessening of pain. Foods that are frequently eaten can become stressors and produce food addiction with this excessive rise beyond a homeostatic normal of both serotonin and endorphins. All addictions, whether occurring from exogenous narcotics, stimulants or foods that have developed into stressors due to the frequency of use, function on the same basis. When the food or chemical is contacted, there is a higher than normal production of serotonin and self-made opiates. At the time of this rise in serotonin-endorphin complex, there is a rise in body pH. All narcotics, whether exogenous or self-made, are alkaloids. Alkaloids alkalinize the body. Thus, it is understood that endorphins are a component of the body's capacity to remain alkaline. In this state of higher than normal endorphins, the body enzymes function at an optimum level. This include the production of ATP and of oxidative remnant negative pole (south-seeking) magnetism and also the processing of the free radical superoxide spin-off from the oxidation phosphorylation process. There are a set of oxidoreductase enzymes that process all these end products of oxida- tion-reduction. The varied substances produced by this superoxide are peroxides, oxyacids, aldehydes and alcohols. In this state, it needs to be understood that addictive reactions to foods and chemicals is aspect of this disordered stress chemistry. At the exposure level to the addictive substance, the subject is comfortable, even more than comfortable, even euphoric. The withdrawal phase, after this initial exposure, occurs three to four hours later in which there is a drop in serotonin and endorphins below the homeostatic

normal. In this situation, acidity develops below the body's homeostatic alkaline level. Pain develops. Depression develops. Again, judgment is altered but this time, in a negative way of depression, obsessive thoughts and com- pulsive acts. Food addiction or the maladaptive response to frequently used foods or chemicals behaves the same way with this see-saw effect of feeling extra good, pain free and with a dis- torted judgment in which risks are taken only to be followed by the symptoms of the withdrawal phase in which pains and depression develop. Judgment is altered, but in this case, a depressive obsession develops in which there is a fear of any normal risk taking. Providing a situation of chemical exposure or between meal feedings that raises the serotonin level to the chronic state of stress equivalent to an acute state of stress has a symptom relieving value. However, it also is stress. Also, this chemistry of stress (serotonin-endorphin complex above homeostatic levels) is, itself, a biological stress and eventually leads to disordered biological function and degenerative diseases.

The answer is not to handle the drop in serotonin and opiates by an added stress at sufficient intervals to again raise the serotonin and endorphins, but rather, to cancel out the stress factor by anti- stress. This can be achieved by providing exposure to a negative (south-seeking) magnetic field, which is anti-stress. It does not raise endorphins and opiates, but rather, normalizes the homeostatic level of serotonin and self-made opiates. Not only does exposure to the area of discomfort and the brain relieve the withdrawal symptoms, but also sound, energy-restoring sleep produced by a negative (south-seeking) magnetic field will normalize the homeostasis of serotonin and endorphins.

The question is logically asked, "What evidence is there from peer reviewed or non-peer reviewed publications that a negative (south-seeking) magnetic field is capable of achieving this anti-stress goal?" The following chapter has evidence from the peer reviewed and non-peer reviewed writings on this subject of separateness of the magnetic poles and the significance of the biological response to each separate pole.

Scientific Peer Reviewed Literature Evidence of Separate and Opposite Biological Responses to Separate and Opposite Magnetic Fields

Instrument evidence of separate magnetic fields:

A magnetometer is an accepted scientific instrument that identifies magnetic poles of static field magnets as positive and negative. Furthermore, a magnetometer identifies the magnetic poles produced at the opposite electromagnetic poles of a DC circuit as being positive and negative. The magnetometer identifies the north pole of the earth as negative and the south pole of the earth as positive. The gauss meter agrees with the magnetometer. The gauss meter also identifies magnetic polarity as positive and negative. Thus, it is seen that to understand these accepted scientific instruments used to identify magnetic poles there is a need to understand magnetic poles in terms of electromagnetic positive and negative.

It is universally accepted that a negative (south-seeking) static magnetic field spins electrons counterclockwise and the positive (north-seeking) static magnetic field spins electrons clock- wise. Thus, again there is the identification of opposite response to separate and opposite mag- netic fields.

What Evidence is There That Biological Responses to Opposite Magnetic Fields are Opposite?

The following is from peer review scientific literature giving evidence of opposite biological responses to opposite magnetic pole fields.

1) A positive (north-seeking) magnetic fields encourages cancer growth while a static negative (south-seeking) magnetic field discourages cancer growth.

2) The negative electromagnetic field of a DC circuit evokes a biological alkaline pH response of 10 while the positive electromagnetic field of a DC circuit evokes a biological acid pH response of 2. The biological response of a pH of 2 at the positive electromagnetic pole of a DC circuit and a pH of 10 at the electromagnetic negative pole of a DC circuit has been confirmed by G. 0. O'Clock, Ph.D.

3) A positive (north-seeking) static magnetic field blocks melatonin production by the pineal gland and a negative (south-seeking) static magnetic field stimulates production of mela- tonin by the pineal gland.

Privately Published, Non-Peer Reviewed Publications That Have Been Confirmed by the Above Peer Review Publications

1) The physicist, Albert Roy Davis spent 60+ years detailing in animals the opposite biological response to opposite static

magnetic fields. He found the biological response to a static positive (north-seeking) magnetic field is acidification while the biological response to a static negative (south-seeking) magnetic field is alkalinization. This agrees with the peer reviewed literature.

2) Robert O. Becker, M.D., demonstrated the opposite biological response to opposite static magnetic fields. The static positive (north-seeking) magnetic field is stressful and signals biological injury and neuronal excitation. The static negative (south-seeking) magnetic field is antistressful and necessary for biological healing and neuronal control of excitation. Mental patients subject to psychosis are excited by the positive (north-seeking) magnetic field sun flares frequently producing hospitalization and also confirmed by the "bad" days in mental institutions. On the other hand, neuronal excitement can be controlled by the negative (south-seeking) magnetic field and was used by him to produce general anesthesia in his salamanders.

The privately published non-peer reviewed research records of Albert Roy Davis and Robert O. Becker have been confirmed by peer reviewed published data. Thus, there is confirmed evidence of the separate and opposite biological response to the separate and opposite static magnetic fields.

The physicist, Albert Roy Davis spent sixty years documenting the separate and oppositeness of magnetic fields. He first observed this separateness and oppositeness in relationship to the behavior of earthworms. He documented the evidence that the biological response to a static negative (south-seeking) magnetic field is that of alkalinization and oxygenation. It is this evidence that attracted me to examine the biological response to magnetic fields. I found Albert Roy Davis' work to be reliable. I reproduced exactly what he said about alkalinization plus oxygenation with a negative (south-seeking) magnetic field and acidification plus lack of oxygen with a positive (north-seeking) magnetic field. It is on the basis of a negative (south-seeking) magnetic field producing alkaline-hyperoxia that maladaptive symptoms can be relieved. I have demonstrated that symptoms such as responses to food reactions, chemicals or inhalants was acidifying and reducing in oxygen and could simply be relieved by alkalinization and

oxygenation. I originally used baking soda and the breathing of oxygen to relieve the symptoms.

I found that a negative (south-seeking) magnetic field provided even more reliable value than baking soda and the breathing of oxygen.

Now that we have documented peer review journal articles that have documented the separateness of the biological responses to the separate magnetic poles, we can understand and accept the evidence that both Albert Roy Davis and Robert 0. Becker have provided us in their documented evidence of the biological response separateness of the opposite magnetic poles. You cannot treat degenerative diseases such as cancer with a static positive (north-seeking) magnetic pole field of a static field magnet. It only makes it worse. Treating with a static negative (south-seeking) magnetic pole field and the alkaline-hyperoxia that is produced by this biological response to a negative (south-seeking) magnetic pole can and does reverse cancer and a lot of other symptoms that relate to chronic degenerative diseases.

The only way a positive (north-seeking) magnetic field can be used to kill cancer is with a DC current electrolysis in which a cellular destructive pH of 2.0 is produced. A positive (north-seeking) static magnetic field from a static field magnet produces an acid medium below the normal 7.4 and into a pH of below 7.0, but not a pH of 2.0. The acidic medium biological response produced by a positive (north-seeking) static magnetic field is in the pH range that supports cancer cellular replication, microorganism replication and fermentation. Fermentation is acid-hypoxic dependent.

Otto Warburg was given a Nobel Prize for demonstrating the evidence that fermentation is the process by which cancer makes it's adenosine-triphosphate. Fermentation is an acid-hypoxic-dependent functional state. Alkaline-hyperoxia produced by a negative (south-seeking) magnetic field defeats the acid-hypoxia necessary for the fermentation process. This principle of alkaline-hyperoxia replacing acid-hypoxia is also present when acute symptoms are relieved or degenerative diseases reversed. This principle of acid-hypoxia is present when acute symptoms are evoked and also when chronic diseases develop.

FINAL WORD

Both the withdrawal symptoms and symptom relief phases of addiction are biologically stressful. When the serotonin-endorphin complex is below biological homeostasis levels for serotonin and endorphins such as occurs during the addictive withdrawal phase of addiction or as a fatigued manifestation of chronic stress is, itself, a deteriorating biological stress leading to degenerative diseases. When the serotonin-endorphin complex is above biological homeostasis levels for serotonin and endorphins such as the symptom relief phase of addiction, or as raised by chemicals including those that raise serotonin by preventing it's normal degradation is, itself, a deteriorating biological stress leading to degenerative diseases.

The primary method of handling stress is by avoiding the stressors. This includes avoidance of food addiction, alcohol addiction, tobacco addiction, caffeine addiction or any chemicals frequently used that raise serotonin and endorphins. This need for avoidance includes substances that chronically raise the serotonin-endorphin complex beyond normal homeostatic levels (SSRI chemicals such as Prozac, Zoloft, Paxil, Serzone, Luvox, Effexor, Remoren and MAGI chemicals such as Nardil and Parnate). Food addiction can be handled by spacing the same specific food contacts by a four day rotation diet. Non-food addictions need to be prevented or reversed by complete avoidance.

When it was demonstrated that serotonin was low in states of chronic physical and emotional disorders this was heralded as a marvelous discovery. There was a spin-off of this evidence in the development of antidepressants, anti-obsessive-compulsive medication and also the use of frequently used carbohydrate-protein between meal feedings to raise serotonin. What was originally heralded as a wonderful discovery, has now resulted in the evidence that raising serotonin, which is the chemistry of stress, is itself a stress and therefore, symptom-producing and degenerative disease producing. One of these substances (Redox), used for appetite reduc- tion and weight management, has been withdrawn from the market due to the severity of it's potential life-threatening symptoms. Those that are still on the market (Prozac, Zoloft, Paxil, Serzone, Luvox, Effexor, Remaren, Nardil and Parnate) all have serious side-effects that, if chronically used, can lead to degenerative diseases. It is an injustice to the physician and his patients that

these still remain on the market. The answer now resulted in the evidence that raising serotonin, which is the chemistry of stress, is itself a stress and therefore, symptom-producing and degenerative disease producing. The answer to stress is not to raise chronically the chemistry of stress (serotonin-endorphin complex) but rather to magnetically, through the use of a negative (south-seeking) magnetic field, produce the necessary homeostatic level of anti-stress. The answer for the correction of the disordered chemistry of stress (chronically raising serotonin-endorphins above the homeostatic normal) is to provide a negative (south-seeking) anti-stress magnetic field providing a homeostatic normalization of serotonin-endorphins and alkaline-hyperoxia.

THE ANSWERS FOR PREVENTING AND REVERSING STRESS CHEMISTRY DISEASES ARE:
1) AVOIDANCE OF STRESSORS
2) PROVIDE METABOLIC HOMEOSTASIS BY MAGNETIC ANTI-STRESS LUVOX AND THE COLORADO SCHOOL HOMICIDE-SUICIDE DISASTER

Eric Harris, the leader of this murder-suicide disaster was under treatment with LUVOX. LUVOX is one of the stress chemistry medications that raises serotonin and endorphins. LUVOX has serious side effects including a suicidal compulsion. LUVOX can turn a suicidal or homicidal obsession into a homicide-suicidal compulsion. There is a fair chance that LUVOX played a role in the Colorado school murder-suicide disaster.

Disordered Biochemical Homeostasis Illness
VS
Biochemical Homeostasis Wellness
Methylation and Sulfur

S-adenosylmethine (SAM) which is methylated methionine and due to its many biological values is being heralded as "methyl magic". Sulfur is the necessary mineral for the methylation of methionine.

Dimethyl sulfone (MSM) is a metabolite of dimethyl sulfoxide (DMSO) which contains sulfur which is necessary for methylation is being heralded for its marvelous inflammatory symptom-reducing values. Supplementing SAM can have the unfortunate symptom side-effect of changing a depression into a mania. SAM used as a nutritional supplement is sold as Tosylate or Butane Disulfanate (SAM sulfate). SAM is the biological methylated end-product which can disorder

biological homeostasis, whereas MSM is a sulfur containing product which is a precursor to the enzymatic catalytic methylation and does not force methylation into a disordered homeostasis. SAM is a biological stress chemical that raises serotonin the same as SSRI chemicals and for this reason has the same disadvantages as SSRI tranquilizers-antidepressants.

The Necessity of Biological Homeostasis

There are many products that are necessary for biological life, which if chronically sustained either by a chronic stress on the organism that produces an excessive amount of the product or the product being supplied from an external source, produce diseases. Such products are such as adrenocortical hormones, serotonin, endorphins, and methylated anti-inflammatory products. When these are extended by any internal or external means to be chronically present then disease results. Homeostasis is the order of health. Disordered homeostasis is the order of disease.

Chemical stressors that chronically raise the serotonin-endorphin complex produce mental and physical symptoms which in time become diseases because they disorder homeostasis. A chronically raised serotonin-endorphin complex is equivalent to chronically riding the high crest (higher than homeostatic normal serotonin-endorphin) of addiction which is itself a state of biological disordering stress. Depression is biochemically equivalent to the down side withdrawal phase of addiction in which serotonin-endorphin complex is lower than homeostatic normal. Chronically raising the serotonin-endorphin complex higher than homeostatic normal is equivalent to the high side of addiction and can produce mania.

The Role of a Negative Magnetic Field in Maintaining Homeostasis

A negative (south-seeking) magnetic field is the great oxidoreductase enzyme energy activator which maintains biological homeostasis. The enzyme energy driving force of a negative (south-seeking) magnetic field normalizes biological functions and never disorders biological homeostasis. A negative (south-seeking) magnetic field relieves symptoms without producing stress chemical disordered diseases. A negative (south-seeking) magnetic field is equally valuable in treating depression or mania precisely because a negative

(south-seeking) magnetic field produces biological homeostasis.

Summary

The bad news is that when chronic physical or psychological stress disordered stress chemistry, such as serotonin, endorphins, adrenocortical hormone or methylation drive these chemis- tries to chronic levels beyond biological homeostasis, it is itself a stress-producing disease state. Any system that chronically raises the stress chemistries beyond homeostasis is disease-producing. Equally, providing external sources of these stress chemistries will also lead to disease. Diabetes mellitus Type II and its many complications is a logical and predictable consequence of a chronically high stress chemistry. As useful as these stress chemistries are for reducing symptoms, with chronic use, they end up producing disordered biological homeostasis and thus, degenerative diseases.

The good news is that the biological response to a static negative (south-seeking) magnetic field orders biological homeostasis and is thus symptom relieving and chronic disease reversing. Adequate nutrition for the building blocks of tissues, hormones, enzymes and so forth, plus a static negative (south-seeking) magnetic field ordering biological function is the road to health and longevity. The road to health is paved with adequate nutrition. The energy for driving life's vehicle down this road is a static negative (south-seeking) magnetic field with the balance between a positive (north-seeking) magnetic stress field and a negative (south-seeking) mag- netic anti-stress field being on the negative (south-seeking) magnetic anti-stress field side. A positive (north-seeking) magnetic field is the biological stress field (physical and mental energy expressions). A static negative (south-seeking) magnetic field is the anti-stress energy field that controls the production of biological energy (ATP and oxidation remnant magnetism) and the control over the static stress positive (north-seeking) magnetic field energy expressions.

All enzyme catalysis has a measurable magnetic field produced when electrons move between enzyme and substrate. It is the presence of the magnetic fields that bind enzymes to substrate. A negative (south-seeking) magnetic field as an enzyme energy activator is also present in ATP energy activated enzymes. Therefore, a negative (south-seeking) magnetic field

also aids in energy activation of ATP energy activated enzymes. This fact of energy catalysis dependence on a magnetic field is the secret why a negative (south-seeking) magnetic field is so universal in relieving so many types of symptoms and also reversing degenerative diseases.

The human body functions in an alkaline medium and its enzyme systems are alkaline-negative (south-seeking) magnetic field dependent other than the acid-dependent gastric en- zymes. On the other hand, cancer cells, microorganisms and parasites make ATP by acid-posi- tive magnetic field-dependent transferase enzyme catalysis. A negative (south-seeking) magnetic field maintains a positive-negative magnetic field homeostasis on the negative (south-seeking) magnetic field side, acid base homeostasis on the alkaline side and also is anti-carcinogenic, antibiotic and anti-parasitic. never addicting

DON'T

Don't resort to addictive biological homeostatic disordering stress chemistries to relieve symptoms.

Don't use SSRI tranquillizers-antidepressants to chronically raise serotonin-endorphin.

Don't use SAM to relieve symptoms. SAM is a stress chemistry and can produce mania.

Don't use between meal feedings to raise serotonin-endorphin. The frequent use of foods on a twice a week frequency or more basis can produce food addiction.

Don't use a positive (north-seeking) static magnetic field or combined positive-negative static magnetic field to relieve symptoms. A positive (north-seeking) static magnetic field is a stressor and raises serotonin-endorphins. Like SSRI chemicals, a low gauss strength positive (north-seeking) static magnetic field or combined positive-negative magnetic field can relieve symptoms but can also become an addictant.

Don't use an alkali diet to reduce symptoms of food addiction. This does not prevent the development of diabetes mellitus.

Don't use between meal feedings of protein or a combination of carbohydrate/ protein or carbohydrate/protein/ fat feedings to reduce symptoms of food addiction. These diets do not pre- vent the development of diabetes mellitus.

DO

Do use nutrition plus a static negative (south-seeking) magnetic field to order biological homeostasis.

Do provide adequate nutrition for enzyme production and other biological function and tissue building.

Do use MSM as a supplement to a negative (south-seeking) magnetic field to relieve symptoms.

Do use a static negative magnetic field for optimum energy-restoring sleep, detoxification, maintenance of alkaline-hyperoxia and symptom relief.

Do use a 4-day food family rotation diet. Food addiction does not occur on a 4 day rotation diet.

Do use a negative (south-seeking) static magnetic field as an anti-stress field to relieve symptoms by producing alkaline-hyperoxia. A negative (south-seeking) static magnetic field is an anti-stressor and never addicting.

Do use a four day food rotation to reverse food addiction with its numerous symptoms during the compensated diabetes mellitus disease process and the end-stage of diabetes mellitus type II with its numerous complications. A 4-Day Diversified Rotation Diet is the only, and therefore, ultimate diet that can reverse the symptoms of food addiction and therefore prevent and reverse the many degenerative disease symptoms developing during the compensated diabe- tes mellitus stage and the final clinically significant diabetes mellitus type II.

DON'T

Don't treat pain with a positive magnetic field or combined positive/negative magnetic field due to 1) an acid-hypoxia biological response producing vasculitis. 2) stress response evoked endorphins which, with frequent repetition, produces addiction.

Don't treat the heart with a positive or combined positive/negative magnetic field due to 1) a stress response can precipitate irregular cardiac rhythm including tachy-cardia in predisposed subjects, 2) a vasculitis response predisposing to a coronary occlusion.

Don't treat an acute injury with edema and bleeding with a positive magnetic field or combined positive and negative magnetic field due to a) an inflammatory vasodilatation from acid- hypoxia response, b) an increase in bleeding, c) increase in microorganism replication response to acid-hypoxia.

Don't treat the head with a positive magnetic field or combined positive/negative magnetic fields due to 1) stress evoked endorphins producing euphoria, altered judgement, sleep deprivation and when used frequently, the development of addiction, 2) a stress-evoked seizure in subjects predisposed to seizures, 3) an increase of replication of microorganisms when present, 4) stress-evoked acid-hypoxia increasing atherosclerosis and amyloidosis.

Don't use a positive magnetic field or a combined positive-negative magnetic field to relieve pain or other symptoms. If used at all, use briefly and not frequently due to the limitations of activation of cancer cells, microorganisms and parasites as well as the potential of producing magnetic addiction and vasodilatation producing local edema.

DO

Do treat pain with a negative magnetic field due to a biological response of alkaline-hyperoxia normalization of metabolic function. A negative magnetic field is anti-stress, does not evoke endorphins and is not addicting.

Do treat the heart to a negative magnetic field to resolve atheromatous plaques, oxygenate the heart with alkaline-hyperoxia and stop pain and cardiac irregularities and resolve vasculitis.

Do use a nightly exposure of the heart to a negative (south-seeking) magnetic field to resolve cardiac atherosclerosis.

Do treat an acute injury with edema to a negative magnetic field to:

a) reduce edema and reduce inflammation. b) decrease bleeding. antibiotic effect.

Do treat the brain to a negative magnetic field due to 1) a magnetic control over anxiety, depression, psychosis and seizures, 2) an antibiotic effect, 3) alkaline-hyperoxia response resolving atheromatous plaques and amyloidosis.

DON'T

Don't use a positive (north-seeking) magnetic field or a combined positive-negative magnetic field on the head to treat pain, neurotic symptoms, psychotic symptoms or seizure disorders. All these can be made worse with the positive (north-seeking) magnetic field. The stress field of a positive (north-seeking) magnetic field can evoke the production of endorphins producing euphoria and altered judgement. Chronic, frequent

application of a positive (north-seeking) magnetic field will produce positive magnetic field addiction. Due to the euphoria and altered judgement, the person will be fooled, thinking he is getting better when he is getting worse.

Don't use food neutralization to manage the symptoms of food maladaptive reactions. This does not prevent the development of diabetes mellitus.

Don't use non-steroid anti-inflammatory agents to relieve the symptoms of food addiction. This does not prevent the development of diabetes mellitus and there are serious deteriorating consequences to frequent use of non-steroid anti-inflammatory agents.

Don't use steroids to handle the symptoms of food addiction. This does not prevent the development of diabetes mellitus and can even hasten the development of diabetes.

Don't use tranquilizers and anti-depressants to handle the symptoms of food addiction. This does not prevent the development of diabetes and even hastens the development of diabetes.

Don't use food neutralization. This does not prevent the development of diabetes mellitus.

DO

Do use a negative (south-seeking) magnetic field to relieve pain and other symptoms, relieve edema and for its antibiotic, anticancer and anti-parasitic values. The longer the application of a negative (south-seeking) magnetic field, the better.

Do use a positive (north-seeking) magnetic field for brief (3-5 minute) periods to reestablish neuronal function after "neuronal extinction of disuse" following an accident or a bout of mul- tiple sclerosis.

Do use a negative (south-seeking) magnetic field on the head to reverse pain, neurotic symptoms, psychotic symptoms and seizure disorders. The more frequent and more prolonged the exposure of the head to a negative (south-seeking) magnetic field, the better.

Do use food rotation to reverse the symptoms of food addiction.

DON'T

Don't use non-steroid anti-inflammatory agents to relieve the symptoms of food addiction. This does not prevent the development of diabetes mellitus and there are serious deteriorating

consequences to frequent use of non-steroid anti-inflammatory agents.

Don't use steroids to handle the symptoms of food addiction. This does not prevent the development of diabetes mellitus and can even hasten the development of diabetes.

Don't use tranquilizers and anti-depressants to handle the symptoms of food addiction. This does not prevent the development of diabetes and even hastens the development of diabetes.

References

Becker, Robert O., *Cross Currents* Geremy P. Tarcher, Inc.: Los Angeles, CA. 1990)

Becker, Robert O. and Marino, A.A. *Electromagnetism & Life.* (State University of New York Press; Albany, NY 1982)

Becker, 0 and Selden, G. *The Body Electric: Electromagnetism & the Foundation of Life.* (William Morrow & Co: New York, NY. 1985)

Cooney, Craig, Ph.D. *Methyl Magic.* (Andrew McMeel Publishing: 4520 Main Street, Kansas City, MO 64111, 1999)

Davis, A.R and Rawls, W. The Magnetic Blueprint of Life (Acres USA: Kansas City, MO. 1979) Davis, A.R and Rawls, W. The Magnetic Effect (Acres USA: Kansas City, MO. 1975) Davis, A.R. The Anatomy of Biomagnetism (Acres USA: Kansas City, MO. 1975) Desmaisons, Kathleen Ph.D. *Potatoes not Prozac.* (Simon & Schuster: NY, NY., 1998)

Fernstrom, J.D. and Wurtman, R.J. Brain Serotonin Content: Physiological Regulation by Plasma Neutral Amino Acids. Science (1972), 178:414-416.

Fersht, Alan. *Enzyme Structure and Mechanism, Second Edition. (W.H.* Freeman and Co.: New York, New York. 1994)

Fyfe, William S. Oxidative Remnant Magnetism New Encyclopedia. Vol. 24, pg 200 (Encyclopedia Britannica, Inc.: Chicago. 1986)

Jacob, Stanley W., M.D., Lawrence, Ronald M., M.D., Ph.D., and Zucker, Martin, *The Miracle of MSM. The Natural Solution for Pain.* (G.P. Putman's Sons: New York, NY., 1999) Klonowski, W and Klonowski, M. Aging Process - Enzymatic Proteins. Journal of Bioelectricity. 4(1), 93-1 02 (1985).

Lieberman, H.; Wurtman J.; and Chew, B., Changes in Mood After Carbohydrate Consump- tion Among Obese Individuals. American Journal of Clinical Nutrition (1987), Volume 44.

Magnetic Fields in Enzyme Catalysis. Encyclopedia Britannica. Vol. 15. Pg 1068. (Encyclopedia Britannica, Inc.: Chicago. 1986)

Norden, Michael J., M.D. *Beyond Proac.* (Harper Collins Publishers, Inc.: New York, NY) Nordenstrom, B.E.W., Biologically Closed Electric Circuits. (Nordic Medical Publications: Stock-holm, Sweden, 1983)

Nordenstrom, B.E.W., "Electrochemical treatment of cancer; variable response to anodic and cathodic fields". Am Journal Clinical Oncology, 1989: 12:530-536.

Nordenstrom, B.E.W., "Survey of mechanisms in electrochemical treatment (ECT) of cancer". European Journal Surgical Supply. 1994: 574:93-1 09.

Nordenstrom, B.E.W., "Biokinetic impacts on structure and imaging of the lung: the concept of biologically closed electric circuits". American Journal Roentqenol. 1985; 145:447-467.

O'Clock, G.D., "Studies of the effects of in vitro electrical stimulation on Eukaryotic cell proliferation". MA Thesis (Biological Sciences, Mankato State University, Mankato, MN, 1991) O'Clock Jr. G.D., & Lyte, M., "Potential uses of low-level direct current electrotherapy for the treatment of cancer". Proceedings of the 15th Annual International Conference of the IEEE Engineering in Medicine and Biology Society, San Diego, CA, Part 3:1993; 1515-1516.

Pomeranz, B: Recent Advances in Acupuncture Research. Temple Univ. Center for Frontier Sciences Symposium. April 26, 1994.

Randolph, T.G. "The Enzymatic and Hypoxia, Endocrine Concept of Allergic Inflammation".

Clinical Ecology. pp 577-596. (Charles C. Thomas Publisher: Springfield, Illinois, 1976) Semm, P., Schneider, T. & Vollrath, L. "The Effects of an Earth Strength Magnetic Field on the Electrical Activity of Pineal Cells". Nature, 1980; 288: 607-608.

Tavnock, T.E., and Rotin, O., "Acid pH in Tumors and its Potential for Therapeutic Exploitation". Cancer Res, 1989. 49:437-4384

Trappier, Arthur, et al. "Evaluating Perspectives on the Exposure Risks from Magnetic Fields", Journal of the National Medical Association, 82:9, September 1990.

Warburg, O., The Metabolism of Tumors. F. Dickens (Trans) (Arnold Constable: London, 1930)

Warburg, O., On the Origin of Cancer Cells. Science 123 (1956) 309-315.

Warburg, O. "The Prime Cause and Prevention of Cancer". Revised lecture at the meeting of the Nobel laureates on June 30, 1966. National Cancer Institute Bethesda, MD.1967

Wiley, T.S. with Formby, Bent, Ph.D., *Lights Out.* (Simon & Schuster, Inc: New York, NY., 2000)

Wurtman, J. "The Involvement of Brain Serotonin in Excessive Carbohydrate Snacking by Obese Carbohydrate Cravers". Journal of the American Diet Association (1894) 84:1004-1007.

Wurtman, R. and Wurtman, J. "Nutrition Control of Central Neurotransmitters". The Psychology of Anorexia Nervosa, ed. by K.M. Pirke and D. Ploog, pp. 4-11. (Berlin: Springer Verlag, 1984)

Wurtman, R., and Wurtman, J. *Nutrition and the Brain.* Vol. 7. (New York: Raven Press, 1986) Wurtman, J. and Suffes, Susan. *The Serotonin Solution.* (Fawcett Columbine. 1996)

[*Magnetic Health Quarterly* "The Ultimate Non-Stress Non-Addsiction Diet," Vol. VI, 1st Qtr, 2000 (2001Revision)]

ANSWERS TO ASSERTIONS

SEPARATE BIOLOGICAL EFFECTS OF OPPOSITE MAGNETIC POLE FIELDS

Evidence from non-peer reviewed science literature, value confirmed

DEFINITION OF MAGNETIC POLARITY Compass needle geographic definition

vs

Electromagnetic definition

VALUES AND LIMITATIONS OF BOTH MAGNETIC POLES The following is in response to requests for a review of specific assertions.

ASSERTIONS:

This is used to designate the assertions that are made for which a review has been requested. This presentation focuses on the issues raised by assertions and purposely does not identify the persons making the assertions.

W.H. PHILPOTT'S ANSWERS TO THE ABOVE ASSERTIONS & ANSWERS

Assertion:

"There is no proven benefits to the idea that putting a north, south or alternating sides of a magnet toward the body is better. The benefits of magnets are derived from the Hall effect. Magnetic fields can influence the speed of blood flow by dilating blood vessels which will increase circulation and accelerate the healing process."

Assertion:

Positive and negative magnetic fields are also misleading and inaccurate terms that originated with the British Admiralty's efforts to improve the compass. They had created a freely flowing magnetic needle mounted over a card containing markings to indicate graduations in direction based on the orientation of the needle when it points to the geographic north pole. The end of the needle that points north was called the north, or positive pole of the magnet. Actually, it should have been called, north-seeking pole which would have meant that it was actually negative rather than positive. By the time this error was recognized, the terminology had become so ingrained that it was too late to correct it."

Assertion:

"Various claims are made by different manufacturers with respect to the superiority of their product design or the benefits of applying either pole or both poles to the body. However, there is absolutely no clinical evidence that these magnetic fields produce any biological effects that are superior, safer or even different."

Assertion:

"The terms positive and negative applies only to electric poles and not to magnetic poles." The magnetometer is an accepted scientific instrument which is used to identify the magnetic poles in terms of positive and negative. This scientific instrument identifies magnetic poles as positive and negative whether we are examining a static field magnet, the magnetic poles of the earth or the magnetic poles formed at the poles of a direct current circuit. A direct electric current circuit forms magnetic poles at each electric pole. A negative DC circuit electric pole forms a negative magnetic field. A positive DC circuit electric pole forms a positive magnetic field. This is why a magnetometer can be used to identify the separate magnetic poles of a static field magnet, the separate magnetic poles of the earth or the separate electromagnetic poles of a DC circuit. The present day use of magnetic positive and magnetic negative bears no relationship to the British Admiralty's

use that they may have made of the terms positive and negative as applied to magnetic poles of the earth determined by a compass needle. The history that I have been able to find about the discovery that the navigators had incorrectly named the poles does not make any reference to any consideration that the British Admiralty made on the subject of magnetic positive and magnetic negative.

William Gilbert in 1600, in the classic book on magnetism entitled, *De Magnete*, described the fact that the compass needle that points towards the north pole of the earth is indeed a south pole rather than a north pole (1). Through the years, others have followed suit in making correction of the original misnaming of magnetic polarity. Despite these corrections, the traditional way of naming poles is still either north or north-seeking, or south or south-seeking. B. Beleney (2) describes the traditional way of naming magnetic poles as being incorrect and therefore producing "semantic confusion". His solution to this is to use the electrical definition of positive and negative. This is justified because there is always a magnetic field created at each electric pole and that magnetic field justifiably has the same sign as the electric pole. This correct way of naming the poles is particularly satisfying to the physician who deals with the human body which has a direct current circuit. Therefore by naming the poles according to the electrical definition, there is no kind of interpretation needed. The magnetometer is a scientific instrument used to identify either the electric poles of a D.C. circuit or magnetic poles of a D.C. static field permanent magnet in terms of electromagnetic positive and negative.

The question is: is there scientific justification for naming the poles of a direct current circuit (which of course always has a magnetic field) and the poles of a DC static field magnet as positive and negative? A magnetometer tells us they are one and the same. A gauss meter tells us they are one and the same. Biological responses tells us they are one and the same. The physicist, B. Beleney, states the problem and solution in the following quotes from the *New Encyclopedia Britannica*, (1986), (Vol 18), pp 274, 275: "Attractive forces appear when poles of opposite signs are close together; repulsive forces are found when poles of the same sign are close together. Briefly, like poles repel and opposite poles attract. This result gives rise to some semantic confusion in the nomenclature for magnetic poles. The north pole of a compass needle is the pole that points toward, (that is, is attracted by) the

north magnetic pole of the earth. It is more accurately known as the north-seeking pole. By analogy with electrical charges, the terms positive and negative magnetic poles can be used rather than north and south poles. These may sometimes be designated by the symbols $+q_m$ and $-q_m$ respectfully, in which the subscript "m" denotes magnetic. Thus, poles of the same sign repel one another and poles of the opposite sign attract one another."

Thus, we see on good, peer reviewed, scientific authority that the electromagnetic definition of positive and negative is even recommended as being applied to static field magnetic poles. There is an advantage in doing this since we are treating the human body and the human body functions on a direct current circuit formed from magnetic fields with the neurons of the brain and spinal cord being positive poled in relationship to the extensions of the neurons which are negative poled. This makes it easy to understand the significance of the work of Robert O. Becker, M.D., in which he instrumentally demonstrated the presence of a positive magnetic field measured electromagnetically at a site of injury and the negative magnetic field as being present of necessity during the healing process(3). This fact also clearly defines the separateness of the biological response to the positive and negative magnetic fields whether created by a direct current circuit or being supplied from a static magnetic field. The biological response are one and the same for the magnetic field produced by electric + or - and static magnetic $+q_m$ or $-q_m$ because the magnetic field from these separate sources are one and the same. The biological responses are the same whether the magnetic field is from a DC circuit or a DC static field magnet. The biological responses to separate positive and negative magnetic fields are opposite.

It is understood that the use of positive and negative applied to static field magnetism applies to the understanding of the relationship between a DC electric circuit that produces magnetic fields and bears no relationship to any consideration that was ever made about the field as indicated by a compass needle as being called positive and negative by the British Admiralty. The assertion is made that the British Admiralty made a mistake in calling the needle that pointed to the north pole of the earth as being positive when actually it should have been called negative. The fact is that if you relate positive and negative as it is currently being used relative to positive and negative electric poles, then the statement made about the British Admiralty wrongly naming the poles is in

error. The magnetic compass needle polarity pointing to the north pole of the earth is truly electromagnetic positive and not electromagnetic negative therefore, this statement made in this book simply states it wrong. Anyone that tries to use this information and think that this is referring to the same positive and negative fields as currently used that relates to electromagnetism would be confused because this is named wrong. This incorrect assertion merely adds to the semantic confusion that already exists in naming the poles incorrectly in the first place.

What about the assertion that there is no clinical evidence of biological response difference of the opposite poles? There is abundance of evidence that there is a difference in the biological response to the two poles. There is separate and opposite biological response to the separate and opposite magnetic poles. If there was not published data on this subject in the peer review literature, a person could be correct in saying there is no published data in the peer review literature justifying the opinion that there is a separate opposite biological response to the separate opposite magnetic poles. However, this is not the case. There is published documentation in peer review literature that there is a separate and opposite biological response difference to the magnetic poles (4). This article documents that a positive (north-seeking) magnetic field encourages the growth of cancer cells and that a negative (south-seeking) magnetic field inhibits the growth of cancer cells. Thus, we see there is documentation in the peer review medical literature stating an opposite effect to the opposite magnetic fields. There are several other peer reviewed articles, also.

This documented magnetic fact in peer review literature now justifies the abundance of recorded evidence of the separate and opposite biological response to magnetic fields. Robert Becker published work in his books, *Cross Currents* and *Body Electric* cannot be considered peer review literature. He very definitely understood and documented the separateness of the two poles. The positive (north-seeking) magnetic pole is a stress field and becomes the signal of injury. A negative (south- seeking) magnetic pole is an anti-stress field and is present during healing and it has to be maintained negative (south-seeking) or healing does not occur. There are other evidences that he well understood separateness of the two poles. He refers to sun flares disordering mental function in those that are so predisposed to a disordered mental function. Sun flares are known to be a positive (north-

seeking) magnetic field. The admission of psychiatric patients to mental institutions coincided with sun flares. Also, the disturbed days as observed in mental institutions coincides also with the positive (north-seeking) magnetic field sun flares. In terms of a negative (south-seeking) magnetic field, he knew of its neuronal calming affect and was able to produce magnetic general anesthesia in sala- manders by using a negative (south-seeking) magnetic field on the back of the head. Thus the peer reviewed journal simply reinforces the observations by Becker of the oppositeness of the two poles

SCIENTIFIC PEER REVIEWED LITERATURE EVIDENCE OF SEPARATE AND OPPOSITE BIOLOGICAL RESPONSES TO SEPARATE AND OPPOSITE MAGNETIC FIELDS

Instrument evidence of separate magnetic fields:

A magnetometer (5) is an accepted scientific instrument that identifies magnetic poles of static field magnets as· positive and negative. Furthermore, a magnetometer identifies the magnetic poles produced at the opposite electromagnetic poles of a DC circuit as being positive and negative. The magnetometer identifies the north pole of the earth as negative and the south pole of the earth as positive. The gauss meter agrees with the magnetometer. The gauss meter also identifies magnetic polarity as positive and negative. Thus, it is seen that to understand these accepted scientific instruments used to identify magnetic poles there is a need to understand magnetic poles in terms of electromagnetic positive and negative.

It is universally accepted that a negative (south-seeking) static magnetic field spins electrons counterclockwise and the positive (north-seeking) static magnetic field spins electrons clockwise. Thus, again there is the identification of opposite response to separate and opposite magnetic fields.

WHAT EVIDENCE IS THERE THAT BIOLOGICAL RESPONSES TO OPPOSITE MAGNETIC FIELDS ARE OPPOSITE?

The following is from peer review scientific literature giving evidence of opposite biological responses to opposite magnetic pole fields.

1) A positive (north-seeking) magnetic fields encourages cancer growth while a static negative (south-seeking) magnetic field discourages cancer growth (4).

2) The negative electromagnetic field of a DC circuit evokes a biological alkaline pH response of 10 while the positive electromagnetic field of a DC circuit evokes a biological acid pH response of 2 (6).

The biological response of a pH of 2 at the positive electromagnetic pole of a DC circuit and a pH of 10 at the electromagnetic negative pole of a DC circuit has been confirmed by G. D. O'Clock, Ph.D. (7).

3) A positive (north-seeking) static magnetic field blocks melatonin production by the pineal gland and a negative (south-seeking) static magnetic field stimulates production of melatonin by the pineal gland (8).

PRIVATELY PUBLISHED, NOT PEER REVIEWED PUBLICATIONS THAT HAVE BEEN CONFIRMED BY THE ABOVE PEER REVIEW PUBLICATIONS

1) The physicist, Albert Roy Davis spent 60+ years detailing in animals the opposite biological response to opposite static magnetic fields. He found the biological response to a static positive (north-seeking) magnetic field is acidification while the biological response to a static negative (south-seeking) magnetic field is alkalinization. This agrees with the peer reviewed literature (9).

2) Robert O. Becker, M.D., demonstrated the opposite biological response to opposite static magnetic fields. The static positive (north-seeking) magnetic field is stressful and signals biological injury and neuronal excitation. The static negative (south-seeking) magnetic field is anti-stressful and necessary for biological healing and neuronal control of excitation. Mental patients subject to psychosis are excited by the positive (north-seeking) magnetic field sun flares frequently producing hospitalization and also confirmed by the "bad" days in mental institutions. On the other hand, neuronal excitement can be controlled by the negative (south-seeking) magnetic field and was used by him to produce general anesthesia in his salamanders (3).

The privately published non-peer reviewed research records of Albert Roy Davis and Robert O. Becker have been confirmed by peer reviewed published data. Thus, there is confirmed evidence of the separate and opposite biological response to the separate and opposite static magnetic fields.

The physicist, Albert Roy Davis (9) spent sixty years documenting the separate and oppositeness of magnetic fields.

He first observed this separateness and oppositeness in relationship to the behavior of earthworms. He documented the evidence that the biological response to a static negative (south-seeking) magnetic field is that of alkalinization and oxygenation. It is this evidence that attracted me to examine the biological response to magnetic fields. I found Albert Roy Davis' work to be reliable. I reproduced exactly what he said about alkalinization plus oxygenation with a negative (south-seeking) magnetic field and acidification plus lack of oxygen with a positive (north-seeking) magnetic field. It is on the basis of a negative (south-seeking) magnetic field producing alkaline-hyperoxia that maladaptive symptoms can be relieved. I have demonstrated that symptoms such as responses to food reactions, chemicals or inhalants was acidifying and reducing in oxygen and could simply be relieved by alkalinization and oxygenation. I originally used baking soda and the breathing of oxygen to relieve the symptoms. I found that a negative (south-seeking) magnetic field provided even more reliable value than baking soda and the breathing of oxygen. Now that we have documented peer review journal articles that have documented the separateness of the biological responses to the separate magnetic poles, we can understand and accept the evidence that both Albert Roy Davis and Robert 0. Becker have provided us in their documented evidence of the biological response separateness of the opposite magnetic poles. You cannot treat degenerative diseases such as cancer with a static positive (north-seeking) magnetic pole field of a static field magnet. It only makes it worse. Treating with a static negative (south-seeking) magnetic pole field and the alkaline- hyperoxia that is produced by this biological response to a negative (south-seeking) magnetic pole can and does reverse cancer and a lot of other symptoms that relate to chronic degenerative diseases.

The only way a positive (north-seeking) magnetic field can be used to kill cancer is with a DC current electrolysis in which a cellular destructive pH of 2.0 is produced. A positive (north-seeking) static magnetic field from a static field magnet produces an acid medium below the normal 7.4 and into a pH of below 7.0, but not a pH of 2.0. The acidic medium produced by a positive (north- seeking) static magnetic field is in the pH range that supports cancer cellular replication, microorganism replication and fermentation. Fermentation is acid-hypoxic dependent.

VALUES AND LIMITATIONS OF A POSITIVE (NORTH-SEEKING) MAGNETIC FIELD

All magnets that are on the market have therapeutic value. The testimonials stated by those who combined positive (north-seeking) and negative (south-seeking) magnetic poles or a positive (north- seeking) magnetic pole are believable. I am certainly not making any statement that these magnets using both poles or a positive (north-seeking) magnetic pole as long as the gauss strength is low enough, does not relieve pain. Of course, they relieve pain. The negative (south-seeking) magnetic pole by itself relieves pain no matter how high you go on the gauss strength. The positive (north- seeking) magnetic pole will relieve pain as long as you are low enough on your gauss strength in order for the body to counter the response with a counter-irritant reflex response. The use of the two poles side by side is also effective in relieving pain as long as you are low enough in your magnetic gauss field so that the counter-irritant reflex response can work. Not that there is any claim being made that these magnets have no value, it is the limitations that is the concern. Not the initial value. I doubt if anyone is making false statements about their claim of pain relief.

If the magnetic gauss strength is low enough, the body will respond with a correction which is symptom relieving. The problem with this is that the body quits making a counter stress response of providing a negative (south-seeking) magnetic field as a correction of the positive (north-seeking) or mixed poles that have been applied. This is about eight weeks in duration. There is documented evidence that this occurs by none other than Dr. Nakagawa (10), the inventor of magnetic beds. This evidence is recorded in his article published in *Japanese Medical Journal* by the title of *Magnetic Deficiency Syndrome*. This doctor, due to a faulty experiment, concluded that the biological response to opposite magnetic poles is the same. The biological response to the separate magnetic poles are the same if the gauss strength is low enough. However, you can be exposed to the negative (south-seeking) magnetic field without any limitation in duration because it is not a stress field. Dr. Nakagawa's experiment failed to test this. If you are exposed to the positive (north-seeking) magnetic field or the mixed field as his experiment was doing, there is a time limitation because the counter-irritant reflex fatigues and quits functioning. He calls this adaptation. He says this develops in about eight weeks.

Another limitation of a low gauss positive (north-seeking) magnetic field or a low gauss positive- negative mixed magnetic field is that of vasodilatation. It is oxygenation that is needed, not vasodila- tation. To assume that the only way extra oxygen can get to the affected area is by vasodilatation is incorrect. Oxygenation occurs when the area is alkalinized with the negative (south-seeking) magnetic field which activates the bicarbonate buffer system making it possible for the oxidoreductase enzymes to function. Oxidoreductase enzymes are alkaline dependent so first of all there has to be alkalinization. Then an activation of the enzymes. A negative (south-seeking) magnetic field serves both purposes. It activates alkalinization and activates the oxidoreductase enzymes in an alkaline medium. This releases oxygen from its bound state in free radicals, peroxides, acids, alcohols, and aldehydes. Vasodilatation limits the usefulness of either a positive (north-seeking) magnetic field or a positive (north-seeking) combined with a negative (south-seeking) magnetic field. When an acute injury, such as a bruise, an insect sting or other injury occurs, vasodilatation automatically occurs because the area becomes acidic. Blood becomes stagnated in this area because of the edema that the acidity produces. It is true that extra oxygen is needed but in this acute edematous injury blood cannot flow into the area and it is met with the acidity of the area which ties up the oxygen as it tries to get into the area.

When a negative (south-seeking) magnetic field only is placed over the area, the acidity rapidly leaves. Oxygen is released from its bound state in these inflammatory substances and now you have alkaline-hyperoxia and the edema goes down rapidly and the area, even though it could be turning dark, now becomes pink and there is no need for the extra blood to flow because there is an abun- dance of oxygen and alkalinity. Therefore, one of the serious limitations of using a positive (north-seeking) magnetic field or a combined positive-negative magnetic field is the problem created by vasodilation. Those using these methods say to put ice on this and wait a few hours for the cold to help clear the area of its edema and then use the magnets. Using a negative (south-seeking) magnetic field works immediately on this acute injury. It works just as well in a sub-acute or chronic injury state whereas the positive (north-seeking) magnetic field or the combined positive-negative magnetic field can only be used in the sub-acute or chronic state. There is absolutely no advantage in using the positive (north-

seeking) magnetic field or a combined positive-negative magnetic field over that of a negative (south-seeking) magnetic field only.

There is something that can fool a person into thinking that a positive (north-seeking) magnetic field or mixed positive-negative magnetic field is superior to a negative (south-seeking) magnetic field and that is that the stress of a positive (north-seeking) magnetic field or the presence of a positive (north-seeking) magnetic field in the mixed positive-negative magnetic field is that of evoking self-made narcotics (endorphins). This provides for a quick relief of pain. Whereas using a negative (south-seeking) magnetic field, instead of relief immediately such as within a minute, the relief would occur within 5-10 minutes. The narcotic relief is simply a different way of relieving pain from that of a correction of physiology such as alkalinization and oxygenation that a negative (south- seeking) magnetic field produces. To evoke a narcotic is itself a disadvantage because a person can become fooled by frequently using this to relieve pain when they actually become addicted to their self-evoked narcotics. It is very important not to use the positive (north-seeking) magnetic field or the positive-negative combined fields on the head because to do so will evoke endorphins which produces a sense of euphoria and also an altered judgement and when frequently used leads to addiction. There are documented cases of addiction to a positive (north-seeking) magnetic field.

Another limitation of using a positive (north-seeking) magnetic field or a positive-negative combined magnetic field is that of the inability to treat the heart. The heart is a very sensitive organ and is most sensitive to stress. A positive (north-seeking) magnetic field is a stress field and will speed up the heart. In a normal person it will usually speed it up ten points. Whereas a negative (south-seeking) magnetic field is an anti-stress field and will characteristically, in a normal person, slow the heart down by ten points. For those who have a predisposition to cardiac pains, sense of heaviness, disordered frequency such as skipped beats or tachycardia, a positive (north-seeking) magnetic field or a combined positive- negative magnetic field can precipitate symptoms. An example is a woman who called me stating that she placed a magnetic pad that is used for pain over her heart. Her heart started racing. She went to the doctor and he put her in the hospital. Inquiring as to what magnet she used, it was a pad that has both positive (north-seeking) and negative (south-seeking)

magnetic fields, side-by-side. A pad such as is used by some for pain. These pads used for pain are not suitable to use over the heart or the brain. These are simply limitations of that type of application whereas, a negative (south-seeking) magnetic field is useful for relieving pain in the heart, correcting the rhythm of the heart, and cleaning out arteriosclerosis of the heart. A negative (south-seeking) magnetic field is useful when applied to the head for the relief of anxiety, depression, and major psychotic symptoms such as delusions and hallucinations, and also for the control of seizures. A negative (south-seeking) magnetic field is also observed to have a measurable control over various types of movement disorders.

Another limitation is the documentation in the peer review literature that the pineal gland's response to a positive (north-seeking) magnetic field is to prevent the production of melatonin whereas, the response to a negative (south-seeking) magnetic field is to produce melatonin (8). This article is another evidence from the peer review articles of the separateness of the magnetic poles. the electromagnetic terms positive and negative applied to static magnetic fields is a peer review recommendation.

The bottom line is that the assertions that there is no evidence of a biological response difference to the two poles is simply not justified in view of the several peer review articles stating the separateness of the biological response to the separate poles. There is abundance of evidence from non-peer review objective-observed published information stating the separateness of the biological response to the separate poles. Now that we have peer review published confirming evidence, then this non-peer review published evidence is applicable. My documentation to the separateness to the two poles has not been peer review published, however, it consistently agrees with that which has been peer review published by D. Semm, Arthur Trappier, B. Nordestrom, and G. D. O'CLOCK, as well as the non-peer review documentations made by Albert Roy Davis, and Robert 0 Becker.

Conclusions

1) The naming of the magnetic poles using the electromagnetic definition of positive and negative rather than the geographic definition of north-seeking (north) or south-seeking (south) is recom- mended by the physicist, B. Belaney (2).

2) Separate opposite biological responses to separate and opposite biological magnetic fields are documented by peer

reviewed journals and reinforced by non-peer reviewed privately published objective observations made by both physicists and physicians.

3) The low gauss strength positive (north-seeking) magnetic field or low gauss strength combined positive (north-seeking) and negative (south-seeking) magnetic field, although therapeutically useful, have limitations not present when using a negative (south-seeking) magnetic field only with either low gauss strength or high gauss strength.

4) The limitations of a positive (north-seeking) magnetic field or a combined positive (north-seeking) and negative (south-seeking) magnetic field application are such as:

(1) Production of acid-hypoxia which encourages microorganism replication and cancer cell replication.

(2) Fatiguing of the counter irritant response at about eight weeks at which time symptoms can return.

(3) Magnetic addiction produced by evoking self-made narcotics (endorphins). This addiction is caused by the frequent use of a positive (north-seeking) magnetic field or mixed positive-negative magnetic field. Magnetic addiction produces the same biological deteriorating effects as any other addiction.

(4) Disordered heart function due to the stress of the positive magnetic field.

(5) The evoking of vasodilatation which makes this unsuited for treating acute injuries where vasodilatation and edema has already developed.

(6) An inability to treat chronic diseases due to the evoking of acid-hypoxia by the positive (north-seeking) magnetic field.

(7) The positive (north-seeking) magnetic field interference with melatonin production by the pineal gland.

(8) EEG readings prove the positive (north-seeking) magnetic field is a stress field and that the negative (south-seeking) magnetic field is an anti-stress field.

The bottom line is that a positive (north-seeking) magnetic field or a positive-negative magnetic field has no advantage over a negative (south-seeking) magnetic field only in terms of treating pain or treating insomnia.

A negative (south-seeking) magnetic field has the advantage of being able to treat acute disorders where there is swelling, edema and vasodilatation.

Magnetic Free Energy

The Secret of Magnetic Therapy

Biological life exists in a sea of free electrons (electrostatic field). Enzymes harness these free electrons as an energy source for the joining of enzymes to substrate (catalysis). The movement of electrons between enzyme and substrate produces a magnetic field. It is ultimately the magnetic field attraction that magnetically joins enzyme and substrate. Thus the free energy source of free electrons is more than electric, it is also electro-magnetic. Classically, in the presentation of enzyme catalysis, the magnetic aspect is not identified as being present. Ignoring the magnetic component of free energy during enzyme catalysis is an error since magnetic free energy from a static magnetic field can be harnessed to product enzyme catalysis. Thus there need not be dependence on the constant electron free energy since a static magnetic field can also supply free energy by activation of electrons. This magnetic free energy from a static magnetic field is the secret of magnetic therapy. The higher the gauss strength of the magnetic field the more efficient the enzyme catalysis. This fact changes the energy activation of enzymes from a constant energy activation of static electric field electrons producing a so-called "spontaneous" response to that of a maneuverable, variable, measurable and predictable enzyme catalysis. This is based on the static magnetic field moving free electrons.

The activation of enzymes in biological systems is temperature and pH dependent. Variations of temperature and pH from physiological normal influence the efficiency of the enzymes catalysis. Most human metabolic enzymes are alkaline dependant. The oxidoreductase enzymes necessary for human function are alkaline dependant. Oxidoreductase enzyme catalysis occurring from free elec- trons produces a negative magnetic field. Thus a static negative magnetic field from an external source such as a static field magnet can increase the efficiency of the oxidoreductase enzyme cataly- sis. Varying the static magnetic field gauss strength determines the efficiency of the enzyme function.

A static negative magnetic field activates the mineral bicarbonates by attaching to these paramag- netic bicarbonates. Thus, a static negative magnetic field alkalinizes and provides for the alkaliniza- tion necessary for oxidoreductase enzyme function. At the same time a static negative magnetic field energizes oxidoreductase enzyme catalysis. Four of these oxidoreductase enzymes are necessary for the production of adenosinetriphosphate

(ATP). At the same time as ATP is produced, oxidation remnant magnetism is produced. Oxidation remnant magnetism is a negative magnetic field.

This self-made negative magnetic field, oxidation remnant magnetism, is used to maintain alkalinity and for enzyme catalysis. There are ATP dependant enzymes which are, at the same time, also negative magnetic field dependant. Oxidoreductase enzymes have the assignment of processing the end products of oxidation, which are superoxide free radicals and their end products (peroxides, oxyacids, alcohols and aldehydes) and environmental toxins such as acids, alcohols, aldehydes, petrochemicals and toxic heavy metals.

All heavy metals in solvent form are electro-positive and therefore produce free radicals and complex with tissues. In the presence of a static negative magnetic field the electro-positivity of heavy metals is reversed; free radicals are processed to water and molecular oxygen and heavy metal complexing with tissues is prevented and reversed.

Enzyme catalysis is the energy movement making life energy available as well as the detoxification of toxins that would destroy biological life. Research discovery of the nutrients compromising enzymes is providing a necessary component of understanding how to make and maintain life energy.

The electro-magnetic component of non-nutritional free energy has been largely ignored or simply regarded as a nonvariable 'spontaneous' free energy enzyme activating system. In fact external magnetic fields provide a free energy activating source for enzyme catalysis, both for the produc- tion of life energy and its necessary defense against life destroying toxins. This use of an external magnetic source of free energy is magnetic therapy.

April 18, 2004

Dear Jon,

This letter concerns your question as to whether there is any university pursuing the evidence I have that a negative magnetic field reverses cancer.

About three years ago, Charles Steinberg had his wife in Montreal Neurological Institute. She had cancer of the brain. Charles Steinberg is a researcher at McGill University and Montreal Neurological Institute is a part of McGill University. Charles Steinberg has a Ph.D. in statistics. His wife had a diagnosed brain tumor at the Montreal Neurological Institute. She had lost much of the function of her left arm and leg. The tumor was on the right side of her head. Twice, she had been hospitalized and had gone through the usual treatment including surgery and chemotherapy.

She was now in her third hospitalization and there was nothing more to be done. She was there to die. The time had been projected for her death which was to be soon. Charles Steinberg called me, making inquiry about magnetic therapy. When he told me where his wife was, I told him he wouldn't have a chance because hospitals are not yet honoring magnetic therapy as an experiment. He said he would see what he could do about that. He found a law in Canada that states that if a subject is using a particular modality and it has not been demonstrated that modality is harmful, they can continue it. He told them that the United States FDA had classified magnet therapy to humans as not being harmful. They gave him permission to follow my instructions and place a 4" x 6" x 1" magnet on the right side of her head which was directly over the tumor. They told him that he would have to be responsible for placing the magnet there. He spent much of his time at her bedside with the 4" x 6" x 1" magnet in place. Within a three week period, which was projected as the time that she was expected to die, she had now regained the use of her left arm and left leg. The nurse came in and gave his wife an intravenous injection. Shortly after this, she coughed up blood and hemorrhaged and died in his presence. It turned out that this was an anticoagulant which was routinely given to people who were at bed rest. It had nothing to do with the treatment of the tumor. He looked at the record and found that she had been given an overdose. He approached the university, stating that he didn't want to sue them and would not sue them if they would do magnetic research on brain cancer. Based on this, I prepared a magnetic research protocol for brain tumor. It consisted of using my super magnetic head unit which I invented for the purpose of this research program. It consisted of using twelve 4" x 6" x 1" magnets. It places four on each side of the head and four on the crown of the head. For this project, I also invented the super magnetic hat composed of neodymium disc magnets that are 1" x 1/8". These are all around the head in the fabric of the hat. Half of the magnets were just attached to the outside of the magnets that were inside of the hat so that the quantity of magnets could be placed directly over where the tumor was.

It was agreed to that eighteen cases would be in the project. These were not to be end-stage cases, ready to die but cases that were judged as early stage and three months without any traditional treatment would not be considered endangering the life of the patient. The oncologist was enthusiastic about the program. Unfortunately, an economic crisis occurred in Quebec in which their legislature has been floundering as to what they were going to do about their Medicare. The oncologist at the Montreal Neurological Institute where they treated only brain tumors was discouraged, left the university and went to New York University. He carried with him the protocol but now he has no funds to carry out his

project. There has been no stable appointment of an oncologist to take his place so the Montreal Neurological Institute has not been able to fulfill their agreement for a research project. We are just sitting and hoping that two things will happen. One, that an oncologist will be appointed to the Montreal Neurological Institute who will proceed with the agreed program and that the oncologist at the New York University will obtain money for a research project, thus being two research projects. We are just sitting in limbo in the meantime. Since then, something interesting has happened over at the Jewish Hospital in Montreal. A physician at the Jewish Hospital had a relative with a brain tumor. He knew of the project that was planned at the Montreal Neurological Institute so he proposed to the Jewish Hospital that he proceed with the program using the head unit and the magnetic hat that I had invented for that project. This was a bad case. The subject had hydrocephalus because it was an enlarged, inoperable tumor that had become cystic and the cystic fluid of the tumor had to be drained even though they could not do any surgical intervention with the tumor. Even under these adverse circumstances, we won and the tumor was killed.

There is a Veterans Administration in Connecticut in which the Physical Therapy Department is using magnets they purchase from Enviro-Tech Products which is the organization owned by my daughter and son-in-law that makes the magnets that I use. They also purchase these magnets and send them home with the patients. They have also been influential in the Veteran's Administration Hospital purchasing several of our sleep system beds. They have not yet purchased the 70-magnet bed that I consider therapeutic but they have purchased several of our sleep beds. I have about 160 doctors who have signed statements that they will send me information about their patients. They send me patients or I send them patients, whichever it may be. We really are doing very well. The success rate of treating cancer is phenomenal. Cancer does die 100% of the time with adequate gauss strength and adequate duration. We can't win every time because some subjects bring to us the inability for them to survive no matter what is being done. Those are the ones where we cannot win. They are such as depleted liver function, gastrointestinal blockage with the health of the patient unable to undergo surgery, or obstructive lung disease being difficult one. Some of them come to us on oxygen. Other cases are such as hydrocephalus from a tumor that has blocked the flow of cerebral spinal fluid. We can still win if the patient is capable of surviving. We have won even in cases where the cancer from such as an ovarian tumor has spread throughout the abdomen. In those cases, besides the bed, we place a suspension unit which holds 4-6 of these 4" x 6" x 1" magnets directly over the person without any weight from the magnets.

We are also having fantastic results with treating schizophrenia. The

case histories of two of those were placed in my quarterly on Cancer. I find that schizophrenics all give a history of their childhood learning and behavioral difficulties. I find that the child with attention deficit disorder, obsessive compulsive disorder, dyslexia and other disruptive behavioral disorders (and this includes autism) are all the same illnesses as schizophrenia. Their brain simply hasn't been injured as much by the viral infections. I find they all have the same viral infections which is either Epstein-Barr, cytomegalovirus or both. All of these lesser childhood behavioral and learning disorders are candidates for schizophrenia and we have those which we diagnosed with these disorders and by the time they are 20, they are schizophrenics who are now hallucinating and delusional. Not all progress to this latter state but all are candidates. All have been injured by the same viral infections. Originally, I tested broadly both by antibody and cultural studies. I found that it narrowed down that consistently these brain disorders had either Epstein-Barr, cytomegalo or both. So therefore, in later years I narrowed my examination down to antibodies of Epstein-Barr, cytomegalovirus and human herpes virus #6. It turns out that human herpes virus #6 produces multiple sclerosis. That virus is consistently present in multiple sclerosis, therefore the treatment for all of these conditions is to treat the viruses with a strong negative magnetic field which our 70 magnet bed supplies. The herpes viruses do not die. The body has no ability to immunologically kill these viruses. The reason is these viruses have what is called stealth adaptation. That is, they can drop out whatever the immune system is responding to. They still survive because the human immune system cannot kill them because of their stealth adaptation. They can even have a viral infection received from a person whose viruses have undergone stealth adaptation and the immune system of the subject will not produce any antibodies and yet they can be cultured as live viruses from the blood. In order to develop schizophrenia, the child has to receive this viral infection in early life. That injures the brain from its ability for normal development. If however, they get this disease after the brain is mature, the disease will probably be called infectious mononucleosis and the chronic state will be called chronic fatigue and fibromyalgia, which of course always includes depression but not psychosis. Thus, these viruses are really very wicked. There are other infectious states that can have similar symptoms as these viral infections. One that is prominently showing up now is Lyme's disease. The program of the 70 magnet bed will kill any of these organisms. It is interesting that a stool culture showing numerous pathological bacteria and fungi will, after three months of treatment on the bed, show none of these pathogens. However, the good bacteria will be flourishing. The reason for this is that all of the invading microorganisms and parasites are positive

magnetic oriented and make their ATP by fermentation either entirely or at least substantially. Whereas, the good bacteria are negative magnetic oriented and they cannot invade the human body because their negativity is repelled by the cellular negativity of the human cells. Yet they can grow in the gastrointestinal tract and make vitamins for us. It is classic that textbooks will give a picture of a competing space in the gastrointestinal tract between the pathogens and the good bacteria. However, that is not what happens when a person sleeps on a strong negative magnetic bed. There is not competition. The good bacteria are flourishing and the bad pathologi- cal bacteria and parasites all die.

My first use of negative magnetic field energy was that of reversing symptoms that had been created by food testing and the deliberate exposure to chemicals. The next step I took is to provide magnets treating the brain and other parts of the body before the deliberate exposure to substances that I knew they reacted to from prior tests and I found it was just as easy to prevent a symptom from occurring as it was to relieve it once it had occurred. Based on this, I have incorporated exposure to magnets ahead of a meal. With this system, we don't have to wait three months for desensitization to occur but they can start their rotation immediately. We more often use a seven day rotation. A negative magnetic field is desensitizing.

It is desensitizing to allergies and addictions and toxicities. A negative magnetic field is the best method of all of desensitization. The quantity of the antigen can be a large quantity. The negative magnetic field will always block the response. Providing exposure to the antigen with the negative magnetic field blocking it and desensitizes. The positive magnetic field is the ideal sensitizer and can be used for vaccination.

A current project is that in preparation is the making of a CD disc that will pulse within the anti-stress range which is below 13 cycles per second. Two cycles per second is ideal. The magnetic state of the brain can be driven by sensory impulse; sight, sound and tactile. I am also going to make a DVD that synchronizes sight and sound. With this, we can do the same things that I do with placing a magnet on the head because we can drive the neuronal state of the brain cells and thus of course, secondarily the other cells of the body will join the neurones pulsing. Deep sleep is two cycles per second. Anesthesia is one cycle every 2 seconds. My life goal is to place on

the market, magnetic anesthesia. It will be completely harmless. No toxicity whatsoever. It will not influence heart function or respiration. It will replace chemical anesthesia. Also, it could be used for local anesthesia wherever there is pain. Any pain will leave in the presence of magnetic anesthesia and is likely to stay away for an extended period of time and can be repeated as often as necessary without any harm. I visualize the day when psychiatrists will have a magnetic anesthetic machine in their office. A subject can come into the office insane and a few, minutes later, leave sane. This could be repeated as often as necessary and do so without harm. Electric shock is an electrically produced state of magnetic anesthesia. First, with a high level positive magnetic field stimulation a seizure is produced. Following this, the brain automatically switches to a negative magnetic field for several minutes. This is the benefit of electric shock. Not the seizure.

Magnet therapy has a bright future. It is an antibiotic. It is anticancerous. It is the most detoxifying system there is. It will replace chemical anesthesia and on and on. Thanks for listening.

Sincerely,
William H. Philpott, M.D.
February 14, 2005

As I have thought about it, I thought you would be interested in more of the history of magnet therapy and particularly as it relates to reversal and the death of cancer. There exists a communication problem with traditionally trained physicists. I have explained this in the Energy Medicine quarterly that I have sent to you. The original model of magnetic response only dealt with the ferromagnetic response to magnetic fields. A ferromagnetic material responds to either a positive or negative magnetic field in the same way, which is of course, an attraction. This gives the impression that magnetism is one energy. The physicist comes out of his training, even if he is a Ph.D, with the concept that magnetism is one energy. There is nothing in the physicist's training relating the biological response to separate magnetic fields. I made a presentation at a medical meeting in which I demonstrated particularly the heart's response to separate positive and negative magnetic fields. I observed that in a normal person without a heart problem, that when the heart is exposed to a negative magnetic field it slows down ten beats a minute which makes it behave like a person who is well-exercised and capable of relaxation. Whereas, when the heart is exposed to a positive magnetic field it behaves as a person under stress, that is the heart will beat ten times a minute more. I also observed that the heart skipping beats will normalize its pulsing frequency if and when it is exposed to a negative magnetic field. I also observed that a positive magnetic field can set off tachycardia in a person whose heart is

predisposed to this possibility and that a negative magnetic field can reverse the tachycardia. There were two physicists present who had publicly stated that they wanted to contribute to magnet therapy. Both of them offered the criticism of my observations by stating that a magnetic field is only one energy and they completely discounted my objective observations of the heart's response to the separate positive and negative magnetic fields. They had absolutely no experience in exposing the human biological system to the positive and negative magnetic fields. They just discounted it and said that my observations were wrong. Thus, if you have two physicists who want to contribute their knowledge to medicine and they are blocked by their original model that is published in the books that they are reading that indicates that magnetism is only one energy. I think this is sad. We can't make progress until the physicists understand that there are two energies and that the biological response is opposite to these two energies.

Albert Roy Davis was a high school science teacher. He didn't have a Master's degree and he didn't have a Ph.D. He simply was an interested science teacher at the high school level. He had a hobby of fishing and using earthworms for his fishing. He had a horseshoe magnet on a bench and just by chance, he had two cartons of earthworms and had set one at the positive pole and one at the negative pole. A few days later, he was ready to go fishing and picked up his two cartons. The worms that were at the negative pole had shriveled up and died. The worms at the positive pole had eaten through the carton. Obviously, the worms at the negative pole couldn't feed and the worms at the positive pole were active and feeding. This caused him to start looking at the separate biological responses of the two magnetic fields. He did find that an earthworm, the intestinal tract of smooth muscle and the intestinal muscles were inactivated at the negative pole and at the positive pole the smooth muscle was activated. In time, he was able to demonstrate that the negative pole is anti-stress and that the smooth muscle does tend to calm down and that the positive pole causes the smooth muscle to become more activated which is a stress. Therefore, he was able to outline the negative magnetic field as biologically anti-stress and the positive field as biological stress. He was able to demonstrate that the biological response to the negative magnetic pole is alkaline-hyperoxia and to the positive magnetic pole, the biological response is acid-hypoxia. He cultured cancer on rat's skin and then treated them with a negative magnetic field. The negative magnetic field killed the cancer. He then planted cancer on his own skin and came up with the same results that the negative magnetic field killed the cancer and the positive magnetic field would make the cancer grow. He did this 6 times on himself, thus coming up with convincing evidence that with the negative

magnetic field sustained, it kills cancer. This was never published in peer reviewed literature. It was published in the book that he wrote of his observations. He tried to get publication in peer reviewed literature. No one would publish his findings. He tried to get government funds for research and he could never get funds. He did have small amount of money given to him which supported him as he proceeded. One of my friends who was at the time a flourishing real estate agent in Los Angeles, sent him $25,000 regularly for several years. All he had was this small group of supporters to help him. His work was in Jacksonville, Florida. When I was practicing in St. Petersburg, just by chance, I heard of Albert Roy Davis. I went to see him. He had died just a few months before. Walter Rauls showed me around. He had helped him in writing his research observations and put them into a small book. I was given a copy of a sale of a 4" x 6" x 1/2" magnet to the Research Department of MD Anderson Hospital in Houston, TX. Their research department had examined the response of cancer to a negative magnetic field. This researcher enthusiastically called Albert Roy Davis and said that he also had observed that a negative magnetic field kills cancer. A few days later, Albert Roy Davis received a call from a physician at MD Anderson Hospital and he was told that he was forbidden to make any statement about the observation of their researcher. Then, they dismissed the researcher. This all occurred about 35 years ago. This researcher was a friend of Albert Szent-Gyorgyi who had written a book called *Electronic Biology and Cancer: A New Theory of Cancer*. It made sense to this researcher that a negative magnetic field could kill cancer. Albert Szent-Gyorgyi had stated that cancer results from a disorder from self-proliferation regulators such as occurs in hypoxia and oxidoreductase enzyme inhibition. At that time, he had not isolated that it was a negative magnetic field although he had postulated that there was an energy that controlled cellular proliferation. Since then, we have confirmed that the negative magnetic field controls cellular proliferation. We now know what he was looking for. Thus, MD Anderson Hospital had the evidence better than 30 years ago that a negative magnetic field will kill cancer. They forbade this information to be made public and fired the researcher. MD Anderson Hospital has focused its attention on chemotherapy and ignored the potentials of magnet therapy.

What we need published in the peer review literature is a new model of magnetism that incorporates the established biological responses of the separate positive and negative magnetic fields. With this, the physicists in training will be prepared to work with the physician with the significance of the two opposite biological responses to positive and negative magnetic fields. As it is now, they are stuck with a model that has ignored biological responses to separate magnetic fields. I am

telling you this because I hope that you or some of your friends that are chemists or physicists will take up some of the responsibility of making a modernized model for magnetism. I can tell you something about how to respond. Of course, first of all, you do observe the biological responses of both positive and negative magnetic fields and outline this such as the heart response, skin response, brain response and the EEG response. There are many ways of establishing the separateness of the biological response to the separate magnetic fields. Even the response of electrolysis is valuable. At the positive electric pole, which of course is surrounded by a positive magnetic field, the pH is 2. At a negative electric pole, which is of course surrounded by the negative magnetic field, the pH will be 8. So here you have the acid-alkaline separate responses even in electrolysis. On my own skin, I placed a neodymium disc magnet that was 1" across and 1/8" thick. I placed a positive magnetic field on my skin and a few inches away, I placed a negative magnetic field. I left them on for 2 weeks. At the end of 2 weeks, under the negative magnetic field, the skin was entirely normal. Under the positive magnetic field, there was a vasculitis with pustules. Also, it was painful and of course, there was no pain at all under the negative magnetic field. It is easy to demonstrate also that a skin infection will die in the presence of a negative magnetic field and will grow in the presence of a positive magnetic field. The same is true of skin cancers. Just for your interest, I have sent you pictures of the treatment of basal cells. This was done at the local university medical school here in Oklahoma City. This dermatologist had taken a picture of before and after. This was on a man who was a representative of a drug company and knew the doctors well because he frequently visited them. He had had these pictures taken. The cancer died in the presence of the negative magnetic field and the pictures showed this. This patient got me to communicating with the dermatologist. He invited me to come to the dermatology department of the university and make a presentation. To arrange for this, he contacted his superior who was in charge of the department. This department head would have nothing to do with this so he had to call me and say, "I can't arrange for you to make a presentation. My department head will not allow it" Then he said, "I have investigated and NIH would give us funds for a research project but I can't do the project because my superior won't let me."

Katherine and I were under the care of the eye department at the university. Katherine and I both had some cataracts. Katherine could no longer thread a needle. We both treated our eyes with the negative magnetic field. Our cataracts were markedly improved and Katherine can even thread a needle now. So I proposed to this ophthalmologist who was in charge of the ophthalmology depart- ment at the university

that he do a research project on the value of a negative magnetic field in reversing cataracts and of course, under his observation, we had already demonstrated the value in both Katherine and I. He really was frightened by the idea. He said, "I would have to go to the university and get permission to use magnets in a research. I would be laughed at. I can't do this. I won't do this." He really was adamant and obviously frightened about even the idea so of course, the project never got done even though, under his supervision, we had demonstrated the evidence of the value.

It is of interest to know about what happened at a committee meeting at the National Institutes of Health on electromagnetism. In order to fulfill Congress' request to examine alternative medicine, the NIH formed committees in important areas. One was the Electromagnetic Committee. Five Ph.D. Physicists from universities were appointed. Two M. D.'s were appointed — Robert O. Becker and myself. I was already in my program of observing the values of magnetic therapy. None of the physicists had anything to say. None of them had a program that related physics to medicine. I then, told of my program and of course, I emphasized the separate biological responses to positive and negative magnetic fields. At that time, I had no knowledge of Dr. Becker's observations. I had not read his two books. Dr. Becker immediately endorsed what I was doing and said I was doing the right thing in the right way. He also observed that I was using the static magnetic field in my research and not a pulsing field and he said "even though I am a party to a bone treatment instrument called the Bassett Instrument which does pulse, there is really no reason for it to be pulsing because you achieve the same results with a static magnetic field." In fact he said there is nothing that a pulsing magnetic field can do that a static magnetic field doesn't also do. One of the physicists who was not the chairman of the committee but assumed the role of speaking for the physicists, commented, "We want to help you physicians." Dr. Becker, surprisingly and rather curtly, answered him back saying, "We physicians already know the value of magnetic application to humans. We ask you to tell us how it works." There was no further comment by the physicists and so in all the intensity, it appeared the meeting was over so Dr. Becker and I got up and left. All the physicists stayed. Dr. Becker then said to me, "I come up with my best formulation, and these Ph.D.'s try to cut me down." In his attempt to publish in peer reviewed literature, he had met the criticism of Ph.D.'s and particularly the one that spoke up and said we want to help you. They were critical of his work and interfered with him getting published in peer reviewed literature. This is the same physicist that later criticized my observations about the biological effects of the separate positive and negative magnetic fields, especially as they related to heart function. His criticism was simply that a magnetic field

is one field and not two fields and therefore, my observations simply were not valid. He didn't even consider that there would be a value in seeing if someone could confirm what I had observed. I knew of course, that it had been confirmed by Dr. Becker and had been initially even stated by Albert Roy Davis. I had gotten my information from Albert Roy Davis. When I did read Dr. Becker's work, I found that we were in agreement. In my later writings, I frequently refer to Robert O. Becker as a confirmation of what I had observed. Beverly Rodrick, Ph.D., of Temple University was chairman of the committee on electromagnetism. As it turned out, the physicists had all stayed after Becker and I left and had their own committee. Their opinion was that I was wrong in my observations. They purposely did not want to state that I had a program that should be endorsed. The final statement by Dr. Rodrick said nothing about my statement or Dr. Becker's endorsement of my research and in fact, when I received this final statement which in itself was a good one, but made no mention of the separate biological response to the separate poles, my name was left out of even being on the committee. I wrote to her and pointed out that my name was not on the committee. She wrote a letter back to me that it was an oversight. It is as though I wasn't important to the committee. They purposely didn't endorse what I had observed and by error my name was even left out as having been on the committee.

I received a phone call from the National Institutes of Health asking me if I would be on a committee deciding grants in magnetism. I had to think about it and the timing that would be involved. I wrote a letter stating that I would be pleased to be on the committee. I didn't hear from them right away so therefore I called and was told that in the meantime before they received my letter, they had found someone else to be on the committee to take my place. They said they would call me at a later date. I haven't heard from them and it has been over a year. I understand that Dr. Robert Becker is on the committee deciding grants. The Cardiac Research Department of Oklahoma University Medical School did apply for a grant and was turned down. The program was not a good program and I would have to have turned it down also had I been on the committee. I am in communication with them and hopefully can encourage them to apply for a grant in the treatment of cardiac arrhythmia. They haven't decided to do that, however, interesting enough, they will send me subjects for my research.

I recently wrote a protocol for a brain tumor case and, as usual, I sent along a copy for the monitoring physician. The oncologist had done everything he could for his patient and had come to the end of his rope and had no more treatment for her. When he examined the protocol, he laughed about the idea of a magnetic field treating a brain tumor and

in humor he said to the patient, "Did you say that doctor's name was 'crackpot'?"

Recently I was called by a medical doctor friend of mine and he said, do you have any idea how many times your name appears on the Internet. I, of course, have no idea. I don't even have an Internet, although Enviro-Tech Company has my name there. He says my name is on the Internet 2,500 times. Most of these of course are good, but I also know of one, an oncologist who was so incensed by the idea of a negative magnetic field treating cancer that he wrote a denial and placed it on the Internet. His denial was that Otto Warburg made his statement back in the 30's for which he of course was given the Nobel prize and then he says, "That was so long ago that certainly it is now outdated and not correct." He gave no evidence that this is true, in fact, we have even recent evidence confirming that Otto Warburg was right all the while. Of course, I used to have writings on nutrition and I did write chapters to 17 books that I did not author. Every once in awhile, someone will tell us that they got my name off of the Internet because someone had been so pleased with their treatment that they told about it and put it on the Internet.

Of course we meet with resistance of something new. Even when MRI was being developed, there was considerable resistance with physicists simply saying, "It can't work." Now it has an honorable position in medicine. Interestingly enough, the doctor who invented MRI started out to determine if he could develop a magnetic treatment for cancer. His sister had died of cancer and this was his motivation. He got side-tracked from his original goal of finding a magnetic answer for cancer and developed the MRI. He never did proceed to determine if he could use a negative mag- netic field to reverse cancer. It would be incorrect for me to give you the impression that I am meeting a lot of resistance. I am meeting a lot of open-minded physicians. I have at least 160 who have reported cases of value to me. There are lots of grateful people who are now using magnets for many kinds of conditions. It just happens that more cases of cancer are now coming to me than any other kind simply because medicine has such a poor answer and in the majority, we have an answer. We also have a beautiful answer for schizophrenia, manic-depressive. No tranquilizers. No antidepressants. We have subjects who were useless, hallucinating or delusional, who, with the magnetic program, have no symptoms of psychosis at all and are attending the universities. Just imagine a universal antibiotic. We have it. And it works. Just imagine a universal anti-inflammatory agent. We have it and it works. Just imagine a universal anti-stress system. We have it and it predictably works. The future of magnetic therapy is bright and it's efficiency is such that it

will be a substantial part of tomorrow's medicine. It's efficiency is such that it is making its inroads today. In my years of medical practice, I never found anything with the predictableness of magnetic therapy.

What about you and your physicists and M.D. friends doing a project providing an updated physics magnetic model including separate responses to the positive and negative magnetic fields. You could head up the research project and obtain money from NIH. Research grants in magnetism are being provided. You could hire physicians to do segments of the projects.

Sincerely,
William H. Philpott, M.D.
Dear Dr.

I am delighted to receive your call and your interest in the recent program testing the value of magnet therapy. I am an experienced psychiatrist, having given over 70,000 electric shock treatments and over 50,000 non-seizure electrical stimulation of the brain treatments using the Reiter Sedac. Therefore, I am in a position to make judgement about the values.

The simplest and most minimal magnet therapy treatment for the brain, whether this is tension, anxiety, depression, phobias, delusions or hallucinations, is that of using ceramic disc magnets that are 1-1/2" across and 1/2" thick. These are flat magnets with opposite magnetic fields on opposite sides, therefore the single polarity field can be applied. Place the negative magnetic field of the disc magnets bitemporally, that is above the ears and in front of the ears about an inch or so. These are placed directly over the amygdala and it is through the amygdala that this influences our brain. Usually within five minutes, sometimes even up to 15 minutes, we will have symptom relief. It doesn't matter whether these are minor or major symptoms, neurotic or psychotic. Symptom relief nearly always occurs. This simply calms the brain. A non-stress state of the brain is a negative magnetic field which is a pulsing of the brain no higher than 12 cycles per second. I am a neurologist as well as a psychiatrist and have much experience in EEG, having been in charge of the EEG Department of a hospital and having read thousands of EEG's. The placement of a static magnetic field on the brain has a response of the brain pulsing. With the negative magnetic field, the brain pulses below 12 cycles per second. The higher the gauss strength, the slower the pulsing field. When using a positive magnetic field on the brain, the pulsing field is 13 cycles and beyond. The higher the gauss strength, the higher the pulsing field and it can go dear up to 35 cycles per second, producing a seizure. Disc magnets are strong enough to calm the brain down. I find this to be superior than any tranquilizers, antidepressants or electric shock treatment whether this is seizure

produced or non-seizure produced. The treatment of seizures is a magnetic treatment. Seizure level magnetic treatment is a high positive magnetic field with a frequency of 35 cycles per second. The value is not the treatment. The value is the brain adaptation for correction of that high stress. The subject goes into an anesthetic state in which the brain is pulsing very slow and this is the value. However, when we are using the negative magnetic field on the brain, we are not going through the stress to arrive at a reflex non-stress. We are going directly to the non-stress. Therefore, there is no disturbance of consciousness and no symptom production at all, only symptom reduction. This certainly deserves to be statistically studied. It costs $21.95 for these magnets and the band that holds them and it costs $8.50 to ship these two magnets and the band.

I do not, however, consider this minimal treatment to be optimal at all for my patients because what I have found is that they are reacting to foods and chemicals. I found that on an average they will react to at least six different foods and sometimes more. We discovered this by fasting our patients for five days which to my surprise, they were symptom-free. They were all schizophrenic or manic depressive and even if they were a seclusion case, after five days of just water only, they were sane. I mean they were routinely sane, not just occasionally. Then feeding them meals of single foods showed which foods evoked which symptoms. The foods that evoked symptoms more frequently than any other was that of gluten foods -- wheat, rye, oats, barley and corn. But, it could be any food that they use frequently.

It wasn't foods that they used infrequently, only foods they used frequently. We determined that there were three mechanisms. One is addiction in which the symptoms emerged in the withdrawal stage of the addiction. Food addiction is very real, just as much as narcotic addiction. Or food allergy is another mechanism. Toxicity is another. Anyway, the frequency made all the difference as to whether this happened or not. Therefore, we had our patients go without any of these foods that produced symptoms for three months. Interestingly, schizophrenics have more physical symptoms than they have mental symptoms. Gastrointestinal symptoms are very common. With a 4 or 7 day rotation diet, many subjects were symptom-free. They had to be sure they were not addicted to anything like tobacco or alcohol because they would develop their symptoms again if they used any addictive substances, including addiction to foods. Allergy to a food and addiction to foods behave alike. They both have a delayed withdrawal phase which occurs at about 3-4 hours after eating the food. The only way you can tell a difference between an allergy and an addiction is to whether there were antibodies to the food or not. If there weren't antibodies, then this is either a food addiction or a food toxicity. Routinely, both are present. We did

antibodies on thousands of cases.

Dr. Theron G. Randolph of Chicago had taught me to use soda and potassium bicarbonate after a person had symptoms to a food. This was fair in it's relief. If necessary, we gave bicarbonate intrave- nously. However, just by chance I heard about a negative magnetic field producing alkaline-hyperoxia. From this basis, I tested to see if it relieved my patient's symptoms from the food reac- tions and it did a marvelous job. Better than the bicarbonate. The next step was to discover if I put the magnets to the head, heart and the liver ahead of a meal, did it prevent the reactions from occur- ring and lo and behold, it did. We can block these reactions by treating the patient ahead of the meal with magnets. We use the bitemporal placement and then a 4" x 6" x 1/2" magnet over the heart and one over the liver. The one over the head is essentially adequate. The heart of course will treat the blood. All the cellular elements as well as the water will be magnetized or ionized negatively. The liver, of course, being a detoxifying organ, would quickly detoxify. We really are having marvelous results with this.

William H. Philpott, M.D.

Magnetic Free Energy
The Secret of Magnetic Therapy

Biological life exists in a sea of free electrons (electrostatic field). Enzymes harness these free electrons as an energy source for the joining of enzymes to substrate (catalysis). The movement of electrons between enzyme and substrate produces a magnetic field. It is ultimately the magnetic field attraction that magnetically joins enzyme and substrate. Thus the free energy source of free electrons is more than electric, it is also electro-magnetic. Classically, in the presentation of enzyme catalysis, the magnetic aspect is not identified as being present. Ignoring the magnetic component of free energy during enzyme catalysis is an error since magnetic free energy from a static magnetic field can be harnessed to product enzyme catalysis. Thus there need not be dependence on the constant electron free energy since a static magnetic field can also supply free energy by activation of electrons. This magnetic free energy from a static magnetic field is the secret of magnetic therapy. The higher the gauss strength of the magnetic field the more efficient the enzyme catalysis. This fact changes the energy activation of enzymes from a constant energy activation of static electric field electrons producing a so-called "spontaneous" response to that of a maneuverable, variable, measurable and predictable enzyme catalysis. This is based on the static magnetic field moving free electrons.

The activation of enzymes in biological systems is temperature and pH dependent. Variations of temperature and pH from physiological normal influence the efficiency of the enzymes catalysis. Most human

metabolic enzymes are alkaline dependant. The oxidoreductase enzymes necessary for human function are alkaline dependant. Oxidoreductase enzyme catalysis occurring from free elec- trons produces a negative magnetic field. Thus a static negative magnetic field from an external source such as a static field magnet can increase the efficiency of the oxidoreductase enzyme cataly- sis. Varying the static magnetic field gauss strength determines the efficiency of the enzyme function.

A static negative magnetic field activates the mineral bicarbonates by attaching to these paramag- netic bicarbonates. Thus, a static negative magnetic field alkalinizes and provides for the alkaliniza- tion necessary for oxidoreductase enzyme function. At the same time a static negative magnetic field energizes oxidoreductase enzyme catalysis. Four of these oxidoreductase enzymes are necessary for the production of adenosinetriphosphate (ATP). At the same time as ATP is produced, oxidation remnant magnetism is produced. Oxidation remnant magnetism is a negative magnetic field.

This self-made negative magnetic field, oxidation remnant magnetism, is used to maintain alkalinity and for enzyme catalysis. There are ATP dependant enzymes which are, at the same time, also negative magnetic field dependant. Oxidoreductase enzymes have the assignment of processing the end products of oxidation, which are superoxide free radicals and their end products (peroxides, oxyacids, alcohols and aldehydes) and environmental toxins such as acids, alcohols, aldehydes, petrochemicals and toxic heavy metals.

All heavy metals in solvent form are electro-positive and therefore produce free radicals and complex with tissues. In the presence of a static negative magnetic field the electro-positivity of heavy metals is reversed; free radicals are processed to water and molecular oxygen and heavy metal complexing with tissues is prevented and reversed.

Enzyme catalysis is the energy movement making life energy available as well as the detoxification of toxins that would destroy biological life. Research discovery of the nutrients compromising enzymes is providing a necessary component of understanding how to make and maintain life energy.

The electro-magnetic component of non-nutritional free energy has been largely ignored or simply regarded as a nonvariable 'spontaneous' free energy enzyme activating system. In fact external magnetic fields provide a free energy activating source for enzyme catalysis, both for the production of life energy and its necessary defense against life destroying toxins. This use of an external magnetic source of free energy is magnetic therapy.

www.ingramcontent.com/pod-product-compliance
Lightning Source LLC
Chambersburg PA
CBHW020717180526
45163CB00001B/10